ARTS IN AMERICA

A BIBLIOGRAPHY

BERNARD KARPEL
Editor

VOLUME 1

Art of the Native Americans

Architecture

Decorative Arts

Design

Sculpture

Art of the West

(SECTIONS A-G)

VOLUME 2

Painting and Graphic Arts

(SECTIONS H-M)

VOLUME 3

Photography

Film

Theater

Dance

Music

Serials and Periodicals

Dissertations and Theses

Visual Resources

(SECTIONS N-U)

VOLUME 4

Index

RUTH W. SPIEGEL, *Editor for the Publisher*

SMITHSONIAN INSTITUTION PRESS

WASHINGTON, D.C.

ARCHIVES OF AMERICAN ART, SMITHSONIAN INSTITUTION

ARTS IN AMERICA
A BIBLIOGRAPHY

BERNARD KARPEL

Editor

VOLUME 3

SECTIONS N–U

Photography
Film
Theater
Dance
Music
Serials and Periodicals
Dissertations and Theses
Visual Resources

SMITHSONIAN INSTITUTION PRESS

WASHINGTON, D.C.

Library of Congress Cataloging in Publication Data
Main entry under title:

Arts in America, A Bibliography

 CONTENTS: v. 1. Art of the Native Americans,
architecture, decorative arts, design, sculpture,
art of the West. — v. 2. Painting and graphic arts. —
v. 3. Photography, film, theater, dance, music,
serials and periodicals, dissertations and theses,
visual resources. — v. 4. Index.
 1. Arts, American — Bibliography. 2. Arts — United
States — Bibliography. I. Karpel, Bernard, 1911-
II. Archives of American Art, Smithsonian Institution.
Z5961.U5A77 [NX503.A1] 016.7'00973 79-15321
ISBN 0-87474-578-0

CONTENTS
Volume 3

N

Photography

BEAUMONT NEWHALL

CONTENTS

INTRODUCTION

Photography came to America in the fall of 1839, just a few months after the English inventor William Henry Fox Talbot published his "photogenic drawing" process, and Louis Jacques Mandé Daguerre's process was publicly disclosed by the French government. The medium of photography took root at once, and almost immediately books began to appear—largely technical manuals based on English and French publications. Over eighty of these instruction books were published between 1840 and the outbreak of the Civil War. The first periodical in the world devoted exclusively to photography, *The Daguerreian Journal* [N315], was launched in November 1850, to be followed by two others within months. From this beginning, the bibliography of American photography grew rapidly, keeping pace with every technical innovation — and increasing interest in photography as an art form. *The Philadelphia Photographer* [N324] bound an original photograph in each of its monthly issues, beginning in 1864, and this constitutes a rich collection of the work of leading American and European professional photographers. With the advent, toward the end of the century, of photomechanical reproductions of photographs, thousands of amateur photographers were provided with professional models. Alfred Stieglitz devoted a great part of his time to publishing and editing; his quarterlies *Camera Notes* [N310] and *Camera Work* [N312, N824] helped to alter the course of pictorial photography.

The publication of monographs of the work of individual photographers is more recent, and has become a principal vehicle for the photographer's presentation, supplementing and documenting exhibitions. Yet more recent are scholarly histories of photography—international, national, and regional. Without the vast body of previously published material, historians would be at a loss to grasp the development of the art of photography, to trace its remarkable growth, and to identify the interrelated directions it has taken.

This bibliography is limited to the description of publications I have found basic. The aim is to furnish a guide to what is now a massive body of literature. I have chosen, so far as possible, key works. If these works contain substantial and scholarly bibliographies, I have refrained from repeating entries beyond those that I consider basically essential. In general I have limited my entries to books. Where none yet exist, I have entered periodical articles. I have also included periodical articles that have appeared since the publication of standard works, and consequently do not yet appear in their bibli-

ographies. Where titles do not fully describe the contents, and where value judgments appear helpful, I have made brief annotations. I hope the reader will find these annotations useful. In the compilation of this bibliography I have been greatly aided by Thomas F. Barrow, Richard D. Zakia, Diana Edkins, Susan Harder, Anne Tucker, and especially Bernard Karpel, whose encouragement, patience, and ever-ready cooperation has been of the greatest help. To all these colleagues I express my deep thanks.

BEAUMONT NEWHALL

HISTORY, CRITICISM, COLLECTIONS, AND EXHIBITIONS

Reference Works

BIBLIOGRAPHIES

N1. Boni, Albert, ed. Photographic Literature: An International Bibliographic Guide to General and Specialized Literature on Photographic Processes; Techniques, Theory, Chemistry, Physics, Apparatus, Materials and Applications, Industry, History, Biography, and Aesthetics. New York: Morgan & Morgan, 1962. 535 p.

N1a. Boni, Albert, ed. Photographic Literature, 1960-1970: An International Bibliographic Guide to General and Specialized Literature on Photographic Processes. Hastings-on-Hudson, N.Y.: Morgan & Morgan, 1972. 535 p.

The two complementary volumes [N1 and N1a] comprise the most comprehensive bibliography on photography in print, in dictionary form with an excellent author index. Many of the entries are carefully annotated; key works are noted with a prominent symbol, and bibliographies within cited works are described. This is an essential reference tool for the technologist though of limited value to the art historian, social historian, and creative photographer.

N2. Bunnell, Peter C., and Sobieszek, Robert A., eds. The Literature of Photography: Sixty-Two Books. New York: Arno Press, 1973. 24 p., illus.

A series of primary titles selected by the advisory editors and listed for publication by the Arno Press. Choices cover the nineteenth and twentieth century, English and American, and are supported by excellent annotations. Comment by Beaumont Newhall: "History cannot be written without constant reference to original sources. . . . The publication by Arno Press of a basic library is a significant contribution to furthering the study of the history of photography and its establishment in universities and colleges as an academic discipline. The choice of titles is admirable. The originals of most of them are now extremely rare, and many are unavailable even in major libraries. As an historian and teacher, I welcome the program, and look forward to its expansion." There is an ad-

The word CATALOG in the heading of an entry refers to the exhibition catalog as a whole and not to the catalog list, checklist, or catalog section of the work.

denda of all the published issues (1–12) for the gallery and group known as 293; these issues were ORIGINALLY PUBLISHED (1915–1916). Also included is a special introduction by Dorothy Norman and a new cumulative table of contents; 291 is reproduced in the original four colors. REPRINT EDITION: Arno Series on Contemporary Art, edited by Bernard Karpel.

Contents: (1) Anderson, A. J., *The Artistic Side of Photography in Theory and Practice* (London, 1910), illus. *(2)* Anderson, Paul L., *The Fine Art of Photography* (Philadelphia and London, 1919), illus. *(3)* Beck, Otto Walter, *Art Principles in Portrait Photography: Composition, Treatment of Backgrounds, and the Processes Involved in Manipulating the Plate* (New York, 1907), illus. *(4)* Bingham, Robert J., *Photogenic Manipulation: Containing the Theory and Plain Instructions in the Art of Photography, Or, the Production of Pictures Through the Agency of Light;* pt. 1, 9th ed.; pt. 2, 5th ed., illustrated by woodcuts (London, 1852). *(5)* Bisbee, A., *The History and Practice of Daguerreotyping* (Dayton, Ohio, 1853), illus. *(6)* Boord, W. Arthur, ed., *Sun Artists,* original ser. 1–8 (London: Oct. 1889–1891), illus. *(7)* Burbank, W. H., *Photographic Printing Methods: A Practical Guide to the Professional and Amateur Worker,* 3d ed. (New York, 1891), illus. *(8)* Burgess, N. G., *The Photograph Manual: A Practical Treatise, Containing the Cartes de visite Process, and the Method of Taking Stereoscopic Pictures, Including the Albumen Process, the Dry Collodion Process, the Tannin Process, the Various Alkaline Toning Baths,* 8th ed. (New York, 1863). *(9)* Coates, James, *Photographing the Invisible: Practical Studies in Spirit Photography, Spirit Portraiture, and Other Rare but Allied Phenomena* (Chicago and London, 1911), illus.

(10) Sobieszek, Robert A. ed., *An Original Anthology: The Collodion Process and the Ferrotype; Three Accounts, 1854–1872* (New York, 1973), illus. Includes Archer, Frederick Scott, *The Collodion Process on Glass* (London, 1854); and Blanquart-Evrard, L. D., *On the Intervention of Art in Photography,* translated from the French by Alfred Harral, with an introduction by Thomas Sutton (London, 1864); and Trask, A. K. P., *Trask's Practical Ferrotyper* (Philadelphia, 1872). *(11)* Croucher, J. H., and Le Gray, Gustave, *Plain Directions for Obtaining Photographic Pictures by the Calotype and Energiatype, Also, upon Albumenized Paper and Glass, by Collodion and Albumen,* pts. 1–3 (Philadelphia, 1853), illus. *(12)* Sobieszek, Robert A. ed. *An Original Anthology: The Daguerreotype Process: Three Treatises, 1840–1849* (New York, 1973). Includes Claudet, Antoine, *Researches on the Theory of the Principal Phaenomena*

of Photography in the Daguerreotype Process (London, 1849); and Fauvel-Gouraud, François, *Description of the Daguerreotype Process, Or, a Summary of M. Gouraud's Public Lectures, According to the Principles of M. Daguerre; with a Description of a Provisory Method for Taking Human Portraits* (Boston, 1840); and Humphrey, S. D., and M. Finley, *A System of Photography, Containing an Explicit Detail of the Whole Process of Daguerreotype, According to the Most Approved Methods of Operating; Including All the Late Valuable Improvements* (Canandaigua, N.Y., 1849). *(13)* Delamotte, Philip H., *The Practice of Photography: A Manual for Students and Amateurs,* 2d ed (London, 1855), illus. *(14)* Draper, John William, *Scientific Memoirs; Being Experimental Contributions to A Knowledge of Radiant Energy* (London, 1878), illus. *(15)* Emerson, Peter Henry, *Naturalistic Photography for Students of the Art* (London, 1889). *(16)* Emerson, Peter Henry, *Naturalistic Photography for Students of the Art,* 3d ed. Includes "The Death of Naturalistic Photography" (London, 1891; New York, 1899), illus. *(17)* Fenton, Roger, *Roger Fenton, Photographer of the Crimean War; His Photographs and His Letters from the Crimea, with an Essay on His Life and Work by Helmut and Alison Gernsheim* (London, 1954), illus. *(18)* Fouque, Victor, *The Truth Concerning the Invention of Photography: Nicephore Niépce—His Life, Letters, and Works,* translated by Edward Epstean from the original FRENCH EDITION (Paris, 1867; New York, 1935). *(19)* Fraprie, Frank R., and Woodbury, Walter E., *Photographic Amusements Including Tricks and Unusual or Novel Effects Obtainable with the Camera,* 10th ed. (Boston, 1931), illus.

(20) Gillies, John Wallace, *Principles of Pictorial Photography* (New York, 1923), illus. *(21)* Gower, H. D., Jast, L. Stanley and Topley, W. W., *The Camera as Historian: A Handbook to Photographic Record Work for Those Who Use a Camera and for Survey or Record Societies* (London, 1916), illus. *(22)* Guest, Antony, *Art and the Camera* (London, 1907), illus. *(23)* Harrison, W. Jerome, *A History of Photography Written as a Practical Guide and an Introduction to Its Latest Developments;* with a biographical sketch of the author, and an appendix by Dr. Maddox on the discovery of the Gelatino-Bromide process (New York, 1887), illus. *(24)* Hartmann, Sadakichi [Sidney Allan], *Composition in Portraiture* (New York, 1909), illus. *(25)* Hartmann, Sadakichi [Sidney Allan], *Landscape and Figure Composition,* illustrated by Photoengravings from Celebrated Paintings and Original Photographs (New York, 1910), illus. *(26)* Hepworth, T. C., *Evening Work for Amateur Photographers,* illustrated with Camera and Pencil by the Author (London, 1890), illus. *(27)* Hicks, Wilson, *Words and Pictures: An Introduction to Photojournalism* (New York, 1952), illus. *(28)* Hill, Levi L., and W. McCartey, Jr., *A Treatise on Daguerreotype,* pts. 1–4 (Lexington and New York, 1850). *(29)* Humphrey, S. D., *American Handbook of the Daguerreotype: Giving the Most Approved and Convenient Methods for Preparing the Chemicals, and the Combinations Used in the Art; Containing the Daguerreotype, Electrotype, and Various Other Processes Employed in Taking Heliographic Impressions,* 5th ed. (New York, 1858), illus. *(30)* Hunt, Robert, *A Manual of Photography,* 3d ed. (London, 1853), illus. *(31)* Hunt, Robert, *Researches on Light: An Examination of All the Phenomena Connected with the Chemical and Molecular Changes Produced by the Influ-*

ence of the Solar Rays: Embracing All the Known Photographic Processes, and New Discoveries in the Art (London, 1844), illus. *(32)* Jones, Bernard E., ed., *Cassell's Cyclopaedia of Photography* (London, 1911), illus. *(33)* Lerebours, N. P., *A Treatise on Photography; Containing the Latest Discoveries and Improvements Appertaining to the Daguerreotype,* translated by J. Egerton (London, 1843). *(34)* Litchfield, R. B., *Tom Wedgwood, the First Photographer: An Account of His Life, His Discovery and His Friendship with Samuel Taylor Coleridge; Including the Letters of Coleridge to the Wedgwoods and an Examination of Accounts of Alleged Earlier Photographic Discoveries* (London, 1903), illus. *(35)* Maclean, Hector, *Photography for Artists* (London, 1896), illus. *(36)* Martin, Paul, *Victorian Snapshots,* introduction by Charles Harvard (London, 1939), illus. *(37)* Mortensen, William, *Monsters and Madonnas* (San Francisco, 1936), illus. *(38)* Bunnell, Peter C., *Nonsilver Printing Processes: four selections, 1886–1927* (New York, 1973), illus. Includes Bennett, Colin N., *Elements of Photogravure* (Boston and London, 1927); and Maskell, Alfred, and Robert Demachy, *Photo-Aquatint or the Gumbichromate Process* (London, 1898); and Mortimer, F. J., and S. L. Coulthurst, *The Oil and Bromoil Processes* (London, 1909); and Pizzighelli, Giuseppe, and Baron A. Hubl, *Platinotype,* edited by Capt. W. de W. Abney, Translated by J. F. Iselin (London, 1886), illus. *(39)* Ourdan, J. P., *The Art of Retouching by Burrows & Colton,* rev. ed., AMERICAN EDITION (New York, 1880), illus.

(40) Potonniée, Georges, *The History of the Discovery of Photography,* translated by Edward Epstean (New York, 1936). *(41)* Price, William Lake, *A Manual of Photographic Manipulation, Treating of the Practice of the Art; and Its Various Applications to Nature,* 2d ed (London, 1868), illus. *(42)* Pritchard, H. Baden, *About Photography and Photographers: A Series of Essays for the Studio and Study, to Which Are Added European Rambles with a Camera;* Scovill Photographic Series, no. 14 (New York, 1883), illus. *(43)* Pritchard, H. Baden, *The Photographic Studios of Europe* (London, 1882), illus. *(44)* Robinson, Henry Peach, and W. de W. Abney, *The Art and Practice of Silver Printing* (New York, 1881), illus. *(45)* Robinson, Henry Peach, *The Elements of a Pictorial Photograph* (Bradford, 1896), illus. *(46)* Robinson, Henry Peach, *Letters on Landscape Photography* (New York, 1888), illus. *(47)* Robinson, Henry Peach, *Picture-Making by Photography,* 5th ed. (London, 1897), illus. *(48)* Robinson, Henry Peach, *The Studio and What to Do in It* (London, 1891), illus. *(49)* Rodgers, H. J., *Twenty-Three Years under a Skylight, Or, Life and Experiences of a Photographer* (Hartford, Conn., 1872), illus.

(50) Roh, Franz, and Jan Tschichold, eds., *Foto-Auge: Oeil et photo/Photo-Eye: Seventy-Six Photos of the Period* (Stuttgart, Germany, 1929), illus. *(51)* Ryder, James F., *Voigtlander and I in Pursuit of Shadow Catching: A Story of Fifty-Two Years' Companionship with a Camera* (Cleveland, 1902), illus. *(52)* Society for Promoting Christian Knowledge, *The Wonders of Light and Shadow* (London, 1851), illus. *(53)* Sparling, W., *Theory and Practice of the Photographic Art; Including Its Chemistry and Optics, with Minute Instructions in the Practical Manipulation of the Various Processes, Drawn from the Author's Daily Practice* (London, 1856), illus. *(54)* Tissandier, Gaston, *A History and Handbook of Photography,* edited by J. Thomson; appendix by

Henry Fox Talbot, 2d ed. (London, 1878), illus. *(55)* University of Pennsylvania. *Animal Locomotion, the Muybridge Work at the University of Pennsylvania: The Method and the Result* (Philadelphia, 1888), illus. *(56)* Vitray, Laura; Mills, John, Jr.; and Ellard, Roscoe, *Pictorial Journalism* (New York and London, 1939), illus. *(57)* Vogel, Hermann, *The Chemistry of Light and Photography* REPRINTED from the International Scientific series, vol. 14. (New York, 1875), illus. *(58)* Wall, Alfred H., *Artistic Landscape Photography: A Series of Chapters on the Practical and Theoretical Principles of Pictorial Composition* (London, 1896), illus. *(59)* Wall, Alfred H., *A Manual of Artistic Colouring, as Applied to Photographs: A Practical Guide to Artists and Photographers* (London, 1861).

(60) Werge, John, *The Evolution of Photography; with a Chronological Record of Discoveries, Inventions, Contributions to Photographic Literature, and Personal Reminiscences Extending Over Forty Years* (London, 1890), illus. *(61)* Wilson, Edward L., *The American Carbon Manual; Or, the Production of Photographic Prints in Permanent Pigments* (New York, 1868), illus. *(62)* Wilson, Edward L., *Wilson's Photographics: A Series of Lessons, Accompanied by Notes, on All the Processes Which Are Needful in the Art of Photography* (New York, 1881), illus. *Addenda:* first twelve issues of the publication 291; *see* [N165].

N3. **Carver, George T., and Freemesser, Bernard L.** LITERATURE OF PHOTOGRAPHY: THE ESSAY, PHILOSOPHY, CRITICISM, HISTORY; A PARTIAL BIBLIOGRAPHY. Eugene, Ore.: University of Oregon, 1966. 48 p.

An alphabetical listing, largely by author and/or photographer, of 1,420 entries. Unfortunately the listing contains errors, incomplete entries, and serious omissions.

N4. New York. **Columbia University Library.** A CATALOGUE OF THE EPSTEAN COLLECTION ON THE HISTORY AND SCIENCE OF PHOTOGRAPHY AND ITS APPLICATIONS, ESPECIALLY TO THE GRAPHIC ARTS. New York: Columbia University Press, 1937. 109 p., illus.

Collection catalog.

A classified, unannotated listing of 1,418 entries, with author and subject index. Although this catalog is international in scope, it is essential for the study of American photography. FACSIMILE REPRINT, with an appreciation and bibliography of Edward Epstean by Beaumont Newhall (Pawlet, Vt.: Helios). This contains two privately printed addenda: Authors and Short Title Index, corrected, with additions to May 1, 1938; and Accessions, May 1938—Dec. 1941, with further addenda, 1942.

N5. New York. **The Museum of Modern Art Library.** CATALOG OF THE LIBRARY OF THE MUSEUM OF MODERN ART. New York and Boston: G. K. Hall, 1976. vol. 2.

Reprint of the card catalog under the supervision of Inga Forslund, Librarian. The reprint records a detailed report on the significant photographic literature (books, exhibition catalogs, periodicals, and articles) begun under the museum librarian, Beaumont Newhall. The collection reflects, therefore, the initiative of the library for three decades together with the special requirements of three successive directors of the Department of Photography, Beaumont Newhall, Edward Steichen, and John Szarkowski. The catalog includes the cards for the book collection in the Department of Photography, the professional preparation of which has been the continuing responsibility of the library. The Hall reprint, in reduced facsimile, comprises extensive references in the photographic section. [Supplemental material is documented elsewhere; *see*, for example, N682–N688, N789–N790.]

N6. London. **Royal Photographic Society of Great Britain.** LIBRARY CATALOGUE. London, 1939. 48 p.

Author and short title catalog. A classified subject index was published in 1952, and a periodicals catalog in 1955.

N7. Vienna. **Höhere Graphische Bundes- Lehr-und Versüchsanstalt.** BIBLIOTHEKS KATALOG DER GRAPHISCHEN SCHÜLERARBEIT IM ANSTALTSBETRIEB. Vienna, 1936. 163 p.

A short-title bibliography arranged by authors of the notable library founded by Josef Maria Eder, scientist and pioneer photographic historian. Although oriented toward the scientific and technical, the bibliography contains much American material.

N8. New York. **Witkin Gallery.** CATALOGUE 4: RARE AND CONTEMPORARY PRINTS AND BOOKS. New York, 1976. 206 p., illus.

Sales catalog.

A sales catalog with 750 illustrations, covering the entire history of photography. Important for its bibliographical references as well as its pictorial corpus.

In addition to the entries listed above, there are throughout this bibliography many works that have useful bibliographies. Without pointing out the obvious in the histories—Gernsheim [N117], Newhall [N123], and Pollack [N126], for example—or attempting to indicate all, I call attention to the following: Hartmann [*see* N78]; Hurley [*see* N173 and N266]; Life Library of Photography [*see* N12]; Lyons [*see* N50]; Rudisill [*see* N147]; Taft [*see* N141]; Wall [*see* N206]. It is a matter of regret that major depositories like the International Museum of Photography, Rochester, N.Y., have not yet issued detailed documentation of their unique library resources.

DICTIONARIES AND ENCYLOPEDIAS

N9. THE FOCAL ENCYCLOPEDIA OF PHOTOGRAPHY. London: Focal Press, 1956. 2 vols. illus. (color).

A comprehensive, well-illustrated encyclopedia, largely technological, with helpful articles on the history of photography and biographies. ALSO PUBLISHED in a one-volume edition with diagrams in the text but no plates. SUBSEQUENT EDITION, rev. and enl. (New York: McGraw-Hill Book Co., 1975), 2,400 articles, 1,750 illus.

N10. **Jones, Bernard E., ed.** CASSELL'S CYCLOPAEDIA OF PHOTOGRAPHY. London: Cassell & Co., 1911. 572 p., illus. (color). [*cont.*]

An indispensable reference work, containing not only state of the art working directions, but those of long-obsolete processes. Text is illustrated by hundreds of line drawings, and twenty-four full-page plates. Also contains historical essays, biographies, and chemical terms. FACSIMILE REPRINT (New York: Arno Press, 1973).

N11. **Lewis, Steven; McQuaid, James; and Tait, David.** PHOTOGRAPHY, SOURCE AND RESOURCE: A SOURCE BOOK FOR CREATIVE PHOTOGRAPHY. State College, Pa.: Turnip Press, 1973. 214 p.

Preface by Thomas F. Barrow. Articles on teaching, photographic workshops, publishing, critics, and galleries. Bibliography of academic theses on photography. Summary guide to collections; well indexed.

N12. LIFE LIBRARY OF PHOTOGRAPHY, BY THE EDITORS OF TIME-LIFE BOOKS (SERIES EDITOR, ROBERT G. MASON). New York: Time-Life Books, 1970–1972. 17 vols., illus. (color).

This is an indispensable series of well-illustrated books, covering all aspects of photography with special emphasis on its use as a medium of communication and expression. The history of the medium is integrated with technical exposition. Each volume includes a bibliography. The series comprises the following books: (1) *The Camera* [N195]; (2) *Light and Film* [N122]; (3) *The Print* [N166]; (4) *Color* [N202]; (5) *Photography as a Tool* [N237]; (6) *The Great Themes* [N69]; (7) *Photojournalism* [N267]; (8) *Special Problems; (9) The Studio* [N249]; (10) *The Art of Photography* [N68]; (11) *Great Photographers* [N353]; (12) *Photographing Nature; (13) Photographing Children; (14) Documentary Photography* [N210a]; (15) *Frontiers of Photography* [N181]; (16) *Travel Photography; (17) Caring for Photographs* [N279].

N13. **McDarrah, Fred W.** PHOTOGRAPHY MARKET PLACE. 2d ed. New York and London: R. R. Bowker Co., 1977. 475 p,

According to the publisher's brochure, this volume contains 6,000 entries which list "picture buyers, custom labs, photo shops, galleries, antique photo dealers, professional associations, photo magazines, photography schools and where to get grants and prizes . . . over forty sections . . . complete descriptions of goods and services." Bibliography of reference books is included.

N14. **Mathews, Oliver.** EARLY PHOTOGRAPHS AND EARLY PHOTOGRAPHERS: A SURVEY IN DICTIONARY FORM. London: Reedminster Publications, 1973. 198 p., illus.

International in scope; although somewhat limited in selection, a useful reference volume with 252 illustrations.

N15. **Morgan, Willard D., ed.** THE COMPLETE PHOTOGRAPHER. Chicago: National Educational Alliance, 1941–1943. 10 vols., illus.

Although there is a later revised edition [*see* N16], this edition should also be consulted since many fine articles were not carried over into the revision.

N16. **Morgan, Willard D., ed.** THE ENCYCLOPEDIA OF PHOTOGRAPHY; THE COMPLETE PHOTOGRAPHER: THE COMPREHENSIVE GUIDE AND REFERENCE FOR ALL PHOTOGRAPHERS. New York: Greystone Press, 1963–1964. 20 vols., illus. (color).

Containing signed articles by leading American photographers, reproductions of their photographs, and often biographical essays about them, this work is indispensable. It is a revision of *The Complete Photographer*, also edited by Willard D. Morgan [*see* N15].

N17. **Snelling, Henry Hunt.** A DICTIONARY OF THE PHOTOGRAPHIC ART; TOGETHER WITH A LIST OF ARTICLES OF EVERY DESCRIPTION EMPLOYED IN ITS PRACTICE. New York: H. H. Snelling, 1854. illus.

Two Pts. in 1 vol. Pt. 2 has special title page: A Comprehensive and Systematic Catalogue of Photographic Apparatus and Material, Manufactured, Imported, and Sold by E. Anthony. Of particular value for its documentation of the daguerreotype technique.

N18. **Stroebel, Leslie; and Todd, Hollis N.** DICTIONARY OF CONTEMPORARY PHOTOGRAPHY. Dobbs Ferry, N.Y.: Morgan & Morgan, 1974. 217 p., illus.

Alphabetical listing of terms, largely concerning technical aspects of photography, cinematography, and the photomechanical processes.

N19. LIFE LIBRARY OF PHOTOGRAPHY, BY THE EDITORS OF TIME-LIFE BOOKS (SERIES EDITOR, ROBERT G. MASON). New York: Time-Life Books, 1970–1972. 17 vols., illus. (color).

[*See* N12, N236.]

N20. **Wilson, Edward L.** WILSON'S CYCLOPAEDIC PHOTOGRAPHY: A COMPLETE HANDBOOK OF THE TERMS, PROCESSES, FORMULAE AND APPLIANCES AVAILABLE IN PHOTOGRAPHY, ARRANGED IN CYCLOPAEDIC FORM FOR READY REFERENCE. New York: Edward L. Wilson, 1894. 480 p., illus.

In addition to the detailed text, passages from a large number of authorities are quoted in extensive footnotes. Especially informative on practices of studio photography. Wilson was the editor and publisher of the influential periodical, *The Philadelphia Photographer* (1864–1888).

Collections of Photographs

COLLECTING: GUIDES AND TECHNIQUES

N20a. Dennis, Landt, and Dennis, Lisl. COLLECTING PHOTOGRAPHS: A GUIDE TO THE NEW ART BOOM. New York: E. P. Dutton & Co., 1977. 244 p., illus.

Partial contents cover "a brief survey of the inventors of photography and the artists"; "conservation and restoration"; buyers, collectors and prices; photography galleries, dealers, auction houses, museum and library collections; and a reading list.

N21. Deschin, Jacob. WHERE ARE THEY NOW? *Popular Photography* 69 (Nov. 1971): 102–105, 138–39.

Present location of collections formed by Frank Roy Fraprie, Lloyd E. Varden, Louis Walton Sipley, Gabriel Cromer, Alden Scott Boyer, Helmut and Alison Gernsheim, the Camera Club of New York, Josef Maria Eder, Edward Epstean, Joseph S. Mertle, Jacob A. Riis, the Byron Studio, and Alfred Stieglitz.

N22. PHOTOGRAPHS AND PROFESSIONALS: A DISCUSSION. *Print Collector's Newsletter* 4 (July–Aug. 1973): 54–60, illus. (ports.)

An informal, informed, and intensive exchange among specialists (Peter Bunnell, Ronald Feldman, Lucien Goldschmidt, Harold Jones, Aaron Siskind, Lee Witkin) who consider "a market of more recent importance to collectors—photography." Without attempting to index in detail relevant articles in *Print Collector's Newsletter*, the following excerpted *contents* from vol. 7:2 (May–June 1976) indicate the coverage provided from time to time by this relatively new journal: *(a)* Ackley, Clifford S., "Fashion Photography," p. 51–52, illus.; commentary occasioned by the exhibition *Fashion Photography: Six Decades* at Hofstra University; *(b)* Barth, Miles, "Notes on Conservation and Restoration of Photographs," p. 48–50; includes "basic bibliography" and "basic supplies" list, p. 49–50; *(c)* Brody, Jacqueline, "Photography: A Personal Collection," p. 37–44, illus. "Prints and Photographs Published" is a regular series.

N23. Rauch, Nicolas. LA PHOTOGRAPHIE DES ORIGINES AU DÉBUT DU VINGTIÈME SIÈCLE. Geneva, 1961. 88 p., illus.

Sales catalog, no. 30.

A superb, annotated, and illustrated sales catalog of 241 items, primarily European apparatus and processes of the nineteenth century.

N24. Sipley, Louis Walton. MUSEUMS AND COLLECTIONS OF PHOTOGRAPHS. In: MORGAN, WILLARD D., ED. ENCYCLOPEDIA OF PHOTOGRAPHY. New York: Greystone Press, 1963–1964. vol. 13, p. 2458–77, illus.

N25. Welling, William. COLLECTORS GUIDE TO NINETEENTH-CENTURY PHOTOGRAPHS. New York: Collier Books; London: Collier Macmillan, 1976. 204 p., illus.

Contents: cased photographs, tintypes, stereographs, card photographs, photographic prints, photographic literature, photographic miscellany, photographic listings, photographic archives, photographic societies; appendix, bibliography, notes, and index. The author is a director of the Photographic Historical Society of New York.

N26. Wood, Charles B., III. THE PHOTOGRAPH AND THE BOOK, CATALOGUE 37. South Woodstock, Conn.: By the author, 1976. 81 p., illus.

"A selection of rare and out-of-print photographically illustrated books, albums, prints and photogravures." Material is divided into sections on books, albums, and prints and photogravures. Lists 366 annotated items followed by sixty-eight pages of illustrations. *Supplement* issued for nos. 367–400 (no. illus.). Introduction by Eugenia Parry Janis.

PRIVATE COLLECTIONS

N27. Albuquerque, N.M. **Museum of Albuquerque. Van Deren Coke Collection.** PHOTOGRAPHS FROM THE COKE COLLECTION. 16 p., illus.

Exhibition: Oct. 26–Nov. 20, 1969. Also shown at the Indiana University Museum of Art, spring 1958; Des Moines Art Center, Des Moines, Ia., Aug. 10–Sept. 13, 1970; and the Everson Museum of Art, Syracuse, N.Y., Oct. 19–Nov. 14, 1971.

Illustrated catalogs were published at the institutions where the exhibition was shown.

N28. Chicago, Ill. [ARNOLD CRANE COLLECTION.] [*See* N684.]

Note: No catalog of this extensive collection has been published to date.

N29. Seattle. **Seattle Art Museum. Joseph and Elaine Mansen Collection.** PRINTS FROM THE MANSEN COLLECTION OF AMERICAN PHOTOGRAPHY. INTRODUCTION BY ANITA VENTURA MOZLEY. Seattle, 1976. 155 p., illus.

Collection catalog.

An extraordinary comprehensive selection of photographs covering the history of American photography. Short bibliography.

N30. Philadelphia. **Philadelphia Museum of Art. Dorothy Norman Collection.** SELECTIONS FROM THE DOROTHY NORMAN COLLECTION ON EXHIBITION. Philadelphia, 1968. unpag., illus.

Exhibition.

Catalog of an exhibition containing photographs by Alfred Stieglitz, Ansel Adams, Paul Strand, Brett Weston,

Edward Weston, and other photographers, as well as art works in other media. Chronology of Stieglitz and of Norman is included in this catalog.

PUBLIC COLLECTIONS

ALBUQUERQUE, NEW MEXICO

N31. Albuquerque. **University of New Mexico, University Art Museum.** Notes on the Collection. Written by Thomas F. Barrow. University Art Museum, *Bulletin* 5–6 (1971–72): 1–44, illus.

Introduction by Beaumont Newhall. Includes catalog of the photographic print collection.

N32. Albuquerque. **University of New Mexico, University Art Museum,** Nineteenth Century Photographs from the Collection. Preface by Beaumont Newhall. Introduction by Van Deren Coke. Albuquerque, 1976. 26 p., illus.

Collection catalog.

Includes forty-one reproductions.

BOSTON, MASSACHUSETTS

N33. Boston. **Boston Public Library.** Photographs from the Boston Public Library. Catalog by Rachel Johnston Homer. Introduction by Sinclair Hitchings. Boston, 1970. 32 p., illus.

A description of the photographic collection, with reproductions of twenty-eight photographs.

CHICAGO, ILLINOIS

N34. **Travis, David.** Photography at the Art Institute of Chicago. The Art Institute of Chicago, *Bulletin* 70 (May–June 1976): 4–8, 17–22.

A brief description of the collection, notable for its representation of the work of Alfred Stieglitz and his Photo Secessionist contemporaries, and Edward Weston. Ten reproductions and illustrated cover.

N35. Chicago. **Exchange National Bank.** A Collection of Photographs. Catalog by Beaumont and Nancy Newhall. New York: Aperture, 1969. 88 p., illus. (color).

Short biographies and plates of the work of photographers represented in the collection of the Exchange National Bank of Chicago. Also published in the magazine *Aperture* 14:2 (1968).

LAWRENCE, KANSAS

N36. Lawrence, Kans. **University of Kansas Art Museum.** Language of Light: A Survey of the Photography Collection. Lawrence, 1974. 96 p., illus.

Exhibition.

Catalog of an exhibition organized by students, which includes essays, biographical statements, and bibliography.

NEW YORK, NEW YORK

N37. **McKendry, John J.** Photographs in the Metropolitan. The Metropolitan Museum of Art, *Bulletin* 27 (Mar. 1969): 333–63, illus.

An account of the development of the photography collection of The Metropolitan Museum of Art. Focuses on the Stieglitz Collection, which was begun with a gift by Alfred Stieglitz of his own work and those of his friends. The collection includes documents as well as selections from later accessions.

N38. New York. **The Museum of Modern Art.** An Appointment Calendar with Photographs from the Collection of the Museum of Modern Art. New York: Museum of Modern Art, Junior Council, 1966. unpag., illus.

Foreword—with information about the collection—by John Szarkowski.

N39. New York. **The Museum of Modern Art.** Looking at Photographs: One Hundred Pictures from the Collection of The Museum of Modern Art. Catalog by John Szarkowski. New York, 1973. 216 p., illus.

Collection catalog.

A comprehensive selection of a hundred excellent reproductions of representative photographs, from 1840 to the present day.

N40. **New York. New-York Historical Society.** Old New York in Early Photographs, 1853–1901: One Hundred Ninety-Six Prints from the Collection of the New-York Historical Society. Catalog by Mary Black. New York: Dover Publications, 1973. 228a p., illus.

Collection catalog.

The photographs are arranged geographically. There is an index of identified photographs, a chronological index, and a general index. This volume is based on the 1970 exhibition, *Eye on the City.*

OTTAWA, CANADA

N41. Ottawa. **National Gallery of Canada.** The Photograph as Object, 1843–1969: Photographs from the Collection of the National Gallery of Canada. Ottawa, 1969. unpag., illus.

Exhibition: Cosponsored by the Art Gallery of Ontario. Traveling exhibition.

Historical introduction, glossary, bibliography, and catalog of the exhibition prepared for circulation by the Art Gallery of Ontario and the National Gallery of Canada.

N42. **Bunnell, Peter C.** The National Gallery Photographic Collection, A Vital Resource. *Artscanada* 192–95 (Dec. 1974): 37–44, illus.

[For this entire special issue of *Artscanada, see* N56.]

RICHMOND, VIRGINIA

N43. ARTS IN VIRGINIA, Virginia Museum Photographic Collection special issue. 16 (fall 1975): 40 p., illus.

Collection catalog.

The entire issue of the magazine is devoted to the Virginia Museum's photographic collection. Two American photographers are represented: Gertrude Käsebier (with twelve reproductions and an essay by Peter C. Bunnell), and Lewis W. Hine (eleven reproductions and an essay by George Cruger).

ROCHESTER, NEW YORK

N44. **Rochester, N.Y. International Museum of Photography at George Eastman House.** A CENTURY OF CAMERAS FROM THE COLLECTIONS OF THE INTERNATIONAL MUSEUM OF PHOTOGRAPHY AT GEORGE EASTMAN HOUSE. CATALOG BY EATON S. LOTHROP, JR. FOREWORD BY ROBERT J. DOHERTY, JR. Dobbs Ferry, N.Y.: Morgan & Morgan, 1973. 150 p., illus.

Collection catalog.

This is a scholarly well-documented work. Included is a detailed description of the development of the camera, from Daguerre's 1839 camera to the 1937 Minox.

WASHINGTON, D.C.

N45. **McCoy, Garnett.** PHOTOGRAPHS AND PHOTOGRAPHY IN THE ARCHIVES OF AMERICAN ART. Archives of American Art, *Journal* 12:3 (1972): 1–18, illus.

This article surveys photographs (represented in the Archives collection) and their use as a record of America's art history, touching on such events as the Armory Show and the WPA project. Further information on photographs in the Archives of American Art collection may be found in Garnett McCoy's *Archives of American Art: A Directory of Resources* (New York and London: R. R. Bowker Co., 1972), where numerous references to photography occur in the 555 collections listed—although the term "photography" does not appear in the book's index.

N46. Washington, D.C. **Library of Congress.** SELECTIVE CHECKLIST OF PRINTS AND PHOTOGRAPHS. Washington, D.C., 1949–1954. 4 vols.

A useful index to groups of photographs on a variety of subjects, described by lot. Not illustrated.

WORCESTER, MASSACHUSETTS

N47. **Jareckie, Stephen B.** PHOTOGRAPHY AT THE WORCESTER ART MUSEUM. Worcester Art Museum, *Bulletin* 3 (Feb. 1974): 1–16, illus.

A history of the museum's photographic activity from 1905 to 1974, by the curator of photography, with a list of photographers represented in the collection and of photographic exhibitions shown from Oct. 1962 through Jan. 1974.

Criticism and the Critics

COLLECTED ESSAYS

N48. **Adams, W. I. Lincoln, ed.** SUNLIGHT AND SHADOW: A BOOK FOR PHOTOGRAPHERS, AMATEUR AND PROFESSIONAL. New York: Baker & Taylor, 1897. 141 p., illus.

This book is a collection of essays from photographic periodicals, including the essay on "The Hand Camera," by Alfred Stieglitz. This volume is valuable for its illustrations of well-known as well as lesser-known pictorial photographers of the 1890s.

N49. **Goldsmith, Arthur.** THE PHOTOGRAPHY GAME: WHAT IT IS AND HOW TO PLAY IT. New York: Viking Press, 1971. 160 p., illus.

Articles from periodicals on the historical background of photography, techniques, marketing photographs, aesthetics, and the photographic approach of Henri Cartier-Bresson, W. Eugene Smith, Dorothea Lange, and Alfred Eisenstaedt.

N50. **Lyons, Nathan, ed.** PHOTOGRAPHERS ON PHOTOGRAPHY: A CRITICAL ANTHOLOGY. Englewood Cliffs, N.J.: Prentice-Hall; Rochester, N.Y. George Eastman House, 1966. 190 p., illus.

A selection of critical essays, largely aesthetic in nature, by photographers from 1889 to 1963. The volume is especially valuable for the section "Biographical Notes," p. 177–90, containing detailed chronologies and bibliographies on the twenty-three photographers represented.

N51. **Newhall, Beaumont, ed.** ON PHOTOGRAPHY: A SOURCE BOOK OF PHOTO HISTORY IN FACSIMILE. Watkins Glen, N.Y.: Century House, 1956. 192 p., illus. (color).

Facsimile reproductions of technical descriptions of the main photographic processes—by their inventors. Critical articles by both laymen and photographers are also included.

CRITICISM AND AESTHETICS

N52. **Abbott, Berenice.** PHOTOGRAPHY AT THE CROSSROADS. *Universal Photo Almanac* (1951): 42–47, illus.

Definition of the photographic environment, and its

influence, with a plea for the documentary approach: "What we need is a return, on a mounting spiral of historic understanding, to the great tradition of realism." REPRINT EDITION: Lyons, Nathan, ed., *Photographers on Photography* (Englewood Cliffs, N.J.: Prentice-Hall, 1966), p. 17–22.

N53. **Anderson, Paul L.** THE FINE ART OF PHOTOGRAPHY. Philadelphia and London: J. B. Lippincott Co., 1919. 315 p., illus.

Covers composition theory and approaches in various fields. Many of the plates are by members of the lately dissolved Photo Secession. FACSIMILE REPRINT (New York: Arno Press, 1973).

N54. **Anderson, Paul L.** PICTORIAL PHOTOGRAPHY: ITS PRINCIPLES AND PRACTICE. Philadelphia and London: J. B. Lippincott Co., 1917. 302 p., illus.

The author was lecturer at the Clarence H. White School of Photography, and this manual describes the aesthetic of the post–Photo Secession movement. Of special value are instructions for working the pigment processes, hand-coating platinum, and the technique of photogravure.

N55. **Arnheim, Rudolf.** ON THE NATURE OF PHOTOGRAPHY. *Critical Inquiry* 1 (Sept. 1974): 149–61.

A denial of photography's claim as a creative art form because it is too closely rooted to life. This belief is also expressed in his work on "Visual Thinking," specifically in the single paragraph on photography and the exclusion of illustrations. The *Critical Inquiry* article is REPRINTED in *Afterimage* 2:10 (Apr. 1975): 10–12.

N56. ARTSCANADA, an Inquiry into the Aesthetics of Photography special issue. 192–95 (Dec. 1974): 1–97, illus. (color).

Partial contents: Peter C. Bunnell, "The National Gallery Photographic Collection: A Vital Resource" (p. 37–44); "One Hundred Thirty-Five Years of Photography: Twenty-three Photographs from the National Gallery of Canada" (p. 45–68, all plates); James Borcoman, "Purism Versus Pictorialism: The One Hundred Thirty-Five Years' War" (p. 69–82); William Stott, "Walker Evans, Robert Frank and the Landscape of Disassociation" (p. 83–89); and Geoffrey James, "A Basic Bibliography," p. 97.

N57. **Beck, Otto Walter.** ART PRINCIPLES IN PORTRAIT PHOTOGRAPHY: COMPOSITION, TREATMENT OF BACKGROUNDS, AND THE PROCESSES INVOLVED IN MANIPULATING THE PLATE. New York: Baker & Taylor, 1907. 244 p., illus.

A treatise on composition of the portrait in painting, with instructions on how the "plain photograph" can be made painterly by manipulation of the negative. FACSIMILE REPRINT (New York: Arno Press, 1973).

N58. **Bunnell, Peter C.** PHOTOGRAPHY AS PRINTMAKING. *Artist's Proof* 9 (1969): 24–40, illus.

An examination of the photograph in its relation to other forms of printmaking, indicating the range of possibilities open to the creative artist.

N59. **Chini, Renzo.** IL LINGUAGGIO FOTOGRÀFICO. Turin: Società editrice internationale, 1968. 181 p., illus. (color).

A brilliant analysis of photographic aesthetics, based largely on psychological theories of perception in three chapters: "The Structure and Nature of Photography"; "Photographic Narration"; "Photographic Culture and Trends." This ninety-one page unillustrated essay is followed by a dictionary of terms, a detailed bibliography, and brief biographies of and reproductions of work by 114 photographers, of whom forty-five are American.

N60. **Coke, Van Deren.** UNITED STATES PAINTING AND PHOTOGRAPHY: HOW ARTISTS TRANSFORM THE CAMERA VISION. *Art News Annual* 30 (Nov. 1965): 64–81, 180–84, illus.

N61. **Evans, Walker.** PHOTOGRAPHY. In: KRONENBERGER, LOUIS, ED. QUALITY, ITS IMAGE IN THE ARTS. New York: Atheneum Publishers, 1969. p. 169–211, illus. (color).

A penetrating essay on the aesthetic characteristics of photography, with a selection of twenty-one photographs by as many nineteenth- and twentieth-century photographers, with comments on each.

N62. **Gillies, John Wallace.** PRINCIPLES OF PICTORIAL PHOTOGRAPHY. New York: Falk Publishing, 1924. 253 p., illus.

Statements by Clarence H. White and Edward Weston. Their views of Weston conflict with the author's views, and constitute one of the first Weston proposals for pure photography. FACSIMILE REPRINT (New York: Arno Press, 1973).

N63. **Hartmann, Sadakichi.** COMPOSITION IN PORTRAITURE. New York: Edward L. Wilson, 1909. 116 p., illus.

FACSIMILE REPRINT (New York: Arno Press, 1973) includes 136 reproductions.

N64. **Hartmann, Sadakichi.** DIE KUNST-PHOTOGRAPHIE IN IHRER BEZIEHUNG ZUR MALEREI. *Sadakichi Hartmann Newsletter* 5 (summer 1974): 3–6.

Translated by Hans-Peter Breuer. The first of over 700 articles on photography by Sadakichi Hartmann, with wood-engravings from photographs by Alfred Stieglitz, F. Holland Day, and Robert Demachy. REPRINTED from *Sonntagsblatt der N.Y. Staats-Zeitung* (Jan. 30, 1898): p. 1, illus. In the fall of 1973, the newsletter ceased publication at the University of California, Riverside, and moved to its present site at East Texas State University.

N65. **Hartmann, Sadakichi.** LANDSCAPE AND FIGURE COMPOSITION. New York: Baker & Taylor, 1910. 121 p., illus.

An exposition of spatial arrangements, originally written for *The Photographic Times*. FACSIMILE REPRINT (New

York: Arno Press, 1973). Illustrated by photoengravings from celebrated paintings and original photographs.

N66. **Kouwenhoven, John A.** Living in a Snapshot World. In: Green, Jonathan, ed. The Snapshot. Millerton, N.Y.: Aperture, 1974, p. 106–108, illus.

The author believes that the basic distinction between painting and stylistic photography is best exemplified in hastily taken, unselective amateur snapshots. The author notes that snapshots follow no pictorial tradition and teach us to see the world without the screening of pictorial conventions. This article is adapted from a lecture given at The Metropolitan Museum of Art, New York.

N67. **Kracauer, Siegfried.** Theory of Film: The Redemption of Physical Reality. New York: Oxford University Press, 1965. 363 p., illus.

The first chapter is a penetrating aesthetic analysis of the medium of photography.

N68. The Art of Photography, by the editors of Time-Life Books (series editor, Robert G. Mason). New York: Time-Life Books, 1971. 230 p., illus. (color). Life Library of Photography.

An explanation of how the camera sees, principles of design, photography and time, and other aesthetic problems.

N69. The Great Themes, by the editors of Time-Life Books (series editor, Robert G. Mason). New York: Time-Life Books, 1971. 246 p., illus. Life Library of Photography.

Photographs arranged by groups—the human condition, still life, portraits, the nude, nature, war—with discussion of aesthetic problems by the prominent photographers whose work is reproduced. Bibliography.

N70. **Morgan, Barbara.** Kinetic Design in Photography. *Aperture* 1 (1953): 18–27, illus.

N71. **Newhall, Beaumont.** Photographing the Reality of the Abstract. In: Laughlin, James, ed. New Directions 15: An Anthology in Prose and Poetry. New York: Meridian Books, 1955. p. 161–71, illus. REPRINTED, with revisions, in *Aperture* 4 (1956): 30–33.

N72. **Newhall, Nancy.** Controversy and the Creative Concepts. *Aperture* 2 (1953): 3–13.

The first of a never-completed series; a penetrating observation on the differences between the American and European approaches to photography as an artistic medium.

N73. **Sontag, Susan.** Photography. *New York Review of Books* 20 (Oct. 18, 1973): 59–63.

N73a. **Sontag, Susan.** Freak Show. *New York Review of Books* 20 (Nov. 15, 1973): 13–19.

N73b. **Sontag, Susan.** Shooting America. *New York Review of Books* 21 (Apr. 18, 1974): 17–24. [*cont.*]

N73c. **Sontag, Susan.** Mixed-up Photography. *New York Review of Books* 21 (Nov. 28, 1974): 35–39.

In this series of articles, ostensibly book reviews, the author presents a photographic aesthetic based on the cultural response to the product, with little sympathy for photography's position as an expressive art.

N74. New York. **The Museum of Modern Art.** Looking at Photographs: One Hundred Pictures from the Collection of The Museum of Modern Art. Catalog by John Szarkowski. New York, 1973. 216 p., illus.

Collection catalog.

A comprehensive collection of one hundred excellent reproductions of photographs from 1840 to the present day, each accompanied by a short, succinct, and often brilliant analysis of the aesthetic, social, and historical significance of the picture.

N75. **Szarkowski, John.** The Photographer's Eye. New York: Museum of Modern Art, 1966. 156 p., illus.

A richly illustrated examination of the concern of photographers from the time of the daguerreotype to the present utilizing five concepts: the thing itself, the detail, the frame, time, and vantage point. This is a stimulating examination of photographic aesthetics.

CRITICS AND HISTORIANS

COKE, VAN DEREN

N76. **Coke, Van Deren.** Publications. In: Coke, Van Deren. Photographs 1956–1973. Albuquerque: University of New Mexico Press, 1973. 20 p., illus.

Includes list of publications by Van Deren Coke.

EPSTEAN, EDWARD

N77. **Newhall, Beaumont.** A Bibliography of Edward Epstean. *PSA Journal* 14 (July 1948): 370–71.

Translator of the classical histories of photography by J. M. Eder, Erich Stenger, author of articles on the subject. REPRINTED in *Catalogue of the Epstean Collection* [N4]. FACSIMILE REPRINT (Pawlet, Vt.: Helios, 1972).

HARTMANN, SADAKICHI

N78. Riverside, Calif. **University of California, University Library.** The Life and Times of Sadakichi Hartmann. Riverside, 1970. 76 p., illus.

Sadakichi Hartmann, writing under his own name and that of Sidney Allan, was a prolific writer on photography. A partial list of his articles. [*See also* N78a.]

N78a. **Tucker, Kay.** Sadakichi's Impact on Photography. *Sadakichi Hartmann Newsletter* 5 (summer 1974): 1–3.

NEWHALL, BEAUMONT

N79. **Coke, Van Deren, ed.** BEAUMONT NEWHALL. Rochester, N.Y.: George Eastman House, 1971. unpag.

A bibliography of 632 entries of writings by Newhall, with reminiscences by his colleague, James Card; biographical data; and a tribute by former Eastman House president, Cyril J. Staud.

N80. **Ginsberg, Paul; and Hagen, Charles.** BEAUMONT NEWHALL: AN INTERVIEW. *Afterimage* 2 (Feb. 1975): 9–11, port.

Outline of Newhall's approach to writing the history of photography, and views on directions in photography.

NEWHALL, NANCY

N81. **Fuller, Patricia G.** NANCY NEWHALL (1908–1974). *Image* 18 (Mar. 1975): 1–5.

Biographical essay with a portfolio of photographs by

Nancy Newhall. Bibliography of eighty-one entries.

TAFT, ROBERT

N82. **Newhall, Beaumont.** ROBERT TAFT (1894–1955). *Image* 5 (Apr. 1956): 95.

An obituary on the author of the seminal work, *Photography and the American Scene* [N141].

N83. Baltimore, Md. **The Baltimore Museum of Art.** FOURTEEN AMERICAN PHOTOGRAPHERS. INTRODUCTION BY RENATO DANESE. Baltimore, 1974. 87 p., illus.

Exhibition catalog.

Includes Walker Evans, Robert Adams, Lewis Baltz, Paul Caponigro, William Christenberry, Linda Connor, Cosmos (Cosmos Sarchiapone), Robert Cummings, William Eggleston, Lee Friedlander, John R. Gossage, Gary Hallman, Tod Papageorge, and Garry Winogrand. Biographical and bibliographical data.

Exhibition Catalogs

Entries included in this group document exhibitions of historical significance. A chronological finding list of exhibitions included in this group is as follows:

For one-man and one-woman exhibitions, *see under* name of individual photographer, N364 *et seq.*

N84. Boston. **Museum of Fine Arts.** PRIVATE REALITIES: RECENT AMERICAN PHOTOGRAPHY. TEXT BY CLIFFORD ACKLEY. Boston, 1974. unpag., illus.

Exhibition.

Catalog of an exhibition of photographs by Emmet Gowin, Gary Wasserman, Jerry Uelsmann, John Benson, Linda Connor, David Batchelder, Leslie Krims, Benno Friedman, and Kelly Wise. Biographical and bibliographical data.

N85. Buffalo, N.Y. **The Buffalo Fine Arts Academy, Albright Art Gallery.** CATALOGUE OF THE INTERNATIONAL EXHIBITION OF PICTORIAL PHOTOGRAPHY. Buffalo, 1910. 41 p.

Exhibition: Nov. 3–Dec. 1, 1910.

Unillustrated catalog of the exhibition organized by the Photo Secession, under the direction of Alfred Stieglitz, who probably wrote the short notes on various photographers in the invitation section.

N86. Cambridge, Mass. **Massachusetts Institute of Technology, Hayden Gallery.** LIGHT SEVEN: AN EXHIBITION. EDITED BY MINOR WHITE. Cambridge, 1968. 74 p., illus.

M.I.T. VISUAL ART SERIES, NO. 1.

Exhibition: October 1968.

The plates are presented with neither titles nor photographer's names; identification is by index only. Philosophical text at end by the editor. Also published (with illustrations) in *Aperture* 14 (1968): 74 p., under the title *Light Seven: Photographs from an Exhibition on a Theme.*

N87. Hanover, Germany. **Kunstverein.** KUNST AUS FOTOGRAFIE. Hanover, 1973. 83 p., illus.

Exhibition: May 27–July 22, 1973.

"Was machen Künstler heute mit Fotografie? Montagen - Übermalungen - Gemälde - Dokumente - Fotobilder." An international exhibition of twenty-seven artists who employ varied media. Americans include Bruce Nauman, Robert Smithson, and Keith Sommer. This exhibition traces the modernist concern with the integration of photography and color photography as aspects of their formmaking.

N88. Hartford, Conn. **Hartford Camera Club.** THE WORK OF THE WOMEN PHOTOGRAPHERS OF AMERICA. Hartford, 1906.

Exhibition: Apr. 6–9, 1906.

Includes 156 prints by thirty photographers. Exhibition catalog cited by Margery Mann [N108, p. 32].

N89. Lincoln. **University of Nebraska, Sheldon Memorial Art Gallery.** AMERICAN PHOTOGRAPHY, THE SIXTIES: AN INVITATIONAL EXHIBITION OF RECENT TRENDS. INTRODUCTION BY JERALD C. MADDOX. Lincoln, 1966. 48 p., illus.

Exhibition: Feb. 22–Mar. 20, 1966.

Catalog of an exhibition; fifty-nine reproductions are included.

N90. Lincoln. **University of Nebraska, Sheldon Memorial Art Gallery.** FIVE PHOTOGRAPHERS: EIKOH HOSOE, RALPH EUGENE MEATYARD, JOSEF SUDEK, GARRY WINOGRAND, AND JOHN WOOD. PREFACE BY N. A. GESKE AND M. MCLOUGHLIN. Lincoln, 1968. 48 p., illus.

Exhibition: May 7–June 2, 1968.

The Americans included in this invitational exhibition are Meatyard, Winogrand, and Wood. The catalog is composed chiefly of illustrations; brief biographical data and checklists are appended.

N91. New Haven, Conn. **Yale University Art Gallery.** FOUR DIRECTIONS IN MODERN PHOTOGRAPHY: PAUL CAPONIGRO, JOHN T. HILL, JERRY N. UELSMANN, AND BRUCE DAVIDSON. PREFACE BY ALAN SHESTACK. INTRODUCTION BY RICHARD BRETTELL. New Haven, 1972. 24 p., illus.

Exhibition: Dec. 4, 1972–Feb. 25, 1975.

Selected for excellence and representation of "a particular genre in the world of contemporary photography." Includes statements by the photographers and seventeen reproductions.

N92. New Haven, Conn. **Yale University Art Gallery.** PHOTOGRAPHY IN AMERICA, 1850–1965. EDITED BY ROBERT M. DOTY. New Haven, 1965. 56 p., illus.

Exhibition: Oct. 13–Nov. 28, 1965.

Catalog (160 items) with an essay by the editor. Brief bibliography.

N93. New York. **The Museum of Modern Art.** THE FAMILY OF MAN: THE PHOTOGRAPHIC EXHIBITION CREATED BY EDWARD STEICHEN FOR THE MUSEUM OF MODERN ART. PROLOGUE BY CARL SANDBURG. New York: Simon & Schuster, 1955. 207 p., illus.

Exhibition: Jan. 24–May 8, 1955.

A record of the entire exhibition, of more than 500 photographs, with installation views of the original presentation at The Museum of Modern Art. A detailed description of the design of the exhibition is given in the Life Library of Photography, *Caring for Photographs* [N279, p. 161–71]. *The Family of Man* had various DELUXE, TRADE, AND PAPERBACK EDITIONS, and one published jointly with the Maco Magazine Corp.

N94. New York. **The Museum of Modern Art.** PHOTOGRAPHY, 1839–1937. INTRODUCTION BY BEAUMONT NEWHALL. New York, 1937. 131 p., illus.

Exhibition: Mar. 17–Apr. 18, 1937.

Catalog of a now-classic exhibition on the histry of photography, with a historical essay. This exhibition catalog is of permanent value because of the consistent application of critical and qualitative standards to its 841 exhibits. Includes ninety-one illustrations covering chronological and technical developments, even moving pictures. Bibliography.

N95. New York. **The Museum of Modern Art.** POWER IN THE PACIFIC: A DRAMATIC SEQUENCE OF OFFICIAL NAVY, COAST GUARD AND MARINE CORPS PHOTOGRAPHS, DEPICTING THE MEN, THE SEA, THE SHIPS AND PLANES, BOMBARDMENTS, LANDING OPERATIONS AND ATTACKS ON THE ENEMY FLEET. TEXT BY L. ROARK BRADFORD, USNR. New York, 1945. 32 p., illus.

Exhibition: Jan. 23–Mar. 20, 1945.

"This book has been compiled from the exhibition at The Museum of Modern Art, designed and directed by Capt. Edward Steichen, USNR. Design by Lt. Robert J. Wolff, USNR."

N96. New York. **Riverside Museum.** PAINTINGS FROM THE PHOTO. INTRODUCTION BY ORIOLE FARB. New York, 1970. 16 p., illus.

Exhibition: Dec. 9, 1969–Feb. 15, 1970.

Includes biographical data on and personal statements by Harold Bruder, Richard Estes, Audrey Flack, Howard Kanovitz, Malcolm Morley, and Joseph Raffael. Biographical data and personal statements.

N97. New York. **Whitney Museum of American Art.** PHOTOGRAPHY IN AMERICA. EDITED BY ROBERT DOTY. INTRODUCTION BY MINOR WHITE. New York: Random House; for the Whitney Museum of American Art, 1974. 255 p., illus. (color).

Exhibition: Nov. 20, 1974–Jan. 12, 1975.

Published on the occasion of an exhibition at the Whitney Museum of American Art, this catalog was described as "the permanent and complete record." Doty, who had organized the Yale show of 1965 [N92], here expands that effort into a handsome collection of 260 reproductions of the work of eighty-six photographers active from 1840 to the present. The selection is mainly of frequently published images, with a short historical essay by the editor and a brief synoptic analysis by Minor White. The notes include information on the exhibition. Index to the photographers.

N98. Pasadena, Calif. **Pasadena Art Museum.** THE PHOTOGRAPH AS POETRY. PREFACE BY THOMAS W. LEAVITT. Pasadena, 1960. 24 p., illus.

Exhibition: May 24–June 19, 1960. [*cont.*]

"An invitational exhibition of nine West Coast photographers." Nine definitions of poetry by Carl Sandburg. Includes photographs and statements by Dick McGraw, Ansel Adams, Imogen Cunningham, William Webb, Don Worth, William Garnett, Wynn Bullock, Brett Weston, and Ruth Bernhard.

N99. New York. **Photography in the Fine Arts.** MUSEUM DIRECTORS' SELECTIONS FOR THE 1965 NEW YORK WORLD'S FAIR EXHIBITIONS. New York, 1965. 44 p., illus., port.

Exhibition.

This is the catalog for the sixth of a series of six exhibitions organized between 1959 and 1965 by Ivan Dmitri (director of Photography in the Fine Arts) and the *Saturday Review* to further the recognition of photography by art museums. Each of the first four exhibitions was juried by prominent members of the art world. The fifth was a selection of all work admitted; the jury was composed exclusively of art museum directors. Each show was circulated to art museums, with catalogs bearing the exhibiting museum's imprint, and containing a list of exhibitors and illustrations, as follows: Exhibition *1:* REPRINT from *Saturday Review,* May 16, 1959. Exhibition *2:* REPRINT from *Saturday Review,* May 28, 1960. Exhibition *3:* REPRINT from *Saturday Review,* June 17, 1961. Exhibition *4:* pamphlet, 30 p., with statement by A. Hyatt Mayor, REPRINTED from *Saturday Review,* May 18, 1963. Exhibition *5:* pamphlet, 36 p., with portraits of museum directors by Yousuf Karsh, as well as statements by them. Exhibition *6:* World's Fair Exhibition, 1965 [*see* head entry, above], supplemented by news release and list of 106 photographers and titles of their 139 pictures.

N100. **Mayor, A. Hyatt.** HOW TO MAKE AN EXHIBITION. New York: Photography in the Fine Arts, 1964. 23 p., illus.

Apparently occasioned by the series of photographic shows (1959–1965) organized by the *Saturday Review* and Photography in the Fine Arts [*see* N99]. Includes a commentary on relationships by Bartlett H. Hayes, Jr., and notes by Carl Zahn. Also includes notes on the design of photographic exhibitions by the curator of prints of The Metropolitan Museum of Art (Mayor), the director of the Addison Gallery of American Art (Hayes), and the museum designer of the Museum of Fine Arts, Boston (Zahn). For commentary on the Ivan Dmitri (Levon West) archive, including documentation and prints related to these 1959–1967 exhibitions, *see* Garnett McCoy, *Archives of American Art: A Directory of Resources* (New York and London: R. R. Bowker Co., 1972), p. 143, collection 533.

N101. Rochester, N.Y. **George Eastman House.** PHOTOGRAPHY AT MID-CENTURY. INTRODUCTION by BEAUMONT NEWHALL. Rochester, 1959. 96 p., illus.

Exhibition.

International, invitational exhibition, juried by Newhall, Walter Chappell, and Nathan Lyons.

N102. Rochester, N.Y. **George Eastman House.** PHOTOGRAPHY 63: AN INTERNATIONAL EXHIBITION OF PHOTOGRAPHY. FOREWORD BY NATHAN LYONS. Rochester, 1963. 99 p., illus.

Exhibition: Cosponsored by the New York State Exposition.

Included are brief biographies of the photographers represented.

N103. Rochester, N.Y. **George Eastman House.** PHOTOGRAPHY 64: AN INVITATIONAL EXHIBITION OF PHOTOGRAPHY. FOREWORD BY NATHAN LYONS. Rochester, 1964. 46 p., illus.

Exhibition: Cosponsored by the New York State Exposition.

The work of twenty-five established photographers nominated by participants in the George Eastman House exhibition, *Photography 63.* Biographies and bibliographic data for each photographer.

N104. Rochester, N.Y. **George Eastman House.** VISION AND EXPRESSION. New York: Horizon Press; with the George Eastman House, 1969. 175 p.

Exhibition: Opened in Feb. 1969.

"Prepared on the occasion of the exhibition *Vision and Expression,* which opened at the George Eastman House in February of 1969." A selection from over 6,000 photographs submitted by 1,500 photographers, as a "continuing directory of contemporary photographers." Includes 154 illustrations. Brief biographies of each photographer. Catalog edited by Nathan Lyons.

N105. Rochester, N.Y. **International Museum of Photography at George Eastman House.** NEW TOPOGRAPHICS: PHOTOGRAPHS OF A MAN-ALTERED LANDSCAPE. Rochester, 1975. 48 p., illus. (color).

Exhibition.

Includes photographs by Robert Adams, Lewis Baltz, Bernd and Hilla Becher, Joe Deal, Frank Gohlke, Stephen Shore, and Henry Wessel, Jr. There are fifty-six reproductions, of which three are in color.

N106. Rochester, N.Y. **International Museum of Photography at George Eastman House.** THE EXTENDED DOCUMENT. ESSAY BY WILLIAM JENKINS. Rochester, 1975. 32 p., illus.

Exhibition.

Catalog of an exhibition of photographs by John Baldessari, Thomas Barrow, Michael Bishop, Marcia Resnick, Richard W. Schaeffer, and William Wegman.

N107. San Francisco. **Golden Gate International Exhibition.** A PAGEANT OF PHOTOGRAPHY. San Francisco, 1940. 48 p., illus. (color).

Exhibition: 1940.

"This book is designed to perpetuate and to broadcast the 1940 photographic show in the Palace of Fine Arts," according to Ansel Adams, director. *Contents:* Introduction by Ansel Adams; "Photography as an Art," by Beaumont Newhall; "A Statement," by Edward Weston; "Photography," by L. Moholy-Nagy; "Documentary

Photography," by Dorothea Lange; "Astronomical Photography," by N. U. Mayall; "Lick Observatory: The Motion Picture," by Grace L. McCann Morley; and "A note on Color Photography," by Paul Outerbridge. Checklist of exhibition. Numerous illustrations with captions.

N108. San Francisco. **San Francisco Museum of Art.** WOMEN OF PHOTOGRAPHY: AN HISTORICAL SURVEY. CATALOG BY MARGERY MANN AND ANNE NOGGLE. San Francisco, 1975. unpag., illus.

Exhibition: Apr. 18–June 15, 1975.

A comprehensive and substantial catalog. The bulk of the publication consists of fair reproductions, one to each photographer, with biographical and professional data on the facing page. Selections begin with Julia Cameron, *b.* 1815, and end with Marcia Resnick, *b.* 1950. The selected bibliography is listed alphabetically by photographer. [For the list of photographers included, *see* N360.]

N109. Washington, D.C. **Library of Congress.** IMAGE OF AMERICA: EARLY PHOTOGRAPHY, 1839–1900. ESSAY BY BEAUMONT NEWHALL. Washington, D.C., 1957. 88 p., illus.

Exhibition: Feb.–Mar. 1957.

The exhibits are arranged by topics and historical periods. There were 348 items, with Library of Congress negative numbers of copy prints.

The History of Photography

GENERAL WORKS

N110. **Beaton, Cecil, and Buckland, Gail.** THE MAGIC IMAGE: THE GENIUS OF PHOTOGRAPHY FROM 1839 TO THE PRESENT DAY. Boston: Little, Brown & Co., 1975. 304 p., illus. (color).

Critical introduction by Sir Cecil Beaton. A broad survey of photography's history, followed by concise biographies, often anecdotal and highly opinionated, of 208 photographers, one-third of whom are American by birth or adoption. Excellent choice of illustrations.

N111. **Brevern, Marilies von.** KÜNSTLERISCHE PHOTOGRAPHIE VON HILL BIS MOHOLY-NAGY. Berlin: Gebr. Mann, 1971. 40 p., illus.

One of a series of books published for the Staatliche Museen of Berlin. Many of the forty-eight photographs reproduced are from the collections of Ernst Juhl and Fritz Matthies-Masuren, historians and collectors of the period. A few Americans are represented.

N112. **Braive, Michel F.** THE PHOTOGRAPH: A SOCIAL HISTORY. TRANSLATED BY DAVID BRITT. New York: McGraw-Hill Book Co., 1966. 367 p., illus.

A study of the social position of photography, richly illustrated with reproductions of photographs of wide variety and of international provenance, together with documents and caricatures. Translated from the French edition. Bibliography; filmography. ALSO PUBLISHED AS *The Era of the Photograph* (London: Thames & Hudson, 1966).

N113. **Coke, Van Deren, ed.** ONE HUNDRED YEARS OF PHOTOGRAPHIC HISTORY: ESSAYS IN HONOR OF BEAUMONT NEWHALL. Albuquerque, N.Mex.: University of New Mexico Press, 1975. 180 p., illus.

Of special interest in the history of American photography are the essays, "The Cubist Photographs of Paul Strand and Morton Schamberg," by Van Deren Coke; "Stereographs: A Neglected Source of History of Photography," by William C. Darrah; "Photography as Folk Art," by Jerald Maddox; "Models for Critics," by Henry Holmes Smith; and "The Science of Seeing," by Minor White. Included are 110 illustrations.

N114. **Coke, Van Deren.** THE PAINTER AND THE PHOTOGRAPH FROM DELACROIX TO WARHOL. Rev. and enl. ed. Albuquerque: University of New Mexico Press, 1972. 324 p., illus.

The 568 illustrations document in a dramatic way the use made of photographic images by artists since the inception of photography in 1839. The author's concluding sentence succinctly explains this interdependence: "What provokes an artist's interest cannot be predicted even by himself; and today's photographs are so geared to life that one can learn more from them than from life itself." The notes section provides references which are also mentioned in the author's introduction. ORIGINAL EDITION (1964).

N115. **Eder, Josef Maria.** HISTORY OF PHOTOGRAPHY. TRANSLATED BY EDWARD EPSTEAN. New York: Columbia University Press, 1945. 860 p.

A translation of the FOURTH EDITION (1932) of the author's *Geschichte der Photographie*, the first scholarly history of photography. While mainly scientific and technical, the work is still of importance. The translation is not illustrated, and the reader should refer to the two-volume original edition. The work is especially valuable for its discussion of photomechanical processes.

N116. **Gassan, Arnold.** A CHRONOLOGY OF PHOTOGRAPHY: A CRITICAL SURVEY OF THE HISTORY OF PHOTOGRAPHY AS A MEDIUM OF ART. Athens, Ohio: Arnold Gassan Handbook Co., 1972. 373 p., illus.

The first part of the book surveys the history of photography by subject categories; the second part is a chronology of important developments in photography including other events of cultural importance.

N117. Gernsheim, Helmut, and Gernsheim, Alison. A CONCISE HISTORY OF PHOTOGRAPHY. London: Thames & Hudson, 1965. 314 p., illus. (color).

A survey of the entire history of photography. Bibliography.

N118. Gernsheim, Helmut, and Gernsheim, Alison. THE HISTORY OF PHOTOGRAPHY FROM THE CAMERA OBSCURA TO THE BEGINNINGS OF THE MODERN ERA. 2d ed. New York: McGraw-Hill Book Co., 1969. 599 p., illus.

An encyclopedic, thoroughly researched, and richly illustrated history of photography—principally as an art medium—from its inception to approximately 1914. The second edition, which contains 390 illustrations, includes chapters on aerial photography, underwater photography, the photography of criminals, and medical photography. Appendix; bibliography; index.

N119. Gernsheim, Helmut. CREATIVE PHOTOGRAPHY: AESTHETIC TRENDS 1839–1960. Boston: Boston Book & Art Shop, 1962. 258 p., illus.

Gernsheim discusses photography's past not in a chronological progression, but by aesthetic concepts and specific fields, such as portraiture, "the photographer as stage manager," the nude, and categories suggested by the history of painting (impressionistic photography, the new objectivity, surrealism). Short biographies of photographers whose work is illustrated; bibliography; concise notes on techniques. This volume is a useful complement to the Gernsheim history books of 1965 [N117] and 1969 [N118].

N120. Kahmen, Volker. ART HISTORY OF PHOTOGRAPHY. TRANSLATED BY BRIAN TUBB. New York: Viking Press, 1973. 232 p., illus.

An essay leaning heavily on the aesthetic theories of the German Marxist writer Walter Benjamin, stressing the importance of subject and object. A large number of the 370 illustrations are lifted from standard works. The BRITISH EDITION is titled *Photography as Art*. Forty-four American photographers are represented. Bibliography.

N120a. Lloyd, Valerie, ed. PHOTOGRAPHY: THE FIRST EIGHTY YEARS. London: P. D. Colnaghi & Co., 1976. 262 p., illus.

Sales catalog.

This sales catalog is of such comprehensiveness, including extensive biographical information, and richness of illustration, that it is itself a concise history of photography. Contains 300 illustrations, glossary, and bibliography.

N121. Lucie-Smith, Edward. THE INVENTED EYE: MASTERPIECES OF PHOTOGRAPHY, 1839–1914. New York, London, and Toronto: Paddington Press, 1975. 256 p., illus.

A sixty-page essay on the stylistic development of photography by a noted art historian, followed by technical data, biographies (including twenty-six Americans), 156 plates (somewhat weakly reproduced), and a short bibliography.

N121a. Washington, D.C. Lunn Gallery/Graphics International. CATALOGUE FIVE: NINETEENTH AND TWENTIETH CENTURY PHOTOGRAPHS. FOREWORDS BY HARRY H. LUNN, JR., AND PETER GALASSI. Washington, D.C., 1976. 190 p., illus.

Sales catalog.

A comprehensive stock list of photographs covering the entire history of the medium, well documented with 218 illustrations. Foreword by Harry H. Lunn, Jr., discusses the current interest in collecting photography.

N122. LIGHT AND FILM, BY THE EDITORS OF TIME-LIFE BOOKS (SERIES EDITOR, ROBERT G. MASON). New York: Time-Life Books, 1970. 227 p., illus. (color). LIFE LIBRARY OF PHOTOGRAPHY.

Basically a text book on exposure and lighting. Pages 45 to 118 contain a brief history of photography, an exposition on working long obsolete techniques, and the documentation of the Civil War and Europe. Bibliography. Historic material is contained in almost every volume of this series, which also includes bibliography.

N123. Newhall, Beaumont. THE HISTORY OF PHOTOGRAPHY FROM 1839 TO THE PRESENT DAY. 4th ed. New York: Museum of Modern Art; with George Eastman House, 1964. 215 p., illus.

According to the foreword, "Ever since 1839 photography has been a vital means of communication and expression. The growth of this contribution to the visual arts is the subject of this book. It is a history of a medium, rather than a technique." Bibliography. [For ORIGINAL EDITION, *see* N125.]

N124. Newhall, Beaumont. LATENT IMAGE: THE DISCOVERY OF PHOTOGRAPHY. Garden City, N.Y.: Doubleday, 1967. 147 p., illus.

A history of the scientific researches and publications of photographic processes by the pioneers: Nicéphore Niepce, Louis Jacques Mandé Daguerre, and William Henry Fox Talbot. Brief bibliography.

N125. Newhall, Beaumont. THE HISTORY OF PHOTOGRAPHY FROM 1839 TO THE PRESENT DAY. New York: Museum of Modern Art, 1949. 256 p., illus. (color).

"This book was begun as an illustrated catalog of the exhibition *Photography 1839–1937*, which I organized for the Museum of Modern Art in 1937. In 1938 the text and illustrations were reprinted, with minor revisions, as *Photography: A Short Critical History*. The present text, although based on this earlier research, has been entirely rewritten and a new selection of illustrations has been made. Two of the chapters first appeared in the *Magazine of Art* and *Antiques*." Sources of quotations, p. 248–50. Selected bibliography; index. REVISED AND ENLARGED FOURTH EDITION (New York: Museum of Modern Art; with George Eastman House, 1964), 215 p., illus. A new chapter has been added discussing recent trends.

N126. **Pollack, Peter.** THE PICTURE HISTORY OF PHOTOGRAPHY: FROM THE EARLIEST BEGINNINGS TO THE PRESENT DAY. Rev. and enl. ed. New York: Harry N. Abrams, 1969. 708 p., illus. (color).

Contents are as follows: Pt. 1, The Beginnings of Photography; Pt. 2, Master of the Nineteenth Century; Pt. 3, Masters of the Modern Era; Pt. 4, Color: Another Dimension; Pt. 5, Extending the Range of Human Vision (Science); Pt. 6, Photography Today. Bibliography; index. This volume is of value especially for its rich collection of reproductions.

N127. **Scharf, Aaron.** ART AND PHOTOGRAPHY. London: Allen Lane, 1968. 314 p., illus.

An exhaustive study of the use made of photography by painters in Europe and America. Detailed bibliographical notes are included.

N128. **Scharf, Aaron.** PIONEERS OF PHOTOGRAPHY: AN ALBUM OF PICTURES AND WORDS. London: British Broadcasting Corp., 1975. 168 p., illus.

Based on a series of television programs produced by the BBC, this well-illustrated and documented book concentrates on nineteenth-century masters. American work is included with an important chapter on the Photo Secession.

N129. **Skopec, Rudolf.** PHOTOGRAPHIE IM WANDEL DER ZEITEN. Prague, ovakia: Artia, 1964. 317 p., illus. (color).

Although this general history of photography contains little on American photography, it is invaluable for its wealth of illustrations.

AMERICAN HISTORY

N130. CENTENNIAL OF PHOTOGRAPHY. *Pennsylvania Arts and Sciences*, history of photography special issue. 4 (fall 1939): 1–94, illus.

The complete issue is devoted to the history of photography, particularly in America and with special emphasis on Philadelphia. The piece was edited by Louis Walton Sipley, director of the American Museum of Photography in Philadelphia, and is illustrated from the museum's collections. [*See also* N139.]

N131. **Chicago. Chicago Historical Society.** CHICAGO PHOTOGRAPHERS, 1847 THROUGH 1900, AS LISTED IN CHICAGO CITY DIRECTORIES. Chicago, 1958. unpag.

This is an unillustrated, alphabetical listing useful for reference value only.

N132. **Doty, Robert, ed.** PHOTOGRAPHY IN AMERICA. New York: Random House; for the Whitney Museum of American Art, 1974. 255 p., illus. (color).

Introduction by Minor White.

N133. **Jensen, Oliver; Kerr, Joan Paterson; and Belsky, Murray.** AMERICAN ALBUM. New York: American Heritage Publishing, 1968. 352 p., illus.

Photographs of the American scene in the nineteenth century. Unlike most compilers of photographs of social significance, the editors of this collection also recount the history of photography, with excellent illustrations of photographers at work—from the days of the daguerreotype to the turn of the century. ABRIDGED EDITION (New York: American Heritage; Ballantine Books, 1970).

N134. **Jussim, Estelle.** VISUAL COMMUNICATION AND THE GRAPHIC ARTS: PHOTOGRAPHIC TECHNOLOGIES IN THE NINETEENTH CENTURY. New York and London: R. R. Bowker Co., 1974. 364 p., illus.

According to the introduction, the period studied by Jussim "is that of the triumph of photography and its revolutionizing effect on picture making and picture reproduction." Subjects covered include "the impact of photography," "illustrators and the photographic media," and "expositions: history captured by photography." In addition to graphic arts (the volume's prime thrust), the index also incorporates numerous references to photography. Selected bibliography, p. 331–37.

N135. **Lipke, William C., and Grime, Philip N., eds.** VERMONT LANDSCAPE IMAGES, 1776–1976. Burlington, Vt.: Robert Hull Fleming Museum, 1976. 119 p., illus. (color).

"This Bicentennial event, five exhibitions on a single theme, is about Vermont as it appeared to in- and outsiders, and how they chose to record the experience over a period of two hundred years. It is based on a simple proposition: every generation sees the landscape anew . . . because its vision is differently motivated" (foreword). Essay by W. C. Lipke, "Changing Images of the Vermont Landscape." Illustrations by various media, including photography, are arranged by periods: 1776–1826, 1826–1876, 1876–1926, 1926–1976. Bibliography. (Project funded by the National Endowment for the Humanities.)

N136. **Meltzer, Milton, and Cole, Bernard.** THE EYE OF CONSCIENCE: PHOTOGRAPHERS AND SOCIAL CHANGE; WITH ONE HUNDRED PHOTOGRAPHS BY NOTED PHOTOGRAPHERS, PAST AND PRESENT. Chicago: Follett Publishing Company, 1974. 192 p., illus.

Essays and photos by T. H. O'Sullivan, Jacob A. Riis, Lewis W. Hine, Dorothea Lange, and others. Bibliography.

N137. **Root, Marcus Aurelius.** THE CAMERA AND THE PENCIL: OR, THE HELIOGRAPHIC ART, ITS THEORY AND PRACTICE IN ALL ITS VARIOUS BRANCHES. Philadelphia: M. A. Root; J. B. Lippincott Co., 1864. 456 p., illus.

Although primarily an instructional manual, this volume is especially valuable for its informal historical notes. Root, formerly a teacher of penmanship, was a pioneer daguerreotypist, with studios in Mobile, New Orleans, Saint Louis, Philadelphia, and New York. FACSIMILE EDI-

TION (Pawlet, Vt.: Helios, 1971), with biographical essay on Root by Beaumont Newhall.

N138. Sachse, Julius F. PHILADELPHIA'S SHARE IN THE HISTORY OF PHOTOGRAPHY. Franklin Institute Science Museum and Planetarium, *Journal* 135 (1893): 271–87, illus.

This important, illustrated article on the introduction of the daguerreotype process to Philadelphia claims priority for Robert Cornelius in making the first portrait with a camera, and comments also on the work of the Langenheim brothers.

N139. Sipley, Louis Walton. COLLECTOR'S GUIDE TO AMERICAN PHOTOGRAPHY. Philadelphia: American Museum of Photography, 1957. 40 p., illus. (color).

A useful guide to the identification of various obsolete photographic processes, and a summary of the history of nineteenth-century photography in America.

N140. New York. **The Museum of Modern Art.** THE PHOTOGRAPHER AND THE AMERICAN LANDSCAPE. EDITED BY JOHN SZARKOWSKI. BIOGRAPHICAL NOTES BY DAVIS PRATT. New York, 1963. 48 p., illus.

Exhibition.

This catalog was published to accompany an exhibition in which the work of nineteen photographers of the nineteenth and twentieth centuries was included. Includes biographical notes on the photographers.

N141. Taft, Robert. PHOTOGRAPHY AND THE AMERICAN SCENE: A SOCIAL HISTORY, 1839–1889. New York: Macmillan Co., 1938. 546 p., illus.

The first comprehensive and scholarly history of photography in America. Despite the subtitle, the book is technological and, to a certain extent, aesthetically as well as sociologically oriented. Well illustrated, and with exhaustive notes containing detailed bibliographical references. REPRINTED (New York: Macmillan Co., 1942). ALSO PUBLISHED IN PAPERBACK (New York: Dover Publications, 1964).

THE DAGUERREOTYPE AND CALOTYPE

Books containing working instructions for the daguerreotype process can also be found in the listing of manuals [N219–N251]. Most early manuals describe several photographic processes; the titles or annotations indicate which ones discuss the daguerreotype process [*see especially* N230, N233, N234, N241]. For instructions on making daguerreotypes today, *see Light and Film* [N122].

N142. Fauvel-Gouraud, François. DESCRIPTION OF THE DAGUERREOTYPE PROCESS; OR, A SUMMARY OF M. GOURAUD'S PUBLIC LECTURES, ACCORDING TO THE PRINCIPLES OF M. DAGUERRE, WITH A DESCRIPTION OF A PROVISORY METHOD FOR TAKING HUMAN PORTRAITS. Boston: Dutton and Wentworth, 1840. 16 p.

Basically a condensation of Daguerre's instruction manual, with instructions to build a studio (with a large window, truncating walls to a backdrop; paint all white, reflect light with mirrors, and use a meniscus [spectacle] lens). Exposure estimated at twenty seconds. FACSIMILE REPRINT in Sobieszek, Robert A., ed., *The Daguerreotype Process: Three Treatises, 1840–1849* (New York: Arno Press, 1973).

N143. Gernsheim, Helmut; and Gernsheim, Alison. L. J. M. DAGUERRE: THE HISTORY OF THE DIORAMA AND THE DAGUERREOTYPE. New York: Dover Publications, 1968. 246 p., illus.

A biography of Daguerre plus the history of his invention. Chap. 5: The Introduction of the Daguerreotype to America. The appendix contains a bibliography, lists of Daguerre's paintings, prints and daguerreotypes, and a bibliography by Beaumont Newhall of Daguerre's instruction manuals. A basic work with 116 plates.

N144. Newhall, Beaumont. THE DAGUERREOTYPE IN AMERICA. New York: Duell, Sloan & Pearce, 1961. 176 p., illus.

A history of the daguerreotype in America as a business and an art, with a detailed description of the technique. A well-documented biographical dictionary of daguerreotypists mentioned in the text; eighty-three illustrations; brief bibliography. REVISED EDITION (Greenwich, N.Y.: New York Graphic Society, 1968).

N145. Oakland, Calif. **The Oakland Museum.** MIRROR OF CALIFORNIA: DAGUERREOTYPES. CATALOG BY THERESE THAU HEYMAN. Oakland, 1974. 32 p., illus.

Exhibition: Nov. 6, 1973–Jan. 27, 1974.

Catalog of an exhibition of an excellent collection of daguerreotypes, including twenty illustrations and a folding panorama (in six plates) of San Francisco.

N146. Rinhart, Floyd; and Rinhart, Marion. AMERICAN DAGUERREIAN ART. New York: Clarkson N. Potter, 1967. 135 p., illus. (color).

The eighty-nine plates reproduce, for the most part, daguerreotypes and thermoplastic cases owned by the authors. A brief historical introduction is followed by a useful biographical index, bibliographical index, and bibliography.

N147. Rudisill, Richard. MIRROR IMAGE: THE INFLUENCE OF THE DAGUERREOTYPE ON AMERICAN SOCIETY. Albuquerque: University of New Mexico Press, 1971. 342 p., illus.

An absorbing account of the meaning of daguerreotype to Americans of all walks of life, with a meticulously documented history of the process and its use. This is, in fact, the first cogent explanation of the popularity of the daguerreotype in America. The rich collection of reproductions supplement, but seldom duplicate, the illustrations in Newhall and Rinhart, but are disappointingly small in size and confusingly laid out. Detailed notes; index. The annotated bibliography (p. 239–55) is the most complete on the subject.

N148. **Ryder, James F.** Voigtländer and I: A Story of Fifty-Two Years's Companionship with a Camera. Cleveland: Cleveland Printing & Publishing Co., 1902. 251 p., illus.

Inclusion of the reminiscences of a traveling daguerreotypist gives this volume special interest. Ryder's work after the daguerreotype period is routine.

THE CIVIL WAR

N149. Washington, D.C. **Library of Congress.** Civil War Photographs, 1861–1865. Catalog by Hirst D. Milhollen and Donald H. Mugridge. Washington, D.C., 1961. 74 p., frontispiece.

Collection catalog.

A catalog of 1,047 photographs by Mathew B. Brady, Alexander Gardner, Timothy H. O'Sullivan, and others, arranged by campaigns, with a complete index of proper names, including photographers when known. This catalog of copy negatives was made from originals selected from the Mathew B. Brady Collection in the Prints and Photographs Division of the Library of Congress. The introductory essay contains the most reasonable explanation of the relation between Brady, as director of photography, and his cameramen and rivals who worked in the field. A microfilm of all of the cataloged photographs is available from the Library of Congress. [For additional material on the photographers included in this catalog, *see* individual names under the rubric for individual photographers, N364 *et seq.*]

N150. **Miller, Francis Trevelyan, ed.** Photographic History of the Civil War. New York: Review of Reviews Co., 1911. 10 vols., illus.

A classic work, with hundreds of photographs from the collection formed by Mathew B. Brady (now in the Library of Congress), including work done under Brady's direction as well as that commissioned by Alexander Gardner. Unfortunately individual photographers are not identified. Reprinted (New York: Castle Books, 1974), 10 vols.; also reprinted (New York: Thomas Yoseloff, 1957), 5 vols., with foreword by Henry Steele Commager.

THE WEST

N151. **Andrews, Ralph W.** Photographers of the Frontier West: Their Lives and Works, 1875–1915. Seattle: Superior Publishing Co., 1965. 182 p., illus.

N152. **Andrews, Ralph W.** Picture Gallery Pioneers, 1850–1875. Seattle: Superior Publishing Co., 1964. 192 p., illus.

Biographies and reproductions of photographs by a large number of photographers who worked in the West.

N153. **Bartlett, Richard A.** Great Surveys of the American West. Norman, Okla.: University of Oklahoma Press, 1962. 402 p., illus.

An account of the exploration of the land between the Mississippi and the Sierra Nevadas by those government expeditions—later consolidated into the United States Geological Survey—commanded by Ferdinand Vandeveer Hayden, Clarence King, John Wesley Powell, and Capt. John M. Wheeler. Contains descriptions of the photographs taken on each survey.

N154. **Buckland, Gail.** Reality Recorded: Early Documentary Photography. Greenwich, Conn.: New York Graphic Society, 1974. 128 p., illus.

This volume is mainly on British nineteenth-century photographers, but there is a chapter on American expeditionary photography of the West. Contains 203 illustrations and bibliography.

N155. Chicago. **University of Chicago, David and Alfred Smart Gallery.** The Documentary Photograph as a Work of Art: American Photographs, 1860–1876. Foreword by Edward A. Maser. Chicago, 1976. 49 p., illus.

Exhibition: Oct. 12–Dec. 12, 1976.

Essays: "Documentation, Art, and the Nineteenth Century," by Alan Fern; "Photographers and Photographs of the Civil War," by Joel Snyder; "Photographing the Western Sublime," by John Cawelti; and "The Practice of Wet Plate Photography," by Doug Monson. Bibliography.

N156. **Curtis, Edward S.** Portraits from North American Indian Life. New York: Outerbridge & Lazard; with the American Museum of Natural History; distributed by E. P. Dutton & Co., 1972. 176 p., illus.

The original work consisted of twenty volumes of text with 1,500 small plates bound in, plus twenty portfolios of unbound gravure plates, approximately 2,500 pictures—"one of the largest photographic archives ever made by a single artist" (preface). Included are legends (expanded captions) for plates. The edition was under the supervision of Frederick Webb Hodge, who is in charge of the Bureau of Ethnology, Smithsonian Institution. Introductions by A. D. Coleman and T. C. McLuhan. First edition (Cambridge, Mass.: University Press, vols. 1–5; Norwood, Mass.: Plimpton Press, vols. 6–20, 1907). Reprinted (New York: Promontory Press, 1972).

N157. **Darrah, William Culp.** Powell of the Colorado. Princeton, N.J.: Princeton University Press, 1951. 426 p., illus.

A scholarly biography of John Wesley Powell, geologist and ethnologist. Passing reference is made to the photographers who accompanied him on his expeditions in the West: E. O. Beaman, J. Fennemore, J. K. Hillers, and W. C. Powell. Extensive bibliography.

N158–N159. [Deleted.]

N160. Buffalo, N.Y. **Albright-Knox Art Gallery, The Buffalo Fine Arts Academy.** Era of Exploration:

THE RISE OF LANDSCAPE PHOTOGRAPHY IN THE AMERICAN WEST, 1860–1885. CATALOG AND ESSAYS BY WESTON J. NAEF AND JAMES N. WOOD; ADDITIONAL ESSAY BY THERESE THAU HEYMAN. Buffalo, 1975. 260 p., illus.

Exhibition: Also shown at The Metropolitan Museum of Art, New York, 1975.

Catalog of an exhibition, with 126 plates included. The introduction—a detailed and well-illustrated discussion of the aesthetic of landscape photography, with reference to European influences—is followed by biographies of Carleton E. Watkins, Timothy H. O'Sullivan, Eadweard J. Muybridge, Andrew Joseph Russell, and William Henry Jackson. (Naef wrote the essays on Watkins, Muybridge and Jackson; Wood wrote the O'Sullivan essay; and Heyman contributed the essay on Russell.) All of the essays include detailed notes and bibliography.

N161. **Phillips, David R., ed.** THE TAMING OF THE WEST: A PHOTOGRAPHIC PERSPECTIVE. Chicago: Henry Regnery Co., 1974. 232 p., illus.

A pictorial documentation of the peoples and life-style of the American West, 1859–1900, from the wet-plate negatives in the collection of the editor. *Contents:* "The American Dream"; "The Way West"; "Golden Alaska"; "The Native Americans"; and "The Beautiful Land." Compiled and edited by David R. Phillips, with commentary by Robert A. Weinstein and David R. Phillips.

N162. **Scherer, Joanna Cohan; and Walker, Jean Burton.** INDIANS: THE GREAT PHOTOGRAPHS THAT REVEAL NORTH AMERICAN INDIAN LIFE, 1847–1929, FROM THE UNIQUE COLLECTION OF THE SMITHSONIAN INSTITUTION. New York: Crown Publishers, 1973. 190 p., illus.

An impressive anthology of photographs of Indians—with the photographers meticulously recorded—from the Bureau of American Ethnology and National Anthropological Archives. Included in this volume is an index to photograph and negative numbers in the collection.

N163. [Deleted.]

PHOTO SECESSION

N164. **Caffin, Charles Henry.** PHOTOGRAPHS AS A FINE ART: THE ACHIEVEMENTS AND POSSIBILITIES OF PHOTOGRAPHIC ART IN AMERICA. New York: Doubleday, Page & Co., 1901. 191 p., illus.

A survey of the work of those photographers who were to form the Photo Secession: Alfred Stieglitz, Gertrude Käsebier, Frank Eugene, Joseph T. Keiley, Clarence H. White, William B. Dyer, and Edward J. Steichen. Two FACSIMILE REPRINTS (Hastings-on-Hudson, N.Y.: Morgan & Morgan, 1971), introduction by Thomas F. Barrow; and (New York: Amphoto, 1972), introduction by Peter Pollack.

N165. **Doty, Robert.** PHOTO-SECESSION: PHOTOGRAPHY

AS A FINE ART. Rochester, N.Y.: George Eastman House, 1960. 104 p., illus.

A survey in depth of the group formed in 1903 by Alfred Stieglitz, Edward Steichen, Clarence H. White and other photographers. This organization was formed to promote the recognition of photography as an art medium, and subsequently was instrumental in introducing modern art in other media to America. The text at hand, which includes fifty-six plates, is supplemented by a selected bibliography, a list of exhibitions held at "The Little Galleries of the Photo-Secession" (later called 291, from its address at 291 Fifth Avenue, Manhattan), and a roster of members of the society. Foreword by Beaumont Newhall.

N166. THE PRINT, BY THE EDITORS OF TIME-LIFE BOOKS (SERIES EDITOR, ROBERT G. MASON). New York: Time-Life Books, 1970. 235 p., illus. (color). LIFE LIBRARY OF PHOTOGRAPHY.

Essentially a technical manual on developing the negative and printing it, the book also contains an essay on Alfred Stieglitz and the Photo Secession, with excellent color reproductions of typical pages of the quarterly, *Camera Work.* [For additional data on *Camera Work, see* N312. For additional annotation on *The Print, see* N182.]

N167. New York. **The Metropolitan Museum of Art.** THE PAINTERLY PHOTOGRAPH, 1890–1914. CATALOG BY WESTON NAEF WITH THE ASSISTANCE OF SUZANNE BOORSCH. New York, 1973. unpag., illus.

Exhibition: Jan. 8–Mar. 15, 1973.

The nineteen photographers included are mainly members of the Photo Secession. Bibliography included.

N168. **Norman, Dorothy.** ALFRED STIEGLITZ: AN AMERICAN SEER. New York: Random House, 1973.

Chap. 6 is on "Dissolution of the Photo Secession."

N169. **Akmakjian, Hiag.** THE YEARS OF BITTERNESS AND PRIDE: FARM SECURITY ADMINISTRATION (FSA) PHOTOGRAPHS, 1935–1943. New York: McGraw-Hill Book Co., 1975. unpag., illus.

A selection of eighty-five photographs, mainly by Walker Evans, Ben Shahn, and Dorothea Lange. Includes a five-page preface.

FARM SECURITY ADMINISTRATION

N170. **Anderson, Sherwood.** HOME TOWN: PHOTOGRAPHS BY FARM SECURITY PHOTOGRAPHERS. New York: Alliance Book Corp., 1940. 145 p., illus. THE FACE OF AMERICA series.

An essay on small-town life integrated with photographs by most of the photographers of Roy Stryker's team.

N171. Balboa, Calif. **Newport Harbor Art Museum.** JUST BEFORE THE WAR: URBAN AMERICA FROM 1935 TO 1941 AS SEEN BY THE PHOTOGRAPHERS OF THE FARM SECURITY ADMINISTRATION. INTRODUCTION BY

THOMAS H. GARVER. Balboa, 1968. 70 p., illus.

Exhibition: Sept. 30–Nov. 10, 1968. Also shown at the Library of Congress, Washington, D.C., Feb. 14–Mar. 30, 1969.

Excellent interview with Roy E. Stryker. Statements by Arthur Rothstein and John Vachon. Shooting scripts ("assignments") by Stryker and fifty-seven illustrations. "Catalogue list" by photographers includes Library of Congress negative numbers.

N172. **Doherty, Robert J., Jr.** USA FSA: FARM SECURITY ADMINISTRATION PHOTOGRAPHS OF THE DEPRESSION ERA. *Camera* 41 (Oct. 19, 1962): 9–51, illus.

[This article appears in the international magazine *Camera*, published in Lucerne, Switzerland.]

N173. **Hurley, F. Jack.** PORTRAIT OF A DECADE: ROY STRYKER AND THE DEVELOPMENT OF DOCUMENTARY PHOTOGRAPHY IN THE THIRTIES. Baton Rouge, La.: Louisiana State University Press, 1972. 196 p., illus.

A definitive study, with photographic editing by Robert J. Doherty. Extensive bibliography included.

N174. **McCoy, Garnett, comp.** ARCHIVES OF AMERICAN ART: A DIRECTORY OF RESOURCES. New York and London: R. R. Bowker Co., 1972. 163 p.

McCoy's description of available Stryker documents in the artist's possession is as follows: "Correspondence, reports, articles and other publications. c.600 items. 1932–1962. In the late 1930s Roy Stryker was chief of the Farm Security Administration's historical section which produced thousands of Depression scene photographs. His papers consist of articles and typescripts describing this project, correspondence and reports reflecting its operation, speeches, lists, photographs, field work instructions, exhibition material, and reviews. Stryker's correspondence with the photographers John Collier, Walker Evans, Dorothea Lange, Edwin Locke, Arthur Rothstein, and John Vachon is included" (p. 134).

N175. New York. **The Museum of Modern Art.** THE BITTER YEARS, 1935–1941: RURAL AMERICA AS SEEN BY THE PHOTOGRAPHERS OF THE FARM SECURITY ADMINISTRATION. EDITED BY EDWARD STEICHEN. New York, 1962. 8 p., illus.

Exhibition.

Statements by Edward Steichen, Rexford Guy Tugwell, and Grace M. Mayer are included in this publication, put out on the occasion of an exhibition.

N176. Memphis, Tenn. **Memphis State University, Oral History Research Office Project.** INTERVIEWING MR. ROY E. STRYKER BY F. JACK HURLEY. Transcription from 2 reels of microform. 50 p. Mississippi Valley Collection, 1967.

Material collected by Hurley for his book, *Portrait of a Decade: Roy Stryker and the Development of Documentary Photography in the Thirties* (1972). Stryker talks about the FSA photographers Walker Evans, Edwin Locke, Dorothea Lange, and Russell Lee.

N177. **Stryker, Roy Emerson; and Wood, Nancy.** IN THIS PROUD LAND: AMERICA 1935–1943, AS SEEN IN THE FSA PHOTOGRAPHS. Greenwich, Conn.: New York Graphic Society, 1973. 191 p., illus.

A collection of 189 photographs selected from his personal collection by Stryker, Director of the Farm Security Administration Historical Section and photographic documentation project, with a statement about his choices. Biographical essay on Stryker by Nancy Wood. Typical shooting scripts by Stryker. Index to plates by photographer, and list of negative numbers. Bibliography. ALSO ISSUED (New York: Galahad Books, 197?), 191 p., illus.

N178. **Tugwell, Rexford Guy; Munro, Thomas; and Stryker, Roy E.** AMERICAN ECONOMIC LIFE AND THE MEANS OF ITS IMPROVEMENT. 2d ed. New York: Harcourt Brace, 1925. 633 p., illus.

Second edition of the textbook coauthored by the Secretary of Agriculture (Tugwell) and the Director of the Historical Section of the Farm Security Administration (Stryker). "The first edition of this book was privately printed and used in the course called *An Introduction to Contemporary Civilization* in Columbia College." Richly illustrated with photographs of sociological interest, seventy-five of which are by Lewis W. Hine.

RECENT TRENDS

N179. **Haworth-Booth, Mark, ed.** THE LAND: TWENTIETH CENTURY LANDSCAPE PHOTOGRAPHS, SELECTED BY BILL BRANDT. New York: Da Capo Press, 1976. 32 p., illus.

A highly sensitive selection of forty-eight photographs that were exhibited under the same title at the Victoria and Albert Museum, London. Of the forty-eight photographers, twenty are American. Preface by Roy Strong, introduction by the editor, essays by Jonathan Williams, Aaron Scharf, and Keith Critchlow.

N180. **Lyons, Nathan, ed.** TOWARD A SOCIAL LANDSCAPE. New York: Horizon Press; with George Eastman House, 1966. 68 p., illus.

Exhibition.

"Prepared on the occasion of the exhibition, 'Toward a Social Landscape,' which opened at the George Eastman House in December of 1966." Brief biographies of the photographers; bibliographies. Includes works of Bruce Davidson, Lee Friedlander, Garry Winogrand, Danny Lyon, and Duane Michals.

N181. FRONTIERS OF PHOTOGRAPHY, BY THE EDITORS OF TIME-LIFE BOOKS (SERIES EDITOR, ROBERT G. MASON). New York: Time-Life Books, 1972. 202 p., illus. (color). LIFE LIBRARY OF PHOTOGRAPHY.

Includes discussion on mixed media, darkroom techniques for altering the camera image, and photographs produced in three dimensions. Picture credits; index; bibliography.

N182. THE PRINT, BY THE EDITORS OF TIME-LIFE BOOKS (SERIES EDITOR, ROBERT G. MASON). New York: Time-Life Books, 1970. 235 p., illus. (color).
LIFE LIBRARY OF PHOTOGRAPHY.

A lively selection of work by photographers using multiple exposures, photograms, gum-bichromate print techniques, solarization, and other control processes. Chapters include *(1)* The Art of the Print; *(2)* How to Develop the Negative; *(3)* How to Print the Positive; *(4)* Modern Masterpieces; *(5)* Images Created in the Darkroom; *(6)* A Revolution in Printmaking. Bibliography: Techniques, History, Biography, Photographic Art, and Periodicals (p. 231). Picture credits; index. *Note especially* far out prints of the avant-garde, p. 204–208. [For additional annotation on *The Print, see* N166.]

N183. Rochester, N.Y. **George Eastman House.** PHOTO-GRAPHICS. ESSAY BY VAN DEREN COKE. Rochester, 1971. unpag., illus.

Exhibition: Jan. 1971.

This exhibition was organized for the University Art Museum, University of New Mexico, Albuquerque, and other institutions.

N184. Waltham, Mass. **Brandeis University, Rose Art Museum, Poses Institute of Fine Arts.** TWELVE PHOTOGRAPHERS OF THE AMERICAN SOCIAL LANDSCAPE: BRUCE DAVIDSON, ROBERT FRANK, LEE FRIEDLANDER, RALPH GIBSON, WARREN HILL, RUDOLPH JANU, SIMPSON KALISHER, DANNY LYON, JAMES MARCHAEL, DUANE MICHALS, PHILIP PERKIS, AND TOM ZIMMERMAN. ESSAY BY THOMAS H. GARVER. Waltham, Mass., 1967. unpag., illus.

Exhibition: Jan. 9–Feb. 12, 1967.

"The title of this exhibition was taken from a statement quoted in the Fall 1963 issue of *Contemporary Photographer*: 'In his personal work Lee Friedlander is mainly preoccupied with what he calls "the American social landscape and its condition."'"

N185. Yonkers, N.Y. **Hudson River Museum.** LIGHTS AND LENS: METHODS OF PHOTOGRAPHY. FOREWORD BY DONALD L. WERNER. INTRODUCTION BY DENNIS LONGWELL. New York: Hudson River Museum, 1973. 82 p., illus. (color).

Exhibition.

Published on the occasion of an exhibition of the work of experimental photographers who have revived techniques of the past and depart from the traditions of straight photography. Werner is curator of photography at the Hudson River Museum. Glossary included.

PHOTOGRAPHIC TECHNIQUES AND METHODS: BOOKS AND SERIALS

Techniques, Methods, and Manuals

AERIAL PHOTOGRAPHY

N186. **Smith, John T.; and Anson, Abraham, eds.** MANUAL OF COLOR AERIAL PHOTOGRAPHY. Falls Church, Va.: American Society of Photogrammetry, 1968. 550 p., illus. (color).

A scholarly, indispensable, and comprehensive work, covering aerospace photography from the planning of the flight, the processing of the film, and its interpretation. Each subject is written by an expert. Contains a glossary of aerial photographic terms. The bibliography is extensive, and contains abstracts of each entry.

N187. **Ives, Herbert E.** AIRPLANE PHOTOGRAPHY. Philadelphia and London: J. B. Lippincott Co., 1920. 422 p., illus.

A detailed account of taking, processing, and interpreting aerial photographs as practiced during World War I.

N188. **Newhall, Beaumont.** AIRBORNE CAMERA: THE WORLD FROM THE AIR AND OUTER SPACE. New York: Hastings House Publishers, 1969. 144 p., illus. (color).

A history of aerial photography, including a reproduction and discussion of the first successful results which were obtained in Boston in 1861. Bibliography.

N189. **Nicks, Oran W., ed.** THIS ISLAND EARTH. Washington, D.C.: National Aeronautics and Space Administration, 1970. 182 p., illus. (color).

A selection of dramatic and revealing photographs taken by and from spacecraft.

CAMERAS

N190. **Adams, Ansel.** CAMERA AND LENS, THE CREATIVE APPROACH: STUDIO, LABORATORY AND OPERATION. Hastings-on-Hudson, N.Y.: Morgan & Morgan, 1970. 361 p., illus.

Particularly useful for its exposition of the use of the view camera, with illustrations of perspective effects obtained by swinging and tilting the lens in respect to the lens axis.

The word CATALOG in the heading of an entry refers to the exhibition catalog as a whole and not to the catalog list, checklist, or catalog section of the work.

N191. **Gilbert, George, comp.** PHOTOGRAPHIC ADVERTISING FROM A TO Z. Riverdale, N.Y.: Yesterday's Cameras, 1970–1972. 2 vols., illus.

A compilation of advertisements of cameras, from periodicals and other sources, reproduced in facsimile. Vol. 1: *From the Kodak to the Leica* (1970), 192 p. Vol. 2: *More Photographic Advertising from A to Z* (1972), 198 p. Reproductions in actual size from the pages of the leading magazines of America from the 1880s to the 1920s are arranged by camera trade name. Gives date of advertisement (but not source). There are no explanations or descriptions.

N192. **Holmes, Edward.** AN AGE OF CAMERAS. Kings Langley, England: Fountain Press, 1974. 159 p., illus.

A technological history, well illustrated, with emphasis on cameras of British construction.

N193. **Jenkins, Reese V.** IMAGES AND ENTERPRISE: TECHNOLOGY AND THE AMERICAN PHOTOGRAPHIC INDUSTRY, 1839–1925. Baltimore and London: Johns Hopkins University Press, 1975. 371 p., illus.

A scholarly, well-documented, and well-illustrated history of the production of cameras and sensitized goods (daguerreotype plates, gelatin-bromide plates, and film). Most of the text concerns the growth of the Eastman Kodak Co., with a precise account of the many companies absorbed by Eastman. Although the use of photography as an art form is not the subject of the author's presentation, the phenomenal growth of photography can hardly be understood without knowledge of the tools and materials that Eastman Kodak Co. made available in abundant quantities.

N194. **Lothrop, Eaton S., Jr.** A CENTURY OF CAMERAS FROM THE COLLECTIONS OF THE INTERNATIONAL MUSEUM OF PHOTOGRAPHY AT GEORGE EASTMAN HOUSE. Dobbs Ferry, N.Y.: Morgan & Morgan, 1973. 150 p., illus.

[*See* N44.]

N195. THE CAMERA, BY THE EDITORS OF TIME-LIFE BOOKS (SERIES EDITOR, ROBERT G. MASON). New York: Time-Life Books, 1970. 236 p., illus. LIFE LIBRARY OF PHOTOGRAPHY.

A general introduction to photography. Detailed analysis of camera types, lenses, and their function. Pt. 4, "The Little Black Box," is a history of the camera.

N196. **Stroebel, Leslie.** VIEW CAMERA TECHNIQUES. London and New York: Focal Press, 1967. 311 p., illus.

A technical manual, with a summary history of the view camera; illustrations are largely from the collections of the International Museum of Photography at George Eastman House, Rochester, N.Y.

COLOR

N197. **Elisofon, Eliot.** COLOR PHOTOGRAPHY. New York: Viking Press, 1961. 153 p., illus. (color).

Stimulating for its suggestions of the use of color filters to modify the naturalistic rendition of most color films. Written by one of the most active *Life* photographers and consultant to Hollywood film producers.

N198. **Evans, Ralph M.** AN INTRODUCTION TO COLOR. New York: John Wiley & Sons; London: Chapman & Hall, 1948. 340 p., illus. (color).

The color control department head of the Eastman Kodak Co. writes on the phenomena of color perception—in highly scientific and theoretical language. One chapter is devoted to "Color in Photography," another to "Color in Art." There are no examples of color photography as an aesthetic medium.

N199. **Evans, Ralph M.; Hanson, W. T., Jr.; and Brewer, W. Lyle.** PRINCIPLES OF COLOR PHOTOGRAPHY. New York: John Wiley & Sons; London: Chapman & Hall, 1953. 709 p., illus.

Color perception and the technology of the photographic recording of color, particularly by multilayer dye-coupling processes.

N200. **Friedman, Joseph S.** HISTORY OF COLOR PHOTOGRAPHY. London: Focal Press, 1968. 586 p., illus.

Reprint of the FIRST EDITION (1944), with appendix by Lloyd Varden bringing the historical survey up to date. Of technological and scientific interest.

N201. **Hill, Levi L.** A TREATISE ON HELIOCHROMY; OR, THE PRODUCTION OF PICTURES, BY MEANS OF LIGHT, IN NATURAL COLORS. New York: Robinson & Caswell, 1856. 175 p.

Hill, a daguerreotypist in New York State, claimed the invention of a color photographic technique. His manual indicates that he used the properties of photochlorides. Of no practical value, the book is an indication of the universal desire for a color process. FACSIMILE REPRINT (State College, Pa.: Carnation Press, 1972), with an introduction by William B. Becker.

N202. COLOR, BY THE EDITORS OF TIME-LIFE BOOKS (SERIES EDITOR, ROBERT G. MASON). New York: Time-Life Books, 1970. 240 p., illus. (color). LIFE LIBRARY OF PHOTOGRAPHY.

History and techniques of photography. *Contents: (1)* How Color Film Works; *(2)* The Search for a Color Process; *(3)* Colors of the Day; *(4)* Techniques of Color Photography; *(5)* An Innovation in Color (Ernst Haas); *(6)*

Do-It-Yourself Color; *(7)* Colors that Never Were. Index. Bibliography: General, History, Science of Color, Technique, and Magazines. REPRINT (1971).

N203. **Newhall, Beaumont.** THE SEARCH FOR COLOR— A SHORT HISTORY. *Color Photography Annual* (1956): 19–25, 167–69, illus. (color).

N204. **Sipley, Louis Walton.** A HALF CENTURY OF COLOR. New York: Macmillan Co., 1951. 216 p., illus. (color).

A history of the technology of color photography, especially the photomechanical reproduction of color photographs and art work, written by the late director of the American Museum of Photography in Philadelphia.

N205. **Spencer, D. A.** COLOUR PHOTOGRAPHY IN PRACTICE. London: Focal Press, 1966. 410 p., illus. (color).

ORIGINALLY PUBLISHED in 1938, the present edition (with 111 illustrations) has been revised by L. A. Mannheim to include the fundamentals of color, color processes, and techniques and color reproduction.

N206. **Wall, E. J.** HISTORY OF THREE-COLOR PHOTOGRAPHY. London: Focal Press, 1970. 748 p., illus.

Reprint of the classic ORIGINAL EDITION (1925). A scientific and technical survey of the development of processes, with a bibliography of over 12,000 articles and patents, and 203 diagrams and illustrations.

DOCUMENTARY PHOTOGRAPHY

N207. **Abbott, Berenice.** NEW GUIDE TO BETTER PHOTOGRAPHY. Rev. ed. New York: Crown Publishers, 1953. 180 p., illus.

An excellent technical manual, with a chapter on photographic aesthetics emphasizing the documentary approach, and a rich plate selection of eighty-five photographs by the author, works by contemporary documentary photographers, and a few historical examples. FIRST EDITION (1941).

N208. **Conrat, Maisie, comp.** EXECUTIVE ORDER 9066: THE INTERNMENT OF 110,000 JAPANESE AMERICANS. PHOTOS BY DOROTHEA LANGE, ET AL. Cambridge, Mass.: M.I.T. Press; for the California Historical Society, 1972. 120 p., illus.

A post facto picture record of an event in American history, presented in the spirit of the documentary movement of the 1930s and 1940s, featuring photographs by Dorothea Lange, a prime force in the documentary movement. Introduction by Edison Uno; epilogue by Tom C. Clark.

N209. **Grierson, John.** GRIERSON ON DOCUMENTARY. EDITED BY FORSYTH HARDY. London: Collins, 1946. 256 p., illus.

A series of collected essays. Although concerned primarily with motion pictures, the documentary approach

outlined by Grierson was of great importance to the documentary photographers of the 1930s.

N210. Lawrence, Kans. **University of Kansas Museum of Art.** No Mountains in the Way: Kansas Survey, NEA. Photographs by James Enyeart, Terry Evans, and Larry Schwarm. Preface by Charles C. Eldredge. Introduction by James Enyeart. Lawrence, 1975. unpag., illus.

Exhibition.

Reproductions of 103 photographs are included in this exhibition catalog, publication of which was supported by a grant from the National Endowment for the Arts.

N210a. Documentary Photography, by the editors of Time-Life Books (series editor, Robert G. Mason). New York: Time-Life Books, 1972. 241 p., illus.
Life Library of Photography.

A broad coverage, including the origins of that form of sociological photography termed "documentary" (as evidenced in the work of Jacob A. Riis, Lewis W. Hine, and the Farm Security Administration photographers) as well as photographs of the human condition by photographers not commonly identified with the movement (Cartier-Bresson, André Kertész, and Paul Strand) and the photographers whose work has been called "the social landscape" (Diane Arbus, Robert Frank, Lee Friedlander, and Garry Winogrand).

N211. **Siegel, Arthur.** Fifty Years of Documentary. *American Photography* 45 (1951): 21–26, illus.

This is a historical survey of photography done in the realist spirit since 1900. According to the author, "that the documentary attitude will expand its techniques and understanding is a foregone conclusion. The documentary photographer of the future bears a tremendous responsibility; let us hope he is adequate to his task."

N212. **Stott, William.** Documentary Expression and Thirties America. New York: Oxford University Press, 1973. 361 p., illus.

A study of documentary rhetoric, especially in the work of the Farm Security Administration photographers and of Walker Evans in particular.

N213. **Stryker, Roy E.** Documentary Photography. *The Complete Photographer* 4 (Apr. 10, 1942): 1564–74, illus.

A definition and an explanation of the specific style of photographic recording and interpretation that came to be called "documentary." The author was head of the Farm Security Administration's photographic documentation project.

FLASH

N214. **Edgerton, Harold E., and Killian, James R., Jr.** Flash! Seeing the Unseen by Ultra High-Speed Photography. 2d ed. Boston: Charles T. Branford, 1954. 215 p., illus.

Edgerton was the inventor of the high-speed electronic flash. The illustrations cover a wide variety of the uses of this light source. "Supplementary data" includes the theory and technology of electronic flash, plus a bibliography.

LENSES AND OPTICS

N215. **Cox, Arthur.** Photographic Optics. Rev. and enl. ed. London: Focal Press, 1971. 502 p., illus.

This work provides theoretical and practical information on lenses and optical systems, including automatic focusing, fibre optics, and holography. Original edition (1943).

N216. **Kingslake, Rudolf.** The Development of the Photographic Objective. In: Henney, Keith, and Dudley, Beverly, eds. Handbook of Photography. New York: McGraw-Hill Book Co., 1939. p. 37–67.

Detailed description of approximately 400 lenses, old and new.

N217. **Kingslake, Rudolf.** Lenses in Photography. New York: A. S. Barnes, 1963. 278 p., illus.

A practical guide to optics—with 199 illustrations—written especially for photographers who want to get the most from their equipment.

N218. **Neblette, C. B., and Murray, Allen, eds.** Photographic Lenses. Dobbs Ferry, N.Y.: Morgan & Morgan, 1973. 131 p., illus.

This book includes an account of the historical development of photographic lenses. The properties and performance of photographic lenses is discussed, as are zoom lenses and mirror lens systems. Glossary; bibliography.

MANUALS: 1849–1976

The entries included in this group are highly selective, and consist mainly of the most popular and most technically explicit instruction books. Special attention has been given to books that combine technological instructions with picture-taking problems. The chronological list below provides a record of the state of the art at a given period of time.

1849: Humphrey [N233, N234]
1849: Snelling [N241]
1850: Hill [N230]
1853: Bisbee [N223]
1863: Burgess [N225]
1864: Towler [N245]
1887: Wilson [N251]
1888: Wilson [N250]
1891: Burbank [N224]
1935: Adams [N222]
1935: Morgan, Lester, et al. [N239] [*cont.*]

1938: Morgan and Lester [N240]
1939: Henney and Dudley [N231]
1941: Abbott [N219]
1953: Abbott [N220]
1953: Deschin [N228]
1967: Stroebel [N243]
1970: Adams [N221]
1970–1971: Spencer [N242]
1970–1972: Mason [N236, N237]
1971: Horder [N232]
1971: Morgan and Lester [N238]
1971: Williams [N249]
1972: Davis [N227]
1973: Kemp and Wilson [N235]
1974: Swedlund [N244]
1975: Craven [N226]
1975: Vestal [N247]
1976: White, et al. [N248]
1976: Hedgecoe and Bailey [N229]

N219. Abbott, Berenice. A GUIDE TO BETTER PHOTOG-
RAPHY. New York: Crown Publishers, 1941. 182 p., il-
lus.

An excellent technical manual, distinguished by its
choice of seventy-one photographs taken by the author
and other master photographers, including those work-
ing in the nineteenth century.

N220. Abbott, Berenice. NEW GUIDE TO BETTER
PHOTOGRAPHY. Rev. ed. New York: Crown Publishers,
1953. 180 p., illus.

An excellent technical handbook, with a chapter on
photographic aesthetics emphasizing the documentary
point of view; and a rich eighty-five-plate selection of
photographs by the artist, photographs by contemporary
documentary photographers, and a few historical ex-
amples. ORIGINAL EDITION (1941).

N221. Adams, Ansel. CAMERA AND LENS: THE CREA-
TIVE APPROACH; STUDIO, LABORATORY AND OPERA-
TION. Hastings-on-Hudson, N.Y.: Morgan & Morgan,
1970. 301 p., illus.
BASIC PHOTO SERIES, NO. 1.

In this book, subtitled "Basic Photo One," Ansel Adams
describes a creative approach to photography "which re-
lates to visualization of the end result—the print—prior
to the moment of exposure" by means of the application
of sensitometric principles through his Zone System.
Highly detailed instructions on the choice and use of
cameras, exposure meters, and lenses follow, with speci-
fications for darkroom and studio equipment. Bibliogra-
phy. The other volumes in the Basic Photo Series (now
out of print) continue Adams's thorough and detailed ex-
position of the medium: *The Negative* (1948); *The Print*
(1950); *Natural Light Photography* (1952); and *Artificial
Light Photography* (1956).

N222. Adams, Ansel. MAKING A PHOTOGRAPH: AN IN-
TRODUCTION TO PHOTOGRAPHY. London: Studio; New
York: Studio Publications, 1935. 96 p., illus.

Concise technical manual with thirty-two superb,
tipped–in reproductions; all illustrations are by Adams.

A REVISED EDITION, with a color plate, was published in
1939, and a THIRD EDITION, with color frontispiece and
thirty-seven plates, in 1948.

N223. Bisbee, A. THE HISTORY AND PRACTICE OF
DAGUERREOTYPING. Dayton, Ohio: L. F. Claflin & Co.,
1853. 104 p.

Also contains instruction for the collodion process. FAC-
SIMILE REPRINT (New York: Arno Press, 1973).

N224. Burbank, W. H. PHOTOGRAPHIC PRINTING
METHODS: A PRACTICAL GUIDE TO THE PROFESSIONAL
AND AMATEUR WORKER. 3d ed. New York: Scovill &
Adams Co., 1891. 225 p., illus.

Among the many processes for which working direc-
tions are given are albumen paper, platinotype, carbon,
and printing on fabrics and ceramics. FACSIMILE RE-
PRINT (New York: Arno Press, 1973).

N225. Burgess, N. G. THE PHOTOGRAPH MANUAL: A
PRACTICAL TREATISE, CONTAINING THE CARTES-DE-
VISITE PROCESS, AND THE METHOD OF TAKING
STEREOSCOPIC PICTURES, INCLUDING THE ALBUMEN
PROCESS, THE DRY COLLODION PROCESS, THE TANNIN
PROCESS, THE VARIOUS ALKALINE TONING BATHS.
New York: D. Appleton & Co., 1863. 267 p.

FACSIMILE REPRINT (New York: Arno Press, 1973).

N226. Craven, George M. OBJECT AND IMAGE; AN IN-
TRODUCTION TO PHOTOGRAPHY. Englewood Cliffs,
N.J.: Prentice-Hall, 1975. 280 p., illus.

An excellent textbook, distinguished by its choice of
photographs from the entire history of photography.
Annotated bibliography.

N227. Davis, Phil. PHOTOGRAPHY. Dubuque, Iowa:
William C. Brown, 1972. 254 p., illus.

A textbook including historical survey, glossary, and bib-
liography. The illustrations are largely diagrams.

N228. Deschin, Jacob. 35MM PHOTOGRAPHY: AP-
PROACHES AND TECHNIQUES WITH THE MINIATURE
CAMERA. San Francisco: Camera Craft Publishing Co.,
1953. 191 p., illus.

A technical manual, with an excellent selection of photo-
graphs by W. Eugene Smith, Henri Cartier-Bresson,
Alfred Eisenstaedt, and others.

N229. Hedgecoe, John; with Bailey, Adrian. THE BOOK
OF PHOTOGRAPHY: HOW TO SEE AND TAKE BETTER
PICTURES. New York: Alfred A. Knopf, 1976. 256 p., il-
lus. (color).

A lavishly produced technical manual, with more than
850 illustrations, mostly photographs by the author and
drawings of equipment and procedures. [For a history of
photography, *see* p. 18–32.] John Hedgecoe is a British
commercial photographer and professor at the Royal
College of Art in London.

N230. Hill, Levi L.; and McCartey, W., Jr. A TREATISE

ON DAGUERREOTYPE. Lexington, N.Y.: Holman & Gray, 1850. 3 vols.-in-2.

The FIRST EDITION was published in 1849; no copies appear to exist. Apparently it was identical to vol. 1, Pt. 1 of the 1850 work. Vol. 2 is titled *A Treatise on Daguerreotype*. Pt. 2 is by L. L. Hill and to it is added Pt. 3 by W. McCartey, Jr. Vol. 3 is titled *Hill's Treatise on Daguerreotype: The Magic Buff and Other Improvements*, Pt. 4. Hill became famous for his alleged discovery of a color photographic process, undoubtedly based on the photochloride phenomenon as demonstrated by Niepce de Saint Victor in Paris. Hill's *Treatise* ranks in importance with the manuals of Snelling and Humphrey. FACSIMILE REPRINT in one volume (New York: Arno Press, 1973).

N231. **Henney, Keith, and Dudley, Beverly, eds.** HANDBOOK OF PHOTOGRAPHY. New York: McGraw-Hill Book Co., 1939. 871 p., illus.

An encyclopedic work, with articles—by leading specialists—on the technology of photography. Each chapter has a bibliography.

N232. **Horder, Alan.** THE MANUAL OF PHOTOGRAPHY. New York: Chilton Book Co., 1971. 596 p., illus.

FIRST PUBLISHED over eighty years ago, this work has gone through several revisions and remains one of the best practical books dealing with the theory and practice of photography. A number of appendixes deal with exposure guides, mathematics tables, formulae, standards, and special developers. There are 231 illustrations.

N233. **Humphrey, Samuel Dwight.** A SYSTEM OF PHOTOGRAPHY; CONTAINING AN EXPLICIT DETAIL OF THE WHOLE PROCESS OF DAGUERREOTYPE; ACCORDING TO THE MOST APPROVED METHODS OF OPERATING, INCLUDING ALL THE LATE VALUABLE IMPROVEMENTS. 2d ed. Albany, N.Y.: C. Van Benthuysen, 1849. 144 p.

Humphrey, editor of *The Daguerreian Journal*, was—with Snelling—one of the most influential writers on photography in its early period in America. Besides the daguerreotype, Humphrey gives instructions on the calotype process and the production of glass positives on albumen plates for projection or viewing in stereoscopes introduced as "Hyalotypes." He leans heavily on European publications, particularly Robert Hunt's *Photography* (London, 1851), which he published in 1852 in New York. Later editions of *A System of Photography* are titled *American Handbook of the Daguerreotype*. FACSIMILE REPRINT of the fifth edition (New York: Arno Press, 1973). [For the FIRST EDITION, *see* N234].

N234. **Humphrey, Samuel Dwight, and Finley, M.** A SYSTEM OF PHOTOGRAPHY, CONTAINING AN EXPLICIT DETAIL OF THE WHOLE PROCESS OF DAGUERREOTYPE; ACCORDING TO THE MOST APPROVED METHODS OF OPERATING ALL THE LATE VALUABLE IMPROVEMENTS. Canandaigua, N.Y.: Office of the Ontario Messenger, 1849. 82 p.

Although this edition is basically a manual for making daguerreotypes, brief directions are given for the calotype. FACSIMILE REPRINT (New York: Arno Press, 1973), in collective volume, *The Daguerreotype Process: Three Treatises, 1840–1849*, edited by Robert A. Sobieszek.

N235. **Kemp, Weston D., and Wilson, Tom Muir.** PHOTOGRAPHY FOR VISUAL COMMUNICATORS. Englewood Cliffs, N.J.: Prentice-Hall, 1973. 279 p., illus. (color).

Foreword by Ralph M. Hattersley. A textbook on photographic technique and creative approaches, with a rich collection of photographs by masters, old and new. Contains historical introduction, glossary, and bibliography.

N236. LIFE LIBRARY OF PHOTOGRAPHY, BY THE EDITORS OF TIME-LIFE BOOKS (SERIES EDITOR, ROBERT G. MASON). New York: Time-Life Books, 1970–1972. 17 vols., illus. (color).

Concise working directions, in words and pictures, for all modern photographic techniques (as well as many obsolete ones) are furnished in this series of seventeen books, which relate technique to the finished product by lavish illustrations of the work of prominent photographers of today and the past. Each volume contains a bibliography. The individual books in the series are listed by title under appropriate subject categories. [For a list of the entire series, *see* N12.]

N237. PHOTOGRAPHY AS A TOOL, BY THE EDITORS OF TIME-LIFE BOOKS (SERIES EDITOR, ROBERT G. MASON). New York: Time-Life Books, 1970. 236 p., illus. (color). LIFE LIBRARY OF PHOTOGRAPHY.

"This book introduces some of the wonders of scientific and industrial photography. But it does not limit itself to the technical side. There remain many areas combining the technical with the esthetic" (Introduction). *Contents: (1)* The Fast and Slow Revealed; *(2)* Pictures Bigger than Life; *(3)* The Distant Made Near; *(4)* Photographing the Invisible; *(5)* An Aid to Technology and Medicine; *(6)* The Camera's Unique View. Appendix: Equipment. Bibliography: General, Electronic Flash and High-Speed Photography, Photomacrography and photomicrography, Aerial and Astronomical Photography, Underwater Photography, X-Ray, Ultra-Violet and Infrared Photography, and Periodicals. Index.

N238. **Morgan, Willard D.; and Lester, Henry M.** GRAPHIC GRAFLEX PHOTOGRAPHY. Hastings-on-Hudson, N.Y.: Morgan & Morgan, 1971. 396 p., illus.

This is a facsimile reprint of the NINTH EDITION (1952) of this popular manual, which includes articles by leading photographers, as well as specific information on the use of Graflex and Graphic cameras.

N239. **Morgan, Willard D.; Lester, Henry M.; et al.** THE LEICA MANUAL: A MANUAL FOR THE AMATEUR AND PROFESSIONAL COVERING THE ENTIRE FIELD OF LEICA PHOTOGRAPHY. New York: Morgan & Lester, 1935. 483 p., illus.

The first of a series of publications which not only describes the use of specific cameras, but includes essays on various aspects of photography by leaders in the field; these publications are invaluable to the art student. In the volume at hand, the introductory essay by the writer

Manuel Komroff states that "except for a very few specialized things, this handbook applies equally to all cameras in the miniature field." The manual sets a pace that is still followed by similar titles published by Morgan & Lester and Morgan & Morgan.

N240. Morgan, Willard D.; and Lester, Henry M.; eds. MINIATURE CAMERA WORK; EMPHASIZING THE ENTIRE FIELD OF PHOTOGRAPHY WITH MODERN MINIATURE CAMERAS. New York: Morgan & Lester, 1938. 303 p., illus. (color).

Technical data and processing methods, plus articles by leading photographers on various fields.

N241. Snelling, Henry Hunt. THE HISTORY AND PRACTICE OF THE ART OF PHOTOGRAPHY; OR, THE PRODUCTION OF PICTURES THROUGH THE AGENCY OF LIGHT, CONTAINING ALL THE INSTRUCTIONS NECESSARY FOR THE COMPLETE PRACTICE OF THE DAGUERREAN AND PHOTOGENIC ART, BOTH ON METALLIC PLATES AND ON PAPER. New York: G. P. Putnam, 1849. 139 p., illus.

This work is among America's first photographic manuals to cover both the daguerreotype and calotype processes, with heavy emphasis on the former [see also N233, N234]. Snelling was one of the most influential writers on photography. He edited *The Photographic Art Journal* as well as other manuals. The work at hand was published in five editions, the last dated 1858. FACSIMILE REPRINT of first edition, with essay on Snelling by Beaumont Newhall (Hastings-on-Hudson, N.Y.: Morgan & Morgan, 1970).

N242. Spencer, D. A., ed. L. P. CLERC'S PHOTOGRAPHY: THEORY AND PRACTICE. London: Focal Press, 1970–1971. 6 vols.

The ORIGINAL EDITION (*La technique photographique*), first published in 1926 by L. P. Clerc, was a comprehensive treatise on the theory and practice of photography. Recently the work has been brought up to date and is presented as a series of volumes covering a variety of topics in depth.

N243. Stroebel, Leslie. VIEW CAMERA TECHNIQUES. London and New York: Focal Press, 1967. 311 p., illus.

A thorough description of the imagery available with cameras having lens boards and backs which can be set at angles other than 90 degrees with the optical axis. A summary history of the view camera is included, and applications of view camera techniques are illustrated.

N244. Swedlund, Charles. PHOTOGRAPHY: A HANDBOOK OF HISTORY, MATERIALS, AND PROCESSES. New York: Holt, Rinehart & Winston, 1974. 368 p., illus.

A well-illustrated textbook basically on photographic technique, together with basic facts of the history of photography. Includes 765 illustrations.

N245. Towler, John. THE SILVER SUNBEAM: A PRACTICAL AND THEORETICAL TEXT-BOOK ON SUN DRAWING AND PHOTOGRAPHIC PRINTING; COMPREHEND-ING ALL THE WET AND DRY PROCESSES AT PRESENT KNOWN, WITH COLLODION, ALBUMEN, GELATINE, WAX, RESIN, AND SILVER. New York: Joseph H. Ladd, 1864. 351 p., illus.

The most detailed and popular instruction manual for the collodion and related processes. Later editions contain this text with supplements; the NINTH AND FINAL EDITION appeared in 1879. FACSIMILE REPRINT (Hastings-on-Hudson, N.Y.: Morgan & Morgan, 1969), with an introduction by Beaumont Newhall.

N246. Upton, Barbara; and Upton, John. PHOTOGRAPHY; ADAPTED FROM THE LIFE LIBRARY OF PHOTOGRAPHY. Boston: Little, Brown & Co., 1976. 354 p., illus. (color).

A richly illustrated manual of photographic technique, with reproductions of many classic photographs and a chapter on the history of photography. Glossary; bibliography.

N247. Vestal, David. THE CRAFT OF PHOTOGRAPHY. New York: Harper & Row, 1975. 364 p., illus.

A well-produced manual, with instructions on the processing of 35 mm black-and-white film and printing the negatives by contact and projection. The section on mounting, framing, and exhibiting is highly informative. A brief historical introduction covers highlights, and the conclusion presents picture possibilities and aesthetic discussion. Useful glossary and bibliography of photochemistry.

N248. White, Minor; with Zakia, Richard D.; and Lorenz, Peter. THE NEW ZONE SYSTEM MANUAL. Dobbs Ferry, N.Y.: Morgan & Morgan, 1976. 139 p., illus.

Foreword by Nathan Lyons. A complete revision of White's earlier *Zone System Manual* (Morgan & Morgan, 1966). The 1976 edition was revised with the collaboration of Richard Zakia, a photographic scientist at the Rochester Institute of Technology, and Peter Lorenz, a teacher of photography at the New England School of Photography. A method worked out by Ansel Adams, for measuring the level of brightness of the subject and determining processing procedures from this data, is discussed.

N249. THE STUDIO, BY THE EDITORS OF TIME-LIFE BOOKS (SERIES EDITOR, RICHARD L. WILLIAMS). New York: Time-Life Books, 1971. 236 p., illus. (color). LIFE LIBRARY OF PHOTOGRAPHY.

Contents: (1) The Photographer in Control; (2) Evolution of the Studio; (3) The Studio on Location; (4) Focusing on Fashion; (5) A Versatile Studio Tool; (6) The Studio at Home; and (7) The Art in Everyday Objects. Bibliography: general, periodicals; index.

N250. Wilson, Edward L. WILSON'S PHOTOGRAPHICS: A SERIES OF LESSONS, ACCOMPANIED BY NOTES, ON ALL THE PROCESSES WHICH ARE NEEDFUL IN THE ART OF PHOTOGRAPHY. New York: Edward L. Wilson, 1888. 366 p., illus.

A detailed manual, with extensive footnotes from various authorities. FACSIMILE REPRINT (New York: Arno Press, 1973).

N251. **Wilson, Edward L.** WILSON'S QUARTER CENTURY IN PHOTOGRAPHY: A COLLECTION OF HINTS ON PRACTICAL PHOTOGRAPHY WHICH FORM A COMPLETE TEXT-BOOK OF THE ART. New York: Edward L. Wilson, 1887. 528 p., illus.

A manual, with extensive footnotes by other authorities, illustrated by wood engravings.

POLAROID

N252. **Adams, Ansel.** POLAROID LAND PHOTOGRAPHY: A TECHNICAL HANDBOOK. New York: Morgan & Morgan, 1963. 192 p., illus.

An advanced manual, largely devoted to the application of Polaroid Land sensitive materials to Adams's Zone System. For a general introduction to the Polaroid Land System, Adams recommends John Wolbarst [N254].

N253. **Adams, Ansel.** SINGULAR IMAGES. Dobbs Ferry, N.Y.: Morgan & Morgan, 1974. unpag., illus.

A collection of photographs taken by the Land Polaroid process, with essays by the inventor, Edwin H. Land, Jon Holmes, David H. McAlpin, and Adams. Edited by Liliane De Cock.

N254. **Wolbarst, John.** PICTURES IN A MINUTE. 2d ed. New York: American Photographic Publishing Co., 1958. 176 p., illus.

An instructional manual on the Polaroid process.

PHOTOMONTAGE

N255. **Morgan, Barbara.** PHOTOMONTAGE. In: MORGAN, WILLARD D., AND LESTER, HENRY M., EDS. New York: Morgan & Lester, 1938. p. 145–66, illus.

Historical survey of all types of photomontage: collage, multiple exposure, multiple printing, with specific laboratory techniques.

PHOTOGRAPHY BY INVISIBLE LIGHT

The possibilities of creative photography by radiation invisible to the eye has been strangely overlooked. The challenge of this technique is clearly indicated in the pioneer works entered below.

N256. **Clark, Walter.** PHOTOGRAPHY BY INFRARED: ITS PRINCIPLES AND APPLICATIONS. London: Chapman & Hall, 1939. 397 p., illus.

N257. **Wood, R. W.** PHOTOGRAPHY BY INVISIBLE RAYS. *Photographic Journal* 50 (1910): 329–38.

PHOTOJOURNALISM AND NEWS PHOTOGRAPHY

N258. **Andrist, Ralph K.** AMERICAN CENTURY: ONE HUNDRED YEARS OF CHANGING LIFE STYLES IN AMERICA. New York: American Heritage Press, 1972. 351 p., illus. (color).

From the gilded age (1872–1879) to the restless years (1960–1972) over 600 black-and-white photographs and thirty-two pages of color illustrations bring to life American mores and culture. This "collection of memorabilia," utilizing a picture editor (Linda S. Sykes) and an archive (from Montgomery Ward) combine to produce a representative example of photojournalism in book form, of which genre *The Taming of the West* [see N161] is another typical specimen.

N259. **Baynes, Ken, ed.** SCOOP, SCANDAL, AND STRIFE: A STUDY OF PHOTOGRAPHY IN NEWSPAPERS. New York: Hastings House, 1971. 144 p., illus.

Although primarily British, of importance for its historical sections by Tom Hopkinson and Derrick Knight, and design by Allen Hutt.

N260. **Capa, Cornell, ed.** THE CONCERNED PHOTOGRAPHER. New York: Grossman Publishers, 1968. unpag., illus.

Text by Robert Sagalyn and Judith Friedberg. Contains excellent biographical and bibliographical data, and notes on the pictures by each photographer. Includes the photographs of Werner Bischof, Robert Capa, David Seymour ("Chim"), André Kertész, Leonard Freed, and Dan Weiner.

N261. **Capa, Cornell, ed.** THE CONCERNED PHOTOGRAPHER 2. New York: Grossman Publishers, 1972. unpag., illus.

Text by Michael Edelson. Based on an exhibition held by the International Fund for Concerned Photography at the Israel Museum, Jerusalem, 1973. Documentation similar to ORIGINAL PUBLICATION published in 1968 [see N260]. Includes the photographs of Marc Riboud, Roman Vishniac, Bruce Davidson, Gordon Parks, Ernst Haas, Hiroshi Hamaya, Donald McCullin, and W. Eugene Smith.

N262. **Faber, John.** GREAT MOMENTS IN NEWS PHOTOGRAPHY. New York: T. Nelson, 1960. 126 p., illus.

A collection of prizewinning and outstanding news photographs, by the historian of the National Press Photographers Association.

N263. **Gidal, Tim N.** MODERN PHOTOJOURNALISM: ORIGINS AND EVOLUTION, 1910-1933. New York: Macmillan Co., 1973. 96 p., illus.

A translation of *Deutschland—Beginn des modernen Photojournalismus.* Although devoted to the early days of German photojournalism, this work is important for the understanding of the American picture press, which was

strongly influenced by the German illustrated weeklies. Gidal, himself a pioneer, worked in America, and some of the photographers presented, Martin Munkacsi, Alfred Eisenstaedt, and André Kertész, are American by long residence and association.

N264. Hicks, Wilson. WORDS AND PICTURES: AN INTRODUCTION TO PHOTOJOURNALISM. New York: Harper & Bros., 1952. 171 p., illus.

A classic work by the late executive editor of *Life* magazine who was largely responsible for its use of photographs in its early period. Discusses the role of the photographer, the editor, and the writer in producing the "third effect," one that is greater than words and pictures alone. FACSIMILE REPRINT (New York: Arno Press, 1973).

N265. Hood, Robert E. TWELVE AT WAR: GREAT PHOTOGRAPHERS UNDER FIRE. New York: G. P. Putnam's Sons, 1967. 159 p., illus.

Photographs by and biographical essays on Mathew B. Brady, Jimmy Hare, Margaret Bourke-White, Edward Steichen, Carl Mydans, David Douglas Duncan, Horst Faas, David Seymour, Henri Cartier-Bresson, and Robert Capa.

N266. Hurley, Gerald D.; and McDougall, Angus. VISUAL IMPACT IN PRINT: HOW TO MAKE PICTURES COMMUNICATE; A GUIDE FOR THE PHOTOGRAPHER, THE EDITOR, AND THE DESIGNER. Chicago: American Publishers Press, 1971. 208 p., illus.

Basically a picture editor's guide on the design of the photo essay or picture story, with advice on how to crop and retouch photographs to give them "impact," typography, and caption writing. Useful for its extensive bibliography, chosen by twenty-three photographers, editors, journalism professors, and curators of photography.

N267. PHOTOJOURNALISM, BY THE EDITORS OF TIME-LIFE BOOKS (SERIES EDITOR, ROBERT G. MASON). New York: Time-Life Books, 1971. 227 p., illus. (color). LIFE LIBRARY OF PHOTOGRAPHY.

A survey of the development of news photography and the rise of photojournalism, with exposition on editing the picture story. *Contents: (1)* Covering the News; *(2)* Stories in Pictures; *(3)* Pictures that Persuade; *(4)* Photojournalism for Amateurs; *(5)* The Professional Assignment; and *(6)* The Ubiquitous Photograph. Lists editorial staff. Bibliography includes sections on general history, biography, special fields, and magazines. Picture credits; index.

N268. Mich, Daniel D., and Eberman, Edwin. THE TECHNIQUE OF THE PICTURE STORY: A PRACTICAL GUIDE TO THE PRODUCTION OF VISUAL ARTICLES. New York and London: McGraw-Hill Book Co., 1945. 239 p., illus.

A detailed exposition by the executive editor and art director of *Look* magazine of the production of photo essays, with illustrations of completed stories, layouts, and scripts.

N269. Moran, Tom. THE PHOTO ESSAY: PAUL FUSCO AND WILL MCBRIDE. New York: Thomas Y. Crowell Co., 1974. 96 p., illus. (color).

Discussion of the problems of the photojournalist. Technical section.

N270. Newhall, Nancy. THE CAPTION: THE MUTUAL RELATION OF WORDS AND PHOTOGRAPHS. *Aperture* 1 (1952): 17–29, illus.

A study of the effect which the word has upon the photograph and vice versa, in the creation of what has been called the "third effect."

N271. Rayfield, Stanley. LIFE PHOTOGRAPHERS: THEIR CAREERS AND FAVORITE PICTURES. Garden City, N.Y.: Doubleday & Co., 1957. 89 p., illus.

Statements about, portraits of, and two pages of photographs by forty photographers who worked for the magazine *Life* at the height of its popularity. A final spread, "About Technique," concludes with the statement, "the *Life* photographer routinely picks up the bag he keeps in his locker and departs on short notice for his next assignment. Before he has finished, it may take him half-way round the world."

N272. Rothstein, Arthur. PHOTOJOURNALISM: PICTURES FOR MAGAZINES AND NEWSPAPERS. 2d ed. New York: American Photographic Book Publishing Co., 1965. 215 p., illus. (color).

The former director of photography for *Look* magazine describes the syntax of the photo essay and the various approaches to pictorial communication. Includes a short discussion of technique.

N273. Schuneman, R. Smith, ed. PHOTOGRAPHIC COMMUNICATION: PRINCIPLES, PROBLEMS, AND CHALLENGES OF PHOTOJOURNALISM. New York: Hastings House Publishers; London: Focal Press, 1972. 379 p., illus.

Discussion by leading photojournalists, with illustrations of their work and photo stories. Based on contributions from the Wilson Hicks International Conference on Photocommunication Arts, University of Miami, Fla. The yearly conference was sponsored by the American Society of Magazine Photographers.

N274. New York. **The Museum of Modern Art.** FROM THE PICTURE PRESS. CATALOG BY JOHN SZARKOWSKI. New York, 1973. 95 p., illus. *Exhibition.*

The photographs from this exhibition of news photography are reproduced with credit lines and publication data only; cutlines are gathered at the end of the book.

N275. FOUR HOURS A YEAR: A PICTURE-BOOK STORY OF TIME INC.'S THIRD MAJOR PUBLISHING VENTURE—THE MARCH OF TIME. New York: Time, 1936. 71 p., illus.

An outsize (15 x 11-1/2 in.) promotion book for the mo-

tion picture series *The March of Time* which, in its choice of photographs, layout, and discussion of the position of photography, predicts the editorial style of *Life* magazine.

N276. **Vitray, Laura; Mills, John, Jr.; and Ellard, Roscoe.** PICTORIAL JOURNALISM. New York: McGraw-Hill Book Co., 1939. 437 p., illus.

A text book on all phases of newspaper photography and editing. Especially valuable for its discussion of layout, and the relation of picture and text. FACSIMILE REPRINT (New York: Arno Press, 1973).

N277. **Whiting, John R.** PHOTOGRAPHY IS A LANGUAGE. Chicago and New York: Ziff-Davis Publishing Co., 1946. 142 p., illus.

An excellent treatise on editorial problems in the use of photographs in magazines, with particular attention to the "photo essay" or "picture story." Includes a glossary for photojournalism.

RESTORATION AND CONSERVATION

N278. **Barth, Miles.** NOTES ON CONSERVATION AND RESTORATION OF PHOTOGRAPHS. *Print Collector's Newsletter* 7 (May–June 1976): 48–51.

A basic introduction to the problem, with an excellent bibliography and list of suppliers of archival materials, by the curatorial assistant of the Photography Department of The Art Institute of Chicago.

N279. CARING FOR PHOTOGRAPHS: DISPLAY, STORAGE, AND RESTORATION, BY THE EDITORS OF TIME-LIFE BOOKS (SERIES EDITOR, ROBERT G. MASON). New York: Time-Life Books, 1972. 192 p., illus. (color). LIFE LIBRARY OF PHOTOGRAPHY.

Excellent exposition of methods and techniques for the conservation of photographs. Essay on "Restoring Photographs: How "Lost Images" Are Recaptured," by Walter Clark (now director of the conservation center at the International Museum of Photography, Rochester, N.Y.). Index; bibliography.

N280. **Ostroff, Eugene.** CONSERVING AND RESTORING PHOTOGRAPHIC COLLECTIONS. *Museum News* 52 (May 1974): 42–44; 53 (Nov. 1974): 42–45; 53 (Dec. 1974): 34–36, illus.

Authoritative series of articles by the curator of photography of the National Museum of History and Technology, Smithsonian Institution, covering processing, restoration, and storage. *See also* "Preservation of Photographs," *Photographic Journal* (Oct. 1967): 309–314.

SCIENTIFIC THEORY

N281. **Baines, H., and Bomback, E. S.** THE SCIENCE OF PHOTOGRAPHY. London: Fountain Press, 1970. 318 p.,

illus. (color).

Written especially for those photographers who may be curious about the theory underlying the practice of photography but who have little or no background in science or mathematics. In each chapter, just enough basic scientific concepts are included to make the chapter understandable. With 142 illustrations.

N282. **Berg, Wolfgang Friedrich.** EXPOSURE: THEORY AND PRACTICE. 4th rev. ed. London and New York: Focal Press, 1971. 457 p., illus.

A basic book on the measurement of light and its effect upon photographic materials.

N283. **James, T. H., and Higgins, G. C.** FUNDAMENTALS OF PHOTOGRAPHIC THEORY. Dobbs Ferry, N.Y.: Morgan & Morgan, 1968. 345 p., illus.

Fundamental chemical and physical concepts are used to give a general explanation of the theory of the photographic process. Most of the chapters assume a basic knowledge of physics and chemistry. There are 120 illustrations.

N284. **Hillson, Peter J.** PHOTOGRAPHY: A STUDY IN VERSATILITY. Garden City, N.Y.: Doubleday & Co., 1969. 191 p., illus. (color).

A description of photographic theory and practice, from a scientific point of view. Includes chapters on stereoscopic photography and holography. Although largely based on conventional silver processes, "alternative systems" such as electrophotography and television are discussed. Brief bibliography.

N285. **Neblette, C. B.** FUNDAMENTALS OF PHOTOGRAPHY. New York: Van Nostrand Reinhold Co., 1970. 351 p., illus. (color).

Written to be used in college courses in photography, the book contains twenty-three chapters dealing with some of the theory and much of the practice of photography. Some background in high school science and mathematics would be helpful in understanding the theory presented.

N286. **Neblette, C. B.** PHOTOGRAPHY: ITS MATERIALS AND PROCESSES. 6th ed. Princeton, N.J.: Van Nostrand, 1962. 508 p., illus. (color).

A collective work of contributions by nineteen photo-scientists, extremely technical and theoretical in nature. There is no discussion of photography as a visual medium; instead, there is a description of the process.

N287. **Todd, Hollis N., and Zakia, Richard D.** PHOTOGRAPHIC SENSITOMETRY: THE STUDY OF TONE REPRODUCTION. Hastings-on-Hudson, N.Y.: Morgan & Morgan, 1969. 312 p., illus.

A description and explanation of how the photographic process can be manipulated to produce a good scale of tones (zones). Included is a chapter on process control for those interested in statistical techniques for obtaining repeatable photographic results.

STEREOSCOPIC PHOTOGRAPHY

N288. **Darrah, William Culp.** STEREO VIEWS: A HISTORY OF STEREOGRAPHS IN AMERICA AND THEIR COLLECTION. Gettysburg, Pa.: Times & News Publishers, 1964. 255 p., illus.

Includes checklists of photographers and publishers, arranged alphabetically and also geographically. Bibliography.

N289. **Darrah, William Culp.** STEREOGRAPHS: A NEGLECTED SOURCE OF HISTORY OF PHOTOGRAPHY. In: COKE, VAN DEREN, ED. ONE HUNDRED YEARS OF PHOTOGRAPHIC HISTORY: ESSAYS IN HONOR OF BEAUMONT NEWHALL. Albuquerque, N.M.: University of New Mexico Press, 1975, p. 42–46.

Includes statistics revealing the vast number of stereographs produced in the United States with notes on a few provincial photographers generally overlooked: W. N. Hobbs (ca. 1860–1880); M. A. Kleckner (ca. 1860–1880); J. Freeman (ca. 1865–1880); J. H. Hamilton (ca. 1875–1882); Theodore Lilienthal (ca. 1860–1875); Charles H. Shute; and Carl Meinerth.

N290. **Holmes, Oliver Wendell.** SOUNDINGS FROM THE ATLANTIC. Boston: Ticknor & Fields, 1864. 468 p.

Essays from the *Atlantic Monthly*, including three on photography, with special emphasis upon stereoscopic photography: *(1)* "The Stereoscope and the Stereograph" (June 1859), *(2)* "Sun Painting and Sun Sculpture" (July 1861), and *(3)* "Doings of the Sunbeam" (July 1863). Holmes described how he designed light weight and skeleton stereoscopes in the *Philadelphia Photographer* (Jan. 1869), p. 1–3.

N291. **Mabie, Roy W.** THE STEREOSCOPE AND THE STEREOGRAPH: A HANDBOOK, PRICE LIST AND CATALOGUE FEATURING THE AMERICANA IN THE STEREOSCOPE AND STEREOGRAPH, AND LISTING EARLY EUROPEAN VIEWS. New York: Mabie's Stereoscopic Galleries, 1942. 72 p., illus.

Basically a handbook for collectors, with drawings of various styles of stereoscopes, lists of stereo photographers, and value estimates.

N292. **Morgan, Willard D., and Lester, Henry M., eds.** STEREO-REALIST MANUAL. New York: Morgan & Lester, 1954. 400 p., illus. (color).

Although directed towards the use of the Stereo-Realist camera, the book is a general text of stereoscopic photography. The illustrations are in stereo pairs, and a plastic stereoscope is provided with which to view them in three dimensions. Introduction by Harold Lloyd. Historical essay by Beaumont Newhall, with bibliography.

N293. **Moss, George H., Jr.** DOUBLE EXPOSURE: EARLY STEREOGRAPHIC VIEWS OF HISTORIC MONMOUTH COUNTY, NEW JERSEY, AND THEIR RELATIONSHIP TO PIONEER PHOTOGRAPHY. Sea Bright, N.J.: Ploughshare Press, 1971. 176 p., illus.

Although primarily concerned with stereographs, this book contains many reproductions of daguerreotypes, and a brief history of photography in America. Bibliography. Foreword by Carlin Gasteyer.

TINTYPE

N294. **Estabrooke, Edward M.** THE FERROTYPE AND HOW TO MAKE IT. Cincinnati, Ohio, and Louisville, Ky.: Gatchel & Hyatt, 1872. 200 p.

Standard manual which appeared almost unchanged in many editions. FACSIMILE REPRINT (Hastings-on-Hudson, N.Y.: Morgan & Morgan, 1972), with introduction by Eugene Ostroff.

N295. **Trask, A. K. P.** TRASK'S PRACTICAL FERROTYPER. Philadelphia: Benerman & Wilson, 1872. 63 p., frontispiece.

FACSIMILE REPRINT (New York: Arno Press, 1973).

SERIALS AND PERIODICALS

N296. AFTERIMAGE. Rochester, N.Y. (1972—).

A publication of the Visual Studies Workshop, this well-illustrated journal of opinion, history, and criticism is notable for its frequent interviews with leading photographers and for extensive book reviews. Sometimes listed as *After-Image.*

N297. ALBUM. London. 1:1–12 (1970).

Edited by Bill Jay; published by A. Ellis and T. Powell. An attractive periodical of interest to the history of American photography. Articles on W. Eugene Smith (no. 2); Lewis W. Hine, Les Krims, Thomas Barrow, Emmet Gowin (no. 5); collections of the George Eastman House, Rochester, N.Y. (no. 6); Berenice Abbott, Duane Michals (no. 7); Roger Mertin (no. 8); Naomi Savage, Anne Noggle (no. 10); Gordon Bennett (no. 11); and Elliott Erwitt, Group f/64 (no. 12).

N298. AMERICAN AMATEUR PHOTOGRAPHER. Brunswick, Me., and Boston. (1889–1907).

Important for the early years of the pictorial movement. Edited from July 1893 to Feb. 1896 by Alfred Stieglitz. Well illustrated, often with photogravures, and with reviews of the most important exhibitions.

N299. AMERICAN ANNUAL OF PHOTOGRAPHY. New York and Boston. (1887–1953).

An important yearbook, well illustrated with plates of recent work and halftones in the text. Contains contributions by leading photographers.

N300. AMERICAN JOURNAL OF PHOTOGRAPHY AND THE ALLIED ARTS AND SCIENCES. New York. (1852–1867).

One of the earliest photography journals published in America. Mostly composed of working directions, with reminiscences of photographers. Edited by Charles A. Seely.

N301. AMERICAN PHOTOGRAPHY. Boston. 1–47 (July 1907–July 1953).

An illustrated monthly edited by Frank Roy Fraprie. Mainly directed to the amateur, and with technical articles. A champion of pictorial photography. Absorbed *Photo-Era* magazine [N327] in 1932, and *The Photo-Miniature* [N328] in 1939. [*See also* S22.]

N302. ANTHONY'S PHOTOGRAPHIC BULLETIN. New York. 1–33 (Feb. 1870–Apr. 1902).

Geared to the professional photographer. Contains reminiscenses of veteran photographers. [*See also* S27.]

The word CATALOG in the heading of an entry refers to the exhibition catalog as a whole and not to the catalog list, checklist, or catalog section of the work.

N303. APERTURE. Rochester, N.Y. and Millerton, N.Y. 1— (Apr. 1952—).

A journal on creative photography, edited by Minor White and, since 1967, by Michael E. Hoffman; the most important publication in its field. Originally a periodical of opinion, news, and handsome reproductions of contemporary creative photographs, the quarterly has in the past few years emphasized the work of individual photographers by monographic numbers. [*See also* S31.]

N304. BEACON. Chicago. (1889–1892).

"A journal devoted to photography in all its phases." An amateur's magazine, continued as *Photo-Beacon* 1–19 (Jan. 1889–June 1907). [*See also* N326.]

N305. THE BLACK PHOTOGRAPHERS ANNUAL. Brooklyn, N.Y. (1952—).

An annual collection of photographs by black photographers.

N306. BULLETIN OF PHOTOGRAPHY. Philadelphia. (1907–1919).

Largely addressed to the professional.

N307. CAMERA. Lucerne. (1922—).

A handsomely produced international magazine for photography, published in French, German, and English language editions, which includes a minimum of technology. Many excellent reproductions of photographs by Americans; also includes biographical and critical articles.

N308. CAMERA. Philadelphia. (July 1897–July 1953).

Largely aimed at the amateur; it is valuable for reproductions of the period. Vols. 1–76 published by Columbia Photographic Society. Absorbed *Photographic Journal of America* in July 1923 and *Bulletin of Photography* in July 1931. Merged with *Photography.*

N309. CAMERA CRAFT. San Francisco. 1–49 (May 1900–1942).

A well-illustrated magazine, directed primarily toward the amateur. Of special importance for documentation of the West Coast school of the 1930s called "Group f/64," formed by Ansel Adams and Willard Van Dyke, is its controversy with William Mortensen.

N310. CAMERA NOTES. New York. 1–6 (July 1897–1903).

Edited by Alfred Stieglitz, the quarterly is distinguished by the high quality of the plates, often made by photogravure. International in scope. Contains proceedings and activities of the Camera Club.

N311. CAMERA 35. New York. (1967—). [*cont.*]

A consumer magazine, directed toward the "advanced amateur," with excellent technical articles, interviews with professional photographers, and reviews of books and exhibitions. Issued by United States Camera Publishing, it merged with *Popular Photography* [N342] in 1975.

N312. CAMERA WORK: ILLUSTRATED QUARTERLY MAGAZINE DEVOTED TO PHOTOGRAPHY. New York. 1–49/50 (Jan. 1903–June 1917).

A photographic quarterly, edited and published by Alfred Stieglitz, this journal was also the unofficial organ of the Photo Secession. This beautifully produced quarterly has been hailed as the finest publication of its kind. Each of the fifty issues contains superb plates, largely photogravures made under the direction of Stieglitz. The journal is of importance not only for the history of photography, but also for the introduction of modern art to America. A selection of articles, and excellent reproductions of many of the plates, appears in Jonathan Green's *Camera Work: A Critical Anthology* [N824]. This volume is a key to *Camera Work* and its contents, with detailed indexes, bibliography, and biographical data on contributors. The entire fifty issues of the quarterly have been REPRINTED (Nendeln, Liechtenstein: Kraus Reprint, 1969). [*See also* S100.]

N313. CONTEMPORARY PHOTOGRAPHER. Oberlin, Ohio and Lexington, Mass. (1960–1967).

A magazine of criticism, oriented toward the publication of photographs by contemporaries. Vol. 6, no. 1 is a monograph by Charles W. Millard III titled "Charles Sheeler, American photographer."

N314. CREATIVE CAMERA. London. (1963–).

An international survey of current photography that has consistently carried articles on American work. Formerly *Camera Owner.*

N315. *The Daguerreian Journal.* New York. (Nov. 1850–Dec. 1851).

The world's first periodical devoted solely to photography. Edited by S. D. Humphrey; continued as *Humphrey's Journal of Photography* [N319] until 1870. A working manual for the profession, with notes on the activities of daguerreotypists throughout the country. In the first issues a "Daguerreotype director" was a regular feature. Microfilm in the series Daguerreian Era (Pawlet, Vt.).

N316. EXPOSURE. New York. (1968–).

Originally a mimeographed, unillustrated newsletter. *Exposure: Journal of the Society for Photographic Education* has in recent years become a well-illustrated periodical of general interest, with excellent bibliographical notes.

N317. EYE TO EYE. Washington, D.C. and Madison, Wis. 1–8 (June 1953–1954 [?]).

Bulletin of the Graphic History Society of America. Edited by Paul Vanderbilt, founder of the society, which is "an association of [those] interested in collecting and publishing prints, paintings and photographs and other

pictures from the standpoint of the subjects which they represent." The contents are predominantly photographic; it includes biographies of photographers, notes on picture sources, and filing techniques. There is a thorough index in no. 8. The last issue is a monograph on S. J. Morrow.

N318. THE GRAPHIC ANTIQUARIAN. Indianapolis. 1— (July 1970—).

A quarterly magazine for collectors of objects relating to photography.

N319. HUMPHREY'S JOURNAL OF PHOTOGRAPHY AND THE ALLIED ARTS AND SCIENCES. 1–21 (Nov. 1, 1850–July 15, 1870.).

Continuation of *The Daguerreian Journal* [N315]. Subtitle varies. Microfilm in the series, Daguerreian Era (Pawlet, Vt.). [*See also* S138.]

N320. IMAGE. Rochester, N.Y. (1952–1965).

This is the journal of photography of the George Eastman House, Rochester, N.Y. Mainly devoted to articles on the history of photography, this periodical has appeared in various formats, and at irregular time intervals. Many leading historians have contributed to its pages, although most of the articles are written by the staff, and rely heavily on the collections of the George Eastman House (now part of The International Museum of Photography).

N321. INFINITY. New York. (1952—).

FIRST PUBLISHED as *ASMP News* for the American Society of Magazine Photographers. An important source of information about photojournalism, this magazine has contained many biographical articles.

N322. MINICAM PHOTOGRAPHY. Cincinnati, Ohio. (Sept. 1937–Jan. 1940).

An uneven publication, with "how-to-do-it" articles for the amateur and a number of excellent articles on prominent photographers. Published by Automobile Digest Publishing. Continued as *Modern Photography* [N323].

N323. MODERN PHOTOGRAPHY. New York. (Aug. 1950—).

Continuation of *Minicam Magazine* [N322]. Oriented toward the "advanced amateur" with articles on technique. Has published excellent articles on prominent photographers and occasionally on aspects of the history of photography. [For further data, *see* S176.]

N324. THE PHILADELPHIA PHOTOGRAPHER. Philadelphia. 1–25 (1864–1888).

Published by Benerman & Wilson. Edited by Edward L. Wilson. A publication for the profession. Each issue contains an original photograph as frontispiece. The most valuable source of information on the status of photography in the 1870–1880s. Microfilm in the series, Daguerreian Era (Pawlet, Vt.). [For continuing publication data, *see* S199.]

N325. PHOTO AMERICAN. New York. (1891–1898).

An illustrated monthly magazine for amateur photographers published by C. H. Loeber.

N326. PHOTO-BEACON. Chicago. 1–19 (Jan. 1889–June 1907).

Continuation of *The Beacon* 5–20 (Jan. 1889–June 1907). Editor: F. D. Todd (1894–1907). United with *American Amateur Photographer* to form *American Photography*.

N327. PHOTO-ERA MAGAZINE: THE AMERICAN JOURNAL OF PHOTOGRAPHY. Boston. (1898–1932).

Of particular interest for its opposition to Alfred Stieglitz and the Photo Secession.

N328. THE PHOTO-MINIATURE. New York. (Apr. 1899–Sept. 1939).

Published by Tennant and Ward. Editor: John A. Tennant. Although monthly, basically a series of monographs on varied photographic subjects, with news notes. Merged into *American Photography*, Oct. 1939.

N329. PHOTO NOTES. New York. (1938–1950).

Published irregularly by the Photo League in mimeographed form except for the last three issues, which were photolithographed with illustrations. An invaluable record of Photo League activities as well as other photographic activities in New York. Noted contributors included Berenice Abbott, Elizabeth McCausland, Ansel Adams, Milton Brown, Beaumont and Nancy Newhall, Aaron Siskind, W. Eugene Smith, Leo Hurwitz, and Paul Strand. It is not known how many issues were published. The most complete set is in the International Museum of Photography, Rochester, N.Y.

N330. THE PHOTO-SECESSION. New York. 1–7 (Dec. 1902–June 1909).

A series of well-printed leaflets, from one to six pages, 4-1/4 x 7 in., on gray paper. Contains news of value to members, mostly about exhibitions.

N331. PHOTOGRAMS OF THE YEAR. London. 1–59 (1895–1954).

At first a record of photographs exhibited at the two principal exhibitions of photography in London, organized by The Royal Photographic Society and by The Linked Ring (as The Photographic Salon), the publication contains reports on photography in various countries, including America. Alfred Stieglitz contributed reports on pictorial photography in America in the issues published in the years 1895, 1896, and 1897. Vols. 1–59 published by Dawbarn & Ward; 1954 edition published for *Amateur Photographer* (London: Iliffe & Sons).

N332. THE PHOTOGRAPHER'S FRIEND. Baltimore. (1871–1874).

"A practical, independent magazine, devoted to the photographic art." Edited by G. O. Brown, this is a quarterly publication. The *Commercial Photographic News* was

issued with the above, Jan.–Oct. 1872. Microfilm in the series, Daguerreian Era (Pawlet, Vt.).

N333. PHOTOGRAPHIC AND FINE ART JOURNAL. New York. (1854–1860).

Continuation, in larger format, of *Photographic Art-Journal* [N335]. Distinguished for the inclusion of original photographic prints, made by a modification of the calotype process. Published by W. B. Smith, the editor in 1851 was Henry Hunt Snelling. Microfilm in the series, Daguerreian Era (Pawlet, Vt.). [*See also* S200.]

N334. PHOTOGRAPHIC ANTIQUES AND LITERATURE. Pawlet, Vt. (1971—).

N335. PHOTOGRAPHIC ART-JOURNAL. New York. (1851–1853).

The second oldest American photographic periodical; indispensable for a study of the daguerreotype era. Contains extensive reprints and translations from European periodicals and text books. Of special interest are biographical essays on prominent photographers, accompanied by lithographic portraits. Published by W. B. Smith as a monthly; Henry Hunt Snelling was editor. Continued as *Photographic and Fine Art Journal* [N333]. Microfilm in the series, Daguerreian Era (Pawlet, Vt.).

N336. THE PHOTOGRAPHIC COLLECTORS' NEWSLETTER. Brooklyn, N.Y. (1968—).

At first oriented toward the history of cameras and other apparatus, the magazine now contains information on the history of picturemaking by photography. Edited and published by Eaton S. Lothrop, Jr.

N337. PHOTOGRAPHIC MOSAICS. Philadelphia and New York. (1866–1901).

"An annual record of photographic progress" for the profession. Includes working directions and information on new products.

N338. PHOTOGRAPHIC TIMES. New York. 1–47 (Jan. 1871–Dec. 1915).

A handsomely produced, well-rounded publication. The later issues contain excellent photogravure plates, particularly of the members of that group of American photographers who formed the Photo Secession. Absorbed the *Amateur Painter for Amateur Photographers* in Mar. 1902, and *Anthony's Photographic Bulletin* in May 1902. Merged into *Popular Photography* [N342].

N339. PHOTOGRAPHIC HISTORICAL SOCIETY OF NEW YORK NEWS. New York.

A publication of the society, continued in vol. 5, no. 1 as *Photographica*. News of interest to collectors of photographs and particularly of cameras and apparatus.

N340. PHOTOGRAPHY ANNUAL. Chicago. (1951—).

"A selection of the world's finest photographs compiled by the editors of *Popular Photography*." With articles of

varying interest. Numerous illustrations. Published by Ziff-Davis.

N341. PHOTOGRAPHY YEAR. New York. (1973—).

An annual publication, presenting portfolios of photographs from major exhibitions, new technology, little-known contemporary photographers, awards, and book reviews. Published by Time-Life Books, New York, which also issues another series, Life Library of Photography [see N12].

N342. POPULAR PHOTOGRAPHY. Chicago and New York. 1— (May 1937—).

This magazine has the largest circulation of any photographic magazine. Consumer oriented, particularly to the amateur photographer. While its material varies, It has consistently published the work of leading professionals, and has many excellent biographical essays. [See also S204.]

N343. P. S. A. JOURNAL. Philadelphia. (1935—).

From 1935 to 1946, the magazine was titled *Journal of the Photographic Society of America*. Edited for the hobbyist, the periodical nevertheless often contains feature articles of a more serious nature.

N344. U.S. CAMERA. New York. (1938—).

Quarterly, then monthly. Editors included Edward Steichen, Anton Bruehl, Paul Outerbridge, Jr., Willard D. Morgan, Phillip Andrews, and Tom Maloney. Begun as a handsome, oversize publication with excellent reproductions (including some in color), the magazine was reduced in size and oriented toward the amateur to compete with consumer magazines.

N345. U.S. CAMERA ANNUAL. New York. (1935—).

Vol. 1 issued in 1935 by Duell, Sloan & Pearce, with selections by Edward Steichen, and T. J. Maloney as editor. Includes articles, biographical essays, numerous reproductions, and special sections.

N346. UNTITLED. Carmel, Calif. (1972—).

A photographic quarterly of the Friends of Photography. Numbers of this lively periodical have appeared in various formats, covering a wide field of creative photography.

N347. WILSON'S PHOTOGRAPHIC MAGAZINE. New York and Philadelphia. (1889–1914).

Edited by Edward L. Wilson. A continuation of *The Philadelphia Photographer* [N324] but lacking the quality of that publication.

N348. YOUNG AMERICAN PHOTOGRAPHY. New York. 1 (1974), illus.

Vol. 1 edited by Gary Wolfson. Issued by Lustrum Press, 1974. No text provided. Unpaged, 102 plates. A collection of student work "selected from over 2,000 submissions from more than 50 schools associated with photography."

SELECTED WORKS ON
INDIVIDUAL PHOTOGRAPHERS

Collective Biography

N349. **Forsee, Aylesa.** FAMOUS PHOTOGRAPHERS. Philadelphia: Macrae Smith, 1968. 223 p., illus.

Biographical essays on Edward Steichen, Ansel Adams, Cecil Beaton, Yousuf Karsh, and David D. Duncan, with reproductions of photographs by each. Selected bibliography.

N350. **Gernsheim, Helmut.** CREATIVE PHOTOGRAPHY: AESTHETIC TRENDS, 1829–1960. Boston: Boston Book & Art Shop, 1962. 258 p., illus.

Contains short biographies, with bibliographical data, on the photographers whose work is illustrated.

N351. **Green, Jonathan, ed.** THE SNAPSHOT. Millerton, N.Y.: Aperture, 1974. 128 p., illus.

ALSO PUBLISHED as *Aperture* 19 (1974). A collection of contemporary photographs made, in the opinion of the editor, in the tradition of the unsophisticated family "snapshot." Statements and photographs by the following: Richard Albertine, Walker Evans, Robert Frank, Emmet Gowin, Steven Halpern, Gus Kayafas, Joel Meyerowitz, Wendy Snyder MacNeil, Lisette Model, Tod Papageorge, Nancy Rexroth, Paul Strand, Judith Wechsler, Henry Wessel, Jr., Garry Winogrand, and Bill Zulpo-Dane. The essay by John A. Kouwenhoven is illustrated with anonymous snapshots.

N352. **Gruber, L. Fritz.** GROSSE PHOTOGRAPHEN UNSERES JAHRHUNDERTS. Berlin: Deutsche Buch-Gemeinschaft; Düsseldorf: Econ Verlag, 1964. 208 p., illus. (color).

Similar in format to the Newhalls' *Masters of Photography* [N356], this well-produced volume includes biographical sketches and plates of Alfred Stieglitz, Edward Steichen, Edward Weston, Man Ray, Paul Strand, Dorothea Lange, Alfred Eisenstaedt, Weegee, Ansel Adams, Andreas Feininger, Philippe Halsman, Irving Penn, W. Eugene Smith, Richard Avedon, and William Klein, plus twenty non-American photographers.

N353. GREAT PHOTOGRAPHERS, by the editors of TIME-LIFE BOOKS (SERIES EDITOR, ROBERT G. MASON). New York: Time-Life Books, 1971. 246 p., illus. (color). LIFE LIBRARY OF PHOTOGRAPHY.

The word CATALOG in the heading of an entry refers to the exhibition catalog as a whole and not to the catalog list, checklist, or catalog section of the work.

A history of photography in biographical form. Includes information on the lives of sixty-eight photographers, working from 1840 to 1960. The six chapters are divided into sections: 1840 to 1860; 1860 to 1880; 1880 to 1900; 1900 to 1920; 1920 to 1940; and 1940 to 1960. "Photographers Represented in This Book" also includes references to other titles in the Life Library of Photography which contain illustrations by the photographers listed; Some are more heavily indexed than others. Bibliography.

N354. **Lyons, Nathan.** PHOTOGRAPHY IN THE TWENTIETH CENTURY. New York: Horizon Press; with George Eastman House, 1967. 16 p., illus.

An album of 143 excellent reproductions, selected from as many photographers. Two-page introductions; list of plates.

N355. **Newhall, Beaumont, and Newhall, Nancy.** A COLLECTION OF PHOTOGRAPHS. New York: Aperture, 1969. 88 p., illus. (color).

Short biographies and plates of the work of photographers represented in the collection of the Exchange National Bank of Chicago. ALSO PUBLISHED in *Aperture* 14:2 (1968).

N356. **Newhall, Beaumont, and Newhall, Nancy.** MASTERS OF PHOTOGRAPHY. New York: George Braziller, 1958. 192 p., illus.

Brief biographies and reproductions of Europeans and the following Americans: Albert Sands Southworth, Josiah Johnson Hawes, Alexander Gardner, Timothy H. O'Sullivan, Alfred Stieglitz, Edward Steichen, Paul Strand, Edward Weston, Dorothea Lange, Walker Evans, and Ansel Adams. With historical introduction, selected bibliography, and "a note on techniques." REPRINT (New York: Bonanza Books; New York: A & W Visual Library, 1975), with reproductions of lesser quality.

N357. Philadelphia. **Philadelphia College of Art, Photography Department.** AN EXHIBITION OF WORK BY THE JOHN SIMON GUGGENHEIM MEMORIAL FOUNDATION FELLOWS. Philadelphia, 1966. 64 p., illus.

Exhibition: Apr. 15–May 13, 1966.

Biographical data on thirty photographers, with reproductions of their work. Also issued as a number of *Camera* (1966).

N358. **Racanicchi, Piero, and Donzelli, Pietro.** CRITICA

E STORIA DELLA FOTOGRAFIA. Milan: Edizioni Techniche Milano, 1963. unpag., illus.

Collected articles by the authors which appeared in the periodical *Popular Photography Italiana*. The book includes the following Americans: Mathew B. Brady, George Eastman, Alfred Stieglitz, Ansel Adams, Jacob A. Riis, Dorothea Lange, Alfred Eisenstaedt, Margaret Bourke-White, David Douglas Duncan, William Henry Jackson, Lewis W. Hine, W. Eugene Smith, and Edward Weston. Other American photographers are discussed in the articles "Farm Security Administration," "Il Photo Secession," and "Il 'Pictorialism.'" Prefaces by Beaumont Newhall and Giovanni Romano.

N359. **Rudisill, Richard.** PHOTOGRAPHERS OF THE NEW MEXICO TERRITORY, 1854–1912. Santa Fe, N.M.: Museum of New Mexico, 1973. 74 p.

A useful list of photographers, compiled from city directories, newspaper advertisements, and the examination of photographs. Not illustrated.

N360. San Francisco. **San Francisco Museum of Art.** WOMEN OF PHOTOGRAPHY: AN HISTORICAL SURVEY. CATALOG BY MARGERY MANN AND ANNE NOGGLE. San Francisco, 1975. unpag., illus.

Exhibition: Apr. 18–June 15, 1975.

Includes valuable biographical sketches and checklist of exhibitions for the following photographers (* indicates that a bibliography is included): Julia Margaret Cameron (1815–1879)*; Lady Filmer (ca. 1840–1903); Gertrude Käsebier (1852–1934)*; Chansonetta Stanley Emmons (1858–1935); Frances Benjamin Johnston (1864–1952)*; Alice Austen (1866–1952)*; Anne W. Brigman (1869–1950)*; Jane Reece (1869–1961)*; Kate Matthews (1870–1956)*; Jessie Tarbox Beals (1871–1942)*; Adelaide Hanscom (1876–1932)*; Imogen Cunningham (*b.* 1883)*; Doris Ulmann (1884–1934)*; Laura Gilpin (*b.* 1891)*; Nell Dorr (*b.* 1895)*; Dorothea Lange (1895–1965)*; Louise Dahl Wolfe (*b.* 1895); Lotte Jacobi (*b.* 1896)*; Tina Modotti (1896–1942)*; Berenice Abbott (*b.* 1898)*; Barbara Morgan

(*b.* 1900)*; Carlotta M. Corpron (*b.* 1901); Florence Henri (*b.* 1902)*; Margaret Bourke-White (1904–1971)*; Ruth Bernhard (*b.* 1905)*; Lisette Model (*b.* 1906)*; Gisèle Freund (*b.* 1912)*; Reva Brooks (*b.* 1913)*; Marion Palfi (*b.* 1917)*; Jeannette Klute*; Mary Koga (*b.* 1920); Diane Arbus (1923–1971)*; Sonia Landy Sheridan (*b.* 1925)*; Naomi Savage (*b.* 1927)*; Alice [Alisa] Wells (*b.* 1929)*; Elsa Dorfman (*b.* 1937)*; Joan Lyons (*b.* 1937); Ingeborg Gerdes (*b.* 1938)*; Betty Hahn (*b.* 1940); Joanne Leonard (*b.* 1940)*; Judy Dater (*b.* 1941)*; Mary Ellen Mark (*b.* 1941)*; Abigail Heyman (*b.* 1942)*; Ellen Land-Weber (*b.* 1943); Markéta Luskačová (*b.* 1944)*; Bobbi Carrey (*b.* 1946); Claudine Guéniot (*b.* 1946)*; Karen Truax (*b.* 1946); JoAnn Frank (*b.* 1947); and Marcia Resnick (*b.* 1950)*.

N361. **Sipley, Louis Walton.** PHOTOGRAPHY'S GREAT INVENTORS. Philadelphia: American Museum of Photography, 1965. 170 p., illus.

Short biographies, with portraits, of scientists and technologists who have contributed to the technique of photography. Chronology. Selected by an international committee for the International Hall of Fame.

N362. **Tucker, Anne, ed.** THE WOMAN'S EYE. New York: Alfred A. Knopf, 1973. 169 p., illus.

Selections from the photographic work of Berenice Abbott, Diane Arbus, Margaret Bourke-White, Judy Dater, Frances Benjamin Johnston, Gertrude Käsebier, Dorothea Lange, Barbara Morgan, Bea Nettles, and Alice Wells, with biographical essay and bibliography for each photographer.

N363. **Wise, Kelly, ed.** PHOTOGRAPHERS' CHOICE: A BOOK OF PORTFOLIOS AND CRITICAL OPINION. Danbury, N.H.: Addison House, 1975. 215 p., illus. (color).

A large (12 x 9-1/4 in.), well-produced book of photographs by forty-five contemporary photographers. Includes critical essays by Max Kozloff, Harold Jones, and John Upton. Interview with Duane Michals by William Jenkins.

Monographs and Other Works on Individual Photographers

ABBOTT, BERENICE 1898—

N364. BERENICE ABBOTT PHOTOGRAPHS. New York: Horizon Press, 1970. 175 p., illus.

A retrospective collection of Berenice Abbott's photographs, in excellent reproduction (although undated). Chronology; bibliography; list of exhibitions. Captions for the photographs of scientific experiments written by Berenice Abbott. Foreword by Muriel Rukeyser. Introduction by David Vestal.

N365. **McCausland, Elizabeth.** CHANGING NEW YORK. PHOTOGRAPHS BY BERENICE ABBOTT. New York: E. P. Dutton & Co., 1939. 208 p., illus.

A publication of the Federal Art Project of the Works Progress Administration in the City of New York, under the supervision of the Guilds' Committee for Federal Writers' Publications. A superb documentary of photographs of New York City, the negatives of which are in the Museum of the City of New York. FACSIMILE REPRINT entitled *New York in the Thirties* (New York: Dover Publications, 1973).

N366. **Abbott, Berenice.** A Guide to Better Photography. New York: Crown Publishers, 1941. 182 p., illus.

An excellent technical manual, distinguished by its choice of seventy-one photographs taken by the author and other master photographers, including those working in the nineteenth century.

N367. **Abbott, Berenice.** New Guide to Better Photography. Rev. ed. New York: Crown Publishers, 1953. 180 p., illus.

An excellent technical handbook, with a chapter on photographic aesthetics emphasizing the documentary point of view, and a rich plate selection of eighty-five photographs by the artist, contemporary photographers, and a few historical examples. original edition (1941).

N368. **Hall, Chenoweth.** A Portrait of Maine, Photographs by Berenice Abbott. New York: Macmillan Co., 1968. 170 p., illus.

These photographs document fishing, logging, farming, and small-town life.

N369. **Lanier, Henry Wysham.** Greenwich Village Today and Yesterday. Photographs by Berenice Abbott. New York: Harper & Bros., 1949. 161 p., illus.

A walking tour in pictures through Greenwich Village in New York City.

N370. New York. **Marlborough Gallery.** Berenice Abbott. New York, 1976. 32 p., illus. (port.).

Exhibition: Jan. 6–24, 1976. Also shown at the Lunn Gallery/Graphics International, Washington, D.C., Apr. 3–May 10, 1976.

Includes eighteen illustrations and a list of 189 photographs. Two texts include "The Photography of Berenice Abbott," by Elizabeth McCausland (from *Trend*, Mar.–Apr. 1935), and "From a Talk at the Aspen Institute Conference on Photography, Oct. 6, 1951," by Berenice Abbott. Included also are a chronology (1898–1975) and a list of books by Abbott (1939–1969).

N371. **Tucker, Anne.** Berenice Abbott. In: The Woman's Eye. New York: Alfred A. Knopf, 1973. p. 77–91, illus.

[*See* N362.]

N372. **Valens, E. G.** The Attracting Universe: Gravity and the Shape of Space. Cleveland and New York: World Publishing Co., 1969. 190 p., illus.

Photographs by Berenice Abbott, mainly stroboscopic, of physical experiments.

ADAMS, ANSEL 1902—

Works by Adams

N373. **Adams, Ansel.** Born Free and Equal: Photographs of the Loyal Japanese-Americans at Manzanar Relocation Center, Inyo County, California. New York: U.S. Camera, 1944. 111 p., illus.

Text by Ansel Adams. A protest in the form of an affirmative documentation of the democratic community—created by the victims of war hysteria—who were deported from their homes on the California coast through no fault of their own.

N374. **Adams, Ansel.** Camera and Lens: The Creative Approach; Studio, Laboratory, and Operation. Hastings-on-Hudson, N.Y.: Morgan & Morgan, 1970. 301 p., illus.
Basic Photo Series 1.

In this book, Ansel Adams describes a creative approach to photography "which relates to visualization of the end result—the print—prior to the moment of exposure" by means of the application of sensitometric principles through his Zone System. Highly detailed instructions on the choice and use of cameras, exposure meters, and lenses follow, with specifications for darkroom and studio equipment. Bibliography. The other volumes in the Basic Photo Series (now out of print) continue Adams's thorough and detailed exposition of the medium: vol. 2—*The Negative* (1948); vol. 3—*The Print* (1950); vol. 4—*Natural Light Photography* (1952); and vol. 5—*Artificial Light Photography* (1956).

N375. **Adams, Ansel.** The Expanding Photographic Universe. In: Morgan, Willard D., and Lester, Henry M., eds. Miniature Camera Work. New York: Morgan & Lester, 1938. p. 69–75, illus.

A "working rationale of the miniature camera" stressing the photography of the active moment. With illustrations by Adams and others.

N376. **Adams, Ansel, and Newhall, Nancy.** Fiat Lux: The University of California. New York: McGraw-Hill Book Co., 1967. 192 p., illus.

An extensive description, in the photographs of Ansel Adams and the words of Nancy Newhall, of the several campuses and experimental stations of the University of California, published on the occasion of its centenary. Includes notes.

N377. **Adams, Ansel.** Images 1923–1974. Boston: New York Graphic Society, 1974. 127 p., illus.

Superb reproductions of 115 photographs in large format (14-1/4 x 17-1/4 ins.). Chronology and bibliography compiled by Nancy Newhall. Foreword by Wallace Stegner.

N378. **Adams, Ansel; with historical text by Edward Joesting.** The Islands of Hawaii. Photography by Ansel Adams. Honolulu: Bishop National Bank of Hawaii, 1958. 80 p., illus.

A handsome, oversized (11 x 14 in.). Collection of 105 photographs of Hawaii with accompanying historical text. Designed by Herbert Bayer. revised edition, including color plates, was published under the title *Introduction to Hawaii* (San Francisco: Five Associates, 1964).

N379. **Adams, Ansel.** MAKING A PHOTOGRAPH: AN INTRODUCTION TO PHOTOGRAPHY. London: Studio; New York: Studio Publications, 1935. 96 p., illus.

Concise technical manual with thirty-two superb, tipped-in reproductions. Illustrations are by Adams. REVISED EDITION, with a color plate, was published (1939), along with a THIRD EDITION, with color frontispiece and thirty-seven plates (1948).

N380. **Adams, Ansel; Newhall, Nancy; and Hamlin, Edith.** MISSION SAN XAVIER DEL BAC. San Francisco: Five Associates, 1954. 71 p., illus. (color).

A photographic interpretation of the great Spanish Colonial church near Tucson, Ariz., by Ansel Adams. Includes history and iconographic explanation by Nancy Newhall and drawings by Edith Hamlin locating statues.

N381. **Adams, Ansel.** MY CAMERA IN THE YOSEMITE VALLEY: TWENTY-FOUR PHOTOGRAPHS AND AN ESSAY ON MOUNTAIN PHOTOGRAPHY. Yosemite National Park, Calif.: Virginia Adams; Boston: Houghton Mifflin Co., 1949. 70 p., illus.

Twenty-four superb reproductions, the size of the original prints; on each facing page, technical and environmental data. The essay on mountain photography describes the principles and application of Adams's Zone System. Bibliography.

N382. **Adams, Ansel.** MY CAMERA IN THE NATIONAL PARKS. Yosemite National Park, Calif.: Virginia Adams; Boston: Houghton Mifflin Co., 1950. 97 p., illus.

Foreword by Ansel Adams. The thirty plates, uncaptioned, are on right-hand pages, titles on left; comb binding enables the thirty photographs to be removed for display. Extensive notes on the photographs; informative notes on the National Parks and monuments; bibliography.

N383. **Adams, Ansel, and Newhall, Nancy.** THE PAGEANT OF HISTORY AND THE PANORAMA OF TODAY IN NORTHERN CALIFORNIA. San Francisco: American Trust Co., 1954. 64 p., illus.

Fifty-seven superb reproductions, with descriptive text.

N384. **Adams, Ansel.** PERSONAL CREDO. *American Annual of Photography* 58 (1944): 7–16.

REPRINTED in Lyons, Nathan, ed., *Photographers on Photography* [N50, p. 25–31].

N385. **Adams, Ansel.** PHOTOGRAPHS OF THE SOUTHWEST: SELECTED PHOTOGRAPHS MADE FROM 1928 TO 1968 IN ARIZONA, CALIFORNIA, COLORADO, NEW MEXICO, TEXAS, AND UTAH. Boston: New York Graphic Society, 1976. 128 p., illus.

With a statement by the photographer and an essay on the land by Lawrence Clark Powell.

N386. **Adams, Ansel.** POLAROID LAND PHOTOGRAPHY: A TECHNICAL HANDBOOK. New York: Morgan & Morgan, 1963. 192 p., illus.

An advanced manual, largely devoted to the application of Polaroid Land sensitive materials to Adams's Zone System. For a general introduction to the Polaroid Land System, Adams recommends John Wolbarst's *Picture in a Minute.*

N387. **Adams, Ansel.** SIERRA NEVADA: THE JOHN MUIR TRAIL. Berkeley, Calif: Archetype Press, 1938. 4 p., illus.

Foreword by Ansel Adams. The fifty plates are tipped-in varnished halftones of exquisite quality. Printed in an edition of 250.

N388. **De Cock, Liliane, ed.** SINGULAR IMAGES. PHOTOGRAPHS BY ANSEL ADAMS. Dobbs Ferry, N.Y.: Morgan & Morgan, 1974. unpag., illus.

A collection of fifty-three photographs taken by the Land Polaroid process, with essays by the inventor Edwin H. Land, Jon Holmes, David H. McAlpin, and Adams.

N389. **Adams, Ansel.** THESE WE INHERIT: THE PARKLANDS OF AMERICA. San Francisco: Sierra Club, 1962. 103 p., illus., portfol.

"Derived in large part from *My Camera in the National Parks,* by Ansel Adams . . . 1950." A portfolio of forty-two excellent reproductions. Preface by the editor and designer. David Brower. Foreword by Ansel Adams. Also includes the essays, "The Park Concept" and "About National Park Ideals."

N390. **Adams, Ansel, and Newhall, Nancy.** THIS IS THE AMERICAN EARTH. San Francisco: Sierra Club, 1960. 89 p., illus.

A poetic text by Nancy Newhall integrated with photographs of the natural scene, mostly taken by Ansel Adams. The first of the Sierra Club's "exhibition format" books (13-3/4 x 10-1/2 ins.). A smaller PAPERBACK EDITION, with the same contents, was published (New York: Ballantine Books, 1968).

N391. **Newhall, Nancy, ed.** YOSEMITE VALLEY. PHOTOGRAPHY BY ANSEL ADAMS. San Francisco: Five Associates, 1959. 11 p., illus.

Foreword by Nancy Newhall. Excerpts from Adams's previous writings on Yosemite accompany the forty-five photographs. Essay on problems of photographing in Yosemite. Bibliography.

PORTFOLIOS AND PRINTS

N392. **Adams, Ansel.** PARMELIAN PRINTS OF THE HIGH SIERRAS. San Francisco: Grabhorn Press, 1927. illus.

N393. **Adams, Ansel.** PORTFOLIO 1: IN MEMORY OF ALFRED STIEGLITZ. San Francisco: Grabhorn Press, 1948. illus.

Foreword by Ansel Adams.

N394. **Adams, Ansel.** PORTFOLIO 2: THE NATIONAL PARKS AND MONUMENTS. San Francisco: Grabhorn Press, 1950. illus.

Foreword by Ansel Adams.

N395. **Adams, Ansel.** PORTFOLIO 3: YOSEMITE VALLEY. San Francisco: Sierra Club, 1960. illus.

Foreword by Ansel Adams.

N396. **Adams, Ansel.** PORTFOLIO 4: WHAT MAJESTIC WORD; IN MEMORY OF RUSSELL VARIAN. San Francisco: Sierra Club, 1963. illus.

Foreword by Ansel Adams. Biographical essay on Russell Harrison Varian (1898–1959) by Dorothy Varian. Sponsored by the Varian Foundation, Palo Alto, Calif.

N397. **Adams, Ansel.** PORTFOLIO 5. New York: Parasol Press, 1971. illus.

Foreword by Nancy Newhall.

N398. **Adams, Ansel.** PORTFOLIO 6. New York: Parasol Press, 1974. illus.

Foreword by Beaumont and Nancy Newhall.

N399. **Austin, Mary.** TAOS PUEBLO. PHOTOGRAPHY BY ANSEL ADAMS. San Francisco: Grabhorn Press, 1930. unpag., illus.

Twelve original photographs of Indians and the architectural environment of the pueblo at Taos, N.M. The text by Mary Austin and the photographs are printed on the same fine paper, which was specially photosensitized for the purpose.

N400. **Adams, Ansel, and Newhall, Nancy.** DEATH VALLEY. San Francisco: Five Associates, 1954. 55 p., illus. (color).

Photographs by Ansel Adams, story by Nancy Newhall, Ruth Kirk, and others. Maps drawn by Edith Hamlin. The text is a historical account of the discovery of Death Valley and adventures of pioneers. It is followed by the photographs in portfolio. Discussion on p. 14 on photography in Death Valley.

N401. **De Cock, Liliane.** ANSEL ADAMS. Hastings-on-Hudson, N.Y.: Morgan & Morgan, 1972. unpag., illus.

Basically a portfolio of 117 reproductions, with chronology, selected bibliography, and a summary list of exhibitions. Foreword by Minor White.

WORKS ABOUT ADAMS

N402. **Newhall, Beaumont, and Newhall, Nancy.** A COLLECTION OF PHOTOGRAPHS. New York: Aperture, 1969. 24 p.

[*See* N355.]

N403. **Newhall, Beaumont, and Newhall, Nancy.** MASTERS OF PHOTOGRAPHY. New York: George Braziller, 1958. p. 172–87, illus.

[*See* N356.]

N404. **Newhall, Nancy.** ANSEL ADAMS: THE ELOQUENT LIGHT. San Francisco: Sierra Club, 1963. 176 p., illus.

First volume of a projected series on the life and photo-

graphic career of Ansel Adams up to 1938. For extensive bibliography and chronology, *see Ansel Adams Photographs, 1923–1963: The Eloquent Light* (San Francisco, Calif.: M. H. de Young Memorial Museum, 1963), 16 p., a booklet privately published on the occasion of this exhibition.

N405. San Francisco, Calif. **San Francisco Museum of Art.** ANSEL ADAMS: RECOLLECTED MOMENTS. FOREWORD BY JOHN HUMPHREY. STATEMENT BY ANSEL ADAMS.

Exhibition: Oct. 14, 1972–Jan. 14, 1973.

Chronology; selected bibliography; list of major exhibitions.

N406. Tucson, Ariz. **Center for Creative Photography.** ANSEL ADAMS ARCHIVES. Tucson, 1970.

Includes literary and photographic material.

N407. **Leiser, Ruth.** INTERVIEW WITH ANSEL ADAMS. 1972. Oral History Program, Bancroft Library, University of California, Berkeley.

[Not transcribed.]

N408. ANSEL ADAMS, PHOTOGRAPHER. DIRECTED BY DAVID MEYERS. PRODUCED BY LARRY DAWSON. SCRIPT BY NANCY NEWHALL. NARRATED BY BEAUMONT NEWHALL. Motion cture. Released by International Film Bureau. 20 min.; sound, black and white, 16 mm.

N409. PHOTOGRAPHY: THE INCISIVE EYE. DIRECTED BY ROBERT KATZ. San Francisco: KQED–TV, producing organization.

Released for National Educational Television, 1960. A series of five films.

N410. YOSEMITE, VALLEY OF LIGHT. DIRECTED BY TOM THOMAS. MOTION PICTURE. 1957.

"Adams served as consultant and protagonist" (Beaumont Newhall).

ADAMS, ROBERT 1937—

N411. **Adams, Robert.** THE NEW WEST: LANDSCAPES ALONG THE COLORADO FRONT RANGE. Boulder, Colo.: Colorado Associated University Press, 1974. 120 p., illus.

The "urban sprawl" of cheap housing related to the natural scene of the Rocky Mountain area. Foreword by John Szarkowski.

ALINDER, JIM 1941—

N412. **Alinder, Jim.** CONSEQUENCES: PANORAMIC PHOTOGRAPHS. Lincoln, Nebr.: By the author, 1974. illus.

Outsize plates (7-1/2 x 15-3/8 in.). Introduction by Alinder, with brief biographical data.

ANDERSON, JOHN A. 1869–1948

N413. **Doll, Don, S.J., and Alinder, Jim, eds.** CRYING FOR A VISION: A ROSEBUD SIOUX TRILOGY, 1886–1976. PHOTOGRAPHS BY JOHN A. ANDERSON, EUGENE BUECHEL, S.J., AND DON DOLL, S.J. Dobbs Ferry, N.Y.: Morgan & Morgan, 1976. unpag., illus.

Documentation of Brule Sioux Indians on the Rosebud Reservation, S.Dak., by three generations of photographers. Foreword by Ben Black Bear, Jr. Introduction by Herman Viola.

ARBUS, DIANE 1923–1971

N414. New York. **The Museum of Modern Art.** DIANE ARBUS. Millerton, N.Y.: Aperture, 1972. 15 p., 80 plates.

Exhibition.

"An Aperture monograph . . . published in conjunction with a major exhibition of the photographs of Diane Arbus at The Museum of Modern Art (New York). . . . The text on the following pages was edited from tape recordings of a series of classes Diane Arbus gave in 1971 as well as from some interviews and some of her writings." Book edited and designed by Doon Arbus, the daughter of the photographer, and Marvin Israel, Diane Arbus's friend. Biographical data and appreciations by John Szarkowski and Hilton Kramer on rear cover.

N415. **Bunnell, Peter C.** DIANE ARBUS. *Print Collector's Newsletter* 3 (Jan.–Feb. 1973): 128–30, illus.

"Diane Arbus was a photographer of great originality and even greater purity who steadfastly refused to make any concessions whatsoever to the public. Clearly, she must be considered among the two or three major photographers of the last decade."

N416. **Goldman, Judith.** DIANE ARBUS: THE GAP BETWEEN INTENTION AND EFFECT. *Art Journal* 1 (fall 1974): 30–35.

N417. **Tucker, Anne.** THE WOMAN'S EYE. New York: Alfred A. Knopf, 1973. p. 109–123, illus.

[*See* N362.]

AVEDON, RICHARD 1923—

N418. **Avedon, Richard.** OBSERVATIONS. New York: Simon & Schuster, 1959. 151 p., illus.

There are 104 photographs, which are largely portraits of celebrities in the arts and entertainment. Designed by Alexey Brodovitch. Comments by Truman Capote.

N419. **Avedon, Richard.** PORTRAITS. New York: Farrar, Straus & Giroux, 1976. illus.

The portraits are mainly famous personalities in the art and literary world; each is dated to the day of the sitting. "Portraits: A Meditation on Likeness," by Harold Rosenberg, p. 9–29.

N420. **Avedon, Richard, and Baldwin, James.** NOTHING PERSONAL. New York: Atheneum Publishers, 1964. unpag., illus.

Photographs by Richard Avedon and text by James Baldwin. There are fifty-two strong, unflattering portraits of celebrities. Also published in a smaller PAPERBACK EDITION (New York: Dell Publishing Co., 1964).

N421. Minneapolis, Minn. **Minneapolis Institute of Arts.** AVEDON. Minneapolis, 1970. 12 p., illus.

Exhibition: July 2–Aug. 30, 19$0.

Catalog of an exhibition. Boxed material: *(1)* Folded single sheet with 240 miniature reproductions of portrait photographs in the exhibition. *(2)* Twelve-page leaflet with statement by the artist, chronology, bibliography. *(3)* Ten reproductions on heavy card.

N422. New York. **Marlborough Gallery.** RICHARD AVEDON, PHOTOGRAPHER. New York, 1975. unpag., illus.

Exhibition.

Chronology; bibliography.

BARNARD, GEORGE N. 1819–1902

N423. **Barnard, George N.** PHOTOGRAPHIC VIEWS OF SHERMAN'S CAMPAIGN, EMBRACING SCENES OF THE OCCUPATION OF NASHVILLE, THE GREAT BATTLES AROUND CHATTANOOGA AND LOOKOUT MOUNTAIN, THE CAMPAIGN OF ATLANTA, MARCH TO THE SEA, AND THE GREAT RAID THROUGH THE CAROLINAS. New York: 589 Broadway, 1866. illus., maps.

A portfolio of original photographs, published by the photographer, priced at $100. A thirty-page unillustrated pamphlet, *Photographic Views of Sherman's Campaign.* (New York: Wynkoop & Hallenbeck, 1866) was issued to accompany the portfolio. FACSIMILE REPRINT (New York: Dover Publications, 1976), with introduction by Beaumont Newhall. From negatives taken in the field, by George N. Barnard.

N424. **Slosek, Anthony M.** GEORGE N. BARNARD. In: SLOSEK, ANTHONY M. OSWEGO COUNTY, NEW YORK, IN THE CIVIL WAR. Oswego, N.Y.: Oswego County Civil War Centennial Committee, 1946. p. 39–45, illus.

Biographical sketch. The twenty-eight illustrations are largely from Barnard's *Photographic Views of Sherman's Campaign* (1866). Bibliographical footnotes.

BELLOCQ, E. J. *active* 1896–1938

N425. New York. **The Museum of Modern Art.** E. J. BELLOCQ: STORYVILLE PORTRAITS; PHOTOGRAPHS FROM THE NEW ORLEANS RED LIGHT DISTRICT, CIRCA 1912. TEXT BY JOHN SZARKOWSKI. PREFACE BY LEE FRIEDLANDER. New York, 1970. 18 p., illus.

Exhibition: Nov. 19, 1970–Jan. 10, 1971.

The thirty-three plates are from modern prints made by Lee Friedlander from the original negatives. The text includes a transcript of a conversation between Friedlander and six people who knew Bellocq and his works.

BENNETT, HENRY HAMILTON 1843–1908

N426. Milwaukee, Wis. **Milwaukee Art Center.** The Wisconsin Heritage in Photography: Bennett. Foreword by Tracy Atkinson. Milwaukee, 1970. 28 p., illus.

Exhibition.

Catalog of an exhibition with seventeen illustrations. Essay on Henry Hamilton Bennett by Arnold S. Gore and Saralee G. Fine.

BIERSTADT, ALBERT 1830–1902

N427. **Snell, Joseph W.** Some Rare Western Photographs by Albert Bierstadt Now in the Kansas Historical Society Collections. *Kansas Historical Quarterly* 26 (spring 1958): 1–5, illus.

A short note on five photographs taken by the painter Albert Bierstadt of Kansas in 1859; three reproductions are included.

BLACK, ALEXANDER 1859–1914

N428. **Black, Alexander.** A Capital Courtship. New York: Charles Scribner's Sons, 1897. 104 p., illus.

A work of fiction, based on the "picture play" of 250 lantern slides, shown in theatrical presentation while the author recited the text. A pioneer predecessor of the motion picture. With seventeen illustrations from life photographs taken by the author.

N429. **Black, Alexander.** Miss Jerry. New York: Charles Scribner's Sons, 1895. 121 p., illus.

Based on "picture plays" of lantern slides, projected before an audience while the author read the text. Pioneer predecessor of sound-image projection. Twenty-seven illustrations from life photographs by the author.

N430. **Black, Alexander.** Time and Chance: Adventures with People and Print. New York: Farrar & Rinehart, 1937. 335 p., illus.

The autobiography of a pioneer in the use of the hand camera, and a prolific writer on amateur photography.

BOUGHTON, ALICE

N431. **Boughton, Alice.** Photographing the Famous. New York: Avondale Press, 1928. 111 p., illus.

There are twenty-eight portraits, poorly reproduced, with anecdotes of the sittings. Foreword by James L. Ford.

BOURKE-WHITE, MARGARET 1904–1971

Works by Bourke-White

N432. **Bourke-White, Margaret.** "Dear Fatherland, Rest Quietly": A Report on the Collapse of Hitler's "Thousand Years." New York: Simon & Schuster, 1946. 175 p., illus.

"This book is a description of Germany as I saw it in defeat and collapse," Bourke-White has written. Bourke-White's words are as strong as her photographs—a powerful documentary.

N433. **Bourke-White, Margaret.** Eyes on Russia. New York: Simon & Schuster, 1931. 135 p., illus.

This includes thirty-nine photographs with travel diary of a five-week trip to the U.S.S.R. in the summer of 1930, when Bourke-White traveled 5,000 miles and took 800 photographs. Preface by Maurice Hindus.

N434. **Bourke-White, Margaret.** Halfway to Freedom: A Report on the New India in the Words and Photographs of Margaret Bourke-White. New York: Simon & Schuster, 1949. 244 p., illus.

N435. **Bourke-White, Margaret.** Portrait of Myself. New York: Simon & Schuster, 1963. 333 p., illus.

Autobiography, emphasizing the author's adventures in securing photographs for *Life* magazine on land, on sea, in the air—in peace and in war.

N436. **Bourke-White, Margaret, and Caldwell, Erskine.** Say Is This the USA? New York: Duell, Sloan & Pearce, 1941. 182 p., illus.

Documentary photographs. Technical notes, p. 176–82.

N437. **Bourke-White, Margaret.** Shooting the Russian War. New York: Simon & Schuster, 1942. 298 p., illus.

Text and pictures by Bourke-White.

N438. **Bourke-White, Margaret.** They Called It "Purple Heart Valley": A Combat Chronicle of the War in Italy. New York: Simon & Schuster, 1944. 182 p., illus.

Text by Bourke-White, with photographs taken of American action in the Italian theater, World War II.

N439. **Bourke-White, Margaret, and Caldwell, Erskine.** You Have Seen Their Faces. New York: Viking Press, 1937. 190 p., illus.

A documentary study of poverty-stricken rural life in the Southern states of America. paperback edition (New York: Modern Age Books, 1937). facsimile reprint (New York: Arno Press; with Deribooks, 1975), with new introduction by Erskine Caldwell.

Works about Bourke-White

N440. **Brown, Theodore M.** Margaret Bourke-

WHITE, PHOTOJOURNALIST. Ithaca, N.Y.: Andrew Dickson White Museum of Art, 1972. 136 p., illus.

A study of the position of photography in society during Bourke-White's life. Excellent selected bibliography of books (and reviews of them) chronologically arranged, principal photo essays by Bourke-White, and articles about her. Also brief, and highly useful, bibliography of documentary photography, photojournalism, and the history of magazines.

N441. **Callahan, Sean.** THE PHOTOGRAPHS OF MARGARET BOURKE-WHITE. Greenwich, Conn.: New York Graphic Society, 1972. 208 p., illus.

Brief biography, rich collection of photographs laid out in typical *Life* photo-essay style. Brown's bibliography [N440] reprinted here. Introduction by Theodore M. Brown. Foreword by Carl Mydans.

N442. **LaFarge, John, S.J.** A REPORT ON THE AMERICAN JESUITS. PHOTOGRAPHS BY MARGARET BOURKE-WHITE. New York: Farrar, Straus & Cudahay, 1956. 237 p., illus.

A record of Jesuit outreach programs. "Note by Margaret Bourke-White," p. 215–36. "All photographs in this volume by permission of *Life* magazine."

N443. **Tucker, Anne.** MARGARET BOURKE-WHITE. In: TUCKER, ANNE. THE WOMAN'S EYE. New York: Alfred A. Knopf, 1973. p. 45–59, illus.

[*See* N362.]

BRADY, MATHEW B. 1823–1896

N444. **Horan, James D.** MATHEW BRADY: HISTORIAN WITH A CAMERA. New York: Crown Publishers, 1955. 244 p., illus.

Biographical essay, followed by "A Picture Album" of 453 reproductions, largely of Civil War Photographs credited to "Brady or assistant." Useful index of photographs from the Brady collection reproduced in *Harper's Weekly* and *Frank Leslie's Illustrated Newspaper*. Bibliography.

N445. **Lester, Charles Edwards, ed.** THE GALLERY OF ILLUSTRIOUS AMERICANS, CONTAINING THE PORTRAITS AND BIOGRAPHICAL SKETCHES OF TWENTY-FOUR OF THE MOST EMINENT CITIZENS OF WASHINGTON. New York: M. B. Brady, F. D'Avignon, and C. Edwards Lester, 1850. 26 p., illus.

Despite the title page, the table of contents lists only the twelve portraits in the Library of Congress copy. Several of the daguerreotypes copied are clearly not by Brady, and one—the portrait of William E. Channing—bears the credit "S. Gambardella pinx." From daguerreotypes by Brady, engraved by D'Avignon.

N446. **Meredith, Roy.** MR. LINCOLN'S CAMERA MAN, MATHEW B. BRADY. 2d rev. ed. New York: Dover Publications, 1974. 368 p., illus.

A somewhat romanticized biography, with 350 illustrations from the collection assembled by M. B. Brady of

Civil War photographs now at the Library of Congress. This second edition has been revised, with new attributions, and negative numbers.

BRIGMAN, ANNE W. 1869–1950

N447. Oakland, Calif. **Oakland Museum.** ANNE BRIGMAN: PICTORIAL PHOTOGRAPHER, PAGAN, AND MEMBER OF THE PHOTO SECESSION. TEXT BY THERESE THAU HEYMAN. Oakland, 1974. 18 p., illus.
Exhibition.

Catalog of an exhibition of the work of Anne Brigman, Californian photographer, who specialized in posing nude or partially draped figures with rocks and tree in the Sierra wilderness. Short biographical essay; bibliography.

BRODOVITCH, ALEXEY 1898—

N448. **Denby, Edwin.** BALLET: ONE HUNDRED AND FOUR PHOTOGRAPHS. PHOTOGRAPHY BY ALEXEY BRODOVITCH. New York: J. J. Augustin, 1945. 143 p., illus.

"On stage" photographs, taken when the blur of motion, the grain of the film, the not-focused image, were not accepted as part of the photographic idiom.

BROOK, JOHN 1924—

N449. **Brook, John.** ALONG THE RIVERRUN. San Francisco: Scrimshaw Press, 1970. unpag., illus.

Lovers and babies romantically seen, in now-sharp, now-blurred photographs, presented without text, titles, or other documentation.

BRUGUIÈRE, FRANCIS 1880–1945

N450. **Bruguière, Francis, and Sieveking, Lancelot.** BEYOND THIS POINT. London: Duckworth, 1930. 164 p., illus.

Extraordinary "absolute collaboration . . . the text, written by Sieveking, is inseparable from the photographs." The photographs are abstract forms of cut paper, double exposed.

N451. **Bruguière, Francis, and Blakeston, Oswell.** FEW ARE CHOSEN: STUDIES IN THE THEATRICAL LIGHTING OF LIFE'S THEATRE. London: Eric Partridge, 1931. 116 p., illus.

Fiction, accompanied with photographs of cut paper forms.

N452. **Bruguière, Francis.** SAN FRANCISCO. San Francisco: H. S. Crocker Co., 1918. 61 p., illus.

Twenty-six views in and around San Francisco.

BUECHEL, EUGENE, S.J. 1874–1954

N453. El Cajon, Calif. **Grossmont College Development**

Foundation. EUGENE BUECHEL, S.J.: ROSEBUD AND PINE RIDGE PHOTOGRAPHS, 1922–1942. FOREWORD BY DAVID WING. El Cajon, 1974. 55 p., illus.

Exhibition: Shown at the 1974 Grossmont Summer Photography Workshop. Cosponsored by the Buechel Memorial Lakota Museum, St. Francis, S. Dak.

A selection from more than 12,000 photographs taken by the Buechel.

N454. **Doll, Don, S.J., and Alinder, Jim, eds.** CRYING FOR A VISION: A ROSEBUD SIOUX TRILOGY, 1886–1976. PHOTOGRAPHS BY JOHN A. ANDERSON, EUGENE BUECHEL, S.J., AND DON DOLL, S.J. Dobbs Ferry, N.Y.: Morgan & Morgan, 1976. unpag., illus.

Documentation of Brule Sioux Indians on the Rosebud Reservation, South Dakota, by three generations of photographers. Foreword by Ben Black Bear, Jr. Introduction by Herman Viola.

BULLOCK, WYNN 1902–1976

N455. **Badger, Gerry.** WYNN BULLOCK. *Photographic Journal* 115 (May 1975): 206–213, illus. (color).

Published on the occasion of Bullock's exhibition at the Royal Photographic Society, London. A perceptive essay on the photographer's philosophical concepts of what he terms "space time."

N456. **Bullock, Barbara.** WYNN BULLOCK. San Francisco: Scrimshaw Press, 1971. 142 p., illus.

Introduction by Barbara Bullock. Acknowledgements by Dave Bohn. Scattered among sixty-two plates arranged in approximate chronological groups are Wynn Bullock's notes, such as the following: "Pictures, in order to have any meaning—other than the physical matter they are made of—must have magic, a magic that evokes experiences apart from the material If I photograph in such a way that I meaningfully evoke a sense of the known and the unknown, I feel I have succeeded."

N457. **Bullock, Wynn.** SPACE AND TIME. *Photography* 17 (1962): 42–49.

A discussion of the fourth dimension in pictures, with a description of Bullock's abstract "light pictures." REPRINTED in *Photographers on Photography* [N50, p. 37–40].

N458. WYNN BULLOCK. Millerton, N.Y.: Aperture, 1976. 96 p., illus.

Essay by David Fuess. Chronology; selected bibliography; list of films.

N459. BULLOCK, WYNN—PHOTOGRAPHS 1951–1973. Yosemite, Calif.: Ansel Adams Gallery, 1974. unpag., illus.

Portfolio contains twelve original photographs, approximately 8 x 10 in. Limited edition of twenty-five. Introduction by Ansel Adams.

N460. **Bullock-Wilson, Barbara.** WYNN BULLOCK, PHOTOGRAPHY: A WAY OF LIFE. EDITED BY LILIANE

DE COCK. Dobbs Ferry, N.Y.: Morgan & Morgan, 1973. 160 p., illus.

The text is a lengthy discussion of Bullock's philosophy towards photography as a "space time" medium. Chronography; bibliography; list of exhibitions; lectures; and list of institutions owning Bullock photographs.

N461. **Newhall, Beaumont, and Newhall, Nancy.** WYNN BULLOCK. In: NEWHALL, BEAUMONT, AND NEWHALL, NANCY. A COLLECTION OF PHOTOGRAPHS. New York: Aperture, 1969. p. 52–53, illus. (color). [*See* N355.]

N462. Tucson, Ariz. **University of Arizona, Center for Creative Photography.** WYNN BULLOCK ARCHIVES. 1970.

Includes photographic and literary materials.

N463. [Deleted.]

N464. TWO PHOTOGRAPHERS: WYNN BULLOCK AND IMOGEN CUNNINGHAM. PRODUCED BY FRED PADULA. Motion Picture. San Francisco: Canyon Cinema Co-Operative, distributor.

BYRON, PERCY C. 1879–1959

N465. **Mayer, Grace M.** ONCE UPON A CITY: NEW YORK FROM 1890 TO 1910 AS PHOTOGRAPHED BY BYRON. New York: Macmillan Co., 1958. 511 p., illus.

Joseph Byron and his family, including his son Percy C., came to America from England and established a New York studio. From the cameras of the Byrons came an extensive photographic documentation of the city. In 1942 Percy C. Byron presented some 10,000 negatives to the Museum of the City of New York; from these the illustrations for this book were selected. Foreword by Edward Steichen.

CALLAHAN, HARRY 1912—

N466. **Callahan, Harry.** PHOTOGRAPHS. Santa Barbara: El Mochuelo Gallery, 1964. 60 p., illus.

A superbly reproduced collection of 125 plates. Foreword by Hugo Weber. Extensive bibliography by Bernard Karpel.

N467. New York. **The Museum of Modern Art.** HARRY CALLAHAN. New York, 1967. 84 p., illus.

An excellent selection of sixty plates presented as three groups: Eleanor, the city, and landscape. Chronology by Grace M. Mayer. Selected bibliography. Introductory essay by Sherman Paul.

N468. **Newhall, Beaumont, and Newhall, Nancy.** HARRY CALLAHAN. In: NEWHALL, BEAUMONT, AND NEWHALL, NANCY. A COLLECTION OF PHOTOGRAPHS. New York: Aperture, 1969. p. 76–77, illus. [*See* N355.]

N469. **Szarkowski, John.** CALLAHAN. Millerton, N.Y.: Aperture; with The Museum of Modern Art, 1976. 203 p., illus.

A retrospective monograph including photographs taken between 1942 and 1974, and a biographical essay. Bibliography and chronology by Diana Edkins.

N470. Tucson, Ariz. **University of Arizona, Center for Creative Photography.** HARRY CALLAHAN ARCHIVES. 1970.

Includes photographic and literary materials.

N471. **Vestal, David.** WHO IS CALLAHAN? *Travel and Camera* 32 (1969): 69–72, 104, illus.

Review of an exhibition of five-hundred photographs by Callahan's students, with biographical essay.

CAPA, CORNELL 1918—

N472. **Huxley, Matthew, and Capa, Cornell.** FAREWELL TO EDEN. New York and Evanston, Ill.: Harper & Row, 1964. 244 p., illus. (color).

Picture and text documentation of the Amahuaca Indians of Peru.

CAPA, ROBERT (André Friedman) 1913–1954

N473. **Capa, Cornell, and Karia, Bhupendra, eds.** ROBERT CAPA, 1913–1954. New York: Grossman Publishers, 1974. 127 p., illus.
INTERNATIONAL FUND FOR CONCERNED PHOTOGRAPHY, LIBRARY OF PHOTOGRAPHERS, VOL. 1.

Includes writings by the photographer, Robert Capa, and also the following authors: John Hersey, William Saroyan, John G. Morris, John Mecklin, Irwin Shaw, Louis Aragon, John Steinbeck, and Ernest Hemingway. Chronology; exhibitions; bibliography.

N474. **Capa, Robert.** IMAGES OF WAR. New York: Grossman Publishers, 1964. 175 p., illus.

Well-reproduced album of Capa's photographs, with an appreciation by John Steinbeck. Text collected from Capa's writings.

N475. **Capa, Robert.** SLIGHTLY OUT OF FOCUS. New York: Henry Holt, 1947. 243 p., illus.

Autobiography of André Friedman, who, under the pseudonym of Robert Capa, specialized in combat photography.

N476. **Forbes-Robertson, Diana, and Capa, Robert.** THE BATTLE OF WATERLOO ROAD. New York: Random House, 1941. 124 p., illus.

Photographs by Robert Capa of the bombing of London during World War II, the damage to the city, and the effect upon the people.

N477. **Shaw, Irwin, and Capa, Robert.** REPORT ON ISRAEL. New York: Simon & Schuster, 1950. 144 p., illus.

Superb pictorial document on the people of the then-new independent state of Israel.

N478. **Steinbeck, John.** A RUSSIAN JOURNAL. PHOTOGRAPHS BY ROBERT CAPA. New York: Viking Press, 1948. 220 p., illus.

N479. **Wertenbaker, Charles Christian.** INVASION! PHOTOGRAPHS BY ROBERT CAPA, LIFE STAFF PHOTOGRAPHER. New York and London: D. Appleton-Century Co., 1944. 168 p., illus.

CAPONIGRO, PAUL 1932—

N480. PHOTOGRAPHY: A CONTEMPORARY COMPENDIUM. *Camera* 54 (Dec. 1975): 24, 42, illus.

This is essentially biographical material. [On instant photography, *see Camera* 53 (Oct. 1974): 54–58, illus.]

N481. **Caponigro, Paul.** LANDSCAPE. New York: McGraw-Hill Book C., 1975. unpag., illus.

Brief statements by the photographer interspersed with plates.

N482. **Caponigro, Paul.** SUNFLOWER. New York: Filmhaus, 1974. unpag., illus.

There are fifty-six photographs of sunflowers.

N483. **Newhall, Beaumont, and Newhall, Nancy.** PAUL CAPONIGRO. In: NEWHALL, BEAUMONT, AND NEWHALL, NANCY. A COLLECTION OF PHOTOGRAPHS. New York: Aperture, 1969. p. 82–83, illus.
[*See* N355.]

CHAPPELL, WALTER 1925—

N484. **Lyons, Nathan; Labrot, Syl; and Chappell, Walter.** UNDER THE SUN: THE ABSTRACT ART OF CAMERA VISION. New York: George Braziller, 1960. 22 p., illus. (color).

The volume includes twelve black-and-white photographs by Walter Chappell with a statement.

CLARK, LARRY 1943—

N485. **Clark, Larry.** TULSA. New York: Lustrum Press, 1971. unpag., illus.

Photographs of young people taking drugs and of the consequences, with a minimum of words.

COKE, VAN DEREN 1921—

N486. **Coke, Van Deren.** VAN DEREN COKE: PHOTOGRAPHS 1956–1973. Albuquerque: University of New Mexico Press, 1973. 80 p., illus.

There are fifty-two plates. Foreword by Henry Holmes Smith; afterword by Van Deren Coke. Chronology; list of exhibitions; bibliography.

COLLIER, JOHN, JR. 1913—

N487. **Collier, John, Jr.** VISUAL ANTHROPOLOGY: PHOTOGRAPHY AS A RESEARCH METHOD. New York: Holt, Rinehart & Winston, 1967. 138 p., illus.

By a former photographer for the Farm Security Administration, this text is an extension of the documentary approach. Bibliography.

COSINDAS, MARIE 1925—

N488. New York. **The Museum of Modern Art.** MARIE COSINDAS: POLAROID COLOR PHOTOGRAPHS. New York, 1966. unpag., illus.

Exhibition: Also shown at The Art Institute of Chicago; and the Museum of Fine Arts, Boston, 1966–1967.

A small portfolio of ten color reproductions, with short statements by John Szarkowski, Perry T. Rathbone, and Hugh Edwards.

N489. **Newhall, Beaumont, and Newhall, Nancy.** MARIE COSINDAS. In: NEWHALL, BEAUMONT, AND NEWHALL, NANCY. A COLLECTION OF PHOTOGRAPHS. New York: Aperture, 1969. p. 79, illus.

[*See* N355.]

CUNNINGHAM, IMOGEN 1883–1976

N490. **Cunningham, Imogen.** IMOGEN CUNNINGHAM PHOTOGRAPHS. Seattle and London: University of Washington Press, 1970. 32 p., illus.

Biographical essay; ninety-four illustrations; list of exhibitions; and bibliography. Introduction by Margery Mann.

N491. **Daniel, Edna Tartaul.** INTERVIEW WITH IMOGEN CUNNINGHAM. Transcription. 215 p. Bancroft Library, University of California, Berkeley, 1961.

General review of Cunningham's career as a photographer, with details on equipment. Transcription contains bibliographic data. Foreword by Beaumont Newhall.

N492. **Newhall, Beaumont, and Newhall, Nancy.** IMOGEN CUNNINGHAM. In: NEWHALL, BEAUMONT, AND NEWHALL, NANCY. A COLLECTION OF PHOTOGRAPHS. New York: Aperture, 1969. p. 25–26, illus.

[*See* N355.]

N493. Seattle, Wash. **University of Washington. Henry Art Gallery.** IMOGEN CUNNINGHAM PHOTOGRAPHS, 1910-1973. INTRODUCTION BY MARGERY MANN. Seattle, 1974. 110 p., illus.

Exhibition: Mar. 23–Apr. 21, 1974.

List of exhibitions; selected bibliography.

N494. TWO PHOTOGRAPHERS: WYNN BULLOCK AND IMOGEN CUNNINGHAM. PRODUCED BY FRED PADULA. Motion Picture. San Francisco: Canyon Cinema Co-Operative, distributor, ca. 1975.

CURTIS, EDWARD S. 1868–1952

N495. **Andrews, Ralph W.** CURTIS' WESTERN INDIANS. New York: Bonanza Books, 1962. 176 p., illus.

Biography. The first republication of a selection of the plates in *The North American Indian*, by Edward S. Curtis.

N496. **Brown, Joseph Epes.** THE NORTH AMERICAN INDIANS: A SELECTION OF PHOTOGRAPHS BY EDWARD S. CURTIS. Millerton, N.Y.: Aperture, 1972. 96 p., illus.

The foreword by Brown is of anthropological interest; no attempt is made to place Curtis in the stream of photographic history. There are seventy-three excellent reproductions from the original photogravures in the collection of the Philadelphia Museum of Art. ALSO PUBLISHED in *Aperture* 10:4 (1964).

N497. **Fowler, Don D.** IN A SACRED MANNER WE LIVE: PHOTOGRAPHS OF THE NORTH AMERICAN INDIAN. PHOTOGRAPHS BY EDWARD S. CURTIS. Barre, Mass.: Barre Publishers, 1972. 152 p., illus.

A selection by Rachael J. Homer of plates from Curtis's twenty-volume treatise, *The North American Indian*. Introduction and commentary Don D. Fowler. Extensive bibliographical notes on Curtis and this major project.

N498. **Curtis, Edward S.** THE NORTH AMERICAN INDIAN; BEING A SERIES OF VOLUMES PICTURING AND DESCRIBING THE INDIANS OF THE UNITED STATES AND ALASKA. EDITED BY FREDERICK WEBB HODGE. Seattle: E. S. Curtis; Cambridge, Mass.: University Press, 1907–1930. 20 vols., illus., portfols.

A monumental documentation of the manners, customs, and environment of the American Indian, seen by Curtis as the last of a dying race. Curtis's work was somewhat colored by his desire to preserve the Indian traditions. The entire work has been REPRINTED (New York: Johnson Reprint Corp., 1970) under the title *The Sioux and the Apsaroke*. Vols. 3 and 4 have been edited by Stuart Zoll in one vol. (New York: Harper & Row, 1975), 105 p. Other editions are available. Foreword by Theodore Roosevelt. Field research conducted under the patronage of J. Pierpont Morgan.

N499. **Curtis, Edward S.** PORTRAITS FROM NORTH AMERICAN INDIAN LIFE. New York: Promontory Press, 1972. illus.

A folio volume (14-3/4 x 18-1/4 ins.) reproducing eighty-eight plates, in approximately original size, from *The North American Indian*, with captions edited from Curtis's writings. Despite the title, the plates include many scenes of Indian life that are not, strictly speaking, portraits. Introductions by A. D. Coleman and T. C. McLuhan.

N500. **McLuhan, T. C.** TOUCH THE EARTH: A SELF-PORTRAIT OF INDIAN EXISTENCE. New York: Outerbridge & Dienstfrey, 1971. 185 p., illus.

Text by Indian writers, with illustrations from Edward S. Curtis's *The North American Indian*.

D'ALESSANDRO, ROBERT

N501. **D'Alessandro, Robert.** GLORY. New York: Elephant Publishing Corp., 1974. unpag., illus.

Each of the thirty-nine photographs—mostly taken in urban areas—includes a United States flag.

DATER, JUDY 1941—

N502. **Dater, Judy, and Welpott, Jack.** WOMEN AND OTHER VISIONS. Dobbs Ferry, N.Y.: Morgan & Morgan, 1975. illus.

Introductory essay by Henry Holmes Smith. Includes chronology.

N503. **Tucker, Anne.** JUDY DATER. In: TUCKER, ANNE. THE WOMAN'S EYE. New York: Alfred A. Knopf, 1973. p. 141–53, illus.

[*See* N362.]

DAVIDSON, BRUCE 1933—

N504. **Davidson, Bruce.** EAST 100TH STREET. Cambridge, Mass.: Harvard University Press, 1970. 129 p., illus.

A documentary of one block in East Harlem, New York City, with a one-page statement by the artist.

N505. **Newhall, Beaumont, and Newhall, Nancy.** BRUCE DAVIDSON. In: NEWHALL, BEAUMONT, AND NEWHALL, NANCY. A COLLECTION OF PHOTOGRAPHS. New York: Aperture, 1969. p. 70–71.

[*See* N355.]

DAY, FRED HOLLAND 1864–1933

N506. Wellesley, Mass. **The Wellesley College Museum.** THE PHOTOGRAPHIC WORK OF F. HOLLAND DAY. CATALOG BY ELLEN FRITZ CLATTENBURG. Wellesley, 1975. 64 p., illus.
Exhibition: Feb. 21–Mar. 24, 1975.

Catalog of an exhibition with biographical essay, excellent bibliography, and a detailed description of works included.

DE CARAVA, ROY 1919—

N507. **De Carava, Roy, and Hughes, Langston.** THE SWEET FLYPAPER OF LIFE. New York: Hill & Wang, 1955. 96 p., illus.

A sequence of photographs linked together skillfully by a brief text.

N508. Lincoln Nebr. **University of Nebraska, Sheldon Memorial Art Gallery.** ROY DE CARAVA, PHOTOGRAPHER. Lincoln, 1970. 16 p., illus.
Exhibition: Apr. 28–May 24, 1970.
Afterword by Jim Alinder.

DE COCK, LILIANE 1939—

N509. **De Cock, Liliane.** LILIANE DE COCK: PHOTOGRAPHS. Hastings-on-Hudson, N.Y.: Morgan & Morgan; with Amon Carter Museum of Western Art, 1973. 64 p., illus.

There are forty-two plates, and a list of exhibitions. Foreword by Ansel Adams.

N510. **Newhall, Beaumont, and Newhall, Nancy.** LILIANE DE COCK. In: NEWHALL, BEAUMONT, AND NEWHALL, NANCY. A COLLECTION OF PHOTOGRAPHS. New York: Aperture, 1969, p. 78, illus.

[*See* N355.]

DEAN, NICHOLAS 1933—

N511. **Williams, Jonathan.** BLUES AND ROOTS, RUE AND BLUETS: A GARLAND FOR THE APPALACHIANS. PHOTOGRAPHS BY NICHOLAS DEAN. New York: Grossman Publishers, 1971. unpag., illus.

Poetry opposite Dean's photographs for the most part.

DOLL, DON, S.J. 1937—

N512. **Doll, Don, S.J., and Alinder, Jim, eds.** CRYING FOR A VISION: A ROSEBUD SIOUX TRILOGY, 1886–1976. PHOTOGRAPHS BY JOHN A. ANDERSON, EUGENE BUECHEL, S.J., AND DON DOLL, S.J. Dobbs Ferry, N.Y.: Morgan & Morgan, 1976. unpag., illus.

Documentation of Brule Sioux Indians on the Rosebud Reservation, South Dakota, by three generations of photographers. Foreword by Ben Black Bear, Jr. Introduction by Herman Viola.

DORR, NELL 1895—

N513. **Dorr, Nell.** MOTHER AND CHILD. New York: Harper & Bros., 1954. unpag., illus.

Brief text by the photographer, a Fellow of the Royal Photographic Society of London, England. This small volume is aptly described as "a prose poem in praise of motherhood." In *U.S. Camera 1939*, Edward Steichen says, in one of his rare reviews of a photographic book, "one would have to go deep into the works of the poets to find an equivalent expression of lyric loveliness. Here is a document in photography that is the opposite of what is generally labeled documentary photography today, just as subjective is opposite to objective. Here is the autobiography of a sensitive, strong woman, a book containing essences distilled from a mingling of cool waters and warm earth." About eighty reproductions are included in this volume.

DUNCAN, DAVID DOUGLAS 1916—

N514. **Duncan, David Douglas.** I PROTEST! New York: New American Library, 1968. unpag., illus.

Photographs taken in Feb. 1968, during eight days of

combat by United States Marines with North Vietnamese army divisions. Photographic and biographical data in appendix.

N515. **Duncan, David Douglas.** THE KREMLIN. Greenwich, Conn.: New York Graphic Society, 1960. 170 p., illus. (color).

Color photographs, superbly reproduced, of art treasures and historical relics in the Kremlin in Moscow.

N516. **Duncan, David Douglas.** PRISMATICS: EXPLORING A NEW WORLD. New York: Harper & Row, 197(?). 105 p., illus. (color).

A collection of forty-two optically distorted color photographs, with technical instructions for production.

N517. **Duncan, David Douglas.** THE PRIVATE WORLD OF PABLO PICASSO. New York: Harper & Bros., 1958. 176 p., illus.

The artist photographed at home, at work, and at play. The text describes the activities photographed.

N518. **Duncan, David Douglas.** GOODBYE PICASSO. New York: Grosset & Dunlap, 1974. 299 p., illus. (color).

This book is the last in a series of books which record a special relationship between painter and photographer. *See also Picasso's Picasso* (New York: Harper & Row, 1961).

N519. **Duncan, David Douglas.** SELF PORTRAIT, U.S.A.: THE NATIONAL CONVENTIONS, MIAMI BEACH AND CHICAGO. New York: Harry N. Abrams, 1969. 240 p., illus.

Preface dated 1969. A handsomely produced folio volume of coverage of the Democratic and Republican national conventions, with pictures of the candidates, the delegates, and spectators.

N520. **Duncan, David Douglas.** THIS IS WAR! A PHOTO-NARRATIVE IN THREE PARTS. New York: Harper & Bros., 1951. unpag., illus.

Powerful photographs of soldiers during combat in the Korean War. One page of photographic data.

N521. **Duncan, David Douglas.** YANKEE NOMAD: A PHOTOGRAPHIC ODYSSEY. New York, Chicago, and San Francisco: Holt, Rinehart & Winston, 1966. 480 p., illus. (color).

An autobiography, with a large selection of photographs. Introduction by John Gunther. Lacks both chronology and bibliography.

N522. **Duncan, David Douglas.** WAR WITHOUT HEROES. New York and Evanston, Ill.: Harper & Row, 1970. 252 p., illus.

Combat photographs of United States Marines in the Vietnam War. Photographic data, p. 252.

EAKINS, THOMAS COWPERTHWAITE 1844–1916

N523. **Hendricks, Gordon.** A FAMILY ALBUM: PHOTO-GRAPHS BY THOMAS EAKINS, 1880–1890. New York: Coe Kerr Gallery, 1976. 14 p., illus.

Photographs from the author's collection, including intimate portraits and scenes. There are thirty-five illustrations.

N524. **Hendricks, Gordon.** THE PHOTOGRAPHS OF THOMAS EAKINS. New York: Grossman Publishers, 1972. 214 p., illus.

Approximately 240 photographs taken by the American painter Thomas Eakins in the period 1880–1900, chronologically presented, plus photographs of the artist. For a discussion of the ways in which Eakins used his photographs in his paintings, see the author's catalog for the exhibition, *Thomas Eakins: His Photographic Works,* held at the Pennsylvania Academy of the Fine Arts, Philadelphia, in 1969.

N525. **Homer, William I., and Talbot, John.** EAKINS, MUYBRIDGE, AND THE MOTION PICTURE PROCESS. *Art Quarterly* 26 (summer 1963): 194–216, illus.

A scholarly account of Eakins's experiments with the techniques of Muybridge, and especially Marey, in photographing the human figure in motion. Extensive footnotes.

EASTMAN, GEORGE 1854–1932

N526. **Ackerman, Carl W.** GEORGE EASTMAN. Boston and New York: Houghton Mifflin Co.; Cambridge: Riverside Press, 1930. 522 p., illus.

An official biography, with more emphasis on Eastman's business career than on his photographic contributions. The twenty illustrations are mostly official portraits of personalities. Excellent index. Introduction by Edwin R. A. Seligman.

N527. **Butterfield, Roger.** THE PRODIGIOUS LIFE OF GEORGE EASTMAN: THE KODAK BROUGHT HIM A FORTUNE AND PHOTOGRAPHY TO MILLIONS. *Life* 36 (Apr. 26, 1954): 154–56, 158, 160, 165–66, 168, illus.

The best biography of George Eastman yet to appear. Accompanied by a brief history of photography by Beaumont Newhall, placing Eastman's contributions in context.

N528. **Jenkins, Reese V.** TECHNOLOGY AND THE MARKET: GEORGE EASTMAN AND THE ORIGINS OF MASS AMATEUR PHOTOGRAPHY. *Technology and Culture* 16 (Jan. 1975): 1–19, illus.

EGGLESTON, WILLIAM 1939—

N529. **Eggleston, William.** WILLIAM EGGLESTON'S GUIDE. New York: Museum of Modern Art, 1976. 112 p., illus. (color).

Included are forty-seven color photographs, largely of the suburban environment. Brief biographical data. Essay by John Szarkowski.

EICKEMEYER, RUDOLF, JR. 1862–1932

N530. Yonkers, N.Y. **Hudson River Museum at Yonkers.** PHOTOGRAPHS OF RUDOLF EICKEMEYER, JR. Yonkers, 1972. 28 p., illus.

Exhibition: Mar. 12–Apr. 30, 1972.

Catalog of an exhibition with twelve illustrations. Biographical essay by Mary Jean Madigan. Chronology; bibliography; list of works in the exhibition.

EISENSTAEDT, ALFRED 1898—

N531. **Eisenstaedt, Alfred, with Goldsmith, Arthur.** THE EYE OF EISENSTAEDT, *"Life"* PHOTOGRAPHER. New York: Viking Press, 1969. 199 p., illus. (color).

An autobiography of the noted photojournalist who worked for *Life* magazine from its inception.

N532. **Eisenstaedt, Alfred.** EISENSTAEDT'S ALBUM: FIFTY YEARS OF FRIENDS AND ACQUAINTANCES. New York: Viking Press, 1976. unpag., illus.

There are 372 photographs of celebrities by Eisenstaedt, with their autographs, comments, and sometimes sketches or caricatures. Not indexed. Introduction by Philip B. Kunhardt, Jr.

N533. **Eisenstaedt, Alfred.** PEOPLE. New York: Viking Press, 1974. 264 p., illus.

A survey of photojournalistic work by one of *Life's* first photographers.

N534. **Eisenstaedt, Alfred.** WITNESS TO NATURE. New York: Viking Press, 1971. 126 p., illus. (color).

Illustrations include landscapes, forest scenes, close-ups of flowers, and animals, with a two-page introduction, and notes on each of the 119 photographs.

N535. **Eisenstaedt, Alfred.** WITNESS TO OUR TIME. New York: Viking Press, 1966. 343 p., illus.

A rich collection of photographs, varied in content and scope, by one of *Life's* first photographers. Minimal text.

N536. EYES THAT SEE: AN INTERVIEW WITH ALFRED EISENSTAEDT. In: MORGAN, WILLARD D., AND LESTER, HENRY M., EDS. MINIATURE CAMERA WORK. New York: Morgan & Lester, 1938. p. 55–67, illus.

"The following composite interview has been prepared with the cooperation of Eisenstaedt and his partner, Leon Daniel" (Introduction).

ELISOFON, ELIOT 1911–1973

N537. **Elisofon, Eliot.** COLOR PHOTOGRAPHY. New York: Viking Press, 1961. 153 p., illus. (color).

A stimulating technical book, by the late *Life* magazine photographer and consultant to Hollywood film producers on color photography.

N538. **Elisofon, Eliot.** JAVA DIARY. New York: Macmillan Co., 1969. 298 p., illus. (color).

Based on photographs taken for *Life* magazine.

N538a. **Elisofon, Eliot.** THE NILE. New York: Viking Press, 1964. 292 p., illus. (color).

Introduction by Laurens Van der Post.

N538b. **Elisofon, Eliot.** THE SCULPTURE OF AFRICA. New York: Praeger Publishers, 1959. 256 p., illus.

Text by William Fagg. Preface by Ralph Linton. The sculptures were collected by the photographer during his travels.

EMERSON, PETER HENRY 1856–1936

N539. **Emerson, Peter Henry.** NATURALISTIC PHOTOGRAPHY FOR STUDENTS OF THE ART. London: Sampson Low, 1889.

Emerson's controversial writings were of great importance to American photographers. Besides these two American editions of his classic *Naturalistic Photography,* he contributed an "English Letter" to the *American Amateur Photographer.* The BRITISH EDITION (London, 1889), is not illustrated, and was REPRINTED (New York: Arno Press, 1973). The SECOND REVISED EDITION (New York: E. & F. Spon, 1890), 313 p., was REPRINTED (New York: Amphoto, 1972), with an introduction by Peter Pollack. THIRD REVISED EDITION (London: Dawbarn & Ward, 1899). Another EARLY EDITION (New York: Scovill & Adams, 1899), was REPRINTED (New York: Arno Press, 1973).

N540. **Emerson, Peter Henry.** PICTURES OF EAST ANGLIAN LIFE. London: Sampson Low, 1888. illus.

"Illustrated with thirty-two photogravures by P. H. Emerson. Limited to seventy-five deluxe and five-hundred ordinary copies. Emerson gave a copy of this work to every English photographic society. He pasted on the inside cover a broadside 'To the Student,' dated September 1889, keying the plates to *Naturalistic Photography* The broadside was subsequently withdrawn by the author" (Nancy Newhall [N541], p. 162).

N541. **Newhall, Nancy.** P. H. EMERSON: THE FIGHT FOR PHOTOGRAPHY AS A FINE ART. New York: Aperture, 1975. 265 p., illus.

A comprehensive and warm appreciation based on long study of Emerson's own writings and correspondence, particularly with Stieglitz. Emerson is seen as a "pioneer in word images; rarely is his acute and detailed as well as expressive, documentation in words a literal description of the photographs, and seldom do the photographs illustrate the words. They cast a spell over the book; they live in your mind as you read." Pt. 2 consists of Emerson's photographs, accompanied by excerpts from his albums and *Naturalistic Photography.* Chronology; bibliography.

N542. **Newhall, Nancy.** P. H. EMERSON: ARTIST,

PHOTOGRAPHER, WRITER. *Complete Photographer* 4 (1942): 1484–88, illus.

REPRINTED: *The Encyclopedia of Photography* (New York: Greystone Press, 1963), p. 1,254–57; *See also* "Peter Henry Emerson," in Beaumont and Nancy Newhall's *Masters of Photography* [N356, p. 54–59].

ENYEART, JAMES

N543. Lawrence, Kans. **University of Kansas, Museum of Art.** KANSAS LANDSCAPE: AN EXHIBITION OF PHOTOGRAPHS BY JIM ENYEART. INTRODUCTION BY WILLIAM W. HAMBLETON. Lawrence, 1971. 64 p., illus.

Exhibition: Sept. 26–Nov. 7, 1971.

Sixty plates by Enyeart, the museum's curator of photography. [*See* also N210.]

ERWITT, ELLIOTT 1928—

N544. **Callahan, Sean.** THE PRIVATE EXPERIENCE: ELLIOTT ERWITT. London: Thames & Hudson; New York: Thomas Y. Crowell, 1974. 97 p., illus. (color).

A biography. The illustrations include contact sheets, photo essays from magazines, and single images. Technical section.

N545. **Homes, Sam.** PHOTOGRAPHS AND ANTI-PHOTOGRAPHS. PHOTOGRAPHS BY ELLIOTT ERWITT. Greenwich, Conn.: New York Graphic Society, 1972. 128 p., illus.

Sharply observed photographs of people who were unaware that the photographer was taking their picture. Introduction by John Szarkowski.

N546. **Erwitt, Elliott.** SON OF A BITCH. New York: Grossman Publishers, 1974. 127 p., illus.

Photographs of a dog. Introduction by P. G. Wodehouse.

EVANS, WALKER 1903–1975

N547. **Agee, James, and Evans, Walker.** LET US NOW PRAISE FAMOUS MEN: THREE TENANT FAMILIES. New York: Houghton Mifflin Co., 1960. 471 p., illus., portfol.

A reissue of the ORIGINAL EDITION (1941), with sixty-two photographs in place of the original thirty-one, and a foreword by Walker Evans. A landmark collaboration of photographer and writer; the photographs, uncaptioned, are in a folio section preceeding the text. Agee writes, "The photographs and the text are coequal, mutually independent, and fully collaborative." PAPERBACK EDITION (New York: Ballantine Books, 1966).

N548. **Beals, Carleton.** THE CRIME OF CUBA. PHOTOGRAPHS BY WALKER EVANS. Philadelphia and London: J. B. Lippincott Co., 1933. 441 p., illus.

The thirty-one photographs are grouped in the back of the book following the half-title "Cuba: A Portfolio of Photographs by Walker Evans."

N549. **Crane, Hart.** THE BRIDGE: A POEM. PHOTOGRAPHS BY WALKER EVANS. Paris: Black Sun Press, 1930. 82 p., illus.

The illustrations comprise three small photogravures, two of the Brooklyn Bridge and one looking down from the bridge on a tugboat and barges.

N550. **Kirstein, Lincoln.** AMERICAN PHOTOGRAPHS. PHOTOGRAPHS BY WALKER EVANS. New York: Museum of Modern Art, 1938. 198 p., illus.

The first presentation in book format of Evans's photographs is now considered a classic. Reissued with foreword by Monroe Wheeler (1962). REPRINTED as a paperback (New York: East River Press, 1975).

N551. **Evans, Walker.** COMMENTS ON POSTCARDS. In: GREEN, JONATHAN, ED. THE SNAPSHOT. Millerton, N.Y.: Aperture, 1974. p. 94–95.

"The postcard field is rich in realism, sentiment, comedy, fantasy, and minor historical document." This article is an adaptation of articles that appeared in *Fortune* (May 1948 and Jan. 1962), on the American city postcard, with two illustrations.

N552. **Evans, Walker.** MANY ARE CALLED. Boston: Houghton Mifflin Co., 1966. 178 p., illus.

Unpaged text plus plates consisting of remarkable photographs taken during the 1930s and 1940s in New York City subway cars. The photographs are reproduced on right-hand pages without captions. Introduction by James Agee.

N553. **Evans, Walker.** MESSAGE FROM THE INTERIOR. New York: Eakins Press, 1966. 4 p., illus.

An oversized (14-1/2 x 14-1/4 in.) bound portfolio of twelve superbly reproduced photographs. One-page statement by John Szarkowski.

N554. **Evans, Walker.** WALKER EVANS: PHOTOGRAPHS FOR THE FARM SECURITY ADMINISTRATION. New York: Da Capo Press, 1973. unpag., illus.

There are 448 small reproductions of all the Evans photographs in the FSA files in the Library of Congress. Introduction by Jerald C. Maddox.

N555. **Evans, Walker.** PHOTOGRAPHY. In: KRONENBERGER, LOUIS, ED. QUALITY: ITS IMAGE IN THE ARTS. New York: Atheneum, 1969. p. 169–211, illus.

The noted photographer describes a selection of twenty-one photographs, ranging from the work of Julia Margaret Cameron to the Lunar Orbiter photograph of "Earth from Moon."

N556. **Evans, Walker.** THE RE-APPEARANCE OF PHOTOGRAPHY. *Hound & Horn* 5 (Oct.–Dec. 1931): 125–28.

A review of six books on photography, in which an aesthetic based on the straightforward use of the camera is hailed.

N557. **Evans, Walker.** THE THING ITSELF IS SUCH A SECRET AND SO UNAPPROACHABLE. *Image* 17 (Dec. 1974): 12–18, illus.

An interview first published in the *Yale Alumni Magazine* (Feb. 1974). Largely similar to the Katz interview [N558] but with an important statement on Evans's recent interest in color as produced by the Polaroid System.

N558. **Katz, Leslie.** AN INTERVIEW WITH WALKER EVANS. *Art in America* 59 (Mar.–Apr. 1971): 82–89, illus.

The photographer's philosophy is brilliantly brought forth in this interview. *See also* an interview in the Archives of American Art, Smithsonian Institution, Washington, D.C., conducted by Paul Cummings, dated Oct.–Dec. 1971.

N559. New York. **The Museum of Modern Art.** WALKER EVANS. INTRODUCTION BY JOHN SZARKOWSKI. New York, 1971. 191 p., illus.

Exhibition.

Published on the occasion of the museum's retrospective of Walker Evans's photography. The plates, covering the period 1929 to 1970, are superbly reproduced. Bibliography of 101 entries by Anne Tucker Cohn and William Burbank, including picture essays by or edited by Evans.

N560. **Newhall, Beaumont, and Newhall, Nancy.** WALKER EVANS. In: NEWHALL, BEAUMONT, AND NEWHALL, NANCY. MASTERS OF PHOTOGRAPHY. New York: George Braziller, 1958. p. 150–59, illus.

[*See* N356.]

N560a. **Newhall, Beaumont, and Newhall, Nancy.** WALKER EVANS. In: NEWHALL, BEAUMONT, AND NEWHALL, NANCY. A COLLECTION OF PHOTOGRAPHS. New York: Aperture, 1969. p. 49–50, illus.

[*See* N355.]

N561. **Soby, James Thrall.** THE MUSE WAS NOT FOR HIRE. *Saturday Review* 45 (Sept. 22, 1962): 57–58, illus.

Lively account of the author's experience as a photographic pupil of Evans, an old friend.

N562. WALKER EVANS: HIS TIME, HIS PRESENCE, HIS SILENCE. PRODUCED BY SEDAT PAKAY, ISTANBUL, 1970. Motion Picture. New York: Rodim Films, Film Images, distributor. 22 min.; sound, black and white, 16 mm.

Individual photographic prints by Walker Evans accompanied by music by Sidney Bechet and his New Orleans Feetwarmers, Al Jolson and the Andrew Sisters, and the Goldman Band.

FEININGER, ANDREAS 1906—

N563. **Feininger, Andreas.** THE WORLD THROUGH MY EYES: THIRTY YEARS OF PHOTOGRAPHY. New York: Crown Publishers, 1963. 52 p., illus. (color).

A survey of 172 Feininger photographs in many fields. Works included range from photographs of landscapes, people, and forms of nature to industry; the works are presented by categories. An autobiographical essay is included.

N564. **Hattersley, Ralph.** ANDREAS FEININGER. Dobbs Ferry, N.Y.: Morgan & Morgan, 1973. 160 p., illus.

A brief text, followed by excellent reproductions of Feininger's photographs arranged in groups: nature, shells, trees, bones, people, sculpture, cities, industry, motion, and masks. With chronology; exhibition list; bibliography.

N565. New York. **International Center of Photography.** ANDREAS FEININGER: A RETROSPECTIVE. INTRODUCTION BY BHUPENDRA KARIA. New York, 1976. 68 p., illus.

Exhibition.

Catalog of an exhibition. Chronology; list of exhibitions; bibliography.

FELLIG, ARTHUR
See **WEEGEE**

FERNANDEZ, BENEDICT J. 1935—

N566. **Fernandez, Benedict J.** IN OPPOSITION: IMAGES OF AMERICAN DISSENT IN THE SIXTIES. New York: Da Capo Press, 1968. unpag., illus.

Statement by the photographer. Preface by Aryeh Neier, director, New York Civil Liberties Union.

FRANK, ROBERT LOUIS 1924—

N567. **Bennett, Edna.** BLACK AND WHITE ARE THE COLORS OF ROBERT FRANK. *Aperture* 9 (1961): 20–22.

An essay outlining Frank's approach to photography. Includes fourteen photographs by Frank and four stills from his motion pictures.

N568. **Frank, Robert.** LES AMÉRICAINS. Paris: Robert Delpire, 1958. 164 p., illus.

Text consists of quotations, collected by Alain Bosquet, placed opposite the plates.

N568a. **Frank, Robert.** THE AMERICANS: PHOTOGRAPHS. New York: Grove Press, 1959. unpag., illus.

Illustrated filmography. Introduction by Jack Kerouac. SECOND EDITION, rev. and enl. (New York: Grossman Publishers, 1969), 189 p., illus. FRENCH EDITION (1958).

N569. **Frank, Robert.** LETTER FROM NEW YORK. *Creative Camera* 60 (June 1969): 202; 61 (July 1969): 234–35; 62 (Aug. 1969): 390; 65 (Nov. 1969): 376–77; 66 (Dec. 1969): 414.

A series of letters written to Bill Jay, revealing his views on New York, films, painting, and life.

N570. **Frank, Robert.** THE LINES OF MY HAND. New York: Lustrum Press, 1972. 119 p., illus.

A visual autobiography. Includes the early photographs made in Switzerland, in New York in the late 1940s, and in Peru, plus heretofore unpublished photographs of Paris, Spain, and America in the 1950s, and stills from Frank's films.

N571. **Frank, Robert.** ROBERT FRANK. Millerton, N.Y.: Aperture, 1976. 96 p., illus.

Appreciation by Rudolph Wurlitzer. Chronology; selected bibliography; list of exhibitions and films.

N572. **Frank, Robert.** A STATEMENT. *U.S. Camera Annual* 19 (1958): 115.

REPRINTED in *Photographers on Photography* [N50, p. 66–67].

FREEDMAN, JILL

N573. **Freedman, Jill.** OLD NEWS: RESURRECTION CITY. New York: Grossman Publishers, 1970. 138 p., illus.

"I knew I had to shoot the Poor Peoples Campaign when they murdered Martin Luther King, Jr. . . . Another march on Washington. Another army camping . . . Always have been poor people . . . Nothing protects the innocent." Some text, but the book is chiefly illustrations of blacks, young and old, hopeful and weary, and whites—in confrontation. Journalistic images.

FRIEDLANDER, LEE 1934—

N574. **Friedlander, Lee.** THE AMERICAN MONUMENT. New York: Eakins Press Foundation, 1976. unpag., illus.

An oversized (12 x 17 in.) album of reproductions of photographs of civic statuary and sculptured memorials. An essay by Leslie Katz appears at the end of the book.

N575. **Friedlander, Lee.** SELF PORTRAIT. New City, N.Y.: Haywire Press, 1970. 86 p., illus.

One-page foreword by the author; forty-two illustrations.

N576. **Friedlander, Lee, and Dine, Jim.** WORK FROM THE SAME HOUSE. London: Trigram Press, 1969. upag. illus.

Includes sixteen photographs and sixteen etchings.

N577. **Soby, James Thrall.** LEE FRIEDLANDER. *Art in America* 48 (summer 1960): 67–68, illus.

An interesting early review of Lee Friedlander's series on New Orleans jazz musicians.

GAGLIANI, OLIVER 1917—

N578. OLIVER GAGLIANI. Menlo Park, Calif.: Ideograph Publications, 1974. 108 p., illus.

A collection of work by the California photographer. Introductions by Van Deren Coke and Leland Rice. Afterword by Jack Welpott. Sixty-two plates; chronology.

GARDNER, ALEXANDER 1821–1882

N579. **Cobb, Josephine.** ALEXANDER GARDNER. *Image* 7 (June 1958): 124–36.

The most complete biography yet published, with details on Gardner's business relationship with Mathew B. Brady.

N580. **Gardner, Alexander.** GARDNER'S PHOTOGRAPHIC SKETCH BOOK OF THE WAR. Washington, D.C.: Philip & Solomons, 1865–1866. 2 vols., illus.

The book includes one hundred mounted original photographs—by Gardner and other Civil War photographers—with text on facing pages. REPRINTED in one volume (New York: Dover Publications, 1959).

N581. **Newhall, Beaumont, and Newhall, Nancy.** ALEXANDER GARDNER. In: NEWHALL, BEAUMONT, AND NEWHALL, NANCY. MASTERS OF PHOTOGRAPHY. New York: George Braziller, 1958. p. 38–45. illus.

[*See* N356.]

GARNETT, WILLIAM A. 1916—

N582. **Owings, Nathaniel Alexander.** THE AMERICAN AESTHETIC. PHOTOGRAPHS BY WILLIAM GARNETT. New York: Harper & Row, 1969. 198 p., illus. (color).

Superb aerial photographs of the American land and cities in a book devoted to architecture and planning. Introduction by S. Dillon Ripley.

GENTHE, ARNOLD 1869–1942

N583. **Genthe, Arnold.** AS I REMEMBER. New York: Reynal & Hitchcock, 1936. 290 p., illus.

An autobiography, with 112 plates included.

N584. **Genthe, Arnold.** THE BOOK OF THE DANCE. New York: Mitchell Kennerley, 1916. 229 p., illus.

Foreword by Shaemas O'Sheel.

N585. **Genthe, Arnold.** ISADORA DUNCAN: TWENTY-FOUR STUDIES. New York and London: Mitchell Kennerley, 1929. unpag., illus.

There are twenty-four photographs. Foreword by Max Eastman.

N586. **Irwin, Will.** PICTURES OF OLD CHINATOWN. PHOTOGRAPHS BY ARNOLD GENTHE. New York: Moffat, Yard & Co., 1908. 57 p., illus.

Documentary photographs of the Chinese quarter of San Francisco before its destruction by the earthquake and fire of 1906. In the foreword, Irwin addresses Genthe, "You, who found art in the snap shot . . . were . . . the

sole recorder of old Chinatown. I but write as a frame for your pictures; I am illustrating you."

N587. New York. **Staten Island Museum. The James F. Curr Collection.** ARNOLD GENTHE, 1869–1942: PHOTOGRAPHS AND MEMORABILIA. Staten Island, 1975.

Exhibition.

Includes the essays, "A Review of His Life and Word," by Jerry E. Patterson, and "As I Remember Arnold Genthe," by Dorothy Wilcock Neumeyer.

GIBSON, RALPH 1939—

N588. **Gibson, Ralph.** DAYS AT SEA. New York: Lustrum Press, 1974. unpag., illus.

This volume includes thirty-four plates; no text.

N589. **Gibson, Ralph.** DÉJÀ-VU. New York: Lustrum Press, 1973. unpag., illus.

There are forty-five photographs included in this volume.

N590. **Gibson, Ralph.** THE SOMNAMBULIST. New York: Lustrum Press, 1970. unpag., illus.

There are forty-six photographs included in this volume.

GILPIN, LAURA 1891—

N591. **Gilpin, Laura.** THE ENDURING NAVAHO. Austin, Tex.: University of Texas Press, 1968. 263 p., illus. (color).

N592. **Gilpin, Laura.** PORTRAITURE. In: MORGAN, WILLARD D., AND LESTER, HENRY M. GRAPHIC GRAFLEX PHOTOGRAPHY. New York: Morgan & Lester, 1952. p. 145–153.

REISSUED (Hastings-on-Hudson, N.Y.: Morgan & Morgan, 1971).

N593. **Gilpin, Laura.** THE PUEBLOS: A CAMERA CHRONICLE. New York: Hastings House, 1941. 124 p., illus.

N594. **Gilpin, Laura.** THE RIO GRANDE, RIVER OF DESTINY: AN INTERPRETATION OF THE RIVER, THE LAND, AND THE PEOPLE. New York: Duell, Sloan & Pearce, 1949. 243 p., illus.

N595. **Gilpin, Laura.** TEMPLES IN YUCATAN: A CAMERA CHRONICLE OF CHICHÉN ITZÁ. New York: Hastings House, 1948. 124 p., illus.

The volume includes an essay; descriptive captions correspond to the plates. Chronology; bibliography.

GUTMANN, JOHN 1905—

N596. San Francisco. **San Francisco Museum of Modern Art.** AS I SAW IT: PHOTOGRAPHS BY JOHN GUTMANN.

ESSAY BY JOHN HUMPHREY. San Francisco, 1976. 32 p., illus.

Exhibition.

The catalog includes a chronology.

HAGEMEYER, JOHAN 1884–1962

N597. **Gile, Corinne L.** INTERVIEW WITH JOHAN HAGEMEYER. Typewritten. 1956. 107 p. Bancroft Library, University of California, Berkeley.

In 1917 Hagemeyer took up photography and became a close friend of Edward Weston, especially during the 1920s.

HALSMAN, PHILIPPE 1906—

N598. **Halsman, Philippe.** THE CANDIDATE: A PHOTOGRAPHIC INTERVIEW WITH THE HONORABLE JAMES DURANTE. New York: Simon & Schuster, 1952. 118 p., illus.

Satiric photographs by Halsman and others.

N599. **Halsman, Philippe.** DALI'S MUSTACHE: A PHOTOGRAPHIC INTERVIEW. New York: Simon & Schuster, 1954. 126 p., illus.

A highly informed confrontation.

N600. **Halsman, Philippe.** THE FRENCHMAN: A PHOTOGRAPHIC INTERVIEW. New York: Simon & Shuster, 1949. unpag., ports.

A pioneer of this once-popular photographic essay form uses twenty-four portraits in which, by facial expression, the model replies to questions asked in the caption. The model is Fernandel (Fernand Contandin), the actor. The photos were probably taken Oct. 26, 1948, and first appeared in *Life* (Dec. 27, 1948).

N601. **Halsman, Philippe.** HALSMAN ON THE CREATION OF PHOTOGRAPHIC IDEAS. New York: Ziff-Davis Publishing Co., 1961. 91 p., illus.

A stimulating approach to illustration photography.

N602. **Halsman, Philippe.** JUMP BOOK. New York: Simon & Schuster, 1959. 94 p., illus.

Celebrities jumping before the camera are caught by electronic flash.

N603. **Halsman, Philippe.** SIGHT AND INSIGHT: WORDS AND PHOTOGRAPHS. Garden City, N.Y.: Doubleday & Co., 1972. 186 p., illus.

Photographs of celebrities, largely taken for *Life* magazine, with commentary on the personalities.

HARBUTT, CHARLES 1935—

N604. **Newhall, Beaumont, and Newhall, Nancy.** CHARLES HARBUTT. In: NEWHALL, BEAUMONT, AND

Newhall, Nancy. A Collection of Photographs. New York: Aperture, 1969. p. 68, illus.

[*See* N355.]

HAWES, JOSIAH JOHNSON 1808–1901

For additional materials, *see* entries listed for Albert Sands Southworth [N819–N823], who became Hawes's partner in 1843.

N605. **Hawes, Josiah Johnson.** Stray Leaves from the Diary of the Oldest Professional Photographer in the World. *Photo Era* 16 (Feb. 1906): 104–107.

N606. **Homer, Rachel Johnston.** The Legacy of Josiah Johnson Hawes: Nineteenth-Century Photographs of Boston. Barre, Mass.: Barre Publishers, 1972. 132 p., illus.

The postdaguerreotype work of Hawes. Mainly photographs of buildings, of primary interest for the history of architecture. Bibliography.

N607. **Sobieszek, Robert A., and Appel, Odette M.** The Spirit of Fact: The Daguerreotypes of Southworth & Hawes, 1843–1862. Boston: David R. Godine; Rochester, N.Y.: International Museum of Photography at George Eastman House, 1976. 163 p., illus.

Beautiful reproductions of daguerreotypes by the Boston gallery of Albert Sands Southworth and Josiah Johnson Hawes, with a scholarly introduction and bibliography. The entire sixteen-page pamphlet, *Description of the Daguerreotype Process; Or, A Summary of M. Gouraud's Public Lectures* (Boston, 1840), is reprinted in this volume.

HAYNES, FRANK JAY

N608. **Tilden, Freeman.** Following the Frontier with F. Jay Haynes: Pioneer Photographer of the Old West. New York: Alfred A. Knopf, 1964. 406 p., illus.

A somewhat popular account of the photographic career of Haynes, who held the concession for photographing Yellowstone National Park. His photographic equipment is described and illustrated in an appendix.

HEATH, DAVID 1931—

N609. **Hagen, Charles.** Le grand album ordinaire: An Interview with David Heath. *Afterimage* 1 (Feb. 1974): 2–6, 13, illus.

This article is concerned with the slide-sound presentation as a medium, with specific reference to Heath's most recent show (*Le grand album ordinaire*) made up of thirteen "found" photographs.

N610. **Heath, Dave.** A Dialogue with Solitude. Culpeper, Va.: Community Press, 1965. unpag., illus.

A somewhat autobiographical organization of photographs, based on a slide-sound presentation. Foreword by Hugh Edwards.

HEYMAN, KEN 1930—

N611. **Carpenter, Edmund.** They Became What They Beheld. Photography by Ken Heyman. New York: Outerbridge & Dienstfrey; Ballantine Books, 1970. unpag., illus.

An anthropological study.

N612. **Mead, Margaret.** Family. Photography by Ken Heyman. New York: Macmillan Co., 1965. 208 p., illus.

International in scope, Margaret Mead's anthropological text examines the human relationships between family members, friends, and adolescents. The photographs by Ken Heyman document these human relationships.

HILLERS, JOHN K. 1843–1925

N613. **Andrews, Ralph M.** John K. Hillers. In: Andrews, Ralph M. Picture Gallery Pioneers, 1850 to 1875. Seattle: Superior Publishing Co., 1964. p. 18–23, illus.

N614. **Fowler, Don D., ed.** Photographed All the Best Scenery: Jack Hiller's Diary of the Powell Expeditions, 1871–1875. Salt Lake City: University of Utah Press, 1972. 225 p., illus.

HINE, LEWIS WICKES 1874–1940

N615. **Gutman, Judith Mara.** Lewis W. Hine and the American Social Conscience. New York: Walker & Co., 1967. 156 p., illus.

Biographical essay, with special attention to the sociological aspects of Hine's photography. Excellent, well-reproduced plate section. Detailed bibliography, including a list of articles illustrated with Hine photographs.

N616. **Gutman, Judith Mara; Capa, Cornell; Karia, Bhupendra, eds.** Lewis W. Hine, 1874–1940: Two Perspectives. New York: Grossman Publishers, 1974. 84 p., illus.
International Fund for Concerned Photography, Library of Photographers, vol. 4.

Included are a chronology; list of exhibitions and collections; bibliography.

N617. **Hine, Lewis W.** Men at Work: Photographic Studies of Modern Men and Machines. New York: Macmillan Co., 1932. 48 p., illus.

Photographs of ironworkers constructing the Empire State Building, railroad men, miners, and machinists.

N618. **Barrow, Thomas F.** Photographs by Lewis W. Hine. Rochester, N.Y.: George Eastman House, 1970. 4 p., 12 plates.

Loose plates in small folder, reproduced from photographs made from the original negatives in the collection of the International Museum of Photography at George Eastman House. "The twelve plates selected are not in-

tended to represent Hine's enormous range. They do indicate rather well the uniqueness of his seeing."

N619. **Newhall, Beaumont, and Newhall, Nancy.** LEWIS W. HINE. In: NEWHALL, BEAUMONT, AND NEWHALL, NANCY. A COLLECTION OF PHOTOGRAPHS. New York: Aperture, 1969. p. 14–15, illus.

[*See* N355].

HOYNINGEN-HUENE, GEORGE 1900–1968

N620. **Reyes, Alfonso.** MEXICAN HERITAGE. PHOTOGRAPHS BY GEORGE HOYNINGEN-HUENE. New York: J. J. Augustin Publishers, 1946. 126 p., illus.

HUFFMAN, LATON ALTON 1854–1931

N621. **Brown, Mark H., and Felton, W. R.** THE FRONTIER YEARS: L. A. HUFFMAN, PHOTOGRAPHER OF THE PLAINS. New York: Bramhall House, 1955. 272 p., illus.

[*See also* N621a.]

N621a. **Brown, Mark H., and Felton, W. R.** BEFORE BARBED WIRE: L. A. HUFFMAN, PHOTOGRAPHER ON HORSEBACK. New York: Bramhall House, 1956. 256 p., illus.

Both this and the previous volume contain bibliographies and notes on the plates, which supplement the narrative.

JACKSON, WILLIAM HENRY 1843–1942

N622. **Andrews, Ralph W.** WILLIAM HENRY JACKSON. In: ANDREWS, RALPH W. PICTURE GALLERY PIONEERS, 1850 TO 1875. Seattle: Superior Publishing Co., 1964. p. 25–36, illus.

[*See* N162.]

N623. **Forsee, Aylesa.** WILLIAM HENRY JACKSON: PIONEER PHOTOGRAPHER OF THE WEST. PHOTOGRAPHS BY WILLIAM HENRY JACKSON. New York: Viking Press, 1964. 205 p., illus.

A popular, well-written narrative of Jackson's photographic career. Also illustrated with drawings by Douglas Gorsline.

N624. **Jackson, Clarence S.** PICTURE MAKERS OF THE OLD WEST: WILLIAM H. JACKSON. New York and London: Charles Scribner's Sons, 1947. 308 p., illus.

A biography of the pioneer frontier and expeditionary photographer by his son. Reproductions of Jackson's drawings and paintings are included along with photographs. No documentation is offered.

N625. **Jackson, William Henry, and Driggs, Howard R.** THE PIONEER PHOTOGRAPHER: ROCKY MOUNTAIN ADVENTURES WITH A CAMERA. Yonkers-on-Hudson, N.Y.: World Book Co., 1929. 314 p., illus.

A narrative of Jackson's travels in the West, with inferior reproductions of a selection of his photographs.

N626. **Jackson, William Henry.** TIME EXPOSURE. New York: Cooper Square Publishers, 1970. 341 p., illus.

Unabridged reprint of the ORIGINAL EDITION (1940). This is an informal, lively narrative. While the reproductions of Jackson's photographs are inadequate both in quantity and quality, and both bibliography and index are lacking, the work is nonetheless indispensable. (The subtitle of the work states that it is "profusely illustrated with photographs, paintings, and drawings by the author.")

N627. **Jackson, William Henry.** NEGATIVES. State Historical Society of Colorado, Denver; Library of Congress, Washington, D.C.

All of Jackson's negatives, with the exception of some produced for the United States Geological Survey (and now held by the Survey) were acquired by the Detroit Publishing Co. They were sold to Henry Ford, and stored at the Edison Institute in Dearborn, Mich., until all negatives of areas west of the Mississippi were deposited in the State Historical Society of Colorado, Denver, and all of areas east of the Mississippi were deposited in the Library of Congress, Washington, D.C.

N628. **Naef, Weston J.** WILLIAM HENRY JACKSON. In: BUFFALO, N.Y. ALBRIGHT-KNOX ART GALLERY, THE BUFFALO FINE ARTS ACADEMY. ERA OF EXPLORATION: THE RISE OF LANDSCAPE PHOTOGRAPHY IN THE AMERICAN WEST, 1860–1885. Buffalo, 1975. p. 219–50, illus.

Exhibition: Also shown at The Metropolitan Museum of Art, New York, 1975.

[*See* N160.]

N629. **Newhall, Beaumont, and Edkins, Diana E.** WILLIAM H. JACKSON. Dobbs Ferry, N.Y.: Morgan & Morgan; Fort Worth, Tex.: Amon Carter Museum of Western Art, 1974. 158 p., illus.

Essentially an album of 104 excellent reproductions of photographs by William Henry Jackson or photographs in the collection he formed for the Detroit Publishing Co. [*see* N627]. Detailed chronology compiled from Jackson's extensive writings; bibliography. Critical essay by William L. Broecker.

JACOBI, LOTTE 1896—

N630. Essen, West Germany. **Museum Folkwang.** MENSCHEN VON GESTERN UND HEUTE: FOTOGRAFISCHE PORTRAITS, SKIZZEN UND DOKUMENTATIONEN VON LOTTE JACOBI. Essen, 1974. 45 p., illus.

Exhibition.

Foreword entitled "Lotte Jacobi oder die kritische Unschuld."

JOHNSTON, FRANCES BENJAMIN 1864–1952

N631. **Daniel, Pete, and Smock, Raymond.** A TALENT FOR DETAIL: THE PHOTOGRAPHS OF MISS FRANCES BENJAMIN JOHNSTON, 1889–1910. New York: Harmony Books, 1974. 182 p., illus.

A brief biography plus reproduction of 122 photographs in the Library of Congress of the photojournalistic and documentary work of this prolific photographer. Includes records of factory workers, schoolrooms (especially in black institutions), rural black families, news events, and portraits of famous people.

N632. New York. **The Museum of Modern Art.** THE HAMPTON ALBUM. INTRODUCTION BY LINCOLN KIRSTEIN. PHOTOGRAPHS BY FRANCES BENJAMIN JOHNSTON. New York, 1966. 56 p., illus.

Exhibition.

"These photographs, originally made for the Paris Exposition of 1900 . . . as part of an exhibition demonstrating contemporary life of the American Negro, constitute a body of work almost inexhaustibly revealing" (Lincoln Kirstein, introduction).

N633. **Tucker, Anne.** FRANCES BENJAMIN JOHNSTON. In: TUCKER, ANNE. THE WOMAN'S EYE. New York: Alfred A. Knopf, 1973. p. 29–43, illus.

[*See* N362.]

KANAGA, CONSUELA 1894—

N634. New York. **Blue Moon Gallery.** CONSUELA KANAGA PHOTOGRAPHS: A RETROSPECTIVE. New York, 1974. 32 p., illus.

Exhibition: May 14–31, 1974. Cosponsored by the Lerner-Heller Gallery.

Includes "An Autobiographical Note," by the artist and "Concerning This Catalogue," by L. M. Saphire.

KÄSEBIER, GERTRUDE 1852–1934

N635. **Caffin, Charles Henry.** GERTRUDE KÄSEBIER AND THE ARTISTIC-COMMERCIAL PORTRAIT. In: CAFFIN, CHARLES HENRY. PHOTOGRAPHY AS A FINE ART. New York: Doubleday Page, 1901. p. 53–81, illus.

N636. **Hartmann, Sadakichi.** GERTRUDE KÄSEBIER. *Photographic Times* 32 (1900): 195–99.

A somewhat harsh criticism of the photographer.

N637. **Tucker, Anne.** GERTRUDE KÄSEBIER. In: TUCKER, ANNE. THE WOMAN'S EYE. New York: Alfred A. Knopf, 1973. p. 13–37, illus.

[*See* N362.]

KERTÉSZ, ANDRÉ 1894—

N638. **Ducrot, Nicolas, ed.** ANDRÉ KERTÉSZ: SIXTY YEARS OF PHOTOGRAPHY, 1912–1972. New York: Grossman Publishers, 1972. 224 p., illus.

Beyond the short preface, this is a picture book without text. Chronology; bibliography.

N639. **Fárová, Anna, ed.** ANDRÉ KERTÉSZ. New York: Grossman Publishers, 1966. 25 p., illus.

There are sixty-six plates, and the volume includes Kertész's notes on some of his photographs. Biography; bibliography. Introduction by Anna Fárová. AMERICAN EDITION adapted by Robert Sagalyn.

N640. **Ducrot, Nicolas, ed.** DISTORTIONS. PHOTOGRAPHS BY ANDRÉ KERTÉSZ. New York: Alfred A. Knopf, 1976. unpag., illus.

Includes 126 photographs of nude models as reflected in a distorting mirror, taken in Paris in the 1930s.

N640a. **Ducrot, Nicolas, ed.** J'AIME PARIS: PHOTOGRAPHS SINCE THE TWENTIES. New York: Grossman Publishers, 1974. 224 p., illus.

The title is misleading inasmuch as almost all of the photographs were taken in the decade 1920–1929. A book of plates.

N640b. **Kertész, André.** ON READING. New York: Grossman Publishers, 1971. 68 p., illus.

Includes illustrations of people reading books, magazines, and newspapers, in a variety of situations.

N640c. **Kertész, André.** WASHINGTON SQUARE. New York: Grossman Publishers, 1975. 96 p., illus.

There are 103 plates, with an appreciation by Brendan Gill.

N641. **Newhall, Beaumont, and Newhall, Nancy.** ANDRÉ KERTÉSZ. In: NEWHALL, BEAUMONT, AND NEWHALL, NANCY. A COLLECTION OF PHOTOGRAPHS. New York: Aperture, 1969. p. 56–57, illus.

[*See* N355.]

N642. **Szarkowski, John.** A. KERTÉSZ, PHOTOGRAPHER. New York: Museum of Modern Art, 1964. 64 p., illus.

Introduction by John Szarkowski. Chronology; bibliography.

KINSEY, DARIUS 1869–1945

N643. **Andrews, Ralph W.** THIS WAS LOGGING! SELECTED PHOTOGRAPHS OF DARIUS KINSEY. Seattle: Superior Publishing Co., 1954. illus.

N644. **Kinsey, Darius, and Kinsey, Tabitha.** KINSEY PHOTOGRAPHER: A HALF CENTURY OF NEGATIVES. San Francisco: Scrimshaw Press, 1975. 2 vols., illus.

A lavishly illustrated work. Vol. 1: The Family Album and Other Early Work; vol. 2: The Magnificent Years. A superb documentation of lumbering in the Pacific Northwest. With contributions by the son, Darius, Jr., and the daughter, Dorothea. Edited by Dave Bohn and Rudolfo Petschek.

KRIMS, LESLIE 1943—

N645. **Krims, Les.** EIGHT PHOTOGRAPHS. Garden City, N.Y.: Doubleday & Co., 1970. [*cont.*]

According to the introduction by A. D. Coleman, Krims is the "most durable comic photographer around and, at the same time, profound enough to scare the living hell out of me." Eight unbound reproductions in a box, with a one-page text and illustrated table of contents.

N646. LES KRIMS: CAN I TAKE YOUR PHOTOGRAPH? *Afterimage* 1 (Nov. 1972): 2–49, illus.

A perceptive interview, revealing Krims's attitude toward the subject.

LABROT, SYL 1929—

N647. **Labrot, Syl.** WORK IN PROGRESS. *Afterimage* 2 (Sept. 1974): 7–10, illus. (color).

Excerpts from a forthcoming book. Includes a two-page color montage.

N648. **Lyons, Nathan; Labrot, Syl; and Chappell, Walter.** UNDER THE SUN: THE ABSTRACT ART OF CAMERA VISION. New York: George Braziller, 1960. 22 p., illus. (color).

The volume includes five color plates and seven black-and-white photographs by Syl Labrot, in addition to a statement by Labrot.

N649. **Newhall, Beaumont, and Newhall, Nancy.** SYL LABROT. In: NEWHALL, BEAUMONT, AND NEWHALL, NANCY. A COLLECTION OF PHOTOGRAPHS. New York: Aperture, 1969. 72 p., illus. (color).

[*See* N355.]

LANGE, DOROTHEA 1895–1965

N650. **Dixon, Daniel.** DOROTHEA LANGE. *Modern Photography* 16 (Dec. 1952): 68, 77, 138–41, illus.

N651. **Lange, Dorothea, and Dixon, Daniel.** PHOTOGRAPHING THE FAMILIAR. *Aperture* 1 (1952): 4–15.

REPRINTED in *Photographers on Photography* [N50, p. 68–72].

N652. **Lange, Dorothea, and Taylor, Paul Schuster.** AN AMERICAN EXODUS: A RECORD OF HUMAN EROSION IN THE THIRTIES. New Haven and London: Yale University Press; for the Oakland Museum, 1969. 148 p., illus.

A new, redesigned edition of the author's classic 1939 book, documenting problems of agricultural workers during the Depression, with photographs and quotations. Includes a new introduction by Paul Schuster Taylor.

N653. **Newhall, Beaumont.** DOROTHEA LANGE LOOKS AT THE AMERICAN COUNTRY WOMAN. PHOTOGRAPHS BY DOROTHEA LANGE. Fort Worth, Tex.: Amon Carter Museum of Western Art; Los Angeles: Ward Ritchie Press, 1967. 72 p., illus.

A photographic essay by Dorothea Lange with a commentary by Beaumont Newhall. Based on an exhibition shown by the United States Information Agency in Italy and France in 1960. This collection consists of photographs of fifteen rural women and their homes. The photographs were taken for the Farm Security Administration. For two of the subjects, a "typical field documentation" from FSA files is given.

N654. **Lange, Dorothea, and Mitchell, Margaretta K.** TO A CABIN. New York: Grossman Publishers, 1973. 128 p., illus.

Family photographs of life in a summer cabin by Dorothea Lange, posthumously edited by a friend. This volume is of personal rather than universal interest.

N655. **Lorentz, Pare.** DOROTHEA LANGE, CAMERA WITH A PURPOSE. *U.S. Camera* 1 (1941): 93–98, illus.

N656. New York. **The Museum of Modern Art.** DOROTHEA LANGE. INTRODUCTORY ESSAY BY GEORGE P. ELLIOTT. New York, 1966. 112 p., illus.
Exhibition.

Chronology; selected bibliography.

N657. **Newhall, Beaumont, and Newhall, Nancy.** DOROTHEA LANGE. In: NEWHALL, BEAUMONT, AND NEWHALL, NANCY. A COLLECTION OF PHOTOGRAPHS. New York: Aperture, 1969. p. 42–43, illus.

[*See* N355.]

N658. **Newhall, Beaumont, and Newhall, Nancy.** DOROTHEA LANGE. In: NEWHALL, BEAUMONT, AND NEWHALL, NANCY. MASTERS OF PHOTOGRAPHY. New York: George Braziller, 1958. p. 140–49, illus.

[*See* N356.]

N659. **Tucker, Anne.** DOROTHEA LANGE. In: TUCKER, ANNE. THE WOMAN'S EYE. New York: Alfred A. Knopf, 1973. p. 61–75, illus.

[*See* N362.]

N660. **Riess, Suzanne B.** INTERVIEW WITH DOROTHEA LANGE. Transcription, 1968. 257 p. Bancroft Library, University of California, Berkeley.

Review of Lange's photographic career, with special emphasis on the Farm Security Administration photographic project. *Addenda:* memorial service and obituaries.

N661. Oakland, Calif. **The Oakland Museum.** THE PHOTOGRAPHIC COLLECTION OF DOROTHEA LANGE.

Dorothea Lange's photographic estate was donated by her husband, Paul Schuster Taylor, to The Oakland Museum. Her negatives made for the Farm Security Administration are in the Library of Congress, Washington, D.C.

LAUGHLIN, CLARENCE JOHN 1905—

N662. **Laughlin, Clarence John.** GHOSTS ALONG THE

MISSISSIPPI: AN ESSAY IN THE POETIC INTERPRETA-
TION OF LOUISIANA'S PLANTATION ARCHITECTURE.
New York and London: Charles Scribner's Sons, 1948.
22 p., illus.

Each of the one hundred photographs is accompanied by
text. Many photographs are double exposures in the sur-
realist style of the photographer.

N663. **Laughlin, Clarence John.** THE PERSONAL EYE.
Millerton, N.Y.: Aperture, 1973. 132 p., illus.

The reproductions are followed by extensive notes on
each photograph by Laughlin. Chronology; list of exhibi-
tions; bibliography. ALSO PUBLISHED in *Aperture* 17: 3–4
(1971) and as a catalog for the Laughlin exhibition at the
Philadelphia Museum of Art, Nov. 1973–Jan. 1974. The
introduction is by Jonathan Williams, the text by
Lafcadio Hearn, and the captions are by the photogra-
pher.

N664. **Smith, Henry Holmes.** AN ACCESS OF AMERICAN
SENSIBILITY: THE PHOTOGRAPHS OF CLARENCE JOHN
LAUGHLIN. *Exposure* 11 (Nov. 1973): 4–5.

An interpretation of Laughlin's imagery. "Preprint of
article in author's forthcoming *On Photography*" (B. New-
hall). *Exposure* is published by The Society of Photo-
graphic Education.

LEE, RUSSELL 1903—

N665. Austin. **University of Texas, University Art Mu-
seum.** RUSSELL LEE, RETROSPECTIVE EXHIBITION
1934-64. INTRODUCTION BY MARIAN DAVIS. Austin,
1965. 16 p., illus.

Exhibition: Feb. 28–Mar. 29, 1965.

Contains an autobiography. Comment by Barbara
Morgan. Photos show Farm Security Administration,
1936–1943; Air Transport Command, 1943–1945 (text by
Pare Lorentz); Federal Coal Mines Administration,
1946–1947; industrial photography, 1947–1964; images
of Italy, 1960; and journalistic photography, 1947–1964.
Epilogue by Russell Lee.

N666. **Hurley, F. Jack.** RUSSELL LEE. *Image* 16 (Sept.
1973): 1–32, illus.

An excellent essay, with bibliographic notes. The twenty-
five illustrations include reproductions on front and back
covers.

N667. **Lee, Russell.** IMAGE OF ITALY. *Texas Quarterly* 4
(summer 1961): 260 p., illus.

Special number edited by William Arrowsmith with 146
photographs by Russell Lee.

N668. Memphis, Tenn. **Memphis State University, Oral
History Research Project.** INTERVIEW WITH RUSSELL
LEE BY F. JACK HURLEY. 1973. Memphis State Univer-
sity, Mississippi Valley Collection.

There are nine taped interviews for the Oral History Re-
search Program recorded in Austin, Texas. This is a

detailed, 5-1/2 hour tape, recounting his life, work with
the Farm Security Administration photographic project,
World War II, and teaching at the universities of Missouri
and Texas.

LERNER, NATHAN

N669. Chicago. **Allan Frumkin Gallery.** NATHAN
LERNER: CHICAGO, THE NEW BAUHAUS: 1935–1945.
Chicago, 1976. unpag., illus.

Exhibition and sales catalog.

Essay by Gyorgy Kepes, "Nathan Lerner, Photographer."

LEVI, HANS

N670. **Levi, Hans.** STREET JESUS. San Francisco: Scrim-
shaw Press, 1972. unpag., illus.

"A story of Christian revolution in Berkeley, told in six-
ty-two pictures." Preface by the author. Statement by
Roberto, "one of the street people."

LEVITT, HELEN 1913—

N671. **Levitt, Helen.** A WAY OF SEEING: PHOTOGRAPHS
OF NEW YORK. New York: Viking Press, 1965. 78 p., il-
lus.

Essay by James Agee. Volume includes fifty plates.

N672. **Newhall, Beaumont, and Newhall, Nancy.**
HELEN LEVITT. In: NEWHALL, BEAUMONT, AND NEW-
HALL, NANCY. A COLLECTION OF PHOTOGRAPHS. New
York: Aperture, 1969. p. 46–47, illus.

[*See* N355.]

LYON, DANNY 1942—

N673. **Lyon, Danny.** THE BIKERIDERS. New York: Mac-
millan Co., 1968. 94 p., illus.

"The material in this book was collected between 1963
and 1967 in an attempt to record and glorify the life of
the American bikerider."

N674. **Lyon, Danny.** CONVERSATIONS WITH THE DEAD:
PHOTOGRAPHS OF PRISON LIFE WITH THE LETTERS
AND DRAWINGS OF BILLY MCCUNE 122054. New
York: Holt, Rinehart & Winston, 1969. 196 p., illus.
(color).

Photographs of convict life in Texas, taken over a period
of fourteen months, beginning in late 1967.

N675. **Lyon, Danny.** THE DESTRUCTION OF LOWER
MANHATTAN. New York: Macmillan Co., 1969. 148 p.,
illus.

Photographic documentation of the demolition of nine-
teenth-century buildings in New York City.

N676. Newport Beach, Calif. **Newport Harbor Art
Museum.** DANNY LYON: TEN YEARS OF PHOTO-

GRAPHS. Newport Beach, 1973. 37 p., illus. (color).
Exhibition: Apr. 17–June 3, 1973.

Chronology; bibliography. Includes eighteen illustrations.

LYONS, NATHAN 1930—

N677. **Lyons, Nathan.** NOTATIONS IN PASSING: VISUALIZED BY NATHAN LYONS. Cambridge, Mass.: M.I.T. Press; with Light Impressions Corporation, 1974. 121 p., illus.

An exhibition catalog with the same title has also been published. No text.

N678. **Lyons, Nathan; Labrot, Syl; and Chappell, Walter.** UNDER THE SUN: THE ABSTRACT ART OF CAMERA VISION. New York: George Braziller, 1960. 22 p., illus. (color).

The volume includes twelve black-and-white photographs by Nathan Lyons with a statement.

N679. Ottawa. **National Gallery of Canada.** NOTATIONS IN PASSING: PHOTOGRAPHS BY NATHAN LYONS. Ottawa, 1971. 28 p., illus.
Exhibition.

Text in English and French; statement by the artist; chronology; list of exhibitions; and bibliography.

MC DARRAH, FRED W. 1926—

N680. **Cummings, Paul.** INTERVIEW WITH FRED W. MCDARRAH. Transcription. 1970. 75 p. Archives of American Art, Smithsonian Institution, Washington, D.C.

Biographical, educational, and vocational data. Emphasis on Greenwich Village and the work of this photojournalist and picture editor for *The Village Voice.*

N681. **McDarrah, Fred W.** THE ARTIST'S WORLD IN PICTURES. New York: E. P. Dutton & Co., 1961.

A record of the New York scene reported by this photojournalist, later picture editor of *The Village Voice* (New York).

MAN RAY 1890–1976

N682. **Gruber, L. Fritz, ed.** MAN RAY PORTRAITS. Gütersloh, West Germany: Sigbert Mohn Verlag, 1963. 15 p., illus.

Introduction by L. Fritz Gruber. The volume also includes a statement and captions by Man Ray for this collection of his portrait photographs.

N683. **Man Ray.** SELF PORTRAIT. Boston and Toronto: Little, Brown & Co., 1963. 400 p., illus.

A loosely written, anecdotal autobiography.

N684. Milwaukee, Wis. **Milwaukee Art Center. Arnold**
H. Crane Collection. MAN RAY: PHOTO GRAPHICS. FOREWORD BY ARNOLD CRANE. Milwaukee, 1973. unpag., illus.
Exhibition: Feb. 10–Mar. 11, 1973.

An exhibition catalog with twenty-one illustrations. Chronology; bibliography. The exhibition was assembled from the large collection of Arnold Crane of Chicago, for which there is no published catalog.

N685. **Newhall, Beaumont, and Newhall, Nancy.** MAN RAY. In: NEWHALL, BEAUMONT, AND NEWHALL, NANCY. A COLLECTION OF PHOTOGRAPHS. New York: Aperture, 1969. p. 30–31, illus.
[*See* N355.]

N686. Milan. **Galleria Schwarz.** MAN RAY: SIXTY YEARS OF LIBERTIES. CATALOG BY ARTURO SCHWARZ. Milan, 1971. 156 p., illus. (color).
Exhibition.

"Catalog for the retrospective [exhibition], with 225 works (1912–1971): paintings, watercolors, drawings, collages, objects, Rayographs, photographs, and numbered editions." Extracts in Italian, French, and English from articles and books by Man Ray and others of his surrealist colleagues. Extensive chronology and bibliography.

N687. **Soby, James Thrall.** PHOTOGRAPHS BY MAN RAY, PARIS 1920–1934. Hartford, Conn.: By the author, 1934. illus.

A well-reproduced collection of 104 photographs by Man Ray, formerly in the collection of James Thrall Soby and now in The Museum of Modern Art, New York. The volume includes short texts by Man Ray, Paul Eluard, André Breton, Rose Sélavy (pseudonym of Marcel Duchamp), and Tristan Tzara, in original French with English translation. Spiral bound. REPRINTED (New York: East River Press, 1976).

N688. **Jones, John.** INTERVIEW WITH MAN RAY. Transcription. 1965. 9 p. Archives of American Art, Smithsonian Institution, Washington, D.C.

General discussion of Man Ray's artistic career, with passages on photography and film.

MEATYARD, RALPH EUGENE 1925–1972

N689. **Hall, James Baker, ed.** RALPH EUGENE MEATYARD: REMINISCENCES BY GUY DAVENPORT. Millerton, N.Y.: Aperture, 1974. 141 p., illus.

A collection of photographs with a short foreword. Chronology, bibliography.

N690. **Meatyard, Ralph Eugene.** THE FAMILY ALBUM OF LUCYBELLE CRATER. Jargon Society, 1974. 84 p., illus.

Photographic sequence of two models wearing masks; the text is related to the sixty-four pictures. Texts by Jonathan Green, Ronald Johnson, Ralph Eugene Meatyard, Guy Mendes, Thomas Meyer, and Jonathan Williams.

N691. **Meatyard, Ralph Eugene.** PORTFOLIO THREE: THE WORK OF RALPH EUGENE MEATYARD. Louisville, Ky.: Center for Photographic Studies, 1974. illus.

Edition limited to one hundred copies for general sale and thirty proof copies for friends and associates of the center. Announcement (folding) includes ten illustrations with a statement by Van Deren Coke: "He pushed to an extreme the camera's ability to suspend time and capture the quality and uneasy dimensions of unbound 'reality.' "

MICHALS, DUANE 1932—

N692. **Michals, Duane.** THE JOURNEY OF THE SPIRIT AFTER DEATH. New York: Winter House, 1971. unpag., illus.

Includes twenty-seven photographs.

N693. **Michals, Duane.** SEQUENCES. Garden City, N.Y.: Doubleday, 1970. unpag., illus.

Includes ninety-five photographs.

N694. **Michals, Duane.** THINGS ARE QUEER. Cologne, West Germany: Ann & Jurgen Wilde, 1972. unpag., illus.

Includes nine photographs.

N695. **Michals, Duane.** TAKE ONE AND SEE MT. FUJI-YAMA AND OTHER STORIES. New York: By the author, 1976. unpag., illus.

Contains four narrative sequences of images with handwritten captions.

N696. **Ratcliff, Carter.** DUANE MICHALS. *Print Collector's Newsletter* 6 (Sept.–Oct. 1975): 93–96, illus.

The eight-image sequence "Fallen Angel" is reproduced.

MINICK, ROGER

N697. **Minick, Bob.** THE HILLS OF HOME: THE RURAL OZARKS OF ARKANSAS. PHOTOGRAPHS BY ROGER MINICK. San Francisco: Scrimshaw Press, 1975. 164 p., illus.

A documentary study, with illustrated text and eighty photographs. Photographs by Roger Minick, text by Bob Minick, and drawings and etchings by Leonard Sussman.

MOHOLY-NAGY, LÁSZLÓ 1895–1946

N698. Claremont, Calif. **Pomona College. William Larson Collection.** PHOTOGRAPHS OF MOHOLY-NAGY. CATALOG BY LELAND D. RICE AND DAVID W. STEADMAN. Claremont, 1975. 64 p., illus.

Exhibition: Apr. 4–May 8, 1975. Also shown at the Galleries of the Claremont Colleges (Pomona and Scripps), Apr. 4–May 8; San Francisco Museum of Art, July 8–Aug. 24; and the University of New Mexico Art Museum, Sept. 28–Nov. 2, 1975.

The illustrations contain many hitherto unpublished photographs and photograms. Essays by Lloyd C. Engelbrecht on Moholy-Nagy ("perfecting the eye by means of photography"), and by Henry H. Smith (Moholy-Nagy's "contribution to photography in the United States"). Bibliography.

N699. **Kostelanetz, Richard, ed.** MOHOLY-NAGY. New York and Washington, D.C.: Praeger Publishers, 1970. 238 p., illus. (color).

An anthology of writings by and about Moholy-Nagy, with chronology and extensive bibliography.

N700. **Moholy-Nagy, László.** FROM PIGMENT TO LIGHT. *Telehor* 1 (1936): 32–36.

A definition of the plastic possibilities of the photographic process. REPRINTED in *Photographers on Photography* [N50, p. 73–80].

N701. **Moholy-Nagy, László.** THE FUTURE OF THE PHOTOGRAPHIC PROCESS. *Transition* 15 (Feb. 1929): 289–93, illus.

An important early statement, translated from the German. The plates include a photogram, a photograph, and two photomontages.

N702. **Moholy-Nagy, László.** THE NEW VISION; AND ABSTRACT OF AN ARTIST. New York: George Wittenborn, 1947. 92 p., illus.

Fourth edition of the work FIRST PUBLISHED (1928) as *Von Material zu Architektur* in the Bauhausbücher series. Introduction by Walter Gropius. Includes "Abstract of an Artist," a new essay described by the author as "an attempt to picture the feelings, thoughts, and efforts upon which my artistic development has been based." Brief chronology; bibliography.

N703. **Moholy-Nagy, László.** PAINTING, PHOTOGRAPHY, FILM. Cambridge, Mass.: M.I.T. Press, 1969. 150 p., illus.

Translation of *Malerei, Fotografie, Film* (1925), another influential publication of the Bauhausbucher series.

N704. **Moholy-Nagy, László.** PORTRAIT OF ETON. London: Muller, 1949. 80 p., illus.

A documentary record. Introduction by Bernard Fergusson.

N705. **Moholy-Nagy, László, and Benedetta, Mary.** THE STREET MARKETS OF LONDON. New York: Blom, 1972. 201 p., illus.

A reprint of a documentary work FIRST PUBLISHED in London (1936).

N706. **Moholy-Nagy, László.** VISION IN MOTION. Chicago: Paul Theobald, 1947. 371 p., illus.

Photography is an important part of the artist's total concept of kinetic form.

N707. **Moholy-Nagy, Sibyl.** MOHOLY-NAGY: EXPERI-

MENT IN TOTALITY. 2d ed. Cambridge, Mass., and London, England: M.I.T. Press, 1969. 259 p., illus. (color).

A moving biography by the artist's widow, with a detailed account of the founding of the Institute of Design in Chicago. Bibliography of publications by and about Moholy-Nagy in English. Introduction by Walter Gropius.

MORATH, INGE

N708. **Newhall, Beaumont, and Newhall, Nancy.** INGE MORATH. In: NEWHALL, BEAUMONT, AND NEWHALL, NANCY. A COLLECTION OF PHOTOGRAPHS. New York: Aperture, 1969. p. 70, illus.
[*See* N355.]

MORGAN, BARBARA 1900—

N709. **Morgan, Barbara, ed.** BARBARA MORGAN. Hastings-on-Hudson, N.Y.: Morgan & Morgan, 1972. 159 p., illus.

The wide range of Barbara Morgan's works is well represented in this monograph, which includes her essay, "Working Thoughts." Chronologies by William Swan include biographical data, a bibliography, lists of exhibitions, lectures, seminars, and collections containing the photographer's work. Introduction by Peter Bunnell.

N710. **Morgan, Barbara.** KINETIC DESIGN IN PHOTOGRAPHY. *Aperture* 1 (1953): 18–27, illus.

N711. **Morgan, Barbara.** MARTHA GRAHAM: SIXTEEN DANCES IN PHOTOGRAPHS. New York: Duell, Sloan & Pearce, 1941. 160 p., illus.

Remarkable photographs of the dance, lighted by the photographer, and taken in her studio.

N712. **Morgan, Barbara.** PHOTOGRAPHING THE DANCE. In: MORGAN, WILLARD D., AND LESTER, HENRY M. GRAPHIC GRAFLEX PHOTOGRAPHY. New York: Morgan & Lester, 1952. p. 217–25, illus.

Technical details are described, with specifications of lighting, but the essay concentrates the aesthetic problems and the significance of dance photography. FACSIMILE EDITION (Hastings-on-Hudson, N.Y.: Morgan & Morgan, 1971).

N713. BARBARA MORGAN. In: MORGAN, WILLARD D., AND LESTER, HENRY M. MINIATURE CAMERA WORK. New York: Morgan & Lester, 1938. p. 145–66, illus.

Historical survey of all types of photomontage: collage, multiple exposure, and multiple printing. Included in the volume are illustrations of photomontages by Barbara Morgan and others.

N714. **Morgan, Barbara.** SUMMER'S CHILDREN: A PHOTOGRAPHIC CYCLE OF LIFE AT CAMP. Scarsdale, N.Y.: Morgan & Morgan, 1951. 159 p., illus.

A record of children at summer camp. Foreword by Dr. Mary Fisher Langmuir and Helen Haskell.

N715. **Newhall, Beaumont, and Newhall, Nancy.** BARBARA MORGAN. In: NEWHALL, BEAUMONT, AND NEWHALL, NANCY. A COLLECTION OF PHOTOGRAPHS. New York: Aperture, 1969. p. 40–41, illus.
[*See* N355.]

N716. **Tucker, Anne.** BARBARA MORGAN. In: TUCKER, ANNE. THE WOMAN'S EYE. New York: Alfred A. Knopf, 1973. p. 93–107, illus.
[*See* N362.]

MORRIS, WRIGHT 1910—

N717. **Morris, Wright.** THE INHABITANTS. New York and London: Charles Scribner's Sons, 1946. 111 p., illus.

Pioneering work of fiction, integrating photographs taken by the author. [*See also* N717a and N717b.] REPRINTED (New York: Da Capo Press, 1972).

N717a. **Morris, Wright.** THE HOME PLACE. New York: Charles Scribner's Sons, 1948. 176 p., illus.

REPRINTED (Lincoln, Nebr.: University of Nebraska Press, 1968).

N717b. **Morris, Wright.** GOD'S COUNTRY AND MY PEOPLE. New York: Harper & Row, 1968. unpag., illus.

N718. Lincoln, Nebr. **University of Nebraska, Sheldon Memorial Art Gallery.** WRIGHT MORRIS: STRUCTURES AND ARTIFACTS, PHOTOGRAPHS 1933–54. Lincoln, 1975. 124 p., illus.
Exhibition.

A well-reproduced selection of photographs, most of which appeared originally in Morris's novels [N717, N717a, N717b]. Statement by Wright Morris. Interview by Jim Alinder. Chronology.

MORROW, STANLEY J. 1843–1921

N719. **Lass, William E.** STANLEY J. MORROW. *Eye to Eye* 8 (June 1956): 1–56, illus.

An excellent biography, with twenty-four illustrations by this photographer (*active* 1869–1881) of the Dakota Territory.

MORTENSEN, WILLIAM

N720. **Mortensen, William.** MONSTERS AND MADONNAS. San Francisco: Camera Craft Publishing Co., 1936. unpag., illus.

Founded by Ansel Adams and Willard Van Dyke in the early 1930s, Group f/64 rebelled largely against the work of William Mortensen. Pompous, overtheatrical, heavily made-up models were posed by Mortensen in seductive,

often semi-erotic situations. Of Mortensen's many books, this title gives the student fair sampling. REVISED EDITION by Jacques de Langre (Hollywood, Calif., 1967). REPRINTED (New York: Arno Press, 1973).

MUGNIER, GEORGE FRANÇOIS 1855–1936

N721. **Bridaham, Lester Burbank, ed.** NEW ORLEANS AND BAYOU COUNTRY: PHOTOGRAPHS 1880-1910. PHOTOGRAPHS BY GEORGE FRANÇOIS MUGNIER. Barre, Mass.: Barre Publishing Co., 1972. 127 p., illus.

An interesting series of views of cotton picking, city scenes, and housing. These photographs were taken from 1880 through 1910.

MUYBRIDGE, EADWEARD 1830–1904

N722. **Andrews, Ralph W.** EADWEARD MUYBRIDGE. In: ANDREWS, RALPH W. PICTURE GALLERY PIONEERS, 1850 TO 1875. Seattle: Superior Publishing Co., 1964. p. 68–71, illus.

The pictures show Muybridge's landscape work in California; biography included.

N723. **Haas, Robert Bartlett.** MUYBRIDGE: MAN IN MOTION. Berkeley, Los Angeles, and London: University of California Press, 1976. 207 p., illus.

A detailed biographical study based on twenty years of research by the director of Arts/Extension, University of California, Los Angeles. Haas traces the varied career of Edward James Muggeridge (who later took the name Eadweard Muybridge in the belief that it was the original Anglo-Saxon version of his name). From his beginnings in England, Muybridge's career included his early travels, West Coast photography, personal tragedy, the period in Central America, creative expansion (1878–1893), public acclaim, and retirement. Haas concludes, "Whether the photographs deal with the stillness of beauty or with unveiling the flow of movement, Muybridge has made an aesthetic gift to the world, for behind the emotionless lens was always the living photographer" (p. 203). Includes footnotes; 156 illustrations; index.

N724. **Hendricks, Gordon.** EADWEARD MUYBRIDGE: THE FATHER OF THE MOTION PICTURE. New York: Grossman Publishers, 1975. 275 p., illus.

An extremely detailed, well-documented biography. Includes a rich selection of 198 illustrations covering Muybridge's entire career. Many photographs included in this volume were not previously published. Bibliography included.

N725. **Hood, M. V. Jessup, and Haas, R. B.** EADWEARD MUYBRIDGE'S YOSEMITE VALLEY PHOTOGRAPHS. California Historical Society, *Quarterly* 42 (Mar. 1963): 5–26, illus.

N726. **MacDonnell, Kevin.** EADWEARD MUYBRIDGE: THE MAN WHO INVENTED THE MOVING PICTURE. Bos-

ton and Toronto: Little, Brown & Co., 1972. 158 p., illus.

Biographical essay, followed by reproductions of Muybridge's photographs of California and his animal locomotion series. Bibliography.

N727. **Muybridge, Eadweard.** ANIMAL LOCOMOTION: AN ELECTROPHOTOGRAPHIC INVESTIGATION OF CONSECUTIVE PHASES OF ANIMAL MOVEMENTS, 1872-1885. Philadelphia: University of Pennsylvania, 1887. 16 vols.

A classic and monumental work consisting of a series of collotype plates, sold separately, or bound with title page in eleven volumes. Vol. 1, *Males (Nude)*, was REPRINTED (New York: Da Capo Press, 1969). Muybridge REPRINTED many of the plates in reduced size in *Animals in Motion* (London: Chapman & Hall, 1899), and *The Human Figure in Motion* (London: Chapman & Hall, 1901); for recent REPRINT EDITIONS, *see* [N728 and N729].

N728. **Brown, Lewis S., ed.** ANIMALS IN MOTION. PHOTOGRAPHY BY EADWEARD MUYBRIDGE. New York: Dover Publications, 1957. 74 p., illus.

The introduction contains technical description of Muybridge's photography, and analyses of the evidence contained in the 183 photographs.

N729. **Taft, Robert, ed.** THE HUMAN FIGURE IN MOTION. PHOTOGRAPHY BY EADWEARD MUYBRIDGE. New York: Dover Publications, 1955. 17 p., illus.

Reduced reproductions of 195 selected collotype plates. Taft's essay contains detailed bibliographical notes.

N730. **Naef, Weston J.** EADWEARD J. MUYBRIDGE. In: BUFFALO, N.Y. ALBRIGHT-KNOX ART GALLERY, THE BUFFALO FINE ARTS ACADEMY. ERA OF EXPLORATION: THE RISE OF LANDSCAPE PHOTOGRAPHY IN THE AMERICAN WEST, 1860–1885. Buffalo, 1975. p. 167–200, illus.

Exhibition: Also shown at The Metropolitan Museum of Art, New York, 1975.

The illustrations and the text are mainly concerned with Muybridge's landscape work. [For additional information on the catalog as a whole, *see* N160.]

N731. **Newhall, Beaumont.** MUYBRIDGE AND THE FIRST MOTION PICTURE: THE HORSE IN THE HISTORY OF THE MOVIES. *Image* (Jan. 1956): 4–11, illus.

Included in this volume is a facsimile of a newspaper account of the first public screening of a motion picture to a paid audience, which occurred in 1880. REPRINTED in *U.S. Camera Annual 1957*, p. 235–42.

N732. **Stanford, Calif. Stanford University Museum and Art Gallery.** EADWEARD MUYBRIDGE: THE STANFORD YEARS, 1872-1882. Stanford, 1972. 136 p., illus.

Exhibition: Oct. 7–Dec. 4, 1972. Also shown at the E. B. Crocker Art Gallery, Sacramento, Dec. 16, 1972–Jan. 14, 1973; and the University Galleries, University of

Southern California, Los Angeles, Feb. 8–Mar. 11, 1973.

A scholarly, well-documented catalog. *Contents:* "Introduction," by Anita Ventura Mozley; "Eadweard Muybridge, 1830–1904," by Robert Bartlett Haas; "Photographs by Muybridge, 1872–1880"; "Catalog and Notes on the Work," by Anita Ventura Mozley; "Marey, Muybridge, and Meissonier: The Study of Movement in Science and Art," by Françoise Forster-Hahn: "Documents: Selected and Annotated," by Anita Ventura Mozley and J. Sue Porter (p. 110–33). Bibliography; extensive footnotes throughout.

N733. **Stillman, J. D. B.** THE HORSE IN MOTION AS SHOWN BY INSTANTANEOUS PHOTOGRAPHY, WITH A STUDY ON ANIMAL MECHANICS FOUNDED ON ANATOMY AND THE REVELATION OF THE CAMERA IN WHICH IS DEMONSTRATED THE THEORY OF QUADRUPEDAL LOCOMOTION. Boston: James R. Osgood; for Leland Stanford, 1882. 127 p., illus.

First publication in book form of the Muybridge animal locomotion photographs with 107 plates. Appendix describes photographic techniques.

N734. Philadelphia, Pa. **University of Pennsylvania.** ANIMAL LOCOMOTION: THE MUYBRIDGE WORK AT THE UNIVERSITY OF PENNSYLVANIA; THE METHOD AND THE RESULT. Philadelphia: J. B. Lippincott Co., 1888. 136 p., illus.

Includes essays on "The Mechanism of Instantaneous Photography," by William Dennis Marks; "Materials for a Memoir on Animal Locomotion," by Harrison Allen; "A Study of Some Normal and Abnormal Movements Photographed by Muybridge." The photographic work of Thomas Eakins is briefly discussed. The illustrations are drawn from photographs. FACSIMILE REPRINT (New York: Arno Press, 1973).

MYDANS, CARL 1907—

N735. **Mydans, Carl.** MORE THAN MEETS THE EYE. New York, 1959. 310 p.

Autobiography of a *Life* photographer. REPRINT EDITION (Westport, Conn.: Greenwood Press, 1975).

NAMUTH, HANS 1915—

N736. **Cummings, Paul.** INTERVIEW WITH HANS NAMUTH. Transcription. Aug.–Sept. 1971. 26 p. Archives of American Art, Smithsonian Institution, Washington, D.C.

This interview touches on details of Namuth's life and career. The collection of material on Namuth at the Archives of American Art also includes architectural photographs, portraits of American artists, and photographs of his work and life in New York City.

NATALI, ENRICO 1933—

N737. **Natali, Enrico.** NEW AMERICAN PEOPLE. Hast-

ings-on-Hudson, N.Y.: Morgan & Morgan, 1972. unpag., illus.

An album, with brief introduction by Hugh Edwards, the former curator of photography at The Art Institute of Chicago. Chronology; list of exhibitions and publications of Natali's photographs.

NETTLES, BEA 1946—

N738. **Tucker, Anne.** BEA NETTLES. In: TUCKER, ANNE. THE WOMAN'S EYE. New York: Alfred A. Knopf, 1973. p. 155–69, illus.
[*See* N362.]

NEWMAN, ARNOLD 1918—

N739. **McCoy, Garnett.** [ARNOLD NEWMAN PAPERS.] In: McCOY, GARNETT. ARCHIVES OF AMERICAN ART: A DIRECTORY OF RESOURCES. New York and London: R. R. Bowker Co., 1972. p. 104.

The Arnold Newman archives consist of forty-four photographs (1941–1960) presented by the photographer (portrait photos of forty-two American artists); an interview by Dorothy G. Seckler, Sept. 1964, 19 p.; and the transcription of an interview by Paul Cummings, July–Aug. 1971, 72 p.

N740. **Goldsmith, Arthur.** ARNOLD NEWMAN: THE PORTRAIT AS RECORD AND INTERPRETATION. *Popular Photography* 73 (Nov. 1973): 122, 172, 198, 201, illus.

This article is based on interviews with the photographer. Eleven of Goldsmith's portraits are reproduced with stylistic analysis of each.

N741. **Newman, Arnold.** ONE MIND'S EYE: THE PORTRAITS AND OTHER PHOTOGRAPHS OF ARNOLD NEWMAN. Boston: David R. Godine, 1974. 19 p., illus.

The 192 plates included in this volume constitute a retrospective collection of Newman's work, composed largely of portraiture. The introduction by Robert Sobieszek places Newman's "environmental" portrait style in its historical context. Chronology; extensive bibliography. Foreword by Beaumont Newhall.

NORMAN, DOROTHY 1905—

N742. New York. **Ex Libris.** DOROTHY NORMAN: PHOTOGRAPHS 1932–1956. New York, 1976. 4 p., port. *Exhibition:* Mar. 30–Apr. 30, 1976.

Biographical note. Subjects included in this exhibition: Alfred Stieglitz 1932–1936, city and country in the 1930s, and personages and presences, 1930–1956. No checklist. [For Norman's monographs on Stieglitz, *see* N843, N844.]

O'SULLIVAN, TIMOTHY H. 1840–1882

N743. **Andrews, Ralph W.** T. H. O'SULLIVAN. In: ANDREWS, RALPH W. PICTURE GALLERY PIONEERS,

1850 TO 1875. Seattle: Superior Publishing Co., 1964. p. 12–17, illus.
[*See* N152.]

N744. **Baumhofer, Hermine M.** T. H. O'SULLIVAN. *Image* 2 (Apr. 1953): 20–21.

N745. **Gardner, Alexander.** GARDNER'S PHOTOGRAPHIC SKETCH BOOK OF THE WAR. Washington, D.C.: Philip & Solomons, 1865–1866. 2 vols., illus.

The one hundred mounted original photographs by Civil War photographers in this book include works by T. H. O'Sullivan. Text is found on facing pages. REPRINTED in one volume (New York: Dover Publications, 1959).

N746. **Horan, James D.** TIMOTHY O'SULLIVAN, AMERICA'S FORGOTTON PHOTOGRAPHER: THE LIFE AND WORK OF THE BRILLIANT PHOTOGRAPHER WHOSE CAMERA RECORDED THE AMERICAN SCENE FROM THE BATTLEFIELDS OF THE CIVIL WAR TO THE FRONTIERS OF THE WEST. Garden City, N.Y.: Doubleday, 1966. 334 p., illus.

A survey of the life and work of O'Sullivan, with a historical summary on the introduction of photography to America. Bibliography.

N747. **Wood, James N.** TIMOTHY H. O'SULLIVAN. In: BUFFALO, N.Y. ALBRIGHT-KNOX ART GALLERY, THE BUFFALO FINE ARTS ACADEMY. ERA OF EXPLORATION: THE RISE OF LANDSCAPE PHOTOGRAPHY IN THE AMERICAN WEST, 1860–1885. Buffalo, 1975. p. 125–66, illus.

Exhibition: Also shown at The Metropolitan Museum of Art, New York, 1975.
[*See* N160.]

N748. **Newhall, Beaumont, and Newhall, Nancy.** T. H. O'SULLIVAN, PHOTOGRAPHER. Rochester, N.Y.: George Eastman House; with the Amon Carter Museum of Western Art, 1966. unpag., illus.

Short biographical text by Beaumont and Nancy Newhall; an appreciation by Ansel Adams; forty plates; chronology; bibliography.

N749. **Newhall, Beaumont, and Newhall, Nancy.** TIMOTHY H. O'SULLIVAN. In: NEWHALL, BEAUMONT, AND NEWHALL, NANCY. MASTERS OF PHOTOGRAPHY. New York: George Braziller, 1958. p. 38–45, illus.
[*See* N356.]

N750. **Sampson, John.** PHOTOGRAPHS FROM THE HIGH ROCKIES. *Harper's New Monthly Magazine* 39 (Sept. 1869): 465–75, illus.

Although O'Sullivan is not named, the illustrations to this article are from photographs he took on the Clarence King survey, and "the photographer" is identified as having taken views of the Civil War. The photographer's experiences on the survey are described in a style that indicates the text is based on an interview.

OUTERBRIDGE, PAUL, JR. 1896–1959

N751. **Howe, Graham.** PAUL OUTERBRIDGE, JR., 1896–1959. *Exposure* 14 (Dec. 1976): 3–7, illus.

Biographical essay with quotations from Outerbridge's notebooks. Seven photographs are reproduced.

N752. **Outerbridge, Paul, Jr.** PHOTOGRAPHING IN COLOR. New York: Random House, 1940. 204 p., illus. (color)., frontispiece (color).

An excellent technical manual for the production of transparencies and color printing by the dye-transfer process. Included in the volume are fourteen mounted color plates.

N753. **Outerbridge, Paul, Jr.** PHOTOGRAPHS BY PAUL OUTERBRIDGE, JR. *International Studio* (Apr. 1924): 63–73, illus.

This article includes a short statement by Outerbridge accompanied by thirteen photographs.

OWENS, BILL

N754. **Owens, Bill.** OUR KIND OF PEOPLE: AMERICAN GROUPS AND RITUALS. San Francisco: Straight Arrow Books; New York: Simon & Schuster, 1975. unpag., illus.

Chiefly reproductions of photographs.

N755. **Owens, Bill.** SUBURBIA. San Francisco: Straight Arrow Books, 1973. 108 p., illus.

A hard look at the manners and customs of suburban life.

PENN, IRVING 1917—

N756. **Penn, Irving.** WORLDS IN A SMALL ROOM. New York: Grossman Publishers, 1974. 95 p., illus.

Portrait photographs taken in various countries in a portable studio.

PLOWDEN, DAVID 1932—

N757. **Plowden, David.** THE HAND OF MAN ON AMERICA. Washington, D.C.: Smithsonian Institution Press, 1971. 77 p., illus.

"As a photographer, I have turned to the way I know best to express my deep distress over our appalling indifference and our misplaced priorities . . . to show on the one hand what we are capable of and on the other what we are doing" (preface). The seventy-five photographs illustrate these themes: space, the land possessed, habitat, a rage upon the land, and neglect and solitude. Text, captions, and quotations accompany the photographs of places, people, architecture, and landscape. References.

PLUMBE, JOHN, JR. 1809–1857

N758. **Fern, Alan, and Kaplan, Milton.** JOHN PLUMBE,

JR., AND THE FIRST ARCHITECTURAL PHOTOGRAPHS OF THE NATION'S CAPITAL. LIBRARY OF CONGRESS, *Quarterly Journal* 31 (Jan. 1974): 3–16, illus.

Publication of five daguerreotypes of Washington, D.C., buildings with a biographical sketch about Plumbe and details on the "plumbeotype" process of lithography. Bibliographical footnotes.

PORTER, ELIOT 1901—

N759. **Matthiessen, Peter.** THE TREE WHERE MAN WAS BORN: ELIOT PORTER—THE AFRICAN EXPERIENCE. New York: E. P. Dutton & Co., 1972. 247 p., illus. (color).

The text is by Matthiessen; the ninety-two color photographs by Porter are of African wildlife and their environment.

N760. **Newhall, Beaumont, and Newhall, Nancy.** ELIOT PORTER. In: NEWHALL, BEAUMONT, AND NEWHALL, NANCY. A COLLECTION OF PHOTOGRAPHS. New York: Aperture, 1969. p. 36–37, illus. (color).

[*See* N355.]

N761. **Porter, Eliot.** APPALACHIAN WILDERNESS: THE GREAT SMOKY MOUNTAINS. New York: E. P. Dutton & Co., 1970. 123 p., illus. (color).

Reproductions largely colorplates. SUBSEQUENT EDITION (New York: Promontory Press, 1975). Epilogue by Harry M. Caudill. Essay on "Natural and Human History," by Edward Abbey.

N762. **Krutch, Joseph Wood.** BAJA CALIFORNIA AND THE GEOGRAPHY OF HOPE. PHOTOGRAPHS BY ELIOT PORTER. San Francisco: Sierra Club, 1967. 174 p., illus. (color).

Edited by Kenneth Brower. Foreword by David Brower. Quotations from Octavio Paz.

N763. **Porter, Eliot.** BIRDS OF NORTH AMERICA: A PERSONAL SELECTION. New York: E. P. Dutton & Co., 1972. 144 p., illus. (color).

Eliot Porter achieved prominence for his contribution to ornithology in the form of spectacular and exact photographs of birds. In this volume, which includes eighty-eight plates, mostly in color, he recounts his experiences in producing a vast corpus of records which combine scientific observation with a strong sense of design.

N764. **Porter, Eliot.** FOREVER WILD: THE ADIRONDACKS. Blue Mountain Lake, N.Y.: Adirondack Museum; New York and London: Harper & Row, 1966. unpag., illus. (color).

Photographs by Eliot Porter, with captions by William Chapman White.

N765. **Porter, Eliot.** IN WILDNESS IS THE PRESERVATION OF THE WORLD. San Francisco: Sierra Club, 1962. 167 p., illus. (color).

An oversize (13-3/4 x 10-1/2 ins.) volume of seventy-two color photographs of the natural scene (largely forest). Each photograph is accompanied on its facing page with quotations from Thoreau's *Journal*. Selections and photographs by Eliot Porter. Introduction by Joseph Wood Krutch.

N766. **Porter, Eliot.** THE PLACE NO ONE KNEW: GLEN CANYON ON THE COLORADO. San Francisco: Sierra Club, 1963. 186 p., illus. (color).

An exploration of an area submerged by the building of a dam. Foreword by the volume editor, David Brower. Introduction and essay, "The Geology of Glen Canyon," by Eliot Porter. Illustrations include eighty colorplates. List of fauna and flora. Bibliography.

N767. **Porter, Eliot.** SUMMER, ISLAND: PENOBSCOT COUNTY. San Francisco: Sierra Club, 1966. 200 p., illus. (color).

A description in words and photographs of a small island off the coast of Maine which has been Porter's summer residence since childhood. Autobiographical commentary. Edited by David Brower.

RAY, MAN
See **MAN RAY**

RIIS, JACOB AUGUST 1849–1914

N768. **Alland, Alexander, Sr.** JACOB A. RIIS, PHOTOGRAPHER AND CITIZEN. Millerton, N.Y.: Aperture, 1974. 220 p., illus.

Biographical sketch followed by eighty-two plates from prints made by the author from the original 4 x 5 in. glass negatives which, at his suggestion, were donated to the Museum of the City of New York. Each plate is accompanied by excerpts from the writings of Riis and contemporary comments on his book, *The Battle with the Slums*. A definitive and moving work. Bibliography. Preface by Ansel Adams.

N769. **Cordasco, Francesco, ed.** JACOB RIIS REVISITED: POVERTY AND THE SLUM IN ANOTHER ERA. Garden City, N.Y.: Doubleday & Co., 1968. 418 p., illus.

Excerpts from books by Jacob A. Riis, with sixteen reproductions of Riis photographs. Introduction by the volume editor.

N770. **Essen, West Germany. Museum Folkwang.** JACOB A. RIIS: BEGINN EINER SOZIALKRITISCHEN FOTOGRAFIE IN DEN USA, MIT WEITEREN BILDERN VON LEWIS HINE UND ANDEREN. Essen, 1971. 84 p., illus.

Exhibition: Nov. 29, 1971–Jan. 5, 1972.

Catalog of an exhibition. Statement by Otto Steinert. *See also* Rune Hasser, *Jacob A. Riis und die soziale Dokumentation mit der Kamera: Anfang des 20. Jahrhunderts in den USA.* There are twenty-four illustrations; bibliography. The photographs exhibited are from the Rune Hasser Collection in Stockholm, and from American lenders.

N771. **Riis, Jacob A.** How the Other Half Lives: Studies Among the Tenements of New York. With Illustrations Chiefly from Photographs Taken by the Author. New York: Charles Scribner's Sons, 1890. 304 p., illus.

A classic of documentary photography. Riis's photographs are reproduced partly by line cuts from drawings made from the photographs and partly by crude and unsatisfactory halftones. SUBSEQUENT EDITION (1906). The most recent EDITION (New York: Dover Publications, 1971) contains the entire text, unabridged, and one hundred fair-quality reproductions of prints from the Museum of the City of New York.

ROBINSON, HERBERT F. *ca.* 1865–1956

N772. Santa Fe. **Museum of New Mexico. The H. F. Robinson Collection.** A Catalogue of Photographs. Compiled by Robert J. Brewer. Santa Fe, 1974. unpag., illus.

Collection catalog.

Catalog of 885 negatives (with eighteen illustrations) largely of Indian life in the Southwest, taken by an irrigation engineer in his travels.

ROSENBLUM, WALTER 1919—

N773. Cambridge, Mass. **Harvard University, Fogg Art Museum.** Walter Rosenblum Photography. Introduction by Milton W. Brown. Cambridge, 1975. 24 p., illus.

Exhibition: Mar. 7–Apr. 13, 1975.

Introduction covers biographical and critical aspects, concluding the fact that Rosenblum's "abiding passion is for humanity." The sixteen illustrations have occasional comments by Rosenblum. Chronology; "publications" (eleven personal items); exhibitions and lectures (1943–1973). Selected bibliography includes the following materials: Paul Strand, *Forty Photographs, Walter Rosenblum Exhibition* (New York: Brooklyn Museum, 1949), p. 1–2; Minor White, "Walter Rosenblum: Photographer in the Classic Tradition," *Image* (Dec. 1955): 70.

ROTHSTEIN, ARTHUR 1915—

N774. **Saroyan, William.** Look at Us, Let's See, Here We Are, Look Hard, Speak Soft, I See, You See, We All See. Stop, Look, Listen. Beholder's Eye. Don't Look Now, but Isn't That You? (Us? U.S.?) Photographs by Arthur Rothstein. New York: Cowles Educational Corp., 1967. 202 p., illus.

Text by William Saroyan on verso pages; 101 photographs by Arthur Rothstein on rectos.

RUBINSTEIN, EVA

N775. Eva Rubinstein. Dobbs Ferry, N.Y.: Morgan & Morgan, 1974. unpag., illus.

Introduction; sixty-seven plates; exhibitions list. Preface by Sean Kernan.

RUSCHA, EDWARD 1937—

N776. Minneapolis. **Minneapolis Institute of Arts.** Edward Ruscha, Young Artist: A Book Accompanying the Exhibition. Minneapolis, 1972. unpag., illus.

Exhibition.

Chiefly illustrations. Ruscha has produced a number of small brochures, without publication data. These include *Various Small Fires and Milk* (1964); *Royal Road Text* (with Mason Williams and Patrick Campbell); *Twenty-six Gasoline Stations; Colored People* (1972); and *Thirty-four Parking Lots in Los Angeles* (1967).

N777. **Ruscha, Edward.** The Strip: A Graphic Portrait of Sunset Boulevard. Los Angeles, 1966. 48 p., illus.

An accordion fold edition of numerous small pictures, intended to be viewed at maximum extension. Book designer: Robert Kennedy.

RUSSELL, ANDREW JOSEPH 1840–1902

N778. **Andrews, Ralph W.** A. J. Russell. In: Andrews, Ralph W. Picture Gallery Pioneers. Seattle: Superior Publishing Co., 1964. p. 164–67, illus.

[*See* N152.]

N779. **Combs, Barry B.** Westward to Promontory; Building the Union Pacific across the Plains and Mountains: A Pictorial Documentary. Photography by Andrew J. Russell. New York: Garland Books, 1969. 79 p., illus.

Photography as history: the building of the transcontinental railroad.

N780. **Hayden, Francis Vandeveer.** Sun Pictures of Rocky Mountain Scenery, with a Description of the Geographical and Geological Features, and Some Account of the Resources of the Great West; Containing Thirty Photographic Views Along the Line of the Pacific Railroad from Omaha to Sacramento. Original Photographic Prints by A. J. Russell. New York: Julius Bien, 1870.

N781. **Heyman, Therese Thau.** Andrew Joseph Russell. In: Buffalo, N.Y. Albright-Knox Art Gallery, The Buffalo Fine Arts Academy. Era of Exploration: The Rise of Landscape Photography in the American West, 1860–1885. Buffalo, 1975. p. 201–218, illus.

Exhibition: Also shown at The Metropolitan Museum of Art, New York, 1975.

[*See* N160.]

N782. **Pattison, W. D.** The Pacific Railroad Rediscovered. *Geographical Review* (1962): 25–36. [*cont.*]

Account of locating the Russell negatives in the American Geographical Society in New York. These negatives were subsequently presented to The Oakland Museum in California.

SAMARAS, LUCAS 1936—

N783. **Samaras, Lucas.** SAMARAS ALBUM: AUTOINTERVIEW, AUTOBIOGRAPHY, AND AUTOPOLAROID. New York: Whitney Museum of American Art; Pace Editions, 1971. 104 p., illus. (color).

From Jean Lipman's paragraph of introduction: "This book—autobiographical analysis, autophoto album, auto-interview—is a unique multimedia portrait of the artist. What he says becomes visible in his photographs, and the photographic images are implicit in his writing." Chiefly small but clear illustrations, in which the artist is the model and autoeroticism the leitmotif.

N784. Long Beach, Calif. **California State University, Long Beach Art Galleries.** LUCAS SAMARAS: PHOTO-TRANSFORMATIONS, AN EXHIBITION. ESSAY BY ARNOLD B. GLIMCHER. Long Beach, 1975. 63 p., illus. (color).

Exhibition.

Edited by Constance W. Glenn. Catalog has sixty-one plates, forty of which are in color. Chronology.

SAVAGE, CHARLES R. 1832-1909

N785. **Andrews, Ralph W.** CHARLES R. SAVAGE. In: ANDREWS, RALPH W. PICTURE GALLERY PIONEERS, 1850 TO 1875. Seattle: Superior Publishing Co., 1964. p. 152–64, illus.

[*See* N152.]

SCHAEFFER, RICHARD W.

N786. **Schaeffer, Richard W.** TURQUOISE PLEASURES, FEATURING PHOTOGRAPHS OF THE FABULOUS HOTEL-CASINOS OF LAS VEGAS. Rochester, N.Y.: Silver Screen Publishing Co., 1974. 65 p., illus.

This volume is composed chiefly of illustrations.

SCHAMBERG, MORTON 1881—1918

N787. **Coke, Van Deren.** THE CUBIST PHOTOGRAPHS OF PAUL STRAND AND MORTON SCHAMBERG. In: COKE, VAN DEREN. ONE HUNDRED YEARS OF PHOTO-GRAPHIC HISTORY: ESSAYS IN HONOR OF BEAUMONT NEWHALL. Albuquerque: University of New Mexico Press, 1975. p. 36–42, illus.

The first publication and notice of the contribution to photography by the little-known painter Morton Schamberg. Included in the essay is a reproduction of a semi-abstract photograph of roof tops (1917). [For additional annotation, *see* N849.]

SEYMOUR, DAVID ("CHIM") 1911—1956

N788. **Capa, Cornell, and Karia, Bhupendra, eds.** DAVID SEYMOUR ("CHIM"), 1911–1956. New York: Grossman Publishers, 1974. 95 p., illus. INTERNATIONAL FUND FOR CONCERNED PHOTOGRAPHY, LIBRARY OF PHOTOGRAPHERS, VOL. 3.

Statements by the photographer, Henri Cartier-Bresson, Judith Friedberg, Eileen Shneiderman, Horace Sutton, and William Richardson. Chronology; list of exhibitions; bibliography.

SHAHN, BEN 1898—1969

N789. **Weiss, Margaret R.,ed.** BEN SHAHN, PHOTOGRAPHER: AN ALBUM OF THE THIRTIES. New York: Da Capo Press, 1973. 9 p., illus.

In addition to a short introduction, this publication contains a selection of eighty-two photographs taken for the Farm Security Administration.

N790. Cambridge, Mass. **Harvard University, Fogg Art Museum.** BEN SHAHN AS PHOTOGRAPHER. INTRODUCTION BY DAVIS PRATT. Cambridge, 1969. 16 p., illus.

Exhibition: Oct. 29—Dec. 14, 1969.

List of sixty-nine exhibits; includes twelve illustrations.

SHEELER, CHARLES 1883—1965

N791. **Friedman, Martin,** CHARLES SHEELER. New York: Watson-Guptill Publications, 1975. 224 p., illus.

This work is primarily concerned with the paintings and drawings of Sheeler, but also contains important considerations of his position as a photographer. Reproduces twenty-seven photographs. Chronology; bibliography.

N792. Los Angeles, Calif. **University of California at Los Angeles, Art Galleries.** CHARLES SHEELER: A RETROSPECTIVE EXHIBITION. FOREWORD BY WILLIAM CARLOS WILLIAMS. ESSAYS BY BARTLETT H. HAYES, JR., AND FREDERICK S. WIGHT. Los Angeles, 1954. 47 p., illus. (color).

Exhibition.

Reproduces five Sheeler photographs. Chronology; bibliography.

N793. **Millard, Charles W., III.** CHARLES SHEELER, AMERICAN PHOTOGRAPHER. *Contemporary Photographer* 6 (1967): unpag., illus.

"This issue . . . devoted entirely to the work of Charles Sheeler . . . is the first time a large body of his photographs has been published in a single volume." Includes a detailed account of Sheeler's photographic career, with forty-two plates, extensive footnotes, and brief bibliography.

N794. New York. **The Museum of Modern Art.** CHARLES SHEELER: PAINTINGS, DRAWINGS, PHOTO-

GRAPHS. INTRODUCTION BY WILLIAM CARLOS WILLIAMS. New York, 1939. 53 p., illus.

Exhibition.

Reproductions of six photographs; chronology; bibliography.

N795. **Rourke, Constance.** CHARLES SHEELER: ARTIST IN THE AMERICAN TRADITION. New York: Harcourt Brace, 1938. 203 p., illus.

A biography, with but passing reference to Sheeler's photographic activity. Includes four photographs.

N796. **Cowdrey, Bartlett, and Friedman, Martin.** INTERVIEW WITH CHARLES SHEELER. Transcription. 1958–1959. 119 p. Archives of American Art, Smithsonian Institution, Washington, D.C.

General review of Sheeler's artistic career, with sections on his photography.

N797. Washington, D.C. **National Collection of Fine Arts, Smithsonian Institution.** CHARLES SHEELER. ESSAYS BY MARTIN FRIEDMAN, BARTLETT HAYES, AND CHARLES MILLARD. Washington, D.C.: Smithsonian Institution Press; for the National Collection of Fine Arts, 1968. 156 p., illus. (color).

Exhibition: Oct. 11–Nov. 24, 1968. Also shown at the Philadelphia Museum of Art, Jan. 10–Feb. 16, 1969; and the Whitney Museum of American Art, Mar. 17–Apr. 27, 1969.

Millard's essay is from the article in *Contemporary Photography* 1 (1968) on Sheeler's photographs. Sheeler's review from *The Arts* (May 1923) is on Stieglitz's photographs. This exhibition catalog also includes a list of exhibitions and a good bibliography.

SIEGEL, ARTHUR 1913—

N798. **Newhall, Beaumont, and Newhall, Nancy.** ARTHUR SIEGEL. In: NEWHALL, BEAUMONT, AND NEWHALL, NANCY. A COLLECTION OF PHOTOGRAPHS. New York: Aperture, 1969. p. 73, illus.

[*See* N355.]

SINSABAUGH, ART 1924—

N799. **Anderson, Sherwood.** SIX MID-AMERICA CHANTS. PHOTOGRAPHY BY ART SINSABAUGH. Highlands, N.J.: J. Williams, 1964. unpag., illus.

Texts on Anderson by E. Dahlberg and F. Eckman are included, as well as eleven Midwest photographs by Art Sinsabaugh.

N800. **Newhall, Beaumont, and Newhall, Nancy. Art Sinsabaugh.** In: NEWHALL, BEAUMONT, AND NEWHALL, NANCY. A COLLECTION OF PHOTOGRAPHS. New York: Aperture, 1969. p. 80–81, illus.

[*See* N355.]

SISKIND, AARON 1903—

N801. Chicago. **University of Chicago. David and Alfred Smart Gallery.** PHOTOGRAPHS BY AARON SISKIND IN HOMAGE TO FRANZ KLINE. Chicago, 1975. 12 p., illus.

Exhibition: Oct. 9–Nov. 23, 1975.

Brief comment by Edward A. Maser and Joel Snyder. Essay by Carl Chiarenza, "Siskind's Homage to Kline (1972–1975)."

N802. **Lyons, Nathan, ed.** AARON SISKIND, PHOTOGRAPHER. INTRODUCTION BY NATHAN LYONS. ESSAYS BY HENRY HOLMES SMITH AND THOMAS B. HESS. Rochester, N.Y.: George Eastman House, 1965. 74 p., illus.

Exhibition.

Published to accompany an exhibition. Included is a list of exhibitions; bibliography; chronology; forty-four excellent reproductions. Statement by Aaron Siskind.

N803. **Siskind, Aaron.** AARON SISKIND PHOTOGRAPHS; JOHN LOGAN POEMS. Rochester, N.Y.: Visual Studies Workshop, 1976. 36 p., illus.

This volume was issued in an edition of six hundred copies.

N804. **Morgan, William.** BUCKS COUNTY: PHOTOGRAPHS OF EARLY ARCHITECTURE. PHOTOGRAPHY BY AARON SISKIND. New York: Horizon Press, 1974. 120 p., illus.

N805. **Siskind, Aaron.** THOUGHTS AND REFLECTIONS. *Afterimage* 1 (Mar. 1973): 2–6, illus.

An excellent transcription of an interview, taped at the Visual Studies Workshop, Rochester, N.Y., in which Siskind discusses his early style and general approach. Accompanied by six photographs.

N806. **Newhall, Beaumont, and Newhall, Nancy.** AARON SISKIND. In: NEWHALL, BEAUMONT, AND NEWHALL, NANCY. A COLLECTION OF PHOTOGRAPHS. New York: Aperture, 1969. p. 74–75, illus.

[*See* N355.]

N807. **Siskind, Aaron.** PHOTOGRAPHS. New York: Horizon Press, 1969. 7 p., illus.

Introduction by Harold Rosenberg. Biographical notes and statement on dust jacket.

SLAVIN, NEAL

N808. **Slavin, Neal.** PORTUGAL. New York: Lustrum Press, 1971. unpag., illus.

Personal views of Portugal in thirty-two untitled photographs. Afterword by Mary McCarthy.

SMITH, W. EUGENE 1918–1978

N809. DICTIONNAIRE DES PHOTOGRAPHES: W. EUGENE SMITH. *Terre d'Images* 7 (July 1963): 3.

Chronology; bibliography.

N810. **Mack, Emily A.** A MYTH NAMED SMITH. *Camera 35* 4 (Dec. 1959–Jan. 1960): 44–47, illus.

A perceptive biographical essay.

N811. **Newhall, Beaumont, and Newhall, Nancy.** W. EUGENE SMITH. In: NEWHALL, BEAUMONT, AND NEWHALL, NANCY. A COLLECTION OF PHOTOGRAPHS. New York: Aperture, 1969. p. 48–49, illus.

[*See* N355.]

N812. **Smith, W. Eugene, and Smith, Aileen.** MINAMATA. New York: Holt, Rinehart & Winston, 1975. 192 p., illus.

A powerful documentary in words and fifty-one photos of industrial pollution in Japan and the destructive effects of mercury poisoning on the people. For an account of the circumstances, *see* Arthur Goldsmith's review of the portfolio of ten photographs (Tokyo: Soju-sha, 1973) in *Popular Photography* (Feb. 1974): 97–99, 123–24.

N813. **Smith, W. Eugene.** PITTSBURGH. In: 1959 PHOTOGRAPHY ANNUAL. New York: Ziff-Davis Publishing Co., 1958. p. 96–133, illus.

One of Smith's major photo essays, with eighty-nine photographs. Introduction by H. M. Kinzer.

N814. W. EUGENE SMITH: HIS PHOTOGRAPHS AND NOTES. New York: Aperture, 1969. unpag., illus.

This is basically a book of excellent reproductions, representing a rich selection of Smith's work, with a chronology and an extensive bibliography compiled by Peter C. Bunnell. Includes a complete list of photographs by Smith published in *Life* magazine from 1938 to 1954. The afterword, by Lincoln Kirstein, is a seventeen-page critical and biographical essay. ALSO PUBLISHED in *Aperture* 14: 2 (1968).

N815. W. EUGENE SMITH TALKS ABOUT LIGHTING. *Popular Photography* 39 (Nov. 1956): 48–49.

Despite its title, this interview covers many other aspects of Smith's approach to photography.

SOMMER, FREDERICK 1905—

N816. FREDERICK SOMMER: 1939–1962 PHOTOGRAPHS. *Aperture* 10 (1962): 134–74, illus.

Excellent reproductions; poetic text by the artist; brief chronology; bibliographical notes. ALSO PUBLISHED AS a separate monograph.

N817. Philadelphia, Pa. **Philadelphia College of Art.** FREDERICK SOMMER: AN EXHIBITION OF PHOTOGRAPHS. ESSAY BY GERALD NORDLAND. PREFACE BY GEORGE D. CULLER. Philadelphia, 1968. 27 p., illus.

Exhibition: Nov. 1–30, 1968.

There are fifteen excellent reproductions included in this exhibition catalog. Also notes and bibliography; chronology; list of 127 exhibited photographs, many from the Pasadena Art Museum.

SOULE, WILLIAM STIMSON 1836–1908

N818. **Belous, Russell E., and Weinstein, Robert A.** WILL SOULE: INDIAN PHOTOGRAPHER AT FORT SILL, OKLAHOMA, 1869–74. Los Angeles: Ward Ritchie Press, 1969. 120 p., illus.

Weinstein's essay gives a succinct history of photography of the Indians, up to the visit of the Boston photographer Soule to Fort Sill. Belous discusses Indian civilization.

SOUTHWORTH, ALBERT SANDS 1811–1894

For additional materials on Southworth's partner, Josiah Johnson Hawes, see N605–N607.

N819. New York. **The Metropolitan Museum of Art. The Hawes-Stokes Collection.** AMERICAN DAGUERREOTYPES BY ALBERT SANDS SOUTHWORTH AND JOSIAH JOHNSON HAWES. CATALOG BY I. N. PHELPS STOKES. New York, 1939. 21 p., illus.

Collection catalog.

N820. **Newhall, Beaumont.** FIRST AMERICAN MASTERS OF THE CAMERA. *Art News Annual* 46 (1948): 93–98, illus.

Brief sketch of the lives and work of Albert Sands Southworth and Josiah Johnson Hawes. Illustrated from daguerreotypes in The Metropolitan Museum of Art, New York.

N821. **Newhall, Beaumont, and Newhall, Nancy.** ALBERT SANDS SOUTHWORTH AND JOSIAH JOHNSON HAWES. In: NEWHALL, BEAUMONT, AND NEWHALL, NANCY. MASTERS OF PHOTOGRAPHY. New York: George Braziller, 1958. p. 22–31, illus.

[*See* N356.]

N822. **Sobieszek, Robert A., and Appel, Odette M.** THE SPIRIT OF FACT: THE DAGUERREOTYPES OF SOUTHWORTH & HAWES, 1843–1862. Boston: David R. Godine; Rochester, N.Y.: International Museum of Photography at George Eastman House, 1976. 163 p., illus.

Beautiful reproductions of daguerreotypes by the Boston gallery of Albert Sands Southworth and Josiah Johnson Hawes, with a scholarly introduction and bibliography. The entire sixteen-page pamphlet, *Description of the Daguerreotype Process; Or, A Summary of M. Gouraud's Public Lectures* (Boston, 1840), is reprinted in this volume.

N823. **Southworth, Albert Sands.** AN ADDRESS TO THE NATIONAL PHOTOGRAPHIC ASSOCIATION OF THE UNITED STATES. *Philadelphia Photographer* 8 (Oct. 1871): 315–23.

Autobiographical account of Southworth, a Boston pioneer, who learned the daguerreotype process from François Gouraud in 1840, and became the partner of Josiah Johnson Hawes in 1843. In this address, Southworth stresses the importance of portraiture, and states his approach: "What is to be done is obliged to be done quickly. The whole character of the sitter is to be read at first sight."

STEICHEN, EDWARD 1879–1973

N824. **Green, Jonathan, ed.** CAMERA WORK: A CRITICAL ANTHOLOGY. New York: Aperture, 1973. 375 p., illus.

An impressive review and celebration of the publication entitled *Camera Work*, Alfred Stieglitz's illustrated quarterly journal of photography and art [*see* N312]. This anthology highlights Steichen's part in the unique publication. The anthology includes a name index (which needs supplementation). Also included are biography; chronological plate index; reproductions including one painting in color; and bibliography. One of the references in the bibliography (p. 347) is to "the Steichen book" (New York: Alfred Stieglitz, 1906), a book which Green says consists of selected proofs by Steichen from *Camera Work*. Green's entry probably refers to the *Special Steichen Supplement*, a volume published by *Camera Work* as a supplement to their Apr. 1906 issue.

N825. **Homer, William Innes.** EDWARD STEICHEN AS PAINTER AND PHOTOGRAPHER, 1897–1908. *American Art Journal* 6 (Nov. 1974): 45–55, illus.

The first comparison of Steichen's activity in painting and in photography. The author shows the strong influence of Whistler and Impressionism in Steichen's paintings. Homer observes that the artist's modernism is to be found in his photography, concluding that his abandonment of painting was for the better. The volume reproduces six paintings in black and white.

N826. New York. **The Museum of Modern Art.** STEICHEN THE PHOTOGRAPHER. TEXTS BY CARL SANDBURG, ALEXANDER LIBERMAN, EDWARD STEICHEN, AND RENÉ D'HARNONCOURT. New York, 1961. 80 p., illus.

Exhibition.

Published to accompany a retrospective exhibition. Bibliography of 105 entries by Bernard Karpel. Biographical outline by Grace M. Mayer.

N827. **Newhall, Beaumont, and Newhall, Nancy.** EDWARD STEICHEN. In: NEWHALL, BEAUMONT, AND NEWHALL, NANCY. MASTERS OF PHOTOGRAPHY. New York: George Braziller, 1958. p. 76–91, illus.

[*See* N356.]

N827a. **Newhall, Beaumont, and Newhall, Nancy.** EDWARD STEICHEN. In: NEWHALL, BEAUMONT, AND NEWHALL, NANCY. A COLLECTION OF PHOTOGRAPHS. New York: Aperture, 1969. p. 16–17, illus. (color).

[*See* N355.]

N828. **Norman, Dorothy.** ALFRED STIEGLITZ: AN AMERICAN SEER. New York: Random House, 1973.

References to Steichen: p. 36, 47, 68–74, 80, 97–98, 102–107, 109–112, 121–23, 195, 235–36, 240. Included elsewhere in the work is a chronology of photographic exhibitions. FIRST EDITION (1960).

N829. **Sandburg, Carl.** STEICHEN THE PHOTOGRAPHER. New York: Harcourt Brace, 1929. 70 p., illus.

The text by Sandburg deprecates Steichen's early "soft focus" work and praises his abrupt change to "commercial" work. The volume includes forty-eight photographs made in the years immediately preceding publication.

N830. **Steichen, Edward.** A LIFE IN PHOTOGRAPHY. Garden City, N.Y.: Doubleday & Co.; London: W. H. Allen; with the Museum of Modern Art, 1963. unpag., illus. (color).

Autobiography, with 249 reproductions covering the entire career of Steichen. Chronology by Grace M. Mayer, condensed from her biographical outline in *Steichen the Photographer* [N826].

N831. New York. **The Museum of Modern Art.** THE FAMILY OF MAN: THE PHOTOGRAPHIC EXHIBITION CREATED BY EDWARD STEICHEN FOR THE MUSEUM OF MODERN ART. PROLOGUE BY CARL SANDBURG. New York: Simon & Schuster, 1955. 207 p., illus.

[*See* N93.]

N832. **Steichen, Edward.** "NEWS" PHOTOGRAPHY. In: RINGEL, FRED J., ED. AMERICA AS AMERICANS SEE IT. New York: Harcourt Brace, 1932. p. 293–95, illus.

Foreword by Frank Crowninshield. A defense of the importance of news reportage.

N833. INFINITY, special Steichen issue. Dec. 1954–Jan. 1955).

Entire issue of the journal published by the American Society of Magazine Photographers. Text by Mary Steichen Calderone, and interview by Wayne Miller (Steichen's assistant on "The Family of Man"). Also includes articles by D. J. Ebin, *Vanity Fair* magazine photographer, and by Capt. Victor Jorgensen, USNR.

N834. **Thoreau, Henry David.** WALDEN; OR, LIFE IN THE WOODS. PHOTOGRAPHS BY EDWARD STEICHEN. Boston: Merrymount Press; for members of the Limited Editions Club, 1936. 290 p., illus.

Introduction by Henry Seidel Canby. Illustrations comprise photographs taken by Steichen at Walden Pond during the various seasons.

N835. **Cummings, Paul.** INTERVIEW WITH EDWARD STEICHEN. Transcription. 1970. 22 p. Archives of American Art, Smithsonian Institution, Washington, D.C.

Review of Steichen's career as a photographer, including service in World War II and directorship of the Department of Photography of The Museum of Modern Art, New York.

STERN, BERT 1930—

N836. **Cornfield, Jim.** THE PHOTO ILLUSTRATION: BERT STERN. Los Angeles: Petersen Publishing Co., 1974. 96 p., illus. (color).

The career and methods of a highly successful advertising photographer.

STETTNER, LOUIS 1922—

N837. **Stettner, Louis.** WORKERS: TWENTY-FOUR PHOTOGRAPHS. New York: Stettner Studio, 1975. illus., portfol.

Unbound reproductions in slip case. Introductory essays by Howard Greenberg and Jacob Deschin.

N837a. **Stettner, Louis.** WOMEN: TWENTY-TWO PHOTOGRAPHS. New York: Stettner Studio, 1975. illus., portfol.

Unbound reproductions in slip case. Introductory essay by the author.

STIEGLITZ, ALFRED 1864–1946

N838. Boston. **Museum of Fine Arts.** ALFRED STIEGLITZ: PHOTOGRAPHER. TEXT BY DORIS BRY. Boston, 1965. 28 p., 62 plates.

Collection catalog.

High-quality reproductions of the complete Stieglitz collection in the Museum of Fine Arts, Boston. The text is revised by Doris Bry from the essay first published in the catalog for the *Exhibition of Photographs by Alfred Stieglitz,* held by the National Gallery of Art, Washington, D.C., 1958. Chronology; excellent bibliography.

N839. **Dijkstra, Bram.** THE HIEROGLYPHICS OF A NEW SPEECH: CUBISM, STIEGLITZ, AND THE EARLY POETRY OF WILLIAM CARLOS WILLIAMS. Princeton, N.J.: Princeton University Press, 1970. 218 p., illus.

Dijkstra discusses Stieglitz in relation to the introduction of modern art and literature to America. "It was Stieglitz who, for Williams as well as for the painters, provided the essential example of the means by which the artist could reach out to a new, more accurate mode of representing the world of experience." Excellent bibliography on Alfred Stieglitz, the Stieglitz group, and 291. [On 291, *see* N165. From this gallery name came the use of the term "291" to refer to the artists associated with Photo Secession and this gallery.]

N840. **Frank, Waldo, et al., eds.** AMERICA AND ALFRED STIEGLITZ: A COLLECTIVE PORTRAIT. Garden City, N.Y.: Doubleday, Doran & Co., 1934. 339 p., illus.

Twenty-five specialists trace the career of Stieglitz as photographer, champion of photography as an art medium, collector of modern art, philosopher, editor, and publisher. Chronology; list of exhibitions held at Stieglitz's various galleries; selected bibliography.

N841. **Green, Jonathan, ed.** CAMERA WORK: A CRITICAL ANTHOLOGY. New York: Aperture, 1973. 375 p., illus.

A superb testimonial—with introduction, text, fine reproductions, name and plate indexes, and bibliography—to Stieglitz's major publication *Camera Work,* which is, in its genre, still unique in conception, execution, and quality. [For additional annotation, *see* N312, N824. For additional material on *Camera Work* and Stieglitz, *see* N844, S100.]

N842. **Newhall, Beaumont, and Newhall, Nancy.** ALFRED STIEGLITZ. In: NEWHALL, BEAUMONT, AND NEWHALL, NANCY. A COLLECTION OF PHOTOGRAPHS. New York: Aperture, 1969. p. 8–11.

[*See* N355.]

N842a. **Newhall, Beaumont, and Newhall, Nancy.** ALFRED STIEGLITZ. In: NEWHALL, BEAUMONT, AND NEWHALL, NANCY. MASTERS OF PHOTOGRAPHY. New York: George Braziller, 1958. p. 60–75, illus.

[*See* N356.]

N843. **Norman, Dorothy, ed.** ALFRED STIEGLITZ MEMORIAL PORTFOLIO, 1864–1946. New York: Twice a Year Press, 1947. 63 p., illus.

Included in this volume are eighteen excellent reproductions, unbound, accompanied by tributes from various colleagues and friends, including Paul Strand, Frank Lloyd Wright, Edward Steichen, Edward Weston, Ansel Adams, Arthur Dove, Hart Crane, Beaumont and Nancy Newhall, and Henri Cartier-Bresson.

N844. **Norman, Dorothy.** ALFRED STIEGLITZ: AN AMERICAN SEER. New York: Random House, 1973. 254 p., illus.

A beautifully produced biography, by a close associate of Stieglitz during his later years. Chronology; list of gallery exhibitions directed by Stieglitz; extensive bibliography. Seventy-eight superior reproductions. Index.

N845. **Norman, Dorothy.** ALFRED STIEGLITZ. Millerton, N.Y.: Aperture, 1976. 95 p., illus.

Chronology; bibliography.

N846. **Stieglitz, Alfred.** THE HAND CAMERA—ITS PRESENT IMPORTANCE. *American Annual of Photography* (1897): 19–26, illus.

Definition of an approach to photography made possible by the newly introduced hand-held camera. "Watch the passing figures and await the moment in which everything is in balance; that is, satisfies your eye." Cropping advised. REPRINTED with original illustrations in Beaumont Newhall, ed., *On Photography* (Watkins Glen, N.Y.: Century House, 1956), p. 133–40.

N847. Washington, D.C. **National Gallery of Art, Department of Graphic Arts.** ALFRED STIEGLITZ COLLECTION. 1949.

The key set of over 1,400 Stieglitz prints, given to the museum by Georgia O'Keeffe at the time of Stieglitz's death. Although it does not contain prints of all his photographs, this is the largest collection of Stieglitz works. Duplicate prints were made available to other collections.

STODDARD, SENECA RAY 1844–1917

N848. **De Sormo, M. C.** SENECA RAY STODDARD: VERSATILE CAMERA ARTIST. Saranac Lake, N.Y.: Adirondack Yesterdays, 1972. 190 p., illus.

The photographic work of S.R. Stoddard, the American writer, lecturer, editor, and conservationist—active largely in the Adirondack wilderness of New York State—presented by the present owner of his negatives.

STRAND, PAUL 1890–1975

N849. **Coke, Van Deren.** THE CUBIST PHOTOGRAPHS OF PAUL STRAND AND MORTON SCHAMBERG. In: COKE, VAN DEREN. ONE HUNDRED YEARS OF PHOTOGRAPHIC HISTORY: ESSAYS IN HONOR OF BEAUMONT NEWHALL. Albuquerque: University of New Mexico Press, 1975. p. 36–42, illus.

The machine photographs of Paul Strand in relation to the proto-Dada work of Francis Picabia and the painter Morton Schamberg.

N850. **Keller, Ulrich.** AN ART HISTORICAL VIEW OF PAUL STRAND. *Image* 17 (Dec. 1974): 1–11, illus.

A discussion largely of subject matter favored by Strand, from the machine to man's position in nature. There are eight illustrations, including front and back covers.

N851. **Newhall, Beaumont, and Newhall, Nancy.** PAUL STRAND. In: NEWHALL, BEAUMONT, AND NEWHALL, NANCY. MASTERS OF PHOTOGRAPHY. New York: George Braziller, 1958. p. 102–117.

[*See* N356.]

N851a. **Newhall, Beaumont, and Newhall, Nancy.** PAUL STRAND. In: NEWHALL, BEAUMONT, AND NEWHALL, NANCY. A COLLECTION OF PHOTOGRAPHS. New York: Aperture, 1969. p. 18–21, illus.

[*See* N355.]

N852. New York. **The Museum of Modern Art.** PAUL STRAND. TEXT BY NANCY NEWHALL. New York, 1945. 32 p., illus.

Exhibition.

Published to accompany the retrospective exhibition of Strand's photographs. Biographical essay; twenty-three plates; chronology; bibliography.

N853. PAUL STRAND: A RETROSPECTIVE MONOGRAPH. New York: Aperture, 1971. 2 vols., illus.

Vol. 1: 1915–1946; vol. 2: 1950–1968. There are 307 superb reproductions, interspersed with critical comments by various writers. Detailed chronology and bibliography by Peter C. Bunnell.

N854. PAUL STRAND: SIXTY YEARS OF PHOTOGRAPHS. Millerton, N.Y.: Aperture, 1976. 183 p., illus.

The foreword is revised from a profile by Calvin Tomkins in *The New Yorker*. Chronology; selected bibliography. Ninety plates and text illustrations. Excerpts from correspondence, interviews, and other documents are included.

N855. **Strand, Paul.** THE ART MOTIF IN PHOTOGRAPHY. *British Journal of Photography* 70 (1923): 613–14.

A lecture in the Clarence H. White School of Photography. REPRINTED in *Photographers on Photography* [N50, p. 144–54].

N856. **Strand, Paul.** COMMENTS ON THE SNAPSHOT. In: GREEN, JONATHAN, ED. THE SNAPSHOT. Millerton, N.Y.: Aperture, 1974. p. 46–49, illus.

Based on a taped interview, in which Strand states that the word "snapshot" has no meaning. Important statement on his deliberate desire in 1915 to make photographs different from those of the Photo Secessionists. Includes praise of Cartier-Bresson.

N857. **Strand, Paul.** PHOTOGRAPHY TO ME. *Minicam Photography* 8 (May 1945): 42–46, 86, 90.

N858. **Strand, Paul, and Aldridge, James.** LIVING EGYPT. New York: Horizon Press; London: MacGibbon & Kee, 1969, illus.

Photographs by Strand, text by Aldridge.

N859. **Strand, Paul, and Davidson, Basil.** GHANA: AN AFRICAN PORTRAIT. PHOTOGRAPHS BY PAUL STRAND. Millerton, N.Y.: Aperture, 1976. 160 p., illus.

Commentary by Basil Davidson. The commentary is historical and conceived independently of the photographs. As Davidson writes, "we thought of the book . . . as one that could yield a continual and meaningful counterpoint between photographs and text . . . each the richer for its companion" (p. 8).

N860. **Strand, Paul, and Davidson, Basil.** TIR A'MHURAIN: OUTER HEBRIDES. PHOTOGRAPHS BY PAUL STRAND. London: MacGibbon & Kee, 1962. 151 p., illus.

Photographs taken on the island of South Uist, Outer Hebrides. The text is descriptive of the history and culture of the people. Commentary by Basil Davidson.

N861. **Strand, Paul.** TIME IN NEW ENGLAND. EDITED BY NANCY NEWHALL. New York: Oxford University Press, 1950. 250 p., illus.

The photographs by Paul Strand are selected from his earlier work. This volume, edited by Nancy Newhall, contains writings by New Englanders.

N862. **Roy, Claude.** LA FRANCE DE PROFIL. PHOTO-

GRAPHS BY PAUL STRAND. Lausanne: La Guilde de Livre, 1952. 126 p., illus.

The text is documentary in character, and integrated with the photographs by Strand. The volume as a whole gives a remarkable and intense impression of rural France.

N863. **Zavattini, Cesare.** UN PAESE. PHOTOGRAPHS BY PAUL STRAND. Turin: Giulio Einaudi, 1955. 107 p., illus.

Photographs taken in the village of Luzzaro, the birthplace of Zavattini, the filmmaker who wrote the text.

N864. **Strand, Paul.** PHOTOGRAPHS OF MEXICO. New York: Virginia Stevens, 1940. folio.

Portfolio of twenty hand-pulled sheet-fed gravures, in an edition of two hundred and fifty copies. Foreword by Leo Hurwitz. A SECOND EDITION was printed from the original plates under the supervision of Paul Strand and Aperture (New York: Grossman Publishers, 1967), with foreword by David Alfaro Siqueiros. The plates in this superbly produced portfolio, which can be considered direct serial productions, are the quality of fine impressions of etchings, rather than reproductions. The second edition was ALSO PUBLISHED AS *The Mexican Portfolio* (New York: Da Capo Press, 1967), limited to one thousand copies, each signed by Paul Strand. Includes letterpress reprint of the original foreword by Leo Hurwitz, Paul Strand's note on the second edition, and a statement by David Alfaro Siqueiros.

N865. **Brown, Milton.** INTERVIEW WITH PAUL STRAND. Transcription. 1971. 81 p. Archives of American Art, Smithsonian Institution, Washington, D.C.

TABER, ISAAC W. 1830–1912

N866. **Andrews, Ralph W.** ISAAC W. TABER. In: ANDREWS, RALPH W. PICTURE GALLERY PIONEERS, 1850 TO 1875. Seattle: Superior Publishing Co., 1964. p. 63–67, illus.
[*See* N152.]

TICE, GEORGE A. 1938—

N867. **Tice, George A.** URBAN LANDSCAPE: A NEW JERSEY PORTRAIT. New Brunswick, N.J.: Rutgers University Press, 1975. unpag., illus.

In a one-page "statement," Tice writes that this book is a continuation of his documentation of New Jersey, begun in his volume, *Paterson.* "The photographs are presented here as documents, but I am sure the art motive was primary."

N868. **Brand, Millen.** FIELDS OF PEACE: A PENNSYLVANIA GERMAN ALBUM. PHOTOGRAPHS BY GEORGE A. TICE. Garden City, N.Y.: Doubleday & Co., 1970. 160 p., illus.

This book includes 110 photographs by George A. Tice of the landscapes, people, and interiors of that part of Pennsylvania inhabited by Amish and Mennonite sects. Bibliography relates to Millen Brand's text which is sociohistorical in nature.

UELSMANN, JERRY N. 1934–

N869. **Uelsmann, Jerry N.** EIGHT PHOTOGRAPHS. Garden City, N.Y.: Doubleday & Co., 1970. 1 p., folio, illus.

Eight unbound reproductions in a box, with a one-page text and illustrated table of contents. Introduction by William E. Parker, who writes that the "darkroom ritual will always be a form of alchemy, capable of revealing an innermost world of mystery, enigma, and insight."

N870. **Uelsmann, Jerry.** SOME HUMANISTIC CONSIDERATIONS OF PHOTOGRAPHY. *Photographic Journal* 3 (Apr. 1971): p. 165–82, illus.

The fourth Bertram Cox lecture of the Royal Photographic Society. An inquiry into the aesthetics of postvisualization, with technical details of his methods. REPRINTED in *Afterimage* 1 (Mar. 1972): 6, illus.

N871. **Uelsmann, Jerry.** SILVER MEDITATIONS. Dobbs Ferry, N.Y.: Morgan & Morgan, 1975. unpag., illus.

Introduction by Peter C. Bunnell to 149 photographs. Chronology; list of exhibitions; bibliography.

N872. **Ward, John L.** THE CRITICISM OF PHOTOGRAPHY AS AN ART: THE PHOTOGRAPHS OF JERRY UELSMANN. Gainesville, Fla.: University of Florida Press, 1970. 76 p., illus.

N873. Philadelphia, Pa. **Philadelphia Museum of Art.** JERRY N. UELSMANN. INTRODUCTION BY PETER C. BUNNELL. FABLES BY RUSSELL EDSON. Philadelphia: Philadelphia Museum of Art; New York: Aperture, 1970. 98 p., illus.

Exhibition: Dec. 12, 1970–Feb. 7, 1971.

A collection of Uelsmann's works in excellent reproduction. Chronology; bibliography. ALSO PUBLISHED as *Aperture* 15:4 (1969).

ULMANN, DORIS 1882–1934

N874. **Clift, William.** THE DARKNESS AND THE LIGHT: PHOTOGRAPHS BY DORIS ULMANN. Millerton, N.Y.: Aperture, 1974. 111 p., illus., portfol.

A portfolio of sixty-seven reproductions of Ulmann's photographs of blacks, largely in South Carolina. Biographical essay by William Clift. Sociological essay by Robert Coles, "A New Heaven and a New Earth."

N875. **Ulmann, Doris.** APPALACHIAN PHOTOGRAPHS. Penland, N.C.: Jargon Society, 1971. unpag., illus.

This is a presentation of sixty-three photographs of Appalachian mountain people. Ulmann is quoted as say-

ing, "I have been more deeply moved by some of my mountaineers than by any literary person. A face that has the marks of having lived intensely, that expresses some phase of life, some dominant quality, or intellectual power, constitutes for me an interesting face." Included in the volume is a remembrance by John Jacob Niles; preface by Jonathan Williams.

VAN DER ZEE, JAMES 1886—

N876. **De Cock, Liliane, and McGhee, Reginald.** JAMES VAN DER ZEE. Dobbs Ferry, N.Y.: Morgan & Morgan, 1973. 159 p., illus., portfol.

A portfolio of excellent reproductions with a short, informative biographical essay concerning photography in Harlem. Introduction by Regenia A. Perry.

VISHNIAC, ROMAN 1897—

N877. **Capa, Cornell, and Karia, Bhupendra, eds.** ROMAN VISHNIAC. New York: Grossman Publishers, 1974. 96 p., illus. (color).
INTERNATIONAL FUND FOR CONCERNED PHOTOGRAPHY, LIBRARY OF PHOTOGRAPHERS, VOL. 6.

Photomicrographs and documentation on Polish Jews. Statements by Eugene Kinkead and the photographer, Roman Vishniac. Chronology; list of exhibitions; bibliography.

VROMAN, ADAM CLARK 1856–1916

N878. **Jackson, Helen Hunt.** RAMONA: A STORY. Boston: Little, Brown & Co., 1922. 308 p., illus.

Introduction by A. C. Vroman. Illustrations from original photographs by A. C. Vroman; decorative headings from drawings by Henry Sandham.

N879. **Mahood, Ruth I., ed.** PHOTOGRAPHER OF THE SOUTHWEST: ADAM CLARK VROMAN, 1856-1916. Los Angeles: Ward Ritchie Press, 1961. 127 p., illus.

Includes an introduction and a biographical essay by Beaumont Newhall and the following essays: "Discovering the Lost Vroman Plates," by Ruth I. Mahood; "Printing the Vroman Negatives," by William Webb; and "The Enchanted Mesa" by Adam Clark Vroman.

N880. **Webb, William, and Weinstein, Robert A.** DWELLERS AT THE SOURCE: SOUTHWESTERN INDIAN PHOTOGRAPHS OF A. C. VROMAN, 1895-1904. New York: Grossman Publishers, 1973. 214 p., illus.

A superb collection of modern prints by William Webb from the original negatives, with detailed notes on the subject matter. Chronology; essay on "Vroman's Technique"; inventory of his equipment in 1895; history of the negative collection; and bibliography. Original material is from the A. C. Vroman Collection at the Natural History Museum of Los Angeles County.

WALKER, TODD 1917—

N881. **Kelly, Charles.** TODD WALKER: AN INTERVIEW. *Afterimage* 2 (Mar. 1974): p. 2–5, illus.

This article is based on the transcription of an interview taped at the Visual Studies Workshop. An excellent account of the photographer's development from his student days at the Art Center School, Los Angeles, including his work with the Sabattier effect and dye coupling, and recent work with photomechanical techniques.

N882. **Walker, Todd.** PORTFOLIO. Thumbprint Press, 1968.

This publication comprises eighteen reproductions of photographs.

WATKINS, CARLETON E. 1829–1916

N883. **Andrews, Ralph W.** CARLETON E. WATKINS. In: ANDREWS, RALPH W. PICTURE GALLERY PIONEERS, 1850 TO 1875. Seattle: Superior Publishing Co., 1964. p. 63–67, illus.
[*See* N152.]

N884. **Giffen, Helen S.** CARLETON E. WATKINS: CALIFORNIA'S EXPEDITIONARY PHOTOGRAPHER. *Eye to Eye* 6 (Sept. 1954): 26–32.

An excellent biographical essay, unfortunately not illustrated.

N885. **Johnson, J. W.** THE EARLY PACIFIC COAST PHOTOGRAPHS OF CARLETON E. WATKINS. Berkeley, Calif.: Water Resources Center, University of California, 1960. 64 p., illus.
ARCHIVES SERIES, REPORT NO. 8.

Biography, photographic methods, list of holdings by various libraries. The illustrations are of Watkins's studio; none of his photographic work is reproduced.

N886. **Naef, Weston J.** CARLETON E. WATKINS. In: BUFFALO, N.Y. ALBRIGHT-KNOX ART GALLERY, THE BUFFALO FINE ARTS ACADEMY. ERA OF EXPLORATION: THE RISE OF LANDSCAPE PHOTOGRAPHY IN THE AMERICAN WEST, 1860–1885. Buffalo, 1975. p. 79–124, illus.

Exhibition: Also shown at The Metropolitan Museum of Art, New York, 1975.
[*See* N160.]

N887. **Watkins, Carleton E.** PHOTOGRAPHIC VIEWS OF THE FALLS AND VALLEY OF YO-SEMITE IN MARIPOSA COUNTY, CALIFORNIA. San Francisco, 1863. illus.

Album of fifty original photographs, with handwritten titles. The title page is a photograph of handwritten copy. Size: 20 x 17-1/2 in. The album is in the collection of the Center for Creative Photography, University of Arizona. A copy with thirty photographs is in The New York Public Library.

WEBB, TODD 1905—

N888. Fort Worth, Tex. **Amon Carter Museum of Western Art.** Todd Webb Photographs: Early Western Trails and Some Ghost Towns. Introduction by Beaumont Newhall. Fort Worth, 1965. 44 p., illus.

Exhibition.

List of exhibitions; biographical data.

N889. **Robinson, Willard B.** Texas Public Buildings of the Nineteenth Century. Photographs by Todd Webb. Austin: University of Texas Press; for the Amon Carter Museum of Western Art, 1974. 290 p., illus.

Foreword by Drury Blakely Alexander.

N890. **Webb, Todd.** The Gold Rush Trail and the Road to Oregon. Garden City, N.Y.: Doubleday & Co., 1963. 224 p., illus.

N891. **Webb, Todd.** Gold Strikes and Ghost Towns. Garden City, N.Y.: Doubleday & Co., 1961. 160 p., illus.

N892. **Noggle, Anne.** Interview with Todd Webb. Phonotape. 1971. Collection of Anne Noggle, Albuquerque, N.M.

Biographical information about Webb's beginnings in photography, with discussions of his work in France and his work with the Standard Oil Co. The tape (1-1/2 hours) was made under the auspices of the Oral History Program of the Museum of New Mexico, Santa Fe, where Noggle was the curator of photography (she is currently associated with the University of New Mexico).

WEED, CHARLES L. *active* 1865–1875

N893. **Andrews, Ralph W.** Charles L. Weed. In: Andrews, Ralph W. Picture Gallery Pioneers, 1850 to 1875. Seattle: Superior Publishing Co., 1964. p. 72–77, illus.

[*See* N152.]

WEEGEE 1900–1968

N894. **Weegee (Arthur Fellig).** Naked City. New York: Essential Books, 1945. 243 p., illus.

Foreword by William McCleery, editor of *PM Picture News.* A highly personal and intimate view, occasionally shrewd, whimsical, and compassionate.

N895. **Weegee, and Harris, Mel.** Naked Hollywood. New York: Pellegrini & Cudahy, 1953. unpag., illus.

A collection of photographs of Hollywood, in the satirical style of *Naked City.*

WEINER, DAN 1919–1959

N896. **Capa, Cornell, and Weiner, Sandra, eds.** Dan Weiner, 1919–1959. New York: Grossman Publishers, 1975. 96 p., illus. International Fund for Concerned Photography, Library of Photographers, vol. 5.

Statements by the photographer, Arthur Miller, Alan Paton, and Sandra Weiner. Chronology; list of exhibitions; bibliography.

WELLS, ALICE 1929—

N897. **Tucker, Anne.** Alisa Wells. In: Tucker, Anne, ed. The Woman's Eye. New York: Alfred A. Knopf, 1973. p. 125–39, illus.

[*See* N362.]

WELPOTT, JACK 1923—

N898. **Dater, Judy, and Welpott, Jack.** Women and Other Visions. Dobbs Ferry, N.Y.: Morgan & Morgan, 1975. unpag., illus.

This publication includes 108 plates, with chronologies. Introduction by Henry Holmes Smith.

N899. San Francisco. **San Francisco Museum of Art.** Jack Welpott: The Artist as Teacher, the Teacher as Artist; Photographs 1950–1975. Introduction by Rodney C. Stuart. San Francisco, 1975. unpag., illus.

Exhibition.

This exhibition catalog includes fourteen reproductions. Also included is the essay, "Some Thoughts on an Artist Teacher," by Henry Holmes Smith. Chronology; record of exhibitions and workshops; bibliography.

WESTON, BRETT 1911—

N900. **Aikin, Roger.** Brett Weston and Edward Weston: An Essay in Photographic Style. *Art Journal* 32 (summer 1973): 394–404, illus.

A scholarly article, in which Brett Weston's emphasis on negative form is contrasted with that of his father. Extensive footnotes; twelve illustrations.

N901. **Armitage, Merle.** Brett Weston Photographs. New York: E. Weyhe, 1956. 92 p., illus.

Introduction by Merle Armitage, with reprint of his review of Brett Weston's 1930 exhibition. Superb reproductions of twenty-eight photographs in the size of the original (8 x 10 in. prints).

N902. Fort Worth, Tex. **Amon Carter Museum of Western Art.** Brett Weston Photographs. Introduction by Nancy Newhall. Fort Worth, 1966. 40 p., illus.

Exhibition: Jan. 27–Mar. 20, 1966.

The introduction is a revision of Nancy Newhall's introduction to the White Sands portfolio (which was also

published in *Photography* 16 [June 1961]:44–45). Bibliography; list of exhibitions.

N903. [Halliday, F. H.]. BRETT WESTON, PHOTOGRAPHER. *Camera Craft* 47 (Mar. 1940): 113–22, illus.

Text by Charis Wilson Weston, whose occasional pseudonym is F. H. Halliday. A most perceptive essay, with stylistic analysis: "In these photographs the blacks are no longer just shadows; they have been transformed into substantial bodies that seem to rest on the surface of the sand."

N904. Newhall, Beaumont, and Newhall, Nancy. BRETT WESTON. In: NEWHALL, BEAUMONT, AND NEWHALL, NANCY. A COLLECTION OF PHOTOGRAPHS. New York: Aperture, 1969. p. 32–33, illus.
[*See* N355.]

N905. Parella, Lew. BRETT WESTON. *U.S. Camera* (1956): 238–44, illus.

N906. Turner, David G. BRETT WESTON ALASKAN PHOTOGRAPHS. *Popular Photography* 75 (July 1974): 111, 180.

Review of an exhibition of photographs at the Oregon Art Museum, Feb. 3–Mar. 3, 1974; included is a commentary of a general nature with a definition of the photographer's style.

N907. Warren, Dody. BRETT WESTON, PHOTOGRAPHER. *American Photography* 46 (Sept. 1952): 32–39, illus.

Dody Warren was formerly Weston's wife; she also writes under the name Dody Weston Thompson.

N908. Albuquerque, N.M. The University of New Mexico, University Art Museum. VOYAGE OF THE EYE. AFTERWORD BY BEAUMONT NEWHALL. Millerton, N.Y.: Aperture, 1975. 105 p., illus.

Exhibition: Mar. 17–Apr. 28, 1975.

The photographs for this exhibition were selected by Beaumont and Nancy Newhall from fifty years of Brett Weston's work. Passages from poems by Robinson Jeffers and Hart Crane are printed on pages opposite to the plates. The afterword is a biographical essay by Beaumont Newhall. Chronology; selected bibliography.

N909. BRETT WESTON: PHOTOGRAPHER. PRODUCED, DIRECTED, AND PHOTOGRAPHED BY ART WRIGHT. PRODUCTION ASSISTANCE BY STEPHEN WAGNER, BERNARD FREEMESSER, AND GEORGE BELTRAN. NARRATED BY BEAUMONT NEWHALL. Motion Picture. Pocatello, Idaho: Art Wright, distributing organization, 1972. Rev. ed. 1974.

Assistance for producing this film was in the form of a grant from the National Endowment for the Humanities.

N910. Weston, Brett. PORTFOLIO. San Francisco, 1938.

N910a. Weston, Brett. BRETT WESTON. *Aperture* 7 (1960): 136–50, portfol.

A portfolio of eleven photographs, without text.

N910b. Weston, Brett. WHITE SANDS: A PORTFOLIO OF TEN ORIGINAL PHOTOGRAPHS. San Francisco: Grabhorn Press, 1949. portfol.

Foreword by Nancy Newhall.

N910c. Weston, Brett. NEW YORK: TWELVE PHOTOGRAPHS. Monterey, Calif.: Adrian Wilson, 1951. portfol.

Foreword by Beaumont Newhall.

N910d. Weston, Brett. FIFTEEN PHOTOGRAPHS. San Francisco: Grabhorn Press, 1961. portfol.

N910e. Weston, Brett. TWELVE PHOTOGRAPHS. 1963. portfol.

N910f. Weston, Brett. A PORTFOLIO OF PHOTOGRAPHS ON BAJA, CALIFORNIA: FIFTEEN PHOTOGRAPHS. San Francisco: Grabhorn Press, 1967.

N910g. Weston, Brett. FIFTEEN PHOTOGRAPHS OF JAPAN. Carmel, Calif., 1970. portfol.

N910h. Weston, Brett. EUROPE: TWELVE PHOTOGRAPHS. Carmel, Calif.: George Beltran, 1973. portfol.

Foreword by Gerald Robinson.

WESTON, EDWARD 1886–1958

N911. Lyons, Nathan. WESTON ON PHOTOGRAPHY. *Afterimage* 3 (May–June 1975): 8–12, illus.

A lecture delivered at The Museum of Modern Art, New York, on the occasion of the Edward Weston retrospective exhibition. Weston's writings on photography were the subject of the lecture.

N912. Armitage, Merle, ed. FIFTY PHOTOGRAPHS: EDWARD WESTON. New York: Duell, Sloan & Pearce, 1947. unpag., illus.

This work was edited and designed by Armitage. Included are essays by Merle Armitage, Donald Bear, Robinson Jeffers, and Edward Weston. Summary bibliography.

N913. Maddow, Ben. EDWARD WESTON: FIFTY YEARS; THE DEFINITIVE VOLUME OF HIS PHOTOGRAPHIC WORK. Millerton, N.Y.: Aperture, 1973. 284 p., illus.

The 150 superb plates reproduce Weston's photographs in their original size, and were chosen and sequenced by Michael E. Hoffman. The text is a lively biography of Weston, stressing his personal problems above his extraordinary contribution to photography. A somewhat prosaic, yet helpful chronology and an excellent bibliography appear as appendixes.

N914. Millard, Charles W. A LOOK AT EDWARD WESTON. *Print Collector's Newsletter* 6 (July–Aug. 1975): 68–70, illus. [*cont.*]

A brief stylistic analysis of Weston's photographic work.

N915. **Newhall, Beaumont.** EDWARD WESTON IN RETROSPECT. *Popular Photography* 18 (Mar. 1946): 42–46, illus.

A brief biographical sketch and a description; also includes a discussion of Weston's technique and darkroom procedures with formulas.

N916. **Newhall, Beaumont, and Newhall, Nancy.** EDWARD WESTON. In: NEWHALL, BEAUMONT, AND NEWHALL, NANCY. A COLLECTION OF PHOTOGRAPHS. New York: Aperture, 1969. p. 22–23.

[*See* N355.]

N916a. **Newhall, Beaumont, and Newhall, Nancy.** EDWARD WESTON. In: NEWHALL, BEAUMONT, AND NEWHALL, NANCY. MASTERS OF PHOTOGRAPHY. New York: George Braziller, 1958. p. 118–33. illus.

[*See* N356.]

N917. **Newhall, Nancy, ed.** MEXICO, vol. 1. In: THE DAYBOOKS OF EDWARD WESTON. Millerton, N.Y.: Aperture, 1973. 214 p., illus.

FIRST EDITION (Rochester, N.Y.: George Eastman House, 1961). A careful transcription of what was left of the original, handwritten journal of Edward Weston shortly before his death, with a glossary of Mexican words and phrases, and a note on Weston's technique by Beaumont Newhall. There are thirty-two plates and selected bibliography.

N918. **Newhall, Nancy, ed.** CALIFORNIA, vol. 2. In: THE DAYBOOKS OF EDWARD WESTON. Millerton, N.Y.: Aperture, 1973. 290 p., illus.

FIRST EDITION (1966). A sequel to the Mexican Daybooks, covering the years 1927 to 1934, plus forty plates and a retrospective note dated Apr. 22, 1944.

N919. **Newhall, Nancy, ed.** EDWARD WESTON: THE FLAME OF RECOGNITION. 3d ed. Millerton, N.Y.: Aperture, 1975. 104 p., illus.

The essence of Weston's writing is presented in this volume of excerpts from the published *Daybooks* and from unpublished letters to Beaumont and Nancy Newhall. Excellent reproductions of sixty-five of Weston's photographs are included, together with portraits of Weston by Ansel Adams, Cole Weston, and Beaumont Newhall. Bibliography; chronology; and glossary of people and places mentioned by Weston. Excerpts first appeared in *Aperture* 6:1 (1958).

N920. New York: **The Museum of Modern Art.** THE PHOTOGRAPHS OF EDWARD WESTON. CATALOG BY NANCY NEWHALL. New York, 1946. 36 p., illus. (port.). *Exhibition.*

Published to accompany a retrospective exhibition of Weston's photographs. Biographical essay; twenty-four plates; chronology; list of exhibitions; selected yet extensive bibliography. Portrait of Weston by Ansel Adams.

N921. **Thompson, Dody Weston.** EDWARD WESTON. *The Malahat Review* 14 (Apr. 1970): 39–80, illus.

Personal recollections by Edward Weston's daughter-in-law. Excellent reproductions. REPRINTED in *Untitled* 1 (1972): 3–24, illus. [On Dody Weston Thompson, *see* N907.]

N922. **Weston, Charis Wilson, and Weston, Edward.** CALIFORNIA AND THE WEST. New York: Duell, Sloan & Pearce, 1940. 127 p., illus.

A narrative of a photographic expedition undertaken while Weston was a Fellow of the John Simon Guggenheim Foundation. Includes a statement by Edward Weston dealing with his approach and technique: "These are not my 'Hundred Best Photographs,' nor do they make up a full-length picture of California as I have seen it. They are a compromise of all these selecting-viewpoints and a shorthand resume of the two most prolific years of my photographic life." A *U.S. Camera* book with ninety-six photographs.

N923. **Weston, Edward.** MY CAMERA ON POINT LOBOS. Yosemite National Park, Calif.: Virginia Adams; Boston: Houghton Mifflin Co., 1950. 81 p., illus.

This volume includes thirty photographs and excerpts from the Edward Weston daybooks. Superb reproductions, the size of the original 8 x 10 in. prints. Introduction by Dody Weston Thompson [*see* N907]. Brief bibliography. REPRINTED (New York: Da Capo Press, 1968).

N924. **Weston, Edward.** PHOTOGRAPHY AS A MEANS OF ARTISTIC EXPRESSION. *Afterimage* 3 (Jan. 1976): 14.

A hitherto unpublished lecture given by Weston to the College Women's Club in Los Angeles, Oct. 18, 1916. In this lecture Weston alluded to the basic concepts of his philosophy of the "straight," unmanipulated photograph.

N925. **Whitman, Walt.** LEAVES OF GRASS. PHOTOGRAPHS BY EDWARD WESTON. New York: Paddington Press, 1976. 275 p., illus.

EARLIER EDITION (1942); REPRINTED (1976) by the Limited Editions Club with forty-nine unnumbered and uncaptioned plates. A list of titles is lacking, but the photographs themselves are cleanly reproduced on white pages, instead of the contrived backgrounds of green leaves of the original edition. The introduction to this 1976 edition is by Richard Ehrlich and concerns Weston; the original introduction by Mark Van Doren on Walt Whitman is also included.

N926. THE DAYBOOKS OF EDWARD WESTON: HOW YOUNG I WAS, PT. 1; THE STRONGEST WAY OF SEEING, PT. 2. WRITTEN, DIRECTED AND PRODUCED BY ROBERT KATZ. CAMERA WORK BY PHILIP GREENE. EDITED BY ROBERT KATZ AND PHILIP GREENE. Motion Picture. San Francisco: KQED-San Francisco Unit for National Educational Television, producing organization, 1966; Bloomington, Ind.: NET Film Service, Audio Visual Department, University of Indiana, distributing organization. 30 min.; sound, black and white, 16 mm.

N927. THE NAKED EYE. DIRECTED AND PRODUCED BY LOUIS CLYDE STOUMEN. NARRATED BY RAYMOND MASSEY. MUSIC COMPOSED AND CONDUCTED BY ELMER BERNSTEIN. Motion Picture. New York: Film Representations, distributing organization. 35 min.; sound, black and white, 71 mm.

Contains a section on Weston.

N928. THE PHOTOGRAPHER. WRITTEN BY IRVING JACOBY. DIRECTED BY WILLARD VAN DYKE. EDITED BY ALEXANDER HAMMID. PRODUCED BY THE UNITED STATES INFORMATION AGENCY. Motion picture. New York: Castle Films Division, United World Films, distributing organization. 30 min.; black and white, 16 mm.

"Van Dyke, a former student, fellow founder of Group f/64, and close friend, photographed Weston in his Carmel home, on Point Lobos, printing in his darkroom; revisited with him Death Valley, Lake Tenaya, the ghost towns and other places explored on his Guggenheim. During the shooting, Weston himself was photographing entirely in color. The only film in which he personally appears" (Nancy Newhall).

WHITE, CLARENCE HUDSON 1871–1925

N929. **Bunnell, Peter C., and White, Clarence H., Jr.** THE ART OF CLARENCE HUDSON WHITE. *Ohio University Review* 7 (1965): 40–65.

WHITE, MINOR 1908–1976

N930. **Newhall, Beaumont, and Newhall, Nancy.** MINOR WHITE. In: NEWHALL, BEAUMONT, AND NEWHALL, NANCY. A COLLECTION OF PHOTOGRAPHS. New York: Aperture, 1969. p. 34–35, illus.

[*See* N355.]

N931. **White, Minor.** BE-ING WITHOUT CLOTHES. New York: Aperture, 1970. 96 p., illus.

ALSO PUBLISHED in *Aperture* 15:3 (1969) and as the catalog of an exhibition held at the Massachusetts Institute of Technology, Nov. 3–29, 1970. Included is extensive text by Minor White, who organized the show.

N932. **White, Minor.** EQUIVALENCE: THE PERENNIAL TREND. *PSA Journal* 29 (July 1963): 168–75.

An extension of Alfred Stieglitz's concept of "The Equivalent" as a state of mind—the photographer's as well as the beholder's—which probes beneath the surface appearance. REPRINTED in *Photographers on Photography* [N50, p. 168–75].

N933. **White, Minor.** MIRRORS, MESSAGES, MANIFESTATIONS. New York: Aperture, 1969. 242 p., illus.

Photographs sized and sequenced by the artist, with statements and poetic fragments. The "image chronology" at the end of the book gives factual data on each photograph. A chronology, list of exhibitions, and extensive bibliography by Peter C. Bunnell are included.

N934. **White, Minor.** ZONE SYSTEM MANUAL: PRE-VISUALIZATION, EXPOSURE, DEVELOPMENT, AND PRINTING. New York: Morgan & Morgan, 1961. 111 p., illus.

A technical manual, with emphasis on the production of prints as the result of an aesthetic experience felt before making the exposure. [*See also* N935.]

N935. **White, Minor; with Zakia, Richard D.; and Lorenz, Peter.** THE NEW ZONE SYSTEM MANUAL. Dobbs Ferry, N.Y.: Morgan & Morgan, 1976. 139 p., illus.

[*See* N248.]

WINNINGHAM, GEOFF 1943—

N936. Houston. **The Museum of Fine Arts.** GEOFF WINNINGHAM: PHOTOGRAPHS. TEXT BY E. A. CARMEAN, JR. Houston, 1974. unpag., illus. (color).

Exhibition.

WINOGRAND, GARRY 1928—

N937. **Winogrand, Garry.** THE ANIMALS. New York: Museum of Modern Art, 1969. 54 p., illus.

Brilliant, satirical photographs of the human comedy as reflected in animals. There are forty-four photographs taken at the zoo. Includes brief biography. Afterword by John Szarkowski.

N938. **Bishop, Helen Gary.** WOMEN ARE BEAUTIFUL. PHOTOGRAPHS BY GARRY WINOGRAND. New York: Farrar, Straus & Giroux, 1975. unpag., illus.

There are eighty-four informal photographs of women, largely taken in an urban environment. Includes the essay, "Winogrand on Women." Essay by Helen Gary Bishop.

WITTICK, BEN

N939. **Packard, Gar, and Packard, Maggy.** SOUTHWEST 1880 WITH BEN WITTICK: PIONEER PHOTOGRAPHER OF INDIAN AND FRONTIER LIFE. Santa Fe, N.M.: Packard Publications, 1970. 47 p., illus.

Photographs from the collection in the Museum of New Mexico.

WORTH, DON

N940. San Francisco. **San Francisco Museum of Art.** DON WORTH: PHOTOGRAPHS 1956–1972. ESSAYS BY ANSEL ADAMS, JACK WELPOTT, AND DON WORTH. San Francisco, 1973. unpag., illus.

Exhibition: Jan. 16–Mar. 25, 1973.

O

Film

GEORGE REHRAUER

CONTENTS

INTRODUCTION

The following bibliography centers on the film itself and its escalating documentation. During the past generation, the publication of film literature has increased in an almost geometrical progression. For example, a pioneer bibliographic reference like *The Film Index* [O25] listed seven hundred book titles on the first forty years of motion pictures. A later bibliography, *Cinema Booklist* [O42], written by the present author, covered approximately the period from 1940 to 1971 and referenced 1,500 books. In a complementary publication, *Cinema Booklist: Supplement One* [O43], over nine hundred titles are listed, the great majority published from 1971 to 1973. The acceptance of the film as an art form of the twentieth century, as well as the availability of a vast reservoir of old and recent films on television, has developed an appreciable appetite for information about films. The increasing production of film books is the publishers' response to this demand.

For this bibliography, an attempt has been made to examine titles—those published over the first seventy-five years of motion picture history—that deal either totally or in part with the film in America. Until 1950 the world's screens were dominated by American films. Later, the acceptance of films dealing with more serious themes suggested reevaluation of the American film industry, which had been thought of primarily as a provider of entertainment. The recent outpouring of books about American films and filmmakers may be attributed to this reevaluation. *It should be noted that only English-language books are annotated in this work.* Few volumes dealing with aesthetics, filmmaking techniques, writing, photography, or technology are included. Fictional works dealing with American films were not considered, nor were promotional materials such as souvenir or press books.

Titles included here deal wholly or in part with the film in America. The other major criterion for inclusion is that a book offer some information or a point of view that is not readily available elsewhere. The user may, for example, find a sensationalized paperback biography listed because it is the only book about a given personality. In other instances, a book may be poor in its text but may contain outstanding visuals or an excellent annotated filmography. Usually the reasons for selection are indicated in the annotation for the individual volume. The compiler of this bibliography examined or read a large number of the books mentioned; in a very few cases, other sources were consulted for reliable information.

This bibliographic listing should not be interpreted as one of books in print. Some volumes are out of print but are available through specialized book dealers or stores. Others are candidates for reprinting by publishers—such as Arno Press, Jerome S. Ozer, or in the past B. Blom—who specialize in reissuing older volumes. In each case the annotation given for the book refers to the volume examined, which may not always be the original edition. For each book, an attempt has been made to provide information, description, and evaluation. Those entries that lack evaluations by this bibliographer may be judged as "average" works.

Much attention is paid to illustrative or visual materials. Since film is a visual experience, information can be conveyed as much by photographs and stills as by words. In most cases, an estimate is made of the illustrative material in the books.

The classification of the material was dictated by the needs of the user. Locating or retrieving information should be as simple as possible for the user. The structure of the bibliography places reference and information sources first, followed by those sections that define film and its effects. The largest sections are devoted to the films themselves and to those who make them. With some exceptions, items are listed only once and are not cross-referenced. Admittedly, the assignment of a book to a particular category is a subjective judgment. Moreover, owing to certain logistical factors, there are limitations to this bibliography. The closing date for entries was April 1974; a highly selective supplement was added about December 1975. The author acknowledges with gratitude the assistance of Enos P. Hernandez and John Gerardi in preparing the manuscript.

GEORGE REHRAUER

DOCUMENTATION AND DEFINITION OF FILM AND FILMMAKING

Reference Works

The reference works that follow represent some of the most important and valuable books about film. An attempt was made to list the outstanding volumes in each area—encyclopedias, yearbooks, almanacs, bibliographies. The reader should be aware that some books placed elsewhere in this bibliography of film may also be considered as reference sources. This is especially true of certain volumes in the short film section [*see* O379 *et seq.*] and the collective biography section [*see* O731 *et seq.*].

O1. **Aaronson, Charles, ed.** INTERNATIONAL MOTION PICTURE ALMANAC. New York. (1930—).

Probably the most used and most popular reference book dealing with film, this annual published by Quigley Publications offers biographies, film information, and data on production, distribution, and exhibition. In addition, it covers awards, newspapers, and periodicals dealing with film. Although the coverage is international, the emphasis is on the American film industry. Many useful advertisements appear in its pages.

O2. **Amberg, George, ed.** THE NEW YORK TIMES FILM REVIEWS, 1913–1970. New York: Quadrangle Books, 1971. 495 p., illus.

A one-volume collection of four hundred *New York Times* film reviews chosen from the larger seven-volume set. Selection of the reviews was dictated by a desire not only to present the major film achievements of 1913 to 1970, but also to offer a record of the growth, evolution, and development of the motion picture art. The 128 postage-stamp portraits are unimpressive. Index.

O2a. **Amberg, George; Dworkin, Martin S.; Jowett, Garth S.; and Karpel, Bernard, comps.** ONE HUNDRED AND TEN BOOKS ON FILM, CINEMA, MOVIES. Rev. ed. New York: Arno Press, 1975. 26 p.

An annotated list for a selection of reprints, domestic and foreign. The latest catalog includes dissertations on film, published for the first time. Reference should be made to the *1976 Catalog of Benjamin Blom Books Now Published by Arno Press,* since it contains in the sections on "Film" and "Theatre—United States" important reprint titles, and to another 1976 catalog: *The Performing Arts: Theatre, Cinema, Music, Dance.*

O3. **American Film Institute.** THE AMERICAN FILM INSTITUTE CATALOG. EDITED BY KENNETH W. MUNDEN. New York: R. R. Bowker Co., 1971. 2 vols.

The subject of this first of nineteen projected publications is some 7,000 American feature films made from 1921 to 1930. The first volume lists the films in alphabetical order, giving data, credits, sources, synopses. The second volume includes three indexes: persons, institutions, and corporate names credited in the films; literary and dramatic sources; and subjects.

O4. **Artel, Linda J., and Weaver, Kathleen, comps.** FILM PROGRAMMER'S GUIDE TO 16MM RENTALS. Albany, Calif.: Reel Research, 1973. 164 p.

A limited reference book with a listing of 8,000 selected feature and short films. The one-line entries for each film offer concentrated, abbreviated data—director, running time, date, distributor, rental cost. It should be noted that educational films are not treated and that the 8,000 films listed are only a sampling of what is available. However, this paperback edition is a tightly packed source of film information.

O4a. **Batty, Linda.** RETROSPECTIVE INDEX TO FILM PERIODICALS, 1930–1971. New York: R. R. Bowker Co., 1975. 425 p.

This bibliography uses as its base the entire contents of fourteen English-language film periodicals. In addition, film reviews and articles from *The Village Voice* are included. Three separate but interrelated sections comprise the text: film titles, film subjects, and film book review citations. The forty-year scope of this index makes it a most useful aid in film research.

O5. **Blum, Eleanor.** BASIC BOOKS IN THE MASS MEDIA. Urbana: University of Illinois Press, 1972. 252 p.

In this selected bibliography of 665 annotated titles, 109 are devoted to motion pictures. Whether the titles selected are "basic" is questionable; some are perhaps more appropriate for categories other than film.

O5a. **Bowles, Stephen E., ed.** INDEX TO CRITICAL FILM REVIEWS. New York: Burt Franklin, 1974. 2 vols.

A two-volume reference work that contains two parts: an index to 20,000 reviews of 600 films and an index to 6,000 reviews of 1,200 books on film. Several supporting indexes for directors, reviewers, and authors are included. The period covered is 1930 to 1972, and some

twenty-nine English-language periodicals were used. Although this is a valuable and useful reference source, it offers only a selected and limited content.

O6. Cawkwell, Tim, and Smith, John M., eds. WORLD ENCYCLOPEDIA OF THE FILM. New York: World Publishing Co., 1973. 444 p., illus.

Films and personalities are the two major elements of this reference work. A biographical dictionary with almost 2,000 entries offers relatively complete filmographies. Director coverage is comprehensive. The other major part of the volume is devoted to a listing of 20,000 films (through 1971) along with cast, credits, and other information. Almost 500 photographs are used in the book.

O6a. Chaneles, Sol, and Wolsky, Albert, eds. THE MOVIE MAKERS. Secaucus, N.J.; Derbibooks, 1974. 544 p., illus.

A biographical dictionary of over 2,500 film performers and directors. Each entry offers limited and selected information, which often varies in pertinence and occasionally in accuracy. Over 1,000 photographs accompany the abundance of information. A name index is provided for cross-listings.

O7. New York. **Cinemabilia.** CATALOGUE OF FILM LITERATURE. New York, 1972. 264 p., illus.

Sales catalog.

Some 3,500 entries are listed under seventeen headings in this dealer's softcover catalog. Annotations consist of a few words and do not evaluate the work in question. An author-name index is appended. Reference use is difficult if the classified heading is not known.

O8. Cowie, Peter, ed. INTERNATIONAL FILM GUIDE. New York. (1949—), illus.

In addition to an American section in the world survey, many of the articles in this annual reference volume published by A. S. Barnes deal with American films, directors, awards, and books. Hundreds of stills appear throughout, and although many are small, they are well reproduced. Contains much advertising.

O9. Dimmitt, Richard, comp. ACTOR'S GUIDE TO THE TALKIES. Metuchen, N.J.: Scarecrow Press, 1967. 2 vols.

Vol. 1 lists 8,000 American and foreign feature films made from 1949 to 1964 alphabetically by title. Data given include year of production, producing company, and cast. Vol. 2 is an alphabetical index of more than 30,000 names of performers with page references to vol. 1.

O10. Dimmitt, Richard, comp. A TITLE GUIDE TO THE TALKIES. Metuchen, N.J.: Scarecrow Press, 1965. 2 vols.

These two volumes provide an alphabetical listing of 16,000 feature-length films made from 1927 to 1963. For each film entry, the release date, the copyright applicant, and the source material upon which the film was based are given. This source material includes author, pub-

lisher, date, pagination. An index of author's names is appended.

O11. DIRECTORS GUILD OF AMERICA: DIRECTORY OF MEMBERS. Hollywood, Calif.: Directors Guild of America, 1971. 369 p., illus.

A listing of current active members of the Directors Guild of America. Entry length and content vary considerably: some offer biographical data and credits while others indicate only name, home city, and directorial ranking. Revised and updated periodically.

O12. INTERNATIONAL INDEX TO MULTI-MEDIA INFORMATION. Pasadena, Calif. (1970—).

An annual index of film reviews published by Audio-Visual Associates. Published cumulatively in four issues each year, this reference work examines more than ninety publications in its search for film reviews. Films are first arranged alphabetically by title with review citations listed below each. In a second section, the films are rearranged under subject headings. Distributors' data included. PUBLISHED AS *Film Review Index* 1—3 (1970—1972), edited by Wesley A. Doak and William J. Speed.

O13. Donchin, Fannie, comp. MOVIES FOR TV: TWENTY-ONE YEARS OF RATINGS. Mount Vernon, N.Y.: Consumers Union, 1968. 48 p.

A summary of ratings for almost 6,000 feature films from 1947 to 1968. Subscribers to Consumers Union supply one averaged rating while the consensus of the professional critics is also expressed in a single rating. The ratings are generally in agreement. Paperback.

O14. Enser. A. G. S., comp. FILMED BOOKS AND PLAYS. New York: London House & Maxwell, 1968. 448 p.

This reference volume, occasionally updated, lists titles of British and American films produced during the sound era that had their origin in books and plays. Three indexes are given: Film Title, Author, and Change of Original Title. Not completely exhaustive, but a valuable source of information.

O15. Fawcett, Marion, and Lester, Sandra, eds. INDEX TO FILMS IN REVIEW. New York. (1961—).

One of the oldest and best film periodicals is *Films in Review*, published by the National Board of Review of Motion Pictures. The following indexes are currently available: *Index to Films in Review: 1950—1959*, and *Index to Films in Review: 1960—1964*, by Marion Fawcett; and *Index to Films in Review: 1965—1969*, by Sandra Lester.

O16. WID'S YEAR BOOK, 1918-1922. New York. various dates, illus.

Issued as a reprint of the original edition by Arno Press. Also issued by Arno Press as part of a complete microfilm of the *Film Daily Yearbook of Motion Pictures, 1918—1969* [O17], which absorbed *Wid's*. The initial four volumes offer a comprehensive portrait of an evolutionary period in the motion picture industry. The volumes when

ISSUED covered respectively 1918, 1919–1920, 1921, and 1921–1922: *Wid's Year Book*, New York, 1–4 (1918–1922).

O17. FILM DAILY YEARBOOK OF MOTION PICTURES, 1918-1919. Microfilm. New York: Arno Press, 1972. 18 reels.

Includes vols. 1–4, *Wid's Year Book*, 1918–1922, and subsequent yearbooks, 1923–1969, in microfilm only. The books offer a vast amount of information on all aspects of the motion picture, including "approximately 33,000 films issued since 1915" annually reported by the *Film Daily* (New York). [For 1970, *see* O18.]

O18. **Fordin, Hugh, ed.** FILM DAILY YEARBOOK: 1970. New York: Arno Press, 1970. 1074 p., illus.

This oversized yearbook is a most popular and useful film reference. The fifty-eighth EDITION is scheduled for 1976. Known as the bible of the American film industry, it prints data, statistics, credits, information, articles. In 1970 it incorporated television coverage. [For other editions, *see* O16, O17.]

O19. **Fisk, Margaret, ed.** ENCYCLOPEDIA OF ASSOCIATIONS. Detroit: Gale Research Co., 1968. Vol. 1.

This limited reference source notes the organizations—both existing and defunct—concerned with film matters. Several indexes help the user locate the information relevant to film.

O20. **Forman, Evan, comp.** INTERNATIONAL DIRECTORY OF 16MM FILM COLLECTORS. Mobile, Ala.: Privately printed, 1973. 69 p.

This paperback volume appears at irregular intervals and lists the names and addresses of those individuals in the United States who collect films. Arrangement of names is by state, and occasionally special interests of the collectors are noted.

O21. **Fredrik, Nathalie, ed.** HOLLYWOOD AND THE ACADEMY AWARDS. Los Angeles: Award Publications, 1968. 203 p., illus.

The focus in this survey is on the acting awards and the best film. For each year from 1927 to 1967, the winners in each of the four acting categories and the best film are described by a short paragraph. Other category winners are summarized by decades. Picture selection and reproduction is ordinary. Designed for mass audience popularity, the book is only of limited reference value for the awards. Updated at intervals under various titles.

O21a. **Gerlach, John, and Gerlach, Lana, comps.** THE CRITICAL INDEX: A BIBLIOGRAPHY OF ARTICLES ON FILM IN ENGLISH, 1946-1973. ARRANGED BY NAMES AND TOPICS. New York: Teachers College Press, 1974. 774 p.

A computer-generated bibliography of periodical articles about film. Twenty-two "primary" English-language periodicals covering the period from 1946 to 1973 were indexed to provide some 5,000 items arranged by name and topic. Reservations about this reference may include its limited coverage and its arrangement of material. An author index and a title index help somewhat.

O22. **Graham, Peter, ed.** A DICTIONARY OF THE CINEMA. New York: A. S. Barnes, 1964. 158 p., illus.

This small volume includes 628 entries—mostly biographies and definitions—and has an index to over 5,000 film titles mentioned in the text. The range is worldwide, and thus the editor was obliged to be selective. Picture reproduction is only fair. Revised occasionally, this book is useful for quick reference.

O23. **Halliwell, Leslie, ed.** THE FILMGOER'S COMPANION: FROM NICKELODEON TO NEW WAVE. 2d ed. New York: Hill & Wang, 1967. 847 p.

This encyclopedic reference work, which concentrates on American and British films, personalities, and themes, is updated and expanded regularly. The fourth edition promises more than five hundred photographs and about three times the number of listings found in the original volume. The numerous entries are accurate, well written, and concise, making this book one of the most valuable film reference volumes available.

O24. **Jones, Karen, ed.** INTERNATIONAL INDEX TO FILM PERIODICALS, 1972. New York: R. R. Bowker Co., 1973. 344 p.

A reference book that indexes about sixty film periodicals selected from both English-speaking and other countries. In this particular volume there are 7,000 annotated entries of varying length and quality arranged under eleven broad categories. Annotations are brief but satisfactory, and a final subject index facilitates use of the book.

O25. **Leonard, Harold, ed.** THE FILM INDEX: A BIBLIOGRAPHY. VOL. 1: THE FILM AS ART. New York: Arno Press, 1966. 723 p., illus.

An exhaustive and pioneer bibliography compiled under the sponsorship of the Museum of Modern Art Film Library and H. W. Wilson Company. Still crucial, this classified and annotated bibliography of film literature to 1936 presents more than 8,500 entries covering 700 books, 3,000 articles and 4,000 film reviews. Some of the sections include history, technique, types of film, actors, directors, etc. Excellent index. ORIGINAL EDITION: Compiled by the Film Writers section, WPA (New York: H. W. Wilson Co., and the Museum of Modern Art Film Library, 1941).

O26. **Library of Congress.** THE LIBRARY OF CONGRESS CATALOG: MOTION PICTURES AND FILMSTRIPS. Washington, D.C. (1948—).

A separate listing of films and filmstrips for which copyright application was made. The following volumes have been issued or announced: vol. 24 for 1948–1952 (1953), Ann Arbor: J. W. Edwards; vol. 28 for 1953–1957 (1958); vols. 53, 54 for 1958–1962 (1963); and vols. 71, 72 for 1963–1967 (in preparation).

O27. **Limbacher, James L., comp.** FEATURE FILMS ON 8MM AND 16MM: A DIRECTORY OF 8MM AND 16MM

FEATURE FILMS AVAILABLE FOR RENTAL, SALE, AND LEASE IN THE UNITED STATES. 3d ed. New York: R. R. Bowker Co., 1971. 269 p.

This listing of over 10,000 films provides specific information on studio, release date, time, actors. Distributor data are also offered. Some of the information is either outdated or fragmentary, but the work is constantly supplemented, updated, and revised. Most of the films are of American origin. Includes an index of directors and a list of film reference works.

O28. Low, John B., comp. MOTION PICTURE, TV, AND THEATRE DIRECTORY. Tarrytown, N.Y.: Motion Picture Enterprises Publishers, 1972. 148 p., illus.

A guide to companies that supply services and products to films, television, and the theater in the United States. In addition to the expected listings, there are some unusual ones, such as rentals on trained animals, helicopters, and underwater filming equipment. Published semi-annually. Paperback.

O29. Hollywood, Calif. **Larry Edmunds Bookshop.** CINEMA CATALOG. EDITED BY GIT LUBOVSKI. Hollywood, various dates. illus.

Sales catalog.

A dealer's catalog of film literature and materials that is a concentrated source of reliable information. No evaluations are offered, but the data given are interesting and valuable—descriptive annotations, authors, dates. Designed to promote sales, but useful nevertheless; published at convenient intervals.

O29a. MacCann, Richard Dyer, and Perry, Edward S., comps. THE NEW FILM INDEX. New York: E. P. Dutton & Co., 1975. 542 p.

A massive reference work that provides a bibliography of magazine articles in English from 1930 to 1970. It classifies the hundreds of articles into 278 categories, which are listed under nine major headings. A general index to the articles is also provided. About forty film periodicals have been indexed completely; many other general periodicals have been cited for pertinent articles. The volume differs considerably from *The Film Index* [O25], but it can be used with the same high degree of satisfaction.

O30. McCarty, Clifford, comp. FILM COMPOSERS IN AMERICA: A CHECKLIST OF THEIR WORK. Hollywood: Oxford Press, 1953. 193 p.

An early McCarty checklist of 165 composers covering both the sound and silent eras. The second section lists many films alphabetically with a numerical reference to the composer.

O31. Maltin, Leonard, comp. TV MOVIES. New York: Signet Books, 1970. 536 p., illus.

Over 8,000 films are listed alphabetically by title in this useful reference book. Each entry includes rating, release date, running time, director, several cast names, and synopsis. Paperback.

O32. Manvell, Roger, ed. THE INTERNATIONAL ENCYCLOPEDIA OF FILM. New York: Crown Publishers, 1972. 574 p., illus.

An impressive reference book with more than 1,200 entries that concentrate on film as art and as industry. Filmmaking, technology, and other specialized, complex topics are treated, along with general terms and definitions, national cinemas, and personalities. A chronology of film history, a bibliography, and more than 1,000 visuals are also included. The index of film titles lists more than 6,500 entries, and a separate index contains over 3,000 names.

O33. Michael, Paul, comp. THE ACADEMY AWARDS. Indianapolis: Bobbs-Merrill Co., 1964. 341 p., illus.

A pictorial record from 1929 to 1964. Notes winners in most categories, but unsuccessful nominees are not listed. Revised and updated periodically. Over 300 photographs. Index.

O34. Michael, Paul, ed. THE AMERICAN MOVIES REFERENCE BOOK: THE SOUND ERA. Englewood Cliffs, N.J.: Prentice-Hall, 1969. 629 p., illus.

A large reference book divided into six sections: history, players (600), films (1,000), directors (50), producers (50), and awards. The selected entries under each vary in length and quality, but much detail and information is offered. Covers the American sound film to 1967 with both text and hundreds of visuals. The films and players sections are now available as separate volumes. Bibliography; index.

O35. National Audiovisual Center, comp. GOVERNMENT FILMS. Washington, D.C.: General Services Administration, 1969. 165 p.

A catalog of films and filmstrips—made by the many agencies of the United States government—that are currently available for purchase. The films are arranged under subject headings, and a descriptive annotation is provided for each. An alphabetical title list concludes the catalog. Revised and updated at irregular intervals.

O36. INDEX TO THE NEW YORK TIMES FILM REVIEWS, 1913–1968. New York, Arno Press, 1970. 1,142 p., illus.

Planned for the six-volume edition, this volume contains a personal name index with a complete list of films to 1968, citations to the *Times* reviews, a film title index, a film corporation index, an awards section, and a postage-stamp picture gallery of 2,000 film performers. The index (vol. 6) can be used independently in a variety of ways without the other five volumes.

O37. THE NEW YORK TIMES FILM REVIEWS, 1913–1972. New York: New York Times, 1970–1973. 9 vols., illus.

A massive reference work consisting of eight volumes of reviews and an index. More than 22,000 *Times* film reviews covering the years 1913 to 1972 are reprinted in the chronological order of their first appearance in that newspaper. The three-part index volume has more than 25,000 entries providing access to the reviews by person,

title, or production company. Portraits, awards, and other features are also offered by this 1,300-page index. In addition, there is a six-volume edition (1913–1968) and separate volumes (including an index) for 1969–1970, 1971–1972, and 1973–1974 available for independent purchase. [See also O2, O38.]

O38. THE NEW YORK TIMES DIRECTORY OF THE FILM. New York: Arno Press, 1971. 1,243 p., illus.

A most useful reference work derived from the much more elaborate *New York Times* film review set of six large volumes. An awards section is followed by reprints of reviews of over 500 films selected by the various awards groups. The largest section is the personality index, which gives filmographies in the form of *Times* reviews from 1913 to 1968 for actors, directors, writers, etc. A picture gallery of 2,000 actors and a film corporation index conclude the book. [See O2.]

O39. **Niver, Kemp R., and Bergsten, Bebe, eds.** MOTION PICTURES FROM THE LIBRARY OF CONGRESS PRINT COLLECTION 1894–1912. Berkeley: University of California Press, 1967. 402 p.

Descriptions of about 3,000 films produced the world over during the first eighteen years of the existence of the motion picture are presented in this reference volume. The films were transferred from the original paper prints deposited for copyright purpose. This catalog lists casts, length, dates, and other data that are available. Note that this group constitutes only about one-third of the total number of films produced during those early years. Index.

O39a. **Pickard, Roy, ed.** A COMPANION TO THE MOVIES FROM 1903 TO THE PRESENT DAY. New York: Hippocrene Books, 1974. 287 p., illus.

A reference book that contains over 1,000 entries about films and filmmakers distributed among twelve genre categories. The text consists primarily of mini-biographies and film reviews. There are some fine appendixes for cameramen, film scores, original scripts, and Academy Awards. A wealth of information is offered; some good illustrations and a name index add further dimension to the work. Minor reservations may be noted concerning selection placement and the lack of a film title index.

O40. **Osborne, Robert, ed.** THE ACADEMY AWARDS ILLUSTRATED. La Habra, Calif.: Ernest Schworck, 1969. 321 p., illus.

Considers only five categories: the best picture and the four acting awards. The text offers description and background for each year's awards. All nominees are indicated, and short biographies of winners are given. Revised and updated periodically. Over 500 photographs.

O41. **Pickard, R. A. E., ed.** DICTIONARY OF ONE THOUSAND BEST FILMS. New York: Associated Press, 1971. illus.

This book deals predominantly with American films, but its scope is international. Film entries are listed in alphabetical order and include the major players, a synopsis, comments, and production credits. Some stills from the films are adequately reproduced. Pickard's selection is obviously subjective, but his criteria are serviceable: personal, critical, and/or popular acceptance seem to determine his choices. A useful reference work that is also delightful reading.

O41a. **Powers, Anne, ed.** BLACKS IN AMERICAN MOVIES: A SELECTED BIBLIOGRAPHY. Metuchen, N.J.: Scarecrow Press, 1974. 157 p.

This bibliography is an excellent guide to information about blacks in American films. The major section notes 662 periodical articles while other sections include a filmography (1904–1930) and an author-subject index. A most valuable reference work.

O42. **Rehrauer, George, ed.** CINEMA BOOKLIST. Metuchen, N.J.: Scarecrow Press, 1972. 473 p.

A comprehensive guide to film literature with the emphasis on titles published from 1940 to 1970. All subject classifications and all formats of books are considered. Over 1,600 evaluative descriptions are offered. Lists of published screenplays and film periodicals are appended along with indexes for author and subject.

O43. **Rehrauer, George, ed.** CINEMA BOOKLIST: SUPPLEMENT ONE. Metuchen, N.J.: Scarecrow Press, 1972. 405 p.

A continuation of the guide to film literature begun with *Cinema Booklist* [O42], this volume emphasizes books published from 1971 to 1973. Some 900 titles are described and evaluated. In addition, more than 100 souvenir books are noted, and there is an index to interviews of over 400 filmmakers. A cumulative subject index and author index complete the work.

O44. **Reid, Seerley, and Grubbs, Eloyse, comps.** U.S. GOVERNMENT FILMS FOR PUBLIC EDUCATIONAL USE: CIRCULAR NUMBER 742. Washington, D.C.: Government Printing Office, 1968. 532 p.

A selective list of 6,000 films that belong to the federal government. Distribution and reproduction rights vary with each film. All pertinent data are given for the films, including a lengthy subject index and a list of sources.

O45. **Reilly, Adam, comp.** CURRENT FILM PERIODICALS IN ENGLISH. New York: Educational Film Library Association, 1972. 25 p.

A useful paperback listing of English-language film periodicals with much detailed information about each. Price, size, content, theme, and the like are noted.

O46. **Roberts, James R., ed.** ACADEMY PLAYERS DIRECTORY. Los Angeles. (1937—), illus.

An annual pictorial guide to many American actors currently available for film work. Two large volumes were published for 1972; the first lists women and children, the

second, men. Credits, addresses, agents are noted along with a photograph of each actor. This paperback is published by the Academy of Motion Picture Arts and Sciences.

O47. Sadoul, Georges, ed. DICTIONARY OF FILM-MAKERS. Berkeley: University of California Press, 1972. 288 p.

This excellent paperback reference work lists about 1,000 filmmakers—directors, cameramen, writers, etc. Each entry gives biographical information, a filmography, and some critical comments.

O48. Sadoul, Georges, and Morris, Peter, eds. DICTIONARY OF FILMS. Berkeley: University of California Press, 1972. 432 p.

Over 1,000 films that the authors consider important have been incorporated. The scope is wide in that it encompasses films made in fifty countries over seventy years. Arranged alphabetically by title, each entry gives country of origin, date, technical data, credits, plot summary, background information, and critical comment. Many American films appear throughout the volume. Paperback.

O49. Salem, James M., comp. A GUIDE TO CRITICAL REVIEWS. PT. 4: THE SCREENPLAY FROM THE JAZZ SINGER TO DR. STRANGELOVE. Metuchen, N.J.: Scarecrow Press, 1971. 2 vols.

A bibliography of reviews of feature films released from 1927 to 1963. Nearly 12,000 films are cited with reviews appearing in film periodicals and in the *New York Times.* A very valuable and useful reference work.

O50. Scheuer, Steven H., ed. MOVIES ON TV. 6th ed. New York: Bantam Books, 1971. 498 p.

A paperback reference book designed primarily for home use with a television set, this volume has many other possible uses. Listing 8,000 feature films alphabetically, it offers a release date, a rating, some cast names, a short synopsis, and a few words of evaluation. Editions are revised and updated at approximately four-year intervals.

O51. Schoolcraft, Ralph Newman, ed. PERFORMING ARTS BOOKS IN PRINT. New York: Drama Book Specialists, 1973. 761 p.

This newly entitled updating of the former *Theatre Books in Print* includes a large section on motion pictures, television, and radio. The coverage is not comprehensive but selective. Several hundred volumes pertaining to film have been included by the editor, placed under large subject headings, and then arranged alphabetically according to author. The annotations are descriptive rather than evaluative. Author and subject indexes and a list of publisher addresses complete this valuable reference work.

O52. Schuster, Mel, ed. MOTION PICTURE DIRECTORS. Metuchen, N.J.: Scarecrow Press, 1973. 418 p.

Another fine bibliographic reference tool for locating ar-

ticles in periodicals. Twenty-three hundred film directors, filmmakers, and animators are arranged alphabetically. Articles are listed chronologically under each entry. The author used 340 periodicals from 1900 to 1972 in compiling this bibliography. His effort and achievement are obvious throughout this useful volume.

O53. Schuster, Mel, ed. MOTION PICTURE PERFORMERS: A BIBLIOGRAPHY OF MAGAZINE AND PERIODICAL ARTICLES, 1900–1969. Metuchen, N.J.: Scarecrow Press, 1971. 702 p.

Several thousand motion picture actors are listed alphabetically in this most helpful reference work. Under each name, the articles about the actor that have appeared in magazines and periodicals from 1900 to 1969 are cited in chronological order. This is a basic reference-research tool that has impressive scope and design.

O53a. Seltz-Petrash, Ann, and Wolff, Kathryn, eds. AAAS SCIENCE FILM CATALOG. New York: R. R. Bowker Co., 1975. 398 p.

This catalog, developed by the American Association for the Advancement of Science (AAAS), identifies some 5,600 science films currently available from commercial, government, industry, and university sources. The films are divided according to their suitability for two specific audiences; the elementary school group and the junior high to adult group. Arranged in each section according to the Dewey Decimal System, the entries are descriptive and informational rather than evaluative. The content and its arrangement for easy reference make this book a most welcome aid.

O54. Speed, F. Maurice, ed. FILM REVIEW. New York. (1947—), illus.

This handsome annual survey of world cinema published by A. S. Barnes includes American films. Its many sections are highlighted by good illustrations and quality texts. Especially valuable for reference is the annotated critical filmography of the year's releases. Index.

O55. Spigelgass, Leonard, ed. WHO WROTE THE MOVIE AND WHAT ELSE DID HE WRITE? Los Angeles: Academy of Motion Picture Arts and Sciences, 1970. 491 p.

A reference work for the period from 1936 to 1969 that lists some 2,000 screen writers and the films for which they wrote. Other writing credits are also noted. The film index of 13,000 entries includes writers, producing companies, and alternate titles. A final, indexed section is devoted to writing awards.

O56. Thompson, Howard, ed. THE NEW YORK TIMES GUIDE TO MOVIES ON TV. Chicago: Quadrangle Books, 1970. 223 p., illus.

Arranged alphabetically by title, 2,000 films released for the most part from 1950 to 1969 are reviewed in brief for television viewers. Illustrations are good, film data are quite complete, and critical comments are often devastating. Paperback.

O57. Los Angeles. **University of California of Los Angeles, Theatre Arts Library.** MOTION PICTURES: A CATALOG OF BOOKS, PERIODICALS, SCREEN PLAYS AND PRODUCTION STILLS. Boston: G. K. Hall & Co., 1973. 2 vols., illus.

A reference work that lists the holdings of UCLA's Theatre Arts Library. Documents on the cinema include books, periodicals, personal papers, clippings, and production records. More than 87,000 stills are noted along with some 3,000 unpublished screenplays.

O58. **United States Copyright Office.** MOTION PICTURES (IDENTIFIED FROM THE RECORDS OF THE U.S. COPYRIGHT OFFICE). Washington, D.C.: Government Printing Office, 1953–1960. 4 vols.

Although the format of these volumes varies, generally the first section lists film titles and data, the middle section notes the copyright claimants, and the final section is devoted to series. Volumes published include: 1894–1912 (1953), 92 p.; 1912–1939 (1951), 1256 p.; 1940–1949 (1953), 599 p.; and 1950–1959 (1960), 494 p. For films after 1959, consult the *Library of Congress Catalog: Motion Pictures and Filmstrips* [O26].

O59. **Vincent, Carl; Redi, Riccardo; and Venturini, France, eds.** GENERAL BIBLIOGRAPHY OF MOTION PICTURES. New York: Arno Press, 1972. 252 p.

An Italian-French-English bibliography of books and articles in periodicals. Entries from 1910 to 1950 are arranged alphabetically by author under eleven major headings. This trilingual reference work is difficult to use and treats many obscure European sources that are hard to obtain. An Arno reprint of the ORIGINAL EDITION (Padua, 1953) produced by the Cinematographic Center of Padua.

O60. **Wasserman, Paul, ed.** AWARDS, HONORS, AND PRIZES. Detroit: Gale Research Co., 1972. 579 p.

This reference work deals with awards in business, art, literature, etc., in addition to those offered in the field of motion pictures. The information is cross-indexed for easy retrieval.

O61. **Weaver, John T.** FORTY YEARS OF SCREEN CREDITS. Metuchen, N.J.: Scarecrow Press, 1970. 2 vols., illus.

A listing of several thousand actors along with their screen credits given in chronological order. This useful reference work covers the period 1929 to 1969. The few photos are unnecessary but pleasing.

O62. **Weaver, John T.** TWENTY YEARS OF SILENTS. Metuchen, N.J.: Scarecrow Press, 1971. 514 p.

A guide to the credits of actors, directors, and producers active in silent films after 1908. Each entry provides birth and death dates and a chronological listing of film credits. A listing of silent film producers and distributors completes the book.

O63. **Weber, Olga S., ed.** AUDIOVISUAL MARKETPLACE: A PARTIAL FILM REFERENCE. New York: R. R. Bowker Co., 1970. 187 p.

This informative paperback source book contains material about distributors, film review services, film libraries, professional organizations, film festivals, etc. Emphasis is on the educational or short film. Revised periodically, this work contains a bibliography and an index.

O64. **Willis, John, ed.** SCREEN WORLD. New York. (1949—). illus.

This annual picture book, almanac, and reference work usually offers over one thousand well-reproduced photographs along with a survey of the year's casts, personnel, credits, and other topics. Index.

O65. **Young, William C., ed.** AMERICAN THEATRICAL ARTS: A GUIDE TO MANUSCRIPTS AND SPECIAL COLLECTIONS IN THE U.S. AND CANADA. Chicago: American Library Association, 1971. 168 p.

Although the emphasis is on theatrical materials, this survey of 138 collections is also useful for locating film items. Collections are listed by state; there is an index of subjects and personalities.

O66. **Zwerdling, Shirley, ed.** FILM AND TV FESTIVAL DIRECTORY, WORLDWIDE. New York: Back Stage Publications, 1970. 174 p.

This directory of information about international film festivals contains one large section on activities in the United States, listing awards, categories, dates, and other information.

Filmmaking as Art and Craft

The titles that follow were selected from the large reservoir of books on filmmaking. Works in this subject area tend to be either theoretical discussions or practical treatises that advise the reader on methods and techniques. Moreover, most of the works within this subject area are international in scope. The titles listed here are those that relate specifically to American filmmaking.

AESTHETICS

O67. **Coynik, David.** FILM: REAL TO REEL. Winona, Minn.: St. Mary's College Press, 1972. 274 p., illus.

Described as a "companion book for a course in film study." Using hundreds of film examples in both text and

stills, the author considers aesthetics, genres, directors, and several other topics. Many short films are cited in support of his statements. Paperback.

O68. **Durgnat, Raymond.** FILMS AND FEELINGS. Cambridge, Mass.: M.I.T. Press, 1967. 288 p., illus.

This rather verbose discussion examines film as a popular and cultural art and tries to formulate an aesthetic for cinema. Many American films are considered in the four sections of the text, which is original, perceptive, and witty. The picture section is quite unimpressive. A bibliography and an index of the films discussed in the text complete the volume.

O69. **Fischer, Edward.** FILM AS INSIGHT. Notre Dame, Ind.: Fides Publishers, 1971. 208 p., illus.

Films as a reflection of man is the theme of this excellent paperback volume. The first section discusses techniques that filmmakers use to indicate what it is like to be "a person." The second, longer section offers examples from many films in support of the author's thesis that the finest films are mirrors of man. Index.

O70. **Freeburg, Victor Oscar.** THE ART OF PHOTOPLAY MAKING. New York: Arno Press, 1970. 191 p., illus.

An early discussion of film aesthetics as presented at Columbia University, 1915–1916, and originally published in 1918.

O71. **Gessner, Robert.** THE MOVING IMAGE: A GUIDE TO CINEMATIC LITERACY. New York: E. P. Dutton & Co. 1968. 444 p., illus.

The author considers the shooting script the major element in filmmaking and devotes this volume to a study of film writing and production. Analyses of many scenes from American films are presented along with good illustrations, cinema literacy tests, film lists, rental sources, and an evaluation chart. Other useful features include a glossary, a bibliography, and an index, each of them extensive.

O72. **Jacobs, Lewis.** INTRODUCTION TO THE ART OF THE MOVIES. New York: Farrar, Straus & Giroux, 1960. 302 p., illus.

A paperback collection of articles that explore various aspects of film as an art form. Thirty-six contributors are represented from the 1910 period to the fifties. Their articles vary widely in style, content, and quality.

O73. **Jacobs, Lewis.** THE MOVIES AS MEDIUM. New York: Farrar, Straus & Giroux, 1970. 335 p., illus.

This anthology, designed to explain the nature of film art, includes articles by twenty-two filmmakers. References are made to many American films. Some excellent illustrations, a bibliography, and an index complete the volume.

O74. **Kinder, Marsha, and Houston, Beverle.** CLOSE-UP. New York: Harcourt Brace Jovanovich, 1972. 395 p., illus.

In this attempt to establish a film aesthetic, the authors analyze many films critically. Their approach is historical-chronological and includes examples of American film. This paperback edition, which includes good illustrations, provides a distributor list.

O75. **Kirschner, Allen, and Kirschner, Linda.** FILM: READINGS IN THE MASS MEDIA. New York: Odyssey Press, 1971. 315 p.

This paperback anthology addresses itself to three aspects of film: form and technique, audience and effect, and criticism. Authors who represent different periods in film history have been selected to provide diverse comments, and viewpoints. Many of the contributors are part of American motion picture history: D. W. Griffith, Mack Sennett, James Agee, Irving Thalberg.

O76. **Kuhns, William, and Stanley, Robert.** EXPLORING THE FILM. Dayton: George A. Pflaum, 1968. 190 p., illus.

This exceptional paperback text book on film appreciation considers many elements of motion pictures and presents them in an attractive format. Visuals are used intelligently to involve the reader and to complement the informative text.

O77. **Lawson, John Howard.** FILM: THE CREATIVE PROCESS. New York: Hill & Wang, 1964. 380 p., illus.

Written in the Soviet Union by a blacklisted Hollywood screen writer, this book applies Marxist theory to films. The emphasis is on Russian film achievements, but the author discusses the work of American directors such as Griffith, Chaplin, and von Stroheim, and provides analyses of American films such as *Greed* (1923), *City Lights* (1931), and *Citizen Kane* (1941).

O78. **Limbacher, James L.** FOUR ASPECTS OF THE FILM. New York: Brussel & Brussel, 1969. 386 p., illus.

Color, width, depth, and sound are the subjects of the title. Each is treated historically with text, references, diagrams, and illustrations. A bibliography, several appendixes, and an index round out the volume.

O79. **Lindsay, Vachel.** THE ART OF THE MOVING PICTURE. New York: Liveright, 1970. 324 p.

This is a reprint of an early attempt to formulate and establish the importance of film as an art form. Not only was Lindsay a poet and an initiator of film criticism, but his theories of film foreshadowed those of many later authorities. The status of the American film during the early silent years as considered here is vital to an understanding of the evolution of the motion picture in the United States. This classic volume was probably the first text book in film study. Index. ORIGINAL EDITION (Macmillan Co., 1915). Less known is the MACMILLAN, 1922, EDITION containing a preface by the director of The Art Institute of Chicago, George William Eggers, the first recognition by the American museum world of the cultural import of this new popular medium. [For Lindsay aesthetics, *see* O85.]

O80. **McAnany, Emile G., and Williams, Robert, S. J.** THE FILMVIEWER'S HANDBOOK. Glen Rock, N.J.: Paulist Press, 1965. 208 p.

Many topics pertinent to American films are treated in this paperback handbook. After discussing film history and language, the book describes the organization of a film society. Includes several useful appendixes and a fine annotated bibliography.

O81. **Manvell, Roger.** FILM. Baltimore: Penguin Books, 1950. 240 p., illus.

An early paperback classic that surveys selected areas of world cinema: history, sociology, aesthetics, etc. The Manvell text is literate and persuasive. American films are treated throughout. There are small but adequate visuals provided in a center section. Indexes, appendixes, and a bibliography all add to this influential and frequently reissued work.

O82. **Russ, T. J.** FILM AND THE LIBERAL ARTS. New York: Holt, Rinehart & Winston, 1970. 419 p.

A paperback anthology-text that examines the relationship of film to certain liberal arts. Under each liberal art category, several articles appear, followed by suggested questions. The book is indexed, and a short bibliography is appended, along with a group of recommended films.

O83. **Solomon, Stanley J.** THE FILM IDEA. New York: Harcourt Brace Jovanovich, 1972. 403 p., illus.

A triangular exploration in paperback of the narrative film. A discussion of the elements of film is followed by a historical account of the development of the narrative film. Some theories of aesthetics are reviewed in the final section. Many American films and personalities appear in the text and in the attractive illustrations. Glossary; selected filmography; bibliography; and index.

O84. **Talbot, Daniel, ed.** FILM: AN ANTHOLOGY. New York: Simon & Schuster, 1959. 650 p.

Talbot's collection includes articles of varying quality on the theory, aesthetics, history, and criticism of American film, particularly for the period 1923–1957. Includes essays by many well known contributing authors.

O85. **Wolfe, Glenn Joseph.** VACHEL LINDSAY: THE POET AS FILM THEORIST. New York: Arno Press, 1973. 191 p.

A doctoral dissertation that explores and analyzes Vachel Lindsay's theory of film. In 1915, Lindsay published the first important book on film aesthetics [see O79]. The factors in Lindsay's life that contributed to the formulation of that theory are the subject of Wolfe's thesis. In later sections, Lindsay's theory is examined and compared to the theories of some of his contemporaries.

FILMMAKING IN GENERAL

O86. **Baker, Fred, and Firestone, Ross, eds.** MOVIE PEOPLE. New York: Douglas Book Corp., 1972. 193 p., illus.

This anthology on filmmaking was inspired by a series of lectures. Each aspect of the filmmaking process is discussed by an experienced professional. Contributors include directors Sidney Lumet and Francis Ford Coppola, composer Quincy Jones, actor Rod Steiger, writer Terry Southern.

O87. **Bayer, William.** BREAKING THROUGH, SELLING OUT, DROPPING DEAD, AND OTHER NOTES ON FILMMAKING. New York: Macmillan Co., 1971. 227 p.

Diverse comments on filmmaking make up this witty, cynical, abrasive book. Arranged by topics, the advice given by the author is honest and candid, based as it is on his experience in the film industry.

O87a. **Brosnan, John.** MOVIE MAGIC. New York: St. Martin's Press, 1974. 285 p., illus.

A rich survey that considers the history, personnel, and techniques of special effects in various types of films. Supporting the detailed text are sections on special effects; Academy Award nominees and winners from 1939 to 1973; a bibliography; and an index. The many illustrations have been selected with care but are poorly reproduced.

O88. **Butler, Ivan.** THE MAKING OF FEATURE FILMS: A GUIDE. Baltimore: Penguin Books, 1970. 191 p., illus.

Personal interviews with American and British filmmakers and artisans are used to describe the making of feature films in the sixties. Producers, directors, writers, actors, cameramen, art directors, composers, are among those questioned. A short biographical sketch and a filmography are given for some of the contributors. This paperback volume has acceptable visuals and an index.

O88a. **Chase, Donald.** FILMMAKING THE COLLABORATIVE ART. Boston: Little, Brown & Co., 1975. 330 p., illus.

The process of making feature films is explored by using excerpts from the seminars and discussions sponsored by the American Film Institute. All the major creative elements are considered: direction, acting, writing, photography, production design, costume design, etc. Because of the author's skill in selecting and assembling his material, the book seems like several roundtable discussions on aspects of filmmaking. Mini-biographies of the participants are included.

O89. **Colman, Hila.** MAKING MOVIES: STUDENT FILMS TO FEATURES. New York: World Publishing Co., 1969. 192 p., illus.

This volume on careers for young people describes filmmaking by interviews, description, drawings, and an account of the making of Alice's Restaurant (1968). Colleges that offer training in filmmaking, along with certain film unions and their training programs, are listed in the appendix.

O90. **Cooke, David C.** BEHIND THE SCENES IN MOTION PICTURES. New York: Dodd, Mead & Co., 1960. 64 p., illus. [cont.]

Using the Paramount studios as an example, the author attempts to explain the commercial filmmaking process. The demise of the studios and the dated material place this volume in the nostalgia-history category. Originally intended for a juvenile audience, the book has a good collection of visuals to supplement the text.

O91. **Couffer, Jack.** SONG OF WILD LAUGHTER. New York: Simon & Schuster, 1963. 190 p., illus.

A description of how films of animals are made. The author was director and cameraman for several of the famous Disney wildlife adventure films. The many illustrations of animals and the simplified text are appropriate for a young audience.

O92. **Field, Alice Evans.** HOLLYWOOD, U.S.A.: FROM SCRIPT TO SCREEN. New York: Vantage Press, 1952. 256 p., illus.

This general treatment of studio filmmaking in America includes a list of films made from literary sources.

O93. **Freeburg, Victor Oscar.** PICTORIAL BEAUTY ON THE SCREEN. New York: Arno Press, 1970. 191 p., illus.

About twenty stills from American silent films illustrate this discussion of frame composition. The emphasis is on camera location, angle, and lighting. ORIGINAL EDITION (1923).

O94. **Kiesling, Barrett C.** TALKING PICTURES, HOW THEY ARE MADE AND HOW TO APPRECIATE THEM. Richmond, Va.: Johnson Publishing Co., 1937. 332 p., illus.

The steps in making and distributing a feature film during the thirties are detailed. A weak discussion of film appreciation is accompanied by good illustrations. Glossary of terms.

O95. **Naumburg, Nancy.** WE MAKE THE MOVIES. New York: W. W. Norton & Co., 1937. 284 p., illus.

An early anthology of essays about making sound feature films. Creative personalities and artists of the thirties—Jesse Lasky, Bette Davis, Paul Muni, Max Steiner, etc.—describe the contribution of their particular craft to filmmaking. Biographical sketches; glossary of film terms.

O96. **Rivkin, Allen, and Kerr, Laura.** HELLO HOLLYWOOD. New York: Doubleday & Co., 1962. 571 p.

An anthology of "the story of the movies by the people who make them." Articles and excerpts from periodicals and books are arranged in an awkward movie format. The authors provide the connecting commentary between the pieces, which vary in quality and pertinence.

O96a. **Steen, Mike.** HOLLYWOOD SPEAKS: AN ORAL HISTORY. New York: G. P. Putnam's Sons, 1974. 384 p.

A collection of twenty-five interviews with people "who make the movies." Each creative profession—actor, actress, director, writer, editor—is represented. Each interview begins with biographical information, career training, and beginnings in the film industry. The work

of the subject is explained and embellished by opinions, reminiscences, and professional statements. Steen is a fine interviewer, and his choice of subjects is noteworthy.

O97. **Talbot, Frederick, A.** MOVING PICTURES: HOW THEY ARE MADE AND WORKED. New York: Arno Press, 1970. 340 p., illus.

This volume by an American film pioneer gives some historical background and suggests possible educational potential for films. Much of the text describes the technical elements of filmmaking during that early period. More than 160 illustrations accompany the text. ORIGINAL EDITION (1912).

O98. **Taylor, Theodore.** PEOPLE WHO MAKE MOVIES. Garden City, N.Y.: Doubleday, 1967. 158 p., illus.

The creative artists or departments who cooperate to make a feature film are each given a chapter in this book. A general description of their contribution is offered along with specific examples from films. The emphasis is on the behind-the-scenes activity typical of a major Hollywood studio, and many familiar American filmmakers are discussed. Glossary.

O99. **Wagner, Rob.** FILM FOLK. New York: Century House Publishing, 1918. 356 p., illus.

A different approach to a description of filmmaking is used in this book. Early Hollywood procedures are described in separate chapters devoted to fictional characters—for example, extra, director, and writer.

O100. **Watts, Stephen, ed.** BEHIND THE SCREEN: HOW FILMS ARE MADE. New York: Dodge Publishing Co., 1938. 176 p., illus.

The author list for this anthology on theatrical filmmaking reads like the credits on an MGM spectacular of the thirties. Hunt Stromberg, George Cukor, Frances Marion, Adrian, Douglas Shearer, and others all contribute articles on their specialties. Nicely illustrated.

O100a. **Wise, Arthur, and Ward, Derek.** STUNTING IN THE CINEMA. New York: St. Martin's Press, 1973. 248 p., illus.

A survey of film stunting that combines history, personalities, and specific examples found in American films. Although the illustrations are few, there are chapter notes, a lengthy bibliography, and a detailed index.

DIRECTING, ACTING, AND WRITING

O101. **Albertson, Lillian.** MOTION PICTURE ACTING. New York: Funk & Wagnalls, 1947. 135 p.

Drawing upon her experiences with many actors at the Paramount and RKO studios in the thirties and forties, the author puts forward some basic generalizations about screen acting. Testimonials by many screen performers introduce the text.

O102. **Bare, Richard L.** THE FILM DIRECTOR. New York:

Macmillan Co., 1972. 243 p., illus.

Advice and comment about film and TV directing from a veteran Hollywood artist. He draws on the experience of other American directors. Bibliography; index.

O103. **Corliss, Richard, ed.** THE HOLLYWOOD SCREEN-WRITERS. New York: Avon Publishing Co., 1972. 328 p.

A paperback anthology on screen writing taken mostly from the magazine *Film Comment*. Representatives from many periods in Hollywood's history are included in the essays, articles, and interviews. The final section is a symposium with twelve writers responding to the same questions.

O103a. **Corliss, Richard.** TALKING PICTURES: SCREEN-WRITERS IN THE AMERICAN CINEMA. Woodstock, N.Y.: Overlook Press, 1974. 426 p., illus.

This ambitious volume is concerned with thirty-eight American screenwriters active from 1927 to 1973. Each writer is considered in turn on the basis of his film efforts and an extended evaluation of a few representative films. The composition of the script is the major aesthetic theme treated in these lengthy reviews. A detailed filmography of the hundred films discussed in the text is appended.

O103b. **Guiles, Fred Lawrence.** HANGING ON IN PARADISE. New York: McGraw-Hill Book Co., 1975. 514 p., illus.

The experiences of famous writers in the Hollywood studios during the thirties and forties are recalled. Dorothy Parker, Lillian Hellman, Aldous Huxley, and Robert Sherwood are among those discussed. Several portrait sections are weakened by poorly written captions. Selected filmographies; a bibliography; some source notes; and index.

O104. **Pate, Michael.** THE FILM ACTOR. New York: A. S. Barnes, 1970. 245 p., illus.

One of the few books written about motion picture acting, *The Film Actor* describes and illustrates the various requisites of the profession. Contains a glossary, exercises, practice scenes, diagrams. Index.

O105. **Phillips, Henry A.** THE PHOTODRAMA. New York: Arno Press, 1970. 221 p.

This is a reprint of a pre–1920s work on photodrama, or screen writing principles. Phillips treats plots, dramatic construction, and film techniques of that period. Examples; glossary. FIRST EDITION (1914).

O106. **Thomas, Bob, ed.** DIRECTORS IN ACTION. Indianapolis: Bobbs-Merrill Co., 1973. 283 p., illus.

A paperback anthology taken from *Action*, the official magazine of the Directors Guild of America. The director and the art of direction are the major topics considered, with the use of specific examples. The poor arrangement of this excellent material is compensated for by the provision of indexes for titles and names. The visuals are well produced and well integrated into the text. A listing of director's awards is added.

LITERATURE, THEATER, AND FILM

O107. **Bluestone, George.** NOVELS INTO FILM: THE METAMORPHOSIS OF FICTION INTO CINEMA. Berkeley: University of California Press, 1957. 237 p.

In this classic 1957 paperback study, the author examines the conversion of novels into film. Using six famous American films and the novels from which they are derived, he notes similarities, differences, and changes between the forms, and finally concludes that each medium is autonomous. A fine bibliography and an index complete this pioneer work.

O108. **Geduld, Harry M., ed.** AUTHORS ON FILM. Bloomington: Indiana University Press, 1972. 303 p.

An anthology on the development of the motion picture as seen through the eyes of thirty-five well-known authors. Using articles, essays, and interviews, the relationship of the writer to the medium is traced from 1896 (Maxim Gorky) to the present day (James Baldwin). The topics and personalities discussed are international, but much attention is directed toward Hollywood and its films.

O109. **Hurt, James, ed.** FOCUS ON FILM AND THEATRE. Englewood Cliffs, N.J.: Prentice-Hall, 1974. 188 p., illus.

An exploration of the relationships between film and theater. Contributors are divided into two groups: writers and practicing artisans. The few illustrations are unnecessary, but a filmography, a bibliography, and an index add to the book's value.

O110. **Magny, Claude-Edmonde.** THE AGE OF THE AMERICAN NOVEL. New York: Frederick Ungar Publishing Co., 1972. 239 p.

An examination of the relationship between the American novel and film. The author's provocative argument is that films inspired a new literary form of fiction in the period 1920–1940. She analyzes the novels of Hemingway, Steinbeck, Dos Passos, and Faulkner to point out literary equivalents of film techniques: close-up, jump cut, long shot, etc. Index.

O111. **Marcus, Fred H., ed.** FILM AND LITERATURE: CONTRASTS IN MEDIA. Scranton, Pa.: Chandler Publishing Co., 1971. 283 p.

This paperback anthology considers differences and similarities between films and their literary sources. The selection of articles and authors is representative of several periods and of many differing viewpoints. Novels are emphasized over short stories and plays. Illustrations are not well selected.

O112. **Murray, Edward.** THE CINEMATIC IMAGINATION. New York: Frederick Ungar Publishing Co., 1972. 330 p.

A study of the effect of films on the writing of plays and novels. The works of modern authors are examined to discern cinematic techniques and style. Many detailed notes accompany the text. Index.

O113. **Nicoll, Allardyce.** Film and Theatre. New York: Thomas Y. Crowell Co., 1936. 255 p.

An exposition of film principles followed by a comparison of screen and stage. The author seems more secure with theater than with screen, but the work is well documented and uses some American films as examples. Detailed bibliography; index.

O114. **Ortman, Marguerite G.** Fiction and the Screen. Boston: Marshall Jones Co., 1935. 148 p., illus.

This is an early attempt to look at all sources of screenplays—short story, novel, play, original script—to determine their value for the screen.

O114a. **Petaja, Emil.** Photoplay Edition. San Francisco: Sisu Publishers, 1975. 211 p., illus.

An index to a special type of hardbound book published to coincide with the release of a film. Usually fiction, these editions include stills from the film on their dust jackets and within their pages. Over 800 such titles published from 1914 to 1972 are listed here. The index also includes about one hundred illustrations, a bibliography, and a section devoted to paperbacks. Arrangement and selection of the material is sometimes weak, but this is the only such index currently available.

O115. **Richardson, Robert.** Literature and Film. Bloomington: Indiana University Press, 1969. 150 p.

In his discussion of literature and film, the author uses many examples of American films to show similarities and differences between selected literary genres and certain motion pictures. Bibliography; some chapter notes; and an index.

O116. **Vardac, A. Nicholas.** Stage to Screen, Theatrical Method from Garrick to Griffith. New York: B. Blom, 1968. 283 p., illus.

A scholarly study of the influence of the theatrical stage on early motion pictures. After a detailed description of the nineteenth-century stage, some correlations are made between theatrical practices and motion picture techniques. Reprint of ORIGINAL EDITION (Cambridge: Harvard University Press, 1949).

O117. **White, David Manning, ed.** Pop Culture in America. Chicago: Quadrangle Books, 1970. 279 p.

The purpose of this paperback anthology is to survey the popular arts in America. The section devoted to film contains four articles, the best of which is a debate on theater versus film between Carl Foreman (film) and Tyrone Guthrie (theater). Index.

MUSIC

O118. **Hofmann, Charles.** Sounds for Silents. New York: Drama Book Shop, 1970. illus.

A short history of film music from 1900 to 1930. Some stills, scores, excerpts, and other musical memorabilia are added to the brief text. A plastic disk with four samples of silent film music is enclosed.

O119. **Lang, Edith, and West, George.** Musical Accompaniment of Moving Pictures. New York: Arno Press, 1970. 64 p., illus.

This is a reprint of a manual for film pianists and organists that gives principles for the musical interpretation of films. The volume contains three sections: equipment, musical interpretation, and the "theatre-organ." ORIGINAL EDITION (1920).

O119a. **Limbacher, James L., comp. and ed.** Film Music: From Violins to Video. Metuchen, N.J.: Scarecrow Press, 1974. 835 p.

The first section of this lengthy book is an anthology of articles about film music written by composers and critics. A short bibliography concludes this portion. The remainder is a reference work that is divided into four parts: film titles and dates, films and their composers, composers and their films, and recorded musical scores. These combine into a major reference source offering a wealth of information about film music.

O120. **Mattfeld, Julius.** Variety Music Cavalcade: Musical-Historical Review, 1620–1969. 3d ed. Englewood Cliffs, N.J.: Prentice-Hall, 1971. 713 p.

The third edition of this volume lists many, but not all, of the popular songs of America from 1620 to 1969. Although the early years are telescoped, each of the recent years is treated individually, with a summary of show business for the year followed by the most popular songs. Data about composers, publisher, medium, etc., are noted. Many of the popular songs that were written for American films are included in this volume. Title index.

O121. **Rapee, Erno.** Encyclopedia of Music for Pictures. New York: Arno Press, 1970. 510 p.

This is a comprehensive collection of silent film music classified by the mood desired. ORIGINAL EDITION (1925).

O122. **Rapee, Erno.** Motion Picture Moods for Pianists and Organists. New York: Arno Press, 1970. 678 p.

This sampling of piano-organ music designed to accompany silent films contains over 200 themes representing fifty-two moods. The ORIGINAL EDITION (1924) is now reprinted by Arno Press.

O123. **Skinner, Frank.** Underscore. New York: Criterion Music, 1961. 239 p., illus.

The composer of the music for many American films talks about his method of writing scores for the motion pictures. Glossary of terms.

O124. **Thomas, Tony.** Music for the Movies. New York: A. S. Barnes, 1973. 270 p., illus.

A survey of film music and its composers. Using explanation and comment from twenty-four composers to ex-

plain writing, scoring, and conducting, Thomas adds connective narrative and information to create a most enthusiastic text. A listing of seventy-six composers and the long-playing recordings of their scores is appended along with filmographies for the twenty-four composers treated in the text. Index.

HISTORICAL AND SOCIAL ASPECTS OF FILM

History of the American Film

Each decade of the twentieth century has seen the publication of several books that address themselves to the history of the film in America. In addition, certain books have allocated a section or a few pages to this topic. The books that follow look at American film history from the sociological, economic, and technological perspectives.

O125. **Anderson, John, and Fülop-Miller, René.** THE AMERICAN THEATRE AND THE MOTION PICTURE IN AMERICA. New York: Dial Press, 1938. illus.

This volume provides a history of the motion picture in America, accompanied by many fine photographs.

O126. **Bardèche, Maurice, and Brasillach, Robert.** THE HISTORY OF MOTION PICTURES. New York: Arno Press, 1970. 412 p., illus.

This classic volume surveys the period from 1895 to 1935. The scope is international. The early years of film history are described with documentation, narrative, and—the book's weakest element—opinion. A postscript covers 1935 to 1938. The book was translated from French and edited by Iris Barry, and it contains a film title index and a general index. ORIGINAL EDITION: *History of the Film* (New York: W. W. Norton & Co., 1938).

O127. **Baxter, John.** HOLLYWOOD IN THE SIXTIES. New York: A. S. Barnes, 1972. 172 p., illus.

Another in the Hollywood history series, this paperback volume examines Hollywood's attempts at survival in the face of social and economic change. The films of established directors are contrasted with the successes of the newer breed. Studio decline and several film genres are also discussed. Illustrations are above average. Index.

O128. **Baxter, John.** HOLLYWOOD IN THE THIRTIES. New York: A. S. Barnes, 1968. 160 p., illus.

A paperback survey of the films made by Hollywood in the thirties along with an examination of the artists who made the films. Emphasis is on the major studios of the period. Illustrations are adequate. Index.

O129. **Blum, Daniel.** A NEW PICTORIAL HISTORY OF THE TALKIES. New York: G. P. Putnam's Sons, 1973. 318 p., illus.

The book is arranged chronologically and contains over 4,000 stills for movies produced from 1927 to 1973. Each year is briefly described. Reproduction quality varies but is acceptable for the most part. Detailed index. ORIGINAL EDITION: *A Pictorial History of the Talkies* (New York: G. P. Putnam's Sons, 1958), 318 p., illus.

O130. **Blum, Daniel.** A PICTORIAL HISTORY OF THE SILENT SCREEN. New York: Grosset & Dunlap, 1953. 334 p., illus.

A treasury of more than 3,000 photographs is the substance of this picture history of the silent screen. Arranged chronologically, the visuals cover the era from 1889 to 1930. The text is sparse, but informative. Index. REPRINT (New York: G. P. Putnam's Sons, 1972).

O131. **Brownlow, Kevin.** THE PARADE'S GONE BY. New York: Alfred A. Knopf, 1968. 590 p., illus.

A recent history of the silent film in America from 1916 to 1928, this volume contains a number of original interviews interwoven into a complete narrative containing analysis, comment, and informarion. The 300 photographs are outstanding; most are unfamiliar. Index.

O132. **Casty, Alan.** DEVELOPMENT OF THE FILM. New York: Harcourt Brace Jovanovich, 1973. 425 p., illus.

This paperback history of international film is divided into three major parts: a silent film section, which treats discoveries and expression; a sound section, which emphasizes realism and social effect of films; and a final section on new consolidations and directions. Many American directors and films are reviewed in the text. The illustrations are appropriate, and their reproduction is adequate. Index.

O133. **Marek, Kurt W. [C. W. Ceram].** ARCHEOLOGY OF THE CINEMA. New York: Harcourt Brace, 1965. 264 p., illus.

A history of the cinema before 1897, this beautifully illustrated and printed volume is worldwide in scope. The author includes discussion of those pioneer American inventors who contributed so much to the development of the motion picture. Contains nearly three hundred rare visuals, a bibliography, and an index.

O134. **Cowie, Peter, ed.** A CONCISE HISTORY OF THE CINEMA. New York: A. S. Barnes, 1971. 2 vols., illus.

Although the scope is worldwide, considerable attention

is paid to American films in this paperback history of the motion picture. Vol. 1 covers to 1940; vol. 2 considers the next three decades. The quality of the pictures is very good. Index.

O135. **Dickinson, Thorold.** A DISCOVERY OF CINEMA. New York: Oxford University Press, 1971. 164 p., illus.

A short paperback statement on the evolution of the motion picture. In attempting to relate achievement to the technical means available, the author betrays a bias that ignores American films in favor of foreign productions. He does recognize the work of Griffith, Flaherty, Welles, von Stroheim, and a few other American directors. Index.

O136. **Dickson, W. K. L., and Dickson, Antonia.** HISTORY OF THE KINETOGRAPH, KINETOSCOPE, AND KINETO-PHONOGRAPH. New York: Arno Press, 1970. 65 p., illus.

This volume by Edison's assistant describes the invention of early film machines and shows original frames taken from films used in them. A reprint of the ORIGINAL EDITION (1895).

O137. **Everson, William K.** THE AMERICAN MOVIE. New York: Atheneum Publishers, 1963. 149 p., illus.

A short selective survey of American film history with the emphasis on pioneers and classic films. It boasts a reliable text and 275 illustrations, but many of these are too small to be effective. Intended for young people.

O137a. **Fell, John.** FILM AND THE NARRATIVE TRADITION. Norman: University of Oklahoma Press, 1974. 304 p., illus.

With the aid of some fascinating historical research, the author argues a provocative thesis concerning the influence of nineteenth-century entertainments (novels, comic strips, illustrations, magazines, theater, fairs on the development of the motion picture. A scholarly approach is supported by appropriate illustrations, a filmography, a bibliography, and indexes. •

O138. **Fielding, Raymond.** A TECHNOLOGICAL HISTORY OF MOTION PICTURES AND TELEVISION. Berkeley: University of California Press, 1967. 255 p., illus.

A collection of articles that traces the development of both motion pictures and television. Taken from *The Journal of the Society of Motion Picture and Television Engineers*, the articles cover a fifty-year span, contain detailed accounts of early inventions and technological discoveries, and include personal reminiscences of film pioneers. The rare photographs and drawings are excellent.

O139. **Fulton, A. R.** MOTION PICTURES: THE DEVELOPMENT OF AN ART FROM SILENT PICTURES TO THE AGE OF TELEVISION. Norman: University of Oklahoma Press, 1960. 320 p., illus.

A history of the motion picture that gives greater attention to the earlier years and the directors. Particular films are treated in detail, and the challenges of translating literature into film are explored. Glossary; bibliography; filmography; some illustrations; and index.

O139a. **Geduld, Harry M.** BIRTH OF THE TALKIES: FROM EDISON TO JOLSON. Bloomington: Indiana University Press, 1975. 337 p.

A carefully researched and written history of various attempts to produce sounds to accompany motion pictures, this volume notes all the important advances made during the early years of this century. Major attention is given to *Don Juan* (1926) and *The Jazz Singer* (1927). The text tends to be somewhat technical and pedantic in its discussion of inventions, patents, court cases, etc.

O140. **Gow, Gordon.** HOLLYWOOD IN THE FIFTIES. New York: A. S. Barnes, 1971. 208 p., illus.

A survey of a decade of change in Hollywood. In 1950 the appearance of television encouraged attempts by Hollywood to bolster decreasing box office revenues. Gow describes these remedies along with the silms, personalities, themes, and events that affected Hollywood during this period. The illustrations are well selected but often too reduced in size to be effective. This paperback volume is one of a series. Index.

O141. **Grau, Robert.** THE THEATRE OF SCIENCE. New York: B. Blom, 1969. 465 p., illus.

This is a detailed historical account of the development of the motion picture from 1876 to 1914. All aspects of the young industry are covered, and more than eighty-seven pages of rare photographs supplement the entertaining text. This reprint of the ORIGINAL EDITION (1914) is now available from Arno Press.

O142. **Green, Abel, and Laurie, Joe, Jr.** SHOW BIZ: FROM VAUDE TO VIDEO. New York: H. Holt, 1951. 612 p.

A survey of all types of show business in America during the first half of the twentieth century. The many sections devoted to motion pictures provide a detailed history of the founding and development of the industry. The emphasis is on personalities, trends, and economics. Index. REPRINT (Port Washington, N.Y.: Kennikat Press, 1972), 2 vols.

O143. **Green, Fitzhugh.** THE FILM FINDS ITS TONGUE. New York: B. Blom, 1971. 316 p., illus.

This history emphasizes the role of the Warner Brothers Studios in developing the sound motion picture. Attention is given to the problems met by film actors as they prepared for the new medium. About thirty photographs are poorly reproduced. This reprint of the ORIGINAL EDITION (1929) is now available from Arno Press.

O144. **Griffith, Mrs. D. W.** WHEN THE MOVIES WERE YOUNG. New York: B. Blom, 1968. 256 p., illus.

This memoir is an account of early movie making written by the wife of the famed film director. The period described covers the early days at the Biograph Studios (1907–1913) to the start of production on *Birth of a Nation* (1914). The illustrations are quite unusual. This reprint of

the ORIGINAL EDITION (1925) is now available from Arno Press.

O145. Griffith, Richard, and Mayer, Arthur. THE MOVIES. Rev. ed. New York: Simon & Schuster, 1970. 494 p., illus.

A history of the American motion picture with a witty, intelligent text and more than 1,300 attractive photographs. Digressions from a historical presentation distract a bit, but the scope and treatment compensate. This is a popular rather than a critical book. Index. ORIGINAL EDITION (1957).

O146. Hall, Hal, ed. CINEMATOGRAPHIC ANNUAL, 1930–1931. New York: Arno Press, 1972. 2 vols., illus.

Along with the wide range of topics contained in the seventy articles of the text, the numerous illustrations help to describe American cinematography at the beginning of the sound era. The ORIGINAL EDITION (1930–1931) was published by the American Society of Cinematographers.

O147. Hampton, Benjamin B. HISTORY OF THE AMERICAN FILM INDUSTRY FROM ITS BEGINNINGS TO 1931. New York: Dover Publications, 1970. 456 p., illus.

This paperback history emphasizes commercial and technical aspects rather than artistic ones. It describes the early inventions, legal battles, distribution practices, the star system, and other economic matters of the silent motion picture industry. The current edition of this classic volume has reproduced its almost 200 rare photographs poorly and has added several pages of advertising. Index. ORIGINAL EDITION (1931).

O148. Hendricks, Gordon. BEGINNINGS OF THE BIOGRAPH. New York: Beginnings of the American Film, 1964. 78 p., illus.

A scholarly, well-documented research study of the invention of the Biograph camera and projector along with the card-flipping mutoscope. The period covered is from 1896 to 1897, and some early film showings are described in detail. A number of rare, unfamiliar illustrations are included. Index. [For the REPRINT EDITION, see now O151.]

O149. Hendricks, Gordon. THE EDISON MOTION PICTURE MYTH. Berkeley: University of California Press, 1961. 216 p., illus.

The author presents a case for the recognition of W. K. L. Dickson, an Edison employee, as a major pioneer in early motion picture developments. Many original sources are used as evidence, emphasizing the four-year period from 1888 to 1892. Index. [See O151.]

O150. Hendricks, Gordon. THE KINETOSCOPE. New York: Beginnings of the American Film, 1966. 182 p., illus.

A study of the first commercially successful motion picture exhibition in America. In addition to documenting the invention and development of the kinetoscope and

its films, Hendricks also describes other devices of the period. Short biographies of William Kennedy Laurie Dickson and the Lathams are appended. The sixty illustrations are rarely seen. [See O151.]

O151. Hendricks, Gordon. ORIGINS OF THE AMERICAN FILM. New York: Arno Press, 1971. illus.

A combined reprint of three volumes written by Hendricks and originally published in 1961, 1964, and 1966. [See O148–O150.]

O152. Higham, Charles, and Greenberg, Joel. HOLLYWOOD IN THE FORTIES. New York: A. S. Barnes, 1968. p. 192, illus.

This paperback survey of the forties emphasizes films. Grouping them by genre, it offers evaluations and background material. The connecting narrative provides an overview of the personalities, trends, and accomplishments of Hollywood during World War II and the recovery period that followed. The illustrations are interesting. Index.

O153. Houston, Penelope. THE CONTEMPORARY CINEMA. Baltimore: Penguin Books, 1963. 222 p., illus.

This survey of international cinema since World War II includes many American films and directors. The text by the editor of *Sight and Sound* (London) is imaginative and readable. Prepared as an original paperback, it contains over thirty good photographs, a checklist of directors and films, a bibliography, and an index.

O154. Jacobs, Lewis. THE EMERGENCE OF FILM ART: THE EVOLUTION AND DEVELOPMENT OF THE MOTION PICTURE AS AN ART FROM 1900 TO THE PRESENT. New York: Hopkinson & Blake, 1969. 453 p., illus.

This anthology covers seventy years of international film history and is divided into three major eras: the silent film (1900–1930); the sound and color film (1930–1950); and the creative present (1950–1970). Jacobs has selected articles and essays by directors, critics, technicians, and others and organized them into a comprehensive survey. Index.

O155. Jacobs, Lewis. THE RISE OF THE AMERICAN FILM: A CRITICAL HISTORY. New York: Teachers College Press, 1968. 631 p., illus.

A critical history in paperback of the American motion picture from its beginnings until the late thirties. This classic survey considers artistic and commercial aspects of the medium and is characterized by impressive scholarship and research. It contains excellent illustrations, a bibliography, and detailed indexes for film titles, names, and general subjects. In this reissue of the ORIGINAL EDITION 1939), Jacobs has added an essay on experimental film in America from 1921 to 1947.

O156. Kardish, Laurence. REEL PLASTIC MAGIC. Boston: Little, Brown & Co., 1972. 297 p., illus.

A short history that treats the usual topics—technology, actors, directors, finance, economics—along with some

newer ones: black films, underground films, etc. Emphasis in both text and illustrations is on the silent and the early sound years. Some suggested film programs and a bibliography provide variety to a mostly familiar text. Index.

O157. **Karr, Kathleen.** THE AMERICAN FILM HERITAGE. Washington, D.C.: Acropolis Books, 1972. 184 p., illus.

This entertaining collection of thirty-four essays was inspired by the American Film Institute's work in locating and preserving important American films of the past. The range of films and topics is wide, and the contributing authors' names are impressive. More than 190 attractive photographs accompany the text. Index.

O158. **Knight, Arthur.** THE LIVELIEST ART. New York: New American Library, 1959. 352 p., illus.

Now available in paperback, this general history of the motion picture has enjoyed much popularity since the fifties. International in scope, the text concentrates mostly on the American film from 1895 to 1955. Certain supporting materials such as the bibliography and the distributor list are somewhat dated, but the title index and general index remain useful. The visuals are small but adequate.

O159. **Kriegsman, Sali-Ann, ed.** THE AMERICAN FILM INSTITUTE REPORT, 1967–1971. Washington, D.C.: American Film Institute, 1972. 80 p., illus.

A paperback account of the first four years of the American Film Institute and of the many activities and events it has sponsored.

O160. **Krows, Arthur E.** THE TALKIES. New York: H. Holt, 1930. 245 p., illus.

An early account of the development of talking pictures in America. Many of the early sound techniques are described. The illustrations are interesting and rare.

O161. **Kuhns, William.** MOVIES IN AMERICA. Dayton: George A. Pflaum, 1972. 248 p., illus.

A paperback social history that traces the evolution of film from novelty to art form. Kuhns's theme, the relationship of film and society, is one he develops by identifying specific periods of American history and then examining the films that appeared within each period. Hundreds of carefully selected examples are well reproduced and arranged throughout the book.

O161a. **Leish, Kenneth W.** CINEMA. New York: Newsweek Books, 1974. 192 p., illus.

A brief survey of film history highlights, a sampling of biographical excerpts, and a chronology. The survey emphasizes the rise and fall of Hollywood, independent filmmaking, and international cinema. World happenings and major film events are compared in the chronology. Award-winning and top-grossing films are presented together with a short bibliography and many attractive visuals. Index.

O162. **Lindgren, Ernest.** A PICTURE HISTORY OF THE CINEMA. New York: Macmillan Co., 1960. 160 p., illus.

A picture book that covers the history of the motion picture to 1960. Although there is a discernible prejudice against American films in the text of this volume, the many fine illustrations minimize the bias. Index.

O163. MOVIE LOT TO BEACHHEAD, BY THE EDITORS OF LOOK MAGAZINE. Garden City, N.Y.: Doubleday, Doran & Co., 1945. 292 p., illus.

A pictorial history of the contribution made by the motion picture during World War II in which the pictures, intelligently selected and well reproduced, take precedence over the brief text.

O164. **MacGowan, Kenneth.** BEHIND THE SCREEN: THE HISTORY AND THE TECHNIQUES OF THE MOTION PICTURE. New York: Delacorte Press, 1965. 528 p., illus.

A unique study of the development of motion pictures, both historically and technologically. The value standard used is commercial success, and the text emphasizes the Hollywood financial structure. Other details, facts, and opinions are plentiful; there are more than two hundred fine illustrations. Index.

O165. **Manvell, Roger.** NEW CINEMA IN THE USA. New York: E. P. Dutton & Co., 1968. 160 p., illus.

The history of the American film is covered from 1946 to 1967 analytically rather than chronologically. Manvell considers the contributions made by the established directors, the new breed, and the experimentalists in making realistic films and films in the various American genres—Western, musical, gangster, youth, and others. The 150 illustrations in this paperback are very good. Index.

O166. **Mast, Gerald.** A SHORT HISTORY OF THE MOVIES. New York: Bobbs-Merrill Co., 1971. 432 p., illus.

This international history of the motion picture focuses on the innovative directors and their important films. Attention is given to technological, sociological, and economic aspects of the motion picture. The illustrations are adequate, and there is a bibliography. Index.

O167. **North, Joseph H.** THE EARLY DEVELOPMENT OF THE MOTION PICTURE, 1887–1909. New York: Arno Press, 1973. 313 p.

This study, a doctoral dissertation based on detailed research in original sources, considers neglected areas such as films made by scientists, businessmen, and the United States War Office. Exhibitions, inventions, lawsuits, and many other topics are treated.

O168. **O'Leary, Liam.** THE SILENT CINEMA. New York: E. P. Dutton & Co., 1965. 160 p., illus.

An attractive visual survey of international film during the silent era (1895–1927). The 140 well-reproduced photographs and the brief text concentrate on American films of the twenties, although personalities, films, and contributions of other countries are noted. Index.

O169. **Pratt, George C.** SPELLBOUND IN DARKNESS. Rev.

ed. Greenwich, Conn.: New York Graphic Society, 1973. 576 p., illus.

This paperback collection of readings, comments, articles, and information offers a unique and most satisfying history of the silent screen from 1896 to 1929. The reproduction of the pictures is outstanding, and the author provides a rich commentary on the articles he has selected. Index. ORIGINAL EDITION (1966).

O170. **Quigley, Martin.** MAGIC SHADOWS: THE STORY OF THE ORIGIN OF MOTION PICTURES. New York: Quigley Publishing Co., 1960. 191 p., illus.

This volume is a history of man's attempt in the pre-screen era to create the illusion of motion. Photographs and drawings depict the events and devices that contributed to the development of the motion picture camera and projector. Bibliography.

O171. **Ramsaye, Terry.** A MILLION AND ONE NIGHTS. New York: Simon & Schuster, 1964. 868 p., illus.

This classic history, now available in paperback, describes the first quarter-century of the motion picture. The journalist-author writes well but is occasionally more romantic than factual. The illustrations are fine, and there is a detailed index. ORIGINAL EDITION (1926) in two volumes.

O172. **Rideout, Eric H.** THE AMERICAN FILM. London: Butler & Tanner, 1937. 163 p., illus.

An overview of the American film to 1936. Index.

O173. **Robinson, David.** THE HISTORY OF WORLD CINEMA. New York: Stein & Day Publishers, 1973. 440 p., illus.

Seventy-five years of international film are examined in this ambitious volume. The author provides factual and critical coverage of many films and personalities in terms of aesthetics, technology, audience, economics, and so on. It is a bit surprising to find that the contribution of America and its filmmakers is minimized in certain sections and eras. The book contains more than a hundred good illustrations; a bibliography; selected filmographies (listed by director); and indexes of films, names, and general subjects.

O174. **Robinson, David.** HOLLYWOOD IN THE TWENTIES. New York: A. S. Barnes, 1968. 176 p., illus.

The last decade of the silent film is described in this paperback volume. Pioneer directors, imported foreign artists, and emerging American personalities are discussed along with the films they created. The excellent narrative is supported by adequate visuals and an index.

O175. **Robson, E. W., and Robson, M. M.** THE FILM ANSWERS BACK: AN HISTORICAL APPRECIATION OF THE CINEMA. London: John Lane, The Bodley Head, 1939. 336 p., illus.

In this historical-sociological appreciation, many films from a wide range of countries are cited, but the emphasis is on American cinema. The authors argue that profit determines content, that the screen reflects national cultures, and finally that the film is an instrument for social improvement. Some adequate illustrations and an index complete the book. REPRINT (New York: Arno Press, 1972).

O176. **Rotha, Paul, and Griffith, Richard.** THE FILM TILL NOW. New York: Funk & Wagnalls, 1949. 755 p., illus.

Written in the early thirties, this lengthy historical survey of world cinema has been reissued and updated several times. Rotha covers the silent era, while Griffith describes the later sound period. American films are prominent in both sections. The many illustrations are excellent. Appendixes; glossary; bibliography; and index.

O177. **Sands, Pierre Norman.** A HISTORICAL STUDY OF THE ACADEMY OF MOTION PICTURE ARTS AND SCIENCES (1927–1947). New York: Arno Press, 1973. 262 p.

A doctoral dissertation that provides a lot of information on the history and contributions of the Academy of Motion Picture Arts and Sciences; service to the film industry is apparently much greater than to education. A bibliography and some appendixes support a seemingly biased study.

O178. **Schickel, Richard.** MOVIES: THE HISTORY OF AN ART AND AN INSTITUTION. London: Macgibbon & Kee, 1965. 208 p., illus.

A short history of the motion picture emphasizing American films. Flawed by unsupported criticism, major omissions, and strongly biased personal opinions, the volume attempts more than it accomplishes. Picture reproduction is only fair, and the bibliographic essay is misleading. Index.

O179. SCREEN MONOGRAPHS 1–2. New York: Arno Press, 1970. 2 vols., illus.

This compilation of eight compact titles in reprint includes texts from 1915 to the thirties. The two volumes cover historical and critical aspects both here and abroad. Contents: VOL. 1. *The Art of Cineplastics* by Elie Faure (1923); *The Technique of the Film* by Bernard Gtrdon and Julian Zimet; *Parnassus to Let* by Eric W. White (1928). VOL. 2: *The Crisis of the Film* by John G. Fletcher; *The American Influence in France* by Philippe Soupault (1930); *The Photodrama* by William M. Hannon (1915); *See and Hear* by Will Hays (1929).

O180. **Seldes, Gilbert.** AN HOUR WITH THE MOVIES AND THE TALKIES. Philadelphia: J. P. Lippincott Co., 1929. 156 p.

This brief early history of the film investigates the impact of sound films, examines America's inability to produce another artist of Chaplin's stature, and asks why films have not fulfilled their potential as art. REPRINT (New York: Arno Press, 1972).

O181. **Seldes, Gilbert.** THE MOVIES COME FROM AMERICA. New York: Scribner, 1937. 120 p., illus.

An informal survey of American films to 1937, this early work by Seldes contains information, comment, and criticism. The illustrations are excellent. BRITISH EDITION: *Movies for the Millions.*

O182. **Slide, Anthony, and O'Dell, Paul.** EARLY AMERICAN CINEMA. New York: A. S. Barnes, 1970. 192 p., illus.

This paperback history of American films covers the period from Edison up to the 1920s. Early film companies, personalities, and films are discussed in a bland but readable text. The illustrations have been selected and reproduced with care. Bibliography; index.

O183. **Taylor, Deems; Peterson, Marcelene; and Hale, Bryant.** A PICTORIAL HISTORY OF THE MOVIES. New York: Simon & Schuster, 1950. 376 p., illus.

This was one of the earliest pictorial histories of the motion picture. Although it is international in scope, the emphasis is on the American film. The more than seven hundred visuals are well selected, but reproduction quality varies with each edition. The accompanying text is informative but occasionally inaccurate. Listing of the Academy Awards; detailed index. ORIGINAL EDITION (1943).

O184. **Thrasher, Frederick, ed.** OKAY FOR SOUND: HOW THE SCREEN FOUND ITS VOICE. New York: Duell, Sloan, & Pearce, 1946. 303 p., illus.

This history of the American film features an excellent collection of over two hundred photographs combined with a modest text. The selection and reproduction of the visuals are of a consistently high level.

O185. **Van Zile, Edward Sims.** THAT MARVEL: THE MOVIE. New York: G. P. Putnam's Sons, 1923. 229 p.

An early evaluation of motion pictures. A history of the medium is followed by a discussion of its potential for good and evil. Film statistics for the early years are appended.

O186. **Wagenknecht, Edward.** THE MOVIES IN THE AGE OF INNOCENCE. Norman: University of Oklahoma Press, 1962. 280 p., illus.

The American silent film is recalled in this well documented critical history, which is based on research and personal recollections, reactions, and experiences. The author covers early short films, D. W. Griffith, Mary Pickford, and many other personalities and the later feature films. Many informative footnotes, some illustrations, and a biography of Lillian Gish are also presented.

O186a. **Wenden, D. J.** THE BIRTH OF THE MOVIES. New York: E. P. Dutton & Co., 1975. 192 p., illus.

A well-researched review of the silent screen era. Tracing the development of film from novelty to art form, the text considers history, economics, society, and politics. The emergence of Hollywood as the film capital of the world and the arrival of sound films are the substance of the book's closing pages. The somewhat familiar text is supplemented by clearly reproduced photographs, references, and suggested readings. Index.

O187. **Wiseman, Thomas.** CINEMA. New York: A. S. Barnes, 1965. 181 p., illus. (color).

Described as the history of a business and an art, this world survey of the evolution and development of motion pictures covers the period from 1895 to 1960. It has some unusual emphasis and biases. The American film industry is adequately represented; major attention is given to Chaplin and von Stroheim. The book contains plentiful illustrations, a short bibliography, and an index.

O188. **Wood, Leslie.** THE MIRACLE OF THE MOVIES. London: Burke, 1947. 352 p., illus.

This history is international in scope but emphasizes events in America and Britain. More than 120 unusual photographs accompany a critical account of the early history of the motion pictures that deals with personalities, films, and incidents.

Hollywood and the Film Industry

Over the years the American film industry and Hollywood have to many people been synonymous. For a portrait of life in Hollywood during the various eras of its history, *see* the first group under this rubric [O189–O233]. For information on the motion picture business, *see* the second group [O234–O265a]. On investigations of the American motion picture industry by the federal government, see the titles that constitute the third group [O266–O273].

HOLLYWOOD

O189. **Anderson, Clinton.** BEVERLY HILLS IS MY BEAT. Englewood Cliffs, N.J.: Prentice-Hall, 1960. 218 p., illus.

What it was like to be a police chief in Beverly Hills during Hollywood's heyday is the theme of this volume. Written with discretion, it tells few secrets and withholds real names on the more provocative cases.

O190. **Anger, Kenneth.** HOLLYWOOD BABYLON. Phoenix: Associated Professional Services, 1965. 271 p., illus.

The experimental filmmaker best known for *Scorpio Rising* (1963) has also written the most infamous and shocking expose on Hollywood. Describing with text and frank pictures many of the known and suspected scandals of Hollywood, the author uses many real names. With certain blind items, the probable subject appears innocuously on the following page. [*See* O190a.]

O190a. **Anger, Kenneth.** HOLLYWOOD BABYLON. Rev. and enl. ed. New York: Simon & Schuster, 1975. 292 p., illus.

Although this version still contains a large amount of the scandalous text of the FIRST EDITION [see O190], some of the stronger items have been deleted. A few pictures that are part of the public record have been substituted, and the result is nausea rather than shock. Not surprisingly, the original volume was one of the most popular film books ever printed. This follow-up volume can be expected to be widely read and circulated.

O191. **Canfield, Alyce.** GOD IN HOLLYWOOD. New York: Wisdom House, 1961. 160 p.

A paperback survey of the religions and beliefs of selected Hollywood personalities. The subjects describe the comfort and help they have found in various religious groups and orders in Hollywood. An attempt is made to link religion, success, and happiness.

O192. **Carr, William H. A.** HOLLYWOOD TRAGEDY: FROM FATTY ARBUCKLE TO MARILYN MONROE. New York: Lancer Books, 1962. 159 p.

A rapid review of the most notorious Hollywood scandals is provided by the sensationalized text of this paperback.

O193. **Davidson, Bill.** THE REAL AND THE UNREAL. New York: Harper & Bros., 1961. 275 p.

Hollywood in the fifties is reflected in this collection of actor profiles and articles. Entertaining, objective, and informative.

O194. **Day, Beth.** THIS WAS HOLLYWOOD. Garden City, N.Y.: Doubleday, 1960. 287 p., illus.

An affectionate memoir of the golden age of Hollywood. The people and the studios as they were in the thirties and forties are described. Some good illustrations accompany the chatty, informal text.

O194a. **Eder, Shirley.** NOT THIS TIME CARY GRANT! Garden City, N.Y.: Doubleday, 1973. 240 p., illus.

A collection of short pieces about Hollywood celebrities. The material is bland, trivial, and often simply uninteresting, but it is indicative of a kind of Hollywood journalism prevalent during the sixties and the seventies.

O195. **Evans, Charles.** THE REVEREND GOES TO HOLLYWOOD. New York: Crowell-Collier Press, 1962. 222 p.

A portrait of Hollywood by a minister turned motion picture actor. The period covered is the forties and fifties.

O196. **Fadiman, William.** HOLLYWOOD NOW. New York: Liveright, 1972. 174 p.

A look at work and thought in Hollywood during the early seventies. The author discusses various Hollywood professions and the industry structure. Reference is made to some form of subsidy and the potential of the film cassette. Short bibliography; index.

O197. **Geisler, Jerry, and Martin, Pete.** HOLLYWOOD LAWYER: THE JERRY GEISLER STORY. New York: Pocket Books, 1962. 342 p., illus.

What happens when famous people get into trouble is the substance of this paperback. Jerry Geisler acted as defense attorney for many film personalities, several of whose cases are described, with candid photographs.

O198. **Gelman, Barbara, ed.** PHOTOPLAY TREASURY. New York: Crown Publishers, 1972. 373 p., illus.

A collection of material from *Photoplay* magazine from 1917 to 1949. Included are articles, photographs, advertisements, columns, editorials, etc. The volume offers a reflection of Hollywood in its heyday. Unfortunately, the quality of reproduction is so consistently poor that the value of the book is greatly diminished. Index.

O199. **Goodman, Ezra.** THE FIFTY-YEAR DECLINE AND FALL OF HOLLYWOOD. New York: Simon & Schuster, 1961. 465 p.

One of the first volumes to acknowledge the death of Hollywood. Using familiar topics—stars, pioneers, gossip, publicity, reviewers, studio heads—Goodman makes a bitter, cynical statement about Hollywood and the inevitability of its demise. An index is provided to the strong, opinionated text.

O200. **Gordon, Jan, and Gordon, Cora.** STARDUST IN HOLLYWOOD. London: Harrap, 1930. 301 p., illus.

An anecdotal account of a six-month visit to Hollywood during the early sound years.

O201. **Graham, Sheilah.** CONFESSIONS OF A HOLLYWOOD COLUMNIST. New York: Bantam Books, 1969. 310 p.

A collection of gossip, innuendo, tale-telling, and dubious opinion, this volume represents typical Hollywood columnist writing. Graham is a bit more frank and outspoken than others, but the style is still waspish. Many major screen personalities are subjected to this gossip-queen's questionable dissection.

O202. **Graham, Sheilah.** THE GARDEN OF ALLAH. New York: Crown Publishers, 1970. 256 p., illus.

In 1927, Alla Nazimova converted her Hollywood estate into a bungalow hotel. The Garden of Allah became a private playground and residence for many Hollywood personalities. This account is a poor treatment of rich material.

O203. **Graham, Sheilah.** THE REST OF THE STORY. New York: Coward-McCann, 1964. 317 p., illus.

Life as a Hollywood gossip columnist in the forties and fifties is described in this paperback account of an aggressive self-creation.

O204. **Griffith, Richard.** THE TALKIES. New York: Dover Publications, 1971. 360 p., illus.

A superior paperback collection of 150 articles and

hundreds of illustrations from *Photoplay* magazine, 1928–1940. The articles, which render a romantic view of Hollywood during the thirties, are placed into four general categories: people, movieland, fans, and films. Visuals, including advertisements, are attractively reproduced. The thoroughness of Griffith in his selections and arrangements will inform, entertain, and satisfy one's nostalgia.

O205. **Hamblett, Charles.** THE HOLLYWOOD CAGE. New York: Hart Publishing Co., 1969. 450 p., illus.

A British magazine writer's negative perception of Hollywood, with major attention given to many popular film performers of the sixties. Marilyn Monroe and Kim Novak are singled out for extended treatment. Some candid photographs; index.

O206. **Higham, Charles.** HOLLYWOOD AT SUNSET. New York: Saturday Review Press, 1972. 181 p., illus.

According to the author, Hollywood's sun set between 1946 and 1971. To support his description of the demise of Hollywood as a film capital, Higham suggests many causes, including blockbuster films, studio moguls, agents, television, and runaway production costs. He presents a surface coverage rather than any detailed analysis. A center pictorial section adds little.

O207. **Holstius, E. Nils.** HOLLYWOOD THROUGH THE BACK DOOR. New York: Longmans, Green & Co., 1937. 319 p.

A prejudiced look at Hollywood in the thirties by a writer who tried to crash the party and was rejected.

O208. **Hopper, Hedda.** FROM UNDER MY HAT. Garden City, N.Y.: Doubleday & Co., 1952. 311 p.

Some biography, many anecdotes, but mostly innuendo and gossip make up this volume. The author's long association with the film industry and its personalities began in Hollywood in 1915.

O209. **Kleiner, Dick.** ESP AND THE STARS. New York: Grosset & Dunlap, 1970. 209 p.

Psychic experiences related by many film personalities and others.

O210. **Knight, Arthur, and Elisofon, Eliot.** THE HOLLYWOOD STYLE. New York: Macmillan Co., 1969. 219 p., illus.

Knight suggests that Hollywood personalities were America's equivalent to European royalty and describes the life-style made possible by motion pictures. A look at the palatial homes built in Hollywood over a forty-year period is provided by Elisofon's many beautiful photographs.

O211. **Levin, Martin, ed.** HOLLYWOOD AND THE GREAT FAN MAGAZINES. New York: Arbor House, 1970. 224 p., illus.

A sampling of articles taken mostly from popular fan magazines of the thirties. The inane, studio-generated material is accompanied by poor reproductions. Some possible value as nostalgia or as a quarry for sociologists may justify its compilation.

O212. **Lewis, Arthur H.** IT WAS FUN WHILE IT LASTED. New York: Trident Press, 1973. 320 p., illus.

A lament for the Hollywood that was. In the early seventies, the author held informal conversations with many of Hollywood's legendary personalities. Their views of present-day Hollywood and its future are bleak and depressing. Some poorly selected visuals are included in a center section.

O212a. **Loos, Anita.** KISS HOLLYWOOD GOODBYE. New York: Ballantine Books, 1975. 239 p., illus.

Anita Loos, who began writing screenplays in 1912, continues her autobiographical reminiscences in this haphazard account of Hollywood in the thirties. She is skillful in providing perceptive character sketches of the famous, but her ability to look at herself with humor and objectivity provides the book's major appeal. A list of her screenplays is added.

O213. **MacCann, Richard Dyer.** HOLLYWOOD IN TRANSITION. Boston: Houghton, Mifflin Co., 1962. 208 p.

This volume is concerned with Hollywood in the post-television years of the fifties. Adapted from previously published articles, the fragmented and dated text considers censorship, studio control, market, demands, and assembly-line production.

O214. **Marlowe, Don.** THE HOLLYWOOD THAT WAS. Fort Worth: Branch-Smith, 1969. 192 p., illus.

A scrapbook memoir—by a former Hollywood child actor—consisting of rare candid photographs, anecdotes, brief biographical sketches, and recollections.

O215. **Mayersberg, Paul.** HOLLYWOOD, THE HAUNTED HOUSE. New York: Ballantine Books, 1967. 211 p.

An exploration of a conflict basic to making motion pictures: business *versus* art. Using excerpts from interviews with filmmakers, the author surveys the American film industry. A weakly presented argument with some unsound conclusions. The unusual bibliography includes works of fiction.

O216. **Miller, Max.** FOR THE SAKE OF SHADOWS. New York: E. P. Dutton & Co., 1936. 200 p.

Impressions of Hollywood in the thirties by the author of *I Cover the Waterfront*, which was made into a film with the same title in 1933.

O217. **Morin, Edgar.** THE STARS. New York: Grove Press, 1960. 192 p., illus.

The star system is investigated and analyzed in this paperback volume. Using several approaches—social, historical, economic—the text explores the relationships between film stars and audience. Picture selection is good, but reproduction is poor. Chronology of landmarks.

O218 ARTS IN AMERICA: A BIBLIOGRAPHY

FILM

O218. Murray, Ken. THE GOLDEN DAYS OF SAN SIMEON. Garden City, N.Y.: Doubleday, 1971. 163 p., illus.

A picture book devoted mostly to San Simeon. Many Hollywood personalities are shown enjoying the hospitality of William Randolph Hearst and Marion Davies. The book is more fascinating if *Citizen Kane*'s Xanadu is mentally substituted for Hearst's San Simeon.

O218a. Niven, David. BRING ON THE EMPTY HORSES. New York: G. P. Putnam's Sons, 1975. 369 p., illus.

Niven covers the period from the mid-thirties to the early sixties in this reminiscence of Hollywood life. Various personalities receive chapter coverage, while many others are mentioned in anecdotes and quotations. Niven's story-telling ability is impressive.

O219. Los Angeles. **Otis Art Institute.** HOLLYWOOD COLLECTS. Los Angeles, 1970. unpag., illus.

Beautiful plates and attractive photographs of works of art collected by Hollywood personalities are displayed in this paperback volume. These visual delights show a relatively unknown side of Hollywood.

O220. Paul, Elliot. FILM FLAM. London: Frederick Muller, 1956. 160 p.

A writer of note comments caustically on Hollywood.

O221. Powdermaker, Hortense. HOLLYWOOD, THE DREAM FACTORY. Boston: Little, Brown & Co., 1951. 342 p.

Hollywood as seen and interpreted by an anthropologist. Working in the late forties and applying the methods of her discipline, the author explores the effects of Hollywood's social structure on its product: motion pictures. Her findings are predictable, though the analysis of them is controversial.

O222. Roeburt, John. GET ME GEISLER. New York: Belmont Books, 1962. 191 p.

This paperback contains a short biographical sketch of a successful Hollywood lawyer, followed by accounts of his famous cases. Some of the more notable involve Errol Flynn, Robert Mitchum, and Charlie Chaplin.

O223. Rosenberg, Bernard, and Silverstein, Harry. THE REAL TINSEL. New York: Macmillan Co., 1970. 436 p., illus.

A collection of edited interviews is used to describe Hollywood's earlier years. A cross-section of professional personnel is represented: executives, actors, directors, writers, stuntmen, cameramen. Some rare photographs add dimension to the book. Detailed index.

O224. Rosten, Leo C. HOLLYWOOD: THE MOVIE COLONY, THE MOVIE MAKERS. New York: Harcourt Brace, 1941. 436 p.

A sociological survey conducted in the thirties, this volume examines life in Hollywood and considers four creative groups operating within that life: producers,

directors, actors, and writers. Much of the text sounds familiar and superficial today.

O225. Schulberg, Budd. THE FOUR SEASONS OF SUCCESS. Garden City, N.Y.: Doubleday, 1972. 203 p.

The effect of Hollywood on six famous writers—Scott Fitzgerald, Dorothy Parker, William Saroyan, Nathanael West, Thomas Heggen, and John Steinbeck—is recalled by the author who knew them all personally.

O226. Los Angeles. **Sotheby, Parke-Bernet Galleries.** 20TH CENTURY FOX MEMORABILIA CATALOG. Los Angeles, 1971. 275 p., illus.
Sales catalog.

A paperback catalog of the properties offered for sale by a major Hollywood studio in 1971. Reproduced with pictures of the articles for sale are stills from many 20th Century Fox films. The changes in major studio operation at the end of the sixties are documented in this volume.

O227. Spears, Jack. HOLLYWOOD: THE GOLDEN ERA. New York: A. S. Barnes, 1971. 440 p., illus.

A collection of twelve varied articles that originally appared in *Films in Review*. Included are topics such as World War I, baseball, comic strips, and the work of Max Linder, Marshall Neilan, etc. Selected filmographies; film title and general subject indexes. The illustrations are fascinating in content, but poorly presented.

O228. Thomas, Bob. THE HEART OF HOLLYWOOD. Los Angeles: Price, Stern, Sloan, 1971. 112 p., illus.

A pictorial history of Hollywood and the Motion Picture and Television Relief Fund. Fifty years of the Fund's service are described by text and many candid photographs.

O229. Thorpe, Edward. THE OTHER HOLLYWOOD. London: Michael Joseph, 1970. 174 p.

An examination of Hollywood in the late sixties. The text offers sensationalized sociology that treats tourists, housewives, high school students, and others removed from the fantasy of the studio world. Written by an Englishman, this is a somewhat different view of Hollywood in decline.

O229a. Wagner, Walter. YOU MUST REMEMBER THIS: ORAL REMINISCENCES OF THE REAL HOLLYWOOD. New York: G. P. Putnam's Sons, 1975. 320 p.

A collection of twenty-five interviews. Although distance lends perceptible enchantment to some of the recollections, most are interesting, first-hand statements.

O230. Walker, Alexander. STARDOM: THE HOLLYWOOD PHENOMENON. New York: Stein & Day Publishers, 1970. 392 p., illus.

A documented analysis of the American phenomenon known as the star system. From its origins with Florence Lawrence to today's instant stars, the system was and is a unique Hollywood institution. Using fact and opinion, the text considers many personalities and films. The il-

lustrations are good, as are the bibliographic references. Index.

O231. **Weegee, and Harris, Mel.** NAKED HOLLYWOOD. New York: Pellegrini & Cudahy, 1953. unpag., illus.

A photographer's portrait of Hollywood at the beginning of its demise in the early fifties. There are sections on The Dream Factory, The People, Private Lives, and Street Scene. The visuals by Weegee are outstanding.

O232. **Wilk, Max.** THE WIT AND WISDOM OF HOLLYWOOD. New York: Atheneum Publishers, 1971. 330 p.

A collection of toasts, stories, quips, anecdotes, and gags that refer mostly to the period and personalities of the thirties and forties. The wit is present in abundance, but the wisdom is rather elusive.

O233. **Wiseman, Thomas.** THE SEVEN DEADLY SINS OF HOLLYWOOD. London: Oldburne Press, 1957. 222 p., illus.

A London reporter's view of Hollywood, written during the fifties and including many interviews and a few articles. Despite the title, the coverage is international. The illustrations are acceptable.

THE INDUSTRY

O234. **Bergsten, Bebe.** THE GREAT DANE AND THE GREAT NORTHERN FILM COMPANY. Los Angeles: Locare Research Group, 1973. 116 p., illus.

A biography of Ole Olsen, the pioneer Danish filmmaker who founded the Nordisk Film Company. The distribution and exhibition of Nordisk films in America is discussed at length. In addition to noting the contributions of Olsen and his coworkers, Ingvald Oes and August Blom, the book describes sixteen Nordisk films in some detail. The many illustrations are well reproduced. Index.

O235. **Bleum, A. William, and Squire, Jason E., eds.** THE MOVIE BUSINESS: AMERICAN FILM INDUSTRY PRACTICE. New York: Hastings House, 1972. 368 p.

A collection of articles by forty-three professionals who look on film as a vast economic enterprise. There are sections on the development of a film package, budget, company management, production, distribution, and exhibition. The contributors are bankers, agents, directors, writers, executives, producers. The appendix offers sample forms and contracts. Index.

O236. **Cassady, Ralph, Jr.** MONOPOLY IN MOTION PICTURE PRODUCTION AND DISTRIBUTION: 1908–1915. Los Angeles: University of Southern California Press, 1959. 66 p.

Early practices of the Motion Picture Patents Company and the General Film Company are described in this brief account.

O237. **Conant, Michael.** ANTITRUST IN THE MOTION PICTURE INDUSTRY: ECONOMIC AND LEGAL ANALYSIS. Berkeley: University of California Press, 1961. 240 p.

A well-researched summary and analysis of many antitrust cases involving the American film industry. A scholarly, accurate, and specialized attempt to show the impact of these cases on the industry. Bibliography; index of cases; and general index.

O238. **Crowther, Bosley.** THE LION'S SHARE. New York: E. P. Dutton & Co., 1957. 320 p., illus.

In this discussion of the motion picture industry, the author concentrates on the people and events of one studio—MGM—from its founding until its reorganization in 1956. Many stories and anecdotes are provided in this popular history. Good illustrations; index.

O239. **Dunne, John Gregory.** THE STUDIO. New York: Farrar, Straus & Giroux, 1968. 255 p.

A close-up of a major American film studio, 20th Century Fox, as it was operating in the mid-sixties. This penetrating report covers one year and describes the preparation and making of some high-budget musicals. Other filmmaking activities are recorded in detail, and personalities are intimately observed.

O240. **Federal Council of Churches of Christ in America.** THE PUBLIC RELATIONS OF THE MOTION PICTURE INDUSTRY. New York: Jerome S. Ozer, 1971. 155 p.

This investigation of the motion picture industry's attempts to create a better public image centers mostly on the Hays office. The study was made by questionnaire, and a summary of the findings concludes the volume. Index. The ORIGINAL EDITION (1931) is now available in this reprint edition.

O241. **Fernett, Gene.** HOLLYWOOD'S POVERTY ROW, 1930–1950. Satellite Beach, Fla.: Coral Reef Publications, 1973. 163 p., illus.

An exploration of a group of small studios that produced low-budget films in Hollywood from 1930 to 1950. Included are such organizations as Republic, Monogram, Mascot, and Tiffany. The text has been carefully prepared, and the accompanying illustrations are most effective. A neglected film topic has been handled with style in this volume. Index.

O242. **Fernett, Gene.** NEXT TIME DRIVE OFF THE CLIFF! Cocoa, Fla.: Cinememories; privately printed, 1968. 205 p., illus.

A fascinating study of a "poverty row" studio called Mascot Pictures is presented in text and pictures. The energy of its president was responsible for the production of many serials, features, and shorts during the decade from 1927 to 1937. Some noted actors were introduced to the screen by Mascot Productions. Since the book was printed privately, the edition lacks professional finish.

O243. **Foort, Reginald.** THE CINEMA ORGAN. Vestal, N.Y.: Vestal Press, 1970. 199 p., illus.

This book explores the motion picture organ that was

once a fixture in many American movie palaces. Specific installations are described and a few photographs are included. This is a reprint of the ORIGINAL EDITION (1932).

O244. Grau, Robert. THE BUSINESS MAN IN THE AMUSEMENT WORLD. A VOLUME OF PROGRESS IN THE FIELD OF THE THEATRE. New York: Jerome S. Ozer, 1972. 362 p., illus.

The author of this account of the commercial side of motion pictures, a booking agent at the beginning of the century, notes the rise of motion pictures as both entertainment and social force. The illustrations have an added interest because of their rarity. This book is a reprint of the ORIGINAL EDITION (1910).

O245. Guback, Thomas H. THE INTERNATIONAL FILM INDUSTRY: WESTERN EUROPE AND AMERICA SINCE 1945. Bloomington: Indiana University Press, 1969. 244 p., illus.

Foreign films in America and American films on foreign screens are two aspects of the international film industry emphasized in this well-documented book. Other topics include quotas, tariffs, markets, and subsidies. Tables of data support material in the text.

O246. Hall, Ben M. THE BEST REMAINING SEATS: THE STORY OF THE GOLDEN AGE OF THE MOVIE PALACE. New York: Bramhall House, 1961. 260 p., illus.

This impressive tribute to the great movie houses has special significance for historians, sociologists, and architects. Many fine illustrations and a droll but sentimental text trace the development of the film cathedrals from the nickelodeon to the period of theater opulence in the twenties and thirties. All facets of the giant movie houses are considered: furnishings, staff, organs, orchestras, etc. Index. REPRINTED AS *The Golden Age of the Movie Palace: The Best Remaining Seats* (New York: C. N. Potter; distributed by Crown Publishers, 1975).

O246a. Higham, Charles. THE WARNER BROTHERS. New York: Charles Scribner's Sons, 1975. 325 p., illus.

In a selective and critical text that contains some errors and important omissions, the author traces the lives of the Warner brothers from humble beginnings to motion picture mogul prominence. Concentrating on the period of Warner film production from 1918 to 1954, the text offers a valid portrait of a major Hollywood studio—its philosophy, tempo, methods, and attitudes. The volume contains a pictorial section and an index.

O247. Huettig, Mae D. ECONOMIC CONTROL OF THE MOTION PICTURE INDUSTRY. Philadelphia: University of Pennsylvania Press, 1944. 163 p., illus.

This well-documented study of the motion picture industry emphasizes financial-economic conditions. Covering the period from the first film trust in 1909 to the early forties, Huettig explores the intercorporate relations and policies in exhibition and distribution. Bibliography.

O248. Hulfish, David Sherill. MOTION-PICTURE WORK. New York: Arno Press, 1970. 297 p., illus.

The American motion picture industry in its infancy is surveyed in this volume. Specific attention is given to production, distribution, and exhibition. The more than three hundred illustrations include technical drawings and stills. This book is a reprint of the ORIGINAL EDITION (1915).

O249. Jobes, Gertrude. MOTION PICTURE EMPIRE. Hamden, Conn.: Archon Books, 1966. 398 p., illus.

The emphasis in this economic history of the film industry is on the early years and includes such topics as inventions, trusts, financial battles, film czars, etc. Little attention is given to the post–World War II years. Bibliography; index.

O250. Kennedy, Joseph P. THE STORY OF FILMS. New York: A. W. Shaw Co., 1928. 377 p., illus.

A series of lectures on the motion picture industry in the twenties given for a course at Harvard. Representatives from all sectors of the industry appeared: Will Hays, Cecil B. De Mille, Adolph Zukor, and others. Information, anecdotes, and reminiscences about the growth of the silent screen. REPRINT (New York: Jerome S. Ozer, 1971).

O251. King, Clyde L., and others. AMERICAN ACADEMY OF POLITICAL AND SOCIAL SCIENCE. ANNALS, SUPPLEMENTARY NUMBERS. New York: Arno Press, 1970. 236 p., illus.

This is a reprint of *The Motion Picture in Its Economic and Social Aspects*, edited by Clyde L. King and Frank A. Tichenor (*Annals*, Nov. 1926); and *The Motion Picture Industry*, edited by Gordon S. Watkins (*Annals*, Nov. 1947).

O252. Klingender, F. D., and Legg, Stuart. MONEY BEHIND THE SCREEN. London: Lawrence & Wishart, 1937. 79 p.

The financial bases of both the American and British film industries are the concerns of this short volume.

O253. Lahue, Kalton C. DREAMS FOR SALE: THE RISE AND FALL OF THE TRIANGLE FILM CORPORATION. New York: A. S. Barnes, 1971. 216 p., illus.

The Triangle Film Corporation was designed by Harry Aitken for the talents of D. W. Griffith, Thomas Ince, and Mack Sennett. Its short existence and the reasons for its demise are related in this well-researched book. The quality of the more than one hundred reproductions is uneven. Index.

O254. Lahue, Kalton C., and Brewer, Terry. KOPS AND CUSTARDS: THE LEGEND OF KEYSTONE FILMS. Norman: University of Oklahoma Press, 1968. 177 p., illus.

This book presents a history of the Keystone Film Company from 1912 to 1920. The reasons for the studio's success as a "fun factory" were two: Mack Sennett, and the personalities he gathered into his studio. Reproduction of the illustrations is poor, but a filmography of the Keystone comedies and two indexes are useful.

O255. **Lahue, Kalton C., ed.** MOTION PICTURE PIONEER: THE SELIG POLYSCORE COMPANY. New York: A. S. Barnes, 1973. 224 p., illus.

An account of one of the first motion picture companies in America. In addition to a short text, the author has used photographs, bulletins, advertisements, stills, editorials, and reviews in this history of an early film studio.

O255a. **Larkin, Rochelle.** HAIL COLUMBIA. New Rochelle, N.Y.: Arlington House, 1975. 445 p., illus.

This is the only currently available title that deals exclusively with the history of Columbia Pictures. Unfortunately, the wealth of material on the studio, its films, directors, and actors is presented in a disappointing manner. However, the production of the book provides some compensation owing to its many fine illustrations. An appendix lists over 1,600 films made by Columbia Pictures from 1922 to 1975.

O256. **Lewis, Howard T.** THE MOTION PICTURE INDUSTRY. New York: Van Nostrand, 1933. 454 p.

The production, distribution, and exhibition of theatrical films in America is discussed in this survey of the film industry in the early thirties.

O257. **McClelland, Doug.** THE UNKINDEST CUTS: THE SCISSORS AND THE CINEMA. New York: A. S. Barnes, 1972. 220 p., illus.

An examination of the arbitrary cutting of films by persons other than censors and film editors. By unkind cuts, the author means those made because of personal prejudice, competition, dislike, or economic greed. Many examples of films which have been so mutilated are offered. Some of the author's documentation appears vulnerable or even absent, but his theme remains a fascinating one. The twenty-eight pages of illustrations are weakened by uneven reproduction and unwarranted reduction. Index.

O257a. **Madsen, Axel.** THE NEW HOLLYWOOD: AMERICAN MOVIES IN THE '70S. New York: Thomas Y. Crowell Co., 1975. 207 p., illus.

An exploration of twenty years of change in the motion picture industry from mogul domination to corporate board control. Much emphasis is given to the new forms and systems of filmmaking prevalent in Hollywood during the seventies. Two sets of illustrations and an index are included.

O258. **Minus, Johnny, and Hale, William Storm.** THE MOVIE INDUSTRY BOOK: HOW OTHERS MADE AND LOST MONEY IN THE MOVIE INDUSTRY. Hollywood: Seven Arts Press, 1970. 601 p., illus.

A sometimes facetious overview of what was necessary in terms of contracts to produce films in Hollywood during the sixties. The potpourri of material is not always coherently organized or even pertinent, but it is usually informative. Among other things, advice, information, reviews, awards, and evaluations are offered. The practical presentation of complex economic and legal considerations should be most useful.

O259. **Morella, Joe; Epstein, Edward Z.; and Clark, Eleanor.** THOSE GREAT MOVIE ADS. New Rochelle, N.Y.: Arlington House, 1972. 320 p., illus.

An exploration of certain aspects of film advertising: newspapers, magazines, billboards, posters, press books. While a strong connecting narrative is missing, the collection of eight hundred pieces of advertising has been well selected. The reproduction of the illustrations is uneven.

O260. **Nizer, Louis.** MY LIFE IN COURT. Garden City, N.Y.: Doubleday, 1962. 524 p.

The proxy battle for control of the MGM Studios is given extended attention in this volume.

O261. **Photoplay Research Society.** OPPORTUNITIES IN THE MOTION PICTURE INDUSTRY. New York: Arno Press, 1970. 117 p., illus.

A historical perspective on careers in the silent film industry can be obtained from this volume. Directors, performers, exhibitors, and educators give information and optimistic advice. A few illustrations and a glossary are added. This is a reprint of the ORIGINAL EDITION (1922).

O262. **Ross, Murray.** STARS AND STRIKES. New York: Columbia University Press, 1941. 233 p.

This is an objective study of the unionization of Hollywood, based on facts and statistics.

O263. **Seabury, William Marston.** THE PUBLIC AND THE MOTION PICTURE INDUSTRY. New York: Jerome S. Ozer, 1971. 340 p.

This volume from the twenties recommends greater accountability from the motion picture industry and offers suggestions for obtaining it. The author regards the motion picture industry as a public utility and urges certain reforms by public action and the enactment of regulatory laws. This is a reprint of the ORIGINAL EDITION (1926).

O264. **Sharp, Dennis.** THE PICTURE PALACE AND OTHER BUILDINGS FOR THE MOVIES. New York: Praeger Publishers, 1969. 224 p., illus.

A survey of the buildings in which motion pictures have been shown in America and abroad. The evolution from nickelodeons to picture palaces is shown by floor plans, illustrations, and sketches. An informative text accompanies the many fine reproductions. Selected list of buildings; bibliography; index.

O265. **Sweeney, Russell C.** COMING NEXT WEEK: A PICTORIAL HISTORY OF FILM ADVERTISING. New York: A. S. Barnes, 1973. 303 p., illus.

A scrapbook of motion picture advertising covering 1920 to 1940. No text accompanies the many illustrations, which range from the pen and ink drawings of the twenties to the halftones and photographs of the thirties. The reproduction of the visuals is adequate.

O265a. **Toeplitz, Jerzy.** HOLLYWOOD AND AFTER: THE

CHANGING FACE OF MOVIES IN AMERICA. Chicago: Henry Regnery Co., 1975. 288 p., illus.

Recent changes in both the American film industry and its product are reported in this book, which is translated from Polish. It treats such topics as: films and TV, the disappearance of the major studios, and the replacement of studio heads by corporate boards. The current scene is described in detail; predictions are given. Bibliographical notes; three indexes.

GOVERNMENTAL INVESTIGATIONS

O266. **Bentley, Eric, ed.** ARE YOU NOW OR HAVE YOU EVER BEEN? New York: Harper & Row, 1973. 160 p., illus.

An edited reconstruction in paperback edition of some moments from the House Un-American Activities Committee investigations of 1947–1958. Many film personalities appear in text and illustrations.

O267. **Bentley, Eric, ed.** THIRTY YEARS OF TREASON. New York: Viking Press, 1973. 991 p.

A paperback collection of excerpts from hearings held by the House Un-American Activities Committee, 1938 to 1968. Many film personalities appeared, and samples of their testimony are included. This lengthy record of a shameful period in American history is interesting to read and useful for reference purposes. Index.

O268. **Bessie, Alvah.** INQUISITION IN EDEN. New York: Macmillan Co., 1965. 268 p.

An account of the confrontation between the Hollywood Ten and the House Un-American Activities Committee. The personalities involved received detailed attention from the author, one of the Ten.

O269. **Cogley, John.** REPORT ON BLACKLISTING: PT. 1. MOVIES. New York: Fund for the Republic, 1956. 312 p.

Five hundred people concerned with blacklisting in some way were interviewed for this study. This volume deals with the motion picture industry and the hearings of the House Un-American Activities Committee on communism in films. Statistics, records of the hearings, articles, statements, and lists of films are offered to illuminate this shocking period in American film history. Index.

O270. **Kahn, Gordon.** HOLLYWOOD ON TRIAL. New York: Boni & Gaer, 1948. 229 p.

A biased, somewhat hysterical paperback account of the 1947 hearings of the House Un-American Activities Committee on the motion picture industry. The indictment of the Hollywood Ten for contempt and their subsequent blacklisting are discussed. Paperback. REPRINT (New York: Arno Press, 1972).

O271. **Kanfer, Stefan.** A JOURNAL OF THE PLAGUE YEARS. New York: Atheneum Publishers, 1973. 306 p., illus.

An account of a dark period in film history. After tracing some of the origins of blacklisting, the author concentrates on the years from 1947 to 1962. His subjective attitudes toward the participants in the hearings of the House Un-American Activities Committee produce a strong statement against those who capitulated under pressure.

O272. **Manfull, Helen, ed.** ADDITIONAL DIALOGUE: LETTERS OF DALTON TRUMBO, 1942–1962. New York: M. Evans, 1970. 576 p.

Trumbo, the author of many screenplays, was one of the Hollywood Ten and a victim of industry blacklisting. The letters are concerned mostly with the 1947 hearings of the House Un-American Activities Committee and reflect that shameful period of terrorism and film industry timidity. The lingering effect on Trumbo and his family is described, as is his successful struggle for social and professional survival.

O273. **Vaughn, Robert.** ONLY VICTIMS. New York: G. P. Putnam's Sons, 1972. 355 p.

A study of blacklisting in the entertainment world. Based on the author's doctoral dissertation in which he questioned a hundred ex-witnesses, the text shows the effect of blacklisting on lives, careers, and creativity in the performing arts. Five different HUAC hearings are also described, and the author suggests implications for today. Appendixes and a detailed bibliography are added. Index.

Film and Society

For several decades, the motion picture was the most important mass medium in America and had an enormous effect on the lives of its audience. That vast and varied audience and certain of its responses to film viewing are documented in the books in this first part of this section [see O274–O299]. Federal, state, and private attempts to control certain effects by regulating the content of films are discussed under the rubric for censorship [see O300–O323]. Hollywood's attempts at self-regulation are also included. Few books have attempted to analyze the content of American motion pictures. Some of the more impressive ones are included in the final group of this section [see O323a–O347].

AUDIENCE AND EFFECT

O274. **Adler, Mortimer.** ART AND PRUDENCE: A STUDY IN PRACTICAL PHILOSOPHY. New York: Longmans, Green & Co., 1937. 700 p. [cont.]

In this study of motion pictures as a moral problem, Adler discusses the Payne Fund Studies, censorship, the need for values and standards, and related topics.

O275. **Blumer, Herbert.** Movies and Conduct. New York: Arno Press, 1970. 257 p.

A Payne Fund Study of the effect of film viewing on conduct. Comments by adolescents and young adults on experiences connected in some way with films were interpreted and generalizations formulated. This is a reprint of the ORIGINAL EDITION (1933).

O276. **Blumer, Herbert, and Hauser, Philip M.** Movies, Delinquency, and Crime. New York: Arno Press, 1970. 233 p.

This Payne Fund Study questioned young criminals, delinquents, and children from slum areas about the influence of films on their lives. This is a reprint of the ORIGINAL EDITION (1933).

O277. **Charters, W. W.** Motion Pictures and Youth: A Summary. New York: Arno Press, 1970. 73 p.

This volume served as an introduction and summary of the Payne Fund Studies done in the early thirties. The studies were initiated to examine the influence of motion pictures on the youth of America and have been reprinted as a series by the Arno Press.

O278. **Dale, Edgar.** Children's Attendance at Motion Pictures. New York: Macmillan Co., 1935. 81 p.

A Payne Fund Study of the frequency of attendance of school children at commercial motion pictures (1929–1930), this is a model of early research and a pioneer sociological investigation. REPRINT (New York: Arno Press, 1970).

O279. **Dysinger, Wendell S., and Rucknick, Christian A.** The Emotional Responses of Children to the Motion Picture Situation. New York: Arno Press, 1970. 122 p.

One of the Payne Fund Studies that used a galvanometer to measure the emotional responses of children to such film situations as danger, horror, and hunger. Reprinted from the ORIGINAL EDITION (1933).

O280. **Forman, Henry James.** Our Movie-made Children. New York: Macmillan Co., 1933. 288 p.

A summary of the twelve Payne Fund Studies of the effects of motion pictures on children. Done in the early thirties, the individual studies were pioneer research efforts in mass media. REPRINT (New York: Arno Press, 1968).

O281. **Handel, Leo A.** Hollywood Looks at Its Audience: A Report of Film Audience Research. Urbana: University of Illinois Press, 1950. 240 p.

This summary of research procedures used with American film audiences indicates the concerns of the industry during the thirties and forties. Filmgoers were surveyed about such things as story preference, attendance habits, and performer favorites. Many charts, graphs, and tables of data accompany the text. REPRINTED by Arno Press.

O282. **Hughes, Robert, ed.** Film: Book 1: The Audience and the Filmmaker. New York: Grove Press, 1959. 170 p., illus.

In addition to foreign contributions, this anthology offers original essays, opinions, statements, and replies from American directors and writers on the relationship between filmmaker and audience.

O283. **Jarvie, I. C.** Movies and Society. New York: Basic Books, 1970. 394 p., illus.

A theoretical exploration of the social effect of films, this volume treats three large areas: filmmakers, film viewers, and film discrimination. The author's enthusiasm for film often prevents a totally objective treatment. A long bibliography and an index are most helpful.

O283a. **Jowett, Garth.** Film: The Democratic Art. Boston: Little, Brown & Co., 1976. 482 p.

This important volume is a sociological history of the film that concentrates on American moviegoing during the past seventy-five years. Well researched and written, it examines the effects of the movies on morals, attitudes, and manners. Copious references; footnotes; lengthy bibliography.

O284. **Klapper, Joseph T.** The Effects of Mass Communication. Glencoe, Ill.: Free Press, 1960. 302 p.

This volume attempts to summarize the findings of over one thousand pieces of published research regarding social and psychological effects of mass communication. The first part deals with persuasion; the second, with the effects of diverse contents. Film is not emphasized, but there are many film references listed in the extended bibliography. Index.

O285. **Lawson, John Howard.** Film in the Battle of Ideas. New York: Masses & Mainstream, 1953. 126 p.

This controversial argument for overhauling the American film was written by one of the Unfriendly Ten Hollywood personalities cited by the House Un-American Activities Committee in 1947. After a discussion of several Hollywood films, Lawson presents his proposals for change. Paperback.

O286. **Lynch, William F., S.J.** The Image Industries. New York: Sheed & Ward, 1959. 159 p.

A scholar-priest argues that the motion picture and television industries have caused a crisis in American cultural life and politics. He cites as very dangerous the mixture of realism and fantasy so often found in films and television. Examples of American films are considered in his text.

O287. **MacCann, Richard Dyer.** Film and Society. New York: Charles Scribner's Sons, 1964. 182 p. [cont.]

This anthology considers such topics as audience values, how the screen reflects and influences society, whether controls should exist for films, television, and overseas distribution of films. Almost forty articles by noted writers present a variety of viewpoints.

O288. **McClure, Arthur F., ed.** THE MOVIES: AN AMERICAN IDIOM: READINGS IN THE SOCIAL HISTORY OF THE AMERICAN MOTION PICTURE. Cranbury, N.J.: Fairleigh Dickinson University Press, 1971. 440 p.

A collection of essays and other writing assembled to show the contribution of the motion picture to American life. The articles, which deal with various aspects of the film medium, are arranged chronologically. The names of the contributors are impressive and include critics, actors, writers, and historians.

O289. **Manvell, Roger.** THE FILM AND THE PUBLIC. Baltimore: Penguin Books, 1955. 352 p., illus.

Written as a successor to his earlier volume, *Film* [O81], this paperback emphasizes the art of film and its social importance. Worldwide in scope, it includes many American films, personalities, and examples. Director list; good illustrations; fine bibliography; index.

O290. **Mitchell, Alice Miller.** CHILDREN AND MOVIES. New York: Jerome S. Ozer, 1971. 181 p.

This investigation of children and movies predated the Payne Fund Studies. Mitchell investigated the movie experience of ten thousand American children, asking them questions about attendance, companion choice, film selection, and comparisons with other recreations. Many statistical tables; index.

O291. **Moley, Raymond.** ARE WE MOVIE-MADE? New York: Macy-Masius, 1938. 64 p.

A short companion volume to the Payne Fund Studies that deals with the effect of movies on the minds of young people.

O292. **Peters, Charles C.** MOTION PICTURES AND STANDARDS OF MORALITY. New York: Arno Press, 1970. 285 p.

A Payne Fund Study done in the early thirties to determine whether the films of that period were in conflict with the existing standards of morality. Topics used in the study included lovemaking, female aggression, parent-child relationships. The research methodology involved showing specific scenes to various groups and then asking for reactions. This is a reprint of the ORIGINAL EDITION (1933).

O293. **Peterson, Ruth C., and Thurstone, L. L.** MOTION PICTURES AND THE SOCIAL ATTITUDES OF CHILDREN. New York: Arno Press, 1970. 75 p.

A Payne Fund Study from the early thirties that indicated social attitudes towards crime, prejudice, war, punishment, etc. could be affected by motion pictures.

O293a. **Random, Henry.** MEMOIRS OF A MOVIEGOER. San Francisco: Editorial Service Bureau, 1975. 144 p.

A memoir that concentrates on moviegoing in America during the thirties. Although the text rambles, the author's respect, enthusiasm, and affection for his past film experiences are convincingly stated. Poorly produced the book lacks both illustrations and an index.

O294. **Renshaw, Samuel; Miller, Vernon L.; and Marquis, Dorothy P.** CHILDREN'S SLEEP. New York: Arno Press, 1970. 242 p.

The effect of motion pictures upon the sleep of children is the theme of this Payne Fund Study. Other unrelated factors are also considered. This is a reprint of the ORIGINAL EDITION (1933).

O295. **Robinson, W. R., ed.** MAN AND THE MOVIES. Baton Rouge: Louisiana State University Press, 1967. 371 p., illus.

This anthology of twenty articles and essays has as its central theme the impact of motion pictures on American culture. Its three sections deal with film genres, directors, and writer-critics. The articles were written by English teachers, writers, and poets. Bibliography; indexes.

O296. **Seldes, Gilbert.** THE GREAT AUDIENCE. New York: Viking Press, 1951. 239 p.

A discussion of the relationships between the mass audience and film, radio, and television. The section on film cites mostly American films and personalities in its arguments.

O297. **Shuttleworth, Frank K., and May, Mark A.** THE SOCIAL CONDUCT AND ATTITUDES OF MOVIE FANS. New York: Arno Press, 1970.

A group of moviegoing children were compared to a group of nonattenders by testing, teacher opinion, records, etc. in this Payne Fund Study. Attitudes toward race, crime, war, capital punishment, and other topics were investigated. ORIGINAL EDITION (1933).

O298. **Thomson, David.** MOVIE MAN. New York: Stein & Day Publishers, 1967. 233 p., illus.

The effect of cinema on modern man is the theme of this provocative book. The author argues that acceptance of film and its uses by today's society has brought forth the movie man: director, actor, character, and spectator. Evaluations of certain American films and directors are offered to support sociological discussion. The illustrations are good and a filmography for directors mentioned in the text is given. Index.

O299. **Thorp, Margaret Farrand.** AMERICA AT THE MOVIES. New Haven, Conn.: Yale University Press, 1939. 313 p., illus.

A survey of moviegoing during the thirties, this volume considers the audience, its tastes, the industry, film as art and as propaganda, and the effects of film. It discusses how audiences are influenced by films and how they in turn affect film content. Index.

CENSORSHIP

O300. **Beman, Lamar T., comp.** SELECTED ARTICLES ON CENSORSHIP OF THE THEATRE AND MOVING PICTURES. New York: Jerome S. Ozer, 1971. 385 p.

This is a reprint of a 1931 study on censorship in films and the theater. The film section of the study is presented in a debate format, which is accompanied by a detailed bibliography, separated into general, positive, and negative sections. The articles from periodicals which follow are arranged in the same three categories. ORIGINAL EDITION (1931).

O301. **Carmen, Ira H.** MOVIES, CENSORSHIP, AND THE LAW. Ann Arbor: University of Michigan Press, 1966. 339 p.

A well-researched history of American film censorship presented in two parts: the early period (covering 1915 to 1952) and the modern period (from 1953 to 1965). The pedantic account given here is accompanied by a detailed review of important court decisions. National, state, and local censorships are considered. Table of cases; bibliography; index.

O302. **U.S. Commission on Obscenity and Pornography.** THE REPORT OF THE COMMISSION. New York: Bantam Books, 1970. 700 p.

The official government study on the effects of pornography and obscenity on American society presents findings, overviews, recommendations, reports of panels. The report has implications for many individuals and groups in America. Paperback. ILLUSTRATED EDITION: *The Illustrated Presidential Report of the Commission on Obscenity and Pornography* (San Diego: Greenleaf Classics, 1970), 352 p. This paperback edition, with an introduction by Eason Monroe of the American Civil Liberties Union, includes numerous frank illustrations and a variety of prefaces.

O303. **Ernst, Morris L.** THE FIRST FREEDOM. New York: Macmillan Co., 1946. 316 p.

One section of this volume on censorship is devoted to film.

O304. **Ernst, Morris L., and Lindey, Alexander.** THE CENSOR MARCHES ON. New York: Doubleday Doran & Co., 1940. 346 p.

This survey of the 1940 mass media in America continues Ernst's crusade against unfair censorship. Films are included with radio, literature, etc. Contains transcriptions of court decisions. REPRINT (New York: Da Capo Press, 1971).

O305. **Ernst, Morris L., and Lorentz, Pare.** CENSORED: THE PRIVATE LIFE OF THE MOVIE. New York: J. Cape & H. Smith, 1930. 199 p., illus.

An early account of film censorship with many examples cited. The argument is against the censorship of films.

O306. **Ernst, Morris L., and Schwartz, Alan U.** CENSORSHIP: THE SEARCH FOR THE OBSCENE. New York: Macmillan Co., 1964. 288 p.

The effect of censorship on the creative artist is the major theme. Using a history of censorship, the authors chide the film industry on its passive acceptance of censorship. The court case involving *The Miracle* (1959) is described.

O306a. **Facey, Paul W.** THE LEGION OF DECENCY: A SOCIOLOGICAL ANALYSIS OF THE EMERGENCE AND DEVELOPMENT OF A SOCIAL PRESSURE GROUP. New York: Arno Press, 1974. 206 p.

A published dissertation, written in 1945, that analyzes the emergence and development of the Legion of Decency, a Roman Catholic pressure group that influenced American film content for many years. The Legion appeared in 1934 after years of planning. Its structure, goals, methods, effects, and relationships with other social groups are treated. It should be noted that this well-researched dissertation was written by a Catholic priest at a Catholic university. As a result, some readers may not find it completely objective. Bibliography.

O307. **Farber, Stephen.** THE MOVIE RATING GAME. Washington, D.C.: Public Affairs Press, 1972. 128 p.

An examination and critique of the current movie rating system. Background and documentation are offered in an aggressive text. The author served on the board that issues G, PG, R, and X ratings and writes from personal experience and disillusionment. Some appendixes are added.

O308. **Hart, H. H., ed.** CENSORSHIP: FOR AND AGAINST. New York: Hart Publishing Co., 1972. 255 p., illus.

An original anthology of twelve essays by critics, lawyers, and publicists, this volume provides a good summary of the many aspects of censorship. Hollis Alpert and Judith Crist write about censorship of the motion picture.

O309. **Harley, John Eugene.** WORLD-WIDE INFLUENCES OF THE CINEMA: A STUDY OF OFFICIAL CENSORSHIP AND THE INTERNATIONAL CULTURAL ASPECTS OF MOTION PICTURES. Los Angeles: University of Southern California Press, 1940. 320 p.

A study of the relationships between governments and motion picture industries. Attempts made by various countries to control or censor film content are noted. American examples of official and unofficial censorship are used.

O310. **Inglis, Ruth A.** FREEDOM OF THE MOVIES. Chicago: University of Chicago Press, 1947. 241 p.

A report of the Commission on Freedom of the Press, this book treats self-regulation of the screen, the social role of film, early attempts at control, and other aspects of censorship. A factual, detailed analysis.

O311. **Lane, Tamar.** WHAT'S WRONG WITH THE MOVIES? New York: Jerome S. Ozer, 1971. 254 p.

This is an analytical critique of the motion picture industry and its product in the early twenties. Lane argues in

favor of a change in the public image of the movies, the right of privacy for actors, and increased responsibility on the part of the press in its coverage of the industry.

O312. **Martin, Olga J.** Hollywood's Movie Commandments. New York: Arno Press, 1970. 301 p.

This is a detailed analysis of the Production Code, Hollywood's first attempt at self-regulation. The author considers various sections of the code, describes censorship in other countries, and reproduces the entire code at the end of the book. ORIGINAL EDITION (1937).

O313. **Moley, Raymond.** The Hays Office. Indianapolis: Bobbs-Merrill Co., 1945. 266 p., illus.

An account of the American motion picture industry's attempts at self-regulation. A short history of the economic and organizational development of the industry introduces the major topics: Will Hays, the Production Code, and the Hays office. Contains several appendixes and an index. REPRINT (New York: Jerome S. Ozer, 1971).

O314. **National Conference on Motion Pictures.** The Community and the Motion Picture. New York: Jerome S. Ozer, 1971. 96 p.

This is a report on a four-day film conference in which a diverse group discussed such topics as censorship, morals, production, exhibition, and distribution. ORIGINAL EDITION (1929).

O315. **Nizer, Louis.** New Courts of Industry: Self Regulation under the Motion Picture Code. New York: Jerome S. Ozer, 1971. 344 p.

This volume analyzes the operation of the Hays office and the administration of the Production Code, presenting problems, solutions, and suggestions for improvement. ORIGINAL EDITION (1935).

O316. **Oberholtzer, Ellis Paxson.** The Morals of the Movie. New York: Jerome S. Ozer, 1971. 251 p.

This account of operating a film censor's office for six years unintentionally provides evidence about restrictions on films in the twenties. Topics examined are sex films, melodramas, serials, comedies, politics, child audiences, and censor boards. Selected censorship rules from other localities appear in the appendix.

O317. **Paul, Elliot, and Quintanilla, Louis.** With a Hays Nonny Nonny. New York: Random House, 1942. 188 p., illus.

An argument against the Hays Code and Hollywood censorship. By considering and ultimately disqualifying the stories of the Bible as screen material, the authors provide a wealth of comment on filmmaking in the late thirties. Some good line sketches accompany the humorous text.

O318. **Perlman, William J.** The Movies on Trial. New York: Macmillan Co., 1936. 254 p.

A collection of articles that are for movies and against censorship. Contributors to this symposium of the thirties on film censorship include actors, writers, editors, etc.

O319. **Quigley, Martin.** Decency in Motion Pictures. New York: Macmillan Co., 1937. 100 p.

An analysis of film censorship and the Production Code.

O320. **Randall, Richard S.** Censorship of the Movies: The Social and Political Control of a Mass Medium. Madison: University of Wisconsin Press, 1968. 280 p.

A detailed and well-documented history of film censorship in the United States. This is the most comprehensive volume on the subject. Statistics, legal references, court decisions, and state codes are considered in a statement that represents a libertarian view.

O321. **Schumach, Murray.** The Face on the Cutting Room Floor. New York: William Morrow, 1964. 305 p., illus.

An informal, haphazard exploration of film censorship, this volume concentrates on describing specific examples of changing films to satisfy various pressures. The code, government, blacklists, guardian groups, and other influences on film content are noted. Because of the author's unpedantic approach to historical material, the book is both informative and entertaining. Clearly reproduced visuals, several appendixes, and an index add to the text.

O322. **Vizzard, Jack.** See No Evil. New York: Simon & Schuster, 1970. 381 p.

In relating his experiences with censorship and the Hollywood Production Code, the author recalls many interesting situations involving specific films and personalities. An in-depth look behind the scenes at Hollywood's attempts at self-regulation is provided. A copy of the code is appended.

O323. **Young, Donald Ramsey.** Motion Pictures: A Study in Social Legislation. New York: Jerome S. Ozer, 1971. 109 p.

This book examines moral standards in the motion picture. The argument that state censorship is the only valid method of controlling film content is indicative of the author's viewpoint. ORIGINAL EDITION (1922).

CONTENT OF FILMS

O323a. **Atkins, Thomas R.** Sexuality in the Movies. Bloomington: Indiana University Press, 1975. 288 p., illus.

This anthology consists of three major headings: social and cultural perspectives; categories and genres; and contemporary landmarks. Articles and essays appearing under each heading vary in quality, but most are quite effective. A superb collection of illustrations enhances this tasteful treatment of a controversial subject.

O324. **Bogle, Donald.** Toms, Coons, Mulattos, Mammies, and Bucks. New York: Viking Press, 1973. 260 p., illus.

A documentary of the changes in the film portrait of the black in American films, this book discusses the black as comic jester, servant, musical performer, problem personality, and film star. Some fine photographs help to interpret the text. Index.

O324a. **Betancourt, Jeanne.** WOMEN IN FOCUS. Dayton: George A. Pflaum, 1974. 186 p., illus.

Dealing with women in films, this book notes various movies that present portraits of real women rather than stereotypes. Title index; filmmaker's index; annotated film index; theme index; bibliography; and distributor list.

O325. **Butler, Ivan.** RELIGION IN THE CINEMA. New York: A. S. Barnes, 1969. illus.

In this superficial exploration of a broad topic, many American feature films are cited as examples. They are presented under broad classifications, which include bible stories, crusades, Christ in films, churches, monks, priests, nuns. This paperback contains pertinent illustrations, a bibliography, and an index.

O326. **Dale, Edgar.** THE CONTENT OF MOTION PICTURES. New York: Arno Press, 1970. 234 p.

This Payne Fund Study analyzes aspects of film and newsreel content such as crime, marriage, and locale. ORIGINAL EDITION (1935).

O327. **Deming, Barbara.** RUNNING AWAY FROM MYSELF. New York: Grossman Publishers, 1969. 210 p., illus.

The author examines certain films from the thirties and forties that she believes reflect the dreams, wishes, and fears of America at that time. Character types such as the war hero, the success boy, the possessive heroine, are examined in individual sections. A filmography is included in this controversial and provocative presentation. Index.

O328. **Durgnat, Raymond.** EROS IN THE CINEMA. London: Calder & Boyars, 1966. 207 p., illus.

The author examines sexual content and suggestion in films by citing many examples, some American. The approach is historical, serious, and subjective. Illustrations are only fair.

O329. **Friar, Ralph, and Friar, Natasha.** THE ONLY GOOD INDIAN. New York: Drama Book Specialists, 1973. 332 p., illus.

A study of the portrait of the American Indian in both silent and sound films. Its theme is that the distortion of truth for dramatic purpose has resulted in stereotyping and the misrepresentation of much authentic Indian culture. Final sections include a listing of actors who regularly played the part of Indians and a filmography arranged by subject category. The eighty visuals are interesting and add much to this definitive study.

O330. **Furhammar, Leif, and Isaksson, Folke.** POLITICS AND FILM. New York: Praeger Publishers, 1971. 257 p., illus.

A historical survey of film used as a political tool. Concentrating mostly on the Soviet Union, Germany, and the United States, the text is divided into three major sections: history, films, and principles. Many examples of specific films are offered, along with some acceptable stills, a bibliography, and an index.

O331. **Harmon, Francis S.** THE COMMAND IS FORWARD. New York: Richard R. Smith, 1944. 56 p.

Some aspects of the role that motion pictures play in wartime are discussed in these excerpts from speeches given by the author, who was chairman of the War Activities Committee in the forties.

O332. **Haskell, Molly.** FROM REVERENCE TO RAPE. New York: Holt, Rinehart & Winston, 1973. 388 p., illus.

An overview of how women have been portrayed in films. Developing her theme around various directors, the author concludes that women have lost ground in the films from 1920 to 1970. Examples from many films are given in support of her conclusion. The illustrations are few but are nicely reproduced. Index.

O333. **Holoday, Perry W., and Stoddard, George P.** GETTING IDEAS FROM THE MOVIES. New York: Arno Press, 1970. 102 p.

The authors of this Payne Fund Study were concerned with the retention of film content by children. ORIGINAL EDITION (1933).

O334. **Johnston, Winifred.** MEMOS ON THE MOVIES: WAR PROPAGANDA, 1914–1939. Norman, Okla.: Cooperative Books, 1939. 68 p.

This short paperback analysis of the role that films play in preparing a population for war stops short of World War II but predicts its inevitability.

O335. **Knight, Arthur, and Alpert, Hollis.** PLAYBOY'S SEX IN CINEMA. (1970—), illus.

For each year this paperback surveys the sexual content of films, discusses the performers involved, and provides a gallery of well-reproduced stills. Published by Playboy Press, Chicago.

O335a. **Leab, Daniel J.** FROM SAMBO TO SUPERSPADE: THE BLACK EXPERIENCE IN MOTION PICTURES. Boston: Houghton Mifflin Co., 1975. 301 p., illus.

Although much of the material in this book has appeared elsewhere, the account is workmanlike, the visuals are very good, and a bibliography is included. Index.

O336. **Lee, Raymond.** FIT FOR THE CHASE. New York: A. S. Barnes, 1969. 237 p., illus.

A survey of the automobiles that have been an integral part of films—as chase vehicles, lovers' locations, comedy objects, or dramatic props. Over two hundred illustrations are offered.

O336a. **Manvell, Roger.** FILMS AND THE SECOND

WORLD WAR. New York: A. S. Barnes, 1974. 320 p., illus.

Although this volume is international in scope, enough attention is paid to the role of American films in World War II to warrant inclusion here. Film as a medium for propaganda is a major theme, and many wartime documentaries are mentioned. Supporting Manvell's literate, comprehensive text are many good illustrations, a bibliography, and separate indexes for names and film titles. The book is a model of popular research and writing.

O337. Mapp, Edward. BLACKS IN AMERICAN FILMS: TODAY AND YESTERDAY. Metuchen, N.J.: Scarecrow Press, 1972. 278 p., illus.

The evolution of the film image of the black is traced from silent films to 1970. Emphasis is on the decade of the sixties when the changing status of blacks in America was reflected on the screen. New stereotypes, emerging stars, and similar topics are treated in the well-researched text. Bibliography; index.

O337a. Maynard, Richard A. THE BLACK MAN ON FILM: RACIAL STEREOTYPING. Rochelle Park, N.J.: Hayden Book Co., 1974. 134 p., illus.

A high school text that has some value as a source book and an introduction to a major issue in American history, this book includes material on *Birth of a Nation*, Stepin Fetchit, *Carmen Jones*, and Sidney Poitier. A final chapter is devoted to parallel consideration of "the movie Indian" and "the movie Jew."

O337b. Maynard, Richard, ed. PROPAGANDA ON FILM. Rochelle Park, N.J.: Hayden Book Co., 1975. 144 p., illus.

This anthology explores the relationship between theatrical films and political propaganda during periods of war; it describes selected American propaganda films from both world wars and the cold war. Filmography; list of rental sources.

O338. Mellen, Joan. WOMEN AND SEXUALITY IN THE NEW FILM. New York: Horizon Press, 1973. 255 p., illus.

An exploration of how women are treated in today's films. The author approaches her subject in two ways. Specific topics, such as lesbianism, and sexual politics, are treated in individual chapters. Similar attention is focused on selected directors such as Bergman, Visconti, and Bunuel. Even Mae West is analyzed in one essay. Stills from forty films are used to supplement the author's argument. Paperback.

O338a. Murray, James. TO FIND AN IMAGE: BLACK FILMS FROM UNCLE TOM TO SUPER FLY. Indianapolis: Bobbs-Merrill Co., 1973. 223 p., illus.

The topic of black cinema is covered by interviews, history, survey, and filmographies in this volume. Its emphasis is on changes in content and character found in recent Black films. A summary is given and some predictions about Black cinema are made. Good illustrations; several appendixes; filmographies; and an index.

O339. Noble, Peter. THE NEGRO IN FILMS. New York: Arno Press, 1970. 288 p., illus.

A rediscovered pioneer work, Noble's survey examines the portrait of the Negro in films during the first half century of the motion picture. Some biographical sketches of black performers are included. Nearly fifty carefully selected illustrations; bibliography; and filmography for the period 1902–1948.

O340. Rosen, Marjorie. POPCORN VENUS. New York: Coward, McCann & Geoghegan, 1973. 416 p., illus.

A general survey of women in films. Strongest are sections on the image of women as reflected in films, as seen by themselves, and as viewed by society. Supplementary material, such as film history, biographies, actors and actresses, and women behind the camera, is provided. In attempting to cover too many aspects of the topic, the author weakens her total statement. Two portrait galleries and a lengthy bibliography accompany the text. Index.

O341. Savary, Louis M., and Carrico, J. Paul, eds. CONTEMPORARY FILM AND THE NEW GENERATION. New York: Association Press, 1971. 160 p., illus.

An examination of today's films. Stills, script excerpts, and personality comments accompany the treatment of topics such as audience, violence, religion, heroes, directors. Many American films are mentioned. Paperback.

O341a. Smith, Julian. LOOKING AWAY: HOLLYWOOD AND VIETNAM. New York: Charles Scribner's Sons, 1975. 236 p., illus.

The argument put forth in this volume is that Hollywood ignored the Vietnam War. Not only did this unpopular war cause public attitudes toward government and the military to change appreciably, but it also affected the content of other war films, some of which were used as metaphors for the Vietnam conflict. Smith's exploration of the reasons for Hollywood's rejection of the Vietnam War as film material makes disturbing and provocative reading.

O342. United States. Congress, House. Subcommittee on Communications and Power. FILMS AND BROADCASTS DEMEANING ETHNIC, RACIAL, OR RELIGIOUS GROUPS. Washington, D.C.: Government Printing Office 1970, 97 p.; 1971, 67 p.

Records of two hearings that offer testimony, letters, exhibits, etc., on the reinforcement of negative stereotypes in American films, TV, and radio. Examples of government and citizen involvement with mass media are noted in these reports. Paperback.

O343. Tyler, Parker. SCREENING THE SEXES: HOMOSEXUALITY IN THE MOVIES. New York: Holt, Rinehart & Winston, 1972. 384 p., illus.

A detailed paperback examination of homosexuality in the motion picture. In addition to treating the recent obvious examples, Tyler also contributes gay interpretations of many older straight films: *The Wizard of Oz* (1939), *Test Pilot* (1938), *Gilda* (1946), and others. Tyler's narrative

style is less obscure regarding these films, but still contains a mixture of intellectuality, gutter language, gossip, conjecture, and analysis. Almost seventy unusual illustrations accompany the provocative text. Index.

O344. **Walker, Alexander.** THE CELLULOID SACRIFICE: ASPECTS OF SEX IN THE MOVIES. New York: Hawthorne Books, 1967. 241 p., illus.

This volume examines the sexuality of women (Bara, Bow, West, Pickford, Garbo, Dietrich, Harlow, Monroe, and Taylor) on the American screen, looks at certain controls of the sex drive expressed in films, and argues that screen heroes have been victimized by dominant females. Acceptable illustrations; bibliography; and index. Paperback edition: *Sex in the Movies.*

O345. **Wolfenstein, Martha, and Leites, Nathan.** MOVIES: A PSYCHOLOGICAL STUDY. Glencoe, Ill.: Free Press, 1950. 316 p., illus.

For this study the authors examined the content of 166 American films and then made comparisons with French and British films, exploring common themes, recurring patterns, stereotypes. REPRINT (New York: Atheneum Publishers, 1970).

O346. **Wollen, Peter.** SIGNS AND MEANING IN THE CINEMA. Bloomington: Indiana University Press, 1969. 168 p., illus.

A serious, sophisticated argument for a new film aesthetic. The author uses Eisenstein, John Ford, Howard Hawks, and other directors to explain the *auteur* theory and to show how a new aesthetic can use semiology as an analytical tool. Photographs and appendixes are added. Paperback.

O346a. **Wood, Michael.** AMERICA IN THE MOVIES OR "SANTA MARIA, IT HAD SLIPPED MY MIND." New York: Harper & Row, 1975. 206 p., illus.

A study of recurring themes found in American films of the thirties and forties. The author's thesis is that Hollywood films lacked contact with the important moral and social issues of the period. Some important questions are raised, but their treatment is less than satisfactory. Index.

O347. **Worth, Sol, and Adair, John.** THROUGH NAVAJO EYES. Bloomington: Indiana University Press, 1972. 286 p., illus.

An account of an anthropological study involving Navajo Indians and film communication. Filmmaking was taught to the Indians, and the films they eventually made were analyzed. Stills; bibliography; and index.

Film and Education

The use of films for educational purposes by schools, libraries, and other institutions dates back almost to the time when films were invented. More recent interpretations of the role of film in these settings have included purposes such as appreciation, entertainment, communication, and self-expression. Books dealing with the ways that American institutions use film make up the first group in this category [*see* O348–O372].

Religions have found film helpful in communicating their beliefs, philosophies, and values. Accounts of this relatively new movement can be found in the middle group of entries [*see* O373–O378]. The short film is the most important and popular film format used by institutions. This final group here surveys the literature of the short film, noting many reference sources [*see* O379–O399].

EDUCATION

O348. **Amelio, Ralph J.** FILM IN THE CLASSROOM: WHY USE IT; HOW TO USE IT. Dayton: George A. Pflaum, 1971. 208 p.

The educational experiment described here, known as the Willowbrook Cinema Study Project, is one example of a film course in an American secondary school in the 1970s.

O349. **Amelio, Ralph J.** WILLOWBROOK CINEMA STUDY PROJECT. Dayton: George A. Pflaum, 1969. 84 p.

This paperback volume describes the experience of designing, presenting, and evaluating a course on film appreciation developed at Willowbrook High School in Villa Park, Ill. A good bibliography is included.

O350. **Brown, James W., ed.** EDUCATIONAL MEDIA YEARBOOK, 1973. New York: R. R. Bowker Co., 1973. 453 p.

This multi-media reference book contains a collection of outstanding articles; listings of media organizations, foundations, and federal granting agencies; an index of publishers, producers, and distributors; and a hundred-page annotated bibliography of various media. Several indexes to the text are provided.

O351. **Brown, Roland G.** A BOOKLESS CURRICULUM. Dayton: George A. Pflaum, 1972. 135 p., illus.

A paperback account of a secondary school curriculum experiment that substituted films and other nonprint media for textbooks. The design, procedures, objectives, test instruments, and other particulars are described, and

the film, discussion, and project units are given a final evaluation. Filmography; bibliography.

O352. **Callenbach, Ernest.** OUR MODERN ART: THE MOVIES. Chicago: Center for the Study of Liberal Education for Adults, 1955. 116 p.

An early paperback volume that suggests methods of using films with adult discussion groups, this study devotes separate chapters to several American films and includes much background information and many valuable suggestions for group leaders.

O353. DIRECTORY OF FILM LIBRARIES IN NORTH AMERICA. (1971—).

A biennial paperback listing of over 1,800 film libraries in North America. Published in New York by the Film Library Information Council.

O354. **Dale, Edgar.** HOW TO APPRECIATE MOTION PICTURES. New York: Arno Press, 1970. 243 p.

This Payne Fund Study is a manual on film criticism and evaluation for high school students. ORIGINAL EDITION (1937).

O355. **Fensch, Thomas.** FILMS ON THE CAMPUS: CINEMA PRODUCTION IN COLLEGES AND UNIVERSITIES. New York: A. S. Barnes, 1970. 534 p., illus.

A survey of campus filmmaking that samples college programs in three regions of the United States: East, Midwest, and West. Films, scripts, courses, professors, and other particulars are examined and described. The two hundred illustrations are merely adequate. Glossary; index.

O356. **Feyen, Sharon, ed.** SCREEN EXPERIENCE: AN APPROACH TO FILM. Dayton: George A. Pflaum, 1969. 273 p., illus.

This paperback contains suggestions about the use of films with various groups, including much information on literary adaptations, genre films, short films. Annotated list of films; bibliography; and index.

O357. **Herling, Michele, ed.** GUIDE TO COLLEGE COURSES IN FILM AND TELEVISION. Washington, D.C.: Acropolis Books, 1973. 309 p.

An annual paperback publication of the American Film Institute that lists those colleges in United States offering courses, programs, or degrees in film or television. In the early seventies about 700 institutions with more than 6,000 courses were described. Data are included on courses, curriculum, faculty, and scholarships.

O358. **Hoban, Charles, and Van Ormer, Edward.** INSTRUCTIONAL FILM RESEARCH 1918-1950: RAPID MASS LEARNING. New York: Arno Press, 1970. unpag.

A summary of research on the instructional film during the first half of this century. This pioneer work was first published with military support and cooperation owing to the armed forces' interest in rapid mass learning. ORIGINAL EDITION (1950.

O359. **Hoban, Charles F.** MOVIES THAT TEACH. New York: Dryden Press, 1946. 189 p., illus.

Experiences with the use of educational films with the armed forces during World War II form the basis for this report. Statistics; charts; diagrams.

O359a. **Indiana University Audio-Visual Center.** UNIVERSITY AND COLLEGE FILM COLLECTIONS. New York: Educational Film Library Association, 1974. 75 p.

This volume lists over four hundred film libraries, providing information about personnel, budget, collection size, policy, and so on.

O360. **Lewin, William.** PHOTOPLAY APPRECIATION IN AMERICAN HIGH SCHOOLS. New York: Appleton-Century, 1935. 122 p.

An early experiment that gave support to the use of films in the American classroom and to the inclusion of film appreciation in the curriculum. Bibliography; questionnaire.

O361. **McDonald, Gerald D.** EDUCATIONAL MOTION PICTURES AND LIBRARIES. Chicago: American Library Association, 1942. 184 p.

This volume, which is an argument for film service in libraries, provides many specific examples of pioneer efforts in the use of films in American libraries. Index.

O362. **Mallery, David.** THE SCHOOL AND THE ART OF MOTION PICTURES. Boston: National Association of Independent Schools, 1964. 101 p.

Suggestions on the use of the feature film in American secondary schools. Hundreds of films are classified under suggested teaching units, and each film is given a descriptive evaluation. List of rental libraries; index. Paperback.

O363. **Manchel, Frank.** FILM STUDY: A RESOURCE GUIDE. Cranbury, N.J.: Fairleigh Dickinson University Press, 1973. 422 p.

An impressive reference book designed for film study but useful in many other situations. Manchel has divided his text into accepted film study categories, such as aesthetics, genres, themes, and history. With each he has furnished annotated listings of pertinent books, periodicals, and films. Seven separate indexes.

O363a. **Melton, Hollis, comp.** MUSEUMS WITH FILM PROGRAMS. New York: Educational Film Library Association, 1974. 20 p.

Over five hundred museums in the United States and Canada that have film programs are identified in this volume. Taken from *The Official Museum Directory* (Washington, D.C.: American Association of Museums; and Skokie, Ill.: National Register Publishing Co., 1971), the information is selected and fragmentary; but it does reflect considerable usage of film by American museums.

O364. **Mirwis, Allan.** A DIRECTORY OF 16MM FILM COLLECTIONS IN COLLEGES AND UNIVERSITIES IN THE UNITED STATES. Bloomington: Indiana University Press, 1972. 74 p.

A paperback survey of 16mm film libraries in American colleges and universities. Information about collection size, loans, rentals, catalogs is given. Entries are arranged alphabetically by state.

O365. **Poteet, G. Howard, ed.** THE COMPLETE GUIDE TO FILM STUDY. Urbana, Ill.: National Council of Teachers of English, 1972. 242 p., illus.

A paperback anthology that contains suggestions for teaching about film in American secondary schools. Using examples from many films, the articles treat film history, language, literature, composition, and curriculum. Filmography; screenplay listing; short bibliography; and index.

O366. **Reed, Rochelle, ed.** UNIVERSITY ADVISORY COMMITTEE SEMINAR. Washington, D.C.: American Film Institute, 1972. 24 p., illus.

An incomplete report on the proceedings of a meeting held in 1972 to explore the relationship between the American Film Institute and the academic community.

O367. **Rehrauer, George.** THE FILM USER'S HANDBOOK. New York: R. R. Bowker & Co., 1975. 224 p., illus.

This manual for persons and institutions concerned with film service reviews the history of film service in America and offers much practical information on policies, budgets, study guides, selection, evaluation, programming. The current use of films in libraries and museums receives considerable attention.

O368. **Schillaci, Anthony, and Culkin, John M., eds.** FILMS DELIVER. Englewood Cliffs, N.J.: Citation Press, 1970. 348 p., illus.

A paperback text and reference work for teachers who use films in secondary schools. An outgrowth of Fordham University's National Film Study Project, the book offers advice, a filmography, a bibliography and an index of titles.

O369. **Sheridan, Marion, and others.** THE MOTION PICTURE AND THE TEACHING OF ENGLISH. New York: Appleton-Century-Crofts, 1965. 168 p., illus.

Harold Owens, Ken MacRorie, and Fred Marcus collaborated in this much criticized paperback volume on how the study of film can be integrated into the English curricula of secondary schools. Literary bias, errors, and out-of-date information belie the good intentions of the volume. Bibliography; several indexes.

O370. **Starr, Cecile.** DISCOVERING THE MOVIES. New York: Van Nostrand, 1972. 144 p., illus.

A film study text designed for young people that has appeal for all. Using film history, biography, criticism, comment, reviews, and a fine collection of stills, the author provides an attractive guide for studying and making films. Supplementary notes; index.

O371. **Stewart, David C., ed.** FILM STUDY IN HIGHER EDUCATION. Washington, D.C.: American Council on Education, 1966. 174 p., illus.

In this paperback educators, scholars, and filmmakers offer opinion and suggestion on improving film study in higher education. Contains useful appendixes; bibliography.

O372. **Waldron, Gloria.** THE INFORMATION FILM: A REPORT OF THE PUBLIC LIBRARY INQUIRY. New York: Columbia University Press, 1949. 281 p.

A study of the use of film in sixty American public libraries during the late forties. Commissioned by the Public Library Inquiry, the report is now dated, but it offers a historical view of the beginnings of film service in libraries.

THE CHURCH

O373. **Heyer, Robert, S.J., and Meyer, Anthony, S.J.** DISCOVERY IN FILM. New York: Association Press; and Paramus, N.J.: Paulist Press, 1969. 220 p., illus.

This paperback exploration of the use of nonfeature motion pictures with teenagers considers many American short films. Discussion questions, data, and resource material are given for each of the films, which are classified into five categories. Several appendixes and some fine illustrations contribute to the excellence of this useful book.

O374. **Hurley, Neil P.** THEOLOGY THROUGH FILM. New York: Harper & Row, 1970. 212 p., illus.

A strong statement about the use of films to communicate religious values. Individual chapters on topics such as freedom, the inner man, evil, death, and grace compare the message of the filmmaker with that of the religious leader. Many examples from films are cited. Good illustrations and footnotes for each chapter are included in this stimulating book. Index.

O375. **Jones, G. William.** SUNDAY NIGHT AT THE MOVIES. Richmond, Va.: John Knox Press, 1967. 126 p., illus.

This paperback volume discusses the use of films in American church groups. Many valuable suggestions about film discussions. Bibliography; film list; and some rental sources.

O376. **Kahle, Roger, and Lee, Robert E. A.** POPCORN AND PARABLE. Minneapolis: Augsburg Publishing House, 1971. 128 p., illus.

This argument for the use of films in churches examines today's films and suggests ways in which they can help further the work and goals of religious groups. Short Bibliography.

O377. **Konzelman, Robert G.** MARQUEE MINISTRY. New York: Harper & Row, 1972. 123 p., illus.

A statement about cooperation between the local film industry representative and the church. Suggestions are made to integrate certain church and movie theater activities rather than wage continual battles about censor-

ship and controls. Film festivals, discussions, and study groups are advocated. Short bibliography.

O378. Wall, James M. CHURCH AND CINEMA: A WAY OF VIEWING FILM. Grand Rapids, Mich.: William B. Eerdmans Publishing Co., 1971. 135 p., illus.

Written to encourage the acceptance and use of film by the church, this provocative book provides an approach to the critical evaluation of films. The author develops his standards for judgment by using examples and reviews of many recent films. The illustrations are excellent. Index.

THE SHORT FILM

O379. Abrams, Nick, ed. AUDIO VISUAL RESOURCE GUIDE. 9th ed. New York: Friendship Press, 1972. 477 p.

A paperback reference book that contains thousands of reviews and annotations of nonprint media. Films, including many American titles, are the subject of most of the reviews. Short films are given detailed evaluations, and there is a lengthy section describing recommended features. Designed for religious educators, much of this material has pertinence for other groups and individuals. Subject indexes and addresses of distributors are provided.

O380. Cushing, Jane. ONE HUNDRED AND ONE FILMS FOR CHARACTER GROWTH. Notre Dame, Ind.: Fides Publishers, 1969. 110 p.

Many American short films appear in this paperback collection of one hundred study guides. A rating, data, a synopsis, and questions are given for each.

O381. Daglish, William A., ed. MEDIA TWO: FOR CHRISTIAN FORMATION. Dayton: George A. Pflaum, 1970. 502 p., illus.

Evaluative data and annotations for more than two hundred short films are contained in this paperback reference work on nonprint media. Published for church groups, the book can be used by many others. An earlier title, *Media for Christian Formation* (1969), treats another two hundred or so short films.

O382. Educational Film Library Association. FILM EVALUATION GUIDE, 1946–1965. New York: Educational Film Library Association, 1965. 526 p.

This first compilation of reviews from the Education Film Library Association consists of 4,500 short films made from 1946 to 1965. The thousands of evaluations of American short films constitute an indispensible reference source. Subject index; distributor data. *Supplement 1 1965–1967). Supplement 2 (1967–1970).*

O383. Educational Media Council. EDUCATIONAL MEDIA INDEX. New York: McGraw-Hill Book Co., 1964. 14 vols.

The editorial and financial difficulties encountered in publishing a massive fourteen-volume index to audiovisual materials caused almost immediate discontinuance of this reference work. Many American short films were treated in the sections on motion pictures.

O383a. Gordon, Malcolm W. DISCOVERY IN FILM, BOOK 2. New York: Paulist Press, 1973. 162 p., illus.

This volume offers descriptions of eighty-one short films and suggestions for their use in a variety of educational settings. More modest in content and production than *Book 1*, this is still an excellent resource for short film usage. Index.

O384. Hall, C. Edward, ed. MULTI-MEDIA REVIEWS INDEX. Ann Arbor. (1970—).

An annual index to reviews of films, filmstrips, and tapes published by Pierian Press. It offers data about each film and indicates the tone of the review as positive, negative, or neutral. In the 1971 edition, the authors were indexing over 130 periodicals and offering almost 20,000 citations.

O385. Horkheimer, Mary Foley, and Diffor, John W., eds. EDUCATORS' GUIDE TO FREE FILMS. Randolph, Wis. (1949—).

Several thousand free films are classified under curriculum areas in this annual published by Educators' Progress Service. Many of the films are sponsored by American corporations and government institutions and agencies. Title guide; subject index; source index.

O386. Jones, Emily, ed. THE COLLEGE FILM LIBRARY COLLECTION. Williamsport, Pa.: Bro-Dart Publishing Co., 1971. 154 p.

A list of recommended films for college collections arranged by subject area. Each film is described by data and a synopsis. Feature film list; distributor list; subject index. Paperback.

O387. Kone, Grace Ann, ed. 8MM FILM DIRECTORY. New York: Educational Film Library Association, 1969–70. 532 p.

Descriptive annotations are provided for several thousand films available in one or more of the 8mm formats. Indexes, visuals, addresses, and other particulars help make this a valuable reference source for many short films.

O388. Krahn, Frederick A., ed. EDUCATIONAL FILM GUIDE. 11th ed. New York: H. W. Wilson Co., 1953. 1037 p.

This reference work was discontinued after two supplements covering the period to 1962 were published. Many American short films were classified under Dewey Decimal System subject headings, and a brief description was given for each.

O389. Kuhns, William. THEMES: SHORT FILMS FOR DISCUSSION. Dayton: George A. Pflaum, 1968. illus.

A series of 134 discussion guides for short films. Each film is presented on a separate sheet and placed alphabetically by title in a three-ring binder. Data, synopses, and sugges-

tions for use are given for the films, many of which are of American origin. The illustrations are acceptable. [*See* O389a.]

O389a. **Kuhns, William.** THEMES TWO. Dayton: George A. Pflaum, 1974. 193 p., illus.

This second volume of *Themes* [O389] offers a selection of one hundred short films along with a narrative review-outline of each. Credits and technical data are given for each. Although the format of this volume differs from that of the first, the quality of Kuhn's information and evaluations remains high. Small illustrations; list of distributors; booklist; and thematic index.

O390. **Landers Associates.** LANDERS FILM REVIEWS. Los Angeles. (1956—).

A collection of reviews of 16mm short films is contained in each issue provided by this service. Complete data and a critical evaluation are provided for each film. This publication is often cumulated and thus serves as a reference book.

O391. **Lee, Rohama, ed.** FILM NEWS OMNIBUS, VOL. 1. New York: Film News, 1973. 270 p., illus.

A paperback collection of film reviews taken from *Film News*. The period covered is 1955 to 1972; a majority of the reviews are taken from the more recent years. Features and shorts are considered in separate sections. Subject listing; distributor information; reviewer credentials; and index.

O392. **Limbacher, James L., ed.** FILM SNEAKS ANNUAL, 1972. Ann Arbor, Mich.: Pierian Press, 1972. 121 p.

A paperback guide to 4,500 nontheatrical films containing a summary of selected evaluations made by librarians from more than forty participating institutions. Films are scored poor, fair, average, good, very good, or excellent.

O393. **McCaffrey, Patrick J.** A GUIDE TO SHORT FILMS FOR RELIGIOUS EDUCATION. Notre Dame, Ind.: Fides Publishers, 1968. 2 vols., illus.

Useful paperbacks containing discussion and study guides for short films. Vol. 1 treats over seventy films; vol. 2, more than fifty. Text suggests questions, age levels, and usage, and provides evaluation, data, and outline for each film.

O394. **National Information Center for Educational Media.** INDEX TO 8MM EDUCATIONAL MOTION CARTRIDGES. 4th ed. Los Angeles: University of Southern California; NICEM, 1974.

Thousands of cartridge films are listed in the third edition of this reference book. The films are mostly of the short educational genre and are arranged alphabetically by title. The information provided includes running time,

year of release, producer, distributor, a brief description of content, audience level, and other details. The films are described but not evaluated.

O395. **National Information Center for Educational Media.** INDEX TO 16MM EDUCATIONAL FILMS. 4th ed. Los Angeles: University of Southern California; NICEM, 1972. 2 vols.

More than 70,000 16mm films are listed alphabetically by title in this reference book. Each film is described by its title, running time, a brief description of its content, producer, distributor, year of release, audience level, etc. Several subject indexes; lists of distributors.

O396. **Parlato, Salvatore J., Jr.** FILMS: TOO GOOD FOR WORDS. New York: R. R. Bowker Co., 1973. 209 p.

A collection of almost one thousand short films that have no narration. Descriptive annotations are provided for each film along with the usual data on running time, release date, etc. A broad classification scheme involving thirteen categories, an alphabetical index, and a subject index facilitate use.

O397. **Rehrauer, George.** AN ILLUSTRATED GUIDE TO FIVE HUNDRED RECOMMENDED SHORT FILMS. New York: Macmillan Co., 1975. 225 p., illus.

A collection of five hundred films gathered from the recommendations in thirty-five books about short films. Besides the usual data for each film, the author provides a synopsis, suggested areas of use, audience levels, and references to the books that recommended the film. The books, comprising a basic collection of texts on the short film, are given detailed, evaluative annotations. The films listed provide a core collection of the most popular short films in general use in America to date. Over one hundred stills from the films supplement the descriptions.

O398. **Schrank, Jeffrey.** MEDIA IN VALUE EDUCATION: A CRITICAL GUIDE. Chicago: Argus Communications, 1970. 168 p., illus.

The largest section in this paperback volume is devoted to reviews of seventy-five short films, many American, along with suggested questions that might be used in a study discussion. Other media are discussed briefly, and there are guides to suppliers and distributors in addition to a title index.

O399. **Sohn, David.** FILM: THE CREATIVE EYE. Dayton: George A. Pflaum, 1970. 176 p., illus.

Seventeen short films and their creators are the concern of this paperback volume. The films are classified under four general headings, and information is presented about how and why each was made. Attractive stills from the films accompany the text.

FILMS: BOOKS, SCREENPLAYS, PERIODICALS

The Feature Film

In this category collective studies of American films appear first, followed by studies of specific film genres. Titles are arranged within this second group *alphabetically by genre* [*see* O427–O502] with the original author's words or titles dictating the particular type—including some unusual genres such as thriller, or screwball. Books devoted to the study of a single American film appear in the next group, which is arranged *alphabetically by film title* [*see* O503–O534a]. Published scripts of American films are arranged *alphabetically by title* [O535 *et* *seq.*]. Many books in this last group contain information, interviews, and articles in addition to the script. The script, however, is treated as the most important element in the given volume. In a few cases a book title is listed along with the film title if the two titles are not identical; see, for example, *More About All About Eve* [O540]. Those few works that contain script and text of equal importance are listed here and also elsewhere in the bibliography, as for example *The Citizen Kane Book* [O512] and *Salt of the Earth* [O529].

COLLECTIVE STUDIES

O400. **Alloway, Lawrence.** Violent America: The Movies, 1946–1964. New York: Museum of Modern Art, 1971. 95 p., illus.

An examination of thirty-five examples of the American action film from 1946 to 1964. Inspired by a retrospective show at The Museum of Modern Art, the book is an impressive production. Full-page stills are faithfully reproduced, and the text treats the essential aspects of the genre. Copious footnotes and a filmography also add to the quality of the volume.

O401. **Appelbaum, Stanley, and Cirker, Hayward.** The Movies: A Picture Quiz Book. New York: Dover Publications, 1972. 244 p., illus.

An outstanding paperback collection of film stills in a quiz format. The visuals are carefully reproduced and illustrate many types of film from 1900 to 1960. Indexes for performers and film titles.

O401a. **Appelbaum, Stanley.** Silent Movies: A Picture Quiz Book. New York: Dover Publications, 1974. 220 p., illus.

A high-quality picture album for the silent screen era, arranged by topics and personalities. The quiz format is not important; it is the superb selection and reproduction of the photographs that gives distinction to this volume.

O402. **Barbour, Alan G.** A Thousand and One Delights. New York: Macmillan Co., 1971. 177 p., illus.

A recollection of selected films from the forties. The criterion for inclusion is simply the author's pleasant memory of a particular film. Most of the films are B pictures starring such personalities as Maria Montez, Sabu, Lon Chaney, Jr., and Abbott and Costello. The 260 photographs provide more substance than the brief text; their selection is very good, their reproduction above average.

O403. **Baxter, John.** Sixty Years of Hollywood. New York: A. S. Barnes, 1973. 254 p., illus.

A historical survey of typical Hollywood films, from 1894 to 1971. The films selected were not necessarily popular or critical successes. For example, for 1949 Baxter selects *Act of Violence, The Fountainhead,* and *On the Town.* The author examines many of the films in detail, providing a critical review; cast and production credits; and studio. The illustrations are consistently helpful and are well reproduced. Index.

O404. **Bayer, William.** The Great Movies. New York: Grosset & Dunlap, 1973. 252 p., illus. (color).

A personal selection of sixty well-known films accompanied by a witty, informed text, useful data, and many beautifully reproduced visuals. The choices are equally divided into twelve genres, such as Westerns, musicals, and comedies. The visuals are most unusual. Index.

O405. **Bergman, Andrew.** We're in the Money: Depression America and Its Films. New York: New York University Press, 1971. 200 p., illus.

An adaptation of a doctoral dissertation on almost one hundred American films of the thirties. The book is divided into two sections, the first dealing with films from the severe depression years of 1930 to 1933, the second with films of the Roosevelt recovery years 1933 to 1940. The author's argument that films can explain or identify an era is persuasive. Sixteen pages of appropriate illustrations; notes; filmography; and good bibliography.

The word CATALOG in the heading of an entry refers to the exhibition catalog as a whole and not to the catalog list, checklist, or catalog section of the work.

O406. **Biograph Company.** Biograph Bulletins, 1896–1908. Edited by Kemp Niver. Los Angeles: Locare Research Group, 1971. 464 p., illus.

A collection of weekly bulletins issued by the Biograph studios about the films they made. Using reproductions of the original bulletins, the book provides rare, firsthand source material about the early motion picture. A fine introduction drawing on newspaper accounts, inventions, and programs is most helpful. Reproduction quality is excellent. This original research effort includes indexes, filmographies, and helpful explanatory notes. [For further coverage *see* O407.]

O407. **Biograph Company.** Biograph Bulletins, 1908–1912. New York: Octagon Books, 1973. 471 p., illus.

A continuation of the preceding volume, this volume covers the period from 1908 to 1912, roughly the Griffith years at the studio. [For earlier materials, *see* O406.] Each bulletin describes a film, gives some data, and has one or more stills. Some of these bulletins have annotations by Billy Bitzer. Reproduction quality is very good. Index.

O408. **Bowser, Eileen, ed.** Film Notes. New York: Museum of Modern Art, 1969. 128 p.

This paperback revision of the original *Film Notes* (1935; 1949) discusses many silent and sound films, includes production and cast credits, and provides a bibliography and indexes of films and directors.

O409. **British Film Institute.** Fifty Famous Films, 1915–1945, London, 1945. 106 p.

Film notes for many American silent and sound films are given in this older volume.

O410. **Carey, Gary.** Lost Films. New York: Museum of Modern Art, 1970. 91 p., illus.

Over 150 attractive illustrations and a short but persuasive text plead the cause of film preservation. This paperback contains stills and full descriptions of thirty American motion pictures thought to be lost forever.

O411. **Cowie, Peter.** Seventy Years of Cinema. New York: A. S. Barnes, 1969. 287 p., illus.

A survey of 235 motion pictures from 1895 to 1967. For each year, a few influential films are described in detail, but minimal attention is given to others, even if important. The strong, subjective text is not always completely accurate, and the selection of pictures is often questionable. Index.

O412. **Crowther, Bosley.** The Great Films: Fifty Golden Years of Motion Pictures. New York: G. P. Putnam's Sons, 1967. 258 p., illus.

The American film is well represented in this international array of fifty films. Each is described with several stills, an essay, some credits, and a full cast listing. The essays provide background information, description, and critical comment. A second list of one hundred films is appended. The selection of the films is controversial. Bibliography; indexes of films and names.

O413. **Currie, Hector, and Staples, Donald.** Film: Encounter. Dayton: George A. Pflaum, 1973. 272 p., illus.

A fine paperback collection of stills from classic films, American and foreign. Some highbrow captions accompany the attractive visuals, but it is the latter that impress. Reproduction is very good, and selection is outstanding.

O414. **Films, Inc.** A Half Century of American Film. New York: Films, Inc., n.d. 160 p., illus.

A fascinating paperback catalog of five hundred American films with production data, synopsis, critical comment, and visuals for each. Arranged chronologically by decade, the films also reflect changes in American life and thought. Index.

O415. **Franklin, Joe.** Classics of the Silent Screen: A Pictorial Treasury. New York: Citadel Press, 1959. 255 p., illus.

This excellent picture book is divided into two main sections: a review of fifty American silent films and biographies of seventy-five silent film stars. Although the text is affectionate and lively, emphasis is on the pictorial. Other sections include cast credits for the films and a group of questions most frequently asked about the silent film era (answers provided).

O415a. **Higham, Charles.** The Art of the American Film, 1900–1971. Garden City, N.Y.: Doubleday, 1973. 384 p., illus.

A concise survey emphasizing creative filmmakers, many of whom are given individual treatment. Higham has drawn on his previously published writing, so the text seems familiar. The material, including the visuals, has lasting appeal and interest; but its treatment here is quite subjective. Index.

O416. **Jones, Rev. G. William.** Dialogue with the World: A Modern Approach to the Humanities. Wilmette, Ill.: Films, Inc., 1969. 206 p., illus.

A paperback collection of discussion guides to one hundred feature films, most of these made by American studios. Each guide provides a still, a synopsis, credits, awards, critical comments, and a group of questions for discussion. The films are divided into general categories, such as prejudice, war, and the meaning of existence. The book provides valuable and interesting information that can be used in a variety of ways.

O416a. **Kaminsky, Stuart M.** American Film Genres. Dayton: Pflaum-Standard, 1974. 232 p., illus.

The author makes suggestions for analyzing film genres that may lead to new approaches to film appreciation and criticism. Contains good illustrations, bibliographies, and genre filmographies.

O417. **Kerbel, Michael, and Edelstein, Robert, eds.** Macmillan Audio-Brandon Films. Mount Vernon, N.Y.: Macmillan Audio-Brandon, 1973. 630 p., illus.

This massive paperback catalog contains much informa-

tion about many American films produced during the past seventy years: data, synopses, stills, and critical excerpts. Photographs are nicely reproduced throughout this attractive book, which also has much reference value.

O417a. **Langman, Larry.** Cinema and the Schools: A Guide to One Hundred and One Major American Films. Dayton: George A. Pflaum, 1975. 157 p., illus.

This is a listing of one hundred and one films suitable for use in secondary schools. Technical data, plot, characterization, dramatic/literary techniques, and themes are given for each film. A glossary, a film distributor list, a chronological listing, a classification of genres, a list of literary sources, a list of publishers, and a name index are given. The illustrations add little to this otherwise excellent book.

O417b. **Lawton, Richard.** A World of Movies: Seventy Years of Film History. New York: Delacorte Press, 1974. 384 p., illus.

A superb collection of visuals is the main attraction of this volume. Other than an introductory essay on motion picture history, the book consists mostly of hundreds of carefully selected, beautifully reproduced photographs. Portraits, production shots, and stills are placed in two major sections; the silents and the talkies. Brief captions and a connecting narrative provide a minimal continuity. Academy Award winners are noted in a final section. Index.

O418. **London Film Society.** Film Society Programmes, 1925–1939. New York: Arno Press, 1972. 456 p., illus.

A reprint of programs for 108 showings given from 1925 to 1939 by the London Film Society. Information on casts, directors, plots, production, historical background of nine hundred films is noted. Many American films are included. Index.

O419. **Mayer, Michael F.** Foreign Films on American Screens. New York: Arno Press, 1965. 119 p., illus.

A paperback survey of the postwar foreign film in America, this volume treats actors, directors, economics, censorship, etc. The text is literate, and many excellent illustrations are used throughout. Some information in the appendixes appears outdated.

O420. **Miller, Don.** "B" Movies. New York: Curtis Books, 1973. 350 p., illus.

A paperback history and overview of the films that customarily appeared as the lower half of a double feature program from the early thirties to the close of World War II. Films from major and minor studios are described critically, along with the personalities that appeared in them. The few illustrations are pleasing, and there is a lengthy, helpful index.

O421. **Niver, Kemp R.** The First Twenty Years: A Segment of Film History. Los Angeles: Locare Research Group, 1968. 176 p., illus.

More than one hundred short films made between 1894 and 1913 and recently restored from the Library of Congress paper prints are described in this fine example of film research and scholarship. Selection of the films was based on uniqueness of theme or technique. The illustrations are fascinating. [*See* O422.]

O422. **Niver, Kemp R., ed.** In the Beginning. New York: Brandon Books, 1967. 60 p., illus.

A paperback collection of film notes written to accompany one hundred early films that were preserved by transfer from the paper rolls used for copyright. Material was taken from the author's *The First Twenty Years* [O421].

O422a. **Ostrach, Herbert F., and Hodgkinson, Anthony.** The American Film Heritage: A Film Study Unit. Chelmsford, Mass.: Screen Studies, 1968.

A film study unit that explores American film genres, such as Westerns, spectaculars, and musicals. An introductory section deals with the history, aesthetics, and social significance of motion pictures.

O423. **Quigley, Martin, Jr., and Gertner, Richard.** Films in America, 1929–1969. New York: Golden Press, 1970. 319 p., illus.

This pictorial survey considers almost 400 films, mostly American. Each of the survey chapters begins with a general review of the year, followed by reviews of from eight to fifteen films that provide cast and production credits, etc. More than four hundred visuals are used; the few large ones are the most effective. Index.

O424. **Routt, William D., and Leahy, James.** Rediscovering the American Cinema. Wilmette, Ill.: Films, Inc., 1970. 112 p., illus.

A reminder of the consistent excellence of the American motion picture, this paperbook catalog of older, often forgotten films distributed by Films, Inc., is categorized by style, genre, personality, studio. It provides abundant information, bibliographical suggestions, good illustrations, and a title index.

O425. **Sennett, Ted.** Warner Brothers Presents. New Rochelle, N.Y.: Arlington House, 1971. 428 p., illus.

This study of Warner Brothers Studio from 1930 to 1950 provides very brief biographical sketches of the actors and other studio personnel, discusses the films according to genre, and recounts anecdotes about the operation of the studio. A listing of awards, a short bibliography, and a complete annotated filmography of the 976 titles produced are included, along with 168 attractive illustrations. Index.

O425a. **Spehr, Paul C.** The Civil War in Motion Pictures. A Bibliography of Films Produced in the U.S. since 1897. Washington, D.C.: Library of Congress, 1961. 109 p.

This listing is arranged into theatrical films, educational

films, and newsreels. It also includes information about film sources and an index.

O426. **Zinman, David.** FIFTY CLASSIC MOTION PICTURES: THE STUFF THAT DREAMS ARE MADE OF. New York: Crown Publishers, 1970. 311 p., illus.

Forty-nine American films and one lone French one made during Hollywood's golden age (1930–1950) are treated in this entertaining book. The word "classic" is obviously used broadly when applied to films like *Charlie Chan at the Opera* (1936) or *Maytime* (1937). The films are arranged under categories, such as monsters, he-men, and intrigue. The reproduction of the illustrations is outstanding, but the text is too fondly emotional to be effective.

O426a. **Trent, Paul.** THOSE FABULOUS MOVIE YEARS. Barre, Mass.: Barre Publishing Co., 1975. 192 p., illus. (color).

This tribute to movies of the thirties uses more than 300 stills and portraits, most of which represent American films and performers. The selection is outstanding. An acceptable text and a filmography accompany the pleasing visual survey. The lack of an index is a definite weakness.

GENRE STUDIES

ANIMATED FILMS

O427. **Stephenson, Ralph.** THE ANIMATED FILM. Rev. and enl. ed. New York: A. S. Barnes, 1973. 206 p., illus.

This paperback discusses the animated film here and abroad; highlights trends; and lists selected animators and their films. Some effective illustrations. Index. ORIGINAL EDITION: *Animation in the Film* (1967).

COMEDY FILMS

O428. **Durgnat, Raymond.** THE CRAZY MIRROR: HOLLYWOOD COMEDY AND THE AMERICAN IMAGE. London: Faber & Faber, 1969. 280 p., illus.

This excellent analysis of American screen comedy attempts to show that the screen images were valid but distorted reflections of the society and events of the period during which they were created. More than five hundred films and many famous comedians are considered. Good illustrations complement the scholarly but readable text. Indexes of films and actors.

O429. **Lahue, Kalton C.** WORLD OF LAUGHTER: THE MOTION PICTURE COMEDY SHORT, 1910–1930. Norman: University of Oklahoma Press, 1966. 240 p., illus.

A historical survey of the estimated 40,000 short comedy films made during the last two decades of the silent screen. The well-researched text deals with production, distribution, and exhibition. An impressive appendix offers filmographies for leading comedians or teams. Many fine illustrations; bibliography; index.

O430. **McCaffrey, Donald W.** THE GOLDEN AGE OF SOUND COMEDY. New York: A. S. Barnes, 1973. 208 p., illus.

A review of American film comedy in the thirties. Along with chapters on Fields, Chaplin, Laurel and Hardy, and the Marx Brothers, there are sections on genres, such as the musical, the sophisticated comedy, and the middle class comedy. The text is selective and descriptive rather than critical. Each chapter is accompanied by a good selection of attractive stills. Bibliography; index.

O431. **Mast, Gerald.** THE COMIC MIND: COMEDY AND THE MOVIES. Indianapolis: Bobbs-Merrill Co., 1973. 288 p., illus.

Using examples from both silent and sound comedies, the author appraises the work of performers and directors. About eighty photographs help one interpret the analyses, and there are also notes and an appendix. Index.

O432. **Montgomery, John.** COMEDY FILMS. London: George Allen & Unwin, 1954. 337 p., illus.

Although this volume is of British origin, it treats many American comedy personalities and films. The author's evaluations are vulnerable, and his view of comedy is now dated. Illustrations; bibliography; and separate indexes for names and films.

O433. **Robinson, David.** THE GREAT FUNNIES: A HISTORY OF FILM COMEDY. New York: E. P. Dutton & Co., 1969. 160 p., illus.

More than one hundred fine illustrations enliven this paperback account of screen comedy from the music halls, theaters, and vaudeville stages of the 1890s to the television programs of the late sixties. The styles of Keaton, Chaplin, Langdon, and others are analyzed. Index.

DETECTIVE FILMS

O434. **Everson, William K.** THE DETECTIVE IN FILM. Secaucus, N.J.: Citadel Press, 1972. 247 p., illus.

Over 450 excellent stills and a dependable text combine in a historical overview from the first *Sherlock Holmes* (1903) to *Gumshoe* (1972). Index.

DOCUMENTARY FILMS

O434a. **Barnouw, Erick.** DOCUMENTARY: A HISTORY OF THE NON-FICTION FILM. New York: Oxford University Press, 1974. 332 p., illus.

A history of the nonfiction film focusing on its makers. Using a chronological approach, Barnouw discusses the work of Flaherty, Wiseman, Lorentz, the Maysles brothers, and others. Although the scope is international, many American filmmakers are considered. Notes; a long bibliography; index.

O435. **Barsam, Richard Meran.** NONFICTION FILM: A CRITICAL HISTORY. New York: E. P. Dutton & Co., 1973. 332 p., illus. [*cont.*]

A well-researched paperback survey of documentary films from the twenties to the seventies. The emphasis is on the British and American schools, with individual attention given to Robert Flaherty and John Grierson. Social and political background are provided to explain the origin and importance of these films. Good illustrations; appendixes; bibliography; and index.

O436. **Issari, M. Ali.** CINÉMA VÉRITÉ. East Lansing: Michigan State University Press, 1971. 208 p., illus.

A history of the documentary film from the work of Dziga Vertov and Flaherty in the twenties to that of Jean Rouch and Richard Leacock in the sixties, this book contains selected filmographies and biographies, a few mediocre illustrations, a multilanguage bibliography, and an index.

O437. **Jacobs, Lewis.** THE DOCUMENTARY TRADITION FROM NANOOK TO WOODSTOCK. New York: Hopkinson & Blake, 1971. 530 p., illus.

This anthology attempts to chronicle the history of the documentary film in about one hundred short articles. Selected from more than fifty film sources, such as periodicals, monographs, and studies, the pieces vary in length, quality, and pertinence. Jacobs tries to unify the elements by arranging them chronologically and then writing an introduction to each decade. Filmography; bibliography; index of names and titles.

O438. **Leyda, Jay.** FILMS BEGET FILMS. COMPILATION FILMS FROM PROPAGANDA TO DRAMA. London: George Allen & Unwin, 1964. 176 p.

Compilation films are those made by splicing together pieces of existing films. Leyda surveys the history of this film form, analyzes its impact on audiences, and focuses on documentary films made for purposes of propaganda, art, instruction, history, advertising, nostalgia, and so on. Several appendixes, a listing of his sources of information, and an index increase the book's reference value.

O439. **MacCann, Richard Dyer.** THE PEOPLE'S FILMS. New York: Hastings House, 1973. 238 p., illus.

A history of films made by or for the United States government. Written originally as a doctoral dissertation, the text has been expanded and updated. The author discusses the thirties, Pare Lorentz, World War II, the United States Film Service, films for foreign policy, and the importance of television for both Congress and the president. The few visuals are disappointing and not representative. Index.

O439a. **Mamber, Stephen.** CINÉMA VÉRITÉ IN AMERICA: STUDIES IN UNCONTROLLED DOCUMENTARY. Cambridge, Mass.: MIT Press, 1973. 288 p., illus.

This volume concentrates on the *cinéma vérité* work of American filmmakers such as Robert Drew, Richard Leacock, D. A. Pennebaker, the Maysles brothers, and Frederick Wiseman. The author provides a detailed scholarly account that includes filmographies, a bibliography, notes, and an index.

EXPERIMENTAL FILMS

O440. **Battcock, Gregory, ed.** THE NEW AMERICAN CINEMA: A CRITICAL ANTHOLOGY. New York: E. P. Dutton & Co., 1967. 256 p., illus.

A paperback anthology of twenty-nine essays by critics and filmmakers about underground films in the United States. The search for new expressive forms; the dedication, imagination, and vitality of the filmmakers; and the techniques and theories of some of the more famous ones are among the topics covered. The illustrations are below average. Index.

O441. **Curtis, David.** EXPERIMENTAL CINEMA: A FIFTY YEAR EVOLUTION. New York: Universe Books, 1971. 168 p., illus.

This short survey of the avant-garde or underground film from the twenties to the seventies, focuses on the post–1945 American movement with many fine illustrations and details on hundreds of individuals and their films.

O442. **Manvell, Roger, ed.** EXPERIMENT IN THE FILM. New York: Arno Press, 1970. 285 p., illus.

This collection of essays about avant-garde films includes information on American filmmakers and their distinctive experimentation. A reprint of the ORIGINAL EDITION (1949).

O443. **Markopoulos, Gregory J.** QUEST FOR SERENITY. New York: Film-Maker's Cinemathèque, 1965. 79 p.

The diary of an underground filmmaker working in America during the sixties. Paperback.

O444. **Renan, Sheldon.** AN INTRODUCTION TO THE AMERICAN UNDERGROUND FILM. New York: E. P. Dutton & Co., 1967. 318 p., illus.

This paperback survey describes the underground film, explores its history in America, and includes twenty-six biographical sketches of filmmakers involved in the genre. Illustrated with almost one hundred photographs, mostly from film frames, it has some out-of-date information on distributors and an index.

O444a. **Sitney, P. Adams.** VISIONARY FILM: THE AMERICAN AVANT-GARDE. New York: Oxford University Press, 1974. 452 p., illus.

This volume provides a history and analysis of the American avant-garde film. The contributions of twenty-four famous American filmmakers to this genre are examined. Chapter notes, references, and sixty-six illustrations document the text. Sitney's explanations, arguments, and descriptions are presented clearly and objectively. Index.

O445. **Stauffacher, Frank, ed.** ART IN CINEMA: A SYMPOSIUM ON THE AVANT-GARDE FILM. New York: Arno Press, 1968. 104 p., illus.

This anthology of essays deals mostly with foreign films, but also considers the attention given by American institutions to art and experimental films. Many fine il-

lustrations, a bibliography, and an index are included. The ORIGINAL EDITION (1947) was published by the San Francisco Museum of Art to complement a program of lectures and screenings of early avant-garde films.

O446. **Tyler, Parker.** UNDERGROUND FILM: A CRITICAL HISTORY. New York: Grove Press, 1969. 249 p., illus.

A survey of the avant-garde or experimental film from 1915 to 1969. Tyler provides history, interpretation, and criticism as he delineates this genre. He notes the debt of commercial films to this film form and refers to many underground filmmakers and their films. The photographs are reproduced with fidelity, and a filmography is appended.

O447. **Youngblood, Gene.** EXPANDED CINEMA. New York: E. P. Dutton & Co., 1970. 432 p., illus.

This fascinating exploration of new forms of cinema discusses many American filmmakers who experiment with film. It features a difficult but provocative text, various interviews, many illustrations, a bibliography, and an index. Paperback.

GANGSTER FILMS

O448. **Baxter, John.** THE GANGSTER FILM. New York: A. S. Barnes, 1970. 160 p., illus.

An essay on the gangster film introduces this dictionary of 220 entries on actors, writers, directors, themes, terms. This paperback includes many helpful illustrations and an index of more than nine hundred films.

O448a. **Gabree, John.** GANGSTERS FROM "LITTLE CAESAR" TO "THE GODFATHER." New York: Pyramid Publications, 1973. 160 p., illus.

A strong genre study that follows a chronological exposition from *Little Caesar* (1930) to the 1970s. Written with clarity and taste, the text is comprehensive, informative, and entertaining. The illustrations are above average. Filmography; bibliography; index.

O449. **Karpf, Stephen Louis.** THE GANGSTER FILM, 1930-1940. New York: Arno Press, 1973. 299 p., illus.

A doctoral dissertation dealing with the analysis of a film genre. After a detailed examination of some early sound gangster films, the author studies the decay of the form and notes some contributions it made to later films. Script excerpts, synopses, casts, and credits are provided. Bibliography.

O450. **Lee, Raymond, and Van Hecke, B. C.** GANGSTERS AND HOODLUMS: THE UNDERWORLD IN THE CINEMA. New York: A. S. Barnes, 1971. 246 p., illus.

The only distinguishing feature of this volume is the presence of almost 350 stills. The quality of both text and reproductions is poor.

O451. **McArthur, Colin.** UNDERWORLD USA. London: Secker & Warburg, 1972. 176 p., illus.

An examination of the American gangster film genre along with a subset called thrillers. After some introductory chapters, the book analyzes the work of nine directors in this field. A fine collection of stills supports the author's argument about the force and function of the gangster film. Index.

HORROR FILMS

O452. **Butler, Ivan.** HORROR IN THE CINEMA. Rev. ed. New York: A. S. Barnes, 1970. 176 p., illus.

This paperback survey proceeds from early films to those of Clouzot, Hitchcock, Polanski, and Corman. It includes a lengthy annotated chronology, about forty good illustrations, a bibliography, and an index. The ORIGINAL EDITION (1967) was entitled *The Horror Film.*

O453. **Clarens, Carlos.** AN ILLUSTRATED HISTORY OF THE HORROR FILM. New York: G. P. Putnam's Sons, 1967. 256 p., illus.

This detailed, well-documented survey that begins with Méliès and concludes with *Alphaville* (1965) describes and evaluates many horror films and contains some fascinating illustrations. Casts and credits are given for more than three hundred horror films.

O454. **Douglas, Drake.** HORROR! New York: Macmillan Co., 1966. 309 p., illus.

This book classifies horror films according to the monster involved—werewolf, vampire, mummy—and discusses the literary origins of the films. Filmography; bibliography; index.

O455. **Gifford, Denis.** MOVIE MONSTERS. New York: E. P. Dutton & Co., 1969. 159 p., illus.

Each of a dozen monster categories—vampire, golem, werewolf—is treated separately in this interesting paperback picture book. Its 120 photographs have been selected with care and are well reproduced. A detailed filmography concludes each section.

O456. **Gifford, Denis.** A PICTORIAL HISTORY OF HORROR MOVIES. New York: Hamlyn, 1973. 216 p., illus.

An oversized pictorial survey of the horror film. Arranged under facetious headings, the films are discussed superficially. The almost four hundred illustrations are well reproduced but poorly identified. The appendixes include a filmography, a bibliography, and a listing of films not suitable for young people. Index.

O457. **Glut, Donald Frank.** THE FRANKENSTEIN LEGEND. Metuchen, N.J.: Scarecrow Press, 1973. 398 p., illus.

Only one portion of this book is concerned with the Frankenstein films; it divides them roughly between the Universal Studio (1930–1950) and the Hammer Studio (1950–1970). Much information is given about the stars, stories, scores, etc. Other portions of the volume consider the appearance of Frankenstein's monster in other

media: literature, radio, theater, etc. The quality of the pictures is acceptable. Index.

O458. Huss, Roy, and Ross, T. J. FOCUS ON THE HORROR FILM. Englewood Cliffs, N.J.: Prentice-Hall, 1972. 186 p., illus.

A paperback collection of articles arranged under four headings: horror, gothic horror, monster terror, and psychological thriller. The essays, critical reviews, script excerpts, and chronology provide an overview of the genre from 1910 to 1970. A bibliography and a filmography are added along with some unexciting stills. Index.

O459. McNally, Raymond T., and Florescu, Radu. IN SEARCH OF DRACULA. Greenwich, Conn.: New York Graphic Society, 1972. 223 p., illus., maps.

A detailed historical survey of the Dracula legend that includes a chapter on the vampire in fiction and film. Most impressive is the filmography, which lists over one hundred films from 1896 to 1971 dealing with vampires. Bibliography.

O459a. Moss, Robert F. KARLOFF AND COMPANY. New York: Pyramid Publications, 1974. 159 p., illus.

This volume attempts to survey Boris Karloff's films and also horror films in general—a goal that may be over ambitious. The text vacillates between a historical coverage of the horror film genre and a Karloff filmography. Some clearly reproduced illustrations help to make this an informative but limited survey. Filmography; bibliography; index.

O460. Willis, Donald C. HORROR AND SCIENCE FICTION FILMS: A CHECKLIST. Metuchen, N.J.: Scarecrow Press, 1972. 612 p.

A well-researched reference guide providing thorough and impressive coverage to 4,400 films of the horror-science fiction genre. Detailed information is given for each title; the critical comment is subjective and varies in quality. Appendixes.

KUNG FU FILMS

O460a. Glaessner, Verina. KUNG FU: CINEMA OF VENGEANCE. New York: Crown Publishers, 1975. 134 p., illus.

Although Kung Fu originated in the Eastern world, its fascination for American audiences is unquestionable. This volume describes the genre, its star performers, and several popular films. A chapter on Bruce Lee is included.

MESSAGE FILMS

O461. White, David M., and Averson, Richard. THE CELLULOID WEAPON. Boston: Beacon Press, 1972. 271 p., illus.

Over six hundred American films that had a purpose beyond mere entertainment are the subject of this volume, which considers social consciousness, propaganda, and message films. The authors present a detailed history of this rather broad film form rather than a critical analysis. About two hundred illustrations are clearly reproduced. Bibliography; indexes.

MUSICALS

O461a. Appelbaum, Stanley, ed. THE HOLLYWOOD MUSICAL: A PICTURE QUIZ BOOK. New York: Dover Publications, 1974. 225 p., illus.

A collection of 215 stills arranged by personality, composer, and topic. Questions are proposed for each, and answers are given at the back of the book. This "game" approach can be easily overlooked when the quality of the stills and the supporting name-title indexes are considered. Excellent production, selection, and arrangement characterize this volume.

O462. Burton, Jack. THE BLUE BOOK OF HOLLYWOOD MUSICALS. Watkins Glen, N.Y.: Century House Publishing, 1953. 296 p., illus.

A year-by-year survey of Hollywood musicals from 1927 to 1952 that treats two categories: the pure musical and the film with music, listing studio, director, players, songs, etc. The illustrations are few and poor. Film title index.

O463. Kobal, John. GOTTA SING, GOTTA DANCE: A PICTORIAL HISTORY OF FILM MUSICAL. New York: Hamlyn, 1970. 320 p., illus.

This pictorial history of the musical film covers the period from 1926 to 1968, including one chapter on foreign musicals. The seven hundred visuals are well selected, but their reproduction is only fair. Index.

O463a. Kreuger, Miles, ed. THE MOVIE MUSICAL FROM VITAPHONE TO 42ND STREET. New York: Dover Publications, 1975. 367 p., illus.

A rewarding compilation of articles, reviews, and visuals on the musical film that appeared in *Photoplay* magazine from 1926 to 1933. The material, which is presented chronologically, carefully integrates personalities, films, reviews, and photographs. The excellent selection and arrangement provide a fine example of nostalgic history that both informs and entertains.

O464. McVay, Douglas. THE MUSICAL FILM. New York: A. S. Barnes, 1967. 175 p., illus.

In this year-by-year survey from 1927 to 1966, McVay selects certain musicals and describes them with data, synopses, comments, and quotations. The book is not comprehensive and is biased by arbitrary selections and misdirected criticism. The illustrations are modest. Bibliography; title index.

O464a. Stern, Lee Edward. THE MOVIE MUSICAL. New York: Pyramid Publications, 1974. 160 p., illus.

A literate text and attractive visuals combine here to show in a decade-by-decade approach the evolution of the movie musical. Filmography; bibliography; index.

O465. **Taylor, John Russell, and Jackson, Arthur.** THE HOLLYWOOD MUSICAL. New York: McGraw-Hill Book Co., 1971. 278 p., illus.

A selected survey of a film genre is presented in this attractive, useful reference book. After some opening essays, a selected but detailed filmography of 275 titles is offered. In addition to the usual data for these films, the songs are noted with the names of the performers who sang and/or danced them. A second section is a listing of 1,100 performers with a filmography of their musical appearances; separate indexes are provided for the 2,750 song titles and for the 1,443 film titles. Over one hundred illustrations are attractively combined with the text.

O466. **Thomas, Lawrence B.** THE MGM YEARS. New Rochelle, N.Y.: Arlington House, 1972. 138 p., illus.

A closeup of forty MGM musicals from *The Wizard of Oz* (1939) to *The Boy Friend* (1971). Each is described by cast, production credits, plot outline, song titles, critical excerpts, and several attractive stills. A detailed chronology of two hundred MGM musicals, more than one hundred short biographical sketches of the major MGM musical personalities, and information on dubbing, soundtrack recording, awards, and songs from dramatic films are included. Bibliography; discography.

O467. **Springer, John.** ALL TALKING, ALL SINGING, ALL DANCING. New York: Citadel Press, 1966. 256 p., illus.

A pictorial history of the musical film told via the dominant personalities and periods of this genre. The excellent stills and affectionate, accurate text describe many musicals from *The Jazz Singer* (1927) to *The Sound of Music* (1966). Includes a listing of selected songs. Index.

O468. **Vallance, Tom.** THE AMERICAN MUSICAL. New York: A. S. Barnes, 1970. 192 p., illus.

An encyclopedia of the American film musical, this paperback has more than five hundred entries. Emphasizing mostly performers and artisans, it also considers selected areas and topics pertinent to the musical. An index to 1,750 musical films completes the profusely illustrated work.

NEWSREELS

O469. **Baechlin, Peter.** NEWSREELS ACROSS THE WORLD. New York: Columbia University Press, 1952. 100 p., illus.

An international survey of newsreels—their history, costs, problems, coverage, etc.

O470. **Fielding, Raymond.** THE AMERICAN NEWSREEL, 1911–1967. Norman: University of Oklahoma Press, 1972. 392 p., illus.

A history of the American newsreel from its initial primitive forms to its death at the hand of TV newscasts. Using many quotations, the pedantic, well-researched text describes news filming, personalities, reconstructions, suppression, economics, censorship, companies. The illustrations are very good. Index.

PORNOGRAPHIC FILMS

O471. **Grove, Martin A., and Ruben, William S.** THE CELLULOID LOVE FEAST. New York: Lancer Books, 1971. 174 p., illus.

A paperback survey of a movie genre that appeared on American public screens in the early seventies: the hardcore sex film. A literate text considers history, directors, content, audience, and a few films. The photographs are erotic, and a good bibliography is included.

O472. **Rotsler, William.** CONTEMPORARY EROTIC CINEMA. New York: Ballantine Books, 1973. 280 p., illus.

A survey in paperback of a controversial genre: the pornographic film. In addition to interviews, definitions, descriptions, and critical reactions, the author draws on his own experience as a writer/director. An evaluative filmography of selected titles completes the book. The illustrations are suggestive softcore, and the text may offend some readers.

O472a. **Turan, Kenneth, and Zito, Stephen F.** SINEMA: AMERICAN PORNOGRAPHIC FILMS AND THE PEOPLE WHO MAKE THEM. New York: Praeger Publishers 1974. 244 p., illus.

This volume is particularly successful in applying a factual, analytical, and scholarly approach to an overview of a controversial film genre. Interviews with American directors and performers are accompanied by an account of the evolution of the erotic film from *Fatima's Dance* in the 1890s to the present. Too often the important aspects of this study are sacrificed in favor of the sensational elements, and so some of the material and illustrations in this book may be offensive to or unsuitable for certain readers.

SCIENCE FICTION FILMS

O472b. **Amelio, Ralph J.** HAL IN THE CLASSROOM: SCIENCE FICTION FILMS. Dayton: George A. Pflaum, 1974. 153 p., illus.

An anthology consisting of nine articles on science fiction films. Both the genre and individual films are discussed. An annotated filmography, a lengthy annotated bibliography, and a list of film distributors complete this useful reference resource.

O472c. **Annan, David.** MOVIE FANTASTIC: BEYOND THE DREAM MACHINE. New York: Crown Publishers, 1975. 132 p., illus.

A genre study emphasizing the historical backgrounds of this style. The author uses myths, machines, visions, and nightmares for his general headings, assigning specific films in a subjective, often debatable manner. Over three hundred varied illustrations add considerable dimension to this impressive volume. The text is international in scope, but many American films are discussed.

O473. **Baxter, John.** SCIENCE FICTION IN THE CINEMA. New York: A. S. Barnes, 1970. 240 p., illus.

Many American films are described in this survey of a motion picture genre. Starting with Méliès (1902), this critical history ends with *2001: A Space Odyssey* (1968). The text is literate, but many of the illustrations are too small to be effective. Contains a fine filmography and a bibliography.

O474. **Gifford, Denis.** SCIENCE FICTION FILM. New York: E. P. Dutton & Co., 1970. 160 p., illus.

A paperback survey of a film genre that begins with Méliès (1897) and ends with *2001: A Space Odyssey* (1968). Many American films are described in its three sections: invention, exploration, and prediction. Contains 120 very good illustrations. Index.

O475. **Harryhausen, Ray.** FILM FANTASY SCRAPBOOK. New York: A. S. Barnes, 1972. 118 p., illus.

The author is well known as a creator of special effects, an animator, and a producer. He reviews some highlights of his career by describing how three-dimensional animated films, such as *King Kong* (1933) and *Jason and the Argonauts* (1963), were made. The text is short and lacks detail. It is supported by 250 sketches and stills, most of them effective.

O476. **Johnson, William, ed.** FOCUS ON THE SCIENCE FICTION FILM. Englewood Cliffs, N.J.: Prentice-Hall, 1972. 182 p., illus.

A chronologically arranged collection of materials that offers a generalized history of the science fiction film. The informative, absorbing text is divided into four major periods and considers trends, techniques, directors, scripts. A short filmography and a bibliography are included. Index. Paperback.

O476a. **Lee, Walt, and Warren, Bill.** REFERENCE GUIDE TO FANTASTIC FILMS. Los Angeles: Chelsea-Lee Books, 1972–1974. 3 vols., illus.

A massive reference work that covers more than 20,000 science fiction, fantasy, and horror films. In addition to concise factual information, succinct synopses are presented with wit and style. The illustrations blend well with the text, and films difficult to classify are noted. The author's effort in assembling this work is justified by the impressive result.

O477. **Steinbrunner, Cris, and Goldblatt, Burt.** CINEMA OF THE FANTASTIC. New York: Saturday Review Press, 1972. 282 p., illus.

A collection of fifteen film evaluations depicting the development of a film genre. Arranged chronologically from *A Trip to the Moon* (1902) to *Forbidden Planet* (1956), the films are described by plot, narrative, and other data. The reproduction of the visuals is poor, and the selection of certain titles is questionable.

O477a. **Willis, Donald C.** HORROR AND SCIENCE FICTION FILMS: A CHECKLIST. Metuchen, N.J.: Scarecrow Press, 1972. 612 p.

[*See* O460.]

SCREWBALL FILMS

O478. **Sennett, Ted.** LUNATICS AND LOVERS. New Rochelle, N.Y.: Arlington House, 1973. 368 p., illus.

An affectionate tribute to the screwball and romantic comedies of the thirties and forties. The films are placed under broad headings, such as Cinderella, boss ladies, and lambs and wolves. Plots are related, performances are listed, and other information is given; what is lacking is interpretation, evaluation, and criticism. However, the long filmography, the bibliography, and the numerous capsule biographies of the moviemakers are impressive, as are the fine illustrations. Index.

SERIALS

O479. **Barbour, Alan G.** DAYS OF THRILLS AND ADVENTURE. New York: P. F. Collier, 1970. 168 p., illus.

This definitive picture history of the sound serial covers the period from 1930 to 1956. The coverage is wide, and a lengthy listing of the serials is given in the appendix. More than two hundred well-reproduced illustrations help to recall the excitement and fascination of this film genre.

O480. **Harmon, Jim, and Glut, Donald F.** THE GREAT MOVIE SERIALS. New York: Doubleday & Co., 1972. 384 p., illus.

A survey of the American motion picture sound serial. The serials are listed under such headings as science fiction, jungle, aviator, girls, and Western. The information and commentary on each serial are copious and include cast, plot outlines, script excerpts, and special effects. The visual support for the repetitive text is weak. Index.

O481. **Lahue, Kalton C.** BOUND AND GAGGED: THE STORY OF THE SILENT SERIALS. New York: A. S. Barnes, 1968. 352 p., illus.

This history of the silent serial describes how the serials were made; their stars, plots, and directors; and the causes for their demise. The script for the 1920 Pathé serial *Pirate Gold* is reprinted with interviews with the actors. The rare illustrations are well chosen, and a separate index of serials accompanies the general index.

O482. **Lahue, Kalton C.** CONTINUED NEXT WEEK. A HISTORY OF THE MOVING PICTURE SERIAL. Norman: University of Oklahoma Press, 1964. 293 p., illus.

This survey considers only the silent film from 1914 to 1930. The subject has been well researched but poorly interpreted. The selection and reproduction of the illustrations are merely adequate. Most impressive is a 123-page appendix giving credits, dates, producers, and chapter titles of many silent serials.

O483. **Weiss, Ken, and Goodgold, Edwin.** TO BE CONTINUED. New York: Crown Publishers, 1972. 341 p., illus.

A survey of film serials made from 1929 to 1956. More than 230 serials are arranged chronologically by years.

The important ones are more fully described, but data are given for each title. Four hundred illustrations are included in this nicely arranged volume. Index of titles.

SERIES

O484. Essoe, Gabe. TARZAN OF THE MOVIES. New York: Citadel Press, 1968. 208 p., illus.

A pictorial history of the Tarzan character in films. Since 1918 there have been more than forty Tarzan films made by American studios. Using four hundred photographs and a critical and descriptive text, this volume records the films and the fifteen actors who have assumed the role. The quality of the illustrations varies.

O485. Fenton, Robert W. THE BIG SWINGERS. Englewood Cliffs, N.J.: Prentice-Hall, 1967. 258 p., illus.

This biography of Edgar Rice Burroughs contains a history of the Tarzan films. Photographs of all the movie Tarzans are also included. Index.

O486. Maltin, Leonard. THE GREAT MOVIE SHORTS. New York: Crown Publishers, 1972. 236 p., illus.

A study of the one- and two-reel movie shorts that were part of most American film programs in the thirties and forties. The shorts were often made as series films with the same leading characters in each: Robert Benchley, Our Gang, Pete Smith, etc. The book treats over one thousand titles, and includes plot summaries, critical comments, and other information. Cartoons are not treated. Over two hundred well-selected illustrations accompany Maltin's informative, well-researched text. Index.

O487. Parish, James Robert, ed. THE GREAT MOVIE SERIES. New York: A. S. Barnes, 1971. 333 p., illus.

A study of twenty-five sound film series, such as Blondie, Andy Hardy, Charlie Chan, and Tarzan. Each chapter treats one film series and offers a description, history, synopsis, leading player biographies, and other particulars. More than three hundred illustrations add to this unusual reference work. All of the series are American except James Bond.

O488. Zinman, David. SATURDAY AFTERNOON AT THE BIJOU. New Rochelle, N.Y.: Arlington House, 1973. 511 p., illus.

A survey of the series films. Most of these films were inexpensively made and featured the same actors in the same roles: Sherlock Holmes, Blondie, Andy Hardy, etc. The text is chatty and informative in recalling what has now become a television staple. However, title selection is quite subjective, with major omissions and some unusual inclusions, e.g., doctor-in-the-house films. For each series, one film is described in detail to suggest its flavor. A complete series filmography and more than 250 illustrations aid the descriptions. Bibliography; index.

SHAKESPEAREAN FILMS

O489. Ball, Robert Hamilton. SHAKESPEARE ON SILENT FILM: A STRANGE EVENTFUL HISTORY. New York: Theatre Arts Books, 1968. 403 p., illus.

A scholarly study of the use of Shakespeare's works as material for the silent screen from 1899 to 1929. Not only was Shakespeare brought to a mass audience, but, in turn, respectability was brought to the young film industry. Notes, review excerpts, stills, enlarged frames, a glossary, a bibliography, and indexes are included.

O490. Eckert, Charles W. FOCUS ON SHAKESPEAREAN FILMS. Englewood Cliffs, N.J.: Prentice-Hall, 1972. 184 p., illus.

A survey of Shakespearean films. Following a few introductory articles, the text offers a chronological selection of thirteen major films based on the plays and reprints one or two critical reviews for each. A filmography, a bibliography, and a few stills complete the book. Index. Paperback.

O491. Manvell, Roger. SHAKESPEARE AND THE FILM. New York: Praeger Publishers, 1971. 172 p., illus.

A survey of a number of sound films based on Shakespeare's plays. A brief chapter comments on Shakespeare's plays in the silent film. Selected sound films from several countries are then analyzed in detail. Personalities, such as Olivier and Welles, who have frequently used the plays for screen material are also discussed. The illustrations are brilliantly reproduced. Detailed filmography; short bibliography; index.

SPY FILMS

O491a. Parish, James Robert, and Pitts, Michael R. THE GREAT SPY PICTURES. Metuchen, N.J.: Scarecrow Press, 1974. 585 p., illus.

Some 463 selected spy films are critically evaluated in this genre survey. Each film is described by the usual data and credits along with a short paragraph of plot, comment, and background. Radio programs, novels, and television programs about spies are noted. A good selection of illustrations helps the witty, informative, and entertaining text.

SUSPENSE FILMS

O492. Gow, Gordon. SUSPENSE IN THE CINEMA. New York: A. S. Barnes, 1968. 167 p., illus.

An examination of ninety-two films that provide a quality of suspense. Although the author fails to define his topic, he describes it by film examples and illustrations. Film selection is arbitrary and includes many of American origin. Illustrations are varied but not always carefully reproduced. Paperback.

THRILLERS

O493. Davis, Brian. THE THRILLER. New York: E. P. Dutton & Co., 1973. 160 p., illus.

A survey of a film genre that is rather broad in definition. Crime, detective, and spy films are treated along with the realistic documentary forms popular in the late forties. The robbery and chase are examined as elements of this genre; its reflection of political and social problems is also studied. Well-reproduced visuals are prominent throughout and support the provocative text fully. Index. Paperback.

WAR AND PEACE FILMS

O493a. **Butler, Ivan.** THE WAR FILM. New York: A. S. Barnes, 1974. 191 p., illus.

A study of a film genre that uses both historical and critical approaches. In a text that is provocative and often disturbing, the author covers the silent era, World War II, and the postwar period. A valuable listing of films arranged by specific wars—Napoleonic, Civil, Korean—is also included. Picture selection and reproduction are average.

O494. **Dougall, Lucy.** THE WAR/PEACE FILM GUIDE. Berkeley, Calif.: World Without War Council, 1970. 51 p.

About one hundred films that deal with war and peace are annotated in this volume. The group—which includes American short films and features—is arranged in broad categories, and suggestions for use are given. A bibliography and some rental sources conclude this useful reference work. Paperback.

O495. **Hughes, Robert.** FILM: BOOK 2: FILMS OF PEACE AND WAR. New York: Grove Press, 1962. 255 p., illus.

This anthology focuses on films of war and peace by presenting essays, scripts, and replies to questions. It also raises some questions, e.g., do governments discourage antiwar films? The script for John Huston's *Let There Be Light* (1946) and a discussion of his *The Battle of San Pietro* (1949) are part of the provocative material. The contributor list is impressive. The illustrations are acceptable.

O496. **Jones, Ken D., and McClure, Arthur F.** HOLLYWOOD AT WAR. New York: A. S. Barnes, 1973. 320 p., illus.

A pictorial survey of over four hundred World War II films. Cast, studio, director, release, date, and a still are given for each. The only narrative offered is a short introductory essay. It is the visuals that are most effective in this volume.

O496a. **Kagan, Norman.** THE WAR FILM. New York, Pyramid Publications, 1974. 160 p., illus.

The war film genre is examined in a chronological fashion along with separate considerations of comedy in war films and antiwar films. Two classic films—*The Birth of a Nation* (1915) and *Shoulder Arms* (1918)—receive special attention. A filmography, a bibliography, and many illustrations complete the coverage. A most satisfactory treatment of a demanding topic.

WESTERNS

O497. **Barbour, Alan G.** THE THRILL OF IT ALL. New York: Macmillan Co., 1971. 204 p., illus.

A pictorial history of the "B" Western film. After an opening chapter on the silent films, the text considers cowboys of the thirties, villains, trios, singing cowboys, serials, and other topics related to the Western. A brief but informative text accompanies the hundreds of visuals, which are nicely reproduced.

O497a. **Calder, Jenni.** THERE MUST BE A LONE RANGER: THE MYTH AND REALITY OF THE AMERICAN WILD WEST. New York: Taplinger Publishing Co., 1975. 241 p., illus.

A comparison of film characters, incidents, locales with their real-life counterparts. All aspects of the Western film genre are scrutinized. Chapter notes, a film list, a bibliography, and an index supplement the author's unique study. The few illustrations are inadequate for such a broad topic.

O497b. **Cawelti, John G.** THE SIX-GUN MYSTIQUE. Bowling Green, Ohio: Popular Press, 1970. 138 p.

A long essay that uses an American film genre to formulate some basic principles about the interpretation of popular narrative drama. Stimulating analysis can be found in the text, but the supporting appendixes are poorly arranged.

O498. **Everson, William K.** A PICTORIAL HISTORY OF THE WESTERN FILM. New York: Citadel Press, 1969. 246 p., illus.

This pictorial history of an American film genre covers the period from *The Great Train Robbery* (1903) to *Will Penny* (1968) and other films of the sixties. Almost five hundred illustrations accompany a literate, accurate text. Index.

O499. **Eyles, Allen.** THE WESTERN: AN ILLUSTRATED GUIDE. New York: A. S. Barnes, 1967. 183 p., illus.

The people of the Western film are the topic of this volume. Over 350 personalities associated with the Western—as actor, director, real person, or fictional character—are given biographical descriptions in a directory format. The latter section is a title index to 2,200 Western films and is correlated to the first section by number references. The illustrations are good, but their reproduction suffers from placing too many on a page in montage arrangement. REVISED PAPERBACK EDITION (1974).

O500. **Fenin, George N., and Everson, William K.** THE WESTERN: FROM SILENTS TO THE SEVENTIES. New York: Grossman Publishers, 1973. 396 p., illus.

A complete coverage of the Western film from *The Great Train Robbery* (1903) to *The Life and Times of Judge Roy Bean* (1972). The text is scholarly yet written in an informative, entertaining style. A chronological approach is used for

the description and evaluation of thousands of western films and personalities. Production, including visual choice and reproduction, is average. Index. ORIGINAL EDITION: *The Western: From Silents to Cinerama* (1962).

O500a. **French, Philip.** WESTERNS. New York: Viking Press, 1974. 176 p., illus.

In this genre study, the author notes the changes that have appeared in post–World War II Westerns. Under scrutiny are such elements as plot, background, villain, hero, woman, and attitudes towards minorities. The illustrations do not add much to the bright, original text. A filmography of directors and a bibliography complete the volume.

O501. **Kitses, Jim.** HORIZONS WEST. Bloomington: Indiana University Press, 1969. 176 p., illus.

Directors Anthony Mann, Budd Boetticher, and Sam Peckinpah are profiled in this volume. The Western films they have made are given a detailed analysis. Filmographies and good illustrations enhance this study of the contemporary Western film. Paperback.

O501a. **Maynard, Richard A., ed.** THE AMERICAN WEST ON FILM. Rochelle Park, N.J.: Hayden Book Company, 144 p., illus.

This anthology explores the legend of the American West, the films it inspired, and the implications of each. Both literary works and films are examined via essays, script excerpts, questions, etc. The final section discusses the cowboy anti-hero of the sixties in such films as *The Wild Bunch, Doc,* and *Hud.* The selection of the articles is good, making this a worthwhile and distinctive approach to the Western film.

O501b. **Nachbar, Jack, ed.** FOCUS ON THE WESTERN. Englewood Cliffs, N.J.: Prentice-Hall, 1974. 150 p., illus.

This anthology explores the Western film genre by giving attention to its history, form, structure, characters, etc. The choice of articles is tasteful, with many fine writer-critics represented, such as Kitses, Cawelti, and Warshow. A few photographs in a center section add little. The bibliography, a chronology, and an index provide stronger support.

O502. **Parkinson, Michael, and Jeavons, Clyde.** A PICTORIAL HISTORY OF WESTERNS. New York: Hamlyn, 1973. 217 p., illus.

An oversized pictorial survey of the western film genre. The entertaining text is divided into sections on films, stars, stalwarts, and directors. Two later subgenres are also treated: the spaghetti and TV westerns. The quality of the 380 pictures varies from fair to excellent; identifying them is often a problem. Index.

Individual Films

THE ADVENTURERS

O503. **Wolfe, Maynard Frank.** THE MAKING OF THE ADVENTURERS. New York: Paperback Library, 1970. 239 p., illus.

This pictorial account of the film is accompanied by an interview with the director-producer and several short sections of narrative. It is an example of a high-budget American film made in the United States, Italy, and Colombia with an international cast. Paperback.

AN AMERICAN IN PARIS

O504. **Knox, Donald.** THE MAGIC FACTORY. HOW MGM MADE AN AMERICAN IN PARIS. New York: Praeger Publishers, 1973. 217 p., illus.

An account of the making of *An American in Paris* (1950). Documentation is provided by original material, such as sketches, posters, designs, and budgets, and by present-day recollections of the artists who took part in making the film: a most unusual format used to describe musical filmmaking at a major Hollywood studio in the fifties. The visuals are most attractive, and musical numbers are listed in the appendix.

THE ANATOMY OF A MURDER

O505. **Griffith, Richard.** ANATOMY OF A MOTION PICTURE. New York: St. Martin's Press, 1959. 119 p., illus.

Detailed visual account of the making of *The Anatomy of a Murder* (1959). All the elements of filmmaking are presented by the text and by many candid location shots.

THE BIRTH OF A NATION

O506. **Aitken, Roy E.** THE BIRTH OF A NATION STORY. Middleburg, Va.: Denlinger's Publishers, 1956. 96 p., illus.

A memoir of the silent film business that revolves around the financial backing of *The Birth of a Nation* (1915). The era is presented by a subjective text and more than one hundred illustrations weakened by sepia toning.

O507. **Silva, Fred.** FOCUS ON THE BIRTH OF A NATION. Englewood Cliffs, N.J.: Prentice-Hall, 1971. 184 p., illus.

A well-selected collection of reviews, articles, comments, and criticism about *The Birth of a Nation* (1915). Information about the film is offered by cast, credits, synopsis, and content outline. Although the eight pages of photo-

graphs are only average, the filmography and bibliography are impressive. Index. Paperback.

BONNIE AND CLYDE

O508. **Cawelti, John G., ed.** FOCUS ON BONNIE AND CLYDE. Englewood Cliffs, N.J.: Prentice-Hall, 1973. 176 p., illus.

A collection of reviews, interviews, essays, comments, criticism, and other items about *Bonnie and Clyde* (1967). Data about the film are accompanied by a synopsis and a content outline. Filmography; bibliography; index. Paperback.

BREWSTER MC CLOUD

O509. **McClelland, C. Kirk.** ON MAKING A MOVIE: BREWSTER MCCLOUD. New York: Signet Books, 1971. 359 p., illus.

A day-by-day journal of the on-location (Houston) shooting of *Brewster McCloud* (1971). The script of the film is included with some stills and candid photographs of the production. Paperback.

THE CANDIDATE

O510. **Bahrenburg, Bruce.** FILMING THE CANDIDATE. New York: Warner Paperback Library, 1972. 254 p., illus.

A behind-the-scenes account of making *The Candidate* (1971) in and around San Francisco. Written in a chronological fashion, individual chapters tend to emphasize one of the creative people involved, i.e., star, director, etc. Some candid photographs appear in a center section. Paperback.

CASABLANCA

O510a. **Anobile, Richard J., ed.** MICHAEL CURTIZ'S CASABLANCA. New York: Publishing Co., Avon 1975. 256 p., illus.

An interview with Ingrid Bergman introduces this fine volume, which uses more than 1,500 clear-frame enlargements and the original dialogue to recreate the 1943 film classic.

CAST A GIANT SHADOW

O511. **Shavelson, Melville.** HOW TO MAKE A JEWISH MOVIE. Englewood Cliffs, N.J.: Prentice-Hall, 1971. 244 p., illus.

An account of making the film *Cast a Giant Shadow* (1966) in Rome and Israel by an American film company and cast. Other portions of the book describe the author's career at several major Hollywood studios.

CITIZEN KANE

O512. **Gottesman, Ronald.** FOCUS ON CITIZEN KANE. Englewood Cliffs, N.J.: Prentice-Hall, 1971. 178 p., illus.

Interviews, essays, reviews, commentaries, and many other well-selected elements are combined in this anthology of *Citizen Kane* (1941). This impressive volume also offers a bibliography, some fine illustrations, a filmography, and an index. Paperback.

O513. **Kael, Pauline; Mankiewicz, Herman J.; and Welles, Orson.** THE CITIZEN KANE BOOK. Boston: Atlantic–Little, Brown & Co., 1971. 424 p., illus.

A fascinating combination of the long essay "Raising Kane" (which appeared originally in *The New Yorker* magazine) and the shooting script of *Citizen Kane* (1941). Kael's argument concerns the contribution of scriptwriter Herman Mankiewicz to the final film. The book has a detailed listing of Mankiewicz's credits, some 81 frame enlargements from the film, and an index.

CLEOPATRA

O514. **Bodsky, Jack, and Weiss, Nathan.** THE CLEOPATRA PAPERS: A PRIVATE CORRESPONDENCE. New York: Simon & Schuster, 1963. 175 p.

Although *Cleopatra* (1963) was made overseas, its importance to the Hollywood film industry in general and to the 20th Century Fox Studio in particular was crucial. This series of letters, phone calls, and cablegrams gives a portrait of the old-style filmmaking that became obsolete after this film.

O515. **Wanger, Walter, and Hyams, Joe.** MY LIFE WITH CLEOPATRA. New York: Bantam Books, 1963. 182 p.

An account of making the film *Cleopatra* (1963) by the producer. Made in Rome at an enormous cost, the film was a principal cause of the decline of the 20th Century Fox Studios in the sixties. Paperback.

DEEP THROAT

O516. **Smith, Richard N.** GETTING INTO DEEP THROAT. New York: Berkley Publishing Co., 1973. 286 p., illus.

A subjective, selective account of the notoriety surrounding *Deep Throat* (1972). Interviews with porno filmmakers and court testimony from an obscenity trial comprise most of the book's content. The few illustrations are not pertinent; however, the interviews are quite candid and may shock some readers. Paperback.

EARTHQUAKE

O516a. **Fox, George.** EARTHQUAKE: THE STORY OF THE MOVIE. New York: Signet Books, 1974. 128 p., illus.

The first section of this book retells the plot of the film in novelized-script form. A selective general account of the making of the film from idea to actual production is given. The special effects used in the film are explained. A few small illustrations and limited film credits complete the volume.

THE EXORCIST

O516b. Blatty, William Peter. WILLIAM PETER BLATTY ON THE EXORCIST FROM NOVEL TO FILM. New York: Bantam Books, 1974. 414 p., illus.

Blatty was not only the author of the original novel *The Exorcist* but also served as writer and producer of the film. Here he tells of writing the book, the initial efforts to get it filmed, and the many compromises necessary during production. He has included the first draft of the screenplay, the final one, and cast production credits. A center section of photographs adds to this absorbing account of filmmaking.

O516c. Travers, Peter, and Reiff, Stephanie. THE STORY BEHIND THE EXORCIST. New York: Crown Publishers, 1974. 262 p., illus.

Much background material concerning the making of *The Exorcist* (1973) is offered in this volume. Biographies, exorcist ritual, credits, interviews, reviews, and accounts of controversies are integrated into an interesting narrative. Over one hundred photographs help to depict the film and its production. Index.

FRANKENSTEIN

O516d. Anobile, Richard J., ed. FRANKENSTEIN. New York: Avon Publishing Co., 1974. 256 p., illus.

The classic horror film *Frankenstein* (1931) has been reconstructed in book form by using more than one thousand frame enlargements and the original dialogue. There is an interesting introduction about the film and its director James Whale. The picture reproduction is good.

FRIENDLY PERSUASION

O517. West, Jessamyn. TO SEE THE DREAM. New York: Harcourt Brace, 1957. 314 p.

A journal that records the making of *Friendly Persuasion* (1956). The author, who wrote the book upon which the film was based, acted as scriptwriter and adviser to the production.

THE GODFATHER

O518. Zuckerman, Ira. THE GODFATHER JOURNAL. New York: Manor Books, 1972. 143 p.

A diary of the making of *The Godfather* (1972). The author served as apprentice assistant director on the film and records his day-by-day observations and comments. He has provided an intelligent look at American location filmmaking in the seventies. The text is both objective and perceptive. Paperback.

GONE WITH THE WIND

O518a. Lambert, Gavin. GWTW: THE MAKING OF GONE WITH THE WIND. Boston: Little, Brown & Co., 1973. 158 p., illus.

This is one of the best accounts of studio filmmaking during the thirties currently available. In a knowledgeable, affectionate, and compassionate text, Lambert recalls in detail much of the drama and trauma that accompanied the production. Much of his narrative is nicely visualized by stills and portraits. A short bibliography and an index conclude the book.

THE GREAT GATSBY

O518b. Bahrenburg, Bruce. FILMING THE GREAT GATSBY. New York: Berkley Medallion, 1974. 255 p., illus.

A chronological coverage of the making of *The Great Gatsby* (1974). The book includes descriptions of both professional and private incidents. Well organized and presented, the diary is accompanied by a center section of illustrations.

GREED

O519. Weinberg, Herman G. THE COMPLETE GREED OF ERICH VON STROHEIM. New York: Arno Press 1972. Unpag., illus.

A brilliant reconstruction of von Stroheim's *Greed* (1923) —not the mutilated two-hour film but the intended eight-hour, forty-reel version. Using about 350 rare stills from the film along with more than 50 production stills, the author discusses much of the background of the film: its making, meaning, style, symbolism, etc. The production of the volume is outstanding.

JAWS

O519a. Gottlieb, Carl. THE JAWS LOG. New York: Dell Publishing Co., 1975. 221 p., illus.

A chatty, rather informal recollection of the making of the very popular film *Jaws* (1975). Using statistical data, observation, gossip, and opinion, the author describes the actual production, with particular attention to the influence that the filmmakers had on the local citizenry. The description of the special effects used in the film is especially good. Some fine illustrations accompany this informative, personalized account of American filmmaking in the seventies.

KING KONG

O519b. Goldner, Orville, and Turner, George E. THE MAKING OF KING KONG. New York: A. S. Barnes, 1975. 271 p., illus.

An absorbing account of the creation of the now classic film, *King Kong* (1933), this volume is divided into three parts: genesis, making, and postlude. Ten appendixes and an index support the text. With respect and affection, the

authors recall the plot and tell how individual scenes were created. Since one of the authors, Orville Goldner, served as a technician on the film, this account is probably more creditable than others published elsewhere. The quality of the visuals varies owing to the need to use specific blow-ups to accompany explanations of special effects.

LOVE STORY

O520. **Meyer, Nicholas.** THE LOVE STORY STORY. New York: Avon Publishing Co., 1971. 224 p., illus.

An account of the making of *Love Story* (1970) by the unit publicist of that film. All participants emerge as publicists see them: positive, saintly figures. The author is better at describing the details of filmmaking in the seventies. A few attractive illustrations are included. Paperback.

THE LOVED ONE

O521. **Southern, Terry.** THE JOURNAL OF THE LOVED ONE. New York: Random House, 1965. 116 p., illus.

A volume that purportedly was a record of the filming of *The Loved One* (1965). The candid photographs are interesting, but the text is clogged with inside humor and attempts at levity that fall flat. Paperback.

THE MALTESE FALCON

O521a. **Anobile, Richard J., ed.** JOHN HUSTON'S THE MALTESE FALCON. New York: Avon Books, 1974. 256 p., illus.

A reconstruction of John Huston's classic 1941 thriller using over 1,400 well-reproduced frame enlargements and all of the original dialogue. A study of the frames shows that Huston's use of the camera obscures the fact that the film contains very little action.

MEDICINE BALL CARAVAN

O522. **Forcade, Thomas King.** CARAVAN OF LOVE AND MONEY. New York: New American Library, 1972. 128 p., illus.

The travels of a film company as they cross the United States trying to make a sequel to *Woodstock* (1970). The activities of the crew, performers, hippie camp-followers, and other assorted characters are related in an excessive, coarse narrative. The pictures are suggestive. Everything about this venture including the resulting film *Medicine Ball Caravan* (1972) was a failure. Paperback.

O523. **Grissom, John, Jr.** WE HAVE COME FOR YOUR DAUGHTERS: WHAT WENT DOWN ON THE GREAT MEDICINE BALL CARAVAN. New York: William Morrow, 1972. 254 p., illus.

A journal of the tour made across America to make a rock film *Medicine Ball Caravan* (1972). About 150 "hippies" were funded by Warner Bros. with the hope of producing another *Woodstock* (1970). The catastrophic results are vividly described by the subjective text and candid photographs.

THE MISFITS

O524. **Goode, James.** THE STORY OF THE MISFITS. Indianapolis: Bobbs-Merrill Co., 1963. 331 p., illus.

An account of the making of *The Misfits* (1961). A censored diary that records the externals of American filmmaking on location, this volume offers some factual information, little analysis, and a few candid photographs. The history and legends surrounding the film and its players were not known when this book was written.

MY FAIR LADY

O525. **Beaton, Cecil.** FAIR LADY. New York: Holt, Rinehart & Winston, 1964. 128 p., illus.

A diary kept by the costume and set designer of *My Fair Lady* (1964). The sophisticated text and the attractive visuals offer insight into musical filmmaking from the viewpoint of a behind-the-scenes artisan.

THE NEXT VOICE YOU HEAR

O526. **Schary, Dore, and Palmer, Charles.** CASE HISTORY OF A MOVIE. New York: Random House, 1950. 242 p., illus.

A detailed account of the making of the MGM film *The Next Voice You Hear* (1950). How a film progresses from original idea to sneak preview is related. A few illustrations do little to save the mild text.

NINOTCHKA

O526a. **Anobile, Richard J., ed.** ERNST LUBITSCH'S NINOTCHKA. New York: Avon Publishing Co., 1975. 256 p., illus.

Over 1,500 frame enlargements have been carefully reproduced to recreate a book version of Ernst Lubitsch's 1939 comedy *Ninotchka*. All of the original dialogue has been placed with the appropriate visuals.

AN OCCURRENCE AT OWL CREEK BRIDGE

O527. **Barrett, Gerald R., and Erskine, Thomas L.** AN OCCURRENCE AT OWL CREEK BRIDGE. Encino, Calif.: Dickenson Publishing Co., 1973. 216 p., illus.

In the first section of this book, the original Ambrose Bierce short story is reprinted along with six critical articles about it. In the second section, short analyses of the two films based on the short story are offered: *The Bridge* (1931) and *An Occurrence at Owl Creek Bridge* (1956). Five critical articles about the films and some suggested questions and activities complete the book. The visuals are frame enlargements and are most helpful in the short analyses sections. Paperback.

PSYCHO

O527a. **Anobile, Richard J., ed.** PSYCHO. New York: Avon Publishing Co., 1974. 256 p., illus.

Using all the dialogue and over 1,300 frame blowups, Richard Anobile has reconstructed Alfred Hitchcock's 1960 thriller *Psycho* in book form. Hitchcock's reliance on the visual for telling his stories is emphasized in this engrossing re-creation.

THE RED BADGE OF COURAGE

O528. **Ross, Lillian.** PICTURE. New York: Rinehart & Co., 1952. 258 p., illus.

An account of the making of *The Red Badge of Courage* (1951) at the MGM Studios. From the initial enthusiasm to the final disillusioning dismemberment of the film for commercial release, the author's account of the evolution of an idea into a film provides a classic examination of the Hollywood studio system.

SALT OF THE EARTH

O529. **Biberman, Herbert.** SALT OF THE EARTH: THE STORY AND SCRIPT OF THE FILM. Boston: Beacon Press, 1965. 373 p., illus.

An account of the many difficulties the author endured when he attempted to produce, distribute, and exhibit *Salt of the Earth* (1953). The filmmaker-author was one of the Hollywood Ten, and it was this, rather than the film itself, that caused the continuing harassment. The script of the film and some stills are included in this recital of the effects of blacklisting.

SILENT SNOW, SECRET SNOW

O530. **Barrett, Gerald R., and Erskine, Thomas L.** Silent Snow, Secret Snow. Encino, Calif.: Dickenson Publishing Co., 1972. 193 p., illus.

A collection of materials dealing with the translation of fiction into film. In this instance, Conrad Aiken's short story *"Silent Snow, Secret Snow"* is the topic. A reprinting of the story is followed by several critical articles. The second section deals with the short film of the same title made in 1966 by Gene Kearney. A short analysis, the script, and five articles conclude the book. The illustrations are helpful in understanding the film. Paperback.

THE TEN COMMANDMENTS

O531. **Noerdlinger, Henry S.** MOSES AND EGYPT. Los Angeles: University of Southern California Press, 1956. 202 p., illus.

The research necessary to produce authenticity in films is explained and documented in this volume. With *The Ten Commandments* (1956) as an example, the author discusses the use of 1,900 books, 3,000 photographs, and the resources found in 30 museums and libraries. The scholarly text is reinforced by an interesting group of photographs. Many footnotes, a bibliography, and an index complete the book. Paperback.

TRILOGY

O532. **Capote, Truman; Perry, Eleanor; and Perry, Frank.** TRILOGY: AN EXPERIMENT IN MULTI-MEDIA. New York: Macmillan Co., 1969. 276 p., illus.

A discussion of the evolution of three American short stories into scripts for television and for a motion picture. Author Truman Capote, scriptwriter Eleanor Perry, and director Frank Perry contribute to the text. The original stories and the scripts are included.

2001: A SPACE ODYSSEY

O533. **Agel, Jerome.** THE MAKING OF KUBRICK'S 2001. New York: New American Library, 1970. 368 p., illus.

An example of overseas production by an American film company, *2001* was made at the MGM studios in England. This fine collection of stories, comments, interviews, reviews, and illustrations describes the making of an extraordinary special effects film and its reception by critics and the public. Paperback.

STAGECOACH

O533a. **Anobile, Richard J.** JOHN FORD'S STAGECOACH. New York: Avon Publishing Co., 1975. 256 p., illus.

Certain of the more than 1,200 frame enlargements used in this reconstruction of John Ford's classic 1939 Western are a bit fuzzy owing to the preponderance of action in the sequences from the film. All of the original dialogue is included. Some remarks by Ford provide an appropriate introduction to this satisfying re-creation.

THE STEAGLE

O533b. **Sylbert, Paul.** FINAL CUT: THE MAKING AND BREAKING OF A FILM. New York: Seabury Press, 1974. 253 p.

A downbeat account of the making of *The Steagle* (1971), of the difficulties and the few successes the producer encountered. Written with cynicism and sarcasm, the book is populated with film industry villians, some of whom are identified by name. A subjective but absorbing report on American filmmaking.

A WALK IN THE SPRING RAIN

O534. **Maddux, Rachel; Silliphant, Stirling; and Isaacs, Neil D.** FICTION INTO FILM: A WALK IN THE SPRING RAIN. Knoxville: University of Tennessee Press, 1970. 240 p., illus.

This volume contains the original novella, the screenplay, and an account of the making of *A Walk in the*

Spring Rain (1970). The diary addresses itself to the problems of translating literature into cinematic terms. Over one hundred illustrations are offered in the book, along with several appendixes and an index.

WEDDING MARCH

O534a. **Weinberg, Herman G.** THE COMPLETE WEDDING MARCH OF ERICH VON STROHEIM. Boston: Little, Brown & Co., 1974. 348 p., illus.

A pictorial reconstruction of both parts of *The Wedding March* (1927), using 255 stills arranged in accordance with Stroheim's original script. Captions and titles enable the reader to follow the plot, and a lengthy introductory essay provides the appropriate background. Reproduction, design, presentation, and text quality are all outstanding.

Published Screenplays

For details on works listed below, *see* the headnote preceding O400.

O535. ACROSS THE EVERGLADES (1958). New York: Random House, 1958.

O536. ADAM'S RIB (1949). New York: Viking Press, 1972.

O537. THE ADVENTURES OF MARCO POLO (1938). New York: Covici-Friede, 1937.

O538. THE AFRICAN QUEEN (1951). In: AGEE ON FILM. VOL. 2: FIVE FILM SCRIPTS. New York: McDowell, Obolensky, 1960.

O539. ALICE'S RESTAURANT (1970). New York: Doubleday, 1970.

O540. ALL ABOUT EVE (1950). In: MORE ABOUT ALL ABOUT EVE. New York: Random House, 1972.

O541. THE ALL AMERICAN BOY (1973). New York: Farrar, Straus & Giroux, 1973.

O542. ALL THAT MONEY CAN BUY (1941). In: TWENTY BEST FILM PLAYS. New York: Crown Publishers, 1943.

O543. ALL THE KING'S MEN (1949). In: THREE SCREENPLAYS. Garden City, N.Y.: Doubleday, 1972.

O544. ALL THE WAY HOME (1963). New York: Avon Publishing Co., 1963.

O545. AMERICAN GRAFFITI (1973). New York: Ballantine Books, 1973.

O546. THE APARTMENT (1961). In: FILM SCRIPTS THREE. New York: Appleton-Century-Crofts, 1972.

O547. BABY DOLL (1956). New York: New Directions Publishing Corp., 1956.

O548. THE BACHELOR PARTY (1957). New York: New American Library, 1957.

O549. THE BANK DICK (1940). New York: Simon & Schuster, 1973.

O550. THE BATTLE AT ELDERBUSH GULCH (1914). In: Griffith, D.W. THE BATTLE AT ELDERBUSH GULCH. Los Angeles: Locare Research Group, 1972.

O551. THE BEST MAN (1964). IN: FILM SCRIPTS FOUR. New York: Appleton-Century-Crofts, 1972.

O552. THE BIBLE. (1966). New York: Pocket Books, 1966.

O553. THE BIG SLEEP (1946). In: FILM SCRIPTS ONE. New York: Appleton-Century-Crofts, 1971.

O553a. BILLY JACK (1973). New York: Avon Publishing Co., 1973.

O553b. BILLY THE KID (1973). [*See* 640a.]

O554. THE BIRTH OF A NATION (1914). New York: Museum of Modern Art, 1961.

O555. BLUE MOVIE (1970). New York: Grove Press, 1970.

O556. BONNIE AND CLYDE (1966). In: THE BONNIE AND CLYDE BOOK. New York: Simon & Schuster, 1972.

O557. BREWSTER MCCLOUD (1970). In: ON MAKING A MOVIE: BREWSTER MCCLOUD. New York: Signet Books, 1971.

O558. BRIAN'S SONG (1972). New York: Bantam Books, 1972.

O559. THE BRIDE COMES TO YELLOW SKY (1952). In: AGEE ON FILM. VOL. 2: FIVE FILM SCRIPTS. New York: McDowell, Obolensky, 1960.

O560. THE BRIDGE (1931). In: AN OCCURRENCE AT OWL CREEK BRIDGE. Encino, Calif.: Dickenson Publishing Co., 1973.

O561. BUTCH CASSIDY AND THE SUNDANCE KID (1969). New York: Bantam Books, 1969.

O562. CARNAL KNOWLEDGE (1971). New York: Farrar, Straus & Giroux, 1971.

O563. CASABLANCA (1943). In: CASABLANCA: SCRIPT AND LEGEND. Woodstock, N.Y.: Overlook Press, 1973.

O564. CHAFED ELBOWS (1967). New York: Lancer Books, 1967.

O565. CHARADE (1963). In: FILM SCRIPTS THREE. New York: Appleton-Century-Crofts, 1973.

O566. CISCO PIKE (1971). New York: Bantam Books, 1971.

O567. CITIZEN KANE (1941). In: THE CITIZEN KANE BOOK. Boston: Little, Brown & Co., 1971.

O568. A CLOCKWORK ORANGE (1971). New York: Ballantine Books, 1972.

O569. COMING APART (1969). New York: Lancer Books, 1970.

O570. DAVID HOLZMAN'S DIARY (1970). New York: Farrar, Straus & Giroux, 1970.

O571. A DAY AT THE RACES (1937). New York: Viking Press, 1972.

O572. THE DEFIANT ONES (1958). In: FILM SCRIPTS TWO. New York: Appleton-Century-Crofts, 1971.

O573. DOC (1971). New York: Paperback Library, 1971.

O574. DON'T LOOK BACK (1967). New York: Ballantine Books, 1968.

O575. DOUBLE INDEMNITY (1945). In: THE BEST FILM PLAYS OF 1945. New York: Crown Publishers, 1946.

O576. DRAGON SEED (1944). In: BEST FILM PLAYS OF 1943-1944. New York: Crown Publishers, 1945.

O577. DUCK SOUP (1933). In: MONKEY BUSINESS. New York: Simon & Shuster, 1972.

O578. DUET FOR CANNIBALS (1970). New York: Farrar, Straus & Giroux, 1969.

O579. EASY RIDER (1969). New York: New American Library, 1970.

O580. EVENTS (1970). New York: Grove Press, 1970.

O581. A FACE IN THE CROWD (1957). New York: Random House, 1957.

O582. FACES (1968). New York: New American Library, 1970.

O583. THE FIGHT FOR LIFE (1940). In: TWENTY BEST FILM PLAYS. New York: Crown Publishers, 1943.

O584. THE FORGOTTEN VILLAGE (1941). New York: Viking Press, 1941.

O585. FORTUNE COOKIE (1966). New York: Praeger Publishers, 1971.

O586. FURY (1936). In: TWENTY BEST FILM PLAYS. New York: Crown Publishers, 1943.

O587. THE GODDESS (1958). New York: Simon & Schuster, 1958.

O588. GOING MY WAY (1944). In: BEST FILM PLAYS 1943-1944. New York: Crown Publishers, 1945.

O589. THE GOOD EARTH (1937). In: GREAT FILM PLAYS. VOL. 1: SCRIPTS OF SIX CLASSIC FILMS. New York: Crown Publishers, 1959.

O590. THE GRAPES OF WRATH (1940). In: TWENTY BEST FILM PLAYS. New York: Crown Publishers, 1943.

O591. GREED (1924). New York: Simon & Schuster, 1972.

O592. HAIL, THE CONQUERING HERO (1944). In: BEST FILM PLAYS 1943-1944. New York: Crown Publishers, 1945.

O593. THE HAPPIEST MILLIONAIRE (1967). New York: Scholastic Book Services, 1967.

O594. HERE COMES MR. JORDAN (1941). In: TWENTY BEST FILM PLAYS. New York: Crown Publishers, 1943.

O595. HIGH NOON (1952). In: FILM SCRIPTS TWO. New York: Appleton-Century-Crofts, 1971.

O596. HOW GREEN WAS MY VALLEY (1941). In: TWENTY BEST FILM PLAYS. New York: Crown Publishers, 1943.

O597. THE HUSTLER (1961). In: THREE SCREENPLAYS. Garden City, N.Y.: Doubleday, 1972.

O598. I NEVER SANG FOR MY FATHER (1970). New York, Signet Books, 1970.

O599. IN OLD CHICAGO (1938). Beverly Hills: 20th Century Fox. 1937.

O600. INTOLERANCE (1916). New York: Museum of Modern Art, 1966.

O601. IRMA LA DOUCE (1963). New York: Tower Publications, 1963.

O602. IT HAPPENED ONE NIGHT (1943). In: TWENTY BEST FILM PLAYS. New York: Crown Publishers, 1943.

O603. JOE (1970). New York: Avon Publishing Co., 1970.

O604. JUAREZ (1939). In: TWENTY BEST FILM PLAYS. New York: Crown Publishers, 1943.

O605. JUDGMENT AT NUREMBERG (1961). London: Cassell, 1961.

O606. LADY FOR A DAY (1933). In: FOUR STAR SCRIPTS: ACTUAL SHOOTING SCRIPTS AND HOW THEY ARE

WRITTEN. Garden City, N.Y.: Doubleday, Doran & Co., 1936.

O607. THE LIFE AND TIMES OF JUDGE ROY BEAN (1972). New York: Bantam Books, 1973.

O608. THE LIFE OF EMILE ZOLA (1937). In: TWENTY BEST FILM PLAYS. New York: Crown Publishers, 1943.

O609. LILIES OF THE FIELD (1963). New York: Globe Book Co., 1972.

O610. LILITH (1963). In: THREE SCREENPLAYS. Garden City, N.Y.: Doubleday, 1972.

O611. THE LION IN WINTER (1968). New York: Dell Publishing Co., 1968.

O612. LITTLE CAESAR (1930). In: TWENTY BEST FILM PLAYS. New York: Crown Publishers, 1943.

O613. LITTLE FAUSS AND BIG HALSEY (1970). New York: Picket Books, 1970.

O614. LITTLE MURDERS (1968). New York: Paperback Library, 1968.

O615. LITTLE WOMEN (1933). In: FOUR STAR SCRIPTS: ACTUAL SHOOTING SCRIPTS AND HOW THEY ARE WRITTEN. Garden City, N.Y.: Doubleday, Doran & Co. 1936.

O616. THE LOST WEEKEND (1945). In: THE BEST FILM PLAYS OF 1945. New York: Crown Publishers, 1946.

O617. MAIDSTONE (1968). New York: Signet Books, 1971.

O618. MAKE WAY FOR TOMORROW (1937). In: TWENTY BEST FILM PLAYS. New York: Crown Publishers, 1943.

O619. MARTY (1955). In: THE LIVELY ARTS: FOUR REPRESENTATIVE TYPES. New York: Globe Book Co. 1968.

O620. A MEDAL FOR BENNY (1945). In: THE BEST FILM PLAYS OF 1945. New York: Crown Publishers, 1946.

O621. THE MIGHTY BARNUM (1935). New York: Covici-Friede, 1934.

O622. MINNIE AND MOSKOWITZ (1972). Los Angeles: Black Sparrow Press, 1973.

O623. THE MIRACLE OF MORGAN'S CREEK (1964). In: BEST FILM PLAYS 1943-1944. New York: Crown Publishers, 1945.

O624. THE MISFITS (1961). New York: Viking Press, 1961.

O625. MONKEY BUSINESS (1931). New York: Simon & Schuster, 1972.

O626. THE MORE THE MERRIER (1943). In: BEST FILM PLAYS 1943-1944. New York: Crown Publishers, 1945.

O627. MOROCCO (1930). In: MOROCCO, SHANGHAI EXPRESS. New York: Simon & Schuster, 1973.

O628. MR. SMITH GOES TO WASHINGTON (1939). In: TWENTY BEST FILM PLAYS. New York: Crown Publishers, 1943.

O629. MRS. MINIVER (1942). In: TWENTY BEST FILM PLAYS. New York: Crown Publishers, 1943.

O630. MY MAN GODFREY (1936). In: TWENTY BEST FILM PLAYS. New York: Crown Publishers, 1943.

O631. NEVER GIVE A SUCKER AN EVEN BREAK (1941). New York: Simon & Schuster, 1973.

O632. A NIGHT AT THE OPERA (1935). New York: Viking Press, 1972.

O633. THE NIGHT OF THE HUNTER (1955). In: AGEE ON FILM. VOL. 2: FIVE FILM SCRIPTS. New York: McDowell, Obolensky, 1960.

O634. NINOTCHKA (1939). New York: Viking Press, 1972. 114 p.

O635. NONE BUT THE LONELY HEART (1944). In: BEST FILM PLAYS 1943-1944. New York: Crown Publishers, 1945.

O636. NORTH BY NORTHWEST (1959). New York: Viking Press, 1972.

O637. THE NORTH STAR (1943). New York: Viking Press, 1943.

O638. AN OCCURRENCE AT OWL CREEK BRIDGE (1956). Encino, Calif.: Dickenson Publishing Co., 1973.

O639. OVER 21 (1945). In: THE BEST FILM PLAYS OF 1945. New York: Crown Publishers, 1946.

O640. THE OXBOW INCIDENT (1943). In: THREE MAJOR SCREENPLAYS. New York: Globe Book Co., 1972.

O640a. PAT GARRETT AND BILLY THE KID (1973). New York: Signet Books, 1973.

O641. POINT OF ORDER (1964). New York: W.W. Norton & Co., 1964.

O642. THE PRINCE AND THE SHOWGIRL (1957). New York: New American Library, 1957.

O643. THE PURPLE HEART (1944). In: BEST FILM PLAYS 1943-1944. New York: Crown Publishers, 1945.

O644. THE QUILLER MEMORANDUM (1966). In: FIVE SCREENPLAYS. London: Methuen, 1971.

O645. REBECCA (1940). In: GREAT FILM PLAYS. VOL. 1: SCRIPTS OF SIX CLASSIC FILMS. New York: Crown Publishers, 1959.

O646. ROMEO AND JULIET (1936). New York: Random House, 1936.

O647. SALESMAN (1961). New York: Signet Books, 1969.

O648. SALT OF THE EARTH (1953). Boston: Beacon Press, 1965.

O649. SATURDAY MORNING (1971). New York: Avon Publishing Co., 1971.

O650. SHANGHAI EXPRESS (1932). In: MOROCCO, SHANGHAI EXPRESS. New York: Simon & Schuster, 1973.

O651. SILENT SNOW, SECRET SNOW (1966). Encino, Calif.: Dickenson Publishing Co., 1972.

O652. THE SILVER STREAK (1934). Los Angeles: Haskell-Traverse, 1935.

O653. SINGIN' IN THE RAIN (1951). New York: Viking Press, 1972.

O654. SOME LIKE IT HOT (1959). New York: Signet Books, 1959.

O655. THE SOUTHERNER (1945). In: THE BEST FILM PLAYS OF 1945. New York: Crown Publishers, 1946.

O656. SPELLBOUND (1945). In: THE BEST FILM PLAYS OF 1945. New York: Crown Publishers, 1946.

O657. SPLENDOR IN THE GRASS (1961). New York: Bantam Books, 1961.

O658. THE SPY (1931). In: AN OCCURRENCE AT OWL CREEK BRIDGE. Encino, Calif.: Dickenson Publishing Co., 1973.

O659. STAGECOACH (1939). In: GREAT FILM PLAYS. VOL. 1: SCRIPTS OF SIX CLASSIC FILMS. New York: Crown Publishers, 1959.

O660. THE STORY OF G.I. JOE (1945). In: THE BEST FILM PLAYS OF 1945. New York: Crown Publishers, 1946.

O661. THE STORY OF LOUIS PASTEUR (1936). In: FOUR STAR SCRIPTS: ACTUAL SHOOTING SCRIPTS AND HOW THEY ARE WRITTEN. Garden City, N.Y.: Doubleday, Doran & Co., 1936.

O662. A STREETCAR NAMED DESIRE (1951). In: FILM SCRIPTS ONE. New York: Appleton-Century-Crofts, 1971.

O663. SWEET SWEETBACK'S BAADASSSSS SONG (1971). New York: Lancer Books, 1971.

O664. TAKING OFF (1971). New York: Signet Books, 1971.

O665. THIRTY SECONDS OVER TOKYO (1965). New York: Crown Publishers, 1946.

O666. THIS LAND IS MINE (1943). In: TWENTY BEST FILM PLAYS. New York: Crown Publishers, 1943.

O667. TILLIE AND GUS (1933). In: NEVER GIVE A SUCKER AN EVEN BREAK. New York: Simon & Schuster, 1973.

O668. TO KILL A MOCKINGBIRD (1963). New York: Harcourt Brace, 1962.

O669. TRANSATLANTIC MERRY-GO-ROUND (1934). In: THE NEW TECHNIQUE OF SCREEN WRITING. New York: Whittlesey House, 1936.

O670. A TREE GROWS IN BROOKLYN (1945). In: THE BEST FILM PLAYS OF 1945. New York: Crown Publishers, 1946.

O670a. TRILOGY (1969). In: TRILOGY: AN EXPERIMENT IN MULTI-MEDIA. New York: Macmillan Co., 1969.

O671. TWELVE ANGRY MEN (1957). In: FILM SCRIPTS TWO. New York: Appleton-Century-Crofts, 1971.

O672. TWO FOR THE ROAD (1966). New York: Holt, Rinehart & Winston, 1967.

O673. TWO-LANE BLACKTOP (1971). New York: Award Books, 1971.

O673a. VIVA ZAPATA! (1952). New York: Viking Press, 1975.

O674. A WALK IN THE SPRING RAIN (1970). In: FICTION INTO FILM: A WALK IN THE SPRING RAIN. Knoxville: University of Tennessee Press, 1970.

O675. WATCH ON THE RHINE (1943). In: BEST FILM PLAYS 1943–1944. New York: Crown Publishers, 1945.

O675a. WESTWORLD (1973). New York: Bantam Books, 1973.

O676. WHO IS HARRY KELLERMAN AND WHY IS HE SAYING THOSE TERRIBLE THINGS ABOUT ME? (1971). New York: Signet Books, 1971.

O677. WILSON (1944). In: BEST FILM PLAYS 1943–1944. New York: Crown Publishers, 1945.

O678. THE WOMEN (1939). In: TWENTY BEST FILM PLAYS. New York: Crown Publishers, 1943.

O679. WUTHERING HEIGHTS (1939). In: TWENTY BEST FILM PLAYS. New York: Crown Publishers, 1943.

O680. YELLOW JACK (1938). In: TWENTY BEST FILM PLAYS. New York: Crown Publishers, 1943.

Criticism, Essays, and Journals

Comment, criticism, and evaluation of American films and related topics are grouped under this rubric. The first group [O681–O686] comprises critical anthologies. The middle group [O687–O725] is made up of books of film criticism written by individual authors. The third group [O726–O731a] contains a selection of key periodicals.

CRITICAL ANTHOLOGIES

O681. Boyum, Joy Gould, and Scott, Adrienne, eds. FILM AS FILM: CRITICAL REPONSES TO FILM ART. Boston: Allyn & Bacon, 1971. 397 p., illus.

Nearly one hundred essays and reviews on twenty-five classic films are offered in this exploration of film criticism. The films are international in scope, but ten American productions are represented. The few illustrations seem unnecessary. A short list of suggested readings is appended. Paperback.

O682. Cooke, Alistair, ed. GARBO AND THE NIGHT WATCHMAN: A SELECTION FROM THE WRITINGS OF BRITISH AND AMERICAN FILM CRITICS. London: J. Cape, 1937. 352 p.

A selection of film criticism written in the thirties by both American and British reviewers, this volume evaluates and discusses many American films. In one section, nine writers consider Chaplin's *Modern Times* (1935). Almost 150 illustrations are used. An annotated index and other new materials have been added to the reissue of this book (New York: McGraw-Hill Book Co., 1972).

O683. Kauffmann, Stanley, ed. AMERICAN FILM CRITICISM. New York: Liveright, 1972. 443 p.

This anthology corrects the widely accepted assumption that there was no worthwhile film criticism before the forties. The comments and reviews taken from the period 1896 to 1941 are divided into three chronological groupings: beginnings, feature films, and sound. Although all the critics represented are American writers, they are concerned here with significant films from America and from other countries. Author notes, a selected bibliography, and a long, detailed index complete the volume.

O684. McBride, Joseph, ed. PERSISTENCE OF VISION. Madison: Wisconsin Film Society Press, 1968. 222 p.

A most unusual example of collected film criticism published by a small film society, this volume treats topics from both the silent and the sound eras. Welles, Lugosi, Karloff, Keaton, *King Kong* (1933) and *Casablanca* (1943) are some typical subjects.

O684a. Murray, Edward. NINE AMERICAN FILM CRITICS: A STUDY OF THEORY AND PRACTICE. New York: Fredrick Ungar Publishing Co., 1975. 256 p.

An evaluation and analysis of the film criticism of nine

American writers: James Agee, Robert Warshow, Andrew Sarris, Parker Tyler, John Simon, Pauline Kael, Stanley Kauffmann, Vernon Young, and Dwight MacDonald. The theories of film that guide each and their implementation in print are considered. The volume is a unique investigation of film criticism that is characterized by substance and logic. Index.

O685. Nobile, Philip, ed. FAVORITE MOVIES. New York: Macmillan Co., 1973. 301 p.

Twenty-seven film critics select their favorite film and then justify their choice in this interesting collection of articles. The contributors are well known, and some of their choices are provocative. Index.

O686. Schickel, Richard, and Simon, John, eds. FILM 67/68. New York: Simon & Schuster, 1968. 320 p.

Now published as an annual, this first anthology was a collection of some of the best film reviews of the year 1967–1968. More than sixty films are evaluated by members of the National Society of Film Critics in this sampling of superior film criticism. The editorship now rotates each year, but the format and quality is constant. Index. Paperback.

CRITICAL MONOGRAPHS

O687. Adler, Renata. A YEAR IN THE DARK: JOURNAL OF A FILM CRITIC, 1968–1969. New York: Random House, 1969. 355 p.

Renata Adler was a film critic for the *New York Times* for fourteen months during 1968–1969. A collection of 130 film reviews and 50 essays is presented here. The author's style is crisp, provocative, and entertaining; she favors the small, special film over the studio superproduction. She describes a film critic's problems in an introductory section.

O688. Agee, James. AGEE ON FILM. VOL. 1: CRITICISM AND COMMENT ON THE MOVIES. New York: McDowell, Obolensky, 1958. 432 p., illus.

Agee's film reviews and comments taken from periodicals such as *Time* and *The Nation* provides an overview of the films of the forties. A perceptive, witty critic, Agee's writing has gained much recognition and appreciation during the past three decades. Index.

O689. Alpert, Hollis. THE DREAMS AND THE DREAMERS: ADVENTURES OF A PROFESSIONAL MOVIE-GOER. New York: Macmillan Co., 1962. 258 p.

A collection of articles by a film critic about actors, directors, and other related film subjects makes up the content of this witty entertainment.

O690. Arnold, James. SEEN ANY GOOD DIRTY MOVIES

LATELY? Cincinnati: St. Anthony Messenger Press, 1972. 118 p., illus.

A look at contemporary films by a Catholic newspaper critic. The text offers a general introduction, chapters on youth and film, sex and love in films, and a debate between the author and a concerned mother. The final half reprints many of Arnold's reviews. American films are well represented in the text and figure among the many fine illustrations. Index. Paperback.

O691. **Barry, Iris.** LET'S GO TO THE MOVIES. New York: Payson & Clarke, 1926. 293 p., illus.

Iris Barry was a film pioneer who founded The Museum of Modern Art Film Library in the mid-thirties and fought successfully for the acceptance of film as an art form. These samples of her film criticism written during the twenties give evidence of her early enthusiasm and zeal in this cause. A few illustrations accompany the text. REPRINT (New York: Arno Press).

O692. **Bogdanovich, Peter.** PIECES OF TIME. New York: Arbor House Publishing Co., 1973. 269 p.

A collection of articles, essays, and reviews by a young American director. Taken from *Esquire* magazine, the pieces are divided into first impressions, actors, preferences, directors, and recent impressions. The author is a devotee of motion pictures and a filmmaker. His intelligence, informed background, and feeling of obligation to and respect for past film personalities are evident throughout. Index.

O693. **Crist, Judith.** THE PRIVATE EYE, THE COWBOY, AND THE VERY NAKED GIRL. New York: Holt, Rinehart & Winston, 1968. 292 p.

The film criticism of Judith Crist, written during a five-year period in the mid-sixties, is presented in this volume. The author writes intelligent, entertaining articles that are aimed at a middlebrow audience. Index.

O693a. **Crist, Judith.** JUDITH CRIST'S TV GUIDE TO THE MOVIES. New York: Popular Library, 1974. 415 p.

This volume contains a personal selection of 1,500 films, which are given mini-reviews by this witty, incisive critic. Her choices include a few TV movies, some older B films, and many films from the sixties. Although it is not a total guide to films on TV, it does serve as a showcase for Crist's perceptive film criticism.

O694. **Farber, Manny.** NEGATIVE SPACE: MANNY FARBER ON THE MOVIES. New York: Praeger Publishers, 1971. 288 p.

Examples of the film criticism of Manny Farber collected over a twenty-five-year period are presented here. Original, entertaining, and eccentric at times, Farber has his own film aesthetic. The selection of articles favors many older American films, actors, and directors. Index.

O694a. **Fulford, Robert.** MARSHALL DELANEY AT THE MOVIES. Toronto: Peter Martin, 1974. 244 p.

In this collection of reviews by a Canadian film critic,

there is one section devoted to American films. Delaney, whose approach is fresh, stimulating, and often irritating, is a new voice in film criticism.

O695. **Gilliatt, Penelope.** UNHOLY FOOLS, WITS, COMICS, DISTURBERS OF THE PEACE. New York: Viking Press, 1973. 384 p., illus.

A collection of film and theater criticism covering the period from 1960 to 1972. The author's method is to recall as closely as possible the film being considered and then to offer critical comment and judgment. Her writing style is marked with wit, honesty, and insight. She has a thorough understanding of film comedy.

O696. **Greene, Graham.** GRAHAM GREENE ON FILM. New York: Simon & Schuster, 1972. 284 p., illus.

A volume of film criticism from the years 1935–1939. Graham Greene, more widely known today for his novels, here indicates a major talent for using words and a minor talent for film criticism. However, a nostalgic review of some films of the thirties is offered, and over one hundred very good illustrations are added. Index.

O697. **Kael, Pauline.** DEEPER INTO MOVIES. Boston: Little, Brown & Co., 1973. 458 p.

A collection of Kael's writing for *The New Yorker* magazine from 1969 to 1972. Her perceptive comments on more than 150 films are presented in this worthwhile volume.

O698. **Kael, Pauline.** GOING STEADY. Boston: Little, Brown & Co., 1970. 304 p.

A collection of film criticism taken from *The New Yorker* magazine, 1968–1969. Kael offers a thoughtful summary in chronological order of motion pictures at the close of the sixties. Index.

O699. **Kael, Pauline.** I LOST IT AT THE MOVIES. Boston: Little, Brown & Co., 1965. 365 p.

Articles and reviews that Kael wrote from 1953 to 1963 reappear in this first published collection of her film criticism. Much positive attention is given to American films as the author deflates certain educators, filmmakers, and film theories. Index.

O700. **Kael, Pauline.** KISS KISS BANG BANG. New York: Bantam Books, 1969. 498 p., illus.

This was the second collection of Kael's film criticism to be published, and it includes reviews, articles, profiles, etc. In one retrospective section, there are short capsule reviews of more than 250 older films that Kael recommends. Other articles spotlight Marlon Brando, Orson Welles, Stanley Kramer, and the making of *The Group* (1966).

O701. **Kauffmann, Stanley.** FIGURES OF LIGHT: FILM CRITICISM AND COMMENT. New York: Harper & Row, 1971. 296 p.

A collection of film reviews and essays written from 1966 to 1970. Kauffmann is a critic who is not as concerned

with the mass film audience as he is with his personal preferences. His style lacks warmth but does offer intelligence, logic, and background. Index.

O702. Kauffmann, Stanley. A WORLD ON FILM: CRITICISM AND COMMENT. New York: Harper & Row, 1966. 437 p.

A collection of film reviews and criticism written during the period 1958–1965. Arrangement of the reviews is by national cinema or topic rather than chronologically. The author's content is comprehensive, but his style is thoughtful, pedantic, and often plodding. Index.

O703. Lennig, Arthur, ed. CLASSICS OF THE FILM. Madison, Wisconsin Film Society Press, 1965. 250 p., illus.

Re-evaluations of thirty films, along with a few articles on the horror film. The films examined are American and foreign, silent and sound. A few illustrations. Paperback.

O704. Lennig, Arthur, ed. FILM NOTES. Madison: Wisconsin Film Society Press, 1960. 150 p., illus.

Although this volume includes foreign films, individual attention is given to American film comedians and to *Intolerance* (1916), *The Phantom of the Opera* (1925), *Romeo and Juliet* (1936), and *Citizen Kane* (1941). Other American films are reviewed briefly. The few illustrations are unnecessary, but the book itself is a fine example of film literature published by a small American film society. Paperback.

O705. Lennig, Arthur. THE SILENT VOICE. Troy, N.Y.: By the author, 1969.

Comments, essays, and reviews on silent films. The author of several books on film, Lennig writes with style, authority, and sophistication on many early neglected films.

O706. Lewis, Leon, and Sherman, William David. LANDSCAPES OF CONTEMPORARY CINEMA. Buffalo: Buffalo Spectrum Press, 1967. 97 p.

Three general headings are used to classify the entertaining and informative essays in this volume: directors, Hollywood in the sixties, and film around the world. The authors' stated purpose is to examine modern cinema and communicate their enthusiasm for it. Paperback.

O706a. Lorentz, Pare. LORENTZ ON FILM: MOVIES 1927 TO 1941. New York: Hopkinson & Blake, 1975. 228 p., illus.

A collection of film criticism and writing by Pare Lorentz, the well known documentary filmmaker of the thirties. The sampling offered here is taken from the years 1927 to 1941 and is characterized by style, wit, and intelligence. A delightful reading experience with nostalgic overtones.

O707. Lounsbury, Myron Osborn. THE ORIGINS OF AMERICAN FILM CRITICISM. New York: Arno Press, 1973. 547 p.

A doctoral dissertation that provides an examination of American film criticism before World War II. The changing relationship of film and society is noted in the development of film reviewing. By tracing the development of selected critics, the author indicates the acceptance of film as an art form.

O708. MacDonald, Dwight. DWIGHT MACDONALD ON MOVIES. Englewood Cliffs, N.J.: Prentice-Hall, 1969. 492 p.

In one of the finest collections of film criticism, the author surveys world cinema via reviews, essays, and articles. His maturity, wisdom, and knowledge are applied to many American film subjects in this witty, irreverent volume. Index.

O709. Mekas, Jonas. MOVIE JOURNAL: THE RISE OF THE AMERICAN CINEMA, 1959–1971. New York: Macmillan Co., 1972. 434 p.

A collection of comment and criticism by a most ardent enthusiast of experimental film. Mekas, a critic for the *Village Voice*, has selected a number of his weekly columns from the period 1959 to 1971 for reprinting here. The author is informed, opinionated, and dedicated. Index.

O710. Pechter, William S. TWENTY-FOUR TIMES A SECOND: FILMS AND FILMMAKERS. New York: Harper & Row, 1971. 324 p.

A collection of essays on films and filmmakers. Although the emphasis is on foreign film directors, there is considerable reference to American films and directors. His style is positive, sensible, and enthusiastic. The articles are from the 1960–1970 period. Index.

O711. Reed, Rex. BIG SCREEN, LITTLE SCREEN. New York: Macmillan Co., 1971. 433 p., illus.

A third volume of articles by Rex Reed, this one includes an account of his experience in making *Myra Breckenridge* (1970). Other films and screen performers are considered.

O711a. Reed, Rex. PEOPLE ARE CRAZY HERE. New York: Delacorte Press, 1974. 348 p., illus.

This fourth collection of interview-articles includes Hollywood personalities and celebrities from sports and rock music. Reed is a bit more mellow here but still offers light, breezy reading.

O712. Sarris, Andrew. CONFESSIONS OF A CULTIST: ON THE CINEMA 1955–1969. New York: Simon & Schuster, 1970. 480 p.

A collection of film writing from the *Village Voice* critic who is one of the foremost proponents of the auteur theory of filmmaking. Provocative, well written, and enjoyable. Index.

O713. Sarris, Andrew. THE PRIMAL SCREEN. New York: Simon & Schuster, 1973. 337 p.

A collection of Sarris's essays, reviews, and comments taken from a variety of periodical sources. The typical

wit, style, intelligence, and dedication are evident as the text offers perspective, information, and entertainment. Index.

O713a. Scaramazza, Paul A., ed. TEN YEARS IN PARADISE. New York: Cinemabilia (Pleasant Press), 1974. 289 p., illus.

A collection of 4,200 film reviews taken from *Photoplay* covering the period 1920–1930. Arranged year-by-year, the reviews consist of a few capsule comments and the month of release. A total index to the films is added, along with a selection of *Photoplay* covers.

O714. Schickel, Richard. SECOND SIGHT: NOTES ON SOME MOVIES, 1965-1970. New York: Simon & Schuster, 1972. 351 p.

A collection of film reviews that this critic wrote for *Life* magazine from 1965 to 1970. A unique rereading by the author of his original comments has resulted in additional comment as well as recantation of and apology for some of his first impressions. Both views are presented together in this perceptive, imaginative book. Index.

O715. Simon, John. MOVIES INTO FILM: FILM CRITICISM, 1967–1970. New York: Dial Press, 1971. 464 p.

A collection of Simon's film criticism taken from *The New Leader*. Simon dislikes the majority of films that he reviews and often engages in a kind of intellectual sadism and snobbery that seems a commercial affectation rather than a thoughtful approach. Index.

O716. Simon, John. PRIVATE SCREENINGS. New York: Macmillan Co., 1967. 316 p.

Film criticism written by John Simon from 1963 to 1966 is presented here. Simon is a very controversial critic whose background, education, and writing ability are impressive. Unfortunately, his articles are often characterized by snobbery, abrasive intellectualism, and irritating attacks.

O717. Tyler, Parker. THE HOLLYWOOD HALLUCINATION. New York: Creative Age Press, 1944. 246 p.

In this early volume, Tyler presents a series of essays about the relationships of film and audience. His style is unique in that it often lacks clarity and logic but still provides provocative and interesting comment.

O718. Tyler, Parker. MAGIC AND MYTH OF THE MOVIES. New York: H. Holt, 1947. 283 p., illus.

The meanings, myths, and symbols found in the films of the forties are explored in this volume of film criticism. Freudian interpretations are freely used in this discussion of film as the folk art of America. Some acceptable visuals are added. REPRINT (New York: Simon & Schuster, 1970).

O719. Tyler, Parker. SEX, PSYCHE, ETCETERA IN THE FILM. New York, Horizon Press, 1969. 239 p.

A collection of previously published essays and criticism by a most provocative writer. Divided into the categories ritual, sex, psyche, aesthetics, and artist's crisis, the articles focus mostly on unusual, experimental films and their makers. Index.

O720. Tyler, Parker. THE THREE FACES OF FILM. New York: Thomas Yoseloff, 1960. 150 p., illus.

The three faces treated here are the art, the dream, and the cult. As usual, Tyler's blending of aesthetics with psychological and sociological implications makes for provocative and challenging reading. The accompanying illustrations are also grouped in three sections. An index is provided.

O721. Warshow, Robert. THE IMMEDIATE EXPERIENCE. Garden City, N.Y.: Doubleday, 1962. 282 p.

The major portion of this volume of reviews and essays (1946–1955) is devoted to film criticism and comment. Several articles about American genre films are regarded as outstanding examples of Warshow's ability as a writer-critic.

O722. Weinberg, Herman G. SAINT CINEMA. New York: Drama Book Specialists Publishers, 1970. 354 p.

A collection of varied criticism and comment written over four decades, this volume lacks a central theme but does offer an informed view of past films and performers. Some of the observations seem dated, but the author's enthusiasm, mixed with affection and respect for film art and artists, is always apparent.

O723. Wilson, Robert, ed. THE FILM CRITICISM OF OTIS FERGUSON. Philadelphia: Temple University Press, 1971. 475 p.

A collection of film criticism written for *The New Republic* from 1934 to 1942. Ferguson had a short but rather distinguished career. His love of films is evident in his writing, which offered new insights into and arguments for film as an art form. Index.

O724. Young, Vernon. ON FILM. Chicago: Quadrangle Books, 1972. 428 p.

A collection of essays, reviews, and articles published mostly in *The Hudson Review*. Written during the 1950–1970 period, the articles are characterized by a sophisticated, intelligent, and sensitive style. Young attemps to re-create the films in the minds of his readers by plot outlines, descriptions of action, etc. Index.

O725. Zinsser, William K. SEEN ANY GOOD MOVIES LATELY? Garden City, N.Y.: Doubleday, 1958. 239 p.

A collection of humorous articles that explore the film critic's profession. Includes a serious discussion about the practical realities the film reviewer must face.

SELECTED SERIALS AND PERIODICALS

The few titles that follow constitute a necessarily limited selection. The reader may profit further by consulting the substantial body of periodical references in *The Film Index,* the classic listing done by the WPA [O25], now vastly enriched by *The New Film Index* [O29a], a 1975 title entirely devoted to magazines. In addition, obvious supplemental sources will be found most helpful: Gerlach [O21a], Jones [O24], Reilly [O45], and Schuster [O53] should be consulted not merely for specific articles, but also for citations of key periodicals.

O726. Close-Up. Geneva and London. 1–10 (1927–1933).

An early periodical devoted to serious film criticism and edited by Kenneth Macpherson and Winifred Bryher, this magazine's major concerns were history, aesthetics, theory, and criticism. Many attractive film stills were reproduced. REPRINT (New York: Arno Press), 10 vols. Includes a three-part index.

O727. Experimental Cinema. New York. 1–5 (1930–1934).

A film journal of the thirties, edited by Seymour Stern and Lewis Jacobs, which was dedicated to a progressive, socially aware cinema. Articles by American writers are featured in the five illustrated issues that were published. REPRINT (New York: Arno Press). Contains a cumulative index and an introduction by George Amberg.

O728. Film Culture. New York. 1— (1955—).

Well-chosen selections from this independent, high-quality filmmaker's magazine are available in *A Film Culture Reader,* edited by P. Adams Sitney (New York: Praeger Publishers, 1970), 438 p., illus. The preface by Sitney constitutes an excellent introduction to the magazine and its central personality, editor Jonas Mekas.

O729. Films: A Quarterly of Discussions and Analysis. New York. 1–4 (1939–1940).

International in its coverage, the magazine discussed some American films and artists and included a section on literature of the film. The editors were Lincoln Kirstein, Jay Leyda, and Mary Losey. REPRINT (New York: Arno Press, 1968), 1 vol.

O729a. Films in Review. New York. (1909—).

A basic record of American film production, published by the National Board of Review, which in its earlier years provided capsulated data. Later, as a general magazine, it incorporated factual and critical articles from such contributors as James Agee, Arthur Knight, Gilbert Seldes, and Herman Weinberg. REPRINT of the first four years of the general magazine: *Films in Review, 1950–1953* (New York: Arno Press).

O730. Hound and Horn. Portland, Me., New York. (1927–1934).

This Harvard journal, edited by Lincoln Kirstein and others, commented on all the arts, and many articles on cinema were devoted to foreign films. Some attention is paid to animated cartoons, Cagney, Lubitsch, Dietrich, Garbo, and others. Its contributors included Americans, such as Jere Abbott, Alfred Barr, Jr., Lincoln Kirstein, and Henry-Russell Hitchcock, Jr., who were to play a part later in The Museum of Modern Art, which established the first department of film in the thirties. REPRINT: *Hound and Horn's Selected Essays on Cinema* (New York: Arno Press, 1971).

O731. Movie. London. 1— (1962—).

A selection of articles from this British periodical entitled *Movie Reader* was edited by Ian Cameron (New York: Praeger Publishers, 1972), 120 p., illus. Devoted mostly to analyses of various American directors, the articles treat their films, methods, themes, techniques, etc. The writing is of consistently high quality, but picture reproduction is uneven.

O731a. The New York Times Film Reviews. New York. 1— (1970—).

A continuing series of compact reprints by Arno Press of reviews by *Times* critics, starting with the silent era. Portraits of actors and actresses; cumulative index. ISSUED 1–6 (1913–1968); 7 (1969–1970); 8 (1971–1972); 9 (1973–1974). Vol. 6 is the index; index updates appear in each subsequent volume. REVIEWS by Mordaunt Hall, Frank S. Nugent, Renata Adler, Bosley Crowther, and others. [*See also* O2.]

FILMMAKERS: BIOGRAPHIES, STUDIES, APPRECIATIONS

Whether actor or director, writer or editor, child star or comedian, producer or cameraman, sex goddess or cowboy, the significant participant in American filmmaking is the subject of this final category. Under this rubric are biographies, interviews, appreciations, analyses—in short, any book that helps to define the life and career of the subject at hand. Collective biographies, those that treat many personalities in one book, are the core of the first section [O731b–O812]. The second deals with individuals or groups that might be considered as a unit, such as the Marx Brothers or Laurel and Hardy. In a very few cases, the same title may appear under two equally important subjects, as in the case of *Tracy and Hepburn* [O1003, O1171a].

Obviously, the reader's convenience rather than collective classification governs placement.

A brief word about effective use of the citations that follow: The researcher is encouraged to link related references. For example, for articles in periodicals about American filmmakers, see *Motion Picture Performers* [O53] and *Motion Picture Directors* [O52] by Schuster as well as *American Film Directors* [O757a] by Hochman and *Film Directors* [O783a] by Parish and Pitts. General titles are as significant as specific ones, to wit *The Film Index* [O25] and its worthy complement *The New Film Index* [O29a], both rich in periodical references and documentation of the wide world of the motion picture.

Collective Works

O731b. **Ash, Rene L.** THE MOTION PICTURE EDITOR. Metuchen, N.J.: Scarecrow Press, 1974. 171 p., illus.

Two articles on film editing introduce a collection of filmographies for 652 editors. An index of film titles and a listing of editing awards complete the book.

O732. **Bailey, David, and Evans, Peter.** GOODBYE BABY AND AMEN. New York: Coward-McCann, 1969. 239 p., illus.

This "Saraband for the Sixties" is an oversized picture book that contains many full page portraits of actors, directors, writers, and producers. The text is entertaining, but the visuals provide the book's major appeal.

O732a. **Belton, John.** THE HOLLYWOOD PROFESSIONALS. Vol. 3. New York: A. S. Barnes, 1974. 182 p., illus.

A collective biography of directors Howard Hawks, Frank Borzage, and Edgar G. Ulmer. Each receives a critical essay which considers the subject's life and career. Filmographies and a general index are included.

O733. **Best, Marc.** THOSE ENDEARING YOUNG CHARMS. New York: A.S. Barnes, 1971. 279 p., illus.

A survey of fifty child actors which offers a brief biography, some stills, and a partial filmography for each. Subjectivity is evident in the selection of performers and in the incomplete filmographies. The uninspired text is supplemented by three hundred good illustrations, adequately reproduced.

O734. **Bruno, Michael.** VENUS IN HOLLYWOOD: THE CONTINENTAL ENCHANTRESS FROM GARBO TO LOREN. New York: Lyle Stuart, 1970. 275 p., illus.

A verbose, padded account of the sex goddesses of Hollywood. The subjects are fascinating, but much of what is presented is not documented and seems conjecture rather than fact. The uninspired text and the bland illustrations are improved somewhat by indexes and a bibliography.

O735. **Bull, Clarence, and Lee, Raymond.** THE FACES OF HOLLYWOOD. New York: A. S. Barnes, 1968. 256 p., illus.

This volume comprises a collection of almost four hundred selected portraits made by Clarence Bull during his tenure as studio photographer at MGM. A niggardly text is added, but it is the fine reproduction of the visuals that gives the book its distinction.

O736. **Cahn, William.** A PICTORIAL HISTORY OF THE GREAT COMEDIANS. New York: Grosset & Dunlap, 1970. 224 p., illus.

The latter half of this volume on "American comedy from 1787 to 1970" treats comedians who were popular on American screens. Clowns of both sexes are included, as well as representatives from the silent and sound eras. The text is very slight, but the more than two hundred visuals are attractive. Index. ORIGINAL EDITION: *The Laugh Makers: A Pictorial History of American Comedians* (1957).

O737. **Cameron, Ian, and Cameron, Elisabeth.** DAMES. New York: Praeger Publishers, 1969. 144 p., illus.

This selective and arbitrary collection of post-1939 film "dames" is really a combination of mini-biographies and stills. The molls, tarts, and saloon girls shown in the excellent photographs are familiar actresses whose identity is not always known. The biographies and a filmography remedy this situation.

O738. **Cameron, Ian, and Cameron, Elisabeth.** THE HEAVIES. New York: Praeger Publishers, 1969. 144 p., illus.

This collection treats more than eighty-four bad men by offering a visual, a short biography, and a filmography

for each. The selection is arbitrary, but the text is both entertaining and informative. Picture quality is satisfactory.

O739. **Carr, Larry.** FOUR FABULOUS FACES: GARBO, SWANSON, CRAWFORD, DIETRICH. New Rochelle, N.Y.: Arlington House, 1970. unpag., illus.

Much more than the usual picture book, this magnificent collection of studio shots, stills, publicity pictures, etc., demonstrates the artistry of the studio technicians, provides a fashion cavalcade, indicates changes in popular taste, and, finally, gives a pictorial mini-history of its four subjects. The more than one thousand photographs used in this oversized volume have been selected with taste; reproduction is exceptional.

O740. **Carroll, David.** THE MATINEE IDOLS. New York: Arbor House Publishing Co., 1972. 159 p., illus.

Leading men from the theater and the silent screen are the subjects of this collective biography. Each actor is profiled by a brief essay and some photographs. In a few cases, articles about the subject are reprinted. Picture quality is acceptable and often helps to explain the actor's appeal to the females in the audience. Index.

O741. **Corneau, Ernest N.** THE HALL OF FAME OF WESTERN STARS. North Quincy, Mass.: Christopher Publishing House, 1969. 307 p., illus.

About 150 Western film stars appear in this collective biography. Selection is arbitrary, and illustrations are offered in a montage arrangement. Both a general index and an alphabetical index assist in locating specific information.

O741a. **Denton, Clive; Canham, Kingsley; and Thomas, Tony.** THE HOLLYWOOD PROFESSIONALS. VOL. 2. New York, A. S. Barnes, 1974. 192 p., illus.

A collective biography of directors Sam Wood, Henry King, and Lewis Milestone. Each receives a critical essay which considers the subject's life and career. Filmographies and a general index are included.

O742. **Everson, William K.** THE BAD GUYS: A PICTORIAL HISTORY OF THE MOVIE VILLAIN. New York: Citadel Press, 1964. 241 p., illus.

A survey of movie villains from *The Great Train Robbery* (1903) to *Dr. Strangelove* (1964). Villains are nicely classified as Western outlaws, mad doctors, etc. A few "bad girls" are noted in a concluding chapter. Most examples are from American films. The book has a witty, knowledgeable text and more than five hundred well-chosen photographs. Indexes are provided for both the visuals and the general subjects.

O743. **Eyles, Allen, and Billings, Pat.** HOLLYWOOD TODAY. New York: A. S. Barnes, 1971. illus.

This dictionary lists some 370 artists who have made some contribution to recent American films. A short biographical sketch and a post-1960 filmography is given for each. Many illustrations are used, and an index to film titles is provided. Paperback.

O744. **French, Philip.** THE MOVIE MOGULS. Chicago: Henry Regnery Co., 1969. 170 p., illus.

A collective biography of the European immigrants who came to America and created the eight major corporations which dominated the film industry for several decades. Mayer, Goldwyn, Zukor, Fox, and the Warner Brothers are among those whose biographies are related by anecdotes, incidents, quotations, and narratives. Notes, a bibliography, photographs, and an index are furnished.

O745. **Freulich, Roman, and Abramson, Joan.** FORTY YEARS IN HOLLYWOOD. New York: A. S. Barnes, 1971. 201 p., illus.

A series of anecdotes about Hollywood personalities accompanies this collection of almost two hundred pictures taken by the author. Since the author was a studio portrait photographer at Universal and Republic studios, most of his visuals are fascinating. The text is far less interesting. There is little organization to the visuals except by period, but they are nicely reproduced.

O746. **Frost, David.** THE AMERICANS. New York: Stein & Day Publishers, 1970. 250 p.

A collection of interviews with American personalities made originally for a television show and transcribed in this volume. Orson Welles, Jon Voight, Peter Fonda, Dennis Hopper, and Raquel Welch are among those questioned.

O747. **Froug, William.** THE SCREENWRITER LOOKS AT THE SCREENWRITER. New York: Macmillan Co., 1972. 352 p.

A collection of interviews with twelve screenwriters. A lengthy article by Froug introduces the volume. Each interview is preceded by the writer's credits, a background essay, and a sample script page. Most interesting is the attitude of writers toward the auteur theory of filmmaking. The author's questioning is efficient and indicates the high economic state but low morale of screenwriters today.

O748. **Gabor, Mark.** THE PIN-UP: A MODEST HISTORY. New York: Universe Books, 1972. 271 p., illus.

A pictorial history of the visuals which offer sex appeal as their primary interest. There are two sections devoted to the heroines and heroes of the screen, along with chapters on calendars, posters, sex magazines, etc. The hundreds of beautifully reproduced visuals are the chief attraction in this volume; it should be noted, however, that full frontal nudity is presented in some photographs. The chapters on sexual minorities may be controversial for some readers.

O749. **Geduld, Harry M.** FILM MAKERS ON FILMMAKING. Bloomington: Indiana University Press, 1967. 302 p.

Thirty film directors offer statements on their art. Taken from books and periodicals, the statements are divided

into "pioneers and prophets" and "film masters and film mentors." American directors are represented by Griffith, Chaplin, Anger, Flaherty, Hitchcock, von Stroheim, Welles, Sennett, and others.

O750. **Gelmis, Joseph.** THE FILM DIRECTOR AS SUPER-STAR. Garden City, N.Y.: Doubleday, 1970. 316 p., illus.

Sixteen directors are interviewed in this lively survey of current trends and attitudes. The questions cover a wide range of topics, and there are short biography-filmography introductions with a photograph for each director. Subjects include some American filmmakers such as John Cassavetes, Arthur Penn, and Mike Nichols.

O751. **Griffith, Richard.** THE MOVIE STARS. Garden City, N.Y.: Doubleday, 1970. 498 p., illus.

Along with a collection of photographs, historical comment and factual information are mixed with gossip about Hollywood stars and the system which produced them. The almost six hundred illustrations are consistently pleasing, and the text is witty and informative. It should be noted that, although the subjects are numerous, the book is not comprehensive or definitive. Griffith's selections are his personal, perhaps arbitrary choices.

O752. **Gruen, John.** CLOSE-UP. New York: Viking Press, 1968. 206 p., illus.

A collection of interviews with celebrities, both American and foreign. Includes Bette Davis, Judy Garland, Shelley Winters, Candice Bergen, Maria Montez, Vivien Leigh, Simone Signoret, Busby Berkeley, Joseph Losey, and Ruby Keeler.

O753. **Hallowell, John.** THE TRUTH GAME. New York: Simon & Schuster, 1969. 253 p.

A collection of film actor interviews, along with some general articles about show business. The author's style is subjective and opinionated; the all-star cast of interviewees outshines the author.

O754. **Harmon, Bob.** HOLLYWOOD PANORAMA. New York: E. P. Dutton & Co., 1971. 95 p., illus.

This book consists of thirty entertaining full color spreads containing caricatures of one thousand Hollywood personalities in their most famous roles. Identification keys and an index are provided. Paperback.

O755. **Higham, Charles.** HOLLYWOOD CAMERAMEN. Bloomington: Indiana University Press, 1970. 176 p., illus.

Seven famous Hollywood cameramen are interviewed in this informative book. The results are presented as statements rather than in question-and-answer format. Various periods of Hollywood filmmaking are represented, and the contribution of the cameraman is well stated. Photographs and filmographies are given for each. Index.

O756. **Higham, Charles, and Greenberg, Joel.** THE CELLULOID MUSE: HOLLYWOOD DIRECTORS SPEAK. Chicago: Henry Regnery Co., 1971. 268 p., illus.

A series of taped interviews with Hollywood directors: Irving Rapper, Jean Negulesco, John Frankenheimer, Robert Aldrich, Curtis Bernhardt, George Cukor, Alfred Hitchcock, Fritz Lang, Rouben Mamoulian, Lewis Milestone, Vincente Minnelli, Mark Robson, Jacques Tourneur, King Vidor, and Billy Wilder. Includes a filmography and an index.

O757. **Hirsch, Phil.** HOLLYWOOD CONFIDENTIAL. New York: Pyramid Books, 1967. 222 p.

A collective biography written for a nondemanding audience, this book is made up of articles taken from *Man's Magazine.* Spare, nonanalytical biography on some interesting subjects, such as Jack Palance, Alan Ladd, and Peter O'Toole. Paperback.

O757a. **Hochman, Stanley, ed.** AMERICAN FILM DIRECTORS. New York: Frederick Ungar Publishing Co., 1974. 604 p.

A collection of short articles, excerpts, and comments about sixty-five American film directors. Over three hundred writers are represented, with the result that each director receives an objective sampling of critical opinion. A filmography is provided for each director, and a detailed index lists the critics and film titles mentioned. There is a wealth of material in this fine reference work, which is characterized by easy arrangement and intelligent selection.

O758. **Hughes, Elinor.** FAMOUS STARS OF FILMDOM (MEN). Boston: L. C. Page, 1932. 342 p., illus.

A collective biography of some Hollywood leading men of the 1930 period. A fan magazine text and poor visuals diminish the value of the book. REPRINT (Freeport, N.Y.: Books for Libraries Press).

O759. **Hughes, Elinor.** FAMOUS STARS OF FILMDOM (WOMEN). Boston: L. C. Page, 1931. 341 p., illus.

Collective biography of some female Hollywood stars of the early thirties. The insipid text and inadequate visuals detract from the book's possible historical interest. REPRINT (Freeport, N.Y.: Books for Libraries Press, 1970).

O760. **Hughes, Langston, and Meltzer, Milton.** BLACK MAGIC: A PICTORIAL HISTORY OF THE NEGRO IN AMERICAN ENTERTAINMENT. Englewood Cliffs, N.J.: Prentice-Hall, 1967. 375 p., illus.

Only about two dozen pages in this oversized book are devoted to black film performers. The illustrations are fine, but film as a topic is slighted. Index.

O761. **Kantor, Bernard R.; Blackner, Irwin R.; and Kramer, Anne.** DIRECTORS AT WORK. New York: Funk & Wagnalls, 1970. 442 p.

An excellent collection of director interviews characterized by preliminary research and intelligent questioning. Subjects include Richard Brooke, George Cukor, Norman Jewison, Elia Kazan, Stanley Kramer, Richard Lester, Jerry Lewis, Elliot Silverstein, Robert Wise, and William Wyler. In each case the setting for the interview is described and a filmography is offered.

O761a. **Kobal, John, ed. and comp.** FIFTY SUPER STARS. New York: Crown Publishers, 1974. 168 p., illus.

A parade of film personalities is featured in this spiral-bound oversized volume. For each of fifty subjects the author has provided a mini-biography, a filmography, and several pages of film stills, portraits, posters, sheet music covers, etc. Many of the illustrations are in color, and overall reproduction quality is good. This is a volume rich in visual pleasures.

O762. **Kobal, John.** GODS AND GODDESSES OF THE MOVIES. New York: Crescent Books, 1973. 152 p., illus.

A collective biography of the film actors and actresses who appeared in romantic films, selected mostly from the period 1930 to 1960. The text is descriptive rather than critical. The illustrations are adequate, although some are weakened by poor reproduction. Index.

O763. **Lahue, Kalton C., and Gill, Sam.** CLOWN PRINCES AND COURT JESTERS: SOME GREAT COMICS OF THE SILENT SCREEN. New York: A. S. Barnes, 1970. 406 p., illus.

Fifty comedians, both male and female, of the American silent screen are profiled in individual chapters. The arrangement is alphabetical, and for each player the authors have described his career and noted his best films. The text is often pedestrian, and the quality of the pictures is variable.

O764. **Lahue, Kalton C.** GENTLEMEN TO THE RESCUE: THE HEROES OF THE SILENT SCREEN. New York: A. S. Barnes, 1972. 244 p., illus.

A collective biography of thirty male stars from the American silent screen era. For each subject the author furnishes several pages of biographical narrative and a few more pages of stills. The book's production is poor, and the text is bland. It is the selection of subjects that gives this volume its lone distinction.

O765. **Lahue, Kalton C.** LADIES IN DISTRESS. New York: A. S. Barnes, 1971. 334 p., illus.

In this collective biography, some forty heroines of the silent screen are considered. The short narrative given for each discusses her professional and private life. In addition, there are illustrations indicating the famous screen roles with which they were identified.

O766. **Lahue, Kalton C.** MACK SENNETT'S KEYSTONE: THE MAN, THE MYTH, AND THE COMEDIES. New York: A. S. Barnes, 1971. 315 p., illus.

A history and review of the Sennett Keystone Studio. An introductory essay deals with Mack Sennett and is followed by individual chapters for the leading Keystone actors: Mabel Norman, Mack Swain, Chester Conklin, Fatty Arbuckle, etc. Selected Keystone films are described in detail. Many of the nearly three hundred illustrations are frame enlargements which lack clarity. A detailed filmography is impressive, and there are separate indexes for film titles and names.

O767. **Lahue, Kalton C.** WINNERS OF THE WEST: THE SAGEBRUSH HEROES OF THE SILENT SCREEN. New York: A. S. Barnes, 1970. 353 p., illus.

A collective biography of thirty-eight Western personalities of the silent screen. Both men and women players are among the subjects of this volume. For each a few stills and a career summary are offered. The text is factual rather than critical or interpretive; picture quality is often poor.

O768. **Lamparski, Richard.** WHATEVER BECAME OF? New York: Ace Books, 1967. 207 p., illus.

An adventure into then-and-now nostalgia with one hundred personalities of the past. A capsule biography reviews the former career of the subject and tells what they are doing at present. A picture of the subject taken at the peak of celebrity is contrasted with a candid shot of today. Many of the subjects were American motion picture performers. Four volumes are now (1975) available in this series. Paperback.

O768a. **Landay, Eileen.** BLACK FILM STARS. New York: Drake Publishers, 1973. 194 p., illus.

In this volume more than two hundred well-reproduced illustrations accompany a critical text on the black image in films. The material, arranged chronologically, considers both films and performers. Intelligence, taste, and a high standard of selection are evident throughout. Contains a good bibliography and a helpful index.

O769. **Lee, Raymond.** NOT SO DUMB (ANIMALS IN THE MOVIES). New York: A. S. Barnes, 1970. 380 p., illus.

Animals who have had important roles in films are the subject of this book. Their contributions to many films are noted by the text and the many interesting photos. In addition to a wide range of animals, the book discusses their trainers, directors, co-stars, etc.

O770. **Levin, G. Roy.** DOCUMENTARY EXPLORATIONS. Garden City, N.Y.: Doubleday, 1972. 420 p., illus.

A paperback collection of interviews with eighteen documentary filmmakers. Biographical information and a filmography are given for each of the subjects, who come from America, Great Britain, Belgium, and France. The author's introductory historical essay, in addition to his thoughtful questioning and the provocative responses, provides a comprehensive overview of documentary filmmaking. A bibliography and twenty-four pages of photographs complete the volume. Index.

O771. **McCaffrey, Donald W.** FOUR GREAT COMEDIANS: CHAPLIN, LLOYD, KEATON, LANGDON. New York: A. S. Barnes, 1968. 175 p., illus.

The emphasis in this book is on technique as evidenced in the films rather than on a collective biography. Other silent screen comedians are discussed in the text, which is based on shot-by-shot studies of each comedian's films. The illustrations are adequate, and an extensive bibliography is offered. Paperback.

O772. **McClure, Arthur F., and Jones, Ken D.** HEROES, HEAVIES, AND SAGEBRUSH: A PICTORIAL HISTORY OF THE "B" WESTERN PLAYER. New York: A. S. Barnes, 1972. 350 p., illus.

A collective biography of film actors who spent some or all of their careers appearing in inexpensive Western films. Subjects range from John Wayne to Iron Eyes Cody. Divided into five categories—heroes, heavies, side kicks, indians, and assorted players—they each receive a short biographical sketch accompanied by one or more stills. The reproduction of over five hundred photographs is above average. Reference value is lessened by the lack of an index to the subjects.

O772a. **McClure, Arthur F., and Jones, Ken D.** STAR QUALITY. New York: A. S. Barnes, 1974. 285 p., illus.

A volume which pays tribute to those performers who were more than featured players but never attained stardom: George Brent, Cyd Charisse, Inger Stevens, and others. Two sections are provided. The first offers a full page of biographical-visual data for each of 79 subjects; the second contains about 400 small portraits with minimal biographical information accompanying each. Selection and emphasis are not only subjective but often questionable. Reproduction of the photographs is above average.

O773. **McDowall, Roddy.** DOUBLE EXPOSURE. New York: Delacorte Press, 1968. 253 p., illus.

This handsome oversized picture book boasts many full-page celebrity portraits, all taken by author-actor McDowall. Accompanying each of the attractive visuals is a tribute to the subject written by another famous person: Sidney Poitier described by Harry Belafonte, Judy Holliday by George Cukor, etc. This novel device and its execution make for an outstanding picture book.

O774. **Maltin, Leonard.** BEHIND THE CAMERA. New York: New American Library, 1971. 240 p., illus.

A paperback collection of five interviews with well-known cameramen and a long essay about their contribution to the motion picture art. A filmography is provided for each, and recognition via awards and nominations is noted. The photographs are a representative sampling of the subject's work. Index.

O775. **Maltin, Leonard.** MOVIE COMEDY TEAMS. New York: Signet Books, 1970. 352 p., illus.

A collective biography that treats famous comedy teams of motion pictures. Along with a critical essay about each team, there are appropriate stills and a filmography. The text is accurate, affectionate, and informative. Paperback.

O776. **Maltin, Leonard, ed.** THE REAL STARS. New York: Curtis Books, 1973. 320 p., illus.

A collection of articles and interviews about the character actors of the screen. The text pays tribute to all those unknown performers whose faces are so familiar. Each individual article is accompanied by several good illustrations and a filmography. Paperback.

O777. **Manchel, Frank.** YESTERDAY'S CLOWNS. New York: Franklin Watts, 1973. 154 p., illus.

A collective biography of the most famous silent screen comedians: Chaplin, Lloyd, Keaton, etc. In addition to describing the style and careers of various performers, the book provides a general survey of silent film comedy from 1915 to 1925. The illustrations have been carefully selected and reproduced, and a bibliography is included.

O778. **Martin, Pete.** HOLLYWOOD WITHOUT MAKEUP. New York: J. B. Lippincott Co., 1948. 255 p.

An anthology of edited articles from *The Saturday Evening Post.* The personalities are often unusual and represent a good sampling of Hollywood royalty in the forties.

O779. **Martin, Pete.** PETE MARTIN CALLS ON ... New York: Simon & Schuster, 1962. 510 p.

The author has collected some forty interviews that he did for *The Saturday Evening Post.* While the style seems dated, the subjects are still of interest.

O780. **Meyers, Warren B.** WHO IS THAT? New York: Personality Posters, 1967. 63 p., illus.

A guide to the character actors whose faces are familiar, but whose names are unknown. Inexpensively produced for a mass television viewing audience, this volume is useful for reference. The arrangement of its subjects into categories—society ladies and foreign villains among others—makes retrieval easier and quicker. An index of names is also provided.

O781. **Miller, Edwin.** SEVENTEEN INTERVIEWS: FILM STARS AND SUPERSTARS. New York: Macmillan Co., 1970. 384 p., illus.

A collection of fifty-eight short, positive fan interviews taken from *Seventeen* magazine. The subjects are mostly film personalities, and the writing style is tailored for a juvenile audience. A photograph of each interviewee is reproduced.

O781a. **Morella, Joe, and Epstein, Edward Z.** GABLE & LOMBARD & POWELL & HARLOW. New York: Dell Publishing Co., 1975. 272 p., illus.

This collective biography is unusual since it interweaves the lives of four major film stars of the thirties. It is well researched and written with a breezy frankness. William Powell, the one surviving and most sedate member of the quartet, receives the least attention. A few illustrations are added; but it is the style, approach, and sense of popular appeal that make this a most enjoyable biography.

O782. **Morella, Joe, and Epstein, Edward Z.** REBELS: THE REBEL HERO IN FILMS. New York: Citadel Press, 1971. 210 p., illus.

Nearly five hundred photographs are used to identify and describe the rebel hero, an unhappy nonconformist. The careers of the actors who specialized in this role, both onscreen and off, are summarized from John Garfield in the thirties to Peter Fonda, Steve McQueen, and Robert Redford in the sixties.

O783. **Newquist, Roy.** A Special Kind of Magic. Chicago: Rand McNally & Co., 1967. 156 p., illus.

A collection of longer interviews with the stars and director of *Guess Who's Coming to Dinner* (1967). Outstanding are the sessions with Katharine Hepburn, Spencer Tracy, and Stanley Kramer. Discussion is not limited to the film but covers a wide variety of topics. The illustrations are pleasant but hardly essential.

O783a. **Parish, James Robert, and Pitts, Michael R.** Film Directors: A Guide to their American Films. Metuchen, N.J.: Scarecrow Press, 1974. 436 p., illus.

Only American films are considered in this collection of 520 director filmographies. Each entry shows name, birth date, birth place, and death date, if applicable. The films which follow are arranged by year of release. Criteria for selection are noted, and a few illustrations are added.

O784. **Parish, James Robert.** The Fox Girls. New Rochelle, N.Y.: Arlington House, 1971. 722 p., illus.

A collective biography of fifteen of the Fox Studio's leading ladies. For each, a short biography, using mostly factual material with only a bit of critical interpretation, is followed by a gallery of photographs. A filmography listing major cast and production credits concludes each of the fifteen chapters. Picture quality is average, but reductions to small size are a disservice.

O784a. **Parish, James Robert, and Stanke, Don E.** The Glamour Girls. New Rochelle, N.Y.: Arlington House, 1975. 752 p., illus.

A collective biography of nine female film stars from the period 1930 to 1955. The subjects are Joan Bennett, Yvonne DeCarlo, Rita Hayworth, Audrey Hepburn, Jennifer Jones, Maria Montez, Kim Novak, Merle Oberon, and Vera Ralston. A portrait, stills, candid shots, and a filmography accompany the text for each actress. Film careers are emphasized rather than private lives.

O784b. **Parish, James Robert.** Good Dames: Virtue in the Cinema. New York: A. S. Barnes, 1974. 277 p., illus.

A collective biography of five well-known supporting actresses: Eve Arden, Agnes Moorehead, Angela Lansbury, Thelma Ritter, and Eileen Heckart. A lengthy biographical essay, some clearly reproduced photographs, and a filmography are provided for each subject. A great deal of information is offered about five actresses who are noted for stealing many scenes from more prominently billed names.

O784c. **Parish, James Robert.** Hollywood's Great Love Teams. New Rochelle, N.Y.: Arlington House, 1974. 828 p., illus.

A collective biography of famous Hollywood stars who appeared as romantic partners in several films: Garbo-Gilbert, Harlow-Gable, Loy-Powell, etc. Each of twenty-eight popular teams is introduced in male-then-female order, with biographical data and a filmography given for both performers. A collection of stills introduces the films they made together. Each of these films is described by a synopsis, review excerpts, background material, and some critical evaluation. Final pages follow the separate careers of each after the partnership terminated.

O785. **Parish, James Robert, and Bowers, Ronald L.** The MGM Stock Company: The Golden Era. New Rochelle, N.Y.: Arlington House, 1973. 862 p., illus.

A collective biography of almost 150 personalities who at one time were under long term contract to MGM. The subjects range from superstars (Harlow, Gable, Crawford, Tracy) to featured players (Rags Ragland, Connie Gilchrist). Each receives a short biographical essay which is both descriptive and critical. A few illustrations and a filmography conclude each profile. A history of MGM, some capsule biographies of studio executives, and a listing of MGM nominations and awards are added. Index.

O786. **Parish, James Robert.** The Paramount Pretties. New Rochelle, N.Y.: Arlington House, 1972. 587 p., illus.

A collective biography of sixteen film actresses who were under contract to Paramount Pictures for part of their career. The separate chapter provided for each offers a factual biographical essay, some stills, and a filmography. A small amount of critical comment and gossip is buried amidst the copious information and data in the narrative sections. The 350 stills vary in quality and size. An appendix gives short biographies of selected Paramount directors and producers.

O786a. **Parish, James Robert.** The RKO Gals. New Rochelle, N.Y.: Arlington House, 1974. 258 p., illus.

A collective biography of female film stars who began their careers at the RKO studios. Included are Ann Harding, Constance Bennett, Irene Dunne, Ginger Rogers, Katharine Hepburn, Anne Shirley, Lucille Ball, Joan Fontaine, Wendy Barry, Lupe Velez, Maureen O'Hara, Jane Russell, Barbara Hale, and Jane Greer. The biographies stress the stars' professional careers rather than their private lives. Good illustrations and a filmography accompany each biography. A history of the RKO studios and biographical information about selected executives and producers appear in the appendix.

O787. **Parish, James Robert.** The Slapstick Queens. New York: A. S. Barnes, 1973. 298 p., illus.

A collective biography of five film comediennes: Marjorie Main, Martha Raye, Joan Davis, Judy Canova, and Phyllis Diller. For each, there is a critical biography, followed by a picture gallery and a filmography. The text consists of comment, reviews, quotations, and information. The illustrations are uniformly good in selection and reproduction.

O788. **Phillips, Gene D.** The Movie Makers: Artists in an Industry. Chicago: Nelson-Hall Co., 1973. 249 p., illus.

An appreciative review of the work of twelve directors

and one cameraman. Divided into American and British sections, the book gives for each subject a brief career outline, some recurring themes, a detailed discussion of his films, and a filmography. Many excellent stills and candid shots accompany the text, as do notes and a selected bibliography. Index.

O789. **Platt, Frank C., ed.** GREAT STARS OF HOLLYWOOD'S GOLDEN AGE. New York: Signet Books, 1966. 214 p., illus.

A compilation of articles published in *Liberty* magazine from 1929 to 1942, this volume offers examples of fan magazine writing in America during the golden era of films. Subjects include Harlow, Valentino, Chaplin, Lombard, and Barrymore. Paperback.

O790. **Reed, Rex.** CONVERSATIONS IN THE RAW. New York: World Publishing Co., 1969. 312 p.

In these reports of his conversations with celebrity subjects, Reed is able to present entertaining, although prejudiced, portraits. He can be sensitive, devastating, and even ruthless. His talent consists of a readable reportorial style along with an ability to invade the private life of his subject.

O791. **Reed, Rex.** DO YOU SLEEP IN THE NUDE? New York: Signet Books, 1968. 255 p.

The pieces in this first Rex Reed interview book have a quality that later efforts do not possess. Although he is obviously a master of the interview technique, he gives an indication of innocence and naiveté here that was lost later on. His film impressions and interpretations of film notables offer rich entertainment. Paperback.

O792. **Robinson, Gerda.** FILM FAME. Beverly Hills, Calif.: Fame Publishing Co., 1966. 210 p., illus.

One hundred full-page portraits of film stars are attractively presented. Accompanying each is a literate biography. Paperback.

O793. **Rosenthal, Alan.** THE NEW DOCUMENTARY IN ACTION: A CASEBOOK IN FILM-MAKING. Berkeley: University of California Press, 1971. 320 p., illus.

A collection of seventeen interviews with filmmakers who are concerned with various types of documentary films. Each interview is preceded by a brief career review. The interviews are characterized by an intelligent approach owing to the background and ability of the author, who also contributes a historical introduction. The illustrations are acceptable. Index.

O794. **Ross, Lillian, and Ross, Helen.** THE PLAYER: A PROFILE OF AN ART. New York: Simon & Schuster, 1962. 459 p., illus.

The fifty-five biographies in this volume include those of many film personalities, although the selection seems based upon theatrical performance. Each short interview-essay makes an attempt to explore the theory of acting practiced by the subject. A small portrait precedes each article. Index.

O795. **Sarris, Andrew.** THE AMERICAN CINEMA: DIRECTORS AND DIRECTIONS, 1929-1968. New York: E. P. Dutton & Co., 1968. 383 p.

More than two hundred directors who were active in American filmmaking from 1929 to 1968 are evaluated here. Includes a "Directorial Chronology, 1915-1967" and an index of six thousand films, with release date and director indicated for each.

O796. **Sarris, Andrew.** INTERVIEWS WITH FILM DIRECTORS. New York: Avon Books, 1967. 557 p.

The author has collected forty previously published director interviews for this anthology. The general topics for each interview are the art of the film and the filmmaker's own works. A perceptive introduction by Sarris is given to each director, along with a portrait and a filmography. Paperback.

O796a. **Schickel, Richard.** THE MEN WHO MADE THE MOVIES. New York: Atheneum Publishers, 1975. 308 p., illus.

Derived from Schickel's television series, this volume profiles eight American film directors: Raoul Walsh, Alfred Hitchcock, King Vidor, Frank Capra, William Wellman, Howard Hawks, George Cukor, and Vincente Minnelli. The illustrations and supporting materials are most impressive. Index.

O797. **Schickel, Richard.** THE STARS. New York: Dial Press, 1962. 287 p., illus.

A pictorial survey of American film stars. More than four hundred photographs and a highly personal, inconsistent text are used to trace the star system in America from 1920 to 1960. Biographical sketches of the subjects are offered in addition to the visuals, which are well selected and adequately reproduced. Index.

O798. **Shay, Don.** CONVERSATIONS. Albuquerque: Kaleidoscope Press, 1969. unpag., illus.

There are eight lengthy, probing interviews, mostly from the sixties. Personalities are Buster Crabbe, Peter Falk, Henry Fonda, Charlton Heston, Karl Malden, Gregory Peck, Edward G. Robinson, and Rod Steiger. The quality of the questions and the apparently candid responses make this a better-than-average interview book. Fine illustrations and detailed filmographies also add to the book's quality.

O799. **Sherman, Eric, and Rubin, Martin.** THE DIRECTOR'S EVENT: INTERVIEWS WITH FIVE AMERICAN FILM-MAKERS. New York: Atheneum Publishers, 1970. 200 p., illus.

Five American directors—Budd Boetticher, Peter Bogdanovich, Samuel Fuller, Arthur Penn, and Abraham Polonsky—are interviewed in this fine collection. Questions stress specific instances in each man's films. The illustrations are ineffective because of their small size, but the filmographies following each interview are helpful. An appendix lists the distributors of the films mentioned.

O800. Shipman, David. THE GREAT MOVIE STARS: THE GOLDEN YEARS. New York: Crown Publishers, 1970. 576 p., illus.

A collective biography of 181 film personalities popular during the golden era of film, 1920 to 1945. Each mini-biography includes photographs, critical quotations, gossip, comment, and data. In certain cases, the selection is questionable, and the reproduction of over 450 illustrations is not always adequate. Useful as a reference source, the book has a bibliography and an index.

O801. Shipman, David. THE GREAT MOVIE STARS: THE INTERNATIONAL YEARS. New York: St. Martin's Press, 1972. 568 p., illus.

A collective biography of 220 performers who enjoyed their greatest screen popularity after World War II. Each subject receives a detailed survey of his career and some critical analysis of his work. The pictures are well chosen and nicely reproduced. The text is informative and entertaining. A brief bliography and a list of film title changes complete the volume. Index.

O802. Slide, Anthony. THE GRIFFITH ACTRESSES. New York: A. S. Barnes, 1973. 181 p., illus.

A collective biography of eight actresses who achieved fame under the guidance of D. W. Griffith. An introductory chapter describes the typical Griffith heroine. Individual chapters are given to each of the octet, while a final section notes some less successful ladies who also worked with the master director. Some American Biograph players and a long list of nearly all the actresses who appeared in Griffith films is given. Visual reproduction is adequate, and a bibliography is included.

O802a. Smith, Sharon. WOMEN WHO MAKE THE MOVIES. New York: Hopkinson & Blake, 1974. 307 p., illus.

This volume presents a historical overview of women as filmmakers and then identifies those women currently active in creating motion pictures. International in scope, the text contains sections on the United States. Included are interviews, mini-biographies, name listings, and organizations. A selection of portrait-photos adds to the quality of the book. Bibliography; index.

O803. Stuart, Ray. IMMORTALS OF THE SCREEN. Los Angeles: Sherbourne Press, 1965. 224 p., illus.

This album offers over six hundred visuals in its presentation of more than one hundred screen personalities. A short biography, a studio portrait, and a few stills are given for each. The selection of the actors is entirely subjective, ranging from stars (Gable, Harlow, Fields) to supporting actors (Alan Hale, Henry Armetta). Picture quality is adequate.

O804. Talmey, Allene. DOUG AND MARY AND OTHERS. New York: Macy-Masius, 1927. 181 p., illus.

Short, bright biographies of stars, producers, and directors of the twenties: Fairbanks, Pickford, Swanson, Talmadge, etc. Amusing, perceptive, and witty, with woodcuts by Bertrand Zadig.

O805. Thomas, Tony. CADS AND CAVALIERS: THE FILM ADVENTURERS. New York: A. S. Barnes, 1973. 242 p., illus.

A collective biography of eight actors who were known for their roles in swashbuckler films: Errol Flynn, Douglas Fairbanks, etc. Each main subject is treated at length. A final section offers a selection of other actors who have taken part in at least one duel on film. An admirable collection of stills is provided to support the well-written text. Index.

O806. Thomey, Tedd, and Wilner, Norman. THE COMEDIANS. New York: Pyramid Books, 1970. 208 p.

A collective biography on multi-media comedians, many of whom played supporting roles in films, e.g., Phyllis Diller, Oscar Levant, Phil Silvers, Martha Raye, and Jackie Gleason. Major stars included are Red Skelton and Laurel and Hardy. The writing in this entertaining paperback is brisk and breezy.

O807. Trent, Paul. THE IMAGE MAKERS: SIXTY YEARS OF HOLLYWOOD GLAMOUR. New York: McGraw-Hill Book Co., 1972. 327 p., illus.

A beautiful picture book designed by Richard Lawton and devoted to Hollywood glamour. The title word refers to the public image of stars developed by studios. During Hollywood's golden years, gallery portraits were made of the performers to reinforce an image of which this magnificent collection offers evidence. Arranged by decades, the visuals manifest the charisma of the subjects in almost every instance. Detailed index.

O807a. Truitt, Evelyn Mack, ed. WHO WAS WHO ON SCREEN. New York: R. R. Bowker Co., 1974. 363 p.

More than six thousand film performers are listed in this useful necrology covering the era 1920–1971. For each entry there is noted the subject's birth date, birth place, along with the date, place, and cause of death. Marriages, divorces, and other bits of biographical information are often included. The major portion of each entry is the filmography, arranged chronologically. This major reference work is characterized by accuracy, wide coverage, and ease of use.

O808. Twomey, Alfred E., and McClure, Arthur F. THE VERSATILES. New York: A. S. Barnes, 1969. 304 p., illus.

An alphabetical arrangement of four hundred supporting character actors in the American motion picture from 1930 to 1955 occupies the first section of this book. A photograph and a short biography is given for each. Another two hundred players appear in a second section with only a photograph and a few credits. Unless names are known, the book is difficult to use as a reference source. Reproduction of the portraits is below average.

O809. Wilde, Larry. THE GREAT COMEDIANS TALK ABOUT COMEDY. New York: Citadel Press, 1968. 382 p., illus.

A collection of sixteen interviews with well-known comedians. Each interview is preceded by a biographical

sketch and presents an edited transcript of a taped conversation. Since most of the subjects have appeared in American films, their ideas on comedy are of interest.

O810. **Zierold, Norman J.** THE CHILD STARS. New York: Coward-McCann, 1965. 250 p., illus.

A collective biography of child stars who were popular during the twenties and thirties. Includes Jackie Coogan, Baby LeRoy, Shirley Temple, Jane Withers, Judy Garland, Freddie Bartholomew, Deanna Durbin, Mickey Rooney, and Jackie Cooper. The book is a series of superficial reports, and the intimate childhood of each subject remains a mystery. The well-reproduced illustrations evoke nostalgia.

O811. **Zierold, Norman.** THE MOGULS. New York: Coward-McCann, 1969. 354 p., illus.

The studio moguls responsible for the early establishment of the film industry were Jewish refugees who came to America to escape foreign oppression. Based on interviews, this collective biography deals separately with such pioneers as Goldwyn, Zukor, Lasky, Mayer, Cohn, Fox, etc. Many of the subjects have received fuller treatment elsewhere. The illustrations are acceptable. Index.

O812. **Zierold, Norman.** SEX GODDESSES OF THE SILENT SCREEN. Chicago: Henry Regnery Co., 1973. 207 p., illus.

A collective biography of five exotic film actresses from the twenties: Clara Bow, Theda Bara, Pola Negri, Mae Murray, and Barbara LaMarr. A critical biography is provided for each, along with a filmography and several good illustrations. A short closing section is devoted to some less successful silent screen vamps.

Monographs on Actors, Actresses, Directors, Producers, Writers, and Other Personalities

ABBOTT, BUD

COSTELLO, LOU

O813. **Anobile, Richard J., ed.** WHO'S ON FIRST? New York: Darien House, 1972. 256 p., illus.

Using frame blowups and dialogue excerpts, an attempt is made to recreate several of Abbott and Costello's famous routines. The films are those done for Universal and are representative of the film comedy that pleased audiences in the forties.

O813a. **Mulholland, Jim.** THE ABBOTT AND COSTELLO BOOK. New York: Popular Library, 1975. 254 p., illus.

A combination of materials on Bud Abbott and Lou Costello is offered in this volume: Interviews, script excerpts, filmography, biography, plot synopses. The team's appearances in media other than film are noted. Some clearly reproduced visuals add dimension to this satisfying appreciation of the famous comedy duo.

AHERNE, BRIAN

O814. **Aherne, Brian.** A PROPER JOB. Boston: Houghton Mifflin, 1969. 355 p., illus.

Aherne was a competent actor who appeared in many Hollywood films during the thirties. This well-written autobiography describes the Hollywood period of his life along with accounts of his earlier years. The more than thirty pages of illustrations are very good.

ALDRICH, ROBERT

O815. **Henstell, Bruce, ed.** ROBERT ALDRICH. Washing-

ton, D.C.: American Film Institute, 1972. 27 p.

A 1972 interview with Aldrich during which he discusses *The Dirty Dozen* (1971) and his other films. A bibliography and a filmography are included. Paperback.

ANDREWS, JULIE

O816. **Windeler, Robert.** JULIE ANDREWS: A BIOGRAPHY. New York: G. P. Putnam's Sons, 1970. 253 p., illus.

A biography of a British girl who became a famous Broadway and Hollywood star. Good visuals cannot disguise the sentimental, press release quality of this superficial biography.

ARLISS, GEORGE

O817. **Arliss, George.** MY TEN YEARS IN THE STUDIOS. Boston: Little, Brown & Co., 1941. 349 p., illus.

George Arliss was in his seventies when this autobiography was written. He tells of the first decade of sound motion pictures during which he made his only films. The photographs are fine, and are supplemented by a filmography with casts and credits.

ARNOLD, EDWARD

O818. **Arnold, Edward.** LORENZO GOES TO HOLLYWOOD. New York: Liveright, 1940. 282 p., illus.

This is an early autobiography of the well-known character actor Edward Arnold that ends with the making of *Mr. Smith Goes To Washington* (1939). Arnold's film work is treated minimally, however, with most of the text devoted to stage work and personalities.

ASTAIRE, FRED

O819. **Astaire, Fred.** STEPS IN TIME. New York: Harper & Bros., 1959. 338 p., illus.

A careful but unrevealing autobiography of the musical screen's greatest performer. Astaire's descriptions of his film work are interesting, but his underevaluation of both his career and his contribution to film art limits the effectiveness of the book. The illustrations, filmography, and index are also modest.

O820. **Croce, Arlene.** THE FRED ASTAIRE–GINGER ROGERS MOVIE BOOK. New York: E.P. Dutton & Co., 1971. 192 p., illus.

A detailed record of the Astaire–Rogers screen partnership that lasted through a series of nine films (1933–1939) and had a reunion a decade later (1949). Includes synopses, analyses of dance numbers, songs, interviews. Contains more than one hundred photographs and two flip sequences that simulate dance motion.

O821. **Hackl, Alphons.** FRED ASTAIRE AND HIS WORK. Vienna: Edition Austria International, 1970. 122 p., illus.

All aspects of Fred Astaire's career are covered in this attractive volume. Separate sections are provided for his stage, screen, television, and recording performances. The illustrations are very good. Index.

O822. **Thompson, H.** FRED ASTAIRE: A PICTORIAL TREASURY OF HIS FILMS. New York: Crescent Books, 1970. 160 p., illus.

Astaire's films from *Dancing Lady* (1933) to *Finian's Rainbow* (1968) are described by text and more than 165 visuals. A detailed filmography with casts and directors concludes the book.

ASTOR, MARY

O823. **Astor, Mary.** A LIFE ON FILM. New York: Dell Publishing Co., 1972. 245 p., illus.

An honest, absorbing book that describes a long film career. Miss Astor concentrates on many of her 109 films, her co-workers, and the motion picture industry. In this second autobiographical volume, her self-portrait is that of an actress who continually sought and used a professional approach to her work, regardless of personal problems. The illustrations are only partly effective, but the filmography offers rather complete credits. Index. Paperback.

O824. **Astor, Mary.** MARY ASTOR, MY STORY. Garden City, N.Y.: Doubleday, 1959. 332 p.

The first of two revealing autobiographies, this book gives major attention to Miss Astor's personal life and problems. Views of film personalities and backstage Hollywood are presented with honesty and candor.

BACALL, LAUREN

O824a. **Hyams, Joe.** BOGART AND BACALL. New York: David McKay Co., 1975. 245 p., illus.

This dual biography employs a parallel structure as it traces the lives of Humphrey Bogart and Lauren Bacall until they merge into a professional and private team during the early forties. Attention is given to their personal lives and to their films. The illustrations used are mostly candid shots and newsphotos. Hyams's friendship with the pair has made him privy to incidents and anecdotes not found in other books. Index.

BALABAN, ABRAHAM J.

O825. **Balaban, Carrie.** CONTINUOUS PERFORMANCE. New York: G. P. Putnam's Sons, 1940. 240 p., illus.

Written by an adoring wife, this biased biography of Chicago movie magnate Abe J. Balaban tells incidentally of his rise from nickelodeon operator to theater chain ownership as it delineates family life, travels, etc. Chronology from 1900 to 1942; index.

BALL, LUCILLE

O825a. **Gregory, James.** THE LUCILLE BALL STORY. New York: Signet Books, 1974. 224 p., illus.

A biography based on an interview done for a shortlived movie periodical. The interview serves as the frame around which Gregory builds his research. The star's life is related in chronological order ending with her appearance in *Mame* (1973). A center section of illustrations adds to the public portrait presented here.

O826. **Morella, Joe, and Epstein, Edward Z.** LUCY: THE BITTER SWEET LIFE OF LUCILLE BALL. Secaucus, N.J.: Lyle Stuart, 1973. 287 p., illus.

An unauthorized biography that concentrates mostly on her television and personal relationships rather than on her past film career. It is the post-1950 period that receives the greatest attention. Two sections of bland photographs are added to a rather pedestrian text.

BALSHOFER, FRED J.

O827. **Balshofer, Fred J., and Miller, Arthur C.** ONE REEL A WEEK. Berkeley: University of California Press, 1967. 218 p., illus.

A dual autobiography of two film pioneers who recall, in alternate chapters, the beginnings of the motion picture industry and the middle years in Hollywood. During their fifty years of experience, they were owners, producers, and filmmakers. An index of proper names and some good visuals are included.

BANKHEAD, TALLULAH

O828. **Gill, Brendan.** TALLULAH. New York: Holt, Rinehart & Winston, 1972. 287 p., illus.

A large pictorial biography that pays much attention to Bankhead's films in its graceful text and fascinating visuals. A biographical essay is followed by 170 pages of

superb pictures that describe Bankhead's personal and professional life. A chronology of her professional activities, including films, completes this attractive volume. Index.

O829. **Israel, Lee.** MISS TALLULAH BANKHEAD. New York: G. P. Putnam's Sons, 1972. 384 p., illus.

A good biography of a personality-actress who made relatively few films. The major ones are described in this forthright study of a legendary theatrical figure. The author is compassionate yet objective.

BARRETT, RONA

O829a. **Barrett, Rona.** MISS RONA: AN AUTOBIOGRAPHY. Los Angeles: Nash Publishing Corp., 1974. 285 p., illus.

An autobiography of a Hollywood gossip queen of the seventies, this volume tells the story of an ordinary girl who combined a bright mind and ambition to achieve eminence in her field. Care is needed to separate the ambivalent from the factual, the ambiguous from the clarified report. Nonetheless, rumor and gossip, as well as films, constitute a mirror of Hollywood life that has long fascinated the American audience. Some illustrations, most of which are irrelevant, are included.

THE BARRYMORES

O830. **Alpert, Hollis.** THE BARRYMORES. New York: Dial Press, 1964. 397 p., illus.

A collective biography of Ethel, Lionel, and John that pays attention to their film work. The colorful legendary subjects are given objective, honest handling by film critic Alpert. Fine illustrations and a detailed index add much to the fascinating text.

O831. **Barrymore, Lionel, and Shipp, Cameron.** WE BARRYMORES. New York: Appleton-Century-Crofts, 1951. 311 p., illus.

An autobiography that reluctantly recognizes films while glorifying the theater. Although Barrymore tells of John and Ethel, the emphasis is on his own life and career. An early chapter deals with D. W. Griffith, the Biograph Studio, and silent filmmaking. A later chapter is entitled "Don't Sell Movies Short," which is probably unintentionally ironic. Index.

BARRYMORE, DIANA

O832. **Barrymore, Diana, and Frank, Gerold.** TOO MUCH TOO SOON. New York: H. Holt, 1957. 380 p., illus.

An autobiography of a film star's daughter who had a brief career in films in the forties. Hollywood and the Barrymores are part of her story which includes other motion picture personalities. The illustrations are mostly candid family photos.

BARRYMORE, JOHN

O833. **Fowler, Gene.** GOOD NIGHT SWEET PRINCE. New York: Viking Press, 1944. 477 p., illus.

Although John Barrymore appeared in more than seventy films, mention is made in this fine biography of only a few. Otherwise, his life and career is described with affection and understanding. A few attractive photographs are used to introduce the text. Index.

BEATON, CECIL

O834. **Beaton, Cecil.** CECIL BEATON: MEMOIRS OF THE 40s. New York: McGraw-Hill Book Co., 1972. 310 p., illus.

Cecil Beaton is well known as a photographer and a designer of sets and costumes. In this account of his life in the forties, Beaton candidly discusses his working and social acquaintances. Many American film personalities, including Greta Garbo, appear in the narrative and in the attractive illustrations. Sketches of his work are well reproduced. Index.

BELAFONTE, HARRY

O835. **Shaw, Arnold.** BELAFONTE: AN UNAUTHORIZED BIOGRAPHY. New York: Pyramid Books, 1960. 287 p., illus.

The emphasis is on Belafonte's career as a singer-performer rather than as a film actor. Some mention is made of his screen appearances. The illustrations are unimpressive. Paperback.

BENCHLEY, ROBERT

O836. **Rosmond, Babette.** ROBERT BENCHLEY: HIS LIFE AND GOOD TIMES. Garden City, N.Y.: Doubleday, 1969. 239 p., illus.

Benchley's ability to stand out in minor or supporting film roles and his appearances in the Benchley-MGM comedy shorts of the thirties and forties are noted in this biography. Film stills are included, along with a filmography.

BENNETT, JOAN

O837. **Bennett, Joan, and Kibbee, Lois.** THE BENNETT PLAYBILL. New York: Holt, Rinehart & Winston, 1970. 332 p., illus.

Very little attention to films, and then only to Joan's. Little mention is made of Richard or Constance Bennett's screen appearances. The Wanger-Lang shooting is a prominent topic in the latter portion of the book. An unimpressive photo section is included.

BERGMAN, INGRID

O838. **Brown, Curtis F.** INGRID BERGMAN. New York:

Pyramid Publications, 1973. 157 p., illus.

A paperback survey of the life and career of Ingrid Bergman. Each of her films is described, her stage work is acknowledged, and elements of her private life are related. The visuals are attractive and complementary to the text. Filmography; bibliography; index.

O839. Quirk, Lawrence J. THE FILMS OF INGRID BERGMAN. New York: Citadel Press, 1970. 224 p., illus.

A handsome picture book that covers, not only the film career of Ingrid Bergman, but also her stage and television appearances. Her films are arranged chronologically, with stills, cast, credits, synopses, and review excerpts given for each.

O840. Steele, Joseph Henry. INGRID BERGMAN: AN INTIMATE PORTRAIT. New York: Popular Library, 1959. 332 p., illus.

Written by a professional associate of Ingrid Bergman, this biography is quite objective in noting the strengths and weaknesses of the actress. Published after the Rossellini affair, the book devotes a bit too much attention to that well-reported liaison. Some information is offered about her work in American films and on the New York stage. Paperback.

BERKELEY, BUSBY

O840a. Pike, Bob, and Martin, Dave. THE GENIUS OF BUSBY BERKELEY. Los Angeles: Sherbourne Press, 1974. 1974 p., illus.

A tribute to Busby Berkeley that includes a 1963 interview, a biography, a picture section, and a filmography containing numerous review excerpts. The many contributions Berkeley made to film technique through his lavish musical films are noted.

O841. Thomas, Tony; Terry, Jim; and Berkeley, Busby. THE BUSBY BERKELEY BOOK. Greenwich, Conn.: New York Graphic Society, 1973. 192 p., illus.

An attractive pictorial tribute to Busby Berkeley and his films. Although the narrative is satisfactory, it is the selection and reproduction of the visuals that make this book unique. Stills and production pictures are used to illustrate Berkeley's filmmaking techniques. Index.

BICKFORD, CHARLES

O842. Bickford, Charles. BULLS, BALLS, BICYCLES AND ACTORS. New York: Paul S. Eriksson, 1965. 336 p.

A negative, disappointing autobiography that is disproportionate in its emphases. Bickford's attitude toward his work and the film industry can be detected by his concentration on nonfilm matters and his omission of the reasons for his celebrity.

BITZER, G. W.

O843. Bitzer, G. W. BILLY BITZER: HIS STORY. New

York: Farrar, Straus & Giroux, 1973. 266 p., illus.

An uncompleted autobiography of D. W. Griffith's cameraman that covers only the period to 1920. Since these were the years of his close association with Griffith, his account is informative and fascinating. Personalities and events are recalled in the straightforward text and the ninety-five well-reproduced photographs. A Bitzer filmography is supplied. Index.

BOGART, HUMPHREY

O844. Barbour, Alan G. HUMPHREY BOGART. New York: Pyramid Publications, 1973. 160 p., illus.

An appreciation of Bogart that is composed of a biography and a review of his films. The opening section is about Bogart's personal and professional life. A detailed evaluation of each of his films follows. Picture reproduction is above average, as are all the other elements of this fine book. Filmography; bibliography; index. Paperback.

O844a. Benchley, Nathaniel. HUMPHREY BOGART. Boston and Toronto: Little, Brown & Co., 1975. 242 p., illus.

A biography written by a longtime friend and admirer of Bogart. The complex actor is recalled in a series of moods, incidents, and activities. Some objectivity is sacrificed, but the personal recollections are rewarding. The illustrations are excellent and add to the affectionate text. No filmography or index is provided.

O845. Gehman, Richard. BOGART. Greenwich, Conn.: Gold Medal Books, 1965. 159 p., illus.

A well written, honest account of Bogart as actor and friend. The attention given to film work is enhanced by Bogart's evaluation of his own performances. Some good illustrations are included in this original paperback.

O846. Goodman, Ezra. BOGEY, THE GOOD-BAD GUY. New York: Lyle Stuart, 1965. 223 p.

A bittersweet view of Bogart that will balance the more favorable biographies. People who knew or worked with the actor are quoted, and the final portrait is rather negative.

O846a. Hyams, Joe. BOGART AND BACALL. New York: McKay, 1975. 245 p., illus.

[See O824a.]

O847. Hyams, Joe. BOGIE: THE BIOGRAPHY OF HUMPHREY BOGART. New York: New American Library, 1966. 211 p., illus.

The author of this biography had the cooperation of Lauren Bacall, but the result is disappointing. A wealth of detail is offered, but the portrait is subjective and indicates the undisguised admiration of the author for his subject. Some candid photographs do not help much.

O848. McCarty, Clifford. BOGEY: THE FILMS OF

HUMPHREY BOGART. New York: Bonanza Books, 1965. 190 p., illus.

More than 400 photographs recreate the film career of Humphrey Bogart in 75 feature films, two shorts, two trailers, and three unbilled guest appearances. A synopsis, along with cast and production credits, accompany the stills for each feature film. Picture quality is very good throughout.

O849. **Michael, Paul.** HUMPHREY BOGART: THE MAN AND HIS FILMS. Indianapolis: Bobbs-Merrill Co., 1965. 191 p., illus.

An introductory biographical essay is followed by a chronological presentation of Bogart's seventy-five films. Each film is given a synopsis, a cast and production credit listing, and one or more illustrations. The latter have been well selected and are clearly reproduced. Index.

O850. **Ruddy, Jonah, and Hill, Jonathan.** BOGEY: THE MAN, THE ACTOR, THE LEGEND. New York: Tower Publications, 1965. 248 p.

Another biography that uses quotations of persons who knew Bogart: friends, directors, co-workers. The narrative is nonlinear and may cause some initial confusion. A filmography is appended. Paperback.

BONOMO, JOE

O851. **Bonomo, Joe.** THE STRONGMAN. New York: Bonomo Studios, 1968. 352 p., illus.

A pictorial autobiography of a Hollywood stunt man. Joe Bonomo offers some 750 illustrations, taken mostly from films of the twenties and thirties, along with a refreshing nonliterary text. Stunts, physical culture, and muscles are featured in this unusual memoir. Picture reproduction varies, but the selection is fascinating. Paperback.

BRAKHAGE, STAN

O852. **Reed, Rochelle, ed.** STAN BRAKHAGE, ED EMSHWILLER. Washington, D.C.: American Film Institute, 1973. 24 p., illus.

Two interviews with experimental filmmakers, Brakhage and Emshwiller, held in 1972. The illustrations are pictures taken during the interviews. Paperback.

BRANDO, MARLON

O853. **Carey, Gary.** BRANDO. New York: Pocket Books, 1973. 279 p., illus.

Although unauthorized, this is a very good biography of Brando. It includes his 1973 rejection of the Academy Award. The text is critical when it considers the films and the performances but remains factual when discussing the actor's personal life and behavior. The illustrations are adequate. Paperback.

O853a. **Fiore, Carlo.** BUD: THE BRANDO I KNEW. New York: Delacorte Press, 1974. 294 p., illus.

Selected intimate recollections from 1944 to 1960 by a former friend-confidant. The text dwells on personal and private activities, and the reader may feel he is learning as much about the author as about Brando. Others may find the betrayal of a friendship disturbing. Personal photographs accompany this sensationalized memoir.

O854. **Jordan, René.** MARLON BRANDO. New York: Pyramid Publications, 1973. 157 p., illus.

A survey of the life and career of Marlon Brando. Some attention is given to Brando offscreen, but the major portion of this volume analyzes his films. With the use of nicely reproduced visuals and a good critical text, the twenty-seven films are described in some detail. Filmography; bibliography; index. Paperback.

O855. **Morella, Joe, and Epstein, Edward Z.** BRANDO: THE UNAUTHORIZED BIOGRAPHY. New York: Crown Publishers, 1973. 248 p., illus.

Much of the material presented in the introductory biographical section has been taken from public sources. The second, stronger section deals with Brando's film and theatre work. The quality of the illustrations varies considerably; a good filmography and an index complete the volume.

O856. **Offen, Ron.** BRANDO. Chicago: Henry Regnery Co., 1973. 222 p., illus.

This unauthorized biography of Brando consists of little more than a study of the periodical literature and film references. It does offer a good summary chapter on Brando's contribution to film acting. Some visuals and a filmography are good additions to a pedestrian text.

O857. **Thomas, Tony.** THE FILMS OF MARLON BRANDO. Secaucus, N.J.: Citadel Press, 1973. 246 p., illus.

A picture book survey of Brando's films. A worshipful biographical essay introduces the film section, which offers both critical evaluation and plot description. Casts and production credits are also noted. Almost four hundred visuals are used; reproduction quality is below average in the biographical portion but acceptable elsewhere.

BRONSON, CHARLES

O857a. **Harbinson, W. A.** BRONSON! New York: Pinnacle Books, 1975. 166 p., illus.

An original paperback that purports to be a "speculative" biography. Based on published interviews, the text suffers from the author's invention of Bronson's thoughts, emotions, and reactions. A center section of illustrations and a filmography are more satisfying. This is the only biography of Bronson.

BROWN, JIM

O858. **Toback, James.** JIM: THE AUTHOR'S SELF-CENTERED MEMOIR ON THE GREAT JIM BROWN. Garden City, N.Y.: Doubleday, 1971. 133 p., illus. [*cont.*]

A biography that tells as much about the author as it reveals about the subject. Jim Brown's life as symbol of hedonism, athlete and actor is described in a most personal way. Brown's films receive little attention here.

BROWN, JOE E.

O859. **Brown, Joe E., and Hancock, Ralph.** LAUGHTER IS A WONDERFUL THING. New York: A. S. Barnes, 1956. 312 p., illus.

This memoir recalls many incidents in Brown's early life, but scant attention is given to his films. Although he made over forty-five films and was a leading player in nearly all, he speaks here of wartime USO tours, vaudeville, etc. The illustrations relate to family rather than career.

BURTON, RICHARD

O860. **Cottrell, John, and Cashin, Fergus.** RICHARD BURTON, VERY CLOSE UP. Englewood Cliffs, N.J.: Prentice-Hall, 1971. 385 p., illus.

A biography of an English actor who achieved his greatest success in American films. Comment on these films is sparing. Much of the narrative is devoted to his Welsh village childhood, the theater, and, finally, life with Elizabeth Taylor. The latter receives much attention in the final half of the book. The illustrations are few and are not representative of the text or of Burton's career.

CAGNEY, JAMES

O861. **Bergman, Andrew.** JAMES CAGNEY. New York: Pyramid Publications, 1973. 156 p., illus.

An appraisal of the career and films of James Cagney. Since the subject has stressed his privacy, the biographical elements are minimal and the book focuses on Cagney's career. Appraisal of the films is provided most satisfactorily in a critical, literate text. The visuals are numerous and sharply reproduced. Bibliography; filmography; index. Paperback.

O862. **Dickens, Homer.** THE FILMS OF JAMES CAGNEY. Secaucus, N.J.: Citadel Press, 1972. 249 p., illus.

The professional life of James Cagney is the subject of this picture book. A brief essay on the anti-hero introduces the Cagney filmography of shorts and sixty-two features. For each feature, there are stills, credits, a synopsis, review excerpts, and notes. Cagney's theater work in the twenties is reviewed at the book's close. Poor reproduction of many of the stills.

O863. **Offen, Ron.** CAGNEY. Chicago: Henry Regnery Co., 1972. 217 p., illus.

An unauthorized biography that has caused some reaction and reprisal from Cagney. Reconstructed from external sources, it covers Cagney's life and career thoroughly. His films are described in detail and with admirable objectivity. The pictures are average and the filmography is slight. At present, only this biography and two career surveys on Cagney are available.

CAPRA, FRANK

O864. **Capra, Frank.** FRANK CAPRA: THE NAME ABOVE THE TITLE. New York: Macmillan Co., 1971. 513 p., illus.

One of the best Hollywood autobiographies yet written, this volume emphasizes Hollywood filmmaking over several decades (1920–60). Director Frank Capra is opinionated, corny, and aggressive, but never dull. The photographs are excellent. The only missing element is a Capra filmography. Index.

O864a. **Glatzer, Richard, and Raeburn, John, eds.** FRANK CAPRA: THE MAN AND HIS FILMS. Ann Arbor: University of Michigan Press, 1974. 190 p., illus.

A collection of articles, reviews, essays, and interviews about Frank Capra and his films. Some interesting material has been arranged chronologically, beginning with the Langdon silents and closing with the films of the fifties. The attention accorded individual films is variable, and the supporting bibliography and filmography are quite minimal. There is no index.

O865. **Silke, James R., ed.** FRANK CAPRA: ONE MAN–ONE FILM. Washington, D.C.: American Film Institute, 1971. 27 p., illus.

An interview of Capra in 1971 in which he discusses his career and his films. Filmography; bibliography; and index. Paperback.

O865a. **Willis, Donald C.** THE FILMS OF FRANK CAPRA. Metuchen, N.J.: Scarecrow Press, 1974. 220 p., illus.

Critical analyses of Frank Capra's films are offered in this volume. Although the approach of the author is subjective, this is justified by a highly readable text. He arranges the films under appropriate headings and presents data, analyses, and opinion about each. Appendixes; index.

CARROLL, NANCY

O866. **Nemcek, Paul L.** THE FILMS OF NANCY CARROLL: A CHARMER'S ALMANAC. New York: Lyle Stuart, 1969. 223 p., illus.

A short biography is followed by a list of films that Nancy Carroll made in her rather short career. The data given for each are cast, credits, songs, synopsis, and critical quotations. Picture reproduction and selection are excellent.

CASSAVETES, JOHN

O867. **Henstell, Bruce, ed.** JOHN CASSAVETES, PETER FALK. Washington, D.C.: American Film Institute, 1972. 23 p.

This joint interview with Cassavetes and Falk was held in 1971. Both had worked together in *Husbands* (1971). A

bibliography and a filmography for Cassavetes is included, along with some shots taken during the interview. Paperback.

CHANEY, LON

O868. Anderson, Robert G. FACES, FORMS, FILMS: THE ARTISTRY OF LON CHANEY. New York: A. S. Barnes, 1971. 216 p., illus.

An appreciation of Lon Chaney that emphasizes his career. A short biographical sketch introduces the films and the roles that Chaney played in them. Many of the 156 good illustrations are used to show the variety of his disguises and make-ups. Detailed filmography; index.

CHAPLIN, CHARLES SPENCER

O868a. Asplund, Uno. CHAPLIN'S FILMS. New York: A. S. Barnes, 1975. 240 p., illus.

A detailed filmography translated from the Swedish. After three short sections on Chaplin's life, career, imitators, and trouble with the censor, the filmography is presented by studio association (Keystone, Mutual, etc.). Asplund retells plots, offers background material, and provides some critical analysis. Footage and running times of the films; bibliography; and index.

O869. Chaplin, Charlie. CHARLIE CHAPLIN'S OWN STORY. Indianapolis: Bobbs-Merrill Co., 1916. 257 p., illus.

The first autobiography—very early and somewhat premature. Perhaps Chaplin thought so since he requested that the publisher destroy all copies. A copy exists in the Library of Congress.

O870. Chaplin, Charles. MY AUTOBIOGRAPHY. New York: Simon & Schuster, 1964. 512 p., illus.

This unsatisfying autobiography is an ego exercise in which the author persists in self-glorification rather than in an appraisal of his life and career. There are many sections that indicate the richness of his experiences, but a larger number are devoted to name-dropping and status justification. Major incidents are minimized, ignored, or omitted. The early years provide stronger text material, and the more than one hundred illustrations are interesting and adequately reproduced. Index.

O871. Chaplin, Charles. MY TRIP ABROAD. New York: Harper & Bros., 1922. 155 p., illus.

Chaplin's trip to Europe in the early twenties is described. He gives evidence of wanting to replace "The Little Fellow" with ideas of consequence as a result of this experience.

O872. Chaplin, Charles, Jr.; with Rau, N.; and Rau, M. MY FATHER, CHARLIE CHAPLIN. New York: Popular Library, 1970. 287 p.

A respectful portrait of Chaplin written by his oldest son, this volume is personal, honest, and objective. This view of a legendary father by a neglected son offers revealing information not found elsewhere. Paperback.

O873. Chaplin, Lita Grey, with Cooper, Morton. MY LIFE WITH CHAPLIN. New York: Dell Publishing Co., 1966. 284 p.

A sensationalized account of the relationship between Chaplin at age 35 and the 15-year-old "author" that presents another view of the actor. The impressions of Hollywood in the silent era are fascinating, but much of the personal material is in questionable taste. Paperback.

O874. Cotes, Peter, and Niklaus, Thelma. THE LITTLE FELLOW: THE LIFE AND WORK OF CHARLES SPENCER CHAPLIN. New York: Citadel Press, 1965. 181 p., illus.

A sympathetic biographical essay and a stimulating critical analysis of Chaplin's screen art provide the two major sections of this book. Annotations of Chaplin's films, excerpts from his writing, and a long review of his autobiography strengthen the text. Good photographs; bibliography; index.

O875. Huff, Theodore. CHARLIE CHAPLIN. New York: Henry Schuman, 1951. 354 p., illus.

The definitive biography of Chaplin, written with affection, respect, and objectivity. Huff tends toward a straight recital of Chaplin's off-screen life and saves his analytical skills for evaluations of Chaplin's artistry. Synopses, casts, biographical sketches, and other data are given for all the films. Good visuals and a detailed index enhance this excellent book. REPRINT (New York: Arno Press, 1972).

O876. McCaffrey, Donald W., ed. FOCUS ON CHAPLIN. Englewood Cliffs, N.J.: Prentice-Hall, 1971. 174 p., illus.

An examination and evaluation of Chaplin's work. Divided into four categories—career, working method, essays, and reviews—the book also includes script excerpts, a bibliography, a filmography, and an index. The familiar illustrations are poorly reproduced. Noteworthy are five articles by Chaplin and the original reviews of his films. Paperback.

O877. McDonald, Gerald D.; Conway, Michael; and Ricci, Mark. THE FILMS OF CHARLIE CHAPLIN. New York: Bonanza Books, 1965. 224 p., illus.

Eighty films of Chaplin are listed chronologically (1914–1957) in this attractive picture book, with stills, casts, plots, and review excerpts given for each. Only *The Countess from Hong Kong* (1967) is missing. An introductory essay covers biography and technique. The over three hundred photographs have been well selected and include some that are rarely seen. Index.

O877a. Manvell, Roger. CHAPLIN. Boston and Toronto: Little, Brown & Co., 1974. 254 p., illus.

A familiar story has been brought up to date in this biography. Emphasis is placed on Chaplin's early accomplishments, with his later feature films receiving brief consideration. A few illustrations are grouped in a center section, and there is a most impressive annotated bibliography. Manvell continues to write with the style and confidence that give a familiar story surprising freshness. Index.

O877b. **Moss, Robert F.** CHARLIE CHAPLIN. New York: Pyramid Publications, 1975. 158 p., illus.

A most creditable study of Chaplin the film artist is presented here. Critical assessments, some good visuals, a bibliography, a filmography, and an index are combined in an impressive evaluation. The author suggests that Chaplin has often been adoringly praised and blindly overrated.

O878. **Payne, Robert.** THE GREAT CHARLIE. London: André Deutsch, 1952. 287 p., illus.

This detailed analysis of Chaplin's screen character notes predecessors and contemporaries who may have influenced his style. Excellent stills and a sound critical text. EARLIER EDITIONS entitled *Charlie Chaplin* and *The Great God Pan.*

O879. **Quigly, Isabel.** CHARLIE CHAPLIN: EARLY COMEDIES. New York: E. P. Dutton & Co., 1968. 159 p., illus.

An entertaining and informative combination of text and pictures describes the early short films Chaplin made for Keystone, Essanay, Mutual, and First National. The text is both descriptive and critical; picture reproduction is good. Paperback.

O880. **Tyler, Parker.** CHAPLIN: LAST OF THE CLOWNS. New York: Vanguard Press, 1947. 200 p., illus.

A typical Parker Tyler essay that is part biography, part analysis, and part conjecture. Themes, symbols, and meanings found in Chaplin's films are related to his early life. A different and challenging view of Chaplin.

CHEVALIER, MAURICE

O881. **Chevalier, Maurice.** THE MAN IN THE STRAW HAT: MY STORY. New York: Thomas Y. Crowell Co., 1949. 245 p., illus.

A disappointing biography that covers Chevalier's life up to World War II. His career in American films is discussed.

COHN, HARRY

O882. **Thomas, Bob.** KING COHN: THE LIFE AND TIMES OF HARRY COHN. New York: G. P. Putnam's Sons, 1967. 344 p., illus.

The head of Columbia pictures was one of Hollywood's strongest and most colorful personalities. Cohn's attitudes, methods, and actions were often outrageous; but he ran a studio that produced many classic films. In this very popular biography, the many sides of this complex mogul are skillfully revealed. Good illustrations and an index add to an entertaining text.

COOPER, GARY

O883. **Carpozi, George, Jr.** THE GARY COOPER STORY. New York: Arlington House, 1970. 263 p., illus.

A bland biography that is mostly factual, this volume is enhanced by almost sixty photographs and a detailed filmography of ninety-five films. Index.

O884. **Dickens, Homer.** THE FILMS OF GARY COOPER. New York: Citadel Press, 1970. 280 p., illus.

Over four hundred photographs help record the film career of Gary Cooper in this attractive volume. In addition to cast, credits, synopsis, and critical notes for each of Cooper's 92 films, a short biography is given. Many of the visuals are informal, candid shots.

O884a. **Jordan, René.** GARY COOPER. New York: Pyramid Publications, 1974. 160 p., illus.

A biography and critical evaluations of eighty-five film performances of Gary Cooper. Good illustrations, a filmography, and a bibliography accompany this appreciation of a screen personality whose art was often misunderstood or underrated. Index.

COOPER, MIRIAM

O885. **Cooper, Miriam, and Herdon, Bonnie.** DARK LADY OF THE SILENTS. New York: Bobbs-Merrill Co., 1973. 256 p., illus.

A mild autobiography of a Griffith actress who married director Raoul Walsh. This reminiscence of silent filmmaking contains mostly familiar material; however, the filmography indicates a busy career, which should have inspired a more exciting and detailed volume. Three sections of photographs are of some interest in this very general depiction of the silent film era. Index.

CORMAN, ROGER

O886. **Will, David, and Willemen, Paul.** ROGER CORMAN: THE MILLENIC VISION. Edinburgh: Edinburgh Film Festival, 1970. 102 p., illus.

A collection of essays about Corman that was published for a film festival, this volume was the first to recognize his directorial skill. Content, themes, and style are treated in the text, and there are many excellent photographs. Filmography; biographical sketch. Paperback.

COSTELLO, LOU
See O813–O813a

CRAWFORD, JOAN

O886a. **Carr, Larry.** FOUR FABULOUS FACES: GARBO, SWANSON, CRAWFORD, DIETRICH. New Rochelle, N.Y.: Arlington House, 1970.
[*See* O739.]

O887. **Crawford, Joan, with Ardmore, Jane Kesner.** A PORTRAIT OF JOAN: THE AUTOBIOGRAPHY OF JOAN CRAWFORD. Garden City, N.Y.: Doubleday, 1962. 239 p., illus.

A selected account of the life and career of a legendary film star. In this autobiography Crawford carefully recreates the image built up in Hollywood for more than four decades. Some exceptional illustrations and a filmography accompany the fan magazine text.

O887a. **Harvey, Stephen.** JOAN CRAWFORD. New York: Pyramid Publications, 1974. 159 p., illus.

A tribute to Joan Crawford that examines her eighty-one films in both descriptive and critical fashion. Extended attention is given to her twenty-two silent films; an attempt is made to define her durable "star" quality. Many pleasing illustrations, a filmography, a bibliography, and an index add to a rewarding study.

O888. **Quirk, Lawrence J.** THE FILMS OF JOAN CRAWFORD. New York: Citadel Press, 1968. 222 p., illus.

A short biographical essay introduces the film career of Joan Crawford. Her more than eighty films from *Pretty Ladies* (1925) to *Berserk* (1968) are arranged chronologically with stills, cast, credits, a lengthy plot outline, and review excerpts for each. Some off-camera photographs are used in addition to many studio stills and portraits. *Throg*, made in 1969, is omitted.

CROSBY, BING

O889. **Crosby, Bing, and Martin, Pete.** CALL ME LUCKY: BING CROSBY'S OWN STORY. New York: Simon & Schuster, 1953. 228 p.

An older biography designed to reinforce a popular image. The few sections on films are well written, but they stand in isolation amidst long accounts of golf and baseball. Paperback.

CUKOR, GEORGE

O890. **Carey, Gary.** CUKOR AND CO.: THE FILMS OF GEORGE CUKOR AND HIS COLLABORATORS. New York: Museum of Modern Art, 1970. 167 p., illus.

Director Cukor's reliance on plays and books as film material, as well as his taste in actors and settings, is noted in this assessment of his career. An extended filmography is presented, with cast and production details, synopses, and critical analyses. Some of the author's comments are debatable, but the subject matter is rich with personalities, incidents, and films. Paperback.

O891. **Lambert, Gavin.** ON CUKOR. New York: G. P. Putnam's Sons, 1972. 276 p., illus.

A portrait of a major director and his work. In a series of interviews, Lambert used thirty-three of Cukor's films for conversation and questioning. The author's queries indicate knowledge and preparation; Cukor's replies, sophistication, intelligence, wit, and professional knowledge. Cukor's remarks about the actors with whom he has worked are indicative of his sensitivity. The illustrations are excellent, and a solid Cukor filmography is appended. Index.

DANDRIDGE, DOROTHY

O892. **Dandridge, Dorothy, and Conrad, Earl.** EVERYTHING AND NOTHING: THE DOROTHY DANDRIDGE TRAGEDY. New York: Abelard-Schuman, 1970. 215 p., illus.

An appealing but somewhat sensational autobiography of the first black actress to win an Academy Award nomination for best actress in *Carmen Jones* (1954).

O893. **Mills, Earl.** DOROTHY DANDRIDGE: A PORTRAIT IN BLACK. Los Angeles: Holloway House Publishing Co., 1970. 250 p., illus.

A rewarding biography of a black film star written by a friend and business associate. The narrative is frank and often shocking as it tells of the many compromises the star made to achieve success. The visuals are a strong asset. Paperback.

DAVIES, MARION

O894. **Guiles, Fred Lawrence.** MARION DAVIES. New York: McGraw-Hill Book Co., 1972. 419 p., illus.

A fine biography based on interviews, letters, and other documents. Miss Davies's life is traced from childhood in Brooklyn to the post-Hearst years in California. Many pages of photographs accompany the colorful text. Filmography; bibliography; index.

DAVIS, BETTE

O895. **Davis, Bette.** THE LONELY LIFE: AN AUTOBIOGRAPHY. New York: G. P. Putnam's Sons, 1962. 254 p., illus.

One of the best Hollywood autobiographies, this volume concentrates on the public and private life of an ambitious professional. Observations, philosophy, and anecdotal recall characterize the text. The illustrations are adequately chosen but poorly reproduced.

O896. **Noble, Peter.** BETTE DAVIS: A BIOGRAPHY. London: Skelton Robinson, 1948. 231 p., illus.

An early biography that concentrates on Davis's golden era of films, 1930–1947. The star's participation is limited to an unenthusiastic foreword; the worshipful text had to rely completely upon public information. Contains a partial filmography.

O897. **Ringgold, Gene.** THE FILMS OF BETTE DAVIS. New York: Bonanza Books, 1965. 191 p., illus.

Bette Davis has starred in more than eighty films and is still active. This record covers from *Seed* (1930) to *The Nanny* (1965). A biographical sketch introduces the chronological listing, which contains stills, casts, credits, synopses, and some critical comments. Picture quality and selection are adequate.

O897a. **Stine, Whitney.** MOTHER GODDAM: THE STORY

OF THE CAREER OF BETTE DAVIS. New York: Hawthorn Books, 1974. 382 p., illus.

A gushy, adoring biography of Bette Davis, redeemed somewhat by the actress's running commentary (written in red ink), some good photographs, a filmography, and an index.

O898. **Vermilye, Jerry.** BETTE DAVIS. New York: Pyramid Publications, 1973. 159 p., illus.

The life and career of Bette Davis are related by text and pictures in this attractive book. Her films are divided into biographical categories—the battle with Warners, the fright films, etc. Good illustrations; filmography; bibliography; index. Paperback.

DAY, DORIS

O898a. **Thomey, Tedd.** DORIS DAY. Derby, Conn.: Monarch Books, 1962. 139 p., illus.

This original paperback amounts to nothing more than a fan magazine text. [For a more recent autobiographical work see the following: *Doris Day: Her Own Story,* by A. E. Hotchner (New York: William Morrow, 1976), 313 p., illus.; filmography; index.]

DEAN, JAMES

O899. **Bast, William.** JAMES DEAN: A BIOGRAPHY. New York: Ballantine Books, 1956. 149 p.

A posthumous biography written by an intimate friend. Dean made only three major films in 1955–1956 but nevertheless has become a legendary film star. This paperback tribute provides an interesting but rather biased portrait.

O899a. **Dalton, David.** JAMES DEAN: THE MUTANT KING. San Francisco: Straight Arrow Press, 1974. 368 p., illus.

This biography of James Dean is most comprehensive and detailed. It offers a well-researched study of an elusive subject and a subsequent evaluation that differentiates between the person, the performer, and the cult hero. Well-chosen visuals, a long bibliography, and an index support this solid biography.

O899b. **Herndon, Venable.** JAMES DEAN: A SHORT LIFE. Garden City, N.Y.: Doubleday, 1974. 304 p., illus.

A well-balanced portrait of a complex actor is offered in this better-than-average biography. Based on research, interviews, and previous biographies of Dean, the text is narrative rather than critical. Astrological reading; index.

DE ACOSTA, MERCEDES

O900. **De Acosta, Mercedes.** HERE LIES THE HEART. New York: Reynal, 1960. 372 p., illus.

A portrait of Hollywood is presented in this autobiogra-

phy of a scriptwriter who was a friend of many Hollowood personalities.

DE MILLE, CECIL B.

O901. **De Mille, Cecil B., and Hayne, Donald.** THE AUTOBIOGRAPHY OF CECIL B. DE MILLE. Englewood Cliffs, N.J.: Prentice-Hall, 1959. 465 p., illus.

In this careful, unrevealing autobiography De Mille tells more about his films than about himself. He refutes certain stories and legends but clings to a noncontroversial recitation of recorded facts. The sections on his films are the strongest. Filmography; index.

O902. **Essoe, Gabe, and Lee, Raymond.** DE MILLE: THE MAN AND HIS PICTURES. New York: A. S. Barnes, 1970. 319 p., illus.

The poorly selected text and many badly reproduced photographs are a disservice to the memory of this productive personality.

O903. **Higham, Charles.** CECIL B. DE MILLE. New York: Charles Scribner's Sons, 1973. 335 p., illus.

A biography which places its emphasis on the silent film era. Written with the cooperation of De Mille's daughter, the book uses original material and photographs to present the famous director. This commendable effort produces almost the same final portrait presented in earlier biographies of De Mille. A filmography and rarely seen illustrations are helpful. Index.

O904. **Koury, Phil.** YES, MR. DE MILLE. New York: G. P. Outnam's Sons, 1959. 319 p.

A critical portrait of the famous director, created by arranging anecdotes, observations, and legends in a chronological fashion. Koury was a De Mille assistant for several years, and part of the book is based on this background.

O905. **Ringgold, Gene, and Bodeen, De Witt.** THE FILMS OF CECIL B. DE MILLE. New York: Citadel Press, 1969. 377 p., illus.

This excellent picture book shows the films of Cecil B. De Mille in a distinctive way. Picture selection and reproduction are outstanding; the text is succinct, accurate and informative; and an account of De Mille's association with the Lux Radio Theatre is presented in detail. Each film is accompanied by stills, cast, and production credits, a synopsis, and extracts from critical reviews.

DE MILLE, WILLIAM C.

O906. **De Mille, William C.** HOLLYWOOD SAGA. New York: E. P. Dutton & Co., 1939. 319 p., illus.

William C. De Mille came to Hollywood in 1914 and stayed for twenty years as director and writer. His account of the silent era includes some description of his brother Cecil's directorial techniques. The illustrations are impressive.

DIETRICH, MARLENE

O906a. **Carr, Larry.** FOUR FABULOUS FACES: GARBO, SWANSON, CRAWFORD, DIETRICH. New Rochelle, N.Y.: Arlington House, 1970

[See O736.]

O907. **Dickens, Homer.** THE FILMS OF MARLENE DIETRICH. New York: Citadel Press, 1968. 223 p., illus.

More than fifty films in which Dietrich appeared are arranged chronologically in this admirable tribute. Seventeen films were made in Germany before *The Blue Angel* (1930), followed by a productive career that extended into the seventies. In addition to films, the book contains photographs of her nightclub and stage appearances, along with informal shots of her Berlin cabaret days and her work with GIs in World War II. Besides giving the cast, credits, a synopsis, and critical comments for each film, the stills allow the reader to follow visually the evolution of a cabaret girl into a legend.

O908. **Frewin, Leslie.** DIETRICH: THE STORY OF A STAR. New York: Stein & Day Publishers, 1967. 192 p., illus.

Other than a very good selection of illustrations and a filmography covering 1923 to 1962, this volume has little else to offer. Published in England as *Blonde Venus, a Life of Marlene Dietrich.*

O909. **Griffith, Richard.** MARLENE DIETRICH: IMAGE AND LEGEND. New York: Museum of Modern Art Film Library, 1959. 32 p., illus.

Produced for a Museum of Modern Art retrospective program, this short volume discusses Dietrich's career up to *Touch of Evil* (1958). Visuals include both studio stills and candid shots. A filmography is given in three sections: extra, featured player, star. Paperback.

O910. **Kobal, John.** MARLENE DIETRICH. New York: E. P. Dutton & Co., 1968. 160 p., illus.

The technical quality of the illustrations in this biography is exemplary. Combined with a well-written text, the visuals present Dietrich's life and career with beauty, intelligence, and style. Filmography; discography; short bibliography.

O910a. **Silver, Charles.** MARLENE DIETRICH. New York: Pyramid Publications, 1974. 160 p., illus.

The author devotes chapters to Dietrich's portrayals of salon ladies, saloon girls, and others in this pleasing volume. The care shown in photographing an ageless Dietrich throughout the years is evident in the many attractive visuals found here. Bibliography; filmography; index.

DISNEY, WALT

O911. **Field, Robert D.** THE ART OF WALT DISNEY. New York: Macmillan Co., 1942. 290 p., illus.

A study of the Disney Studios during the early forties, this beautifully produced book considers their history, operation, and product. Many color plates and other visuals support the comprehensive text.

O911a. **Finch, Christopher.** THE ART OF WALT DISNEY: FROM MICKEY MOUSE TO THE MAGIC KINGDOMS. New York: New American Library, 1975. 457 p., illus.

An expensive art book that is important for its many visuals, all beautifully reproduced. About half of the 763 varied illustrations are in full color; most are substantial in size. A bland text covers animation technique, Disney's career, his studios, and the Disney films, along with other related topics.

O912. **Maltin, Leonard.** THE DISNEY FILMS. New York: Crown Publishers, 1973. 312 p., illus.

A survey of the feature films produced by Walt Disney. From *Snow White and the Seven Dwarfs* (1937) to *The Happiest Millionaire* (1963), each film is described by visuals, a synopsis, evaluation of the author, and critical and popular response. In addition, Maltin describes the social climate of the country when each film appeared. Final chapters discuss the feature films made by the studio after Disney's retirement, the short films, and the television programs. Many illustrations were provided by the Disney Studios, although color is missing, these visuals are adequate in most cases. Index.

O913. **Miller, Diane Disney, and Martin, Pete.** THE STORY OF WALT DISNEY. New York: H. Holt, 1956. 247 p., illus.

This biography of Disney, written by his daughter, covers his life and career in a subjective, predictable way. This unexciting volume provides a useful contrast to other biographies. The illustrations are negligible.

O914. **Schickel, Richard.** THE DISNEY VERSION. New York: Simon & Schuster, 1968. 384 p.

A debunking of the myth and image presented in other volumes, this book is subtitled "the life, times, art, and commerce of Walt Disney." Written without the cooperation of subject or studio, Schickel's account contains no illustrative material and is not very complimentary. A good bibliography is offered as part of this fascinating cultural study of Walt Disney Productions.

O915. **Thomas, Bob.** WALT DISNEY: THE ART OF ANIMATION. New York: Simon & Shuster, 1958. 185 p., illus.

This beautifully produced book contains many visual examples taken from the Disney films. Its clearly written text emphasizes the elements of animation filmmaking. Final section include a glossary, credits, and a listing of Academy Awards given to Disney films. The appeal of this excellent volume will extend from children to adults.

DOUGLAS, KIRK

O916. **Thomas, Tony.** THE FILMS OF KIRK DOUGLAS. Secaucus, N.J.: Citadel Press, 1972. 256 p., illus.

A pictorial record of the film career of Kirk Douglas. Some fifty-four films are described by visuals, casts, credits, and author comments. A brief biographical essay introduces the filmography. The more than four hundred, including candids and stills, are adequately reproduced.

DRESSLER, MARIE

O917. **Dressler, Marie.** THE LIFE STORY OF AN UGLY DUCKLING. New York: Robert McBride, 1924. 234 p., illus.

An early autobiography which tells about making silent films at the Keystone studios, among other things. The illustrations are unusual and fascinating.

O918. **Dressler, Marie, and Harrington, Mildred.** MY OWN STORY. Boston: Little, Brown & Co., 1934. 290 p., illus.

An autobiography written by a film actress in her autumn years should say more about her work than this one does. Some mention is made of her motion picture career, but the major portion of the text is devoted to philosophy, advice, and tributes to friends. Negligibly illustrated.

DURANTE, JIMMY

O919. **Fowler, Gene.** SCHNOZZOLA. New York: Perma Books, 1953. 287 p., illus.

Since the last two decades are missing, this is a partial biography of Durante. Written with style and affection, the text pays little attention to Durante's film career. Paperback.

DWAN, ALLAN

O920. **Bogdanovich, Peter.** ALLAN DWAN: THE LAST PIONEER. New York: Praeger Publishers, 1971. 200 p., illus.

Using some four hundred films as a basis for several interviews, the author spotlights a rather unknown director. Although Dwan's career in Hollywood spanned several decades (1911–1961), many of his films are now lost. A long filmography and many interesting stills pay tribute to a neglected artist in this excellent volume.

EASTWOOD, CLINT

O920a. **Kaminsky, Stuart M.** CLINT EASTWOOD. New York, Signet Book, 1974. 174 p., illus.

A most unauthorized biography that gives primary attention to Clint Eastwood's films. The text includes quotations, a filmography, and an interview. Kaminsky provides a brisk review of Eastwood's career to date.

EISENSTEIN, SERGEI M.

O921. **Montagu, Ivor.** WITH EISENSTEIN IN HOLLYWOOD: A CHAPTER OF AUTOBIOGRAPHY. Berlin: Seven Seas Publishers, 1968. 356 p., illus.

An account of Eisenstein's visit to Hollywood in the early thirties. His collaboration in the writing of two unfilmed scripts, *Sutter's Gold* and *An American Tragedy*, is described. The completed scripts appear in the closing section of the book. The few photographs and drawings are of limited appeal. Bibliography; index. Paperback.

FAIRBANKS, DOUGLAS, SR.

O922. **Cooke, Alistair.** DOUGLAS FAIRBANKS: THE MAKING OF A SCREEN CHARACTER. New York: Museum of Modern Art, 1940. 36 p., illus.

An early Museum of Modern Art monograph, this attractive volume considers the creation of a screen image by the Hollywood studio. Fairbanks is examined as an example of this developmental process. Personality, films, and events are cited; but the book is too short to offer anything but surface coverage. Some good visuals, a filmography and an index help somewhat.

O923. **Hancock, Ralph, and Fairbanks, Letitia.** DOUGLAS FAIRBANKS: THE FOURTH MUSKETEER. New York: H. Holt, 1953. 278 p., illus.

The first portion of this biography mentions Fairbanks's stage appearances. In 1915 he entered films and became a screen legend. The latter portion of the book describes his films, personal relationships, and his sad death in 1939. This sympathetic but objective portrait is accompanied by a few illustrations.

O923a. **Schickel, Richard.** HIS PICTURE IN THE PAPERS: A SPECULATION ON CELEBRITY IN AMERICA, BASED ON THE LIFE OF DOUGLAS FAIRBANKS, SR. New York: Charterhouse Books, 1974. 173 p., illus.

Selecting Douglas Fairbanks, Sr., as his model, Richard Schickel examines American film stardom in the twenties. Exploiting previously published volumes for information, the author supplies interpretation, conjecture, and imagination to the subject of celebrity. A center section of photographs and an index support the provocative text.

FAIRBANKS, DOUGLAS, JR.

O924. **Connell, Brian.** KNIGHT ERRANT. Garden City, N.Y.: Doubleday, 1955. 255 p., illus.

A biography of Douglas Fairbanks, Jr., an adequate film actor who was intimately associated with people who achieved much greater fame: his father, his first wife (Joan Crawford), his stepmother (Mary Pickford). The problem of having famous parents is emphasized in the early portions of this likeable and modest book. The illustrations are rather bland.

FALK, PETER

O924a. **Henstell, Bruce, ed.** JOHN CASSAVETES, PETER FALK. Washington, D.C.: American Film Institute, 1972. 23 p.

[See O867.]

FARMER, FRANCES

O925. Farmer, Frances. WILL THERE REALLY BE A MORNING? New York: G. P. Putnam's Sons, 1972. 318 p., illus.

An outstanding autobiography by a film actress who was unable to cope with personal and professional pressures. For many years, Frances Farmer was an alcoholic and a mental patient. This frank, shocking account of her life tells of early Hollywood success, deterioration, and eventual recovery with a modified peace of mind. There are very few illustrations provided for this powerful story.

FAYE, ALICE

O925a. Moshier, W. Franklyn. THE ALICE FAYE MOVIE BOOK. Harrisburg, Pa.: Stackpole Books, 1974. 206 p., illus.

Research, documentation, and illustration are all outstanding in this appreciation. An opening biographical section introduces the three phases of her film career: the Harlow star, star light–star bright, and superstar. An epilogue, a discography, and a portrait gallery conclude this attractive book.

O926. Moshier, W. Franklyn. THE FILMS OF ALICE FAYE. San Francisco: Privately printed, 1971. 182 p., illus.

This pictorial record of the film career of Alice Faye contains a biographical chapter, followed by the Faye filmography. Cast, credits, stills, and notes are given for each film. In this well-produced volume, the more than three hundred visuals are uniformly pleasing. Paperback REPRINT (Stackpole Books, 1974).

FIELDS, W. C.

O927. Anobile, Richard J., ed. A FLASK OF FIELDS. New York: Darien House, 1972. 272 p., illus.

Recreations of famous sequences from ten films by Fields. Using visuals and original dialogue from his Paramount and Universal films, the book recaptures only partially the special quality of Fields's humor.

O928. Deschner, Donald. THE FILMS OF W. C. FIELDS. New York: Citadel Press, 1966. 192 p., illus.

Beginning with a one reel short in 1915, W. C. Fields appeared in ten silent feature films, five sound shorts, and twenty-four sound features. Each of the films is presented, with stills, cast, credits, a synopsis, and review excerpts. Two original articles by Fields and several other essays supplement the many fine visuals. Index.

O929. Everson, William K. THE ART OF W. C. FIELDS. Indianapolis: Bobbs-Merrill Co., 1967. 232 p., illus.

Everson, the noted film historian, provides a biography and a detailed analysis of all of Fields's films. Supporting this penetrating portrait of both person and performer are 128 unusual photographs: stills, candids, location shots, etc. A definitive assessment of Fields.

O930. Fields, W. C., and Fields, Ronald J. W. C. FIELDS, BY HIMSELF. Englewood Cliffs, N.J.: Prentice-Hall, 1973. 510 p., illus.

A collection of letters, notes, scripts, and articles written by Fields in his early years. The twenties and thirties are almost ignored, and the editorial contributions by Fields's grandson are suspiciously self-serving. Fields's self-portraits are fascinating, but the other illustrations and drawings vary in quality and appeal. Index.

O931. Monti, Carlotta. W. C. FIELDS AND ME. Englewood Cliffs, N.J.: Prentice-Hall, 1971. 221 p., illus.

An intimate portrait of Fields is provided by his mistress. For fourteen years she was the recipient of his affection and his sarcasm. Her memoir is revealing, funny, and yet sad.

O932. Taylor, Robert Lewis. W. C. FIELDS: HIS FOLLIES AND HIS FORTUNES. Garden City, N.Y.: Doubleday, 1949. 340 p., illus.

Both the life and the personality of Fields are treated here. Written before Fields became a cult figure, the biography contains anecdotes, analyses, and description. The illustrations are unimpressive, but the text is pleasant and respectful.

FITZGERALD, F. SCOTT

O933. Latham, Aaron. CRAZY SUNDAYS: F. SCOTT FITZGERALD IN HOLLYWOOD. New York: Viking Press, 1971. 308 p., illus.

F. Scott Fitzgerald and his struggle with major studio (MGM) routine is the subject of his partial biography. The filmscript material, interviews, photographs, and diagrams all help to describe in general terms the profession of screenwriter in the thirties and specifically Hollywood's treatment of Fitzgerald. The author writes with a biased pen about five major films on which Fitzgerald worked.

FLAHERTY, ROBERT J.

O934. Calder-Marshall, Arthur. THE INNOCENT EYE: THE LIFE OF ROBERT J. FLAHERTY. New York: Harcourt, Brace & World, 1963. 304 p., illus.

In addition to outstanding biographical material, this volume devotes much attention to the films of Robert Flaherty. Well-reproduced photographs, an index, a filmography, and a bibliography round out an excellent account of the documentary filmmaker.

O935. Flaherty, Frances Hubbard. THE ODYSSEY OF A FILM-MAKER: ROBERT FLAHERTY'S STORY. Urbana, Ill.: Beta Phi Mu, 1960. 45 p., illus.

Concentrating on four of his most famous documentary films, the wife of Robert Flaherty pays tribute to the professional rather than the person. This short description of his methods and techniques is enriched by eighteen attractive stills. Chronology of Flaherty's life. REPRINT (New York: Arno Press, 1972).

O936. **Griffith, Richard.** THE WORLD OF ROBERT FLAHERTY. Boston: Little, Brown & Co., 1953. 165 p., illus.

American director Robert Flaherty's world consists of those countries in which he made his classic documentaries. Individual chapters are devoted to the Pacific, Hudson Bay, India, Ireland, and the United States. Excerpts from letters, diaries, and journals describe filmmaking at these locations. The illustrations are excellent.

FLYNN, ERROL

O937. **Flynn, Errol.** MY WICKED, WICKED WAYS. New York: Dell Publishing Co., 1959. 512 p.

This autobiography seems to be a valid reflection of its author during his early years in Hollywood. He is candid, colorful, and stylish about himself and others who crossed his life. The final years of his life (1955–1959), which were sad and even tragic, are mentioned only briefly. Paperback.

O938. **Haymes, Nora Eddington Flynn.** ERROL AND ME. New York: Signet Books, 1960. 176 p., illus.

A chronicle of a seven-year marriage to a hedonistic actor, addicted to drugs and alcohol. The deterioration of Errol Flynn is described in a popularized version, which nevertheless gives an unvarnished portrait. Paperback.

O939. **Thomas, Tony; Behlmer, Rudy; and McCarty, Clifford.** THE FILMS OF ERROL FLYNN. New York: Citadel Press, 1969. 224 p., illus.

Greer Garson introduces this survey of Errol Flynn's film career. All fifty-eight films in which he appeared are listed, with stills, cast, credits, synopses, and background notes. Biographical material appears throughout the book rather than as an introductory essay.

THE FONDAS

O940. **Brough, James.** THE FABULOUS FONDAS. New York: David McKay Co., 1973. 296 p., illus.

An unauthorized collective biography of Henry, Jane, and Peter Fonda. Stressing the private life of the Fondas, the author emphasizes marriages, suicides, divorces, and other newsworthy events. The films are mentioned in passing. Index.

O941. **Springer, John.** THE FONDAS: THE FILMS AND THE CAREERS OF HENRY, JANE, AND PETER FONDA. New York: Citadel Press, 1970. 279 p., illus.

The films of the three Fondas are considered in chronological order after a long introductory section. Each film is described with stills, cast, credits, and critical excerpts. The introduction contains mostly tributes and factual information; comment on the personal lives of the subjects is absent. The more than four hundred photographs are well selected and reproduced.

FONDA, JANE

O942. **Kiernan, Thomas.** JANE: AN INTIMATE BIOGRAPHY. New York: G. P. Putnam's Sons, 1973. 358 p.

A strong, objective *unauthorized* biography of Jane Fonda. This controversial, complex woman is described sequentially as child, student, actress, hedonist, radical, and activist. Henry and Peter Fonda are prominent in this story, and the author seems fascinated by Roger Vadim. Public knowledge, privileged information, and conjecture have provided Kiernan with enough material for a revealing portrait of a fine actress and a most unusual woman.

FORD, JOHN

O943. **Baxter, John.** THE CINEMA OF JOHN FORD. New York: A. S. Barnes, 1971. 176 p., illus.

An appreciation and examination of the work of John Ford from *Cameo Kirby* (1923) to *Donovan's Reef* (1963). Many of Ford's films are described and analyzed. A major thesis is that Ford's work is far more complex than it appears on first viewing. Over sixty poorly contrasted stills; filmography; and a short bibliography. Paperback.

O944. **Bogdanovich, Peter.** JOHN FORD. Berkeley: University of California Press, 1968. 144 p., illus.

In addition to an analysis of his films, this volume contains an extended interview with Ford, a filmography, a bibliography, and many fine illustrations. The author's admiration for the films and the man are reflected throughout this appropriate tribute.

O945. **Burrows, Michael.** JOHN FORD AND ANDREW V. MCLAGLEN. Saint Austell with Fowey, England: Primestyle, 1970. 32 p., illus.

A brief reviews of the careers of two American directors. Bits of interviews, narrative, critical quotes, and interpretation are combined in this study of Ford and his disciple. Picture reproduction is only passable. Brief filmographies; bibliography.

O945a. **McBride, Joseph, and Wilmington, Michael.** JOHN FORD. New York: DaCapo Press, 1975. 234 p., illus.

After two short introductory chapters and an interview, this volume concentrates on Ford films that are examples of his major themes: *The West, Men at War, Ireland Rebels,* and *Truth vs. Myth.* A filmography and a bibliography conclude this impressive analysis of Ford and his films.

FOX, WILLIAM

O946. **Allvine, Glendon.** THE GREATEST FOX OF THEM ALL. New York: Lyle Stuart, 1969. 244 p., illus.

A biography of the film mogul William Fox that pays some attention to the studio. Uneven content and style

weaken this story of a Hollywood legend who died in 1952 after several years in prison.

O947. **Sinclair, Upton.** UPTON SINCLAIR PRESENTS WILLIAM FOX. New York: Arno Press, 1970. 371 p.

First published under Fox's sponsorship, this reprinted biography of the founder of the Fox Studios is partial and biased. Many statistics accompany the hard sell narrative that seems designed as a therapy for Fox as he expressed his hostilities against bankers, lawyers, etc. It was written shortly after Fox began his fall from power. ORIGINAL EDITION (1933).

FRANKENHEIMER, JOHN

O948. **Pratley, Gerald.** THE CINEMA OF JOHN FRANKENHEIMER. New York: A. S. Barnes, 1969. 240 p., illus.

A synopsis of each of the films is followed, first by the author's discussion and then by director Frankenheimer's comments. By interweaving biography, philosophy, and criticism, a good portrait of a professional results. Frankenheimer is more objective about his films than the author. Stills, candids, and script excerpts complete the work. Paperback.

FULLER, SAMUEL

O949. **Garnham, Nicholas.** SAMUEL FULLER. New York: Viking Press, 1972. 176 p., illus.

An examination of the films of Samuel Fuller. The text considers influences, settings, and themes recurring in the films rather than treating each film in isolation. A detailed filmography is most useful in recalling the films. Picture quality is fair.

O950. **Hardy, Phil.** SAMUEL FULLER. New York: Praeger Publishers, 1970. 144 p., illus.

Fuller is known as a director of low-budget action films. Here his films are classified under thematic headings, described, and analyzed. Contains some good illustrations and a filmography of both his film and television work. Paperback.

GABLE, CLARK

O951. **Carpozi, George J.** CLARK GABLE. New York: Pyramid Books, 1961. 160 p., illus.

This paperback biography, a chronological recital of events in Gable's life, provides an acceptable survey of his film work. The illustrations are good.

O952. **Essoe, Gabe.** THE FILMS OF CLARK GABLE. New York: Citadel Press. 1970. 255 p., illus.

A long biographical essay introduces Gable's sixty-seven films, each meticulously documented by stills, cast, credits, plot outline, and critical comments. Appreciations, tributes, and reminiscences add to the biographical section. The more than four hundred visuals are outstanding in selection and reproduction.

O953. **Essoe, Gabe, and Lee, Ray.** GABLE: A COMPLETE GALLERY OF HIS SCREEN PORTRAITS. Los Angeles: Price, Stern, Sloan, 1967. 144 p., illus.

An early picture book review of Gable's films, this volume contains many rare, well-reproduced stills. Each film is described by illustrations, cast, credits, a synopsis, and some extracts from reviews. Paperback.

O954. **Gable, Kathleen.** CLARK GABLE: A PERSONAL PORTRAIT. Englewood Cliffs, N.J.: Prentice-Hall, 1961. 153 p., illus.

An account of a marriage more than a total biography, this book includes photographs from the author's personal collection.

O955. **Garceau, Jean, with Cocke, Inez.** DEAR MR. G.: THE BIOGRAPHY OF CLARK GABLE. Boston: Little, Brown & Co., 1961. 297 p., illus.

A disappointing biography of Gable by the woman who was his secretary for more than twenty years. Lacking depth and emphasis, the text offers only a recital of well-known facts and stories. Attention is given to Carole Lombard, but even she gets the flattering treatment accorded Gable. A few illustrations offer little relief from the adoring text.

O955a. **Harris, Warren G.** GABLE & LOMBARD. New York: Simon & Schuster, 1974. 205 p., illus.

The concentration in this volume is on the period of the Gable-Lombard romance and marriage. Other aspects of their lives are covered briefly. The author is objective, calling attention to their faults and virtues in a fresh, breezy narrative. A few illustrations and an index accompany this entertaining dual biography.

O956. **Jordan, René.** CLARK GABLE. New York: Pyramid Publications, 1973. 159 p., illus.

An objective study in paperback of the professional career of Clark Gable. The opening section gives a biographical overview of the man, the actor, and the legend. The major section is devoted to the films, which are placed in chronological divisions. The selection and reproduction of many photographs and the quality of the text are impressive. Bibliography; filmography; index.

O957. **Samuels, Charles.** THE KING: A BIOGRAPHY OF CLARK GABLE. New York: Popular Library, 1963. 262 p.

A fine biography that combines factual detail with an objective evaluation of the life and career of Hollywood's leading male star. In his text, Samuels captures the Gable persona and emphasizes the similarity between the private and the public image. Paperback.

GARBO, GRETA

O958. **Bainbridge, John.** GARBO. Garden City, N.Y.: Doubleday, 1955. 256 p., illus.

The most satisfying of the Garbo biographies, this book contains factual material, analysis, and interpretation,

along with a detailed filmography and many fine illustrations. Updated REPRINT (1971).

O959. **Billquist, Fritiof.** GARBO: A BIOGRAPHY. New York: G. P. Putnam's Sons, 1960. 255 p., illus.

A biography of Garbo translated from the Swedish. Emphasis is on the early life and career. Sources include letters, recalled conversations, and periodicals. Filmography; index.

O959a. **Carr, Larry.** FOUR FABULOUS FACES: GARBO, SWANSON, CRAWFORD, DIETRICH. New Rochelle, N.Y.: Arlington House, 1970.

[See O739.]

O960. **Conway, Michael; McGregor, Dion; and Ricci, Mark.** THE FILMS OF GRETA GARBO. New York: Bonanza Books, 1963. 155 p., illus.

Parker Tyler provides an introduction to this examination of twenty-seven Garbo films. Starting in 1922 with her early Swedish films, each is represented by stills, cast, production credits, a synopsis, and some critical excerpts. Her last film, *Two Faced Woman*, was made in 1941. Text and picture reproduction are not impressive.

O960a. **Corliss, Richard.** GRETA GARBO. New York, Pyramid Publications, 1974. 157 p., illus.

A study of twenty-five Garbo feature films, this volume also offers a unique view of the actress. The interesting illustrations are carelessly reproduced, but the filmography, bibliography and index are most impressive complements to Corliss's rich text.

O961. **Durgnat, Raymond, and Kobal, John.** GRETA GARBO. New York: E. P. Dutton & Co., 1965. 160 p., illus.

The life and career of Garbo told in more than 150 attractive visuals and a vigorous text. An annotated filmography and a lengthy bibliography are also impressive.

O962. **Palmborg, Rilla Page.** THE PRIVATE LIFE OF GRETA GARBO. Garden City, N.Y.: Doubleday, 1931. 282 p., illus.

An early biography of Garbo, written in the style of the thirties. Information was obtained from the usual public sources and from, of all people, Garbo's cook and butler. Some unfamiliar illustrations are included.

O963. **Sjolander, Ture.** GARBO. New York: Harper & Row, 1971. 139 p., illus.

A pictorial study of Garbo supported by a brief text, horoscopes, handwriting analysis, and caricatures. Most of the pictures are informal shots of Garbo offscreen, although a short section of film stills makes up the book's final pages. Picture reproduction is above average in most cases.

GARDNER, AVA

O964. **Hanna, David.** AVA: A PORTRAIT OF A STAR.

New York: G. P. Putnam's Sons, 1960. 256 p., illus.

Written by a professional associate of Miss Gardner, this volume is more character study than biography, emphasizing the pressures and demands that stardom entails. The period covered is mostly the late fifties, from *The Barefoot Contessa* (1954) to *On The Beach* (1959).

O964a. **Higham, Charles.** AVA. New York: Delacorte Press, 1974. 281 p., illus.

An unofficial biography based on interviews with people who knew Ava Gardner. The book is a diluted account, redeemed partially by a filmography and some good illustrations. Index.

GARFIELD, JOHN

O964b. **Swindell, Larry.** BODY AND SOUL: THE STORY OF JOHN GARFIELD. New York: William Morrow, 1975. 279 p., illus.

A full-scale biography of a unique screen personality. Garfield's meteoric career during the forties and fifties is described by a blending of fact, opinion, interpretation, and comment. Two photographic sections and a filmography support the well-researched text. Index.

GARGAN, WILLIAM

O965. **Gargan, William.** WHY ME? AN AUTOBIOGRAPHY. Garden City, N.Y.: Doubleday, 1969. 311 p., illus.

An autobiography of a film actor whose career consisted mostly of "B" films and an early television series. The portrait of Hollywood in the thirties is interesting, as are descriptions of well-known personalities of that period. Latter sections deal with Gargan's laryngectomy and rehabilitation. The illustrations are mediocre.

GARLAND, JUDY

O965a. **Dahl, David, and Kehoe, Barry.** YOUNG JUDY. New York: Mason/Charter, 1975. 250 p., illus.

Some diligent research is evident in this reconstruction of Judy Garland's life from 1922 to 1925. The cast consists of the three Gumm sisters and their parents, Frank and Ethel. The main thesis is that Frank's homosexuality affected and ultimately shaped the lives of his wife and his daughter Frances, later known as Judy Garland. Illustrations and quotations help to recreate Garland's early life. Chronology of appearances; chapter notes; and a long bibliography.

O966. **Deans, Mickey, and Pinchot, Ann.** WEEP NO MORE, MY LADY. New York: Hawthorn Books, 1972. 247 p., illus.

A biography emphasizing the last months of Judy Garland's life. The early portions of her career are related in a factual, reportorial style. The candid photographs tell a sadder story than the authors. Index.

O966a. **Finch, Christopher.** RAINBOW: THE STORMY

LIFE OF JUDY GARLAND. New York: Grosset & Dunlap, 1975. 225 p., illus.

Probably the most satisfying Garland biography, this volume is an ideal blend of text and visuals. The portrait of person and performer is objective, with no trace of the awe or sentimentality evident in other Garland books.

O966b. **Frank, Gerold.** JUDY. New York: Harper & Row, 1975. 704 p., illus.

A massive biography prepared with the cooperation of Judy Garland's relatives, ex-husbands, acquaintances, and coworkers. Detailed description is provided for many incidents and events, but others of equal importance have been minimized. More than six hundred pages of unhappiness are required to recount the legend of Judy Garland.

O966c. **Juneau, James.** JUDY GARLAND. New York: Pyramid Publications, 1974. 159 p., illus.

Although the emphasis of this volume is on Judy Garland's career, enough of her life is discussed to give the reader some insight into her personal problems. The author is objective about the person but subjective about her film work. *The Wizard of Oz* (1939) and *A Star Is Born* (1955) receive special attention. The illustrations are above average. A filmography, a bibliography, and an index complete this rewarding tribute to a legendary performer.

O967. **Morella, Joe, and Epstein, Edward.** JUDY: THE FILMS AND CAREER OF JUDY GARLAND. New York: Citadel Press, 1969. 217 p., illus.

This picture book concentrates on Garland's films, but it does include some coverage of her concert, club, and television appearances. A short biographical essay precedes the film section. Each of the films has stills, synopsis, credits, comments, and excerpts from reviews. The more than three hundred pictures, including many candid shots, are well selected and reproduced. Some tributes have been offered by the personalities who worked with Garland.

O968. **Steiger, Brad.** JUDY GARLAND. New York: Ace Publishing Co., 1969. 190 p., illus.

This original paperback biography offers a factual, objective retelling of Garland's life. Horoscopes, handwriting analysis, and numerology are considered in later chapters. Filmography with review quotations.

GARNETT, TAY

O969. **Garnett, Tay.** LIGHT UP YOUR TORCHES AND PULL UP YOUR TIGHTS. New Rochelle, N.Y.: Arlington House, 1973. 416 p., illus.

The author's insistence on gags, stories, and trivia diminishes the value of this autobiography. Tay Garnett's experience as a Hollywood director lasted more than three decades, during which time he worked with many serious and creative people. In this loosely woven text, he avoids critical comment for the most part and is willing

to settle for a short anecdote rather than an analysis or evaluation. The illustrations are too small. Filmography; TV-radio credits; index.

GISH, DOROTHY
GISH, LILLIAN

O969a. **Gish, Lillian.** DOROTHY AND LILLIAN GISH. New York: Charles Scribner's Sons, 1973. 300 p., illus.

An attractive oversized collection of more than eight hundred visuals that documents the careers of Dorothy and Lillian Gish. The photographs are well selected and reproduced, but the captions tend to be folksy and overly coy. Much attention is given to the silent screen era when the sisters were at the peak of their fame.

O970. **Gish, Lillian, and Pinchot, Ann.** THE MOVIES, MR. GRIFFITH, AND ME. Englewood Cliffs, N.J.: Prentice-Hall, 1969. 388 p., illus.

A tribute to D. W. Griffith and to the silent film era, this memoir by Lillian Gish gives affectionate attention to all three subjects of her title. Her respect for Griffith as a professional and as a person is documented many times, as is her admiration for many of her co-workers. She carries her own career up to the end of the silent era, with only a brief treatment of the next four decades. The photographs are attractive. Index.

GOLDWYN, SAMUEL

O971. **Goldwyn, Samuel.** BEHIND THE SCREEN. New York: George H. Doran Co., 1923. 263 p., illus.

An early Goldwyn public relations effort that is a blend of autobiography, observation, and name-dropping. Contains some fascinating rare photographs.

O972. **Griffith, Richard.** SAMUEL GOLDWYN, THE PRODUCER AND HIS FILMS. New York: Museum of Modern Art, 1956. 48 p., illus.

A brief biographical sketch is followed by notes on approximately twenty-four Goldwyn films. This short volume was prepared for a Goldwyn retrospective and concludes with a list of all Goldwyn's independent productions. The few illustrations are adequate. Paperback.

O973. **Johnston, Alva.** THE GREAT GOLDWYN. New York: Random House, 1937. 99 p., illus.

A short biography that is factual, objective, and well written but offers little insight into the personality of Goldwyn. A few illustrations are included.

GRANT, CARY

O974. **Deschner, Donald.** THE FILMS OF CARY GRANT. New York: Citadel Press, 1973. 256 p., illus.

The more than seventy films in which Cary Grant played are arranged chronologically in this volume. For each, cast, credits, stills, a plot synopsis, and critical comments

are offered. Hundreds of photographs that cover his film and stage career, along with his private life, are used to document his progress from a stilt walker to a stylish film personality.

O975. **Eyles, Allen.** CARY GRANT FILM ALBUM. Shepperton, England: Ian Allen, 1971. 52 p., illus. (color).

A pictorial review of the films of Cary Grant. Arranged chronologically from *This Is the Night* (1932) to *Walk, Don't Run* (1966), each film is represented by some comment and one or more stills. Reproduction quality is high.

O976. **Govoni, Albert.** CARY GRANT. Chicago: Henry Regnery Co., 1971. 233 p., illus.

A mild recital of the known facts of Grant's life and career. The text gives disproportionate attention to the later years, and the illustrations are not at all representative of Grant's film work since over sixty films are ignored. A critical filmography is the book's best feature.

O976a. **Vermilye, Jerry.** CARY GRANT. New York: Pyramid Publications, 1973. 160 p., illus.

The major portion of this volume is devoted to recalling Grant's roles in some seventy-two films. Only matters of public record are used in the biographical portions, resulting in a rather sterile portrait of the actor. It is the detailed account of his films, along with some fine visuals, a bibliography, and a filmography, that gives the book its distinction. Index.

GRIFFITH, DAVID WARK

O977. **Barry, Iris.** D. W. GRIFFITH: AMERICAN FILM MASTER. Rev. ed. New York: Museum of Modern Art, 1965. 40 p., illus.

An early biography and evaluation—by the former director of the museum's Film Department—that includes candid shots, stills, and notes, supplemented by an annotated filmography by Eileen Bowser. ORIGINAL EDITION (1940).

O978. **Brown, Karl.** ADVENTURES WITH D. W. GRIFFITH. New York: Farrar, Straus & Giroux, 1973. 252 p., illus.

A reminiscence about the making of *Birth of a Nation* (1914) and *Intolerance* (1915). The author served as assistant to cameraman Billy Bitzer on those films. He recalls D. W. Griffith's directorial techniques and describes filmmaking procedures of the period.

O979. **Croy, Homer.** STAR MAKER: THE STORY OF D. W. GRIFFITH. New York: Duell, Sloan & Pearce, 1959. 210 p., illus.

An early biography of Griffith aimed at a youthful audience. Index.

O980. **Geduld, Harry, ed.** FOCUS ON D. W. GRIFFITH. Englewood Cliffs, N.J.: Prentice-Hall, 1971. 182 p., illus.

A collection of diverse material on Griffith, including much of his own writing and remarks. Essays on his films and his artistry provide the remainder. A filmography and a good annotated bibliography are appended. The few stills are not impressive. Index. Paperback.

O980a. **Gish, Lillian, and Pinchot, Ann.** THE MOVIES, MR. GRIFFITH, AND ME. Englewood Cliffs, N.J.: Prentice-Hall, 1969. 388 p., illus.

[*See* O970.]

O981. **Hart, James, ed.** THE MAN WHO INVENTED HOLLYWOOD. Louisville, Ky.: Touchstone Publishing Co., 1972. 170 p., illus.

A partial autobiography of D. W. Griffith, surrounded by interview notes, illustrations, and a concluding section. Griffith's writing style is consistent with his Victorian attitudes and background, but he does offer firsthand information about his early life up to making *Intolerance* (1915). His later years are described by Hart. Picture quality is good, and a Griffith chronology is appended.

O982. **Henderson, Robert M.** D. W. GRIFFITH: HIS LIFE AND HIS WORK. New York: Oxford University Press, 1972. 326 p., illus.

A scholarly evaluation of Griffith's life and career. Heavily detailed and documented, the unemotional text traces Griffith's career from a Kentucky boyhood through international fame and final obscurity. The illustrations are good, but their contribution to the book is diminished by placing them together in one section. Filmography; notes; index.

O983. **Henderson, Robert M.** D. W. GRIFFITH: THE YEARS AT BIOGRAPH. New York: Farrar, Straus & Giroux, 1970. 250 p., illus.

Using many original materials in his research, the author has provided a documented, detailed study of Griffith and filmmaking from 1908 to 1913. The director's use of Biograph studios as a laboratory in which he perfected his artistry is noted. The pedantic text is not relieved by the few unimpressive pictures. Film list; actor list; bibliography; index.

O984. **O'Dell, Paul, and Slide, Anthony.** GRIFFITH AND THE RISE OF HOLLYWOOD. New York: A. S. Barnes, 1970. 163 p., illus.

Emphasis is given to *Birth of a Nation* (1914) and *Intolerance* (1915), with passing attention to other films, personalities, and incidents of this early period from 1914 to 1919. The stills are excellent. Bibliography; index. Paperback.

O984a. **Wagenknecht, Edward, and Slide, Anthony.** THE FILMS OF D. W. GRIFFITH. New York: Crown Publishers, 1975. 276 p., illus.

After a short chapter on D. W. Griffith's years at Biograph, his films from *Judith of Bethulia* (1914) to *The Struggle* (1931) are described and discussed critically. Cast, credits, and other data are noted. The visuals include stills, portraits, program covers, and posters. A filmography for Griffith's Biograph period, a bibliography, and an index complete this comprehensive survey.

HAGNER, JOHN G.

O985. **Hagner, John G.** FALLING FOR STARS. Hollywood: El Jon, 1965. 126 p., illus.

A Hollywood stuntman's account of his film work.

HARDWICKE, CEDRIC

O986. **Hardwicke, Sir Cedric, and Brough, James.** A VICTORIAN IN ORBIT. Garden City, N.Y.: Doubleday, 1961. 311 p., illus.

An autobiography written with irreverence and wit. Hardwicke's comments on life and work in Hollywood are devastating, cynical, and negative. Most of the text and the illustrations are concerned with theatrical performances.

HARLOW, JEAN

O987. **Conway, Michael, and Ricci, Mark.** THE FILMS OF JEAN HARLOW. New York: Citadel Press, 1965. 159 p., illus.

Jean Harlow appeared in several short films and in twenty-three feature films. Each of the latter group is presented here with stills, cast, credits, critical comments, and plot synopsis. The biographical essay that introduces the book and the more than two hundred stills and candids are above average.

O988. **Pascal, John.** THE JEAN HARLOW STORY. New York: Popular Library, 1964. 158 p., illus.

A biography of Harlow that avoids sensationalism and offers some fine illustrations and a short filmography. Paperback.

O989. **Shulman, Irving.** HARLOW: AN INTIMATE BIOGRAPHY. New York: Bernard Geis Associates, 1964. 408 p., illus.

One of the most popular film biographies ever published, this controversial and sensationalized account was based on rather questionable sources. The final portrait, which emphasizes sexual material, seems unfair and is a disservice to a legendary screen personality.

HART, WILLIAM S.

O990. **Hart, William S.** MY LIFE EAST AND WEST. New York: B. Blom, 1968. 346 p., illus.

In this autobiography, Hart describes the filming of westerns during the middle of the silent era. A long section preceding his account of motion pictures tells of his stage career. Some poor photographs are included. Detailed index. ORIGINAL EDITION (Houghton Mifflin Co., 1929).

HAWKS, HOWARD

O991. **Bogdanovich, Peter.** THE CINEMA OF HOWARD HAWKS. New York: Museum of Modern Art, 1962. 38 p., illus.

A short program supplement designed for a Hawks retrospective in 1962, this enlarged filmography contains Hawks's comments on each film. The illustrations are adequate. Paperback.

O992. **McBride, Joseph.** FOCUS ON HOWARD HAWKS. Englewood Cliffs, N.J.: Prentice-Hall, 1972. 178 p., illus.

A collection of material about Howard Hawks, including essays, film evaluations, and interviews. Emphasis is placed on the directorial methods and themes used by Hawks. Bibliography; filmography; index. Paperback.

O993. **Wood, Robin.** HOWARD HAWKS. New York: Doubleday & Co., 1968. 200 p., illus.

This analysis of Hawks's films classifies them under various recurring themes or attitudes. A well presented critical discussion, supported by example, explanation; and opinion. Picture quality is outstanding. Filmography.

HAYAKAWA, SESSUE

O994. **Hayakawa, Sessue.** ZEN SHOWED ME THE WAY. Indianapolis: Bobbs-Merrill Co., 1961. 256 p., illus.

An autobiography of a popular star of the American silent screen. He recounts his early successes in Hollywood and talks of his return after a stay in Europe. Much attention is given to the influence of Zen on his life.

HAYDEN, STERLING

O995. **Hayden, Sterling.** WANDERER. New York: Bantam Books, 1965. 407 p.

An autobiography that tells about the actor's life but little about the many films in which he has appeared. The author concentrates mostly on concerns outside his profession, although he does discuss his prominent role in the congressional hearings of the late forties concerning communism in Hollywood. Paperback.

HAYS, WILL H.

O996. **Hays, Will.** THE MEMOIRS OF WILL HAYS. Garden City, N.Y.: Doubleday, 1955. 600 p.

In the early portions of this volume, Hays tells of the experience that led to his being appointed postmaster general of the United States. The latter sections deal with his two decades in Hollywood as moral guardian to the motion picture industry. Censorship, self-regulation, and the Hays office are major concerns of the text.

HAYWARD, SUSAN

O997. **McClelland, Doug.** SUSAN HAYWARD: THE DIVINE BITCH. New York: Pinnacle Books, 1973. 221 p., illus. [cont.]

An exploration of the career of Susan Hayward. A smattering of biographical information accompanies the detailed account of all her films from *Hollywood Hotel* (1936) to some television films in 1972. The text is affectionate and admiring rather than critical. A filmography and a few visuals accompany this tribute. Index. Paperback.

HEAD, EDITH

O998. **Head, Edith, and Ardmore, Jane Kesner.** THE DRESS DOCTOR. Boston: Little, Brown & Co., 1959. 249 p., illus.

Edith Head is a noted Hollywood designer. Books on costume design for films are rare, and this purported autobiography does include some information on this specialized art. Very quickly, however, biography and profession are ignored in favor of name-dropping and grooming advice.

HECHT, BEN

O999. **Hecht, Ben.** A CHILD OF THE CENTURY. New York: Signet Books, 1954. 608 p., illus.

This autobiography of a famous author touches only briefly on his notable career as a writer of screenplays. It does offer many anecdotes about Hollywood personalities.

HELLINGER, MARK

O1000. **Bishop, Jim.** THE MARK HELLINGER STORY: A BIOGRAPHY OF BROADWAY AND HOLLYWOOD. New York: Appleton-Century-Crofts, 1952. 367 p., illus.

A biography of a motion picture writer and producer whose films contain many elements of his experiences as a New York reporter. Hellinger worked in Hollywood during the decade preceding his death in 1947.

HENIE, SONJA

O1001. **Henie, Sonja.** WINGS ON MY FEET. New York: Prentice-Hall, 1940. 177 p., illus.

An early biography of the skating star, coupled with some instruction on ice skating.

HEPBURN, KATHARINE

O1002. **Dickens, Homer.** THE FILMS OF KATHARINE HEPBURN. New York: Citadel Press, 1971. 244 p., illus.

The author departs slightly from the usual format in this account of Hepburn and her films. The biographical sketch is well written, notes and comments on the films are included, and the plot outlines are thankfully short. Each film is represented by stills, cast, credits, synopsis, and some critics' remarks. Attention is paid to Hepburn's stage career, and the gallery of portraits that concludes the book is most impressive.

O1002a. **Higham, Charles.** KATE: THE LIFE OF KATHARINE HEPBURN. New York: W. W. Norton & Co., 1975. 244 p., illus.

A pleasing biography written with the cooperation of the subject. In addition to interviews with the actress, her friends, and professional acquaintances, Higham has researched the standard reference and information sources: reviews, articles, newspaper items, etc. The fascination of the volume lies in its recital of the many ways that Hepburn is perceived by the interviewees. Index.

O1003. **Kanin, Garson.** TRACY AND HEPBURN. New York: Viking Press, 1971. 307 p.

A popular dual biography, based in part on personal reminiscences of the author. Alternate chapters are presented on the two stars in this warm memoir, which consists mostly of anecdotes characterized by appreciation and affection.

O1004. **Marill, Alvin H.** KATHARINE HEPBURN. New York: Pyramid Publications, 1973. 160 p., illus.

A pictorial survey of Hepburn's career. The biographical material is limited. The text investigates her career in categorical fashion: the stage years, the RKO years, the MGM years, and the independent years. A filmography, a bibliography, and a list of radio appearances are added. The illustrations are well selected but reproduced with less than average quality. Index. Paperback.

HESTON, CHARLTON

O1005. **Henstell, Bruce, ed.** CHARLTON HESTON, JACK NICHOLSON. Washington, D.C.: American Film Institute, 1972. 31 p.

Two interviews given in 1972 are contained in this book. Heston talks about the many directors with whom he has worked; Nicholson emphasizes his work with Roger Corman. Bibliographies for both actors are included. Paperback.

HITCHCOCK, ALFRED

O1006. **Bogdanovich, Peter.** THE CINEMA OF ALFRED HITCHCOCK. New York: Museum of Modern Art, 1963. 48 p., illus.

A booklet that preceded Truffaut's work on Hitchcock. Interview questions and answers about Hitchcock's films up to *The Birds* (1963) make up the content. The illustrations are acceptable. Paperback.

O1006a. **Durgnat, Raymond.** THE STRANGE CASE OF ALFRED HITCHCOCK. Cambridge: MIT Press, 1974. 419 p., illus.

After a short biographical introduction, all of Hitchcock's films are critically analyzed in chronological order. There are ample cross-references regarding themes, characters, and genres. Stills; bibliography; filmography; index.

O1007. **Henstell, Bruce, ed.** ALFRED HITCHCOCK. Washington, D.C.: American Film Institute, 1972. 27 p.

A 1970 interview with Hitchcock that ranges over a wide variety of filmmaking topics. Bibliography; filmography. Paperback.

O1008. **LaValley, Albert J., ed.** FOCUS ON HITCHCOCK. Englewood Cliffs, N.J.: Prentice-Hall, 1972. 186 p., illus.

A collection of Hitchcock interviews, articles, film evaluations, and appreciations. Outstanding is a lengthy analysis of the cornfield sequence in *North by Northwest* (1959). Filmography; bibliography; and index. Paperback.

O1009. **Perry, George.** THE FILMS OF ALFRED HITCHCOCK. New York: E. P. Dutton & Co., 1965. 160 p., illus.

This impressive combination of visuals and text is a guide to Hitchcock's films from the silents of the twenties to *Marnie* in 1964. More than 150 well-reproduced photographs complement the text, which is factual, descriptive, and critical. Biographical details are scattered throughout. Paperback.

O1010. **Truffaut, François.** HITCHCOCK. New York: Simon & Schuster, 1967. 256 p., illus.

Truffaut's well-known interview of Hitchcock used about five hundred pertinent questions and supplemented the resulting dialogue with almost the same number of visuals. The films are presented in chronological chapters, which also contain bits of biographical information. The author's knowledge and preparation, his interviewing skills, and his admiration for Hitchcock are continually apparent. Filmography; bibliography; indexes.

O1011. **Wood, Robin.** HITCHCOCK'S FILMS. New York: A. S. Barnes, 1969. 204 p., illus.

Eight of Hitchcock's American films are analyzed in detail in this volume. The critical text, emphasizing themes and techniques, is accompanied by poorly presented visuals. Filmography; bibliography. Paperback.

HOPE, BOB

O1012. **Hope, Bob and Martin, Pete.** HAVE TUX, WILL TRAVEL: BOB HOPE'S OWN STORY. New York: Simon & Schuster, 1954. 308 p.

The predictable is offered in this early autobiography. Some attention is given to the films, but significant information becomes buried in dated humor. Index. Paperback.

O1013. **Morella, Joe; Epstein, Edward Z.; and Clark, Eleanor.** THE AMAZING CAREERS OF BOB HOPE. New Rochelle, N.Y.: Arlington House, 1973. 256 p., illus.

A summary of Bob Hope's professional life. Although there are elements of biography included, the emphasis is on vaudeville, radio, television, and films. The section on film contains recreated scenes, dialogue, critical reaction, comment, analysis, and a complete filmography. More than one hundred good illustrations.

HOPPER, HEDDA

O1014. **Eels, George.** HEDDA AND LOUELLA. New York: G. P. Putnam's Sons, 1972. 360 p., illus.

A dual biography of two powerful Hollywood gossip columnists: Hedda Hopper and Louella Parsons. Told in alternate-chapter fashion, the book surveys the rise, reign, and demise of two very powerful female journalists. A portrait of the industry and the society in which they operated so successfully is also presented. The impressive illustrations are grouped in a center section. Index.

O1015. **Hopper, Hedda, and Brough, James.** THE WHOLE TRUTH AND NOTHING BUT. Garden City, N.Y.: Doubleday, 1963. 331 p., illus.

The second volume of autobiography by a Hollywood gossip columnist. An example of the typical output of Hedda Hopper, the book is a bit more outspoken about Hollywood behavior and morals than earlier volumes; but for full comprehension, an ability to read between the lines is useful. The few illustrations offered are good.

HORNE, LENA

O1016. **Horne, Lena, and Schickel, Richard.** LENA. New York: Signet Books, 1966. 224 p., illus.

A solid autobiography that includes a portrait of Hollywood and its inhabitants during the forties and some comments on the problems faced by one of the first black female stars in motion pictures. The few illustrations are adequate. Paperback.

HOUSEMAN, JOHN

O1017. **Houseman, John.** RUN THROUGH: A MEMOIR. New York: Simon & Schuster, 1972. 507 p., illus.

A highly praised memoir of the period from 1902 to 1942 by director-producer-actor Houseman. Greatest attention is given to the theatre of the thirties and to the rise of Orson Welles to celebrity. The concluding sections of the book describe the making of *Citizen Kane* (1941). Many fine illustrations accompany the literate and fascinating text. Index.

HOWARD, LESLIE

O1018. **Howard, Leslie Ruth.** A QUITE REMARKABLE FATHER. New York: Harcourt Brace, 1959. 307 p., illus.

Although it is not emphasized in this biography, Leslie Howard made some important American films during the thirties. The emphasis here is on family life and theater. Index.

HUGHES, HOWARD

O1019. **Dietrich, Noah, and Thomas, Bob.** HOWARD: THE AMAZING MR. HUGHES. Greenwich, Conn.: Fawcett, 1972. 303 p., illus.

A biography of Howard Hughes that describes his Hollywood careers as producer, agent, studio head, etc. The authors are qualified to tell this complex story since Dietrich spent thirty-two years in Hughes's employ. They give appropriate attention to many Hollywood personalities and to incidents that have become legendary. Other biographies of Hughes exist, but this one seems to be the most accurate. Paperback.

O1020. **Gerber, Albert B.** BASHFUL BILLIONAIRE. New York: Dell Publishing Co., 1968. 352 p.

Using a "Tom Swift" format, the author emphasizes the making of *Hell's Angels* (1930) and *The Outlaw* (1944). The purchase of the RKO studios and Hughes's relationships with female film stars are also noted. Paperback.

O1021. **Keats, John.** HOWARD HUGHES. New York: Random House, 1967. 304 p., illus.

Howard Hughes's career in films gets appropriate attention in this well-written biography. The illustrations are acceptable.

HUSTON, JOHN

O1022. **Nolan, William F.** JOHN HUSTON: KING REBEL. Los Angeles: Sherbourne Press, 1965. 247 p., illus.

Here is an unofficial biography of a film director who never fulfilled his potential. A selection of tributes by film associates is followed by a short account of his early years. Separate chapters are devoted to each of his major films. Too many anecdotes are substituted for critical analysis in the text. The illustrations are negligible; a short bibliography is appended.

O1023. **Tozzi, Romano.** JOHN HUSTON: A PICTORIAL TREASURY OF HIS FILMS. New York: Crescent, 1970. 160 p., illus.

A pictorial guide to Huston's films that offers over 165 well selected and reproduced photographs, a spare text, and a filmography. Although the quality of the book could be improved, it presents a valid record of Huston as director-writer-actor.

JOLSON, AL

O1024. **Freedland, Michael.** JOLSON. New York: Stein & Day, 1972. 256 p., illus.

A biography of Jolson that gives proportionate attention to his work in films. Because of legalities, some gaps exist, such as the Jolson-Keeler marriage, but most of Jolson's egomania and show business charisma are well described. Some illustrations and a bibliography support the careful text. Index.

KARLOFF, BORIS

O1025. **Ackerman, Forrest J.** THE FRANKENSCIENCE MONSTER. New York: Ace Publishing Co., 1969. 191 p., illus.

A tribute to Boris Karloff in the form of articles, interviews, biographies, filmographies, and appreciations. Much of the material is unusual, and the entire book is surprisingly rewarding. A good picture section is included. Paperback.

O1026. **Barbour, Alan; Marill, Alvin; and Parish, James Robert.** KARLOFF. Kew Gardens, N.Y.: Cinefax, 1969. 64 p., illus.

A survey of Karloff's career that uses stills from many of his films, along with some publicity shots. A short biographical introduction and a filmography complement the photographs. Paperback.

O1027. **Gifford, Denis.** KORLOFF, THE MAN, THE MONSTER, THE MOVIES. New York: Curtis Books, 1973. 352 p., illus.

A fine collection of information and comment about Karloff. A short, factual biography is followed by a critical filmography that begins with *His Majesty the American* (1919) and ends with *House of Evil* (1968). Cast, credits, and plot outlines accompany the critical comment. Some review extracts are also given. A discography, a list of his writings, and descriptions of some unfilmed projects complete the volume. The few illustrations are below average, but the rest of the book is most impressive. Paperback.

O1027a. **Jensen, Paul M.** BORIS KARLOFF AND HIS FILMS. New York: A. S. Barnes, 1975. 208 p., illus.

A workmanlike study of Boris Karloff and his films. Plots, settings, and characters are described in detail. Selected stills, portraits, and frame enlargements help to visualize the films. Bibliography; filmography; several indexes.

O1028. **Underwood, Peter.** KARLOFF. New York: Drake Publishers, 1972. 238 p., illus.

An indifferent biography of Karloff, based on two early interviews and other previously published material. A bibliography, a discography, and a gallery of portraits are more impressive than the many quotations gathered by the author. Index.

KAYE, DANNY

O1029. **Singer, Kurt D.** THE DANNY KAYE STORY. New York: Thomas Nelson, 1958. 241 p., illus.

A sentimental biography about a poor boy's rise to fame and fortune. Kaye's activities in all media are noted.

KAZAN, ELIA

O1029a. **Ciment, Michel.** KAZAN ON KAZAN. New York:

Viking Press, 1974. 199 p., illus.

An extended 1971 interview with Elia Kazan has been augmented by some fine photographs and a good filmography. Emphasis is on his film work, although theater and radio are also treated. Ciment is a well-prepared questioner, and Kazan's responses are informative and surprisingly candid.

KEATON, BUSTER

O1030. **Blesh, Rudi.** KEATON. New York: Macmillan Co., 1966. 395 p., illus.

There are elements of biography, analysis, and evaluation in this account of Keaton's life and career. The text describes many of the films in detail. There are some excellent illustrations among the more than 100 used here. A listing of Keaton's 129 films made from 1917 to 1966 is given, along with partial credits for each. Index.

O1031. **Keaton, Buster, and Samuels, Charles.** MY WONDERFUL WORLD OF SLAPSTICK. Garden City, N.Y.: Doubleday, 1960. 282 p., illus.

Keaton's accounts of his early life, his entrance into films, and the creation of his masterpieces in the twenties are the substance of this book. Some attention is paid to other biographical elements, such as his decline at MGM in the thirties and his partial reemergence as a celebrity in the fifties and the sixties.

O1032. **Lebel, J.P.** BUSTER KEATON. New York: A. S. Barnes, 1967. 180 p., illus.

This analysis of Keaton's style uses examples from his films throughout the text rather than providing a detailed discussion of individual ones. A short biographical sketch introduces the discussion of Keaton's art and the review of his career. Paperback.

O1033. **Robinson, David.** BUSTER KEATON. Bloomington: Indiana University Press, 1969. 198 p., illus.

Each of Keaton's feature length silents is analyzed in detail. In addition, there is biographical coverage, a shot analysis of the last reel of *Our Hospitality* (1923), a filmography of Keaton's silents, and some excellent illustrations.

KELLY, GENE

O1033a. **Hirschhorn, Clive.** GENE KELLY. Chicago: Henry Regnery Co., 1975. 336 p., illus.

A substantial biography, written with Kelly's cooperation. An objective text tells of Kelly's early success on Broadway and his evolution into a major film artist who directly influenced the development of the musical film. In addition to the career coverage, attention is given to the private life of the dancer. A filmography and an index add to the quality of this excellent volume.

KELLY, GRACE

O1034. **Gaither, Gant.** PRINCESS OF MONACO: THE STORY OF GRACE KELLY. New York: H. Holt, 1957. 176 p., illus.

A biography of a film star who gave up a career for a royal marriage. The first third of this surface portrait deals with the subject's early life and career in Hollywood. The remainder deals with life in Monaco. Three section of photographs assist in telling a saccharine story.

KUBRICK, STANLEY

O1035. **Kagan, Norman.** THE CINEMA OF STANLEY KUBRICK. New York: Holt, Rinehart & Winston, 1972. 204 p., illus

A detailed description of the nine films Kubrick made from *Fear and Desire* (1953) to *2001: A Space Odyssey* (1968). In addition to a long visualized summary of each film, the text offers Kubrick's comments, a sampling of reviews, notes, and the author's comments. The 350 illustrations are most helpful in recalling the films. Bibliography; filmography; index.

O1036. **Walker, Alexander.** STANLEY KUBRICK DIRECTS. New York: Harcourt Brace Jovanovich, 1971. 272 p., illus.

A short interview and an essay open this account of the work and personality of Stanley Kubrick. The films from *Fear and Desire* (1953) to *A Clockwork Orange* (1971) are discussed, with special detailed examination of *Paths of Glory* (1957), *Dr. Strangelove* (1963) and *2001: A Space Odyssey* (1968). Over three hundred well-reproduced stills support the analyses given in the text. Filmography.

LAEMMLE, CARL

O1037. **Drinkwater, John.** THE LIFE AND ADVENTURES OF CARL LAEMMLE. New York: G. P. Putnam's Sons, 1931. 288 p., illus.

In 1931, Carl Laemmle was at the end of his career as a Hollywood studio head. This perfunctory recital of his early career and his subsequent founding of Universal Studios in 1912 is disappointing, as are the illustrations that accompany the admiring text. This autobiography was commissioned, which probably accounts for its superficiality.

LAKE, VERONICA

O1038. **Lake, Veronica, and Bain, Donald.** VERONICA: THE AUTOBIOGRAPHY OF VERONICA LAKE. London: W. H. Allen, 1969. 248 p., illus.

A frank, sometimes lurid autobiography about a Hollywood star told in a cynical, objective style. Veronica Lake was created by the Paramount Studios in the early forties and was a has-been by the fifties. Her professional and

private misfortunes are related here, along with several sexual encounters. Index of personalities.

LAMARR, HEDY

O1039. **Lamarr, Hedy.** Ecstasy and Me: My Life as a Woman. Greenwich, Conn.: Bartholomew House, 1966. 256 p., illus.

An example of bad taste in autobiography, this book does consider a few events in Lamarr's screen career. Unfortunately, the emphasis is on personal sexual confessions. The few visuals cannot overcome this lapse in judgment. Paperback.

LANCASTER, BURT

O1039a. **Thomas, Tony.** Burt Lancaster. New York: Pyramid Publications, 1975. 160 p., illus.

A collection of fine visuals and a preceptive text highlight this coverage of Burt Lancaster's career. His films from *The Killers* (1946) to *The Midnight Man* (1974) are discussed. Bibliography; filmography; index.

O1040. **Vermilye, J.** Burt Lancaster: A Pictorial Treasury of His Films. New York: Crescent Books, 1970. 160 p., illus.

In this pictorial review of Burt Lancaster, a continuous text describes the films in chronological sequence. Over 165 pictures are reproduced adequately, and a filmography with partial credits is offered.

LANG, FRITZ

O1041. **Bogdanovich, Peter.** Fritz Lang in America. New York: Praeger Publishers, 1967. 144 p., illus.

An extended interview with Fritz Lang that examines the American films he made from 1936 to 1956. The author's film background and interview expertise bring forth the important aspects of this famous director's American experiences. The illustrations are very good. A total filmography for Lang is included, along with a short bibliography. Paperback.

O1042. **Jensen, Paul M.** The Cinema of Fritz Lang. New York: A. S. Barnes, 1969. 223 p., illus.

Some slight attention is given to biographical material, but major focus is on the themes of Fritz Lang's films. His career from 1917 to 1960 included films made during his stay in Hollywood. Interesting stills; filmography; bibliography. Paperback.

LANZA, MARIO

O1043. **Bernard, Matt.** Mario Lanza. New York: Mac-Fadden-Bartell, 1971. 224 p.

Another sensationalized biography that emphasizes excesses rather than accomplishments. Reconstructed conversations, unidentified interviews, and sexual fantasies

predominate in the only Lanza biography currently available. Paperback

LASKY, JESSE L.

O1044. **Lasky, Jesse L., and Weldon, Don.** I Blow My Own Horn. Garden City, N.Y.: Doubleday, 1957. 284 p.

Jesse Lasky was a film pioneer associated mostly with Famous Players Company and Paramount Pictures. In this autobiography he recalls his early career in vaudeville and his later success in the silent film industry. Many anecdotes and personality descriptions help to balance the self-satisfied portrait. Index.

LAUGHTON, CHARLES

O1045. **Brown, William.** Charles Laughton: A Pictorial Treasury of His Films. New York: Crescent, 1970. 160 p., illus.

The continuous, unimpressive text of this picture book combines both the professional and private life of Laughton. Although the placement of certain of the 165 photographs is questionable, the quality of reproduction is above average. Abbreviated filmography.

O1046. **Lanchester, Elsa.** Charles Laughton and I. New York: Harcourt, Brace & Co., 1938. 269 p., illus.

A partial biography of two character actors, this memoir covers the first meeting of Lanchester and Laughton, their early careers, marriage, and their arrival in the United States in the early thirties. The illustrations are acceptable. REPRINT (London: Faber & Faber, 1968).

O1047. **Singer, Kurt.** The Laughton Story. Philadelphia: John C. Winston, 1954. 308 p., illus.

Despite inaccuracies, this early biography considers Laughton's film career in some detail. The author portrays many dimensions of Laughton's personality. In the closing sections, his speaking tours are described. The illustrations are adequate.

LAUREL, STAN

HARDY, OLIVER

O1048. **Barr, Charles.** Laurel and Hardy. Berkeley: University of California Press, 1968. 144 p., illus.

In this appreciation and analysis of the famous team, examples are used from both the silent shorts and the sound features. Certain stills are employed to show the development of the team's sight gags; others are related to special sections of the text. The evaluative and expanded filmography is most useful. Bibliography; index.

O1049. **Everson, William K.** The Films of Laurel and Hardy. New York: Citadel Press, 1967. 223 p., illus.

One of the most popular picture books published, this tribute to Laurel and Hardy emphasizes ninety-nine of

their films. Using about four hundred illustrations and a literate text, the author has perceptively analyzed both the comedy style of the team and each of the films. Careful production, combined with painstaking research, has made this an outstanding volume. Paperback.

O1050. **McCabe, John.** MR. LAUREL AND MR. HARDY. New York: New American Library, 1966. 175 p., illus.

A dual biography that is admiring and affectionate toward its subjects. Those portions that deal with the off-screen lives of the comedy team are carefully selected from well known public sources. It is the analysis and appreciation of the screen artistry that makes for strong text material. Thirty-two pages of poorly reproduced photographs; filmography; index. Paperback.

O1051. **Maltin, Leonard, ed.** THE LAUREL AND HARDY BOOK. New York: Curtis Books, 1973. 301 p., illus.

A collection of supplementary, peripheral materials on the famous comedy team. Taken in a large part from *The Newsletter of the Sons of the Desert,* the content includes articles about the team, their stock company of actors, separate filmographies, and a final team filmography. The illustrations are very good and have been selected with care. Paperback.

LEIGH, VIVIEN

O1052. **Dent, Alan.** VIVIEN LEIGH: A BOUQUET. London: Hamish Hamilton, 1969. 219 p., illus.

A tribute to the actress that offers anecdotes and incidents concerning the nineteen films she made. Filmography.

O1053. **Robyns, Gwen.** LIGHT OF A STAR: THE CAREER OF VIVIEN LEIGH. New York: A. S. Barnes, 1970. 256 p., illus.

A biography that leans heavily at times on previously published material. The emphasis is on the marriage and professional relationship with Laurence Olivier. Leigh's nineteen films are given attention, along with her theatrical appearances. The illustrations are good. Index.

LEISEN, MITCHELL

O1054. **Chierichetti, David.** HOLLYWOOD DIRECTOR. New York: Curtis Books, 1973. 398 p., illus.

An exploration of the career and films of American director Mitchell Leisen. Biographical material is minimal in this excellent critical study of Leisen's many films. The narrative material is based on an American Film Institute oral history project. Many fine visuals and a detailed filmography support the text. Paperback.

LE ROY, MERVYN

O1055. **LeRoy, Mervyn, and Canfield, Alyce.** IT TAKES MORE THAN TALENT. New York: Alfred A. Knopf, 1953. 300 p.

Since 1924, Mervyn LeRoy has been associated with the American film industry in many capacities, as director, producer, etc. This volume is part biography and part fan magazine advice and coverage. With so much firsthand experience upon which to draw, LeRoy's account is most disappointing.

O1055a. **LeRoy, Mervyn, and Kleiner, Dick.** MERVYN LEROY: TAKE ONE. New York: Hawthorn Books, 1974. 256 p., illus.

An autobiography that traces the career of the immodest director-producer from newsboy to Hollywood power. The narrative is self-serving rather than introspective and contains some factual inaccuracies. Two picture sections; filmography; index.

LEWIS, JERRY

O1056. **Gehman, Richard.** THAT KID: THE STORY OF JERRY LEWIS. New York: Avon Books, 1964. 192 p., illus.

An obscure paperback biography of Jerry Lewis. Unfortunately, this American film comedian has been overlooked or ignored by American writers and critics. This well written, objective account of Lewis's rise to success suggests some of the qualities that make the comedian so lovable, tough, and outspoken. Paperback.

LEWTON, VAL

O1057. **Siegel, Joel E.** VAL LEWTON: THE REALITY OF TERROR. New York: Viking Press, 1973. 176 p., illus.

An admirable account of Lewton's life and work. The first section deals with biographical matters through interviews, letters, and reminiscences. In the second part, each of Lewton's fourteen films is described with data and a critical essay. Picture reproduction is disappointing; a list of Lewton's motion picture credits is appended. Paperback.

LLOYD, HAROLD

O1058. **Cahn, William.** HAROLD LLOYD'S WORLD OF COMEDY. New York: Duell, Sloan & Pearce, 1964. 208 p., illus.

Much extraneous material diminishes the effectiveness of this partial biography. Some of the two hundred visuals are not pertinent, and the text is negligible; but there are some fine illustrations of Lloyd in his early screen roles. Index.

O1059. **Lloyd, Harold C., and Stout, Wesley W.** AN AMERICAN COMEDY: AN AUTOBIOGRAPHY. New York: Longmans, Green & Co., 1928. 204 p., illus.

Lloyd's early life related with modesty and candor. The development of his all-American bespectacled screen character is described.

O1059a. **Schickel, Richard.** HAROLD LLOYD: THE SHAPE

OF LAUGHTER. Greenwich, Conn.: New York Graphic Society, 1974. 218 p., illus.

A critical biography of Harold Lloyd and an assessment of his methods, techniques, and films are offered in this handsome volume. The repetition of American values in Lloyd's films receives special attention. Over two hundred photographs are well-reproduced, and a filmography by Eileen Bowser supports the readable text. This is a major study of a heretofore neglected American film artist.

LOCKLEAR, ORMER

O1060. **Ronnie, Art.** LOCKLEAR: THE MAN WHO WALKED ON WINGS. New York: A. S. Barnes, 1973. 333 p., illus.

A biography of a stunt flyer who had a brief career in films immediately after World War I. Two films, *The Great Air Robbery* (1919) and *Skyway* (1920), are discussed in detail. Filmmaking, aerial photography, and stunting are described, and a period of film history is recreated. Rare visuals; lengthy bibliography; index.

LOMBARD, CAROLE

O1060a. **Harris, Warren G.** GABLE & LOMBARD. New York: Simon & Schuster, 1974. 205 p., illus.

[*See* 955a.]

O1061. **Ott, Frederick W.** THE FILMS OF CAROLE LOMBARD. Secaucus, N.J.: Citadel Press, 1972. 192 p., illus.

A pictorial review of the film career of Carole Lombard. A short biography is followed by a filmography of her sixty-four films. For each, cast, credits, synopsis, and critical comments are provided. The reproduction quality of the several hundred stills is mediocre. Bibliography.

LOOS, ANITA

O1062. **Loos, Anita.** A GIRL LIKE I. New York: Viking Press, 1966. 275 p., illus.

A partial autobiography of Anita Loos that ends in 1926 with the publication of her book *Gentlemen Prefer Blondes*. As a Hollywood script writer from 1912 to 1920, she worked with many film personalities. Excellent illustrations accompany this fine memoir.

LORENTZ, PARE

O1063. **Snyder, Robert L.** PARE LORENTZ AND THE DOCUMENTARY FILM. Norman: University of Oklahoma Press, 1968. 232 p., illus.

Devoted mostly to a discussion of the documentary films that Lorentz made for the United States government in the thirties. This well-researched volume also notes his struggle to obtain continuing financial support for his United States Film Service. The illustrations are acceptable. Filmography; bibliography; index.

LOSEY, JOSEPH

O1064. **Leahy, James.** THE CINEMA OF JOSEPH LOSEY. New York: A. S. Barnes, 1967. 175 p., illus.

Losey's films from 1948 to 1967, along with their themes, are considered in chronological order. Interspersed among these analyses are excerpts from Losey interviews. Biographical elements are negligible, although Losey's reasons for becoming an expatriate are presented. Stills; filmography; bibliography.

O1065. **Milne, Tom.** LOSEY ON LOSEY. London: Secker & Warburg, 1967. 192 p., illus.

Although Losey achieved his greatest fame after McCarthyism forced him to work overseas, he does comment on the making of some of his American films in this interview book. The stills are fine, and a total Losey filmography to 1967 is given.

LOVELACE, LINDA

O1066. **Lovelace, Linda.** INSIDE LINDA LOVELACE. New York: Pinnacle Books, 1973. 184 p., illus.

A questionable autobiography by the most widely publicized pornographic film actress in America. Since this genre has had such a social and economic effect on the film industry in recent times, some of Lovelace's comments and opinions may be of interest. They are candid, sexually excessive, and certainly not appropriate for all audiences. The illustration are nude studies of Lovelace alone. Paperback.

LUBITSCH, ERNST

O1067. **Weinberg, Herman G.** THE LUBITSCH TOUCH: A CRITICAL STUDY. New York: E. P. Dutton & Co., 1968. 344 p., illus.

A biographical section, interviews, script excerpts, and detailed analysis of his films define the Lubitsch style. In addition to Weinberg's admiring text, there are almost eighty illustrations, a filmography, and a bibliography. Paperback.

LUGOSI, BELA

O1067a. **Lennig, Arthur.** THE COUNT: THE LIFE AND FILMS OF BELA "DRACULA" LUGOSI. New York: G. P. Putnam's Sons, 1974. 347 p., illus.

A detailed, affectionate biography that traces Bela Lugosi's life and career from the Hungarian theater to Broadway and Hollywood. The sympathetic yet critical text, some fine visuals, a filmography, and a lengthy index combine to make this a biography of high quality.

MC LAGLEN, ANDREW

O1067b. **Burrows, Michael.** JOHN FORD AND ANDREW

V. McLaglen. Saint Austell with Fowey, England: Primestyle, 1970. 32 p., illus.

[*See* O945.]

MC LAGLEN, VICTOR

O1068. **McLaglen, Victor.** Express to Hollywood. London: Jarrolds, 1934. 287 p., illus.

An early autobiography that devotes two short chapters to McLaglen's film career. The few illustrations are fascinating.

MAC LAINE, SHIRLEY

O1069. **MacLaine, Shirley.** Don't Fall Off the Mountain. New York: W. W. Norton & Co., 1970. 270 p.

A popular autobiography that has wit, charm, and style, this volume tells of Shirley MacLaine's struggle to attain film fame, her marriage, and her adventures after finding celebrity. Opinions, philosophy, and attitudes are openly and bravely expressed.

MC QUEEN, STEVE

O1069a. **McCoy, Malachy.** Steve McQueen: The Unauthorized Biography. Chicago: Henry Regnery Co., 1974. 223 p., illus.

An unauthorized biography based upon matters of public record. By adding subjective inperpretation and evaluation, the author supplies substance to a mostly favorable portrait. Stills; filmography; a short index.

O1070. **Nolan, William.** Steve McQueen: Star on Wheels. New York: Berkley Medallion Books, 1972. 143 p.

An unauthorized biography created by adding extra material to two interviews prepared for a racing magazine. Film work is slighted with the exception of *Bullitt* (1968) and *Le Mans* (1971). The biographical sections are short, factual, and uncritical. Paperback.

MAMOULIAN, ROUBEN

O1071. **Milne, Tom.** Mamoulian. Bloomington: Indiana University Press, 1969. 176 p., illus.

In this critical study, each of the sixteen films that Mamoulian directed, from *Applause* (1929) to *Silk Stockings* (1959), is examined in detail. The innovations that he introduced to filmmaking are noted. A strong text about this underrated director is supplemented by some very good illustrations and a filmography. Paperback.

O1072. **Silke, James R., ed.** Rouben Mamoulian: Style Is the Man. Washington, D.C.: American Film Institute, 1971. 35 p., illus.

A 1970 interview with Mamoulian that reviews his career and several of the techniques that he helped to develop for films. Bibliography; filmography; list of stage productions; index. Paperback.

MANSFIELD, JAYNE

O1073. **Mann, May.** Jayne Mansfield. New York: Drake Publishers, 1973. 300 p., illus.

A biography that dwells on the sensational rather than the professional. Mansfield's life is related by her best friend as a struggle to achieve celebrity and to retain it. Attention is given to he influence of her occult beliefs. Many of the sixty illustrations are candid photographs.

MANTZ, PAUL

O1074. **Dwiggins, Don.** Hollywood Pilot: The Biography of Paul Mantz. New York: Doubleday & Co., 1967. 249 p., illus.

This biography of Hollywood's most publicized stunt flyer emphasis aviation rather than filmmaking. Mantz was killed in a "simulated" plane crash while filming *Flight of the Phoenix* (1965).

MARCH, FREDERIC

O1075. **Quirk, Lawrence J.** The Films of Frederic March. New York: Citadel Press, 1971. 255 p., illus.

The careers of Frederic March on screen and stage are covered by this picture book. A long biographical essay introduces the chronological review of March's films from *The Dummy* (1929) to *Tick ... Tick ... Tick ...* (1970). For each film, cast, production credits, a plot outline, and review excerpts are noted. A final section lists the eighteen stage plays that March appeared in from 1920 to 1961.

MARION, FRANCES

O1076. **Marion, Frances.** Off with Their Heads. New York: Macmillan Co., 1972. 356 p., illus.

An autobiography that has been carefully laundered into a Hays Office approved script. The author was a Hollywood scriptwriter for several decades (1916 to 1953) and had a rich experience upon which to draw. The development of Hollywood and its many colorful personalities are recalled in a flat, bland narrative. The sharply reproduced photographs add dimension to the volume. A Marion filmography of 137 titles completes this well-intentioned volume. Index.

THE MARX BROTHERS

O1077. **Adamson, Joe.** Groucho, Chico, Harpo, and Sometimes Zeppo. New York: Simon & Schuster, 1973. 512 p., illus.

A collective biography of the Marx Brothers, with emphasis on the film years from 1929 to 1939. It includes script excerpts, reviews, gossip, and anecdotes in addi-

tion to the author's commentary and evaluation. Coincidentally, a portrait of Hollywood in the thirties is presented. A bibliography and many pleasant visuals accompany the text.

O1078. Anobile, Richard J., ed. Why a Duck? Greenwich, Conn.: New York Graphic Society, 1971. 288 p., illus.

Using several hundred frame enlargements and accompanying dialogue excerpts, this volume recreates some classic sequences from nine early Marx Brothers films.

O1079. Crichton, Kyle. The Marx Brothers. Garden City, N.Y.: Doubleday, 1950. 310 p., illus.

The early lives and careers of the Marx family, including Mother Minnie and Father Frenchy. Ending in 1928 just as the Brothers were entering films, the book does indicate the emergence and development of their individual and collective style.

O1080. Eyles, Allen. The Marx Brothers: Their World of Comedy. New York: A. S. Barnes, 1966. 175 p., illus.

Each of the Marx Brothers' films is described in detail, with plots, generous dialogue excerpts, descriptions of comedy routine, visual gags, and verbal puns recalled. In addition to some biographical background material, a good selection of visuals, a bibliographical, and a filmography are included. Paperback.

O1081. Marx, Groucho, and Anobile, Richard J. The Marx Bros. Scrapbook. New York: Darien House, 1973. 256 p., illus.

A recollection of the Marx Brothers and a fully detailed portrait of the present day Groucho Marx are provided here. Groucho's memories, comments, and opinions have been recorded in several interviews, transcribed, edited, and reprinted here. Other individuals who knew the Marxes have also been questioned; their comments provide alternate chapters. The illustrations are outstanding and include stills, candids, publicity shots, song sheets, posters, and programs. Groucho's language is vulgar; his portrait is negative; but the book is fascinating.

O1082. Zimmerman, Paul D., and Goldblatt, Burt. The Marx Brothers at the Movies. New York: G. P. Putnam's Sons, 1968. 224 p., illus.

The thirteen films of the Marx Brothers are described in detail here by text and over two hundred illustrations. Original dialogue, frame enlargements, descriptions of physical action, critical reviews, and factual data are offered for each. Picture quality is uneven.

MARX, GROUCHO

O1083. Marx, Arthur. Life with Groucho. New York: Simon & Schuster, 1954. 310 p.

A son's account of what life is like with the most verbal Marx Brother. A somewhat softened view of Groucho

when compared with the later book *Son of Groucho* [O1084].

O1084. Marx, Arthur. Son of Groucho. New York: David McKay Co., 1972. 357 p., illus.

A disillusioning portrait of Groucho Marx by his son. The relationship between a difficult celebrity-father and his male offspring is detailed here in a mixture of sadness and humor. A few pictures of the pair are included in a center section. [*See* O1083.]

MARX, HARPO

O1085. Marx, Harpo, and Barber, Rowland. Harpo Speaks. New York: Avon Books, 1961. 384 p., illus.

Harpo's autobiography concentrates on his early life and on the personalities of the literary Algonquin set who adopted him. Film work is not emphasized. The visuals are not especially helpful. Paperback.

MAYER, ARTHUR

O1086. Mayer, Arthur. Merely Colossal. New York: Simon & Schuster, 1953. 264 p., illus.

During the twenties and thirties Mayer worked for the film industry in several capacities. This biography is made up of anecdotes and comments about his experiences at that time. A joking, exaggerated exposition weakens the text. The illustrations are cartoons that help little.

MAYER, LOUIS B.

O1087. Crowther, Bosley. Hollywood Rajah: The Life and Times of Louis B. Mayer. New York: Holt, Rinehart & Winston, 1960. 339 p., illus.

The life of Louis B. Mayer (1882–1957) is related in this unsympathetic biography that emphasizes his long tenure as head of the Metro-Goldwyn-Mayer studios. The relationships between Mayer and his stars are discussed, but Mayer's influential role throughout the industry is slighted. The illustrations are fine, and the detailed index is most useful.

O1088. Marx, Samuel. Mayer and Thalberg: The Make-Believe Saints. New York: Random House, 1975. 273 p., illus.

Written by a story editor for Metro-Goldwyn-Mayer, this volume concentrates on the personal and professional relationships between Louis B. Mayer and Irving Thalberg from 1923 to 1936. Since much of the background material in the book concerns the stars and films of that period, the emergence of the Metro-Goldwyn-Mayer Studio as a major Hollywood institution is also depicted.

MENJOU, ADOLPHE

O1089. Menjou, Adolphe, and Musselman, M. M.

IT TOOK NINE TAILORS. New York: Whittlesey House, 1948. 238 p., illus.

A fine biography that describes Hollywood filmmaking from the twenties to the forties. Menjou played a leading role in Chaplin's *A Woman of Paris* (1923), and his account of making that film is included.

MERMAN, ETHEL

O1090. **Merman, Ethel, and Martin, Pete.** WHO COULD ASK FOR ANYTHING MORE? Garden City, N.Y.: Doubleday, 1955. 252 p.

An early biography of a musical comedy star who never achieved similar success in films. Merman relates some of her experiences in films from a few Warner Brothers shorts in 1929 to *There's No Business Like Show Business* (1955).

MILLAND, RAY

O1090a. **Milland, Ray.** WIDE-EYED IN BABYLON: AN AUTOBIOGRAPHY. New York: William Morrow, 1974. 288 p., illus.

An autobiography that is as bland, passive, and frail as most of its subject's screen performances. The path from a Welsh boyhood to film actor is related in an anemic text. Concentrating on youth and early manhood, Milland mentions only a few of his two hundred films in passing and curtails his story in 1946 with the Academy Award for *The Lost Weekend* (1945). A few illustrations do not help this disappointing memoir, but it is the only one available at this writing.

MILLER, ANN

O1091. **Miller, Ann, and Browning, Norma Lee.** MILLER'S HIGH LIFE. Garden City, N.Y.: Doubleday, 1972. 283 p., illus.

A biography of a durable tap dancer whose career in Hollywood spanned three decades. Written in a fan magazine style, the text is helped by thirty-six pages of photographs.

MILLER, ARTHUR C.

O1091a. **Balshofer, Fred J. and Miller, Arthur C.** ONE REEL A WEEK. Berkeley: University of California Press, 1967. 218 p., illus.
[See O827.]

MILLER, VIRGIL E.

O1092. **Miller, Virgil E.** SPLINTERS FROM HOLLYWOOD TRIPODS. New York: Exposition Press, 1964. 139 p., illus.

A short, rambling memoir of a Hollywood cameraman. Aside from some description of his work with Lon Chaney, he tells little of his Hollywood experience and offers poems and other literary efforts instead. The illustrations are acceptable.

MINNELLI, VINCENTE

O1092a. **Minnelli, Vincente, and Arce, Hector.** I REMEMBER IT WELL. Garden City, N.Y.: Doubleday, 1974. 391 p., illus.

This is a stylish and tasteful autobiography of Vincente Minnelli that concentrates mostly on the making of his thirty-five feature films. Modest about his own achievements, he is also kind, considerate, and admiring about the women in his private life: Judy Garland, Liza Minnelli, Denise Minnelli, and others. Good illustrations and a lengthy index are most helpful, but a filmography would have been preferable to the film listing offered here.

MITCHUM, ROBERT

O1093. **Tomkies, Mike.** THE ROBERT MITCHUM STORY. Chicago: Henry Regnery Co., 1972. 271 p., illus.

A fascinating biography of a film star who is never quite what he seems. The mysterious charismatic appeal of Mitchum is at least a bit clearer as a result of the author's text, but Mitchum's many witty, intelligent comments provide its true strength. The films are given appropriate attention in the narrative and in a filmography. The few illustrations provided are satisfactory. Index.

MIX, TOM

O1094. **Mix, Olive Stokes, and Heath, Eric.** THE FABULOUS TOM MIX. Englewood Cliffs, N.J.: Prentice-Hall, 1957. 177 p., illus.

This partial biography gives some description of the production of the Tom Mix Western films during the silent era. More attention is paid to circuses, rodeos, roping stunts. The illustrations are adequate.

O1095. **Mix, Paul E.** THE LIFE AND LEGEND OF TOM MIX. New York: A. S. Barnes, 1972. 206 p., illus.

A detailed biography that is overwhelmed by the author's research and devotion to his subject. Facts, quotations, statistics, and historical references attest to the integrity of the book. The critical evaluations are weak, and the personal charisma of Tom Mix is not properly presented. Poor reproduction defeats the selection of 125 unusual photographs. A filmography is listed; some microfilm resources are noted. Index.

MONROE, MARILYN

O1096. **Conway, Michael, and Ricci, Mark.** THE FILMS OF MARILYN MONROE. New York: Citadel Press, 1964. 160 p., illus.

Marilyn Monroe appeared in twenty-eight films, considered individually here. The usual information—cast, credits, plot, critical comments—is given for each, along

with some familiar stills. A biographical essay and a tribute complete the contents of this uninspired recital.

O1097. **Guiles, Fred Lawrence.** NORMA JEAN: THE LIFE OF MARILYN MONROE. New York: McGraw-Hill Book Co., 1969. 341 p., illus.

A biography of the personal life and career of Monroe based on interviews and research. Much detail is presented in documentary fashion. A few pictures and an index complete this sympathetic portrait.

O1098. **Hoyt, Edwin P.** MARILYN: THE TRAGIC VENUS. New York: Duell, Sloan & Pearce, 1965. 279 p., illus.

A biography based on interviews with persons who knew Monroe. The author's initial lack of knowledge about her films and the fact that certain key figures in her life did not cooperate weakens the sympathetic portrait evoked here. Index.

O1098a. **Kobal, John, ed.** MARILYN MONROE. New York: Hamlyn Publishing, 1974. 176 p., illus.

A collection of Monroe photographs that gives further evidence of the love affair between the actress and the camera. Fine photo reproduction and a connecting text. Filmography; bibliography; discography; index.

O1099. **Mailer, Norman.** MARILYN: A BIOGRAPHY. New York: Grosset & Dunlap, 1973. 270 p., illus.

A controversial biography, supplemented by many attractive, unusual, and beautifully reproduced illustrations. The text is well written, but its content is similar to that found in earlier volumes on Monroe. The more than one hundred visuals, including many in color, offer a better review of Monroe's life and career.

O1100. **Mellen, Joan.** MARILYN MONROE. New York: Pyramid Publications, 1973. 157 p., illus.

An exploration of the Marilyn Monroe legend in terms of her private life and public image. Major attention is given to her roles in *Bus Stop* (1956) and *The Misfits* (1961). Much of the real Monroe is reflected in these two characterizations. The analysis of Monroe's screen roles and her personal experiences is offered by Mellen with insight and intelligence. The visuals are most helpful. Bibliography; filmography; index. Paperback.

O1101. **Rosten, Norman.** MARILYN: AN UNTOLD STORY. New York: Signet Books, 1973. 125 p., illus.

An affectionate memoir of Marilyn Monroe. During the last seven years of her life, Rosten was a personal friend and confidant of the actress. In this short volume, he recalls incidents which reveal simple, positive, honest qualities about Monroe that are not obvious in the other biographies. Some candid photographs help to define the subject and her relationship to the author. Paperback.

O1102. **Wagenknecht, Edward, ed.** MARILYN MONROE: A COMPOSITE VIEW. New York: Chilton Book Co., 1969. 200 p., illus.

This character portrait of Marilyn Monroe was created

by assembling a collection of articles, essays, and comments on the actress. The resulting portrait is incomplete and partial since it derives from so many unconnected statements. A few routine illustrations are added.

O1103. **Zolotow, Maurice.** MARILYN MONROE. New York: Harcourt, Brace & Co., 1960. 340 p., illus.

A fine biography written with the subject's cooperation is presented here. Not only is the personal life of Monroe described, but her films are given explanation and evaluation. The text has been carefully researched and written. The photographs used are mostly unfamiliar.

MOORE, COLLEEN

O1104. **Moore, Colleen.** SILENT STAR. Garden City, N.Y.: Doubleday, 1968. 262 p., illus.

An autobiography of a well-known silent film star. In a factual, objective recollection of her career, the author concentrates on Hollywood from 1915 to 1930. Numerous anecdotes are used to describe personalities of the period. Some attractive visuals are added to this fascinating memoir.

MOORE, GRACE

O1105. **Moore, Grace.** YOU'RE ONLY HUMAN ONCE. Garden City, N.Y.: Doubleday, 1944. 275 p.

An autobiography of the opera singer who had a brief success as a Hollywood star. Two chapters are devoted to her experiences in Hollywood during the thirties.

MUNI, PAUL

O1105a. **Druxman, Michael B.** PAUL MUNI: HIS LIFE AND FILMS. New York: A. S. Barnes, 1974. 229 p., illus.

A biography and a review of Paul Muni's films are provided in this bland volume. Its importance is found in the detailed coverage of Muni's twenty-three feature films. The illustrations are acceptable.

O1105b. **Lawrence, Jerome.** ACTOR: THE LIFE AND TIMES OF PAUL MUNI. New York: G. P. Putnam's Sons, 1974. 380 p., illus.

An objective portrait of Paul Muni that shows both his weaknesses and strengths. Muni's devotion and dedication to acting is stressed. Based on a personal acquaintance with the actor, the book is packed with detail and anecdote. The author's treatment of his well-researched material is outstanding. The visuals are intelligently selected and well reproduced in this excellent biography. Index.

MURPHY, GEORGE

O1106. **Murphy, George, and Lasky, Victor.** "SAY ... DIDN'T YOU USED TO BE GEORGE MURPHY?" New York: Bartholomew House, 1970. 438 p., illus.

An autobiography of a song-and-dance actor who became a United States senator from California. The right Republican viewpoint is promoted throughout. Accounts of his films and co-workers are informative and most enjoyable, but they get somewhat lost in the political hard-sell. Some uninteresting photos; index.

MURRAY, MAE

O1107. **Ardmore, Jane.** THE SELF-ENCHANTED: MAE MURRAY, IMAGE OF AN ERA. New York: McGraw-Hill Book Co., 1959. 262 p., illus.

An outstanding biography of a silent film personality. Written with compassion and intelligence, it describes Mae Murray's rise from chorus girl to film star. Many anecdotes make her description of Hollywood during the twenties most fascinating. Excellent visuals are provided.

MUYBRIDGE, EADWEARD

O1107a. **Hendricks, Gordon.** EADWEARD MUYBRIDGE, THE FATHER OF THE MOTION PICTURE. New York: Grossman Publishers, 1975. 271 p., illus.

Gordon Hendricks has drawn a minutely detailed portrait of Eadweard Muybridge in this fine volume. His studies on motion, the photographic work, a murder trial, and his final years are interpreted from information obtained from primary sources. Nearly two hundred rare visuals complement the impressive research. A rich contribution to film history.

O1108. **MacDonnell, Kevin.** EADWEARD MUYBRIDGE: THE MAN WHO INVENTED THE MOVING PICTURE. Boston: Little, Brown & Co., 1972. 158 p., illus.

Although he was an Englishman, Muybridge spent many years in America as a photographer, writer, inventor, and speaker. His discoveries in animal and human locomotion and in pictorial representation of it are recounted in this volume, along with other biographical data and incident. Several appendixes and a bibliography are included. The visuals are most helpful in comprehension of the man, his work, and the period.

NEGRI, POLA

O1109. **Negri, Pola.** MEMOIRS OF A STAR. Garden City, N.Y.: Doubleday, 1970. 453 p., illus.

The author looks at her life and career with all the subjectivity that is usually associated with a superstar of the silent screen. However, her description of Hollywood in the twenties is informative and most entertaining. The illustrations are quite good and evocative of the period.

NEWMAN, PAUL

O1109a. **Kerbel, Michael.** PAUL NEWMAN. New York: Pyramid Publications, 1974. 160 p., illus.

A critical account of Paul Newman's film career forms the substance of this volume. After a short personality sketch, his films from *The Silver Chalice* (1954) to *The Sting* (1973) are reviewed. His ability as a film director is considered, and there are many illustrations of high quality from his films. Bibliography; filmography; list of stage appearances; index.

O1110. **Quirk, Lawrence.** THE FILMS OF PAUL NEWMAN. New York: Citadel Press, 1971. 224 p., illus.

A rather interesting introductory essay precedes a listing of Newman's films in this somewhat premature volume. The actor is in his forties and is still most active in filmmaking. The films are presented with stills, cast, credits, critical excerpts, and plot outlines. More than four hundred photographs show Newman in both public and private life and as a subject for a portrait gallery.

NICHOLSON, JACK

O1110a. **Crane, Robert David, and Fryer, Christopher.** JACK NICHOLSON FACE TO FACE. New York: M. Evans & Co., 1975. 192 p., illus.

An appreciative biography of Jack Nicholson, derived from interviews with the subject, acquaintances, and coworkers. A filmography and a varied selection of visuals support the colorful portrait.

O1110b. **Henstell, Bruce, ed.** CHARLTON HESTON, JACK NICHOLSON. Washington, D.C.: American Film Institute, 1972. 31 p.

[*See* O1005.]

NIVEN, DAVID

O1111. **Niven, David.** THE MOON'S A BALLOON. New York: G. P. Putnam's Sons, 1972. 380 p., illus.

A popular autobiography of an English actor who became a Hollywood star. Much of his life is related in detail, but he largely ignores his films. He does, however, mention many of the famous personalities he met during his days as film star. Most pleasant is his view of himself as a person with a minimal talent who parlayed it into a long career. The photographs, like the text, deal with personal matters and as such are satisfactory. Index.

O'BRIEN, PAT

O1112. **O'Brien, Pat.** THE WIND AT MY BACK. New York: Avon Books, 1967. 286 p., illus.

A fine autobiography of an actor from the Warner Brothers stock company. Pat O'Brien was never a leading star, but he made many films during his career. When film work ended around 1950, he changed his image from feature actor to professional Irishman for TV and the stage. A detailed portrait of filmmaking at Warners in the thirties and forties is accompanied by opinion, observation, and anecdotes. The few pictures are negligible. Paperback.

OPPENHEIMER, GEORGE

O1113. **Oppenheimer, George.** THE VIEW FROM THE SIXTIES. New York: David McKay Co., 1966. 273 p.

A rambling autobiography that includes a long reminiscence of Hollywood during the 1935–1945 period. The author was a scriptwriter employed by the MGM, Columbia, and Goldwyn Studios. He recalls filmmaking during the World War II era. In 1955 the author became drama critic for *Newsday* (Long Island). Index.

PARSONS, LOUELLA O.

O1113a. **Eels, George.** HEDDA AND LOUELLA. New York: G. P. Putnam's Sons, 1972. 360 p., illus.
[*See* O1014.]

O1114. **Parsons, Louella O.** THE GAY ILLITERATE. Garden City, N.Y.: Garden City Publishing Co., 1944. 194 p.

An early autobiography of a powerful Hollywood gossip columnist. Subjective, opinionated comments about Hollywood personalities and many self-serving anecdotes characterize the writing. Some of her observations, written in the forties, are now embarrassing.

O1115. **Parsons, Louella.** TELL IT TO LOUELLA. New York: G. P. Putnam's Sons, 1961. 316 p., illus.

A second autobiography by Hollywood's most powerful gossip columnist, this volume covers the period of declining influence that began in the fifties. The illustrations and text are below average but reflect the period in which Parsons held power.

PASTERNAK, JOE

O1116. **Pasternak, Joe.** EASY THE HARD WAY. London: W. H. Allen, 1956. 224 p., illus.

The impressive career of a film producer who specialized in musicals is recorded in this "story book" autobiography. Pasternak discusses his tenure at Universal and Metro and comments on the many talented actors who starred in his films. The humble, happy ending approach typical of most musicals is also used in this volume. Some uninspired visuals offer little help.

PECKINPAH, SAM

O1117. **Evans, Max.** SAM PECKINPAH: MASTER OF VIOLENCE. Vermillion, S. Dak.: Dakota Press, 1972. 92 p., illus.

A collection of materials about a controversial American director. Written during the making of *The Ballad of Cable Hogue* (1970), the book contains anecdotes and comments about Peckinpah and descriptions of his filmmaking techniques. A brief survey of his other films is provided in the introductory section and by a group of unimpressive stills.

PENN, ARTHUR

O1118. **Wood, Robin.** ARTHUR PENN. New York: Praeger Publishers, 1970. 144 p., illus.

A critical survey of Arthur Penn's films, this volume examines in depth each one from *The Left Handed Gun* (1958) to *Little Big Man* (1970). Picture reproduction is poor. There is a filmography, which also includes Penn's television work. Paperback.

PETERS, JEAN

O1119. **Strait, Raymond.** MRS. HOWARD HUGHES. Los Angeles: Holloway Publishing Co., 1970. 244 p., illus.

A biography of film actress Jean Peters that emphasizes her Hollywood years. Many fine illustrations. Paperback.

PICKFORD, MARY

O1120. **Cushman, Robert B.** TRIBUTE TO MARY PICKFORD. Washington, D.C.: American Film Institute, 1970. 20 p., illus.

A factual and critical essay about Mary Pickford's career introduces this informative booklet. Film notes are offered on nine of her best known feature films. The complete Pickford filmography of 141 short films and 52 features concludes this affectionate look at Mary Pickford. The illustrations are well selected and reproduced. Paperback.

O1121. **Lee, Raymond.** THE FILMS OF MARY PICKFORD. New York: A. S. Barnes, 1970. 175 p., illus.

This poorly produced volume covers 125 short films and 52 features. A good introduction by Edward Wagenknecht cannot overcome poor picture reproduction, missing film information, and lamentable design. The book will have to be used, however, until a better one is published.

O1122. **Niver, Kemp R.** MARY PICKFORD, COMEDIENNE. Los Angeles: Locare Research Group, 1969. 156 p., illus.

The many rare illustrations provide a record of some of the films Mary Pickford made at the Biograph studios from 1909 to 1912. Plot outlines for thirty-seven films are given.

O1123. **Pickford, Mary.** SUNSHINE AND SHADOW. Garden City, N.Y.: Doubleday, 1955. 382 p., illus.

A solid autobiography of America's sweetheart. Pickford is not only aware of her position in motion picture history, but she understands her own strengths and weaknesses as a performer. Some fine illustrations accompany this very business-like account of a most unusual life and career.

O1123a. **Windeler, Robert.** SWEETHEART: THE STORY OF MARY PICKFORD. New York: Praeger Publishers, 1974. 268 p., illus.

FILMMAKERS: ACTORS, ACTRESSES, DIRECTORS, PRODUCERS, WRITERS, PERSONALITIES

An unofficial biography of Mary Pickford, based on interviews, and public records, but written without the cooperation of the subject. The book lacks objectivity in its approach to an ambitious, intelligent actress. Descriptions of early filmmaking in New York and Hollywood are stronger than the biographical content. Good illustrations; filmography; index.

POITIER, SIDNEY

O1124. **Ewers, Carolyn H.** SIDNEY POITIER: THE LONG JOURNEY. New York: Signet Books, 1969. 126 p., illus.

A worshipful biography of Poitier that presents him as a hero of great proportions. The factual content is more helpful than the analysis and is aided by twenty-four pages of good photographs. Paperback.

O1125. **Hoffman, William.** SIDNEY. New York: Lyle Stuart, 1971. 175 p., illus.

A superficial and unofficial biography that accents Poitier's climb toward success. The text consists mostly of familiar material taken from public sources, blended with the opinions of the author. Some ordinary illustrations are added.

PORTER, COLE

O1126. **Eels, George.** THE LIFE THAT LATE HE LED. New York: Berkley Publishing, 1967. 447 p., illus.

A biography of a popular composer whose songs were constantly used by Hollywood. Some attention is given here to Porter's original film scores and to the film adaptations of many of his stage musicals. A diary of his first trip to Hollywood to prepare *Born to Dance* (1936) is included. A Cole Porter chronology is added. Index.

PREMINGER, OTTO

1126a. **Frischauer, Willi.** BEHIND THE SCENES OF OTTO PREMINGER. West Caldwell, N.J.: William Morrow, 1974. 279 p., illus.

An unauthorized biography of Otto Preminger, written by a friend of long standing. The emphasis is on personal matters rather than Preminger's films, although his directorial methods are noted. The selection of the material is subjective, with some major omissions. Bibliography; filmography; a few production shots; index.

O1127. **Pratley, Gerald.** THE CINEMA OF OTTO PREMINGER. New York: A. S. Barnes, 1971. 191 p., illus.

This guide to the films of Otto Preminger contains extensive interview material in the first section concerning his biography, general comments, and philosophy. In the lengthy filmography that follows, Preminger's comments about each film are placed after the credits and a plot synopses. His stage productions are also noted. Many illustrations are too small to be effective. Paperback.

PRESLEY, ELVIS

O1128. **Hopkins, Jerry.** ELVIS. New York: Simon & Schuster, 1971. 448 p., illus.

An unauthorized biography that recalls all the published facts and material in fan magazine style. Many photographs; filmography; discography.

PRICE, VINCENT

O1128a. **Parish, James Robert, and Whitney, Steven.** VINCENT PRICE UNMASKED. New York, Drake, 1974. 296 p., illus.

Vincent Price is best known for his films although he has worked in the theater, in radio, on TV, as an art collector, and as an author. All aspects of his professional and private life are covered here in a factual, non-interpretive fashion. The biographical portions are bland; the book's value rests largely in the copious career information provided. Some visuals are included, but the absence of an index is a major disappointment.

QUINN, ANTHONY

O1129. **Quinn, Anthony.** THE ORIGINAL SIN. Boston: Little, Brown & Co., 1972. 311 p.

A partial autobiography that emphasizes the pre-screen years. The author uses psychiatric sessions and the literary metaphor of an eleven-year-old boy to represent his years of immaturity. In candid language, Quinn tells of his life as a Chicano and his early career in show business. Episodes that deal with making *The Plainsman* (1935) and with studio salary negotiations are memorable.

RAFT, GEORGE

O1129a. **Yablonski, Lewis.** GEORGE RAFT. New York: McGraw-Hill Book Co., 1974. 289 p., illus.

In this authorized biography George Raft is characterized as an easy going, pleasant man who might have preferred some other career than that of film star. The contrast of the personal man with the screen image makes a fascinating study. Filmography; bibliography; index.

RATHBONE, BASIL

O1129b. **Druxman, Michael B.** BASIL RATHBONE: HIS LIFE AND HIS FILMS. New York: A. S. Barnes, 1975. 256 p., illus.

A mild biography precedes a review of Basil Rathbone's films from *Innocent* (1921) to *Hillbillys in a Haunted House* (1967). The usual data, credits, synopsis, critical excerpts, and background material are given for each film, along with a few stills.

O1130. **Rathbone, Basil.** IN AND OUT OF CHARACTER. Garden City, N.Y.: Doubleday, 1962. 278 p., illus.

Rathbone's preference for theater over film is shown throughout this autobiography. Scant attention is given to his films, and most of his comments about motion pictures are negative. The photographs are unimpressive.

REAGAN, RONALD

O1131. **Reagan, Ronald, and Hubler, Richard G.** WHERE'S THE REST OF ME? THE RONALD REAGAN STORY. New York: Duell, Sloan & Pearce, 1965. 316 p.

An autobiography of a film actor who became governor of California. Much attention is given to his early film career and his work with the Screen Actors Guild. A portrait of Hollywood in the thirties and forties is drawn in detail. Later sections deal with television and politics. Index.

ROACH, HAL

O1132. **Everson, William K.** THE FILMS OF HAL ROACH. New York: Museum of Modern Art, 1970. 96 p., illus.

This short, excellent survey does not consider all of the two thousand films that Roach was concerned with in some capacity. Instead, some critical analysis of the comedy techniques found in the films is offered, along with biographical information and an interview with Roach. Some forty illustrations; bibliography. Paperback.

ROBINSON, EDWARD G., SR.

O1132a. **Hirsch, Foster.** EDWARD G. ROBINSON. New York: Pyramid Publications, 1975. 160 p., illus.

A short exploration of the screen character that Edward G. Robinson developed introduces this appreciation. Divided into the decades from the thirties to the sixties, Robinson's eighty-seven films are described and examined critically. More attention is paid to his performance than to the over-all quality of the films. Bibliography, filmography, an index, and many fine illustrations accompany these analyses.

O1133. **Parish, James Robert, and Marill, Alvin H.** THE CINEMA OF EDWARD G. ROBINSON. New York: A. S. Barnes, 1972. 270 p., illus.

A pictorial survey of the career and films of Edward G. Robinson. The usual biographical essay is followed by a listing of his stage appearances. Each of his 86 films from *The Bright Shawl* (1923) to *Song of Norway* (1970) is described. Short sections on radio and television roles are appended. Picture quality is acceptable for the most part.

O1134. **Robinson, Edward G., and Spigelgass, Leonard.** ALL MY YESTERDAYS. New York: Hawthorn Books, 1973. 344 p., illus.

A fine autobiography of an actor whose screen image was not an extension of his own personality. A gentle, sensitive man who amassed a famous art collection, Robinson wrote most of this volume before he died in 1973; Leonard Spigelgass completed the account. Robinson dis-

cusses his film roles in some detail and is generous in praising his co-workers from the Warner Brothers stock company. Two sections of illustrations and a list of Robinson's stage appearances complete the book. Index.

ROBINSON, EDWARD G., JR.

O1135. **Robinson, Edward G., Jr., and Duffy, William.** MY FATHER—MY SON. New York: Popular Library, 1958. 237 p.

This autobiography of Edward G. Robinson, Jr., describes childhood and adolescence in Hollywood in the thirties and forties. Affluence and a famous father are factors in the author's rebellious early years. Written in a raw, sensationalized style, the book does present a portrait of Edward G. Robinson, Sr., and Hollywood in the golden era. Paperback.

ROGERS, GINGER

O1135a. **Croce, Arlene.** THE FRED ASTAIRE/GINGER ROGERS MOVIE BOOK. New York: E. P. Dutton & Co., 1971. 192 p., illus.
[*See* O820.]

O1136. **Richards, Dick.** GINGER: SALUTE TO A STAR. Brighton, England: Clifton Books, 1969. 192 p., illus.

An unauthorized biography, this volume is a recital of previously published information, diluted by an adoring, worshipful approach. The filmography is good, but the illustrations are ordinary. Index.

ROGERS, WILL

O1137. **Croy, Homer.** OUR WILL ROGERS. New York: Duell, Sloane & Pearce, 1953. 377 p.

A good biography of Will Rogers. The author, who met Rogers when he was making his first sound film *They Had to See Paris* (1929), discusses Rogers's work in both silent and sound films in some detail. In addition, other aspects of Rogers's life are noted. The sources for Croy's text are listed in the appendix. Index.

O1138. **Day, Donald.** WILL ROGERS. New York: David McKay Co., 1962. 370 p., illus.

A good biography that has only one short chapter on Rogers's sound films.

O1139. **Ketchum, Richard M.** WILL ROGERS: THE MAN AND HIS TIMES. New York: American Heritage Press, 1972. 448 p., illus.

A biography of Rogers that includes over four hundred illustrations and a recording. Rogers's film work is covered by both text and photographs.

O1140. **O'Brien, P. J.** WILL ROGERS: AMBASSADOR OF GOOD WILL, PRINCE OF WIT AND WISDOM. Chicago: John C. Winston Co., 1936. 288 p., illus.

A comprehensive biography that has one chapter tracing

Rogers's films from *Laughing Bill Hyde* (1919) to *Steamboat Round the Bend* (1935). The visuals are effective in recreating this era.

O1141. **Rogers, Betty.** WILL ROGERS: HIS WIFE'S STORY. Indianapolis: Bobbs-Merrill Co., 1941. 312 p., illus.

A biography of Will Rogers, written by his wife. She discusses his film career from the silents to the mid-thirties, with major emphasis given to the early films. Only a few illustrations accompany this detailed and affectionate memoir.

ROONEY, MICKEY

O1142. **Rooney, Mickey.** I.E.: THE AUTOBIOGRAPHY OF MICKEY ROONEY. New York: G. P. Putnam's Sons, 1965. 249 p., illus.

In this frank autobiography, Rooney recalls mostly the thirties and forties when he was at the height of his popularity with American audiences. Philosophical about his good and bad fortunes, he remains dispassionate and objective in what he chooses to reveal of himself. The few illustrations are unimpressive.

ROSSEN, ROBERT

O1143. **Casty, Alan.** THE FILMS OF ROBERT ROSSEN. New York: Museum of Modern Art, 1969. 95 p., illus.

A brief but excellent overview of Rossen and his films is presented here. The opening biographical essay includes analyses of the films; the closing section is a chronological catalog. Cast and production credits are noted for each film. Short bibliography.

RUSSELL, ROSALIND

O1143a. **Yanni, Nicholas.** ROSALIND RUSSELL. New York: Pyramid Publications, 1975. 160 p., illus.

A survey of Russell's films from *Evelyn Prentice* (1934) to *Mrs. Pollifax—Spy* (1971), this volume offers some fine visuals and a critically objective text. Bibliography; filmography; index.

SANDERS, GEORGE

O1144. **Sanders, George.** MEMOIRS OF A PROFESSIONAL CAD. New York: G. P. Putnam's Sons, 1960. 192 p., illus.

More philosophical rambling than straightforward biography, this book does discuss some of Sanders's films. The fragmented text is a blend of witty cynicisms, in keeping with the author's public image. The photographs are poorly selected.

SCOTT, AUDREY

O1145. **Scott, Audrey.** I WAS A HOLLYWOOD STUNT GIRL. Philadelphia: Dorrance & Co., 1969. 119 p.

A short autobiography of a performer who has doubled for many famous female stars. The narrative is spare and consists mostly of descriptions of her most dangerous stunts and discussions of her leisure-time interests.

SCOTT, EVELYN F.

O1146. **Scott, Evelyn F.** HOLLYWOOD WHEN SILENTS WERE GOLDEN. New York: McGraw-Hill Book Co., 1972. 223 p., illus.

A description of life in Hollywood from 1916 to 1930. The author's mother was a screenwriter, and this innocent memoir recalls many famous names and incidents of the period with much naiveté. Growing up with the De Mille, Fairbanks, and Lasky families is described in the antiseptic text. The pictures are disappointing.

SEASTROM, VICTOR

O1147. **Pensel, Hans.** SEASTROM AND STILLER IN HOLLYWOOD. New York: Vantage Press, 1969. 106 p., illus.

An attempt to give recognition to the contributions to the silent film, between 1923 and 1930, of the Swedish directors Victor Seastrom and Mauritz Stiller. Good photographs; separate filmographies; bibliography.

SELZNICK, DAVID O.

O1148. **Behlmer, Rudy, ed.** MEMO FROM DAVID O. SELZNICK. New York: Viking Press, 1972. 518 p., illus.

A selection of the writing of David O. Selznick, chosen from the vast reservoir left by the producer. Included are letters, telegrams, notes, memos, etc. Arranged chronologically and edited, they provide, not only a portrait of the author, but also a firsthand description of Hollywood studio life in the thirties and forties. The appendixes include a Selznick lecture and a cast of the characters mentioned in the text. Several groups of fine illustrations are provided. Behlmer's contribution in selection, arrangement, and editing is most impressive. Index.

O1149. **Thomas, Bob.** SELZNICK. Garden City, N.Y.: Doubleday, 1970. 361 p., illus.

A well-researched biography that includes material about Myron and Lewis Selznick in addition to David. Using incident, anecdote, and gossip, the author offers a general history of Hollywood in telling the Selznicks' story. The 147 illustrations are good. Filmography; index.

SENNETT, MACK

O1150. **Fowler, Gene.** FATHER GOOSE: THE STORY OF MACK SENNETT. New York: Covici-Friede, 1934. 407 p., illus.

An early biography, written with style, affection, and compassion. Many familiar names of the silent screen populate the narrative, and the total portrait of Sennett is most satisfying. The clearly reproduced visuals are fascinating.

O1151. **Sennett, Mack, and Shipp, Cameron.** KING OF COMEDY: MACK SENNETT. London: Peter Davies, 1965. 284 p., illus.

Based in part on interviews, this autobiography is composed of the memoirs of an elderly man and a factual account of a film career. Emphasis is on personal affairs rather than analysis of films or style. The photographs are very disappointing.

SILVERS, PHIL

O1152. **Silvers, Phil, and Saffron, Robert.** THIS LAUGH IS ON ME: THE PHIL SILVERS STORY. Englewood Cliffs, N.J.: Prentice-Hall, 1973. 276 p., illus.

An autobiography that touches the many careers and the personal life of Phil Silvers. The general theme of the book is that Silvers was usually happier on stage than off. In addition to motion pictures, Silvers has been a performer in vaudeville, burlesque, radio, theater, and television. His films from *Tom, Dick, and Harry* (1942) to *Boatniks* (1970) are treated in some detail. Two sections of visuals are adequate in selection and reproduction.

SINATRA, FRANK

O1153. **Douglas-Home, Robin.** SINATRA. New York: Grosset & Dunlap, 1962. 64 p., illus.

A short profile of Sinatra as he was in 1961. A very entertaining text, combined with some well chosen photographs, describes Sinatra's talent and charisma.

O1154. **Lonstein, Albert I., and Marino, Vito R.** THE COMPLETE SINATRA. Monroe, N.Y.: Library Research Association, 1970. 388 p., illus.

An unusual reference book that deals in detail with the many careers of Frank Sinatra. The film section begins with his first short film in 1935 and gives data and a synopsis of each film up to *Dirty Dingus Magee* (1970). The illustrations are well selected and include candids, publicity shots, and stills.

O1155. **Ringgold, Gene, and McCarty, Clifford.** THE FILMS OF FRANK SINATRA. New York: Citadel Press, 1971. 249 p., illus.

A pictorial survey of Frank Sinatra's career in films. A factual biography introduces the filmography, which covers the period from *Las Vegas Nights* (1941) to *Dirty Dingus Magee* (1970). Cast, credits, stills, plot, and review excerpts are provided for each. Short film appearances are noted at the book's end. Most of the four hundred photographs are well reproduced, but some are poorly selected.

O1156. **Shaw, Arnold.** SINATRA: TWENTIETH-CENTURY ROMANTIC. New York: Holt, Rinehart & Winston, 1968. 371 p., illus.

An unofficial biography, based primarily upon previously published materials. Although the narrative is wide in scope, little notice is given to the films, but much attention is paid to Sinatra's recordings. Short film list; recording titles.

SIRK, DOUGLAS

O1157. **Sirk, Douglas, and Halliday, Jon.** SIRK ON SIRK. New York: Viking Press, 1972. 176 p., illus.

A review of the career and twenty-two films of a little known Hollywood director. Of Danish birth, Sirk (original name spelled Detlef Sierck) worked in Germany and came to the United States in 1937. Described mostly through a series of interviews made in 1970, Sirk's work in America took place at the Columbia Studios (1942–1948) and at Universal (1950–1958). A detailed bio-filmography summarizes the interview material. The illustrations are acceptable, and there is an unusual non-Sirk bibliography added. It seems no one ever wrote about him. ORIGINAL EDITION (London, 1971).

SKOURAS, SPYROS

O1157a. **Curti, Carlo.** SKOURAS: KING OF THE FOX STUDIOS. Los Angeles: Holloway House Publishing Co., 1967. 311 p.

An official biography of a studio mogul. The first section of this volume tells of the rise of Spyros Skouras from penniless immigrant to head of the Twentieth-Century Fox Studios. Two other sections deal with Marilyn Monroe and Elizabeth Taylor, both of whom affected the fortunes of the Fox Studios. Much of the volume is sensationalized gossip and innuendo. Paperback.

SMITH, ALBERT E.

O1158. **Smith, Albert E., and Koury, Phil A.** TWO REELS AND A CRANK: FROM NICKELODEON TO PICTURE PALACES. Garden City, N.Y.: Doubleday, 1952. 285 p., illus.

A biography of a relatively unknown film pioneer who was active in motion picture production, distribution, and exhibition at the turn of the century. Later he helped to establish Vitagraph Pictures. Portraits of silent film personalities and anecdotes are plentiful in this enjoyable memoir. The illustrations are very good.

STANWYCK, BARBARA

O1159. **Smith, Ella.** STARRING MISS BARBARA STANWYCK. New York: Crown Publishers, 1973. 340 p., illus.

A critical examination of the career and films of Barbara Stanwyck. Biographical material is minimal here, but the attention to the films is thorough and detailed. From *Broadway Nights* (1927) to recent films made for television, Stanwyck has been a symbol of the no-nonsense professional actress. The many illustrations are outstanding and include some full-page portraits that prove Stanwyck a handsome woman for more than four

decades. A filmography and a list of awards and honors complete this attractive book. Index.

O1159a. Vermilye, Jerry. BARBARA STANWYCK. New York: Pyramid Publications, 1975. 159 p., illus.

A rewarding survey of Barbara Stanwyck's career over a period of four decades. Attention is given to her many films, for which the author provides both description and critical evaluation. The illustrations have been selected to show the maturing of the talented, ambitious young actress into a respected and dedicated professional.

STEVENS, GEORGE

O1160. Richie, Donald. GEORGE STEVENS, AN AMERICAN ROMANTIC. New York: Museum of Modern Art, 1970. 104 p., illus.

A short monograph on an important American director. Using thirty-nine stills and an informative text, Stevens's directorial techniques and his films are analyzed. A filmography and a list of awards are added. Paperback.

STEWART, JAMES

O1161. Jones, Ken D.; McClure, Arthur F.; and Twomey, Alfred E. THE FILMS OF JAMES STEWART. New York: A. S. Barnes, 1970. 256 p., illus.

A foreword by Henry Fonda and a short biography introduce the films of James Stewart. Cast, credits, plot outline, and a few stills are given for each of the films, which are presented in nonstop fashion. Picture reproduction, design, and layout are all poor. This is the only record of Stewart's films currently available. A bibliography does not help much.

STILLER, MAURITZ

O1161a. Pensel, Hans. SEASTROM AND STILLER IN HOLLYWOOD. New York: Vantage Press, 1969. 106 p., illus.

[See O1147.]

STURGES, PRESTON

O1162. Ursini, James. PRESTON STURGES: AN AMERICAN DREAMER. New York: Curtis Books, 1973. 240 p., illus.

A satisfying paperback biography of a rather enigmatic American film director. With much detail, the author traces the career of Preston Sturges by interviews, memorabilia, a reviewing of the films, and other research. Each major film is treated separately with both descriptive and critical comment. Notes; filmography; bibliography.

SWANSON, GLORIA

O1163. Hudson, Richard, and Lee, Raymond. GLORIA SWANSON. New York: A. S. Barnes, 1970. 269 p., illus.

A pictorial tribute to a film star whose career has spanned several decades. Picture selection is good, as is an annotated filmography; but the text and the production of the book are poor.

O1163a. Carr, Larry. FOUR FABULOUS FACES: GARBO, SWANSON, CRAWFORD, DIETRICH. New Rochelle, N.Y.: Arlington House, 1970.

[See O739.]

TAYLOR, ELIZABETH

O1163b. Hirsch, Foster. ELIZABETH TAYLOR. New York: Pyramid Publications, 1973. 160 p., illus.

After a short, provocative biographical essay, the major portion of this pleasing volume is devoted to a chronological survey of Elizabeth Taylor's films. Employing wit and style, the author assigns the films to groups with appropriate names: horses and dogs, puppy love, the wrong man, the cat, the queen, and the shrew. Good illustrations; bibliography; filmography; index.

O1164. Taylor, Elizabeth. ELIZABETH TAYLOR: AN INFORMAL MEMOIR. New York: Harper & Row, 1964. 177 p., illus.

In this short volume, Taylor reminisces about her actions, career, and personality. Not an autobiography, it is rather a reflection and evaluation of a screen star by herself. Some appropriate illustrations are provided by Roddy McDowall.

O1165. Waterbury, Ruth. ELIZABETH TAYLOR. New York: Popular Library, 1964. 255 p.

An objective biography of the popular actress, written by a writer-editor of motion picture fan magazines. This nonrevealing account covers Taylor's life until the Burton marriage in 1964. Some of her films are discussed, but the emphasis is on the personal life of a motion picture superstar. Paperback.

TAYLOR, ROBERT

O1166. Wayne, Jane Ellen. THE LIFE OF ROBERT TAYLOR. New York: Warner Books, 1973, 349 p., illus.

A very good original paperback biography characterized by the author's integrity and objectivity. With the help of Taylor's widow and by the use of letters, interviews, public records, etc., the author has reconstructed a portrait of a handsome actor who lacked aggressiveness. The few illustrations show Taylor with his most famous leading ladies. Good filmography. Paperback.

TEMPLE, SHIRLEY

O1166a. Basinger, Jeanine. SHIRLEY TEMPLE. New York: Pyramid Publications, 1975. 158 p., illus.

A review of the films of Shirley Temple, along with an outsider's look at her private life. The films are evaluated objectively; the visuals show the change from a dimpled

little child star to a mediocre adolescent actress. Her adult years are covered briefly. Bibliography; filmography; index.

O1167. **Eby, Lois.** SHIRLEY TEMPLE. Derby, Conn.: Monarch Books, 1962. 143 p.

A biography of the most famous child film star of American motion pictures, including her marriage to Charles Black in 1950. Paperback.

THALBERG, IRVING

O1167a. **Marx, Samuel.** MAYER AND THALBERG: THE MAKE-BELIEVE SAINTS. New York: Random House, 1975. 273 p., illus.

[See O1088.]

O1168. **Thomas, Bob.** THALBERG: LIFE AND LEGEND. Garden City, N.Y.: Doubleday, 1969. 415 p., illus.

A biography of a much revered Hollywood producer and executive. During his short career Irving Thalberg was responsible for many classic films that raised the prestige of the American motion picture industry. His work at Universal and MGM is noted in detail, but little information is offered about the man himself. His most important films are summarized by cast credits, synopses, stills, and award listings. More than 140 fine illustrations; good bibliography; index.

TIOMKIN, DIMITRI

O1169. **Tiomkin, Dimitri, and Buranelli, Prosper.** PLEASE DON'T HATE ME. Garden City, N.Y.: Doubleday, 1961. 261 p.

A well-known composer of film music recalls his life and experiences in Hollywood in this light, superficial memoir.

TODD, MIKE

O1170. **Cohn, Art.** THE NINE LIVES OF MICHAEL TODD. New York: Pocket Books, 1959. 344 p.

A biography that in its later pages treats of Todd's Hollywood adventures. His relationships with many female stars are noted, as are his operations with the major studios. Attention is given to the Todd-AO wide screen process and to the making of *Around the World in 80 Days* (1956). Paperback.

TRACY, SPENCER

O1171. **Deschner, Donald.** THE FILMS OF SPENCER TRACY. New York: Citadel Press, 1968. 255 p., illus.

Composed of several articles and tributes, the usual biographical introduction is overlong in this survey of Tracy's films from *Up the River* (1930) to *Guess Who's Coming to Dinner* (1967). Each film is described by stills, synopsis, cast, and credits; certain films have additional com-

ments provided by actors and critics. Picture selection is not representative, and there are informational errors.

O1171a. **Kanin, Garson.** TRACY AND HEPBURN. New York: Viking Press, 1971. 307 p.

[See O1003.]

O1172. **Swindell, Larry.** SPENCER TRACY. New York: World Publishing Co., 1969. 319 p., illus.

A fine biography of a complex, difficult but respected actor. Covering the early years quickly, the author emphasizes the screen years of 1930 to 1967. Films and performances are evaluated, and much insight into the off-screen personality is given. Thirty-two pages of good illustrations and a filmography accompany the informative text. Index.

O1172a. **Tozzi, Richard.** SPENCER TRACY. New York: Pyramid Publications, 1973. 159 p., illus.

This volume contains a very fine collection of visuals. The text is largely factual and avoids any in-depth critical analysis. Filmography; bibliography; index.

TURNER, LANA

O1173. **Morella, Joe, and Epstein, Edward Z.** LANA: THE PUBLIC AND PRIVATE LIVES OF LANA TURNER. New York: Citadel Press, 1971. 297 p., illus.

An unauthorized biography, based on public documents and private, unacknowledged interviews. By careful phrasing, much more is suggested than stated. However, the great similarity between the onscreen image and the private person is related in detail. A central collection of sixteen pages of illustrations has been selected to further the sensationalism of the text.

VALENTINO, RUDOLPH

O1174. **Arnold, Alan.** VALENTINO: A BIOGRAPHY. New York: Library Publications, 1954. 165 p., illus.

A biography of the silent film star that attempts an objective approach. In addition to an interesting portrait of Valentino, the Hollywood of the twenties is described. Illustrated with thirty-three photographs.

O1175. **Shulman, Irving.** VALENTINO. New York: Trident Press, 1967. 499 p., illus.

A biography of the silent screen star, padded by an extended account of his funeral and some other postmortem events. In the central biographical section, the author seems to rely more on documented information than on speculation, gossip, and innuendo (as he did with Jean Harlow). The picture selection is disappointing.

O1176. **Steiger, Brad, and Mank, Chaw.** VALENTINO. New York: Macfadden-Bartell, 1966. 192 p., illus.

A sensationalized biography of the silent film star, illustrated with eighteen small photographs. Paperback.

O1177. **Ullman, S. George.** VALENTINO AS I KNEW HIM. New York: A. L. Burt Co., 1926. 218 p., illus.

Perpetuation of the onscreen image of Valentino by his manager and friend. The text is biased, but the illustrations are fine.

VAN DYKE, W. S.

O1178. **Cannom, Robert.** VAN DYKE AND THE MYTHICAL CITY OF HOLLYWOOD. Culver City, Calif.: Murray & Gee, 1948. 424 p., illus.

An appreciation of the MGM director with elements of biography. Many anecdotes about MGM stars accompany this worshipful account of Van Dyke and his career. Filmography. REPRINT (New York: Garland Publishing, 1977).

VIDOR, KING

O1179. **Vidor, King.** KING VIDOR ON FILM MAKING. New York: David McKay Co., 1972. 239 p., illus.

A second partial autobiography of a Hollywood director whose work spanned more than four decades. In addition to comments and advice on filmmaking, Vidor recalls incidents, personalitites, and examples from his own experiences. Illustrations are poorly selected from Vidor's many films and rich Hollywood background. Index.

O1180. **Vidor, King.** A TREE IS A TREE. New York: Harcourt Brace, 1953. 365 p., illus.

A biography of a Hollywood director whose career spanned four decades. Offering a director's view of Hollywood, he discusses his films, other personalities, and the motion picture industry. Comments, opinions and anecdotes are plentiful and help to fill in the biographical gaps. The illustrations are acceptable.

VIERTEL, SALKA

O1181. **Viertel, Salka.** THE KINDNESS OF STRANGERS. New York: Holt, Rinehart & Winston, 1969. 338 p.

An autobiography of a foreign born actress and writer who arrived in Hollywood in 1929 and became acquainted with actors, writers, directors, etc. In addition to theatrical life in Vienna and Berlin, the book covers the golden age of Hollywood, concluding with the era of the blacklisted Hollywood Ten. Many famous Hollywood names appear as characters in her story.

VON STERNBERG, JOSEF

O1182. **Baxter, John.** THE CINEMA OF JOSEF VON STERNBERG. New York: A. S. Barnes, 1971. 192 p., illus.

A guide to the films of von Sternberg. Enhanced by intelligent interpretation, perceptive analysis, and personal recollection, the text examines all of von Sternberg's films critically. The illustrations are most suitable. Bibliography; filmography. Paperback.

O1183. **Sarris, Andrew.** THE FILMS OF JOSEF VON STERNBERG. New York: Museum of Modern Art; distributed by Doubleday, 1966. 56 p., illus.

All eighteen of von Sternzerg's films are assessed by film critic Sarris in this short but effective survey. After an opening biographical statement, the films from *Salvation Hunters* (1925) to *Anatahan* (1953) are analyzed critically. A concise bibliography accompanies the text.

O1184. **Von Sternberg, Josef.** FUN IN A CHINESE LAUNDRY. New York: Macmillan Co., 1965. 348 p., illus.

This rambling memoir is filled with anecdotes about the personalities who have touched on von Sternberg's career. Using stylish venom and cynicism, the text is for one starring role. Comments about actors, aesthetics, film theory, and practice, techniques, and, most of all, directors are plentiful. The illustrations add to this unusual autobiography.

O1185. **Weinberg, Herman G.** JOSEF VON STERNBERG: A CRITICAL STUDY OF THE GREAT FILM DIRECTOR. New York: E. P. Dutton & Co., 1967. 255 p., illus.

An exhaustive and perceptive study of the films and career of von Sternberg. All the films are analyzed in detail as is the Dietrich—von Sternberg relationship. A lengthy interview; script excerpts; filmography; bibliography; and more than fifty illustrations. Paperback.

VON STROHEIM, ERICH

O1186. **Curtiss, Thomas Quinn.** VON STROHEIM. New York: Farrar, Straus & Giroux, 1971. 357 p., illus.

A biography of the famed director and actor, written by a man who knew him during his later years. There is little new information or interpretation offered, but the summary of von Stroheim's life and career is restated with sensitivity and affection. An account of the first screening of the complete forty-two reel version of *Greed* (1923) and a filmography are appended. The edition includes many attractive stills and is an outstanding production by itself.

O1187. **Finler, Joel W.** STROHEIM. Berkeley: University of California Press, 1968. 144 p., illus.

An appreciation of von Stroheim's films, with the major portion devoted to *Greed* (1923). The style of the director is discussed, along with shorter analyses of his other films. His career as an actor is not treated. The stills used throughout are impressive. Filmography; bibliography.

O1188. **Noble, Peter.** HOLLYWOOD SCAPEGOAT: ERICH VON STROHEIM. London: Fortune Press, 1950. 246 p., illus.

An early biography of von Stroheim that embraces his total career. His preoccupation with screen sex is noted, as well as his relationships with the actors he directed. The text is factual, accurate, and comprehensive. His work as actor, director, and writer from 1914 to 1950 is listed separately. In the lengthy appendix there are several articles of appreciation. The illustrations are excellent. Index. REPRINT (New York: Arno Press).

O1188a. **Weinberg, Herman G.** STROHEIM: A PICTORIAL HISTORY OF HIS NINE FILMS. New York: Dover Publications, 1975. 259 p., illus.

A pictorial summary and reconstruction of the nine films that Erich von Stroheim directed are offered in this attractive volume. Introductory essays, synopses, casts, credits, background notes, and other data are provided for the films. Most important are the superb stills, which are remarkably clear and sharp. Weinberg has provided a literate, intelligent appreciation consistent with the quality of the book's visuals. [For Weinberg's illustrated edition of the script for von Stroheim's *Greed*, see O519.]

WALLIS, HAL

O1189. **Mancia, Adrienne.** HAL WALLIS, FILM PRODUCER. New York: Museum of Modern Art, 1970. 12 p., illus.

A short survey of Hal Wallis's films and career. This booklet includes an interview and a detailed listing of his films from *Dawn Patrol* (1930) to *Anne of the Thousand Days* (1969). Paperback.

WALSH, RAOUL

O1189a. **Walsh, Raoul.** EACH MAN IN HIS TIME. New York: Farrar, Straus & Giroux, 1974. 427 p., illus.

This autobiography, written by octagenarian Raoul Walsh, shows no lessening of talent or wit. His memoirs are rich as they range from Hollywood's beginning to its postwar decline. Walsh does not bother with dates or with an exact chronological account, but his recollections of a full life are delightful and rewarding. Index.

WARHOL, ANDY

O1190. **Coplans, John.** ANDY WARHOL. Greenwich, Conn.: New York Graphic Society, 1970. 160 p., illus.

One of the three essays about Warhol found in this book is about his films. Written by Jonas Mekas, the evaluation of Warhol's work is uniformly positive. Some film stills appear among the more than one hundred illustrations. Filmography; bibliography.

O1191. **Crone, Rainer.** ANDY WARHOL. New York: Praeger Publishers, 1970. 331 p., illus.

A rather complete catalog of all of Warhol's work: paintings, prints, objects, films, etc. In addition, there is comment and evaluation by the author, along with visual representation of over 325 works. Filmography; lengthy bibliography.

O1192. **Gidal, Peter.** ANDY WARHOL. New York: E. P. Dutton & Co., 1970. 160 p., illus.

In this volume, the Warhol films get major critical attention and analysis. Other media are treated, and there is a useful chronology. An attractive group of photographs accompanies the perceptive text. Index. Paperback.

O1193. **Koch, Stephen.** STARGAZER: ANDY WARHOL AND HIS FILMS. New York: Praeger Publishers, 1973. 216 p., illus.

A description of the Warhol phenomenon and detailed analysis of several of his films are offered in this book. The author traces the development and growth of the underground film to indicate its effect on Warhol's work. An interpretation of the films is given by the author. The two sections of visuals are acceptable. Filmography; index.

WARNER, JACK L.

O1194. **Warner, Jack L., and Jennings, Dean.** MY FIRST HUNDRED YEARS IN HOLLYWOOD. New York: Random House, 1965. 331 p., illus.

Written with wit and a touch of vengeance, this autobiography is filled with fascinating anecdotes involving the famous names of Hollywood and, specifically, the Warner Brothers Studios. The historical and personal portions are presented in a straightforward, unsentimental narrative. The cumulative portrait of a major studio and the cynical views of the personnel within give appeal and interest to the text. The few illustrations are adequate.

WAYNE, JOHN

O1194a. **Barbour, Alan G.** JOHN WAYNE. New York, Pyramid Publications, 1974. 160 p., illus.

For this volume an unusual approach was required, owing to the great number of films John Wayne has made. After a comparison of Wayne's screen image and the private man, ten major films are described in detail as "The Essential Wayne." The remaining films are treated by decade from the thirties to the seventies. The many visuals have been well selected, but their reproduction is wanting. Bibliography; filmography; index.

O1195. **Carpozi, George.** THE JOHN WAYNE STORY. New Rochelle, N.Y.: Arlington House, 1972. 279 p., illus.

A superficial biography of John Wayne, based primarily on public records. Wayne's life and career are covered, but inconsistencies and omissions diminish the quality of the book. The selection and reproduction of illustrations is average. Index.

O1196. **Ricci, Mark; Zmijewsky, Boris; and Zmijewsky, Steve.** THE FILMS OF JOHN WAYNE. New York: Citadel Press, 1970. 288 p., illus.

When this volume was published, it credited 144 films to John Wayne, who made many more since. From *Mother Machree* (1928) to *Rio Lobo* (1969), each film is represented by one or more stills, cast, credits, and synopsis. The more than four hundred visuals serve the book better than its bland text. A portrait gallery is especially noteworthy.

O1197. **Tomkies, Mike.** DUKE: THE STORY OF JOHN

WAYNE. Chicago: Henry Regnery Co., 1971. 149 p., illus.

Wayne was an active performer who appeared in more than 250 films. This pleasing biography gives attention to many of the films and to some aspects of the star's private life. Although incomplete, the final portrait is one of an honest, sincere professional who had a sense of humor. The visuals are adequate, and a filmography from 1928 to 1970 is included.

O1197a. **Zolotow, Maurice.** SHOOTING STAR: A BIOGRA-PHY OF JOHN WAYNE. New York: Simon & Schuster, 1974. 416 p., illus.

A positive account of John Wayne's rise from stuntman to film superstar. Wayne's cooperation has enabled the author to give detailed attention to personal qualities and incidents. Index.

WELLES, ORSON

O1198. **Bessy, Maurice.** ORSON WELLES. New York: Crown Publishers, 1971. 195 p., illus.

A satisfying collection of materials on Welles. The long biographical essay is followed by interviews, quotations, an unpublished script, reviews, and appreciations. Filmography; bibliography; index. Paperback.

O1199. **Bogdanovich, Peter.** THE CINEMA OF ORSON WELLES. New York: Museum of Modern Art, 1961. 16 p., illus.

Another booklet prepared by Bogdanovich for The Museum of Modern Art. Welles's films are listed and analyzed. The illustrations are adequate. Paperback.

O1200. **Cowie, Peter.** A RIBBON OF DREAMS. Rev. ed. New York: A. S. Barnes, 1973. 262 p., illus.

A study of the films and career of Orson Welles. Cowie provides a most readable text, and the more than one hundred illustrations are carefully selected. However, reproduction quality is only fair. A good bibliography and listings of Welles's work in other media are appended. Index. ORIGINAL EDITION: *The Cinema of Orson Welles* (1965).

O1201. **Higham, Charles.** THE FILMS OF ORSON WELLES. Berkeley: University of California Press, 1970. 210 p., illus.

Biographical elements are minimized in favor of analysis of Welles's films in this controversial volume. Individual chapters devoted to each of the films contain interviews, a provocative text, and excellent visuals. 230 stills, a filmography, and a bibliography are also included. The only element missing is Welles himself who did not choose to participate.

O1202. **McBride, Joseph.** ORSON WELLES. New York: Viking Press, 1972. 192 p., illus.

A critical study of the film work of Orson Welles. An in-troductory essay-interview offers background information on Welles and his filmmaking methods. Beginning with a 1934 short, all of Welles's films are analyzed except *The Stranger* (1946). The appendix treats the careers of Welles as director, actor, writer, stage performer, radio actor, and recording artist. Paperback.

O1203. **Noble, Peter.** THE FABULOUS ORSON WELLES. London: Hutchinson & Co., 1956. 276 p., illus.

This early biography is both admiring and forgiving in delineating the first fifteen years of Welles's film career. Using many anecdotes in a carefully researched text, the author has also selected some exceptional photographs that are beautifully reproduced. Index.

WELLMAN, WILLIAM

O1203a. **Wellman, William A.** A SHORT TIME FOR IN-SANITY. New York: Hawthorne Books, 1974. 284 p., illus.

Director William Wellman uses a stream of consciousness technique in this fragmented and partial account of his life. A filmography and an index are somewhat helpful in bringing order to the diffuse and rambling text.

WEST, MAE

O1204. **Weintraub, Joseph.** THE WIT AND WISDOM OF MAE WEST. New York: G. P. Putnam's Sons, 1967. 94 p., illus.

Through a selection of good stills and appropriate quotations, the personality of Mae West is presented in this modest volume.

O1205. **West, Mae.** GOODNESS HAD NOTHING TO DO WITH IT. New York: Avon Books, 1959. 223 p., illus.

An autobiography designed to perpetuate her public image. The uncritical, selective approach is more entertainment than biography. The REVISED AND UPDATED EDITION (1970) contains material on *Myra Breckenridge* (1970) and other recent experiences. Paperback.

WHITE, PEARL

O1206. **Weltman, Manuel, and Lee, Raymond.** PEARL WHITE: THE PEERLESS FEARLESS GIRL. New York: A. S. Barnes, 1969. 226 p., illus.

A biography of the silent screen serial queen that is weakened by an artificial text. Recreated dialogues and a life-scenario detract rather than explain. However, the data supplied, along with a fine selection of three hundred visuals, almost compensate for the gimmicky narrative. Filmography.

WILDER, WILLIAM

O1207. **Madsen, Axel.** BILLY WILDER. Bloomington: Indiana University Press, 1969. 167 p., illus. [*cont.*]

A balanced appreciation of a Hollywood director. With careful documentation, the author reviews Wilder's twenty-two films made from 1942 to 1966. A portrait of a complex director results: Wilder is shown as abrasive, raw, brash, cynical, sarcastic, yet fearful. The illustrations are fine. Filmography. Paperback.

O1208. **Wood, Tom.** THE BRIGHT SIDE OF BILLY WILDER, PRIMARILY. Garden City, N.Y.: Doubleday, 1969. 257 p., illus.

Biographical closeup of director Wilder by film publicist Wood. Wilder's experiences with Monroe, Bogart, *et al.*, are exposed and many "Wilderisms" are recalled. Covers the period from Wilder's first important script *Menschen am Sonntag* (1929) to *The Private Life of Sherlock Holmes* (1969). Filmography; a few adequate illustrations; index.

WILLIAMS, PAUL

O1209. **Henstell, Bruce, ed.** PAUL WILLIAMS. Washington, D.C.: American Film Institute, 1972. 31 p.

An interview with a young American director in 1970. The topic was filmmaking and how one gets into it. A bibliography and a three-title filmography are appended. Paperback.

WOLPER, DAVID

O1210. **Reed, Rochelle, ed.** DAVID WOLPER. Washington, D.C.: American Film Institute, 1972. 24 p., illus.

An interview with film producer David Wolper. The topics covered include the filming of the 1972 Olympics and the film of today. Three staff members from Wolper's organization also contribute to the discussion. Paperback.

WYLER, WILLIAM

O1210a. **Madsen, Axel.** WILLIAM WYLER: THE AUTHORIZED BIOGRAPHY. New York: Thomas Y. Crowell Co., 1973. 456 p., illus.

Here is an authorized biography distinguished by both authenticity and detail. William Wyler's exceptional career is followed from Europe to New York and finally to Hollywood where he became a most sought-after film director. Attention is given to Wyler's directorial methods and his relationships with his actors. Chapter notes, illustrations, a list of awards, a filmography, and an index complete this rewarding work.

WYNN, KEENAN

O1211. **Wynn, Keenan.** ED WYNN'S SON. Garden City, N.Y.: Doubleday, 1959. 237 p., illus.

An autobiography of a famous actor's son who achieved some degree of success in the same profession. The many films that Keenan Wynn appeared in are slighted to favor an extended discussion of the father-son relationship. Some good illustrations are added to the personal, appealing text.

YOUNG, LORETTA

O1212. **Young, Loretta, and Ferguson, Helen.** THE THINGS I HAD TO LEARN. Indianapolis: Bobbs-Merrill Co., 1961. 256 p., illus.

A sterile autobiography by a film star intent on reinforcing her public image. By concentrating on philosophy, religion, and advice rather than self-evaluation as performer and person, Young provides little information about her films or her life. The few illustrations and a filmography help little.

ZANUCK, DARRYL F.

O1213. **Guild, Leo.** ZANUCK: HOLLYWOOD'S LAST TYCOON. Los Angeles: Holloway House Publishing Co., 1970. 255 p., illus.

A portrait of the Hollywood producer and executive that is marred by exaggerated digressions. The stills are excellent, although they also stress sensation rather than pertinence. Paperback.

O1214. **Gussow, Mel.** DON'T SAY YES UNTIL I FINISH TALKING: A BIOGRAPHY OF DARRYL F. ZANUCK. Garden City, N.Y.: Doubleday, 1971. 318 p., illus.

This biography of a creative motion picture mogul is one of the better ones on film personalities. Zanuck's rise from scriptwriter for Rin-Tin-Tin movies to head of Twentith Century Fox is related with taste, objectivity, and attention to detail. Some fine photographs, a filmography, and an extended index complement the frank but sympathetic text.

ZIMMER, JILL SCHARY

O1215. **Zimmer, Jill Schary.** WITH A CAST OF THOUSANDS. New York: International Publishers, 1963. 525 p.

A memoir of Hollywood during the forties and fifties by the daughter of writer-producer-executive Dore Schary. Many famous names appear in this superficial account of an unusual childhood.

ZUKOR, ADOLPH

O1216. **Irwin, Will.** THE HOUSE THAT SHADOWS BUILT. Garden City, N.Y.: Doubleday, 1928. 293 p., illus.

A biography of Adolph Zukor written in the Horatio Alger style of the twenties. Zukor, an early film pioneer, eventually became president of Paramount Pictures. Anecdotes and descriptions of personalities add to this one-sided portrait. REPRINT (New York: Arno Press).

O1217. **Zukor, Adolph, and Kramer, Dale.** THE PUBLIC IS NEVER WRONG: THE AUTOBIOGRAPHY OF ADOLPH ZUKOR. New York: G. P. Putnam's Sons, 1953. 310 p., illus.

Written when Zukor was in his eighties, this flat autobiography stresses the silent screen era in Hollywood. How Zukor became head of Paramount Pictures is related, along with many anecdotes about famous film personalities. A rather bland recital accompanied by some ordinary illustrations and an index.

P

Theater

PAUL MYERS

CONTENTS

INTRODUCTION

This is a selective bibliography of the American theater, from its beginnings to the bicentennial year. All aspects of theater are referenced, including professional and amateur stage, regional and community theater, college and university productions, children's theater, musical comedy, vaudeville, and phases of production, acting, entertainment, and theater design. Included, too, are works about foreign theater artists who exerted an influence on the American stage, or spent considerable parts of their professional years in the American theater.

When faced with a choice of books, I have tended toward selecting books of American origin rather than texts published abroad. Theater publishing has proliferated since World War II. Examination of Rosamund Gilder's 1932 bibliography [*see* P755] would indicate at once how narrow the field was at that time. Today every minor television star rushes into print and academics turn out volume after volume. Here, I hope, is the best of the now considerable theater library.

PAUL MYERS

BIOGRAPHY AND HISTORY:
THE AMERICAN THEATER AND ITS PERSONALITIES

Collective Biography

At the beginning of this group, several works of collective biography are listed [see P1–P6]. The major listing of biographies [P7–P311] is presented alphabetically by personal subject; when possible, birth and death dates are provided. Note that this listing includes personalities who have careers in both theater and film, as for example Orson Welles. Indeed, it is apparent that a list embracing talents as varied as Cecil Beaton and Jack Paar, Houdini and Walter Winchell, uses a flexible definition of theater and its inhabitants. Those included in this group of biographical works indicate limits established by the selected literature rather than limits of definition.

P1. **Blackwell, Earl.** CELEBRITY REGISTER, 1973. New York: Simon & Schuster. 562 p., illus.

First published in 1963 under the editorship of Cleveland Amory, this is a biographical dictionary of "celebrities as differing from VIPs." Many figures from show business are included, with a directory of their addresses. There are prefaces by Cleveland Amory and Earl Blackwell.

P2. **Harriman, Margaret Case.** TAKE THEM UP TENDERLY: A COLLECTION OF PROFILES. New York: Alfred A. Knopf, 1944. 266 p.

Many of these biographies were written first for *The New Yorker*. Included are sketches of Leland Hayward, Cole Porter, Moss Hart, Richard Rodgers, and Lorenz Hart.

P3. **Reignolds, Kate.** YESTERDAY WITH ACTORS. Boston: Cupples & Hurd, 1887. 201 p., illus.

Short sketches of American actors—Charlotte Cushman, Edwin Forrest, Laura Keene, and others—with some personal stage reminiscences by the author.

P4. **Ross, Lillian, and Ross, Helen.** THE PLAYERS: A PROFILE OF AN ART. New York: Simon & Schuster, 1962. 459 p., illus.

Interviews with more than forty actors, 1958–1962. Some of the pieces appeared originally in *The New Yorker*. Index.

P5. PLAYERS GUIDE. New York. 31 (1973–1974), illus.

Issued by Paul L. Ross Publishers, this is the thirty-first ANNIVERSARY EDITION of this annual casting guide for stage, screen, radio, and television. A sample entry includes a head shot of the player, selected credits, and an address or the name of an agent to contact. Edited by Paul and Marion Ross. Index.

P6. **Young, Roland.** ACTORS AND OTHERS. Chicago: Pascal Covici, 1925. 92 p., illus.

A collection of drawings of theater people of the twenties by the actor Roland Young. Introduction by Ashton Stevens.

Individual Biographies of the Stars

ABBOTT, GEORGE 1889—

P7. **Abbott, George.** MISTER ABBOTT. New York: Random House, 1963. 279 p.

The professional career of George Abbott, from *The Misleading Lady* (1913) to *Never Too Late* (1962). Includes list of productions.

ADAMS, JOEY 1911—

P8. **Adams, Joey.** CINDY AND I. New York: Crown Publishers, 1957. 320 p., illus.

P9. **Adams, Joey.** FROM GAGS TO RICHES. New York: Frederick Fell, 1946. 336 p. Forewords by Fiorello H.

LaGuardia, Toots Shor, Frank Sinatra, Gypsy Rose Lee, and Earl Wilson.

P10. **Adams, Joey.** ON THE ROAD FOR UNCLE SAM. New York: Bernard Geis Associates, 1963. 312 p., illus.

Clowning through show business—in war and peace.

ADAMS, MAUDE 1872–1953

P11. **Davies, Acton.** MAUDE ADAMS. New York: Frederick A. Stokes Co., 1901. 110 p., illus.

Little more than a souvenir program, this is still an important publication because it is the first published biography of Maude Adams. For more than twenty

years, Acton Davies served as a drama critic in New York, and his reports of the productions are from first-hand experience.

P12. Patterson, Ada. MAUDE ADAMS: A BIOGRAPHY. New York: Meyer Brothers & Co., 1907. 109 p., illus.

Ada Patterson, an early newspaper advice columnist, started in Salt Lake City as did Maude Adams. This volume is more an expanded newspaper interview than a full-scale biography. Included are full cast lists for many of the productions in which Adams appeared in the 1880s and 1890s.

P13. Robbins, Phyllis. MAUDE ADAMS: AN INTIMATE PORTRAIT. New York: G. P. Putnam's Sons, 1956. 308 p., illus.

This is a full study of Maude Adams by Phyllis Robbins, a long-time friend who inherited most of Maude Adams's papers—scrapbooks, letters, and photographs. Robbins traces Adams's career from her first appearance in 1877 in *La Belle Russe* through her acting and teaching activities. The book, which includes reminiscences of Maude Adams's friends in and out of the theater, focuses on the career of the star of such shows as *Peter Pan, The Little Minister,* and *L'Aiglon,* and attempts to explain Adams's well-known penchant for privacy. The volume is well illustrated and contains a listing of Adams's stage appearances; a genealogy of the Adams's family; an index; and even two pages of food charts prepared by Maude Adams.

P14. Robbins, Phyllis. THE YOUNG MAUDE ADAMS. Francestown, N.H.: Marshall Jones Co., 1959. 163 p., illus.

After the publication of an earlier volume about Maude Adams, Phyllis Robbins gained access to additional papers dealing with Adams's earlier professional career. This book is essentially an account of Maude Adams's years as a young actress, though the epilogue adds a note about her later years.

ADE, GEORGE 1866–1944

P15. Tobin, Terence, ed. LETTERS OF GEORGE ADE. West Lafayette, Ind.: Purdue University Studies, 1973. 251 p., illus.

Though not considered primarily as a playwright, Ade wrote a great deal for the stage. Among his correspondents are Thomas Meighan, F.P.A., Louisa Dresser, Rufus Le Maire, and Will Hays. Many of the letters concern themselves with aspects of show business. Includes foreword by Paul Fatout and an autobiography of George Ade which was written in 1933 for *Authors Today and Yesterday,* edited by Stanley J. Kunitz. Index.

AHERNE, BRIAN 1902—

P16. Aherne, Brian. A PROPER JOB. Boston: Houghton Mifflin Co., 1969. 355 p., illus.

British-born and stage-trained, Brian Aherne bowed in New York in 1932 with Katharine Cornell in *The Barretts of Wimpole Street.* Since that time his career has been largely involved with the American stage and films.

ALDRIDGE, IRA 1807–1867

P17. Malone, Mary. ACTOR IN EXILE: THE LIFE OF IRA ALDRIDGE. London: Crowell-Collier Press, 1969. 88 p., illus.

A brief biography of "The African Roscius." Index.

P18. Marshall, Herbert, and Stock, Mildred. IRA ALDRIDGE: THE NEGRO TRAGEDIAN. London: Rockliff, 1958. 355 p., illus.

Ira Aldridge was, perhaps, the first actor to carry the achievement of the American theater abroad. In the early nineteenth century, he played in many of the most important theaters in the British Isles and on the Continent. Bibliography; index.

ALLEN, FRED 1894–1956

P19. Allen, Fred. MUCH ADO ABOUT ME. Boston: Little, Brown & Co., 1956. 380 p., illus.

Fred Allen is remembered today primarily as a radio comedian. His "Allen's Alley" remains a high point in airwave comedy. He trained, however, in burlesque, vaudeville, and musical comedy; these are his reminiscences of those days. Index.

ANDERSON, JOHN MURRAY 1886–1954

P20. Anderson, Hugh Abercrombie. OUT WITHOUT MY RUBBERS. New York: Library Publishers, 1954. 253 p., illus.

Told in the first person, this purports to be the reminiscences of the famed stagemaster of opulent musicals and cabaret productions. Index.

ANDREWS, JULIE 1935—

P21. Cottrell, John. JULIE ANDREWS: THE STORY OF A STAR. London: Arthur Barker, 1968. 222 p., illus.

APPIA, ADOLPHE 1862–1928

P22. Volbach, Walther R. ADOLPHE APPIA, PROPHET OF THE MODERN THEATRE: A PROFILE. Middletown, Conn.: Wesleyan University Press, 1968. 242 p., illus.

ARLISS, GEORGE 1868–1946

P23. Arliss, George. UP THE YEARS FROM BLOOMSBURY. New York: Blue Ribbon Books, 1927. 321 p., illus., frontispiece.

ENGLISH EDITION: *On the Stage* (London: John Murray, 1928), 341 p., illus., index.

ARONSON, BORIS 1898—

P24. **George, Waldemar.** BORIS ARONSON ET L'ART DU THEATRE. Paris: Editions des Chroniques du Jour, 1928. 16 p., illus.

Though only a few of the thirty-three plates are in color, the reproductions and the text convey some sense of the importance of Boris Aronson's contributions to American stage design.

ARONSON, RUDOLPH 1856–1919

P25. **Aronson, Rudolph.** THEATRICAL AND MUSICAL MEMOIRS. New York: McBride, Nast & Co., 1973. 283 p., illus.

Crossing from the operatic to the musical comedy field with *Erminie* in 1886, Aronson was featured in many of the Casino musicals. Index.

ARTAUD, ANTONIN 1896–1948

P26. **Knapp, Bettina L.** ANTONIN ARTAUD: MAN OF VISION. New York: David Lewis, 1969. 233 p., illus.

Artaud, an actor, director, and writer, was father of the Theater of Cruelty. Bettina Knapp, a scholar of the French theater, has done a worthy study. Preface by Anaïs Nin. Notes; bibliography; index.

ARVOLD, ALFRED G. 1882–1957

P27. **Arvold, Alfred.** IN EVERY MAN'S LIFE. Fargo, N.D.: The Arvold Library, 1957. 128 p., illus.

Completed by his son, Mason, following Alfred Arvold's death, this is the story of the Little Country Theatre in Fargo, N.D., and of Arvold's theater recollections.

ASTAIRE, FRED 1899—

P28. **Green, Stanley, and Goldblatt, Burt.** STARRING FRED ASTAIRE. New York: Dodd, Mead & Co., 1973. 501 p., illus.

Though most of his career has been on the sound stages of Hollywood, Fred Astaire has for a long time brightened the stages of New York and London. This large, matte-illustrated volume covers both aspects of his career. Chronology; discography; index.

AUERBACH, ARNOLD M.

P29. **Auerbach, Arnold M.** FUNNY MEN DON'T LAUGH. Garden City, N.Y.: Doubleday & Co., 1965. 176 p.

The memoirs of a Fred Allen gag writer who was also a creator of skits for musical revues.

BAKER, GEORGE PIERCE 1866–1935

P30. GEORGE PIERCE BAKER: A MEMORIAL. New York: Dramatists Play Service, 1939. 46 p., illus. (frontispiece, maps).

Articles by Baker's students: Eugene O'Neill, John Mason Brown, Donald Oenslager, Sidney Howard, and others. Maps are included which show the location of Baker's students.

P31. **Kinne, Wisner Payne.** GEORGE PIERCE BAKER AND THE AMERICAN THEATRE. Cambridge: Harvard University Press, 1954. 348 p., illus.

A full-scale biography of Baker and the 1947 workshop. Introduction by John Mason Brown. Index.

BANKHEAD, TALLULAH 1903–1968

P32. **Gill, Brendan.** TALLULAH. New York: Holt, Rinehart & Winston, 1973. 287 p., illus.

A large, well-illustrated biography of the fascinating actress. Eugenia Rawls, Bankhead's long-time friend and professional associate, was of great help to Gill in evoking this multifaceted personality. Index.

P33. **Bankhead, Tallulah.** TALLULAH: MY AUTOBIOGRAPHY. New York: Harper & Bros., 1952. 335 p., illus.

This biography of the redoubtable Tallulah was written by the tireless press representative, Richard Maney. Index.

BARNABEE, HENRY CLAY 1833–1917

P34. **Barnabee, Henry Clay.** MY WANDERINGS. EDITED BY GEORGE LEON VARNEY. Boston: Chapple Publishing Co., 1913. 461 p., illus.

Theatrical biography was a rare publishing event in the first two decades of the twentieth century. Though little remembered today, Henry Clay Barnabee's fame in his own day is attested to by the existence of this work.

BARNES, AL G. 1862–1931

P35. **Robeson, Dave.** AL G. BARNES: MASTER SHOWMAN. Caldwell, Ind.: Caxton Printers, 1935. 460 p., illus.

Reminiscences of circus life in the United States almost a century ago. Includes a roster of Al G. Barnes's circus personnel.

BARNUM, PHINEAS T. 1810–1891

P36. **Benton, Joel.** LIFE OF HON. PHINEAS T. BARNUM: COMPRISING HIS BOYHOOD, YOUTH, VICISSITUDES OF EARLY YEARS, HIS HERCULEAN STRUGGLES, BRILLIANT ENTERPRISES, ASTONISHING SUCCESSES, DISASTROUS LOSSES, NAPOLEONIC TRIUMPH; HIS RECEPTION BY KINGS, QUEENS, EMPERORS, AND NOBILITY EVERYWHERE; HIS GENIUS, WIT, GENEROSITY, ELOQUENCE, AND CHRISTIANITY. Edgewood Publishing Co., 1891. 621 p., illus.

An early biography of the showman done in a Horatio Alger style.

P37. Harris, Neil. HUMBUG: THE ART OF P. T. BARNUM. Boston: Little, Brown & Co., 1973.

Discussion of the Indian shows at Barnum's American Museum, New York.

P38. Wallace, Irving. THE FABULOUS SHOWMAN: THE LIFE AND TIMES OF P. T. BARNUM. New York: Alfred A. Knopf, 1959.

Accounts of Barnum's exhibition of Indians and Indian dances at his American Museum in New York.

BARRAULT, JEAN-LOUIS 1910—

P39. Barrault, Jean-Louis. THE THEATRE OF JEAN-LOUIS BARRAULT. TRANSLATED BY JOSEPH CHIARI. London: Barrie & Rockliff, 1961. 244 p., illus.

Preface by Armand Salacrov. Index.

P40. Barrault, Jean-Louis. REFLECTIONS ON THE THEATRE. TRANSLATED BY BARBARA WALL. London: Rockliff, 1951. 185 p., illus.

This present volume was followed by a second volume, *Nouvelles Reflexions sur le Théâtre* (1959), which has not yet been translated into English. ORIGINAL EDITION: *Reflexions sur le Théâtre* (1949).

BARRETT, LAWRENCE 1838—1891

P41. Barron, Elwyn A. LAWRENCE BARRETT: A PROFESSIONAL SKETCH. Chicago: Knight & Leonard, 1889. 98 p., illus.

A brief account of Barrett's professional career, which includes a discussion of his tours with Booth.

BARRY, PHILIP 1896—1949

P42. Gill, Brendan, ed. STATES OF GRACE: EIGHT PLAYS BY PHILIP BARRY. New York: Harcourt Brace Jovanovich, 1975. 640 p., illus.

The volume contains a beautifully done biographical portrait of Barry by Brendan Gill.

BARRYMORE, DIANA 1921—1960

P43. Barrymore, Diana, and Frank, Gerold. TOO MUCH, TOO SOON. New York: H. Holt, 1957. 380 p., illus.

Published only three years before her tragic death, this is the story of the professional and offstage career of John Barrymore's daughter.

BARRYMORE, ETHEL 1879—1959

P44. Barrymore, Ethel. MEMORIES. New York: Harper & Bros., 1955. 310 p., illus.

Begins with her childhood memories of the Drews and ends with the postscript, "Since I have finished this book, Lionel has died. I like to think that he and Jack are together—and that they will be glad to see me." Index.

BARRYMORE FAMILY

P45. Alpert, Hollis. THE BARRYMORES. New York: Dial Press, 1964. 397 p., illus.

BARRYMORE, JOHN 1882—1942

P46. Fowler, Gene. GOOD NIGHT, SWEET PRINCE: THE LIFE AND TIMES OF JOHN BARRYMORE. New York: Viking Press, 1944. 477 p., illus.

An in-depth study of this very complex actor—including a discussion of his professional career as well as his private life and offstage capers. Index.

P47. Power-Waters, Alma. JOHN BARRYMORE: THE LEGEND AND THE MAN. New York: Julian Messner, 1941. 282 p., illus.

In 1939, after a seventeen-year engagement in motion pictures, John Barrymore returned to the stage in *My Dear Children*. Power-Waters, whose husband was company manager for this production, concentrates on Barrymore's marriages and financial status. The book contains a chronology of Barrymore's stage and film roles. There is an introduction by Brooks Atkinson. Index.

P48. Barrymore, John. CONFESSIONS OF AN ACTOR. Indianapolis: Bobbs-Merrill Co., 1926. unpag., illus.

Random reminiscences; includes a letter from George Bernard Shaw to John Barrymore, dated Feb. 22, 1925, after he appeared as Hamlet on the London stage.

BARRYMORE, LIONEL 1878—1954

P49. Barrymore, Lionel, and Shipp, Cameron. WE BARRYMORES. New York: Appleton-Century-Crofts, 1951. 311 p., illus.

A ghostwritten account of the life of Lionel Barrymore, the elder brother of Ethel and John. Includes a genealogical chart of the Drews and Barrymores.

BEATON, CECIL 1904—

P50. Beaton, Cecil. MEMOIRS OF THE 1940s. New York: McGraw-Hill, 1972. 310 p., illus.

Photos by the author. Index.

BEERBOHM, MAX *died* 1956

P51. Mix, Katherine Lyon. MAX AND THE AMERICANS. Brattleboro, Vt.: Stephen Greene Press, 1974. 210 p., illus.

Max Beerbohm's impressions of the United States, beginning with his first visit in 1895, as secretary to his half-brother, Herbert Beerbohm Tree. Appendixes contain lists of source notes and materials pertaining to Max Beerbohm in American collections. Bibliography; index.

BEHAN, BRENDAN

P52. Behan, Brendan. CONFESSIONS OF AN IRISH REBEL. New York: Bernard Geis Associates, 1965. 245 p.

BELASCO, DAVID 1859–1931

P53. Marker, Lise-Lone. DAVID BELASCO: NATURALISM IN THE AMERICAN THEATRE. Princeton: Princeton University Press, 1975. 248 p., illus.

The book is of value both as a study of Belasco and of the influence of European stagecraft on technological procedures for the American stage. Bibliography; index.

P54. Timberlake, Craig. THE LIFE AND WORK OF DAVID BELASCO. New York: Library Publishers, 1954. 491 p., illus.

P55. Winter, William. THE LIFE OF DAVID BELASCO. New York: Moffat, Yard & Co., 1918. 2 vols., illus.

This very detailed account of David Belasco's career as manager, dramatist, and stage director was published after the author's death and was completed by Winter's son. Includes chronology of productions to 1916.

BENNETT, RICHARD 1873–1944

P56. Bennett, Joan, and Kibbee, Lois. THE BENNETT PLAYBILL. New York: Holt, Rinehart & Winston, 1970. 332 p., illus.

BENSON, FRANK R. 1858–1939

P57. Benson, Frank R. MY MEMOIRS. London: Ernest Benn, 1930. 322 p., illus.

British-born and trained, Sir Frank Benson exerted a tremendous influence on the American stage for years. Walter Hampden, Baliol Holloway, Matheson Lang, Ion Swinley, Philip Merivale, and Barry Jones are only a few of the "Bensonians." The Benson style influenced Shakespearean production in the American theater enormously.

P58. Trewin, John Courtenay. BENSON AND THE BENSONIANS. London: Barrie & Rockliff, 1960. 302 p., illus.

A study of Sir Frank Benson's companies, his training methods, and accounts of the many actors who came up through his companies. Included is a Benson genealogical table; casts for many of his London and touring productions (showing the distribution of roles in the repertory); and a foreword by Dorothy Green. Index.

BERG, GERTRUDE 1899–1966

P59. Berg, Gertrude, and Berg, Cherney. MOLLY AND ME. New York: McGraw-Hill Book Co., 1961. 278 p.

Gertrude Berg was known to millions of radio and television listeners as Molly Goldberg in "The Rise of the Goldbergs" (radio) and "The Goldbergs" (television).

Molly and Me is largely about Berg's ancestors, but there is a considerable amount of material about her professional career.

BERGMAN, INGRID 1917—

P60. Steele, Joseph Henry. INGRID BERGMAN: AN INTIMATE PORTRAIT. New York: David McKay Co., 1959. 365 p.

Primarily considered a cinema personality, Ingrid Bergman has done important stage work; Maxwell Anderson's *Joan of Lorraine* is her most remembered stage role in the United States. This biography tells of her stage and screen work abroad. Steele served for a time as Bergman's personal press representative in the United States.

BERLE, MILTON 1908—

P61. Berle, Milton, and Frankel, Haskel. MILTON BERLE: AN AUTOBIOGRAPHY. New York: Delacorte Press, 1974. 337 p., illus.

Berle's life—onstage and off—from his days as a child star to his role as "Uncle Miltie" on television. Index.

BERLIN, IRVING 1888—

P61a. Jay, Dave. THE IRVING BERLIN SONGOGRAPHY. Washington, D.C., 1967. Offset. 57 p., illus.

[*See* P682.]

BERNARDI, BEREL *died* 1932

P62. Bernardi, Jack. MY FATHER, THE ACTOR. New York: W. W. Norton & Co., 1971. 233 p., illus.

All through the days of the great tides of immigration to the United States, the Yiddish theatre was an active segment of the American stage. The Bernardi family—Berel and his wife, Helen (*d.* 1971), and their children—were part of this theater. Herschel, because of his roles on television in *Fiddler on the Roof* and *Zorba, the Greek*, is probably the most widely known of the children. However, the other Bernardi children also continue to work in the arts. Foreword by Herschel Bernardi.

BERNHARDT, SARAH 1844–1923

P63. Bernhardt, Lysianne. SARAH BERNHARDT, MY GRANDMOTHER. TRANSLATED BY VYVYAN HOLLAND. London: Hurst & Blackett, 1949. 232 p., illus.

This book is an account of Bernhardt's career, written at Bernhardt's bidding by her granddaughter, Lysianne. There is much about her American tours, the amputation of her leg, and her adjustment to the surgery. Index.

P64. Rueff, Suze. I KNEW SARAH BERNHARDT. London: Frederick Muller, 1951. 240 p., illus.

A personal account of Sarah Bernhardt by one who was associated with her for more than thirty years. Rueff says

she wrote the book in an attempt "to keep her legend alive." Index.

P65. Skinner, Cornelia Otis. MADAME SARAH. Boston: Houghton Mifflin Co., 1966. 356 p., illus.

Of all the great foreign stars to have played in the United States, Sarah Bernhardt retains the most glamour. Cornelia Otis Skinner, an outstanding actress herself, understood what made Bernhardt a great personality. Beautifully researched, *Madame Sarah* gives a full-length portrait of the great French star. Included is a partial list of Bernhardt's roles and playing dates. Bibliography; index.

P66. Taranow, Gerda. SARAH BERNHARDT: THE ART WITHIN THE LEGEND. Princeton: Princeton University Press, 1972. 287 p.

This is the most recent study of Bernhardt; it concentrates largely on her acting technique and vocal accomplishment and discusses at length her artistic achievement in relation to the other artists of her time. Audiography; filmography; bibliography; index.

P67. Verneuil, Louis. THE FABULOUS LIFE OF SARAH BERNHARDT. TRANSLATED BY ERNEST BOYD. New York: Harper & Bros., 1942. 312 p., illus.

Verneuil, a dramatist and actor, appeared with Bernhardt, wrote for her, and was with her through much of her later life. His is a very personal account of the actress's career, her loves, and her family. Included is a list of Bernhardt's roles and a summary chronology.

BLUMENTHAL, GEORGE 1862–1943

P68. Blumenthal, George, and Menkin, Arthur H. MY SIXTY YEARS IN SHOW BUSINESS. New York: Frederick C. Osberg, 1936. 336 p., illus.

Show business, in this book, is defined as that form of entertainment dispensed by Oscar Hammerstein at the Harlem Opera House and elsewhere.

BOOTH, EDWIN 1833–1893

P69. Lockridge, Richard. DARLING OF MISFORTUNE. New York: Century Co., 1932. illus.

The life of Edwin Booth, tragedian; also included is some history of The Players. Index.

P70. Ruggles, Eleanor. PRINCE OF PLAYERS. New York: W. W. Norton & Co., 1953. 401 p., illus.

Notes; index.

P71. Watermeier, Daniel, ed. BETWEEN ACTOR AND CRITIC: SELECTED LETTERS OF EDWIN BOOTH AND WILLIAM WINTER. Princeton: Princeton University Press, 1971. 329 p., illus.

Letters between the distinguished American actor and the equally distinguished critic and Shakespearean scholar, 1859–1890; also includes entries from Booth's diary. Bibliography; index.

P72. Winter, William. LIFE AND ART OF EDWIN BOOTH. Rev. ed. New York: Macmillan Co., 1896. 437 p., illus. (frontispiece).

Winter revised his earlier biography of Edwin Booth after the actor's death to include an account of his demise and a lengthy section of memorials. ORIGINAL EDITION (New York: Macmillan Co., 1893).

BOOTH, JOHN WILKES 1839–1865.

P73. Clarke, Asia Booth. THE UNLOCKED BOOK. New York: G. P. Putnam's Sons, 1938. 205 p., illus.

A memoir of John Wilkes Booth by his sister.

P74. Forrester, Izola. THIS ONE MAD ACT: THE UNKNOWN STORY OF JOHN WILKES BOOTH AND HIS FAMILY. Boston: Hale, Cushman & Flint, 1937. 500 p., illus.

A biography of the actor by his granddaughter. Basing her work on new evidence found in family records, the author postulates that Booth lived in exile until 1879. Index.

P75. Stern, Philip Van Doren. THE MAN WHO KILLED LINCOLN. New York: Random House, 1939. 376 p., illus.

Contains an afterword and a bibliography.

P76. Wilson, Francis. JOHN WILKES BOOTH: FACT AND FICTION OF LINCOLN'S ASSASSINATION. Boston and New York: Houghton Mifflin Co., 1919. 322 p., illus.

BOOTH FAMILY 1813–1893

P77. Kimmel, Stanley. THE MAD BOOTHS OF MARYLAND. Indianapolis: Bobbs-Merrill Co., 1940. 398 p., illus.

The offstage lives of the Booths were almost as theatrical as the professional. Traces the family history from 1813 to the death of Edwin in 1893. Notes; index.

BOWMAN, LAURA 1881–1957

P78. Antoine, LeRoi. ACHIEVEMENT: THE LIFE OF LAURA BOWMAN. New York: Pageant Press, 1961.

BRADY, WILLIAM A. 1863–1950

P79. Brady, William A. THE FIGHTING MAN. Indianapolis: Bobbs-Merrill Co., 1916. 227 p., illus.

A discussion of Brady's career managing pugilists Jack Johnson, James J. Corbett, and Tom Sharkey, as well as his theatrical career.

P80. Brady, William A. SHOWMAN. New York: E. P. Dutton & Co., 1936. 278 p., illus.

An account of Brady's career in the theater, with an interesting insight on the influence of the movies on the legitimate stage.

BRICE, FANNY 1891–1951

P81. **Katkov, Norman.** THE FABULOUS FANNY. New York: Alfred A. Knopf, 1953. 337 p., illus.

A narrative, easy-reading account of Fanny Brice from her days in vaudeville in Brooklyn, through the Ziegfeld Follies and on to films and "Baby Snooks." Though unindexed, the volume follows a strict chronological pattern throughout.

BROOK, PETER 1925—

P82. **Trewin, John Courtenay.** PETER BROOK: A BIOGRAPHY. London: Macdonald, 1972. 216 p., illus.

Primarily active in the theater of England, Peter Brook created a stir in the American theater with his *Marat-Sade*. Chronology; bibliography; index.

BROWN, JOHN MASON 1900–1969

P83. **Stevens, George.** SPEAK FOR YOURSELF, JOHN: THE LIFE OF JOHN MASON BROWN, WITH SOME OF HIS LETTERS AND MANY OF HIS OPINIONS. New York: Viking Press, 1974.

A biography of the drama critic and author of more than a score of books on the theater, written by a Harvard classmate, coworker and neighbor. Reprinted are letters to and from Brown; an extensive section about his theater associates; and a list of his publications. Index.

BURTON, RICHARD 1925—

P84. **Cottrell, John, and Cashin, Fergus.** RICHARD BURTON: VERY CLOSE UP. Englewood Cliffs, N.J.: Prentice-Hall, 1971. 385 p., illus.

The biography of the Welsh-born stage and screen actor, director, and acting teacher.

CHAPMAN, BLANCHE

P85. **Ford, George D.** THESE WERE ACTORS: A STORY OF THE CHAPMANS AND THE DRAKES. New York: Library Publishers, 1955. 314 p., illus.

COCTEAU, JEAN 1889–1963

P86. **Steegmuller, Francis.** COCTEAU. Boston: Little, Brown & Co., 1970. 583 p., illus.

Notes; index.

COHAN, GEORGE M. 1878–1942

P87. **Cohan, George M.** TWENTY YEARS ON BROADWAY, AND THE YEARS IT TOOK TO GET THERE: THE TRUE STORY OF A TROUPER'S LIFE FROM THE CRADLE TO THE "CLOSED SHOP." New York: Harper & Bros., 1925. 264 p., illus.

An interesting autobiography.

P88. **McCabe, John.** GEORGE M. COHAN: THE MAN WHO OWNED BROADWAY. Garden City, N.Y.: Doubleday, 1973. 296 p., illus.

George M. Cohan has left his stamp on the American theater as a playwright, a songwriter, and a performer. McCabe's account is the most complete portrait of this complex man. Listing of Cohan productions; index.

P89. **Morehouse, Ward.** GEORGE M. COHAN: PRINCE OF THE AMERICAN THEATRE. Philadelphia: J. B. Lippincott Co., 1943. 240 p., illus.

Ward Morehouse knew Cohan personally. Includes a chronology.

CONNELLY, MARC 1890—

P90. **Connelly, Marc.** VOICES OFFSTAGE: A BOOK OF MEMOIRS. New York: Holt, Rinehart & Winston, 1968. 258 p., illus.

CONRIED, HEINRICH 1848–1909

P91. **Moses, Montrose J.** THE LIFE OF HEINRICH CONRIED. New York: Thomas Y. Crowell, 1916. 367 p., illus.

Manager of the Star Theatre, the Irving Place Theatre, and the Metropolitan Opera (1903–8), Conried brought German drama to the United States.

COOKE, GEORGE FREDERICK 1756–1812

P92. **Dunlap, William.** MEMOIRS OF GEORGE FREDERICK COOKE. London: Printed for Henry Colburn, 1813. 2 vols., frontispiece.

SECOND REVISED EDITION (London: Printed for Henry Colburn, 1815).

COOPER, GLADYS 1888–1971

P93. **Cooper, Gladys.** GLADYS COOPER. London: Hutchinson & Co., 1931. 288 p., illus.

P94. **Stokes, Sewell.** WITHOUT VEILS: THE INTIMATE BIOGRAPHY OF GLADYS COOPER. London: Peter Davies, 1953. 243 p., illus.

Introduction by W. Somerset Maugham. Index.

CORNELL, KATHARINE 1898–1974

P95. **Malvern, Gladys.** CURTAIN GOING UP: THE STORY OF KATHARINE CORNELL. New York: Julian Messner, 1943. 244 p., illus.

Foreword by Katharine Cornell. Index.

P96. **Sedgwick, Ruth Woodbury.** I WANTED TO BE AN ACTRESS. New York: Random House, 1939. 361 p., illus.

Purportedly the autobiography of Katharine Cornell, this work was written for *Stage Magazine*. Includes cast lists.

COWARD, NOEL 1899–1974

P97. Hadfield, John, ed. A LAST ENCORE: WORDS BY NOEL COWARD, PICTURES FROM HIS LIFE AND TIMES. Boston: Little, Brown & Co., 1973. 144 p., illus.

An illustrated volume, covering the life and creativity of Noel Coward. The pictures are reproductions of art works and news shots. Also included are Coward's lyrics. Index.

P98. Mander and Mitchenson. THEATRICAL COMPANION TO COWARD. New York: Macmillan Co., 1957. 407 p., illus.

Coward was one of the great talents of the twentieth century theater as a dramatist, composer, and as an actor. Almost all of his plays have been done in the American theater. The volume lists film versions of the plays; Coward's appearances as an actor on stage and in films; a discography; and a list of publication dates of Coward's plays. Includes index to characters, with an appreciation of Coward's work in the theater by Terence Rattigan.

COWELL, SAM 1820–1864

P99. Disher, M. Willson. THE COWELLS IN AMERICA: BEING THE DIARY OF MRS. SAM COWELL DURING HER HUSBAND'S CONCERT TOUR IN THE YEARS 1860–1861. London: Oxford University Press, 1934. illus.

Sam Cowell was "a kind of comic song." His tour of North America was recorded by his wife in a diary bequeathed to her granddaughter, Sydney Fairbrother, an English actress. The book is interesting both for its views of the theater of the period across the United States and for its bits of history. For instance, their paths crossed that of the campaigning Abraham Lincoln in Saint Louis; they were in New York when Fort Sumter was fired upon and the Civil War commenced. Includes genealogical tables. Index.

CRABTREE, LOTTA 1847–1924

P100. Bates, Helen Marie. LOTTA'S LAST SEASON. Brattleboro, Vt.: Privately printed, E. L. Hildreth & Co., 1940. 306 p., illus.

Known on the stage as "Helen Leslie," the author toured with Lotta Crabtree in her final professional season, 1891–92. These are her somewhat flawed reminiscences of that tour.

P101. Dempsey, David, and Baldwin, Raymond P. THE TRIUMPHS AND TRIALS OF LOTTA CRABTREE. New York: William Morrow & Co., 341 p., illus.

A full-scale account of Lotta's beginnings in the mining camps of California and her spectacular rise in the theatrical firmament to become (in her day) perhaps the richest actress in America. Index.

P102. Rourke, Constance. TROUPERS OF THE GOLD COAST: OR, THE RISE OF LOTTA CRABTREE. New York: Harcourt Brace, 1928. illus.

An account of Lotta's early years on the stage playing the mining camps in California. Her path crossed that of Edwin Booth, Jenny Lind, and others. Index.

CRAIG, GORDON 1872–1966

P103. Craig, Edward. GORDON CRAIG: THE STORY OF HIS LIFE. New York: Alfred A. Knopf, 1968. 398 p., illus.

Gordon Craig was one of the visionaries of the modern theater, and his influence on the American theater has been profound. This is a full-scale study by his son who worked with him as "chief assistant" for many years. Bibliographical notes. Index.

CUSHMAN, CHARLOTTE 1816–1876

P104. Leach, Joseph. BRIGHT PARTICULAR STAR: THE LIFE AND TIMES OF CHARLOTTE CUSHMAN. New Haven and London: Yale University Press, 1970. 453 p., illus.

This is the most recent biography of the only American actress in the Hall of Fame. Ahead of her time as a fighter for women's rights, Charlotte Cushman blazed across the nineteenth century American stage with Edwin Booth and Edwin Forrest. Leach has worked from Cushman papers in many American theater archives and from earlier studies of the actress. Bibliography; notes; index.

P105. Stebbins, Emma. CHARLOTTE CUSHMAN: HER LETTERS AND MEMOIRS OF HER LIFE. Boston: Houghton, Osgood & Co., 1878. 308 p., illus.

Those readers who enjoy letters will relish this study of Charlotte Cushman. The volume is liberally interspersed with letters from her childhood to her later years. This is the pioneering biography of Miss Cushman and, as such, is worthy of serious attention. Index.

P106. Waters, Clara Erskine Clement. CHARLOTTE CUSHMAN. Boston and New York: Houghton Mifflin Co., 1882. 193 p., illus.
AMERICAN ACTOR SERIES, NO. 4

The author acknowledges her indebtedness to the earlier volume on Cushman by Stebbins. [*See* P105.] The book is a fairly chronological listing of Charlotte Cushman's accomplishments. The penultimate chapter is a selection from Cushman's letters (which are more fully recorded in Stebbins) and the final chapter is an appreciation of Charlotte Cushman by William Thomas Widnesborough Ball (*d.* 1893), who for more than a decade was the dramatic critic for the *Boston Traveller*. Index.

DALRYMPLE, JEAN 1910—

P107. Dalrymple, Jean. SEPTEMBER CHILD: THE STORY OF JEAN DALRYMPLE BY HERSELF. New York: Dodd, Mead & Co., 1963. 318 p., illus.

The recollections of Miss Dalrymple: her childhood, her years in Wall Street as a press agent, as a producer, as the

director of the New York City Center. Foreword, "May I speak to Miss Jean Dalrymple?" by Mildred Harris. Introduction by Jed Harris.

DALY, ARNOLD 1875–1927

P108. **Goldsmith, Berthold Henry.** ARNOLD DALY. New York: James T. White & Co., 1927. 57 p., illus.

A slim memorial volume to the American actor, this book grew out of research about Daly for a biographical sketch.

DALY, AUGUSTIN 1838–1899

P109. **Daly, Joseph Francis.** THE LIFE OF AUGUSTIN DALY. New York: Macmillan Co., 1917. 672 p., illus.

Daly was among the foremost producers of both the American and the British stage in the latter part of the nineteenth century. This biography by his brother is replete with excerpts from Daly's correspondence and with "inside" accounts of his career, including a note on the settlement of his estate. Index.

P110. **Felheim, Marvin.** THE THEATER OF AUGUSTIN DALY. Cambridge: Harvard University Press, 1956. 329 p., illus.

A study of American theater in the nineteenth century focusing on the professional career of Augustin Daly. Index.

DANDRIDGE, DOROTHY 1924–1965

P111. **Dandridge, Dorothy, and Conrad, William.** EVERYTHING AND NOTHING: THE DOROTHY DANDRIDGE TRAGEDY. New York: Abelard-Schuman, 1970. 215 p., illus.

The tragic story of the black actress who died at 41, and of her experience as "an experiment in integration."

DAVENPORT, EDWARD LOOMIS 1814–1888

P112. **Edgett, Edwin Francis, ed.** EDWARD LOOMIS DAVENPORT: A BIOGRAPHY, New York: The Dunlap Society, 1901. 145 p., illus.

From a manuscript found among the effects of Fanny Davenport, this biography of the nineteenth-century American actor has been edited. E. L. Davenport was a leading actor of the period and a member of an illustrious American theatrical family. Index.

DAVIDGE, WILLIAM 1814–1888

P113. **Davidge, William.** FOOTLIGHT FLASHES. New York: American News Co., 1866. illus., frontispiece.

The comedian, William Davidge, has set down his recollections of his theater career as well as his recollections of Edmund Kean, Gustavus Brooke, and others. The volume is dedicated to Edwin Forrest.

DAVIES, MARION 1897–1961

P114. **Guiles, Fred Lawrence.** MARION DAVIES. New York: McGraw-Hill Book Co., 1972. 419 p., illus.

Known principally for her film career and her reign as queen of Hollywood, Marion Davies came up through the Ziegfeld Follies and New York show business. Filmography; bibliography; index.

DAVIS, OWEN 1874–1956

P115. **Davis, Owen.** MY FIRST FIFTY YEARS IN THE THEATRE. Boston: W. H. Baker Co., 1950. 157 p.

DE MILLE, AGNES 1905—

P116. **De Mille, Agnes.** DANCE TO THE PIPER. Boston: Little, Brown & Co., 1951. 342 p., illus.

P117. **De Mille, Agnes.** AND PROMENADE HOME. Boston: Little, Brown & Co., 1956. 301 p., illus.

Though primarily identified with the world of dance, Agnes De Mille's career has flourished on the musical stage. Her dances for *Oklahoma!* (1943) revolutionized the American musical. These two books [P116 and P117] are her memories of her career and her life. Some of the material appeared originally in the pages of *Atlantic Monthly* and *Ladies Home Journal.*

DENHAM, REGINALD 1894—

P118. **Denham, Reginald.** STARS IN MY HAIR: BEING CERTAIN INDISCREET MEMOIRS. London: T. Werner Laurie, 1958. 256 p., illus.

British-born, Reginald Denham has spent a large part of his professional life in the American theater as actor, director, and playwright. This autobiographical volume ends with the promise "to be continued in our next." Index.

DERWENT, CLARENCE 1884–1959

P119. **Derwent, Clarence.** THE DERWENT STORY: MY FIRST FIFTY YEARS IN THE THEATRE IN ENGLAND AND AMERICA. New York: Henry Schuman, 1953. 304 p., illus.

Much of his life was devoted to the American theater including six years as president of Actors' Equity Association. This is the autobiography of a man whose career was centered around the theater.

DIETZ, HOWARD 1896—

P120. **Dietz, Howard.** DANCING IN THE DARK. New York: Quadrangle/New York Times Book Co., 1974. 370 p., illus.

The autobiography of the man who wrote lyrics for some of the twentieth century theater's best musicals and

served as chief of publicity and advertising for Metro-Goldwyn-Mayer. His shows range from *Dear Sir* in 1924 (music by Jerome Kern) to *Jennie*, in 1963 (music by Arthur Schwartz). Foreword by Alan Jay Lerner. Chronology of productions with notes on New York performances. Lists of casts and songs. Index.

DILLON, WILLIAM A. 1877–1966

P121. **Dillon, William A.** LIFE DOUBLES IN BRASS. Ithaca, N.Y.: House of Nollid, 1944. 239 p., illus.

A song and dance man who toured the country's vaudeville houses, William Dillon writes of a phase of American entertainment that has all but disappeared. Includes music and lyrics of songs.

DRAPER, RUTH 1884–1956

P122. **Zabel, Morton Dauwen.** THE ART OF RUTH DRAPER: HER DRAMAS AND CHARACTERS. Garden City, N.Y.: Doubleday, 1960. 373 p., illus.

Part of this volume is a memoir of the famed solo performer; the remainder is the texts of her monologues. Appendix lists the stage requirements for Draper's monologues. Editor's note.

DRESSLER, MARIE 1869–1934

P123. **Dressler, Marie.** THE EMINENT AMERICAN COMEDIENNE: MARIE DRESSLER IN THE LIFE STORY OF AN UGLY DUCKLING, AN AUTOBIOGRAPHICAL FRAGMENT IN SEVEN PARTS. New York: Robert M. McBride & Co., 1924. 234 p., illus.

Though remembered chiefly for her career in motion pictures, Marie spent her formative years on the stage with Weber and Fields, Lillian Russell, and Anna Held. These volumes are her autobiographical accounts.

P124. **Dressler, Marie.** MY OWN STORY: AS TOLD TO MILDRED HARRINGTON. Boston: Little, Brown & Co., 1934. 290 p., illus.

An updating of her earlier autobiography.

DREW, JOHN 1853–1927

P125. **Dithmar, Edward A.** JOHN DREW. New York: Frederick A. Stokes Co., 1900. 137 p., illus.

An appreciation of the career of John Drew from a critic and historian who witnessed his debut in 1875 and followed his career.

P126. **Drew, John.** MY YEARS ON THE STAGE. New York: E. P. Dutton & Co., 1921. 242 p., illus.

The autobiography of this member of what has been called the "Royal Family" of the American stage: his years with Daly's company, his years as a star, and his hopes for his descendants. Foreword by Booth Tarkington. Index.

P127. **Wood, Peggy.** A SPLENDID GYPSY: John Drew. New York: E. P. Dutton & Co., 1928. 64 p.

An account by a professional associate of John Drew's last grand tour of the United States.

DREW, LOUISA 1820–1897

P128. **Drew, Louisa Lane.** AUTOBIOGRAPHICAL SKETCH OF MRS. JOHN DREW: WITH AN INTRODUCTION BY HER SON JOHN DREW, WITH BIOGRAPHICAL NOTES BY DOUGLAS TAYLOR. London: Chapman and Hall, 1900. 200 p., illus.

Mrs. Drew came first to America in 1827; for years she was the first lady of the Philadelphia stage. Appendix includes the biographical notes by Douglas Taylor.

DUFF, MARY ANN 1799–1857

P129. **Ireland, Joseph N.** MRS. DUFF. Boston: James R. Osgood & Co., 1882. 188 p., illus.
AMERICAN ACTORS SERIES

The introductory note reminds us that Junius Brutus Booth, Sr., pronounced Mrs. Duff the "best actress in the world." This volume is replete with quotes from auditors about her performances. Appendixes: lists of roles performed by Mr. and Mrs. Duff. Index.

DURANG, JOHN 1785–1816

P130. **Downer, Alan S., ed.** THE MEMOIR OF JOHN DURANG: AMERICAN ACTOR, 1785–1816. Pittsburgh: University of Pittsburgh Press; published for the Historical Society of York County and for the American Society for Theatre Research, 1966. 176 p., illus.

Durang's memoir of his years on the American stage was acquired in 1945 by the Historical Society of York County from a local dealer. Its earlier whereabouts are unknown but this is a rich account of a very early period in our stage history. Notes. Index.

DURANTE, JIMMY 1893—

P131. **Cahn, William.** GOOD NIGHT, MRS. CALABASH: THE SECRET OF JIMMY DURANTE. New York: Duell, Sloan & Pearce, 1963. 191 p., illus.

A profusely illustrated, but thin, biography.

P132. **Fowler, Gene.** SCHNOZZOLA: THE STORY OF JIMMY DURANTE. New York: Viking Press, 1951. 261 p., illus.

Although Jimmy Durante said "I don't want nobody to put me on a pedasill," Gene Fowler writes a monumental biography of this entertainer. Before he was a figure in the films, on radio, and on television, Durante, with his partners Clayton and Jackson, was a star of the theater, vaudeville, and night clubs.

DUSE, ELEONORA 1858–1924

P133. Anfuso, Bernice Sciorra. THE PASSING STAR, ELEONORA DUSE IN AMERICA. M.A. thesis, University of California, Los Angeles, 1956. 302 p.

This thesis describes the American tours of the great Italian actress from her first, in 1893, until her death in 1924, in Pittsburgh.

P134. Le Gallienne, Eva. THE MYSTIC IN THE THEATRE: ELEONORA DUSE. New York: Farrar, Straus & Giroux, 1965. 185 p.

A great actress herself, Le Gallienne tries in this little book to pass on the greatness of Duse to young people in the theater who missed the opportunity to see Duse act.

EAGELS, JEANNE 1894–1929

P135. Doherty, Edward. THE RAIN GIRL: THE TRAGIC STORY OF JEANNE EAGELS. Philadelphia: Macrae Smith Co., 1930. 313 p., illus.

Jeanne Eagels will be remembered for her portrayal of Sadie Thompson in *Rain*, the dramatization of a story by W. Somerset Maugham, 1922. This book, made up of a series of articles written for *Liberty* magazine, is a tribute to this actress.

ELIOT, T. S. 1888–1965

P136. Sencourt, Robert. T. S. ELIOT: A MEMOIR. EDITED BY DONALD ADAMSON. New York: Dodd, Mead & Co., 1974. 266 p., illus.

Saint Louis–born, Eliot lived most of his life in Britain. For years his plays have continued to brighten the American stage. Robert Sencourt wrote this memoir, drawing upon his long friendship with the dramatist/poet. Notes; index.

ELKINS, HILLARD

P137. Davis, Christopher. THE PRODUCER. New York: Harper & Row, 1972. 321 p., illus.

This book is more of a generalized study of the theater producer as a type rather than a biography of Hillard Elkins. It details the process of producing a Broadway show.

ELLIOTT, MAXINE 1868–1940

P138. Forbes-Robertson, Diana. MY AUNT MAXINE: THE STORY OF MAXINE ELLIOTT. New York: Viking Press, 1964. 306 p., illus.

American-born, Maxine Elliott made her stage debut in Edmund S. Willard's repertory company in 1890. Though her final performance was in 1920, she occupied a non-performing place in the world of theater until her death in 1940. Chronology; index.

ENGEL, LEHMAN 1910—

P139. Engel, Lehman. THIS BRIGHT DAY: AN AUTOBIOGRAPHY. New York: Macmillan & Co., 1974. 366 p., illus.

Composer-conductor Lehman Engel writes of the groups (Federal Theatre, the Mercury Theatre) and shows (*On the Town, L'il Abner, Lady in the Dark*) with which he worked. Index.

ENTERS, ANGNA 1907—

P140. Enters, Angna. FIRST PERSON PLURAL. New York: Stackpole Sons, 1937. 386 p., illus.

EVANS, EDITH 1888–1976

P141. Trewin, John Courtenay. EDITH EVANS. London: Rockliff, 1954. 116 p., illus.

Dame Edith Evans is another of the English actresses who has illumined the American stage on many occasions. This is a tribute to her career. Chronology of stage and film appearances.

EYTINGE, ROSE 1835–1911

P142. Eytinge, Rose. THE MEMORIES OF ROSE EYTINGE; BEING RECOLLECTIONS AND OBSERVATIONS OF MEN, WOMEN, AND EVENTS DURING HALF A CENTURY. New York: Frederick A. Stokes Co., 1905. 311 p.

Little remembered today, Rose Eytinge was a star of the nineteenth-century stage. These are her remembrances.

FECHTER, CHARLES ALBERT 1824–1879

P143. Field, Kate. CHARLES ALBERT FECHTER. Boston: James R. Osgood, 1882. 205 p., illus.

Fechter made his American debut in 1870, at Niblo's Garden, after a spectacular career in the English theater. This volume also contains recollections of Fechter by Edmund Yates, Herman Vezin, and Wilkie Collins, in addition to some of Fechter's press notices. Index.

FELLOWS, DEXTER *died* 1937

P144. Fellows, Dexter W., and Freeman, Andrew A. THIS WAY TO THE BIG SHOW: THE LIFE OF DEXTER FELLOWS. New York: Viking Press, 1936. 362 p., illus.

The story of the circus by the man who was press agent for Ringling Brothers and other circuses for more than forty years. Index.

FERBER, EDNA 1887–1968

P145. Ferber, Edna. A KIND OF MAGIC. Garden City, N.Y.: Doubleday, 1963. 335 p.

An autobiographical volume that is a paean to the world

and her audience from the playwright who helped give the American theater *The Royal Family, Stage Door,* and *Minick.*

FIELD, AL G. *died* 1921

P146. Field, Al G. Watch Yourself Go By. Columbus, Ohio, 1912. 537 p., illus.

A rambling reminiscence by the famous minstrel man. Drawings by Ben W. Warden.

FISKE, MINNIE MADDERN 1865–1932

P147. Binns, Archie, and Kooken, Olive. Mrs. Fiske and the American Theatre. New York: Crown Publishers, 1955. 436 p., illus.

The definitive biography of the contribution of Minnie Fiske to the American theater. Foreword by George Freedley. Includes list of plays and casts of Fiske's productions. Index.

P148. Griffith, Frank Carlos. Mrs. Fiske. New York: Neale Publishing Co., 1912. 146 p., illus.

A brief recollection by the man who had been her manager, 1897–1910.

P149. Woollcott, Alexander. Mrs. Fiske: Her Views on Actors, Acting, and the Problems of Production. New York: Century Co., 1917. 229 p., illus.

Mr. Woollcott was a great admirer of Fiske's. This book is a result of talks with her on repertory, Ibsen, audiences, and other matters pertaining to the theater.

FITCH, CLYDE 1865–1908

P150. Moses, Montrose J., and Gerson, Virginia. Clyde Fitch and His Letters. Boston: Little, Brown & Co., 1924. 406 p., illus.

In his brief career, Clyde Fitch wrote 62 plays, some of them outstanding hits of their day. This collection of letters to Maude Adams, Otis Skinner, Charles Frohman and other professional associates and friends is almost a day-to-day account of this career. Bibliography; index.

FONDA, HENRY 1905—

P151. Brough, James. The Fabulous Fondas. New York: David McKay Co., 1973. 296 p., illus.

Henry Fonda made his stage debut in 1925. Over the years, he has spent much of his time working in film, but his appearances in legitimate theater are often and important enough to list him as a stage person: *Mr. Roberts, Two for the Seesaw, The Caine Mutiny Court-Martial,* and the one-man *Clarence Darrow.* This volume treats his career as well as that of his famous children, Jane and Peter. Index.

FORBES-ROBERTSON, JOHNSTON 1853–1937

P152. Forbes-Robertson, Johnston. A Player Under Three Reigns. Boston: Little, Brown & Co., 1925. 324 p., illus.

Though a member of the English stage, Forbes-Robertson made several tours of the United States. His portrayal of Hamlet and of the Stranger in Jerome's *The Passing of the Third Floor Back* thrilled American theatergoers. His first visit to America was as a member of Mary Anderson's company in 1885. Index.

P153. Souvenir of Forbes-Robertson's Farewell To America. London, 1913. unpag., illus.

Contains a synopsis of the actor's career and photographs of him and his wife, Gertrude Elliott, in their most famous roles.

FORREST, EDWIN 1806–1872

P154. Alger, William Rounseville. Life of Edwin Forrest: The American Tragedian. Philadelphia: J. B. Lippincott Co., 1877. 2 vols., illus.

Edwin Forrest was one of the outstanding tragedians of the American stage in the nineteenth century. At the time the author wrote the book, he declared: "Of no American actor has there yet been written a biography worthy of the name." This may well be the milestone in this field of literary endeavor. Appendix; index. Reprint (New York: B. Blom, 1972).

P155. Barrett, Lawrence. Edwin Forrest. Boston: James R. Osgood, 1881. 171 p., illus.
American Actor Series.

This is an appreciation of the actor by a fellow professional. The series is edited by Laurence Hutton. Index.

P156. Harrison, Gabriel. Edwin Forrest: The Actor and the Man, Critical and Reminiscent. Brooklyn, 1889. 210 p., illus.

A detailed study of Forrest in his many roles, among which are Othello, Virginius, and King Lear. This volume, too, reprints the text of Forrest's will, which set up the Edwin Forrest Home in Philadelphia.

P157. Moody, Richard. Edwin Forrest: First Star of the American Stage. New York: Alfred A. Knopf, 1960. 427 p., illus.

The most complete biography of the nineteenth-century actor, written from a historical and analytical point of view. The volume assesses Forrest's stage magic, the theater, and the audience of his day. Notes on sources; bibliography; index.

P158. Moses, Montrose, J. The Fabulous Forrest: The Record of an American Actor. Boston: Little, Brown & Co., 1929. 369 p., illus.

Four biographies of Forrest had been published before that of Moses in 1929. Moses felt that three of these had

been written by friends. Therefore, he attempted to view Forrest "in relation to the backdrop of his national surroundings." Index.

P159. Rees, James. THE LIFE OF EDWIN FORREST; WITH REMINISCENCES AND PERSONAL RECOLLECTIONS. Philadelphia: T. B. Peterson & Bros., 1874. 524 p., frontispiece.

One of the biographies written by a friend of Forrest and replete with first-hand recollections of the life and professional career of the actor.

FORREST, SAM 1870–1944

P160. Forrest, Sam. VARIETY OF MISCELLANIA. New York: Privately printed, 1939. 100 p., illus.

A collection of verse. Includes memories of George M. Cohan, Mary Ryan (Mrs. Sam Forrest), Otis Skinner, The Players, and The Lambs.

FOY, EDDIE 1856–1928

R161. Foy, Eddie, and Harlow, Alvin F. CLOWNING THROUGH LIFE. New York: E. P. Dutton & Co., 1928. 331 p., illus.

One of the most beloved clowns of the musical and variety stages. Eddie Foy with his family, the Seven Little Foys, delighted American theatergoers for approximately fifty years.

FREDERICK, PAULINE 1885–1938

P162. Elwood, Muriel. PAULINE FREDERICK: ON AND OFF THE STAGE. Chicago: A. Kroch, 1940. 225 p.

Frederick's great success was *Madame X*, but she made scores of stage and film apearances as well. This is a scantily authenticated, poorly dated, and biased biography of the star. List of stage and screen appearances; index.

FROHMAN, CHARLES 1860–1915

P163. Marcosson, Issac F. and Frohman, Daniel. CHARLES FROHMAN: MANAGER AND MAN. New York: Harper & Bros., 1916. 440 p., illus.

A biography of the producer—recollections of Barrie, Maude Adams, Ethel Barrymore, and the Empire Theatre Stock Co. Appreciation by James M. Barrie. Appendixes; index.

FROHMAN, DANIEL 1851–1940

P164. Frohman, Daniel. MEMORIES OF A MANAGER: REMINISCENCES OF THE OLD LYCEUM AND OF SOME PLAYERS OF THE LAST QUARTER CENTURY. Garden City, N.Y.: Doubleday, Page & Co., 1911. 235 p., illus.

P165. Frohman, Daniel. DANIEL FROHMAN PRESENTS. New York: Claude Kendall & Willoughby Sharp, 1935. 397 p., illus.

A scholarly autobiographical volume, recounting Daniel Frohman's many years in the theater, and his management of the Lyceum Theatre, New York. Index.

P166. Frohman, Daniel. ENCORE. New York: L. Furman, 1937. 295 p., illus., ports., frontispiece.

GAIGE, CROSBY 1882–1949

P167. Gaige, Crosby. FOOTLIGHTS AND HIGHLIGHTS. New York: E. P. Dutton & Co., 1948. 320 p.

Theatre producer, gourmet cook, bibliophile—all part of Crosby Gaige. Index.

GARFIELD, JOHN 1913–1952

P168. Swindell, Larry. BODY AND SOUL: THE STORY OF JOHN GARFIELD. New York: William Morrow & Co., 1975. 288 p., illus.

John Garfield is considered by most as a film star, but his career began in the Group Theatre, and he returned to the stage throughout his too-brief career. This book focuses on his films but there is also considerable information about the theater of the late 1920s and 1930s. Reprinted is an eulogy by Clifford Odets, which appeared in the *New York Times*, May 25, 1952. Filmography; index.

GEDDES, NORMAN BEL 1893–1958

P169. Geddes, Norman Bel. MIRACLE IN THE EVENING. Edited by William Kelley. Garden City, New York: Doubleday, 1960. 352 p.

Scene designer, industrial designer, theater architect, Norman Bel Geddes pens his autobiography. It is unfortunate that the volume is not indexed. Chronology.

GERSHWIN, GEORGE 1898–1937
GERSHWIN, IRA 1896—

P170. Kimball, Robert, and Simon, Alfred. THE GERSHWINS. New York: Atheneum Publishers, 1973. 292 p., illus.

George and Ira Gershwin's first Broadway musical, "La La Lucille," hit town in 1919. Their music has encompassed show musicals, operas, and concert material. Foreword by Richard Rodgers. Introduction by John S. Wilson. Includes chronology of shows; listing of songs; discography; piano rollography; bibliography.

GIELGUD, JOHN 1904—

P171. Gielgud, John. EARLY STAGES. Rev. ed. London: Falcon Press, 1948. 269 p., illus.

Sir John Gielgud has been seen many times on the Ameri-

can stage. A scion of the illustrious Terry stage family, his autobiography tells quite a bit about his own professional career. Preface by Ivor Brown. Includes record of performances and productions. Index. ORIGINAL EDITION (London: Macmillan, 1939).

P172. **Hayman, Ronald.** JOHN GIELGUD. New York: Random House, 1971. 277 p., illus.

At time of publication, the definitive biography of Sir John Gielgud. Includes chronological record of performances and productions.

GILBERT, MRS. GEORGE HENRY (ANN HARTLEY) 1821–1904

P173. **Martin, Charlotte M., ed.** THE STAGE REMINISCENCES OF MRS. GILBERT. New York: Charles Scribner's Sons, 1901. 248 p., illus.

Gilbert made her debut as a dancer in London, though she and her husband emigrated to the United States in 1850. From 1869 to 1899, she was a mainstay of Augustin Daly's Company.

GILLMORE, MARGALO 1897—

P174. **Gillmore, Margalo.** FOUR FLIGHTS UP. Boston: Houghton Mifflin Co., 1964. 171 p.

A highly readable account of the life of a child in a theater family, of touring, and of her appearances as a young actress.

P175. **Gillmore, Margalo, and Collinge, Patricia.** THE B.O.W.S. New York: Harcourt Brace & Co., 1945. 173 p., illus.

The account of the tour diary of *The Barretts of Wimpole Street* starring Katharine Cornell. Gillmore played Arabel Moulton Barrett in this company, which toured the European theater of operations during World War II under the auspices of the American Theatre Wing and the USO.

GISH, LILLIAN 1896—

P176. **Paine, Albert Bigelow.** LIFE AND LILLIAN GISH. New York: Macmillan Co., 1932. 303 p., illus.

A large part of Lillian Gish's career was spent working in the movies. She wrote of this with Ann Pinchot in *The Movies, Mr. Griffith and Me* (Englewood Cliffs, N.J.: Prentice-Hall, 1969). Paine's biography discusses her stage career as well.

GLEASON, JACKIE 1916—

P177. **Bishop, Jim (James Alonzo).** THE GOLDEN HAM: A CANDID BIOGRAPHY OF JACKIE GLEASON. New York: Simon and Schuster, 1956. 298 p.

A frank treatment of the life of Jackie Gleason, and his experiences on stage, screen, in radio, and television.

GOLDEN, JOHN 1874–1955

P178. **Golden, John, and Shore, Viola Brothers.** STAGESTRUCK JOHN GOLDEN. New York: Samuel French, 1927. 324 p., illus.

Playwright, producer, musician, lyricist—John Golden was all of these. Unfortunately, this book was written too early in his career to be in any way a definitive work. Foreword by Irvin S. Cobb. Index.

GOODWIN, NAT C. 1857–1919

P179. **Goodwin, Nat C.** NAT GOODWIN'S BOOK. Boston: Richard G. Badger, Gorham Press, 1914. 364 p., illus.

A reminiscence of Goodwin's career, of the people with whom he acted, and of the theater in which he was a star. Index.

GORDON, MAX 1892–1978

P180. **Gordon, Max, and Funke, Lewis.** MAX GORDON PRESENTS. New York: Bernard Geis Associates; distributed by Random House, 1963. 314 p., illus.

The story of a boy from the Lower East Side of New York who became a most successful theater producer. Among the plays he produced are *The Band Wagon*, *The Cat and the Fiddle*, *The Criminal Code*, *The Shining Hour*, and *Born Yesterday*. Index.

GORDON, RUTH 1896—

P181. **Gordon, Ruth.** MYSELF AMONG OTHERS. New York: Atheneum Publishers, 1971. 389 p.

Ruth Gordon writes as entertainingly as she acts. This is a most readable account of her career, and her associates: Alexander Woollcott, Thornton Wilder, Anita Loos, Helen Keller, and many others.

GRANLUND, NILS THOR *died* 1957

P182. **Granlund, Nils Thor; with Feder, Sid; and Hancock, Ralph.** BLONDES, BRUNETTES, AND BULLETS. New York: David McKay Co., 1957. 300 p.

Known professionally as N-T-G, Granlund was a famed producer of "girlie" shows for theater, vaudeville, and night clubs.

GRANVILLE-BARKER, HARLEY 1877–1946

P183. **Purdom, C. B.** HARLEY GRANVILLE-BARKER: MAN OF THE THEATRE, DRAMATIST, AND SCHOLAR. Cambridge: Harvard University Press, 1956. 322 p., illus.

Though Granville-Barker did only a few productions in the United States in 1915, his effect on the theater was profound. Foreword by Lewis Casson. Includes lists of performances, productions, and writings; index.

GREET, PHILIP BEN 1857–1936

P184. Isaac, Winifred F. E. C. BEN GREET AND THE OLD VIC. London: By the author, 1964. 239 p., illus.

For years Ben Greet kept alive a tradition of Shakespeare productions, and out of his companies came many of our finest twentieth-century classical performers. This biography is more than just a history of his career with the Old Vic and includes material on his American tours. Forewords by Sybil Thorndike, Malcolm Morley, and Leslie French. Appendixes; bibliography.

GUINNESS, ALEC 1914—

P185. Tynan, Kenneth. ALEC GUINNESS. London: Rockliff, 1953. 108 p., illus.

A slim, pithy, and well-illustrated record of Alec Guinness's plays and films. Chronology of career. REVISED EDITION (London, 1961).

GUTHRIE, TYRONE 1900–1971

P186. Guthrie, Tyrone. A LIFE IN THE THEATRE. New York: McGraw-Hill Book Co., 1959. 357 p.

Tyrone Guthrie had both family and professional ties with the American theater. It is unfortunate that this volume does not cover his work with the Minnesota Theatre Company which began in 1963. Index.

HANFF, HELENE

P187. Hanff, Helene. UNDERFOOT IN SHOW BUSINESS. New York: Harper & Row, 1961. 191 p., illus.

An amusing account of the hard knocks of a theatrical childhood and of later attempts to write for the theater. Drawings by Jaf.

HARDWICKE, CEDRIC 1843–1964

P188. Hardwicke, Cedric. LET'S PRETEND: RECOLLECTIONS AND REFLECTIONS OF A LEADING ACTOR. London: Grayson & Grayson, 1932. 258 p., illus.

HARRIGAN, EDWARD 1843–1911

P189. Kahn, Ely Jacques. THE MERRY PARTNERS: THE AGE AND STAGE OF HARRIGAN AND HART. New York: Random House, 1955. 302 p., illus.

Edward Harrigan and Tony Hart remain among the great names of the nineteenth-century American theater. Their collaboration began in 1872 and continued for the next fourteen years. Ely Jacques Kahn's book is a marvelous evocation of their careers.

HART, MOSS 1904–1961

P190. Hart, Moss. ACT ONE: AN AUTOBIOGRAPHY. New York.: Random House, 1959. 444 p.

This volume details the desperate struggle of the playwright for success during the first half of his life. It ends with an account of the triumphant production of his *Once in a Lifetime* in 1930.

HART, TONY 1855–1891

P190a. Kahn, Ely Jacques. THE MERRY PARTNERS: THE AGE AND STAGE OF HARRIGAN AND HART. New York: Random House, 1955. 302 p., illus.

[*See* P189.]

HAVOC, JUNE 1916—

P191. Havoc, June. EARLY HAVOC. New York: Simon & Schuster, 1959. 313 p., illus.

The story of the growth from "Baby Jane" to Broadway stardom told in an affectionate yet revealing manner.

HAYES, HELEN 1900—

P192. Hayes, Helen; and Dody, Sanford. ON REFLECTION: AN AUTOBIOGRAPHY. New York: M. Evans & Co., 1968. 253 p., illus.

Addressed to her grandchildren, this is Helen Hayes's account of her life, her family, and her friends.

P193. Hayes, Helen; with Funke, Lewis. A GIFT OF JOY. New York: M. Evans & Co., 1965. 254 p., illus.

Reminiscences of her family and of cherished pieces of literature.

HELBURN, THERESA 1887–1959

P194. Helburn, Theresa. A WAYWARD QUEST: THE AUTOBIOGRAPHY OF THERESA HELBURN. Boston: Little, Brown, & Co., 1960. 344 p., illus.

Codirector of the Theatre Guild, Theresa Helburn says in the "curtain raiser" to the autobiography that she has not so much written about the Theatre Guild as about herself and the theater in which she worked. Index.

HELD, ANNA 1873–1918

P195. Held, Anna. MÉMOIRES, UNE ÉTOILE FRANÇAISE AU CIEL DE L'AMÉRIQUE. Paris: La Nef de Paris, 1954. 212 p., illus.

It is regrettable that there is no biography in English of this famous Ziegfeld star. The first wife of Florenz Ziegfeld, she was the star of several well-known musical shows in the United States. Preface by Jacques-Charles.

HELLMAN, LILLIAN 1907—

P196. Hellman, Lillian. AN UNFINISHED WOMAN—A MEMOIR. Boston: Little, Brown & Co., 1969. 284 p., illus. [*cont.*]

An autobiography of this remarkable American playwright. She writes as searchingly of her friends, her times, and of her experiences as she does when she creates works for the stage.

P197. Hellman, Lillian. PENTIMENTO: A BOOK OF PORTRAITS. Boston: Little, Brown & Co., 1973. 297 p.

A volume dealing primarily with Hellman's professional colleagues, this offers many revealing glimpses of the author.

HENIE, SONJA 1912—

P198. Henie, Sonja. WINGS ON MY FEET. New York: Prentice-Hall, 1940. 177 p., illus.

The autobiography of the ice-skating star, which discusses her early years in Oslo, and her professional career.

HEYWARD, DU BOSE 1885–1940

P199. Durham, Frank. DUBOSE HEYWARD: THE MAN WHO WROTE PORGY. Columbia: University of South Carolina Press, 1954. 152 p., illus.

Porgy is remembered chiefly as the basis of George Gershwin's *Porgy and Bess*. DuBose Heyward also wrote *Mamba's Daughters*, which Ethel Waters brought glowingly to the stage in 1939. A large part of this slim book, however, is about *Porgy*, its creation, and stage success.

HILL, GEORGE HANDEL "YANKEE" 1809–1849

P200. Northall, W. K., ed. LIFE AND RECOLLECTIONS OF YANKEE HILL: TOGETHER WITH ANECDOTES AND INCIDENTS OF HIS TRAVELS. New York: W. F. Burgess; for Mrs. Cordelia Hill, 1850. 203 p., frontispiece.

A critical study based upon Hill's own reminiscences.

P201. Hill, George Handel (Yankee). SCENES FROM THE LIFE OF AN ACTOR. New York: Garrett & Co., 1853. 246 p., illus.

First-hand reminiscences of touring the stages of the United States in the early nineteenth century are rare; this volume affords such a view. While the account is filled with anecdotes and folktales, the author does not spend enough time discussing the stage itself. REPRINT (New York: B. Blom, 1969.)

HIRSCHFELD, AL 1903—

P202. Hirschfeld, Al. SHOW BUSINESS IS NO BUSINESS. New York: Simon & Schuster, 1951. 142 p., illus.

Random thoughts on the business of the theater from the always agile mind of Al Hirschfeld. The book is liberally interspersed with his famous drawings of show business personalities and Broadway productions. Introduction by Russel Crouse.

HOLLAND, GEORGE 1791–1870

P203. SKETCH OF THE LIFE OF GEORGE HOLLAND, THE VETERAN COMEDIAN; WITH DRAMATIC REMINISCENCES, ANECDOTES, ETC. New York: T. H. Morrell, 1871. 124 p., frontispiece.

A memorial volume recounting the career, illness, and death of the comedian and the establishment of the Holland memorial. Though his early career was on the British stage, Holland made his American bow in 1827 at the Old Bowery Theatre. He was for a long time a favorite on the stages of this country.

HOPKINS, ARTHUR 1878–1950

P204. Hopkins, Arthur. TO A LONELY BOY. Garden City, N.Y.: Doubleday, Doran & Co., 1937. 250 p.

This is an autobiographical work.

HOPPER, DE WOLF 1858–1935

P205. Hopper, De Wolf; and Stout, Wesley Winans. ONCE A CLOWN, ALWAYS A CLOWN: REMINISCENCES OF DE WOLF HOPPER. Boston: Little, Brown & Co., 1927. 238 p., illus.

Famous for his performances on stage, he is also well-known for his recitation of "Casey at the Bat."

HOUDINI, HARRY 1874–1926

P206. Christopher, Milbourne. HOUDINI: THE UNTOLD STORY. New York: Thomas Y. Crowell, 1969. 281 p., illus.

A magician himself, Milbourne Christopher has written an understanding appreciation of the great Houdini. List of sources; bibliography; index.

P207. Gibson, Walter B., and Young, Morris N. HOUDINI'S FABULOUS MAGIC. Philadelphia: Chilton Book Co., 1961. 214 p., illus.

A description of Houdini's most famous feats, such as his escapes, the vanishing elephant, and walking through a brick wall. Bibliography.

HOUSEMAN, JOHN 1902—

P208. Houseman, John. RUN THROUGH: A MEMOIR. New York: Simon & Schuster, 1972. 507 p., index.

One of the most enthralling theatrical biographies of recent years. Houseman writes of his years with the Federal Theatre Project and the Mercury Theatre. The volume covers his life only through 1942. Index.

HOWARD, BRONSON 1842–1908

P209. Frerer, Lloyd Anton. BRONSON HOWARD: DEAN

OF AMERICAN DRAMATISTS. Ph.D. thesis, University of Iowa. 427 p.

Bronson Howard is not often produced today, but his influence on American drama was considerable. This thesis is the only full-length study of Howard. Chronology of plays; bibliography.

HOWARD, LESLIE 1893–1943

P210. **Howard, Leslie Ruth.** A QUITE REMARKABLE FATHER. New York: Harcourt Brace, 1959. 307 p., illus.

A fond reminiscence of the stage and screen star by his daughter. Index.

HUBBARD, ELBERT 1856–1915

P211. **Hubbard, Elbert.** IN THE SPOTLIGHT: PERSONAL EXPERIENCES OF ELBERT HUBBARD ON THE AMERICAN STAGE. East Aurora, N.Y.: The Roycrofters, 1917. 134 p., illus.

HULL, JOSEPHINE 1886–1957

P212. **Carson, William G. B.** DEAR JOSEPHINE: THE THEATRICAL CAREER OF JOSEPHINE HULL. Norman: University of Oklahoma Press, 1963. 313 p., illus.

Bibliography; index.

IBSEN, HENRIK 1828–1906

P213. **Meyer, Michael.** IBSEN: A BIOGRAPHY. Garden City, N.Y.: Doubleday, 1971. 865 p., illus.

Born in Norway, Ibsen exerted a profound influence on modern drama in Europe and in the United States. Since his plays are continually performed all over America, he can still be seen as an important force in the theater.

KANE, WHITFORD 1881–1956

P214. **Kane, Whitford.** ARE WE ALL MET? London: Elkin Mathews & Marrot, 1931. 294 p., illus.

Though never a star, Whitford Kane enjoyed a long career on the stage, from the British Isles to New York. He specialized in playing the role of the gravedigger in *Hamlet* and was in productions starring such actors as Osmund Tearle and Maurice Evans. Preface by St. John Ervine. Index.

KAUFMAN, GEORGE S. 1889–1961

P215. **Teichmann, Howard.** GEORGE S. KAUFMAN: AN INTIMATE PORTRAIT. New York: Atheneum Publishers, 1972. 372 p., illus.

An affectionate biography of the playwright-director, and of the theater of the 1920s–1950s, by the man who coauthored *The Solid Gold Cadillac* with Kaufman. Bibliography; index.

KEAN, CHARLES 1811–1868

P216. **Hardwick, J. M. D., ed.** EMIGRANT IN MOTLEY: THE JOURNEY OF CHARLES AND ELLEN KEAN IN QUEST OF A THEATRICAL FORTUNE IN AUSTRALIA AND AMERICA, AS TOLD IN THEIR HITHERTO UNPUBLISHED LETTERS. London: Rockliff, 1954. 260 p., illus.

Of particular interest are the letters of the Keans' appearances in the United States in the 1860s. Foreword by Anthony Quayle. Index.

LAHR, BERT 1895–1967

P217. **Lahr, John.** NOTES ON A COWARDLY LION; THE BIOGRAPHY OF BERT LAHR. New York: Alfred A. Knopf, 1969. 395 p., illus.

An affectionate biography by his son of the comedian of burlesque, vaudeville, theater, and film, as well as the Cowardly Lion of the cinema version of *The Wizard of Oz*. The appendixes include some of his famous routines including the script of *Flugel Street* by Billy K. Wells. Index.

LANDIS, JESSIE ROYCE 1904–1972

P218. **Landis, Jessie Royce.** YOU WON'T BE SO PRETTY (BUT YOU'LL KNOW MORE). London: W. H. Allen, 1954. 256 p., illus.

A star of the American and English stages for almost fifty years, and member of a theater family, this is a most readable autobiography.

LEIGH, VIVIEN 1913–1967

P219. **Dent, Alan.** VIVIEN LEIGH: A BOUQUET. London: Hamish Hamilton, 1969. 219 p., illus.

Alan Dent, a friend of Vivien Leigh's for twenty-five years and a drama critic, has written an affectionate tribute to this star. List of stage and film appearances; indexes.

LILLIE, GORDON

P220. **Shirley Glenn.** PAWNEE BILL: A BIOGRAPHY OF MAJOR GORDON W. LILLIE. Albuquerque: University of New Mexico Press, 1958. 256 p., illus.

Accounts of his work with the Indians and in the wild west shows. Bibliography; index.

MANNERS, DIANA

P221. **Cooper, Diana.** THE LIGHT OF COMMON DAY. Boston: Houghton Mifflin Co., 1959. 274 p., illus.

In 1958 Lady Diana Cooper published *The Rainbow Comes and Goes*, which is largely about her family. This later volume talks about her work with Max Reinhardt and with *The Miracle*, one of his most memorable productions. Index.

MARX, GROUCHO 1895–1977

P222. Marx, Arthur. SON OF GROUCHO. New York: David McKay, 1972. 357 p., illus.

"What's it like being the son of Groucho?" Arthur Marx recounts some of the joys and some of the heartaches. He adds quite a bit of information about the Marx Brothers' professional careers, their marriages and divorces, their children, stepchildren, and parents.

P223. Marx, Arthur. LIFE WITH GROUCHO. New York: Simon & Schuster, 1954. 310 p.

An author in his own right, Arthur Marx tells of the joys and the sorrows of being a famous comedian's son. Index.

MAUGHAM, W. SOMERSET 1874–1965

P224. Mander, Raymond, and Mitchenson, Joe. THEATRICAL COMPANION TO MAUGHAM. New York: Macmillan Co., 1955. 307 p., illus.

A pictorial guide to the first performances of Maugham's plays in the United States and England, 1901–1933. Included is a discussion of the first publication of Maugham's plays in both countries. Index of characters, with an appreciation of Maugham's dramatic works by J. C. Trewin.

MILLER, ARTHUR 1915–

P225. Hayashi, Tetsumaro. ARTHUR MILLER: CRITICISM (1930–1967). Metuchen, N.J.: Scarecrow Press, 1969. 149 p.

An index to the criticism of Miller's plays, films, and articles.

MILLER, HENRY 1860–1926

P226. Morse, Frank P. BACKSTAGE WITH HENRY MILLER. New York: E. P. Dutton & Co., 1938. 288 p., illus.

The history of many of Henry Miller's great productions (*The Great Divide* being the first in 1906) by Miller's long-time publicity assistant. Introduction by George M. Cohan. Index.

MODJESKA, HELENA 1840–1909

P227. Coleman, Marion Moore. FAIR ROSALIND: THE AMERICAN CAREER OF HELENA MODJESKA. Cheshire, Conn.: Cherry Hill Books, 1969. 1019 p.

The most detailed history of the American career of the Polish actress, Modjeska, who made extensive tours of the United States from 1877 to 1907. Lists of plays and appearances; chronology; notes; index.

P228. Gronowicz, Antoni. MODJESKA: HER LIFE AND LOVES. New York: Thomas Yoseloff, 1956. 254 p., illus.

P229. Modjeska, Helena. MEMORIES AND IMPRESSIONS OF HELENA MODJESKA: AN AUTOBIOGRAPHY. New York: Macmillan Co., 1910. 571 p., illus.

MONTEZ, LOLA 1818–1861

P230. Goldberg, Isaac. QUEEN OF HEARTS: THE PASSIONATE PILGRIMAGE OF LOLA MONTEZ. New York: John Day Co., 1936. 308 p., frontispiece.

Though born in an army barracks in Limerick, Lola Montez was associated as a performer with all that was most licentious in Continental mores. Her personal life was reported with more interest than her professional work. She toured the United States in the mid-nineteenth century and lived for periods in Brooklyn and in California. The sensational story of her exploits continues to interest readers to the present day. Bibliography.

P231. Holdredge, Helen. THE WOMAN IN BLACK: THE LIFE OF LOLA MONTEZ. New York: G. P. Putnam's Sons, 1955. 309 p., illus.

Bibliography; index.

P232. Wyndham, Horace. THE MAGNIFICENT MONTEZ: FROM COURTESAN TO CONVERT. London: Hutchinson & Co., 1935. 288 p., illus.

Appendixes; index.

MOREHOUSE, WARD

P233. Morehouse, Ward. FORTY-FIVE MINUTES PAST EIGHT. New York: Dial Press, 1939. 276 p.

An autobiography of the theater critic and author.

P234. Morehouse, Ward. JUST THE OTHER DAY: FROM YELLOW PINES TO BROADWAY. New York: McGraw-Hill Book Co., 1953, 240 p.

Personal reminiscences of the theater and of the life of the theater critic and author.

MORGAN, HELEN 1900–1941

P235. Maxwell, Gilbert. HELEN MORGAN: HER LIFE AND LEGEND. New York: Hawthorn Books, 1974. 192 p., illus.

Helen Morgan and *Show Boat* are indelibly fixed in the minds of all. Little else is known about the singer and her rather unhappy, brief life. Index.

MORLEY, ROBERT 1908—

P236. Morley, Robert and Stokes, Sewell. ROBERT MORLEY: A RELUCTANT AUTOBIOGRAPHY. New York: Simon & Schuster, 1966. 285 p., illus.

Since his first appearance on the New York stage in *Oscar Wilde* (1938), Robert Morley has been as well known in the United States as in England. He has made numerous films, played more recently on American stages, and is now a familiar face on American television screens. His autobiography is a lively record of this career. Index.

MOROSCO, OLIVER 1876–1945

P237. **Morosco, Helen M., and Dugger, Leonard Paul.** THE ORACLE OF BROADWAY: LIFE OF OLIVER MOROSCO, WRITTEN FROM HIS OWN NOTES AND COMMENTS. Caldwell, Ida.: Caxton Printers, 1944. 391 p., illus.

Much of Oliver Morosco's theater career took place on the Pacific Coast, but he produced and owned theaters in New York. This is a biography largely written from notes accumulated during his professional days. Index.

MORRIS, CLARA 1846–1925

P238. **Morris, Clara.** LIFE ON THE STAGE: MY PERSONAL EXPERIENCES AND RECOLLECTIONS. New York: Mc-Clure, Phillips & Co., 1901. 399 p.

Recollections of a long theater career with Augustin Daly, John E. Owens, and Edwin Adams. The book has a somewhat chatty tone, but will please those with an interest in the theater in the nineteenth centry.

MOWATT, ANNA CORA 1819–1870

P239. **Barnes, Eric Wollencott.** THE LADY OF FASHION: THE LIFE AND THE THEATRE OF ANNA CORA MOWATT. New York: Charles Scribner's Sons, 1954. 402 p., illus.

Known principally for the authorship of *Fashion; Or, Life in New York* (1845), Anna Cora Mowatt was also an actress and an "advanced" lady of her day, interested in the sciences, mesmerism, and literature. Barnes's biography is based upon her autobiographical volume. Notes; index.

P240. **Mowatt, Anna Cora.** AUTOBIOGRAPHY OF AN ACTRESS; OR, EIGHT YEARS ON THE STAGE. Boston: Tichnor, Reed & Fields, 1853. 448 p.

This and other works by Mowatt are library catalogued under the name: Ritchie, Anna Cora.

MUNI, PAUL 1895–1967

P241. **Gerlach, Michael Christopher.** THE ACTING OF PAUL MUNI. Ph.D. thesis, University of Michigan, 1971. 247 p.

Most remember Muni for his screen portrayals, but he also worked in the theater. He began in the Yiddish theater in 1908 and continued with his stage career until 1955, when he appeared in *Inherit the Wind*. This is a study of his many dramatic characterizations. List of roles; bibliography.

NATHAN, GEORGE JEAN 1882–1958

P242. **Nathan, George Jean.** THE BACHELOR LIFE. New York: Reynal & Hitchcock, 1941. 263 p., illus.

Some of the recollections of wining, dining, and theatergoing by one of the American theater's outstanding twentieth-century critics. Illustrations by Irna Selz.

NESBITT, CATHLEEN 1888—

P243. **Nesbitt, Cathleen.** A LITTLE LOVE AND GOOD COMPANY. London: Faber & Faber, 1975. 263 p., illus.

At the urging of Anita Loos, Cathleen Nesbitt has tried to set down her memories of more than sixty years on the stage. Though most of her career was in the English theater, the American stage has been graced by her presence in many memorable productions. She first appeared here in Galsworthy's *Justice* in 1915. Index.

NUGENT, ELLIOTT 1899—

P244. **Nugent, Elliott.** EVENTS LEADING UP TO THE COMEDY: AN AUTOBIOGRAPHY. New York: Trident, 1965. illus.

Elliott Nugent, the brilliant inheritor of the Nugent family acting tradition, suffered a mental collapse. He started this book during his recuperation. He writes of his college years, his friendship and professional association with James Thurber (*The Male Animal*), and of his years in Hollywood.

NUGENT, J. C. 1878–1947

P245. **Nugent, J. C.** IT'S A GREAT LIFE. New York: Dial Press, 1940. 331 p., illus.

The autobiography of the actor, the author (*Kempy*), and a history of the Nugent family.

O'NEILL, EUGENE 1888–1953

P246. **Clark, Barrett H., and Sanborn, Ralph.** A BIBLIOGRAPHY OF THE WORKS OF EUGENE O'NEILL: TOGETHER WITH THE COLLECTED POEMS OF EUGENE O'NEILL. New York: B. Blom, 1968. 171 p., illus.

More of a literary than a dramatic criticism of O'Neill, but important to the O'Neill scholar. Index.

P247. **Gelb, Arthur, and Gelb, Barbara.** O'NEILL. New York: Harper & Bros., 1962. 970 p., illus.

A valuable guide to the life and work of one of the major playwrights of the twentieth century. The Gelbs discuss in detail his family life, which played such a large part in O'Neill's creative development. Chronological listing of the first productions of O'Neill's published plays; index.

P248. **Sheaffer, Louis.** O'NEILL: SON AND PLAYWRIGHT. Boston: Little, Brown, & Co., 1968. 543 p., illus.

P248a. **Sheaffer, Louis.** O'NEILL: SON AND ARTIST. Boston: Little, Brown, & Co., 1973. 750 p., illus.

The definitive study. The second volume won the 1974 Pulitzer Prize in biography. Vol. 1 (1968) traces his life to 1920 and O'Neill's first Broadway production, *Beyond the Horizon*. Vol. 2 (1973) covers the rest of O'Neill's life and professional career. Notes; bibliography; index.

P249. **Skinner, Richard Dana.** EUGENE O'NEILL: A

POET'S QUEST, WITH A CORRECT CHRONOLOGY OF THE O'NEILL PLAYS AS FURNISHED BY EUGENE O'NEILL. New York: Longmans, Green & Co., 1935. 242 p.

This is a study of O'Neill's plays written "from the viewpoint of their inner continuity." It is an important early study of the dramatist.

P250. **Tiusanen, Timo.** O'NEILL'S SCENIC IMAGES. Princeton: Princeton University Press, 1968. 388 p., illus.

An approach to the plays of O'Neill using the scenic images involved. The Finnish author studied theater in the United States and became interested in this study while a student of John Gassner and Alois M. Nagler at Yale. List of plays; floor plans of sets for several plays; bibliography; index.

PAAR, JACK 1918—

P251. **Paar, Jack; and Reddy, John.** I KID YOU NOT. Boston: Little, Brown, & Co., 1959. 220 p., illus.

Introduction by John Reddy.

PAPP, JOSEPH 1921—

P252. **Little, Stuart W.** ENTER JOSEPH PAPP: IN SEARCH OF A NEW AMERICAN THEATRE. New York: Coward, McCann & Geoghegan, 1974. 320 p.

This is more of a study of Joseph Papp at work than a formal biography. It recounts his arduous fight to keep the New York Shakespeare Festival alive, his foray into television, and the battle with Columbia Broadcasting System over the telecast of David Rabe's *Sticks and Bones.* Little's book on Papp grew out of the author's earlier *Off-Broadway: The Prophetic Theater.* Index.

PASTOR, TONY 1837—1908

P253. **Zellers, Parker.** TONY PASTOR: DEAN OF THE VAUDEVILLE STAGE. Ypsilanti, Mich.: Eastern Michigan University Press, 1971. 155 p., illus.

According to the author, Tony Pastor elevated American vaudeville from honky-tonk, fly-by-night entertainment to big business in the late nineteenth century. Notes; bibliography; index.

PAYNE, JOHN HOWARD 1791—1852

P254. **Harrison, Gabriel.** JOHN HOWARD PAYNE: DRAMATIST, POET, ACTOR, AND AUTHOR OF "HOME, SWEET, HOME," HIS LIFE AND WRITINGS. Philadelphia: J. B. Lippincott Co., 1884. 404 p., illus.

When only fourteen, John Howard Payne published a theatrical paper *The Thespian Mirror.* He was a dramatist, songwriter, and poet. List of Payne's dramatic works; index.

PAYTON, CORSE 1867—1934

P255. **Andrews, Gertrude.** THE ROMANCE OF A WESTERN BOY: THE STORY OF CORSE PAYTON. Brooklyn: Andrus Press, 1901. 122 p., illus.

A chatty account of the actor-manager, Brooklyn theater manager, and producer of nineteenth-century melodrama.

PINTER, HAROLD 1930—

P256. **Schroll, Herman T.** HAROLD PINTER: A STUDY OF HIS REPUTATION (1958—1969). Metuchen, N.J.: Scarecrow Press, 1971. 153 p.

Harold Pinter has found a large audience in the United States. This is a review of the production of his plays in America and in England over an eleven-year period. Checklist; bibliography; index.

POLLOCK, CHANNING 1880—1946

P257. **Pollock, Channing.** HARVEST OF MY YEARS. Indianapolis: Bobbs-Merrill Co., 1943. 395 p., illus.

A reminiscence of the experiences of Channing Pollock—dramatist, drama critic, press agent, lecturer, and editorial and magazine writer. Index.

PORTER, COLE 1891—1964

P258. **Kimball, Robert, ed.** COLE. New York: Holt, Rinehart & Winston, 1971. 283 p., illus.

A big, magnificently illustrated biography of the American composer/lyricist. His composing began as a freshman at Yale in 1910, and he turned out musical numbers for stage and screen until 1958. Biographical essay by Brendan Gill. List of song copyrights; chronology of productions with lists of songs.

QUINN, ANTHONY 1915—

P259. **Quinn, Anthony.** THE ORIGINAL SIN: A SELF-PORTRAIT. Boston: Little, Brown, & Co., 1972. 311 p.

Though known primarily for his film roles, Quinn also works in the theater. This is his revealing autobiography.

QUINTERO, JOSÉ 1924—

P260. **Quintero, José.** IF YOU DON'T DANCE THEY BEAT YOU. Boston: Little, Brown & Co., 1974. 291 p.

José Quintero's story is the history of the Circle-in-the-Square, an innovative off-Broadway theater. There are many stories of Quintero's dealings with Carlotta Monterey O'Neill in connection with his productions of Eugene O'Neill's *The Iceman Cometh* and *Long Day's Journey into Night.*

REINHARDT, MAX 1873–1943

P261. Carter, Huntly. THE THEATRE OF MAX REINHARDT. New York: Mitchell Kennerley, 1914. 332 p., illus.

A study of the German stage and film director before production of shows like *The Miracle* and *A Midsummer Night's Dream* created such a flurry in the American theater. Table of productions; index.

RICE, DAN 1823–1900

P262. Gillette, Don Carle. HE MADE LINCOLN LAUGH: THE STORY OF DAN RICE. New York: Exposition Press. 170 p., illus.

Seven writers approached the famous comedian Dan Rice with the proposal to write his biography. Gillette was the eighth to undertake a study of the nineteenth-century comedian.

P263. Kunzog, John C. THE ONE-HORSE SHOW: THE LIFE AND TIMES OF DAN RICE, CIRCUS JESTER, AND PHILANTHROPIST—A CHRONICLE OF EARLY CIRCUS DAYS. Jamestown, N.Y.: By the author, 1962. 434 p., illus.

RICE, ELMER 1892–1967

P264. Rice, Elmer. THE LIVING THEATRE. New York: Harper & Bros., 1959. 306 p.

This book grew out of a course given by Rice at New York University in 1957. He tells of some of his theatrical experiences, his thoughts on the theater, censorship, and other aesthetic and material problems. Index.

RISTORI, ADELAIDE 1822 31906

P265. Ristori, Adelaide. MEMOIRS AND ARTISTIC STUDIES OF ADELAIDE RISTORI. TRANSLATED BY G. MANTELLINI. New York: Doubleday, Page & Co., 1907. 263 p., illus.

Ristori made two tours of the United States and played *Macbeth* with Edwin Booth in the 1880s. Preface by G. Mantellini. Biographical appendix by I. D. Ventura. Index.

ROBESON, PAUL 1898–1976

P266. Graham, Shirley. PAUL ROBESON: CITIZEN OF THE WORLD. New York: Julian Messner, 1946. 264 p., illus.

This volume deals with the complex artistic and social problems faced by the actor/singer Paul Robeson. Foreword by Carl van Doren. Index.

P267. Hoyt, Edwin P. PAUL ROBESON: THE AMERICAN OTHELLO. Cleveland: World Publishing Co., 1967. 228 p.

ROBSON, ELEANOR 1879—

P268. Belmont, Eleanor Robson. THE FABRIC OF MEMORY. New York: Farrar, Straus & Cudahy, 1957. 302 p., illus.

Quoting James M. Barrie, "God gave us memory so that we may have roses in December," Belmont remembers her long theatrical career, her days in stock as a star in *Merely Mary Ann* and *Major Barbara,* and of her work with the Metropolitan Opera Guild. Index.

RODGERS, RICHARD 1902–1980

P269. Rodgers, Richard. MUSICAL STAGES: AN AUTOBIOGRAPHY. New York: Random House, 1975. 341 p., illus.

Rodgers's memories of his years in the theater, from *One Minute, Please* (1917) through his collaborations with Lorenz Hart and Oscar Hammerstein II to *Two By Two* (1970). Index.

ROGERS, WILL 1879–1935

P270. Ketchum, Richard M. WILL ROGERS: THE MAN AND HIS TIMES. New York: Simon & Schuster, 1973. 415 p., illus.

AMERICAN HERITAGE BIOGRAPHY SERIES

Only a part of Will Rogers's life was played upon the stage. He was a cowboy, a newspaper man, and a screen star. He may, however, have been the last example of true Americana in the theater.

ROSENTHAL, JEAN 1912–1969

P271. Rosenthal, Jean, and Wertenbaker, Lael. THE MAGIC OF LIGHT: THE CRAFT AND CAREER OF JEAN ROSENTHAL, PIONEER IN LIGHTING FOR THE MODERN STAGE. Boston: Little, Brown & Co., in association with Theatre Arts Books, 1972. illus.

Both a biography of Jean Rosenthal and a study of her methods of stage lighting. Much of the book was written from tapes dictated by Rosenthal during her terminal illness. Index.

SHAW, GEORGE BERNARD 1856–1950

P272. Mander, Raymond, and Mitchenson, Joe. THEATRICAL COMPANION TO SHAW. New York: Pitman Publishing Corp., 1955. 343 p., illus.

A pictorial guide to the first productions of Shaw's plays, some of which opened in the United States. Includes, also, articles about Shaw by Sybil Thorndike and Lewis Casson. Introduction by Barry Jackson.

SILVERMAN, SIME 1872–1933

P273. Stoddard, Dayton. LORD BROADWAY: VARIETY'S

SIME. New York: Wilfred Funk, 1941. 385 p., illus., fac-sim.

The life of Sime Silverman is also a history of *Variety*, the trade paper. REPRINTS of articles; index

SILVERS, PHIL 1912—

P274. **Silvers, Phil; and Saffron, Robert.** THIS LAUGH IS ON ME. Englewood Cliffs, N.J.: Prentice-Hall, 1973. 276 p., illus.

An American comedian's life in vaudeville, burlesque, radio, and television.

SIMONSON, LEE 1888–1967

P275. **Simonson, Lee.** PART OF A LIFETIME: DRAWINGS AND DESIGNS, 1919–1940. New York: Duell, Sloan & Pearce. 99 p., illus., (color).

An autobiography of the designer and director of the Theatre Guild, beautifully illustrated by reproductions of his designs and photographs of many of the productions he designed.

SKINNER, MAUD DURBIN
SKINNER, OTIS 1858–1942

P276. **Skinner, Cornelia Otis.** FAMILY CIRCLE. Boston: Houghton Mifflin, Co., 1948. 310 p., illus.

A story about the author's theatrical family; her parents, Otis and Maud Durbin Skinner; and herself.

P277. **Skinner, Otis.** FOOTLIGHTS AND SPOTLIGHTS: RE-COLLECTIONS OF MY LIFE ON THE STAGE. Indianapolis: Bobbs-Merrill Co., 1924. 367 p., illus.

Otis Skinner made his debut when still in his teens. He played with Edwin Booth and Mme. Janauschek, and worked under the aegis of Augustin Daly. He went on to become a star in his own right, an actor-manager in the grand theatrical tradition, and dignified the stage until almost in his eighties. Index.

STANISLAVSKY, KONSTANTIN 1863–1938

P278. **Stanislavsky, Konstantin.** MY LIFE IN ART. TRANSLATED BY J. J. ROBBINS. New York: Theatre Arts Books, 1952. 586 p.

The autobiography, theories, and testament of the great Russian director, teacher of acting and profound in-fluence on the twentieth-century American theater. Ap-pendix includes list of productions. Index. ORIGINAL EDI-TION (Boston: Little, Brown & Co., 1924).

TAYLOR, JUSTUS HURD *born* 1834

P279. **Taylor, Justus Hurd.** JOE TAYLOR, BARNSTORMER: HIS TRAVELS, TROUBLES, AND TRIUMPHS DURING FIFTY YEARS IN FOOTLIGHT FLASHES. New York: Wm. R. Jenkins Co., 1913. 248 p., illus.

An autobiographical account of the life of a touring play-er in the United States in the nineteenth century.

TAYLOR, LAURETTE 1884–1946

P280. **Courtney, Marguerite.** LAURETTE. New York: Rinehart & Co., 1955. 433 p.

Written by her daughter, this is a loving biography of Laurette Taylor, star of *The Glass Menagerie*. Introduction by Samuel Hopkins Adams.

TELLEGEN, LOU 1881–1934

P281. **Tellegen, Lou.** WOMEN HAVE BEEN KIND: THE MEMOIRS OF LOU TELLEGEN. New York: Vanguard Press, 1931, 305 p., illus.

TERRY, ELLEN 1847–1928

P282. **Manvell, Roger.** ELLEN TERRY. London: Heine-mann, 1968. 390 p., illus.

A full account of the life of the nineteenth- twentieth-century English actress, the leading lady in several American tours with Sir Henry Irving. Notes; bibliogra-phy; index.

P283. **St. John, Christopher, ed.** ELLEN TERRY AND BER-NARD SHAW. London: Reinhardt, Evans, 1949. 434 p.

Publication of a correspondence between the great dra-matist and the brilliant actress, which lasted from 1892 to 1922. ORIGINAL EDITION (London: Constable and Co., 1931).

THOMAS, AUGUSTUS 1857–1934

P284. **Thomas, Augustus.** THE PRINT OF MY REMEM-BRANCE. New York: Chas. Scribner's Sons, 1922. 477 p., illus.

Now all but forgotten, Augustus Thomas was at one time considered to be in the forefront of American play-wrights. His first play, *Alone,* was written in 1875 and his last, *Nemesis,* in 1921. His hits include *The Copperbird* (1917), *Arizona* (1898), and *The Witching Hour* (1907). List of plays; index.

THORNDIKE, SYBIL 1882–1976

P285. **Sprigge, Elizabeth.** SYBIL THORNDIKE CASSON. London: Victor Gollancz, 1971, 348 p., illus.

Dame Sybil Thorndike was a British actress who brought glamor to the American stage and introduced the art of theater to many American actors. Foreword by Dame Sybil Thorndike Casson. Index.

WATERS, ETHEL 1900–1977

P286. **Waters, Ethel, and Samuel, Charles.** HIS EYE IS ON THE SPARROW. Garden City, N.Y.: Doubleday, 1951., 278 p.

The autobiography of the celebrated black actress-singer.

WATKINS, HARRY *died* 1894

P287. Skinner, Maud Durbin, and Skinner, Otis. ONE MAN IN HIS TIME: THE ADVENTURES OF H. WATKINS, STROLLING PLAYER 1845–1863, FROM HIS JOURNAL. Philadelphia: University of Pennsylvania Press, 1938. 258 p., illus.

Maud Durbin Skinner acquired Harry Watkins's journal from his daughter, Amy Lee. With her husband, she edited the journal of the actor's barnstorming career in the mid-nineteenth century. Index.

WEBER, JOE 1867–1942

P288. Isman, Felix. WEBER AND FIELDS: THEIR TRIBULATIONS, TRIUMPHS, AND THEIR ASSOCIATES. New York: Boni & Liveright, 1924. 345 p., illus.

Weber and Fields were perhaps the top duo of the American musical theater of the late nineteenth and twentieth centuries. Many star performers served an apprenticeship in their troupes. Their travesties of the popular theater of their day caused audiences to flock to their theaters. In addition to the shows in which they starred, they produced works of other dramatists and composers. Includes copies of some of their music.

WEBSTER, MARGARET 1905–1972

P289. Webster, Margaret. THE SAME ONLY DIFFERENT: FIVE GENERATIONS OF A GREAT THEATRE FAMILY. New York: Alfred A. Knopf, 1969. 391 p., illus.

A history of the British-born Webster family, many of whom figured prominently on the American stage. Genealogy and index.

P290. Webster, Margaret. DON'T PUT YOUR DAUGHTER ON THE STAGE. New York: Alfred A. Knopf, 1972. 390 p., illus.

The autobiography of the codirector of the American Repertory Theatre, and director of Paul Robeson in *Othello*, and Maurice Evans in *Hamlet* and *Richard II*.

WELLES, ORSON 1915—

P291. Noble, Peter. THE FABULOUS ORSON WELLES. London: Hutchinson & Co., 1956. 276 p., illus.

Most of the studies of Orson Welles deal almost exclusively with his cinema career. This biography tells of his work as a young actor, of the Mercury Theatre in the late 1930s, and of his stage work in the fifties. (*Moby Dick, King Lear*).

WEMYSS, FRANCIS COURTNEY 1797–1859

P292. Wemyss, Francis Courtney. TWENTY-SIX YEARS OF THE LIFE OF AN ACTOR AND MANAGER; INTERSPERSED WITH SKETCHES, ANECDOTES, AND OPINIONS OF THE PROFESSIONAL MERITS OF THE MOST CELEBRATED ACTORS AND ACTRESSES OF OUR DAY. New York: Burgess Stringer & Co., 1847. 2 vols.

An autobiographical account of the manager of the Walnut Street Theatre, Philadelphia, and other nineteenth-century American houses. In 1956, James M. Barriskill (South Byfield, Mass.) compiled an index to this work, which adds considerably to its value as a reference tool.

WILLIAMS, BERT 1875–1922

P293. Charters, Ann. NOBODY: THE STORY OF BERT WILLIAMS. New York: Macmillan Co., 1970. 157 p., illus.

An affectionate account of the famous song and dance man from his beginnings, playing in the lumber camps on the Pacific Coast, to the Palace and the Ziegfeld Follies. There is some information about the black on the American stage. Discography; index.

P294. Rowland, Mabel, ed. BERT WILLIAMS, SON OF LAUGHTER: A SYMPOSIUM OF TRIBUTE TO THE MAN AND TO HIS WORK, BY HIS FRIENDS AND ASSOCIATES. New York: English Crafters, 1923. 218 p., illus.

A collection of pieces in appreciation of Bert Williams. Among the contributors are Ring Lardner, Heywood Broun, W. C. Fields, Leon Errol, George M. Cohan, and Edward F. Albee. Preface by David Belasco.

WILLIAMS, EMLYN 1905—

P295. Williams, Emlyn. EMLYN: AN EARLY AUTOBIOGRAPHY, 1927–1935. New York: Viking Press, 1973. 424 p.

Author of *Night Must Fall* and *The Corn Is Green*, this Welsh-born artist has often played on American stages and has been seen in films in the United States. Index.

WILLIAMS, TENNESSEE 1911—

P296. Donohue, Francis. THE DRAMATIC WORLD OF TENNESSEE WILLIAMS. New York: Frederick Ungar Publishing Co., 1964. 243 p.

An attempt to match Williams's life with his dramatic works. There is particularly interesting material on his very early years. Index.

P297. Jackson, Esther Merle. THE BROKEN WORLD OF TENNESSEE WILLIAMS. Madison: University of Wisconsin Press, 1965. 179 p., illus.

Jackson believes that the opening of *The Glass Menagerie* in 1945 marked the beginning of a new era in American drama. This volume analyzes Williams's plays and their effect. Production list; bibliography; index.

WILLSON, MEREDITH 1902—

P298. Willson, Meredith. BUT HE DOESN'T KNOW THE

TERRITORY. New York: G. P. Putnam's Sons, 1959. 190 p.

Deals with the genesis and production history of *The Music Man* and includes a bit of Willson's personal history.

WILSON, EDDIE 1892–1949

P299. **Lawrence, Versie Lee.** DEEP SOUTH SHOWMAN. New York: Carlton Press, 1962. 33 p.

Eddie Wilson roamed the deep South in the early years of the twentieth century showing films and lecturing. In some small communities, he was the only live entertainment. This is a slight but loving tribute to his career.

WILSON, FRANCIS 1854–1935

P300. **Wilson, Francis.** FRANCIS WILSON'S LIFE OF HIMSELF. Boston: Houghton Mifflin Co., 1924. 463 p., illus.

One of the classic American stage biographies. There is some particularly interesting material on the beginnings of Actor's Equity Association and the strike that preceded it. Index.

WINCHELL, WALTER 1897–1972

P301. **Stuart, Lyle.** THE SECRET LIFE OF WALTER WINCHELL. New York: Boar's Head Books, 1953. 253 p.

Though Mr. Winchell served for many years as a drama critic in New York, this book deals principally with his career as the writer of a gossip column.

WOOD, PEGGY 1892—

P302. **Wood, Peggy.** ACTORS AND PEOPLE: BOTH SIDES OF THE FOOTLIGHTS. New York: D. Appleton, 1930. 178 p.

P303. **Wood, Peggy.** HOW YOUNG YOU LOOK: MEMOIRS OF A MIDDLE-SIZED ACTRESS. New York: Farrar & Rinehart. 277 p., illus.

P304. **Wood, Peggy.** ARTS AND FLOWERS. New York: William Morrow, 1963. 189 p., illus.

Peggy Wood made her New York stage debut in 1910. In these three volumes [P302, P303, P304], she reminisces about her life and her stage associates.

WOOLLCOTT, ALEXANDER 1887–1943

P305. **Adams, Samuel Hopkins.** A. WOOLLCOTT: HIS LIFE AND HIS WORLD. New York: Reynal & Hitchcock, 1945. 386 p., illus.

Alexander Woollcott was a drama critic, playwright, actor, and radio commentator. This full-length biography sketches a picture of his life and of the many individuals whose lives he touched. Index.

WYNN, ED 1886–1966

P306. **Wynn, Keenan, and Brough, James.** ED WYNN'S SON. Garden City, N.Y.: Doubleday, 1959. 237 p., illus.

Ed Wynn had a long career in the American theater, billed as "The Perfect Fool." His son, Keenan, has also made a name for himself in the theater and in films. This is the story of the difficulties of growing up as the son of a famous father, in life and on stage.

YOUNGMAN, HENNY

P307. **Youngman, Henny, and Carroll, Carroll.** TAKE MY WIFE . . . PLEASE: MY LIFE AND LAUGHS. New York: G. P. Putnam's Sons, 1973. 255 p., illus.

A humorous account of how a stand-up comic grows up, trains on the Borscht Circuit in upstate New York, and graduates to radio, cinema, and television.

YURKA, BLANCHE 1887–1974

P308. **Yurka, Blanche.** BOHEMIAN GIRL: BLANCHE YURKA'S THEATRICAL LIFE. Athens: Ohio University Press, 1970. 306 p., illus.

Blanche Yurka occupied a unique place in the American theater from her debut in 1907 through the next five decades. She was famous for her productions of Ibsen, played the nurse in Katharine Cornell's *Romeo and Juliet*, and appeared also in light comedies and films. Afterword by Brooks Atkinson. Index.

ZIEGFELD, FLORENZ 1867–1932

P309. **Cantor, Eddie, and Freedman, David.** ZIEGFELD: THE GREAT GLORIFIER. New York: Alfred H. King, 1934. 166 p., illus.

Written shortly after Ziegfeld's death, this is essentially a eulogy.

P310. **Carter, Randolph.** THE WORLD OF FLO ZIEGFELD. New York: Praeger Publishers, 1974. 176 p., illus.

The book devotes considerable attention to Joseph Urban (1872–1933), who designed many of Ziegfeld's productions and the Ziegfeld Theatre in New York. The appendix to the book gives details of all the "Follies" produced by Ziegfeld, 1907–1931. Dedication by Billie Burke. Appendix; bibliography.

P311. **Higham, Charles.** ZIEGFELD. Chicago: Henry Regnery Co., 1972. 245 p., illus.

A biography that endeavors to assess the work of Ziegfeld and his effect upon the theater. Index.

Historical Works

This section includes histories of the American theater. Excluded from this listing are the many compendium volumes that have merely subsections on the theater in America.

P312. **Anderson, John.** THE AMERICAN THEATRE. New York: Dial Press, 1938. 430 p., illus.

The author describes this history as "strictly a sketch of the American theatre in its relation to the drama." Included in the book is a history of the motion picture in America by René Fülop-Miller. Index.

P312a. **Bentley, Eric.** WHAT IS THEATRE?: A QUERY IN DRAMATIC FORM. New York: Beacon Press, 1956. 273 p.

Supplements *The Dramatic Event: An American Chronicle* [P690], which covers 1952–1954. This title reviews the seasons of 1954–1956. The last chapter comments at length on American theater.

P313. **Blake, Ben.** THE AWAKENING OF THE AMERICAN THEATRE. New York: Tomorrow Publishers, 1935. 63 p., illus.

A pamphlet about the drama groups of the mid–1930s, which were concerned with social drama: the Group Theatre, the New Theatre League, and the Theatre Union. Foreword by John Howard Lawson.

P314. **Blum, Daniel C.** A PICTORIAL HISTORY OF THE AMERICAN THEATRE, 1900–1950. New York: Greenberg, 1950. unpag., illus.

A photographic record of the outstanding productions of the American theatre in the first half of the twentieth century. Index.

P315. **Bond, Frederick W.** THE NEGRO AND THE DRAMA: THE DIRECT AND INDIRECT CONTRIBUTION WHICH THE AMERICAN NEGRO HAS MADE TO DRAMA AND THE LEGITIMATE STAGE, WITH THE UNDERLYING CONDITIONS RESPONSIBLE. College Park, Md.: McGrath Publishing Co., 1969. 213 p.

A study from the beginnings in Africa through minstrelsy to the black theater of the Federal Theater Project. This reprint edition includes a bibliography and index. ORIGINAL EDITION (Associated Publishers, 1940).

P316. **Brockett, Oscar G., and Findlay, Robert R.** CENTURY OF INNOVATION: A HISTORY OF EUROPEAN AND AMERICAN THEATRE AND DRAMA SINCE 1870. Englewood Cliffs, N.J.: Prentice-Hall, 1973. 826 p., illus.

PRENTICE-HALL SERIES IN THEATRE AND DRAMA

This volume focuses on the century heralding the "advent of the modern drama." Bibliography; index.

P317. **Brown, John Mason.** LETTERS FROM GREENROOM GHOSTS. New York: Viking Press, 1934. 207 p.

A series of epistles—written as from a theater person of the past to a stage figure of the 1930s (e.g., Sarah Siddons to Katharine Cornell).

P318. **Brown, Thomas Allston.** HISTORY OF THE AMERICAN STAGE: CONTAINING BIO-SKETCH OF NEARLY EVERY MEMBER OF THE PROFESSION THAT HAS APPEARED ON THE AMERICAN STAGE FROM 1733 TO 1871. New York: B. Blom, 1969. 421 p., illus.

ORIGINAL EDITION (New York, 1871).

P319. **Cheney, Sheldon.** THE NEW MOVEMENT IN THE THEATRE. New York: Mitchell Kennerley, 1914. 303 p., illus.

A study of the theater at the start of World War I when Belasco, Gordon Craig, Max Reinhardt, and a burgeoning number of theater craftsmen and artists were active.

P320. **Cheney, Sheldon.** THE THEATRE: THREE-THOUSAND YEARS OF DRAMA, ACTING, AND STAGECRAFT. 4th rev. ed. New York: David McKay Co., 1972. 710 p., illus.

A reprint, which contains a new bibliography; index. ORIGINAL EDITION (Longmans, Green & Co., 1929), 538 p., illus.

P321. **Churchill, Allen.** THE THEATRICAL TWENTIES. New York: McGraw-Hill Book Co., 1975. 326 p., illus.

The 1920s were a peak period for the Broadway theater: more productions, more theaters, and bigger (though not more highly paid) stars. Toward the end of the decade the talkies and radio made inroads into the legitimate theater from which it has not yet recovered. Index.

P322. [Deleted.]

P323. **Craig, Edward Gordon.** ON THE ART OF THE THEATRE. Chicago: Browne's Bookstore, 1911. 296 p.

Edward Gordon Craig exerted a profound effect on the American theater. This book sets forth his theory of stagecraft.

P324. **Craig, Edward Gordon.** THE THEATRE ADVANCING. Boston: Little, Brown & Co., 1919. 298 p.

A further treatise on Craig's formulae for a better theater. Appendixes. [*See* P323.]

P325. **Craig, Edward Gordon.** TOWARDS A NEW THEATRE:. London and Toronto: J. M. Dent & Sons, 1913. 90 p., illus.

Forty designs for stage scenes by Craig. Includes his notes.

P326. **Crawford, Mary Caroline.** THE ROMANCE OF THE AMERICAN THEATRE. New York: Halcyon House, 1940. 508 p., illus. [*cont.*]

Reports on theater of the principal cities of the East Coast. Index.

P327. Daly, Charles P. First Theater in America: When Was the Drama First Introduced In America? An Inquiry. New York: Dunlap Society, 1896. 115 p., frontispiece.

Focuses on the Hallams in New York; remarks about Williamsburg, 1852.

P328. Dickinson, Thomas H. The Insurgent Theatre. New York: B. W. Guebsch, 1917. 251 p.

A study of the evolving community theater sixty years ago. The valuable appendix includes a list of these theaters and their repertoires. Index.

P329. Disher, Maurice Willson. Blood and Thunder: Mid-Victorian Melodrama and Its Origins. New York: Haskell House, 1974. 280 p., illus.

Includes list of plays; index. original edition (London: Frederick Muller, 1949).

P330. Disher, Maurice Willson. Melodrama: Plots That Thrilled. London: Rockliff. 210 p., illus.

Though British in origin, this is a valuable study of the plays that thrilled America a century or so ago. List of plays and theaters; index.

P331. Duerr, Edwin. The Length and Depth of Acting. New York: Holt, Rinehart & Winston, 1962. 590 p.

A history of acting. Foreword by Alois M. Nagler. Source list; bibliography; index.

P332. Dunlap, William. A History of the American Theatre. 2d ed. New York: Burt Franklin, 1936.

The first history of the American theater. Beginning with a production of *The Merchant of Venice* at Williamsburg, Va., in 1752, Dunlap traces the development of the theater in the United States to the engagement of George Frederick Cooke in 1832. Several interesting appendixes include correspondence about theater, a listing of plays and their authors of this early period in American theater, and the code of regulations of the Theatre Francais "established by the government." The volume is dedicated to James Fenimore Cooper. original edition (New York: J. & J. Harper, 1832), 420 p.

P333. Eaton, Walter Prichard. The Actor's Heritage: Scenes from the Theatre of Yesterday and the Day Before. Boston: Atlantic Monthly Press, 1924. illus.

Some of these essays are concerned with the English theater, but most focus on the American stage, e.g. the Astor Place Opera House riot, the Barrymores, or Weber & Fields. Index.

P334. Eaton, Walter Prichard. The American Stage of Today. Boston: Small, Maynard & Co., 1908. 338 p.

A series of essays on the American theater as it was just after the turn of the twentieth century.

P335. Flanagan, Hallie. Arena. New York: Duell, Sloan & Pearce, 1940. 475 p., illus.

Subject coverage includes the federal theater during the WPA era. [*See also* P364.]

P336. Ford, Paul Leicester. Washington and the Theater. New York: Dunlap Society, 1899. 68 p.
Dunlap Society, New Series, no. 8

P337. Freedley, George, and Reeves, John A. A History of the Theatre. Rev. ed. New York: Crown Publishers, 1955. 960 p., illus.

Standard history. Covers all styles of drama, illustrated with contemporaneous art. Bibliography.

P338. Gassner, John. Form and Idea in Modern Theatre. New York: Dryden Press, 1956. 290 p., illus.

A look "at the paths hitherto followed by those who have sought to modernize dramatic art": Vitruvius, Inigo Jones, Heinrich von Kleist, Craig, Wagner, Ibsen, Strindberg, and Shaw. Chronology of modern theater; notes; brief bibliography; index.

P339. Gassner, John. Theatre at the Crossroads: Plays and Playwrights of the Mid-century American Stage. New York: Holt, Rinehart & Winston, 1960. 327 p.

A bibliography is included in this volume.

P340. Geisinger, Marion. Plays, Players, and Playwrights: An Illustrated History of the Theatre. New York: Hart Publishing Co., 1971. 767 p., illus.

An encyclopedic, well-illustrated history of the theater from the Greeks to *Hair.* Index.

P341. Gillmore, Margalo. The B.O.W.S. New York: Harcourt Brace, 1945. 173 p., illus.
[*See* P75.]

P342. Golden, Joseph. The Death of Tinker Bell: The American Theatre in the Twentieth Century. Syracuse, New York: Syracuse University Press, 1967. 181 p.

A view of the American theater based upon a series of lectures delivered by Golden. He presents a somewhat pessimistic view of the theater's recent trends. Bibliography.

P343. Gorelik, Mordecai. New Theatres for Old. New York: Samuel French, 1957. 553 p., illus.

A study of the theater principally from the standpoint of production. Good glossary; full bibliography; and index. original edition (New York: Samuel French, 1940). Also available in paperback (New York: E. P. Dutton & Co., 1962).

P344. **Green, Paul.** DRAMA AND THE WEATHER: SOME NOTES AND PAPERS ON LIFE AND THE THEATRE. New York: Samuel French, 1958. 220 p.

A collection of the dramatist-director-educator's papers on the theater. Many of them focus on the outdoor festivals for which he has written several plays.

P345. **Harding, Alfred.** THE REVOLT OF THE ACTORS. New York: William Morrow, 1929. 575 p., illus.

A history of the bitter fight for the formation of the Actors' Equity Association and its first sixteen years. The extensive notes are an important adjunct to the text by the long-time editor of *Equity* magazine. Appendix, index.

P346. **Himelstein, Morgan Y.** DRAMA WAS A WEAPON: THE LEFT-WING THEATER IN NEW YORK, 1929–1941. New Brunswick, N.J.: Rutgers University Press, 1963. 300 p., illus.

A study of the ferment in the New York theater between the Depression and World War II: the Group Theatre, Theatre Union, the Mercury Theatre, and the Labor Stage. Foreword by John Gassner. Notes; index.

P347. **Hodge, Francis.** YANKEE THEATRE: THE IMAGE OF AMERICA ON THE STAGE, 1825–1850. Austin: University of Texas Press, 1964. 320 p., illus.

This volume includes a bibliography.

P348. **Hornblow, Arthur.** A HISTORY OF THE THEATRE IN AMERICA FROM ITS BEGINNINGS TO THE PRESENT TIME. Philadelphia: J. B. Lippincott Co., 1919. 2 vols., illus.

P349. **Houghton, Norris.** ADVANCE FROM BROADWAY: 19,000 MILES OF AMERICAN THEATRE. New York: Harcourt, Brace, 1941. 416 p.

[*See* P388.]

P350. **Hughes, Glenn.** A HISTORY OF THE AMERICAN THEATRE, 1700–1950. New York: Samuel French. 562 p., illus.

Includes discussion of television. Bibliography; index.

P351. **Hughes, Glenn.** THE STORY OF THE THEATRE: A SHORT HISTORY OF THEATRICAL ART FROM ITS BEGINNINGS TO THE PRESENT DAY. New York: Samuel French, 1928. 422 p., illus.

Bibliography; index.

P352. **Hughes, Langston, and Meltzer, Milton.** BLACK MAGIC: A PICTORIAL HISTORY OF THE NEGRO IN AMERICAN THEATRE. Englewood Cliffs, N.J.: Prentice-Hall, 1967. 375 p.

P353. **Hutton, Laurence, ed.** OPENING ADDRESSES. New York: Dunlap Society, 1837. 145 p., frontispiece.

Written for and delivered at the first performances at many theaters, from Boston to San Francisco, 1752–1880.

P354. **Hutton, Laurence.** CURIOSITIES OF THE AMERI-CAN STAGE. New York: Harper & Bros., 1891. 347 p., illus.

A collection of essays on various aspects of the American theater. Includes discussion of the drama of the American Indian and that of the blacks. Index.

P355. INTERNATIONAL THEATRE INSTITUTE OF THE UNITED STATES. THEATRE 5, THE AMERICAN THEATRE 1971–72. New York: Charles Scribner's Sons, 1973. 175 p., illus.

A composite study of the American theater with articles by specialists in a variety of areas. Among the pieces included: Harold Clurman on "Producing," Ruth R. Mayleas on "Supporting the Theatre," and Clayton Riley on "Black Theatre." Bibliography.

P356. **Isaacs, Edith J. R.** THE NEGRO IN THE AMERICAN THEATRE. College Park, Md.: McGrath Publishing Co., 1968. 143 p., illus.

FIRST EDITION (New York: Theatre Arts, 1947).

P357. **Krows, Arthur Edwin.** PLAY PRODUCTION IN AMERICA. New York: H. Holt, 1916. 414 p., illus.

A study of the theater around World War I. Bibliography; index.

P358. **Krutch, Joseph Wood.** THE AMERICAN DRAMA SINCE 1918: AN INFORMAL HISTORY. New York: Random House, 1939. 325 p.

A study of American drama between the World Wars. Index.

P359. **Leverton, Garrett H.** THE PRODUCTION OF LATER NINETEENTH-CENTURY AMERICAN DRAMA: A BASIS FOR TEACHING. New York: Teachers College, Columbia University, Bureau of Publications. 131 p.

The purpose of this study, which is essentially Leverton's doctoral thesis, is "to furnish the teacher of dramatics a working method by which plays of this period may be studied and produced in the school theatre with a fair measure of historical accuracy." Bibliography.

P360. **Lewis, Philip C.** TROUPING: HOW THE SHOW CAME TO TOWN. New York: Harper & Row, 1973. 266 p., illus.

A rambling but entertaining and informative history of the American theater when every town had a stage and the theatrical trouper went out to meet the audience. Index of towns and cities; index of plays and musicals; notes.

P361. **Lifson, David S.** THE YIDDISH THEATRE IN AMERICA. New York: Thomas Yoseloff, 1965. 659 p., illus.

A study of the great days of the Yiddish theater—both in New York and across the country—and the decline. The ethnic background of the audience is traced and the nineteenth-century Yiddish dramatists are discussed briefly. The work focuses on the twentieth-century Yiddish Art Theater and its lesser contemporaries. Notes; appendix; bibliography; index.

P362. MacKaye, Percy. THE PLAYHOUSE AND THE PLAY AND OTHER ADDRESSES CONCERNING THE THEATRE AND DEMOCRACY IN AMERICA. New York: Johnson Reprint Corp., 1970. 210 p.

An analysis at the end of the first decade of the twentieth century of what seemed like the first hopeful signs of the establishment of a national theater in America. ORIGINAL EDITION (New York: Macmillan Co., 1909).

P363. Marks, Edward B. THEY ALL HAD GLAMOUR: FROM THE SWEDISH NIGHTINGALE TO THE NAKED LADY. New York: Julian Messner, 1944. 448 p., illus.

A history of the lyric theater in America, beginning with *The Black Crook* in 1866. Appendixes; index.

P364. Mathews, Jane de Hart. THE FEDERAL THEATRE: 1935-1939, PLAYS, RELIEF, AND POLITICS. Princeton: Princeton University Press, 1967. 342 p., illus.

This is a history of the Depression era's federally funded theater, which added so immeasurably to the over-all development of American theater. Bibliography; index.

P364a. Mitchell, Loften. VOICES OF THE BLACK THEATRE. Clifton, N.J.: James T. White & Co., 1975. 238 p., illus.

Conversations with several outstanding artists of the black theater—about its history, its contribution to our culture, and its triumphs and sorrows. Abram Hill, Ruby Dee, Vinette Carroll, Frederick O'Neal, and Paul Robeson are among the artists. Foreword by Ossie Davis. Index.

P365. Moody, Richard. AMERICA TAKES THE STAGE: ROMANTICISM IN AMERICAN DRAMA AND THEATRE, 1750-1900. Bloomington: Indiana University Press, 1955. 322 p., illus.

Moody's thesis is that "for about two hundred and fifty years the political, economic, social and art history of America was permeated with the spirit of romance." In this volume he focuses on the plays and playwrights who best evidenced this trend and traces the evidences of this in the other arts. Play list; notes; bibliography; index.

P366. Morris, Lloyd. CURTAIN TIME: THE STORY OF THE AMERICAN THEATER. New York: Random House, 1953. 381 p., illus.

Morris writes in a fine literary style; his history of the American theater is eminently readable. Though it is completely accurate in its historical detail, some of the text reads like fiction. The book is handsomely illustrated with many reproductions of old theater prints. Index.

P367. Moses, Montrose J. THE AMERICAN DRAMATIST. Boston: Little, Brown & Co., 1925. 474 p., illus.

A history of American drama from colonial times to Eugene O'Neill and the New Drama. Bibliography; index.

P368. Patterson, Lindsay, ed. ANTHOLOGY OF THE AMERICAN NEGRO IN THE THEATRE: A CRITICAL APPROACH. New York: Publishers Co.; under the auspices of the Association for the Study of Negro Life and History, 1967. 306 p., illus. INTERNATIONAL LIBRARY OF NEGRO LIFE AND HISTORY.

In this volume, which is part of a ten-volume set on the black and his culture in America, one hundred years of the black on the American stage are described. Included are excerpts from outstanding plays such as Willis Richardson's *The Chip Woman's Fortune*, which is cited as the "first drama by a Negro to appear on Broadway" (May 15, 1923). Preface by Charles H. Wesley. Biographies; bibliography; index.

P369. Quinn, Arthur Hobson. A HISTORY OF THE AMERICAN DRAMA FROM THE BEGINNING TO THE CIVIL WAR. New York: F. S. Crofts & Co., 1923. 530 p.

List of American plays; bibliography; index. SECOND EDITION (New York, 1943).

P370. Quinn, Arthur Hobson. A HISTORY OF THE AMERICAN DRAMA. New York: F. S. Crofts & Co., 1927. 432 p., illus.

These companion pieces form a source book of American drama up to the mid-1930s. Play lists; bibliography. SECOND EDITION (New York, 1936). [*See* P369.]

P371. Rankin, Hugh F. THE THEATRE IN COLONIAL AMERICA. Chapel Hill: University of North Carolina Press, 1960. 239 p., illus.

A history of theater companies prior to the Revolution. Includes information about the Hallams and the early theater in Williamsburg, Philadelphia, and New York. Notes; index. SECOND EDITION (1965).

P372. Seilhamer, George O. HISTORY OF THE AMERICAN THEATRE. New York: Greenwood Press, 1968. 3 vols.

A detailed account of the American theater from its earliest productions (1732) until just before the end of the eighteenth century. Index. ORIGINAL EDITION (1888).

P373. Speaight, Robert. SHAKESPEARE ON THE STAGE: AN ILLUSTRATED HISTORY OF SHAKESPEAREAN PERFORMANCE. Boston: Little, Brown & Co., 1973. 304 p., illus.

This is a selection of Shakespearean performances worldwide. There are several sections devoted to famous productions of his plays in the United States: Ira Aldridge in *Othello*, Edwin Booth in *Hamlet*, Charlotte and Susan Cushman in *Romeo and Juliet*, and Richard Mansfield in *King Henry V*. Bibliography; index.

P374. Tentori, Tullio. RUDIMENTI DI ARTE DRAMMATICA FRA GLI INDIGENI AMERICANI. In: International Congress of Americanists. São Paulo, Brazil, 1954.; Mexico, Miscellanea Paul Rivet, 1958. p. 189-196.

P375. Vaughan, Stuart. A POSSIBLE THEATRE: THE EXPERIENCES OF A PIONEER DIRECTOR IN AMERICA'S RESIDENT THEATRE. New York: McGraw-Hill Book Co., 1969. 255 p.

A somewhat autobiographical account of the post–World War II decentralization of the American theater. Discusses Vaughan's experiences in directing, principally at the New York Shakespeare Festival, the Phoenix Theatre (New York) and the Seattle (Washington) Repertory Theatre. Index.

P376. **Weisman, John.** GUERRILLA THEATER: SCENARIOS FOR REVOLUTION. Garden City, N.Y.: Anchor Press/Doubleday, 1973. 201 p., illus.

The street theaters, the theaters of the barrios, of the blacks, the Chicanos, and the migrant workers of the 1970s, with examples of some of the plays produced in these areas.

P377. **Wemyss, Francis Courtney.** WEMYSS CHRONOLOGY OF THE AMERICAN STAGE FROM 1752 TO 1852. New York: William Taylor & Co., 1852. 191 p.

A listing of performers, giving biographical details, credits, a list of theatrical managers, and the personnel of the Regular Company of Comedians, Williamsburg, Va., 1752.

P378. **Wilson, Jarff B.** A HISTORY OF AMERICAN ACTING. Bloomington: Indiana University Press, 1966. 310 p., illus.

A survey of American actors and acting by schools: the heroic school (Forrest), the classic school (Edwin Booth), and the comic (Henry Placide). Index.

P379. **Winter, William.** OTHER DAYS: BEING CHRONICLES AND MEMORIES OF THE STAGE. New York: Moffat, Yard & Co., 1906. 389 p., illus.

A collection of essays on American stage figures—Joseph Jefferson, Dion Boucicault, Adelaide Neilson—and the stage of Winter's day. Index.

P380. **Winter, William.** THE WALLET OF TIME; CONTAINING PERSONAL, BIOGRAPHICAL AND CRITICAL REMINISCENCES OF THE AMERICAN THEATRE. New York: Moffat, Yard & Co., 1913. 2 vols., illus.

A collection of Winter's dramatic reviews, remembrances of the actors and productions he had seen, and pieces on the greats of the American theater who predated his own theatergoing.

P381. **Wright, Richardson.** HAWKERS AND WALKERS IN EARLY AMERICA: STROLLING PEDDLERS, PREACHERS, LAWYERS, DOCTORS, PLAYERS AND OTHERS; FROM THE BEGINNING TO THE CIVIL WAR. Philadelphia: J. B. Lippincott Co., 1927. 317 p., illus.

A look at the strolling player in the early days of the United States. Includes other fascinating folk and lore. Index.

REGIONAL THEATER

Community Theater

P382. **Arvold, Alfred G.** THE LITTLE COUNTRY THEATRE. New York: Macmillan Co., 1922. 220 p., illus.

A study of regional theaters, with the emphasis and inspiration drawn from the author's work over many years at the theater of the North Dakota Agricultural College in Fargo. A splendid list of play suggestions for productions at such a theater is included. Appendix.

P383. **Burleigh, Louise.** THE COMMUNITY THEATRE. Boston: Little, Brown & Co., 1917. 188 p., illus.

A study that almost sixty years ago called attention to the diminishing audience for live theater and pointed to the burgeoning community efforts to call this audience back. There is a long prefatory letter from Percy MacKaye, and the appendix lists community theaters all across the United States with a note on their history and/or policy.

P384. THE CANN-LEIGHTON OFFICIAL THEATRICAL GUIDE: JULIUS CAHN'S OFFICIAL THEATRICAL GUIDE, CONTAINING INFORMATION OF THE LEADING THEATRES AND ATTRACTIONS IN AMERICA. New York. 1895/96–1911/12.

These annual volumes carried information essential to touring companies—theaters in towns all across the United States and Canada, transportation facilities, hotels, advertising printers and outlets, mileages, storage dimensions, town population, and theater seating capacities. The work was widely used when the road was vital and touring a viable economic and logistic operation.

P385. **Cutler, Bruce, ed.** THE ARTS AT THE GRASS ROOTS. Lawrence: University of Kansas Press, 1968. 270 p.

The papers that resulted from a conference on this subject held in Wichita, in 1966, in which all of the arts were represented.

P386. **Gard, Robert E., and Burley, Gertrude S.** COMMUNITY THEATRE, IDEA, AND ACHIEVEMENT. New York: Duell, Sloan & Pearce, 1959. 182 p.

A study based upon a 20,000-mile journey to visit community theaters all across the United States. Included are a list of American community theaters; bibliography.

The word CATALOG in the heading of an entry refers to the exhibition catalog as a whole and not to the catalog list, checklist, or catalog section of the work.

P387. **Gard, Robert E; Balch, Marston; and Temkin, Pauline B.** THEATER IN AMERICA: APPRAISAL AND CHALLENGE. New York: Theatre Arts Books; Madison: Pemtar Educational Research Service, 1968. 192 p.

A study done for the National Theatre Conference, with funding from the Rockefeller Foundation, of the theaters across the United States in the third quarter of the twentieth century. Notes; bibliography.

P388. **Houghton, Norris.** ADVANCE FROM BROADWAY: 19,000 MILES OF AMERICAN THEATRE. New York: Harcourt Brace, 1941. 416 p.

A report of a visit to colleges and university theaters, little theaters, and regional theaters, from the Atlantic to the Pacific. Index.

P389. **McCleery, Albert, and Glick, Carl.** CURTAINS GOING UP. New York: Pitman Publishing Co., 1939. 412 p.

A close look at the theaters of the United States in the late 1930s. Lists of community theater groups; lists of plays produced by community theaters; budgets; appendixes; bibliography; index.

P390. **MacKaye, Percy.** COMMUNITY DRAMA: ITS MOTIVE AND METHOD OF NEIGHBORLINESS, AN INTERPRETATION. Boston: Houghton Mifflin Co., 1917. 65 p.

The substance of an address delivered by Percy MacKaye to the American Civic Association, Washington, Dec. 13, 1916. Discusses his idea of recruiting for the theater using the same format as the American army in 1916. The lecture is based upon MacKaye's experiences with the production of *Caliban*. Appendix.

P390a. **Novick, Julius.** BEYOND BROADWAY: THE QUEST FOR PERMANENT THEATRES. New York: Hill & Wang, 1968. 393 p., illus.

A collection of articles about permanent theaters around the United States. The volume discusses fifty organizations, including some university theaters, the established theater festivals, and some groups in Canada. The appendixes give brief histories of such theaters as the American Place Theatre and the Negro Ensemble Company. Index.

P390b. **Patten, Marjorie.** THE ARTS WORKSHOP OF RURAL AMERICA: A STUDY OF THE RURAL ARTS PROGRAM OF THE AGRICULTURAL EXTENSION SERVICE. New York: Columbia University Press, 1937. 202 p.

A study of attempts to foster the arts among rural Americans in the 1930s. Foreword by Edmund de S. Brunner.

P391. Pearson, Talbot. Encores on Main Street: Successful Theatre Leadership. Pittsburgh: Carnegie Institute of Technology Press, 1948. 175 p.

Written with the help of a grant from the National Theatre Conference, this book reflects the widespread feeling in the United States in the late 1940s and early 1950s of the necessity of decentralizing the American theater. Play list; bibliography.

P392. Selden, Samuel, ed. Organizing a Community Theatre. Cleveland: National Theatre Conference, 1945. 128 p.

The collaborative work of several experts (Frederic McConnell, Arch Lauterer, Marcella Cisney, and Richard N. Gage) on starting a productive community theater. The pamphlet was written just at the conclusion of World War II when there was a belief that great talents would come from the demobilizing armed forces.

P393. Young, John Wray. The Community Theatre and How It Works. New York: Harper & Bros., 1957. 166 p.

A practical guide by the director of the very successful Shreveport (La.) Little Theatre. Index.

The Stage in Specific Locales

BLUE HILL, MAINE

P394. The Blue Hill Troupe: Twenty-fifth Anniversary. New York: Blue Hill Troupe, 1949. 96 p., illus.

Starting in Blue Hill, Maine, in 1924, this troupe devoted itself mostly to productions of Gilbert and Sullivan, both in Maine and in New York. List of members and credits.

BOSTON, MASSACHUSETTS

P395. Boston. **Club of Odd Volumes.** Catalogues of Exhibitions. Boston, 1914–1915.

These catalogs carry detailed descriptions of the prints, playbills, advertisements, and autograph letters exhibited. From the collection of Robert Gould Shaw (1850–1931), now a major part of the Theatre Collection at Harvard University.

P396. Clapp, William W., Jr. A Record of the Boston Stage. Boston and Cambridge: James Munroe & Co., 1853. 479 p.

A chronology of stage performances in Boston, this is a study that appeared originally in the pages of the *Boston Evening Gazette.* REPRINT (New York: Greenwood Press, 1969).

P397. French, Charles Elwell, ed. Six Years of Drama at the Castle Square Theatre; With Portraits of the Members of the Company and Complete Programs of All Plays Produced. Boston: Charles Elwell French, 1903. 406 p., illus.

The volume includes the casts and biographical sketches of the principals of productions, May 3, 1897–May 3, 1903. Index.

P398. McGlinchee, Claire. The First Decade of the Boston Museum. Boston: Bruce Humphries, 1940. 188 p., illus.

The Boston Museum and Gallery of Fine Arts played host to all manner of entertainments during its career. It is said that vaudeville was Americanized here. This volume details the activities from 1841 to 1851. Bibliography; index.

P399. Ryan, Kate. Old Boston Museum Days. Boston: Little, Brown & Co., 1915. 264 p., illus.

A history of the famous Boston entertainment center—which was a theater as well as a museum of curiosities—by an actress who played there in the mid-nineteenth century. Index.

P400. Stone, P. M. An Outline History of the Castle Square Theatre, Boston, 1894–1932. Typewritten. Waltham, Mass.: P. M. Stone. 40 p.

This is really the outline for a more fully planned study, but it contains considerable information about the Castle Square Theatre.

P401. Tompkins, Eugene, and Kilby, Quincy. The History of the Boston Theatre, 1854–1901. Boston and New York: Houghton Mifflin Co., 1908. 551 p., illus.

A season-by-season account of the attractions at the Boston Theatre by the man who was the manager of the theater from 1878 to 1901. Index.

CHAPEL HILL, NORTH CAROLINA

P402. Henderson, Archibald, ed. Pioneering a People's Theatre. Chapel Hill: University of North Carolina Press, 1945. 104 p.

A series of articles by Archibald Henderson, Samuel Selden, Frederick H. Koch, Paul Green, and others about the remarkable career of the Carolina Playmakers. Included is a list of their productions, 1918–1944. Bibliography.

P403. **Spearman, Walter, and Selden, Samuel.** THE CAROLINA PLAYMAKERS: THE FIRST FIFTY YEARS. Chapel Hill, 1970. 178 p., illus.

Pays homage to the Carolina Playmakers, 1918–1968.

CHARLESTON, SOUTH CAROLINA

P404. **Hoole, William Stanley.** THE ANTE-BELLUM CHARLESTON THEATRE. University: University of Alabama Press, 1946. 230 p., illus.

A companion piece to Eola Willis's history, this volume focuses on the history of the theater in Charleston to 1862. Included are play lists, player lists, and chronological records. There is a foreword by Arthur Hobson Quinn.

P405. **Willis, Eola.** THE CHARLESTON STAGE IN THE EIGHTEENTH CENTURY; WITH SOCIAL SETTINGS OF THE TIME. Columbia, S.C.: State Co., 1924. 483 p., illus.

Willis traces her history from the early years of the eighteenth century to the turn of the century. She has consulted journals, gazettes, and newspapers. Index.

CHICAGO, ILLINOIS

P406. **McVicker, James Hubert.** THE THEATRE: ITS EARLY DAYS IN CHICAGO. Chicago: Knight & Leonard, 1884. 88 p.

The text of a paper read before the Chicago Historical Society by McVicker, who was both an actor and theater manager.

P407. **Everett, Marshall.** THE GREAT CHICAGO THEATER DISASTER. Publishers Union of America, 1904. 368 p., illus.

An account of the devastating fire that swept the Iroquois Theatre, Dec. 30, 1903, and resulted in the loss of several hundred lives.

P408. **Sherman, Robert L.** CHICAGO STAGE: ITS RECORDS AND ACHIEVEMENTS. Chicago: Robert L. Sherman, 1947. vol. 1, 792 p., frontispiece.

A list of Chicago theaters and attractions, 1833–1871. Index.

CLEVELAND, OHIO

P409. **Flory, Julia McCune.** THE CLEVELAND PLAYHOUSE: HOW IT BEGAN. Cleveland: Press of Western Reserve University, 1965. 136 p., illus.

A history of the Playhouse, gathered from 108 scrapbooks, 1915–1965.

DENVER, COLORADO

P410. **Schoberlin, Melvin.** FROM CANDLES TO FOOTLIGHTS: A BIOGRAPHY OF THE PIKE'S PEAK THEATRE, 1859–1876. Denver: Old West Publishing Co., 1941. 322 p., illus.

A history of the theater in the West from the rugged entertainments of the mining camps in the 1850s and 1860s to the elegance of the opera houses a quarter of a century later. Barrett H. Clark has written the preface. List of theaters; notes; bibliography; index.

P411. **Dier, Caroline Lawrence.** THE LADY OF THE GARDENS: MARY ELITCH LONG. Hollywood: Hollycrofters, 1932. 307 p., illus.

Though this is purportedly a biography of Mary Long, it is really more of a history of Elitch's Gardens in the eighteenth century. There is a foreword by Burns Mantle. Index of illustrations.

DETROIT, MICHIGAN

P412. **Cheney, Sheldon.** THE ART THEATRE: A DISCUSSION OF ITS IDEALS, ITS ORGANIZATION, AND ITS PROMISE AS A CORRECTIVE FOR PRESENT EVILS IN THE COMMERCIAL THEATRE. New York: Alfred A. Knopf, 1917. 249 p., illus.

A study of the Arts and Crafts Theatre of Detroit. Cheney includes photographs of its productions and casts, 1916/17. Index.

FALMOUTH, MASSACHUSETTS

P413. **Houghton, Norris.** BUT NOT FORGOTTEN: THE ADVENTURE OF THE UNIVERSITY PLAYERS. New York: William Sloane Associates, 1952. 346 p., illus.

Out of the tremendous ferment of the twenties came the University Players, an acting troupe that worked summers in Falmouth, Mass. Joshua Logan, Bretaigne Windust, Henry Fonda, and Myron McCormick were some of the artists who worked with this company. A readable history, though lacking in dates, cast lists, and general documentation.

FARGO, NORTH DAKOTA

P414. **Koch, Frederick Henry.** THE DAKOTA PLAYMAKERS: AN HISTORICAL SKETCH. University of North Dakota, *Quarterly Journal* 9 (Oct. 1918): 14–21, illus.

A history of Koch's thirteen years with the Dakota Players.

P415. **Koch, Frederick Henry; with Becker, Albert J.** THE CONSTRUCTION OF THE PLAY-STAGE. University of North Dakota, *Quarterly Journal* 9 (Oct. 1918): 22–30, illus.

GALVESTON, TEXAS

P416. **Gallegly, Joseph.** FOOTLIGHTS ON THE BORDER: THE GALVESTON AND HOUSTON STAGE BEFORE 1900. The Hague: Mouton & Co., 1962. 262 p., illus.

In 1838, when this study begins, Houston was the capital of a new republic, while both Houston and Galveston

were thriving ports. This is a history of the stage in these two cities to the turn of the twentieth century. Index.

GUILFORD, CONNECTICUT

P417. **Harmon, Charlotte, and Taylor, Rosemary.** BROADWAY IN A BARN. New York: Thomas Y. Crowell Co., 1957. 242 p., illus.

The story of Charlotte and Lewis Harmon's operation of the Chapel Playhouse in Guilford, Conn. Illustrations by Sam Norkin.

HARTFORD, CONNECTICUT

P418. **Coote, Albert W.** FOUR VINTAGE DECADES: THE ARTS IN HARTFORD, 1930–1970. Hartford, Conn.: Huntington, 1970. 378 p., illus.

A history of the Horace Bushnell Memorial Hall and of the Bushnell family. Introduction by Raymond E. Baldwin. Appendix; index.

HOBOKEN, NEW JERSEY

P419. **Morley, Christopher.** SEACOAST OF BOHEMIA. Garden City, N.Y.: Doubleday, Doran & Co., 1929. 68 p., illus.

The account of the operation of the Old Rialto Theatre, Hoboken, in the 1920s, by Christopher Morley, Cleon Throckmorton, and Harry Wagstaff Gribble.

IOWA

P420. **Schick, Joseph D.** THE EARLY THEATER IN EASTERN IOWA: CULTURAL BEGINNINGS AND THE RISE OF THE THEATER IN DAVENPORT AND EASTERN IOWA, 1836–1863. Chicago: University of Chicago Press, 1939. 384 p.

A detailed study of theatrical performances, showboats, circuses, lectures: all forms of entertainment in the pre–Civil War days. Lists of performances; bibliography.

KENTUCKY

P421. **Hill, West T., Jr.** THE THEATRE IN EARLY KENTUCKY, 1790–1820. Lexington: University Press of Kentucky, 1971. 205 p., illus.

A study of the theater in what was, during the period under observation, the Western frontier. Record of performances; bibliography; index.

MINNEAPOLIS, MINNESOTA

P422. **Guthrie, Tyrone.** A NEW THEATRE. New York: McGraw-Hill Book Co., 1964. 188 p., illus.

The Tyrone Guthrie Theatre opened in Minneapolis in 1963. This is Guthrie's account of the background and planning of that enterprise. Index.

NASHVILLE, TENNESSEE

P423. **Hunt, Douglas L.** THE NASHVILLE THEATRE, 1830–1840. Birmingham-Southern College, *Bulletin* 28 (May 1935): 89 p.

Though the study centers on the decade cited in the title, Hunt traces theater in Nashville back to 1807.

NEW HAMPSHIRE

P424. **Work Projects Administration. New Hampshire Writer's Project.** PLAYS AND PLAYERS IN NEW HAMPSHIRE. Typewritten. 1942. 91 p.

An account of theater activity in this state since 1752. Copy in Theatre Collection, The New York Public Library.

NEW ORLEANS, LOUISIANA

P425. **Gaisford, John.** THE DRAMA IN NEW ORLEANS. New Orleans: J. B. Steel, 1849. 55 p.

A history of the theaters flourishing in New Orleans in the early nineteenth century.

P426. **Kendall, John Smith.** THE GOLDEN AGE OF THE NEW ORLEANS THEATER. Baton Rouge: Louisiana State University Press, 1952. 624 p., illus.

A history of the theater in the Louisiana metropolis of the nineteenth century. Index.

P427. **Smither, Nelle K.** A HISTORY OF THE ENGLISH THEATRE IN NEW ORLEANS, 1806–1842. New York: B. Blom, 1967. 450 p.

The first performance in English in New Orleans took place in 1806. This history is a study of English theater in New Orleans as opposed to French or American theater. English theater continued until almost the middle of the nineteenth century. Play, player, playwright lists. Bibliography. EARLIER EDITION (New York: B. Blom, 1944).

NEW YORK, NEW YORK

P428. **Brown, Thomas Allston.** A HISTORY OF THE NEW YORK STAGE, FROM THE FIRST PERFORMANCE IN 1732 UNTIL 1901. New York: Dodd, Mead & Co., 1903. 3 vols.

Brown's narration of the development of the New York stage is structured around the individual theater buildings.

P429. **Churchill, Allen.** THE GREAT WHITE WAY: A RECREATION OF BROADWAY'S GOLDEN ERA OF THEATRICAL ENTERTAINMENT. New York: E. P. Dutton & Co., 1962. 310 p., illus.

A history of Broadway from the opening of *Floradora* at the Casino Theatre in 1900 to the actors' strike in 1919. Bibliography; index.

P430. **Dimmick, Ruth Crosby.** OUR THEATRES TODAY

AND YESTERDAY. New York: H. K. Fly Co., 1913. 107 p., illus.

A brief history of the theater in New York, from 1732 to 1913. Index.

P431. Dithmar, Edward Augustin. MEMORIES OF DALY'S THEATRES; WITH PASSING RECOLLECTIONS OF OTHERS, INCLUDING A RECORD OF PLAYS AND ACTORS AT THE FIFTH AVENUE THEATRE AND DALY'S THEATRE, 1869–95. New York: Privately printed, 1897. 143 p., illus.

Augustin Daly was one of the foremost American stage producers. This is a record of productions at his two New York playhouses over a twenty-five-year period.

P432. THE EMPIRE THEATRE: A CHRONOLOGY, 1893–1943. Typewritten. 21 p.

A history of the playhouse with a list of its productions.

P433. Harriman, Margaret Case. THE VICIOUS CIRCLE: THE STORY OF THE ALGONQUIN ROUND TABLE. New York: Rinehart, 1951. 310 p., illus.

Gathered at the round table of the Hotel Algonquin could be Alexander Woollcott, Edna Ferber, George S. Kaufman, Herbert Bayard Swope, Robert Benchley, or Frank Ross. This is a lively account of that literary and theatrical rendezvous.

P434. Henderson, Mary C. THE CITY AND THE THEATRE: NEW YORK PLAYHOUSES FROM BOWLING GREEN TO TIMES SQUARE. Clifton, N.J.: James T. White & Co., 1973. 323 p., illus.

A history of the shifting theater districts in New York, with detailed information on most of the major playhouses. Foreword by August Heckscher. Notes; maps; bibliography; index.

P435. Laufe, Abe. ANATOMY OF A HIT: LONG-RUN PLAYS ON BROADWAY FROM 1900 TO THE PRESENT DAY. New York: Hawthorn Books, 1966. 350 p., illus.

A study of the long-runs (more than 500 performances) in the New York theater of the twentieth century and what made these plays hits. Foreword by Jack Gaver. List of long runs; index.

P436. Leuchs, Fritz A. H. THE EARLY GERMAN THEATRE IN NEW YORK, 1840–1872. New York: Columbia University Press, 1928. 298 p.

A record of the once flourishing German-speaking theater in New York during its earliest years. Lists of productions; bibliography; index.

P437. Martin, Ralph G. LINCOLN CENTER FOR THE PERFORMING ARTS. Englewood Cliffs, N.J.: Prentice-Hall, 1971. 192 p., illus. (color).

A history of New York's Center for the Performing Arts and a guide to some of its activities. Included are many beautiful color plates. Index.

P438. Mason, Alexander Hamilton, IV. FRENCH THEATRE IN NEW YORK: A LIST OF PLAYS, 1899–1939. New York: Columbia University Press, 1940. 442 p.

A listing of French plays (in French and English), with casts, notes about production, and synopses. Bibliography; index.

P439. Moody, Richard. THE ASTOR PLACE RIOT. Bloomington: Indiana University Press, 1958. 243 p., illus.

As a result of the rivalry between the American actor, Edwin Forrest, and the visiting English actor, William Charles Macready, the Astor Place Opera House was the scene of a riot in 1849. This is an account of that event. Bibliography.

P440. Odell, George C. D. ANNALS OF THE NEW YORK STAGE. New York: Columbia University Press, 1927–1939. 15 vols., illus.

The great reference work on the New York stage, which covers the years to 1894. Index. [*See also* P441.]

P441. Odell, George C. D. INDEX TO THE PORTRAITS IN ODELL'S ANNALS OF THE NEW YORK STAGE. American Society for Theatre Research, 1963. 179 p.

Transcribed from the file in the Theatre Collection at Princeton University.

P442. [Hippodrome Theater.] RECORD, SEARS V. NEW YORK HIPPODROME CORPORATION. 171 New York Supplement 181 (Supreme Court, 1918).

The case was brought in a Manhattan municipal court by Harry Sears as a plaintiff against the Hippodrome Corporation and against the agents, Charles Dillingham and Robert H. Burnside, who were named as alternative defendants. Sears claimed that he had sold ideas to the theater, and therefore had a valid contract with the theater. The municipal court ruled against Sears, who then appealed to the next highest court—in New York, the State Supreme Court—which also ruled against Sears. The case is interesting because it discusses the concept of an idea and what constitutes ownership of an idea. The testimony and record in this appellate proceeding contain a description of the theater.

P443. Rosenbach, Abraham S. W. THE FIRST THEATRICAL COMPANY IN AMERICA. American Antiquarian Society, Proceedings, new ser. 48 (1939): 300–310.

PHILADELPHIA, PENNSYLVANIA

P444. Durang, Charles. HISTORY OF THE PHILADELPHIA STAGE BETWEEN THE YEARS 1749 AND 1855. ARRANGED AND ILLUSTRATED BY THOMPSON WESTCOTT. Philadelphia: University of Pennsylvania Library, 1868. 6 vols., illus., ports.

Volumes are located in the libraries of the University of Pennsylvania, Philadelphia Company, Historical Society of Pennsylvania, and Harvard University.

P445. Pollock, Thomas Clark. THE PHILADELPHIA THE-ATRE IN THE EIGHTEENTH CENTURY. Philadelphia: University of Pennsylvania Press, 1933. 445 p., frontispiece.

A list of the theaters in Philadelphia from 1700, with the day book listing costs of all productions in Philadelphia, 1700–1800. Foreword by Arthur Hobson Quinn. Index to plays and players.

PROVIDENCE, RHODE ISLAND

P446. THE ALBEE ALUMNI: A HISTORY OF ELEVEN SEASONS OF THE EDWARD F. ALBEE STOCK CO. AT KEITH'S THEATER, PROVIDENCE, R.I. Providence, 1912. 197 p., illus.

The casts of productions given by the Albee Stock Co., 1901–1911, with a brief account of outstanding events of each season. Preface by Johnson Briscoe.

SAINT LOUIS, MISSOURI

P447. Carson, William G. B. THE BEGINNINGS OF THE THEATRE IN ST. LOUIS. Missouri Historical Society, *Bulletin* 5:2 (1928): 129–65.

P448. THE THEATRE ON THE FRONTIER: THE EARLY YEARS OF THE ST. LOUIS STAGE. Chicago: University of Chicago Press, 1932. 361 p., illus.

A history of the theater in Saint Louis from 1815. Record of performances of individual plays. Bibliography; index.

SAN FRANCISCO, CALIFORNIA

P449. Gage, Edmond M. THE SAN FRANCISCO STAGE: A HISTORY. New York: Columbia University Press, 1950. 264 p., illus.

A history of the theater in the stage capitol of the Pacific Coast. The study is based upon the record compiled by the research department of the San Francisco Federal Theatre. Bibliography; index.

SEATTLE, WASHINGTON

P450. Roher, Mary Katherine. THE HISTORY OF SEAT-TLE STOCK COMPANIES FROM THEIR BEGINNINGS TO 1934. Seattle: University of Washington Press, 1945. 76 p., illus.

The first stock company came to Seattle in 1890. This book provides a history of the various companies and considerable information on the institution of stock. Lists of theaters and companies; appendix; bibliography; index.

THE SOUTH

P451. Dent, Thomas C.; Schechner, Richard; and

Moses, Gilbert, eds. THE FREE SOUTHERN THEATER: A DOCUMENTARY OF THE SOUTH'S RADICAL BLACK THEATRE; WITH JOURNALS, LETTERS, POETRY, ESSAYS AND A PLAY WRITTEN BY THOSE WHO BUILT IT. Indianapolis: Bobbs-Merrill Co., 1969. 233 p., illus., map.

P452. Dorman, James H. THEATER IN THE ANTE-BELLUM SOUTH, 1815–1861. Chapel Hill: University of North Carolina Press, 1967. 322 p., illus.

P453. Harwell, Richard Barksdale. BRIEF CANDLE: THE CONFEDERATE THEATRE. Worchester, Mass.: American Antiquarian Society, 1971. 160 p., illus.

A study of the theater in the South during the Civil War, which focuses on the New Richmond (Va.) Theatre. Included is a day-by-day listing of the attractions at the theater culled from the Richmond newspapers of the period. Index.

TOLEDO, OHIO

P454. Revett, Marion S. A MINSTREL TOWN. New York: Pageant Press, 1955. 335 p., illus.

Revett describes Toledo, Ohio, as a typical American town. This is a history of their theater and its personalities: minstrels, vaudeville, and circus. Bibliography.

P455. Stolzenbach, Norma Frizzelle. THE HISTORY OF THE THEATRE IN TOLEDO, OHIO, FROM ITS BEGINNINGS UNTIL 1893. Ph.D. thesis, University of Michigan. 331 p.

A well-organized history of theater in Toledo from 1839, when theater took place in improvised surroundings, through the building of regular theaters, until the last decade of the nineteenth century.

TOMBSTONE, ARIZONA

P456. Willson, Clair Eugene. MIMES AND MINERS: A HISTORICAL STUDY OF THE THEATER IN TOMBSTONE. University of Arizona, *Bulletin* 6 (Oct. 1935): 207 p.

The theater in a town of the "Old West" before American entertainment became homogenized by the movies, radio, and television. History of the entertainment, 1880–1917. Lists of productions, performers, and managers. Bibliography.

WASHINGTON, D.C.

P457. Atkinson, George, and Kiraly, Victor. A GREAT CURTAIN FALLS. New York: Strand Press, n.d. 68 p., illus.

A history of the National Theatre in the nation's capital—together with a history of the early theater in Washington, D.C. Foreword by John Golden.

TECHNIQUES OF PRODUCTION, ACTING, ENTERTAINMENT, AND DESIGN

Stage Business

In this section, "stage business" does not mean the action of the play but the "business" of the theater. This includes economic studies as well as production techniques. Some of these volumes are now of interest only as historical documents but they give valuable insight into the American theater as it was.

PRODUCTION TECHNIQUES

P458. **Altman, George and others.** THEATER PICTORIAL: A HISTORY OF WORLD THEATER AS RECORDED IN DRAWINGS, PAINTINGS, ENGRAVINGS, AND PHOTOGRAPHS. Berkeley and Los Angeles: University of California Press, 1953. unpag., illus.

P459. **Barton, Lucy.** HISTORIC COSTUME FOR THE STAGE. Boston: Walter H. Baker Co., 1935. 605 p., illus.

A handbook for costuming period productions from the Egyptian to the twentieth century. Index.

P460. **Bates, Esther Willard.** THE CHURCH PLAY AND ITS PRODUCTION. Boston: Walter H. Baker Co., 1938. 303 p., illus.

Esther Bates wrote this book from the experiences gained from several years of production of religious plays at Boston University's School of Religious and Social Work. She discusses all of the facets of this type of production from the creation of the work itself through all of the technical aspects of the production. Bibliography.

P461. **Bay, Howard.** STAGE DESIGN. New York: Drama Book Specialists, 1974. 219 p., illus.

From his experience as a designer of some 150 Broadway productions and as a teacher of stage design, Howard Bay has written both a history of the art and a guide for the embryonic stage designer. Index.

P462. **Bowman, Wayne.** MODERN THEATRE LIGHTING. New York: Mayer & Bros., 1957. 228 p., illus.

A guide to stage lighting for school and community theater. The appendix includes definitions of technical terms, lists of equipment with specifications, and a bibliography. Jean Bowman has provided many detailed drawings which amplify the text. Index.

The word CATALOG in the heading of an entry refers to the exhibition catalog as a whole and not to the catalog list, checklist, or catalog section of the work.

P463. **Bricker, Herschel L., ed.** OUR THEATRE TODAY. New York: Samuel French. 427 p., illus.

A collection of essays by specialists on the "art, craft and management" of the theater. Included are historical pieces, essays on aspects of production and stagecraft, and articles on aspects of stage techniques. Bibliography; index.

P464. **Burris-Meyer, Harold, and Cole, Edward C.** SCENERY FOR THE THEATRE. Boston: Little, Brown & Co., 1938. 473 p., illus.

A guide for the apprentice in the theater to all technical aspects of a production. Arthur Hopkins has added a very brief foreword. Bibliography; index.

P465. **Cameron, Kenneth M., and Hoffman, Theodore C.** THE THEATRICAL RESPONSE. New York: Macmillan Co., 1969. 429 p., illus.

A study of different types of theater, which offers an analysis of several plays and the theater for which each was written. Also includes a guide for the amateur actor and play producer about acting techniques and technical procedures. Glossary; index.

P466. **Canfield, Curtis.** THE CRAFT OF PLAY DIRECTING. New York: Holt, Rinehart & Winston, 1963. 349 p., illus.

A text for the stage director by the first Dean of the Yale School of Drama—a thorough guide to the director's role. Includes essay on "The Collegiate Theatre." Drawings by W. Oren Parker. Appendix; glossary; index.

P467. **Chalmers, Helena.** CLOTHES ON AND OFF THE STAGE: A HISTORY OF DRESS FROM THE EARLIEST TIMES TO THE PRESENT DAY. New York: D. Appleton, 1932. 292 p., illus.

A history of dress for stage purposes with useful information about design, cutting patterns, and execution of costume. Index.

P468. **Cheney, Sheldon.** STAGE DECORATION. New York: John Day Co., 1928. 138 p.

Pt. 2 of this volume is a pictorial record of stage forms and decoration to 1900. Index.

P469. **Claudel, Paul.** CLAUDEL ON THE THEATRE. EDITED BY JACQUES PETIT AND JEAN PIERRE KEMPF. TRANS-

LATED BY CHRISTINE TROLLOPE. Coral Gables, Fla.: University of Miami Press, 1972. 191 p., illus.

Claudel's interest in the technical problems of the theater go back to 1912, when his play *The Tidings Brought to Mary* was produced in Paris at the Theatre de l'Oeuvre. He has exerted an influence on American theater directors and technicians. Index.

P470. **Clay, James H., and Krempel, Daniel.** THE THEATRICAL IMAGE. New York: McGraw-Hill Book Co., 1967. 300 p., illus.

This volume attempts to explore the meaning of the play in relation to the production techniques involved in staging it. Notes; index.

P471. **Clurman, Harold.** ON DIRECTING. New York: Macmillan Co., 1972. 308 p., illus.

Directing notes of Clurman. Index.

P472. **Coburn, Charles.** THEY IMITATED HUMANITY SO ADMIRABLY; IS THE UNIVERSITY CONTENT IN SPONSORING A SPURIOUS THEATRE? Berkeley and Los Angeles: University of California Press, 1942. 10 p.

An address given to the National Theatre Conference on Nov. 16, 1941, based on a course given at University of California, Los Angeles, in the summer of 1941. Focuses on the problem of where the theater will look for professionally trained actors.

P473. **Cole, Toby, and Chinoy, Helen Krich, eds.** DIRECTORS ON DIRECTING: A SOURCE BOOK OF THE MODERN THEATRE. Indianapolis: Bobbs-Merrill Co., 1963. 464 p., illus.

Articles by outstanding stage directors, from the Duke of Saxe-Meiningen (1826–1914) to Joan Littlewood, about the problems of the stage director. Bibliography; index. ORIGINAL EDITION: *Directing the Play* (Indianapolis: Bobbs-Merrill Co., 1953).

P474. **Cornberg, Sol, and Gebaver, Emanuel L.** A STAGE CREW HANDBOOK. Rev. ed. New York: Harper & Bros., 1957. 295 p., illus.

A textbook with detailed drawings, relating to the work of the scenic designer and painter as well as the technical director and stage carpenter. Bibliography; index. ORIGINAL EDITION (1941).

P475. **Corson, Richard.** STAGE MAKEUP. 4th ed. New York: Appleton-Century-Crofts, 1970. 456 p., illus.

A complete manual to stage makeup—includes sample kits, color charts, and period hairstyles. Uta Hagen has written a brief foreword. Index. ORIGINAL EDITION (1949).

P476. **Cullman, Marguerite.** OCCUPATION: ANGEL. New York: W. W. Norton & Co., 1963. 256 p.

Tips on the backing of plays—a view of the business of the theater from this backer's position. Appendix.

P477. **Dabney, Edith, and Wise, Claude Merton.** A BOOK OF DRAMATIC COSTUME. New York: F. S. Crofts & Co., 1930. 163 p., illus.

A guide to stage costume—from the ancient to the modern—for the newcomer to the field. Bibliography.

P478. **D'Amico, Victor Edmond.** THEATER ART. Peoria, Ill.: Manual Arts Press, 1931. 217 p., illus. BOOKS ON THE ARTS SERIES.

The series, under the editorship of William G. Whitford, includes this volume which covers the many aspects of stage production for the embryonic stage aspirant. Bibliography; index.

P479. **Dean, Alexander.** FUNDAMENTALS OF PLAY DIRECTING. New York: Farrar & Rinehart, 1941. 428 p., illus.

An expansion of the lectures from Alexander Dean's first-year class in directing as offered at the Yale University School of Drama. List of terms. Index.

P480. **Dietrich, John.** PLAY DIRECTION. New York: Prentice-Hall, 1953. 484 p., illus.

A manual for the stage director at all levels of experience and achievement with a basic text on what makes theater and what is an audience. Glossary; bibliography; index.

P481. **Downs, Harold, ed.** THEATRE AND STAGE: A MODERN GUIDE TO THE PERFORMANCE OF ALL CLASSES OF AMATEUR, DRAMATIC, OPERATIC AND THEATRICAL WORK. 2 vols., illus.

An encyclopedic guide for the amateur theater worker. All phases of stage production, historic theater, and period drama are discussed in articles written by experts in each field. Barry Jackson has written a foreword. Index.

P482. **Enters, Angna.** ON MIME. Middletown, Conn.: Wesleyan University Press, 1965. 132 p., illus.

A history of the art of mime as well as a "how-to" guide by one of the theater's foremost practitioners. Drawings by the author.

P483. **Fuchs, Theodore.** STAGE LIGHTING. Boston: Little, Brown & Co., 1929. 499 p., illus.

A history of stage lighting and a guide to lighting practices in the theater—fifty years ago. Appendix; index.

P484. **Gassner, John, and Barber, Philip.** PRODUCING THE PLAY, WITH THE NEW SCENE TECHNICIANS HANDBOOK. Rev. ed. New York: Dryden Press, 1953. 915 p., illus.

A comprehensive production guide by Gassner with important contributions like Barber's first *Scene Technicians Handbook* which was published in typed form, New Haven, 1928, and has become a standard reference work in this field. ORIGINAL EDITION (1941). SUBSEQUENT REVISED EDITION (1958).

P485. **Gibson, William.** THE SEESAW LOG: A CHRONICLE OF THE STAGE PRODUCTION, WITH THE TEXT OF *Two for the Seesaw*. New York: Alfred A. Knopf, 1959. 273 p. [*cont.*]

"A log of the adventures or misadventures of a play-script," *Two for the Seesaw,* with the full text of the play. Biographical note.

P486. Gillette, Arnold. STAGE SCENERY: ITS CONSTRUCTION AND RIGGING. New York: Harper & Bros., 1959. 315 p., illus.

Beginning with the organization necessary for efficient production, Gillette treats in detail the manifold problem of scene construction and proper stage utilization. Glossary; bibliography; index.

P487. Goffin, Peter. THE ART AND SCIENCE OF STAGE MANAGEMENT. New York: Philosophical Library, 1953. 120 p.

A slim but informative volume about the stage manager's role in production. Bibliography.

P488. Grimball, Elizabeth B., and Wells, Rhea. COSTUMING A PLAY. New York: Century Co., 1925. 133 p., illus.

A guide to historical costuming and production, with excellent plates and explanatory diagrams.

P489. Grover, Elbert A. THE STAGE MANAGER'S HANDBOOK. New York: Harper & Bros., 1952–1953. 202 p.

A handbook for the special field of stage management, focusing on the many facets of this job. Index.

P490. Hainaux, René, ed. STAGE DESIGN THROUGHOUT THE WORLD SINCE 1935. New York: Theatre Arts Books, 1956. 222 p., illus.

Out of the 4th Congress of the International Theatre Institute in Oslo in 1931 has come this remarkable collection of interior stage designs—including those by such Americans as Sam Leve, Stewart Chaney, Robert Edmond Jones, George Kerz, Boris Aronson, and Mordecai Gorelik. Includes a sketch that serves as a foreword by Jean Cocteau. Preface by Kenneth Rae. Index.

P491. Hartmann, Louis. THEATRE LIGHTING: A MANUAL OF THE STAGE SWITCHBOARD. New York: Appleton & Co., 1930. 138 p., illus.

A manual by David Belasco's chief electrician—a guide to Belasco's stage technology. Foreword by David Belasco.

P492. Heffner, Hubert C.; Selden, Samuel; and Sellman, Hunton D. MODERN THEATRE PRACTICE: A HANDBOOK OF PLAY PRODUCTION. 4th rev. ed. New York: Appleton-Century-Crofts, 1959. 662 p., illus.

Covers directing, lighting, scenery. General introduction includes play analysis. Glossary; bibliography; appendix on costume and makeup by Fairfax Proudfit Walkup. ORIGINAL EDITION (1935).

P493. Hobbs, William. STAGE FIGHT: SWORDS, FIREARMS, FISTICUFFS AND SLAPSTICK. New York: Theatre Arts Books, 1967. 96 p., illus.

A guide to all types of stage battles. Introduction by Laurence Olivier. List of suppliers. Index.

P494. Sixth Congress of the International Federation for Theatre Research, 1969. INNOVATIONS IN STAGE AND THEATRE DESIGN. EDITED BY FRANCIS HODGE. New York: American Society for Theatre Research, Theatre Library Association, 1972. 165 p., illus.

P495. Hollingworth, Harry Levi. THE PSYCHOLOGY OF THE AUDIENCE. New York: American Book Co., 1935. 232 p.

An analysis of types of audiences, this is a study of the psychological effect of the various theatrical and dramatic techniques. For the actor-director-producer, it contains some useful information on how to attract and maintain audience interest. Bibliography.

P496. Hopkins, Arthur. HOW'S YOUR SECOND ACT?: NOTES ON THE ART OF PRODUCTION. New York: Samuel French, 1931. 43 p.

Hopkins's theory of unity in stage production.

P497. Izard, Barbara, and Hieronymus, Clara. REQUIEM FOR A NUN: ONSTAGE AND OFF. Nashville: Aurora Publishers, 1970. 331 p., illus.

William Faulkner's *Requiem for a Nun* first appeared as a novel and was done as a play in several European theaters before its American premiere in 1959. This is a history of the work as done on the stage. Index.

P498. Langley, Stephen. THEATER MANAGEMENT IN AMERICA, PRINCIPLE AND PRACTICE; PRODUCING FOR THE COMMERCIAL, STOCK, RESIDENT, COLLEGE AND COMMUNITY THEATRE. New York: Drama Book Specialists, 1974. 405 p.

A guide to the many problems inherent in theatrical production on a variety of professional levels. Appendix; bibliography.

P499. Leonard, Charles, comp. MICHAEL CHEKHOV, TO THE DIRECTOR AND PLAYWRIGHT. New York and Evanston, Ill.: Harper & Bros., 1963. 329 p., illus.

An amplification of *To the Actor* with the text of Gogol's *Revisor* (adapted by Charles Appleton) interspersed with Michael Chekhov's stage directions.

P500. Parker, W. Oren, and Smith, Harvey K. SCENE DESIGN AND STAGE LIGHTING. New York, 1963. 376 p., illus.

This volume outlines the background and training needed in order to design in the modern theater from concept through execution.

P501. Payne, Darwin Reid. DESIGN FOR THE STAGE: FIRST STEPS. Carbondale and Edwardsville: Southern Illinois University Press, 1974. 265 p., illus.

A textbook which places the "focus on the stage designer's art by emphasizing the theoretical and artistic, rather than the technical." Included are 117 drawings by the author.

P502. The Playground and Recreation Association of

America. COMMUNITY DRAMA: SUGGESTIONS FOR A COMMUNITY-WIDE PROGRAM OF DRAMATIC ACTIVITIES. New York: Century Co., 1926. 240 p., illus.
Appendixes; bibliography.

P503. **Rappel, William J., and Winnie, John R.** COMMUNITY THEATRE HANDBOOK. Iowa City: State University of Iowa, Institute of Public Affairs, 1961. 77 p.
A handbook for organizing and running a healthy community theater. Foreword by Dean Zenor. Includes sets of administrative and production techniques, catalogs of plays and services, and by-laws. Appendixes; bibliography.

P504. **Redgrave, Michael.** MASK OR FACE: REFLECTIONS IN AN ACTOR'S MIRROR. New York: Theatre Arts Books, 1958. illus.
A discussion by the popular British actor on the "Method," stage techniques, and directing.

P505. **Resnik, Muriel.** SON OF ANY WEDNESDAY. New York: Stein and Day Publishers, 1965. 237 p., illus.
A saga of the success story of Resnik's play, *Any Wednesday*. The appendixes include a list of directors and performers who turned the script down.

P506. **Selden, Samuel.** THEATRE DOUBLE GAME. Chapel Hill: University of North Carolina Press, 1969. 123 p.
A series of essays about the play-goer. Bibliography.

P507. **Simon, Bernard, comp.** SIMON'S DIRECTORY OF THEATRICAL MATERIALS: SERVICES AND INFORMATION COVERING THE ENTIRE UNITED STATES AND CANADA. 4th ed. New York: Package Publicity Service, 1962–1970.
A handy guide to where to secure "everything needed for the production of stage attractions and the management of theatres." [For the 1975 edition, *see* P774].

P508. **Simonson, Lee.** THE STAGE IS SET. New York: Harcourt Brace, 1932. 585 p., illus.
A history of stage setting as seen by one of the great stage designers of the American twentieth-century. Notes; bibliography; index.

P509. [Deleted.]

P510. **Southern, Richard.** STAGE-SETTING: FOR AMATEURS AND PROFESSIONALS. New York: Theatre Arts Books, 1960. 272 p., illus.
For the amateur who must often work in poorly equipped auditoriums, this book is written so that the beginner can achieve a well-designed production. Bibliography; index.

P511. **Southern, Richard.** PROSCENIUM AND SIGHTLINES: A COMPLETE SYSTEM OF SCENERY PLANNING; AND A GUIDE TO THE LAYING OUT OF STAGES FOR SCENE DESIGNERS, STAGE MANAGERS, THEATRE ARCHITECTS AND ENGINEERS, THEATRICAL HISTORY AND RESEARCH WORKERS AND THOSE CONCERNED WITH THE PLANNING OF STAGES FOR SMALL HALLS. New York: Theatre Arts Books, 1964. 233 p., illus.
Appendix; index.

P512. **Stanislavsky, Konstantin.** AN ACTOR PREPARES. TRANSLATED BY ELIZABETH REYNOLDS HAPGOOD. New York: Theatre Arts Books, 1936. 293 p.
A beginner's guidebook to Stanislavsky's stage methods. This guide was published in the United States two years before it was published in Russia.

P513. **Stanislavsky, Konstantin.** BUILDING A CHARACTER. New York: Theatre Arts Books, 1949. 292 p.
A continuation of *An Actor Prepares*—more of Stanislavsky's principles for the actor and director. Introduction by Joshua Logan.

P514. **Stanislavsky, Konstantin.** CREATING A ROLE. EDITED BY HERMINE I. POPPER. New York: Theatre Arts Books, 1961. 271 p.
The third volume of Stanislavsky's trilogy on the training of the actor. Foreword by Robert Lewis.

P515. **Stanislavsky, Konstantin.** STANISLAVSKY'S LEGACY: A COLLECTION OF COMMENTS ON A VARIETY OF ASPECTS OF AN ACTOR'S ART AND LIFE. TRANSLATED BY ELIZABETH REYNOLDS HAPGOOD. New York: Theatre Arts Books, 1958. 182 p.
This is part of the large corpus of writings on the theater left in the Stanislavsky archives.

P516. **Stanislavsky, Konstantin.** STANISLAVSKY ON THE ART OF THE STAGE. TRANSLATED BY DAVID MAGARSHACK. New York: Hill and Wang, 1961. 311 p., illus.
A selection of Stanislavsky's papers on the creative process in the theater. Appendix; index.

P517. **Strenkovsky, Serge.** THE ART OF MAKE-UP. EDITED BY ELIZABETH S. TABER. New York: E. P. Dutton & Co., 1937. 350 p., illus.
This is both a guide to the make-up techniques and a study of physiognomy as it affects stage make-up. Bibliography.

P518. **Traube, Shepard.** SO YOU WANT TO GO INTO THE THEATRE? A MANUAL. Boston: Little, Brown & Co., 1936. 258 p.
A dated "how-to" manual for the uninitiated which at one time was a must for all Broadway aspirants. Appendix; stage glossary; lists of Broadway producers and agents. Foreword by Barrett H. Clark.

P519. [Deleted.]

P520. **Wise, Arthur.** WEAPONS IN THE THEATRE. New York: Barnes & Noble, 1968. 139 p., illus.

A book on techniques for the use of weapons in the theater. Index.

P521. **Wright, Edward A.** A PRIMER FOR PLAYGOERS: AN INTRODUCTION TO THE UNDERSTANDING AND APPRECIATION OF CINEMA-STAGE-TELEVISION. Englewood Cliffs, N.J.: Prentice-Hall, 1958. 270 p., illus.

This volume "is designed primarily for the audience who will view the completed production, rather than those who would create or interpret it." The book discusses the various types of dramatic expression, something of its history, and the various artists involved in the finished production. Questions for discussion; glossary; index.

P522. **Young, James.** MAKING UP. New York: M. Witmark & Sons, 1905. 179 p., illus.

A history of make-up, a guide to stage make-up, and a potpourri of essays on the subject by DeWolf Hopper, Wilton Lackaye, Sam Bernard, Otis Skinner, and other stage artists.

ECONOMIC STUDIES

P523. **Anderson, John.** BOX OFFICE. New York: J. Cape & H. Smith, 1929. 121 p.

A valuable study of theater economy which, though outdated, remains of interest.

P524. **Barker, Harley Granville.** THE EXEMPLARY THEATRE. London: Chatto & Windus, 1922. 288 p.

P525. **Barker, Harley Granville.** A NATIONAL THEATRE. London: Sidgwick & Jackson, 1930. 135 p. plans.

Though these volumes were written with the British theater in mind, both volumes [P524, P525] merit attention as guides to national theater planning.

P526. **Baumol, William J., and Bowen, William G.** PERFORMING ARTS: THE ECONOMIC DILEMMA, A STUDY OF PROBLEMS COMMON TO THEATER, OPERA, MUSIC AND DANCE. New York: Twentieth Century Fund, 1966. 582 p.

This is a penetrating study of the entire economic aspect of theater production in the mid-1960s—set against the economy of the period. There is interesting material comparing the economics of the American theater to that of Great Britain. Foreword by August Heckscher. Bibliography; appendix; index. [*See also* P533, P535.]

P527. **Beckhard, Richard, and Effrat, John.** BLUEPRINT FOR SUMMER THEATRE. New York: John Richard Press, 1948. 99 p.

Compiled under the auspices of the American National Theatre and Academy, this manual for summer theater operation has been reprinted and used as a tool for almost three decades.

P528. **Belasco, David.** THE THEATRE THROUGH ITS STAGE DOOR. EDITED BY LOUIS V. DE FOE. New York and London: Harper & Bros., 1919. 264 p., illus.

Theater practices as seen by David Belasco over sixty years ago. A revealing study of the theater as a business written by one of its ablest businessmen.

P529. **Bernheim, Alfred L.; with Harding, Sara, and the staff of the Labor Bureau.** THIS BUSINESS OF THE THEATRE. New York: Actors' Equity Association, 1932. 217 p.

The book falls into two parts: a survey of the economic history of the theater and an analysis of the economic aspects of the current theater. There is material on contractual arrangements, theater real estate, production costs, and admission prices.

P530. [Deleted.]

P531. **Goldman, William.** THE SEASON: A CANDID LOOK AT BROADWAY. New York: Harcourt Brace & World, 1969. 432 p.

A hard look at the Broadway theater and its economic problems. The 1967/68 season is used as the focus of the study. Index.

P532. **MacKaye, Percy.** THE CIVIC THEATRE IN RELATION TO THE REDEMPTION OF LEISURE: A BOOK OF SUGGESTIONS. New York: Mitchell Kennerly, 1912. 308 p.

A collection of essays about publicly supported theater by an early proponent of this concept. MacKaye, a dramatist and poet, worked in public theater and wrote these essays drawing upon his experiences.

P533. **Moore, Thomas Gale.** THE ECONOMICS OF THE AMERICAN THEATRE. Durham, North Carolina: Duke University Press, 1968. 192 p.

A follow-up to the Baumol-Bowen study [*see* P526], this analysis by a professor of economics examines costs, admission prices, and audience statistics.

P534. **Morrison, Jack.** THE RISE OF THE ARTS ON THE AMERICAN CAMPUS. New York: McGraw-Hill Book Co., 1973. 221 p.
CARNEGIE COMMISSION ON HIGHER EDUCATION, PROFILE SERIES, NO. 13.

This study of the arts on American campuses is focused on the performing arts. Among the topics discussed are criteria for teaching of the arts, the student body, economic support, and the place of the arts in the overall curriculum. Appendix; bibliography; index.

P535. **Moskow, Michael H.** LABOR RELATIONS IN THE PERFORMING ARTS: AN INTRODUCTORY SURVEY. New York: Associated Councils on the Arts, 1969. 218 p.

Closely related to the economic study of the theater by Baumol and Bowen [*see* P526], this volume concentrates

on labor and employment as it affects the performing arts. Foreword by John T. Dunlop.

P536. **Poggi, Jack.** THEATER IN AMERICA: THE IMPACT OF ECONOMIC FORCES, 1870–1967. Ithaca, New York: Cornell University Press, 1968. 328 p.

A study of the economic conditions of the American theater for the past century. Bibliography; sources of quotations; tables and graphs; index.

P537. **Reed, Joseph Verner.** THE CURTAIN FALLS. New York: Harcourt Brace, 1935. 282 p., illus.

An account of disillusionment in the theater. With Kenneth MacGowan, Joseph Verner Reed formed a producing firm. This is the story of the conditions which plagued this venture and of Reed's embitterment toward the theater.

P538. **Rockefeller Brothers Fund.** THE PERFORMING ARTS: PROBLEMS AND PROSPECTS. New York: McGraw-Hill Book Co., 1965, 258 p.

A report, prepared by a large panel, on the crises facing the performing arts in America: economic, legislative, the problems of management, audience building, and the training of young artists. Index.

P539. **Schubart, Mark.** PERFORMING ART INSTITUTIONS AND YOUNG PEOPLE. New York: Praeger Publishers, 1972. 109 p.

An account of a study undertaken by the Lincoln Center for the Performing Arts in its search for an audience of young people and a program that would appeal to them.

P540. **Stanton, Sanford E.** THEATRE MANAGEMENT: A MANUAL OF THE BUSINESS OF THE THEATRE INCLUDING FULL TEXTS OF AUTHOR'S AND ACTOR'S STANDARD CONTRACTS. New York: D. Appleton, 1929. 154 p., illus.

Though somewhat outdated, Stanton considers in this volume the ramifications of the then emergent theatrical unions as well as the pieces of labor legislation passed during the 1920s. Preface by Charles B. Dillingham. Appendix includes texts of contracts; bibliography; index.

P541. **Twentieth-Century Fund.** BRICKS, MORTAR AND THE PERFORMING ARTS: REPORT OF THE TWENTIETH-CENTURY FUND TASK FORCE ON PERFORMING ARTS CENTERS, 1970. Millwood, N.Y.: Kraus Reprint, 1973. 99 p., illus.

The report of a task force, guided by Martin Mayer, on the boom in building performing arts centers in the United States. The discussion focuses on the financial crises and mounting operating expenses.

Types of Theater and Theater Organizations

AMATEUR STAGE

P542. **Allensworth, Carl; with Allensworth, Dorothy; and Ranson, Clayton.** THE COMPLETE PLAY PRODUCTION HANDBOOK. New York: Thomas Y. Crowell, 1973. illus.

A guide for the amateur theater producer, director, and technician. It covers all of the aspects involved in getting a play on the stage. Foreword by Richard Moody. Lists of supplies; bibliography; index.

P543. **Bailey, Howard.** THE ABC'S OF PLAY PRODUCING: A HANDBOOK FOR THE NON-PROFESSIONAL. New York: David McKay Co., 1955. 276 p., illus.

A guide for the amateur theater group—from play selection through production of the play. Included are sections on presenting church plays, pageants, and musicals. The book is illustrated with excellent plans and diagrams by Wilbur Dorsett. List of recommended plays; bibliography; index.

P544. **Brown, Gilmor, and Garwood, Alice.** GENERAL PRINCIPLES OF PLAY DIRECTION. New York: Samuel French, 1936. 190 p., illus.

A guide for the director of the amateur play. Glossary; appendix; index.

P545. **Carter, Jean, and Ogden, Jess.** EVERYMAN'S DRAMA: A STUDY OF THE NON-COMMERCIAL THEATRE IN THE UNITED STATES. New York: American Association for Adult Education, 1938. 136 p., illus.

A study of the adult amateur stage in the United States in the 1930s. Although dated, this account is of historical interest.

P546. **Cartmell, Van H.** A HANDBOOK FOR THE AMATEUR ACTOR. Garden City, N.Y.: Doubleday, Doran & Co., 1936. 203 p. BEHAVIORISM OF YE ACTOR.

A guide to the art for the actor in amateur theater. Includes manual of the Amateur Comedy Club, New York which was intended for company managers; stage glossary; and *George*, a one-act play with stage directions. Preface by Gene Lockhart.

P547. **Cartmell, Van H.** A GUIDE FOR ACTOR AND DIRECTOR. Princeton, N.J.: D. Van Nostrand Co., 1961. 220 p. BEHAVIORISM OF YE ACTOR SERIES.

A fuller guide than *The Handbook for the Amateur Actor*, the volume discusses the full set of problems faced in amateur theater production. Appendix.

P548. **Chubb, Percival.** FESTIVALS AND PLAYS IN

School and Elsewhere. New York: Harper & Bros., 1912. 403 p., illus.

A guide to the production of festivals for primary and secondary school classes. The book is based largely on the practices of the Ethical Culture School in New York more than a half century ago. Bibliography; index.

P549. **Clark, Barrett H.** How to Produce Amateur Plays: A Practical Manual. Boston: Little, Brown & Co., 1925. 177 p., illus.

Clark called this book "a primer—which if properly studied enables the amateur producer and actor to approach their work with intelligence." Appendixes include copyright and royalty regulations; lists of plays; bibliography; index. ORIGINAL EDITION (1917).

P550. **Crafton, Allen, and Royer, Jessica.** Acting: A Book for the Beginner. New York: F. S. Crofts & Co., 1928. 318 p., frontispiece.

A primer for the amateur actor: "a presentation which is in harmony with the present day conception of acting." Bibliography; index.

P551. **Crump, Leslie.** Directing for the Amateur Stage. New York: Dodd, Mead & Co., 1935. 235 p., illus.

An elementary guide for the amateur director. Lists of play publishers and agents. Index.

P552. **Dean, Alexander.** Little Theatre Organization and Management: For Community, University and School, including a History of the Amateur in Drama. New York: D. Appleton, 1926. 333 p.

A complete guide to production for the amateur theater worker. Index.

P553. **Ferris, Helen Josephine.** Producing Amateur Entertainments, Varied Stunts, and Other Numbers, with Program Plans and Directions. New York: E. P. Dutton & Co., 1921. 266 p., illus.

A somewhat dated guide for those who work with amateur theater groups, particularly for those working on small budgets. SUBSEQUENT EDITIONS (1925,1927). Index.

P554. **Helvenston, Harold.** Scenery: A Manual of Scene Design. Stanford: Stanford University Press, 1931. 95 p., illus.

A practical manual of scene design for the amateur. Foreword by Kenneth MacGowan. Glossary of terms; index.

P555. **Plugge, Domis.** History of Greek Play Production in American Colleges and Universities from 1881 to 1936. New York: Columbia University, Teachers College, Bureau of Publication, 1938. 175 p.

A study of the plays, producing organizations, and production methods. Tables; index.

P555a. **Smith, Milton.** The Book of Play Production for Little Theatres, Schools and Colleges. New York: D. Appleton-Century Co., 1926. 254 p., illus.

A guide to all the aspects of amateur play production—a result of the outpouring of interest in such activity in the United States in the 1920s. Introduction by Brander Matthews. Index. SECOND EDITION (1935).

P555b. **Trimble, Neil.** Variety Shows and How to Produce Them. Chicago: Beckley-Cardy Co., 1941. 141 p., illus.

A guide for the amateur variety show producer—schools, community organizations, and church groups. Foreword by Oscar W. Anderson. Bibliography.

P556. **Williams, Galen, comp.** A Partial Directory of American Poets and Playwrights. Washington, D.C.: National Endowment for the Arts. 156 p.

A listing of available poets and playwrights for teaching assignments in primary and secondary schools as well as in colleges and universities. Included, too, are film lists, tapes, bibliographies, and other teaching aids.

CHILDREN'S THEATER

Activity in the area of children's theater forms a major part of the American theater. These titles are either histories of this topic or "how-to" books.

P557. **Chorpenning, Charlotte.** Twenty-one Years with Children's Theatre. Anchorage, Ky.: Children's Theatre Press, 1954. 112 p., illus

Reminiscences by one of the foremost children's theater producers of the time.

P558. **Davis, Jed H.; Watkins, Mary Jane Larson; and Busfield, Roger M., Jr.** Children's Theatre: Play Production for the Child Audience. New York: Harper, 1960. 416 p., illus.

A manual for those engaged in children's theater operation.

P559. **Graham, Kenneth L.** An Introductory Study of Evaluations of Plays for Children in the United States. Ph.D. thesis, University of Utah, 1947. 330 p.

Graham's dissertation is a study of the aims of children's theater, the audience, and analyses of successful productions. Appendix; bibliography.

P560. **Gross, Edwin, and Gross, Nathalie.** Teen Theatre: A Guide to Play Production and Six Royalty-free Plays. New York: Whittlesey House, 1953. 245 p., illus.

A useful guide to play production for young amateurs—a "how-to" book. Included is material about publicity for the show, planning and publishing of programs, as well as considerable technical information. Foreword by

Margaret C. Scoggin. Line drawings by Edwin Gross. Glossary of theater terms.

P561. **Siks, Geraldine Brain, and Dunington, Hazel Brain, eds.** CHILDREN'S THEATRE AND CREATIVE DRAMATICS. Seattle: University of Washington Press, 1961. 277 p., illus.

This volume is the result of a study initiated by the American Educational Theatre Association (now the American Theatre Association). It includes essays on children's theater by Kenneth L. Graham, Nellie McCaslin, Sara Spencer, Jed H. Davis, Isabel B. Burger and other leaders in this field. Foreword by Jack Morrison. Notes; bibliography by Paul Kozelka; index.

MARIONETTES

P562. **Bufano, Remo.** BE A PUPPET SHOWMAN. New York: Century House Publishing, 1933. 168 p., illus.

A primer to assist amateurs in building a simple puppet theater.

P563. **Bufano, Remo.** MAGIC STRINGS. New York: Macmillan Co., 1939. 182 p., illus.

A collection of eleven puppet plays with production notes. Illustrated by Boris Artzybasheff.

P564. **Joseph, Helen Haiman.** A BOOK OF MARIONETTES. New York: Viking Press, 1929. 248 p., illus.

This is both a history of marionette production and a "how-to" guide for puppeteers. Bibliography; index. ORIGINAL EDITION (New York: Huebsch, 1920).

P565. **MacIsaac, Frederick John.** THE TONY SARG MARIONETTE BOOK. New York: Huebsch, 1921. 58 p., illus.

A small manual for the puppeteer with Tony Sarg drawings and two plays for homemade marionettes by Anne Stoddard.

P566. **McPharlin, Marjorie Batchelder.** THE PUPPET THEATRE IN AMERICA: A HISTORY, 1524–1948. Enl. ed. Boston: Plays, Inc. 1969. 734 p., illus.

An enlarged edition of Paul McPharlin's 1949 history of American marionette theaters. The book includes a list of puppeteers, 1524–1948. Bibliography; index. SUPPLEMENT: *Puppets in America since 1948.*

P567. **McPharlin, Paul.** A REPERTORY OF MARIONETTE PLAYS: CHOSEN AND TRANSLATED WITH NOTES. New York: Viking Press, 1929. 372 p., illus.

The plays are from a variety of sources. The material about the producers of these plays is of particular historical value. Lists of marionette play producers in England and America. Bibliography; index.

P568. **Philpott, A. R., comp.** DICTIONARY OF PUPPETRY. Boston: Plays, Inc., 1969. 286 p., illus.

A biographical dictionary of important persons working in this field. Includes a glossary of terms.

P569. **Richmond, Arthur, ed.** REMO BUFANO'S BOOK OF PUPPETRY. New York: Macmillan & Co. 1965. 232 p., illus.

A re-creation for a new generation of puppeteers. Captures the magic of Remo Bufano's puppet theater.

ENTERTAINMENT

This section includes works on the circus, tent shows, medicine shows, burlesque, vaudeville, magic—all manner of entertainment.

P570. **Alexander, H. M.** STRIP TEASE: THE VANISHED ART OF BURLESQUE. New York: Knight, 1938. 124 p., illus.

LaGuardia's closing of the burlesque theaters in New York in 1938 marked the end of the strip-tease. This volume is a study of the genre.

P571. **Birdoff, Harry.** THE WORLD'S GREATEST HIT: UNCLE TOM'S CABIN. New York: Vanni, 1947. 440 p., illus.

A history of *Uncle Tom's Cabin* and the part it played in the American theater for more than half a century.

P572. **Bradna, Fred, and Hartzell, Spence.** THE BIG TOP: MY FORTY YEARS WITH THE GREATEST SHOW ON EARTH, INCLUDING A CIRCUS HALL OF FAME. New York: Simon & Schuster, 1952. 333 p., illus.

Fred Bradna came to the United States when the circus returned from a European tour in 1903. For the next forty years he traveled with the circus—first with Barnum and Bailey, and later with Ringling Brothers, Barnum and Bailey. The Circus Hall of Fame describes the greatest circus acts Bradna witnessed in his years under the big top. Glossary of circus terms; index.

P573. **Brick, Hans.** THE NATURE OF THE BEAST. New York: Crown Publishers, 1962. 210 p.

A book on the training of wild animals to perform.

P574. BUFFALO BILL'S WILD WEST: AMERICA'S NATIONAL ENTERTAINMENT, AN ILLUSTRATED TREATISE OF HISTORICAL FACTS AND SKETCHES. Hartford, Conn.: Calhoun Printing Co., 1888. 40 p., illus.

The brochure for the edition of the Wild West Show which toured the United States and parts of Europe in the late nineteenth century.

P575. **Channell, Herbert Walter; Lowry, Velma E.; and Morrill, Miron A., eds.** FIFTY YEARS UNDER CANVAS: A TRIBUTE TO ALL SHOWMEN UNDER THE BIG TOP. Hugo, Okla.: Acme Publishing Co., 1962. 164 p., illus.

Herbert Walter Channell is known professionally as

Herb Walters. He began his career in a minstrel show, then went into vaudeville and musical comedy, and spent his best years with Cole Brothers Circus.

P576. Chindhal, George L. A HISTORY OF THE CIRCUS IN AMERICA. Caldwell, Ida.: Caxton Printers, 1959. 279 p., illus.

A highly readable account of the American circus, from the exhibition of a "Lyon of Barbary," in 1716, through the middle of the twentieth century. List of American circuses, 1771–1956. Notes.

P577. Chipman, Bert J. HEY RUBE. Hollywood: Hollywood Print Shop, 1933. 203 p., illus.

Reminiscences of what life was like traveling across the United States with the circus in the early twentieth century.

P578. Christopher, Milbourne. THE ILLUSTRATED HISTORY OF MAGIC. New York: Thomas Y. Crowell Co., 1973. 452 p., illus. (color).

A handsomely illustrated history of magic from the Egyptians to the television magic shows of today. Milbourne Christopher quotes from excellent primary sources. Bibliography.

P579. Conklin, George, and Root, Harvey W. THE WAYS OF THE CIRCUS; BEING THE MEMORIES AND ADVENTURES OF GEORGE CONKLIN, TAMER OF LIONS. New York: Harper & Brothers, 1921. 309 p., illus.

In 1866, George Conklin joined the Haight and Chambers Steamboat Show in Maysville, Ky. He spent the next forty years with circuses, eventually working with the big ones like Barnum and Bailey and Cole Brothers as a lion tamer. Foreword by Don C. Seitz.

P580. Cooper, Courtney Ryley. CIRCUS DAY. New York: Farrar & Rinehart, 1931. 263 p., illus.

P581. Cooper, Courtney Ryley. LIONS 'N TIGERS 'N EVERYTHING. Boston: Little, Brown & Co., 1924. 260 p., illus.

P582. Cooper, Courtney Ryley. UNDER THE BIG TOP. Boston: Little, Brown & Co., 1923. 238 p., illus.

Cooper was a novelist who was engaged by Roland Butler, publicist for Ringling Brothers, to write human interest stories about the circus. These three volumes [P580, P581, P582] are the results of his endeavors in this field.

P583. Coup, W. C. SAWDUST AND SPANGLES: STORIES AND SECRETS OF THE CIRCUS. Chicago: Herbert S. Stone & Co., 1901. 262 p., illus.

This book was made up from odd notes dictated by W. C. Coup, who had his own circus. Includes biographical sketch.

P584. Coup, W. C. HISTORY OF THE CAPTURE, TRANSPORTATION AND ARRIVAL OF THE WHITE WHALE AT THE NEW YORK AQUARIUM. New York: New York Aquarium, 1876. 13 p., illus.

A characteristic brochure of the nineteenth century.

P585. Dannett, Sylvia G. L. THE YANKEE DOODLER. New York: A. S. Barnes, 1937. 320 p., illus.

An anthology of both humor and the arts in America during the Revolutionary War years.

P586. Deford, Frank. THERE SHE IS, THE LIFE AND TIMES OF MISS AMERICA. New York: Viking Press, 1971. illus.

The Miss America pageant in Atlantic City dates from 1921. This is a history of the annual ceremonies. Index.

P587. DiMeglio, John E. VAUDEVILLE, U.S.A. Bowling Green, Ohio: Bowling Green University Popular Press, 1973. 259 p., illus.

The author came from a vaudeville family. Through research, tape recordings of conversations with vaudevillians, and recollections of others, he has compiled this story of vaudeville in the United States in the twentieth century. Notes; bibliography; index.

P588. Disher, Maurice Willson. CLOWNS AND PANTOMIMES. Boston: Houghton, Mifflin Co., 1925. 344 p., illus.

The author presents a study of the great clowns through the ages—real and fanciful. Index.

P589. Durant, John, and Durant, Alice K. PICTORIAL HISTORY OF THE AMERICAN CIRCUS. New York: A. S. Barnes, 1957. 328 p., illus.

A pictorial presentation of all aspects of circus life which traces the American style from its European roots.

P590. Gardener, Richard M. YOUR BACKYARD CIRCUS. New York: John Day Co., 1959. 128 p., illus.

Tips for the amateur circus entrepreneur. Index.

P591. Golden, George Fuller. MY LADY VAUDEVILLE AND HER WHITE RATS. New York: White Rats of America, 1909. 199 p.

In 1900, George Fuller Golden founded the White Rats, an organization of vaudeville artists. "Rats" is "star" spelled backwards. The organization lasted until 1934 against strong opposition from the agents and managers and the National Vaudeville Artists, which was organized by Edward F. Albee. This is a history of the early years of the White Rats. Appendix includes photographs and testimonials.

P592. Graham, Philip. SHOWBOATS: THE HISTORY OF AN AMERICAN INSTITUTION. Austin: University of Texas, 1951. 224 p., illus.

To many Americans in the nineteenth century, the show boat was the only form of theater known. Bibliography; index.

P593. Green, Abel, ed. THE SPICE OF VARIETY. New York: H. Holt, 1952. 277 p.

Variety is known as the "Bible of show biz." Abel Green,

who edited the newspaper from 1933 until his death in 1973, has selected his favorite pieces from the journal. All phases of show business are represented.

P594. **Green, Abel, and Laurie, Joe, Jr.** SHOW BIZ, FROM VAUDE TO VIDEO. New York: Holt, 1951. 613 p.

A history of vaudeville in the United States from the turn of the century until midcentury when the movies, radio, and, finally television, all but dealt the form a death blow. Glossary; index.

P595. **Greenwood, Isaac J.** THE CIRCUS: ITS ORIGIN AND GROWTH PRIOR TO 1835. New York: Dunlap Society, 1898. 117 p., illus.

A history of the early circuses in the colonies and in the young United States: Astley's, the Franconi family, Ricketts' Circus, and Dan Rise.

P596. **Hacker, Fred A., and Eames, Prescott W.** HOW TO PUT ON AN AMATEUR CIRCUS. Chicago: T. S. Denison, 1923. 112 p., illus.

This volume instructs the young how to stage backyard circuses.

P597. **Hagenbeck, Carl.** BEASTS AND MEN; BEING CARL HAGENBECK'S EXPERIENCES FOR HALF A CENTURY AMONG WILD ANIMALS. TRANSLATED BY HUGH S. R. ELLIOT AND A. G. THACKER. London: Longmans, Green, 1909, illus.

The reminiscences of one of the great animal trainers who worked both in Europe and the United States. Index.

P598. **Hamid, George A., and Hamid, George A., Jr.** CIRCUS. New York: Sterling Publishing Co., 1950. 253 p., illus.

The senior Hamid immigrated to the United States from Lebanon and became one of the outstanding producers of circuses and outdoor entertainment.

P599. **Hoyt, Harlowe B.** TOWN HALL TONIGHT. Englewood Cliffs, N.J.: Prentice-Hall, 1955. 292 p., illus.

The history of repertory companies which toured around the United States with plays like *East Lynne* and *Ten Nights in a Barroom*.

P600. **Hugget, Richard.** SUPERNATURAL ON STAGE: GHOSTS AND SUPERSTITIONS OF THE THEATRE. New York: Taplinger Publishing Co., 1975. 215 p., illus.

Theater people are ridden with superstitions, perhaps because they are often asked to appear "larger than life." This book deals with superstitions, general fears, as well as ill-luck attending productons like *Macbeth*.

P601. **Jennings, John Joseph.** THEATRICAL AND CIRCUS LIFE; OR, SECRETS OF THE STAGE, GREEN-ROOM AND SAWDUST ARENA. Saint Louis: M. S. Barnett, 1882. 608 p., illus.

A volume of historical interest.

P602. **Keegan, Marcia.** WE CAN STILL HEAR THEM CLAPPING. New York: Avon Books, 1975. 159 p., illus.

A study of the vicissitudes of the old vaudevillians who still reside in the Times Square area.

P603. **Laurie, Joe, Jr.** VAUDEVILLE: FROM THE HONKY-TONKS TO THE PALACE. New York: H. Holt, 1953. 561 p.

A history of American vaudeville by one who spent years working in the field. Foreword by Gene Fowler. Index.

P604. **McCarthy, Myles.** THE ADVANCE AGENT: FIRST EXPERIENCE AHEAD OF A SHOW TOLD IN AMUSING ANECDOTE AND YARN. New York: Excelsior Publishing House, 1908. 92 p., illus.

A chatty reminiscence of the days when an advance agent really "hit the road" and didn't fly from town to town. Drawings by J. H. Appleton.

P605. **McNeal, Violet.** FOUR WHITE HORSES AND A BRASS BAND. Garden City, N.Y.: Doubleday, 1947. 267 p.

An autobiographical volume about being a member of a troupe of a medicine show in the early years of the twentieth century.

P606. **Marks, Edward B., and Liebling, Abbott J.** THEY ALL SANG; FROM TONY PASTOR TO RUDY VALLÉE. New York: Viking Press, 1935. 321 p., illus.

Marks was a music publisher. This history focuses on the songs America sang in the nineteenth and twentieth centuries and of the influence of the variety stage which popularized them. The appendixes list songs, variety and minstrel performers, and the locales of the entertainments. Index.

P607. **Millette, Ernest, and Wyndham, Robert.** THE CIRCUS THAT WAS: THE AUTOBIOGRAPHY OF A STAR PERFORMER. Philadelphia: Dorrance & Co., 1971. 180 p., illus.

The Millette Brothers were an acrobatic troupe with Ringling Brothers and with other circuses. Ernest Schlee Millette was elected to the Circus Hall of Fame in 1968.

P608. **Mitchell, Loften.** VOICES OF THE BLACK THEATRE. Clifton, N.J.: James T. White & Co., 1975. 238 p., illus. [*See* P364a.]

P609. **Murray, Marian.** CIRCUS!: FROM ROME TO RINGLING. New York: Appleton-Century-Crofts, 1956. 354 p., illus.

A historical survey, this volume covers both the entertainers as well as the circus itself. Glossary.

P610. **North, Henry Ringling, and Hatch, Alden.** THE CIRCUS KINGS: OUR RINGLING FAMILY STORY. Garden City, N.Y.: Doubleday, 1960. 383 p., illus.

The "family" means the seven Ringling brothers, and the "kings" implies the eminent position at the top of their field and their lavish life style.

P611. **Russell, Don.** THE WILD WEST: A HISTORY OF THE WILD WEST SHOWS. Fort Worth: Amon Carter Museum of Western Art, 1970. 150 p., illus.

Perhaps the most American of all entertainment forms, the Wild West show has traveled all over the world. It now appears as integral parts of musicals, films, and circuses. Index.

P612. **Ryan, Pat M.** WILD APACHES IN THE EFFETE EAST: A THEATRICAL ADVENTURE OF JOHN P. CLUM. Theatre Survey 6 (Nov. 1965): 147–156.

An account of an 1876 tour by a "Wild Apache" troupe doing Indian dances and drama. *Theatre Survey* is published by the University of Pittsburgh Press. Notes.

P613. **Slout, William Lawrence.** THEATRE IN A TENT. Bowling Green, Ohio: Bowling Green University. Popular Press, 1972. 153 p., illus.

A history of the tent show in the United States from the latter part of the nineteenth century. Bibliography; index.

P614. **Sobel, Bernard.** A PICTORIAL HISTORY OF VAUDEVILLE. New York: Citadel Press, 1961. 224 p., illus.

Vaudeville in America from the minstrel shows to the major circuits. Index to more than 400 reproductions. Foreword by George Jessel.

P615. **Taylor, Laurette.** THE GREATEST OF THESE: A DIARY WITH PORTRAITS OF THE PATRIOTIC ALL-STAR TOUR OF OUT THERE. New York: Doran, 1918. 61 p., illus.

A day-by-day account of a fund-raising tour during World War I. In addition to Miss Taylor, the company included George Arliss, Helen Ware, George M. Cohan, Julia Arthur, Chauncey Olcott, James T. Powers, James K. Hackett, and Beryl Mercer.

P616. **Vail, Robert William G.** RANDOM NOTES ON THE HISTORY OF THE EARLY AMERICAN CIRCUS. Worcester, Mass.: American Antiquarian Society, 1934. 75 p.

Notes compiled for a history of the American circus, 1720–1825.

P617. **Vaughan, L. F.** VAUGHAN'S PARADE AND FLOAT GUIDE. Minneapolis: T. S. Denison, 1956. 162 p., illus.

A "how-to" guide for a successful parade—an honored American institution. Foreword by E. E. Seiler.

P618. **Webber, Malcolm.** MEDICINE SHOW. Caldwell, Ida.: Caxton Printers, 1941. 265 p., illus.

For many in rural nineteenth century America, the medicine show was the only regular entertainment from outside the community.

P619. **Wheaton, Rosanna (Ann Williams).** WE OPENED IN ONE: RECOLLECTIONS OF VAUDEVILLE, 1929–30. Hingham, Mass., James W. Wheaton, 1970. 71 p., illus.

Recollections of a tour with the Happiness Girls just before the end of vaudeville's days of glory in the United States.

P620. **Young, Miriam.** MOTHER WORE TIGHTS. New York: Whittlesey House, 1944. 255 p., illus.

Miriam Young's parents were Mr. and Mrs. Frank Burt (1860–1924). This is the story of their days in vaudeville and burlesque told in semifictional style.

P621. **Young, Perry.** THE MISTICK KREWE: CHRONICLES OF COMUS AND HIS KIN. New Orleans: Carnival Press, 1931. 268 p., illus.

A history of the carnival, which focuses on the New Orleans Mardi Gras—its composition, activity and transformation since the eighteenth century.

THEATER ARCHIVES

In this section are catalogs and guides to American theater collections and their holdings.

P622. Boston. **Boston Public Library.** A CATALOGUE OF THE ALLEN A. BROWN COLLECTION OF BOOKS RELATING TO THE STAGE IN THE PUBLIC LIBRARY OF THE CITY OF BOSTON. Boston, 1919. 952 p.

An annotated catalogue of about 3500 titles related to both drama and stage assembled by Brown (1835–1916).

P623. **Freedley, George.** THE TWENTY-SIX PRINCIPAL THEATRE COLLECTION IN AMERICAN LIBRARIES AND MUSEUMS. The New York Public Library, *Bulletin.* 62 (July 1958): 319–29.

[*See* P636.]

P624. **Gamble, William Burt, comp.** THE DEVELOPMENT OF SCENIC ART AND STAGE MACHINERY: A LIST OF REFERENCES IN THE NEW YORK PUBLIC LIBRARY. New York: New York Public Library, 1928. 231 p.

An annotated listing of material on stage techniques—American and foreign. Indexes. EARLIER EDITIONS: *Stage Scenery; A List of References to Illustrated Material since 1900 in The New York Public Library.* (New York: New York Public Library, 1917); *The Development of Scenic Art and Stage Machinery; A List of References in The New York Public Library* (New York: New York Public Library, 1920).

P625. **Gilder, Rosamond, and Freedley, George.** THEATRE COLLECTIONS IN LIBRARIES AND MUSEUMS: AN INTERNATIONAL HANDBOOK. New York: Theatre Arts Books, 1936. 182 p.

A guide to the holdings of theater collections, worldwide. Rosamond Gilder describes the collections in the United States, Canada, Mexico, and South America; George Freedley focuses on the European and Asian collections. The volume also includes an essay by Mr. Freedley on the care and preservation of "fugitive material." Introduction by Rosamond Gilder. Bibliography; index.

P626. Cambridge. **Harvard University Theatre Collection.** CONCERNING THE THEATRE COLLECTION AT HARVARD COLLEGE LIBRARY, ITS EARLY BEGINNING AND GROWTH. Cambridge, Mass. 1930. 7 p., frontispiece.

The Harvard Theatre Collection dates from 1903. It began as a gift by John Drew of the theater library of Robert W. Lowe, the English critic and collector.

P627. Paris. **Hiler Costume Library.** CATALOGUE OF THE HILER COSTUME LIBRARY. Paris, 1928. 70 p.

Since publication of this catalog, the collection has been acquired by the Queens Borough Public Library, New York City.

P628. **Hisz, Evelyn.** HISTORY OF THE THEATRE COLLECTION, NEW YORK PUBLIC LIBRARY AT LINCOLN CENTER. M.A. thesis, Long Island University, Graduate Library School, 1969.

The thesis focuses on the Theatre Collection of The New York Public Library, following its move to Lincoln Center. It describes the major elements of this vast collection. Notes.

P629. **Hunter, Jack W.** THE OHIO STATE UNIVERSITY THEATRE COLLECTION HANDBOOK. Columbus, Ohio: Ohio State University, 1959. 53 p.

This is a study of the classification system employed by the Theatre Collection of Ohio State University which was established in 1950. Preface by John H. McDowell.

P630. **Kauser, Alice.** INDEX OF CLIPPINGS IN THE KAUSER COLLECTION. New York: New York Public Library, 1940. 3 vols.

An index, to clippings and reviews of twentieth-century American theater, which is part of the Theatre Collection of The New York Public Library.

P631. **Melling, John Kennedy.** DISCOVERING THEATRE EPHEMERA. Aylesbury, England: Shire Publications, 1974. 56 p., illus.

A slim but useful volume for collectors of material about the theatre. The author talks about the different forms of material—programs, photographs, tickets, designs—and gives a brief history of collecting in each area. Foreword by John Reed. Index.

P632. **National Theatre Conference, Library Committee.** PRELIMINARY REPORT ON THEATRE BOOKS AND THEATRE COLLECTIONS IN PUBLIC, PRIVATE AND UNIVERSITY LIBRARIES IN THE UNITED STATES: AN INQUIRY INTO THEIR USES AND POSSIBLE DEVELOPMENTS. 1934. 22 p.

The committee (Rosamond Gilder, chairman, Franklin F. Hopper, and Edith J. R. Isaacs) surveyed some 1,200 American collections as a follow-up to an earlier National Theatre Conference study of the nonprofessional theater in the United States.

P633. **The Players.** THE PICTURES AND RELICS OF THE PLAYERS. New York: The Players, 1907. 32 p.
Collection catalog.

A catalog of the treasures housed at The Players Club, New York City.

P634. **Triesch, Manfred, comp.** THE LILLIAN HELLMAN COLLECTION AT THE UNIVERSITY OF TEXAS. Austin: University of Texas, 1966. 167 p., illus. Appendix; index.

An annotated volume describing materials relating to Lillian Hellman in the University library. Appendix; index.

P635. **Van Tiem, John E.** THE THEATRE COLLECTION OF THE NEW YORK PUBLIC LIBRARY. M.S. thesis, Cleveland, Western Reserve University, School of Library Science, 1957. 57 p.

P636. **Veinstein, André.** PERFORMING ARTS LIBRARIES AND MUSEUMS OF THE WORLD. Paris: Editions du Centre de la Recherche Scientifique, 1967. 801 p.

An international guide (in English and in French) to the holdings of performing arts archives. The alphabetization of the volume is French. Preface by Julien Cain and André Veinstein. Index. [*See* P623 for Freedley's work on American libraries.]

P637. **Young, William C.** AMERICAN THEATRICAL ARTS: A GUIDE TO THE MANUSCRIPTS AND SPECIAL COLLECTIONS IN THE UNITED STATES AND CANADA. Chicago: American Library Association, 1971. 166 p.

A guide which lists manuscript holdings of 138 collections. Indexes.

THEATER ASSOCIATIONS AND ORGANIZATIONS

These volumes deal with the history and functions of theater organizations in the United States.

P638. **Balio, Tino, and Norvelle, Lee.** THE HISTORY OF THE NATIONAL THEATRE CONFERENCE. New York: National Theatre Conference, 1968. 119 p.

The National Theatre Conference is an organization of leaders in the field of nonprofit theater. The organization began in 1925 and continues to meet, to publish, and to serve the community, college, and university theater. Bibliography.

P639. **Brown, Kenneth H.** THE BRIG: A CONCEPT FOR THEATRE OR FILM, WITH AN ESSAY ON THE LIVING THEATRE BY JULIAN BECK AND DIRECTOR'S NOTES BY JUDITH MALINA. New York: Hill and Wang, 1965. 107 p. Plans.

This book discusses the Living Theatre whose place in the annals of avant-garde theater is assured by productions such as *The Brig*. Julian Beck's essay focuses on the history of this internationally known group.

P640. **Carson, Julia Margaret.** HOME AWAY FROM HOME: THE STORY OF THE UNITED SERVICE ORGANIZATION. New York and London: Harper & Bros., 1946. 221 p., illus.

The United Service Organization brought theater to the troops during World War II. It deployed companies on a far-flung basis and reached thousands on posts and in the fields.

P641. **Clurman, Harold.** THE FERVENT YEARS: THE STORY OF THE GROUP THEATRE AND THE 1930s. New York: Alfred A. Knopf, 1945. 306 p., illus.

The Group Theatre played a vital role in the American theater. It evolved from a studio production of the Theatre Guild in 1929 and was disbanded in 1941. Index.

P642. **Deutsch, Helen, and Hanau, Stella.** THE PROVINCETOWN: A STORY OF THE THEATRE. New York: Farrar & Rinehart, 1931. 313 p., illus.

The history of the great years of the Provincetown Playhouse—on Cape Cod and in New York—which ended "when Jig Cook went to Greece and Eugene O'Neill went to Broadway and the world." The appendixes include the casts of productions, 1915–1929, an essay by O'Neill on "Strindberg and our theatre," and another essay by Susan Glaspell on George Cram Cook.

P643. **Eaton, Walter Prichard.** THE THEATRE GUILD: THE FIRST TEN YEARS. New York: Brentano's, 1929. 299 p., illus.

An early history of the pioneering producing group with articles by the directors. The book contains casts and credits for all the productions of the Theatre Guild's first decade. [*See* P655.]

P644. **Eaton, Walter Prichard.** AT THE NEW THEATRE AND OTHERS: THE AMERICAN STAGE, ITS PROBLEMS AND PERFORMANCES, 1908–1910. Boston: Small, Maynard & Co., 1910. 359 p.

The New Theatre was a notable attempt to establish a first-class permanent theater in New York. This book of articles discusses that effort.

P645. **Faust, Richard, and Kadushin, Charles.** SHAKESPEARE IN THE NEIGHBORHOOD. New York: Twentieth Century Fund, 1965. 73 p.

A study of the audience reaction to Joseph Papp's production of a *Midsummer Night's Dream,* as produced for the New York Shakespeare Festival Mobile Theatre. Foreword by August Heckscher.

P646. **Henderson, Archibald, ed.** PIONEERING A PEOPLE'S THEATRE. Chapel Hill: University of North Carolina Press, 1945. 104 p.

A history of the Carolina Haymakers (1918–1944) with a list of productions, season by season, as well as a list of publications of the plays. The volume includes articles by Frederick H. Koch, Paul Green, Samuel Selden, and others. Bibliography. [*See* P402.]

P647. **Horner, Charles F.** STRIKE THE TENTS: THE STORY OF THE CHAUTAUQUA. Philadelphia: Dorrance & Co., 1954. 204 p.

For many in rural America in the late nineteenth and early twentieth centuries, the Chautauqua was the only entertainment. It combined theater and music with educational and current events programs. In addition, it brought together such disparate figures as William Jennings Bryan and Mark Twain.

P648. **Houghton, Norris.** BUT NOT FORGOTTEN: THE ADVENTURE OF THE UNIVERSITY PLAYERS. New York: William Sloane Associates, 1952. 346 p.

The history of the University Players, at Falmouth on Cape Cod in the 1930s. Out of this company came Josh Logan, Henry Fonda, Margaret Sullavan, and Myron McCormick.

P649. **Houseman, John, and Landau, Jack.** THE AMERICAN SHAKESPEARE FESTIVAL: THE BIRTH OF A THEATRE. New York: Simon & Schuster, 1959. 96 p., illus.

A history of the American Shakespeare Theatre, Stratford, Conn., 1955–1959. Includes casts of productions.

P650. **Loney, Glen, and MacKay, Patricia.** THE SHAKESPEARE COMPLEX: A GUIDE TO SUMMER FESTIVALS AND YEAR-ROUND REPERTORY IN NORTH AMERICA. New York: Drama Book Specialists, 1975. 182 p., illus.

A handsomely illustrated guide to both the American and Canadian Shakespeare festivals and to the many colleges and universities which have Shakespeare production seasons.

P651. **Neff, Renfreu.** THE LIVING THEATRE: U.S.A. Indianapolis: Bobbs-Merrill, 1970. 253 p., illus.

A history of this avant-garde New York-based theater organization with special emphasis on its international renown. Includes itinerary for Sept. 1968–Mar. 1969. Bibliography; index.

P652. **Pasolli, Robert.** A BOOK ON THE OPEN THEATRE. Indianapolis: Bobbs-Merrill, 1970. 127 p., illus.

A study of the Open Theatre—the theater group organized by Joseph Chaikin as a result of his work with the Living Theatre.

P653. **Porter, Jack.** A HISTORY OF THE PHOENIX THEATRE, NEW YORK CITY, 1953 TO 1961. Ann Arbor: University Microfilms, 1963. 213 p.

The text of a doctoral dissertation done at the University of Denver on the founding of the Phoenix Theatre and its first eight seasons. List of plays; bibliography.

P654. **Schechner, Richard.** ENVIRONMENTAL THEATER. New York: Hawthorn Books, 1973. 339 p., illus.

This is a study of the Performance Group from its founding in 1967, and of their productions like *Macbeth, Dionysus in '69,* and *Commune.*

P655. **Theatre Guild.** THE HISTORY OF THE THEATRE GUILD: THE FIRST NINETEEN YEARS, 1919-1937. New York: Theatre Guild, 1937. 51 p., illus.

An up-dating of the Eaton book [*see* P643].

P656. **Waldau, Roy. S.** VINTAGE YEARS OF THE THEATRE GUILD, 1928-1939. Cleveland: Press of Case Western Reserve University, 1972. 519 p.

In its prime the Theatre Guild made history with its productions of Shaw, O'Neill, and others. This is a penetrating look at its most active decade. Preface by Fred B. Millet. Lists of plays and casts; bibliography.

ACTING AND ACTING TECHNIQUE

P657. **Alberti, Eva.** A HANDBOOK OF ACTING BASED ON THE NEW PANTOMIME. New York: Samuel French, 1932. 205 p.

A primer of acting technique with two pantomime texts by Alberti.

P658. **Albright, Harry Darkes; Halstead, William P.; and Mitchell, Lee.** PRINCIPLES OF THEATRE ART. Boston: Houghton Mifflin Co., 1955. 547 p., illus.

A volume designed to be used as text in a beginning course in dramatic art. Index.

P659. **Boleslavsky, Richard.** ACTING, THE FIRST SIX LESSONS. New York: Theatre Arts Books, 1933. 122 p.

Boleslavsky was a famous member of the well-known Moscow Art Theatre as well as its director. These essays deal with such aspects of acting as concentration, memory of emotion, and dramatic action.

P660. **Chekhov, Michael.** TO THE ACTOR: ON THE TECHNIQUES OF ACTING. New York: Harper & Bros., 1953. 201 p.

Preface by Yul Brynner. Drawings by Nicholas Remisoff.

P661. **Cohen, Robert.** ACTING PROFESSIONALLY: RAW FACTS ABOUT ACTING AND ACTING INDUSTRIES. Palo Alto, Calif.: National Press Books, 1972. 101 p.

A manual on how to get a job in the theater or in the movies. Introduction by Richard Quine.

P662. **Cole, Toby, and Chinoy, Helen Krich, eds.** ACTORS ON ACTING: THE THEORIES, TECHNIQUES, AND PRACTICES OF THE GREAT ACTORS OF ALL TIMES AS TOLD IN THEIR OWN WORDS. New York: Crown Publishers, 1970. 715 p.

From the Athens of Dionysos to the New York of Joseph Chaikin—articles by actors on their art. Bibliography; index. EARLIER EDITIONS (1949, 1954).

P663. **Cole, Toby, comp.** ACTING: A HANDBOOK OF THE STANISLAVSKY METHOD. New York: Crown Publishers, 1947. 223 p., illus.

A collection of essays by and about Konstantin Stanislavsky and the Moscow Art Theatre. There are also articles by Vakhtangov, Michael Chekhov, and Pudovkin. Introduction by Lee Strasberg. SECOND EDITION (1955).

P664. **Eustis, Morton.** PLAYERS AT WORK: ACTING ACCORDING TO THE ACTORS. New York: Theatre Arts Books 1937. 127 p., illus.

Talks with Helen Hayes, the Lunts, Nazimova, Katharine Cornell, Ina Claire, Burgess Meredith, and Fred Astaire about their conception of acting and theater. Includes an article on the singing actor by Lotte Lehmann.

P665. **Franklin, Miriam.** REHEARSAL: THE PRINCIPLES AND PRACTICE OF ACTING FOR THE STAGE. 3rd ed. New York: Prentice-Hall, 1950. 327 p., illus.

A book of acting exercises for students, amateurs, and directors, with token scenes from selected plays that serve as guides to the principles. Index.

P666. **Funke, Lewis, and Booth, John E., eds.** ACTORS TALK ABOUT ACTING—FOURTEEN INTERVIEWS WITH STARS OF THE THEATRE. New York: Random House, 1961. 469 p.

Interviews with a wide spectrum of actors: the Lunts, Paul Muni, John Gielgud, Sidney Poitier, and José Ferrer.

P667. **Goodman, Edward.** MAKE BELIEVE: THE ART OF ACTING. New York: Charles Scribner's Sons, 1956. 242 p., illus.

Edward Goodman turns his forty years' experience as a stage director into a guide to what the professional actor should know about his art. Foreword by Katharine Cornell. Index.

P668. **Irvine, Harry.** THE ACTOR'S ART AND JOB. New York: E. P. Dutton & Co., 1942. 251 p., frontispiece.

An analysis of acting by an actor, together with advice to the stage aspirant. Foreword by Dorothy Stickney and Howard Lindsay. Preface by Alice White.

P669. **McGaw, Charles J.** ACTING IS BELIEVING: A BASIC METHOD FOR BEGINNERS. New York: Rinehart, 1955. 177 p., illus.

A volume devoted to the training of the young actor. Foreword by Margo Jones. Bibliography; index.

P669a. **McGaw, Charles J.** ACTING IS BELIEVING: A BASIC METHOD. 2d ed. New York: Holt, Rinehart & Winston, 1962. 219 p., illus.

Foreword by Alan Schneider. Bibliography; index.

P670. **Selden, Samuel.** A PLAYER'S HANDBOOK: THE THEORY AND PRACTICE OF ACTING. New York: F. S. Crofts & Co., 1934. 252 p., illus.

A volume made up from notes taken during eleven years of production by the eminent teacher of stage techniques and history. Bibliography.

THEATER ARCHITECTURE

P671. Birkmire, William Harvey. THE PLANNING AND CONSTRUCTION OF AMERICAN THEATRES. New York: John Wiley & Sons, 1901. 117 p., illus.

P672. Burris-Meyer, Harold, and Cole, Edward C. THEATRES AND AUDITORIUMS. New York: Reinhold, 1949. 228 p., illus. PROGRESSIVE ARCHITECTURE LIBRARY.

How a theater functions—with detailed studies of different types of stages and auditoriums. Index.

P673. Gerhard, William Paul. THEATRES: THEIR SAFETY FROM FIRE AND PANIC, THEIR COMFORT AND HEALTHFULNESS. New York: The Baker & Taylor Co., 1915. 110 p.

This volume focuses on the prevention of theater fires as well as what should be done if a fire does occur. The author also discusses theater ventilation and sanitation. Index. ORIGINAL EDITION (Boston: Bates & Guild Co., 1900).

P674. McNamara, Brooks. THE AMERICAN PLAYHOUSE IN THE EIGHTEENTH CENTURY. Cambridge: Harvard University Press, 1969. 174 p., illus.

A study of the physical aspects of theaters in the United States beginning with the early Williamsburg, Virginia theater constructed in 1716. Notes; index.

P675. Silverman, Maxwell. CONTEMPORARY THEATRE ARCHITECTURE: AN ILLUSTRATED SURVEY. New York: New York Public Library, 1965. 80 p., illus.

Photographs, floor plans, elevations of fifty theaters in the United States and abroad—all of them post–World War II. Foreword by George Freedley.

P676. Tidworth, Simon. THEATRES: AN ARCHITECTURAL AND CULTURAL HISTORY. New York: Praeger Publishers, 1973. 224 p., illus.

A history of theater architecture from the Greeks to new theaters built in the United States since World War II. Bibliography; index.

MUSICAL THEATER

It has been said that America's single contribution to the theater has been the "musical." This is a field which continues to show vitality and in which some of our foremost stage artists are involved.

P677. Baral, Robert. REVUE: A NOSTALGIC REPRISE OF THE GREAT BROADWAY PERIOD. New York: Fleet Publishing Co., 1962. 288 p., illus.

It has been said that the revue is America's indigenous contribution to the theater. This is a history of the revue as musical entertainment. Abel Green, editor of *Variety*, has written an introduction.

P678. Ewen, David. NEW COMPLETE BOOK OF THE AMERICAN MUSICAL THEATRE. Rev. ed. New York: Holt, Rinehart & Winston, 1970. 800 p., illus.

Mr. Ewen gives production credits, history, and commentary from *The Black Crook* (1866) to *Minnie's Boys* (1970). The book is arranged by title of production. Chronology; list of musical comedy songs; index.

P679. Goldberg, Isaac. TIN PAN ALLEY: A CHRONICLE OF THE AMERICAN POPULAR MUSIC RACKET. New York: John Day Co., 1930. 341 p., illus.

Though a history of popular music, this volume also covers the American musical theater, minstrel shows, and vaudeville. Introduction by George Gershwin. Index.

P680. Green, Stanley. RING BELLS! SING SONGS!: BROADWAY MUSICALS OF THE 1930s. New Rochelle, N.Y.: Arlington House, 1971. 385 p., illus.

A wonderfully nostalgic look at the musicals of the 1930s with a re-creation of the highlights of many of the shows. Casts and credits of 175 productions (1930–1939) are included. Introduction by Brooks Atkinson. Index.

P681. Green, Stanley. THE WORLD OF MUSICAL COMEDY. Rev. and enl. ed. New York: Grosset & Dunlap, 1974. 556 p., illus.

A history of the musical comedy stage in America traced through the careers of its most significant composers and lyricists. A valuable reference guide. Appendix lists musical productions and includes a discography. Index. ORIGINAL EDITION (1960).

P682. Jay, Dave. THE IRVING BERLIN SONGOGRAPHY. Washington, D.C., Privately printed, 1967. 57 p., illus.

Detailed discussion of Berlin's songs from *Marie from Sunny Italy* (1907) to the music for *Mr. President* (1962).

P683. Laufe, Abe. BROADWAY'S GREATEST MUSICALS. New York: Funk & Wagnalls Co., 1969. 465 p.

Though this volume traces the history of the Broadway musical, there is a decided emphasis on the theater as business. Appendix of long-run musicals. Title and name index.

P684. Lewine, Richard, and Simon, Alfred. SONGS OF THE AMERICAN THEATER: A COMPREHENSIVE LISTING OF MORE THAN 12,000 SONGS, INCLUDING TITLES FROM FILM AND TELEVISION PRODUCTIONS. New York: Dodd, Mead, & Co., 1973. 820 p.

Indicates what show a song originated in as well as what songs are in a given musical. The authors provide both types of listings during the years 1925-1971. A chronological list of productions is also included. Introduction by Stephen Sondheim. Index.

P685. Marks, Edward B. THEY ALL HAD GLAMOUR: FROM THE SWEDISH NIGHTINGALE TO THE NAKED LADY. New York: Julian Messner, 1944. 448 p., illus.

Lists of songs and lyrics. Index. [*See also* P363.]

P686. **Mates, Julian.** THE AMERICAN MUSICAL STAGE BEFORE 1800. New Brunswick, N.J.: Rutgers University Press, 1962. 331 p., illus.

A study of the sources of the American musical and of the early examples of this form of stage production. Notes; bibliography; index.

P687. **Mattfeld, Julius.** VARIETY MUSIC CAVALCADE 1620–1961: A CHRONOLOGY OF VOCAL AND INSTRUMENTAL MUSIC POPULAR IN THE UNITED STATES. Rev. ed. New York: Prentice-Hall, 1962, 713 p.

Introduction by Abel Green. Index.

P688. **Samuels, Charles and Samuels, Louise.** ONCE UPON A STAGE: THE MERRY WORLD OF VAUDEVILLE. New York: Dodd, Mead & Co., 1974. 278 p., illus.

A story of the people who made up the flourishing world of American vaudeville in the early years of the twentieth century: the *producers* (Edward Franklin Albee, Benjamin Franklin Keith, and Frederick F. Proctor); the *stars* (Nora Bayes, Sophie Tucker, and Mae West); and the *comedians* (Jimmy Savo, Weber and Fields, and Bert Williams). Index.

REFERENCE WORKS, CRITICISM, AND SERIAL LITERATURE

Dramatic Criticism

P689. **Atkinson, Brooks.** BROADWAY SCRAPBOOK. New York: Theatre Arts Books, 1947. 312 p., illus.

A collection of the Sunday "think-pieces" by the former *New York Times* drama critic, from *The Petrified Forest* in 1935 to *Born Yesterday* in 1947. Includes a reprint of a 1938 piece "No Sunday Article." Hirschfeld's lively drawings animate the text. Index.

P690. **Bentley, Eric.** THE DRAMATIC EVENT: AN AMERICAN CHRONICLE. New York: Horizon Press, 1954. 278 p.

A collection of Bentley's drama reviews for *The New Republic* during the late 1940s and early 1950s. Index. [*See also* P312a.]

P691. **Bentley, Eric.** THE THEATRE OF COMMITMENT AND OTHER ESSAYS ON DRAMA IN OUR SOCIETY. London: Methuen & Co., 1954. 241 p.

Bentley's thoughts on various aspects of drama and theater, written primarily during the 1950s. Index. revised edition (1967).

P692. **Bentley, Eric.** IN SEARCH OF THEATRE. New York: Alfred A. Knopf, 1947. 385 p.

The gospel according to Bentley—his thoughts on theater, drama, and what is worthwhile in both. Index.

P693. **Blau, Herbert.** THE IMPOSSIBLE THEATRE: A MANIFESTO. New York: Macmillan Co., 309 p., illus.

P694. **Brown, John Mason.** DRAMATIS PERSONAE: A RETROSPECTIVE SHOW. New York: Viking Press, 1963. 563 p.

Selections from Brown's writings, with an emphasis on Eugene O'Neill and Bernard Shaw. Includes his "Modern Theatre in Revolt," which had previously been out of print. [*See* P697.]

P695. [Deleted.]

P696. **Brown, John Mason.** BROADWAY IN REVIEW. New York: W. W. Norton & Co., 1940. 295 p.

The word CATALOG in the heading of an entry refers to the exhibition catalog as a whole and not to the catalog list, checklist, or catalog section of the work.

A collection of Brown's theater reviews, written primarily during the 1930s.

P697. **Brown, John Mason.** THE MODERN THEATRE IN REVOLT. New York: W. W. Norton & Co., 1929. 89 p.

Brown's appraisal of the American theater at the end of the 1920s. Bibliography. [*See* P694.]

P698. **Brown, John Mason.** TWO ON THE AISLE. New York: W. W. Norton & Co., 1938. 321 p.

Brown's theater reviews of the 1930s. Index.

P699. **Brown, John Mason.** UPSTAGE: THE AMERICAN THEATRE IN PERFORMANCE. New York: W. W. Norton & Co., 1930. 275 p.

The state of American theater at the start of the third decade of the twentieth century.

P700. **Clurman, Harold.** LIES LIKE TRUTH. New York: Macmillan Co., 1958. 300 p.

A collection of Clurman's theater reviews and essays. Index.

P701. **Clurman, Harold.** THE NAKED IMAGE: OBSERVATIONS ON THE MODERN THEATRE. New York: Macmillan Co., 1966. 312 p.

Clurman's essays taken from *The Nation, New Republic,* and *Partisan Review.* Index.

P702. **Dickinson, Thomas Herbert.** THE CASE OF AMERICAN DRAMA. Boston: Houghton, Mifflin Co., 1915. 223 p.

P703. **Downer, Alan S.** THE AMERICAN THEATER TODAY. New York: Basic Books, 1967. 212 p.

P704. **Eaton, Walter Prichard.** PLAYS AND PLAYERS: LEAVES FROM A CRITIC'S SCRAPBOOK. Cincinnati: Stuart & Kidd, 1916. 424 p., illus.

A collection of Eaton's reviews, 1910–1916. Preface by Barrett H. Clark. Index.

P705. **Gassner, John.** THE THEATRE IN OUR TIMES. New York: Crown Publishers, 1934, 609 p.

A study of the theater in America, 1900–1950, largely based upon John Gassner's years as teacher, playgoer,

and critic. Included is a section on the American film at mid-century. Index. REVISED EDITION (1955).

P706. Gilman, Richard. COMMON AND UNCOMMON MASKS: WRITING ON THEATRE 1961–1970. New York: Random House, 1971. 321 p.

A collection of Gilman's critical essays on the theater of the 1960s. Index.

P707. Gottfried, Martin. A THEATER DIVIDED: THE POSTWAR AMERICAN STAGE. Boston: Little, Brown & Co., 1967. 330 p.

A collection of reviews concerning the American theater. Covers the period between the end of World War II and the 1960s. Index.

P708. Gottfried, Martin. OPENING NIGHTS: THEATER CRITICISM OF THE SIXTIES. New York: G. P. Putnam's Sons, 1969. 384 p.

P709. Hamilton, Clayton. THE THEORY OF THE THEATRE—AND OTHER PRINCIPLES OF DRAMATIC CRITICISM. New York: H. Holt & Co., 1913. 248 p.

An analysis of what makes a play as well as a delineation of the function of the dramatist and actor, by a long-term teacher and critic of the American theater. Index.

P710. Hammond, Percy. THIS ATOM IN THE AU-DIENCE—A DIGEST OF REVIEWS AND COMMENT. New York: John C. Hammond, 1940. 275 p.

A collection of reviews (1909–1933) and essays on the theater by this critic who wrote for the *Chicago Tribune* and the *New York Herald Tribune.* Foreword by John C. Hammond.

P711. Hapgood, Norman. THE STAGE IN AMERICA, 1897–1900. New York: Macmillan Co., 1901. 408 p.

A collection of essays about theatergoing in America, some of which appeared originally in *Bookman, Atlantic Monthly,* and *Forum.* Index.

P712. Henderson, Archibald. THE CHANGING DRAMA: CONTRIBUTIONS AND TENDENCIES. New York: H. Holt, 1914. 321 p.

A study of the drama in the United States and abroad from about 1830 to 1910. Index.

P713. Hopkins, Arthur. REFERENCE POINT. New York: Samuel French, 1948. 135 p.

A series of papers on creativity with a "special reference to creative ways in the theatre." Presented in 1947 at Fordham University.

P714. Kerr, Walter. PIECES AT EIGHT. New York: Simon & Schuster, 1957. 244 p.

Reviews by a perceptive critic and influential journalist.

P715. Kerr, Walter. GOD ON THE GYMNASIUM FLOOR AND OTHER THEATRICAL ADVENTURES. New York: Simon & Schuster, 1971. 320 p.

A collection of Walter Kerr's essays on the theater of the late 1960s—some of them are reprints of articles from the *New York Times, Harper's Magazine,* and the *Saturday Review.* Index.

P716. Lahr, John. ASTONISH ME: ADVENTURES IN CON-TEMPORARY THEATER. New York: Viking Press, 1973. 272 p., illus.

Essays on some of the theater events that have seemed particularly noteworthy to Lahr. Notes; index.

P717. Lewis, Allan. AMERICAN PLAYS AND PLAY-WRIGHTS OF THE CONTEMPORARY THEATRE. New York: Crown Publishers, 1965. 272 p.

An outgrowth of a series of lectures at the New School for Social Research. In these essays, Lewis discusses the plays of Arthur Miller, Tennessee Williams, Edward Albee and other American dramatists of the second quarter of the twentieth century. Index.

P718. Lewis, Emory. STAGES: THE FIFTY-YEAR CHILD-HOOD OF THE AMERICAN THEATRE. Englewood Cliffs, N.J.: Prentice-Hall, 1969. 290 p.

A study of the American theater, 1915–1965. Index.

P719. Moses, Montrose J., and Brown, John Mason, eds. THE AMERICAN THEATRE AS SEEN BY ITS CRITICS, 1752–1934. New York: W. W. Norton & Co., 391 p.

A collection of reviews of American theater productions: from *An Evening at the John Street Theatre* (review signed by "Criticus," New York, 1787) to John Anderson's review of Eugene O'Neill's *Days Without End.* Included are reviews of Edgar Allan Poe, Walt Whitman, Henry James, and Washington Irving along with the better-known names of recent dramatic criticism like Brooks Atkinson, Alexander Woollcott, and Joseph Wood Krutch. The volume appeared just after Montrose Moses's death and is dedicated to him. Chronological index; biographical sketches.

P720. Nathan, George Jean. ENCYCLOPEDIA OF THE THEATRE. New York: Alfred A. Knopf, 1940. 449 p.

A series of essays arranged in dictionary format on a wide variety of subjects of interest to Nathan and theater scholars. Includes entries like "Abacus Britannicus" about contemporary English polite comedy and "Zapfenstrich" on why Nathan resigned from the New York Drama Critics' Circle.

P721. Oppenheimer, George, ed. THE PASSIONATE PLAYGOER: A PERSONAL SCRAPBOOK. New York: Viking Press, 1958. 623 p., illus.

A collection of Oppenheimer's favorite pieces on the theater—reviews, essays, sketches—things Oppenheimer cut out and pasted in his scrapbook of writings on the American theater. Index.

P722. Phelps, William Lyon. THE TWENTIETH CENTURY THEATRE: OBSERVATIONS ON THE CONTEMPORARY ENGLISH AND AMERICAN STAGE. New York: Mac-millan Co., 1918. 147 p. [*cont.*]

Phelps was one of America's most popular lecturers on theater and literature for many years. This is a collection of his essays on the American theater, 1900–1918. Index.

P723. **Pollock, Channing.** THE FOOTLIGHTS FORE AND AFT. Boston: Richard G. Badger; Gorham Press, 1911. 436 p.

Best known as a playwright, Pollock was also an essayist and lecturer. This is a collection of his essays on the theater which appeared in various periodicals in the first decade of the twentieth century. Illustrated by Warren Rockwell.

P724. **Priestly, J. B.** THE ART OF THE DRAMATIST: A LECTURE TOGETHER WITH APPENDICES AND DISCURSIVE NOTES. Boston: The Writer, 1957. 91 p.

The prolific British dramatist's theories of dramatic technique. Evolved from a lecture in 1956 to the members of the Vic-Wells Association.

P725. **Raphaelson, Samson.** THE HUMAN NATURE OF PLAYWRITING. New York: Macmillan Co., 1949. 267 p.

A book which grew out of a course at the University of Illinois in 1948 by the author of *Skylark, The Jazz Singer,* and *Hilda Crane.*

P726. **Rowe, Kenneth Thorpe.** WRITE THAT PLAY. New York: Funk & Wagnalls Co., 1939. 418 p.

Rowe, who is a professor of playwriting at the University of Michigan and head of the play department of the Theatre Guild, wrote this guide on crafting a play. Includes chapter analyses.

P727. **Rowe, Kenneth Thorpe.** A THEATER IN YOUR HEAD. New York: Funk & Wagnalls Co., 1960. 438 p., illus.

An analysis of the form of the play with a view toward production. Excerpts from Gielgud's prompt book for *The Lady's Not for Burning* and Elia Kazan's promptbook for *Death of a Salesman* are used to illuminate Rowe's text. Index.

P728. **Ruhl, Arthur.** SECOND NIGHTS: PEOPLE AND IDEAS OF THE THEATRE TODAY. New York: Charles Scribner's Sons, 1914. 374 p.

A collection of the reviews of Ruhl, 1905–1914.

P729. **Taylor, Jo Beth Boyd.** NEW YORK DRAMA CRITICS' CIRCLE: ITS ACTIVITIES, PROCEDURES, AND ACHIEVEMENT. Ph.D. thesis, East Texas State University, 1968. 418 p.

A history of the Drama Critics' Circle as well as an account of their activities.

P730. **Van Druten, John.** PLAYWRIGHT AT WORK. New York: Harper & Bros., 1953. 210 p., frontispiece.

The author of *Young Woodley, I Remember Mama, The Voice of the Turtle,* and *Bell, Book and Candle* discusses playwriting as a craft. Index.

P731. **Wilde, Percival.** THE CRAFTSMANSHIP OF THE ONE-ACT PLAY. Boston: Little, Brown & Co., 1923. 396 p.

Wilde was a prolific author of one-act plays. Index.

P732. **Willeford, William.** THE FOOL AND HIS SCEPTER: A STUDY IN CLOWNS AND JESTERS AND THEIR AUDIENCE. Chicago: Northwestern University Press, 1969. 265 p., illus.

A study of the clown and jester from the Middle Ages to Chaplin and Keaton. Preface by Enid Welsford. Notes; index.

P733. **Woollcott, Alexander.** ENCHANTED AISLES. New York: G. P. Putnam's Sons, 1924. 260 p.

A collection of essays about the theater and some of its artists like the Duse, Bernhardt, and Mrs. Fiske. Most entertaining is an article predicting the shape of the theater in 1944 which was inspired by a reading of Kenneth MacGowan's *The Theatre of Tomorrow.*

P734. **Woollcott, Alexander.** GOING TO PIECES. New York: G. P. Putnam's Sons, 1928. 256 p.

A second collection of dramatic essays by Woollcott.

P735. **Yurka, Blanche.** DEAR AUDIENCE: A GUIDE TO THE ENJOYMENT OF THE THEATRE. Englewood Cliffs, N.J.: Prentice-Hall, 1959. 167 p., illus.

An attempt by one of America's great actresses to share her enjoyment of theater with others. Drawings by Rafaello Busoni. Bibliography; index.

Bibliographies and Catalogs

This section includes bibliographies of the American theater as well as catalogs of publishing houses and theater archives that have research value.

P736. New York. **American Play Co.** AMERICAN PLAY COMPANY CATALOGUE. 3d ed. New York, 1914. 330 p.

Plays and original casts of more than 300 plays then under lease to them. Index.

P737. **Baker, Blanche M., comp.** DRAMATIC BIBLIOGRAPHY: AN ANNOTATED LIST OF BOOKS ON THE HISTORY AND CRAFT OF THE DRAMA AND STAGE AND ON THE ALLIED ARTS OF THE THEATRE. New York: H. W. Wilson Co., 1933. 320 p.

Books on all aspects of theater—festivals, minstrels, marionettes, and pageants. [*See now* P738.]

P738. **Baker, Blanche M., comp.** THEATRE AND ALLIED ARTS: A GUIDE TO BOOKS DEALING WITH THE HISTORY, CRITICISM, AND TECHNIC OF THE DRAMA AND THEATRE AND RELATED ARTS AND CRAFTS. New York: H. W. Wilson Co., 1952. 536 p.

This is a greatly expanded edition of Baker's *Dramatic Bibliography* [see P737]. Listed in this 1952 volume are hundreds of works in a broad spectrum of the performing arts. Drama, theater, music, dramaturgy, scenic art, costume, and dance are all covered. The volume, which is international in scope, includes titles from 1885 to 1948. There is a classified list of approximately 6,000 items, many of which are English. Indexes.

P739. **Band-Kuzmany, Karin R. M., comp.** GLOSSARY OF THE THEATRE. New York: Elsevier Publishing Co., 1969. 130 p.

A simultaneous translation of stage and theater terms into four languages—English, French, Italian, and German—invaluable to the researcher, librarian, and theater professional.

P740. **Mantle, Burns, ed.** THE BEST PLAYS OF 1919–1920; AND THE YEAR BOOK OF THE DRAMA IN AMERICA. Boston: Maynard, 1920.

The *Year Books* for 1921 through 1945 were edited by Burns Mantle (New York: Dodd, Mead & Co.). Continued under various editors: John Chapman (1947/48 to 1951/52); Louis Kronenberger (1952/53 to 1960/61); Henry Hewes (1961/62 to 1963/64); and Otis L. Guernsey, Jr. (1964/65 to 1973/74). There are also three retrospective volumes: Garrison P. Sherwood (1899–1909; 1909–1919) and Sherwood and John Chapman (1894–1899). An "Index to the Best Play Series, 1949–1960" was published by Dodd, Mead & Co. in 1961. These volumes now form a continuous history of production, along with Odell's *Annals* [see P440], and represent a notable series about the New York stage.

P741. **Bowman, Walter Parker, and Ball, Robert Hamilton.** THEATRE LANGUAGE: A DICTIONARY OF TERMS IN ENGLISH OF THE DRAMA AND STAGE FROM MEDIEVAL TO MODERN TIMES. New York: Theatre Arts Books, 1961. 428 p.

An extensive glossary of stage terms, definitions of titles of stage enterprises, and explanations of initials commonly used in theater parlance.

P742. **Breed, Paul F., and Sniderman, Florence M., eds.** DRAMATIC CRITICISM INDEX: A BIBLIOGRAPHY OF COMMENTARIES ON PLAYWRIGHTS FROM IBSEN TO THE AVANT-GARDE. Detroit: Gale Research Co., 1972. 1022 p.

A bibliography of nearly 12,000 entries in English on nineteenth and twentieth century dramatists. Indexes.

P743. **Briscoe, Johnson, comp.** THE ACTORS' BIRTHDAY BOOK. New York: Moffat, Yard & Co., 1907. illus.

A biographical sketch of stage figures by their birthday. In most cases, a head shot of the individual accompanies Briscoe's character sketch. SECOND EDITION (1908).

P744. **Brockett, Oscar G.; Becker, Samuel L.; and Bryant, Donald C.** A BIBLIOGRAPHIC GUIDE TO RESEARCH IN SPEECH AND DRAMATIC ART. Glenview, Ill.: Scott, Foresman & Co., 1963. 118 p.

A guide designed particularly for the student of speech and dramatic art. It is a selective guide to materials of interest concerning the theater arts, radio, television, mass media, and cinema.

P745. Boston. **Boston Public Library.** A CATALOG OF THE ALLEN A. BROWN COLLECTION OF BOOKS RELATING TO THE STAGE. Boston, 1919.

[*See* P622.]

P746. THE MARIE BURROUGHS ART PORTFOLIO OF STAGE CELEBRITIES: A COLLECTION OF PHOTOGRAPHS OF THE DRAMATIC AND LYRIC ART. Chicago: A. N. Marquis Co., 1894. unpag.

A collection of handsome photographs with biographical sketches of stage artists of the 1890s. As with many such theatrical publications of this era, there is no index, no guide to the arrangement of the volume, and no notation of editorship. The volume is named in honor of Marie Burroughs, a San Francisco–born stage star.

P747. CROWELL'S HANDBOOK OF CONTEMPORARY DRAMA. New York: Thomas Y. Crowell Co., 1971. 505 p.

This encyclopedic volume on drama focuses on the period after World War II, both in Europe and America. Of the editorial staff, Kristin Morrison has done the entries for the United States.

P748. A DICTIONARY OF THE DRAMA: A GUIDE TO THE PLAYS, PLAYWRIGHTS, PLAYERS, AND PLAYHOUSES OF THE UNITED KINGDOM AND AMERICA, FROM THE EARLIEST TIMES TO THE PRESENT. EDITED BY W. DAVENPORT ADAMS. London: Chatto & Windus, 1904. 627 p.

This volume, which was a forerunner of the *Oxford Companion to the Theatre*, was intended to be vol. 1 of a projected encyclopedia of the theater. Unfortunately, this A–G volume was the only one published. It contains biographical sketches, summaries of plays, and is very good on dates of first performances. REPRINT (London: Burt Franklin, 1968).

P749. THE DRAMATIC INDEX. Boston. (1910–1949).

A series of indexes "covering the articles and illustrations concerning the stage and its players in the periodicals of America and England . . . including the dramatic books of the year." Editors: Frederick Winthrop Faxon, 1909–1935; Mary E. Bates, 1936–1940; Mary E. Bates and Anne C. Sutherland, 1941–1943; Anne C. Sutherland, 1944; Anne C. Sutherland and Beulah C. Rathbun, 1945–1947; Anne C. Sutherland and Ruth H. Coombs, 1948; Anne C. Sutherland and John F. Shea, 1949. During the years 1910–1917, the index was published by the Boston Book Co.; from 1918 to 1949, the index was published by F. W. Faxon Co.

P750. **Drury, Francis K. W.** DRURY'S GUIDE TO BEST

PLAYS. Washington, D.C.: Scarecrow Press, 1953. 367 p.

P751. **Salem, James M.** DRURY'S GUIDE TO BEST PLAYS. 2nd ed. Metuchen, N.J.: Scarecrow Press, 1969. 512 p.

These companion volumes [P750, P751] serve as a guide to play texts, intended primarily for "play-givers, play-goers, play-readers and the librarians which serve them." Plot synopses, breakdowns of characters involved, and publishers are provided. Includes address lists and indexes. Also includes "Best Plays" data. [See P757.]

P752. GALLERY OF PLAYERS FROM THE ILLUSTRATED AMERICAN. New York. 1894–1895.

A well-illustrated biographical dictionary of the American stage which includes casts, summaries, and photographs of many productions. While the arrangement is haphazard and the volumes are only partially indexed, they are worth using as research tools. The first volume (1894) was edited by Austin Brereton and published by Illustrated American Publishing Co.; the second volume (1894–1895) was edited by Henry Austin and published by Lorillard Spencer.

P753. **Gamble, William Burt, comp.** THE DEVELOPMENT OF SCENIC ART AND STAGE MACHINERY: A LIST OF REFERENCES IN THE NEW YORK PUBLIC LIBRARY. New York: The New York Public Library, 1920. 128 p.

Index. [See also P624, P754.]

P754. **Gamble, William Burt, comp.** STAGE SCENERY: A LIST OF REFERENCES TO ILLUSTRATED MATERIAL SINCE 1900 IN THE NEW YORK PUBLIC LIBRARY. New York: New York Public Library, 1917. 86 p.

Index. [See also P624, P753.]

P755. **Gilder, Rosamond.** A THEATRE LIBRARY: A BIBLIOGRAPHY OF ONE HUNDRED BOOKS RELATING TO THE THEATRE. New York: Theatre Arts, Inc.; for National Theatre Conference, 1932. 74 p.

During the Depression, Gilder was asked to select the one hundred most important works for a basic theater library. At a time when funds were limited, each choice was imbued with significance. Index.

P756. **Hart, F. Jerome, and Parker, John, eds.** THE GREEN ROOM BOOK AND ANGLO-AMERICAN DRAMATIC REGISTER. New York: Mitchell Kennerley, 1907. illus.

A biographical encyclopedia of the English and American theaters, with a heavy emphasis toward the English. The volume also includes texts on a variety of theater subjects, lists of new plays produced in New York, London, Paris, and Berlin, genealogical tables of theater families, a necrology, and plans of London theaters.

P757. **Guernsey, Otis L., Jr., comp.** DIRECTORY OF THE AMERICAN THEATER, 1894–1971. New York: Dodd, Mead & Co., 1971. 343 p.
BEST PLAY SERIES.

An index (titles, authors, and composers) to the entire Best Plays series to 1971. [See P750, P751.]

P758. **Rachow, Louis, and Hartley, Katherine.** GUIDE TO THE PERFORMING ARTS. Metuchen, N.J.: Scarecrow Press, 1972.

This guide to selected indexed periodicals is a continuation of the *Guide to the Performing Arts* by S. Yancey Belknap which indexed 1957–1967 material. The guide ranges over material dealing with theater, music, film, dance, radio, and television.

P759. **Handel, Beatrice; Spencer, Janet; and Turner, Nolanda, eds.** THE NATIONAL DIRECTORY FOR THE PERFORMING ARTS AND CIVIC CENTERS. 2d ed. Somerville, N.J.: Baker & Taylor; distributor for Handel & Co., 1975.

This directory lists performing arts organizations and theater facilities within each state. In the organization section, there is a brief history, enumeration of staff, indication of funding, and professional affiliation. The facility section gives seating and stage statistics, cost of rental, address, management, and date of construction. This is an indispensable guide for anyone engaged in booking tours as well as for researchers. List of Broadway producers. Indexes. FIRST EDITION (1974).

P760. **Hartnoll, Phyllis, ed.** THE OXFORD COMPANION TO THE THEATRE, 1951. 3d ed. New York: Oxford University Press, 1967. 1088 p., illus.

An encyclopedic reference work.

P761. **Hill, Frank Pierce, comp.** AMERICAN PLAYS, PRINTED 1714–1830, A BIBLIOGRAPHICAL RECORD. Stanford: Stanford University Press, 1934. 152 p., frontispiece.

A guide to the plays and to the location of the texts of the plays. The volume is based primarily on the work of Oscar Wegelin and a catalog, prepared by Fred W. Atkinson, of the plays in the library of the Brooklyn Polytechnic Institute.

P762. **Hunter, Frederick J.** DRAMA BIBLIOGRAPHY: A SHORT-TITLE GUIDE TO EXTENDED READING IN DRAMATIC ART FOR THE ENGLISH-SPEAKING AUDIENCE AND STUDENTS IN THEATRE. Boston: G. K. Hall & Co., 1971. 239 p., frontispiece.

A selection of books and articles of prime interest to students of theater arts. Index.

P763. MCGRAW-HILL ENCYCLOPEDIA OF WORLD DRAMA. GENERAL ADVISOR, BERNARD DUKORE. New York: McGraw-Hill Book Co., 1972. 4 vols., illus.

Though this encyclopedia discusses world drama, American playwrights are, of course, included. The four volumes range from Abag to Zweig, Stefan. Many of the post–1950s dramatists (not locatable in other works) are included: Paul Zindel, Harold Pinter, Lorraine Hansberry, and Neil Simon. Index of play titles (in original language and in English translation).

P764. **Mulgrave, Dorothy I.; Marlor, Clark S.; and Baker, Elmer E., Jr.** BIBLIOGRAPHY OF SPEECH AND ALLIED ARTS, 1950–1960. Westport, Conn.: Greenwood Press, 1962. 184 p.

A selective guide to books and dissertations on theater, speech, radio, and television.

P765. **Fiske, Harrison Grey.** THE NEW YORK MIRROR ANNUAL AND DIRECTORY OF THE THEATRICAL PROFESSION, 1888. New York: New York Mirror, 1888. 208 p., illus.

This is a compendium of information about the theater—a chronological record of events in the theater (openings, deaths, special performances for 1887), a necrology for 1887, a bibliography, material on companies, the interstate commerce law, and a directory of the profession by category. Index.

P766. **Palmer, Helen H., and Dyson, Jane Anne, comps.** AMERICAN DRAMA CRITICISM: INTERPRETATIONS, 1890–1965 INCLUSIVE, OF AMERICAN DRAMA SINCE THE FIRST PLAY PRODUCED IN AMERICA. Hamden, Conn.: Shoe String Press, 1967. 230 p.

Arranged by playwright and by work, this is a guide to criticism of American drama. Index.

P767. **Rae, Kenneth, and Southern, Richard, eds.** AN INTERNATIONAL VOCABULARY OF TECHNICAL THEATRE TERMS IN EIGHT LANGUAGES. New York: Theatre Arts Books, 1959. 139 p.

This is a particularly valuable glossary since it recognizes the differences between American English and British English in stage terms. The eight languages are American English, British English, Dutch, French, German, Italian, Spanish, and Swedish.

P768. **Rigdon, Walter, ed.** THE BIOGRAPHICAL ENCYCLOPEDIA AND WHO'S WHO IN THE AMERICAN THEATRE. New York: James H. Heineman, 1966. 1101 p.

A biographical dictionary of the American theater. The volume includes, too, a history of New York productions, 1900–64, biographies of theater buildings and of theater organizations, and awards history, a bibliography, a discography, and a necrology. A must for any theater research collection. Introduction by George Freedley.

P769. **Roden, Robert F.** LATER AMERICAN PLAYS, 1831–1900; BEING A COMPILATION OF THE TITLES OF PLAYS BY AMERICAN AUTHORS PUBLISHED AND PERFORMED IN AMERICA SINCE 1831. New York: Dunlap Society, 1900. 132 p.

Arranged by author, this is a valuable guide both to the drama of the nineteenth century and plays performed during the earlier period. Biographical details are supplied for the dramatists. Index.

P770. **Ryan, Pat M. comp.** AMERICAN DRAMA BIBLIOGRAPHY: A CHECKLIST OF PUBLICATIONS IN ENGLISH. Fort Wayne: Fort Wayne Public Library, 1969. 240 p.

An attempt to compile a list of significant American plays and playwrights from colonial times to the present.

P771. **Salem, James M.** A GUIDE TO CRITICAL REVIEWS. 2d ed. New York and Metuchen, N.J.: Scarecrow Press, 1967. 2 vols., 353 p.

Guides to twentieth-century American and Canadian Theater Criticism. Vol. 1, which was published in 1966, focuses on American Drama from O'Neill to Albee. Published in 1967, vol. 2 discusses the musical from Rodgers and Hart to Lerner and Loewe. Indexes.

P772. **Santaniello, A. E.** THEATRE BOOKS IN PRINT: AN ANNOTATED GUIDE TO THE LITERATURE OF THE THEATRE, THE TECHNICAL ARTS OF THE THEATRE, MOTION PICTURES, TELEVISION AND RADIO. 2d ed. New York: Drama Book Shop, 1966. 509 p.

Index. FIRST EDITION (1963).

P773. **Sergei, Sherman Louis, ed.** THE LANGUAGE OF SHOW BIZ: A DICTIONARY. Chicago: Dramatic Publishing Co., 1973. 261 p., Illus.

A dictionary of show business vernacular. Introduction by Claudia Cassidy.

P774. **Simon, Bernard, ed.** SIMON'S DIRECTORY. 5th ed. enl. New York: Package Publicity Service, 1975. 384 p.

A guide to theatrical services and materials. Among the new articles are several pieces on theater technical problems. [See also P507.]

P775. **Sobel, Bernard, ed.** THE NEW THEATRE HANDBOOK AND DIGEST OF PLAYS. New York: Crown Publishers, 1959. 749 p.

A one-volume theater encyclopedia that includes biographies, plot summaries of plays, definitions of terms, and lists of plays by subject. Preface by George Freedley. Bibliography. FIRST EDITION (1940).

P776. **Stallings, Roy, and Myers, Paul.** A GUIDE TO THEATRE READING. New York: National Theatre Conference, 1949. 138 p.

An annotated bibliography of the outstanding publications in the field during the sixteen-year period since the publication of Rosamond Gilder's *A Theatre Library*. [P755]. Foreword by Rosamond Gilder. Index.

P777. **Stratman, Carl J.** BIBLIOGRAPHY OF THE AMERICAN THEATRE, EXCLUDING NEW YORK CITY. Chicago: Loyola University Press, 1965. 397 p.

This directory is arranged by state and city and includes books, periodicals, articles, theses and dissertations on all phases of the American theater.

P778. **Stratman, Carl J.; Spencer, David G.; and Devine, Mary Elizabeth.** RESTORATION AND EIGHTEENTH CENTURY THEATRE RESEARCH: A BIBLIOGRAPHIC GUIDE, 1900–1968. Carbondale, Ill.: Southern Illinois University Press, 1971. 811 p. [*cont.*]

A listing of more than 6000 entries in this area of study. The book grew out of a special conference which was instituted by the Modern Language Association. Index.

P779. [Deleted.]

P779a. **Coryn, Stan, ed.** A SELECTIVE GUIDE TO THEATRE MAGAZINE. New York: Scarecrow Press, 1964. 289 p.

An index containing 45,000 references to material which appeared in the pages of *Theatre Magazine,* 1900–1930. Bibliography.

P780. Seattle. **University of Washington.** A CATALOG OF THE DIVISION OF DRAMA LIBRARY. Seattle, 1934. 69 p.

P781. **Wasserman, Paul, ed.** AWARDS, HONORS, AND PRIZES: A DIRECTORY AND SOURCE BOOK. Detroit: Gale Research Co., 1969; 1972.

A guide to the many awards given in a wide variety of areas, including the performing arts. Each volume carries an address of the award-giving body, a history, and concept of the purpose of the award. Includes a subject index of awards.

P782. **Wegelin, Oscar.** EARLY AMERICAN PLAYS, 1714–1830: A COMPILATION OF THE TITLES OF PLAYS AND DRAMATIC POEMS WRITTEN BY AUTHORS BORN IN OR RESIDING IN NORTH AMERICA PREVIOUS TO 1830. New York: Literary Collector Press, 1905. 94 p., frontispiece.

Arranged by author, this volume gives information about plays in the early American theater. Biographical details on the playwrights are supplied. Index.

P783. **Hines, Dixie, and Hanaford, Harry Prescott, eds.** WHO'S WHO IN MUSIC AND DRAMA. New York: H. P. Hanaford, 1914. 560 p., illus.

A biographical encyclopedia of artists in music and drama. Includes costs of New York productions, 1910–1913.

P784. WHO'S WHO IN THE THEATRE. COMPILED AND EDITED BY JOHN PARKER. Boston: Small, Maynard & Co., 1912; London: Isaac Pitman & Sons, 1912–1972.

A biographical dictionary of the theater with an emphasis on the theater of London, though many American figures are included. Also includes lists of long-running New York productions, indexes to New York playbills and to New York theaters, necrologies, and articles of interest on festivals. No theater researcher could exist without recourse to these volumes. The fifteen volumes have been published at irregular intervals.

P785. **Browne, Walter, and Austin, F. A., eds.** WHO'S WHO ON THE STAGE, 1906. New York: Walter Brown & F. A. Austin, 1906. 232 p., illus.

Originally planned as a regular series of biographical dictionaries on the American stage. This volume contains records of the careers of actors, actresses, managers, and playwrights of the American stage.

P786. **Browne, Walter, and Koch, E. DeRoy, eds.** WHO'S WHO ON THE STAGE, 1908. New York: B. W. Dodge & Co., 467 p., illus.

A biographical dictionary of the American theater.

Serials and Periodicals

P787. ANTA NEWSLETTER, 1950–1963. New York.

This is the newsletter of the American National Theatre and Academy. Also published as ANTA News Bulletin and ANTA Spotlight (title varies).

P788. THE BILLBOARD. Cincinnati. (Nov. 1894—).

This publication reports on circuses, rodeos, outdoor amusements, and legitimate theater.

P789. THE BURR MCINTOSH MONTHLY. New York. (April 1903–May 1910).

A journal which reported on the professional theater.

P790. CAHN'S OFFICIAL THEATRICAL GUIDE. New York. (1896–1922).

A guide to theater and theatrical services across the United States.

P791. THE CAST. New York. (1900–1951).

A weekly pamphlet which lists the current casts of New York productions, curtain times, theaters, openings, and closings.

P792. CRITICS' THEATRE REVIEWS. New York. (1940—).

A reprint of the first night notices of Broadway productions.

P793. CUE. New York. (1934—).

A guide, published weekly, to entertainment in New York.

P794. DRAMA MAGAZINE. Chicago. (February 1911–June 1931).

The publication of the Drama League of America, which gave special note to new playwrights and theater groups.

P795. EDUCATIONAL THEATRE JOURNAL. Columbia, Mo. (Oct. 1949—).

The publication of the American Theatre Association (formerly, American Educational Theatre Association).

P796. EQUITY. New York. (1915—).

The official publication of Actors' Equity Association.

P797. MODERN DANCE. Lawrence, Kansas. (May 1958—).

A publication devoted to scholarly research on drama.

P798. NEW THEATRE. New York. (1934–1939).

The publication of the New Drama League.

P799. NEW YORK DRAMATIC MIRROR. New York. (1879–1922).

During its lifetime, the foremost news journal of the American theater.

P800. SHOW, THE MAGAZINE OF THE ARTS. (Oct. 1961–April 1965; Jan.–Sept. 1970).

An elegant, illustrated magazine of the theater published by Huntington Hartford.

P801. SHOW BUSINESS. New York. (1941—).

This New York based publication continues to give casting news in all areas of show business. It is published by Leo Shull. Also published as *Actors Cues* (title varies).

P802. THE SPIRIT OF THE TIMES. New York. (1833–1858).

Published in New York, this journal gave news of show business, itineraries of touring productions, as well as news of the turf and sports.

P803. STAGE MAGAZINE. New York. (1925–1935); (1940–1941).

This was an audience publication reporting on current theater. Also published as *Theatre Guild Magazine* (title varies).

P804. THEATRE ARTS MONTHLY. New York. (1916–1941).

Probably the most important magazine of its era in respect to coverage and quality of exposition and illustration. This classic publication on American dramatic art includes reviews as well as a discussion on film. It is available also in REPRINT (New York: Arno Press).

P805. THEATRE MAGAZINE. New York. (1900–1930).

A monthly periodical which represents a lively and pictorially interesting record of the American theater. Through most of the years under consideration, it was edited by Arthur Hornblow. [*See also* P799.]

P806. VARIETY. New York. (Dec. 1905—).

The so-called Bible of show business. It carries reviews, business statistics, and news items about theater in the United States and abroad. It also features information on film, radio, and television.

Dramas about Historical Figures: A Selection

P807. [Darrow, Clarence] **Lawrence, Jerome, and Lee, Robert. E.** INHERIT THE WIND. New York: Random House, 1958.

P808. [Dickinson, Emily] **Gardner, Dorothy.** EASTWARD IN EDEN. New York: Longmans Green & Co., 1949.

P809. [Douglas, Stephen A.] **Corwin, Norman.** THE RIVALRY. New York: Dramatists Play Service, 1960.

P810. [Foster, Stephen] **Green, Paul.** THE STEPHEN FOSTER STORY. New York: Samuel French, 1960.

P811. [Franklin, Benjamin] **Green, Paul.** "FRANKLIN AND THE KING." IN: SMITH, BETTY. A TREASURY OF NON-ROYALTY ONE-ACT PLAYS. Garden City, N.Y.: Garden City Books, 1958.

P812. [Hill, Joe] **Stavis, Barrie.** THE MAN WHO NEVER DIED. New York: Dramatists Play Service.

P813. [Holmes, Oliver Wendell] **Lavery, Emmet.** THE MAGNIFICENT YANKEE. New York: Samuel French.

P814. [Jefferson, Thomas] **Kingsley, Sidney.** THE PATRIOTS. New York: Dramatists Play Service.

P815. [Keller, Helen] **Gibson, William.** THE MIRACLE WORKER. New York: Samuel French.

P816. [Lee, Robert E.] **Green, Paul.** THE CONFEDERACY. New York: Samuel French.

P817. [Lincoln, Abraham] **Corwin, Norman.** THE RIVALRY. New York: Dramatists Play Service, 1960.
Drinkwater, John. ABRAHAM LINCOLN. New York: Samuel French.
Sherwood, Robert E. ABE LINCOLN IN ILLINOIS. New York: Dramatists Play Service.

P818. [Long, Huey] **Warren, Robert Penn.** ALL THE KING'S MEN. New York: Random House.

P819. [Oakley, Annie] **Fields, Dorothy, and Fields, Herbert.** MUSIC BY IRVING BERLIN. ANNIE GET YOUR GUN. Chicago: Dramatic Publishing Co.

P820. [Stowe, Harriet Beecher] **Clements, Florence Ryerson, and Colin C. Harriet.** New York: Samuel French.

P821. [Washington, George] **Anderson, Maxwell.** VALLEY FORGE. New York: Anderson House.

Q

Dance

GENEVIEVE OSWALD

CONTENTS

INTRODUCTION

This bibliography is a selective, annotated list of citations for printed sources, both books and periodical articles, and for visual and audio materials documenting the American dance. As the first comprehensive bibliography to be compiled on the subject, it reflects the unique peculiarities of the materials available on the dance, and on the American dance in particular.

Dance is enjoying a period of unparalleled brilliance in America. There is an effulgence of dance performances, splendid companies, large audiences, and artists' creativity that has swept beyond our shores until it has become a dominant and provocative force in European theater. The *New York Times* declared that "dance has emerged as perhaps the most vital American art form of the 1970s."[1] And yet the printed material on American dance is meager. There is no history of American theatrical dance, nor any history of American social dancing. Nor is there a serious, comprehensive study of American Indian dancing. The dance field as a whole lacks even that basic staple of any serious discipline, the multivolume encyclopedia.

Books represent about 7 percent of the materials available on dance generally, and on the American dance in particular. That the printed literature is a modest corpus can be determined from the fact that most of the known works in dance publication are represented by only 26,000 books and librettos in the Dance Collection of The New York Public Library, the primary archive for dance research. The remainder, or 93 percent of the material, is nonbook in nature, largely visual and often recherché. Included in this category are nineteenth-century prints that are rare; photographs and motion pictures that are privately made; and clippings, programs, and manuscript letters that may be unique.

Perhaps the reason for the paucity of the material is that dance lives in time and in space and is deprived of the concrete substance of words, stone, wood, or canvas. Nor does it have an easily accessible notation. The true literature of the dance has been handed down from generation to generation by kinesthetic rote through the professional dancers themselves. Comparative studies and histories of dance literature have been difficult if not impossible to write, because the "texts"—i.e., the works themselves—were not available for viewing or for study. With the emergence of motion picture film and videotape, however, the dancer, choreographer, critic, researcher, and historian will be provided with a facility that those working in the fields of drama and music have taken for granted for centuries. For the first time, each will be able to study the repertoire of his art. In time it will be possible to analyze the choreography of our celebrated ballets, to compare a choreographer's several works as we do those of a great writer, or to study the performing styles of our great dancers. Recording on film and videotape is expensive but it does promise the availability of visual records, making possible a representative body of "printed" literature.

As to the printed material on dance now available, then, the researcher must seek these meager and often imperfect records far and wide. The bulk of the standard material is found in the periodical literature, which in fact forms the most substantive part of this bibliography. No attempt has been made to limit the citations to materials currently available. Indeed, in the case of the dance of the American Indians, materials of earlier origins have been sought out.

Manuscripts, scrapbooks, photographs, prints, and other examples of graphic art are voluminous in number and are often unique. For this reason, they are not included as individual entries. Rather, collections of these materials are identified in the section on Source Materials under Nonbook Collections [Q64–Q75]. Individual films are listed, when they are available. Collections of amateur and unique footage are shown as entries in the section on Source Materials [*see* Q65 *et seq.*]. A fascinating and primary source of information is found in the audiotapes or oral interviews with dance professionals. Since these often reflect the opinions of distinguished artists and are not found elsewhere in print, they are cited even though they may not be easily available.

The scope of this bibliography is intentionally broad and represents vividly the richness that is the American dance. Just a partial list of topics covered in this bibliography includes ballet, modern dance, expressionistic, acrobatic, social, folk, variety, vaudeville, burlesque, American Indian, and black dance, religious dance, and musical comedy dance.

The structure of the bibliography (as shown on the contents list preceding) is simple. It is divided into two main parts. The first part, on Source Materials, is subdivided into Printed Reference Works and Nonbook Collections and can be considered a preface to the second part, the main body of literature on American Dance. This second part is divided into Types, Forms, and Styles; Institutions and Personae; Technical, Creative, and Other Aspects. These subsections have a subject orientation that brings together *first*, the kinds of dancing, or the types and styles of dancing found in America; *second*, the institutions and individuals involved in the practice of the art, whether they be dancers, choreographers, critics, or companies; *third*, the technical aspects such as choreography,

[1] "What Makes Dance Our Most Vital Art Form?" *New York Times*, June 8, 1975, Arts and Leisure sec., p. 1.

music, and stage design; and *fourth,* the related other aspects including appreciation, art and dance, history and criticism, notation, and the philosophy and aesthetics of the dance. May it be hoped that when the documentation on all these aspects is woven together, some image of the vitality and richness of the art of dance will emerge, even though the records themselves may be incomplete.

GENEVIEVE OSWALD

SOURCE MATERIALS AND SERIAL LITERATURE

Printed Reference Works

ALMANACS AND YEARBOOKS

Q1. DANCER'S ALMANAC AND WHO'S WHO. New York. 1 (1940): 204 p., illus.

Edited by Ruth E. Howard, this almanac comprises a record of the 1939–1940 dance season in the United States, covering all aspects of dance. The approach is primarily a biographical one, concentrating on dancers, choreographers, teachers, and writers. Some descriptions of dance companies and musical comedies are included. Only one almanac was published.

Q2. DANCE MAGAZINE ANNUAL. New York. 9— (1967—), illus.

[See Q36.]

Q3. DANCE NEWS ANNUAL. New York. 1 (1953), illus. (color).

Edited by Winthrop Palmer and Anatole Chujoy. *Partial contents* of this annual include: "Dance in New York, Season of 1951–1952," by John Martin; "The Problem of Modern Dance," by Beatrice Gottlieb; "Alec, or the Future of Choreography," by Lincoln Kirstein; "Hallmark—American," by Emily Coleman; "Martha Graham and Doris Humphrey," by Walter Terry; "Jose Limon," by Winthrop Palmer; "Theater Dance in My Time," by Leo Lerman; "Ballet Design," by Oliver Smith; "Dance Notation," by Ann Hutchinson; "Dance in Chicago: Season of 1951–1952," by Ann Barzel; "The San Francisco Ballet," by James Graham-Lujan; "Checklist of New Dance Works Presented in New York, 1951–1952"; "Checklist of Books on Dance Published in the United States, 1951–1952." Only one "annual" was published, by Alfred A. Knopf.

Q4. DANCE WORLD. New York. 1— (1966—), illus.

An annual, edited by J. Willis, published by Crown and including performance records of professional and regional dance companies throughout the United States. Well illustrated, with biographical data on dancers and choreographers. Index.

BIBLIOGRAPHY

Q5. **American Association for Health, Physical Educa-** tion, and Recreation. Dance Division. RESEARCH IN DANCE, PT. 1. Washington, D.C., 1968. 45 p.

Lists dance research completed at the graduate level or ongoing work nearing completion, as well as projects, reports, and related research. Subject index. Compilations and supplements issued regularly. *Supplement* to *Compilation of Dance Research, 1901–1964*, edited by Esther E. Pease, Washington, D.C., 1964. 52 p. *Supplement* to *Dance Research, 1964–1967*, edited by Fannie Helen Melcer, Washington, D.C., 1967. 1 vol. (loose-leaf). *Supplement* to *Research in Dance, II*, compiled by Charlotte Irey, Washington, D.C., 1973. 96 p. The *latest supplement* includes "Themes for Dance Research," a list of suggested topics for thesis projects compiled by Fannie Helen Melcer and Genevieve Oswald.

Q6. **Belknap, Sara Yancey, comp.** GUIDE TO THE MUSICAL ARTS: AN ANALYTICAL INDEX OF ARTICLES AND ILLUSTRATIONS, 1953–1956. Metuchen, N.J.: Scarecrow Press, 1957. 1 vol., unpag.

Indexes 15,000 articles—by author and by subject—and 6,000 illustrations, in music, opera, dance, and theater journals. For further treatment, *see* the author, *Guide to the Performing Arts* [Q42].

Q7. CATALOG OF DANCE FILMS. COMPILED BY SUSAN BRAUN AND DOROTHY H. CURRIE. EDITED BY KATHLEEN DURKIN AND PAUL LEVESQUE. New York: Dance Films Association, 1974. 1 vol., unpag., illus.

[See Q66.]

Q8. CORD NEWS. New York. 1–? (Apr. 1969–spring 1974).

A semiannual publication sent to all members of CORD (the Committee on Research in Dance). Special features include reports of CORD membership meetings; readers' views; resource listings of research, publications, and other references related to dance; and membership information. [*See now* the CORD publication, *Dance Research Journal.*]

Q9. DANCE PERSPECTIVES. Brooklyn, N.Y. 1— (winter 1959—), illus.

[See Q59.]

Q10. DANCE YEAR. Boston. 1 (1964): 256 p., illus.

Edited by R. Calvi, *Dance Year* was published once only as an annual by *Dance Spotlight*. The publication serves as a record of the 1963–1964 international dance scene and includes reference to ballet, modern, and some ethnic

dance. Profusely illustrated, with alphabetical listings of recent ballet productions, ballet companies and dance groups, dance artists, and dance schools.

Q11. Davis, Martha, comp. UNDERSTANDING BODY MOVEMENT: AN ANNOTATED BIBLIOGRAPHY. New York: Arno Press, 1972. 190 p.

An annotated list of books and periodicals on movement behavior, or the anthropology and psychology of physical body movement. Includes citations to works on expressive movement, kinesics, nonverbal communication, body language, and psychological aspects of movement, motor activity, and motility. The majority of the titles cover the period between 1900 and June 1971. Subject index.

Q12. ENCICLOPEDIA DELLO SPETTACOLO. Rome. Casa Ed. le Maschere, 1954–1962. 9 vols., illus. (color).

[*See* Q33.]

Q13. FOCUS ON DANCE. Washington, D.C. 1— (1960—), illus.

Published by the National Section on Dance of the American Association for Health, Physical Education, and Recreation. Vols. 1 and 2 (1960–62) include listings of dance research and theses. Bibliographies.

Q14. Belknap, Sara Yancey, comp. GUIDE TO DANCE PERIODICALS. New York. 1–10 (1931–1962).

A useful supplementary reference tool. Absorbed by *Guide to the Performing Arts* [Q42]. [*See now* The New York Public Library, *Dictionary Catalog of the Dance Collection,* Q19.]

Q15. Belknap, Sara Yancey, comp. GUIDE TO THE PERFORMING ARTS. Metuchen, N.J.: Scarecrow Press, 1972.

[*See* Q42.]

Q16. Haywood, Charles, comp. A BIBLIOGRAPHY OF NORTH AMERICAN FOLKLORE AND FOLKSONG. 2d rev. ed. New York: Dover Publications, 1961. 2 vols., maps.

[*See* Q317.]

Q17. Magriel, Paul David, comp. A BIBLIOGRAPHY OF DANCING: A LIST OF BOOKS AND ARTICLES ON THE DANCE AND RELATED SUBJECTS. New York: H. W. Wilson Co., 1936. 229 p., illus., facsims.

A comprehensive annotated list of references on the dance in all of its phases, and of related arts. In eight parts: general works; history and criticism of the dance; folk, national, regional, and ethnological dances; art of dancing; ballet; mime and pantomime; masques; and accessories. Entries are arranged alphabetically by author or by title if no author could be established. Author, subject, and analytical index. *Fourth cumulated supplement, 1936–1940,* New York: H. W. Wilson Co., 1941. 104 p.

Q18. Mueller, John, comp. FILMS ON BALLET AND MODERN DANCE: NOTES AND A DIRECTORY. New York: American Dance Guild, 1974. 100 p.

A selected listing of films on ballet and modern dance with descriptions, evaluations, and sources for rental or loan. Includes a chapter on the use of dance films for teaching purposes; extensive notes for the film series *U.S.A.: Dance* and *Four Pioneers,* and for the film *Night Journey,* choreographed by Martha Graham. Cross-indexed by choreographer.

Q19. New York. **The New York Public Library. Dance Collection.** DICTIONARY CATALOG OF THE DANCE COLLECTION: A LIST OF AUTHORS, TITLES, AND SUBJECTS OF MULTI-MEDIA MATERIALS IN THE DANCE COLLECTION OF THE PERFORMING ARTS RESEARCH CENTER OF THE NEW YORK PUBLIC LIBRARY. New York: New York Public Library and Astor, Lenox & Tilden Foundations; and Boston: G. K. Hall & Co., 1974. 10 vols., color frontispiece.

A project undertaken and completed under the direction of the curator of the collection, Genevieve Oswald, this is a comprehensive listing under author, subject, and title of nearly 30,000 books, 6,000 libretti, and over 40,000 articles. The dictionary also includes materials in nonbook form, such as original drawings, stage designs, costume designs, woodcuts, engravings, lithographs, photographs, motion picture films, videotapes, manuscripts, letters, music scores, dance notation scores, phonograph recordings, and oral history tape recordings. Most of the known rarities in the field of dance publishing are included. [*See also* Q64, Q68.]

Q20. New York. **The New York Public Library.** SCHOMBURG COLLECTION OF NEGRO LITERATURE AND HISTORY: DICTIONARY CATALOG. Boston: G. K. Hall & Co., 1962. 9 vols.

This photographic reproduction of the cards of a dictionary catalog is arranged by author, title, and subject. The main volume contains entries for about 36,000 bound volumes. Includes books in all languages and on all subjects by African authors, as well as significant materials about African peoples. Library of Congress subject headings are used, supplemented by special headings developed for the collection. Although manuscripts, photographs, and vertical file materials are not included, the catalog does contain entries for music and phonorecords. Useful dance headings include: ballet; dance orchestra music; dancing; U.S. folk music; Negro dancers and dancing. *First supplement:* Boston: G. K. Hall & Co., 1967, 2 vols. *Second supplement:* Boston: G. K. Hall & Co., 1972, 4 vols.

Q20a. Oswald, Genevieve, comp. BIBLIOGRAPHY ON DANCE. New York: Rockefeller Brothers Fund, 1963. 50 leaves.

An annotated bibliography on the economic aspects of dance, including patronage, subsidy, arts councils, legislation, careers, regional companies, unions, and arts management. Prepared in conjunction with a report published in 1965 by the Rockefeller Brothers Fund, entitled *The Performing Arts: Problems and Prospects* [Q1376].

Q21. Washington, D.C. **Library of Congress. Music**

Division. CATALOGUE OF OPERA LIBRETTOS PRINTED BEFORE 1800. Washington, D.C., 1914. 2 vols., frontispiece, facsim.

Because interludes in early musical presentations often included some rather lengthy performances of theatrical dancing, this catalog comprises an especially valuable dance source. Contains approximately 6,000 entries arranged alphabetically by title and accompanied by historical, descriptive, and bibliographic notes. The collection of Albert Schatz, purchased by the Library of Congress in 1909, forms the main part of this collection. Composer list; author list.

Q22. **Works Progress Administration.** DANCE INDEX: AN ANNOTATED INDEX IN BIBLIOGRAPHICAL FORM OF DANCE REFERENCES, COMPOSED OF SOURCE MATERIAL EXTRACTED FROM VARIOUS WORKS ON ANTHROPOLOGY, ETHNOLOGY, COMPARATIVE RELIGION, TRAVEL, AND THE ARTS, CONTAINED IN INSTITUTIONAL LIBRARIES OF GREATER NEW YORK. Typewritten. New York: Dance Collection, The New York Public Library, ca. 1936. card file, 45 drawers.

[*See* Q46.]

CHRONOLOGY

Q23. **Chujoy, Anatole.** THE NEW YORK CITY BALLET. PHOTOGRAPHS BY GEORGE PLATT LYNES, WALTER E. OWEN, AND FRED FEHL. New York: Alfred A. Knopf, 1953. 382 p., illus.

[*See* Q865.]

Q24. **Cohen, Selma Jeanne, and Pischl, A. J.** THE AMERICAN BALLET THEATRE: 1940–1960. Brooklyn: Dance Perspectives Foundation, 1960. 120 p., illus.

DANCE PERSPECTIVES, NO. 6.

Chronology. Includes index of dancers, ballets, choreographers, composers, and designers.

Q25. JUDSON: A DANCE CHRONOLOGY. *Ballet Review* 1 (1967): 54–72.

A chronology of avant-garde dance concerts given at the Judson Dance Theatre from July 1962 to March 1967. Included are dates, titles of works, cast lists, and, when possible, program notes.

Q26. **Kirstein, Lincoln.** THE NEW YORK CITY BALLET. PHOTOGRAPHS BY MARTHA SWOPE AND GEORGE PLATT LYNES. New York: Alfred A. Knopf, 1973. 261 p., illus.

[*See* Q883.]

Q27. **Schlundt, Christena Lindborg.** THE PROFESSIONAL APPEARANCES OF RUTH ST. DENIS AND TED SHAWN: A CHRONOLOGY AND AN INDEX OF DANCES, 1906–1932. New York: New York Public Library, 1962. 85 p., illus.

[*See* Q910.]

Q28. **Schlundt, Christena Lindborg.** THE PROFESSIONAL APPEARANCES OF TED SHAWN AND HIS MEN DANCERS: A CHRONOLOGY AND AN INDEX OF DANCES, 1906–1932. New York: New York Public Library, 1967. 75 p., illus.

[*See* Q1021.]

Q29. New York. **Wildenstein & Co. and The New York Public Library, Dance Collection.** STRAVINSKY AND THE DANCE: A SURVEY OF BALLET PRODUCTIONS, 1910–1962, IN HONOR OF THE EIGHTIETH BIRTHDAY OF IGOR STRAVINSKY. New York: Dance Collection of the New York Public Library, 1962. 60 p., illus.

Exhibition: Traveling exhibition circulated under the auspices of The Museum of Modern Art, New York. Sponsored by the Committee for the Dance Collection of The New York Public Library.

[*See* Q930.]

DICTIONARIES AND ENCYCLOPEDIAS

Q30. ENCYCLOPEDIA OF SOCIAL DANCE. COMPILED BY ALBERT AND JOSEPHINE BUTLER. Mimeographed. New York: Albert Butler Ballroom Dance Service, 1975. 1 vol. (loose-leaf), illus.

[*See* Q491.]

Q31. THE DANCE ENCYCLOPEDIA. COMPILED AND EDITED BY ANATOLE CHUJOY AND PHYLLIS WINIFRED MANCHESTER. 2d ed. New York: Simon & Schuster, 1967. 992 p., illus.

A dictionary with brief entries for dancers, choreographers, and companies. Also includes subjects related to ballet, especially ballet since 1940, but also related to modern dance and to folk and ethnic dancing. FIRST EDITION (1949).

Q32. A DICTIONARY OF MODERN BALLET. EDITED BY SELMA JEANNE COHEN. New York: Tudor Publishing Co., 1959. 360 p., illus.

An illustrated encyclopedia containing brief entries documenting contemporary, especially European, ballet. FRENCH EDITION: *Dictionnaire de Ballet Moderne*, Paris: Hazan, 1957. GERMAN EDITION: *Knaurs Ballet Lexikon*, Munich and Zurich: Knaur, 1958. ENGLISH EDITION: *A Dictionary of Modern Ballet*, London: Methuen, 1959.

Q33. ENCICLOPEDIA DELLO SPETTACOLO. Rome: Casa Ed. le Maschere, 1954–1962. 9 vols., illus. (color).

Lengthy articles on all theater arts from antiquity to the present, with lists of works and bibliographies. Includes the theater, opera, ballet, motion pictures, vaudeville, the circus. Treats performers, authors, composers, directors, designers; types of entertainment; dramatic themes; historical and technical subjects; organizations and companies; place names. Good coverage of American dance. The *Aggiornamento, 1955–1965*, is mainly devoted to biographical sketches of contemporary figures not found in

the basic set. It supersedes the text of the 1963 cinema appendix, although different illustrations have been used. The *Indice-Repertorio* is an index of titles of works mentioned in the main set and in the *Aggiornamento*, giving reference to author and composer but not to volume or page. *Supplements, 1963–1968,* 3 vols.: *Appendice di Aggiornamento: Cinema,* Venice: Istituto per la Collaborazione Culturale, 1963, 178 p., illus.; *Aggiornamento, 1955–1965,* Rome: Unione Editoriale, 1966, 1292 columns, illus. (color); *Indice-Repertorio,* Rome: Unione Editoriale, 1968, 1024 p.

Q34. INDEX TO CHARACTERS IN THE PERFORMING ARTS. PT. 3: BALLETS A–Z AND SYMBOLS. COMPILED BY HAROLD S. SHARP AND MARJORIE Z. SHARP. Metuchen, N.J.: Scarecrow Press, 1972. 320 p.

Identifies and indexes ballet characters in "plot" ballets only, from the late sixteenth century to the present. Pertinent information includes the identification of those responsible for the production (composers, choreographers, etc.), plot source, date and place of first performance, and character identification. Alphabetical listing of ballet characters, ballet productions.

Q35. A DICTIONARY OF BALLET. COMPILED BY G. B. L. WILSON. 3d ed. New York: Theatre Arts Books, 1974. 539 p., illus.

A standard dictionary, with brief entries for dancers, choreographers, titles of works, companies, schools, and subjects relating to ballet. Special emphasis is given to European dance.

DIRECTORIES

Q36. DANCE MAGAZINE ANNUAL. New York. 9— (1967—), illus.

Vols. 1–8 (1958–1966) were issued as a part of the Dec. number of *Dance Magazine.* A valuable reference source of information on every facet of the dance in America. Includes data on choreographers; dance companies (ballet, children's, ethnic, historical, jazz, modern and special); honors and awards; lecturers; management and publicity; master teachers; mime; merchandise; music and dance; organizations (governmental, private sponsors, dance teachers, national art foundations); performance centers; dance services; and schools. Some international coverage.

Q37. DANCE YEAR. Boston 1 (1964): 256 p., illus.
[*See* Q10.]

Q38. WHO WAS WHO IN AMERICA: HISTORICAL VOLUME, 1607–1896. Chicago: A. N. Marquis Co., 1963. 670 p.

A companion biographical reference work to *Who's Who in America,* and a component volume of *Who's Who in American History,* this basic reference tool contains short biographical entries for persons in the United States, and those of other countries, who have made contributions to

or whose activity was in some manner related to the history of the United States from 1607 to 1896.

INDEXES

Q39. **Belknap, Sara Yancey, comp.** GUIDE TO THE MUSICAL ARTS: AN ANALYTICAL INDEX OF ARTICLES AND ILLUSTRATIONS, 1953–1956. Metuchen, N.J.: Scarecrow Press, 1957. 1 vol. unpag.
[*See* Q6.]

Q40. ENCICLOPEDIA DELLO SPETTACOLO. Rome: Casa Ed. le Maschere, 1954–1962. 9 vols., illus (color).
[*See* Q33.]

Q41. **Belknap, Sara Yancey, comp.** GUIDE TO DANCE PERIODICALS. New York. 1–10 (1931–1962).
[*See* Q14.]

Q42. **Belknap, Sara Yancey, comp.** GUIDE TO THE PERFORMING ARTS. Metuchen, N.J.: Scarecrow Press, 1972.

A companion to *Guide to the Musical Arts* [Q6], this guide absorbed *Guide to Dance Periodicals* [Q14] and serves as a catalog to the material in selected performing arts periodicals for the librarian, the student, and the researcher. The 1972 edition constituted an index to forty-eight publications. [For dance publications, *see now* The New York Public Library, *Dictionary Catalog of the Dance Collection,* Q19.]

Q43. New York. **The New York Public Library. Dance Collection.** DICTIONARY CATALOG OF THE DANCE COLLECTION: A LIST OF AUTHORS, TITLES, AND SUBJECTS OF MULTI-MEDIA MATERIALS IN THE DANCE COLLECTION OF THE PERFORMING ARTS RESEARCH CENTER OF THE NEW YORK PUBLIC LIBRARY. New York: New York Public Library and Astor, Lenox & Tilden Foundations; and Boston: G. K. Hall & Co., 1974. 10 vols., color frontispiece.
[*See* Q19.]

Q44. INDEX TO CHARACTERS IN THE PERFORMING ARTS. PT. 3: BALLETS A–Z AND SYMBOLS. COMPILED BY HAROLD S. SHARP AND MARJORIE Z. SHARP. Metuchen, N.J.: Scarecrow Press, 1972. 320 p.
[*See* Q34.]

Q45. Washington, D.C. **Library of Congress. Music Division.** CATALOGUE OF OPERA LIBRETTOS PRINTED BEFORE 1800. WASHINGTON, D.C. 1914. 2 vols., frontispiece, facsim.
[*See* Q21.]

Q46. **Works Progress Administration.** DANCE INDEX: AN ANNOTATED INDEX IN BIBLIOGRAPHICAL FORM OF DANCE REFERENCES, COMPOSED OF SOURCE MATERIAL EXTRACTED FROM VARIOUS WORKS ON ANTHROPOLOGY, ETHNOLOGY, COMPARATIVE

Religion, Travel, and the Arts, Contained in Institutional Libraries of Greater New York. Typewritten. New York: Dance Collection, The New York Public Library, ca. 1936; card file, 45 drawers.

This WPA-sponsored project in card-file typescript deposited in the Dance Collection, at The New York Public Library is a bibliographical guide to source materials on ethnic, regional, and folk dancing. There are some 50,000 individual entries, including regional see references; an index of sources; a subjects index; and a shelf-list author index. Preceding the indexes are a key to abbreviations, a foreword, instructions for using the cards, and a list of symbols used for the following li-

braries in New York City: American Geographical Society; Cooper Union Museum (now Cooper-Hewitt Museum of Decorative Arts and Design, Smithsonian Institution); Columbia University; The Metropolitan Museum of Art; Missionary Research Library; Union Theological Seminary; General Theological Seminary; The American Museum of Natural History; and The New York Public Library, both the 135th Street and the 58th Street branches. The dance material is now held centrally by The New York Public Library. The index provides extensive coverage of North American dance (approximately 6,000 entries), in particular on the Indians of North America.

Serials and Periodicals

Q47. American Square Dance. Huron, Ohio. 27— (Jan. 1972—), illus.

This monthly, edited by Stan and Cathie Burdick, contains articles on square, round, and contra dancing in the United States published as *American Squares* (Sept. 1954–1965); *Square Dance* 1966–1971).

Q48. **Association of American Dance Companies.** AADC Newsletter. New York. 3— (July 1972—), illus.

This quarterly publication offers news of current activities of the national organization, which serves as a central coordinating and research agency for performing dance companies throughout the United States. Also includes news of regional companies, conferences, arts patronage, federal subsidy and arts programs, seminars, awards, festivals, and new publications on dance.

Q49. Ballet Review. Brooklyn, N.Y. 1— (1965—), illus.

This periodical, edited by Arlene Croce, has appeared on an irregular basis since 1965. It contains book reviews, critical essays, many substantial in length, with an emphasis on American dance. Indexed in the *Dictionary Catalog of the Dance Collection* [Q19].

Q50. Chrysalis: A Pocket Review of the Arts. Boston. 1—? (1948–1958), illus.

A bimonthly periodical edited by Lily and Baird Hastings. Each issue was devoted to one of the theatrical or graphic arts and consisted usually of a single article by an outstanding writer or artist. The essays pertaining to dance included excellent studies on dancers André Eglevsky, Martha Graham, and Alexandra Danilova; on choreographers Jerome Robbins and Todd Bolender; on stage designer Robert Edmond Jones. Also included are articles on ballet criticism and theater architecture.

Q51. Country Dance and Song. New York. 1— (1968—), illus.

An annual periodical that includes supplementary newsletters published by the Country Dance and Song Society

of America. May Gadd has been the editor since 1968. Contains articles on folk dancing and country dancing, often with music and directions for individual dances. first published as *The Country Dancer.*

Q52. Dance Herald: A Journal of Black Dance. New York. 1— (summer 1975—), illus.

A monthly magazine edited by William Moore. The periodical contains illustrated articles on all aspects of black dance in the United States, including pieces on classical ballet, choreographers, festivals, jazz dancing, schools, modern dance, and personalities. A black dance directory in the first issue lists the leading centers, teachers, and performers throughout the country.

Q53. Dance Index. New York. 1–7 (1942–July/Aug. 1948), illus.

A monthly, edited by Lincoln Kirstein, Marian Eames, Donald Windham, and others, concentrated primarily on ballet. Each authoritative issue was a well-illustrated monograph on some aspect of dance. reprint edition (New York: Arno Press, 1971), 7 vols., with a newly prepared cumulative index. Introduction by Bernard Karpel.

Q54. Dance Life. New York. 1— (spring 1975—), illus.

An irregular quarterly periodical edited by David Lindner. Includes general articles on dance, reviews, and interviews. published as *Dance Life in New York* 1 (spring 1975).

Q55. The Dance Magazine. New York. 1–17 (Jan. 1924–Dec. 1931), illus.

A monthly magazine published by the Dance Publishing Corp. on all aspects of dance, especially dance in the United States, with emphasis on musical comedy, variety, and ballroom dancing. Not to be confused with *Dance Magazine* still published [Q56]. published as *Dance Lovers Magazine* (Jan. 1924–Nov. 1925).

Q56. Dance Magazine. New York. 1— (June 1927—), illus. [cont.]

Comprehensive coverage in this monthly periodical of all forms of dance from all periods and points of view, with major emphasis on American dance of the twentieth century. Indexed in *Reader's Guide to Periodicals*. PUBLISHED AS *American Dancer* (June 1927–Apr. 1942); *Dance* (May–Aug. 1942, Feb. 1945–May 1948); *Dance Magazine* (Sept. 1942–Jan. 1945, June 1948—). *Dance Magazine Annual* (Dec. issues, 1958–1965) is a directory of dance attractions issued separately since 1967.

Q57. DANCE NEWS. New York. 1— (Nov. 1942—), illus.

A monthly periodical (not published in July and Aug.), edited by Helen V. Atlas. Contains professional news of the dance world. Includes performance schedules and projections, grant information, school news, and reviews. The magazine is basically concerned with the United States, although it does include some reports from abroad.

Q58. DANCE OBSERVER. New York. 1–31 (Feb. 1934–Jan. 1964), illus.

A monthly periodical appearing on an irregular basis. Contains news and reviews on all aspects of modern dance in the United States, with some coverage of dance in other countries. Includes teacher directories and notices of workshops and conferences. Indexed: 1–13 (1934–1946).

Q59. DANCE PERSPECTIVES. Brooklyn, N.Y. 1— (winter 1959—), illus.

A quarterly publication edited by A. J. Pischl from 1959 to 1964 and by Selma Jeanne Cohen after 1965. Each issue is a well-illustrated monograph on some aspect of dance. Includes ballet, modern, folk, and ethnic dance.

Q60. EDDY. New York. 1— (Nov. 1937—), illus.

Edited by Tom Borek and published by the Dance Theatre Workshop, this periodical contains essays and reviews concentrating on contemporary American dance, including modern dance and ballet. An occasional historical piece also is included.

Q61. THE FEET. New York. 1–3 ? (Dec. 1970–June 1973), illus.

Devoted to essays and reviews on black dance published by the Modern Organization for Dance Evolvement. There are some errors in volume numbering.

Q62. IMPULSE: DANCE AS A COMMUNICATION. San Francisco. 1–18 (1951–1970), illus.

This annual publication edited by Marian Van Tuyl was initiated as a student periodical of the workshop group at the Halprin-Lathrop Dance Studio, San Francisco. There were two preliminary issues, published in 1948 and 1949 under the sponsorship of that group. Contributors included Martha Graham, Ann Halprin, Lincoln Kirstein, José Limón, Carmelita Maracci, Daniel Nagrin, Alwin Nikolais, Harry Partch, Jean Rosenthal, Anna Sokolow, and Mary Wigman. Subtitle varied.

Q63. ROSIN THE BOW. Paterson, N.J. 1–6 ? (1945–1957 ?), illus.

The frequency of this periodical devoted to folk and square dancing varies. Edited and published by Rod La Farge, the magazine contains news of square and folk dance groups, descriptions of dances and costume, square dance calls, record reviews, bibliographies, and articles on social dance history and folklore. MAY HAVE CEASED PUBLICATION with vol. 6, no. 1 in autumn 1957.

Nonbook Collections

MANUSCRIPTS

Q64. New York. **The New York Public Library. Dance Collection.** DICTIONARY CATALOG OF THE DANCE COLLECTION: A LIST OF AUTHORS, TITLES, AND SUBJECTS OF MULTI-MEDIA MATERIALS IN THE DANCE COLLECTION OF THE PERFORMING ARTS RESEARCH CENTER OF THE NEW YORK PUBLIC LIBRARY. New York: New York Public Library and Astor, Lenox & Tilden Foundations and Boston: G. K. Hall & Co., 1974. 10 vols., color frontispiece.

Nearly 130,000 manuscript items constituting the personal papers of noted figures in the field of dance. Outstanding collections are the Doris Humphrey Collections, the Ruth Page Fisher Collection, the American Ballet Theatre Papers, the Lincoln Kirstein Collection, the José Limón Collection, the Denishawn Collection, the Agnes de Mille Collection, the Edward Gordon Craig–Isadora Duncan Collection, and the Irma Duncan Collection.

Also included are less extensive collections on individual artists. [*See also* names of individual dancers.]

MOTION PICTURES

Q65. **Anderson, Jack.** TOWARDS A DANCE FILM LIBRARY: A GOAL FOR THE DANCE COLLECTION, TACKLED WITH URGENCY AND DETERMINATION. *Dance Magazine* (Sept. 1965): 40–42.

Discusses the Dance Collection of The New York Public Library, particularly its plans for establishing a comprehensive film archive on the dance and the support it is receiving from Jerome Robbins.

Q66. CATALOG OF DANCE FILMS. COMPILED BY SUSAN BRAUN AND DOROTHY H. CURRIE. EDITED BY KATHLEEN DURKIN AND PAUL LEVESQUE. New York: Dance Films Association, 1974. 1 vol., unpag., illus.

A comprehensive list of over 500 16 mm dance films available for rental or sale. Each film is described briefly. The directory includes ballet; modern, ethnic, and folk dance; mime; dance therapy; dance instruction; and cine-dance. Indexed by choreographers, dancers, teachers, dance companies, distributors, and set and costume designers. Includes a directory of contemporary distributors.

Q67. **Mueller, John, comp.** FILMS ON BALLET AND MODERN DANCE: NOTES AND A DIRECTORY. New York: American Dance Guild, 1974. 100 p.

[*See* Q18.]

Q68. New York. **The New York Public Library. Dance Collection.** DICTIONARY CATALOG OF THE DANCE COLLECTION: A LIST OF AUTHORS, TITLES, AND SUBJECTS OF MULTI-MEDIA MATERIALS IN THE DANCE COLLECTION OF THE PERFORMING ARTS RESEARCH CENTER OF THE NEW YORK PUBLIC LIBRARY. New York: New York Public Library and Astor, Lenox & Tilden Foundations; and Boston: G. K. Hall & Co., 1974. 10 vols., color frontispiece.

Contains some 2,000 titles of motion picture films and videotapes documenting ballet, modern, social, musical comedy, tap, folk, and national dance. Arranged under general headings (*see* "motion pictures," "ballet in motion pictures," "ballet in television") and under specific headings (*see* individual choreographers, dancers, dance companies, and dance works). [*See* Q19.]

PHOTOGRAPHS

Q69. New York. **The New York Public Library. Dance Collection.** DICTIONARY CATALOG OF THE DANCE COLLECTION: A LIST OF AUTHORS, TITLES AND SUBJECTS OF MULTI-MEDIA MATERIALS IN THE DANCE COLLECTION OF THE PERFORMING ARTS RESEARCH CENTER OF THE NEW YORK PUBLIC LIBRARY. New York: New York Public Library and Astor, Lenox & Tilden Foundations; and Boston: G. K. Hall & Co., 1974. 10 vols., color frontispiece.

Over 230,000 photographs are listed illustrating all types of dance. (*See* the subheading "visual materials" under names of dancers, companies, subjects, titles of works, and titles of dances.) [*See* Q19.]

Q70. **Van Vechten, Carl.** THE FANIA MARINOFF COLLECTION OF PHOTOGRAPHS OF DANCERS AND ALLIED ARTISTS, 1931–1962. Photographic Materials, 29 boxes. Dance Collection, The New York Public Library.

Constituting about 3,000 items, this group of original black and white photographs and color slides of American dance artists, designers, and composers is housed in the Dance Collection of The New York Public Library. Photographic reproductions of individuals from ballet, modern dance, ethnic dance, and musical comedy are contained in the collection, including such artists as Diana Adams, Alvin Ailey, La Argentina, Agnes de

Mille, Anton Dolin, Katherine Dunham, Ram Gopal, Martha Graham, Gilda Gray, Nora Kaye, John Kriza, Pearl Primus, Bill Robinson, Antony Tudor, and Charles Weidman.

PROGRAMS

Q71. New York. **The New York Public Library. Dance Collection.** DICTIONARY CATALOG OF THE DANCE COLLECTION: A LIST OF AUTHORS, TITLES, AND SUBJECTS OF MULTI-MEDIA MATERIALS IN THE DANCE COLLECTION OF THE PERFORMING ARTS RESEARCH CENTER OF THE NEW YORK PUBLIC LIBRARY. New York: New York Public Library and Astor, Lenox & Tilden Foundations; and Boston: G. K. Hall & Co., 1974. 10 vols., color frontispiece.

Included are approximately 80,000 programs, which are listed under the names of dancers, performing companies, and titles of dance works. [*See* Q19.]

PHONOTAPES

Q72. New York. **The New York Public Library. Dance Collection.** DICTIONARY CATALOG OF THE DANCE COLLECTION: A LIST OF AUTHORS, TITLES, AND SUBJECTS OF MULTI-MEDIA MATERIALS IN THE DANCE COLLECTION OF THE PERFORMING ARTS RESEARCH CENTER OF THE NEW YORK PUBLIC LIBRARY. New York: New York Public Library and Astor, Lenox & Tilden Foundations; and Boston: G. K. Hall & Co., 1974. 10 vols., color frontispiece.

Includes 724 phonotapes and oral interviews. (*See under* "audio materials" for specific entries and *under* "phonotapes" for a general heading.) [*See* Q19.]

PRINTS

Q73. New York. **The New York Public Library. Dance Collection.** DICTIONARY CATALOG OF THE DANCE COLLECTION: A LIST OF AUTHORS, TITLES, AND SUBJECTS OF MULTI-MEDIA MATERIALS IN THE DANCE COLLECTION OF THE PERFORMING ARTS RESEARCH CENTER OF THE NEW YORK PUBLIC LIBRARY. New York: New York Public Library and Astor, Lenox & Tilden Foundations; and Boston: G. K. Hall & Co., 1974. 10 vols., color frontispiece.

About 7,000 prints are included. (*See under* "Prints" and *under* names of individual dancers, companies, subjects, titles of works, and titles of dances.) [*See* Q19.]

STAGE DESIGNS

Q74. New York. **The New York Public Library. Dance Collection.** DICTIONARY CATALOG OF THE DANCE

COLLECTION: A LIST OF AUTHORS, TITLES, AND SUB-JECTS OF MULTI-MEDIA MATERIALS IN THE DANCE COLLECTION OF THE PERFORMING ARTS RESEARCH CENTER OF THE NEW YORK PUBLIC LIBRARY. New York: New York Public Library and Astor, Lenox & Tilden Foundations; and Boston: G. K. Hall & Co., 1974. 10 vols., color frontispiece.

Includes mention of such designers as Oliver Smith, Léon Bakst, Cecil Beaton, Nathalie Gontcharova, and Isamu Noguchi among the seven hundred stage and costume designs listed. (*See under* "stage designs," and "costume designs," as well as titles, dance works, and names of individual designers.) [*See* Q19.]

VIDEOTAPES

Q75. New York. **The New York Public Library. Dance Collection.** DICTIONARY CATALOG OF THE DANCE COLLECTION: A LIST OF AUTHORS, TITLES, AND SUB-JECTS OF MULTI-MEDIA MATERIALS IN THE DANCE COLLECTION OF THE PERFORMING ARTS RESEARCH CENTER OF THE NEW YORK PUBLIC LIBRARY. New York: New York Public Library and Astor, Lenox & Tilden Foundations; and Boston: G. K. Hall & Co., 1974. 10 vols., color frontispiece.

[*See* Q19.]

AMERICAN DANCE

Types, Forms, and Styles

ACROBATIC DANCE

Q76. Barzel, Ann. ACROBATICS AND DANCING. *Dance Magazine* (Dec. 1950): 26–27, 29–30, illus.

A discussion of the techniques and history of acrobatics in America.

Q77. DANCE, FRANCHONETTI SISTERS. Motion picture. New York: American Mutoscope and Biograph Co., producing organization, 1903. 13 sec.; silent, black and white, 16mm.

Three young ladies perform an acrobatic routine.

Q78. DANCE PROGRAM. ASSEMBLED BY GEORGE AMBERG. Motion picture. New York, ca. 1945. 27 min.; silent, black and white, 16 mm.

Dance sequences from early films assembled by George Amberg, former curator of theatre and dance, The Museum of Modern Art, New York: "The Six Sisters Daineff," "Loie Fuller in Her Fire Dance" (1906), "A Peek into an Old-Time Stage Dressing Room, Revealing Facts that Grandpa Wasn't Supposed to Know," "Bombay Pagoda," "The Enchanted Glasses," "The Wonderful Beehive, by Members of Folies Bergères" (1905), Alla Nazimova in the *Dance of the Seven Veils* from the motion picture *Salome* (1923); "The Charleston as Danced on the Toes," "The Ballroom Charleston," two girls dancing the charleston, "The Spanish Charleston."

Q79. Schroeder, Charles R. ADAGIO. St. Louis: Regmar Publishing Co., 1971. 113 p., illus.

A detailed textbook for the teaching of adagio skills. The book includes sections on safety, physiological considerations, basic principles for movement in adagio, class organization, acrobatic adagio, classical adagio, and adagio choreography. Bibliography.

AFRO-CARIBBEAN DANCE

Q80. Buckle, Richard, ed. KATHERINE DUNHAM: HER DANCERS, SINGERS, MUSICIANS. PHOTOGRAPHS BY ROGER WOOD ET AL. London: Ballet Publication, 1949. 79 p., illus.

A largely pictorial study of the life of this company and the contribution of Katherine Dunham and her style of dance to Western theater. The introductory essay, in English and French, is complemented by the pictorial work on the Dunham Dance Company and its distinctive repertoire.

Q81. Dunham, Katherine. KATHERINE DUNHAM'S JOURNEY TO ACCOMPONG. DRAWINGS BY TED COOK. New York: H. Holt, 1946. 162 p., illus.

An account by the dancer-anthropologist of her field research among the Maroons, a black people living in the village of Accompong in Jamaica.

Q82. Dunham, Katherine. THE DANCES OF HAITI. Mexico, 1947. 60 p., illus.

An analysis of the dances of certain areas of Haiti, this anthropological study is based on field research by the famous black American dancer-choreographer. SPANISH EDITION (Mexico, 1947). 64 p. [Q661.]

Q83. Dunham, Katherine. ETHNIC DANCING. *Dance Magazine* (Sept. 1946): 22–23, 34–35, illus.

Impressions and reminiscences of Dunham's trip to the West Indies.

Q84. ETHNIC DANCE: ROUNDTRIP TO TRINIDAD. CONCEIVED AND WRITTEN BY MARTHA MYERS. DIRECTED BY GREG HARNEY. PRODUCED BY JAC VENZA. CHOREOGRAPHED BY GEOFFREY HOLDER. Motion picture. Boston: WGBH–TV, producing organization, 1959. 29 min.; sound, black and white, 16 mm. FROM THE WGBH–TV SERIES A TIME TO DANCE.

Geoffrey Holder discusses the significance of ethnic dance in the field of formal dance. He performs three dances, along with Carmen de Lavallade, Julius Fields, Thelma Hill, Miriam Port, and Charles Saint-Amant: Bele, a West Indian minuet; Yanvalou, a voodoo dance; and Banda, from the musical comedy, *House of Flowers.*

Q85. Stearns, Marshall Winslor, and Stearns, Jean. JAZZ DANCE: THE STORY OF AMERICAN VERNACULAR DANCE. New York: Macmillan Co., 1968. 464 p., illus. [*See* Q340.]

AVANT-GARDE DANCE

Q86. New York. **New York State Council on the Arts.** AVANT-GARDE DANCERS: A NEW YORK STATE COUNCIL ON THE ARTS TRAVELING EXHIBITION, PREPARED IN COLLABORATION WITH THE DANCE COLLECTION OF THE NEW YORK PUBLIC LIBRARY. *Dance Magazine* (Oct. 1968): 47–62, illus.

Exhibition.

This photographic report on an exhibition organized by Marian Eames and designed by Martin Stephen Moskof and Richard Hefter, was prepared for a tour of colleges, libraries, and art centers. The exhibition presents a pictorial review of works by many of the modern dance innovators of the 1960s. Depicts works by Steve Paxton, Merce Cunningham, Paul Sanasardo, Don Redlich, Paul Taylor, Alwin Nikolais, Deborah Hay, Jack Moore, Trisha Brown Schichter, Murray Louis, Erick Hawkins, James Waring, Yvonne Rainer, Ann Halprin, and others.

Q87. **Baker, Robb.** GRAND UNION: TAKING A CHANCE ON DANCE. *Dance Magazine* (Oct. 1973): 40–46, illus.

Includes biographical material on Trisha Brown, Steve Paxton, David Gordon, Barbara Lloyd, Douglas Dunn, and Nancy Green.

Q88. **Cohen, Selma Jeanne.** AVANT-GARDE CHOREOGRAPHY, Pts. 1–3. *Dance Magazine* Pt. 1 (June 1962): 22–24, 57; Pt. 2 (July 1962): 29–31, 58; Pt. 3 (Aug. 1962): 45, 54–56, illus.

[*See* Q358.]

Q89. **Cohen, Selma Jeanne, ed.** THE MODERN DANCE: SEVEN STATEMENTS OF BELIEF. Middletown, Conn.: Wesleyan University Press, 1966. 106 p., illus.

[*See* Q359.]

Q90. **Cunningham, Merce.** MUSIC AND DANCE AND CHANCE OPERATIONS: A FORUM DISCUSSION. Phonotape. Amherst, Mass.: WFCR, broadcaster, 1970. 54-1/2 min. 2 reels (7 in.) 7-1/2 in./sec. Dance Collection, The New York Public Library.
FROM THE WFCR SERIES FIVE-COLLEGE FORUM.

[*See* Q361.]

Q91. **Day, James.** INTERVIEW WITH ALWIN NIKOLAIS. Phonotape. New York: WNET–TV, broadcaster, Nov. 29, 1973. 30 min. 1 reel (7 in.) 3-3/4 in./sec. Dance Collection, The New York Public Library.
AUDIO PORTION BROADCAST ON THE NET SERIES DAY AT NIGHT.

[*See* Q1198.]

Q92. THE DRAMA REVIEW, POST–MODERN DANCE ISSUE. 19 (Mar. 1975): 124 p., illus.

Essays on the post–modern dance development by Noel Carroll, Joan Jonas, Laura Dean, Trisha Brown, Lucinda Childs, Simone Forti, Steve Paxton, and David Gordon. The historical section on Loie Fuller and Nikolai Foregger includes essays by Sally Sommer and Mel Gordon, as well as a written piece by Foregger. Allan Kaprow,

Robert Anton, and Ken Jacobs are discussed in the section concerned with contemporary performances.

Q93. **Forti, Simone.** HANDBOOK IN MOTION. Halifax: Press of the Nova Scotia College of Art and Design; and New York: New York University Press, 1974. 144 p.

Documentation of the performances of the American avant-garde dancer and choreographer Simone Forti, by the artist herself. Forti discusses the ideas behind the performances and the social context from which they developed. This is an important source for those who want to understand the history of the "new dance" and the philosophy and practice of the new post–modern dance generation of the 1970s. Also available in paperback.

Q94. **Johnston, Jill.** THE NEW AMERICAN MODERN DANCE. In: KOSTELANETZ, RICHARD, ED. The New American Arts. New York: Horizon Press, 1965. p. 162–93.

A discussion of the emergence of modern dance as the breakthrough of individual style and form. Particular attention is given to the contributions of Martha Graham, Merce Cunningham, Alvin Nikolais, James Waring, Aileen Passtoff, and the Judson Dance Theatre.

Q95. JUDSON: A DANCE CHRONOLOGY. *Ballet Review* 1 (1967): 54–72.

[*See* Q25.]

Q96. **Kostelanetz, Richard.** METAMORPHOSIS IN MODERN DANCE. *Dance Scope* (fall 1970): 6–21, illus.

A discussion of Merce Cunningham, Alwin Nikolais, and Ann Halprin as the avant-garde leaders of third-generation modern dancers/choreographers. The article includes commentaries on their fourth-generation heirs, including Yvonne Rainer, Twyla Tharp, and Murray Louis.

Q97. **McDonagh, Don.** THE RISE AND FALL AND RISE OF MODERN DANCE. New York: New American Library, 1971. 303 p., illus.

This paperback edition contains corrections and updated chronologies. ORIGINAL EDITION (New York: Outerbridge & Dienstfrey; distributed by E. P. Dutton & Co., 1970.) [*See* Q401.]

Q98. NEW DANCE: A DANCE MAGAZINE PORTFOLIO PRODUCED BY WILLIAM COMO AND RICHARD PHILP AND DESIGNED BY HERBERT MIGDOLL. *Dance Magazine* (Apr. 1974): 37–68, illus.

Eight articles on various aspects of avant-garde, experimental, or "new dance," comparing new trends in dance to new trends in music, theater, cinema, writing, painting, and sculpture. The portfolio also includes an examination of the schools in which new dance techniques are being taught.

Q99. **Nikolais, Alwin.** THE DANCE AND MULTI-MEDIA: FORUM DISCUSSION. Phonotape. Amherst, Mass.: WFCR, broadcaster, 1969. 60 min. 2 reels (7 in.) 7-1/2 in./sec. Dance Collection, The New York Public Library. [*See* Q406.]

Q100. **Nikolais, Alwin.** GROWTH OF A THEME. In:

SORELL, WALTER, ED. THE DANCE HAS MANY FACES. 2d ed. New York: Columbia University Press, 1966. p. 229-37.
[*See* Q775.]

Q101. **Nikolais, Alwin.** LECTURE ON AVANT-GARDE DANCE. Phonotape. New York, 1968. 50 min. 1 reel (7 in.) 3-3/4 in./sec. Dance Collection, The New York Public Library.
[*See* Q776.]

Q102. **Nikolais, Alwin.** NIK, A DOCUMENTARY. EDITED AND WITH AN INTRODUCTION BY MARCIA B. SIEGEL. Brooklyn: Dance Perspectives Foundation, 1971. 56 p., illus. (color).
DANCE PERSPECTIVES, NO. 48.
[*See* Q777.]

Q103. **Rainer, Yvonne.** WORK, 1961–1973. Halifax: Press of the Nova Scotia College of Art and Design; and New York: New York University Press, 1974. 338 p.
NOVA SCOTIA SERIES.
[*See* Q789.]

Q104. **Siegel, Marcia B.** AT THE VANISHING POINT: A CRITIC LOOKS AT DANCE. New York: Saturday Review Press, 1972. 320 p., illus.
[*See* Q1448.]

Q105. **Siegel, Marcia B., ed.** DANCERS' NOTES. New York, 1969. 48 p., illus.

This compilation of statements from well known avant-garde modern dancers includes articles by Marcia Siegel, Lucas Hoving, Jack Moore, Daniel Nagrin, Don Redlich, Murray Louis, Katherine Litz, Remy Charlip, and Judith Dunn.

Q106. **Terry, Walter.** INTERVIEW WITH NORMAN WALKER. Phonotape. New York: WNYC, broadcaster, 1965. 24 min. 1 reel (7 in.) 7-1/2 in./sec. Dance Collection. The New York Public Library.
FROM THE WNYC SERIES INVITATION TO DANCE.
[*See* Q592.]

Q107. **Tomkins, Calvin.** THE BRIDE AND THE BACHELORS: FIVE MASTERS OF THE AVANT-GARDE. New York: Viking Press, 1968. 306 p., illus.
[*See* Q643.]

BALLET

GENERAL REFERENCES

Q108. ART OF BALLET. Motion picture. New York: WCBS–TV, producing organization, 1956. 45 min., sound, black and white, 16 mm.

FROM THE CBS SERIES *Omnibus*.

A brief history of ballet, narrated by Agnes de Mille and illustrated with demonstrations of ballet technique and excerpts from classical and modern works. Performances include dances in the style of Marie Camargo (Agnes de Mille) and of Marie Taglioni (Mary Ellen Moylan); part of the adagio and man's variation from the pas de deux of the second act of *Swan Lake* (Diana Adams and André Eglevsky); and the pas de deux from *Paint Your Wagon* (Gemze De Lappe and James Mitchell). Cast includes Helen Wood and Vladimir Dokoudovsky.

Q109. CLASSICAL BALLET. CONCEIVED AND WRITTEN BY MARTHA MYERS. DIRECTED BY GREG HARNEY. PRODUCED BY JAC VENZA. CHOREOGRAPHED BY LOUIS MERANTE, GEORGE BALANCHINE, AND LEV IVANOV. MUSIC BY TCHAIKOVSKY AND LÉO DELIBES. Motion picture. Boston: WGBH–TV, producing organization, 1959. 29 min.; sound, black and white, 16 mm.
FROM THE WGBH–TV SERIES A TIME TO DANCE.

With the aid of prints, photographs, film clips, and live performance, Martha Myers traces the history, basic technique, and the traditions of the classical ballet. Included are an excerpt from the second act of the Bolshoi Ballet production of *Swan Lake;* barre and center exercises demonstrated by Linda Yourth, George Lee, and Marina Eglevsky and taught by André Eglevsky; the coda from the *Bluebird* pas de deux, performed by Linda Yourth and George Lee; excerpts from the *Sylvia* pas de deux, choreographed by George Balanchine and danced by Maria Tallchief and André Eglevsky; the adagio from the second-act pas de deux of *Swan Lake,* danced by Maria Tallchief and André Eglevsky.

Q110. DANCE INDEX. New York. 1–7 (1942–July/Aug. 1948), illus.
[*See* Q53.]

Q111. DANCE PERSPECTIVES. Brooklyn, N.Y. 1— (winter 1959—), illus.
[*See* Q59.]

Q112. **De Mille, Agnes.** THE BOOK OF THE DANCE. London and New York: Golden Press, 1963. 252 p., illus. (color).
[*See* Q369.]

Q113. **Kirstein, Lincoln.** IN DEFENSE OF THE BALLET. *Modern Music* 11 (May–June 1934): 189–94, illus.

Kirstein, the present director of the New York City Ballet, concerns himself here with dance during the thirties in America and with the popularity of dancers themselves rather than with dance design. The author explores the resentment against classical ballet, caused, he believes, by a nationalistic jealousy of European tradition and by the reluctance of experimenters to surrender their freedom from that tradition. Kirstein urges the development of an American ballet company supported by an educated audience. Written in the early days of the American Ballet Company, a forerunner of the present national company.

Q114. **Odell, George Clinton Densmore.** ANNALS OF
THE NEW YORK STAGE. New York: Columbia University Press, 1927–1949. 15 vols., illus., facsims., maps.

Vols. 1–15 constitute a detailed history of the stage in
New York City from around 1699 to 1894. Odell discusses
actors, dancers, plays, ballets, and theaters in material
collected solely from original sources, including contemporary newspapers, pamphlets, diaries, letters, autobiographies, playbills, and account books. Each volume
has an index of names, titles, and subjects.

Q115. INDEX TO CHARACTERS IN THE PERFORMING
ARTS. PT. 3: BALLETS A–Z AND SYMBOLS. COMPILED
BY HAROLD S. SHARP AND MARJORIE Z. SHARP.
Metuchen, N.J.: Scarecrow Press, 1972. 320 p.

[*See* Q34.]

Q116. **Terry, Walter.** THE DANCE IN AMERICA. New
York: Harper & Row, 1971. 272 p., illus.

[*See* Q433.]

EIGHTEENTH CENTURY

Q117. **Crawford, Mary Caroline.** THE ROMANCE OF THE
AMERICAN THEATRE. Boston, 1913. 407 p., illus., facsims.

A historical survey containing some information on ballet, pantomime, and dancers performing in eighteenth-
and nineteenth-century America. Index.

Q118. **Durang, John.** THE MEMOIR OF JOHN DURANG,
AMERICAN ACTOR, 1785–1816. EDITED BY ALAN S.
DOWNER. Pittsburgh: Published for the Historical
Society of York County and for the American Society
for Theatre Research by the University of Pittsburgh
Press, 1966. 176 p., illus. (color).

An autobiography of the American dancer and actor
edited from the manuscript owned by the Historical
Society of York County. Includes eight Durang watercolors, reproduced in color and owned by the Society.
Notes; index.

Q119. **Moore, Lillian.** THE DUPORT MYSTERY. Brooklyn,
N.Y.: Dance Perspectives Foundation, 1960. 103 p.,
illus.
DANCE PERSPECTIVES, NO. 7.

[*See* Q962.]

Q120. **Moore, Lillian.** JOHN DURANG: THE FIRST AMERICAN DANCER. *Dance Index* 1 (Aug. 1942): 120–39, illus.

[*See* Q963.]

Q121. **Moore, Lillian.** NEW YORK'S FIRST BALLET
SEASON, 1792. New York: New York Public Library,
1961. 18 p., illus.

[*See* Q964.]

Q122. **Moore, Lillian.** SOME EARLY AMERICAN DANCERS. *The Dancing Times* (Aug. 1950): 668–71, illus.

An outline of the careers of such eighteenth-and nineteenth-century American dancers as John Durang, Mary
Ann Lee, Augusta Maywood, George Washington Smith,
and Julia Turnbull.

Q123. **Moore, Lillian.** WHEN BALLET CAME TO
CHARLESTON. *The Dancing Times* (Dec. 1956): 122–24,
illus.

A historical account of ballet in Charleston, S.C., that
flourished as a center of dance culture in the eighteenth
century. Spans the period beginning in 1734 with Henry
Holt, the first professional dancer to appear in America,
and ending with the death of Alexandre Placide in 1812.

Q124. **Pollock, Thomas Clark.** THE PHILADELPHIA THEATRE IN THE EIGHTEENTH CENTURY, TOGETHER WITH
THE DAY BOOK OF THE SAME PERIOD. Philadelphia:
University of Pennsylvania Press; and London: H.
Milford, Oxford University Press, 1933. 445 p., frontispiece.

A history of the theatrical life of eighteenth-century Philadelphia. The important theatrical developments are described in chapters on the entertainments, the performers, and the theaters. A day-by-day chronology gives
details of each performance, with credits and casts. The
records for later years reveal the rise of musical entertainments, including dance, pantomime, and ballet. Indexed by plays, by playwrights and composers, and by
performers.

Q125. **Winter, Marian Hannah.** AMERICAN THEATRICAL DANCING FROM 1750 TO 1800. *The Musical Quarterly* 24 (Jan. 1938): 58–73, illus.

[*See* Q967.]

Q126. **Wynne, Shirley.** FROM BALLET TO BALLROOM:
DANCE IN THE REVOLUTIONARY ERA. *Dance Scope* 10
(fall/winter 1975–1976): 65–73, illus.

[*See* Q522.]

NINETEENTH CENTURY

Q127. **Chevalley, Sylvia.** MADAME FRANCISQUE HUTIN.
Dance Magazine (Apr. 1957): 40–42, 83–85, illus.

An essay of the career of a European ballet dancer who
appeared in America, with details of her trip and her
performances.

Q128. **Chaffee, George.** AMERICAN MUSIC PRINTS OF
THE ROMANTIC BALLET. *Dance Index* (Dec. 1942):
192–212, illus.

The second part of an article, the first of which was
published in *Dance Index*, "A Chart to American Souvenir
Lithographs of the Romantic Ballet, 1825–1870" [Q129.]
Pt. 1 catalogs the easel prints and discusses the iconography of the ballet. Omits some magazine woodcuts. Pt. 2
surveys approximately 150 music-title prints.

Q129. **Chaffee, George.** A CHART TO THE AMERICAN

Souvenir Lithographs of the Romantic Ballet, 1825–1870. *Dance Index* (Feb. 1942): 20–25, illus.

[For the second section of this annotated catalog of seventy-five to one hundred prints, *see* Q128.]

Q130. **Cornell, Joseph, comp.** Americana: Romantic Ballet. *Dance Index* (Sept. 1947): 201–222, illus.

This compilation of literary selections from American nineteenth-century authors reveals a surprisingly widespread intellectual sympathy toward and appreciation for ballet in the United States during the romantic period. Authors quoted include Nathaniel Hawthorne, Horace Greeley, and Edgar Allan Poe. Discussion touches on such famous dancers of the period as Fanny Elssler and Marie Taglioni. Illustrated with reproductions of drawings, prints, and music covers of the period.

Q131. **Delarue, Allison.** The Chevalier Henry Wikoff: Impresario, 1840. Princeton, N.J.: Privately printed at the Princeton University Press, 1968. 60 p., illus., facsims.

A biography of the American-born impresario who brought Fanny Elssler to the United States in 1840.

Q132. **Maynard, Olga.** Barbara Weisberger and the Pennsylvania Ballet. Photographs by Roger Greenawalt. *Dance Magazine* (Mar. 1975): 45–60, illus.

[*See* Q873.]

Q133. **Moore, Lillian.** George Washington Smith. *Dance Index* 4 (June–Aug. 1945): 88–135, illus.

A biography of the first great American classic male dancer whose career in the United States spans the decades between 1830 and 1900. Reprinted in Paul David Magriel, ed. *Chronicles of the American Dance* (New York: H. Holt, 1948), p. 139–88 [Q1384].

Q134. **Moore, Lillian.** Léon Espinosa in America. *The Dancing Times* (Mar. 1951): 333–35, illus.

A historical account in this London periodical of the famous European dancer's extensive American appearances in the 1850s.

Q135. **Moore, Lillian.** Mary Ann Lee: First American Giselle. *Dance Index* (May 1943): 60–71, illus.

[*See* Q984.]

Q136. **Moore, Lillian.** Plainsman and Ballerina. *Dance Magazine* (Oct. 1967): 46–49, illus.

[*See* Q986.]

Q137. **Moore, Lillian.** Prints on Pushcarts: The Dance Lithographs of Currier and Ives. Brooklyn, N.Y.: Dance Perspectives Foundation, 1962. 43 p., illus. (color), frontispiece.
Dance Perspectives, no. 15.

A detailed and scholarly description of the dance prints of the well-known nineteenth-century lithographers

Currier and Ives, and of dancers depicted in them. Written by the outstanding authority on the history of dance in America, the book includes a bibliography and a detailed checklist of prints.

Q138. **Moore, Lillian.** Some Early American Dancers. *The Dancing Times* (Aug. 1950): 668–71, illus.

[*See* Q122.]

Q139. **Wikoff, Henry.** The Reminiscences of an Idler. New York: Fords, Howard & Hulbert, 1880. 596 p., frontispiece.

An autobiographical account of America's first impresario, Chevalier Henry Wikoff, who is celebrated for having brought Fanny Elssler to America in 1840. Wikoff discusses his activities in America, Europe, and in the Near East from 1823 to 1880.

Q140. **Wood, William Burke.** Personal Recollections of the Stage: Embracing Notices of Actors, Authors, and Auditors during a Period of Forty Years. Philadelphia: H. C. Baird, 1855. 477 p.

A personal account of the rise and progress of drama in the southern theaters of Philadelphia, Baltimore, Washington, D.C., and Alexandria, Va., in the early nineteenth century. Written by the theater director at that time for the region, the account includes information on many contemporary dancers, among them Mme Celeste, Fanny Elssler, Augusta Maywood, and the Placide and Ravel families.

TWENTIETH CENTURY

[For individual choreographers of the twentieth century, *see* Q595 *et seq.* For individual dancers, *see* Q994 *et seq.*]

Q141. **Amberg, George.** Ballet in America: The Emergence of an American Art. New York: Duell, Sloan & Pearce, 1949. 244 p., illus.

This discussion of ballet includes a chronology, ballet repertories, and an index. Among dance personnel and companies considered by Amberg are Serge Diaghilev, Lincoln Kirstein, Agnes de Mille, Pavlova, Mordkin, Jerome Robbins, Michael Kidd, William Christiansen, Ballets Russes, Ballet Theatre, and Ballet International.

Q142. American Ballet Theatre: A Close-up in Time. Produced by Jac Venza. Directed by Jerome Schnur. Motion picture. 1973. 90 min.; sound, color, 16 mm.

[*See* Q858.]

Q143. Art of Choreography. Motion picture. New York: WCBS–TV, producing organization, 1956. 58 min.; sound, black and white, 16 mm.
From the CBS–TV series Omnibus.

Agnes de Mille discusses choreography, tracing its development from primitive and ethnic sources to its present place in theatrical dance. Included are a dance from the Congo (Charles Queenan), a Scottish sword dance (James

Jamieson), excerpts from *Les Sylphides* (Diana Adams, Sonia Arova, Frederic Franklin), and examples of Agnes de Mille's choreography: *Rodeo* (Jenny Workman and Frederic Franklin), *Oklahoma* (Kelly Brown), and an untitled pas de deux to music by Trude Rittman (Sonia Arova and James Mitchell). An extended sequence shows de Mille choreographing a new work (*Fall River Legend*) to music by Morton Gould.

Q144. **Bachardy, Don.** BALLET PORTRAITS. Santa Monica, Calif., 1966. illus. (portfol.).

Photographic portraits of members, both past and present, of the New York City Ballet.

Q145. **Balanchine, George, and Mason, Francis.** ONE HUNDRED AND ONE STORIES OF THE GREAT BALLETS. Garden City, N.Y.: Doubleday, 1975. 541 p.

Available in paperback only, this publication contains plots for fifty ballets from the standard repertory and fifty-one pieces that, because they have been choreographed since 1968, were not included in the EARLIER EDITION: Balanchine's *New Complete Stories of the Great Ballets* (Doubleday, 1968). [*See* Q569.]

Q146. **Ballet Society.** COLLECTION OF PROGRAMS AND PUBLICATIONS, 1946/1947 SEASON. New York, 1946-1947. 1 vol. (various pagination), illus.

Contains the *Bulletin* (nos. 1-4) of the Ballet Society and the programs and activities of the Ballet Society's 1946/1947 season. The Ballet Society, founded by Lincoln Kirstein, was a nonprofit membership organization created to encourage the lyric theater by the production of new works. This society was the predecessor of the New York City Ballet.

Q147. **Ballet Society.** A CONFERENCE ON BALLET, A NATIONAL MOVEMENT. New York: City Center of Music and Drama, 1960. 79 p.

The agenda of the conference, of which this is an abridged transcript, included sessions on patronage, the growth of a company, and the dances. Participants at the Nov. 25–26 meeting included Joseph B. Martinson, George Balanchine, Morton Baum, Lew Christensen, Lucia Chase, Janet Reed, and Lillian Moore.

Q148. **Barzel, Ann.** EUROPEAN DANCE TEACHERS IN THE UNITED STATES. *Dance Index* (Apr.–June 1944): 56–100, illus.

A comprehensive outline covering the period between 1672 and 1944. The influx of teachers during the twentieth century is especially well documented.

Q149. **Beiswanger, George W.** DANCE OVER U.S.A., PTS. 1 AND 2. *Dance Observer.* Pt. 1 (Jan. 1943): 4–5; Pt. 2 (Feb. 1943): 16–17.

[*See* Q355.]

Q150. CELEBRATION: DANCE AS A PHOTOGRAPHIC ART. DESIGN AND ART DIRECTION BY HERBERT MIGDOLL. New York: Danad Publishing Co., 1971–1972. 2 vols., illus.

The editors of *Dance Magazine* have selected extraordinary "photographic moments" and compiled a handsome volume of photographs of dancers.

Q151. THE DANCE ENCYCLOPEDIA. COMPILED AND EDITED BY ANATOLE CHUJOY AND PHYLLIS WINIFRED MANCHESTER, 2d ed. New York: Simon & Schuster, 1967. 992 p., illus.

[*See* Q31.]

Q152. **Chujoy, Anatole.** CIVIC BALLET. New York: Published for Central Service for Regional Ballets by *Dance News*, 1958. 30 p.

[*See* Q863.]

Q153. **Chujoy, Anatole.** THE NEW YORK CITY BALLET. PHOTOGRAPHS BY GEORGE PLATT LYNES, WALTER E. OWEN, AND FRED FEHL. New York: Alfred A. Knopf, 1953. 382 p., illus.

[*See* Q865.]

Q154. **Cohen, Selma Jeanne, and Pischl, A. J.** THE AMERICAN BALLET THEATRE: 1940–1960. Brooklyn, N.Y.: Dance Perspectives Foundation, 1960. 120 p., illus.

DANCE PERSPECTIVES, NO. 6.

[*See* Q24.]

Q155. **Cohen, Selma Jeanne.** AVANT-GARDE CHOREOGRAPHY, Pts. 1–3. *Dance Magazine.* Pt. 1 (June 1962): 22–24, 57; Pt. 2 (July 1962): 29–31, 58; Pt. 3 (Aug. 1962): 45, 54–56, illus.

[*See* Q358.]

Q156. **Hering, Doris, ed.** DANCE MAGAZINE: TWENTY-FIVE YEARS OF AMERICAN DANCE. New York: R. Orthwine, 1954. 236 p., illus.

[*See* Q446.]

Q157. **Deakin, Irving.** BALLET PROFILE. New York: Dodge Publishing Co., 1936. 368 p., illus.

A general history of the development of ballet in the twentieth century. Deakin is particularly concerned with the influence of Russian emigrés on the dance in the United States and uses biographical sketches of the artists, choreographers, and administrators in his discussion. Index.

Q158. **De Mille, Agnes.** APPRECIATION AND SUPPORT FOR THE THEATRE IN AMERICA. Phonotape. Washington, D.C.: Recorded at the Association for Childhood Education International, 1967. 53 min. 1 reel (7 in.) 3-3/4 in./sec. Dance Collection, The New York Public Library.

[*See* Q1295.]

Q159. **De Mille, Agnes.** THE BOOK OF THE DANCE. London and New York: Golden Press, 1963. 252 p., illus. (color).

[*See* Q369.]

Q160. **De Mille, Agnes.** THE DANCE IN AMERICA. Washington, D.C.: United States Information Service, 1971. 117 p., illus. (color).

[*See* Q370.]

Q161. **Denby, Edwin.** THE CRITICISM OF EDWIN DENBY. PHOTOGRAPHS BY WALKER EVANS. *Dance Index* (Feb. 1946): 28–56, illus.

[*See* Q1474.]

Q162. [BALANCHINE, GEORGE] *Ballet* 12 (Sept. 1952): 7–10, 13–23, illus.

The article in this London periodical includes three British views of the choreographer and his company, prompted by the New York City Ballet's 1952 London season: "Balanchine and American Classicism," by John Hall; "Balanchine's Plastic Virtues," by Ronald Wilson; and "Balanchine and Tradition," by A. V. Coton.

Q163. **Gruen, John.** THE PRIVATE WORLD OF BALLET. New York: Viking Press, 1975. 464 p., illus.

Based on the author's interviews with seventy dancers and choreographers. Includes conversations with representatives of the earlier generation, e.g. Alexandra Danilova, Leon Danielian, and Patricia Wilde; with contemporary members of American Ballet Theatre, New York City Ballet, and City Center Joffrey Ballet companies; and with choreographers Alvin Ailey, Glen Tetley, Eliot Feld, Arthur Mitchell, and Lar Lubovitch.

Q164. **Haggin, Bernard H.** BALLET CHRONICLE. New York: Horizon Press, 1970. 222 p., illus.

A collection of Haggin's previously published observations on the American ballet scene during the period between 1947 and 1970. Includes photographs. Much of the visual and textual material is devoted to the works of George Balanchine.

Q165. **Hassalevris [Constantine].** SOUVENIR DE BALLET. San Diego, Calif.: Hester & Smith, 1947. 124 p., illus.

Action photographs of thirty-eight ballets, taken from 1940 to 1945 by Hassalevris under the professional name of Constantine. Most of the photographs are of the Ballet Theatre, Ballet Russe de Monte Carlo, and Colonel de Basil's Ballet Russe companies.

Q166. **Himmel, Paul.** BALLET IN ACTION. TEXT BY WALTER TERRY. New York: G. P. Putnam's Sons, 1954. 178 p., illus.

Composite, sequential photographs of eight ballets from the repertoire of the New York City Ballet.

Q167. **Kirstein, Lincoln.** BLAST AT BALLET: A CORRECTIVE FOR THE AMERICAN AUDIENCE. New York: Marstin Press, 1938. 128 p.

A candid opinion of conditions under which the dance and ballet existed in the United States during this period. The book includes sections on the history of ballet in America; the roles of various personnel in producing ballet; the principles of classic dance; ballet production

and performance; the repertoires of various companies. REPRINTED in the author's *Three Pamphlets Collected* (Brooklyn: Dance Horizons, 1967).

Q168. **Kirstein, Lincoln.** CRISIS IN THE DANCE. *North American Review* 243 (spring 1937): 80–103.

[*See* Q936.]

Q169. **Kirstein, Lincoln.** MOVEMENT AND METAPHOR: FOUR CENTURIES OF BALLET. New York: Praeger Publishers, 1970. 290 p., illus.

This important study surveys four centuries of ballet, relating choreographic developments to parallel developments in art, philosophy, politics, and the history of ideas. Five introductory chapters analyze the components of a ballet production (choreography, mimetic gesture, music, costumes, and scenery). Also includes summaries of fifty key works. American works represented are: *Fancy Free,* 1944; *Orpheus,* 1948; and *Agon,* 1957. Accompanying the text are some four-hundred illustrations.

Q170. **Kirstein, Lincoln.** THE NEW YORK CITY BALLET. PHOTOGRAPHS BY MARTHA SWOPE AND GEORGE PLATT LYNES. New York: Alfred A. Knopf, 1973. 261 p., illus.

[*See* Q883.]

Q171. **Kirstein, Lincoln.** OUR BALLET AND OUR AUDIENCE. *The American Dancer* (July 1938): 22–23, illus.

An early and an informative essay on the popularity and acceptance of ballet among American audiences. Kirstein illustrates his points through a discussion of the tours of the Ballet Caravan. The author feels that instead of trying to imitate the Russian repertory style, American companies must find their own formulae and invent their own ballets. An article of historical importance.

Q172. **Kirstein, Lincoln.** WHAT BALLET IS ABOUT: AN AMERICAN GLOSSARY. PORTFOLIO OF PHOTOGRAPHS OF THE NEW YORK CITY BALLET BY MARTHA SWOPE. Brooklyn: Dance Perspectives Foundation, 1958. 80 p., illus.

DANCE PERSPECTIVES, NO. 1.

Precise definitions of many terms related to theatrical dancing and their historical backgrounds for the American audience.

Q173. **Koegler, Horst.** MODERNES BALLETT IN AMERIKA. Berlin: Rembrandt-Verlag, 1959. 65 p., illus.

A brief history of American twentieth-century ballet and modern dance as seen from a European's point of view.

Q174. **Kraus, Richard G.** HISTORY OF THE DANCE IN ART AND EDUCATION. Englewood Cliffs, N.J.: Prentice-Hall, 1969. 371 p., illus.

Intended for a general and scholarly audience. Provides an analysis of the history of dance through the ages, tracing its role as religious ritual, art form, and popular entertainment, and viewing it in relation to the social context

of each period. Also presents a contemprary examination of theater dance, particularly American theater dance, and discusses the newer modern dance and ballet companies and growing government and private foundation support to the performing arts. Includes a review of dance education.

Q175. **Krokover, Rosalyn.** THE NEW BORZOI BOOK OF BALLETS. New York: Alfred A. Knopf, 1956. 320 p., illus.

Plots and brief histories of fifty-seven ballets, including the older classics, such as *Sleeping Beauty*, as well as major twentieth-century works. The author has also inserted an introductory essay, "Looking at Ballet." An appendix provides a comprehensive list of ballets performed in the United States by the four major American-based companies active since 1933: Ballets Russes, Ballet Theatre, New York City Ballet, and the Marquis de Cuevas Grand Ballet de Monte Carlo. Index of names and titles. [For EARLIER EDITION, *see* Q182.]

Q176. **La Roche, Nancy.** HARTFORD BALLET: KICKING THE OLD IMAGE. *Dance Magazine.* (Feb. 1975): 42–47, illus.

[*See* Q886.]

Q177. **Maracci, Carmelita.** THE SYMBOLIC AND PSYCHOLOGICAL ASPECTS OF THE DANCE. In: SORELL, WALTER, ED. THE DANCE HAS MANY FACES. 2d ed. New York: Columbia University Press, 1966. p. 103–112.

A discussion of "meaningless" symbolism in American ballet and modern dance. The author feels strongly that dance "springs forth from immediacy and embraces universal experiences." Text also in FIRST EDITION (New York: World Publishing Co.), 1951 [Q375].

Q178. **Maynard, Olga.** THROUGH A GLASS BRIGHTLY; A LOOK AT AMERICAN BALLET THEATRE TODAY. *Dance Magazine* (June 1970): 48–63, illus.

An anecdotal account of the company's current repertoire, its choreographers, and its dancers. Cynthia Gregory, a dancer in the company, is discussed at length.

Q179. MODERN BALLET. NARRATED BY MARTHA MYERS. PRODUCED BY JAC VENZA. CHOREOGRAPHED BY ANTONY TUDOR. MUSIC BY TCHAIKOVSKY, SCHÖNBERG, FREDERICK DELIUS, AND WILLIAM SCHUMAN. Motion picture. Boston: WGBH–TV, producing organization, 1959. 29 min.; sound, black and white, 16 mm. FROM THE WGBH–TV SERIES A TIME TO DANCE.

[*See* Q841.]

Q180. NEW YORK CITY BALLET. PRODUCED BY JAC VENZA. CHOREOGRAPHED BY GEORGE BALANCHINE. COSTUMES BY KARINSKA. MUSIC BY STRAVINSKY, LOUIS GOTTSCHALK, AND TCHAIKOWSKY. Motion picture. New York: WNET–TV, producing organization, 1965. 30 min.; sound, black and white, 16 mm.

[*See* Q900.]

Q181. **Peralta, Delfor.** JEROME ROBBINS INTERVIEWED. *Dance Magazine* (Dec. 1959): 72–73, 118–19, illus.

[*See* Q795.]

Q182. **Robert, Grace.** THE BORZOI BOOK OF BALLETS. New York: Alfred A. Knopf, 1949. 362 p., illus., frontispiece, facsims.

A critical analysis of sixty-three ballets for American audiences. Includes historical backgrounds, plots, first performance, casts, and photographs. Glossary. [For REVISED EDITION, *see* Q175.]

Q183. **Terry, Walter.** INTERVIEW WITH NORMAN WALKER. Phonotape. New York: WNYC, broadcaster, 1965. 24 min.; 1 reel (7 in.) 7-1/2 in./sec. Dance Collection, The New York Public Library. FROM THE WNYC SERIES INVITATION TO DANCE.

[*See* Q592.]

Q184. **Terry, Walter.** INTERVIEW-DEMONSTRATION WITH MELISSA HAYDEN AND JOHN KRIZA. Phonotape. New York, 1953. 51 min. 1 reel (5 in.) 3-3/4 in./sec. Dance Collection, The New York Public Library. FROM A DANCE LABORATORY HELD AT THE YM-YWHA, NEW YORK.

[*See* Q1101.]

Q185. **Terry, Walter, and Rennert, Jack.** ONE HUNDRED YEARS OF DANCE POSTERS. New York: Avon Publishing Co.; by arrangement with Darien House, 1975. 112 p., illus. (color).

[*See* Q1324.]

Q186. Washington, D.C. **United States Information Agency.** BALLETT UND BÜHNENTANZ IN AMERIKA. Frankfurt am Main, 1958? 32 p., illus.

A booklet prepared by the United States Information Service on ballet and stage dance in America. Includes short biographies of dancers, choreographers, and directors. Bibliography.

Q187. **Van Vechten, Carl.** THE DANCE WRITINGS OF CARL VAN VECHTEN. EDITED AND WITH AN INTRODUCTION BY PAUL PADGETTE. Brooklyn, N.Y.: Dance Horizons, 1974. 182 p., illus.

[*See* Q441.]

Q188. BALLET IN AMERICA, 1939–1945: A CHECKLIST. COMPILED BY RUTHELLA WADE. *The Ballet Annual* 1 (1947): 151–59. illus.

A chronological listing of ballet repertoires and personnel of the foremost American companies of this period: Ballet Russe de Monte Carlo (Serge Denham, director), Foxhole Ballet; Ballet Russe Highlights (Léonide Massine, director); Ballet Theatre; San Francisco Ballet; Ballet International.

Q189. **Wood, Roger.** THE NEW YORK CITY BALLET: IN

ACTION. Mitcham, Surrey, Eng.: Saturn Press, 1953 (?). 48 p., illus.

[See Q920.]

BLACK DANCE

Q190. **Arvey, Verna.** NEGRO DANCE AND ITS INFLUENCE ON NEGRO MUSIC. In: DE LERMA, DOMINIQUE-RENÉ. BLACK MUSIC IN OUR CULTURE: CURRICULAR IDEAS ON THE SUBJECTS, MATERIALS, AND PROBLEMS. Kent, Ohio: Kent State University Press, 1970. p. 79–92, music.

Traces the origins of Negro dance in Africa, its diffusion in Latin America and the United States, and its influence on the American ballet scene. Includes discussion of various kinds of dance and music; Negro dancers instrumental in bringing native dances to the New York stage (Asadata Dafora, Pearl Primus, Katherine Dunham, Syvilla Fort, Mary Hinkson, and Alvin Ailey); and black composers of dance music.

Q191. BALLY-HOO CAKEWALK. Motion picture. New York: American Mutascope and Biograph Co., producing organization, 1903. 42 sec.; silent, black and white, 16 mm. Library of Congress.

A group of Negro men and women perform a cakewalk. Deposited for copyright with the Library of Congress in the form of paper prints.

Q192. BLACKS IN THE ARTS. Phonotape. New York: Science Research Associates, 1975. 60 min. No. 3-11435. 1 cassette. Dance Collection, The New York Public Library.

[See Q1104.]

Q193. **Buckle, Richard, ed.** KATHERINE DUNHAM: HER DANCERS, SINGERS, MUSICIANS. PHOTOGRAPHS BY ROGER WOOD ET AL. London: Ballet Publication, 1949. 79 p., illus.

[See Q80.]

Q194. COMEDY CAKEWALK. Motion picture. New York: American Mutascope and Biograph Co., producing organization, 1903. 27 sec.; silent, black and white, 16 mm.

Three black men and two black women, all formally attired, perform the preliminaries to the cakewalk.

Q195. DANCE HERALD: A JOURNAL OF BLACK DANCE. New York. 1— (summer 1975—), illus.

[See Q52.]

Q196. **Duke, Jerry.** CLOGGING IN THE APPALACHIAN MOUNTAINS. *Let's Dance* (Apr. 1974): 12–15, illus.

A discussion of the black influence on Appalachian dance.

Q197. **Dunham, Katherine.** THE DANCES OF HAITI.

Mexico, 1947. 60 p., illus.

[See Q82.]

Q198. **Dunham, Katherine.** KATHERINE DUNHAM'S JOURNEY TO ACCOMPONG. DRAWINGS BY TED COOK. New York: H. Holt, 1946. 162 p., illus.

[See Q81.]

Q199. **Emery, Lynne Fauley.** BLACK DANCE IN THE UNITED STATES FROM 1619 TO 1970. Palo Alto, Calif.: National Press Books, 1972. 370 p., illus.

An analysis of black dance, with emphasis on its place in the African aesthetic experience. Bibliography.

Q200. ETHNIC DANCE: ROUNDTRIP TO TRINIDAD. CONCEIVED AND WRITTEN BY MARTHA MYERS. DIRECTED BY GREG HARNEY. PRODUCED BY JAC VENZA. CHOREOGRAPHED BY GEOFFREY HOLDER. Motion picture. Boston: WGBH–TV, producing organization, 1959. 29 min.; sound, black and white, 16 mm. FROM THE WGBH-TV SERIES A TIME TO DANCE.

[See Q84.]

Q201. THE FEET. New York. 1–3 (Dec. 1970–June 1973), illus.

[See Q61.]

Q202. **Harnan, Terry.** AFRICAN RHYTHM, AMERICAN DANCE: A BIOGRAPHY OF KATHERINE DUNHAM. New York: Alfred A. Knopf, 1974. 213 p., illus.

The life of the famous black dancer and anthropologist. Based in part on personal interviews, the book stresses her awareness and encouragement of increasing participation of blacks in the arts.

Q203. THE HISTORY OF JAZZ DANCING. Motion picture. San Francisco: KQED–TV, producing organization, 1970. 56 min.; sound, black and white, 16 mm.

[See Q541.]

Q204. Carbondale, Ill. **Southern Illinois University Library.** KATHERINE MARY DUNHAM PAPERS, 1919–1968. 1970. 22 leaves.

[See Q664.]

Q205. **Isaacs, Edith Juliet Rich.** THE NEGRO IN THE AMERICAN THEATRE. New York: Theatre Arts, 1947. 143 p., illus.

A handsomely illustrated and important historical study of black performers in theater, dance, and music. Included is a discussion of black artists in the Federal Theatre Project. No index.

Q206. **Krehbiel, Henry Edward.** AFRO-AMERICAN FOLKSONGS: A STUDY IN RACIAL AND NATIONAL MUSIC. New York: G. Schirmer, 1914. 176 p.

The chapter on "Dances of the American Negroes" deals with Creole music, native African dances, and the influence of Spain and the West Indies (The Antilles,

Habanera, and Martinique). Includes song and dance music.

Q207. Manchester, Phyllis Winifred. ALVIN AILEY: PROFILE. *The Dancing Times* (Oct. 1964): 10–11, illus.

A brief essay in this London periodical on the black American modern dancer choreographer Alvin Ailey and the repertoire of his company, the Alvin Ailey Dance Theatre.

Q208. Martin, John Joseph. BOOK OF THE DANCE: THE STORY OF THE DANCE IN PICTURES AND TEXT. New York: Tudor Publishing Co., 1963. 192 p., illus.
[*See* Q1011.]

Q209. Maynard, Olga. ARTHUR MITCHELL AND THE DANCE THEATER OF HARLEM. *Dance Magazine* (Mar. 1970): 52–63, illus.
[*See* Q898.]

Q210. Nathan, Hans. DAN EMMETT AND THE RISE OF EARLY NEGRO MINSTRELSY. Norman: University of Oklahoma Press, 1962. 496 p., illus., facsims.

This biography includes an account of Negro minstrelsy in America, stressing its early period. Includes material on Negro impersonations and songs in late eighteenth-century England and America, and the development in this country of the minstrel band and syncopation. Of particular interest are the chapters, "Indigenous Negro Minstrel Types (1820–1840)" and "Negro Minstrel Dances." Contains illustrations and an anthology of minstrel songs and banjo tunes of the 1840s and 1850s.

Q211. THE NEGRO IN THE PERFORMING ARTS. In: PLOSKI, HARRY A., AND BROWN, ROSCOE C., JR., COMPS. THE NEGRO ALMANAC. New York: Bellwether Publishing Co., 1967. p. 700–732, illus.

Includes biographies of Alvin Ailey, Josephine Baker, John Bubbles, Katherine Dunham, Florence Mills, Pearl Primus, and Bill Robinson.

Q212. New York. **The New York Public Library.** SCHOMBURG COLLECTION OF NEGRO LITERATURE AND HISTORY: DICTIONARY CATALOG. Boston: G. K. Hall & Co., 1962. 9 vols.
[*See* Q20.]

Q213. RIGHT ON. DIRECTED BY ANN HALPRIN. Motion picture. San Francisco: KQED–TV, producing organization, 1969. 30 min.; sound, black and white, 16 mm.

A documentary on the week of confrontation sessions of two workshop groups in San Francisco: Studio Watts, School for the Arts, located in Los Angeles, and Dancer's Workshop of San Francisco. The purpose of the workshops was to use dance to work through black/white racial barriers and to prepare a choreographic work, *A Ceremony of Us*, based on these sessions.

Q214. Seldes, Gilbert Vivian. THE SEVEN LIVELY ARTS. Rev. ed. New York: Sagamore Press, 1957. 306 p., illus.

An airing of the author's controversial views on the arts and entertainment. Seldes believes "that entertainment of a high order existed in places not usually associated with Art, that the place where an object was to be seen or heard had no bearing on its merits,…that a comic strip might be as worthy of a second look as a considerable number of canvases at most of our museums." The edition under consideration contains a new introduction and commentary by the author. *Contents include* chapters on classical and popular music, Broadway, ballroom and exhibition dancing, burlesque, and film. FIRST EDITION (New York and London: Harper, 1924), 398 p., illus. Index.

Q215. SHANGO. FILMED AND EDITED BY FRITZ HENLE. Motion picture. 1953. 10 min.; sound, black and white, 16 mm.

Geoffrey Holder and his company perform authentic African dances that have made their way to Trinidad.

Q216. Siegel, Marcia B. AT THE VANISHING POINT: A CRITIC LOOKS AT DANCE. New York: Saturday Review Press, 1972. 320 p., illus.
[*See* Q1448.]

Q217. Sorell, Walter, ed. THE DANCE HAS MANY FACES. 2d ed. New York: Columbia University Press, 1966. 276 p., illus.
[*See* Q428.]

Q218. Southern, Eileen. THE MUSIC OF BLACK AMERICANS: A HISTORY. New York: W. W. Norton & Co., 1971. 552 p., illus., facsims., music.

An excellent, well-documented work concerned with the musical activities of blacks in the United States from the colonial period to modern times. This chronicle traces the social, political, and economic forces that helped to shape the development of Negro music. Each chapter is preceded by a chronology of important events, which provides a useful framework on which the history is constructed. Includes much material on dance and dance music. Extensive bibliography; discography; and index.

Q219. TAP HAPPENING. FILMED BY EUGENE MARNER UNDER THE SUPERVISION OF LETICIA JOY. Motion picture. New York: For the Dance Collection at the Bert Wheeler Theatre, 1969. 40 min.; sound, black and white, 16 mm. Dance Collection, The New York Public Library.
[*See* Q543.]

Q220. Terry, Walter. THE DANCE IN AMERICA. Rev. ed. New York: Harper & Row, 1971. 272 p., illus.
[*See* Q433.]

Q221. Terry, Walter. INTERVIEW-DEMONSTRATION WITH PEARL PRIMUS: THE ART OF PERFORMING. Phonotape. New York, 1953. 51 min. 1 reel (5 in.) 3-3/4 in./sec. Dance Collection, The New York Public Library.

FROM A DANCE LABORATORY HELD AT THE YM–YWHA, NEW YORK.

[See Q784.]

Q222. **Terry, Walter.** INTERVIEW WITH ALVIN AILEY. Phonotape. 1969(?) 45 min. 1 reel (7 in.) 3-3/4 in./sec. Dance Collection, The New York Public Library.

[See Q597.]

Q223. **Terry, Walter.** THE STORY OF NEGRO DANCE IN AMERICA: LECTURE. Phonotape. New London, Conn.: Recorded at Connecticut College School of Dance, Aug. 14, 1963. 50 min. 1 reel (5 in.) 3-3/4 in./sec. Dance Collection, The New York Public Library.

Contents include a stereotyped traditional image of the black man; famous black dancers and white blackface dancers of the nineteenth century; tap dancing; black revues, 1895–1910; blackface dancers in two Danish ballets; Katherine Dunham; Pearl Primus; interracial dance companies; Josephine Baker; black and interracial musical comedies; black modern and ballet dancers; appropriate use of black and white dancers.

Q224. **Todd, Arthur.** AMERICAN NEGRO DANCE: A NATIONAL TREASURE. *The Ballet Annual* 16 (1962): 92–105, illus.

A survey in this London periodical of leading black American dancers, from Juba (William Henry Lane) in 1781 to artists in 1962.

Q225. **Toll, Robert C.** BLACKING UP: THE MINSTREL SHOW IN NINETEENTH-CENTURY AMERICA. New York: Oxford University Press, 1974. 310 p., illus.

A detailed history of the minstrel show, which swept the nation in the 1840s and remained the most popular form of entertainment in the United States for over half a century. Explains the social and entertainment contexts from which minstrelsy emerged and its evolution as an institution. Emphasizes the formative role that minstrelsy, both black and white, played in the development of American show business. Bibliography of primary and secondary sources; index.

Q226. **Van Vechten, Carl.** THE DANCE WRITINGS OF CARL VAN VECHTEN. EDITED AND WITH AN INTRODUCTION BY PAUL PADGETTE. Brooklyn, N.Y.: Dance Horizons, 1974. 182 p., illus.

[See Q441.]

Q227. **Winter, Marian Hannah.** JUBA AND AMERICAN MINSTRELSY. *Dance Index* (Feb. 1947): 28–47, illus.

A brief but well illustrated historical account of the origins and development of Negro and blackface minstrelsy written by a well-known writer and dance historian.

COMPUTER DANCE

Q228. **Le Vasseur, Jean, and Beaman, Jeanne.** COM-PUTER DANCE: THE ROLE OF THE COMPUTER; IMPLICATIONS OF THE DANCE. *Impulse* (1965): 25–28.

Examines the potential of computer dance, using the results of an experiment conducted at the University of Pittsburgh. [For more on *Impulse, see* Q62.]

Q229. A COMPUTER-GENERATED BALLET. CHOREO-GRAPHED BY A. MICHAEL NOLL. Motion picture. Murray Hill, N.J.: Bell Telephone Laboratories, 1966(?). 4 min.; silent, black and white, 16 mm.

Stick figures move in patterns determined by the computer program. Dance steps are not shown, but changes in floor pattern, body direction, and arm movements are indicated.

ESKIMO DANCE

Q230. **Hawkes, Ernest William.** THE DANCE FESTIVALS OF THE ALASKAN ESKIMO. University of Pennsylvania, University Museum, *Anthropological Publications* 6 (1941): 41 p., illus.

A study of the ceremonial dance feasts of the Eskimos, based on three years of research in the Bering Strait district.

FIGURE AND DANCE SKATING

Q231. **Boeckl, Wilhelm Richard.** WILLY BOECKL ON FIGURE SKATING. New York: Moore Press, 1937. 212 p., illus.

A discussion of dance-skating style. Includes instructions, with diagrams, for figures.

Q232. THE CHRYSLER RAINBOW OF STARS. DIRECTED BY CLARK JONES. Motion picture. New York: WNBC–TV, broadcaster, 1962. 59 min.; sound, black and white, 16 mm.

Includes Carol Lawrence and Nancy Walker in production numbers, choreographed by Tony Charmoli; Dick Button in an ice-skating solo; the Radio City Music Hall Rockettes, choreographed by Russell Markert and Emilia Sherman; an ice ballet featuring Dick Button, with choreography by John Butler; the Radio City Music Hall corps de ballet, with choreography by Margaret Sande.

Q233. **Claus, Basil.** SKATING AS DANCE AND THEATRE. *Dance Magazine* (Dec. 1942): 20, 21, 24, illus.

An essay on the popularity of ice skating as a performing art.

Q234. **Martin, John Joseph.** ON THE ICE: FIGURE SKATING AS A CHOREOGRAPHIC ART FORM. *New York Times,* Mar. 13, 1938.

The author describes ice ballet as a dance art rather than as a sport. Although he feels there are many superb figure

skaters, Martin argues the need for choreographers and a repertoire of distinction.

Q235. **Ogilvie, Robert S.** BASIC ICE-SKATING SKILLS: AN OFFICIAL HANDBOOK PREPARED FOR THE UNITED STATES FIGURE SKATING ASSOCIATION. Philadelphia: J. B. Lippincott Co., 1968. 176 p., illus., diagrs.

Written for those who wish to understand the fundamental skills of figure and dance skating. There are chapters on preliminary skills and equipment, fundamentals, dance movements, and basic figures. Glossary and index.

Q236. **Owen, Maribel Vinson.** THE FUN OF FIGURE SKATING: A PRIMER OF THE ART SPORT. New York: Harper & Row, 1960. 167 p., illus., diagrs.

Written by a former member of the United States Olympic Figure Skating Team. Includes chapters on free skating and on ice dances, with directions and diagrams.

Q237. **Radspinner, William Ambrose.** SKATING AND SKATE DANCING. New York: By the author, 1950. 102 p., illus.

An excellent pamphlet offering a course on the "international style" of figure skating. Attempts to standardize the ideas of the best amateurs and professionals on fundamentals, steps, holds, dances, and program numbers. Includes thirty-six dances, with diagrams and directions. Index of dances.

Q238. **United States Figure Skating Association.** ICE DANCES: FIGURES AND EXERCISES. Boston, 1966. 90 p., diagrs.

For advanced skaters. Not part of the organization's official rulebook or dance test structure. Includes directions and diagrams for ice dances to be performed to fox trot, march, polka, rhumba, samba, tango, and waltz music. The purpose of this manual is to foster interest and proficiency in ice dancing.

FOLK DANCE

Q239. AMERICAN SHOW. DIRECTED BY ROBERT W. STUM. NARRATED BY MARY BEE JENSEN. Motion picture. Provo, Utah: Department of Motion Picture Productions, Brigham Young University, 1975. 35 min.; sound, color, 16mm.

Dances include Oh, Susanna and the Virginia Reel; running sets, round dance and contras; Smoky Mountain and tap clogs (choreography: Mary Bee Jensen); *Devil's Dream* (choreography: Ann Dirkson); an exhibition square dance (choreoography: Mary Bee Jensen, caller: Don R. Allen); Carolina clogs, Charleston (choreography: Mary Bee Jensen and Don R. Allen); *Swing,* (choreography: Mike Allred); *Saturday Nite Stroll* (choreography: Mike Hamblin). Filmed for the Jerome Robbins Film Archive with the assistance of a grant from the National Endowment for the Arts. Performed by the Brigham Young University International Folk Dancers.

Q240. **Anderson, John Q.** FROLIC: SOCIAL DANCING ON THE SOUTHERN FRONTIER. A DELIGHTFUL, SERIOUS STUDY OF PLEASURIN' AN' SHUFFLIN' AN' CUTTIN' THE PIGEON'S WING, AN' SECH., PTS. 1 AND 2. *Dance Magazine.* Pt. 1 (Oct. 1956): 14–16, 83, 85; Pt. 2 (Nov. 1956): 35, 80–81, illus.

A brief survey of frontier fiddlers, tunes, and types of dances. Includes a description of the evolution of dances in Arkansas, North Carolina, Louisiana, Georgia, Missouri, and Texas, from 1775 to 1854. Bibliography.

Q241. **Beiswanger, George W.** DANCE OVER U.S.A., PTS. 1 AND 2. *Dance Observer.* Pt. 1 (Jan. 1943): 4–5; Pt. 2 (Feb. 1943): 16–17.

[*See* Q355.]

Q242. **Boyd, Neva Leona, and Dunlavy, Tressie M.** OLD SQUARE DANCES OF AMERICA. Chicago, 1925. 96 p.

[*See* Q525.]

Q243. **Briggs, Dudley Towle.** THIRTY CONTRAS FROM NEW ENGLAND. Burlington., Mass., 1953. 77 p., illus., music.

A collection of descriptions and timed calls for thirty-four contra dances with eight chapters on various aspects of this style of dancing.

Q244. **Burchenal, Elizabeth.** AMERICAN COUNTRY DANCES. PIANO ARRANGEMENT BY EMMA HOWELLS BURCHENAL. New York, 1918. 1 vol., diagrs., frontispiece, folio.

An annotated compilation of contra dances (largely from the New England states) by this distinguished dance teacher, anthropologist, and early collector of Americana.

Q245. **Czarnowski, Lucile Katheryn.** DANCES OF EARLY CALIFORNIA DAYS. Palo Alto, Calif.: 1950. 159 p., illus., diagrs.

Dance descriptions, with music, songs, and social settings. Bibliography.

Q246. **Damon, Samuel Foster.** THE HISTORY OF SQUARE DANCING. Barre, Mass.: Barre Gazette, 1952. p. 63–89.

[*See* Q529.]

Q247. **Duggan, Anne Schley; Schlottmann, Jeanette; and Rutledge, Abbie.** THE FOLK DANCE LIBRARY. New York, 1948. 5 vols., illus. (color), music, maps.

The authors describe folk dances of Europe, the British Isles, the United States, and Mexico. Includes music and instructions. Bibliographies.

Q248. **Duke, Jerry.** CLOGGING IN THE APPALACHIAN MOUNTAINS. *Let's Dance* (Apr. 1974): 12–15, illus.

[*See* Q196.]

Q249. **Durlacher, Edward.** HONOR YOUR PARTNER: EIGHTY-ONE AMERICAN SQUARE, CIRCLE AND CON-

TRA DANCES, WITH COMPLETE INSTRUCTIONS FOR DOING THEM. MUSICAL ARRANGEMENTS BY KEN MACDONALD. PHOTOGRAPHS BY IRA ZASLOFF. New York: Bonanza Books, 1949. 286 p., illus., music.

[See Q530.]

Q250. **Hausman, Ruth L., comp.** SING AND DANCE WITH THE PENNSYLVANIA DUTCH. ILLUSTRATED BY FRANCES LICHTEN. New York: E. B. Marks, 1953. 112 p., illus.

A description of the historical background of the Pennsylvania Dutch, of whom there are three principal groups: the Plain People, the Church People, and the Moravians. Hausman provides translations, commentary, and directions for the dances.

Q251. **Lea, Aurora Lucero-White, comp.** FOLK DANCES OF THE SPANISH COLONIALS OF NEW MEXICO. Examiner Publishing Co., 1937. 46 p., diagrs.

Includes tunes, directions, patterns, descriptions, and music for an important and popular pastime in colonial America.

Q252. **Mayo, Margot.** THE AMERICAN SQUARE DANCE. New York: Sentinel Books, 1943. 111 p., illus., music.

An introduction to American square dance. Includes descriptions of types of American square dances, hints to callers, an illustrated glossary, and directions for dances with calls and accompanying illustrations. Bibliography.

Q253. PENNSYLVANIA DUTCH DANCES. Motion picture. Philadelphia: Filmed for the Philadelphia Academy in a project for the United States Office of Education and the University of Pennsylvania, ca. 1966. 11-1/2 min.; sound, color, 16 mm.

[See Q533.]

Q254. **Ryan, Grace Laura, ed.** DANCES OF OUR PIONEERS. MUSIC ARRANGEMENTS BY ROBERT T. BENFORD. ILLUSTRATIONS BY BROOKS EMERSON. New York: A. S. Barnes, 1939. 196 p., illus.

An excellent work containing the music and description of authentic American folk dances (chiefly square dances). Includes term definitions, directions, and calls. Index and list of sources for the music. *Supersedes* the author's earlier publications: *The Handbook for Dances of Our Pioneers*, and *Music for Dances of Our Pioneers*, both New York: A. S. Barnes, 1926.

Q255. **Shaw, Lloyd.** COWBOY DANCES: A COLLECTION OF WESTERN SQUARE DANCES. Rev. ed. Caldwell, Id.: Caxton Printers, 1952. 417 p., illus., diagrs., music.

This book, now considered a classic, was the first attempt to gather in one volume the calls and directions for the square, round, symmetrical, and intermingling dances. A personal, chatty manual celebrating the dances, as "a living bit of the colorful days of the Old West." Includes music for the piano, a chapter on phonograph records, a glossary of terms, and an index.

Q256. **Smith, Frank H., and Hovey, Rolf E.** THE APPALACHIAN SQUARE DANCE. SKETCHES BY MARY ROGERS. PHOTOGRAPHS BY DORIS ULMANN AND MATTSON STUDIO. Berea, Ky.: Berea College, 1955. 86 p., illus., music.

A study of the background and history of Appalachian dancing, describing the function of the caller and the art of the dance teacher. It contains a large collection of dance figures, calls, and tunes.

Q257. **Tolman, Beth.** THE COUNTRY DANCE BOOK. Weston, Vt.: Countryman Press; and New York: Farrar & Rinehart, 1937. 192 p., illus., music.

Descriptions of and instructions for square dances and their variations, accompanied by history and lore. Illustrated with line drawings. Bibliography and discography.

Q258. **Works Progress Administration.** DANCE INDEX: AN ANNOTATED INDEX IN BIBLIOGRAPHICAL FORM OF DANCE REFERENCES, COMPOSED OF SOURCE MATERIAL EXTRACTED FROM VARIOUS WORKS ON ANTHROPOLOGY, ETHNOLOGY, COMPARATIVE RELIGION, TRAVEL, AND THE ARTS, CONTAINED IN INSTITUTIONAL LIBRARIES OF GREATER NEW YORK. New York: Dance Collection The New York Public Library, ca. 1936; card file, 45 drawers.

[See Q46.]

Q259. **Wolford, Leah Jackson.** THE PLAY-PARTY IN INDIANA: A COLLECTION OF FOLKSONGS AND GAMES WITH DESCRIPTIVE INTRODUCTION AND CORRELATING NOTES. Indianapolis: Indiana Historical Commission, 1916. 120 p., illus., music, diagrs.

A collection of traditional songs and accompanying games. Historical introduction on the origins and social environment from which the play-party emerged. Includes tunes, words, and directions. Bibliography.

NORTH AMERICAN INDIAN DANCE

Q260. AMERICAN INDIAN DANCES. FILMED BY PORTIA MANSFIELD. Motion picture. n.d. 18 min.; silent, color, 16 mm.

Excerpts of Indian dances: Acoma harvest dance, Tesuque eagle dance, San Ildefonso harvest dance, San Juan rain dance, Taos war dance, Santa Clara rain basket dance, and Cochiti parrot dance.

Q261. New York. **The American Museum of Natural History.** *Anthropological Papers.* Vols. 11, 16. New York: The Trustees, 1912–1921., illus.

Vol. 11 contains articles on the dancing and ceremonial societies and associations of the North American Plains Indians; vol. 16, articles on the sun dance of the Plains Indians.

Q262. AN INTRODUCTION TO AMERICAN INDIAN

DANCE. Motion picture. Philadelphia: Filmed for the Philadelphia Dance Academy in a project for the United States Office of Education, ca. 1966. 13 min.; sound, color, 16 mm.

The purpose of this film is to develop a comprehensive graded curriculum in dance for secondary schools. Includes the Papago straight war dance steps and fancy war dance steps; excerpts from the eagle dance, the deer dance, the cloud dance, the bow and arrow dance, the pan-Indian dance, and the harvest dance.

Q263. APACHE MOUNTAIN SPIRIT DANCE. INTRODUCTION BY PHILIP CASADORE, PRESIDENT OF THE TRIBAL COUNCIL. FILMED FOR STUDY AND PRESERVATION PURPOSES FOR THE DANCE COLLECTION BY GARDNER COMPTON AND EMILE ARDOLINO. Motion picture. San Carlos Apache Reservation, 1971. 11 min.; sound, color, 16 mm. Dance Collection, The New York Public Library.

A healing dance performed on the last day of the female puberty ceremony. Also known as the crown dance, or the devil dance.

Q264. APACHE PUBERTY RITES FOR A YOUNG WOMAN. Motion picture. San Carlos Apache Reservation, 1961. 18 min.; silent (at sound speed), color, 16 mm.

Includes the mountain spirit dance [*See* Q263].

Q265. **Austin, Mary.** AMERICAN INDIAN DANCE DRAMA. *The Yale Review* 19 (June 1930): 732–45.

An early plea for the retention by the Southwest Indians of the ceremonial dance-drama. The author believed that "the native material is in shape to be accepted and used by the professional theater without scholarly intervention" and that "if the American stage were opened to it, Amerind drama would flow naturally towards legitimate theatrical expression." Includes substantial descriptions and analyses of the Taos deer dance, the dance of the emergence at San Felipe Pueblo, and the corn dance, as well as the various nonreligious pageants and burlesques of white life.

Q266. **Austin, Mary.** GESTURE IN PRIMITIVE DRAMA. *Theatre Arts* (Aug. 1927): 594–605, illus.

A discussion of the survival of universal gesture from primitive times, its use in Greek and in Indian dramas and rituals, and in modern drama of today. Gesture as speech is discussed, and several American Indian dances are described.

Q267. **Austin, Mary.** FOLK PLAYS OF THE SOUTHWEST. *Theatre Arts* (Aug. 1933): 599–606, illus.

A discussion of Southwest Indian dance-plays, some with origins as early as the 1500s. Includes a description of thematic material, performance season, staging, and the possible influence of Spanish drama.

Q268. **Bad Heart Bull, Amos.** A PICTOGRAPHIC HISTORY OF THE OGLALA SIOUX. TEXT BY HELEN H. BLISH. Lincoln: University of Nebraska Press, 1967. 530 p., illus. (color), facsims.

Photographic reproductions of 415 drawings by Amos Bad Heart Buffalo with a text by Helen Blish. The manuscript was begun in 1890 and completed at the artist's death in 1913. Bibliography.

Q269. **Barrett, Samuel Alfred.** THE DREAM DANCE OF THE CHIPPEWA AND MENOMINEE INDIANS OF NORTHERN WISCONSIN. Milwaukee Public Museum, *Bulletin* 1 (1911): 251–406, illus.

Partial contents: a detailed description of the dream dance; a comparison of the dream dance to the ghost dance; and an account of the dream dance held at Whitefish on the Lac Courte Oreilles Reservation of the Chippewa in northern Wisconsin in 1910.

Q270. **Barrett, Samuel Alfred.** THE WINTUN HESI CEREMONY. Berkeley: University of California Press, 1919. 51 p., illus., diagrs. UNIVERSITY OF CALIFORNIA, PUBLICATIONS IN AMERICAN ARCHAEOLOGY AND ETHNOLOGY, VOL. 14, NO. 4.

A study of the Hesi ritual of the Wintun Indians of northeastern California. The object of the Hesi was to insure plentiful wild harvests and to secure the health and general prosperity of the tribe.

Q271. **Boas, Franz.** DANCE AND MUSIC IN THE LIFE OF THE NORTHWEST COAST INDIANS OF NORTH AMERICA. Typewritten. 19 p. Dance Collection, The New York Public Library.

A typescript with holograph notes. Includes a transcript of a lecture given by Franz Boas, an anthropologist well known for his interest in dance, and a discussion led by dancer Franziska Boas.

Q272. **Bogan, Phoebe M.** YAQUI INDIAN DANCES OF TUCSON, ARIZONA: AN ACCOUNT OF THE CEREMONIAL DANCES OF THE YAQUI INDIANS AT PASCUA. Tucson: Archeological Society, 1925. 69 p., illus.

A general description of the annual tribal reunion during week immediately preceding Easter Sunday.

Q273. **Bourke, John Gregory.** THE SNAKE DANCE OF THE MOQUIS OF ARIZONA. New York: Charles Scribner's Sons, 1884. 371 p., illus. (color).

The book gives an account of a journey from Santa Fe to the villages of the Moqui Indians of Arizona. Includes descriptions of the Moqui manners, customs, and dances, especially the snake dance. REPRINT EDITION (Chicago: Rio Grande Press, 1962).

Q274. **Brown, Donald Nelson.** THE DEVELOPMENT OF TAOS DANCE. *Ethnomusicology* 5 (Jan. 1961): 33–41, illus., diagrs.

An essay on the Indian ceremonial dances at Taos Pueblo in New Mexico. The corn dance and the animal dances (the deer dance, buffalo dance, and the tartle dance) are described and analyzed. The Spanish-Catholic influence, and the influences of other tribes, particularly of the Plains Indians, are examined in detail.

Q275. BUCK DANCE. Motion picture. New York: American Mutoscope and Biograph Co., producing organization, 1898. 80 sec.; silent, black and white, 16 mm.

A fragment of a performance of an Indian buck dance.

Q276. **Capron, Louis.** THE MEDICINE BUNDLES OF THE FLORIDA SEMINOLE AND THE GREEN CORN DANCE. United States Bureau of American Ethnology, *Bulletin* 151 (1953): 155–210, illus.

A discussion of the American Indian ceremonial dances of the southeastern United States performed as part of the harvest festival in celebration of the newly ripened corn. ALSO PUBLISHED AS United States Bureau of American Ethnology, *Anthropological Papers*, no. 35.

Q277. CIRCLE DANCE. PRODUCED BY THOMAS A. EDISON. Motion picture. 1897. 50 sec.; silent, black and white, 16 mm. Library of Congress.

A ritual dance performed by American Indians in which fifty men, with their backs to the camera, dance in a slowly revolving circle. Among the earliest American motion pictures that were deposited in the form of paper prints for copyright in the Library of Congress.

Q278. **Third Conference on Research in Dance, 1972.** NEW DIMENSIONS IN DANCE RESEARCH: ANTHROPOLOGY AND DANCE, THE AMERICAN INDIAN. EDITED BY TAMARA COMSTOCK. PUBLISHED FOR THE UNIVERSITY OF ARIZONA, TUCSON, AND THE YAQUI VILLAGES OF TUCSON. *CORD Research Annual* 6 (1974): 354 p., illus.

Contains articles on various aspects of dance anthropology, with major emphasis on the American Indian.

Q279. **Culkin, William E.** TRIBAL DANCE OF THE OJIBWAY INDIANS. *Minnesota History Bulletin* 1 (1915): 83–93.

A brief survey of types, styles, and forms of Chippewa Indian tribal dances.

Q280. DANCERS IN THE SKY. FILMED BY WALTER P. LEWISOHN. NARRATED BY RED ROBIN. Motion picture. 1953. 7 min.; sound, color, 16 mm.

An Acoma harvest dance and a Zuni bow and arrow hunting dance.

Q281. DEER DANCE AT TAOS. In: FERGUSSON, ERNA. DANCING GODS. New York: Alfred A. Knopf, 1931. p. 36–40, illus.

A detailed description of the chiffonette, or clown, an important figure in the deer dance ceremony.

Q282. **Densmore, Frances.** IMITATIVE DANCES AMONG THE AMERICAN INDIANS. *Journal of American Folk Lore* 60 (1947): 73–78.

A general survey of American Indian animal and bird dances in North America. Six musical examples accompany the text: a Menominee song of the rabbit dance, a Winnebago song of the fish dance, a Seminole song of the buzzard dance, a Choctaw song of the terrapin dance, an Alabama song of the duck dance, and a Maidu song of the grizzly bear dance.

Q283. **Dorsey, George Amos.** THE ARAPAHOE SUN DANCE: THE CEREMONY OF THE OFFERINGS LODGE. Chicago: Field Columbian Museum, 1903. 228 p., illus. FIELD COLUMBIAN MUSEUM, *Publications*, NO. 75; ANTHROPOLOGICAL SERIES, VOL. 4.

A detailed, fully documented study of this Arapaho Indian ceremonial dance, indigenous to the Plains tribes.

Q284. **Dorsey, George Amos, and Voth, H. R.** THE MISHONGNOVI CEREMONIES OF THE SNAKE AND ANTELOPE FRATERNITIES: THE STANLEY McCORMICK HOPI EXPEDITION. Chicago: Field Columbian Museum, 1902. 102 p., illus. FIELD COLUMBIAN MUSEUM, *Publications*, NO. 66; ANTHROPOLOGICAL SERIES, VOL. 3, NO. 3.

An early scholarly account of Hopi Indian ceremonial dancing, based on personal observation in the field.

Q285. **Dorsey, George Amos.** THE PONCA SUN DANCE. Chicago: Field Columbian Museum, 1905. 27 p., illus. FIELD COLUMBIAN MUSEUM, *Publications*, NO. 102; CHICAGO NATURAL HISTORY MUSEUM, *Fieldiana: Anthropology*, VOL. 7, NO. 2.

A day-by-day, eyewitness description of a Ponca sun dance ceremony that took place, probably in Oklahoma, in June or July of 1905. Color plates show paint worn at various stages of the ceremony by the dancers of different participating groups.

Q286. **Drucker, Philip.** KWAKIUTL DANCING SOCIETIES. Berkeley and Los Angeles: University of California Press, 1940. 30 p., illus., tables. UNIVERSITY OF CALIFORNIA, ANTHROPOLOGICAL RECORDS, VOL. 2, NO. 6.

An essay on the tribal dancing societies among the Kwakiutl Indians of the Pacific Northwest.

Q287. **Du Bois, Cora Alice.** THE 1870 GHOST DANCE. Berkeley: University of California Press, 1939. 151 p., illus., diagrs., map, tables. UNIVERSITY OF CALIFORNIA, ANTHROPOLOGICAL RECORDS, VOL. 3, NO. 1.

A detailed, well-annotated account of this messianic religious movement among the Indian tribes of California.

Q288. EAGLE DANCE, PUEBLO INDIANS. PRODUCED BY THOMAS A. EDISON. Motion picture. 1898. 67 sec.; silent, black and white, 16 mm.

An Indian chief with a full-feathered war bonnet executes a step-and-a-half dance.

Q289. **Ernst, Alice Henson.** NORTHWEST COAST ANIMAL DANCES. *Theatre Arts* (Sept. 1939): 661–72, illus.

A discussion of various animal dances, including their

origins, their functions in festivals and hunting rituals, and the use of masks by participants. In drawing together her materials, the author deals with man's relation to animals in a homogeneous society.

Q290. **Evans, Bessie, and Evans, May G.** AMERICAN INDIAN DANCE STEPS. New York: A. S. Barnes, 1931. 104 p., illus. (color), music.

This is primarily a study of the dance steps among certain Pueblo tribes of New Mexico, including the San Ildefonso, Tesuque, Santa Clara, Cochiti, and Santo Domingo tribes. Color plates of paintings executed by Poyege, a San Ildefonso Indian, illustrate the six dances discussed in detail: the eagle dance, the war dance, the sun dance, the mata chines, a yebichai dance fragment, and the dog dance. Also accompanying the text are stick-figure drawings by J. Maxwell Miller demonstrating posture and steps.

Q291. **Fenton, William Nelson.** THE IROQUOIS EAGLE DANCE: AN OFFSHOOT OF THE CALUMET DANCE. United States Bureau of American Ethnology, *Bulletin* 156 (1953): 324 p., illus., map, music.

Contains an analysis of the Iroquois eagle dance and songs by Gertrude Prokosch Kurath. Bibliographies.

Q292. **Fergusson, Erna.** DANCING GODS: INDIAN CEREMONIALS OF NEW MEXICO AND ARIZONA. New York: Alfred A. Knopf, 1931. 276 p., illus.

Includes discussions of dances of the Rio Grande, Zuni, Hopi, Navajo, and Apache Indians, illustrated by reproductions of paintings by various artists. [*See also* Q281, Q327.] SECOND EDITION (Albuquerque: University of New Mexico Press, 1957).

Q293. **Fewkes, Jesse Walter.** BUTTERFLY DANCE OF THE HOPI. *American Anthropologist* (Oct. 1910): 588–92, illus.

A brief essay on the Hopi Indian ceremonial dance.

Q294. **Fewkes, Jesse Walter.** A STUDY OF SUMMER CEREMONIALS AT ZUNI AND MOQUI PUEBLOS. Essex Institute, *Bulletin* 22 (1890): 89–113.

An early account of Zuni Indian dances observed during the Hemenway Southwestern Archaeological Expedition.

Q295. **Fletcher, Alice Cunningham.** THE "WAWAN" OR PIPE DANCE OF THE OMAHAS. Peabody Museum of American Archaeology and Ethnology, Harvard University, *Reports* 3 (1884): 308–33.

An early account of an Omaha Indian ceremonial dance.

Q296. **International Congress of Americanists, 1949. Selected Papers.** CHANGING PATTERNS IN KIOWA INDIAN DANCES. BY JOHN I. GAMBLE. Chicago, 1952. vol. 2, p. 94–104.

A brief account of the traditional dances of the Kiowa tribe of the Plains Indians.

Q297. **Gayton, Anna Hadwick.** THE GHOST DANCE OF 1870 IN SOUTHCENTRAL CALIFORNIA. Berkeley: University of California Press, 1930. p. 57–82, illus, map.
UNIVERSITY OF CALIFORNIA, PUBLICATIONS IN AMERICAN ARCHAEOLOGY AND ETHNOLOGY, VOL. 28, NO. 3.

A history of the messianic religious revival among the American Indian tribes of this region of California, as seen in the ghost dance.

Q298. GHOST DANCES IN THE WEST: ORIGIN AND DEVELOPMENT OF THE MESSIAH CRAZE AND THE GHOST DANCE. *Illustrated American* 5 (1891): 327–33, illus.

A brief contemporary account of the ghost dance religion among the American Indians of the far western tribes.

Q299. New York. **Harkness House for Ballet Arts, Gallery of the Dance.** THE DANCE IN CONTEMPORARY AMERICAN INDIAN ART. CATALOG BY MYLES LIBHART. New York, 1967. 34 p., illus.

Exhibition: Jan. 18–Apr. 15, 1967. Organized by the Indian Arts and Crafts Board, United States Department of Interior.

A descriptive catalog of forty works, twenty-four of which are reproduced. This was a pivotal exhibition in the portrayal of the Indian artist's cultural dance heritage, ceremonies, and environment.

Q300. **Howard, James Henri, and Kurath, Gertrude Prokosch.** PONCA DANCES: CEREMONIES AND MUSIC. *Ethnomusicology* 3 (Jan. 1959): 1–14, diagrs.

The Ponca are a small lower Missouri tribe of the Siouan family. The three most important ceremonial dances of this Plains Indian group are described: the sun dance, Wá-wa (or pipe dance), and Hedúška (or war dance). Includes choreography, music, and dance diagrams. Bibliography.

Q301. INDIAN STEPS. Motion picture. Cologne, W. Ger., 1959. 2-1/2 min.; sound, black and white, 16 mm.
BROADCAST ON GERMAN TELEVISION.

Excerpts from a demonstration, by Léonide Massine, of American Indian dances.

Q302. IROQUOIS INDIAN DANCE. FILMED BY CAROL LYNN. Motion picture. Lee, Mass., 1949. 1 min.; silent, black and white, 16 mm.

A segment of a performance by Tom Two Arrows at Jacob's Pillow.

Q303. **James, Harry Clebourne.** THE HOPI INDIAN BUTTERFLY DANCE. ILLUSTRATED BY DON PERCEVAL. Chicago: Melmont Publishers, 1965. 31 p., illus.

A detailed discussion and analysis of one of the ceremonial dances performed by the Hopi Indians of Arizona.

Q304. **Kealiinohomoku, Joann Wheeler.** AN ANTHROPOLOGIST LOOKS AT BALLET AS A FORM OF ETHNIC DANCE. *Impulse* (1969–1970): 24–32.

A refutation of the traditional Western bias toward non-

Western dance exemplified by such terms as "ethnic" and "primitive" as used by dance scholars. The Hopi Indian dance and culture are used as a paradigm. Bibliography.

Q305. **Kurath, Gertrude Prokosch.** DANCE AND SONG RITUALS OF SIX NATIONS RESERVE. Ottawa, Ontario, 1968. 205 p., illus., music.
NATIONAL MUSEUM OF CANADA, FOLKLORE SERIES, NO. 4; CANADA NATIONAL MUSEUM, OTTAWA, MUSEUM BULLETIN, NO. 220.

A choreographic and musical survey of Canadian Longhouse customs and costuming. Bibliography.

Q306. **Kurath, Gertrude Prokosch.** IROQUOIS MUSIC AND DANCE: CEREMONIAL ARTS OF TWO SENECA LONGHOUSES. United States Bureau of American Ethnology, *Bulletin* 187 (1964): 268 p., illus., diagrs., music.

This extensive analysis includes choreographic diagrams and music for unaccompanied melodies of Iroquois dances.

Q307. **Kurath, Gertrude Prokosch.** MICHIGAN INDIAN FESTIVALS. COVER DESIGN BY FRANCES WRIGHT. Ann Arbor: Ann Arbor Publishers, 1966. 132 p., illus.

Twenty years of observation and study by a distinguished dance ethnologist on the Indians of Michigan are recorded: their religious beliefs, rituals, lifestyles, traditions, dances, and music. Includes discussion on the Ottawa, Chippewa, and Potowatomi tribes. Bibliography; list of audio-visual materials; and calendar of summer programs.

Q308. **Kurath, Gertrude Prokosch, and Garcia, Antonio.** MUSIC AND DANCE OF THE TEWA PUEBLOS. Santa Fe: Museum of New Mexico Press, 1970. 309 p., illus., music.
MUSEUM OF NEW MEXICO, RESEARCH RECORDS, NO. 8.

A detailed analysis—with music and choreographic notation—of the dances, music, and ceremonies of the Tewa Pueblos. Bibliography.

Q309. **Kurath, Gertrude Prokosch.** PLAZA CIRCUITS OF TEWA INDIAN DANCERS. *El Palacio* 65 (Feb. 1958): 16–26, illus.

Dances of the Indians of the Tewa tribe from the San Ildefonso and Santa Clara Pueblos of the American Southwest.

Q310. **Lawrence, David Herbert.** THE DANCE OF THE SPROUTING CORN. *Theatre Arts* (1924): 447–57, illus.

An account of the Pueblo Indian corn dance ritual by a celebrated author who describes the philosophy and choreography of the dance in detail. The article is illustrated by the artist's drawings.

Q311. **Lawrence, David Herbert.** THE HOPI SNAKE DANCE. *Theatre Arts* (1924): 836–60, illus.

A discussion on the lifestyle, the religious philosophy, and the snake dance of the Hopi Indians. The ritual is described in detail and illustrated with photographs.

Q312. **Le Sueur, Jacques.** HISTORY OF THE CALUMET AND OF THE DANCE. Museum of the American Indian, Heye Foundation, *Contributions from the Heye Museum* 12 (1952): 22 p., frontispiece (color).

Includes a discussion of the Abnaki Indian pipe dance.

Q313. **Liberty, Margot.** SUPPRESSION AND SURVIVAL OF THE NORTHERN CHEYENNE SUN DANCE. *Minnesota Archaeologist* 27 (1965): 120–43, illus.

A scholarly study on the ritual dance of the Cheyenne Indians. Bibliography.

Q314. **Linton, Ralph.** THE COMANCHE SUN DANCE. *American Anthropologist*, new ser. 37 (1935): 420–28.

A brief discussion of the ritual dance of the Comanche Indians.

Q315. **Lynn, Barry.** THE DANCES OF THE EARLY EASTERN CAROLINA INDIANS. Typewritten. 12 p. Dance Collection, The New York Public Library.

In two sections, the first part consists in excerpts from the papers of John Lawson (ca. 1700) and of Captain John Smith (ca. 1600). In the second part, Lynn describes a particular Indian dance reconstructed from drawings executed by John White (ca. 1585) and Smith.

Q316. **Mason, Bernard Sterling.** DANCES AND STORIES OF THE AMERICAN INDIAN. PHOTOGRAPHS BY PAUL BORIS ET AL. DRAWINGS BY FREDERIC H. KOCH. New York: A. S. Barnes, 1944. 269 p., illus., music, diagrs.

Descriptions of and choreography for adaptations of Indian dances for staging and performances. The author also includes detailed descriptions of make-up and costumes to be worn and percussion instruments to be used for performances.

Q317. **Haywood, Charles, comp.** A BIBLIOGRAPHY OF NORTH AMERICAN FOLKLORE AND FOLKSONG. 2d rev. ed. New York: Dover Publications, 1961. 2 vols., maps.

A comprehensive bibliography of materials covering such areas as folklore, folksong, legends, and dance, as well as music in printed form and on records. An unabridged and revised edition with a new index supplement of composers, arrangers, and performers. The bibliography deals with both native and nonnative Americans north of Mexico. Vol. 2 contains a comprehensive index of names, topics, tribes, and titles for both volumes. Both volumes contain numerous citations to books and articles on dance and dance-related topics. FIRST EDITION (New York: Greenberg Publisher, 1951).

Q318. **McClintock, Walter.** DANCES OF THE BLACKFOOT INDIANS. Los Angeles: Southwest Museum, 1937. 22 p., illus.
SOUTHWEST MUSEUM LEAFLETS, NO. 7.

Recollections by an adopted son of a Blackfoot chief of the dances held concurrently with the sun dance ceremonies in Montana, June 1898. The costumes of the various dancers and those of visiting tribes are described.

Q319. **Miller, David Humphreys.** GHOST DANCE. New

York: Duell, Sloan & Pearce, 1959. 318 p., illus.

An historical account of the nineteenth-century religious movement among the Dakota Sioux Indians. Bibliography.

Q320. **Mooney, James.** The Ghost Dance Religion and the Sioux Outbreak of 1890. Glorieta, N.M.: Rio Grande Press, 1973. 496 p., illus.

In this edition with a new publisher's preface and a new introduction by Bernard Fontana, chaps. 1 through 9 discuss the historical background and the earlier Indian religious movements governing the emergence of the ghost dance religion. Discussed in following chapters: the doctrine of the ghost dance; its manifestations among the various tribes east and west of the Rockies; the Sioux outbreak at Wounded Knee and its aftermath; the ceremony of the ghost dance and comparisons to other religious movements throughout the world; the songs (with some unaccompanied melodies) of the various tribes practicing the ghost dance religion, with accompanying sketches of the tribes, their tribal signs, the tribal synonymies, and a glossary of tribal terms and words. ORIGINAL EDITION: United States Bureau of Ethnology, *Fourteenth Annual Report to the Secretary of The Smithsonian Institution, 1892–1893, Pt. 2* (Washington, D.C.: Government Printing Office, 1896), p. 641–1136. Bibliography.

Q321. Navajo Healing Dance. Filmed for study and preservation purposes for the Dance Collection by Gardner Compton and Emile Ardolino. Motion picture. 1971. 5 min.; sound, black and white, 16 mm. Dance Collection, The New York Public Library.

Six boys with rattles sing and dance on a raised platform before an audience.

Q322. **Oliver, Marion L.** The Snake Dance. *National Geographic Magazine* (Feb. 1911): 107–137, illus. (color).

An early account of the Hopi Indian snake dance.

Q323. Pawnee Indians. Motion picture. n.d. 1-1/2 min.; silent, black and white, 16 mm.

Various ceremonial dances are included in this film study.

Q324. **Payne, John Howard.** The Green Corn Dance: From an Unpublished Manuscript. *Continental Monthly* (Jan. 1862): 17–29.

An early account of the Creek Indian dance performed by this southeastern tribe as the culmination of their feast celebrating the ripening of corn.

Q325. Harrisburg. **Pennsylvania Historical Commission. Department of Public Instruction.** The Tutelo Spirit Adoption Ceremony. Harrisburg, 1942. 125 p., illus.

A study of a ritual of the Tutelos, a tribe from the Carolina region. The article includes selections on the ceremony and music by F. G. Speck and by George Herzog.

Q326. Prophet of Taos: D. H. Lawrence and the Indians. Filmed by Walter P. Lewisohn. Narrated by Aldous Huxley; adapted from D. H. Lawrence. Motion picture. 1953. 14 min.; sound, color, 16 mm.

Dances of the Hopi, Jemez, and Santa Clara Indians. Included are the masked, snake, deer, and eagle dances.

Q327. The Shalako. In: Fergusson, Erna. Dancing Gods. New York: Alfred A. Knopf, 1931. p. 91–106, illus.

A detailed description of the events of the Zuni Shalako festival. [*See also* Q292.]

Q328. **Shimkin, Demitri Boris.** The Wind River Shoshone Sun Dance. United States Bureau of American Ethnology, *Anthropological Papers* 41 (1953): 397–474, illus.

A detailed analytical study of the sun dance ceremony of this Plains Indian tribe.

Q329. **Spier, Leslie.** The Ghost Dance of 1870 among the Klamath of Oregon. University of Washington, *Publications in Anthropology* 2 (1927): 37–55.

An authoritative account of this religious movement among the Klamath Indians. Bibliographical footnotes.

Q330. **Spier, Leslie.** The Prophet Dance of the Northwest and Its Derivatives: The Source of the Ghost Dance. Menasha, Wis.: G. Banta Publishing Co., 1935. 74 p., illus. (charts). General Series in Anthropology, no. 1.

A historical account of the origin and development of the messianic dances performed by the Pacific Northwest American Indian tribes, as part of the ghost-dance tradition. Bibliography.

Q331. **Squires, John L.** American Indian Dances. New York: Ronald Press, 1963. 132 p., illus., diagrs.

The theme, directions, steps, rhythmic structure, costumes, and floor pattern for each dance are described, including nature dances, religious dances, social and comic dances, war and skill dances.

Q332. **Stewart, Dorothy Newkirk.** Indian Ceremonial Dances in the Southwest. Santa Fe: By the author, 1950. 19 p., illus. New Mexico Pueblos, no. 1.

This hand-typeset book contains brief descriptions with accompanying colored screen prints of the dances most frequently seen in New Mexican Pueblos. Included are the corn, eagle, basket, buffalo, deer, and mata china dances, as well a Pueblo Commanche dance. The author also provides a schedule of announced Pueblo dances. Bibliography.

Q333. **Works Progress Administration.** Dance Index: An annotated Index in Bibliographical Form of Dance References, Composed of Source Material Extracted from Various Works on

Anthropology, Ethnology, Comparative Religion, Travel, and the Arts, Contained in Institutional Libraries of Greater New York. New York: Dance Collection, The New York Public Library, ca. 1936. card file, 45 drawers.

[*See* Q46.]

JAZZ DANCE

Q334. **Considine, Robert Bernard.** Interview with Agnes de Mille. Phonotape. New York: NBC Radio, broadcaster, 1960. 6 min. 1 reel. (4 in.) 7-1/2 in./sec. Dance Collection, The New York Public Library.
From the NBC Radio Series Image America.

[*See* Q572.]

Q335. The Dance Theater of Lester Horton, by Larry Warren et al. Brooklyn, N.Y.: Dance Perspective Foundation, 1967. 69 p., illus.
Dance Perspectives, no. 31.

[*See* Q719.]

Q336. **Dehn, Mura.** Is Jazz Choreographic? How to Treat a New Art Form in Terms of Dance Composition. *Dance Magazine* (Feb. 1948): 24–25, illus.

A discussion of the problems of choreographing for jazz dance. The author suggests some possible choreographic approaches.

Q337. Echoes of Jazz. Produced by Jac Venza. Sets by Tom John. Costumes designed by Frank Thompson. Narrated by Big Wilson. Motion picture. New York: WNET–TV, producing organization, 1965. 30 min.; sound, black and white, 16 mm.
From the NET series U.S.A.: Dance.

A demonstration of the development of jazz in American dance. Included are basic tap steps by Honi Coles; a performance of *Storyville, New Orleans* choreographed by Donald McKayle to music by Jelly Roll Morton, performed by Paula Kelly, Dudley Williams, and William Louther; a performance of Grover Dale's *Idiom 59* to music by Duke Ellington, danced by Grover Dale and Michele Hardy; and a performance of John Butler's *Dance* to music by Gunther Schuller, performed by John Butler, Mary Hinkson, and Buzz Miller.

Q338. The History of Jazz Dancing. Motion picture. San Francisco: KQED–TV, producing organization, 1970. 56 min.; sound, black and white, 16 mm.

A lecture-demonstration in which Les Williams illustrates the black man's role in the history of jazz dancing. Also includes demonstrations of the Irish jig, minstrel dances, buck and wing dances, vaudeville dancing, modern tap patterns, and discotheque dancing.

Q339. **Seldes, Gilbert Vivian.** The Seven Lively Arts. Rev. ed. New York: Sagamore Press, 1957. 306 p., illus.

[*See* Q214.]

Q340. **Stearns, Marshall Winslor, and Stearns, Jean.** Jazz Dance: The Story of American Vernacular Dance. New York: Macmillan Co., 1968. 464 p., illus.

A standard reference work on jazz dance. Among the areas considered are the history and pattern of diffusion of jazz; minstrelsy; the vernacular-medicine shows, gillies, carnivals, circuses, and roadshows; Tin Pan Alley—Broadway and Harlem; the early twenties and thirties; technique—pioneers, innovators and stylists; specialities—eccentric dancing, comedy dancing, Russian dancing, acrobatics; class acts; the jitterbug. Bibliography; selected list of films and kinescopes; a section on the analysis and notation of basic Afro-American movements; index.

Q341. **Winter, Marian Hannah.** Juba and American Minstrelsy. *Dance Index* (Feb. 1947): 28–47, illus.

[*See* Q227.]

MALE DANCE

Q342. **Gottlieb, Beatrice.** The Theatre of José Limón. *Theatre Arts* (Nov. 1951): 27, 94–95, illus.

A discussion of Limón as a choreographer and an actor through dance. Works referred to include *The Moor's Pavane* and *La Malinche*.

Q343. **Limón, José.** The Virile Dance. In: Sorell, Walter. The Dance Has Many Faces. 2d ed. New York: Columbia University Press, 1966. p. 82–86.

A major American choreographer's statement on male dancing: that the "male of the human species has always been a dancer." Essay also in the 1951 edition, p. 192–96.

Q344. The Male Image. Brooklyn, N.Y.: Dance Perspectives Foundation, 1969. 47 p., illus.
Dance Perspectives, no. 40.

Contributors Igor Youskevitch, Bruce Marks, Helgi Tomasson, Luis Fuente, and Edward Villella examine the concept of "masculinity" in ballet. These five great dancers consider how the male dancer expresses masculinity in his dancing. Brief biographical sketches of each dancer are included. There is an introduction by Ray L. Birdwhistell.

Q345. **Maynard, Olga.** Edward Villella Talks to Olga Maynard. *Dance Magazine* (May 1966): 50–54, 82–84, illus.

[*See* Q1152.]

Q346. **Nichols, Billy.** Interview with Charles Weidman. Phonotape. New York: National Educational Television, 1965? 60 min. 2 reels (7 in.) 7-1/2 in./sec. Dance Collection, The New York Public Library.
From the NET film Four Pioneers.

[*See* Q847.]

Q347. PRIMITIVE RHYTHMS. CHOREOGRAPHED AND WRITTEN BY TED SHAWN. Motion picture. 1934–1940. 11-1/2 min.; silent, color, 16 mm.

A collection of five dances, the Ponca Indian dance, the Hopi Indian eagle dance, the Sinhalese devil dance, the Dayak spear dance, and the Maori war haka, performed by Ted Shawn and His Men Dancers. Barton Mumaw is one of the dance company. The film opens with text by Ted Shawn.

Q348. **Shawn, Ted.** REMINISCENCES: FROM CHILDHOOD TO THE DISSOLUTION OF DENISHAWN. Phonotape. New York: WNYC, broadcaster; recorded in Eustis, Fla., 1969. 6-1/2 hours; broadcast, 26 min. 2 reels (5 in.) 1-7/8 in./sec. Dance Collection, The New York Public Library.
FROM THE WNYC SERIES INVITATION TO DANCE.
[*See* Q1139.]

Q349. **Shawn, Ted.** THE AMERICAN BALLET. New York: H. Holt, 1926. 136 p., illus.
[*See* Q421.]

Q350. **Shawn, Ted.** PRINCIPLES OF DANCING FOR MEN. *Journal of Health and Physical Eduction* (Nov. 1933): 27–29, 60, illus.

A brief discussion of male dancing from both artistic and professional viewpoints by one of the art's earliest and most vigorous proponents. Several years later Shawn formed an all-male dance company, which toured successfully for nearly a decade.

Q351. **Sorell, Walter, ed.** THE DANCE HAS MANY FACES. 2d ed. New York: Columbia University Press, 1966. 276 p., illus.
[*See* Q428.]

Q352. **Terry, Walter.** INTERVIEW WITH HELEN TAMIRIS. Phonotape. New York: WNYC, broadcaster, 1965. 14 min. 1 reel (7 in.) 7-1/2 in./sec. Dance Collection, The New York Public Library.
FROM THE WNYC SERIES INVITATION TO DANCE.

A discussion of male dancing, touching on the questions of homosexuality and the stereotypical effeminate male dancer. Terry traces American prejudice to a misunderstanding of court etiquette. Terry and Tamiris discuss the need for male dancers and the importance for the American public to be exposed to more dance.

Q353. **Terry, Walter.** INTERVIEW-DEMONSTRATION WITH IGOR YOUSKEVITCH: THE ART OF PERFORMING. Phonotape. New York, 1953. 106 min. 2 reels (5 in.) 3-3/4 in./sec. Dance Collection, The New York Public Library.
FROM A DANCE LABORATORY HELD AT THE YM–YWHA, NEW YORK.
[*See* Q1159.]

Q354. **Terry, Walter.** INTERVIEW-DEMONSTRATION WITH IGOR YOUSKEVITCH AND MARIA YOUSKEVITCH. Phonotape. New York, 1962. 60 min. 1 reel (7 in.) 3-3/4 in./sec. Dance Collection, The New York Public Library.
FROM A DANCE LABORATORY HELD AT THE YM–YWHA, NEW YORK.
[*See* Q1160.]

MODERN DANCE

Q355. **Beiswanger, George W.** DANCE OVER U.S.A., PTS. 1 AND 2. *Dance Observer*. Pt. 1 (Jan. 1943): 4–5; Pt. 2 (Feb. 1943): 16–17.

This two-part article discusses the renaissance of dance in America, including social dancing, Broadway show dancing, tap dancing, ballet, modern dance, and the folk dance movement.

[On modern dance, *see further* the entries for dancers (Q994 *et seq.*) and for choreographers (Q595 *et seq.*).]

Q356. **Betts, Anne.** AN HISTORICAL STUDY OF THE NEW DANCE GROUP OF NEW YORK CITY. M.A. thesis, New York University, 1945. 38 p.

Betts's detailed study of this important organization covers its history, the role of its participants, its concerts, and its contribution to the development of modern dance. Bibliography.

Q357. CLOSE-UP OF MODERN DANCE TODAY: A SYMPOSIUM, PTS. 1 AND 2. *Dance Magazine*. Pt. 1 (Mar. 1958): 38–41; Pt. 2 (Apr. 1958): 44–45, 64–65.

A discussion of the state of modern dance in the 1950s—its problems, its achievements, and its future. *Participants include* Doris Humphrey, Margaret Lloyd, Jack Cole, Carmelita Maracci, Eugene Loring, May O'Donnell, Sybil Shearer, Charlotte Chey, and Jerry Bywaters.

Q358. **Cohen, Selma Jeanne.** AVANT-GARDE CHOREOGRAPHY, Pts. 1–3. *Dance Magazine*. Pt. 1 (June 1962): 22–24, 57; Pt. 2 (July 1962): 29–31, 58; Pt. 3 (Aug. 1962): 45, 54–56, illus.

A superb study and a brilliant analysis of the modern choreographic movement. This trend, which lasted from the late 1940s to the early 1960s, was exemplified in the works of such choreographers as Merce Cunningham, Katherine Litz, Erick Hawkins, Paul Taylor, Alwin Nikolais, George Balanchine, and the young moderns represented by the Judson Theatre School. Reprinted from *Criticism: Quarterly for Literature and the Arts* (winter 1961). For excerpts, *see* Walter Sorell, ed., *The Dance Has Many Faces* [Q428].

Q359. **Cohen, Selma Jeanne, ed.** THE MODERN DANCE: SEVEN STATEMENTS OF BELIEF. Middletown, Conn.: Wesleyan University Press, 1966. 106 p., illus.

Seven choreographers were asked to discuss modern dance and to describe the perfect dance commission—the dance each would create if he or she were given total freedom and unlimited resources in terms of money,

dancers, kind of music, costumes, etc. The only restriction was that the dance had to treat the Prodigal Son theme.

Q360. CREATIVE LEISURE. PRODUCED BY HERBERT KERKOW FOR THE U.S. DEPARTMENT OF THE ARMY. MUSIC BY NORMAN LLOYD. Motion picture. New London, Conn.: Recorded at Connecticut College School of Dance, 1951. 5 min.; sound, black and white, 16 mm.

Various scenes at the Connecticut College School of Dance, including brief shots of Louis Horst, Valerie Bettis, José Limón, Jane Dudley, Sophie Maslow, and William Bales. Doris Humphrey's *Invention* is *performed by* José Limón, Betty Jones, and Ruth Currier.

Q361. **Cunningham, Merce.** MUSIC AND DANCE AND CHANCE OPERATIONS: A FORUM DISCUSSION. Phonotape. Amherst, Mass.: WFCR, broadcaster, 1970. 54-1/2 min. 2 reels (7 in.) 7-1/2 in./sec. Dance Collection, The New York Public Library.
FROM THE WFCR SERIES FIVE-COLLEGE FORUM.

Deals with the impact of electronic music on Cunningham's concept of rhythm; his use of chance operations; his collaboration with composer David Tudor on *Rain Forest;* the relationship of music to dance and the nature of rhythm in his works; *Winterbranch;* choreographing to precomposed music; John Cage's music, *Cheap Imitation* and *Second Hand;* his collaboration with Robert Rauschenberg; his works *Story, How to Pass, Kick, Fall and Run,* and *Summerspace;* the skills and training of his dancers; the work of other avant-garde choreographers. *Participants were* Robert Stern, Marianne Simon, and Anita Page.

Q362. **Dalbotten, Ted.** THE TEACHING OF LOUIS HORST. *Dance Scope* 8 (fall/winter 1973/1974): 26–40, illus.

Contains a biographical introduction to Louis Horst and detailed analyses of his two courses, on preclassic and on modern forms. The course on modern forms served as a major influence in the development of modern-dance choreography.

Q363. DANCE AS AN ART FORM. WRITTEN, DIRECTED, NARRATED, AND CHOREOGRAPHED BY MURRAY LOUIS. PHOTOGRAPHY, WARREN LIEB. MUSIC BY FREE LIFE COMMUNICATIONS, OREGON ENSEMBLE, CORKY SIEGEL. ELECTRONIC SOUND BY ALWIN NIKOLAIS. COSTUMES DESIGNED BY FRANK GARCIA. Motion picture. Chicago: Jack Lieb Productions for Chimera Foundation for Dance, New York, producing organization, 1973. Five films, each approximately 30 min.; sound, color, 16 mm.

[*See* Q755.]

Q364. DANCE MAGAZINE AWARDS, 1957: MARTHA GRAHAM AND AGNES DE MILLE. Phonotape. New York: WNYC, broadcaster, 1957. 20 min.; 1 reel (7 in.) 7-1/2 in./sec. Dance Collection, The New York Public Library.
PARTIAL PROCEEDINGS ON THE WNYC SERIES TODAY IN BALLET.

[*See* Q676.]

Q365. DANCE PERSPECTIVES. Brooklyn, N.Y. 1— (winter 1959—), illus.

[*See* Q59.]

Q366. THE DANCE THEATER OF LESTER HORTON, BY LARRY WARREN ET AL. Brooklyn, N.Y.: Dance Perspective Foundation, 1967. 69 p., illus.
DANCE PERSPECTIVES, NO. 31.

[*See* Q719.]

Q367. A DANCER'S WORLD. PRODUCED BY NATHAN KROLL. DIRECTED AND FILMED BY PETER GLUSHANOK. COMPOSER AND PIANIST, CAMERON MCCOSH. CHOREOGRAPHED BY MARTHA GRAHAM. Motion picture. Pittsburgh: WQED–TV, producing organization, 1957. 30 min.; sound, black and white, 16 mm.

[*See* Q677.]

Q368. **Dell, Cecily.** RANDOM GRAHAM. *Dance Scope* (Spring 1966): 21–26.

[*See* Q678.]

Q369. **De Mille, Agnes.** THE BOOK OF THE DANCE. London and New York: Golden Press, 1963. 252 p., illus. (color).

A well-illustrated history of dance, which includes chapters on American dance and dancers. The author deals with American ballet from its flourishing early nineteenth-century days until its decline in the second half of the century; American music halls and black minstrel shows; Isadora Duncan; George Balanchine; Leonide Massine; the "revolutionists," Ruth St. Denis, Martha Graham, and Doris Humphrey; folk and ethnic dance, including Katherine Dunham; such major American companies as the Metropolitan Opera Ballet, the New York City Ballet, and Ballet Theatre; and contemporary American ballet. The concluding section is on choreography and the working methods of major choreographers, including George Balanchine, Léonide Massine, Martha Graham, and Antony Tudor. Index.

Q370. **De Mille, Agnes.** THE DANCE IN AMERICA. Washington, D.C.: United States Information Service, 1971. 117 p., illus. (color).

This historical survey emphasizing contemporary dance features a personal and rather provocative essay by de Mille. Also included is a section of photo stories on de Mille and seven other American choreographers (John Butler, George Balanchine, Jerome Robbins, Robert Joffrey, Alwin Nikolais, Gerald Arpino, and José Limón). A FRENCH EDITION has also been published.

Q371. THE DRAMA REVIEW, POST–MODERN DANCE ISSUE. 19 (Mar. 1975): 124 p., illus.

[*See* Q92.]

Q372. **Duncan, Isadora.** THE ART OF THE DANCE. EDITED AND WITH AN INTRODUCTION BY SHELDON CHENEY. New York: Theatre Arts, 1928. 147 p., illus.

[*See* Q1058.]

Q373. **Duncan, Isadora.** THE DANCE IN RELATION TO TRAGEDY. *Theatre Arts* (Oct. 1927): 755–61, illus.
[*See* Q1061.]

Q374. **Duncan, Isadora.** "YOUR ISADORA": THE LOVE STORY OF ISADORA DUNCAN AND GORDON CRAIG. EDITED WITH A CONNECTING TEXT BY FRANCIS STEEGMULLER. New York: Random House and the New York Public Library, 1974. 399 p., illus., facsims.
[*See* Q1065.]

Q375. **Erdman, Jean.** THE DANCE AS A NONVERBAL POETIC IMAGE. In: SORELL, WALTER, ED. THE DANCE HAS MANY FACES. New York: World Publishing Co., 1951. p. 197–212.

A detailed description of dances by Valerie Bettis, Jean Erdman, Marie Marchowsky, Sybil Shearer, and Martha Graham, illustrating the author's thesis that dance can become "a direct image of something that was formerly invisible, though denoted or suggested by words."

Q376. **Eversole, Finley, ed.** CHRISTIAN FAITH AND THE CONTEMPORARY ARTS. New York: Abingdon Press, 1962. 255 p., illus.

Essays by various contributors on the crisis of personal identity in an increasingly standardized mass society. The book is divided into two parts. The first part deals with the contemporary artist; the second, with the contemporary arts. Pt. 2 contains discussions on poetry and the novel; drama, motion pictures, and television; music and dance; painting, sculpture, and architecture; and cartoons and comic strips. In her essay on "Contemporary Dance in Christian Perspective," Dora Cargille Sanders discusses modern dance themes, their concern with social problems and human nature, and the American choreographers of the thirties, including Hanya Holm, Charles Weidman, Doris Humphrey, and Martha Graham.

Q377. **Forti, Simone.** HANDBOOK IN MOTION. Halifax: Press of the Nova Scotia College of Art and Design; and New York: New York University Press, 1974. 144 p.
[*See* Q93.]

Q378. **Garnet, Eva Desca.** STATEMENT ON CHARLES WEIDMAN. Phonotape. Recorded in Los Angeles, n.d. 18 min. 1 reel (3 in.) 3-3/4 in./sec. Dance Collection, The New York Public Library.
[*See* Q844.]

Q379. **Genthe, Arnold.** THE BOOK OF THE DANCE. New York, 1916. 227 p., illus., frontispiece.

Thirteen groups of untitled photographs of Duncan Dancers, the Noyes School, and other early exponents of modern dance. The foreword is by Genthe. Index.

Q380. **Graham, Martha.** THE MEDIUM OF DANCE: LECTURE. Phonotape. New York: Recorded at the Student Composer Forum at the Juilliard School of Music, 1952. 45 min. 2 reels (7 in.) 7-1/2 in./sec. Dance Collection, The New York Public Library.
[*See* Q690.]

Q381. **Graham, Martha.** THE NOTEBOOKS OF MARTHA GRAHAM. New York: Harcourt Brace Jovanovich, 1973. 464 p., illus., facsims.
[*See* Q681.]

Q382. **Hawkins, Alma M.** MODERN DANCE IN HIGHER EDUCATION. New York: Columbia University Teachers College, 1954. 123 p.
[*See* Q852.]

Q383. **Horst, Louis.** MODERN DANCE FORMS IN RELATION TO THE OTHER MODERN ARTS. San Francisco: Impulse Publications, 1961. 149 p., illus., music.

The publication contains a foreword by Martha Graham and an essay by Horst. In teaching choreography, he stressed a harmonious relationship between dance and the other modern arts: literature, painting, sculpture, architecture, and, of course, music.

Q384. **Humphrey, Doris.** THE ART OF MAKING DANCES. EDITED BY BARBARA POLLACK. New York: Rinehart, 1959. 189 p., illus.
[*See* Q1204.]

Q385. **Humphrey, Doris.** LECTURE. Phonotape. New York: Recorded at the Juilliard School of Music for National Educational Television, 1956. 60 min. 2 reels (7 in.) 7-1/2 in./sec. Dance Collection, The New York Public Library.
FROM THE NET PROGRAM PIONEERS OF MODERN DANCE.

Humphrey's discussion touches on her own background and early training, projecting to an audience, suitable dance subjects, the Denishawn School and Dancers, Ruth St. Denis, a comparison of careers in dance today and during the Denishawn era, and today's young American modern dancer.

Q386. **Humphrey, Doris.** LECTURE-DEMONSTRATION: THE ART OF CHOREOGRAPHY. Phonotape. New York, 1951. 76 min. 2 reels (5 in.) 3-3/4 in./sec. Dance Collection, The New York Public Library.
FROM A DANCE LABORATORY HELD AT THE YM–YWHA, NEW YORK.
[*See* Q723.]

Q387. INVENTION IN DANCE. PRODUCED BY JAC VENZA. DIRECTED BY GREG HARNEY. CONCEIVED AND WRITTEN BY MARTHA MYERS. CHOREOGRAPHED BY ALWIN NIKOLAIS. Motion picture. Boston: WGBH–TV, producing organization, 1959. 29 min.; sound, black and white, 16 mm.
FROM THE WGBH–TV SERIES A TIME TO DANCE.
[*See* Q771.]

Q388. **Kirstein, Lincoln.** CRISIS IN THE DANCE. *North American Review* 243 (spring 1937): 80–103.
[*See* Q168.]

Q389. **Kirstein, Lincoln.** WHAT BALLET IS ABOUT: AN AMERICAN GLOSSARY. PORTFOLIO OF PHOTOGRAPHS OF THE NEW YORK CITY BALLET BY MARTHA SWOPE. Brooklyn: Dance Perspectives Foundation, 1958. 80 p., illus.
DANCE PERSPECTIVES, NO. 1.
[*See* Q172.]

Q390. **Koegler, Horst.** MODERNES BALLETT IN AMERIKA. Berlin: Rembrandt-Verlag, 1959. 65 p., illus.
[*See* Q173.]

Q391. **Kraus, Richard G.** HISTORY OF THE DANCE IN ART AND EDUCATION. Englewood Cliffs, N.J.: Prentice-Hall, 1969. 371 p., illus.
[*See* Q174.]

Q392. **Kurath, Gertrude Prokosch.** DANCE DESIGN. 33 (July–Aug. 1931): 64–70; 33 (Nov. 1931): 144–48; 33 (Jan. 32): 198–203, illus.
[*See* Q584.]

Q393. LAMENTATION. FILMED BY MR. AND MRS. SIMON MOSELSIO. NARRATED BY JOHN MARTIN. CHOREOGRAPHED BY MARTHA GRAHAM. MUSIC BY ZOLTÁN KODÁLY. ACCOMPANIST, LOUIS HORST. Motion picture. Harmon Film Foundation, producing organization, 1943. 10 min.; sound, color, 16 mm.
[*See* Q684.]

Q394. **Lloyd, Margaret.** THE BORZOI BOOK OF MODERN DANCE. Brooklyn, N.Y.: Dance Horizons, 1969(?). 356 p., illus.

A broad picture of the development of modern dance in the United States to 1949. *Contents:* Forerunners—Anela Isadora Duncan, Mary Wigman, Ruth St. Denis, and Ted Shawn; the three creative revolutionists—Martha Graham, Doris Humphrey, and Charles Weidman; other creative moderns—Helen Tamiris and Hanya Holm; new leaders, new directions—the New Dance Group, José Limón, Anna Sokolow, Esther Junger, Sybil Shearer, Katherine Dunham, Valerie Bettis, and Pearl Primus; modern dance on the West Coast—Lester Horton and Eleanor King; strange subsidies—the Neighborhood Playhouse in New York, Joseph Mann and the Students Dance Recitals Series, William Kolodney and the YMHA Dance Theatre Series, John Martin, the first American dance critic, the Bennington story, and Dance Observer; humanizing ballet and musicomedy dancing—Antony Tudor, Agnes de Mille, Ruth Page, Jerome Robbins, and Michael Kidd; in processed form—radio, video, and movie. Bibliography. ORIGINAL EDITION (New York: Alfred A. Knopf, 1949).

Q395. **Maracci, Carmelita.** THE SYMBOLIC AND PSYCHOLOGICAL ASPECTS OF THE DANCE. In: SORELL, WALTER, ED. THE DANCE HAS MANY FACES. 2d ed. New York: Columbia University Press, 1966. p. 103–112.

A discussion of "meaningless" symbolism in American ballet and modern dance. The author feels strongly that dance "springs forth from immediacy and embraces universal experiences." The article also appears in the FIRST EDITION (New York: World Publishing Co., 1951).

Q396. **Martin, John Joseph.** AMERICA DANCING: THE BACKGROUND AND PERSONALITIES OF THE MODERN DANCE. PHOTOGRAPHS BY THOMAS BOUCHARD. New York: Dodge Publishing Co., 1936. 320 p., illus.
[*See* Q1010.]

Q397. **Martin, John Joseph.** DAYS OF DIVINE INDISCIPLINE. PHOTOGRAPHS BY THOMAS BOUCHARD. Brooklyn: Dance Perspectives Foundation, 1961. 45 p., illus.
DANCE PERSPECTIVES, NO. 12.

A photographic essay on American modern dance and its principal exponents: Martha Graham, Harriette Ann Gray, Hanya Holm, Doris Humphrey, Esther Junger, José Limón, Katherine Litz, Sybil Shearer, Helen Tamiris, and Charles Weidman. Brief biographies are also included.

Q398. **Martin, John Joseph.** THE MODERN DANCE. Brooklyn: Dance Horizons, 1965. 123 p.

A reprint of the original edition of four lectures delivered at the New School for Social Research in New York in the 1931/1932 season. The lectures are concerned with characteristics of modern dance, form, technique, and dance and the other arts. Index. FIRST EDITION (New York: A. S. Barnes, 1933).

Q399. **Maynard, Olga.** AMERICAN MODERN DANCERS: THE PIONEERS. Boston: Little, Brown & Co., 1965. 218 p., illus.

This collection of biographical studies of the early artists of modern dance serves as an introduction to the art. Includes sections on Delsarte, Dalcroze, German modern dance, Mary Wigman, and Isadora Duncan; Martha Graham, Doris Humphrey, Charles Weidman, Hanya Holm, and Tamiris. Bibliography; index.

Q400. **McDonagh, Don.** MARTHA GRAHAM: A BIOGRAPHY. New York: Praeger Publishers, 1973. 341 p., illus.
[*See* Q689.]

Q401. **McDonagh, Don.** THE RISE AND FALL AND RISE OF MODERN DANCE. New York: Outerbridge & Dienstfrey; distributed by E. P. Dutton & Co., 1970. 344 p., illus.

Chiefly concerns the work of the younger modern dance choreographers during the sixties. Contains an introductory sketch of modern dance history. *Partial contents:* the history of modern dance—Merce Cunningham, Robert Dunn, and the Judson Dance Theatre; movement—Twyla Tharp, Steve Paxton, Deborah Hay, Yvonne Rainer, Gus Solomons, Jr., and Meredith Monk; presentation—Alwin Nikolais, Paul Taylor, James Waring, Rudy Perez, Elizabeth Keen, and Art Bauman. Includes chronologies of dance works with first-performance information. Index, no bibliography. REPRINT EDITION

(New York: New American Library, 1971), with corrections and updated chronologies.

Q402. MODERN DANCE, BY MARY WIGMAN ET AL. COMPILED BY VIRGINIA STEWART. New York: E. Weyhe, 1935. 162 p., illus.
DANCE HORIZONS SERIES, NO. 27.

Pt. 1 is on modern dance in Germany and includes articles by Arthur Michel, Mary Wigman, Palucca, Harald Kreutzberg, and Hans Hasting. Pt. 2 is on modern dance in America and includes pieces by Paul Love, Martha Graham, Doris Humphrey, Charles Weidman, Hanya Holm, Virginia Stewart, and Merle Armitage. Pt. 3 includes biographical sketches on Michel, Wigman, Palucca, Kreutzberg, Hasting, Love, Graham, Humphrey, Weidman, and Holm. REPRINT EDITION (Brooklyn: Dance Horizons, 1970), 107 p., illus. Foreword by John Martin.

Q403. THE MODERN DANCE. Motion picture. Pictorial Films, 193(?). 11-1/2 min.; silent, black and white, 16 mm.

Five exercises selected from Doris Humphrey's technique and performed by members of her concert group: Beatrice Seckler, Katherine Manning, Letitia Ide, Edith Orcutt, and Katherine Litz.

Q404. Nichols, Billy. INTERVIEW WITH CHARLES WEIDMAN. Phototape. New York: National Educational Television, 1965(?). 55 min. 2 reels (7 in.) 7-1/2 in./sec. Dance Collection, The New York Public Library.
EXCERPTS USED IN THE NET FILM FOUR PIONEERS.

[*See* Q847.]

Q405. Nichols, Billy. INTERVIEW WITH HANYA HOLM. Phonotape. New York: National Educational Television, 1965. 52 min. 2 reels (7 in.) 7-1/2 in./sec. Dance Collection, The New York Public Library.
EXCERPTS USED IN THE NET FILM FOUR PIONEERS.

Discusses Bennington College Summer School of Dance, 1934–1940; its influence on modern dance in the United States and on Holm's artistic development; her philosophy of dance; her dance, *Trend;* the process of creating a work of art; Charles Weidman; young American dancers and dance students of today.

Q406. Nikolais, Alwin. THE DANCE AND MULTI-MEDIA: FORUM DISCUSSION. Phonotape. Amherst, Mass.: WFCR, broadcaster, 1969. 60 min. 2 reels (7 in.) 7-1/2 in./sec. Dance Collection, The New York Public Library.

Nikolais discusses his concept of multi-media theater as embodied in his choreography; his use of improvisation; dance and film; dance and television; his system of movement notation, Choreoscript.

Q407. Nikolais, Alwin. LECTURE ON AVANT-GARDE DANCE. Phonotape. New York, 1968. 50 min. 1 reel (7 in.) 3-3/4 in./sec. Dance Collection, The New York Public Library.
[*See* Q776.]

Q408. Nikolais, Alwin. THE NEW DIMENSION OF DANCE. In: IMPULSE: ANNUAL OF CONTEMPORARY DANCE THEORIES AND VIEWPOINTS. San Francisco: Impulse Publications, 1958. p. 43–46., illus.

Tendencies in the new modern dance of the 1950s and a discussion of the differences in subject, method, composition, technique, titles, costume, and accompaniment from the modern dance of the Bennington period (1934–1942).

Q409. Nikolais, Alwin. NIK, A DOCUMENTARY. EDITED AND WITH AN INTRODUCTION BY MARCIA B. SIEGEL. Brooklyn, N.Y.: Dance Perspectives Foundation, 1971. 56 p., illus. (color).
DANCE PERSPECTIVES, NO. 48.

[*See* Q777.]

Q410. Owen, Bettie Jane. RECORDS OF GROUP CHOREOGRAPHIC WORKS IN AMERICAN MODERN CONCERT DANCE PRODUCED FROM 1946–1950. M.A. thesis, New York University, 1950. 112 p.

A chronological list of group dances by Valerie Bettis, Jane Dudley, Jean Erdman, Nina Fonaroff, Martha Graham, Hanya Holm, Doris Humphrey, José Limón, Sophie Maslow, and Charles Weidman. Scenarios for some of the works are included.

Q411. Palmer, Winthrop Bushnell. THEATRICAL DANCING IN AMERICA: THE DEVELOPMENT OF THE BALLET FROM 1900. New York: B. Ackerman, 1945. 159 p., illus.

An analysis of the major forces that shaped twentieth-century theatrical dancing in the United States, from Isadora Duncan to Antony Tudor. Illustration index; bibliography.

Q412. Poindexter, Betty. TED SHAWN: HIS PERSONAL LIFE, HIS PROFESSIONAL CAREER, AND HIS CONTRIBUTIONS TO THE DEVELOPMENT OF DANCE IN THE UNITED STATES OF AMERICA FROM 1891 TO 1963. Ph.D. thesis, Texas Woman's University, 1963. 652 p.
[*See* Q799.]

Q413. Rogosin, Elinor. VISITING CHARLES. *Eddy* 6 (spring 1975): 3–15, illus.

In this interview with Charles Weidman, the subject discusses artistry in the dancer; kinetic pantomime; his teaching methods; his association with Doris Humphrey and with the Denishawn Dancers; his current activities.

Q414. Rothschild, Bethsabée de, Baroness. LA DANSE ARTISTIQUE AUX USA: TENDANCES MODERNES. Paris: Editions Elzévir, 1949. 159 p., illus.

A study of the origins and nature of American modern dance, with an emphasis on the influence of American folklore and the "American spirit." Concentrates on the lives, personalities, and choreographic work of Martha Graham, Doris Humphrey, and Charles Weidman. Some attention is given other American modern dancers as well as the leading German modern dancers, ballet, the

major schools and teachers in the United States, and the aesthetic and economic problems of the American modern dance.

Q415. RUTH ST. DENIS AND TED SHAWN. A DIALOGUE. Phonotape. Hollywood, Calif.: Recorded at the Ruth St. Denis Center, 30 min.; 1 reel (7 in.) 3-3/4 in./sec. Dance Collection, The New York Public Library.

[See 1132.]

Q416. **St. Denis, Ruth.** MUSIC VISUALIZATION. *Denishawn Magazine* 1 (spring 1925): 1–7, illus.

A discussion on the translation of music into a visible form through the dance. St. Denis's music visualizations are considered the precursors to abstract American modern dance.

Q417. **Sayler, Oliver Martin, ed.** REVOLT IN THE ARTS. New York: Brentano's, 1930. 351 p.

A survey of the arts in America with contributions by thirty-five authorities in various disciplines. This group of essays by such contributors as Martha Graham, Elizabeth Duncan, and Robert Edmond Jones reflects the state of revolution in the American theater in the thirties and what the editor considered a chaotic condition in all of the arts. Sayler concludes: "In our Machine Age, intimate art may exist alongside mass-production art, deriving support from the latter in return for serving as its laboratory, testing ground and inspiration. It would seem possible, therefore, if we wish it earnestly enough, to preserve the personal touch in the arts, no matter what inroads the machine may make."

Q418. **Schlundt, Christena Lindborg.** THE PROFESSIONAL APPEARANCES OF RUTH ST. DENIS AND TED SHAWN: A CHRONOLOGY AND AN INDEX OF DANCES, 1906–1932. New York: New York Public Library, 1962. 85 p., illus.

[See Q910.]

Q419. **Schlundt, Christena Lindborg.** THE ROLE OF RUTH ST. DENIS IN THE HISTORY OF AMERICAN DANCE, 1906–1922. Typewritten. n.p., n.d. 213 p., illus. Dance Collection, The New York Public Library.

[See Q1138.]

Q420. **Selden, Elizabeth S.** THE DANCER'S QUEST: ESSAYS ON THE AESTHETIC OF THE CONTEMPORARY DANCE. Berkeley: University of California Press. 1935. 215 p., illus., frontispiece.

Illustrated with twenty-six line drawings by the author and thirty-two photographs. *Contents:* the changing ideals of the dance; the new German credo; the basic law of materials; border lines and byways; subject matter of the modern dance: Mary Wigman, Doris Humphrey, Benjamin Zemach, Margaret Gage, Martha Graham, Maja Lex; the importance of weight; the modern idiom of the dance; dynamism and space distribution; form organization and style; in quest of perfection. Index.

Q421. **Shawn, Ted.** THE AMERICAN BALLET. New York: H. Holt, 1926. 136 p., illus.

A review and prescription for the development of an American dance culture written by Ted Shawn, one of the most distinguished creative forces in the field. Introduction by Havelock Ellis. *Contents:* the spiritual basis; the source of thematic material; the classic European ballet tradition; social dancing; American music and composers; dancing and nudity; dancing for men; dancing in the church; dancing and the theater.

Q422. **Shawn, Ted.** DANCE WE MUST. 2d ed. Pittsfield, Mass.: Eagle Printing Co., 1963. 148 p., illus.

Text of lectures delivered by Shawn at George Peabody College for Teachers, Nashville, Tenn., June 13–July 2, 1938. *Contents:* why do we dance?; the history of the dance; the dance as magic; the dance and religion; the relation of the dance to drama and the theatre; the use of the human body for emotional expression; the relationship of music to the dance; the dance as a language; the dance in education; the pedagogy of the dance; the folkdance and ballroom dancing; the ballet, "natural" and other types of dance material; the American dance; dancing for men; the creation of dances; "constants"; what constitutes a work of art in the dance; the future of the dance. Bibliography. Preface dated 1963; ORIGINAL PUBLICATION dated 1950.

Q423. **Shawn, Ted, with Poole, Gray.** ONE THOUSAND AND ONE NIGHT STANDS. Garden City, N.Y.: Doubleday, 1960. 288 p., illus.

[See Q804.]

Q424. **Shawn, Ted.** REMINISCENCES: FROM CHILDHOOD TO THE DISSOLUTION OF DENISHAWN. Phonotape. New York: WNYC, broadcaster; recorded in Eustis, Fla., 1969. 6-1/2 hours; broadcast, 26 min. Dance Collection, The New York Public Library.

FROM THE WNYC SERIES INVITATION TO DANCE.

[See Q1139.]

Q425. **Shawn, Ted.** RUTH ST. DENIS: PIONEER AND PROPHET. San Francisco, 1920. 1 vol. (plates, color), 1 vol. (text).

[See Q1140.]

Q426. **Shawn, Ted.** THIRTY-THREE YEARS OF AMERICAN DANCE, 1927–1959, AND THE AMERICAN BALLET. Pittsfield, Mass.: Eagle Printing Co., 136 p., illus.

[See Q806.]

Q427. **Siegel, Marcia B.** AT THE VANISHING POINT: A CRITIC LOOKS AT DANCE. New York: Saturday Review Press, 1972. 320 p., illus.

[See Q1448.]

Q428. **Sorell, Walter, ed.** THE DANCE HAS MANY FACES. 2d ed. New York: Columbia University Press, 1966. 276 p., illus. [*cont.*]

An anthology of twenty-nine essays by contemporary dancers, choreographers, and critics. Fourteen of the essays from the first edition have been replaced by articles on more timely topics. *Contents:* "The Ethnological Dance Arts," by La Meri; "Religious Manifestations in the Dance," by Ruth St. Denis; "Dance Drama," by Doris Humphrey; "Two Rebels, Two Giants: Isadora and Martha," by Walter Sorell; "The Mary Wigman I Know," by Hanya Holm; "Randon Remarks," by Charles Weidman; "Comedy in Dance," by Clive Barnes; "The Dance and Pantomime: Mimesis and Image," by Angna Enters; "The Virile Dance," by Jose Limon; "Notes on Choreography," by Frederick Ashton; "Marginal Notes on the Dance," by George Balanchine; "The Symbolic and Psychological Aspects of the Dance," by Carmelita Maracci; "The Educational and Therapeutic Value of the Dance," by Rudolf Laban; "Pauline Koner Speaking: Composing for the Dance," by Norman Lloyd; "The Preservation of the Dance Score through Notation," by Ann Hutchinson; "Dance on Film," by John Martin; "Television Ballet," by Birgit Cullberg; "The Stage Image," by Kurt Seligmann; "The Negro Dancer in Our Time," by Donald McKayle; "Favorable Balance of Trade," by Walter Terry; "Present Problems and Possibilities," by Helen Tamiris; "Avantgarde Choreography," by Selma Jeanne Cohen; "The Living Dolls," by George Jackson; "Growth of a Theme," by Alwin Nikolais; "Thoughts on Dance," by Merle Marsicano; "What is the Most Beautiful Dance?" by Erick Hawkins; "The Dwarf Syndrome," by Yvonne Rainer; "In Defense of the Future," by Walter Sorell. Biographies of contributors; bibliography; index. FIRST EDITION (New York: World Publishing Co., 1951).

Q429. **Spiesman, Mildred C.** AMERICAN PIONEERS IN EDUCATIONAL CREATIVE DANCE. *Dance Magazine* Pt. 1 (Nov. 1950): 22–23, 35; continued in subsequent issues through Sept. 1951, illus.

[*See* Q1170.]

Q430. **Stebbins, Genevieve.** DELSARTE SYSTEM OF EXPRESSION. 6th ed., rev. and enl. New York: E. S. Werner, 1902. 507 p., illus., charts.

Theories of the French teacher, Francois Delsarte (1811–1871), whose system of gesture, physical culture, and expression, had great influence on the development of modern dance, and especially on the work of Ruth St. Denis, Ted Shawn, and Isadora Duncan. Also included is a biographical piece on the author by Elsie M. Wilbur.

Q431. TAMIRIS: PAST, PRESENT, FUTURE. Phonotape. New York: Recorded at two performances of a program dedicated to the life and work of Helen Tamiris at the Lincoln Center Library and Museum of the Performing Arts by the Stage Directors' and Choreographers' Workshop Foundation, 1968. 100 min.; 1 reel (7 in.) 3-3/4 in./sec. Dance Collection, The New York Public Library.

Walter Terry Discusses Tamiris's background, career, and choreography. Ann Mackenzie, former member of Tamiris's company, discusses Tamiris's methods of choreographing, her philosophy of dance, and the prob-

lems of reconstructing her dances, specifically *Women's Song.* Mackenzie directs an open rehearsal with music from *Women's Song:* Peggy Hackney of Dance Notation Bureau analyzes the rehearsal. The tape includes a performance of Tamiris's *Negro Spirituals.* In the second program Walter Terry relates anecdotes of Tamiris's life.

Q432. **Tamiris, Helen.** PRESENT PROBLEMS AND POSSIBILITIES. In: SORELL, WALTER, ed. THE DANCE HAS MANY FACES. 2d ed. New York: Columbia University Press, 1966. p. 200–207.

A short essay on the state of dance in this country—its future and its problems—written by one of the pioneers of American modern dance.

Q433. **Terry, Walter.** THE DANCE IN AMERICA. Rev. ed. New York: Harper & Row, 1971. 272 p., illus.

The story of American dance told through biography. Pt. 1, "The Heritage," is devoted to pre–twentieth-century development; Pt. 2, "The Rebellion," includes chapters on such modern dance pioneers as Isadora Duncan, Loie Fuller, Ruth St. Denis, Ted Shawn, Martha Graham, Doris Humphrey, Charles Weidman, Hanya Holm, and Helen Tamiris; Pt. 3, "The Rich Present," deals with twentieth-century developments in modern dance, including black dance, American ballet, the regional ballet movement, ethnic dance, the musical, movies, television, dance education, and dance notation. Index of names, titles and subjects. EARLIER EDITION (New York: Harper, 1956).

Q434. **Terry, Walter.** INTERVIEW AND LECTURE-DEMONSTRATION WITH RUTH ST. DENIS. Phonotape. New York, 1963. 1 hour, 16 min. 1 reel (7 in.) 7-1/2 in./sec. Dance Collection, The New York Public Library.
FROM A DANCE LABORATORY HELD AT THE YM-YWHA, NEW YORK.

[*See* Q1141.]

Q435. **Terry, Walter.** INTERVIEW WITH HELEN TAMIRIS. Phonotape. New York, n.d. 20 min.; 1 reel (7 in.) 3-3/4 in./sec. Dance Collection, The New York Public Library.
FROM A DANCE LABORATORY HELD AT THE YM-YWHA, NEW YORK.

[*See* Q824.]

Q436. **Terry, Walter.** INTERVIEW WITH MARTHA GRAHAM: THE ART OF PERFORMING. Phonotape. New York, 1952. 52 min.; 2 reels (5 in.) 7-1/2 in./sec. Dance Collection, The New York Public Library.
FROM A DANCE LABORATORY HELD AT THE YM-YWHA, NEW YORK.

Martha Graham discusses the elements of a good performance; the problems of the modern dancer as compared with the ballet dancer; her role in *Appalachian Spring;* the flow of energy in dancing; infusing the same movement with different meanings; the modern dancer's dual role of choreographer-performer; revising *The Triumph of Saint Joan;* her philosophy of dance.

Q437. **Terry, Walter.** INTERVIEW WITH NORMAN

WALKER. Phonotape. New York: WNYC, broadcaster, 1965. 24 min.; 1 reel (7 in.) 7-1/2 in./sec. Dance Collection, The New York Public Library.
FROM THE WNYC SERIES INVITATION TO DANCE.
[See Q592.]

Q438. **Terry, Walter.** INTERVIEW WITH RUTH ST. DENIS. Phonotape. New York: Recorded at Ruth St. Denis's apartment, 1960. 62 min.; 1 reel (7 in.) 3-3/4 in./sec. Dance Collection, The New York Public Library.
[See Q1142.]

Q439. **Terry, Walter.** THE LEGACY OF ISADORA DUNCAN AND RUTH ST. DENIS. Brooklyn: Dance Perspectives Foundation, 1960. 60 p., illus.
DANCE PERSPECTIVES, NO. 5.
Includes interviews with Ruth St. Denis, Martha Graham, Doris Humphrey, Charles Weidman, Helen Tamiris, Hanya Holm, José Limón, Agnes De Mille, Lillian Moore, and others.

Q440. **Terry, Walter, and Rennert, Jack.** ONE HUNDRED YEARS OF DANCE POSTERS. New York: Avon Publishing Co.; by arrangement with Darien House, 1975. 112 p., illus. (color).
[See Q1324.]

Q441. **Van Vechten, Carl.** THE DANCE WRITINGS OF CARL VAN VECHTEN. EDITED AND WITH AN INTRODUCTION BY PAUL PADGETTE. Brooklyn, N.Y.: Dance Horizons, 1974. 182 p., illus.
A collection of penetrating essays and reviews written between 1906 and 1962, many of which appeared in the *New York Times.* Outstanding among the articles are those on Isadora Duncan's performances of 1909, 1911, and 1917. *Partial contents:* Pt. 1, American potpourri: Terpsichorean souvenirs; interpretative art; ballet in New York; Metropolitan Opera Ballet; Isadora Duncan; the new Isadora, 1917; Maud Allan, 1910; Loie Fuller, 1909; the Negro theater; the lindy hop; Nassau dancing; eloquent Alvin Ailey; choreography for Americans; relief in an ideal; Terpsichore and the United States Army. Index of names and titles.

Q442. **Weidman, Charles.** RANDOM REMARKS. In: SORELL, WALTER, ED. THE DANCE HAS MANY FACES. 2d ed. New York: Columbia University Press, 1966. p. 51–54.
A perceptive essay on contemporary dance, pantomime, and the audience-artist relationship by one of the founders of American modern dance.

Q443. WHAT IT MEANS TO BE A DANCER: ONE GENERATION TO ANOTHER, A PANEL DISCUSSION. Phonotape. New York: Recorded at New York University by Dance Theatre Workshop and New York University School of the Arts, Feb. 10, 1975. 120 min.; 1 reel (5 in.) 1 7/8 in./sec. Dance Collection, The New York Public Library.
[See Q1029.]

MOTION PICTURE DANCE

Q444. **Copeland, Roger.** NEW DANCE/FILM: PERSPECTIVES ON DANCE AND CINEMA. *Dance Magazine* (Apr. 1974): 44–48., illus.
An in-depth examination of the relationship between film and dance explored from an historical perspective. Different approaches to the problem of combining dance and film as exemplified by such artists as Busby Berkeley, Fred Astaire, and Maya Deren are discussed.

Q445. **Croce, Arlene.** THE FRED ASTAIRE AND GINGER ROGERS BOOK. New York: Outerbridge and Lazard; Distributed by E. P. Dutton & Co., 1972. 191 p., illus.
This definitive work on the Astaire-Rogers epoch is arranged in chronological sequence by film title. It lists credits, cast, plot, and dance numbers in a well written, well researched volume.

Q446. **Hering, Doris, ed.** DANCE MAGAZINE: TWENTY-FIVE YEARS OF AMERICAN DANCE. New York: R. Orthwine, 1954. 236 p., illus.
A well-illustrated collection of articles on ballet, musical comedy and variety, modern dance, comic dance, film dance, social dance, dance education, ethnic dance and dance in television. Some of the articles have been extracted from *Dance Magazine* [see Q56], and some have been prepared expressly for this volume. Bibliography.

Q447. **Green, Stanley.** STARRING FRED ASTAIRE. New York: Dodd, Mead & Co., 1973. 501 p., illus.
Green has included a discussion of Astaire's stage and screen career; a richly illustrated chronological study of his films, with full credits, and excerpted dialogue; a record of his radio and television appearances; discography; and his career at a glance. Index.

Q448. **Hunt, Marilyn.** INTERVIEW WITH GENE KELLY. Phonotape and in transcript. Beverly Hills, Calif., Mar. 10–14, 1975. 8 hours, 38 min.; 3 reels (5 in.) 1-7/8 in./sec. Dance Collection, The New York Public Library.
[See Q1110.]

Q449. **Livingston, D.C.** THE DANCE IN FILMS. *Film Music Notes* 9 (Mar.–Apr. 1950): 20–21.
A brief survey published by the National Film Council of folk, ethnic, and modern dance films available in 1950. Some films believed to have been lost are also mentioned. Includes descriptions of works on film of Ruth St. Denis, Martha Graham, Doris Humphrey, Valerie Bettis, and José Limón. Sources of 16 mm films.

Q450. **Martin, John Joseph.** DANCE ON FILM. In: SORELL, WALTER, ED. THE DANCE HAS MANY FACES. 2d ed. New York: Columbia University Press, 1966. p. 164–68.
A full discussion of the use of motion picture film in recording performances and in preserving dance compositions.

Q451. **Nikolais, Alwin.** THE DANCE AND MULTI-MEDIA: FORUM DISCUSSION. Phonotape. Amherst, Mass.: WFCR, broadcaster, 60 min. 2 reels (7 in.) 7-1/2 in. /sec. Dance Collection, The New York Public Library.
[*See* Q406.]

Q452. NINE VARIATIONS ON A DANCE THEME. PRODUCED AND DIRECTED BY HILARY HARRIS. MUSIC BY MCNEIL ROBBINS. Motion picture. 1967; sound, black and white, 16 mm.

A simple theme is interpreted in nine variations through movement repetition and the manipulation of such film variables as camera angle, filmic time, and, with the use of close-up and zoom lenses, optics. The dancer, Bettie de Jong, and the camera work as partners.

Q453. **Springer, John Shipman.** ALL TALKING! ALL SINGING! ALL DANCING! A PICTORIAL HISTORY OF THE MOVIE MUSICAL. New York: Cadillac Publishing Co., 1966. 256 p., illus.

An entertaining, lively account of the era of the Hollywood musical. Dancers such as Fred Astaire, Gene Kelly, and Ginger Rogers are discussed. Includes an introduction by Gene Kelly. Index of names and titles.

Q454. **Sorell, Walter, ed.** THE DANCE HAS MANY FACES. 2d ed. New York: Columbia University Press, 1966. 276 p., illus.
[*See* Q428.]

Q455. A STUDY IN CHOREOGRAPHY FOR CAMERA. PRODUCED BY MAYA DEREN. Motion picture. 4 min.; black and white, silent, 16 mm.

An experimental film featuring Talley Beatty. The camera creates its own space and time, acting as a creative component of the choreography.

Q456. **Thomas, Tony; Terry, Jim; and Berkeley, Busby.** THE BUSBY BERKELEY BOOK. London: Thames & Hudson, 1973. 192 p., illus.

A profusely illustrated biography of Busby Berkeley, who created an entire genre of musical comedy films that dominated the world of the lavish Hollywood musical during the thirties and forties. Each of his films is discussed, cast credits are listed, and numerous photographs of the dance sequences he directed are included. The foreword is by Ruby Keeler. Name index.

Q457. THE VERY EYE OF NIGHT. CHOREOGRAPHY FOR CAMERA BY MAYA DEREN. MUSIC BY TEIJI ITO. Motion picture. 1958. 15 min.; sound, black and white, 16 mm.

Dancers, resembling sleepwalkers, become four-dimensional through cinematic effects, advancing as if planets in the night sky. The film was made in collaboration with students from the Metropolitan Opera Ballet School, and *the cast includes* Don Freisinger, Richard Sandifer, Patricia Terrier, Bud Bready, Genaro Gomez, Barbara Levin, Richard Englund, Rosemary Williams, Philip Salem, and Antony Tudor, director.

MUSICAL COMEDY DANCE

Q458. **Beiswanger, George W.** DANCE OVER U.S.A., PTS. 1 AND 2. *Dance Observer* Pt. 1 (Jan. 1943): 4--5; Pt. 2 (Feb. 1943): 16--17.
[*See* Q355.]

Q459. **Copeland, Roger.** BROADWAY DANCE. *Dance Magazine* (Nov. 1974): 32--37, illus.
[*See* Q573.]

Q460. **Hering, Doris, ed.** DANCE MAGAZINE: TWENTY-FIVE YEARS OF AMERICAN DANCE. New York: R. Orthwine, 1954. 236 p., illus.
[*See* Q446.]

Q461. **Duke, Vernon.** THE THEATRE MUSIC MARKET. *Theatre Arts* (Mar. 1937): 209--215.

The problems of composing music for the theater, including musical comedy, concert dance, and revues. Duke discusses various methods of collaboration used by the composer and choreographer.

Q462. ETHNIC DANCE: ROUNDTRIP TO TRINIDAD. CONCEIVED AND WRITTEN BY MARTHA MYERS. DIRECTED BY GREG HARNEY. PRODUCED BY JAC VENZA. CHOREOGRAPHED BY GEOFFREY HOLDER. Motion picture. Boston; WGBH--TV, producing organization, 1959. 29 min.; sound, black and white, 16 mm. FROM THE WGH--TV SERIES A TIME TO DANCE.
[*See* Q84.]

Q463. **Ewen, David.** COMPLETE BOOK OF THE AMERICAN MUSICAL THEATRE. New York: Holt, Rinehart & Winston, 1958. 447 p., illus.

Pt. 1 is an alphabetical listing of materials by title, with credits, number of performances, and detailed descriptions. Pt. 2 is a biographical section of "librettists, lyricists, and composers." Index. REVISED EDITION (New York, 1959). EXPANDED EDITION: *New Complete Book of the Musical Theater* (New York: 1970). 300 p., illus.

Q464. **Ewen, David.** THE STORY OF AMERICA'S MUSICAL THEATER. Philadelphia: Chilton Book Co., 1961. 268 p.

History of the American musical theater from 1735 to the 1960s. Index. REVISED EDITION (1968), 278 p.

Q465. **Hammerstein, Oscar.** DANCING IN MUSICALS: A THEATRE "GREAT" DESCRIBES THE CHANGES HE HAS SEEN AND HELPED MAKE HAPPEN. *Dance Magazine* (Apr. 1956): 16--21, illus.

Oscar Hammerstein II discusses dance in musical comedy and the general technical proficiency of the dancers from 1918 through the 1940s. Musicals discussed include *Oklahoma!* and *On Your Toes.*

Q466. **Hunt, Marilyn.** INTERVIEW WITH GENE KELLY. Phonotape and in transcript. Beverly Hills, Calif., 1975.

8 hours, 38 min.; 3 reels (5 in.) 1-7/8 in./sec. Dance Collection, The New York Public Library.

[*See* Q1110.]

Q467. **Moulton, Robert Darrell.** CHOREOGRAPHY IN MUSICAL COMEDY AND REVUE ON THE NEW YORK STAGE FROM 1925 THROUGH 1950. M.A. thesis, University of Minnesota, 1957. 433 p.

Contains a list of musical comedies and revues on the New York stage during the period chronology.

Q468. **Samachson, Dorothy.** LET'S MEET AT THE THEATRE. New York: Abelard-Schuman, 1954. 255 p., illus.

Twenty-five interviews with well-known theater personalities. Bibliography.

Q469. **Taubman, Hyman Howard.** THE MAKING OF THE AMERICAN THEATRE. New York, 1965. 385 p., illus.

A general history of the development of the American theater during the last two hundred years and the influence of social, historical, and economic forces upon it. The major emphasis is on stage plays and musical comedy or revue, but there is also information on vaudeville, the variety theater, playwrights, actors, theaters, and directors.

Q470. **Terry, Walter.** INTERVIEW WITH HANYA HOLM. Phonotape. New York: WNYC, broadcaster, 1967. 24 min. 1 reel (7 in.) 7-1/2 in./sec. Dance Collection, The New York Public Library.

FROM THE WNYC SERIES INVITATION TO DANCE.

[*See* Q718.]

Q471. **Toll, Robert C.** BLACKING UP: THE MINSTREL SHOW IN NINETEENTH-CENTURY AMERICA. New York: Oxford University Press, 1974. 310 p., illus.

[*See* Q225.]

RELIGIOUS DANCE

Q472. **Andrews, Edward Deming.** THE DANCE IN SHAKER RITUAL. In: MAGRIEL, PAUL DAVID, ED. CHRONICLES OF THE AMERICAN DANCE. New York: H. Holt, 1948. p. 2–14., illus.

This article, which first appeared in *Dance Index* 1 (Apr. 1942): 56–67, is an historical account of the Shakers, a religious sect that flourished in America from the 1780s. The use of congregational dancing in Shaker church ritual is discussed.

Q473. **Andrews, Edward Deming.** THE GIFT TO BE SIMPLE. New York: Dover Publications, 1962. 170 p., illus.

A very good study of the songs, dances, and rituals of the American Shakers.

Q474. DANCE AS PRAYER. DIRECTED BY MARVIN SILBERSHER. INTRODUCTION BY DR. GEORGE CROTHERS. NARRATED BY PAUL STEVENS. CHOREOGRAPHED BY MATTEO. SETS DESIGNED BY LLOYD EVANS. Motion picture. New York: WCBS–TV, broadcaster, 1966. 28-1/2 min.; sound, black and white, 16 mm.

FROM THE CBS PROGRAM LAMP UNTO MY FEET.

Matteo, an American ethnic dancer, dances several Hindu prayer dances, and gives a lecture-demonstration on gesture, dance, and prayer.

Q475. THE DANCE IN RELIGION. CHOREOGRAPHED BY MYRA KINCH. MUSIC BY MANUEL GALEA. ADVISOR AND SCRIPT, WALTER TERRY. NARRATED BY RAY MIDDLETON. Motion picture. New York: WNBC–TV, broadcaster, 1955. 29 min.; sound, black and white, 16 mm.

FROM THE NBC PROGRAM FRONTIERS OF FAITH.

Includes discussion on the origin of religious dance in primitive ritual and worship. The role of dance in contemporary Christian worship is demonstrated in gesture and dance. *Dancers include* Myra Kinch, Rhoda Johannson, Celene Keller, Robert Cohan, Harry Jones, and Ralph McWilliams.

Q476. **Eversole, Finley, ed.** CHRISTIAN FAITH AND THE CONTEMPORARY ARTS. New York: Abingdon Press, 1962. 255 p., illus.

[*See* Q376.]

Q477. **Fisk, Margaret Palmer.** THE ART OF THE RHYTHMIC CHOIR. New York: Harper, 1950. 205 p., illus.

On dramatizing religious ideas through movement. Discussion centers on techniques, music, and costumes. Fisk also treats the history of religious dancing and the dancers who have used religious themes (Isadora Duncan, Ruth St. Denis, Ted Shawn, Doris Humphrey, Charles Weidman, and Martha Graham). Bibliography.

Q478. **Guthrie, William Norman.** THE RELATION OF THE DANCE TO RELIGION. New York: Petrus Stuyvesant Book Guild, 1923. 36 p.

A paper reprinted from *The Chronicle* (May 1923) and read before The Club, a clerical organization of the Diocese of New York. Rev. Guthrie discusses dance as "an art of soul expression through the free body."

Q479. RELIGIOUS DANCES. CHOREOGRAPHED BY TED SHAWN. Motion picture. 193? 20-1/2 min.; silent, black and white, 16 mm.

A collection of dances performed by Ted Shawn and His Men Dancers. The dances are *Mevlevi Dervish; Brothers Bernard, Lawrence, and Masseo; Three Varieties of Religious Experience; O Brother Sun and Sister Moon; A Study of St. Francis; Dance of the Redeemed;* and *Negro Spirituals II: Nobody Knows de Trouble I've Seen, Go Down Moses,* and *Swing Low, Sweet Chariot.* Among the *dancers appearing are* Dennis Landers, Wilbur McCormack, and Frank Overlees.

Q480. **Shawn, Ted.** REMINISCENCES: FROM CHILDHOOD TO THE DISSOLUTION OF DENISHAWN. Phonotape.
[*cont.*]

New York: WNYC, broadcaster; recorded in Eustis, Fla., 1969. 6-1/2 hours; broadcast, 26 min.; 2 reels (5 in.) 1-7/8 in./sec. Dance Collection, The New York Public Library.

FROM THE WNYC SERIES INVITATION TO DANCE.

[See Q1139.]

Q481. **St. Denis, Ruth.** INTERVIEW: CONDUCTED BY SHIRLEY AND EARL UBEL. Phonotape. Los Angeles: Recorded at the Ruth St. Denis Center, ca. 1965. 55 min.; 1 reel (7 in.) 7-1/2 in./sec. Dance Collection, The New York Public Library.

[See Q1133.]

Q482. **St. Denis, Ruth.** RELIGIOUS MANIFESTATIONS IN THE DANCE. In: SORELL, WALTER, ED. THE DANCE HAS MANY FACES. 2d ed. New York: Columbia University Press, 1966. p. 12–18.

An investigation into the potential of sacred dance within the "cathedral of the future," written by a famous exponent of religious dance.

Q483. **Shawn, Ted.** THE AMERICAN BALLET. New York, H. Holt, 1926. 136 p., illus.

[See Q421.]

Q484. **Shawn, Ted.** DANCE WE MUST. 2d ed. Pittsfield, Mass.: Eagle Printing Co., 1963. 148 p., illus.

[See Q422.]

Q485. **Taylor, Margaret Fisk.** TIME FOR DISCOVERY. Philadelphia: United Church Press, 1964. 76 p., illus.

A survey of the use of symbolic movement throughout the history of the Christian church. Bibliography.

Q486. **Terry, Walter.** CHRISTMAS: REFLECTIONS ON SACRED AND SECULAR DANCE. Phonotape. New York: WNYC, broadcaster, 1966. 21 min.; 1 reel (7 in.) 7-1/2 in./sec. Dance Collection, The New York Public Library.

FROM THE WNYC SERIES INVITATION TO DANCE.

Includes: *The Nutcracker;* the role of dance in primitive religions; the Christian religion and American Indians of the Southwest; the early Catholic Church and secularization of dance; dancing in the Greek Orthodox, Coptic, and Muslim religions; the Puritans and dancing; New Testament references to dancing; sacred dance in India; religious themes in American modern dance, especially in the work of Ruth St. Denis.

SOCIAL DANCE

Q487. AMERICAN SHOW. DIRECTED BY ROBERT W. STUM. NARRATED BY MARY BEE JENSEN. Motion picture. Provo, Utah: Department of Motion Picture Productions, Brigham Young University, 1975. 35 min.; sound, color. 16 mm.

[See Q239.]

Q488. THE BALLROOM COMPANION. Philadelphia: George S. Appleton, 1849. 64 p., illus.

A handbook designed as a guide for ballroom and evening parties.

Q489. THE BALLROOM MANUAL OF CONTRA DANCES AND SOCIAL COTILLIONS, WITH REMARKS ON QUADRILLES AND SPANISH DANCE. Belfast, Me., 1866. 30 p.

According to the author, a plethora of guides have been written on quadrilles, polkas, cotillions, and other contemporary dances, but few on "the good old, comfortable contra dances of our ancestors, as enjoyed by them in their hours of relaxation and amusements."

Q490. **Baron, Samuel.** PROFESSOR BARON'S COMPLETE INSTRUCTOR IN ALL THE SOCIETY DANCES OF AMERICA, INCLUDING ALL THE FIGURES OF THE GERMAN AND EVERY NEW AND FASHIONABLE WALTZ, ROUND, OR SQUARE DANCE KNOWN IN EUROPE OR AMERICA. THE VERY LATEST AND BEST EDITION. New York: M. Young, 1881. 94 p., illus.

Includes essays on dancing, etiquette of the period, and society dances of the period.

Q491. ENCYCLOPEDIA OF SOCIAL DANCE. COMPILED BY ALBERT AND JOSEPHINE BUTLER. Mimeographed. New York: Albert Butler Ballroom Dance Service, 1975. 1 vol. (loose-leaf), illus.

An alphabetical compendium of social dances popular in the United States, chiefly from 1910 to the present. Includes such dances as the cakewalk; the Charleston; the Maxixe; the Big Apple; the Boogaloo, Frug, Monkey, and Twist; older forms such as the gavotte, mazurka, and the waltz; and Latin-American dances such as the mambo, rumba, samba, and tango. Directions for some two hundred dances are given.

Q492. **Carpenter, D. L.** THE AMATEUR'S PRECEPTOR ON DANCING AND ETIQUETTE. Philadelphia: M'Laughlin Bros., 1854. 76 p.

This handbook for the beginner includes directions for cotillions, quadrilles, and waltzes, and, according to the volume, "those dances that are at the present time most admired at our assemblies, both public and private, in Philadelphia, and in Europe." The text provides insights into the manners and mores of the period.

Q493. **Castle, Irene Foote.** MY HUSBAND. New York: Charles Scribner's Sons, 1919. 264 p., illus.

[See Q1035.]

Q494. **Castle, Vernon, and Castle, Irene.** MODERN DANCING. New York: World Syndicate Co., 1914. 175 p., illus.

Includes directions for such dances as the tango, the Castle Walk, the Hesitation Waltz, and the Maxixe. Chapters on grace and etiquette, fashion, and dance music, the manners of the period.

Q495. **Cleveland, C. H., Jr.** DANCING AT HOME AND

ABROAD. Boston: Oliver Ditson & Co.; New York: C. H. Ditson & Co., 1878. 104 p.

A treasury of American manners of the period. There is discussion of the social dancing academy, systems in teaching, music and musicians, and balls and soirees. Also discussed are fashionable dances of the day. Directions and floor patterns are provided.

Q496. **Damon, Samuel Foster.** THE HISTORY OF SQUARE DANCING. Barre, Mass.: Barre Gazette, 1957. p. 63–89.

[*See* Q529.]

Q497. **Dannett, Sylvia G. Liebowitz, and Rachel, Frank R.** DOWN MEMORY LANE: ARTHUR MURRAY'S PICTURE STORY OF SOCIAL DANCING. New York: Greenberg, 1954. 189 p., illus.

A popular pictorial history of social dance in America.

Q498. **De Garmo, William B.** THE DANCE OF SOCIETY. ILLUSTRATIONS BY THEODORE WUST. New York, 1892. 244 p., illus.

A treasury of American social style of the period with analyses of quadrilles, round dances, and cotillions. FIFTH EDITION (W. A. Pond, 1875). With addenda on additional steps, figures, and music.

Q499. **Durang, Charles.** THE BALLROOM BIJOU. Philadelphia: Turner & Fisher, 1848. 1 vol. (various pagings), illus.

An important contemporary nineteenth-century monograph by Charles Durang, a son of the famous professional dancer John Durang and an established dancing-master in his own right. The popularity, history, and progress of dancing is discussed, and there are accompanying comments on exercises, dancing positions, and rules and etiquette concerning theatrical and private dancing.

Q500. **Durang, Charles.** THE DANCERS OWN BOOK AND BALLROOM COMPANION. Philadelphia: Fisher & Bro., 185(?). 184., illus.

Descriptions of the most popular figures in cotillions or quadrilles. In addition, a discussion of etiquette of the ballroom.

Q501. **Durang, Charles.** DURANG'S TERPSICHORE. Philadelphia: Fisher & Bro., 1857. 192 p., illus.

A ballroom guide covering the theory, practice, and etiquette of dancing. Among the dances Durang discusses are cotillions, the polka and mazurka, quadrilles, gallopades, polonaises, and waltzing. One of the very successful social dance works published by the well known dancing master.

Q502. **Durang, Charles.** THE FASHIONABLE DANCER'S CASKET. Philadelphia: Fisher & Bro., 1856. 192 p., illus., frontispiece, diagrs.

Durang praises his volume as "a new and splendid work on dancing, etiquette, deportment and the toilet."

Q503. **Ellfeldt, Lois, and Morton, Virgil L.** THIS IS BALLROOM DANCE. ILLUSTRATED BY HILDA SACHS. Palo Alto, Calif.; National Press Books, 1974. 114 p., illus.

A well written, clear presentation of the fundamentals of popular American ballroom dances. Includes historical backgrounds and directions for the most popular steps and figures. Glossary of terms; bibliography; chronology of ballroom dances in the United States.

Q504. **Ford, Henry, comp.** "GOOD MORNING": AFTER A SLEEP OF TWENTY-FIVE YEARS, OLD-FASHIONED DANCING IS BEING REVIVED BY MR. AND MRS. HENRY FORD. Dearborn, Mich., Dearborn Publishing Co., 1926. 169 p., illus., diagrs.

A fine compilation of older American dances for couples and groups, the result of a revival of interest in ballroom dancing. Includes authentic dance descriptions and music for many quadrilles and contra dances as well as for some round dances famous in American social dance history.

Q505. **Hart, Oliver.** DANCING EXPLODED: A SERMON, SHEWING THE UNLAWFULNESS, SINFULNESS, AND BAD CONSEQUENCES OF BALLS, ASSEMBLIES, AND DANCES IN GENERAL. DELIVERED IN CHARLESTOWN, SOUTH CAROLINA, MARCH 22, 1778. Charlestown: David Bruce, 1778. 32 p.

A typical eighteenth-century American sermon protesting the sinfulness and immorality of dancing in an attempt to refute the popular contemporary arguments.

Q506. **Hillgrove, Thomas.** A COMPLETE PRACTICAL GUIDE TO THE ART OF DANCING. New York: Dick & Fitzgerald, 1868. 237 p., illus.

One of the most famous of dancing manuals containing the fashionable and approved dances of the day with directions and hints on etiquette, dress, "toilet," and other social accomplishments of this post–Civil War period.

Q507. THE HISTORY OF JAZZ DANCING. Motion picture. San Francisco: KQED–TV, producing organization, 1970. 56 min.; sound, black and white, 16 mm.

[*See* Q541.]

Q508. **Jarosz, Lillian M.** POPULAR BALLROOM DANCES IN THE UNITED STATES AND THE AMERICAN SCENE FROM 1850 TO 1950. M.A. thesis, New York University, 1950. 69 p.

A study of ballroom dancing in the United States from 1850 to 1950 in which Jarosz discusses the social, economic, and political factors affecting popularity and style. Chronology of the dances; directions for seven "outstanding ballroom dances"; and bibliography.

Q509. **Marks, Joseph E.** AMERICA LEARNS TO DANCE: A HISTORICAL STUDY OF DANCE EDUCATION IN AMERICA BEFORE 1900. New York: Exposition Press, 1957. 133 p.

A survey of social dancing in America based on previous

standard histories and original material found in church histories, biographies, school catalogs, and magazines. The history is divided into three parts devoted to the seventeenth, eighteenth, and nineteenth centuries and is intended, according to the author, to serve "as a guide and source book of what in the past was felt to be the place and best use of dance education." Bibliographical notes.

Q510. **McCarthy, Albert J.** Big Band Jazz. London: Barrie & Jenkins, 1974. 300 p., illus.

This profusely illustrated history of the American dance band emphasizes the personalities of the era rather than the music. Discography; index of names; and bibliography.

Q511. **McCarthy, Albert J.** The Dance Band Era: The Dancing Decades from Ragtime to Swing, 1910–1950. Philadelphia: Chilton Book Co., 1971. 176 p., illus.

A pictorial history of the leading dance bands. Excellent text covers the formative years; the twenties and the thirties; the swing era; European dance music; the war years and the aftermath; and the dance music business. Bibliography; discography; and index.

Q512. **McDowell, Lucien L. and McDowell, Flora Lassiter, comps.** Folk Dances of Tennessee: Old Play-Party Games of the Caney Fork Valley. Ann Arbor: Edwards Bros., 1938. 78 p., illus., diagrs.

An excellent historical introduction and explanation of the nineteenth-century social dance folk custom known as the play-party. The steps and dancing position are described, and authentic tunes, directions, diagrams, and words are given for thirty-one dancing games.

Q513. **Murray, Arthur, and Murray, Kathryn.** The Arthur Murray's Dance Secrets. New York, 1946. 110 p., illus.

A lightly humorous guide to hints for making social dancing easy and enjoyable by the most famous social dancing husband and wife team of the twentieth century arbiters of social dancing style.

Q514. **O'Neill, Rosetta.** The Dodworth Family and Ballroom Dancing in New York. In: Magriel, Paul David, ed. Chronicles of the American Dance. New York: H. Holt, 1948. p. 80–100, illus.

A discussion of social dancing in relation to the social history of America; the background of the Dodworth family; the history of the Dodworth Dancing Academy and Allen Dodworth's system of teaching. Notes and bibliographic data.

Q515. Rock Dance, 1960–1970. Videotape. New Jersey: New Jersey Public Broadcasting, broadcaster, 1973. 29 min.; sound, black and white, 1/2 in.
Telecast on the NJPB program Caught in the Act: A Look Back.

Chubby Checker, Judith Lynn Hanna, Jerry Blavett, Jerry Shifren, and Albert Goldman each briefly discuss popular dances of the sixties. *Students demonstrate* the Twist, Watusi, Swim, Slop, Bristol Stomp, Freddy, Mouse, and Monkey. This black and white version of the color original was submitted in partial fulfillment of a doctoral degree in cultural anthropology at New York University by Sharon Leigh Clark.

Q516. **Schneider, Gretchen Adel.** Pigeon Wings and Polkas: The Dance of the California Miners. Brooklyn, N.J.: Dance Perspectives Foundation, 1969. 57 p., illus.
Dance Perspectives, no. 39.

This well documented yet brief history includes lengthy extracts from manuscript sources written at the time of the California Gold Rush boom 1848–1855. Bibliography.

Q517. **Seldes, Gilbert Vivian.** The Seven Lively Arts. Rev. ed. New York: Sagamore Press, 1957. 306 p.
[*See* Q214.]

Q518. **Shawn, Ted.** The American Ballet. New York: H. Holt, 1926. 136 p., illus.
[*See* Q421.]

Q519. **Stearns, Marshall Winslor, and Stearns, Jean.** Jazz Dance: The Story of American Vernacular Dance. New York: Macmillan Co., 1968. 464 p., illus.
[*See* Q340.]

Q520. Theatrical and Social Dancing in Film, 1909–1936, Pt. 1. Motion picture. n.d. 38 min.; silent, black and white, 16 mm.

Includes: 1909, Andalusian dance, tango; 1913, *Moment Musicale,* danced by Geltzer and Tikhomeroff; 1916, *On with the Dance,* in which dance instructors Clay Bassett and Catherine Elliott demonstrate the Corte, Media Luna, Figure Eight, Parisian Tango, Lulu Fado, Habanero, Chasse, fox trot, Hesitation, and canter waltzes; 1924, in Hollywood, Anna Pavlova dances *The Dying Swan, Christmas, Chopiniana* from *Les Sylphides,* an unidentified solo, *Coquetterie de Columbine, Syrian Dance,* and *Californian Poppy.*

Q521. **Works Progress Administration.** Dance Index: An Annotated Index in Bibliographical Form of Dance References, Composed of Source Material Extracted from Various Works on Anthropology, Ethnology, Comparative Religion, Travel, and the Arts, Contained in Institutional Libraries of Greater New York. New York: Dance Collection The New York Public Library, ca. 1936; card file, 45 drawers.
[*See* Q46.]

Q522. **Wynne, Shirley.** From Ballet to Ballroom Dance in the Revolutionary Era. *Dance Scope* 10 (fall/winter 1975–1976): 65–73, illus.

A review of social dancing as practiced by both the Americans and British in America during the Revolutionary period. Early American attitudes toward dancing

are discussed, and there is brief mention of current American theatrical dance. Bibliography.

Q523. THE YOUNG LADY'S BOOK: A MANUAL OF ELEGANT RECREATIONS, EXERCISES, AND PURSUITS. Boston: A. Bowen, and Carter & Hendee; Philadelphia: Carey & Lea, 1830. 504 p., illus.

This is a reprint of the English edition, with engravings after the original cuts by Abel Bowen, Alexander Anderson, and others. According to Abel Bowen in the preface, "The common sense of our day and country . . . has determined, that a woman's happiness as well as her sphere of usefulness will be enlarged, in proportion to her opportunities for cultivating the powers with which nature has endowed her. . . . Hence it is now . . . fashionable to unite in the course of female studies, all that is practically useful in the sciences with all that is beautiful in the arts." One of eighteen chapters is on dancing.

SQUARE, ROUND, AND CONTRA DANCE

Q524. **Anderson, John Q.** FROLIC: SOCIAL DANCING ON THE SOUTHERN FRONTIER. A DELIGHTFUL, SERIOUS STUDY OF PLEASURIN' AN' SHUFFLIN' AN' CUTTIN' THE PIGEON'S WING, AN' SECH, PTS. 1 AND 2. *Dance Magazine* Pt. 1 (Oct. 1956): 14–16, 83, 85; Pt. 2 (Nov. 1956): 35, 80–81, illus.

[*See* Q240.]

Q525. **Boyd, Neva Leona, and Dunlavy, Tressie M.** OLD SQUARE DANCES OF AMERICA. Chicago, 1925. 96 p.

The descriptions and directions for calls and dances in this book were, according to the authors, "procured in southern Iowa, from callers long familiar with the old square dances. Nothing has been added to, nor taken from, each caller's contribution." Included are suggestions for callers and fiddlers; description of position and figures; and groups of dances arranged by type.

Q526. **Burchenal, Elizabeth.** AMERICAN COUNTRY DANCERS. PIANO ARRANGEMENT BY EMMA HOWELLS BURCHENAL. New York, 1918. 1 vol., diagrams, frontispiece, folio.

[*See* Q244.]

Q527. THE SQUARE DANCING ENCYCLOPEDIA. COMPILED BY BILL BURLESON. Minerva, Ohio, 1970. 1 vol., unpag., illus.

Includes discussion of terms, rules, as well as diagrams of specific steps and movements.

Q528. COWBOY SQUARES. FILMED BY PORTIA MANSFIELD. Motion picture. n.d. 18 min.; silent, color, 16 mm.

Excerpts from various square dances.

Q529. **Damon, Samuel Foster.** THE HISTORY OF SQUARE DANCING. Barre, Mass.: Barre Gazette, 1952. p. 63–89.

A superb essay on American square dancing from its seventeenth-century origins in England to its surge of popularity in the 1950s. Thoroughly documented from political, social, and literary sources as well as from the dance and music literature. Reprinted from American Antiquarian Society, *Proceedings* (1952): 63–89.

Q530. **Durlacher, Edward.** HONOR YOUR PARTNER: EIGHTY-ONE AMERICAN SQUARE, CIRCLE AND CONTRA DANCES, WITH COMPLETE INSTRUCTIONS FOR DOING THEM. MUSICAL ARRANGEMENTS BY KEN MACDONALD. PHOTOGRAPHS BY IRA ZASLOFF. New York: Bonanza Books, 1949. 286 p., illus., music.

Includes calls, terms, songs, and a special picture sequence section on square dance figures. Discography; bibliography.

Q531. **Jensen, Clayne R., and Jensen, Mary Bee.** SQUARE DANCING. Rev. ed. Provo, Utah: Brigham Young University Press, 1973. 159 p., illus.

A manual for the rapid development of square dancing skills that contains clear explanations on positions, formations, basic movements, and techniques. Square dancing history, patter calls, singing calls, calling techniques, teaching techniques, and exhibition square dancing are discussed. The authors are directors of the Brigham Young University International Folk Dancers. Glossary.

Q532. **Lovett, Benjamin B., ed.** "GOOD MORNING." 4th ed. Dearborn, Mich.: Dearborn Publishing Co., 1941. 124 p.

This manual, the fourth edition of Henry Ford's *Good Morning* [Q504], was compiled with descriptions by Benjamin B. Lovett: "Music, calls, and directions for Old-time dancing as revived by Mr. and Mrs. Henry Ford." Omits most of the descriptive text of Ford's compilation and appears in larger type with a simplified format.

Q533. PENNSYLVANIA DUTCH DANCES. Motion picture. Philadelphia: Filmed for the Philadelphia Dance Academy in a project for the U.S. Office of Education and the University of Pennsylvania, ca. 1966. 11-1/2 min.; sound, color, 16 mm.

Includes Amish dancing at festivals and Sunday night sings, and Stone Valley and Lykens Valley jigging. *Performed by* the Amish Dancers directed by Brad Smoker, and the Lykens, and Stone Valley Jiggers, directed by Elvin Savidge, with the Feick Family Musicians.

Q534. **Shaw, Lloyd.** COWBOY DANCES: A COLLECTION OF WESTERN SQUARE DANCES. Rev. ed. Caldwell, Id.: Caxton Printers, 1952. 417 p., illus., diagrs., music.

[*See* Q255.]

Q535. **Shaw, Lloyd.** THE ROUND DANCE BOOK. Caldwell, Id.: Caxton Printers, 1948. 443 p., illus., music.

Written by an authority in the field who was responsible for the revival of square and folk dancing. Included are instructions for dances and a discussion of American social dance books.

TAP DANCE

Q536. AMERICAN SHOW. DIRECTED BY ROBERT W. STUM. NARRATED BY MARY BEE JENSEN. Motion picture. Provo, Utah: Department of Motion Picture Productions, Brigham Young University, 1975. 35 min.; sound, color, 16 mm.

[See Q239.]

Q537. **Atwater, Constance.** TAP DANCING: TECHNIQUES, ROUTINES, TERMINOLOGY. Rutland, Vt.: Charles E. Tuttle Co., 1971. 179 p., illus.

A complete text written to update the scanty and obsolete literature.

Q538. **Ballwebber, Edith.** TAP DANCING. Chicago: Clayton F. Summy Co.; London: A. Weeks & Co., 1930. 70 p., illus., music.

This discussion of the fundamentals of tap dancing includes descriptions of routines by a well known member of the field. Glossary.

Q539. **Considine, Robert Bernard.** INTERVIEW WITH AGNES DE MILLE. Phonotape. New York: NBC Radio, broadcaster, 1960. 6 min.; 1 reel (4 in.) 7-1/2 in./sec. Dance Collection, The New York Public Library. FROM THE NBC RADIO SERIES IMAGE AMERICA.

[See Q572.]

Q540. ECHOES OF JAZZ. PRODUCED BY JAC VENZA. SETS BY TOM JOHN. COSTUMES DESIGNED BY FRANK THOMPSEN. NARRATED BY BIG WILSON. Motion picture. New York: WNET–TV, producing organization, 1965. 30 min.; sound, black and white, 16 mm. FROM THE NET SERIES U.S.A.: DANCE.

[See Q337.]

Q541. THE HISTORY OF JAZZ DANCING. Motion picture. San Francisco: KQED–TV, producing organization, 1970. 56 min.; sound, black and white, 16 mm.

A lecture-demonstration in which Les Williams portrays the black man's role in the history of jazz dancing. Includes demonstrations of the Irish jig, minstrel dances, buck-and-wing dances, vaudeville dancing, modern tap patterns, and discotheque dancing.

Q542. **Stearns, Marshall Winslor, and Stearns, Jean.** JAZZ DANCE: THE STORY OF AMERICAN VERNACULAR DANCE. New York: Macmillan Co., 1968. 464 p., illus.

[See Q340.]

Q543. TAP HAPPENING. FILMED BY EUGENE MARNER UNDER THE SUPERVISION OF LETICIA JAY. Motion picture. New York: For the Dance Collection at the Bert Wheeler Theatre, 1969. 40 min.; sound, black and white, 16 mm. Dance Collection, The New York Public Library.

Tap dancing, including sand dancing and the traditional competition line, in which each dancer performs for the others. *The dancers appearing are* Jerry Ames, Lon Chaney, Bert Gibson, Chuck Green, Raymond Kaalund, Rhythm Red, Howard "Sandman" Sims, Jimmy Slyde, and Derby Wilson.

Q544. **Terry, Walter.** INTERVIEW-DEMONSTRATION WITH BILL CALLAHAN: THE ART OF PERFORMING. Phonotape. New York, 1953. 39 min.; 1 reel (5 in.) 3-3/4 in./sec. Dance Collection, The New York Public Library. FROM A DANCE LABORATORY HELD AT THE YM–YWHA, NEW YORK.

Tap and variety dancing for stage, film, and television. Includes a session with Jerome Robbins on *Two's Company.*

Q545. **Terry, Walter.** THE STORY OF NEGRO DANCE IN AMERICA: LECTURE. Phonotape. New London, Conn.: Recorded at Connecticut College School of Dance, Aug. 14, 1963. 50 min.; 1 reel (5 in.) 3-3/4 in./sec. Dance Collection, The New York Public Library.

[See Q223.]

Q546. UNCLE TOM'S CABIN. PRODUCED BY THOMAS A. EDISON. FILMED BY EDWIN S. PORTER. Motion picture. 1903. 21 min.; silent, black and white, 16 mm.

This short drama, among the first American motion pictures deposited in the form of paper prints for copyright, contains early examples of the time step, breaks, the strut, and the cakewalk.

TELEVISION DANCE

Q547. **Bush, Jeffrey C., and Grossman, Peter Z.** VIDEODANCE. *Dance Scope* 9 (spring/summer 1975): 11–17, illus.

A discussion of the problems encountered and the techniques to be used in combining video and dance, as yet a relatively unexplored area for choreographers.

Q548. **Hering, Doris, ed.** DANCE MAGAZINE: TWENTY-FIVE YEARS OF AMERICAN DANCE. New York: R. Orthwine, 1954. 236 p., illus.

[See Q446.]

Q549. **Nikolais, Alwin.** THE DANCE AND MULTI-MEDIA: FORUM DISCUSSION. Phonotape. Amherst, Mass.: WFCR, broadcaster, 1969. 60 min.; 2 reels (7 in.) 7-1/2 in./sec. Dance Collection, The New York Public Library.

[See Q406.]

Q550. **Sorell, Walter, ed.** THE DANCE HAS MANY FACES. 2d ed. New York: Columbia University Press, 1966. 276 p., illus.

[See Q428.]

Q551. **Terry, Walter.** INTERVIEW WITH JOHN BUTLER. Phonotape. New York: WNYC, broadcaster, 1967. 26-1/2 min.; 1 reel (7 in.) 7-1/2 in./sec. Dance Collection, The New York Public Library.
FROM THE WNYC SERIES INVITATION TO DANCE.

A discussion of Terry's choreography and the themes that inspire it, illustrated by examples from *A Season in Hell, Sebastian, Carmina Burana*, and some of his work for television.

Q552. **Terry, Walter.** THE SEX DANCES OF MANKIND. LECTURE-DEMONSTRATION: EROTICISM AND TELEVISION DANCING. Phonotape. New York, 1952. 45-1/2 min.; 2 reels (5 in.) 3-3/4 in./ sec. Dance Collection, The New York Public Library.
FROM A DANCE LABORATORY HELD AT THE YM–YWHA, NEW YORK.

[*See* Q1347.]

VARIETY DANCE:
BURLESQUE, MINSTREL, AND VAUDEVILLE

Q553. **Hering, Doris, ed.** DANCE MAGAZINE: TWENTY-FIVE YEARS OF AMERICAN DANCE. New York: R. Orthwine, 1954. 236 p., illus.

[*See* Q446.]

Q554. THE HISTORY OF JAZZ DANCING. Motion picture. San Francisco: KQED–TV, producing organization, 1970. 56 min.; sound, black and white, 16 mm.

[*See* Q541.]

Q555. **Hunt, Marilyn.** INTERVIEW WITH GENE KELLY. Phonotape and in transcript. Beverly Hills, Calif., 1975. 8 hours, 38 min.; 3 reels (5 in.) 1-7/8 in./sec. Dance Collection, The New York Public Library.

[*See* Q1110.]

Q556. **Duke, Vernon.** THE THEATRE MUSIC MARKET. *Theatre Arts* (Mar. 1937): 209–215.

[*See* Q461.]

Q557. **Gilbert, Douglas.** AMERICAN VAUDEVILLE. New York: Whittlesey House, 1940. 428 p., illus., music.

This major history of American vaudeville contains an appendix listing fifty years of standard acts (1880–1930) and entertainers and their featured routines. Index.

Q558. **Kirstein, Lincoln.** ECCENTRIC DANCING. *Theatre Arts* (June 1940): 443–49, illus.

"Eccentric" or variety dancing is defined by a distinguished authority in this well-illustrated article. Kirstein discusses the history of eccentric dancing briefly and describes the range of styles.

Q559. **Sobel, Bernard.** THE HISTORIC HOOTCHY-KOOTCHY. *Dance Magazine* (Oct. 1946): 13–15, 46, illus.

The story of what, according to Sobel, was once described as the "naughtiest dance in the history of American theatrical entertainment," introduced by "Little Egypt" in 1893 at the Chicago World's Fair. Little Egypt's Chicago appearance was said to have influenced Loie Fuller and Ruth St. Denis.

Q560. **Sobel, Bernard.** ON WITH BURLESQUE. *Dance Magazine* (June 1946): 12–13, 40–41, illus.

In his description of the typical burlesque show in its heyday before the closing of burlesque theaters in New York City, Sobel makes a plea for its revival.

Q561. **Terry, Walter.** LECTURE-DEMONSTRATION: EROTICISM AND THE DANCE. Phonotape. New York, 1951. 75-1/2 min.; 3 reels (5 in.) 3-3/4 in./sec. Dance Collection, The New York Public Library.
FROM A DANCE LABORATORY HELD AT THE YM–YWHA, NEW YORK.

[*See* Q1346.]

Q562. **Terry, Walter.** INTERVIEW-DEMONSTRATION WITH BAMBI LINN AND ROD ALEXANDER. Phonotape. New York, 1953. 44 min.; 1 reel (5 in.) 3-3/4 in./sec. Dance Collection. The New York Public Library.
FROM A DANCE LABORATORY HELD AT THE YM–YWHA, NEW YORK.

The art of performing is considered in terms of motivation, style, projection, and technique. The laboratory concentrates on dance for television and nightclubs.

Q563. **Terry, Walter.** INTERVIEW-DEMONSTRATION WITH BILL CALLAHAN: THE ART OF PERFORMING. Phonotape. New York, 1953. 39 min.; 1 reel (5 in.) 3-3/4 in./sec. Dance Collection, The New York Public Library.
FROM A DANCE LABORATORY HELD AT THE YM–YWHA, NEW YORK.

[*See* Q544.]

Q564. **Terry, Walter.** INTERVIEW WITH HARRIET HOCTOR. Phonotape. New York: WNYC, broadcaster, 1967. 18 min.; 1 reel (7 in.) 7-1/2 in./sec. Dance Collection, The New York Public Library.
FROM THE WNYC SERIES INVITATION TO DANCE.

Her career as a featured variety dancer of the 1920s–1930s; her ballet training and ideas on dance training; the technical skills of two of her pupils, Nancy Crompton and Joyce Cuoco.

Q565. **Terry, Walter.** INTERVIEW WITH MELISSA HAYDEN. Phonotape. New York: WNYC, broadcaster, 1965? 22 min.; 1 reel (7 in.) 3-3/4 in./sec. in Dance Collection, The New York Public Library.
FROM THE WNYC SERIES INVITATION TO DANCE.

[*See* Q1102.]

Q566. **Seldes, Gilbert Vivian.** THE SEVEN LIVELY ARTS. Rev. ed. New York: Sagamore Press, 1957. 306 p., illus. [*See* Q214.]

Q567. **Stearns, Marshall Winslor, and Stearns, Jean.** JAZZ DANCE: THE STORY OF AMERICAN VERNACULAR DANCE. New York: Macmillan Co., 1968. 464 p., illus. [*See* Q340.]

INSTITUTIONS AND PERSONAE

Individual Artists, Companies, Critics, and Schools

CHOREOGRAPHY

Q568. ART OF CHOREOGRAPHY. Motion picture. New York: WCBS–TV, producing organization, 1956. 58 min.; sound, black and white, 16 mm.
FROM THE CBS SERIES OMNIBUS.
[*See* Q648.]

Q569. **Balanchine, George.** NEW COMPLETE STORIES OF THE GREAT BALLETS. EDITED BY FRANCIS MASON. DRAWINGS BY MARTA BECKET. Garden City, N.Y.: Doubleday, 1968. 626 p., illus.
Pt. 1, "Stories of the Great Ballets," lists more than two hundred works arranged alphabetically by title. First-performance information and remarks from reviews are included. Pts. 2–8 include notes on the history of ballet. Glossary; annotated discography; bibliographic material; and index.

Q570. **Barnes, Clive.** AMERICANS ABROAD: AMERICAN CHOREOGRAPHERS ARE DEFINITELY INFLUENCING EUROPE. *Dance Magazine* (July 1965): 40–43, 60.
Choreographers discussed include George Balanchine, Martha Graham, and Benjamin Harkarvy.

Q571. THE DANCE ENCYCLOPEDIA. COMPILED AND EDITED BY ANATOLE CHUJOY AND PHYLLIS WINIFRED MANCHESTER. 2d ed. New York: Simon & Schuster, 1967. 992 p., illus.
[*See* Q31.]

Q572. **Considine, Robert Bernard.** INTERVIEW WITH AGNES DE MILLE. Phonotape. New York: NBC Radio, broadcaster, 1960. 6 min.; 1 reel (4 in.) 7-1/2 in./sec. Dance Collection, The New York Public Library.
FROM THE NBC RADIO SERIES IMAGE AMERICA.
The interview deals with jazz and tap dancing and their historical backgrounds; dance forms in America; American choreographers, including Martha Graham and Jerome Robbins.

Q573. **Copeland, Roger.** BROADWAY DANCE. *Dance Magazine* (Nov. 1974): 32–37, illus.

A discussion of the choreographers who have worked in Broadway musical comedy.

Q574. **Cohen, Selma Jeanne.** AVANT-GARDE CHOREOGRAPHY, Pts. 1–3. *Dance Magazine.* Pt. 1 (June 1962): 22–24, 57; Pt. 2 (July 1962): 29–31, 58; Pt. 3 (Aug. 1962): 45, 54–56, illus.
[*See* Q358.]

Q575. **Croce, Arlene.** BALLETS WITHOUT CHOREOGRAPHY. *Ballet Review* 2 (1967): 7+.
An essay on contemporary American choreographers and their works. Choreographers discussed include John Taras, George Balanchine, and Gerald Arpino.

Q576. **Deakin, Irving.** BALLET PROFILE. New York: Dodge Publishing Co., 1936. 368 p., illus.
[*See* Q157.]

Q577. **De Mille, Agnes.** THE BOOK OF THE DANCE. London and New York: Golden Press, 1963. 252 p., illus. (color).
[*See* Q369.]

Q578. **De Mille, Agnes.** THE DANCE IN AMERICA. Washington, D.C.: United States Information Service, 1971. 117 p., illus. (color).
[*See* Q370.]

Q579. **Duke, Vernon.** THE THEATRE MUSIC MARKET. *Theatre Arts* (Mar. 1937): 209–215.
[*See* Q461.]

Q580. **Gruen, John.** THE PRIVATE WORLD OF BALLET. New York: Viking Press, 1975. 464 p., illus.
[*See* Q163.]

Q581. **Humphrey, Doris.** ADVICE TO YOUNG CHOREOGRAPHERS: NOTES FROM THE OPENING SESSION OF A CLASS IN CHOREOGRAPHY, FEBRUARY 1956. Juilliard School of Music, *The Juilliard Review* 3 (spring 1956): 33–36, illus.
These remarks, which serve as an introduction to her course, contain the essence of Doris Humphrey's theories on dance composition. Included is her advice on the qualities of a good choreographer; common errors for young choreographers to avoid; a discussion of the major

components of movement; her thoughts on the place of the choreographer in the world of aesthetics.

Q582. IN SEARCH OF LOVERS. PRODUCED BY NORMAN SINGER. DIRECTED BY JAC VENZA. CHOREOGRAPHED BY GLEN TETLEY. MUSIC BY NED ROREM. SETS AND COSTUMES DESIGNED BY WILLA KIM. Motion picture. New York: WNET–TV, producing organization, 1966. 30 min.; sound, black and white, 16mm.
FROM THE NET SERIES U.S.A.: DANCE.

[*See* Q832.]

Q583. **Kirstein, Lincoln.** WHAT BALLET IS ABOUT: AN AMERICAN GLOSSARY. PORTFOLIO OF PHOTOGRAPHS OF THE NEW YORK CITY BALLET BY MARTHA SWOPE. Brooklyn: Dance Perspectives Foundation, 1958. 80 p., illus.
DANCE PERSPECTIVES, NO. 1.

[*See* Q172.]

Q584. **Kurath, Gertrude Prokosch.** DANCE DESIGN. *Design* 33 (July–Aug. 1931): 64–70; 33 (Nov. 1931): 144–48; 33 (Jan. 1932): 198–203, illus.

A three-part article on modern dance composition in which it is compared to the three basic elements of architectural design—space, line, and structure. The author feels that few dancers achieve a fusion of design and motion, and that the study of architecture can help dancers appreciate this fusion. The choreographer's function, Kurath believes, is to transform the essence of experience into movement pattern. The dance, the author states, is the visualization of mental states and emotional conflicts through a forceful, restrained, and compact design.

Q585. **Lloyd, Margaret.** THE BORZOI BOOK OF MODERN DANCE. Brooklyn: Dance Horizons, 1969. 356 p., illus.

[*See* Q394.]

Q586. **Mazo, Joseph H.** DANCE IS A CONTACT SPORT. New York: Saturday Review Press, 1974. 313 p., illus.

A behind-the-scenes account of the New York City Ballet Company, written by a theater critic who spent the spring 1973 season attending company classes, rehearsals, performances, and technical sessions. He talked with dancers, administrators, stage hands, conductors, wardrobe artists, musicians, the company's director Lincoln Kirstein, and its three ballet masters, John Taras, Jerome Robbins, and George Balanchine. Biographical information on company members. Index.

Q587. **Owen, Bettie Jane.** RECORDS OF GROUP CHOREOGRAPHIC WORKS IN AMERICAN MODERN CONCERT DANCE PRODUCED FROM 1946–1950. M.A. thesis, New York University, 1950. 112 p.

[*See* Q410.]

Q588. **Martin, John Joseph.** BOOK OF THE DANCE. THE STORY OF THE DANCE IN PICTURES AND TEXT. New York: Tudor Publishing Co., 1963. 192 p., illus.

[*See* Q1011.]

Q589. **Maynard, Olga.** CONVERSATIONS WITH CYNTHIA GREGORY. *Dance Magazine* (Apr. 1975): 36–46, illus.

[*See* Q1094.]

Q590. **Pischl, A. J., and Cohen, Selma Jeanne, eds.** COMPOSER/CHOREOGRAPHER. Brooklyn: Dance Perspectives Foundation, 1963. 60 p., illus.
DANCE PERSPECTIVES, NO. 16.

[*See* Q929.]

Q591. **Terry, Walter.** THE ALCHEMY OF DANCE CREATION. *Dance Magazine.* Pt. 1 (Dec. 1951): 13, 38–41; Pt. 2 (Jan. 1952): 16–17, 29–32, illus.

Highlights of the 1950/1951 dance laboratory lecture series on choreography sponsored by Walter Terry. The series featured interviews with major American choreographers, including Ruth St. Denis, Doris Humphrey, Martha Graham, Helen Tamiris, George Balanchine, Jerome Robbins, Agnes de Mille, and Florence Rogge, in which they discussed and demonstrated their craft. In Terry's view, the choreographer's function is similar to that of the medieval alchemist: he takes the basic movements of the human body and transmutes them into a universal means of communication.

Q592. **Terry, Walter.** INTERVIEW WITH NORMAN WALKER. Phonotape. New York: WNYC, broadcaster, 1965. 24 min.; 1 reel (7 in.) 7-1/2 in./sec. Dance Collection, The New York Public Library.
FROM THE WNYC SERIES INVITATION TO DANCE.

On the differences and interrelationships between ballet and modern dance. Walker discusses how he became involved in choreographing modern dance works for ballet companies through his work with American Dances company; the basic principles of modern dance techniques; the problems of choreographing for ballet dancers; the ballets of Antony Tudor illustrating the influence of modern dance on ballet, particularly *Dark Elegies;* changes in ballet choreography of the twentieth century; the avant-garde preoccupation with "pure" movement; chance methods of choreography; his dance themes.

Q593. IN SEARCH OF LOVERS: THE BIRTH OF A DANCE WORK. PRODUCED BY JAC VENZA AND VIRGINIA KASSEL. Phonotape. National Educational Television, 1966. 11 reels (5 in.) 3-3/4 in./sec. Dance Collection, The New York Public Library.
FROM THE MOTION PICTURE IN SEARCH OF LOVERS.

Interview with Glen Tetley: his career; his ideas for his new work, *In Search of Lovers;* what it is to be a choreographer. Dancer Scott Douglas discusses his career; ballet and modern dance; performing and teaching careers in dance, in America and in Europe. Rehearsal. Tetley discusses his background; dancing as a career; concert dance in America; his dancers; the progress of his new work, *Lovers.* Tetley and designer Willa Kim discuss decor, costumes, and characters for *Lovers;* dancer Carmen de Lavallade. De Lavallade discusses her performing career and her family; working with Tetley on *Lovers.* Norman Singer, administrator of Hunter College Concert

Bureau, discusses producing and financing dance concerts in New York. Rehearsal.

Q594. WHAT IT MEANS TO BE A DANCER: ONE GENERATION TO ANOTHER, A PANEL DISCUSSION. Phonotape. New York: Recorded at New York University by Dance Theater Workshop and New York University School of the Arts, Feb. 10, 1975. 120 min.; 1 reel (5 in.) 1-7/8 in./sec. Dance Collection, The New York Public Library.

[See Q1029.]

CHOREOGRAPHERS

AILEY, ALVIN

Q595. AMERICAN BALLET THEATRE: A CLOSE-UP IN TIME. PRODUCED BY JAC VENZA. DIRECTED BY JEROME SCHNUR. Motion picture. 1973. 90 min.; sound, color, 16mm.

[On this entry, see further Q858. On the choreography of those artists who are primarily solo dancers, see Q1031 et seq.]

Q596. **Manchester, Phyllis Winifred.** PROFILE: ALVIN AILEY. The Dancing Times (Oct. 1964): 10–11, illus.

A brief essay in this London periodical on the black American modern dancer-choreographer Alvin Ailey and the repertoire of his company, the Alvin Ailey Dance Theatre.

Q597. **Terry, Walter.** INTERVIEW WITH ALVIN AILEY. Phonotape. 1969? 45 min.; 1 reel (7 in.) 3-3/4 in./sec. Dance Collection, The New York Public Library.

A discussion of Ailey's new dance, Masekela Language: Hugh Masekela's music; the theme, sets, and costumes of the dance; Ailey's 1967 African tour and its impact on his choreography; folk dancing in Uganda; Ruth Beckford; the inspiration of Katherine Dunham; black dance in America; Judith Jamison.

ARPINO, GERALD

Q598. **Goodman, Saul.** BRIEF BIOGRAPHIES: GERALD ARPINO. Dance Magazine (Oct. 1959): 48, illus.

A summary of Arpino's career through his first choreographic assignments in musical comedy.

Q599. **Maynard, Olga.** ARPINO AND THE BERKELEY BALLETS. PHOTOGRAPHS BY HERBERT MIGDOLL. Dance Magazine (Sept. 1973): 47–61, illus.

An interview with the choreographer about the summer residence of the City Center's Joffrey Ballet at the University of California, Berkeley, in 1971. Out of this Berkeley experience came his "Berkeley Ballets": Trinity, Reflections, Kettentanz, and Sacred Grove on Mount Tamalpais.

Q600. ROBERT JOFFREY. EXECUTIVE PRODUCER, JAC VENZA. CHOREOGRAPHED BY JOFFREY, ARPINO, AND ANNA SOKOLOW. Motion picture. New York: WNET–TV, producing organization, 1965. 30 min.; sound, black and white, 16 mm.
FROM THE NET SERIES U.S.A.: DANCE.

[See Q815.]

BALANCHINE, GEORGE

Q601. ART IS. PRODUCED, DIRECTED, AND WRITTEN BY JULIAN KRAININ AND DEWITT L. SAGE, JR. FILMED BY HENRY STRAUSS ASSOCIATES. CHOREOGRAPHED BY BALANCHINE. Motion picture. New York: Sears-Roebuck Foundation in cooperation with Associated Councils of the Arts, producing organization. 28 min.; sound, color, 16 mm.

In this exploration of the question "What is art?" Leonard Bernstein rehearses the Berkshire Student Symphony; Jerome Robbins discusses dance; Patricia McBride, Helgi Tomasson, and Edward Villella perform works by Robbins and Balanchine; and pantomime Tony Montanaro performs at the New York Free Theater.

Q602. **Balanchine, George.** AN INTERVIEW WITH IVAN NABOKOV AND ELIZABETH CARMICHAEL. Horizon 3 (Jan. 1961): 44–56, illus.

Balanchine reminisces about his career and discusses his views on various subjects, including choreography and government subsidy of the arts.

Q603. **Balanchine, George.** MARGINAL NOTES ON THE DANCE. In: SORELL, WALTER, ED. THE DANCE HAS MANY FACES. 2d ed. New York: Columbia University Press, 1966. p. 93–102. music.

[See Q1190.]

Q604. **Chujoy, Anatole.** THE NEW YORK CITY BALLET. PHOTOGRAPHS BY GEORGE PLATT LYNES, WALTER E. OWEN, AND FRED FEHL. New York: Alfred A. Knopf. 1953. 382 p., illus.

[See Q865.]

Q605. **Cohen, Selma Jeanne.** AVANT-GARDE CHOREOGRAPHY, Pts. 1–3. Dance Magazine. Pt. 1 (June 1962): 22–24, 57; Pt. 2 (July 1962): 29–31, 58; Pt. 3 (Aug. 1962): 45, 54–56, illus.

[See Q358.]

Q606. **Croce, Arlene.** IN BALANCHINE AND OUT. Ballet Review 1 (1966): 20+.

A review of the New York City Ballet repertoire and the choreography of its master-choreographer.

Q607. **Day, James.** INTERVIEW WITH ALEXANDRA DANILOVA. Phonotape. New York: WNET–TV, broadcaster, 1974. 30 min.; 1 reel (7 in.) 3-3/4 in./sec. Dance Collection, The New York Public Library.
FROM THE NET SERIES DAY AT NIGHT.

[See Q1043.]

Q608. **George Balanchine.** Dance Index (Feb.–Mar. 1945): 20–40, illus.

Includes a comment by Lincoln Kirstein, a discussion of choreography by Balanchine, and discussions of Balanchine's choreography Agnes de Mille and Edwin Denby.

Q609. **Godner, Nancy.** The Stravinsky Festival of the New York City Ballet. Photographs by Martha Swope et al. New York: Eakins Press, 1973. 302 p., illus.

A description of the Stravinsky Festival given during the week of June 18–25, 1972, in celebration of the composer's ninetieth birthday. Thirty-one ballets to music by Stravinsky were presented, including twenty-one created for the occasion. The book includes statements by Lincoln Kirstein, George Balanchine, and Igor Stravinsky; reproductions of the printed programs; extensive program notes; descriptions and photographs of the ballets; reviews reprinted from the New York Times, Atlantic Monthly, and other periodicals; and a final section on the preparation for the festival.

Q610. Hommage à Balanchine. Revue Chorégraphique de Paris May 1952: 1–17, illus.

This issue of this Paris periodical is devoted primarily to brief articles about Balanchine and his choreography by Jean Babilee, Serge Lifar, Dinah Maggie, and Jean Silvant. Includes a reprint of a 1931 article by Balanchine on choreography.

Q611. **Kirstein, Lincoln.** The New York City Ballet. Photographs by Martha Swope and George Platt Lynes. New York: Alfred A. Knopf, 1973. 261 p., illus.

[See Q883.]

Q612. **Koegler, Horst.** Balanchine und das modernes Ballett. Velber bei Hannover: Friedrich Verlag, 1964. 84 p., illus.
Reihe Theater Heute, nr. 13.

A valuable biographical and critical study of George Balanchine by a well-known German dance critic. Includes a survey of Balanchine's principal choreographic works, his work with the School of American Ballet and the New York City Ballet, a critical estimate of his American neoclassicism, and a discussion of his influence on European ballet since 1945.

Q613. **Lyon, James.** Interview with Margery Dell, Edward Bigelow, Todd Bolender: The New York City Ballet. Phonotape. New York: WNYC, broadcaster, 1958. 40 min.; 1 reel (7 in.) 7-1/2 in./sec. Dance Collection, The New York Public Library.
From the WNYC series Today in Ballet.

[See Q888.]

Q614. Man Who Dances: Edward Villella. Motion picture. New York: WNBC–TV, producing organization, 1968. 55 min.; sound, color, 16 mm.

From the NBC series Bell Telephone Hour.
[See Q1151.]

Q615. **Maynard, Olga.** Edward Villella Talks to Olga Maynard. Dance Magazine (May 1966): 50–54, 82–84, illus.

An interview in which this New York City Ballet dancer discusses his personal views on dance and his experiences working with George Balanchine.

Q616. New York City Ballet. Produced by Jac Venza. Choreographed by George Balanchine. Music by Stravinsky, Louis Gottschalk, and Tchaikovsky. Costumes designed by Karinska. Motion picture. New York: WNET–TV, producing organization, 1965. 30 min.; sound, black and white, 16 mm.

[See Q900.]

Q617. **Taper, Bernard.** Balanchine. New York: Harper & Row, 1963. 342 p., illus.

The major biography of the distinguished choreographer. This well-illustrated volume contains a chronological list of Balanchine's ballets. Revised edition: New York: Macmillan Co., 1974. With an additional chapter, more photographs, and a revised chronology.

Q618. **Terry, Walter.** The Choreography of George Balanchine. The Ballet Annual 5 (1951): 56–63, illus.

A discussion of Balanchine's emphasis on the forms of classical dance (in Ballet Imperial, Concerto Barocco, Symphony in C, and Theme and Variations), and his accomplishments in dramatic ballet (in Apollo and Orpheus).

Q619. **Terry, Walter.** Interview-demonstration with Maria Tallchief and André Eglevsky. Phonotape. New York, 1962. 60 min.; 1 reel (7 in.) 3-3/4 in./sec. Dance Collection, The New York Public Library.
From a dance laboratory held at the YM-YWHA, New York.

[See Q1085.]

Q620. **Beiswanger, George; Hofmann, Wilfried A.; and Levin, David Michael.** Three Essays in Dance Aesthetics. Brooklyn: Dance Perspectives Foundation, 1973. 47 p., illus.
Dance Perspectives, no. 55.

[See Q1452.]

Q621. **Venza, Jac.** Interviews with George Balanchine and Members of the New York City Ballet. Phonotape. New York: National Educational Television, 1964. 57 min.; 4 reels (7 in.) 7-1/2 in./sec. Dance Collection, The New York Public Library.
Recorded for the NET program The American Arts.

Balanchine interprets his ballet, Agon; Jacques d'Amboise contrasts a dancer's life in Europe and in New York; Balanchine views New York critics and his ballet, Medita-

tion; Arthur Mitchell, Suzanne Farrell, and Balanchine talk about the excitement of performing; Balanchine discusses eroticism in dance, inspiration and craftsmanship in his choreography, and musical training for dancers; d'Amboise speaks on his role in Balanchine's ballet, *Meditation*; company members talk about technique and their work with Balanchine; Edward Villella discusses the Balanchine pas de deux, *Tarantella*, Balanchine's approach to tempo, Villella's own repertory, and his own particular style of dancing.

Q622. WATCHING BALLET. PRODUCED AND DIRECTED BY TRACY WARD AND ROBERT BELL. CHOREOGRAPHED BY BALANCHINE. MUSIC BY HINDEMITH, TCHAIKOVSKY, GOUNOD, SOUSA, HERSHY KAY, AND MENDELSSOHN. Motion picture. New York: New York State Council on the Arts and Ballet Society, producing organizations; made by On Film, 1963, and released by Association Films, 1965. 34 min.; sound, black and white, 16 mm.

Jacques d'Amboise, assisted by Allegra Kent, Colleen Neary, and Paul Mejia, explains and demonstrates some of the elements of ballet technique and performance. Includes brief excerpts from ballets choreographed by Balanchine: *Nutcracker, Gounod Symphony, Stars and Stripes, The Four Temperaments*, and the pas de deux from the last act of *A Midsummer Night's Dream*.

BOLENDER, TODD

Q623. **Lyon, James.** INTERVIEW WITH MARGERY DELL, EDWARD BIGELOW, TODD BOLENDER: THE NEW YORK CITY BALLET. Phonotape. New York: WNYC, broadcaster, 1958. 40 min.; 1 reel (7 in.) 7-1/2 in./sec. Dance Collection, The New York Public Library.
FROM THE WNYC SERIES TODAY IN BALLET.

[*See* Q888.]

BUTLER, JOHN

Q624. A CHOREOGRAPHER AT WORK. PRODUCED BY JAC VENZA. DIRECTED BY GREG HARNEY. CONCEIVED AND WRITTEN BY MARTHA MYERS. CHOREOGRAPHED BY JOHN BUTLER. PIANIST, FREDA MILLER. BALLAD SINGER, LEON BIBB. Motion picture. Boston: WGBH–TV, producing organization, 1959. 29 min.; sound, black and white, 16 mm.
FROM THE WGBH-TV SERIES A TIME TO DANCE.

John Butler and Martha Myers discuss a choreographer's work methods. He and dancers from his company demonstrate the use of rhythm, space, and theme. The picture includes excerpts from his dances and a complete performance of his *Three Promenades with the Lord. Dancers:* Carmen de Lavallade, Sondra Lee, Bambi Linn, James Moore, Charles Saint-Amant, and Glen Tetley.

Q625. **Terry, Walter.** THE SEX DANCES OF MANKIND. LECTURE-DEMONSTRATION: EROTICISM AND TELEVISION DANCING. Phonotape. New York, 1952. 45-1/2 min.; 2 reels (5 in.) 3-3/4 in./sec. Dance Collection, The New York Public Library.

FROM A DANCE LABORATORY HELD AT THE YM–YWHA, NEW YORK.

The tape deals with the manifestation of sexual drives in various dance forms; the relationship of sexual energy to artistic expression; the characteristics in dance of masculine, feminine, and neuter genders; the use of sex in television dancing; the effect of the American puritan heritage on television dancing; the dances for television of John Butler.

CHRISTENSEN, LEW

Q626. AN INFORMAL INTERVIEW WITH LEW CHRISTENSEN, Pts. 1 and 2. *Dance Digest.* Pt. 1 (Feb. 1958): 49–54; Pt. 2 (Mar. 1958): 106–109, 111, illus.

Christensen comments on his choreography, on government subsidy, and on the San Francisco Ballet.

Q627. **Barzel, Ann.** A GALLERY OF AMERICAN DANCERS: LEW CHRISTENSEN. *Dance Magazine* (June 1942): 12–13, illus.

A biographical study of this dancer's career.

Q628. **Christensen, Lew.** STORY AND STORY-LESS BALLETS: AS THE SAN FRANCISCO BALLET COMES EAST, ITS CHOREOGRAPHER EXPLAINS HIS CREDO. *Dance Magazine* (July 1956); 24–25, illus.

Observations on story ballets, abstract choreography, and American classicism in ballet.

Q629. **Maynard, Olga.** THE CHRISTENSEN BROTHERS: AN AMERICAN DANCE DYNASTY. *Dance Magazine* (June 1973): 43–58, illus.

The biography of Lew, Harold, and William Farr Christensen and an account of the ballet companies with which they are associated: the San Francisco Ballet and Ballet West, Salt Lake City.

CHRISTENSEN, WILLIAM

Q630. **Maynard, Olga.** THE CHRISTENSEN BROTHERS: AN AMERICAN DANCE DYNASTY. *Dance Magazine* (June 1973): 43–58, illus.

[*See* Q629.]

CUNNINGHAM, MERCE

Q631. **Cohen, Selma Jeanne.** AVANT-GARDE CHOREOGRAPHY, Pts. 1–3. *Dance Magazine.* Pt. 1 (June 1962): 22–24, 57; Pt. 2 (July 1962): 29–31, 58; Pt. 3 (Aug. 1962): 45, 54–56, illus.

[*See* Q358.]

Q632. **Charlip, Remy.** COMPOSING BY CHANCE: CONCERNING MERCE CUNNINGHAM AND HIS CHOREOGRAPHY. *Dance Magazine* (Jan. 1954): 17–19, illus.

Five dances (*Sixteen Dances for Soloist and Company of Three, Suite by Chance*, an excerpt from *Symphonie pour un*

Homme Seul, the solo suite from *Time and Space,* and *Solo)* illustrate the use of chance in Merce Cunningham's choreography.

Q633. **Cunningham, Merce.** THE FUNCTION OF A TECHNIQUE FOR DANCE. In: SORELL, WALTER, ED. THE DANCE HAS MANY FACES. New York: World Publishing Co., 1951. p. 250–55.

A statement by Merce Cunningham on the role of technique and dance discipline as a means, not an end, to the creative process.

Q634. **Cunningham, Merce.** MUSIC AND DANCE AND CHANCE OPERATIONS: A FORUM DISCUSSION. Phonotape. Amherst, Mass.: WFCR, broadcaster, 1970. 54-1/2 min.; 2 reels (7 in.) 7-1/2 in./sec. Dance Collection, The New York Public Library.
FROM THE WFCR SERIES FIVE-COLLEGE FORUM.
[*See* Q361.]

Q635. **Cunningham, Merce.** CHANGES: NOTES ON CHOREOGRAPHY. EDITED BY FRANCES STARR. New York: Something Else Press, 1969. 1 vol., unpag., illus. (color), diagrs.

Working notes, predominantly by Cunningham, on various pieces he has choreographed. The volume provides specific information on each dance, including theme and diagrams. General comments on dance are interspersed.

Q636. **Klosty, James, ed.** MERCE CUNNINGHAM. New York: Saturday Review Press, 1975. 217 p., illus.

Contributions from some of Merce Cunningham's collaborators include a memoir by Carolyn Brown, recollections by Gordon Mumma of the history of the Cunningham company, John Cage's thoughts on touring with the company, and an interview by Klosty with Jasper Johns. Two early reviews (April 6, 1944 and January 29, 1945) by Edwin Denby are reprinted from his *Looking at the Dance,* 1949 [Q1001]. Other contributors include Earle Brown, Douglas Dunn, Lincoln Kirstein, Lewis Lloyd, Richard Nelson, Pauline Oliveros, Yvonne Rainer, Robert Rauschenberg, Viola Farber Slayton, Paul Taylor, David Tudor, and Christian Wolff. Photographs by the editor.

Q637. **Kostelanetz, Richard.** METAMORPHOSIS IN MODERN DANCE. *Dance Scope* (fall 1970): 6–21, illus.
[*See* Q96.]

Q638. **Tomkins, Calvin.** MERCE CUNNINGHAM AND JOHN CAGE, JASPER JOHNS, ROBERT MORRIS, BRUCE NAUMAN, ROBERT RAUSCHENBERG, FRANK STELLA, ANDY WARHOL: A PORTFOLIO OF SEVEN PRINTS RECORDING COLLABORATIONS WITH MERCE CUNNINGHAM AND DANCE COMPANY. New York: Multiples and Castelli Graphics, 1974. portfolio, unpag.

Seven original prints by seven major twentieth-century artists and designers who have collaborated with the choreographer in works presented by his company. This is a limited edition of a hundred portfolios, each print signed and numbered by the artist. Includes an introductory essay on the artistic relationship of choreographer and artist.

Q639. MERCE CUNNINGHAM: NEW CONCERNS AND NEW FORMS. In: MCDONAGH, DON. THE RISE AND FALL AND RISE OF MODERN DANCE. New York, 1970. p. 52–76, illus.

Contents: Cunningham's impact on modern dance and his influence on younger dancers; his life and an account of his performing career; a critique of his choreography illustrated by examples from his work; a view of a "typical" Cunningham concert; a description of a dance in preparation; his collaborators and the dancers of his company.

Q640. RAINFOREST. PRODUCED BY D. A. PENNEBAKER. CHOREOGRAPHED BY CUNNINGHAM. MUSIC BY DAVID TUDOR. SET DESIGNED BY ANDY WARHOL. Motion picture. Filmed in performance at the Second Buffalo Festival of Arts by Public Broadcasting Laboratory, producing organization, 1969. 26 min.; sound, color, 16 mm.

The film records a performance of *Rainforest;* an interview with John Cage; a rehearsal segment. *Dancers:* Cunningham, Carolyn Brown, Barbara Lloyd, Sandra Neels, Albert Reid, and Gus Solomons, Jr.

Q641. **Scothorn, Carol.** THREE CHOREOGRAPHERS TALK ABOUT THE AUDIENCE. *Impulse* (1962): 16–19.

Hanya Holm, Ruth Currier, and Merce Cunningham discuss the relationship between the performer and/or choreographer and the audience.

Q642. TIME TO WALK IN SPACE. Brooklyn: Dance Perspectives Foundation, 1968. 67 p., illus.
DANCE PERSPECTIVES, NO. 34.

Includes essays, stories, and remarks about Cunningham, by John Cage, Clive Barnes, Edwin Denby, Jill Johnson, Arlene Croce, and Carolyn Brown; a biography by David Vaughan; a contribution by Cunningham on five dances; and a chronology of works compiled by Vaughan.

Q643. **Tomkins, Calvin.** THE BRIDE AND THE BACHELORS: FIVE MASTERS OF THE AVANT-GARDE. Rev. ed. New York: Viking Press, 1968. 306 p., illus.

The volume contains essays on Marcel Duchamp, John Cage, Jean Tinguely, Robert Rauschenberg, and Cunningham. The article on Cunningham is a description of the creation of his new work, *Scramble,* from the early choreographic sessions through the rehearsals to the first performance at the Ravinia Festival in July 1967. Interspersed in the narrative is biographical material, including brief sketches of Cunningham's dancers and other collaborators, a history of the company, the development of Cunningham's ideas, and his use of chance in his choreography. EARLIER EDITIONS (1965; paperback 1968) did not include Cunningham. This revision contains "a new introduction and expanded text."

CURRIER, RUTH

Q644. **Scothorn, Carol.** THREE CHOREOGRAPHERS TALK ABOUT THE AUDIENCE. *Impulse* (1962): 16–19.

[*See* Q641.]

DE MILLE, AGNES

Q645. AMERICAN BALLET THEATRE: A CLOSE-UP IN TIME. PRODUCED BY JAC VENZA. DIRECTED BY JEROME SCHNUR. Motion picture. 1973. 90 min.; sound, color, 16 mm.

[*See* Q858.]

Q646. **De Mille, Agnes.** AND PROMENADE HOME. Boston: Little, Brown & Co.; copublished with Atlantic Monthly Press, 1958. 301 p., illus.

A continuation of *Dance to the Piper* [Q652]. This volume covers the years of the author's early struggles in New York, her marriage, and her success in musical comedy. Index.

Q647. ART OF BALLET. Motion picture. New York: WCBS–TV, producing organization, 1956. 45 min.; sound, black and white, 16 mm.
FROM THE CBS SERIES OMNIBUS.

[*See* Q108.]

Q648. ART OF CHOREOGRAPHY. Motion picture. New York: WCBS–TV, producing organization, 1956. 58 min. sound, black and white, 16 mm.
FROM THE CBS SERIES OMNIBUS.

Agnes de Mille discusses choreography, tracing its development from primitive and ethnic sources to its place in theatrical dance today. Included are a dance from the Congo (performed by Charles Queenan), a Scottish sword dance (James Jamieson), excerpts from *Les Sylphides* (Diana Adams, Sonia Arova, and Frederic Franklin), and examples of Agnes de Mille's choreography: *Rodeo* (Jenny Workman and Frederic Franklin), *Oklahoma* (Kelly Brown), and an untitled pas de deux to music by Trude Rittman (Sonia Arova and James Mitchell). An extended sequence shows de Mille choreographing a new work, *Fall River Legend*, to music by Morton Gould.

Q649. **De Mille, Agnes.** APPRECIATION AND SUPPORT FOR THE THEATRE IN AMERICA. Phonotape. Washington, D.C.: Recorded at the Association for Childhood Education International, 1967. 53 min. 1 reel (7 in.) 3-3/4 in./sec. Dance Collection, The New York Public Library.

[*See* Q1295.]

Q650. **De Mille, Agnes.** ARTISTIC CRITICISM AND APPRECIATION IN AMERICA. Phonotape. Beloit, Wisc.: Recorded at Beloit College, ca. 1960. 46-1/2 min.; 1 reel (7 in.) 3-3/4 in./sec. Dance Collection, The New York Public Library.

[*See* Q1425.]

Q651. **De Mille, Agnes.** THE BOOK OF THE DANCE. London and New York: Golden Press, 1963. 252 p., illus. (color).

[*See* Q369.]

Q652. **De Mille, Agnes.** DANCE TO THE PIPER. Boston: Little, Brown & Co., 1952. 342 p., illus.

This autobiography traces the choreographer's formative years in Hollywood, her London period, Martha Graham's influence on her, and her success in the creation of the ballet *Rodeo* for the Ballet Russe de Monte Carlo. Index. [*For a continuation, see* Q646.]

Q653. **De Mille, Agnes.** LIZZIE BORDEN: A DANCE OF DEATH. Boston: Little, Brown & Co.; copublished by Atlantic Monthly Press, 1968. 302 p., illus.

The choreographer discusses her interest in the Lizzie Borden murders, her decision to create a ballet based on the tragedy, her research into the event, and her subsequent creation of *Fall River Legend* for the American Ballet Theatre Company. Index.

Q654. **De Mille, Agnes.** SPEAK TO ME, DANCE WITH ME. Boston: Little, Brown & Co.; copublished with Atlantic Monthly Press, 1973. 404 p., illus.

Extracts taken from the author's diary, making up a detailed autobiographical account of the choreographer's London period; her work with Marie Rambert, Antony Tudor, and Hugh Laing; her friendship with Ramon Reed.

Q655. **De Mille, Agnes.** THE STATUS OF THE PERFORMING ARTS IN AMERICA: THE "CULTURAL EXPLOSION." Phonotape. Amherst, Mass.: Recorded at the University of Massachusetts, Oct. 15, 1966. 21-1/2 min.; 1 reel (5 in.) 3-3/4 in./sec. Dance Collection, The New York Public Library.

[*See* Q1371.]

Q656. FALL RIVER LEGEND. PRODUCED AND DIRECTED BY BOB SHANKS. CHOREOGRAPHED BY AGNES DE MILLE. MUSIC BY MORTON GOULD. COSTUMES DESIGNED BY MILES WHITE. Motion picture. Sturbridge, Mass.: Filmed at Old Sturbridge Village by Camco Production for Group W, Westinghouse Broadcasting in association with Griffith Productions, producing organization, 1972. 10 min.; sound, color, 16 mm.

Lizzie Borden's story is presented through excerpts from De Mille's *Fall River Legend*. *Dancers:* Sallie Wilson, Gayle Young, Lucia Chase, and Tom Adair of the American Ballet Theatre Company.

Q657. **Terry, Walter.** INTERVIEW-DEMONSTRATION WITH AGNES DE MILLE: THE ART OF CHOREOGRAPHY. Phonotape. New York, 1951. 62 min. 1 reel (5 in.) 3-3/4 in./sec. Dance Collection, The New York Public Library.
FROM A DANCE LABORATORY HELD AT THE YM–YWHA, NEW YORK.

The tape is concerned with the art of De Mille's choreog-

raphy: her early career and the development of her choreography; the relationship of her choreography to music, as in *Three Virgins and a Devil*, and *Rodeo*; her use of folk dance material, as in *Rodeo*; problems encountered in choreographing for ballet, concert dance, and musical comedy; her dances, *Gigue* and *Chorale*.

DUNHAM, KATHERINE

Q658. **Buckle, Richard, ed.** KATHERINE DUNHAM: HER DANCERS, SINGERS, MUSICIANS. ILLUSTRATED BY ROGER WOOD ET AL. London: Ballet Publications, 1949. 79 p., illus.

[*See* Q80.]

Q659. CARNIVAL OF RHYTHM. CHOREOGRAPHED BY DUNHAM. Motion picture. Warner Bros. Pictures, producing organization, 1941. 20 min.; sound, black and white, 16 mm.

Included are songs and dances from Brazil, a South American Indian courtship dance, and a dance from Africa. *Dancers:* Dunham, Talley Beatty, Archie Savage, and members of the Katherine Dunham Dance Company.

Q660. **Cluzel, Magdeleine.** PRÉSENCES: ENTRETIENS SUR L'ART. Paris: G. P. Maisonneuve, 1952. 165 p., illus.

Includes a chapter on Dunham, "Andre Quellier, peintre français, et les ballets de Katherine Dunham." The essay is illustrated with reproductions of four drawings by Quellier made during the dancer's Paris appearances in the early 1950s. ENGLISH-LANGUAGE EDITION: Magdeleine Cluzel, *Glimpses of the Theatre and Dance*, New York: Kamin Publishers, 1953.

Q661. **Dunham, Katherine.** LAS DANZAS DE HAITI. Mexico, 1947. 60 p., illus.
ACTA ANTHROPOLOGICA, VOL. 2.
[*See* Q82 for English edition.]

Q662. **Dunham, Katherine.** KATHERINE DUNHAM'S JOURNEY TO ACCOMPONG. DRAWINGS BY TED COOK. New York: H. Holt, 1946. 162 p., illus.
[*See* Q81.]

Q663. **Harnan, Terry.** AFRICAN RHYTHM — AMERICAN DANCE: A BIOGRAPHY OF KATHERINE DUNHAM. New York: Alfred A. Knopf, 1974. 213 p., illus.

Katherine Dunham's life from early childhood through her career as an artist of international acclaim. Her work for *Treemonisha* performed at Southern Illinois University in 1972, is discussed. Based in part on interviews; stresses her encouragement of blacks in the arts.

Q664. Carbondale, Ill. **Southern Illinois University Library.** KATHERINE MARY DUNHAM PAPERS, 1919-1968. 1970. 22 leaves.

This biography of the black dancer-choreographer-anthropologist includes a detailed inventory of the collec-

tion of her papers deposited at Southern Illinois University. The collection includes correspondence, manuscripts, anthropology notes, and documents relating to the Dunham company, as well as music scores for many of the musical productions performed by her company or choreographed by her. Constitutes a detailed and major archive on black dance in America.

Q665. KATHERINE DUNHAM. In: LLOYD, MARGARET. THE BORZOI BOOK OF MODERN DANCE. New York: Alfred A. Knopf, 1949. p. 243–53.

A brief biography and survey of the career of Katherine Dunham as an anthropologist, dancer, writer, and choreographer of spectacular revues based on Afro-Caribbean culture. A rather full description is given of some of her most successful stage works: *Tropical Revue* (1943), *L'Ag'Ya* (1944), and *Bal Nègre* (1947).

Q666. **Terry, Walter.** INTERVIEW WITH ALVIN AILEY. Phonotape. 1969? 45 min.; 1 reel (7 in.) 3-3/4 in./sec. Dance Collection, The New York Public Library.
[*See* Q597.]

Q667. **Terry, Walter.** THE STORY OF NEGRO DANCE IN AMERICA: LECTURE. Phonotape. New London, Conn.: Recorded at Connecticut College School of Dance, 1963. 50 min.; 1 reel (5 in.) 3-3/4 in./sec. Dance Collection, The New York Public Library.
[*See* Q223.]

FELD, ELIOT

Q668. AMERICAN BALLET COMPANY. DIRECTED BY CHRISTIAN AND MICHAEL BLACKWOOD. NARRATED BY CLIVE BARNES. CHOREOGRAPHED BY FELD. MUSIC BY MAHLER AND BRAHMS. Motion picture. Blackwood Productions, producing organization, 1969. 59 min.; sound, color, 16 mm.

A documentary tracing the development of Eliot Feld's American Ballet Company. Included are appearances at the festival in Spoleto, Italy, and their New York debut at the Brooklyn Academy of Music in 1969. Choreographer Antony Tudor, administrator Lew Lloyd, critic Clive Barnes, ballet masters Richard Thomas and Barbara Fallis, and company pianists Gladys Celeste Mercader and Barbara Malcolm appear briefly. *Dancers:* Christine Sarry, Elizabeth Lee, John Sowinski, Olga Janke, Alfonso Figueroa, David Coll, Jon Engstrom, Larry Grenier, Karen Kelly, Christine Kono, Daniel Levins, Richard Munro, Stephanie Simmons, Cristina Stirling, and Feld rehearse excerpts from Feld's *Meadowlark, Intermezzo, At Midnight,* and *Pagan Spring*.

Q669. **France, Charles Engell.** A CONVERSATION WITH ELIOT FELD. *Ballet Review* 3:6 (1971): 7–15.

A revealing interview with one of America's leading choreographers. Discussion includes Feld's creative work habits; the differences in the artistic policy of the American Ballet Theatre Company and the American Ballet Company; his opinion of contemporary choreographers, and his work as a dancer and a choreographer.

FOKINE, MIKHAIL (MICHEL)

Q670. **Fokine, Michel.** MEMOIRS OF A BALLET MASTER. TRANSLATED BY VITALE FOKINE. EDITED BY ANATOLE CHUJOY. Boston: Little, Brown & Co., 1961. 318 p., illus.

This biography of the celebrated choreographer includes selections from his manuscripts; his work in the United States; his antagonism to the modern dance; the rediscovery of his work in his last years. Chronology of his life; appendix of the ballets, dances in operas, and dramas; index.

Q671. **Terry, Walter.** INTERVIEW-DEMONSTRATION WITH MARIA TALLCHIEF AND ANDRÉ EGLEVSKY. Phonotape. New York, 1962. 60 min.; 1 reel (7 in.) 3-3/4 in./sec. Dance Collection, The New York Public Library.

FROM A DANCE LABORATORY HELD AT THE YM-YWHA, NEW YORK.

[*See* Q1085.]

GRAHAM, MARTHA

Q672. ACROBATS OF GOD. CHOREOGRAPHED BY GRAHAM. MUSIC BY CARLOS SURINACH. SET DESIGNED BY ISAMU NOGUCHI. Motion picture. Martha Graham Center, producing organization, 1968. 22 min.; sound, color, 16 mm.
FROM THE SERIES THREE BY MARTHA GRAHAM.

A comic, satirical dance about the creative process. *Dancers include* Graham, Robert Powell, Bertram Ross, Robert Cohan, Mary Hinkson, Helen McGehee, Takako Asakawa, Phyllis Gutelius, Noemi Lapzeson, Clive Thompson, William Louther, and Robert Dodson.

Q673. APPALACHIAN SPRING. PRODUCED BY NATHAN KROLL. CHOREOGRAPHED BY GRAHAM. MUSIC BY AARON COPLAND. SETS DESIGNED BY ISAMU NOGUCHI. Motion picture. Pittsburgh: WQED–TV, producing organization, 1959. 31 min.; sound, black and white, 16 mm.

A folk tale of the wedding of a young couple in the Appalachian Mountain wilderness. *Dancers include* Graham, Stuart Hodes, Bertram Ross, Matt Turney, Yuriko Kimura, Helen McGehee, Ethel Winter, and Miriam Cole.

Q674. **Armitage, Merle, ed.** MARTHA GRAHAM. New York: By the Author, 1966. 132 p., illus.

A collection of essays by Armitage, John Martin, Lincoln Kirstein, Evangeline Stokowski, Wallingford Riegger, Edith J. R. Isaacs, Stark Young, Roy Hargrave, James Johnson Sweeney, George Antheil, Louis Danz, Margaret Lloyd, and Graham. *Partial contents:* a brief biography by Winthrop Sargeant; affirmations by Martha Graham; a chronology of New York concerts and repertoire; a chronology of concert tours and special events.

Q675. CORTEGE OF EAGLES. CHOREOGRAPHED BY GRAHAM. MUSIC BY EUGENE LESTER. SETS DESIGNED BY ISAMU NOGUCHI. Motion picture. Martha Graham Center, producing organization, 1969. 38 min.; sound, color, 16 mm.

Dancers include Graham, Bertram Ross, Robert Cohan, Robert Powell, William Louther, Moss Cohen, Lar Roberson, Clive Thompson, Mary Hinkson, Matt Turney, Helen McGehee, Takako Asakawa, Noemi Lapzeson, Dawn Suzuki, Yuriko Kimura, Diane Gray, Kenneth Pearl, Hugh Appet, and Robert Dodson.

Q676. DANCE MAGAZINE AWARDS, 1957: MARTHA GRAHAM AND AGNES DE MILLE. Phonotape. New York: WNYC, broadcaster, 1957. 20 min.; 1 reel (7 in.) 7-1/2 in./sec. Dance Collection, The New York Public Library.
PARTIAL PROCEEDINGS ON THE WNYC SERIES TODAY IN BALLET.

De Mille on modern dance in America, her own career, and Martha Graham; Paul G. Hoffman on Graham as a cultural ambassador; Graham on her Asian tour, the nature of communication, and dance as communication.

Q677. A DANCER'S WORLD. PRODUCED BY NATHAN KROLL. DIRECTED AND FILMED BY PETER GLUSHANOK. COMPOSER AND PIANIST, CAMERON McCOSH. CHOREOGRAPHED BY GRAHAM. Motion picture. Pittsburgh: WQED–TV, producing organization, 1957. 30 min.; sound, black and white, 16 mm.

Graham expresses her philosophy as a dancer as members of her company illustrate her theories. *Dancers include* Graham, Yuriko Kimura, Helen McGehee, Gene McDonald, Ellen Siegel, David Wood, Miriam Cole, Lillian Biersteker, Robert Cohan, Ethel Winter, Bertram Ross, and Mary Hinkson.

Q678. **Dell, Cecily.** RANDOM GRAHAM. *Dance Scope* (spring 1966): 21–26.

A student of movement analysis comments on the impact of Graham on dance in general and on her students: Erick Hawkins, Paul Taylor, Merce Cunningham, and Anna Sokolow. Also discussed are her approach to dance and the interplay of her talents as performer and choreographer.

Q679. FOUR PIONEERS. PRODUCED BY JAC VENZA. Motion picture. New York: WNET–TV, producing organization, 1965. 30 min.; sound, black and white, 16 mm.
FROM THE NET SERIES U.S.A.: DANCE.

[*See* Q721.]

Q680. **Graham, Martha.** THE AUDACITY OF PERFORMANCE. *Dance Magazine* (May 1953): 24–25., illus.

An essay on the discipline, the rehearsal, and the exploration involved in the creative process.

Q681. **Graham, Martha.** THE NOTEBOOKS OF MARTHA GRAHAM. New York: Harcourt Brace Jovanovich, 1973. 464 p., illus., facsims. [*cont.*]

Through these selections from the working notebooks of Martha Graham, the reader can discern some of the influences that have played an important role in the choreographer's career. Introduction by Nancy Wilson Ross; fourteen pages reproduced in facsimile (endpapers).

Q682. **Graham, Martha.** MARTHA GRAHAM SPEAKS. *Dance Observer* (Apr. 1963): 53–55.

In these excerpts from a speech given by Graham in 1952 at the Juilliard School of Music, she discusses movement as a barometer of the soul and includes mention of *Appalachian Spring, Letter to the World, Deaths and Entrances,* and *Herodiade.*

Q683. **Horan, Robert.** THE RECENT THEATER OF MARTHA GRAHAM. In: MAGRIEL, PAUL DAVID, ED. CHRONICLES OF THE AMERICAN DANCE. New York: H. Holt, 1948. p. 238–59, illus.

A chronological examination of Graham's choreographic works created in the 1940s, including *Punch and the Judy, Deaths and Entrances, Salem Shore, Appalachian Spring, Herodiade, Dark Meadow,* and *Serpent Heart.* The last four works were created in collaboration with sculptor-designer Isamu Noguchi, whose contribution is described.

Q684. LAMENTATION. FILMED BY MR. AND MRS. SIMON MOSELSIO. NARRATED BY JOHN MARTIN. CHOREOGRAPHED BY GRAHAM. MUSIC BY ZOLTÁN KODÁLY. ACCOMPANIST, LOUIS HORST. Motion picture. Harmon Film Foundation, producing organization, 1943. 10 min.; sound, color, 16 mm.

John Martin gives a brief history of the modern dance; Graham dances excerpts from her celebrated work, *Lamentation.*

Q685. **Leabo, Karl, ed.** MARTHA GRAHAM. COMPILED BY LOUIS HORST AND ROBERT SABIN. PHOTOGRAPHS BY MARTHA SWOPE, BARBARA MORGAN, ANGUS MCBEAN, ET AL. New York: Theatre Arts Books, 1961. 48 p., illus.

A complete chronological list of dances composed by Martha Graham from April 1926 to April 1961. Bibliography.

Q686. **Leatherman, Leroy.** MARTHA GRAHAM: PORTRAIT OF THE LADY AS AN ARTIST. PHOTOGRAPHS BY MARTHA SWOPE. New York: Alfred A. Knopf, 1966. 178 p., illus.

An informal profile of Martha Graham and her company in the mid-sixties, issued to coincide with the first national tour the company had made in twenty years.

Q687. MARTHA GRAHAM. In: LLOYD, MARGARET. THE BORZOI BOOK OF MODERN DANCE. New York: Alfred A. Knopf, 1949. p. 35–76.

Detailed descriptions of her works, including *Errand into the Maze, Cave of the Heart, Dark Meadow, Night Journey, Deaths and Entrances, Primitive Mysteries, Chronicle, American Document, Every Soul Is a Circus, El Penitente, Letter to the World, Punch and the Judy, Appalachian Spring.*

Q688. **Maynard Olga.** AMERICAN MODERN DANCERS: THE PIONEERS. Boston: Little, Brown & Co., 1965. 218 p., illus.

[*See* Q399.]

Q689. **McDonagh, Don.** MARTHA GRAHAM: A BIOGRAPHY. New York: Praeger Publishers, 1973. 341 p., illus.

The major biography of this outstanding modern dancer. Includes chronology of dance works with first-performance information (1926–1973) compiled by Leighton Kerner assisted by Don McDonagh. Bibliography; index.

Q690. THE MEDIUM OF DANCE: LECTURE. Phonotape. New York: Recorded at the Student Composer Forum at Juilliard School of Music, 1952. 45 min.; 2 reels (7 in.) 7-1/2 in./sec. Dance Collection, The New York Public Library.

Includes discussion of Yuriko; the dancer's training; the nature of the dance; Graham's method of collaboration with composers; *Letter to the World; Appalachian Spring, Deaths and Entrances, Herodiade,* and *Night Journey;* ballet and modern dance; music and the dancer.

Q691. MODERN DANCE BY MARY WIGMAN, ET AL. COMPILED BY VIRGINIA STEWART. New York: E. Weyhe, 1935. 155 p., illus.

[*See* Q402.]

Q692. **Morgan, Barbara.** MARTHA GRAHAM: SIXTEEN DANCES IN PHOTOGRAPHS. New York, 1941. 160 p., illus.

An elegant book of fine photographs of sixteen dances with program notes. Also included are essays by George Beiswanger, Morgan, and a chronology of Graham's choreographic works (1926–1941) prepared by Louis Horst.

Q693. NIGHT JOURNEY. PRODUCED BY NATHAN KROLL. DIRECTED BY ALEXANDER HAMMID. FILMED BY STANLEY MEREDITH. CHOREOGRAPHED BY GRAHAM. MUSIC BY WILLIAM SCHUMAN. COSTUMES DESIGNED BY GRAHAM. SETS DESIGNED BY ISAMU NOGUCHI. Motion picture. 1960. 29 min.; sound, black and white, 16 mm.

The Greek legend of Oedipus Rex. *Cast includes* Graham, Bertram Ross, Paul Taylor, Helen McGehee, Ethel Winter, Mary Hinkson, Linda Hodes, Akiko Kanda, Carol Payne, and Bette Shaler.

Q694. **Nuchtern, Jeanne.** MARTHA GRAHAM'S WOMEN SPEAK. *Dance Magazine* (July 1974): 46–51, illus.

Poetic statements illuminate some of the prominent female characters in the works of Martha Graham: Medea, Circe, Clytemnestra, Joan of Arc, and the Young Bride in *Appalachian Spring.* The article forms part of a *Dance Magazine* portfolio on Martha Graham containing contributions by various writers.

Q695. **Rothschild, Bethsabée de, Baroness.** LA DANSE ARTISTIQUE AUX USA: TENDANCES MODERNES. Paris:

Editions Elzévir, 1949. 159 p., illus.

[*See* Q414.]

Q696. **Sayler, Oliver Martin, ed.** REVOLT IN THE ARTS. New York: Brentano's, 1930. 351 p.

[*See* Q417.]

Q697. SERAPHIC DIALOGUE. PRODUCED BY H. POINDEXTER. DIRECTED BY DAVE WILSON. CHOREOGRAPHED BY GRAHAM. MUSIC BY NORMAN DELLO JOIO. SETS DESIGNED BY ISAMU NOGUCHI. Motion picture. Martha Graham Center, producing organization. 25 min.; sound, color, 16 mm.

At the moment of her exaltation, St. Joan of Arc looks back over her life as a young girl, a warrior, and a martyr. *Dancers:* Mary Hinkson, Bertram Ross, Patricia Birch, Helen McGehee, Noemi Lapzeson, Phyllis Gutelius, and Takako Asakawa.

Q698. **Shapiro, Joel.** MARTHA GRAHAM AT THE EASTMAN SCHOOL. *Dance Magazine* (July 1974): 55–57, illus.

Part of a *Dance Magazine* portfolio on Martha Graham containing contributions by various writers. The year Graham taught at the Eastman School in Rochester, N.Y., marked her break with the Denishawn tradition. She began to develop a new technique for dance and in the process created her first choreographic works. Interviews with her former students are included, as well as a chronology of her activities.

Q699. **Shawn, Ted.** REMINISCENCES: FROM CHILDHOOD TO THE DISSOLUTION OF DENISHAWN. Phonotape. New York: WNYC, broadcaster; recorded in Eustis, Fla., 1969. 6-1/2 hours; broadcast 26 min. 2 reels (5 in.) 1-7/8 in./sec. Dance Collection, The New York Public Library.

FROM THE WNYC SERIES INVITATION TO DANCE.

[*See* Q1139.]

Q700. **Sorell, Walter.** TWO REBELS, TWO GIANTS: ISADORA AND MARTHA. In: THE DANCE HAS MANY FACES. 2d ed. New York: Columbia University Press, 1966. p. 27–39. illus.

The innovative art of Isadora Duncan and Martha Graham in relationship to their times.

Q701. **Terry, Walter.** FRONTIERS OF DANCE: THE LIFE OF MARTHA GRAHAM. New York: Thomas Y. Crowell, 1975. 177 p., illus.

WOMEN OF AMERICA SERIES.

This biography traces Graham's turbulent career from her apprentice days with Ruth St. Denis and Ted Shawn to the present. The author, for many years dance critic of the *New York Herald Tribune* and now with *Saturday Review,* captures the excitement of this pioneer of contemporary dance as she confronted, challenged, and captivated her audiences. Chronology of choreographic works; bibliography; index.

Q702. **Terry, Walter.** INTERVIEW WITH MARTHA GRAHAM: THE ART OF PERFORMING. Phonotape. New York, 1952. 52 min. 2 reels (5 in.) 7-1/2 in./sec. Dance Collection, The New York Public Library.

FROM A DANCE LABORATORY HELD AT THE YM–YWHA, NEW YORK.

[*See* Q436.]

Q703. **Terry, Walter.** INTERVIEW WITH MARTHA GRAHAM. Phonotape. New York: Voice of America, broadcaster, 1962. 30 min.; 1 reel (7 in.) 7-1/2 in./sec. Dance Collection, The New York Public Library.

FOR THE VOICE OF AMERICA SERIES ARTS IN THE UNITED STATES.

Terry discusses Martha Graham's background and her choreography. Graham discusses ballet technique and expression; her work, *Deaths and Entrances;* her philosophy of choreography; her technique; the qualities of a good dancer; her company; the audience; her forthcoming tour.

HALPRIN, ANN

Q704. **Kostelanetz, Richard.** METAMORPHOSIS IN MODERN DANCE. *Dance Scope* (fall 1970): 6–21, illus.

[*See* Q96.]

Q705. PROCESSION: CONTEMPORARY DIRECTIONS IN AMERICAN DANCE. DIRECTED BY MARK MCCARTY. FOR THE DEPARTMENT OF DANCE, ALMA M. HAWKINS. CHOREOGRAPHED BY HALPRIN. MUSIC BY MORTON SUBOTNICK. Motion picture. University of California Extension Media Center at Berkeley, producing organization; presented by University of California Department of Arts and Humanities and Department of Dance, 196(?). 18-1/2 min. sound, black and white, 16 mm.

Ann Halprin explains her approach to modern dance and total theater through the elements of the environment: light, sound, and sculpture. *Dancers:* Halprin and members of her company, Daria Halprin, Rana Halprin, John L. Graham, Charles Ross, Lucy Lewis, and A. A. Leath, Jr.

HAWKINS, ERICK

Q706. **Barnes, Clive.** TAYLOR AND HAWKINS. *Dance and Dancers* (Dec. 1965): 30–33, illus.

In this London periodical, Barnes discusses the choreography of Paul Taylor and Erick Hawkins and the music of Lucia Dlugoszewski. The reviewer discusses *From Sea to Shining Sea* (Taylor), *Early Floating* (Hawkins), *Naked Leopard* (Hawkins), *Geography of Noon* (Hawkins), and *Lords of Persia* (Hawkins).

Q707. **Brown, Beverly.** TRAINING TO DANCE WITH ERICK HAWKINS: HAWKINS HAS FORMULATED A "NORMATIVE THEORY OF DANCE MOVEMENT." *Dance Scope* (fall/winter 1971/72): 7–30.

Brown discusses Hawkins's ideas on kinesthetic awareness, body placement, and forms in movement.

Q708. **Cohen, Selma Jeanne, ed.** THE MODERN DANCE: SEVEN STATEMENTS OF BELIEF. Middletown, Conn.: Wesleyan University Press, 1966. 106 p., illus.

[*See* Q359.]

Q709. **Hawkins, Erick.** WHAT IS THE MOST BEAUTIFUL DANCE? In: SORELL, WALTER, ed. THE DANCE HAS MANY FACES. 2d ed. New York: Columbia University Press, 1966. p. 242–43.

An artist-philosopher gives thirty-one replies to the question.

HOLM, HANYA

Q710. FOUR PIONEERS. PRODUCED BY JAC VENZA. Motion picture. New York: WNET–TV, producing organization, 1965. 30 min.; sound, black and white, 16 mm.
FROM THE NET SERIES U.S.A.: DANCE.

[*See* Q721.]

Q711. HOLM, HANYA. In: LLOYD, MARGARET. THE BORZOI BOOK OF MODERN DANCE. New York: Alfred A. Knopf, 1949. p. 155–72.

Lloyd describes Holm as the modern dancer who "has had the most far-reaching of extraneous influences on the American modern dance" since she came from Germany in 1931 to head the New York branch of the Mary Wigman School. Survey of her career in the United States from 1931 to 1949; her teaching methods; her outstanding students and, through them, her influence on the concert and theater fields; her major works of the period, including her choreography for the Broadway work, *Ballet Ballads* (1948).

Q712. **Maynard, Olga.** AMERICAN MODERN DANCERS: THE PIONEERS. Boston: Little, Brown & Co., 1965. 218 p., illus.

[*See* Q399.]

Q713. MODERN DANCE BY MARY WIGMAN ET AL. COMPILED BY VIRGINIA STEWART. New York: E. Weyhe, 1935. 155 p., illus.

[*See* Q402.]

Q714. **Nichols, Billy.** INTERVIEW WITH CHARLES WEIDMAN. Phonotape. New York: National Educational Television, 1965(?). 60 min.; 2 reels (7 in.) 7-1/2 in./sec. Dance Collection, The New York Public Library.
EXCERPTS USED IN THE NET FILM FOUR PIONEERS.

[*See* Q847.]

Q715. **Nichols, Billy.** INTERVIEW WITH HANYA HOLM. Phonotape. New York: National Educational Television, 1965. 52 min.; 2 reels (7 in.) 7-1/2 in./sec. Dance Collection, The New York Public Library.
FROM THE NET FILM FOUR PIONEERS.

The film includes discussion of the Bennington College Summer School of Dance, 1934–1940; its influence on modern dance in the United States and on Holm's artistic development; her philosophy of dance, her dance, *Trend;* The process of creating a work of art; Charles Weidman; young American dancers and dance students of today.

Q716. **Scothorn, Carol.** THREE CHOREOGRAPHERS TALK ABOUT THE AUDIENCE. *Impulse* (1962): 16–19.

[*See* Q641.]

Q717. **Sorell, Walter.** HANYA HOLM: THE BIOGRAPHY OF AN ARTIST. Middletown, Conn.: Wesleyan University Press, 1969. 226 p., illus.

The only full-length biography of this major American modern dancer. Born in Germany and trained there by Mary Wigman, she emigrated to the United States and was active as a choreographer, not only for the concert stage but for such musicals as *Kiss Me Kate, My Fair Lady,* and *Camelot.* Chronology of her choreography for concert dances, musicals, opera, nonmusical plays, motion pictures, and television; bibliographies; and index.

Q718. **Terry, Walter.** INTERVIEW WITH HANYA HOLM. Phonotape. New York: WNYC, broadcaster, 1967. 24 min.; 1 reel (7 in.) 7-1/2 in./sec. Dance Collection, The New York Public Library.
FROM THE WNYC SERIES INVITATION TO DANCE.

The film deals with the differences between choreographing for the concert stage and for musical comedy; how Holm captured the folk feeling of *Tarantella* in *Kiss Me Kate* and the ethnic flavor of England for *My Fair Lady;* the use of Labanotation score from *Kiss Me Kate* in reconstructing the dances; her musical comedy, *Softly.*

HORTON, LESTER

Q719. THE DANCE THEATER OF LESTER HORTON, BY LARRY WARREN ET AL. Brooklyn, N.Y.: Dance Perspective Foundation, 1967. 69 p., illus.
DANCE PERSPECTIVES, NO. 31.

A collection of essays about the major West Coast choreographer who, in 1946, founded in Hollywood the first permanent home for modern dance in America, his Dance Theater. Contributions include a biography by Larry Warren; an essay on Lester Horton's Dance Theater and its productions by Frank Eng; a piece by Bella Lewitsky concerning the fifteen years' experience she had as soloist and collaborator with Lester Horton; and an essay by Joyce Trisler. Chronology of theater works by Lester Horton; list of motion pictures for which he served as choreographer.

HUMPHREY, DORIS

Q720. AIR FOR THE G STRING. MUSIC BY JOHANN SEBASTIAN BACH. CHOREOGRAPHED BY HUMPHREY. Motion picture. 1934. 6 min.; sound, black and white, 16 mm.

An early work created in 1928 and performed by Humphrey and four female dancers.

Q721. FOUR PIONEERS. PRODUCED BY JAC VENZA. Motion picture. New York: WNET–TV, producing

organization, 1965. 30 min.; sound, black and white, 16 mm.

FROM THE NET SERIES U.S.A.: DANCE.

Four pioneers of American modern dance, Martha Graham, Hanya Holm, Doris Humphrey, and Charles Weidman, explain their ideas about dance. Included are recorded speeches, photographs, and film clips. Also, a performance of *Passacaglia*, choreographed by Humphrey and staged by Lucy Venable in 1965 for the American Dance Theater production at Lincoln Center. *Soloists:* Lola Huth and Chester Wolenski.

Q722. **Humphrey, Doris.** DORIS HUMPHREY: AN ARTIST FIRST. EDITED AND COMPLETED BY SELMA JEANNE COHEN. Middletown, Conn.: Wesleyan University Press, 1972. 305 p., illus.

The definitive work on the life and artistry of this great American modern dance pioneer. Humphrey began this account of her personal life shortly before her death in 1958. Using her letters, other unpublished materials and documents, Cohen completed the work. There is an introduction by John Martin and a foreword by Charles Humphrey Woodford. An appendix contains some of Humphrey's dance writings. A valuable and detailed chronology by Christena L. Schlundt lists companies and performers in concert premieres, first-performance data on her concert works, and her choreography for the musical stage. Index.

Q723. **Humphrey, Doris.** LECTURE-DEMONSTRATION: THE ART OF CHOREOGRAPHY. Phonotape. New York, 1951. 76 min.; 2 reels (5 in.) 3-3/4 in./sec. Dance Collection, The New York Public Library.

FROM A DANCE LABORATORY HELD AT THE YM–YWHA, NEW YORK.

The film deals with the absence of a formulated theory of choreography; the choreographic process as seen in Humphrey's dances, *Lament for Ignazio Sanchez Mejias*, and *Day on Earth; the juxtaposition of poetry and dance in Lament for Ignacio Sanchez Mejias.* Dancers include José Limón and members of his company.

Q724. **Humphrey, Doris.** LECTURE. Phonotape. New York: Recorded at Julliard School of Music for National Educational Television, 1956. 60 min.; 2 reels (7 in.) 7-1/2 in./sec. Dance Collection, The New York Public Library.

FROM THE NET PROGRAM PIONEERS OF MODERN DANCE.

[*See* Q385.]

Q725. JACOB'S PILLOW DANCE FESTIVAL. PRODUCED BY JAC VENZA. Motion picture. New York: WNET–TV, broadcaster, 1969. 114 min.; sound, black and white, 16 mm.

FROM THE NET PROGRAM SOUNDS OF SUMMER.

[*See* Q880.]

Q726. LAMENT. FILMED BY WALTER STRATE. CHOREOGRAPHED BY HUMPHREY. Motion picture. 1951. 18 min.; sound, black and white, 16 mm.

Based on a poem by Federico Garcia Lorca, "Lament for Ignacio Sanchez Mejias." *Cast includes* José Limón, Ellen Love, and Letitia Ide.

Q727. THE MODERN DANCE. Motion picture. Pictorial Films, 193?. 11-1/2 min.; silent, black and white, 16 mm.

The film shows five exercises selected from Doris Humphrey's technique, performed by members of her concert group: Beatrice Seckler, Katherine Manning, Letitia Ide, Edith Orcutt, and Katherine Litz.

Q728. MODERN DANCE, BY MARY WIGMAN ET AL. COMPILED BY VIRGINIA STEWART. New York: E. Weyhe, 1935. 162 p., illus.

[*See* Q402.]

Q729. **Nichols, Billy.** INTERVIEW WITH CHARLES WEIDMAN. Phonotape. New York: National Educational Television, 1965? 60 min.; 2 reels (7 in.) 7-1/2 in./sec. Dance Collection, The New York Public Library.

EXCERPTS USED IN THE NET FILM FOUR PIONEERS.

[*See* Q847.]

Q730. **Rothschild, Bethsábee de, Baroness.** LA DANCE ARTISTIQUE AUX USA: TENDANCES MODERNES. Paris: Editions Elzévir, 1949. 159 p., illus.

[*See* Q414.]

Q731. THE SHAKERS. PRODUCED AND DIRECTED BY THOMAS BOUCHARD. CHOREOGRAPHED BY HUMPHREY. Motion picture. 20 min.; sound, black and white, 16 mm.

A dance interpretation of an early meeting of the American religious sect. Mother Ann Lee, founder and eldress of the Shakers, is portrayed by Doris Humphrey. *Other dancers:* Charles Weidman, José Limón, Beatrice Seckler, and Dorothy Bird.

Q732. **Wentink, Andrew Mark.** THE DORIS HUMPHREY COLLECTION: AN INTRODUCTION AND GUIDE. The New York Public Library, *Bulletin* 77 (autumn 1973): 80–142, illus.

A guide to the arrangement and to the contents of the Doris Humphrey Collection, which includes more than 7,000 items: correspondence, manuscripts, business records, and miscellaneous memorabilia.

JOFFREY, ROBERT

Q733. **Barnes, Clive.** JOFFREY. *Dance and Dancers* (Feb. 1967): 25–52, illus.

A brief biography of Robert Joffrey, the young American choreographer who in the sixties was responsible for the creation of the Robert Joffrey Ballet. A discussion in this London periodical of his career, his aims as a choreographer, the school he founded in 1953, the American Ballet Center.

Q734. **Leddick, David.** ROBERT JOFFREY'S AMERICAN

BALLET CENTER: A SCHOOL WITH A VIEW. *Dance Magazine* (Aug. 1960): 48–50, illus.

Founded in 1953, the American Ballet Center in New York is the official school for the Joffrey Ballet Company. According to the author, the school reflects the American attitude toward the study of classical ballet held by its director. Joffrey's philosophy and methods of teaching are discussed.

Q735. ROBERT JOFFREY. EXECUTIVE PRODUCER, JAC VENZA. CHOREOGRAPHED BY JOFFREY, GERALD ARPINO, AND ANNA SOKOLOW. Motion picture. New York: WNET–TV, producing organization, 1965. 30 min.; sound, black and white, 16 mm.
FROM THE NET SERIES U.S.A.: DANCE.

[*See* Q815.]

KONER, PAULINE

Q736. **Cohen, Selma Jeanne, ed.** THE MODERN DANCE: SEVEN STATEMENTS OF BELIEF. Middletown, Conn.: Wesleyan University Press, 1966. 106 p., illus.
[*See* Q359.]

Q737. **Cohen, Selma Jeanne.** A PERFORMANCE IS SEARCHING. *Dance Magazine* (Oct. 1953): 31–32, 66.

The philosophy and performance concepts of modern dancer Pauline Koner.

Q738. THE LANGUAGE OF DANCE: LECTURE-PERFORMANCES BY PAULINE KONER. PRODUCED BY TV SINGAPURA. Motion picture. 1967. 29-1/2 min.; sound, black and white, 16 mm.

Using excerpts from her works *Cassandra* and *Concertino in A Major*, Koner discusses various types of gesture and their transformation into dance movement.

Q739. **Marks, Marcia.** PAULINE KONER SPEAKING, PTS. 1–3. *Dance Magazine.* Pt. 1 (Sept. 1961): 36–37, 68–69; Pt. 2 (Oct. 1961): 38, 59; Pt. 3 (Nov. 1961): 16, 64.

A three-part interview in which the dancer denounces the "trend to nothingness" in contemporary choreography; discusses a dancer's training; explains the elements of performing.

Q740. **Maynard, Olga.** PAULINE KONER: A CYCLIC FORCE. *Dance Magazine* (Apr. 1973): 56–69, illus.

A biographical article encompassing both the personal and the professional life of the American modern dancer and choreographer.

LEWITSKY, BELLA

Q741. THE DANCE THEATER OF LESTER HORTON, BY LARRY WARREN ET AL. Brooklyn, N.Y.: Dance Perspective Foundation, 1967. 69 p., illus.
DANCE PERSPECTIVES, NO. 31.

[*See* Q719.]

Q742. **Moore, Elvi.** THE PERFORMER-TEACHER: AN INTERVIEW WITH BELLA LEWITZKY. *Dance Scope* 8 (fall/winter 1973/1974): 7–11, illus.

An essay on the qualities that make a great teacher, and on the relationship of the arts of performing, teaching, and choreographing.

LIMÓN, JOSÉ

Q743. **Cohen, Selma Jeanne, ed.** THE MODERN DANCE: SEVEN STATEMENTS OF BELIEF. Middletown, Conn.: Wesleyan University Press, 1966. 106 p., illus.
[*See* Q359.]

Q744. **Gottlieb, Beatrice.** THE THEATRE OF JOSÉ LIMÓN. *Theatre Arts* (Nov. 1951): 27, 94–95, illus.

A criticism of José Limón's style, his use of dance to make a dramatic statement, and his range.

Q745. **Humphrey, Doris.** LECTURE-DEMONSTRATION: THE ART OF CHOREOGRAPHY. Phonotape. New York, 1951. 76 min.; 2 reels (5 in.) 3-3/4 in./sec. Dance Collection, The New York Public Library.
FROM A DANCE LABORATORY HELD AT THE YM-YWHA, NEW YORK.

[*See* Q723.]

Q746. JOSÉ LIMÓN. In: LLOYD, MARGARET. THE BORZOI BOOK OF MODERN DANCE. New York: Alfred A. Knopf, 1949. p. 198-213.

A biographical essay focusing primarily on Limón's professional life.

Q747. LAMENT. FILMED BY WALTER STRATE. CHOREOGRAPHED BY DORIS HUMPHREY. Motion picture. 1951. 18 min.; sound, black and white, 16 mm.
[*See* Q726.]

Q748. THE LANGUAGE OF DANCE. PRODUCED BY JAC VENZA. DIRECTED BY GREG HARNEY. CONCEIVED AND WRITTEN BY MARTHA MYERS. CHOREOGRAPHED BY LIMÓN. MUSIC BY NORMAN DELLO JOIO. Motion picture. Boston: WGBH–TV, producing organization, 1959. 29 min.; sound, black and white, 16 mm.
FROM THE WGBH–TV SERIES A TIME TO DANCE.

Martha Myers and Limón discuss and demonstrate the language of the dance, transforming movement, the basic element of the dancer's material, into dance for one person, two people, and finally for a group. Includes a performance of Limón's *There Is a Time. Dancers:* Limón and Pauline Koner, with Lucas Hoving, Betty Jones, Lucy Venable, Lola Huth, Harlan McCallum, Chester Wolenski, and Robert Powell.

Q749. **Limón, José.** COMPOSING A DANCE: "THE TRAITOR." *Impulse* (1958): 9–12, illus.

The choreographer explains his method of creating a dance work to an audience of students of composition.

Q750. **Limón, José.** THE VIRILE DANCE. In: SORELL, WALTER, ED. THE DANCE HAS MANY FACES. 2d ed. New York: Columbia University Press, 1966. p. 82–86. [*See* Q343.]

Q751. THE MOOR'S PAVANE. DIRECTED AND FILMED BY WALTER STRATE. CHOREOGRAPHED BY LIMÓN. MUSIC BY HENRY PURCELL, ARRANGED BY SIMON SADOFF. COSTUMES DESIGNED BY PAULINE LAWRENCE. NARRATED BY BRAM NOSSEN. Motion picture. 1950. 16 min.; sound, color, 16 mm.

The story of Othello portrayed through a series of stylized court dances. A condensed version of the ballet. *Cast includes* Limón, Betty Jones, Lucas Hoving, and Ruth Currier.

Q752. **Palmer, Winthrop Bushnell.** JOSÉ LIMÓN. In: DANCE NEWS ANNUAL. New York: Alfred A. Knopf, 1953. p. 72–78., illus.

A discussion of Limon's physical make-up, his technical ability, and his personality.

LITTLEFIELD, CATHERINE

Q753. **Barzel, Ann.** THE LITTLEFIELDS, PTS. 1 AND 2. *Dance Magazine.* Pt. 1 (May 1945): 10–11; Pt. 2 (June 1945): 8–9, illus.

A biographical article about the Littlefield family, Catherine, Caroline, Dorothie, and Carl, pioneers in American ballet history during the 1930s.

LITZ, KATHERINE

Q754. **Kendall, Elizabeth.** TALKING WITH KATHERINE LITZ. *Dance Scope* 8 (spring/summer 1974): 6–17, illus.

An interview with an American modern dancer who studied with Charles Weidman, danced with the original Humphrey-Weidman Company, and, since the late forties has been working as a choreographer. She speaks of her early training and career; her personal style of movement; and her ideas on space, coordination, and subject matter for her choreography.

LOUIS, MURRAY

Q755. DANCE AS AN ART FORM. WRITTEN, DIRECTED, NARRATED, AND CHOREOGRAPHED BY MURRAY LOUIS. DIRECTOR OF PHOTOGRAPHY, WARREN LIEB. MUSIC BY FREE LIFE COMMUNICATIONS, OREGON ENSEMBLE, CORKY SIEGEL. ELECTRONIC SOUND BY ALWIN NIKOLAIS. COSTUMES DESIGNED BY FRANK GARCIA. Motion picture. Chicago: Jack Lieb Productions for Chimera Foundation for Dance, New York, producing organization, 1973. Five films, each approximately 30 min.; sound, color, 16 mm.

A series of five films utilizing five basic elements to trace dance from its origin in natural gesture to its use as an art form. 1. *Body:* An exploration of the dancer's instrument, the diversity of body size and shape and its preparation from the studio to the performance level. 2. *Motion:* An examination of the selection and arrangement of activities and movements to reveal an understanding of the natural basis underlying dance. 3. *Space:* The use of animation and live action to illustrate the dancer's inner and exterior space. 4. *Time:* An exploration, beyond the musical definition, of the duration, pause, span, speed, and the overlapping of past and present. 5. *Shape:* An emphasis of the sculptural dynamics of the body and the diversity of shapes the dancer utilizes. The dancer is portrayed as a sculptor, his own body as his medium. Excerpts from dance works choreographed by Murray Louis are included in all films. *Cast:* laymen; dance students from the University of California at Los Angeles and Santa Barbara, California State College at Los Angeles, the University of Arizona at Tucson, the University of Utah at Salt Lake City, the University of South Florida at Tampa, and Duke University at Durham; professional artists; ethnic dancers; athletes; children; and talented animals.

Q756. INVENTION IN DANCE. PRODUCED BY JAC VENZA. DIRECTED BY GREG HARNEY. CONCEIVED AND WRITTEN BY MARTHA MYERS. CHOREOGRAPHED BY ALWIN NIKOLAIS. Motion picture. Boston: WGBH–TV, producing organization, 1959. 29 min.; sound, black and white, 16 mm.

FROM THE WGBH-TV SERIES A TIME TO DANCE.

[*See* Q771.]

Q757. **Kostelanetz, Richard.** METAMORPHOSIS IN MODERN DANCE. *Dance Scope* (fall 1970): 6–21, illus.

[*See* Q96.]

Q758. **Page, Anita.** INTERVIEW WITH MURRAY LOUIS. Phonotape. Amherst, Mass.: WFCR, broadcaster, 1968. 27 min.; 1 reel (7 in.) 7-1/2 in./sec. Dance Collection, The New York Public Library.

FROM THE WFCR PROGRAM EXTENSIONS OF DANCE.

The tape includes Louis's nonverbal, nonliteral performances at the Henry Street Playhouse; his reception by audiences in India; dance in colleges and universities; a comparison between his choreography and Alwin Nikolais's; student training at the Henry Street Playhouse.

Q759. **Shaw, Alan J.** MURRAY LOUIS: A PROPORTION FOR MISPROPORTION. PHOTOGRAPHS BY LOIS GREENFIELD. *Dance Magazine* (Mar. 1975): 36–39, illus.

A discussion of the choreographed style, the ideas, and the unique qualities of this outstanding figure in American modern dance for the past twenty years. Some of his recent works are briefly analyzed.

Q760. **Tobias, Tobi.** NIKOLAIS AND LOUIS: A NEW SPACE. *Dance Magazine* (Feb. 1971): 46–54, illus.

A look at the careers of Murray Louis and Alwin Nikolais, including their long association with the Henry Street Playhouse. Tobias also includes a description of

"The Space," their new performing and teaching area in mid-Manhattan.

Q761. TOTEM: AN EXPERIMENTAL INTERPRETATION BY ED EMSHWILLER OF THE BALLET BY ALWIN NIKOLAIS. DIRECTED AND FILMED BY ED EMSHWILLER. CHOREOGRAPHY, SOUND SCORE, AND COSTUMES BY ALWIN NIKOLAIS ASSISTED BY LOUIS. Motion picture. An Evergreen film by Grove Press, 1963. 16 min.; sound, color, 16 mm.

Dancers include Louis and Gladys Bailin, with Beverly Schmidt, Phyllis Lamhut, Bill Frank, Peggy Barclay, Albert Reid, Barbara Bull, Sally Cohen, Ellen Deering, Roger Powell, Ray Broussard, Carol Feldman, Mimi Seawright, and Peggy Novey.

MASSINE, LÉONIDE

Q762. CAPRICCIO ESPAÑOL. DIRECTED BY JEAN NEGULESCO. CHOREOGRAPHED BY MASSINE AND ARGENTINITA. MUSIC BY RIMSKY-KORSAKOV. SETS AND COSTUMES DESIGNED BY MARIANO ANDREU. Motion picture. Warner Bros. Pictures, producing organization, 1941. 20 min.; sound, color.

A one-act ballet in five parts, consisting of *Alborado* (dance of Spanish Galicia); *Variation* (a seguidilla); *Alborada* (a comic interlude); Gypsy scene and dance (based on the steps of the *Buleria, Panadero,* and *Bolero*); and a *Fandango Asturiana. Performed by* the Ballet Russe de Monte Carlo; *featured dancers:* Massine, Tamara Toumanova, Alexandra Danilova, Frederic Franklin, and André Eglevsky.

Q763. GAÎTÉ PARISIENNE. DIRECTED BY JEAN NEGULESCO. CHOREOGRAPHED BY MASSINE. MUSIC BY JACQUES OFFENBACH. SETS AND COSTUMES DESIGNED BY COMTE ETIENNE DE BEAUMONT. Motion picture. Warner Bros. Pictures, producing organization, 1941. 20 min.; sound, color.

A one-act ballet about the adventures of a wealthy Peruvian in a Paris nightclub in the 1890s. *Performed by* Ballet Russe de Monte Carlo; *featured dancers include* Massine, Milada Miladova, Frederic Franklin, Nathalie Krassovska, Igor Youskevitch, Casmir Kokitch, James Starbuck, André Eglevsky, and Lubo Roudenko.

MC KAYLE, DONALD

Q764. JACOB'S PILLOW DANCE FESTIVAL. PRODUCED BY JAC VENZA. Motion picture. New York: WNET–TV, broadcaster, 1969. 114 min.; sound, black and white, 16 mm.
FROM THE NET PROGRAM SOUNDS OF SUMMER.

[*See* Q880.]

Q765. **Cohen, Selma Jeanne, ed.** THE MODERN DANCE: SEVEN STATEMENTS OF BELIEF. Middletown, Conn.: Wesleyan University Press, 1966. 106 p., illus.

[*See* Q359.]

MORDKIN, MIKHAIL

Q766. **Cross, Julia Vincent.** A CLASS WITH MIKHAIL MORDKIN. *Dance Magazine* (Aug. 1956): 40, 52–53, 61, illus.

A former student describes a ballet class with Mikhail Mordkin, the founder of the Mordkin Ballet. The American Ballet Theatre Company later developed from Mordkin's group.

Q767. **Mordkin, Mikhail.** THE STORY OF MY LIFE, PTS. 1-4. The Dance Magazine Pt. 1 (Dec. 1925): 13–15; Pt. 2 (Jan. 1926): 30–32, 60–61; Pt. 3 (Feb. 1926): 34–35, 57–58; Pt. 4 (Mar. 1926): 32–33, 64, illus.

Reminiscences include thoughts on the Moscow Imperial Theater School, the Bolshoi Ballet, Pavlova, and the Ballets Russes.

NIKOLAIS, ALWIN

Q768. **Cohen, Selma Jeanne, ed.** THE MODERN DANCE: SEVEN STATEMENTS OF BELIEF. Middletown, Conn.: Wesleyan University Press, 1966. 106 p., illus.
[*See* Q359.]

Q769. **Copeland, Roger.** A CONVERSATION WITH ALWIN NIKOLAIS. *Dance Scope* 8 (fall/winter 1973/1974): 41–46, illus.

Nikolais discusses his aesthetic philosophy and the criticism that his work is dehumanized.

Q770. FUSION. PRODUCED BY ED EMSHWILLER. CHOREOGRAPHED AND MUSIC COMPOSED BY NIKOLAIS. Motion picture. 1967. 16 min.; sound, color, 16 mm.

Nikolais uses the sponsor's product, Spring Mills, to form a part of the dance pattern in his ballet.

Q771. INVENTION IN DANCE. PRODUCED BY JAC VENZA. DIRECTED BY GREG HARNEY. CONCEIVED AND WRITTEN BY MARTHA MYERS. CHOREOGRAPHED BY NIKOLAIS. Motion picture. Boston: WGBH–TV, producing organization, 1959. 29 min.; sound, black and white, 16 mm.
FROM THE WGBH–TV SERIES A TIME TO DANCE.

Martha Myers and Nikolais discuss modern dance pioneers Isadora Duncan and Ruth St. Denis and the Denishawn School. The film includes slides of dancers, clips of St. Denis in her dance, *Radha*, and a demonstration of Duncan technique. The dances performed include excerpts from Nikolais's *Kaleidoscope,* and Sanctum and Noumenon from *Masks. Performed by* the Henry Street Playhouse Dance Company: Murray Louis, Phyllis Lamhut, Arlene Laub, Coral Martindale, Beverly Schmidt, and Dorothy Vislocky.

Q772. **Kostelanetz, Richard.** METAMORPHOSIS IN MODERN DANCE. *Dance Scope* (fall 1970): 6–21, illus.
[*See* Q96.]

Q773. LIMBO. CHOREOGRAPHY AND ELECTRONIC SCORE

BY NIKOLAIS. Motion picture. New York: WCBS–TV in cooperation with Brooklyn College of the City University of New York for Repertoire Workshop, producing organization, 1968. 29 min.; sound, color, 16 mm.

The film documents an abstract fantasy work that uses electronic visual effects to integrate the dancers' movements with various patterns of color, light, shapes, and sounds. *Performed by* the Alwin Nikolais Dance Company; *featured dancers are* Murray Louis, Phyllis Lamhut, and Carolyn Carlson.

Q774. **Nikolais, Alwin.** THE DANCE AND MULTI-MEDIA: FORUM DISCUSSION. Phonotape. Amherst, Mass.: WFCR, broadcaster, 1969. 60 min.; 2 reels (7 in.) 7-1/2 in./sec. Dance Collection, The New York Public Library.
FROM THE WFCR SERIES FIVE-COLLEGE FORUM

Nikolais discusses his concept of multi-media theater; the kind of performer his works need; his process of working; his background; his philosophy of dance; chance elements in his dances; the use of improvisation in choreographing; dance and film; dance and television; his company; his system of movement notation, Choreoscript. *Other participants were* University of Massachusetts faculty members, Robert Stern, composer, and Robert Mallory, sculptor; and WFCR staff members Fred Calland, music programmer, and Anita Page, dance critic.

Q775. **Nikolais, Alwin.** GROWTH OF A THEME. In: SORELL, WALTER, ED. THE DANCE HAS MANY FACES. 2d ed. New York: Columbia University Press, 1966. p. 229–37.

In a revised version of an article originally published in *Dance Magazine* (Feb. 1961): 30–34, this avant-garde choreographer discusses his creative growth.

Q776. **Nikolais, Alwin.** LECTURE ON AVANT-GARDE DANCE. Phonotape. New York, 1968. 50 min.; 1 reel (7 in.) 3-3/4 in./sec. Dance Collection, The New York Public Library.

In his lecture, Nikolais discusses appreciation of the arts; dance criticism; avant-garde art; Isadora Duncan as an avant-garde artist; the nature of good art; American modern dance and ballet from 1937 to 1947; the development of his own choreographic, visual, and theatrical ideas.

Q777. **Nikolais, Alwin.** NIK, A DOCUMENTARY. EDITED AND WITH AN INTRODUCTION BY MARCIA B. SIEGEL. Brooklyn: Dance Perspectives Foundation, 1971. 56 p., illus. (color).
DANCE PERSPECTIVES, NO. 48.

Journal-like entries on Nikolais's aesthetic and philosophical ideas and his personal impressions of people, places, and events. Extracted from a variety of his unpublished manuscripts.

Q778. **Page, Anita.** INTERVIEW WITH MURRAY LOUIS. Phonotape. Amherst, Mass.: WFCR, broadcaster, 1968.

27 min. 1 reel (7 in.) 7-1/2 in./sec. Dance Collection, The New York Public Library.
FROM THE WFCR PROGRAM EXTENTIONS OF DANCE.
[*See* Q758.]

Q779. **Pischl, A. J., and Cohen, Selma Jeanne, eds.** COMPOSER/CHOREOGRAPHER. Brooklyn: Dance Perspectives Foundation, 1963. 60 p., illus.
DANCE PERSPECTIVES, NO. 16.
[*See* Q929.]

Q780. **Tobias, Tobi.** NIKOLAIS AND LOUIS: A NEW SPACE. *Dance Magazine* (Feb. 1971): 46–54, illus.
[*See* Q760.]

Q781. TOTEM: AN EXPERIMENTAL INTERPRETATION BY ED EMSHWILLER OF THE BALLET BY ALWIN NIKOLAIS. DIRECTED AND FILMED BY ED EMSHWILLER. CHOREOGRAPHY, SOUND SCORE, AND COSTUMES BY NIKOLAIS ASSISTED BY MURRAY LOUIS. Motion picture. An Evergreen film by Grove Press, 1963. 16 min.; sound, color, 16 mm.
[*See* Q761.]

PAGE, RUTH

Q782. **Goodman, Saul.** RUTH PAGE, COSMOPOLITE OF THE CENTRAL PLAINS: A RÉSUMÉ OF THE ALL-ENCOMPASSING CAREER OF AMERICA'S MOST VERSATILE DANCER-CHOREOGRAPHER. *Dance Magazine* (Dec. 1961): 40–47, illus.

View of Ruth Page's career.

Q783. **Kirstein, Lincoln.** BLAST AT BALLET; A CORRECTIVE FOR THE AMERICAN AUDIENCE. New York: Marstin Press, 1938. 128 p.
[*See* Q167.]

PRIMUS, PEARL

Q784. **Terry, Walter.** INTERVIEW-DEMONSTRATION WITH PEARL PRIMUS: THE ART OF PERFORMING. Phonotape. New York, 1953. 51 min.; 1 reel (5 in.) 3-3/4 in./sec. Dance Collection, The New York Public Library.
FROM A DANCE LABORATORY HELD AT THE YM–YWHA, NEW YORK.

In this interview, Primus deals with projecting different moods and meanings to the audience, focusing on calypso, the blues and the African Watusi; making use of the African and Afro-American dance heritages; using different parts of the body in African dance, as seen in *Fanga*, a Swahili prayer, and the serpent dance; a Watusi king's dancers; teaching the art of performing.

Q785. **Terry, Walter.** THE STORY OF NEGRO DANCE IN AMERICA: LECTURE. Phonotape. New London, Conn.: Recorded at Connecticut College School of Dance, Aug. 14, 1963. 50 min.; 1 reel (5 in.) 3-3/4 in./sec. Dance

Collection, The New York Public Library.
[*See* Q223.]

RAINER, YVONNE

Q786. Chin, Daryl. ADD SOME MORE CORNSTARCH; OR, THE PLOT THICKENS: YVONNE RAINER'S WORK 1961-1973. *Dance Scope* (spring/summer 1975): 50–64.

A review of Rainer's work during this period and a discussion of her career and aesthetics.

Q787. Hecht, Robin Silver. REFLECTIONS ON THE CAREER OF YVONNE RAINER AND THE VALUES OF MINIMAL DANCE. *Dance Scope* 8 (fall/winter 1973/1974): 12–25, illus.

A detailed analysis of the development of choreographer Yvonne Rainer's style and ideas on dance. Her early choreographic pieces, performed in 1962 at the Judson Dance Theater, are discussed, in which dancelike movements were used to express dramatic content. Hecht then examines her reevaluation of the traditional elements of dance; her experiments with indeterminacy as a choreographic method; her eventual concentration on "task, work, and natural movement" as the dominant elements of her choreography. Both display and virtuosity have been eliminated in minimal dance.

Q788. Kostelanetz, Richard. METAMORPHOSIS IN MODERN DANCE. *Dance Scope* (fall 1970): 6–21, illus.
[*See* Q96.]

Q789. Rainer, Yvonne. WORK, 1961–1973. Halifax: Press of the Nova Scotia College of Art and Design; New York: New York University Press, 1974. 338 p. NOVA SCOTIA SERIES.

A collection of essays, photos of performances, descriptions and dance scores excerpted from the author's notebooks, with complete scripts for recent works. Rainer, a post–modern dance avant-garde choreographer, is known for her involvement in experimental and minimal dance.

ROBBINS, JEROME

Q790. ART IS. PRODUCED, DIRECTED, AND WRITTEN BY JULIAN KRAININ AND DEWITT L. SAGE, JR. FILMED BY HENRY STRAUSS ASSOCIATES. CHOREOGRAPHED BY GEORGE BALANCHINE. Motion picture. Sears-Roebuck Foundation in cooperation with the Associated Councils of the Arts, producing organization. 28 min.; sound, color, 16 mm.
[*See* Q601.]

Q791. Lyon, James. INTERVIEW WITH MARGERY DELL, EDWARD BIGELOW, TODD BOLENDER: THE NEW YORK CITY BALLET. Phonotape. New York: WNYC, broadcaster, 1958. 40 min.; 1 reel (7 in.) 7-1/2 in./sec. Dance Collection, The New York Public Library.
FROM THE WNYC SERIES TODAY IN BALLET.
[*See* Q888.]

Q792. Manchester, Phyllis Winifred. JEROME ROBBINS: THEATRE MAN. In: THE BALLET ANNUAL. London: A. & C. Black, 1961. p. 11–15, illus.

An appreciation appearing in a London periodical of the American choreographer who had at the time of publication been director of many successful Broadway musical comedies as well as of his own company, Ballets: U.S.A.

Q793. Moore, Lillian. JEROME ROBBINS. *Chrysalis* 3 (1950): 1–9, illus.

A brief biography of a major American choreographer, with emphasis on his formative years with The Ballet Theatre Company and on his early association with the New York City Ballet Company. The article contains a review of his work both as a performer and as the choreographer for his early pieces, *Fancy Free, Facsimile,* and *The Age of Anxiety.* Chronology of ballets and musical comedies.

Q794. Pastore, Louise. MASTERWORKS AND BRIC-A-BRAC. *Dance Magazine* (Aug. 1974): 63, 65, 68–69.

A brief critical evaluation of the major ballets of choreographer Jerome Robbins. The works discussed, which make up the New York City Ballet's repertoire of the artist's oeuvre, are *The Cage, Dances at a Gathering, The Goldberg Variations, Watermill,* and *Dybbuk.*

Q795. Peralta, Delfor. JEROME ROBBINS INTERVIEWED. *Dance Magazine* (Dec. 1959): 72–73, 118–19, illus.

In an interview held shortly after the return of his company, Ballets: U.S.A., from a four-month tour of Europe, Robbins fields questions on his purpose in creating his own ballet company; the training of a dancer; the future of the classic style; his ballets *Moves, The Concert,* and *Opus Jazz.*

SHAWN, TED

Q796. A DAY AT JACOB'S PILLOW. FILMED BY PHILIP BARIBAULT. Motion picture. Lee, Mass.: 1950. 9 min.; silent, color and black and white, 16 mm.

Brief scenes of activity at Jacob's Pillow, including excerpts of performances by Ruth St. Denis, Ted Shawn, La Meri, Matteo, and Jerry Green. Dances include fragments of *White Jade* (St. Denis) and *Prometheus Bound* (Shawn).

Q797. Dreier, Katherine Sophie. SHAWN THE DANCER. New York: A. S. Barnes, 1933. 81 p., illus. (color).

A pictorial essay on the major solo dances of Ted Shawn, with a chronology of Shawn works (1911–1931), a brief biographical sketch, and a short essay on Shawn as a dancer.

Q798. Maynard, Olga. AMERICAN MODERN DANCERS: THE PIONEERS. Boston: Little, Brown & Co., 1965. 218 p., illus.
[*See* Q399.]

Q799. Poindexter, Betty. TED SHAWN: HIS PERSONAL LIFE, HIS PROFESSIONAL CAREER, AND HIS CONTRIBU-

TIONS TO THE DEVELOPMENT OF DANCE IN THE UNITED STATES OF AMERICA FROM 1891 TO 1962. Ph.D. thesis, Texas Woman's University, 1963. 652 p.

A comprehensive study of the life and works of Shawn, an eminent American dance artist-innovator-teacher and the precursor of the American modern dance movement. His life traces the development of dance as an American art form. Bibliography.

Q800. RUTH ST. DENIS AND TED SHAWN, AMERICAN PIONEERS. In: LLOYD, MARGARET. THE BORZOI BOOK OF MODERN DANCE. New York: Alfred A. Knopf, 1949. p. 22–34.

A concise and revealing account of the early days of the Denishawn School, its two founders, and some of its early members, Martha Graham, Charles Weidman, and Doris Humphrey.

Q801. RUTH ST. DENIS AND TED SHAWN: A DIALOGUE. Phonotape. Hollywood, Calif.: Recorded at the Ruth St. Denis Center, 1965. 30 min.; 1 reel (7 in.) 3-3/4 in./sec. Dance Collection, The New York Public Library.

[See Q1132.]

Q802. St. Denis, Ruth. INTERVIEW: CONDUCTED BY SHIRLEY AND EARL UBEL. Phonotape. Hollywood, Calif.: Recorded at the Ruth St. Denis Center, ca. 1965. 55 min.; 1 reel (7 in.) 7-1/2 in./sec. Dance Collection, The New York Public Library.

[See Q1133.]

Q803. Shawn, Ted. CONVERSATIONS RECORDED AT JACOB'S PILLOW IN THE SUMMER OF 1971. Phonotapes. Lee, Mass: Recorded by Sarah Jeter, press representative, 1971. Approximately 5 hours. 5 cassettes. Dance Collection, The New York Public Library.

Included on the tapes: Shawn's talk to students; Shawn and His Men Dancers at Kent State Teachers' College, 1934; anecdotes about his 1914 tour with Ruth St. Denis; comments on Delsarte; comments on Martha Graham during the Denishawn tour of London and Paris in 1922; his solo works; working with large groups; how to set up a course in composition.

Q804. Shawn, Ted, with Poole, Gray. ONE THOUSAND AND ONE NIGHT STANDS. Garden City, N.Y.: Doubleday, 1960. 288 p., illus.

This autobiography covers the period from Shawn's American tour before his first meeting with Ruth St. Denis in 1914, to 1960. An amusing, anecdotal account of theatrical life on tour.

Q805. Shawn, Ted. REMEMBER: JACOB'S PILLOW WAS A STONE; SOME ROCKY REMINISCENCES. Dance Magazine (July 1970): 49–61, illus.

[See Q912.]

Q806. Shawn, Ted. THIRTY-THREE YEARS OF AMERICAN DANCE, 1927–1959, AND THE AMERICAN BALLET. Pittsfield, Mass: Eagle Printing Co., 1959. 136 p., illus.

A reissue of his The American Ballet. Contains a new foreword by the author. EARLIER EDITION (New York: H. Holt, 1926).

Q807. Terry, Walter. INTERVIEW WITH TED SHAWN. Phonotape. New York: WNYC, broadcaster, 1965. 26 min.; 1 reel (7 in.) 7-1/2 in./sec. Dance Collection, The New York Public Library.
FROM THE WNYC SERIES INVITATION TO DANCE.

Shawn discusses the diversity of his career; Denishawn; the Jacob's Pillow Dance Festival; dance education; the avant-garde.

Q808. Terry, Walter. LECTURE-DEMONSTRATION: EROTICISM AND THE DANCE. Phonotape. New York, 1951. 75-1/2 min.; 3 reels (5 in.) 3-3/4 in./sec. Dance Collection, The New York Public Library.

From a dance laboratory held at the YM–YWHA, New York.

[See Q1346.]

Q809. WHY DO WE DANCE? PRODUCED BY LYNN POOLE. INTRODUCTION BY DR. MILTON EISENHOWER. Motion picture. Baltimore, 1958. 29 min.; sound, black and white, 16 mm.
FROM THE SERIES JOHNS HOPKINS FILE SEVEN.

Shawn discusses motivations for dance with interviewer-producer Lynn Poole. Illustrated with photographs and film excerpts.

SOKOLOW, ANNA

Q810. ANNA SOKOLOW DIRECTS "ODES." PRODUCED, DIRECTED, AND EDITED BY DAVID L. PARKER. CHOREOGRAPHED BY SOKOLOW. MUSIC BY EDGAR VARÈSE. Motion picture. Columbus, Ohio: Ohio State University Department of Photography and Cinema; under the auspices of the Office of Educational Services, producing organization, 1972. 29 min.; sound, black and white, 16 mm.

Anna Sokolow, as artist-in-residence at Ohio State University, teaches her work to the university dance group. A full performance concludes the film.

Q811. ANNA SOKOLOW'S "ROOMS." PRODUCED BY JAC VENZA. INTRODUCTION BY CLIVE BARNES. CHOREOGRAPHED BY SOKOLOW. MUSIC BY KENYON HOPKINS. Motion picture. New York: WNET–TV, producing organization, 1966. 30 min.; sound, black and white, 16 mm.
FROM THE NET SERIES U.S.A.: DANCE.

A production of Sokolow's ballet. Performers: Ze'eva Cohen, Jack Moore, Jeff Duncan, Margaret Cicierska, Martha Clarke, Kathryn Posin, Ray Cook, and Chester Wolenski.

Q812. Cohen, Selma Jeanne, ed. THE MODERN DANCE: SEVEN STATEMENTS OF BELIEF. Middletown, Conn.: Wesleyan University Press, 1966. 106 p., illus.

[See Q359.]

Q813. ANNA SOKOLOW. In: Lloyd, Margaret. THE BOR-
ZOI BOOK OF MODREN DANCE. New York: Alfred A.
Knopf, 1949. p. 214–23.

A brief biography of this great American modern dancer.

Q814. OPUS OP. Motion Picture. King Screen Produc-
tions, producing organization, 1967. 20-1/2 min.;
sound, color, 16 mm.

A documentary on a performance of Sokolow's *Opus 65*
by the City Center Joffrey Ballet and the Crome Syrcus in
Seattle. Audience comments and reactions are inter-
spersed with the stage action.

Q815. ROBERT JOFFREY. EXECUTIVE PRODUCER, JAC
VENZA. CHOREOGRAPHED BY JOFFREY, GERALD AR-
PINO, AND SOKOLOW. Motion picture. New York:
WNET–TV, producing organization, 1965. 30 min.;
sound, black and white, 16 mm.
FROM THE NET SERIES U.S.A.: DANCE.

Excerpts from various ballets are performed by artists of
the Robert Joffrey Ballet Company. Includes Joffrey's *Pas
des Déesses* (music: John Field); Sokolow's *Opus 65* (music:
Teo Macero); Joffrey's *Gamelon* (music: Lou Harrison; cos-
tumes: Willa Kim); Arpino's *Incubus* (music: Anton
Webern; costumes: Lewis Brown); and Arpino's *Viva
Vivaldi* (music: Antonio Vivaldi; costumes: Quintana and
Anthony).

TAMIRIS, HELEN

Q816. HELEN TAMIRIS. In: LLOYD, MARGARET. THE
BORZOI BOOK OF MODERN DANCE. New York: Alfred
A. Knopf, 1949. p. 132–55.

A survey of Tamiris's career as a dancer and a choreogra-
pher, ending in 1948 with her work in the musical com-
edy *Inside U.S.A.* Included is a discussion of her produc-
tions for the WPA.

Q817. HELEN TAMIRIS IN NEGRO SPIRITUALS. CHOREO-
GRAPHED BY TAMIRIS. SINGERS, MURIAL RAHN AND
EUGENE BRICE. INTRODUCTION BY JOHN MARTIN. Mo-
tion picture. 1958. 17 min.; sound, black and white,
16 mm.

Tamiris interprets the spirituals: *Go Down, Moses; Swing
Low, Sweet Chariot; Git on Board; Crucifixion;* and *Joshua Fit
the Battle of Jericho.*

Q818. **Horst, Louis.** TAMIRIS. *Dance Observer* (Apr. 1934):
25, 28.

A brief survey by composer-pianist Louis Horst of Ta-
miris's first seven years as a concert artist.

Q819. **Maynard, Olga.** AMERICAN MODERN DANCERS:
THE PIONEERS. Boston: Little, Brown & Co., 1965.
218 p., illus.
[*See* Q399.]

Q820. **Schlundt, Christena Lindborg.** TAMIRIS: A
CHRONICLE OF HER CAREER, 1927–1955. New York:
New York Public Library, 1972. 94 p., illus.

The volume contains biographical information on Ta-
miris and tour itineraries, including theaters, dates,
repertoire, and dancers. *Contents:* early concert years,
1927–1929; the experimental years, 1930–1933; Tamiris
and her sense of mission, 1936–1939; Tamiris's studio
theater, 1940–1944; Tamiris on Broadway, 1944–1955.

Q821. TAMIRIS: PAST, PRESENT, FUTURE. Phonotape.
New York: Recorded at two performances of a pro-
gram dedicated to the life and work of Helen Tamiris
at the Lincoln Center Library and Museum of the Per-
forming Arts by the Stage Directors' and Choreo-
graphers' Workshop Foundation, 1968. 100 min.; 1 reel
(7 in.) 3-3/4 in./sec. Dance Collection, The New York
Public Library.
[*See* Q431.]

Q822. **Tamiris, Helen.** PRESENT PROBLEMS AND POSSI-
BILITIES. In: SORELL, WALTER, ed. THE DANCE HAS
MANY FACES. 2d ed. New York: Columbia University
Press, 1966. p. 200–207.
[*See* Q432.]

Q823. **Terry, Walter.** INTERVIEW WITH HELEN TAMIRIS.
Phonotape. New York: WNYC, broadcaster, 1965. 14
min.; 1 reel (7 in.) 7-1/2 in./sec. Dance Collection, The
New York Public Library.
FROM THE WNYC SERIES INVITATION TO DANCE.
[*See* Q352.]

Q824. **Terry, Walter.** INTERVIEW WITH HELEN TAMIRIS.
Phonotape. New York, n.d. 20 min.; 1 reel (7 in.) 3-3/4
in./sec. Dance Collection, The New York Public Li-
brary.
FROM A DANCE LABORATORY HELD AT THE YM–YWHA,
NEW YORK.

The discussion touches on Tamiris's philosophy of dance;
the development of her career; the late 1920s and 1930s;
self-accompaniment and her ideas on music and dance;
the use of Revolutionary War songs in *Liberty Song* and of
Negro songs in *How Long Brethren.*

Q825. **Wentink, Andrew Mark.** THE HELEN TAMIRIS
COLLECTION: A REGISTER. New York, 1973. Dance
Collection, The New York Public Library.

An index and guide to the papers of Helen Tamiris.

TAYLOR, PAUL

Q826. **Barnes, Clive.** TAYLOR AND HAWKINS. *Dance and
Dancers* (Dec. 1965): 30–33, illus.
[*See* Q706.]

Q827. **Cohen, Selma Jeanne.** AVANT-GARDE CHOREOG-
RAPHY, PTS. 1–3. *Dance Magazine.* Pt. 1 (June 1962):
22–24, 57; Pt. 2 (July 1962): 29–31, 58; Pt. 3 (Aug. 1962):
45, 54–56, illus.
[*See* Q358.]

Q828. **Cohen, Selma Jeanne, ed.** THE MODERN DANCE:

SEVEN STATEMENTS OF BELIEF. Middletown, Conn.: Wesleyan University Press, 1966. 106 p., illus.
[*See* Q359.]

Q829. **Goodman, Saul.** BRIEF BIOGRAPHIES: PAUL TAYLOR. *Dance Magazine* (June 1959): 48–49, illus.

A summary of the first eight years of Taylor's dance career.

Q830. **Page, Anita.** INTERVIEW WITH PAUL TAYLOR. Phonotape. Amherst, Mass.: WFCR, broadcaster, 1967. 25 min.; 1 reel (7 in.) 7-1/2 in./sec. Dance Collection, The New York Public Library.

Beginnings of his dance studies at age twenty-one; formation of his own company; dancing in *Episodes;* his choreographic compositions; touring; government subsidy of dance in America.

Q831. PAUL TAYLOR AND COMPANY: AN ARTIST AND HIS WORK. PRODUCED BY PETER C. FUNK. DIRECTED BY TED STEEG. CHOREOGRAPHED BY TAYLOR. Motion picture. Steeg Productions, producing organization, 1968. 33 min.; sound, color, 16 mm.

Taylor and his company in rehearsal, in performance, and in class. *Dancers:* Taylor, Bettie de Jong, Daniel Williams, Carolyn Adams, Daniel Wagoner, Eileen Cropley, Janet Aaron, Mollie Reinhart, Cliff Keuter, Karla Wolfangle, Senta Driver, and John Nightingale.

TETLEY, GLEN

Q832. IN SEARCH OF LOVERS. PRODUCED BY NORMAN SINGER. DIRECTED BY JAC VENZA. CHOREOGRAPHED BY TETLEY. MUSIC BY NED ROREM. SETS AND COSTUMES DESIGNED BY WILLA KIM. Motion picture. New York: WNET–TV, producing organization, 1966. 30 min.; sound, black and white, 16 mm.

FROM THE NET SERIES U.S.A.: DANCE.

This documentary about the creation of *Lovers* shows rehearsal activity, including set and costume planning. There is also an interview with the producer. *The dancers* (Carmen de Lavallade, Mary Hinkson, Scott Douglas, and Tetley) are also seen in their off-stage lives.

Q833. IN SEARCH OF LOVERS: THE BIRTH OF A DANCE WORK. PRODUCED BY JAC VENZA AND VIRGINIA KASSEL. Phonotape. National Educational Television, 1966. 11 reels (5 in.) 3-3/4 in./sec. Dance Collection, the New York Public Library.

FROM THE MOTION PICTURE IN SEARCH OF LOVERS.
[*See* Q593.]

THARP, TWYLA

Q834. **Kostelanetz, Richard.** METAMORPHOSIS IN MODERN DANCE. *Dance Scope* (fall 1970): 6–21, illus.
[*See* Q96.]

Q835. **Tharp, Twyla.** SPACE, JAZZ, POP, AND ALL THAT STUFF: TWYLA THARP TALKS TO D & D. *Dance and Dancers* (May 1974): 28–31, illus.

In this interview for a London periodical, after touching on her background and her dance company, Tharp discusses her views on space, the dancer's training, music for dance, improvisation, and her work with the Joffrey Ballet.

TUDOR, ANTONY

Q836. AMERICAN BALLET THEATRE: A CLOSE-UP IN TIME. PRODUCED BY JAC VENZA, DIRECTED BY JEROME SCHNUR. Motion picture. 1973. 90 min.; sound, color, 16 mm.
[*See* Q858.]

Q837. **Ames, Suzanne.** ANTONY TUDOR: FROM FREUD TO ZEN. *Dance Magazine* (Oct. 1973): 57–59, illus.

Tudor has choreographed thirteen ballets for the American Ballet Theatre Company since its initial season in 1940. The article deals with the psychological motivation of the characters in his principal dramatic ballets, his methods of working, and the change in his personal philosophy over the years.

Q838. **Anderson, Jack.** THE VIEW FROM THE HOUSE OPPOSITE: SOME ASPECTS OF TUDOR. *Ballet Review* 4 (1974): 14–23.

The choreographer's "psychological ballets," or dance-dramas, are analyzed in terms of motivation analysis and action. Anderson discusses a number of works in the repertoire of the American Ballet Theatre Company, including *Pillar of Fire, Romeo and Juliet, Jardin aux Lilas, Dim Lustre, Undertow, Dark Elegies,* and *Shadowplay.*

Q839. **Bristol, Caroline Jane.** CHOREOGRAPHIC WORKS OF ANTONY TUDOR: 1931-1954. Typewritten. New York, 1956. 36 p.

A chronology of Tudor's works, with detailed first-performance information. Bibliography.

Q840. **Cohen, Selma Jeanne.** ANTONY TUDOR: MAN WITHOUT A THEORY. *Dance Magazine* (Apr. 1954): 15–16, 50–51, illus.

The artist's ideas of choreography. Bibliographical material.

Q841. MODERN BALLET. PRODUCED BY JAC VENZA, NARRATED BY MARTHA MYERS. CHOREOGRAPHED BY TUDOR. MUSIC BY TCHAIKOVSKY, SCHONBERG, FREDERICK DELIUS, AND WILLIAM SCHUMAN. Motion picture. Boston: WGBH-TV, producing organization, 1959. 29 min.; sound, black and white, 16 mm.

FROM THE WGBH-TV SERIES A TIME TO DANCE.

Martha Myers and Tudor discuss trends and developments in the Ballet. Excerpts from the second act of *Swan Lake* and Tudor's ballet *Pillar of Fire, Undertow, Romeo and Juliet,* and *Dim Lustre* are performed by Nora Kaye, Hugh Laing, and Tudor. Included is a film clip of Ekaterina Geltzer.

Q842. **Rosen, Lillie F.** TALKING WITH ANTONY TUDOR: A CHOREOGRAPHER FOR ALL SEASONS. *Dance Scope* 9 (fall/winter 1974/1975): 14–24, illus.

A discussion of Tudor's choreographic style, with parenthetical remarks on various dancers. Ballets discussed are *Lilac Garden, Pillar of Fire, Undertow,* and *Shadowplay.*

Q843. **Terry, Walter.** INTERVIEW-DEMONSTRATION WITH NORA KAYE: THE ART OF PERFORMING. Phonotape. 1953. 40 min.; 1 reel (5 in.) 3-3/4 in./sec. Dance Collection, The New York Public Library. FROM A DANCE LABORATORY HELD AT THE YM–YWHA, NEW YORK.

[*See* Q1109.]

WEIDMAN, CHARLES

Q844. **Garnet, Eva Desca.** STATEMENT ON CHARLES WEIDMAN. Phonotape. Recorded in Los Angeles, n.d. 18 min., 1 reel (3 in.) 3-3/4 in./sec. Dance Collection, The New York Public Library.

Garnet, a former member of the Humphrey-Weidman Company, discusses Weidman during the period between 1936 and 1940; his roles, especially in *With My Red Fires;* his influence on modern dance choreography and instruction; his work, *Opus 51.*

Q845. **Maynard, Olga.** AMERICAN MODERN DANCERS: THE PIONEERS. Boston: Little, Brown & Co., 1965. 218 p., illus.

[*See* Q399.]

Q846. MODERN DANCE BY MARY WIGMAN ET AL. COMPILED BY VIRGINIA STEWART. New York: E. Weyhe, 1935. 155 p., illus.

[*See* Q402.]

Q847. **Nichols, Billy.** INTERVIEW WITH CHARLES WEIDMAN. Phonotape. New York: National Educational Television, 1965? 55 min.; 2 reels (7 in.) 7-1/2 in./sec. Dance Collection, The New York Public Library. EXCERPTS USED IN THE NET FILM FOUR PIONEERS.

A discussion of the Bennington College Summer School of Dance; male dancing; Weidman's choreography; his dance technique contrasted to Doris Humphrey's; Humphrey's dances, *Passacaglia* and *New Dance;* the influence of ballet on the Humphrey-Weidman technique; Hanya Holm's dance, *Trend;* Weidman's dance, *Opus 51;* performing with Martha Graham in vaudeville; his current work with composer Mikhail Santaro.

Q848. **Nichols, Billy.** INTERVIEW WITH HANYA HOLM. Phonotape. New York: National Educational Television, 1965. 52 min.; 2 reels (7 in.) 7-1/2 in./sec. Dance Collection, The New York Public Library. FROM THE NET FILM FOUR PIONEERS.

[*See* Q715.]

Q849. **Rogosin, Elinor.** VISITING CHARLES. *Eddy* 6 (spring 1975): 3–15, illus.

[*See* Q413.]

Q850. **Rothschild, Bethsabée de, Baroness.** LA DANSE ARTISTIQUE AUX USA: TENDANCES MODERNES. Paris: Editions Elzévir, 1949. 159 p., illus.

[*See* Q414.]

Q851. THE SHAKERS. PRODUCED AND DIRECTED BY THOMAS BOUCHARD. CHOREOGRAPHED BY DORIS HUMPHREY. Motion picture. 20 min.; sound, black and white, 16 mm.

[*See* Q731.]

COLLEGES AND UNIVERSITIES

Q852. **Hawkins, Alma M.** MODERN DANCE IN HIGHER EDUCATION. New York: Columbia University Teachers College, 1954. 123 p.

A study developing the concept that the specific contributions of modern dance are in consonance with the goals of education and that those goals determine the principles that should guide the teaching of modern dance.

Q853. **Limón, José.** THE UNIVERSITIES AND THE ARTS. *Dance Scope* (spring 1965): 23+.

The text of a speech given at the opening meeting of the Cornell University Centennial Celebration at the New York State Theater, March 9, 1965, in which Limón states that the modern American university is increasingly concerned with the arts and the artist. The dancer, once viewed with suspicion by the academic world, now occupies a respected place as a contributor to national and world culture. The university still needs to recognize production and performance as part of the regular curriculum and to make room for the creative dance artist who is interested primarily in performance. Limón feels that the university could become the patron of the arts in our era.

Q854. **Nichols, Billy.** INTERVIEW WITH HANYA HOLM. Phonotape. New York: National Educational Television, 1965. 52 min.; 2 reels (7 in.) 7-1/2 in./sec. Dance Collection, The New York Public Library. FROM THE NET FILM FOUR PIONEERS.

[*See* Q715.]

Q855. THE PROFESSIONAL COMPANY IN THE UNIVERSITY. *Impulse* (1968): 112–17.

Statements from the Developmental Conference on Dance, Los Angeles, 1966–1967. Prominent dance educators, choreographers, dancers, and writers on dance discuss curriculum development in colleges and universities and in-service training of future dancers. Colleges and universities, the report states, should provide an atmosphere in which the dancer can develop artistically to his fullest potential; the artist can play a vital role in stu-

dent education; and talented young dancers should have extensive opportunity for performance experience in a professional environment.

Q855a. Cutler, Cheryl, et al. Dance at Wesleyan 1977. Typescript. Wesleyan University, Dance Department, Middletown, Conn., 1977.

A description of the philosophy of dance as taught within a liberal arts education and its practice at this university. Coauthors include Ed Di Lello, Pamela Finney, Laura Pawel. *See also* "Dance in Liberal Arts," a paper by Laura Pawel and Michael Pawel, with excerpts from students at Wesleyan University. On improvisation as a performing discipline, *see* Cheryl Cutler, *An Introduction to Dance Improvisation* (1977), 3 p. Copies of these documents are on deposit at the Wesleyan Dance Department library, Middletown, Conn.

Q856. The Dance Magazine Directory of College and University Dance. Compiled by Mildred C. Spiesman. New York: *Dance Magazine*, 1971. 25 p.

The directory includes schools offering a major in dance or a program with dance emphasis. Although the listing is not complete, it does represent a good sampling. The data for 131 institutions, compiled chiefly from replies to questionnaires sent out to institutions of higher education, include locations, types of institutions, enrollment, tuition costs, types of undergraduate and graduate programs, and the kinds of dance courses available. Two earlier editions: *Dance Magazine* (Feb. 1961) and (Feb. 1966). a complementary publication: *Dance Directory*, 8th ed. Washington, D.C.: American Association for Health, Physical Education, and Recreation, Dance Division, 1973. Presents additional detailed information about college dance programs.

DANCE COMPANIES

Q857. American Ballet Company. Directed by Christian and Michael Blackwood. Narrated by Clive Barnes. Music by Gustav Mahler and Brahms. Choreographed by Eliot Feld. Motion picture. Blackwood Productions, producing organization, 1969. 59 min.; sound, color, 16 mm.

[*See* Q668.]

Q858. American Ballet Theatre: A Close-up in Time. Produced by Jac Venza. Directed by Jerome Schnur. Motion picture. 1973. 90 min.; sound, color, 16 mm.

A presentation of the work of American Ballet Theatre, including a complete performance of Antony Tudor's *Pillar of Fire*, with Sallie Wilson; a staging of David Blair's *Black Swan Pas de Deux*, with Cynthia Gregory and Ted Kivitt; the first movement of Fokine's *Les Sylphides*; the first half of Agnes de Mille's *Rodeo*, featuring Christine Sarry; a movement from Alvin Ailey's *The River*; and the *Tarantella* from Harald Lander's *Etudes*. Included are interviews with de Mille, Lucia Chase, and several of the dancers.

Q859. Austin, R. J. Ballet Theatre after Fifteen Years. *Tempo* 35 (spring 1955): 21–26.

A survey in this London periodical of the first fifteen years of the Ballet Theatre Company (1940–1955). The company's contributions are examined: its decisive influence in establishing the popularity of ballet throughout the United States and its policy of presenting classical ballet together with new works by American and foreign choreographers. The works of Antony Tudor, Jerome Robbins, and Agnes de Mille are discussed at length, as are dancers Alicia Alonso, Nora Kaye, and André Eglevsky.

Q860. Barzel, Ann. The Littlefields, Pts. 1 and 2. *Dance Magazine*. Pt. 1 (May 1945): 10–11; Pt. 2 (June 1945): 8–9, illus.

[*See* Q753.]

Q861. Capriccio Español. Directed by Jean Negulesco. Choreographed by Léonide Massine and Argentinita. Music by Rimsky-Korsakov. Sets and costumes designed by Mariano Andreu. Motion picture. Warner Bros. Pictures, producing organization, 1941. 20 min.; sound, color.

[*See* Q762.]

Q862. Cohen, Selma Jeanne, and Pischl, A. J. The American Ballet Theatre: 1940–1960. Brooklyn: Dance Perspectives Foundation, 1960. 120 p., illus. Dance Perspectives, no. 6

[*See* Q24.]

Q863. Chujoy, Anatole. Civic Ballet. New York: Published for Central Service for Regional Ballets by *Dance News*, 1958. 30 p.

A discussion of the role civic ballets can play in the cultural life of the community and the steps groups can take toward their organization.

Q864. The Dance Encyclopedia. Compiled and edited by Anatole Chujoy and Phyllis Winifred Manchester. 2d ed. New York: Simon & Shuster, 1967. 992 p., illus.

[*See* Q31.]

Q865. Chujoy, Anatole. The New York City Ballet. Photographs by George Platt Lynes, Walter E. Owen, and Fred Fehl. New York: Alfred A. Knopf, 1953. 382 p., illus.

An excellent definitive history of this company and its forerunners to 1952. Biographical information includes material on George Balanchine, Lincoln Kirstein, and Jerome Robbins. An appendix contains a valuable chronological checklist of ballets produced by the American Ballet, the Ballet Caravan, the Ballet Society, and the New York City Ballet from 1935 through the autumn of 1952. The checklist includes credits, principal dancers, and first-performance information. Index of names and titles.

Q866. Dance Comes to Harlem: Arthur Mitchell,

DIRECTOR OF THE DANCE THEATER OF HARLEM TALKS TO D & D, WITH INTERJECTIONS FROM CO-DIRECTOR, KAREL SHOOK. *Dance and Dancers* (Oct. 1974): 14–17, illus.

An account in this London periodical of the formation and growth of the Dance Theatre of Harlem, both the school and the company.

Q867. DANCE YEAR. Boston. 1 (1964): 256 p., illus.
[*See* Q10.]

Q868. **Deakin, Irving.** BALLET PROFILE. New York: Dodge Publishing Co., 1936. 368 p., illus.
[*See* Q157.]

Q869. **Shawn, Ted.** REMINISCENCES: FROM CHILDHOOD TO THE DISSOLUTION OF DENISHAWN. Phonotape. New York: WNYC, broadcaster; recorded in Eustis, Fla., 1969. 6-1/2 hours; broadcast, 26 min. Dance Collection, The New York Public Library.
FROM THE WNYC SERIES INVITATION TO DANCE.
[*See* Q1139.]

Q870. **Fanger, Iris M.** THE FEARSOME FIRST TEN YEARS: BOSTON BALLET TUNNELS OUT. *Dance Magazine* (Oct. 1973): 63–67, illus.

A history of the Boston Ballet Company, which developed from the New England Civic Ballet in the 1960s. The individual dancers (many of them students of Virginia Williams) and the current repertoire of this professional company are discussed by the author.

Q871. GAÎTÉ PARISIENNE. DIRECTED BY JEAN NEGULESCO. CHOREOGRAPHED BY LÉONIDE MASSINE. MUSIC BY JACQUES OFFENBACH. SETS AND COSTUMES DESIGNED BY COMTE ETIENNE DE BEAUMONT. Motion picture. Warner Bros. Pictures, producing organization, 1941. 20 min.; sound, color.
[*See* Q763.]

Q872. **Greskovic, Robert.** THE DANCE THEATER OF HARLEM: A WORK IN PROGRESS. *Ballet Review* 4 (1974): 43–60.

A detailed review, written when the Dance Theater of Harlem was four years old, of the principal dancers and of the repertory of the first all-black classical ballet company.

Q873. **Greskovic, Robert.** SOME ARTISTS OF THE NEW YORK CITY BALLET. *Ballet Review.* 4 (1973): 3–31.

A critical appraisal of the outstanding principal dancers, soloists, and corps de ballet of the New York City Ballet Company.

Q874. **Gruen, John.** THE PRIVATE WORLD OF BALLET. New York: Viking Press, 1975. 464 p., illus.
[*See* Q163.]

Q875. **Himmel, Paul.** BALLET IN ACTION. Text by WALTER TERRY. New York: G. P. Putnam's Sons, 1954. 178 p., illus.
[*See* Q166.]

Q876. **Hodgson, Moira.** PITTSBURGH BALLET THEATRE EDUCATING THE PUBLIC. *Dance Magazine* (Feb. 1975): 54–59, illus.

A history of the first six years of the Pittsburgh Ballet Theatre; its origins, financial difficulties, repertory, and artistic goals.

Q877. **Howard, Ruth Eleanor.** THE STORY OF THE AMERICAN BALLET. PHOTOGRAPHS BY RALPH OGGIANO. New York: Ihra Publishing Co., 1936. 39 p., illus.

A study of George Balanchine's American Ballet Company, founded in 1934 by Lincoln Kirstein and Gerald Warburg. There are brief biographies of twelve American Ballet Company dancers and a list of Balanchine ballets in preparation, including a version of Uncle Tom's Cabin, which was never produced.

Q878. **Humphrey, Doris.** LECTURE. Phonotape. New York: Recorded at Juilliard School of Music for National Educational Television, 1956. 2 reels (7 in.) 7-1/2 in./sec. Dance Collection, The New York Public Library.
FROM THE NET PROGRAM PIONEERS OF MODERN DANCE.
[*See* Q385.]

Q879. INVENTION IN DANCE. PRODUCED BY JAC VENZA. DIRECTED BY GREG HARNEY. CONCEIVED AND WRITTEN BY MARTHA MYERS. CHOREOGRAPHED BY ALWIN NIKOLAIS. Motion picture. Boston: WGBH–TV, producing organization, 1959. 29 min.; sound, black and white, 16 mm.
FROM THE WGBH–TV SERIES A TIME TO DANCE.
[*See* Q771.]

Q880. JACOB'S PILLOW DANCE FESTIVAL. PRODUCED BY JAC VENZA. Motion picture. New York: WNET–TV, broadcaster, 1969. 114 min.; sound, black and white, 16 mm.
FROM THE NET PROGRAM SOUNDS OF SUMMER.

Ted Shawn and his students discuss the history of and the current activities at Jacob's Pillow. Early film clips show Ted Shawn and His Men Dancers, the Denishawn Dancers, and Doris Humphrey. Included on the telecast are Donald McKayle and his group performing *Rainbow 'Round My Shoulder;* Lotte Goslar and her company performing *Life of a Flower, Greetings, Liebestraum,* and *Grandma Always Danced;* Maria Alba and her company performing *Orgia* and an unidentified work; the third-act pas de deux of *Sleeping Beauty,* performed by Toni Lander and Bruce Marks; Nala Najan teaching a class in Indian dance and performing *Durbari Kathak;* and the Norman Walker Dance Company performing his *Baroque Concerto no. 4.*

Q881. **Kirstein, Lincoln.** THE AMERICAN BALLET IN BRAZIL, ARGENTINA, CHILE, AND ON THE WEST COAST—PERU, COLUMBIA, VENEZUELA, PTS. 1-4. *The American Dancer* Pt. 1 (Sept. 1941): 8–9, 19, 23; Pt. 2 (Oct. 1941): 12–13, 25, 29; Pt. 3 (Nov. 1941): 10–11, 31; Pt. 4 (Dec. 1941): 16, 17, 30.

A diary of the company's South American tour reported in four successive issues.

Q882. **Kirstein, Lincoln.** BLAST AT BALLET: A CORRECTIVE FOR THE AMERICAN AUDIENCE. New York: Marstin Press, 1938. 128 p.

[*See* Q167.]

Q883. **Kirstein, Lincoln.** THE NEW YORK CITY BALLET. PHOTOGRAPHS BY MARTHA SWOPE AND GEORGE PLATT LYNES. New York: Alfred A. Knopf, 1973. 261 p., illus.

A detailed and valuable history of the company by one of its creators. Illustrated with studio and performance photographs, some in color and many occupying a full page. Includes a list of premiere performances produced by the American Ballet, the Ballet Caravan, the American Ballet Caravan, the Ballet Society, and the New York City Ballet, from March 1935 through May 1973. Name and title index.

Q884. **Kirstein, Lincoln.** REPERTORY: THE FACE OF A COMPANY. *Center: A Magazine of the Performing Arts* (July 1954): 20–23, illus.

An analysis of ballet companies as reflected in their repertory, with particular emphasis on the New York City Ballet.

Q885. **Koegler, Horst.** BALANCHINE UND DAS MODERNES BALLETT. Velber bei Hannover: Friedrich Verlag, 1964. 84 p., illus.
REIHE THEATER HEUTE, NR. 13.

[*See* Q612.]

Q886. **La Roche, Nancy.** HARTFORD BALLET; KICKING THE OLD IMAGE. *Dance Magazine* (Feb. 1975): 42–47, illus.

A discussion of the company's history and plans; the influences of Michael Uthoff, Lisa Bradley, and Enid Lynn; and the public's interest and support.

Q887. **Lyon, James.** INTERVIEW WITH IGOR YOUSKEVITCH AND DOROTHI PIERRE. Phonotape. New York: WNYC, broadcaster, 1957. 30 min.; 1 reel (7 in.) 7-1/2 in./sec. Dance Collection, The New York Public Library.
FROM THE WNYC SERIES TODAY IN BALLET.

Youskevitch discusses four new ballets of the Ballet Russe de Monte Carlo: *La Dame à la Licorne, Harlequinade, Sombreros,* and *Mikado,* and comments on his starring role in the movie, *Invitation to the Dance.* Dorothi Pierre, Ballet Russe press agent, discusses the four ballets and the history of the company.

Q888. **Lyon, James.** INTERVIEW WITH MARGERY DELL, EDWARD BIGELOW, TODD BOLENDER: THE NEW YORK CITY BALLET. Phonotape. New York: WNYC, broadcasters, 1958. 40 min.; 1 reel (7 in.) 7-1/2 in./sec. Dance Collection, The New York Public Library.
FROM THE WNYC SERIES TODAY IN BALLET.

Discussed in the interview are Balanchine's new ballets, *Episodes* and *Native Dancers;* the forthcoming telecast of Bolender's ballet, *Souvenirs;* the first Festival of Two Worlds at Spoleto, Italy, and Jerome Robbins's company, Ballets: U.S.A.; American audiences; the differences between the New York City Ballet and European companies; the problems involved in televising and filming ballets, in particular Balanchine's *Nutcracker,* and Bolender's *Stillpoint;* Balanchine's *Seven Deadly Sins;* the style and repertory of the New York City Ballet; costume design in Balanchine's ballets. *Guests from the New York City Ballet were* Margery Dell, associate press director; Edward Bigelow, assistant manager; and Todd Bolender, soloist and choreographer.

Q889. **Martin, John Joseph.** BOOK OF THE DANCE. THE STORY OF THE DANCE IN PICTURES AND TEXT. New York: Tudor Publishing Co., 1963. 192 p., illus.

[*See* Q1011.]

Q890. **Mates, Julian.** THE AMERICAN MUSICAL STAGE BEFORE 1800. New Brunswick, N.J.: Rutgers University Press, 1962. 331 p., illus.

[*See* Q1181.]

Q891. **Maynard, Olga.** AMERICAN BALLET THEATRE: THE FIGURE IN THE PRISM. *Dance Magazine* (Jan. 1975): 43–47, illus.

A discussion of the eclectic nature and style of this company and of the dancers and the creative artists affiliated with it.

Q892. **Maynard, Olga.** ARPINO AND THE BERKELEY BALLETS. PHOTOGRAPHS BY HERBERT MIGDOLL. *Dance Magazine* (Sept. 1973): 47–61, illus.

[*See* Q599.]

Q893. **Maynard, Olga.** BARBARA WEISBERGER AND THE PENNSYLVANIA BALLET. PHOTOGRAPHS BY ROGER GREENWALT. *Dance Magazine* (Mar. 1975): 45–60, illus.

This *Dance Magazine* contains historical material on early ballet and ballet dancers of Pennsylvania, as well as material on the contemporary Pennsylvania Ballet.

Q894. **Maynard, Olga.** THE CHRISTENSEN BROTHERS: AN AMERICAN DANCE DYNASTY. *Dance Magazine* (June 1973): 43–58, illus.

[*See* Q629.]

Q895. **Maynard, Olga.** LUCIA CHASE: FIRST LADY OF AMERICAN BALLET. *Dance Magazine* (Aug. 1971): 28–33, illus.

[*See* Q923.]

Q896. **Maynard, Olga.** THROUGH A GLASS BRIGHTLY: A LOOK AT AMERICAN BALLET THEATRE TODAY. *Dance Magazine* (June 1970): 48–63, illus.
[*See* Q187.]

Q897. **Mazo, Joseph H.** DANCE IS A CONTACT SPORT. New York: Saturday Review Press, 1974. 313 p., illus.
[*See* Q586.]

Q898. **Maynard, Olga.** ARTHUR MITCHELL AND THE DANCE THEATER OF HARLEM. *Dance Magazine* (Mar. 1970): 52–63, illus.
A discussion of black dancers, the first major black ballet company, and its director-founder Arthur Mitchell.

Q899. **Maynard, Olga.** DANCE THEATRE OF HARLEM. *Dance Magazine* (May 1975): 51–66, illus.
A profile of Arthur Mitchell, founder and director of the Dance Theatre of Harlem. This account of the formation of the school and company includes biographical data on the staff and members of the company. Comprises *Dance Magazine* portfolio with photographs by Martha Swope, Anthony Crickmay, and Kenn Duncan.

Q900. NEW YORK CITY BALLET. PRODUCED BY JAC VENZA. CHOREOGRAPHED BY GEORGE BALANCHINE. MUSIC BY STRAVINSKY, LOUIS GOTTSCHALK, AND TCHAIKOVSKY. COSTUMES DESIGNED BY KARINSKA. Motion picture. New York: WNET–TV, producing organization, 1965. 30 min.; sound, black and white, 16 mm.
Balanchine's choreography as performed by dancers of the New York City Ballet Company. Included are *Agon Pas de Deux*, performed by Suzanne Farrell and Arthur Mitchell; *Tarantella*, performed by Patricia McBride and Edward Villella; *Meditation*, performed by Suzanne Farrell and Jacques d'Amboise; and *Grand Pas de Deux (Tchaikovsky Pas de Deux)*, performed by Melissa Hayden and Jacques d'Amboise.

Q901. OPUS OP. Motion picture. King Screen Productions, producing organization, 1967. 20-1/2 min.; sound, color, 16 mm.
[*See* Q814.]

Q902. **Oswald, Genevieve, comp.** BIBLIOGRAPHY ON DANCE: ROCKEFELLER BROTHERS FUND. New York: 1963. 40 p.
[*See* Q20a.]

Q903. **Palatsky, Eugene.** "THESE DANCERS HAVE CHARACTER": PHILADELPHIA'S RESIDENT COMPANY, THE PENNSYLVANIA BALLET. *Dance Magazine* (Nov. 1967): 42, illus.
The Pennsylvania Ballet: its financing, early performances, the background of its founder Barbara Weisberger, the diverse background of its members, its repertoire, and the school.

Q904. PLAY MOTIFS, FOLK THEMES. TEXT BY BARTON MUMAW. Motion picture. 1935(?). 14-1/2 min.; silent, black and white with color, 16 mm.
Five works choreographed by Ted Shawn are performed by his company, Ted Shawn and His Men Dancers. The works are *Choric Dance from an Antique Greek Comedy (Choeur Dansé)*, *Gothic*, *Walk together Children*, *Mule Skinner's Dance*, and *Pioneer's Dance*. *Among the dancers appearing are* Foster Fitz-Simmons, Dennis Landers, Wilbur McCormack, Barton Mumaw, and Frank Overlees.

Q905. PRIMITIVE RHYTHMS. TEXT BY TED SHAWN. Motion picture. 1934–1940. 11-1/2 min.; silent, color, 16 mm.
A collection of five dances, choreographed by Ted Shawn and performed by Ted Shawn and His Men Dancers. The dances are *Ponca Indian Dance*, *Hopi Indian Eagle Dance*, *Sinhalese Devil Dance*, *Dayak Spear Dance*, and *Maori War Haka*. *Among the dancers are* Shawn and Barton Mumaw.

Q906. RELIGIOUS DANCES. CHOREOGRAPHED BY TED SHAWN. Motion picture. 193(?). 20-1/2 min.; silent, black and white, 16 mm.
[*See* Q479.]

Q907. ROBERT JOFFREY. EXECUTIVE PRODUCER, JAC VENZA. CHOREOGRAPHED BY JOFFREY, GERALD ARPINO, AND ANNA SOKOLOW. Motion picture. New York: WNET–TV, producing organization, 1965. 20 min.; sound, black and white, 16 mm.
FROM THE NET SERIES U.S.A.: DANCE.
[*See* Q815.]

Q908. RUTH ST. DENIS AND TED SHAWN: AMERICAN PIONEERS. In: LLOYD, MARGARET. THE BORZOI BOOK OF MODERN DANCE. New York: Alfred A. Knopf, 1949. p. 22–34.
[*See* Q800.]

Q909. **St. Denis, Ruth.** INTERVIEW: CONDUCTED BY SHIRLEY AND EARL UBEL. Phonotape. Hollywood, Calif.: Recorded at the Ruth St. Denis Studio, ca. 1965. 55 min. 1 reel (7 in.) 7-1/2 in./sec. Dance Collection, The New York Public Library.
[*See* Q1133.]

Q910. **Schlundt, Christena Lindborg.** THE PROFESSIONAL APPEARANCES OF RUTH ST. DENIS AND TED SHAWN: A CHRONOLOGY AND AN INDEX OF DANCES 1906–1932. New York: New York Public Library, 1962. 85 p., illus.
[*See* Q1020.]

Q911. **Schlundt, Christena Lindborg.** THE PROFESSIONAL APPEARANCES OF TED SHAWN AND HIS MEN DANCERS: A CHRONOLOGY AND AN INDEX OF DANCES, 1906–1932. New York: New York Public Library, 1967. 75 p., illus.
[*See* Q1021.]

Q912. **Shawn, Ted.** REMEMBER: JACOB'S PILLOW WAS A

STONE; SOME ROCKY REMINISCENCES. *Dance Magazine* (July 1970): 49–61, illus.

Ted Shawn recounts the problems he encountered in the forty-year history of Jacob's Pillow.

Q913. **Shelton, Suzanne.** HOUSTON BALLET: BRAINCHILD OF A COMMUNITY. *Dance Magazine* (Feb. 1975): 48–53, illus.

Shelton discusses the company's history and repertoire, the influences of Nina Popova and Henry Holth, and public interest in and support of the company.

Q914. **Sherman, Jane.** A DENISHAWN DANCER WITH THE ZIEGFELD FOLLIES. *Dance Magazine* (June 1975): 32–37, illus.

The diary and letters of a Denishawn dancer in the Far East.

Q914a. SONOMAMA 1976. Videotape. Middletown, Conn., 1976. 30 min.; sound, black and white. 1 reel (7 in.) 7-1/2 in./sec.

An introduction to the Sonomama Improvisation Dance Theater Company, its performing work, and its philosophy of performing and teaching the particular form of dance improvisation it has developed. Performers in the dance company include Joan Burbick, Cheryl Cutler, Randy Huntsberry, Charles Kreiner, Susan Lourie, David Rynick, Willa Needler. Videotape artists: Cathryn Johnston and Leland Johnston. The Sonomama Improvisation Dance Theater is located at Wesleyan University, Middletown, Conn. *See also* Cheryl Cutler, "An Introduction to Dance Improvisation," a paper written in 1977, on deposit in the Wesleyan Dance Department library. This paper is a brief introduction to the philosophy and practice of dance improvisation as a performing art as developed by the Sonomama Improvisation Dance Theater Company.

Q915. **Sorell, Walter.** GENERAL THOUGHTS ON REGIONAL BALLET. *Dance Scope* 6 (spring/summer 1972): 26–31.

The distinguished dance critic discusses the problems and challenges facing a regional company. Excerpted from a speech given in 1970.

Q916. **Terry, Walter.** INTERVIEW WITH JEAN ROSENTHAL: LIGHTING DESIGN FOR THE DANCE. Phonotape. New York: WNYC, broadcaster, 1967. 23 min. 1 reel (7 in.) 7-1/2 in./sec. Dance Collection, The New York Public Library.
FROM THE WNYC SERIES INVITATION TO DANCE.

[*See* Q1273.]

Q917. **Terry, Walter.** INTERVIEW WITH LUCIA CHASE. Phonotape. New York: WNYC, broadcaster, 1966. 20 min. 1 reel (7 in.) 7-1/2 in./sec. Dance Collection, The New York Public Library.
FROM THE WNYC SERIES INVITATION TO DANCE.

[*See* Q924.]

Q918. **Terry, Walter.** INTERVIEW WITH MELISSA HAYDEN. Phonotape. New York: WNYC, broadcaster, 1965(?). 22 min. 1 reel (7 in.) 3-3/4 in./sec. Dance Collection, The New York Public Library.
FROM THE WNYC SERIES INVITATION TO DANCE.

[*See* Q1102.]

Q919. **Venza, Jac.** INTERVIEWS WITH GEORGE BALANCHINE AND MEMBERS OF THE NEW YORK CITY BALLET. Phonotape. New York: National Educational Television 1964(?). 57 min. 4 reels (7 in.) 7-1/2 in./sec. Dance Collection, The New York Public Library.
FROM THE NET PROGRAM THE AMERICAN ARTS.

[*See* Q621.]

Q920. **Wood, Roger.** THE NEW YORK CITY BALLET: IN ACTION. Mitcham, Surrey, Eng.: Saturn Press, 1953(?). 48 p., illus.

A collection of action photographs, with annotations, of the New York City Ballet Company taken during its seasons at the Royal Opera House, Covent Garden, London (1950 and 1952). Critical notes by Phyllis Winifred Manchester. Concludes with a list of ballets, illustrated, with first-performance history.

DANCE COMPANY MANAGERS

CHASE, LUCIA

Q921. AMERICAN BALLET THEATRE: A CLOSE-UP IN TIME. PRODUCED BY JAC VENZA. DIRECTED BY JEROME SCHNUR. Motion picture. 1973. 90 min.; sound, color, 16 mm.

[*See* Q858.]

Q922. **Dolin, Anton.** LUCIA CHASE IS AMERICA'S NATIONAL BALLET THEATRE. *Dance and Dancers* (July 1953): 7–9, illus.

A discussion in this London periodical of the role Chase played in the creation and molding of the character of the Ballet Theatre, a distinguished American company.

Q923. **Maynard, Olga.** LUCIA CHASE: FIRST LADY OF AMERICAN BALLET. *Dance Magazine* (Aug. 1971): 28–33, illus.

A brief account of the development of American Ballet Theatre, from its origins to the present.

Q924. **Terry, Walter.** INTERVIEW WITH LUCIA CHASE. Phonotape. New York: WNYC, broadcaster, 1966. 20 min. 1 reel (7 in.) 7-1/2 in./sec. Dance Collection, The New York Public Library.
FROM THE WNYC SERIES INVITATION TO DANCE.

The interview includes discussion on recent matching grants for American Ballet Theatre from the National Council on the Arts; the problems involved in managing

a company that needs government and/or private support; ABT's repertory; the company's dancers and their training; Ballet Theatre workshops; Chase's history with the company.

KIRSTEIN, LINCOLN

Q925. **Chujoy, Anatole.** THE NEW YORK CITY BALLET. New York: Alfed A. Knopf, 1953. 382 p., illus.

[*See* Q865.]

COMPOSERS

Q926. **Cunningham, Merce.** MUSIC AND DANCE AND CHANCE OPERATIONS: A FORUM DISCUSSION. Phonotape. Amherst, Mass.: WFCR, broadcaster, 1970. 54-1/2 min. 2 reels (7 in.) 7-1/2 in./sec. Dance Collection, The New York Public Library.
FROM THE WFCR SERIES FIVE-COLLEGE FORUM.

[*See* Q361.]

Q927. **Graham, Martha.** THE MEDIUM OF DANCE: LECTURE. Phonotape. New York: Recorded at the Student Composer Forum at Juilliard School of Music, 1952. 45 min. 2 reels (7 in.) 7-1/2 in./sec. Dance Collection, The New York Public Library.

[*See* Q690.]

Q928. **Kostelanetz, Richard, comp.** JOHN CAGE. New York: Praeger Publishers, 1970. 237 p., illus., facsims.

This monograph on John Cage includes essays, reviews, scores, sketches, notes, and designs by Cage himself; criticisms of his work; photographs; essays by Richard Barnes, Virgil Thomson, Henry Cowell, Richard Teitelbaum, Richard Kostelanetz, Edward Downes, Jill Johnston, Eric Salzman, and others; material on his collaboration with modern dancer Merce Cunningham. Organized roughly in chronological order. Catalog of the composer's compositions, recordings, and papers; index.

Q929. **Pischl, A. J., and Cohen, Selma Jeanne, eds.** COMPOSER/CHOREOGRAPHER. Brooklyn: Dance Perspectives Foundation, 1963. 60 p., illus.
DANCE PERSPECTIVES, NO. 16.

A symposium of composers who write for dance. Articles deal with the relationship of music to choreography and the composer to the choreographer. Chronologies of dance scores. *Contributors:* Louis Horst, Vivian Fine, Robert Starer, Norman dello Joio, Lucia Dlugoszewski, Carlos Surinach, Alwin Nikolais, Gunther Schuller, John Cage, Halim El-Dabh, and Norman Lloyd.

Q930. New York. **Wildenstein & Co. and The New York Public Library, Dance Collection.** STRAVINSKY AND THE DANCE: A SURVEY OF BALLET PRODUCTIONS, 1910-1962, IN HONOR OF THE EIGHTIETH BIRTHDAY OF IGOR STRAVINSKY. New York: Dance Collection of the New York Public Library, 1962. 60 p., illus.

Exhibition: Traveling exhibition circulated under the auspices of The Museum of Modern Art, N.Y. Sponsored by the Committee for the Dance Collection of The New York Public Library.

Reproductions of stage designs for twenty-three ballets; portraits of Igor Stravinsky. *Contents:* "Stravinsky and the Muses," by H. Read; "Ballet Productions, 1910–1962," by Selma Jeanne Cohen.

Q931. **Teirstein, Alice.** DANCE AND MUSIC: INTERVIEWS AT THE KEYBOARD. *Dance Scope* 8 (spring/summer 1974): 18–31, illus.

The views of six contemporary musical artists: Norman Lloyd, John Colman, John Cage, Pat Richter, Norma Dalby, and Bruce Lieberman. All have composed for dance or accompanied company classes. Their discussions concern the present and future relationship of music and dance, their working methods, and their recommendations based on their own various approaches.

CRITICS

Q932. **Barrett, John Townsend.** ANALYSIS AND SIGNIFICANCE OF THREE AMERICAN CRITICS OF THE BALLET: CARL VAN VECHTEN, EDWIN DANBY, AND LINCOLN KIRSTEIN. M.A. thesis, Columbia University, 195(?). 55 p.

An analysis of the critical output of the most important and influential writers on American dance. Bibliography.

Q933. **McDonagh, Don; Croce, Arlene; and Dorris, George.** A CONVERSATION WITH EDWIN DENBY, PTS. 1 AND 2. *Ballet Review* 2 (1969): 3–19; 2 (1969): 32–45.

Selections from informal tape-recorded conversations among Denby, Croce, McDonagh, and Dorris. The conversations touch on the modulation of gesture in ballet; the interpretive leeway among dancers; the purpose of ballet criticism; Tanaquil LeClercq and Francisco Moncion; Jerome Robbins's *Dances at a Gathering;* John Clifford's *Fantasies;* and George Balanchine's *Prodigal Son, La Sonnambula, Roma,* and *La Valse.*

Q934. **Denby, Edwin.** THE CRITICISM OF EDWIN DENBY. PHOTOGRAPHS BY WALKER EVANS. *Dance Index* (Feb. 1946): 28–56, illus.

[*See* Q1474.]

Q935. **Denby, Edwin.** DANCERS, BUILDINGS, AND PEOPLE IN THE STREETS. New York, 1965. 287 p.

[*See* Q1427.]

Q936. **Kirstein, Lincoln.** CRISIS IN THE DANCE. *North American Review* 243 (spring 1937): 80–103.

An early polemic on the controversy between supporters of the traditional classic ballet and what Kirstein terms "the so-called 'modern' or 'concert' dance." Although the author is highly critical of the "Diaghilev formula"

employed by the De Basil and other ballet companies, he
believes that dance artists do need tradition. Tradition,
Kirstein believes, is "the accumulation of specific techni-
cal means (classical ballet technique) to train any dancer
to be completely effective before an audience." While
modern dance has served a useful function in stimulating
a sharp re-evaluation and has greatly increased the in-
telligent audience for dance, "ballet [the author con-
cludes] is contemporary expression of stage dancing."

Q937. **Kirstein, Lincoln.** Our Ballet and Our Au-
dience. *The American Dancer* (July 1938): 22–23, illus.
[*See* Q171.]

Q938. **Van Vechten, Carl.** The Dance Writings of
Carl Van Vechten, Edited, and with an In-
troduction by Paul Padgette. Brooklyn, N.Y.:
Dance Horizons, 1974. 182 p., illus.
[*See* Q441.]

DANCERS

GENERAL REFERENCES

Q939. The Dance Encyclopedia. Compiled and
edited by Anatole Chujoy and Phyllis Winifred
Manchester. 2d ed. New York: Simon & Shuster,
1967. 992 p., illus.
[On this entry, *see further* Q31. For dancers who are also
prominent choreographers, *see* Q595 *et seq.*]

Q940. Dance Year. Boston. 1 (1964): 256 p., illus.
[*See* Q10.]

Q941. **Day, James.** Interview with Alexandra Dani-
lova. Phonotape. New York: WNET–TV, broadcaster,
1974. 30 min. 1 reel (7 in.) 3-3/4 in./sec. Dance Collec-
tion, The New York Public Library.
From the NET series Day at Night.
[*See* Q1043.]

Q942. **De Mille, Agnes.** To a Young Dancer: A
Handbook. Illustrated by Milton Johnson.
Boston: Little, Brown & Co.; copublished by Atlantic
Monthly Press, 1962. 175 p., illus.
A handbook for dance students, parents, and teachers. De
Mille concentrates on a dancer's preparation, his educa-
tion, his professional dancing, and choreography rather
than dwelling on dance technique. Includes a suggested
reading list, a list of dance companies, and a list of films.

Q943. **Durang, John.** The Memoir of John Durang,
American Actor, 1785–1816. Edited by Alan S.
Downer. Pittsburgh: Published for the Historical
Society of York County and for the American Society
for Theatre Research by the University of Pittsburgh
Press, 1966. 176 p., illus. (color).
[*See* Q118.]

Q944. **Kirstein, Lincoln.** Blast at Ballet: a Correc-
tive for the American Audience. New York:
Marstin Press, 1938. 128 p.
[*See* Q167.]

Q945. **Kirstein, Lincoln.** What Ballet Is About: An
American Glossary. Portfolio of photographs
of the New York City Ballet by Martha Swope.
Brooklyn, N.Y.: Dance Perspectives Foundation, 1958.
80 p., illus.
Dance Perspectives, no. 1.
[*See* Q172.]

Q946. **Kurath, Gertrude Prokosch.** Dance Design.
Design 33 (July–Aug. 1931): 64–70; 33 (Nov. 1931):
144–48; 33 (Jan. 1932): 198–203, illus.
[*See* Q584.]

Q947. **Marks, Marcia.** Pauline Koner Speaking, Pts.
1–3. *Dance Magazine.* Pt. 1 (Sept. 1961): 36–37, 68–69;
Pt. 2 (Oct. 1961): 38, 59; Pt. 3 (Nov. 1961): 16, 64.
[*See* Q739.]

Q948. **McDonagh, Don.** The Rise and Fall and Rise
of Modern Dance. New York: New American Li-
brary, 1971. 303 p., illus.
[*See* Q97.]

Q949. **Odell, George Clinton Densmore.** Annals of
the New York Stage. New York: Columbia Univer-
sity Press, 1927–1949. 15 vols., illus., facsims., map.
[*See* Q1182.]

Q950. **Peralta, Delfor.** Jerome Robbins Interviewed.
Dance Magazine (Dec. 1959): 72–73, 118–19, illus.
[*See* Q795.]

Q951. Paul Taylor and Company. Produced by
Peter C. Funk. Directed by Ted Steeg. Choreo-
graphed by Taylor. Motion picture. Steeg Produc-
tions, Producing organization, 1968. 33 min.; sound,
color, 16 mm.
[*See* Q831.]

Q952. **Scothorn, Carol.** Three Choreographers Talk
about the Audience. Impulse (1962): 16–19.
[*See* Q641.]

Q953. **Tamiris, Helen.** Present Problems and Possi-
bilities. In: Sorell, Walter, ed. The Dance Has
Many Faces. 2d ed. New York: Columbia University
Press, 1966. p. 200–207.
[*See* Q1222.]

Q954. **Terry, Walter.** The Dance in America. Rev. ed.
New York: Harper & Row, 1971. 272 p., illus.
[*See* Q433.]

Q955. **Terry, Walter.** Interview-demonstration

WITH MARIA TALLCHIEF AND ANDRÉ EGLEVSKY. Pho-
notape. New York, 1962. 60 min. 1 reel (7 in.) 3-3/4
in./sec. Dance Collection, The New York Public Li-
brary.
FROM A DANCE LABORATORY HELD AT THE YM-YWHA,
NEW YORK.

[See Q1085.]

Q956. **Terry, Walter.** INTERVIEW-DEMONSTRATION
WITH MELISSA HAYDEN AND JOHN KRIZA. Phonotape.
New York, 1953. 51 min. 1 reel (5 in.) 3-3/4 in./sec.
Dance Collection, The New York Public Library.
FROM A DANCE LABORATORY HELD AT THE YM-YWHA,
NEW YORK.

[See Q1101.]

Q957. **Terry, Walter.** INTERVIEW WITH MARTHA
GRAHAM: THE ART OF PERFORMING. Phonotape. New
York, 1952. 52 min. 2 reels (5 in.) 7-1/2 in./sec. Dance
Collection, The New York Public Library.
FROM A DANCE LABORATORY HELD AT THE YM-YWHA,
NEW YORK.

[See Q436.]

Q958. **Terry, Walter.** INTERVIEW WITH MELISSA
HAYDEN. Phonotape. New York: WNYC, broadcaster,
1965(?). 22 min. 1 reel (7 in.) 3-3/4 in./sec. Dance Collec-
tion, The New York Public Library.
FROM THE WNYC SERIES INVITATION TO DANCE.

[See Q1102.]

Q959. **Venza, Jac.** INTERVIEWS WITH GEORGE BAL-
ANCHINE AND MEMBERS OF THE NEW YORK CITY
BALLET. Phonotape. National Educational Television,
1964(?). 57 min. 4 reels (7 in.) 7-1/2 in./sec. Dance Col-
lection, The New York Public Library.
RECORDED FOR THE NET PROGRAM THE AMERICAN
ARTS.

[See Q621.]

EIGHTEENTH CENTURY

Q960. **Kieffer, Elizabeth Clarke.** JOHN DURANG: THE
FIRST NATIVE AMERICAN DANCER. *The Dutchman*
(June 1954): 26–38, illus.

A detailed discussion of Durang's career and his place in
American dance and theater history.

Q961. **Mates, Julian.** THE AMERICAN MUSICAL STAGE
BEFORE 1800. New Brunswick, N.J.: Rutgers University
Press, 1962. 331 p., illus.

[See Q1181.]

Q962. **Moore, Lillian.** THE DUPORT MYSTERY. Brooklyn,
N.Y.: Dance Perspectives Foundation, 1960. 103 p.,
illus.
DANCE PERSPECTIVES, NO. 7.

A biography of a family of eighteenth-century dancers:
Pierre Landrin Duport; Louis Duport, his partner Suz-

anne Vaillande; and her lover Alexandre Placide. Ap-
pendixes; bibliography.

Q963. **Moore, Lillian.** JOHN DURANG, THE FIRST AMERI-
CAN DANCER. *Dance Index* 1 (Aug. 1942): 120–39, illus.

A biography of the first native-born American
(1768–1822) to win widespread recognition in a dis-
cipline dominated by foreign artists. The theatrical career
of this founder of a dancing dynasty spanned the early
years of the American Republic. REPRINTED in Paul
David Magriel, ed., *Chronicles of the American Dance* (New
York: H. Holt, 1948), p. 15–37 [Q1384].

Q964. **Moore, Lillian.** NEW YORK'S FIRST BALLET
SEASON, 1792. New York: New York Public Library,
1961. 18 p., illus.

The performers who appeared at the John Street Theatre,
New York, and their repertoire from Jan. 25 to May 14,
1792. An appendix lists fifteen ballets and pantomimes
produced by Alexandre Placide and his company of
French dancers with the Old American company of ac-
tors. Reprinted from The New York Public Library,
Bulletin (Sept. 1960).

Q965. **Moore, Lillian.** SOME EARLY AMERICAN DAN-
CERS. *The Dancing Times* (Aug. 1950): p. 668–71, illus.
[See Q122.]

Q966. **Wenig, Adele.** IMPORTS AND EXPORTS,
1700–1940. *Impulse* (1963/1964): 16–28, illus.

A chronological account of the theatrical dancers and
dance companies, usually European, performing in the
United States and of the Americans performing abroad.
Bibliography.

Q967. **Winter, Marian Hannah.** AMERICAN THEATRI-
CAL DANCING FROM 1750 TO 1800. *The Musical Quar-
terly* 24 (Jan. 1938): 58–73, illus.

A study of theatrical dancing in America from 1750 to
1800 written by an authority in the field. Contains exten-
sive references to Alexandre Placide, Madame Gardie,
and James Byrne, among others.

NINETEENTH CENTURY

Q968. **Beaumont, Cyril William.** FANNY ELSSLER
(1810–1884). London: C. W. Beaumont, 1931. 27 p.,
illus.

An excellent, concise biography of the great nineteenth-
century European ballerina who toured America from
1840 to 1842, and gave some two hundred performances
to great acclaim in this country.

Q969. LA CACHUCHA. Videotape. New York, 1975. 6
min.; sound, black and white. 1 reel (1/2 in.).

A performance of *La Cachucha*, the solo that was choreo-
graphed by Fanny Elssler in 1836 and became famous
during her two-year tour of the Americas in the early
1840s. Reconstructed from Zorn Notation by Linda del
Zio Zoffer, and performed at New York University.

Q970. **Chaffée, George.** AMERICAN MUSIC PRINTS OF THE ROMANTIC BALLET, Pt. 2. *Dance Index* (Dec. 1942): 192–212, illus.

[*See* Q128.]

Q971. **Chaffée, George.** A CHART TO THE AMERICAN SOUVENIR LITHOGRAPHS OF THE ROMANTIC BALLET, 1825–1870, Pt. 1. *Dance Index* (Feb. 1942): 20–25, illus.

[*See* Q129.]

Q972. **Darling, Amanda.** LOLA MONTEZ. New York: Stein & Day, 1972. 240 p.

A recent biography of the woman who was, according to the author, "the most flamboyant femme fatale of the 19th century," who "had an international reputation as a dancer and an actress, but whose really great acting was performed offstage as she reshaped her own story to suit each individual lover." Darling stresses her surprising independence of spirit. From a feminist view, interesting and well written but offering little new insight. No bibliography or index.

Q973. **Delarue, Allison.** THE CHEVALIER HENRY WIKOFF: IMPRESARIO, 1840. Princeton, N.J.: Privately printed at the Princeton University Press.

Wikoff is the American-born impresario who brought Fanny Elssler to the United States in 1840.

Q974. **Ekstrom, Parmenia Migel.** AUGUSTA MAYWOOD, 1825–1876. In: THE BALLERINAS. New York, 1972. p. 179–93.

A biographical account of Augusta Maywood's European career, with much new information on the activities of this celebrated American ballerina.

Q975. **Elssler, Fanny.** THE LETTERS AND JOURNAL OF FANNY ELSSLER WRITTEN BEFORE AND AFTER HER OPERATIC CAMPAIGN IN THE UNITED STATES: INCLUDING HER LETTERS FROM NEW YORK, LONDON, PARIS, HAVANA. New York: H. G. Daggers, 1845. 65 p.

The renowned nineteenth-century ballerina, Fanny Elssler, is said to have written these letters between 1839 and 1842. They reveal her resolution to visit America, her preparations for her two-year circuit, and her experiences while on tour. Her personal observations on American society and on the American artists with whom she appeared provide a valuable first-hand account of the mid–nineteenth-century American theatrical scene as seen through European eyes.

Q976. **Foley, Doris.** THE DIVINE ECCENTRIC: LOLA MONTEZ AND THE NEWSPAPERS. Los Angeles: Westernlore Press, 1969. 228 p., illus.

An account based on press notices appearing in California newspapers from 1853 through 1861, during Montez's stay in America. Bibliography.

Q977. **Guest, Ivor.** FANNY ELSSLER. Middletown, Conn.: Wesleyan University Press, 1970. 248 p., illus.

A well illustrated, authoritative account of the life and career of the famous nineteenth-century Viennese dancer who was the most distinguished European ballerina to visit America in that century. Her tours of the eastern states and Cuba from 1840 to 1842 brought her acclaim unequalled until the arrival of Anna Pavlova. Included is a detailed description of Elssler's American tour: preparations, the conquest of the New World, Havana, and the Deep South, and the second year. Bibliography; genealogy; and index. ENGLISH EDITION (London: A. & C. Black, 1970).

Q978. **Ludlow, Noah Miller.** DRAMATIC LIFE AS I FOUND IT. Saint Louis: G. I. Jones & Co., 1880. 733 p.

[*See* Q1407.]

Q979. **Michel, Arthur.** GREAT AMERICAN BALLERINA, PTS. 1 AND 2. *Dance Magazine.* Pt. 1 (Nov. 1943): 8–9, 30–31; Pt. 2 (Dec. 1943): 6, 25, 32, illus.

Pt. 1 is a discussion of Augusta Maywood's early training, her debut, and her European training and career. Special emphasis is placed on the various choreographers, dancers, and the ballets with which she was associated. In Pt. 2, Michel touches on her rivals, especially those in Italy, her spectacular success, the various roles she danced, and her great dramatic ability. Includes reproductions of lithographs of Maywood and her contemporaries.

Q980. **Montez, Lola.** LOLA MONTEZ: AVENTURES DE LA CÉLÈBRE DANSEUSE RACONTÉES PAR ELLE-MEME. Paris, 1847. 30 p., facsim.

A brief autobiographical essay accompanied by Montez's portrait and a facsimile of her handwriting.

Q981. **Moore, Lillian.** FANNY ELSSLER. In her ARTISTS OF THE DANCE. New York: Thomas Y. Crowell Co., 1938. p. 91–109.

A brief biography of the first ballerina of world renown to visit the United States. Moore includes a detailed description of Elssler's American tour in the early 1840s, which awakened an enthusiastic interest in ballet in America. REPRINT EDITION (Brooklyn, N.Y.: Dance Horizons, 1969).

Q982. **Moore, Lillian.** GEORGE WASHINGTON SMITH. *Dance Index* 4 (June–Aug. 1945): 88–135, illus.

[*See* Q133.]

Q983. **Moore, Lillian.** LEÓN ESPINOSA IN AMERICA. *The Dancing Times* (Mar. 1951): 333–35.

[*See* Q134.]

Q984. **Moore, Lillian.** MARY ANN LEE: FIRST AMERICAN GISELLE. *Dance Index* (May 1943): 60–71, illus.

A biography of the nineteenth-century dancer who was the first American to attain nationwide fame as an exponent of the classic ballet. REPRINTED in Paul David, Magriel, ed. Chronicles of the American Dance (New York: H. Holt, 1948), p. 102–117 [Q1384].

Q985. **Moore, Lillian.** METROPOLITAN OPERA SOLO

DANCERS AND CHOREOGRAPHERS, 1883–1932. Manuscript, ca. 1951. 204 p. Dance Collection, The New York Public Library.

Extensive notes used for the preparation of the author's article, "The Metropolitan Opera Ballet Story: Its Sixty-seven Years in Review," *Dance Magazine* (Jan. 1951): 20–29, 39–40, 42, 44–48.

Q986. **Moore, Lillian.** PLAINSMAN AND BALLERINA. *Dance Magazine* (Oct. 1967): 46–49, illus.

The romance of "Texas" Jack Omohundro, an American frontier scout and Indian fighter, and Italian ballerina Giuseppina Morlacchi; they were married in 1872 after appearing together in a Chicago theatrical production.

Q987. **Moore, Lillian.** SOME EARLY AMERICAN DANCERS. *The Dancing Times* (Aug. 1950): 668–71, illus.
[*See* Q122.]

Q988. **Moore, Lillian.** WHEN FANNY DANCED: NEW YORK IN THE FORTIES AS SEEN BY THE GREAT ELSSLER. *Theatre Guild Magazine* (Nov. 1929): 37–39, illus.

Excerpts from the letters and journal of Fanny Elssler in the United States.

Q989. **Redway, Virginia Larkin.** MUSIC DIRECTORY OF EARLY NEW YORK CITY. New York: New York Public Library, 1941. 102 p., frontispiece.

A file of dancers, dancing teachers, musicians, music publishers, and musical instrument makers listed in New York directories from 1786 through 1835.

Q990. **Ross, Ishbel.** THE UNCROWNED QUEEN: LIFE OF LOLA MONTEZ. New York: Harper & Row, 1972. 349 p., illus.

An entertaining, well-documented biography of the nineteenth-century dancer whose travels brought her to the United States in 1853. Her well-publicized grand tour of America took her to the West, where her San Francisco appearances culminated a fascinating and colorful career. Bibliography.

Q991. **Winter, Marian Hannah.** AUGUSTA MAYWOOD. In: MAGRIEL, PAUL DAVID, ED. CHRONICLES OF THE AMERICAN DANCE. New York: H. Holt, 1948. p. 118–37, illus.

A brief description of Augusta Maywood's early childhood and her parents' careers, her early training, and her success in the United States. Included are comments from contemporary reviews. Her training and successful debut in Paris, her maturation as a dancer, and her subsequent brilliant career as an acclaimed artist are treated. Included in this account are excerpts from journals of the period. Reprinted from *Dance Index* (Jan.–Feb. 1943).

Q992. **Wood, William Burke.** PERSONAL RECOLLECTIONS OF THE STAGE: EMBRACING NOTICES OF ACTORS, AUTHORS, AND AUDITORS DURING A PERIOD OF FORTY YEARS. Philadelphia: H. C. Baird, 1855. 477 p.
[*See* Q140.]

Q993. **Wyndham, Horace.** THE MAGNIFICENT MONTEZ: FROM COURTESAN TO CONVERT. New York: B. Blom, 1969. 288 p. illus., frontispiece.

This is an excellent biography of the nineteenth-century actress-dancer whose flamboyant career took her to America in the 1850s. Wyndham attempts to "disentangle the real facts from the network of lies and fables in which they have been enmeshed." The last five chapters discuss in detail Montez's years in America and the final ten years of her life. Index.

DANCERS OF THE TWENTIETH CENTURY

GENERAL REFERENCES

Q994. **Armitage, Merle.** DANCE MEMORANDA. EDITED BY EDWIN CORLE. New York: Duell, Sloan & Pearce, 1947. 256 p., illus.

The author's impressions of the dance, its creators, and performers. Among those artists discussed are Lincoln Kirstein, Isadora Duncan, Ruth St. Denis, Agnes de Mille, and Martha Graham.

Q995. **Bachardy, Don.** BALLET PORTRAITS. Santa Monica, Calif., 1966. illus.

PORTFOLIO EDITION containing photographic portraits of members, both past and present, of the New York City Ballet.

Q996. CELEBRATION: DANCE AS A PHOTOGRAPHIC ART. DESIGN AND ART DIRECTION BY HERBERT MIGDOLL. New York: Danad Publishing Co., 1971. 2 vols., illus.

The editors of *Dance Magazine* have selected extraordinary "photographic moments" and have compiled them in an anthology.

Q997. **Chujoy, Anatole.** THE NEW YORK CITY BALLET. PHOTOGRAPHS BY GEORGE PLATT LYNES, WALTER E. OWEN, AND FRED FEHL. New York: Alfred A. Knopf, 1953. 382 p., illus.
[*See* Q865.]

Q998. DANCER'S ALMANAC AND WHO'S WHO. New York. 1 (1940): 204 p., illus.
[*See* Q1.]

Q999. A DANCER'S WORLD. PRODUCED BY NATHAN KROLL. DIRECTED AND FILMED BY PETER GLUSHANOK. COMPOSER AND PIANIST, CAMERON MCCOSH. CHOREOGRAPHED BY MARTHA GRAHAM. Motion picture. Pittsburgh: WQED–TV, producing organization, 1957. 30 min.; sound, black and white, 16 mm.
[*See* Q677.]

Q1000. **Deakin, Irving.** BALLET PROFILE. New York: Dodge Publishing Co., 1936. 368 p., illus.
[*See* Q157.]

Q1001. Denby, Edwin. LOOKING AT THE DANCE. New York: Pellegrini & Cudahy, 1949. 432 p., illus.

A collection of criticism and essays on all aspects of dance by one of the most distinguished writers on the subject. This study is based principally on performances given in New York from 1936 to 1947. Index.

Q1002. Esser, Grace Denton. MADAME IMPRESARIO: A PERSONAL CHRONICLE OF AN EPOCH. Yucca Valley, Calif.: Manzanita Press, 1974. 230 p., illus.

An autobiography of the concert manager who was associated with some of the notable performing artists of her time in America, including Ruth St. Denis, Ted Shawn, Adolph Bolm, Ruth Page, the Jooss Ballet, Serge Lifar, the Ballet Russe de Monte Carlo, Doris Humphrey, Charles Weidman, the Sakharoffs, and Katherine Dunham. The heart of the book covers the period from 1923 to 1941. There is a foreword by Merle Armitage.

Q1003. Goodman, Saul. DANCERS YOU SHOULD KNOW. New York: Dance Magazine, 1964. 59 p., illus.

Twenty biographical studies previously published in *Dance Magazine*. Dancers and choreographers include Alvin Ailey, Carmen de Lavallade, Peter Gennaro, Mary Hinkson, Arthur Mitchell, Lupe Serrano, Edward Villella, and Patricia Wilde.

Q1004. Graham, Martha. THE MEDIUM OF DANCE: LECTURE. Phonotape. New York: Recorded at the Student Composer Forum at Juilliard School of Music, 1952. 45 min. 2 reels (7 in.) 7-1/2 in./sec. Dance Collection, The New York Public Library.

[*See* Q690.]

Q1005. Gruen, John. THE PRIVATE WORLD OF BALLET. New York: Viking Press, 1975. 464 p., illus.

[*See* Q163.]

Q1006. Humphrey, Doris. LECTURE. Phonotape. New York: Recorded at Juilliard School of Music for National Educational Television, 1956. 60 min. 2 reels (7 in.) 7-1/2 in./sec. Dance Collection, The New York Public Library.
FROM THE NET PROGRAM PIONEERS OF MODERN DANCE.

[*See* Q385.]

Q1007. Kirstein, Lincoln. THE NEW YORK CITY BALLET. PHOTOGRAPHS BY MARTHA SWOPE AND GEORGE PLATT LYNES. New York: Alfred A. Knopf, 1973. 261 p., illus.

[*See* Q883.]

Q1008. Lloyd, Margaret. THE BORZOI BOOK OF MODERN DANCE. Brooklyn, N.Y.: Dance Horizons, 1959(?). 356 p., illus.

[*See* Q394.]

Q1009. Lynes, George Platt. PHOTOGRAPHS. *Dance Index* (Dec. 1944): 216–27, chiefly illus.

A collection of ballet portraits, with an introductory essay by the photographer on the art of dance photography. Includes full-page black and white photographs of Tamara Toumanova, Tatiana Riabouchinska, Yurek Shabelevski, Alicia Markova, André Eglevsky, Irina Baronova, Vera Zorina, Alexandra Danilova, Frederic Franklin, and William Dollar. Also included are scenes from *Orpheus* and *Pastorales*.

Q1010. Martin, John Joseph. AMERICAN DANCING: THE BACKGROUND AND PERSONALITIES OF THE MODERN DANCE. PHOTOGRAPHS BY THOMAS BOUCHARD. New York: Dodge Publishing Co., 1936. 320 p., illus.

A survey of American dance in the twentieth century. One of the most distinguished works of dance literature written during the period of great development in the modern dance. *Contents:* Pt. 1, the theory and development of the modern dance; Pt. 2, the emergence of an American dance: Isadora Duncan; Denishawn, the Neighborhood Playhouse, Bird Larson; Pt. 3, chief contemporary figures: The Bennington Group; Martha Graham; Doris Humphrey; Charles Weidman. The independents: Helen Tamiris; Esther Junger; Glück-Sandor and Felicia Sorel; Sophia Delza; Agnes de Mille; Elsa Findlay. The younger dancers: Anna Sokolow; José Limón; Jane Dudley. The beginning of an epoch. Index. REPRINT EDITION (Brooklyn, N.Y.: Dance Horizons, 1968).

Q1011. Martin, John Joseph. BOOK OF THE DANCE: THE STORY OF THE DANCE IN PICTURES AND TEXT. New York: Tudor Publishing Co., 1963. 192 p., illus.

A survey with emphasis on American twentieth-century dance. Includes chapters on major companies, choreographers, dancers, black dance, and motion pictures. Name and title index. REVISED AND UPDATED EDITION (New York: Tudor Publishing Co., 1963).

Q1012. Martin, John Joseph. THE MODERN DANCE. Brooklyn, N.Y.: Dance Horizons, 1965. 123 p.

[*See* Q398.]

Q1013. Maynard, Olga. AMERICAN MODERN DANCERS: THE PIONEERS. Boston: Little, Brown & Co., 1965. 218 p., illus.

[*See* Q399.]

Q1014. Mazo, Joseph H. DANCE IS A CONTACT SPORT. New York: Saturday Review Press, 1974. 313 p., illus.

[*See* Q586.]

Q1015. McDonagh, Don. THE RISE AND FALL AND RISE OF MODERN DANCE. New York: Outerbridge & Dienstfrey; distributed by E. P. Dutton & Co., 1970. 344 p., illus.

[*See* Q401.]

Q1016. MODERN DANCE BY MARY WIGMAN ET AL. COMPILED BY VIRGINIA STEWART. New York: E. Weyhe, 1935. 155 p., illus.

[*See* Q402.]

Q1017. **Moore, Lillian.** METROPOLITAN OPERA SOLO DANCERS AND CHOREOGRAPHERS, 1883-1932. Manuscript, ca. 1951. 204 p. Dance Collection, The New York Public Library.

[*See* Q985.]

Q1018. **Owen, Walter E.** BALLERINAS OF THE NEW YORK CITY BALLET. New York: Dance Mart, 1953. 38 p., illus.

Sixteen photographs of Maria Tallchief, Nora Kaye, Janet Reed, Tanaquil LeClercq, Diana Adams, Patricia Wilde, Maria-Jeanne and Yvonne Mounsey performing in works from the repertoire of the New York City Ballet. There is an introduction by Charles Boultenhouse.

Q1019. **Rothschild, Bethsabée de, Baroness.** LA DANSE ARTISTIQUE AUX USA: TENDANCES MODERNES. Paris: Editions Elzévir, 1949. 159 p., illus.

[*See* Q414.]

Q1020. **Schlundt, Christena Lindborg.** THE PROFESSIONAL APPEARANCES OF RUTH ST. DENIS AND TED SHAWN: A CHRONOLOGY AND AN INDEX OF DANCES, 1906–1932. New York: New York Public Library, 1962. 85 p., illus.

Detailed itineraries of tours, with theaters, dates, repertoire, and dancers. Descriptive notes precede each tour itinerary. Comments from reviews are interspersed.

Q1021. **Schlundt, Christena Lindborg.** THE PROFESSIONAL APPEARANCES OF TED SHAWN AND HIS MEN DANCERS: A CHRONOLOGY AND AN INDEX OF DANCES, 1906–1932. New York: New York Public Library, 1967. 75 p., illus.

Detailed itineraries of tours, with theaters, dates, repertoire, and dancers who performed on the various tours. Comments from reviews are interspersed.

Q1022. **Shawn, Ted, with Poole, Gray.** ONE THOUSAND AND ONE NIGHT STANDS. Garden City, N.Y.: Doubleday, 1960. 288 p., illus.

[*See* Q804.]

Q1023. **Taylor, John Russell, and Jackson, Arthur.** THE HOLLYWOOD MUSICAL. New York: McGraw-Hill Book Co., 1971. 278 p., illus. (color).

This survey of the Hollywood motion picture musical is primarily concerned with films made since 1940. Of particular value for its "selected filmographies," the volume includes titles, studios, dates, and credits for producers, directors, actors, choreographers, sets, and costumes, etc. Principal songs and dance numbers are noted, and a very full index of names is included. The index contains biographies of actors, dancers, and filmmakers, with film credits for each individual. Song and film indexes.

Q1024. **Terry, Walter.** INTERVIEW-DEMONSTRATION WITH IGOR YOUSKEVITCH: THE ART OF PERFORMING. Phonotape. New York, 1953. 106 min. 2 reels (5 in.) 3-3/4 in./sec. Dance Collection, The New York Public Library.

FROM A DANCE LABORATORY HELD AT THE YM-YWHA, NEW YORK.

[*See* Q1159.]

Q1025. **Terry, Walter.** INTERVIEW WITH MARTHA GRAHAM. Phonotape. New York: Voice of America, broadcaster, 1962. 30 min. 1 reel (7 in.) 7-1/2 in./sec. Dance Collection, The New York Public Library.

FOR THE VOICE OF AMERICA SERIES ARTS IN THE UNITED STATES.

[*See* Q703.]

Q1026. **Vallance, Tom.** THE AMERICAN MUSICAL. London: A. Zwemmer; New York: A. S. Barnes, 1970. 192 p., illus. (color).

A retrospective guide to artists associated with the Hollywood musical. Includes short biographical notes and screen credits for each artist.

Q1027. **Van Vechten, Carl.** THE DANCE CRITICISMS OF CARL VAN VECHTEN. PT. 1: REVIEWS WRITTEN FOR THE "NEW YORK TIMES." *Dance Index* (Sept.–Nov. 1942): 144–56, illus.

A collection of the dance criticisms of the pioneer dance critic and well-known photographer. The reviews serve as an important source of information on twentieth-century dance.

Q1028. IN SEARCH OF LOVERS: THE BIRTH OF A DANCE WORK. PRODUCED BY JAC VENZA AND VIRGINIA KASSEL. Phonotape. National Educational Television, 1966. 11 reels (5 in.) 3-3/4 in./sec. Dance Collection, The New York Public Library.

FROM THE MOTION PICTURE IN SEARCH OF LOVERS.

[*See* Q593.]

Q1029. WHAT IT MEANS TO BE A DANCER: ONE GENERATION TO ANOTHER, A PANEL DISCUSSION. Phonotape. New York: Recorded at New York University by Dance Theater Workshop and New York University School of the Arts, Feb. 10, 1975. 120 min.; 1 reel (5 in.) 1-7/8 in./sec. Dance Collection, The New York Public Library.

Moderator Jeff Duncan introduces the panel: Stuart Hodes, Anna Sokolow, Valerie Bettis, Daniel Nagrin, and Charles Weidman. The participants discuss how they all began in dance; working with each other; the dominance of social themes in early modern dance; their individual development as artists; their personal theories of dance technique and art; the attitude of current dancers and the lack of inspiration in younger dancers and choreographers; academic versus nonacademic dance and dance training.

Q1030. **Youskevitch, Igor.** GENERATION GAP IN BALLET. *Dance Scope* 5 (spring 1971): 7–15. illus.

A carefully considered essay by one of the most renowned leading dancers of the twentieth century on interpretation in performance and in the classroom. The author suggests that there is a lack of understanding between the avant-garde, "realistic" dancer and the

seasoned artist. This generation gap is reflected in performance, in the use of technique, in the concept of theater, and in the audience-dancer relationship.

ALONSO, ALICIA

Q1031. **Gámez, Tana de.** ALICIA ALONSO AT HOME AND ABROAD. New York: Citadel Press, 1971. 189 p., illus.

A pictorial biography of the Cuban ballerina, emphasizing the internationality of her career. Contains an appreciation of the artist by Arnold Haskell.

ASTAIRE, FRED

Q1032. **Astaire, Fred.** STEPS IN TIME. New York: Harper, 1959. 338 p., illus.

The autobiography of the famous motion picture dancer and actor. Includes a list of performances (New York shows, motion pictures, television and films) from 1917 to 1958. Index.

Q1033. **Croce, Arlene.** THE FRED ASTAIRE AND GINGER ROGERS BOOK. New York: Outerbridge & Lazard: distributed by E. P. Dutton & Co., 1972. 191 p., illus.
[See Q445.]

Q1034. **Green, Stanley, and Goldblatt, Burt.** STARRING FRED ASTAIRE. New York: Dodd, Mead & Co., 1973. 501 p., illus.
[See Q447.]

CASTLE, IRENE AND VERNON

Q1035. **Castle, Irene Foote.** MY HUSBAND. New York: Charles Scribner's Sons, 1919. 264 p., illus.

A memoir written by the wife of this celebrated social dance revolutionary who was killed in World War I.

D'AMBOISE, JACQUES

Q1036. **Greskovic, Robert.** SOME ARTISTS OF THE NEW YORK CITY BALLET. *Ballet Review* 4 (1973): 3–31.
[See Q873.]

Q1037. NEW YORK CITY BALLET. PRODUCED BY JAC VENZA. CHOREOGRAPHED BY GEORGE BALANCHINE. MUSIC BY STRAVINSKY, LOUIS GOTTSCHALK, AND TCHAIKOVSKY. COSTUMES DESIGNED BY KARINSKA. Motion picture. New York WNET–TV, producing organization, 1965. 30 min.; sound, black and white, 16 mm.
[See Q900.]

Q1038. A TIME TO DANCE. PRODUCED BY JAC VENZA. DIRECTED BY GREG HARNEY. NARRATED BY MARTHA MYERS. SPECIAL CONSULTANT, WALTER TERRY. Motion picture. Boston: WGBH–TV, producing organization, 1959. 29 min.; sound, black and white, 16 mm.

FROM THE WGBH–TV SERIES A TIME TO DANCE.
[*See* Q1103.]

Q1039. **Venza, Jac.** INTERVIEWS WITH GEORGE BALANCHINE AND MEMBERS OF THE NEW YORK CITY BALLET. Phonotape. New York: National Educational Television, 1964. 57 min.; 4 reels (7 in.) 7-1/2 in./sec. Dance Collection, The New York Public Library.
RECORDED FOR THE NET PROGRAM THE AMERICAN ARTS.
[*See* Q621.]

Q1040. WATCHING BALLET. PRODUCED AND DIRECTED BY TRACY WARD AND ROBERT BELL. CHOREOGRAPHED BY GEORGE BALANCHINE. MUSIC BY HINDEMITH, TCHAIKOVSKY, GOUNOD, SOUSA, HERSHY KAY, AND MENDELSSOHN. Motion picture. New York: New York State Council on the Arts and Ballet Society, producing organizations; made by On Film, 1963, and released by Association Films, 1965. 34 min.; sound, black and white, 16 mm.
[*See* Q622.]

DANILOVA, ALEXANDRA

Q1041. **Haggin, B. H., and Denby, Edwin.** THE ART OF ALEXANDRA DANILOVA. *Chrysalis* 12 (1959): 3–18. illus.

Selections from reviews (published from 1943 to 1946) by B. H. Haggin in *The Nation* and by Edwin Denby in *Looking at the Dance.*

Q1042. A CONVERSATION WITH ALEXANDRA DANILOVA, PTS. 1 AND 2. *Ballet Review* 4 (1973): 32–51; 4 (1973): 50–60.

Informal reflections by Danilova on her early school life in Russia, her teachers, her years with the Diaghilev, the De Basil, and the Massine-Denham Blum Ballet Russe companies, and her associations with Balanchine, Fokine, Massine, and others. Her candid impressions and opinions of her colleagues, teachers, students, and the ballets in which she has performed are recounted.

Q1043. **Day, James.** INTERVIEW WITH ALEXANDRA DANILOVA. Phonotape. New York: WNET–TV, broadcaster, 1974. 30 min.; 1 reel (7 in.) 3-3/4 in./sec. Dance Collection, The New York Public Library.
FROM THE NET SERIES DAY AT NIGHT.

The tape concerns Danilova's early years and dance training in Russia; dancers' needs, musicality, and personality; her school years during the Russian Revolution; touring with George Balanchine and later with Diaghilev Ballets Russes; ballet in America; national dance styles; the satisfactions of a dancer; the School of American Ballet; teaching ballet.

Q1044. GREAT PERFORMANCE IN DANCE. PRODUCED BY JAC VENZA. DIRECTED BY GREG HARNEY. CONCEIVED AND WRITTEN BY MARTHA MYERS. Motion picture. Boston: WGBH–TV, producing organization, 1959. 29

min.; sound, black and white, 16 mm. FROM THE WGBH–TV SERIES A TIME TO DANCE.

Myers and Walter Terry discuss the interplay of the dancer and the choreographer. The motion picture includes early film clips of Anna Pavlova, Argentinita, and Irene and Vernon Castle. Alexandra Danilova and Frederic Franklin dance the Blue Danube Waltz from Léonide Massine's ballet *Le Beau Danube,* and Edith Jerell and Thomas Andrew perform Walter Terry's modern adaptation of the work. Danilova and Franklin also perform excerpts from *Swan Lake,* choreographed by Lev Ivanov; *A Streetcar Named Desire,* choreographed by Valerie Bettis; and *Coppelia,* choreographed by Arthur Saint-Leon.

Q1045. **Twysden, Aileen Elizabeth.** ALEXANDRA DANI-LOVA. New York: Kamin Dance Publishers, 1947. 175 p., illus.

A biography of Alexandra Danilova, the great twentieth-century ballerina who was trained in St. Petersburg, left Russia in 1924 to tour in Europe, and remained in the West to dance with Serge Diaghilev's Ballets Russes until his death in 1929. She later danced with the De Basil Company and, at the time of publication of this book on her career, was prima ballerina of the Ballet Russe de Monte Carlo (1938–1952). List of roles, 1924–1941; bibliography.

DUNCAN, ISADORA

Q1046. **Ashton, Frederick.** REMINISCENCES OF ISADORA DUNCAN. Phonotape. New York: Recorded at the Dance Collection, 1969. 5 min.; 1 reel (5 in.) 3-3/4 in./sec. Dance Collection, The New York Public Library.

Ashton's impressions of Isadora Duncan, her appearance, and the effect she had on her audience.

Q1047. **Bolitho, William.** ISADORA DUNCAN. In: MAGRIEL, PAUL DAVID, ED. CHRONICLES OF THE AMERICAN DANCE. New York: 1948. p. 190–201, illus.

An exploration of the dancer's philosophical and aesthetic ideas and their sources, including her feelings on marriage, on art and nature, and on politics. The author's essay is reprinted from his *Twelve against the Gods,* New York: Simon & Schuster, 1929.

Q1048. **Clará y Ayats, José.** ISADORA DUNCAN. SOIX-ANTE-DOUZE PLANCHES PAR JOSÉ CLARÁ. PRESENTA-TION DE GEORGES A. DENIS. Paris: Edition Reider, 1928. 9 p., illus.

A portfolio of seventy-two gouaches, drawings, and sketches of Isadora Duncan.

Q1049. **Craig, Edward Gordon.** INDEX TO THE STORY OF MY DAYS: SOME MEMOIRS OF EDWARD GORDON CRAIG, 1872–1907. New York: Viking Press, 1957. 308 p., illus.

In an attempt to assess her artistry, Craig also describes his first meetings with Isadora Duncan and the first time he saw her dance.

Q1050. **Desti, Mary.** ISADORA DUNCAN'S END. London: V. Gollancz, 1929. 351 p., illus., frontispiece, facsims.

A personal account, written by a close friend and companion of Isadora Duncan, stressing the last seven years of her life, (1921–1927): her Russian trip, her marriage to the poet Essenin, and her death in an automobile accident.

Q1051. **Desti, Mary.** THE UNTOLD STORY : THE LIFE OF ISADORA DUNCAN, 1921–1927. New York: H. Liveright, 1929. 281 p., illus., frontispiece, facsims.

The author's account of her experiences with Duncan over the twenty-five-year period of their friendship, and especially of the years after 1921.

Q1052. **Dumesnil, Maurice.** AN AMAZING JOURNEY: Is-ADORA DUNCAN IN SOUTH AMERICA. New York: I. Washburn, 1932. 311 p., illus.

An account of Isadora Duncan's South American tour in 1916 written by her accompanist and musical director at the time.

Q1053. **Divoire, Fernand.** ISADORA DUNCAN, FILLE DE PROMÉTHÉE. PROSES DE FERNAND DIVOIRE. DÉCORÉES PAR E. A. BOURDELLE. Paris: Editions de Muses Françaises, 1919. 59 p., illus. (color).

An essay by a French poet and art critic on Duncan's aesthetic theories and their execution in her dances. The volume includes designs by the French sculptor.

Q1054. **Duncan, Irma.** DUNCAN DANCER: AN AUTOBI-OGRAPHY. Middletown, Conn.: Wesleyan University Press, 1966. 352 p., illus.

An account of the author's life as one of the original pupils of Isadora Duncan: as a Duncan Dancer; her years in Russia with Isadora Duncan and later as artistic director of the Isadora Duncan School in Moscow; her own performances from 1928 to 1933 with a group of her pupils interpreting the works of Isadora Duncan.

Q1055. **Duncan, Irma.** FOLLOW ME: THE AUTO-BIOGRAPHY OF IRMA DUNCAN. Brooklyn: Dance Perspectives Foundation, 1965. 2 vols., illus. DANCE PERSPECTIVES, NOS. 21 AND 22.

Condensed form of Irma Duncan's book, *Duncan Dancer* [Q1054]. Contains an introduction by Doris Hering.

Q1056. **Duncan, Irma, and Macdougall, Allan Ross.** ISADORA DUNCAN'S RUSSIAN DAYS AND HER LAST YEARS IN FRANCE. New York: Covici-Friede, 1929. 371 p., illus. (color).

A chronicle of Isadora Duncan's stay in Russia; her marriage to the poet Essenin; their American tour (1922–1923); her last years (1924–1927) in Berlin, Paris, and Nice. A collaboration of Irma Duncan, a student of Duncan's, and Macdougall, Isadora's close associate.

Q1057. **Duncan, Irma.** Isadora Duncan: Pioneer in the Art of Dance. New York: New York Public Library, 1958. 15 p., illus.

An essay on the early years of Isadora Duncan's life and career to 1905. Included are press reviews and the correspondence between Isadora Duncan and the scientist Ernst Haeckel. REPRINTED: The New York Public Library, *Bulletin* (May 1958), with additional illustrations.

Q1058. **Duncan, Isadora.** The Art of the Dance. Edited and with an introduction by Sheldon Cheney. New York: Theatre Arts, 1928. 147 p., illus.

A memorial volume of essays by Isadora Duncan, with forewords by Raymond Duncan, Margherita Duncan, Mary F. Roberts, and others. Also contains reproductions of original drawings by Léon Bakst, Emile-Antoine Bourdelle, José Clará, and others, and photographs by Arnold Genthe and Edward Steichen. LIMITED EDITION.

Q1059. **Duncan, Isadora.** The Dance. *Theatre Arts* (Dec. 1917): 20–22, illus.

A brief essay on material expression through free dance form as opposed to the formalized style of ballet.

Q1060. **Duncan, Isadora.** Dancing in Relation to Religion and Love. *Theatre Arts* (Aug. 1927): 584–85.

An essay describing the transformation of Eleonora Duse in performance. According to Duncan, Duse had a great influence on her audience, and Duse's example encouraged Duncan to become conscious of her own audience. Also included is a discussion of "sacred" and "profane" dance.

Q1061. **Duncan, Isadora.** The Dance in Relation to Tragedy. *Theatre Arts* (Oct. 1927): 755–61, illus.

Duncan discusses Greek tragedy and the role of the Chorus briefly, then turns to her own theories on dance, and to her schools.

Q1062. **Duncan, Isadora.** The Dance of the Future. Authorized ed. New York: Bowles-Goldsmith, 1908. 28 p., illus.

Chiefly translations of articles and reviews by various authors from German newspapers. Not the same as her *Tanz der Zukunft*, published in Leipzig, 1933.

Q1063. **Duncan, Isadora.** Ecrits sur la Danse. Manuscrits inedits et textes communiques par Ch. Dallies, Fernand Divoire, Mario Meunier, Georges Delaquys. Illustres de dessins inedits par Antoine Bourdelle, José Clará, et Grandjouan. Paris: Editions du Grenier, 1927. 86 p., illus., facsims.

Selected essays on the art of Isadora Duncan accompanied by drawings. Principal dances.

Q1064. **Duncan, Isadora.** My Life. New York: Boni Liveright, 1927. 359 p., illus.

An autobiography of one of the great pioneers in dance and theater history, whose revolutionary influence was felt not only in modern dance but also in the ballet. NEW EDITION, 1933. Contains illustrations by Majeska.

Q1065. **Duncan, Isadora.** "Your Isadora": The Love Story of Isadora Duncan and Gordon Craig. Edited and with a connecting text by Francis Steegmuller. New York: Random House and the New York Public Library, 1974. 399 p., illus.

According to the foreword, "The chief content of the present volume is the major portion of the more than two hundred letters from Isadora to Gordon Craig, written in Europe during the years of association that began late in 1904." Bibliography.

Q1066. Isadora Duncan. Dessins de Albertine Bernouard, de René Piot, et Louis Sue. Hors-texte de E. A. Bourdelle, José Clará et Grandjouan. Paris: La Belle Edition, 1913(?) 19 leaves, illus.

A miscellany indicating the wide response generated by this dynamic personality just before World War I. *Contents:* "Sur Isadora Duncan," by A. Rodin; "Conferénce au Trocadéro," by J. Péladan; "Danses et Choeurs de l'Iphigenie de Christoph Gluck Exécuté par Isadora Duncan avec Ses Eleves de l'Ecole de Danse de Darmstadt et le Concours de M. Mounet-Sully, de la Comédie-Française," [program of a concert at the Théâtre du Châtelet, Paris, in 1913]; "Ce que Doit Etre la Danse," by I. Duncan; "La Danse d'Isadora Duncan," by F. Komisarschewskij; "Sur la Danse d'Isadora Duncan," by E. Carrière.

Q1067. **Dunoyer de Segonzac, André.** Dessins sur les Danses d'Isadora Duncan: Précédés de la Danseuse de Diane. Glose de Fernand Divoire. Paris: La Belle Edition, 192(?). 1 vol., unpag., illus.

Line drawings of Isadora and her pupils by an eminent artist, occasioned by Duncan's performances at the Gaieté Lyrique. Paris, in 1909. Commentary by Fernand Divoire, French poet and critic.

Q1068. An Introduction to "Duncan Dances." Motion picture. Philadelphia: Filmed for the Philadelphia Dance Academy in a project for the U.S. Office of Education and the University of Pennsylvania, ca. 1966. 14-1/2 min.; sound, color, 16 mm.

Duncan and students of the Philadelphia Dance Academy perform her choreography, staged by Hortense Kooluris. The works include *Three Graces* (music: Franz Schubert), *Tanagra* (music: Arcangelo Corelli), *Waltz Studies* (music: Johann Strauss), and *Scarf Dance* (music: Schubert).

Q1069. **Kaye, Joseph Arnold.** The Last Chapters of Isadora's Life, Pts. 1–4. *Dance Magazine* (Apr. 1929): 21–24, 59–60, illus.; Pts. 3 and 4, in subsequent issues.

Isadora Duncan's life from 1921 until her death in 1927, with emphasis on her relationship with Essenin, the poet; her school in Moscow; her tour to the United States; and her final departure for Europe.

Q1070. **Kinel, Lola.** This Is My Affair. Boston: Little, Brown & Co., 1937. 355 p., illus., frontispiece. [*cont.*]

The account of Isadora Duncan's secretary, who traveled in Europe with the dancer and her husband, the Russian poet Sergei Essenin. The author served as translator for Duncan and her husband.

Q1071. **Magriel, Paul David, comp.** BIBLIOGRAPHY OF ISADORA DUNCAN. *Bulletin of Bibliography* 16 (1939): 173–75.

Books and articles by and about Isadora Duncan.

Q1072. **Magriel, Paul David, ed.** ISADORA DUNCAN. New York: H. Holt, 1947. 85 p., illus.

Contains much material from *Dance Index. Contents:* "Isadora Duncan and Basic Dance," by John Martin; "Duncan Concerts in New York," by Carl Van Vechten; "The New Isadora," by Carl Van Vechten; "Isadora Duncan and the Artists," by A. R. Macdougall; "Isadora Duncan: Studies for Six Dance Movements," by Gordon Craig. Chronology; bibliography; albums and books of drawings of Isadora Duncan.

Q1073. New York. **The New York Public Library. Dance Collection.** ISADORA DUNCAN, 1878–1927: IMPRESSION OF HER CONTEMPORARIES. Typewritten. New York, 1969. 53 leaves.

Prepared by the staff of the Dance Collection for an exhibition at the Library. Includes a collection of descriptive profiles, impressions made by Duncan on her contemporaries: Rodin, Edward Gordon Craig, Loie Fuller, Ruth St. Denis, Frederick Ashton, Stanislavski, and Sol Hurok. Bibliography of publications on Duncan in the Dance Collection.

Q1074. **Roslavleva, Natal'ia [pseud.].** STANISLAVSKI AND THE BALLET. Brooklyn: Dance Perspective Foundation, 1965. 52 p., illus. DANCE PERSPECTIVES, NO. 23.

A brief discussion is included of the Stanislavski Method, his early training in dance, his contact with ballet dancers and with Isadora Duncan, and the influence they had on each other. Includes an introduction by Robert Lewis.

Q1075. **Schikowski, John.** DER NEUE TANZ. Berlin: Volksbühnen-Verlags- und Vertriebs-G.m.b.H., 1924. 54 p. KUNST UND VOLK, HEFT 5.

A discussion of Duncan's art, her new style of dancing, her use of music, and her influence on the theater.

Q1076. **Shneider, Il'ia Il'ich.** ISADORA DUNCAN: THE RUSSIAN YEARS. TRANSLATED BY DAVID MAGARSHACK. London: Macdonald, 1968. 221 p., illus.

An account of Isadora Duncan's life in Russia from 1921 to 1924. The author acted as liaison between Duncan and Lunacharsky, Minister of Culture. Shneider was her business manager, her translator, and became director of her school in Moscow.

Q1077. **Spiesman, Mildred C.** AMERICAN PIONEERS IN EDUCATIONAL CREATIVE DANCE. *Dance Magazine* Pt. 1

(Nov. 1950): 22–23, 35; continued in subsequent issues through Sept. 1951, illus. [*See* Q1170.]

Q1078. **Stokes, Sewell.** ISADORA DUNCAN: AN INTIMATE PORTRAIT. London: Brentano's Ltd., 1928. 208 p., illus.

"A realistic memoir" of Isadora Duncan by the author after an acquaintanceship of some days with her in Nice.

Q1079. **Terry, Walter.** INTERVIEW AND LECTURE-DEMONSTRATION WITH RUTH ST. DENIS. Phonotape. New York, 1963. 1 hour, 16 min.; 1 reel (7 in.) 7-1/2 in./sec. Dance Collection, The New York Public Library. FROM A DANCE LABORATORY HELD AT THE YM–YWHA, NEW YORK.

[*See* Q1141.]

Q1080. **Terry, Walter.** ISADORA DUNCAN: HER LIFE, HER ART, HER LEGACY. New York: Dodd, Mead & Co., 1963. 174 p., illus., facsim.

According to the author, "The object of this book is to present Isadora in the light of today: the story of her life and art, her own comments on herself, the commentaries of her contemporaries, her legacies as seen through the eyes of certain of her illustrious successors." Bibliography.

Q1081. **Terry, Walter.** THE LEGACY OF ISADORA DUNCAN AND RUTH ST. DENIS. Brooklyn: Dance Perspectives Foundation, 1960. 60 p., illus. DANCE PERSPECTIVES, NO. 5

[*See* Q439.]

Q1082. **Van Vechten, Carl.** THE DANCE WRITINGS OF CARL VAN VECHTEN. EDITED AND WITH AN INTRODUCTION BY PAUL PADGETTE. Brooklyn: Dance Horizons, 1974. 182 p., illus.

[*See* Q441.]

Q1083. **Werner, Morris Robert.** TO WHOM IT MAY CONCERN: THE STORY OF VICTOR ILYITCH SEROFF. New York: J. Cape & H. Smith, 1931. 277 p.

The final chapter contains reminiscences by Victor Seroff on the last year of Duncan's life, giving a vivid account of her magnetic personality and her problems during this period.

EGLEVSKY, ANDRÉ

Q1084. **Sheridan, Hope.** ANDRÉ EGLEVSKY: THE GREAT CLASSIC DANCER. *Chrysalis* 2 (1949): 1–32, illus.

A short, informative biographical essay of a great American *premier danseur* from his first appearances with De Basil's Ballet Russe in 1931 through his career as a member of the companies of the Ballet Russe de Monte Carlo, Ballet Theatre, the Marquis de Cuevas' Ballet International, and the Grand Ballet de Monte Carlo. His artistry in *Baiser de la fée, Apollo,* and *Giselle* is discussed in some detail.

Q1085. **Terry, Walter.** INTERVIEW-DEMONSTRATION WITH MARIA TALLCHIEF AND ANDRÉ EGLEVSKY. Phonotape. New York, 1962. 60 min. 1 reel (7 in.) 3-3/4 in./sec. Dance Collection, The New York Public Library.
FROM A DANCE LABORATORY HELD AT THE YM-YWHA, NEW YORK.

Style in ballet is the subject of the tape: the development of ballet technique and style; teaching style; George Balanchine's style and how he teaches it; Mikail Fokine's method of teaching style and Eglevsky's experience with him in *Schéhérazade*; Marius Petipa's choreographic style; Balanchine's ballets *Sylvia* and *Orpheus* compared to *Giselle*; the style of Auguste Bournonville; preparing the role of Siegfried in *Swan Lake* and the title role in Cullberg's *Miss Julie*; Balanchine's *Baiser de la fée* and *Scotch Symphony*.

FARRELL, SUZANNE

Q1086. NEW YORK CITY BALLET. PRODUCED BY JAC VENZA. CHOREOGRAPHED BY GEORGE BALANCHINE. MUSIC BY STRAVINSKY, LOUIS GOTTSCHALK, AND TCHAIKOVSKY. COSTUMES DESIGNED BY KARINSKA. Motion picture. New York: WNET-TV, producing organization, 1965. 30 min.; sound, black and white, 16 mm.
[*See* Q900.]

Q1087. **Venza, Jac.** INTERVIEWS WITH GEORGE BALANCHINE AND MEMBERS OF THE NEW YORK CITY BALLET. Phonotape. National Educational Television, 1964. 57 min.; 4 reels (7 in.) 7-1/2 in./sec. Dance Collection, The New York Public Library.
RECORDED FOR THE NET PROGRAM THE AMERICAN ARTS.
[*See* Q621.]

FULLER, LOIE

Q1088. DANCE PROGRAM. ASSEMBLED BY GEORGE AMBERG. Motion picture. New York, ca. 1945. 27 min.; silent, black and white, 16 mm.
[*See* Q78.]

Q1089. **Fuller, Loie.** FIFTEEN YEARS OF A DANCER'S LIFE; WITH SOME ACCOUNT OF HER DISTINGUISHED FRIENDS. Boston: Small, Maynard & Co., 1913. 288 p., illus.

An autobiography of an American dancer who was tremendously popular at the turn of the century. Her use of spectacular and imaginative lighting and costumes had a great influence upon the development of early modern dance. These chatty reminiscences touch briefly on her childhood and early career, dwelling chiefly on her experiences while touring Europe and America with her company. There is an introduction by A. France. FIRST PUBLISHED in France, in 1908. ENGLISH EDITION: (London: Herbert Jenkins).

Q1090. **Marx, Roger.** LA LOIE FULLER. ESTAMPES MODELÉES DE PIERRE ROCHE. Paris: Société des Cent Bibliophiles, 1904. 24 p., illus. (color).

An appreciation of the famous American dancer written in Paris while she was at the height of her fame. Marx describes her performances, including those at the Paris Exposition of 1899/1900 and those in the role of Salome. Illustrated with fourteen embossed color prints by the French sculptor Pierre Roche.

Q1091. **Sommer, Sally R.** LOIE FULLER. *The Drama Review*, post-modern dance issue. 19 (Mar. 1975): 53-67, illus.

An excellent, short biography of Fuller, an American who went to Europe and established herself as a creative force of considerable interest. Her contributions to the theory and practice of theatrical performance are emphasized—her innovations in stage lighting, costume design, and technical stage devices as well as her revolutionary ideas about motion, light, and color.

GREGORY, CYNTHIA

Q1092. AMERICAN BALLET THEATRE: A CLOSEUP IN TIME. PRODUCED BY JAC VENZA. DIRECTED BY JEROME SCHNUR. Motion picture. 1973. 90 min. sound, color, 16 mm.
[*See* Q858.]

Q1093. **Goodman, Saul.** CYNTHIA GREGORY: BRIEF BIOGRAPHY. *Dance Magazine* (June 1965): 58-59.

The dancer discusses her training and stage experience.

Q1094. **Maynard, Olga.** CONVERSATIONS WITH CYNTHIA GREGORY. *Dance Magazine* (Apr. 1975): 36-46, illus.

Gregory speaks on her need for artistic as well as technical challenges; her work with choreographers such as Tudor, Tetley, Feld, and Neumeier; her feelings for contemporary and traditional classic repertoire.

Q1095. **Maynard, Olga.** THROUGH A GLASS, BRIGHTLY: A LOOK AT AMERICAN BALLET THEATRE TODAY. *Dance Magazine* (June 1970): 48-63, illus.

Maynard deals with the company's versatile and eclectic nature as a reflection of the American character and heritage; the singular gifts and sense of commitment felt by its dancers; the range of its repertoire; the career of Cynthia Gregory as a typical American ballerina of the 70s; her training and psychological approach to the interpretation of her roles.

Q1096. **Peres, Louis.** CYNTHIA GREGORY. Brooklyn: Dance Horizons, 1975. 23 p., illus.
DANCE HORIZONS SPOTLIGHT SERIES.

One of a series of profusely illustrated booklets on ballet stars currently performing with American companies. A brief but informative biography.

HAYDEN, MELISSA

Q1097. **Anastos, Peter.** MELISSA HAYDEN ON BALLET, BALLETS, BALANCHINE. *Dance Magazine* (Aug. 1973): 34–39, illus.

An interview with the New York City Ballet dancer, who reminisces about her early career with Ballet Theatre Company and her later career with the New York City Ballet Company. Discussed in the article are her experiences touring South America, dancing with the Alonsos, joining the New York City Ballet, working with choreographers George Balanchine and Jerome Robbins, and her roles with the New York City Ballet.

Q1098. **Greskovic, Robert.** SOME ARTISTS OF THE NEW YORK CITY BALLET. *Ballet Review* 4 (1973): 3–31.

[*See* Q873.]

Q1099. **Hayden, Melissa.** MELISSA HAYDEN, OFF STAGE AND ON. PHOTOGRAPHS BY FRED FEHL. Garden City, N.Y.: Doubleday, 1963. 127 p., illus.

A personal diary by the New York City Ballet dancer. She discusses the ballets she has performed in and their evolution as she has studied and danced them.

Q1100. NEW YORK CITY BALLET. PRODUCED BY JAC VENZA. CHOREOGRAPHED BY GEORGE BALANCHINE. MUSIC BY STRAVINSKY, LOUIS GOTTSCHALK, AND TCHAIKOVSKY. COSTUMES DESIGNED BY KARINSKA. Motion picture. New York: WNET–TV, producing organization, 1965. 30 min.; sound, black and white, 16 mm.

[*See* Q900.]

Q1101. **Terry, Walter.** INTERVIEW-DEMONSTRATION WITH MELISSA HAYDEN AND JOHN KRIZA. Phonotape. New York, 1953. 51 min.; 1 reel (5 in.) 3-3/4 in./sec. Dance Collection, The New York Public Library. FROM A DANCE LABORATORY HELD AT THE YM-YWHA, NEW YORK.

The artists discuss and demonstrate characteristics of the American ballet style, focusing on the diversity of roles they perform, including *The Cage* (Jerome Robbins), *Constantia* (Dollar), *Les Sylphides* (Fokine), *Fancy Free* (Robbins), and *Rodeo* (de Mille). Participants speak of their backgrounds; the ballet steps traditionally performed by the female dancer and the male dancer; the art of partnering.

Q1102. **Terry, Walter.** INTERVIEW WITH MELISSA HAYDEN. Phonotape. New York: WNYC, broadcaster, 1965? 22 min.; 1 reel (7 in.) 3-3/4 in./sec. Dance Collection, The New York Public Library. FROM THE WNYC SERIES INVITATION TO DANCE.

The tape includes discussion on Hayden's background and how she decided to become a dancer; her studies and early professional career in New York in the corps de ballet at Radio City Music Hall and with Ballet Theatre; her roles with Ballet Theatre; her roles at the New York City Ballet, especially on Jerome Robbins's *The Cage;* the

differences between dancing bravura and dramatic roles; the subscription audience of the New York City Ballet; her plans for teaching and coaching upon retirement from performing.

Q1103. A TIME TO DANCE. PRODUCED BY JAC VENZA. DIRECTED BY GREG HARNEY. NARRATED BY MARTHA MYERS. SPECIAL CONSULTANT, WALTER TERRY. Motion picture. Boston: WGBH–TV, producing organization, 1959. 29 min.; sound, black and white, 16 mm. FROM THE WGBH–TV SERIES A TIME TO DANCE.

The first in a television series of the same title, this introductory program presents examples of many kinds of dance. Among the styles presented are flamenco (performed by Maria Alba, Roberto Ximinez, and Manolo Vargas); classical ballet (Melissa Hayden and Jacques d' Amboise in the *Nutcracker Pas de Deux*); modern (Daniel Nagrin in his *Strange Hero*); preclassic; and traditional African, Balinese, and Basque dances.

JAMISON, JUDITH

Q1104. BLACKS IN THE ARTS. Phonotape. Science Research Associates, 1975. 60 min. No. 3–11435. 1 cassette. Dance Collection, The New York Public Library.

Lessons on four black artists, one of whom is dancer Judith Jamison. Olga Maynard discusses Jamison's background, early dancing career with Agnes de Mille, her period with Harkness House Ballet, her present association with the Alvin Ailey Company, and her personal philosophy of dance.

Q1105. **Terry, Walter.** INTERVIEW WITH ALVIN AILEY. Phonotape. 1969? 45 min. 1 reel (7 in.) 3-3/4 in./sec. Dance Collection, The New York Public Library.

[*See* Q597.]

KAYE, NORA

Q1106. **Goodman, Saul.** NORA KAYE: BALLERINA UNIQUELY OF HER TIME, THE TIME OF FAULKNER AND FARRELL AND FREUD, PTS. 1 AND 2. *Dance Magazine* Pt. 1 (Feb. 1965): 36–43; Pt. 2 (Mar. 1965): 54–58, illus.

A biography of a great American dancer who performed with American Ballet Theatre and the New York City Ballet companies. She was known for her brilliant characterizations of dramatic roles. Illustrated with many photographs from the dancer's personal scrapbooks.

Q1107. **Hassalevris [Constantine].** CONSTANTINE INTERVIEWS: NORA KAYE. *Dance Magazine* (Jan. 1945): 5, 19, 26, illus.

The early career of this celebrated American ballet dancer is described. The article recalls her early training at the Metropolitan Opera Ballet School; her formative years as a student of Mikail Fokine; her varied stage career at the Radio City Music Hall; with Balanchine's American Ballet Company, and later with American Ballet Theatre Company as prima ballerina.

Q1108. MODERN BALLET. PRODUCED BY JAC VENZA. NARRATED BY MARTHA MYERS. CHOREOGRAPHED BY ANTONY TUDOR. MUSIC BY TCHAIKOVSKY, SCHÖNBERG, FREDERICK DELIUS, AND WILLIAM SCHUMAN. Motion picture. Boston: WGBH–TV, producing organization, 1959. 29 min.; sound, black and white, 16 mm.

FROM THE WGBH–TV SERIES A TIME TO DANCE.

[See Q841.]

Q1109. **Terry, Walter.** INTERVIEW-DEMONSTRATION WITH NORA KAYE: THE ART OF PERFORMING. Phonotape. New York, 1953. 40 min.; 1 reel (5 in.) 3-3/4 in./sec. Dance Collection, The New York Public Library.

FROM A DANCE LABORATORY HELD AT THE YM–YWHA, NEW YORK.

Deals with Kaye's ideas on successful performing and her approaches to five roles: with Antony Tudor on *Pillar of Fire*; as Odette in *Swan Lake*; as Lizzie Borden in de Mille's *Fall River Legend*; with Tudor, on the Russian ballerina in *Gala Performance*; as *Giselle*.

KELLY, GENE

Q1110. **Hunt, Marilyn.** INTERVIEW WITH GENE KELLY. Phonotape and in transcript. Beverly Hills, Calif., Mar. 10–14, 1975. 8 hours, 38 min.; 3 reels (5 in.) 1-7/8 in./sec. Dance Collection, The New York Public Library.

The tape covers Kelly's family background; studying dance; teaching dance; the development of his dance style; his audition for Monte Carlo Ballet Russe; his appreciation of ballet and modern dance; why most of his dances express joy; early stage work (*Pal Joey, Leave It to Me*); song and dance men; the beginning of his film career; his musical films, including *For Me and My Gal, Cover Girl, Anchors Aweigh, The Pirate, Invitation to the Dance, On the Town, Summer Stock, An American in Paris, Singin' in the Rain*; Judy Garland; Arthur Freed; the role of dance assistants; choreographing for the camera; a dancer's typical filming day; the necessity of convention in film; Fred Astaire; Vincente Minnelli; film acting contrasted with stage acting; women dancers and partnerships; directing (*Flower Drum Song* on Broadway, and *Hello Dolly* on film); his ballet, *Pas de Deux* for the Paris Opera Ballet.

Q1111. INVITATION TO THE DANCE. PRODUCED BY ARTHUR FREED. DIRECTED AND CHOREOGRAPHED BY KELLY. MUSIC BY JACQUES IBERT, ANDRE PREVIN, AND RIMSKY-KORSAKOV. MUSIC ADAPTED BY ROGER EDENS. COSTUMES DESIGNED BY ELIZABETH HAFFENDEN AND ROLF GERARD. Motion picture. Metro-Goldwin-Mayer, producing organization, 1952. 92 min.; color.

Three stories (*Circus, Ring around the Rosy,* and *Sinbad the Sailor*) are told entirely through dance. *The cast includes* Igor Youskevitch, Claire Sombert, Gene Kelly, Tamara Toumanova, Diana Adams, Tommy Rall, and Carol Haney.

Q1112. **Thomas, Tony.** THE FILMS OF GENE KELLY. Secaucus, N.J.: Citadel Press, 1974. 243 p., illus.

This heavily illustrated book on Gene Kelly as an actor, dancer, director, and choreographer in the film industry includes separate discussion of each film, with complete cast and credits.

KENT, ALLEGRA

Q1113. **Greskovic, Robert.** SOME ARTISTS OF THE NEW YORK CITY BALLET. *Ballet Review* (1973): 3–31.

[See Q873.]

MAGALLANES, NICOLAS

Q1114. **Terry, Walter.** LECTURE-DEMONSTRATION: EROTICISM AND THE DANCE. Phonotape. New York, 1951. 75-1/2 min.; 3 reels (5 in.) 3-3/4 in./sec. Dance Collection, The New York Public Library.

FROM A DANCE LABORATORY HELD AT THE YM–YWHA, NEW YORK.

[See Q1346.]

MARACCI, CARMELITA

Q1115. **Maracci, Carmelita.** THE SYMBOLIC AND PSYCHOLOGICAL ASPECTS OF THE DANCE. In: SORELL, WALTER, ED. THE DANCE HAS MANY FACES. 2d ed. New York: Columbia University Press, 1966. p. 103–112.

[See Q177.]

MC BRIDE, PATRICIA

Q1116. **Bivona, Elena.** MCBRIDE. *Ballet Review* 3 (1970): 22–31.

A rather prolix critical appraisal of the artistry of Patricia McBride, valuable for its early appreciation of this dancer for the New York City Ballet.

Q1117. **Greskovic, Robert.** SOME ARTISTS OF THE NEW YORK CITY BALLET. *Ballet Review* 4 (1973): 3–31.

[See Q873.]

Q1118. **Goodman, Saul.** BRIEF BIOGRAPHIES: PATRICIA MCBRIDE. *Dance Magazine* (Feb. 1962): 48–49, illus.

A brief survey of the rise of the New York City Ballet's Patricia McBride.

Q1119. NEW YORK CITY BALLET. PRODUCED BY JAC VENZA. CHOREOGRAPHED BY GEORGE BALANCHINE. MUSIC BY STRAVINSKY, LOUIS GOTTSCHALK, AND TCHAIKOVSKY. COSTUMES DESIGNED BY KARINSKA. Motion picture. New York: WNET–TV, producing organization, 1965. 30 min.; sound, black and white, 16 mm.

[See Q900.]

MITCHELL, ARTHUR

Q1120. Maynard, Olga. ARTHUR MITCHELL AND THE DANCE THEATER OF HARLEM. *Dance Magazine* (Mar. 1970): 52–63, illus.

[*See* Q898.]

Q1121. NEW YORK CITY BALLET. PRODUCED BY JAC VENZA. CHOREOGRAPHED BY GEORGE BALANCHINE. MUSIC BY STRAVINSKY, LOUIS GOTTSCHALK, AND TCHAIKOVSKY. COSTUMES DESIGNED BY KARINSKA. Motion picture. 1965. 30 min.; sound, black and white, 16 mm.

[*See* Q900.]

RHODES, LAWRENCE

Q1122. Gruen, John. CLOSE-UP: LAWRENCE RHODES. *Dance Magazine* (Dec. 1974): 34–36, illus.

The biography of a major American male dancer who has appeared with Ballet Russe de Monte Carlo, the Joffrey Ballet, the Harkness Ballet, the Pennsylvania Ballet, and the Eliot Feld Ballet.

ROGERS, GINGER

Q1123. Croce, Arlene. THE FRED ASTAIRE AND GINGER ROGERS BOOK. New York: Outerbridge & Lazard; distributed by E. P. Dutton & Co., 1972. 191 p., illus.

[*See* Q445.]

ST. DENIS, RUTH

Q1124. THE DANCING PROPHET. DIRECTED BY EDWARD PENNY. FILMED BY SVEN WALNUM AND DAVID HARRINGTON. CHOREOGRAPHED BY ST. DENIS. Motion picture. 1970. 25 min.; sound, color, 16 mm.

A documentary on Ruth St. Denis, using still photographs, historical film footage, graphics, and dance recreations. Alicia Markova, Jack Cole, and Anton Dolin are interviewed.

Q1125. A DAY AT JACOB'S PILLOW. FILMED BY PHILIP BARIBAULT. Motion picture. Lee, Mass., 1950. 9 min.; silent, color and black and white, 16 mm.

[*See* Q796.]

Q1126. FIFTY YEARS OF DANCE. PRODUCED BY SIG MOGLAN. Motion picture. WCBS–TV, producing organization, 1964. 29-1/2 min.; sound, black and white, 16 mm.
FROM THE CBS PROGRAM CAMERA THREE.

A panel discussion with Ruth St. Denis, Ted Shawn, and Walter Terry. The film includes Ruth St. Denis's performance of her *Incense,* and Ted Shawn's performance of his *O Brother Sun and Sister Moon.*

Q1127. THE FIRST LADY OF AMERICAN DANCE: RUTH ST. DENIS. MUSIC ARRANGED AND CONDUCTED BY HARRY JOHN BROWN. CHOREOGRAPHED BY ST. DENIS. Motion picture. William Skipper Productions, supervised by Marcus Blechman, producing organization, 1956. 26 min.; sound, color, 16 mm.

Ruth St. Denis performs four of her dances, introducing each with an explanation of its origin: *White Jade, Black and Gold Sari, Cobras,* and *Yogi.*

Q1128. Humphrey, Doris. LECTURE. Phonotape. New York: Recorded at Juilliard School of Music for National Educational Television, 1956. 60 min.; 2 reels (7 in.) 7-1/2 in./sec. Dance Collection, The New York Public Library.
FROM THE NET PROGRAM PIONEERS OF MODERN DANCE.

[*See* Q385.]

Q1129. INVENTION IN DANCE. PRODUCED BY JAC VENZA. DIRECTED BY GREG HARNEY. CONCEIVED AND WRITTEN BY MARTHA MYERS. CHOREOGRAPHED BY ALWIN NIKOLAIS. Motion picture. Boston: WGBH–TV, producing organization, 1959. 29 min.; sound, black and white, 16 mm.
FROM THE WGBH–TV SERIES A TIME TO DANCE.

[*See* Q771.]

Q1130. RADHA. MUSIC ARRANGED AND CONDUCTED BY JESS MEEKER. FILMED IN 1941 BY DWIGHT GODWIN. CHOREOGRAPHED BY ST. DENIS. Motion picture. 1973. 19 min.; sound, color, 16 mm.

Ruth St. Denis with Donald Saddler, Rex Cooper, Charles Tate, William Skipper, Ray Harrison, Hubert Bland, Rex Harrower, and Richard Reed perform St. Denis's famous dance choreographed in 1906 and filmed in 1941. A six-minute prologue by Walter Terry recorded in 1973 precedes the performance.

Q1131. RUTH ST. DENIS AND TED SHAWN, AMERICAN PIONEERS. In: LLOYD, MARGARET. THE BORZOI BOOK OF MODERN DANCE. New York: Alfred A. Knopf, 1949. p. 22–34.

[*See* Q800.]

Q1132. RUTH ST. DENIS AND TED SHAWN: A DIALOGUE. Phonotape. Hollywood, Calif.: Recorded at the Ruth St. Denis Center, 1965. 30 min.; 1 reel (7 in.) 3-3/4 in./sec. Dance Collection, The New York Public Library.

The tape concerns the Ruth St. Denis Center; Shawn's early career; the Jacob's Pillow Dance Festival; St. Denis's and Shawn's individual philosophies of dance; their working relationship during the Denishawn era; their later artistic differences; Shawn's dance, *Mevlevi Dervish.*

Q1133. St. Denis, Ruth. INTERVIEW: CONDUCTED BY SHIRLEY AND EARL UBEL. Phonotape. Hollywood, Calif.: Recorded at the Ruth St. Denis Center, ca. 1965. 55 min.; 1 reel (7 in.) 7-1/2 in./sec. Dance Collection, The New York Public Library.

Discussed on the tape: St. Denis's dance training; the

Egyptian Deities cigarette poster; *Radha*; her marriage to Ted Shawn; the Denishawn schools and Denishawn House; her ideas on religious dancing and her church performances; dance training for children; her plans for an ashram and for filmmaking.

Q1134. **St. Denis, Ruth.** RUTH ST. DENIS, AN UNFINISHED LIFE: AN AUTOBIOGRAPHY. Brooklyn: Dance Horizons, 1969. 391 p., illus.

Her autobiography is a charming description of her life from her birth on a New Jersey farm to her discovery of the east, where she found a new focus and motivation for dance. FIRST EDITION: (New York: Harper & Bros., 1939).

Q1135. **Schlundt, Christena Lindborg.** AN ACCOUNT OF RUTH ST. DENIS IN EUROPE, 1906–1909. American Association for Health, Physical Education and Recreation, *Research Quarterly* (Mar. 1960).

A discussion of the European cities and theaters where St. Denis appeared, as well as of her repertoire. Based on original manuscript sources.

Q1136. **Schlundt, Christena Lindborg.** INTO THE MYSTIC WITH MISS RUTH. Brooklyn: Dance Perspectives Foundation, 1970. 56 p., illus.

The spiritual aspects of St. Denis's art, including many examples of her poetry. Bibliographical footnotes.

Q1137. **Schlundt, Christena Lindborg.** THE PROFESSIONAL APPEARANCES OF RUTH ST. DENIS AND TED SHAWN: A CHRONOLOGY AND AN INDEX OF DANCES, 1906–1932. New York: New York Public Library, 1962. 85 p., illus.

[*See* Q910.]

Q1138. **Schlundt, Christena Lindborg.** THE ROLE OF RUTH ST. DENIS IN THE HISTORY OF AMERICAN DANCE, 1906–1922. Typewritten. n.p., n.d. 213 p., illus. Dance Collection, The New York Public Library.

An historical account of the professional life of Ruth St. Denis that traces the development of dance in America through her career. Illustrated by original photographs. Bibliography.

Q1139. **Shawn, Ted.** REMINISCENCES: FROM CHILDHOOD TO THE DISSOLUTION OF DENISHAWN. Phonotape. New York: WNYC, broadcaster; recorded in Eustis, Fla., 1969. 6-1/2 hours; broadcast, 26 min. 2 reels (5 in.) 1-7/8 in./sec. Dance Collection, The New York Public Library.
FROM THE WNYC SERIES INVITATION TO DANCE.

The discussion concerns Shawn's problems in writing his autobiography; his hobbies; writing *One Thousand and One Night Stands*; his time at the University of Denver; his father and paternal ancestry; his childhood and adolescence in Kansas City and Denver; his religious background; the role of religion in his earliest dances; male dancing; his early training and career and his life and career in Los Angeles (1912–1913); his partnership with Norma Gould; his film *Dances through the Ages*; the Santa

Fe Railroad crosscountry tour to New York, 1913; studying with Mrs. Perry King; his mother and maternal ancestry; jobs in Denver; his experiments with dance and the spoken word; professional dance in America before World War I; his first meeting with Ruth St. Denis and their relationship; their United States tours and the Orient and Follies tour; the Denishawn schools; Shawn's tour to Germany (1930); the dissolution of Denishawn; Martha Graham.

Q1140. **Shawn, Ted.** RUTH ST. DENIS: PIONEER AND PROPHET. San Francisco, 1920. 1 vol. (text), 1 vol. (plates, color).

The history of the cycle of Oriental dances created by Ruth St. Denis. Vol. 1 includes descriptive material about *Radha, Incense, Cobras, Nautch, The Yogi, The Lotus Pond, The Invocation to the Nile, The Palace Dance, The Veil of Isis, The Dance of Day, The Dance of Night, O-Mika, Bakawali, The Garden of Kama, The Peacock, The Spirit of the Sea, Kuan-Yin, The Arabic Suite, The Scherzo Waltz,* and *Dance Pageant of Egypt, Greece and India.* Concludes with an essay by St. Denis on the future of dance. Vol. 2 includes photographs of the dances discussed and reproductions of paintings of St. Denis.

Q1141. **Terry, Walter.** INTERVIEW AND LECTURE-DEMONSTRATION WITH RUTH ST. DENIS. Phonotape. New York, 1963. 1 hour, 16 min.; 1 reel (7 in.) 7-1/2 in./sec. Dance Collection, The New York Public Library.
FROM A DANCE LABORATORY HELD AT THE YM–YWHA, NEW YORK.

Terry introduces St. Denis and talks about her career. She discusses the quality of professional dance during the period from 1890 to 1900; three spectacles that inspired her; her theory of artistic creation; her philosophical contribution to American dance; Isadora Duncan's dancing compared to her own; the use of materials and draperies; Loie Fuller's *Lily Dance*; Duncan's impact on ballet technique; Shawn's *Japanese Spear Dance* and his *Cosmic Dance of Siva*; St. Denis's rhythmic choirs; her future plans.

Q1142. **Terry, Walter.** INTERVIEW WITH RUTH ST. DENIS. Phonotape. New York: Recorded at St. Denis's apartment, 1960. 62 min.; 1 reel (7 in.) 3-3/4 in./sec. Dance Collection, The New York Public Library.

St. Denis discusses the influence of the Egyptian Deities cigarette poster and her dance, *Egypta*; how she creates a dance; her sources of inspiration; the use of the spoken word in *O-Mika* and in the street scene from *Cobras*; how she technically analyzes her dances for teaching; her method of working with music as inspiration; her definition of dance.

Q1143. **Terry, Walter.** THE LEGACY OF ISADORA DUNCAN AND RUTH ST. DENIS. Brooklyn: Dance Perspectives Foundation, 1960. 60 p., illus.
DANCE PERSPECTIVES, NO. 5

[*See* Q439.]

Q1144. **Terry, Walter.** MISS RUTH: THE "MORE LIVING

LIFE" OF RUTH ST. DENIS. New York: Dodd, Mead & Co., 1969. 206 p., illus.

A biography of this celebrated dancer, based on extensive oral taped interviews and access to primary source material.

TALLCHIEF, MARIA

Q1145. CLASSICAL BALLET. CONCEIVED AND WRITTEN BY MARTHA MYERS. DIRECTED BY GREG HARNEY. PRODUCED BY JAC VENZA. CHOREOGRAPHED BY LOUIS MERANTE, GEORGE BALANCHINE, AND LEV IVANOV. MUSIC BY TCHAIKOVSKY AND LÉO DELIBES. Motion picture. Boston: WGBH–TV, producing organization, 1959. 29 min.; sound, black and white, 16 mm.
FROM THE WGBH–TV SERIES A TIME TO DANCE.
[See Q109.]

Q1146. **Maynard, Olga.** BIRD OF FIRE. New York: Dodd, Mead & Co., 1961. 201 p., illus.

The story of Maria Tallchief, American prima ballerina, based on press accounts and reminiscences of her contemporaries. Repertoire, 1942–1961; index.

Q1147. **Terry, Walter.** LECTURE-DEMONSTRATION: EROTICISM AND THE DANCE. Phonotape. New York, 1951. 50-1/2 min.; 3 reels (5 in.) 3-3/4 in./sec. Dance Collection, The New York Public Library.
FROM A DANCE LABORATORY HELD AT THE YM–YWHA, NEW YORK.
[See Q1346.]

Q1148. **Terry, Walter.** INTERVIEW-DEMONSTRATION WITH MARIA TALLCHIEF AND ANDRÉ EGLEVSKY. Phonotape. New York, 1962. 60 min.; 1 reel (7 in.) 3-3/4 in./sec. Dance Collection, The New York Public Library.
FROM A DANCE LABORATORY HELD AT THE YM–YWHA, NEW YORK.
[See Q1085.]

VILLELLA, EDWARD

Q1149. BALLET WITH EDWARD VILLELLA. PRODUCED BY ROBERT SAUDEK. CHOREOGRAPHED BY GEORGE BALANCHINE AND MARIUS PETIPA. MUSIC BY STRAVINSKY, ADOLPH ADAM, AND TCHAIKOVSKY. NARRATED BY VILLELLA. Motion picture. I.Q. Films, producing organization, 1970. 27 min.; sound, color, 16 mm.

Villella illustrates the control and power necessary in partnering and the discipline required for the development of freedom of movement. He dances excerpts from ballets choreographed by George Balanchine: the *Tchaikovsky Pas de Deux* (with Patricia McBride); the pantomime from the second act of *Giselle* (choreographed by Marius Petipa); a solo from *Apollo*; and an excerpt from *Jewels* (with Patricia McBride and artists of the New York City Ballet Company).

Q1150. **Greskovic, Robert.** SOME ARTISTS OF THE NEW YORK CITY BALLET. *Ballet Review* 4 (1973): 3–31.
[See Q873.]

Q1151. MAN WHO DANCES: EDWARD VILLELLA. Motion picture. New York: WNBC–TV, producing organization, 1968. 55 min.; sound, color, 16 mm.
FROM THE NBC SERIES THE BELL TELEPHONE HOUR.

A documentary on the dance life of Edward Villella. Included are excerpts from works choreographed by George Balanchine: *Tarantella*; the Rubies section of *Jewels*; fragments of *Harlequinade*, *Glinkaiana*, and *Tchaikovsky Pas de Deux* with Patricia McBride and artists of the New York City Ballet Company.

Q1152. **Maynard, Olga.** EDWARD VILLELLA TALKS TO OLGA MAYNARD. *Dance Magazine* (May 1966): 50–54, 82–84, illus.
[See Q615.]

Q1153. NEW YORK CITY BALLET. PRODUCED BY JAC VENZA. CHOREOGRAPHED BY GEORGE BALANCHINE. MUSIC BY STRAVINSKY, LOUIS GOTTSCHALK, AND TCHAIKOVSKY. COSTUMES DESIGNED BY KARINSKA. Motion picture. New York: WNET–TV, producing organization, 1965. 30 min.; sound, black and white, 16 mm.
[See Q900.]

Q1154. **Venza, Jac.** INTERVIEWS WITH GEORGE BALANCHINE AND MEMBERS OF THE NEW YORK CITY BALLET. Phonotape. New York: National Educational Television, 1964. 57 min.; 4 reels (7 in.) 7-1/2 in./sec. Dance Collection, The New York Public Library.
RECORDED FOR THE NET PROGRAM THE AMERICAN ARTS.
[See Q621.]

WILDE, PATRICIA

Q1155. **Terry, Walter.** INTERVIEW WITH PATRICIA WILDE. Phonotape. New York: WNYC, broadcaster, 1966. 25 min.; 1 reel (7 in.) 7-1/2 in./sec. Dance Collection, The New York Public Library.
FROM THE WNYC SERIES INVITATION TO DANCE.

Wilde discusses her background and training; the roles she danced while with Ballet Russe de Monte Carlo; the roles Balanchine created for her; her ideas on training dancers and her plans for implementing them at Harkness House.

WILSON, SALLIE

Q1156. AMERICAN BALLET THEATRE: A CLOSE-UP IN TIME. PRODUCED BY JAC VENZA. DIRECTED BY JEROME SCHNUR. Motion picture. 1973. 90 min.; sound, color, 16 mm.
[See Q858.]

YOUSKEVITCH, IGOR

Q1157. **Lyon, James.** INTERVIEW WITH IGOR YOUSKEVITCH AND DOROTHI PIERRE. Phonotape. New York: WNYC, broadcaster, 1957. 30 min.; 1 reel (7 in.) 7-1/2 in./sec. Dance Collection, The New York Public Library.

FROM THE WNYC SERIES TODAY IN BALLET.

[*See* Q887.]

Q1158. **Quiros, Rod.** IGOR YOUSKEVITCH. Chicago: Dance Press, 1956. 32 p., illus.

A short biography, of a great male classic dancer of the twentieth century. His appearances with the Ballet Russe de Monte Carlo, Ballet Alicia Alonso, and Ballet Theatre companies are discussed.

Q1159. **Terry, Walter.** INTERVIEW-DEMONSTRATION WITH IGOR YOUSKEVITCH: THE ART OF PERFORMING. Phonotape. New York, 1953. 106 min.; 2 reels (5 in.) 3-3/4 in./sec. Dance Collection, The New York Public Library.

FROM A DANCE LABORATORY HELD AT THE YM–YWHA, NEW YORK.

Youskevitch discusses the art of performing: projection, jumping technique, the male ballet dancer, abstract ballets, pantomime, his approach to his roles in Balanchine's ballets *Theme and Variations* and *Apollo*. He also talks about his roles in *Les Sylphides, L'Après-Midi d'un Faune, Spectre de la Rose,* Antony Tudor's *Romeo and Juliet,* and *Giselle.*

Q1160. **Terry, Walter.** INTERVIEW-DEMONSTRATION WITH IGOR YOUSKEVITCH AND MARIA YOUSKEVITCH. Phonotape. New York, 1962. 60 min.; 1 reel (7 in.) 3-3/4 in./sec. Dance Collection, The New York Public Library.

FROM A DANCE LABORATORY HELD AT THE YM–YWHA, NEW YORK.

The tape deals with the art of partnering: Terry discusses Youskevitch's career and background; famous ballet partners and anecdotes about partnering. Youskevitch discusses qualities of a good male partner; the difference between partnering in classical pas de deux and dramatic pas de deux; techniques for partnering turns, jumps, and balancing.

MUSEUMS AND LIBRARIES

Q1161. **Anderson, Jack.** TOWARDS A DANCE FILM LIBRARY: A GOAL FOR THE DANCE COLLECTION, TACKLED WITH URGENCY AND DETERMINATION. *Dance Magazine* (Sept. 1965): 40–42.

[*See* Q65.]

Q1162. **International Federation of Library Association. Section for Theatrical Libraries and Museums.** PERFORMING ARTS LIBRARIES AND MUSEUMS OF THE WORLD. EDITED BY CÉCILE GITEAU WITH THE COLLABORATION OF ROSAMOND GILDER. 2d rev. and enl. ed. Paris: Editions du Centre National de la Recherche Scientifique, 1967. 801 p.

Title page and text in English and French. Published with the cooperation of UNESCO under the direction of Andre Veinstein. Preface by Julien Cain. Detailed information about performing arts collections in public and private libraries and museums in thirty-seven countries. The section on the United States is arranged by state. Gives size and nature of holdings, hours, admission procedure, size of staff, and related activities. Index of names (countries, towns, institutions, persons, organizations, titles of works, periodicals and series publications, and collections whose holdings are separate units within libraries and museums). Subject index. FIRST EDITION, 1960.

Q1163. **Rosen, Lillie F.** DREAM AND FRUITION: THE LINCOLN CENTER DANCE COLLECTION. *Dance Scope* 10 (fall/winter 1975/1976): 22–30, illus.

The emphasis is on the contributions by major donors to the Dance Collection of The New York Public Library, among them Lincoln Kirstein, Lillian Moore, and Jerome Robbins; on the value to the field of the *Dictionary Catalog of the Dance Collection:* on special units within the Collection, most prominently the Jerome Robbins Film Archive and the Oral History Archive.

SCHOOLS

Q1164. **Barzel, Ann.** EUROPEAN DANCE TEACHERS IN THE UNITED STATES. *Dance Index* (Apr.–June 1944): 56–100, illus.

[*See* Q148.]

Q1165. DANCE YEAR. Boston. 1 (1964): 256 p., illus.

[*See* Q10.]

Q1166. FIRST POSITION. PRODUCED AND DIRECTED BY WILLIAM RICHERT. Motion picture. 1972. 90 min.; color, 16 mm.

A fictionalized account of the daily lives of two students at the American Ballet Theatre School. The film includes rehearsals and classes conducted by Yurek Lazowsky, Mme. Valentina Pereyaslavec, Michael Maule, and Leon Danielian and excerpts from *Petrouchka,* with Michael Smuin, Diana Weber, and Keith Lee.

Q1167. **Kirstein, Lincoln.** THE NEW YORK CITY BALLET. PHOTOGRAPHS BY MARTHA SWOPE AND GEORGE PLATT LYNES. New York: Alfred A. Knopf, 1973. 261 p., illus.

[*See* Q883.]

Q1168. **Leddick, David.** ROBERT JOFFREY'S AMERICAN BALLET CENTER: A SCHOOL WITH A VIEW. *Dance Magazine* (Aug. 1960): 48–50, illus.

[*See* Q734.]

Q1169. SCHOOL OF AMERICAN BALLET. PRODUCED BY VIRGINIA BROOKS. Motion picture. 1973. 42 min.; sound, black and white, 16 mm.

A documentary on the New York City Ballet Company's School of American Ballet. Teachers shown with their classes include Alexandra Danilova, Felia Doubrovska, Helene Dudin, Elise Reiman, Muriel Stuart, Antonia Tumkovsky, and Stanley Williams.

Q1170. **Spiesman, Mildred C.** AMERICAN PIONEERS IN EDUCATIONAL CREATIVE DANCE. *Dance Magazine* Pt. 1 (Nov. 1950): 22–23, 35; continued in subsequent issues through Sept. 1951, illus.

Contents: the traditional school of the 1890s; the Isadora Duncan Schools; Gertrude Colby initiates rhythmic dance programme at Speyer School; the Denishawn School; the Bird Larson School of Natural Rhythmic Expression.

STAGE DESIGNERS

Q1171. ARCH LAUTERER: POET IN THE THEATRE. In: IMPULSE: ANNUAL OF CONTEMPORARY DANCE THEORIES AND VIEWPOINTS. San Francisco: Impulse Publications, 1959. 64 p., illus.

Articles about and by Arch Lauterer, production director for the Bennington School of Dance, artistic collaborator with Martha Graham, and a faculty member at Mills College. *Partial contents:* Bennington College productions; Mills College productions; the function of theater; Arch Lauterer on dance in the theater; notes on production of dance-drama; lecture-demonstration on the discovery of art in oneself through movement, time, and space. Bibliography.

Q1172. **Fatt, Amelia.** DESIGNERS FOR THE DANCE, PTS. 1–3. *Dance Magazine* Pt. 1 (Feb. 1967); Pt. 2 (Mar. 1967); Pt. 3 (Apr. 1967): 55–58, illus.

A three-part article concerning the designers Isamu Noguchi, Willa Kim, David Hays, Cecil Beaton, Jo Mielziner, Oliver Smith, Eugene Berman, Rouben Ter-Arutunian, Salvador Dali, Robert O'Hearn, Raoul Pène du Bois, and Robert Rauschenberg. Includes photographs of the designers by Jack Mitchell; black and white reproductions of designs; interviews with each designer; brief biographies.

Q1173. **Delarue, Allison.** THE STAGE AND BALLET DESIGNS OF EUGENE BERMAN. *Dance Index* (Jan. 1946): 4–24, illus.

A brief biography of Berman containing detailed discussions of his designs through 1944. Chronology.

Q1174. **Noguchi, Isamu.** A SCULPTOR'S WORLD. New York: Harper & Row, 1968. 259 p., illus. (color).

This autobiography, which contains a foreword by R. Buckminster Fuller, includes discussion and photographs of Noguchi's designs for various ballets produced by Martha Graham, for *The Seasons* (Cunningham), and for *Orpheus* (Balanchine). Index.

Q1175. **Seligmann, Kurt.** THE STAGE IMAGE. In: SORELL, WALTER, ED. THE DANCE HAS MANY FACES. 2d ed. New York: Columbia University Press, 1966. p. 177–86, illus.

The function of the stage designer is to create a climate favorable to a particular dance. According to the author, composer, choreographer, and designer should collaborate to fuse their work into a perfect alloy. Essay also in EARLIER EDITION: (New York: World Publishing Co., 1951).

Q1176. **Ter-Arutunian, Rouben.** IN SEARCH OF DESIGN. Brooklyn: Dance Perspectives Foundation, 1966. 48 p., illus. (color).
DANCE PERSPECTIVES, NO. 28.

A major statement by a prominent twentieth-century designer on the problems and the function of the modern stage designer. Contains illustrations of many of his stage designs, including ballets for the New York City Ballet Company as well as a list of dance works for which he has designed the sets and costumes.

Q1177. **Terry, Walter.** INTERVIEW WITH ROUBEN TER-ARUTUNIAN. Phonotape. New York: WNYC, broadcaster, 1967. 20 min.; 1 reel (7 in.) 7-1/2 in./sec. Dance Collection, The New York Public Library.
FROM THE WNYC SERIES INVITATION TO DANCE.

Ter-Arutunian discusses his background; the working relationship of designer to choreographer; his decor for Glen Tetley's *Pierrot Lunaire,* and for Balanchine's *Nutcracker* and *Harlequinade;* Martha Graham's flair for costume; designing for musical comedies.

Q1178. **Windham, Donald.** THE STAGE AND BALLET DESIGNS OF PAVEL TCHELITCHEW. *Dance Index* (Jan.–Feb. 1944): 4–30, illus.

An extensive analysis, with ample illustrations, of the ballet and theatrical designs of Tchelitchew, a well known, twentieth-century Russian painter and stage designer who lived in Europe and worked in the United States. Chronological listing of his works.

THEATERS

Q1179. **Ireland, Joseph Norton.** RECORDS OF THE NEW YORK STAGE, FROM 1750 TO 1860. New York: T. H. Morrell, 1866–1867. 2 vols.

A chronological history of the New York stage, often based on first-hand observations. Contains cast listings and excerpted reviews. An edition of two hundred copies.

Q1180. **Martin, Ralph G.** LINCOLN CENTER FOR THE PERFORMING ARTS. Englewood Cliffs, N.J.: Prentice-Hall, 1971. 192 p., illus. (color). [*cont.*]

Contents: the overall concept of Lincoln Center; the New York Philharmonic; the New York State Theater, New York City Ballet, New York City Opera, and Music Theater of Lincoln Center; the Repertory Theater; the Library and Museum of the Performing Arts; the Metropolitan Opera; Juilliard School; and Lincoln Center, Inc., Film Society of Lincoln Center, Chamber Music Society of Lincoln Center. Profusely illustrated.

Q1181. **Mates, Julian.** THE AMERICAN MUSICAL STAGE BEFORE 1800. New Brunswick, N.J.: Rutgers University Press 1962. 331 p., illus.

A study of the origins of America's musical stage. *Contents:* entertainments related to the musical stage; theaters and audiences; theater orchestras; companies; repertory; librettists and composers; performances and criticism. Bibliography: books and plays (but not playbills); periodicals and pamphlets; manuscripts. Index.

Q1182. **Odell, George Clinton Densmore.** ANNALS OF THE NEW YORK STAGE. New York: Columbia University Press, 1927–1949. 15 vols. illus., facsims., map.

A detailed history of the stage in New York City, 1699–1894, covering actors, dancers, plays, ballets, theaters, etc. The material has been collected solely from original sources such as contemporary newspapers, pamphlets, diaries, letters, autobiographies, playbills, and account-books, etc. Each volume has an index of names, titles, and subjects.

Q1183. **Pastore, Louise.** NEW DANCE/SPACES, HERE, THERE, AND EVERYWHERE: OASES FOR MODERN DANCE. *Dance Magazine* (Apr. 1974): 62–67, illus.

A listing with descriptions of performance spaces available to dancers in New York City.

Q1184. **Terry, Walter.** INTERVIEW WITH JUNE DUNBAR: ARCHITECTURE, DESIGNING FOR DANCE. Phonotape. New York: WNYC, 196(?). 24-1/2 min.; 1 reel (7 in.) 7-1/2 in./sec. Dance Collection, The New York Public Library.

FROM THE WNYC SERIES INVITATION TO DANCE.

Dunbar, a teacher at Juilliard School of Music, discusses architectural specifications for dance classrooms, stages, and costume and storage areas for Juilliard's new building at Lincoln Center.

Q1185. **Tobias, Tobi.** SPACES. *Eddy* 4 (summer 1974): 6–10.

Comments on various theaters used for dance in New York City: City Center, Harkness Theater, Brooklyn Academy of Music, and New York State Theater.

Q1186. **Twentieth Century Fund. Task Force on Performing Arts Centers.** BRICKS, MORTAR, AND THE PERFORMING ARTS: REPORT. BACKGROUND PAPER BY MARTIN MAYER. New York, 1970. 99 p., illus.

A study of the financial and managerial problems of cultural centers for the performing arts in the United States. The report addresses itself to the motives for building performing arts centers; the kind of facilities required; the cost of operating and maintaining them; and the sources of revenue available. Constitutes a useful guide for directors, managers, and planners. Among the members of the task Force were Julius Bloom, Martin Feinstein, Joseph Papp, Roger L. Stevens, and others.

TECHNICAL, CREATIVE, AND OTHER ASPECTS OF THE DANCE

Choreography, Music, Stagecraft, and Technique

CHOREOGRAPHY

Q1187. ART OF BALLET. NARRATED BY AGNES DE MILLE. Motion picture. New York: WCBS–TV, producing organization, 1956. 45 min.; sound, black and white, 16 mm.
FROM THE WCBS SERIES OMNIBUS.
[*See* Q108.]

Q1188. ART OF CHOREOGRAPHY. Motion picture. New York: WCBS–TV, producing organization, 1956. 58 min.; sound, black and white, 16 mm.
FROM THE CBS SERIES OMNIBUS.
[*See* Q648.]

Q1189. **Balanchine, George.** AN INTERVIEW WITH IVAN NABOKOV AND ELIZABETH CARMICHAEL. *Horizon* 3 (Jan. 1961): 44–56, illus. (color).
[*See* Q602.]

Q1190. **Balanchine, George.** MARGINAL NOTES ON THE DANCE. In: SORELL, WALTER, ED. THE DANCE HAS MANY FACES. 2d ed. New York: Columbia University Press, 1966. p. 93–102, music.
A famous choreographer's views on technique, choreography, and music. Essay also in EARLIER EDITION (New York: World Publishing Co., 1951).

Q1191. **Balanchine, George.** NOTES ON CHOREOGRAPHY. *Dance Index* (Feb.–Mar. 1945): 20–31.
A series of informal notes made by Balanchine during his work in the classroom and in the theater.

Q1192. **Balanchine, George, and Mason, Francis.** ONE HUNDRED AND ONE STORIES OF THE GREAT BALLETS. Garden City, N.Y.: Doubleday, 1975. 541 p.
[*See* Q1450.]

Q1193. **Chin, Daryl.** ADD SOME MORE CORNSTARCH, OR THE PLOT THICKENS: YVONNE RAINER'S WORK 1961-73. *Dance Scope* 9 (spring/summer 1975): 50–64.
[*See* Q786.]

Q1194. **Cohen, Selma Jeanne.** AVANT-GARDE CHOREOGRAPHY, PTS. 1–30. *Dance Magazine* Pt. 1 (June 1962): 22–24, 57; Pt. 2 (July 1962): 29–31, 58; Pt. 3 (Aug. 1962): 45, 54–56, illus.
[*See* Q358.]

Q1195. **Cohen, Selma Jeanne.** A PROLEGOMENON TO AN AESTHETICS OF DANCE. In: NADEL, MYRON HOWARD, ED. THE DANCE EXPERIENCE. New York, 1970, p. 4–14.
Discussion is limited to theatrical dancing, the only form that consciously provides an aesthetic experience. The author answers many questions basic to an appreciation of dance as an art form and develops her aesthetic ideas around subject matter and stylization, elements the choreographer uses in composing dance.

Q1196. **Copeland, Roger.** BROADWAY DANCE. *Dance Magazine* (Nov. 1974): 32–37, illus.
[*See* Q573.]

Q1197. DANCE AS AN ART FORM. WRITTEN, DIRECTED, NARRATED, AND CHOREOGRAPHED BY MURRAY LOUIS. DIRECTOR OF PHOTOGRAPHY, WARREN LIEB. MUSIC BY FREE LIFE COMMUNICATIONS, OREGON ENSEMBLE, CORKY SIEGEL. ELECTRONIC SOUND BY ALWIN NIKOLAIS. COSTUMES DESIGNED BY FRANK GARCIA. Motion picture. Chicago: Jack Lieb Productions for Chimera Foundation for Dance, New York, producing organization, 1973. Five films, each approximately 30 min.; sound, color, 16 mm.
[*See* Q755.]

Q1198. **Day, James.** INTERVIEW WITH ALWIN NIKOLAIS. Phonotape. New York: WNET–TV, broadcaster, Nov. 29, 1973. 30 min. 1 reel (7in.) 3-3/4 in./sec. Dance Collection, The New York Public Library.
AUDIO PORTION BROADCAST ON THE NET SERIES DAY AND NIGHT.

Nikolais discusses his theory of dance, involving light, sound, and motion; his impressions of Mary Wigman; how he choreographs a work and creates music; nudity in his television work *The Relay.*

Q1199. **Dehn, Mura.** IS JAZZ CHOREOGRAPHIC? HOW TO TREAT A NEW ART FORM IN TERMS OF DANCE COMPOSITION. *Dance Magazine* (Feb. 1948): 24–25, illus.

A discussion of the problems of choreographing for jazz dance. The author suggests some approaches that might be taken by the choreographer.

Q1200. **De Mille, Agnes.** THE BOOK OF THE DANCE. London and New York: Golden Press, 1963. 252 p., illus.
[*See* Q396.]

Q1201. **Garnet, Eva Desca.** STATEMENT ON CHARLES WEIDMAN. Phonotape. Recorded in Los Angeles, n.d. 18 min. 1 reel (3 in.) 3-3/4 in./sec. Dance Collection, The New York Public Library.
[*See* Q844.]

Q1202. **Graham, Martha.** THE AUDACITY OF PERFORMANCE. *Dance Magazine* (May 1953): 24–25.
On the discipline, the rehearsal, and the exploration involved in the creative process.

Q1203. **Humphrey, Doris.** ADVICE TO YOUNG CHOREOGRAPHERS: NOTES FROM THE OPENING SESSION OF A CLASS IN CHOREOGRAPHY, FEBRUARY 1956. Juilliard School of Music, *The Juilliard Review* 3 (spring 1956): 33–36, illus.
[*See* Q581.]

Q1204. **Humphrey, Doris.** THE ART OF MAKING DANCES. EDITED BY BARBARA POLLACK. New York: Rinehart, 1959. 189 p., illus.
A clear exposition of the skills of dance composition presented by one of the leaders of the modern dance movement. She discusses subject matter; theme; "ingredients and tools"; design (symmetry and asymmetry, dances for one or more bodies, the phrase, the stage space, small groups); dynamics; rhythm; motivation and gesture; words; music; sets and props; and form. List of her choreographic works; index.

Q1205. **Humphrey, Doris.** LECTURE-DEMONSTRATION: THE ART OF CHOREOGRAPHY. Phonotape. New York, 1951. 76 min.; 2 reels (5 in.) 3-3/4 in./sec. Dance Collection, The New York Public Library.
FROM A DANCE LABORATORY HELD AT THE YM–YWHA, NEW YORK.
[*See* Q723.]

Q1206. **Hunt, Marilyn.** INTERVIEW WITH GENE KELLY. Phonotape and in transcript. Beverly Hills, Calif., Mar. 10–14, 1975. 8 hours, 38 min.; 3 reels (5 in.) 1-7/8 in./sec. Dance Collection, The New York Public Library.
[*See* Q1110.]

Q1207. **Kirstein, Lincoln.** REPERTORY: THE FACE OF A COMPANY. *Center: A Magazine of the Performing Arts* (July 1954): 20–23, illus.
[*See* Q884.]

Q1208. **Kirstein, Lincoln,** WHAT BALLET IS ABOUT: AN AMERICAN GLOSSARY. PORTFOLIO OF PHOTOGRAPHS OF THE NEW YORK CITY BALLET BY MARTHA SWOPE. Brooklyn: Dance Perspectives Foundation, 1958. 80 p., illus.
DANCE PERSPECTIVES, NO. 1.
[*See* Q172.]

Q1209. **Marks, J.** MOTION, IMAGE, AND FORM: STUDIES IN CHOREOGRAPHY. San Francisco, 1967. 168 leaves.
A general theory of dance composition by the director of the San Francisco Contemporary Dancers. An orientation to the art of choreography. *Partial contents:* the heritage of dance; the dilemma of form, space, time; compositional elements; music; gesture as drama; categorical research; principles of technique; the collective enterprise. Includes comparative studies of four contemporary dance works: José Limón's *The Moor's Pavane*, George Balanchine's *Agon*, Martha Graham's *Circe*, and Alwin Nikolais' *Imago*.

Q1210. **Marks, Marcia.** PAULINE KONER SPEAKING, PTS. 1–3. *Dance Magazine* Pt. , (Sept. 1961): 36–37, 68–69; Pt. 2 (Oct. 1961): 38, 59; Pt. 3 (Nov. 1961): 16, 64.
[*See* Q739.]

Q1211. **McDonagh, Don.** THE RISE AND FALL AND RISE OF MODERN DANCE. New York: New American Library, 1971. 303 p., illus.
[*See* Q97.]

Q1212. **Moulton, Robert Darrell.** CHOREOGRAPHY IN MUSICAL COMEDY AND REVUE ON THE NEW YORK STAGE FROM 1925 THROUGH 1950. M.A. thesis, University of Minnesota, 1957. 436 p.
[*See* Q467.]

Q1213. **Nichols, Billy.** INTERVIEW WITH HANYA HOLM. Phonotape. New York: National Educational Television, 1965. 52 min.; 2 reels (7 in.) 7-1/2 in./sec. Dance Collection, The New York Public Library.
FROM THE NET FILM FOUR PIONEERS.
[*See* Q715.]

Q1214. **Nikolais, Alwin.** THE DANCE AND MULTIMEDIA: FORUM DISCUSSION. Phonotape. Amherst, Mass.: WFCR, broadcaster, 1969. 60 min. 2 reels (7 in.) 7-1/2 in./sec. Dance Collection, The New York Public Library.
[*See* Q406.]

Q1215. **Owen, Bettie Jane.** RECORDS OF GROUP CHOREOGRAPHIC WORKS IN AMERICAN MODERN CONCERT DANCE PRODUCED FROM 1946–1950. M.A. thesis, New York University, 1950. 112 p.
[*See* Q410.]

Q1216. **Page, Ruth.** SOME TRENDS IN AMERICAN CHOREOGRAPHY. In: SORELL, WALTER, ED. THE DANCE HAS MANY FACES. New York: World Publishing Co., 1951. p. 223–36, illus. [*cont.*]

Page reviews the variety of choreography in America and contrasts the modern to the classic styles of some fifteen major American choreographers.

Q1217. Pischl, A.J., and Cohen, Selma Jeanne, eds. COMPOSER/CHOREOGRAPHER. Brooklyn: Dance Perspective Foundation, 1963. 60 p., illus. DANCE PERSPECTIVES, NO. 16.

[*See* Q929.]

Q1218. Nikolais, Alwin. LECTURE ON AVANT-GARDE DANCE. Phonotape. New York, 1968. 50 min.; 1 reel (7 in.) 3-3/4 in./sec. Dance Collection, The New York Public Library.

[*See* Q776.]

Q1219. Scothorn, Carol. THREE CHOREOGRAPHERS TALK ABOUT THE AUDIENCE. *Impulse* (1962): 16–19.

[*See* Q641.]

Q1220. Shawn, Ted. CONVERSATIONS RECORDED AT JACOB'S PILLOW IN THE SUMMER OF 1971. Phonotapes. Lee, Mass.: Recorded by Sarah Jeter, press representative, 1971. Approximately 5 hours. 5 cassettes. Dance Collection, The New York Public Library.

[*See* Q803.]

Q1221. Sorell, Walter, ed. THE DANCE HAS MANY FACES. 2d ed. New York: Columbia University Press, 1966. 276 p., illus.

[*See* Q428.]

Q1222. Tamiris, Helen. PRESENT PROBLEMS AND POSSIBILITIES. In: SORELL, WALTER, ED. THE DANCE HAS MANY FACES. 2d ed. New York: Columbia University Press, 1966. p. 200–207.

In this revised version of her essay, which appeared in the earlier edition, Tamiris discusses the maintenence of creative vitality in dance, its place in the theater, the importance of continuing experimentation, the ongoing development of technique, and the necessity for opportunities for professionals to develop their unique talents independently as well as in collaborative efforts. EARLIER EDITION: (New York: World Publishing Co., 1951).

Q1223. Terry, Walter. THE ALCHEMY OF DANCE CREATION. *Dance Magazine* Pt. 1 (Dec. 1951): 13, 38–41; Pt. 2 (Jan. 1952): 16–17, 29–32, illus.

[*See* Q591.]

Q1224. Terry, Walter. INTERVIEW WITH MARTHA GRAHAM. Phonotape. New York: Voice of America, broadcaster, 1962. 30 min.; 1 reel (7 in.) 7-1/2 in./sec. Dance Collection, The New York Public Library.
FOR THE VOICE OF AMERICA SERIES ARTS IN THE UNITED STATES.

[*See* Q703.]

Q1225. Tomkins, Calvin. THE BRIDE AND THE BACHELORS: FIVE MASTERS OF THE AVANT-GARDE. New York: Viking Press, 1968. 306 p., illus.

[*See* Q643.]

COSTUME DESIGN

Q1226. Lyon, James. INTERVIEW WITH MARGERY DELL, EDWARD BIGELOW, TODD BOLENDER: THE NEW YORK CITY BALLET. Phonotape. New York: WNYC, broadcaster, 1958. 40 min.; 1 reel (7 in.) 7-1/2 in./sec. Dance Collection, The New York Public Library.
FROM THE WNYC SERIES TODAY IN BALLET.

[*See* Q888.]

Q1227. Seligmann, Kurt. THE STAGE IMAGE. In: SORELL, WALTER, ED. THE DANCE HAS MANY FACES. 2d ed. New York: Columbia University Press, 1966. p. 177–86, illus.

[*See* Q1175.]

Q1228. Ter-Arutunian, Rouben. IN SEARCH OF DESIGN. Brooklyn: Dance Perspectives Foundation, 48 p., illus. (color).
DANCE PERSPECTIVES, NO. 28.

[*See* Q1176.]

Q1229. Terry, Walter. INTERVIEW WITH ROUBEN TER-ARUTUNIAN. Phonotape. New York: WNYC, broadcaster, 1967. 20 min.; 1 reel (7 in.) 7-1/2 in./sec. Dance Collection, The New York Public Library.
FROM THE WNYC SERIES INVITATION TO DANCE.

[*See* Q1177.]

INTERPRETATION IN PERFORMANCE

Q1230. Cohen, Selma Jeanne. A PERFORMANCE IS SEARCHING. *Dance Magazine* (Oct. 1953): 31–32, 66, illus.

[*See* Q737.]

Q1231. Denby, Edwin. THE CRITICISM OF EDWIN DENBY. PHOTOGRAPHS BY WALKER EVANS. *Dance Index* (Feb. 1946): 28–56, illus.

[*See* Q1474.]

Q1232. Humphrey, Doris. DORIS HUMPHREY SPEAKS. *Dance Observer* (Mar. 1962): p. 37–40.

Excerpts drawn by Walter Sorell from a speech delivered by Doris Humphrey at the Juilliard School of Music, November 7, 1956. Subjects: Denishawn, and how it started in the dance world; some practical advice for the young dancer; isolation and egocentricity.

Q1233. Humphrey, Doris. LECTURE. Phonotape. New York: Recorded at Juilliard School of Music for National Educational Television, 1956. 2 reels (7 in.) 7-1/2

in./sec. Dance Collection, The New York Public Library.
FROM THE NET PROGRAM PIONEERS OF MODERN DANCE.

[*See* Q385.]

Q1234. **Marks, Marcia.** PAULINE KONER SPEAKING, PTS. 1–3. *Dance Magazine* Pt. 1 (Sept. 1961): 36–37, 68–69; Pt. 2 (Oct. 1961): 38, 59; Pt. 3 (Nov. 1961): 16, 64.

[*See* Q739.]

Q1235. **Terry, Walter.** INTERVIEW-DEMONSTRATION WITH IGOR YOUSKEVITCH: THE ART OF PERFORMING. Phonotape. New York, 1953. 106 min.; 2 reels (5 in.) 3-3/4 in./sec. Dance Collection, The New York Public Library.
FROM A DANCE LABORATORY HELD AT THE YM–YWHA, NEW YORK.

[*See* Q1159.]

Q1236. **Terry, Walter.** INTERVIEW WITH MARTHA GRAHAM: THE ART OF PERFORMING. Phonotape. New York, 1952. 52 min.; 2 reels (5 in.) 7-1/2 in./sec. Dance Collection, The New York Public Library.
FROM A DANCE LABORATORY HELD AT THE YM–YWHA, NEW YORK.

[*See* Q436.]

Q1237. **Terry, Walter.** INTERVIEW-DEMONSTRATION WITH NORA KAYE: THE ART OF PERFORMING. Phonotape. New York, 1953. 40 min.; 1 reel (5 in.) 3-3/4 in./sec. Dance Collection, The New York Public Library.
FROM A DANCE LABORATORY HELD AT THE YM–YWHA, NEW YORK.

[*See* Q1109.]

Q1238. **Terry, Walter.** INTERVIEW-DEMONSTRATION WITH PEARL PRIMUS: THE ART OF PERFORMING. Phonotape. New York, 1953. 51 min.; 1 reel (5 in.) 3-3/4 in./sec. Dance Collection, The New York Public Library.
FROM A DANCE LABORATORY HELD AT THE YM–YWHA, NEW YORK.

[*See* Q784.]

Q1239. **Venza, Jac.** INTERVIEWS WITH GEORGE BALANCHINE AND MEMBERS OF THE NEW YORK CITY BALLET. Phonotape. National Educational Television, 1964. 57 min.; 4 reels (7 in.) 7-1/2 in./sec. Dance Collection, The New York Public Library.
RECORDED FOR THE NET PROGRAM THE AMERICAN ARTS.

[*See* Q621.]

MIME

Q1240. **Cohen, Selma Jeanne.** A PROLEGOMENON TO AN AESTHETICS OF DANCE. In: NADEL, MYRON HOWARD,

ED. THE DANCE EXPERIENCE. New York, 1970. p. 4–14.

[*See* Q1195.]

Q1241. **Enters, Angna.** THE DANCE AND PANTOMIME: MIMESIS AND IMAGE. In: SORELL, WALTER, ED. THE DANCE HAS MANY FACES. 2d ed. New York: Columbia University Press, 1966. p. 68–81.

A discussion of mime and gesture considered from both historical and performing viewpoints. Enters emphasizes the relation of mime to dance.

Q1242. **Enters, Angna.** ON MIME. Middletown, Conn.: Wesleyan University Press, 1965. 132 p., illus.

A record of all twenty sessions of a mime class the author taught to a group of actor-students.

Q1243. **Rolfe, Bari.** MIME IN AMERICA: A SURVEY. *Mime Journal* 1 (1974): 2–12.

A short historical outline of the development of mime in America from the 1790s to the present. Based on a paper delivered to the Festival International de Pantomime in Prague in 1971. Bibliography.

Q1244. **Sorell, Walter, Ed.** THE DANCE HAS MANY FACES. 2d ed. New York: Columbia University Press, 1966. 276 p., illus.

[*See* Q428.]

Q1245. **Sorell, Walter.** MARGINAL NOTES: ON MARIONETTES, MIMES, AND DANCERS. *Dance Scope* 8 (fall/winter 1973/ 1974): 47–51, illus.

A critic's comments on the common essential criteria for dancers, marionettes, and mimes: the power of suggestion and the ability to make the spectator accept the reality of illusion. Artists mentioned include Charlie Chaplin, Alwin Nikolais, Murray Louis, and Alvin Ailey.

Q1246. **Stebbins, Genevieve.** DELSARTE SYSTEM OF EXPRESSION. 6th ed., rev. and enl. New York: E. S. Werner, 1902. 507 p., illus., charts.

[*See* Q430.]

MUSIC

Q1247. **Arvey, Verna.** CHOREOGRAPHED MUSIC: MUSIC FOR THE DANCE. New York: E. P. Dutton & Co., 1941. 523 p., illus., facsim., music.

Partial contents: the influence of the elements of jazz on the world's dance music; the ballets of John Alden Carpenter and William Grant Still; other American ballets. Musical examples; list of miscellaneous dance music not mentioned in the text; bibliography.

Q1248. **Cunningham, Merce.** MUSIC AND DANCE AND CHANCE OPERATIONS: A FORUM DISCUSSION. Phonotape. Amherst, Mass.: WFCR, broadcaster, 1970. 54-1/2 min. 2 reels (7 in.) 7-1/2 in./sec. Dance Collection, The New York Public Library. [*cont.*]

FROM THE WFCR SERIES FIVE-COLLEGE FORUM.
[*See* Q361.]

Q1249. **Duke, Vernon.** THE THEATRE MUSIC MARKET. *Theatre Arts* (Mar. 1937): 209–215.

[*See* Q461.]

Q1250. **Gould, Morton.** MUSIC AND DANCE. In: SORELL, WALTER, ed. THE DANCE HAS MANY FACES. New York: World Publishing Co., 1951. p. 41–48.

The composer discusses the objectives, problems, and limitations in writing music specifically for dance.

Q1251. **Graham, Martha.** THE MEDIUM OF DANCE: LECTURE. Phonotape. New York: Recorded at the Student Composer Forum at Juilliard School of Music, 1952. 45 min.; 2 reels (7 in.) 7-1/2 in./sec. Dance Collection, The New York Public Library.

[*See* Q690.]

Q1252. **Kirstein, Lincoln.** BLAST AT BALLET: A CORRECTIVE FOR THE AMERICAN AUDIENCE. New York: Marstin Press, 1938. 128 p.

[*See* Q167.]

Q1253. **Kirstein, Lincoln.** REPERTORY: THE FACE OF A COMPANY. *Center: A Magazine of the Performing Arts* (July 1954): 20–23, illus.

[*See* Q884.]

Q1254. **Kostelanetz, Richard, comp.** JOHN CAGE. New York: Praeger Publishers, 1970. 237 p., facsims.

[*See* Q928.]

Q1255. **Pischl, A. J., and Cohen, Selma Jeanne, eds.** COMPOSER/CHOREOGRAPHER. Brooklyn: Dance Perspectives Foundation, 1963. 60 p., illus.
DANCE PERSPECTIVES, NO. 16.

[*See* Q929.]

Q1256. **Teirstein, Alice.** DANCE AND MUSIC: INTERVIEWS AT THE KEYBOARD. *Dance Scope* 8 (spring/summer 1974): 18–31, illus.

The views of six contemporary musical artists, including Norman Lloyd, John Colman, John Cage, Pat Richter, Norma Dalby, and Bruce Lieberman, all of whom have either composed for dance or accompanied company classes. Discussion touches on personal philosophies concerning the relationship of music and dance, working methods, recommendations based on various approaches, and conjecture on future interaction of the two art forms.

Q1257. New York. **Wildenstein & Co. and The New York Public Library, Dance Collection.** STRAVINSKY AND THE DANCE: A SURVEY OF BALLET PRODUCTIONS, 1910-1962, IN HONOR OF THE EIGHTIETH BIRTHDAY OF IGOR STRAVINSKY. New York: Dance Collection, The New York Public Library, 1962. 60 p., illus.

Exhibition: Traveling exhibition circulated under the auspices of the Museum of Modern Art, New York. Sponsored by the Committee for the Dance Collection of the New York Public Library.

[*See* Q930.]

STAGECRAFT AND PRODUCTION

Q1258. **Lippincott, Gertrude Lawton, ed.** DANCE PRODUCTION. Washington, D.C.: American Association for Health, Physical Education and Recreation, National Section on Dance, 1956. 102 p., illus.

Partial contents: "The Purposes of Dance Production," by Elizabeth R. Hayes; "Notes on the Selection of Subject Matter for Dance," by Martha C. Myers; "Two Views on Staging: Arena or Proscenium Arch?" by Barbara Mettler; "A Second Look at Dance-in-the-round," by Gertrude Lippincott; "Selection of Music: Interviews with Louis Horst, Doris Dennison, Clara Hofberg, Hazel Johnson, and Ruth Lloyd"; "Lighting the Modern Dance," by Robert Moulton; "A Manual of Procedure for Design in the Dance," by James Thompson; "Notations as an Aid to Production," by Marian Van Loen; "Performing Techniques," by Gertrude Lippincott. Bibliography.

Q1259. **Skelton, Thomas R.** HANDBOOK OF DANCE STAGECRAFT. *Dance Magazine* (Oct.–Dec. 1955); 60–61, 63; continued in 4 subsequent numbers, 1956–1957.

Contents: lighting (Oct.–Dec. 1955); tools of lighting (Jan.–Dec. 1956); preparing a recital (Jan.–June 1957); the touring dance company (July–Sept. 1957); words of wisdom (Oct. 1957).

STAGE DESIGN

Q1260. **Cunningham, Merce.** MUSIC AND DANCE AND CHANCE OPERATIONS: A FORUM DISCUSSION. Phonotape. Amherst, Mass.: WFCR, broadcaster, 1970. 54-1/2 min.; 2 reels (7 in.) 7-1/2 in./sec. Dance Collection, The New York Public Library.
FROM THE WFCR SERIES FIVE-COLLEGE FORUM.
[*See* Q361.]

Q1261. **Kirstein, Lincoln.** WHAT BALLET IS ABOUT: AN AMERICAN GLOSSARY. PORTFOLIO OF PHOTOGRAPHS OF THE NEW YORK CITY BALLET BY MARTHA SWOPE. Brooklyn: Dance Perspectives Foundation, 1958. 80 p., illus.
DANCE PERSPECTIVES, NO. 1.
[*See* Q172.]

Q1262. **Lauterer, Arch.** NOTES ON PRODUCTION OF DANCE-DRAMA. *Impulse* (1959): 44–50, illus., diagr.

An essay on stage production that includes the lighting plots and stage designs for *Trend* (Hanya Holm), *Decade* (Doris Humphrey and Charles Weidman), *Death and Entrances* (Martha Graham), and *Punch and the Judy* (Graham).

Q1263. **Lauterer, Arch.** STAGE DESIGN IN OUR TIME. *Impulse* (1959): 56–58, illus.

An American authority discusses the innovations in stage design during the past forty years. The influence of Adolphe Appia and Edward Gordon Craig is noted in particular.

Q1264. **Seligmann, Kurt.** THE STAGE IMAGE. In: SORELL, WALTER, ED. THE DANCE HAS MANY FACES. 2d ed. New York: Columbia University Press, 1966. p. 177–86, illus.

[*See* Q1175.]

Q1265. **Ter-Arutunian, Rouben.** IN SEARCH OF DESIGN. Brooklyn: Dance Perspectives Foundation, 1966. 48 p., illus. (color).

DANCE PERSPECTIVES, NO. 28.

[*See* Q1176.]

Q1266. **Terry, Walter.** INTERVIEW WITH ROUBEN TER-ARUTUNIAN. Phonotape. New York: WNYC, broadcaster, 1967. 20 min.; 1 reel (7 in.) 7-1/2 in./sec. Dance Collection, The New York Public Library.

FROM THE WNYC SERIES INVITATION TO DANCE

[*See* Q1177.]

STAGE LIGHTING

Q1267. **Watson, Thomas.** THE DANCER'S SPACE. *Impulse* (1967): 10–12.

A short article on lighting design dealing with the manner in which it can support a choreographic concept and aid the dancer in his work. Written by an authority who has worked extensively with dancers.

Q1268. **Graham, Robert.** ON THE DEVELOPMENT OF A LIGHTING SCORE. *Impulse.* (1952): 13–18.

A system based on the annotation of second copies of musical scores. Includes a description and evaluation of standard lighting equipment and procedures.

Q1269. **Lippincott, Gertrude Lawton, ed.** DANCE PRODUCTION. Washington, D.C.: American Association for Health, Physical Education and Recreation, National Section on Dance, 1956. 102 p., illus.

[*See* Q1258.]

Q1270. **Rosenthal, Jean, and Wertenbaker, Lael.** THE MAGIC OF LIGHT: THE CRAFT AND CAREER OF JEAN ROSENTHAL, PIONEER IN LIGHTING FOR THE MODERN STAGE. Illustrated by Marion Kinsella. Boston: Little, Brown & Co., 1972. 256 p., illus.

Includes a list of lighting credits; bibliography.

Q1271. **Rosenthal, Jean.** PATTERN OF LIGHT: LIGHT PATTERNS CAN BE DESIGNED AS AN INTEGRAL PART OF DECORATIVE PRODUCTION. *Impulse* (1956): 11–12.

The relationship of light to movement. Various dance works are cited in describing the importance of light patterns to decorative production, their movement supplementing the choreographic form and the movement of the dancer.

Q1272. **Skelton, Thomas R.** HANDBOOK OF DANCE STAGECRAFT. *Dance Magazine* (Oct.–Dec. 1955): 60–61, 63; continued in 4 subsequent numbers.

[*See* Q1259.]

Q1273. **Terry, Walter.** INTERVIEW WITH JEAN ROSENTHAL: LIGHTING DESIGN FOR THE DANCE. Phonotape. New York: WNYC, broadcaster, 1967. 23 min.; 1 reel (7 in.) 7-1/2 in./sec. Dance Collection, The New York Public Library.

FROM THE WNYC SERIES INVITATION TO DANCE.

Rosenthal speaks about her first lighting design for a dance concert for Martha Graham at Neighborhood Playhouse; the part lighting should play in a dance concert; the different kinds of lighting required for ballets and modern dance works, with reference to Balanchine's *Allegro Brillante* and *Serenade*, and Graham's *Appalachian Spring* and *Alcestis*: working with Balanchine on *Orpheus*; her work for commercial theater and for opera; the differences between lighting a ballet dancer and a modern dance personality portraying a character; lighting to complement the performer's coloring.

TECHNIQUE

Q1274. **Barzel, Ann.** EUROPEAN DANCE TEACHERS IN THE UNITED STATES. *Dance Index* (Apr.–June 1944): 56–100, illus.

A comprehensive outline of the subject, 1672–1944. The twentieth-century influx of teachers is especially well documented.

Q1275. **Cunningham, Merce.** THE FUNCTION OF A TECHNIQUE FOR DANCE. In: SORELL, WALTER, ED. THE DANCE HAS MANY FACES. New York: World Publishing Co., 1951. p. 250–55.

[*See* Q633.]

Q1276. **Cunningham, Merce.** MUSIC AND DANCE AND CHANCE OPERATIONS: A FORUM DISCUSSION. Phonotape. Amherst, Mass.: WFCR, broadcaster, 1970. 54-1/2 min.; 2 reels (7 in.) 7-1/2 in./sec. Dance Collection, The New York Public Library.

FROM THE WFCR SERIES FIVE-COLLEGE FORUM.

[*See* Q361.]

Q1277. **Duncan, Irma.** THE TECHNIQUE OF ISADORA DUNCAN. PHOTOGRAPHS BY HANS V. BRIESEN. New York: Kamin Dance Publishers, 1937. 35 p., illus., frontispiece. (facsim).

A series of twelve lessons, on the fundamentals of Isadora Duncan's technique. Each lesson is divided into a number of exercises. *Contents:* walking; running; skipping; swing-step; jumping; arm movements; lying down and rising;

Tanagra figures; the waltz; twirling; the polka; gymnastics.

Q1278. Tarrytown, N.Y. **Elizabeth Duncan Schools.** CATALOGUE OF AN EXHIBITION OF PAINTINGS AND SCULPTURES REPRESENTING THE DANCE IN MODERN ART. ESSAY BY SHELDON CHENEY. Tarrytown, 1918. 21 p., illus.

Exhibition: May 26–June 23, 1918.

[*See* Q1351.]

Q1279. FIRST POSITION. PRODUCED AND DIRECTED BY WILLIAM RICHERT. Motion picture. 1972. 90 min.; color, 16 mm.

[*See* Q1166.]

Q1280. **Graham, Martha.** THE MEDIUM OF DANCE: LECTURE. Phonotape. New York: Recorded at the Student Composer Forum at Juilliard School of Music, 1952. 45 min.; 2 reels (7 in.) 7-1/2 in./sec. Dance Collection, The New York Public Library.

[*See* Q690.]

Q1281. **Marks, Marcia.** PAULINE KONER SPEAKING, PTS. 1–3. *Dance Magazine* Pt. 1 (Sept. 1961): 36–37, 68–69, Pt. 2 (Oct. 1961): 38, 59; Pt. 3 (Nov. 1961): 16, 64.

[*See* Q739.]

Q1282. **Nichols, Billy.** INTERVIEW WITH CHARLES WEIDMAN. Phonotape. New York: National Educational Television, 1965. 60 min.; 2 reels (7 in.) 7-1/2 in./sec. Dance Collection, The New York Public Library.
EXCERPTS USED IN THE NET FILM FOUR PIONEERS.

[*See* Q847.]

Q1283. **Terry, Walter.** INTERVIEW-DEMONSTRATION WITH MELISSA HAYDEN AND JOHN KRIZA. Phonotape. New York, 1953. 51 min.; 1 reel (5 in.) 3-3/4 in./sec. Dance Collection, The New York Public Library.
[*cont.*]

FROM A DANCE LABORATORY HELD AT THE YM–YWHA, NEW YORK.

[*See* Q1101.]

Q1284. **Terry, Walter.** INTERVIEW WITH MARTHA GRAHAM. Phonotape. New York: Voice Of America, broadcaster, 1962. 30 min.; 1 reel (7 in.) 7-1/2 in./sec. Dance Collection, The New York Public Library.
FOR THE VOICE OF AMERICA SERIES ARTS IN THE UNITED STATES.

[*See* Q703.]

Q1285. **Terry, Walter.** INTERVIEW WITH NORMAN WALKER. Phonotape. New York: WNYC, broadcaster, 1965. 24 min.; 1 reel (7 in.) 7-1/2 in./sec. Dance Collection, The New York Public Library.
FROM THE WNYC SERIES INVITATION TO DANCE.

[*See* Q592.]

Q1286. SCHOOL OF AMERICAN BALLET. PRODUCED BY VIRGINIA BROOKS. Motion Picture. 1973. 42 min.; sound, black and white, 16 mm.

[*See* Q1169.]

Q1287. **Venza, Jac.** INTERVIEWS WITH GEORGE BALANCHINE AND MEMBERS OF THE NEW YORK CITY BALLET. Phonotape. New York: National Educational Television, 1964. 57 min.; 4 reels (7 in.) 7-1/2 in./sec. Dance Collection, The New York Public Library.
RECORDED FOR THE NET PROGRAM THE AMERICAN ARTS.

[*See* Q621.]

Q1288. WHAT IT MEANS TO BE A DANCER: ONE GENERATION TO ANOTHER, A PANEL DISCUSSION. Phonotape. New York: Recorded at New York University by Dance Theater Workshop and New York University School of the Arts, Feb. 10, 1975. 120 min.; 1 reel (5 in.) 1-7/8 in./sec. Dance Collection, The New York Public Library.

[*See* Q1029.]

Exhibitions, Notation, History, and Aesthetics of Dance

APPRECIATION

Q1289. ART IS. PRODUCED, DIRECTED, AND WRITTEN BY JULIAN KRAMIN AND DEWITT L. SAGE, JR. FILMED BY HENRY STRAUSS ASSOCIATES. CHOREOGRAPHED BY GEORGE BALANCHINE. Motion picture. New York: Sears-Roebuck Foundation in cooperation with the Associated Councils of the Arts, producing organization. 28 min.; sound, color, 16 mm.

[*See* Q601.]

Q1290. CLASSICAL BALLET. CONCEIVED AND WRITTEN BY MARTHA MYERS. DIRECTED BY GREG HARNEY.

PRODUCED BY JAC VENZA. CHOREOGRAPHED BY LOUIS MERANTE, GEORGE BALANCHINE, AND LEV IVANOV. MUSIC BY TCHAIKOVSKY AND LÉO DELIBES. Motion picture. Boston: WGBH–TV, producing organization, 1959. 29 min.; sound, black and white, 16 mm.
FROM THE WGBH–TV SERIES A TIME TO DANCE.

[*See* Q109.]

Q1291. **Cohen, Selma Jeanne.** A PROLEGOMENON TO AN AESTHETICS OF DANCE. In: NADEL, MYRON HOWARD, ed. THE DANCE EXPERIENCE. New York, 1970. p. 4–14.

[*See* Q1195.]

Q1292. DANCE: A REFLECTION OF OUR TIMES. PRODUCED BY JAC VENZA. CONCEIVED AND WRITTEN BY MARTHA MYERS. CHOREOGRAPHED BY HERBERT ROSS. Motion picture. Boston: WGBH–TV, producing organization, 1960. 29 min.; sound, black and white, 16 mm.
FROM THE WGBH–TV SERIES A TIME TO DANCE.
[*See* Q1378.]

Q1293. DANCE AS AN ART FORM. WRITTEN, DIRECTED, NARRATED, AND CHOREOGRAPHED BY MURRAY LOUIS. DIRECTOR OF PHOTOGRAPHY, WARREN LIEB. MUSIC BY FREE LIFE COMMUNICATIONS, OREGON ENSEMBLE, CORKY SIEGEL. ELECTRONIC SOUND BY ALWIN NIKOLAIS. COSTUMES DESIGNED BY FRANK GARCIA. Motion picture. Chicago: Jack Lieb Production for Chimera Foundation for Dance, New York, producing organization, 1973. Five films, each approximately 30 min.; sound, color, 16 mm.
[*See* Q755.]

Q1294. A DANCER'S WORLD. PRODUCED BY NATHAN KROLL. DIRECTED AND FILMED BY PETER GLUSHANOK. COMPOSER AND PIANIST, CAMERON MCCOSH. CHOREOGRAPHED BY MARTHA GRAHAM. Motion picture. Pittsburgh: WQED–TV, producing organization, 1957. 30 min.; sound, black and white, 16 mm.
[*See* Q677.]

Q1295. **De Mille, Agnes.** APPRECIATION AND SUPPORT FOR THE THEATRE IN AMERICA. Phonotape. Washington, D.C.: Recorded at the Association for Childhood Education International, 1967. 53 min.; 1 reel (7 in.) 3-3/4 in./sec. Dance Collection, The New York Public Library.
De Mille discusses in her speech the development of art appreciation in America; performing arts organizations and companies of the United States and Europe; theatrical patronage; the American audience; foundations and their policies; the National Council on the Arts; theatrical craft unions; the American psychology; the psychological-sociological role of theater.

Q1296. **De Mille, Agnes.** ARTISTIC CRITICISM AND APPRECIATION IN AMERICA. Phonotape. Beloit, Wisc.: Recorded at Beloit College, ca. 1960. 46-1/2 min.; 1 reel (7 in.) 3-3/4 in./ sec. Dance Collection, The New York Public Library.
[*See* Q1425.]

Q1297. **De Mille, Agnes.** THE LIVING THEATER AND THE LIVING AUDIENCE. Phonotape. Minneapolis: Recorded at the University of Minnesota, Oct. 8, 1959. 1 reel (7 in.) 7-1/2 in./sec. Dance Collection, The New York Public Library.
Convocation address at the University of Minnesota. A brief introduction by the president of the university. De Mille discusses her dancing and choreography during her college years; the performer-audience rapport in live theater and the separation of performer and audience in television theater; the artistic tyranny of the American theater critic; characteristics of the American audience; the old Metropolitan Opera House; understanding art through the understanding of a profession; the function of theaters in society.

Q1298. **De Mille, Agnes.** PATRONAGE OF THE THEATER IN AMERICA. Phonotape. Greencastle, Ind.: Recorded at DePauw University, 1960. 42 min.; 2 reels (7 in., 5 in.) 7-1/2 in./sec. Dance Collection, The New York Public Library.
[*See* Q1369.]

Q1299. **De Mille, Agnes.** THE STATUS OF THE PERFORMING ARTS IN AMERICA: THE CULTURAL EXPLOSION. Phonotape. Amherst, Mass.: Recorded at University of Massachusetts, Oct. 15, 1966. 21-1/2 min.; 1 reel (5 in.) 3-3/4 in./sec. Dance Collection, The New York Public Library.
[*See* Q1371.]

Q1300. **De Mille, Agnes.** THE THEATER AND THE AMERICAN STUDENT. Phonotape. East Lansing, Mich.: Recorded at Michigan State University, 1962. 51-1/2 min.; 1 reel (7 in.) 7-1/2 in./sec. Dance Collection, The New York Public Library.
De Mille discusses in her speech the performer-audience relationship in live theater, in television, and in motion pictures; the responsibilities of the live theater audience; the American audience; the influence of the New York theater critics; the technical unions and their work rules; the intellectual apathy of the American public; the responsibility of students to develop their judgment and discrimination; the essence of artistic appreciation.

Q1301. **Institute of International Education.** DANCE: A SYMPOSIUM. Phonotape. New York, 1970. 3 hours, 55 min.; 2 reels (7 in.) 3-3/4 in./sec. Dance Collection, The New York Public Library.
[*See* Q1374.]

Q1302. INVITATION TO THE DANCE. PRODUCED BY ARTHUR FREED. DIRECTED AND CHOREOGRAPHED BY GENE KELLY. MUSIC BY JACQUES IBERT, ANDRÉ PREVIN, AND RIMSKY-KORSAKOV. MUSIC ADAPTED BY ROGER EDENS. COSTUMES DESIGNED BY ELIZABETH HAFFENDEN AND ROLF GERARD. Motion picture. Metro-Goldwin-Mayer, producing organization, 1952. 92 min.; color.
[*See* Q1111.]

Q1303. **Kirstein, Lincoln.** BLAST AT BALLET: A CORRECTIVE FOR THE AMERICAN AUDIENCE. New York: Marstin Press, 1938. 128 p.
[*See* Q167.]

Q1304. **Kirstein, Lincoln.** MOVEMENT AND METAPHOR: FOUR CENTURIES OF BALLET. New York: Praeger Publishers, 1970. 290 p., illus.
[*See* Q169.]

Q1305. **La Meri.** DANCE AS AN ART FORM: ITS HISTORY AND DEVELOPMENT. New York: A. S. Barnes, 1933. 198 p.

Condensed, basic information for the interested layman. *Partial contents:* a brief history of the Occidental dance art; the ballet dance; the free dance; the ethnologic dance; Eastern dances; the Spanish dance; European national dances; American dances. Includes a table of dances mentioned in the text, with country of origin and dance form. Bibliography.

Q1306. THE LANGUAGE OF DANCE. PRODUCED BY JAC VENZA. DIRECTED BY GREG HARNEY. CONCEIVED AND WRITTEN BY MARTHA MYERS. CHOREOGRAPHED BY JOSÉ LIMÓN. MUSIC BY NORMAN DELLO JOIO. Motion picture. Boston: WGBH–TV, producing organization, 1959. 39 min.; sound, black and white, 16 mm. FROM THE WGBH–TV SERIES A TIME TO DANCE.

[*See* Q748.]

Q1307. **Martin, John Joseph.** INTRODUCTION TO THE DANCE. Brooklyn: Dance Horizons, 1965. 363 p., illus.

Pt. 1, the nature of movement, form, and composition, and the basis of style. Pt. 2, types of dance; why we dance and how (ritual and play, the influence of the spectator, communication); recreational dance; spectacular dance, the ballet; expressional dance (with chapters on Isadora Duncan, American tendencies, Ruth St. Denis, Martha Graham, Doris Humphrey, Charles Weidman, and Hanya Holm); the middle ground (with a chapter on Ted Shawn); dance in education; and contemporary directions. Index. FIRST EDITION: (New York: W. W. Norton & Co., 1939).

Q1308. **Nadel, Myron Howard, and Nadel, Constance Given, eds.** THE DANCE EXPERIENCE: READINGS IN DANCE APPRECIATION. New York: Praeger Publishers, 1970. 388 p., illus.

This compilation of forty-five readings intended as an introduction to the field of dance contains a wide range of articles on all aspects of dance: aesthetic, creative, historical, recreational, and educational. *Contents:* the nature of dance; the creative personality and the choreographic process; forms of dance; the language and literature of dance; dance and the other arts; dance criticism; the dance artist; problems in dance; facets of dance education. Index.

Q1309. **Nikolais, Alwin.** LECTURE ON AVANT-GARDE DANCE. Phonotape. New York, 1968. 50 min.; 1 reel (7 in.) 3-3/4 in./sec. Dance Collection, The New York Public Library.

[*See* Q776.]

Q1310. New York. **Rockefeller Brothers Fund.** THE PERFORMING ARTS: PROBLEMS AND PROSPECTS. New York, 1965. 232 p.

[*See* Q1376.]

Q1311. ROBERT JOFFREY. EXECUTIVE PRODUCER, JAC VENZA. CHOREOGRAPHED BY JOFFREY, GERALD ARPINO, AND ANNA SOKOLOW. Motion picture. New York: WNET–TV, producing organization, 1965. 30 min.; sound, black and white, 16 mm. FROM THE NET SERIES U.S.A.: DANCE

[*See* Q815.]

Q1312. **Terry, Walter.** INVITATION TO DANCE. New York: A. S. Barnes, 1942. 180 p., illus.

A dance critic looks at the development of American dance in an enthusiastic look at the contributions of American innovators Ruth St. Denis, Ted Shawn, Martha Graham, and George Balanchine. He discusses the value of dance as an educational, physical, social, and character-building force in American life. *Partial contents:* high-kickers, hoofers, Duncan, and St. Denis; Denishawn saga; dance becomes contemporary theater; stage show, night club, movie; collegiate dance; dance, the builder of character; charlatans of dance (dancing schools); dance therapeutics; ballroom dance. Bibliography.

Q1313. A TIME TO DANCE. PRODUCED BY JAC VENZA. DIRECTED BY GREG HARNEY. NARRATED BY MARTHA MYERS. SPECIAL CONSULTANT, WALTER TERRY. Motion picture. Boston: WGBH–TV, producing organization, 1959. 29 min.; sound, black and white, 16 mm. FROM THE WGBH–TV SERIES A TIME TO DANCE.

[*See* Q1103.]

Q1314. WATCHING BALLET. PRODUCED AND DIRECTED BY TRACY WARD AND ROBERT BELL. CHOREOGRAPHED BY GEORGE BALANCHINE. MUSIC BY HINDEMITH, TCHAIKOVSKY, GOUNOD, SOUSA, HERSHY KAY, AND MENDELSSOHN. Motion picture. New York: New York State Council on the Arts and Ballet Society, producing organizations; made by On Film, 1963, and released by Association Films, 1965. 34 min.; sound, black and white, 16 mm.

[*See* Q622.]

ARCHITECTURE AND DANCE

Q1315. **Anderson, Jack.** DANCERS AND ARCHITECTS BUILD KINETIC ENVIRONMENTS. *Dance Magazine* (Nov. 1966): 52–56, 74. illus.

On the crossfertilization of avant-garde theater and dance.

Q1316. **Lippincott, Gertrude Lawton.** THE USE OF SPACE IN DANCE AND ARCHITECTURE. *Dance Observer* (Dec. 1957): 149–50, illus.

An essay on the similarities of dance and architecture.

ART AND DANCE

Q1317. **Bad Heart Bull, Amos.** A PICTOGRAPHIC HISTORY OF THE OGLALA SIOUX. TEXT BY HELEN H. BLISH.

Lincoln: University of Nebraska Press, 1967. 530 p., illus. (color), facsims.

[*See* Q268.]

Q1318. **Duncan, Isadora.** THE DANCE. New York: Forest Press, 1909. 28 p., illus.

[*See* Q1476.]

Q1319. New York. **Harkness House for Ballet Arts, Gallery of the Dance.** THE DANCE IN CONTEMPORARY AMERICAN INDIAN ART. CATALOG BY MYLES LIBHART. New York, 1967. 34 p., illus.

Exhibition: Jan. 18–Apr. 15, 1967. Organized by the Indian Arts and Crafts Board, United States Department of Interior.

[*See* Q299.]

Q1320. **Kirstein, Lincoln.** ELIE NADELMAN, SCULPTOR OF THE DANCE. *Dance Index* (June 1948): 129–52. illus.

A biography of the twentieth-century sculptor whose lifelong interest in American theater and dance was reflected in many of his works. The artist sought inspiration from the music hall, vaudeville, the concert stage, theatrical and social dancing, and the circus.

Q1321. **Tomkins, Calvin.** MERCE CUNNINGHAM AND JOHN CAGE, JASPER JOHNS, ROBERT MORRIS, BRUCE NAUMAN, ROBERT RAUSCHENBERG, FRANK STELLA, ANDY WARHOL: A PORTFOLIO OF SEVEN PRINTS RECORDING COLLABORATIONS WITH MERCE CUNNINGHAM AND DANCE COMPANY. New York: Multiples and Castelli Graphics, 1974; portfolio, unpag.

[*See* Q638.]

Q1322. **Moore, Lillian.** PRINTS ON PUSHCARTS: THE DANCE LITHOGRAPHS OF CURRIER & IVES. Brooklyn: Dance Perspectives Foundation, 1962. 43 p., illus., color frontispiece.
DANCE PERSPECTIVES, NO. 15.

A discussion, with a catalog, of seventy-nine Currier & Ives dance prints. Most of the prints were issued during the 1840s and reflect the interest of the American public at that time. Bibliography.

Q1323. **Sachs, Curt.** THE COMMONWEALTH OF ART: STYLE IN THE FINE ARTS, MUSIC, AND THE DANCE. New York: W. W. Norton & Co., 1946. 404 p., illus., music.

The emphasis is chiefly on western European art, with some references to American developments. *Contents:* Pt. 1, an outline of comparative art history; Pt. 2, the nature of style; Pt. 3, the fate of style. Index.

Q1324. **Terry, Walter, and Rennert, Jack.** ONE HUNDRED YEARS OF DANCE POSTERS. New York: Avon Publishing Co.; by arrangement with Darien House, 1975. 112 p., illus. (color).

Over ninety-five full-page posters (including sixty-four in color) are reproduced from original dance posters representing the very best in graphic art and design by such artists as Toulouse-Lautrec, Léon Bakst, Picasso, Ben Shahn, and Robert Rauschenberg. Contains carefully documented notes on each poster and represents the period from the 1860s to the 1970s. Included are such famous American artists and companies as Ruth St. Denis, Ted Shawn, Loie Fuller, Katherine Dunham, Martha Graham, the Ballets Américains of Ruth Page, José Limón, Merce Cunningham, Isadora Duncan, Louis Falco, Alvin Ailey, American Ballet Theatre, Dance Theater of Harlem, Eliot Feld's American Ballet, Jerome Robbins's Ballets U.S.A., and the Joffrey Ballet. No index.

AUDIENCE

Q1325. **De Mille, Agnes.** THE AMERICAN THEATER AND THE AMERICAN AUDIENCE. Phonotape. Tuscaloosa, Ala.: Recorded at the University of Alabama, 1966. 45 min.; 1 reel (7 in.) 3-3/4 in./sec. Dance Collection, The New York Public Library.

[*See* Q1367.]

Q1326. **De Mille, Agnes.** APPRECIATION AND SUPPORT FOR THE THEATRE IN AMERICA. Phonotape. Washington, D.C.: Recorded at the Association for Childhood Education International, 1967. 53 min.; 1 reel (7 in.) 3-3/4 in./sec. Dance Collection, The New York Public Library.

[*See* Q1295.]

Q1327. **De Mille, Agnes.** ARTISTIC CRITICISM AND APPRECIATION IN AMERICA. Phonotape. Beloit, Wisc.: Recorded at Beloit College, ca. 1960. 46-1/2 min.; 1 reel (7 in.) 3-3/4 in./sec. Dance Collection, The New York Public Library.

[*See* Q1425.]

Q1328. **De Mille, Agnes.** PATRONAGE OF THE THEATER IN AMERICA. Phonotape. Greencastle, Ind.: Recorded at DePauw University, 1960. 42 min.; 2 reels (7 in., 5 in.) 7-1/2 in./sec. Dance Collection, The New York Public Library.

[*See* Q1369.]

Q1329. **De Mille, Agnes.** PATRONAGE OF THE THEATER IN AMERICA. Phonotape. Washington, D.C.: Recorded in the Elizabeth Sprague Coolidge Auditorium, Library of Congress, 1961. 2 reels (7 in.) 7-1/2 in./sec. Dance Collection, The New York Public Library.

De Mille discusses her definition of a patron of the arts; the historical tradition in Europe of theatrical patronage and the unique needs of theater for patronage; the audience-performer relationship; the attitude of Americans and American legislators toward theater; opera and dance companies in America and in Europe; commercial Broadway theater; the effects of craft unions in professional theater; the possible regeneration of American theater; the unique contributions theater can make in the areas of therapy, education, and especially, communication.

Q1330. **De Mille, Agnes.** The Place of the Arts in the Everyday and Educational Life of America. Phonotape. St. Paul, Minn.: Recorded at the Fine Arts–Humanities Symposium at Macalester College, 1961. 45 min.; 1 reel (7 in.) 7-1/2 in./sec. Dance Collection, The New York Public Library.

Following introductory remarks about her career as choreographer and a writer, de Mille discusses the status of the arts and of the artist in contemporary American and in European society; sponsorship of the arts by large foundations; the reliance of American dance companies on private support; the attitude of the American public and the legislator toward the performing arts; the theatrical craft unions and the financial effects of their work rules; the nature of the theater; the Tyrone Guthrie Theater in Minneapolis; theater's place in society.

Q1331. **De Mille, Agnes.** The Status of the Performing Arts in America: The Cultural Explosion. Phonotape. Amherst, Mass.: Recorded at the University of Massachusetts, Oct. 15, 1966. 21-1/2 min.; 1 reel (5 in.) 3-3/4 in./sec. Dance Collection, The New York Public Library.

[See Q1371.]

Q1332. **De Mille, Agnes.** The Theater and the American Student. Phonotape. East Lansing, Mich.: Recorded at Michigan State University, 1962. 51-1/2 min.; 1 reel (7 in.) 7-1/2 in./sec. Dance Collection, The New York Public Library.

[See Q1300.]

Q1333. **Ford Foundation.** The Finances of the Performing Arts. New York, 1974. 2 vols., charts, tables.

Vol. 1. A survey of 166 professional nonprofit resident theaters, operas, symphonies, ballets, and modern dance companies. Vol. 2. A survey of the characteristics and attitudes of audiences for theater, opera, symphony, and ballet in twelve American cities. Covers the period between 1965 and 1971.

Q1334. **Institute of International Education.** Dance: A Symposium. Phonotape. New York, 1970. 3 hours, 55 min.; 2 reels (7 in.) 3-3/4 in./sec. Dance Collection, The New York Public Library.

[See Q1374.]

Q1335. **Kirstein, Lincoln.** Blast at Ballet: A Corrective for the American Audience. New York: Marstin Press, 1938. 128 p.

[See Q167.]

Q1336. **Kirstein, Lincoln.** What Ballet Is About: An American Glossary. Portfolio of photographs of the New York City Ballet by Martha Swope. Brooklyn: Dance Perspectives Foundation, 1958. 80 p., illus.
Dance Perspectives, no. 1.

[See Q172.]

Q1337. **Lyon, James.** Interview with Margery Dell, Edward Bigelow, Todd Bolender: The New York City Ballet. Phonotape. New York: WNYC, broadcaster, 1958. 40 min.; 1 reel (7 in.) 7-1/2 in./sec. Dance Collection, The New York Public Library.
From the WNYC series Today in Ballet.

[See Q888.]

Q1338. **Mates, Julian.** The American Musical Stage before 1800. New Brunswick, N.J.: Rutgers University Press, 1962. 331 p., illus.

[See Q1181.]

Q1339. **Oswald, Genevieve, comp.** Bibliography on Dance. New York: Rockefeller Brothers Fund, 1963. 50 leaves.

[See Q20a.]

Q1340. **Scothorn, Carol.** Three Choreographers Talk about the Audience. *Impulse* (1962): 16–19.

[See Q641.]

Q1341. **Terry, Walter.** Interview with Martha Graham. Phonotape. New York: Voice of America, broadcaster, 1962. 30 min.; 1 reel (7 in.) 7-1/2 in./sec. Dance Collection, The New York Public Library.
For the Voice of America series Arts in the United States.

[See Q703.]

Q1342. **Terry, Walter.** Interview with Melissa Hayden. Phonotape. New York: WNYC, broadcaster, 1965. 22 min.; 1 reel (7 in.) 3-3/4 in./sec. Dance Collection, The New York Public Library.
From the WNYC series Invitation to Dance.

[See Q1102.]

EROTICISM

Q1343. **Sonnemann, Ulrich.** Erotic Roots of the Dance. *Dance Magazine* (Oct. 1946): 12, 32–33.

An inquiry into the relationship between sexuality and the dance by a consulting psychologist.

Q1344. **Terry, Walter.** Interview-demonstration with Valerie Bettis: Eroticism and the Dance. Phonotape. New York, 1952. 52 min.; 2 reels (5 in.) 3-3/4 in./sec. Dance Collection, The New York Public Library.
From a Dance Laboratory held at the YM–YWHA, New York.

Bettis discusses the relationship of sex and religion to dance in general and to her own choreography; movements, costumes, and stage properties that contribute to sexuality, as in her solo, *And the Earth Shall Bear Again*, and in her dance, *As I Lay Dying;* her choreography; the kinesthetic sensitizing of the body to achieve sensuality;

her ideas on abstract dance in comparison to expressive dance; sexual themes in her choreography; her dance *Yerma*.

Q1345. **Terry, Walter.** Lecture-demonstration: Eroticism in Ritual Dancing and in the Modern Dance. Phonotape. New York, 1951. 61 min.; 2 reels (5 in.) 3-3/4 in./sec. Dance Collection, The New York Public Library.
From a dance laboratory held at the YM-YWHA, New York.

A discussion of sexual motifs in ritual dancing; general parallels between traditional ceremonial dancing and modern dance; the varieties of erotic dances; the ritual and ceremonial dances of Haiti. *Guest artists for this program:* Jean Léon Destiné and Myra Kinch.

Q1346. **Terry, Walter.** Lecture-demonstration: Eroticism and the Dance. Phonotape. New York, 1951. 75-1/2 min.; 3 reels (5 in.) 3-3/4 in./sec. Dance Collection, The New York Public Library.
From a dance laboratory held at the YM-YWHA, New York.

Terry discusses his dance laboratory program; the creative sources of dance; eroticism; fertility dances; courtship dances; English horn dances; eroticism in theatrical dance; burlesque dancing; Martha Graham's dance work, *Dark Meadow*; eroticism in ballet, especially *Giselle, Pillar of Fire,* Robbins's *The Guests,* and Fokine's *Schéhérazade.* Shawn discusses the Delsarte system of movement analysis; Spanish dancing; the hula. Terry discusses the role of the siren in Balanchine's *Prodigal Son;* Shawn's *Ramadan;* Shawn's American Indian solo; eroticism in classical pas de deux, specifically the *Black Swan Pas de Deux;* Shawn's dance, *Cutting the Sugar Cane;* the love duet from Balanchine's *Orpheus. Guests for this program:* Maria Tallchief, Nicolas Magallanes, and Ted Shawn.

Q1347. **Terry, Walter.** The Sex Dances of Mankind. Lecture-demonstration: Eroticism and Television Dancing. Phonotape. New York, 1952. 45-1/2 min.; 2 reels (5 in.) 3-3/4 in./sec. Dance Collection, The New York Public Library.
From a dance laboratory held at the YM-YWHA, New York.

Terry discusses the manifestation of the sexual drive in various dance forms; the relationship of sexual energy to artistic expression; the characteristics of masculine, feminine, and neuter genders; the use of sex in television dancing; the effect of the American puritan heritage on television dancing; John Butler (whose dances for television were to be demonstrated).

Q1348. **Venza, Jac.** Interviews with George Balanchine and Members of the New York City Ballet. Phonotape. New York: National Educational Television, 1964. 57 min.; 4 reels (7 in.) 7-1/2 in./sec. Dance Collection, The New York Public Library.
Recorded for the NET program The American Arts.

[*See* Q621.]

EXHIBITIONS

Q1349. New York. **New York State Council on the Arts, in collaboration with the Dance Collection of The New York Public Library.** Avant-Garde Dancers. Organized by Marian Eames. Designed by Martin Stephen Moskof and Richard Hefter. *Dance Magazine* (Oct. 1968): 47–62, illus.
Exhibition.

The photographic report of an exhibition prepared for a tour of colleges, libraries, and arts centers. The exhibition offers a pictorial review of works by many of the modern dance innovators who came into prominence during the 1960s. Depicts works by Steve Paxton, Merce Cunningham, Paul Sanasardo, Don Redlich, Paul Taylor, Alwin Nikolais, Deborah Hay, Jack Moore, Trisha Brown Schichter, Murray Louis, Erick Hawkins, James Waring, Yvonne Rainer, Ann Halprin, and others.

Q1350. New York. **Rockefeller Center.** Dance International, 1900–1937: Exhibit of Arts Relating to the Dance. New York, 1937. 30 p.
Exhibition: Nov. 29, 1937–Jan. 2, 1938.

A listing of paintings, sculpture, and costumes from twenty-eight countries relating to all aspects of dance.

Q1351. Tarrytown, N.Y. **Elizabeth Duncan Schools.** The Dance in Modern Art. Essay by Sheldon Cheney. Tarrytown, 1918. 21 p., illus.
Exhibition: May 26–June 23, 1918.

An essay on modern art and the training system of Isadora Duncan and Elizabeth Duncan, as well as a listing of the paintings and drawings by Mary Foote, Robert Jones, Auguste Rodin, Maurice Sterne, and Abraham Walkowitz; fifty photos by Arnold Genthe; and sculpture by Emile-Antoine Bourdelle, Gaston Lachaise, Elie Nadelman, and others.

Q1352. New York. **Harkness House for Ballet Arts, Gallery of the Dance.** The Dance in Contemporary American Indian Art. Catalog by Myles Libhart. New York, 1967. 34 p., illus.
Exhibition: Jan. 18–Apr. 15, 1967. Organized by the Indian Arts and Crafts Board, United States Department of Interior.
[*See* Q299.]

Q1353. New York. **The New York Public Library. Dance Collection.** A Decade of Acquisitions: The Dance Collection, 1964–1973. New York, 1973. 28 p.
Exhibition: Apr. 9–June 2, 1973.

This catalog of an exhibition held at the Library and Museum of the Performing Arts, Lincoln Center contains descriptions of 192 items, including books, prints, stage and costume designs, drawings, manuscripts, photographs, and sculpture.

Q1354. New York. **Wildenstein & Co. and The New**

York Public Library, Dance Collection. STRAVINSKY AND THE DANCE: A SURVEY OF BALLET PRODUCTIONS, 1910–1962, IN HONOR OF THE EIGHTIETH BIRTHDAY OF IGOR STRAVINSKY. New York: Dance Collection of the New York Public Library, 1962. 60 p., illus.

Exhibition: Traveling exhibition circulated under the auspices of The Museum of Modern Art, New York. Sponsored by the Committee for the Dance Collection of The New York Public Library.

[*See* Q930.]

FESTIVALS

Q1355. **Chujoy, Anatole.** CIVIC BALLET. New York: Published for Central Service for Regional Ballets by *Dance News,* 1958. 30 p.

[*See* Q863.]

Q1356. A DAY AT JACOB'S PILLOW. FILMED BY PHILIP BARIBAULT. Motion picture. Lee, Mass., 1950. 9 min.; silent, color and black and white, 16 mm.

[*See* Q796.]

Q1357. **Moore, Claudia.** AN HISTORICAL SURVEY OF SELECTED DANCE REPERTORIES AND FESTIVALS IN THE UNITED STATES SINCE 1920. M.A., New York University, 1942. 63 p.

Contents: repertories of modern dance: the Bennington Festival, Dance Repertory Theatre, Humphrey-Weidman Repertory Company, Marchowsky and Repertory Dance Theatre, Helen Tamiris and group, Benjamin Zemach and Theatre Dance Company, WPA Federal Dance Project; festivals of folk dance: Country Dance Society, Gallup Indian ceremonials, National Folk Festival; festivals including combinations of different types of dancing and related fields: Boas Seminar, Concert Dancers League, Dance International, Holiday Dance Festival, New Dance League, Jacob's Pillow Dance Festival, world's fair dance festivals. Lists of dances performed, participants, and speakers; bibliography.

Q1358. **Shawn, Ted.** REMEMBER: JACOB'S PILLOW WAS A STONE; SOME ROCKY REMINISCENCES. *Dance Magazine* (July 1970): 49–61. illus.

[*See* Q912.]

FIRST PERFORMANCES

Q1359. **Balanchine, George.** NEW COMPLETE STORIES OF THE GREAT BALLETS. EDITED BY FRANCIS MASON. DRAWINGS BY MARTA BECKET. Garden City, N.Y.: Doubleday, 1968. 626 p., illus.

[*See* Q569.]

Q1360. **Balanchine, George, and Mason, George.** ONE HUNDRED AND ONE STORIES OF THE GREAT BALLETS. Garden City, N.Y.: Doubleday, 1975. 541 p.

[*See* Q145.]

Q1361. **Chujoy, Anatole.** THE NEW YORK CITY BALLET. PHOTOGRAPHS BY GEORGE PLATT LYNES, WALTER E. OWEN, AND FRED FEHL. New York: Alfred A. Knopf, 1953. 382 p., illus.

[*See* Q865.]

Q1362. **Kirstein, Lincoln.** THE NEW YORK CITY BALLET. PHOTOGRAPHS BY MARTHA SWOPE AND GEORGE PLATT LYNES. New York: Alfred A. Knopf, 1973. 261 p., illus.

[*See* Q883.]

GOVERNMENT SUBSIDY

Q1363. **Balanchine, George.** AN INTERVIEW WITH IVAN NABOKOV AND ELIZABETH CARMICHAEL. *Horizon* (Jan. 1961): 44–56. illus.

[*See* Q602.]

Q1364. **Baumol, William J., and Bowen, William G.** PERFORMING ARTS: THE ECONOMIC DILEMMA. Cambridge, Mass.: M.I.T. Press, 1968. 582 p.

A study of the economic problems common to theater, opera, and dance. EARLIER EDITION (New York: Twentieth Century Fund, 1966).

Q1365. **Chagy, Gideon.** THE NEW PATRONS OF THE ARTS. New York: Harry N. Abrams, 1973. 128 p., illus. (color).

The fourth in a series of books written under the auspices of the Business Committee for the Arts to discuss the problems in and prospects for business patronage of the arts.

Q1366. **Code, Grant Hyde.** DANCE THEATER OF THE WPA: A RECORD OF NATIONAL ACCOMPLISHMENT, PTS. 1–4. *Dance Observer* Pt. 1 (Oct. 1939): 264–65, 274; Pt. 2 (Nov.–Dec. 1939); Pt. 3 (Mar. 1940); Pt. 4 (June–July 1940), illus.

A concise history of dance productions by the Federal Theater, United States Works Progress Administration, from 1936 to 1939. Based on a speech delivered by the author at a meeting of the Federal Arts Sponsoring Committee at the New School for Social Research, New York, on June 3, 1939.

Q1367. **De Mille, Agnes.** THE AMERICAN THEATER AND THE AMERICAN AUDIENCE. Phonotape. Tuscaloosa, Ala.: Recorded at the University of Alabama, 1966. 45 min.; 1 reel (7 in.) 3-3/4 in./sec. Dance Collection, The New York Public Library.

In a speech at the University of Alabama, de Mille talks on America's current cultural explosion, comparing statistics on arts councils, symphonies, and opera and ballet companies with those of the average European city; traditional American attitudes toward the arts, particularly toward the theater; the attitudes of legislators and foundations; crafts unions in the theater; the North Carolina School of the Performing Arts; the National

Council on the Arts; twentieth-century American psychology.

Q1368. De Mille, Agnes. APPRECIATION AND SUPPORT FOR THE THEATER IN AMERICA. Phonotape. Washington, D.C.: Recorded at the Association for Childhood Education International, 1967. 53 min.; 1 reel (7 in.) 3-3/4 in./ sec. Dance Collection, The New York Public Library.

[*See* Q1295.]

Q1369. De Mille, Agnes. PATRONAGE OF THE THEATER IN AMERICA. Phonotape. Greencastle, Ind.: Recorded at Depauw University, 1960. 42 min.; 2 reels (7 in., 5 in.) 7-1/2 in./ sec. Dance Collection, The New York Public Library.

De Mille discusses patronage: the European tradition of artistic and theatrical patronage; the American attitude toward the arts; Congressman Rooney of New York and his efforts to block government support for the arts; the historical background of the American attitude toward arts; technical theatrical workers' unions and their financial stranglehold on American theater.

Q1370. De Mille, Agnes. PATRONAGE FOR THE THEATER IN AMERICA. Phonotape. Columbus, Ohio: Recorded at the Women's Music Club, 1964. 75 min.; 1 reel (7 in.) 3-3/4 in./sec. Dance Collection, The New York Public Library.

In a speech, de Mille speaks on the nature of patronage: the necessity for patronage in the theater and the European tradition of patronage; the American attitude toward theater and patronage; foundations and the 1964 Ford Foundation grant to Balanchine; theater in America, including opera, dance companies, theatrical repertory companies, commercial theater, and theater in colleges and universities; the growing enlightenment of state legislatures, especially in New York and North Carolina; financial support from the federal government for the arts; American audience and its psychology; the psychology of the theater.

Q1371. De Mille, Agnes. THE STATUS OF THE PERFORMING ARTS IN AMERICA: THE CULTURAL EXPLOSION. Phonotape. Amherst, Mass.: Recorded at the University of Massachusetts, Oct. 15, 1966. 21-1/2 min.; 1 reel (5 in.) 3-3/4 in./sec. Dance Collection, The New York Public Library.

A speech given by de Mille concerning the statistics on burgeoning state arts councils, symphonies, opera companies, and ballet companies; their continuing financial problems; growing federal government support for the arts; the attitude of Americans toward the arts; the importance of the arts.

Q1372. Greyser, Stephen A., ed. CULTURAL POLICY AND ARTS ADMINISTRATION. Cambridge, Mass.: Harvard Summer School Institute in Arts Administration; distributed by the Harvard University Press, 1973. 173 p.

The collected papers delivered at three Harvard Summer School Institute colloquia, reorganized into an overview of cultural policy and arts administration. *Contents:* public aid for the arts, a change of heart?; cultural policy for an open society; on the philosophy of arts administration; art and the majority; fostering the arts by disestablishment; disestablishing the arts; seeking cultural alternatives; cultural indicators for more rational cultural policy; Australia and the arts.

Q1373. Heymann, Jeanne Lunin. DANCE IN THE DEPRESSION: THE WPA PROJECT. *Dance Scope* 9 (spring/summer 1975): 28–40, illus.

On the work of the Federal Dance Project and the Federal Dance Theater administered by the Works Progress Administration during the 1930s. An appendix includes a catalog of major performances sponsored by the Federal Dance Theater, 1936–1939.

Q1374. Institute of International Education. DANCE: A SYMPOSIUM. Phonotape. New York, 1970. 3 hours, 55 min.; 2 reels (7 in.) 3-3/4 in./sec. Dance Collection, The New York Public Library.

Conferees discuss dance as a medium for cultural exchange; obtaining private and governmental subsidy for international exchange programs; developing an audience and relating to communities, both in the United States and on foreign tours; dance scholarships in international exchange programs; dance education in high schools and colleges; international exchange programs; the need for films on international exchange programs. *Participants:* Walter Terry, moderator; Martha Hill; Antony Tudor; Katherine Dunham; William Bales; Matteo; Genevieve Oswald; Norman Lloyd; Selma Jeanne Cohen; Pearl Primus; Zachary Solov; Mark B. Lewis, United States State Department; and Agnes de Mille.

Q1375. Oswald, Genevieve, comp. BIBLIOGRAPHY ON DANCE. New York: Rockefeller Brothers Fund, 1963. 50 leaves.

[*See* Q20a.]

Q1376. New York. **Rockefeller Brothers Fund.** THE PERFORMING ARTS: PROBLEMS AND PROSPECTS. New York, 1965. 232 p.

A report on the future of the performing arts in America: dance, music, opera, and theater. A discussion of economic factors, including corporate, foundation, and governmental support. The report delineates organization and administrative concerns facing the performing arts, among them training and audience development. Notes and sources. [For bibliography, *see* Q20a.]

Q1377. National Endowment for the Arts. Dance Touring Program. DIRECTORY OF DANCE COMPANIES, FISCAL YEAR 1975–1976. Washington, D.C., 1973? 3 vols.

A useful directory of American dance companies participating in the Dance Touring Program of the National Endowment of the Arts. Compiled by Charles Reinhart Management, New York, and issued each fiscal year, the report contains much valuable information: founding date, booking and company managers, touring personnel, fees, booking availability, performance space re-

quirements, available publicity services, technical requirements, available residency activities, purpose, active touring repertory, and tour engagements for the previous year. The 1976 directory lists 111 companies, including such groups as the Alvin Ailey City Center Dance Theater, American Ballet Theatre, Utah Repertory Dance Theatre, and the Pilobolus Dance Theatre.

HISTORY AND CRITICISM

GENERAL REFERENCES

Q1378. DANCE: A REFLECTION OF OUR TIMES. PRODUCED BY JAC VENZA. CONCEIVED AND WRITTEN BY MARTHA MYERS. CHOREOGRAPHED BY HERBERT ROSS. Motion picture. Boston: WGBH–TV, producing organization, 1960. 29 min.; sound, black and white, 16 mm.
FROM THE WGBH–TV SERIES A TIME TO DANCE.

Martha Myers and Herbert Ross discuss the use of dance in social commentary. Includes a performance of excerpts from Ross's *Peon* and *Caprichos*, inspired by Goya's etchings. *Dancers include* John Kriza, Ruth Ann Koesun, Scott Douglas, Jenny Workman, Lupe Serrano, Emy St. Just, and Enrique Martinez.

Q1379. DANCE AS AN ART FORM. WRITTEN, DIRECTED, NARRATED, AND CHOREOGRAPHED BY MURRAY LOUIS. DIRECTOR OF PHOTOGRAPHY, WARREN LIEB. MUSIC BY FREE LIFE COMMUNICATIONS, OREGON ENSEMBLE, CORKY SIEGEL. ELECTRONIC SOUND BY ALWIN NIKOLAIS. COSTUMES BY FRANK GARCIA. Motion picture. Chicago: Jack Lieb Productions, for Chimera Foundation for Dance, New York, 1973. Five films, each approximately 30 min.; sound, color, 16 mm.
[*See* Q755.]

Q1380. DANCE PERSPECTIVES. Brooklyn. 1— (winter 1959—), illus.
[*See* Q59.]

Q1381. **De Mille, Agnes.** THE BOOK OF THE DANCE. New York and London: Golden Press, 1963. 252 p., illus. (color).
[*See* Q369.]

Q1382. **Emery, Lynne Fauley.** BLACK DANCE IN THE UNITED STATES FROM 1619 TO 1970. Palo Alto, Calif.: National Press Books, 1972. 370 p., illus.
[*See* Q199.]

Q1383. **Friedman, Edna A.** AMERICAN OPINIONS ON DANCE AND DANCING FROM 1840 TO 1940. M.A. thesis, New York University, 1940. 84 p.

A collection of opinions on the moral aspects of dance. Bibliography.

Q1384. **Magriel, Paul David, ed.** CHRONICLES OF THE AMERICAN DANCE. New York: H. Holt, 1948. 268 p., illus., facsims.

Thirteen essays on the history of American dance reprinted chiefly from *Dance Index*. *Contents:* historical aspects: "The Dance in Shaker Ritual," by E. D. Andrews; "John Durang, the First American Dancer," by Lillian Moore; "Juba and American Minstrelsy," by Marian Hannah Winter; "The Black Crook and The White Fawn," by George Freedley; "The Dodworth Family and Ballroom Dancing in New York," by Rosetta O'Neill; "The Classic Dancers: Mary Ann Lee, First American Giselle," by Lillian Moore; "Augusta Maywood," by Marian Hannah Winter; "George Washington Smith," by Lillian Moore; "American Innovators: Isadora Duncan," by William Bolitho; "Loie Fuller the Fairy of Light," by Clare de Morinni; "Maud Allan," by Carl Van Vechten; "The Denishawn Era (1914–1931)," by Baird Hastings; "The Recent Theater of Martha Graham," by Robert Horan. Notes and bibliographical data.

Q1385. **Shawn, Ted.** CONVERSATIONS RECORDED AT JACOB'S PILLOW IN THE SUMMER OF 1971. Phonotapes. Lee, Mass.: Recorded by Sarah Jeter, press representative, 1971. 5 hours. 5 cassettes. Dance Collection, The New York Public Library.
[*See* Q803.]

Q1386. **Stearns, Marshall Winslor, and Stearns, Jean.** JAZZ DANCE: THE STORY OF AMERICAN VERNACULAR DANCE. New York: Macmillan, 1968. 464 p., illus.
[*See* Q340.]

Q1387. **Van Vechten, Carl.** THE DANCE WRITINGS OF CARL VAN VECHTEN. EDITED AND WITH AN INTRODUCTION BY PAUL PADGETTE. Brooklyn, N.Y.: Dance Horizons, 1974. 182 p., illus.
[*See* Q441.]

EIGHTEENTH CENTURY

Q1388. **Anderson, Simon Vance.** AMERICAN MUSIC DURING THE WAR FOR INDEPENDENCE, 1775–1783. M.A. thesis, University of Michigan, 1965. 298 p.

An excellent study of musical life during this period. Notes; bibliography.

Q1389. **Benson, Norman Arthur.** THE ITINERANT DANCING AND MUSIC MASTERS OF EIGHTEENTH-CENTURY AMERICA. M.A. thesis, University of Minnesota, 1963. 474 p.

A well documented and informative account of the social and cultural environment of eighteenth-century America in which travelling musicians and dancing masters were active. There are sections on Williamsburg, Va., Charleston, S.C., and Boston. The lives and activities of about a dozen dancing masters are described in some detail. Extensive annotated bibliography.

Q1390. **Cole, Arthur Charles.** THE PURITAN AND FAIR

TERPSICHORE. Brooklyn, N.Y.: Dance Horizons, 1966(?). 34 p.

A social history of dance in America in the first quarter of the nineteenth-century. Reprinted from *The Mississippi Valley Historical Review* 29 (June 1942).

Q1391. **Crawford, Mary Caroline.** THE ROMANCE OF THE AMERICAN THEATRE. Boston, 1913. 407 p., illus., facsim.

An historical survey containing some information on ballet, pantomime, and dancers performing in eighteenth- and nineteenth-century America. Index.

Q1392. **Durang, John.** THE MEMOIR OF JOHN DURANG, AMERICAN ACTOR, 1785-1816. EDITED BY ALAN S. DOWNER. Pittsburgh: Published for the Historical Society of York County and for the American Society for Theatre Research by the University of Pittsburgh Press, 1966. 176 p., illus. (color).

[*See* Q118.]

Q1393. **Mates, Julian.** THE AMERICAN MUSICAL STAGE BEFORE 1800. New Brunswick, N.J., 1962. 331 p., illus.

[*See* Q1181.]

Q1394. **Moore, Lillian.** THE DUPORT MYSTERY. Brooklyn: Dance Perspectives Foundation, 1960. 103 p., illus.

DANCE PERSPECTIVES, NO. 7.

[*See* Q962.]

Q1395. **Moore, Lillian.** JOHN DURANG, THE FIRST AMERICAN DANCER. *Dance Index* 1 (Aug. 1942): 120-39, illus.

[*See* Q963.]

Q1396. **Moore, Lillian.** NEW YORK'S FIRST BALLET SEASON, 1792. New York: New York Public Library, 1961. 18 p., illus.

[*See* Q964.]

Q1397. **Moore, Lillian.** WHEN BALLET CAME TO CHARLESTON. *The Dancing Times* (Dec. 1956): 122-24, illus.

[*See* Q123.]

Q1398. **Nye, Russel Blaine.** THE CULTURAL LIFE OF THE NEW NATION, 1776-1830. New York: Harper & Bros., 1960. 324 p., illus.

THE NEW AMERICAN NATION SERIES.

A study of the cultural development of the United States from the Revolutionary War to 1830 and the impact of an increasingly American point of view upon theology, literature, architecture, and the arts, including dance. Bibliography; index.

Q1399. **Odell, George Clinton Densmore.** ANNALS OF THE NEW YORK STAGE. New York: Columbia University Press, 1927-1949. 15 vols. illus., facsims., map.

[*See* Q1182.]

Q1400. **Pollock, Thomas Clark.** THE PHILADELPHIA THEATRE IN THE EIGHTEENTH CENTURY, TOGETHER WITH THE DAY BOOK OF THE SAME PERIOD. Philadelphia: University of Pennsylvania Press; London: H. Milford, Oxford University Press, 1933. 445 p., frontispiece (facsim.).

[*See* Q124.]

Q1401. **Winter, Marian Hannah.** AMERICAN THEATRICAL DANCING FROM 1750 TO 1800. *The Musical Quarterly* 24 (Jan. 1938): 58-73, illus.

[*See* Q967.]

Q1402. **Wright, Richardson Little.** HAWKERS AND WALKERS IN EARLY AMERICA: STROLLING PEDDLERS, PREACHERS, LAWYERS, DOCTORS, PLAYERS, AND OTHERS, FROM THE BEGINNING TO THE CIVIL WAR. Philadelphia: J. B. Lippincott Co., 1927. 317 p., illus., facsims.

An interesting historical and social study of itinerant professions and trades in America from early colonial days to the Civil War. Includes Yankee peddlers, wandering portrait painters, evangelists, dentists, circuit-riding judges, dancing masters, actors, clowns, and circus acrobats. Material relevant to dance is contained in three chapters: Terpsichore perambulant; the Puritan begins to smile; circus and theater start on tour. Sixty-eight illustrations from old sources. Bibliography.

Q1403. **Wynne, Shirley.** FROM BALLET TO BALLROOM: DANCE IN THE REVOLUTIONARY ERA. *Dance Scope* 10 (fall/winter 1975-1976): 65-73, illus.

[*See* Q522.]

NINETEENTH CENTURY

Q1404. **Chaffée, George.** AMERICAN MUSIC PRINTS OF THE ROMANTIC BALLET. *Dance Index* (Dec. 1942): 192-212, illus.

[*See* Q128.]

Q1405. **Chaffée, George.** A CHART TO THE AMERICAN SOUVENIR LITHOGRAPHS OF THE ROMANTIC BALLET, 1825-1870. *Dance Index* (Feb. 1942): 20-25, illus.

[*See* Q129.]

Q1406. **Cornell, Joseph, comp.** AMERICANA: ROMANTIC BALLET. *Dance Index* (Sept. 1947): 201-222, illus.

[*See* Q130.]

Q1407. **Ludlow, Noah Miller.** DRAMATIC LIFE AS I FOUND IT. Saint Louis: G. I. Jones & Co., 1880. 733 p.

A nineteenth-century account by a widely traveled actor-manager dealing with the period from 1815 to the 1850s. Ludlow is concerned with the development of the dramatic arts in the West and South. Contains anecdotes and biographical sketches of the principal actors and actresses of the day who appeared on the stage in the Mississippi Valley. Includes many references to dancers such as Alexandre Placide, Fanny Elssler, and others.

REPRINTED: (New York: Benjamin Blom, 1966). Introduction by Francis Hodge. Excellent index of titles, persons, topics, and theaters.

Q1408. **Moore, Lillian.** GEORGE WASHINGTON SMITH. *Dance Index* 4 (June–Aug. 1945): 88–135, illus.
[*See* Q982.]

Q1409. **Moore, Lillian.** MARY ANN LEE: FIRST AMERICAN GISELLE. *Dance Index* (May 1943): 60–71, illus.
[*See* Q984.]

Q1410. **Moore, Lillian.** SOME EARLY AMERICAN DANCERS. *The Dancing Times* (Aug. 1950): 668–71, illus.
[*See* Q122.]

Q1411. **Nye, Russel Blaine.** THE CULTURAL LIFE OF THE NEW NATION, 1776–1830. New York: Harper & Bros., 1960. 324 p., illus.
THE NEW AMERICAN NATION SERIES.
[*See* Q1398.]

Q1412. **Odell, George Clinton Densmore.** ANNALS OF THE NEW YORK STAGE. New York: Columbia University Press, 1927–1949. 15 vols., illus., facsims., map.
[*See* Q1182.]

Q1413. **Shawn, Ted.** LECTURE ON FRANÇOIS DELSARTE. Phonotape. New York, 1971. 64 min.; 1 reel (7 in.) 3-3/4 in./sec. Dance Collection, The New York Public Library.

Shawn discusses the history of Delsarte's theories in America; American Delsarte disciples Steele MacKaye and Genevieve Stebbins; the influence of Delsarte's ideas on American modern dance; Ruth St. Denis's dance, *Spirit of the Sea*; the principles of Delsarte movement analysis. Walter Terry serves as moderator.

Q1414. **Winter, Marian Hannah.** JUBA AND AMERICAN MINSTRELSY. *Dance Index* (Feb. 1947): 28–47, illus.
[*See* Q227.]

Q1415. **Wood, William Burke.** PERSONAL RECOLLECTIONS OF THE STAGE: EMBRACING NOTICES OF ACTORS, AUTHORS, AND AUDITORS DURING A PERIOD OF FORTY YEARS. Philadelphia: H. C. Baird, 1855. 477 p.
[*See* Q140.]

Q1416. **Wright, Richardson Little.** HAWKERS AND WALKERS IN EARLY AMERICA, STROLLING PEDDLERS, PREACHERS, LAWYERS, DOCTORS, PLAYERS, AND OTHERS, FROM THE BEGINNING TO THE CIVIL WAR. Philadelphia: J. B. Lippincott Co., 1927. 317 p., illus., facsims.
[*See* Q1402.]

TWENTIETH CENTURY

Q1417. **Allen, Philip Mark.** THE SOCIOLOGY OF ART IN AMERICA. M.A. thesis, Emory University, 1956. 633 p.
On the role of the visual and performing arts, literature, and music as social institutions in the United States. Bibliography.

Q1418. **Barrett, John Townsend.** ANALYSIS AND SIGNIFICANCE OF THREE AMERICAN CRITICS OF THE BALLET: CARL VAN VECHTEN, EDWIN DENBY, AND LINCOLN KIRSTEIN. M.A., Columbia University, 195(?). 55 p.
An analysis of the critical output of the most important and influential writers on American dance.

Q1419. **Beiswanger, George W.** DANCE OVER U.S.A., PTS. 1 AND 2. *Dance Observer* Pt. 1 (Jan. 1943): 4–5; Pt. 2 (Feb. 1943): 16–17.
[*See* Q355.]

Q1420. **Chujoy, Anatole.** THE NEW YORK CITY BALLET. PHOTOGRAPHS BY GEORGE PLATT LYNES, WALTER E. OWEN, AND FRED FEHL. New York: Alfred A. Knopf, 1953. 382 p., illus.
[*See* Q865.]

Q1421. **Code, Grant Hyde.** DANCE THEATER OF THE WPA: A RECORD OF NATIONAL ACCOMPLISHMENT, PTS. 1–4. *Dance Observer* Pt. 1 (Oct. 1939): 264–65, 274; Pt. 2 (Nov.–Dec. 1939); Pt. 3 (Mar. 1940); Pt. 4 (June–July 1940), illus.
[*See* Q1366.]

Q1422. **Cohen, Selma Jeanne, ed.** DANCE AS A THEATRE ART: SOURCE READINGS IN DANCE HISTORY FROM 1581 TO THE PRESENT. New York: Dodd, Mead & Co., 1974. 224 p., illus.

Includes essays by Isadora Duncan, Ruth St. Denis, Martha Graham, Doris Humphrey, Jerome Robbins, George Balanchine, Merce Cunningham, Alwin Nikolais, and Meredith Monk. *Partial contents:* the modern dance: moving from the inside out; the extension of the classical tradition; recent rebels.

Q1423. DANCE MAGAZINE. TWENTY-FIVE YEARS OF AMERICAN DANCE. EDITED BY DORIS HERING. New York, R. Orthwine, ca. 1954. 236 p., illus., ports.
[*See* Q446.]

Q1424. DANCE ON FILM, 1894–1912, PTS. 1 AND 2. Motion picture. Athos-Abbacon Productions, producing organization, using film clips originally produced by Pathé Frères, American Mutoscope and Biograph, Georges Méliès, and Thomas Edison, 1970–1971. 35 min.; sound, color, 16 mm.

A compilation of the earliest dance films, including handcolored footage. Pt. 1 shows ballet artists from the Victorian era: Pierina Legnani, dancers of the Paris Opéra in 1903, lead by Zizi Papillon, star of the Folies Bergeres; Lea Piron as Harlequin; Catherine Bartho performing her celebrated "speedway" dance of vaudeville fame; and Rita Maury in an underwater ballet from

Georges Méliès's *20,000 Leagues under the Sea.* Pt. 2 shows early modern dancers Loie Fuller, Annabella, Ameta, Karine, Ella Lola, and a dancer purported to be Isadora Duncan.

Q1425. **De Mille, Agnes.** ARTISTIC CRITICISM AND APPRECIATION IN AMERICA. Phonotape. Beloit, Wisc.: Recorded at Beloit College, ca. 1960. 46-1/2 min.; 1 reel (7 in.) 3-3/4 in./sec. Dance Collection, The New York Public Library.

De Mille talks about her dance and choreography during her college years; how dance was taught in colleges at that time; performer-audience rapport in live theaters and in television; American, particularly New York City dance and drama critics; the aesthetic and intellectual apathy of the American public; understanding and appreciating the arts.

Q1426. **De Mille, Agnes.** PATRONAGE FOR THE THEATER IN AMERICA. Phonotape. Columbus, Ohio: Recorded at the Women's Music Club, 1964. 75 min.; 1 reel (7 in.) 3-3/4 in./sec. Dance Collection, The New York Public Library.
[*See* Q1370.]

Q1427. **Denby, Edwin.** DANCERS, BUILDINGS, AND PEOPLE IN THE STREETS. New York, 1965. 287 p.

A collection of this distinguished author's criticism and essays written since 1949, primarily on the ballet and on the New York City Ballet, in particular. Contains an introduction by Frank O'Hara.

Q1428. **Denby, Edwin.** LOOKING AT THE DANCE. New York: Pellegrini & Cudahy, 1949. 432 p., illus.
[*See* Q1001.]

Q1429. Carbondale, Ill. **Southern Illinois University Library.** KATHERINE MARY DUNHAM PAPERS, 1919–1968. 1970. 22 leaves.
[*See* Q664.]

Q1430. **Kirstein, Lincoln.** BLAST AT BALLET: A CORRECTIVE FOR THE AMERICAN AUDIENCE. New York: Marstin Press, 1938. 128 p.
[*See* Q167.]

Q1431. **Kirstein, Lincoln.** FOR JOHN MARTIN: ENTRIES FROM AN EARLY DIARY. Brooklyn: Dance Perspectives Foundation, 1973. 55 p., illus.
DANCE PERSPECTIVES, NO. 54.

Excerpts from a diary by Lincoln Kirstein written during the summer of 1933 while he visited Paris and London. His notes concern the personalities and the cultural life of the two capitals, as well as his early association with George Balanchine, whom he subsequently brought to the United States.

Q1432. **Kirstein, Lincoln.** MOVEMENT AND METAPHOR: FOUR CENTURIES OF BALLET. New York: Praeger Publishers, 1970. 290 p., illus.
[*See* Q169.]

Q1433. **Kirstein, Lincoln.** WHAT BALLET IS ABOUT: AN AMERICAN GLOSSARY. PORTFOLIO OF PHOTOGRAPHS OF THE NEW YORK CITY BALLET BY MARTHA SWOPE. Brooklyn: Dance Perspectives Foundation, 1958. 80 p., illus.
DANCE PERSPECTIVES, NO. 1.
[*See* Q172.]

Q1434. **Lloyd, Margaret.** THE BORZOI BOOK OF MODERN DANCE. Brooklyn: Dance Horizons, 1969. 359 p., illus.
[*See* Q394.]

Q1435. **Martin, John Joseph.** AMERICA DANCING: THE BACKGROUND AND PERSONALITIES OF THE MODERN DANCE. PHOTOGRAPHS BY THOMAS BOUCHARD. New York: Dodge Publishing Co., 1936. 320 p., illus.
[*See* Q1010.]

Q1436. **Martin, John Joseph.** BOOK OF THE DANCE: THE STORY OF THE DANCE IN PICTURES AND TEXT. New York: Tudor Publishing Co., 1963. 192 p., illus.
[*See* Q1011.]

Q1437. **Martin, John Joseph.** DAYS OF DIVINE INDISCIPLINE. Photographs by Thomas Bouchard. Brooklyn: Dance Perspectives Foundation, 1961. 45 p., illus.
DANCE PERSPECTIVES, NO. 12.
[*See* Q397.]

Q1438. **Martin, John Joseph.** THE MODERN DANCE. Brooklyn, N.Y.: Dance Horizons, 1965. 123 p.
[*See* Q398.]

Q1439. **McDonagh, Don.** THE RISE AND FALL AND RISE OF MODERN DANCE. New York: Outerbridge & Dienstfrey; distributed by E. P. Dutton & Co., 1970. 344 p., illus.
[*See* Q401.]

Q1440. **McDonagh, Don.** THE RISE AND FALL AND RISE OF MODERN DANCE. New York: New American Library, 1971. 303 p., illus.
[*See* Q97.]

Q1441. **Moore, Claudia.** AN HISTORICAL SURVEY OF SELECTED DANCE REPERTORIES AND FESTIVALS IN THE UNITED STATES SINCE 1920. M.A. thesis, New York University, 1942. 63 p.
[*See* Q1357.]

Q1442. **Moulton, Robert Darrell.** CHOREOGRAPHY IN MUSICAL COMEDY AND REVUE ON THE NEW YORK STAGE FROM 1925 THROUGH 1950. M.A. thesis, University of Minnesota, 1957. 436 p.
[*See* Q1212.]

Q1443. **Nikolais, Alwin.** LECTURE ON AVANT-GARDE DANCE. Phonotape. New York, 1968. 50 min. 1 reel (7 in.) 3-3/4 in./sec. Dance Collection, The New York Public Library.
[*See* Q776.]

Q1444. **Palmer, Winthrop Bushnell.** THEATRICAL DANCING IN AMERICA. THE DEVELOPMENT OF THE BALLET FROM 1900. New York: B. Ackerman, 1945. 159 p., illus.

[See Q411.]

Q1445. **Shawn, Ted.** REMINISCENCES: FROM CHILDHOOD TO THE DISSOLUTION OF DENISHAWN. Phonotape. New York: WNYC, broadcaster; recorded in Eustis, Fla., 1969. 6-1/2 hours; broadcast, 26 min. 2 reels (5 in.) 1-7/8 in./sec. Dance Collection, The New York Public Library.

FROM THE WNYC SERIES INVITATION TO DANCE.

[*See* Q1139.]

Q1446. **Rothschild, Bethsabée de, Baroness.** LA DANSE ARTISTIQUE AUX USA: TENDANCES MODERNES. Paris: Editions Elzévir, 1949. 159 p., illus.

[*See* Q414.]

Q1447. **Sayler, Oliver Martin, ed.** REVOLT IN THE ARTS. New York: Brentano's, 1930. 351 p.

[*See* Q417.]

Q1448. **Siegel, Marcia B.** AT THE VANISHING POINT: A CRITIC LOOKS AT DANCE. New York: Saturday Review Press, 1972. 320 p., illus.

Almost one hundred articles and reviews covering American dance from 1967 to 1971. Articles reprinted from *New York* magazine, *Boston Herald Traveler*, *Los Angeles Times*, *Dance Magazine*, *Ballet Today*, *Wall Street Journal*, and others. *Contents:* ballet, the uncertain establishment; pop dance, the disposable now; black dance, a new separatism; modern dance, the process of redefinition; experimental dance, firebrands, and visionaries. Index.

Q1449. **Tamiris, Helen.** PRESENT PROBLEMS AND POSSIBILITIES. In: SORELL, WALTER, ED. THE DANCE HAS MANY FACES. 2d ed. New York: Columbia University Press, 1966. p. 200–207.

[*See* Q1222.]

Q1450. **Terry, Walter.** FAVORABLE BALANCE OF TRADE. In: SORELL, WALTER, ED. THE DANCE HAS MANY FACES. 2d ed. New York: Columbia University Press, 1966. p. 194–99.

A reversal of Europe's monopoly on the dance art has taken place since World War II. The United States is now exporting its dance art abroad and influencing trends there among choreographers and dancers.

Q1451. **Terry, Walter.** INTERVIEW AND LECTURE-DEMONSTRATION WITH RUTH ST. DENIS. Phonotape. New York, 1963. 1 hour, 16 min.; 1 reel (7 in.) 7-1/2 in./sec. Dance Collection, The New York Public Library.

FROM A DANCE LABORATORY HELD AT THE YM-YWHA, NEW YORK.

[*See* Q1141.]

Q1452. **Beiswanger, George; Hofmann, Wilfried A.; and Levin, David Michael.** THREE ESSAYS IN DANCE AESTHETICS. Brooklyn: Dance Perspectives Foundation, 1973. 47 p., illus.

DANCE PERSPECTIVES, NO. 55.

Contents: "Doing and Viewing Dances: A Perspective for the Practice of Criticism," by George Beiswanger; "Of Beauty and the Dance: Toward an Aesthetics of Ballet," by W. A. Hofmann; "Balanchine's Formalism," by D. M. Levin.

Q1453. **Venza, Jac.** INTERVIEWS WITH GEORGE BALANCHINE AND MEMBERS OF THE NEW YORK CITY BALLET. Phonotape. New York: National Educational Television, 1964. 57 min. 4 reels (7 in.) 7-1/2 in./sec. Dance Collection, The New York Public Library.

RECORDED FOR THE NET PROGRAM THE AMERICAN ARTS.

[*See* Q621.]

Q1454. **Whitlock, Ernest Clyde, and Saunders, Richard Drake, eds.** MUSIC AND DANCE IN TEXAS, OKLAHOMA, AND THE SOUTHWEST. Hollywood, Calif.: Bureau of Musical Research, 1950. 256 p., illus.

MUSIC AND DANCE GEOGRAPHIC SECTIONAL SERIES.

One volume of a series on music and dance in the different sections of the United States. Contains essays of general and regional interest as well as biographies of dancers and teachers active in the region. Other volumes in the series, edited by Sigmund Spaeth, are: *Music and Dance in California and the West* (1948), *Music and Dance in New York State* (1952), *Music and Dance in Pennsylvania, New Jersey, and Delaware* (1954), *Music and Dance in the Central States* (1952), *Music and Dance in the New England States* (1953), and *Music and Dance in the Southeastern States* (1952).

MOTION PICTURES

Q1455. **Anderson, Jack.** FOR LOOKING FOR LEARNING AND FOR FUN. *Dance Magazine* (Sept. 1965): 28–30.

The author publishes the results of a *Dance Magazine* questionnaire revealing various uses made of films in regional ballet companies and their schools.

Q1456. **Barzel, Ann.** FILMS FOR REMEMBRANCE. *Dance Magazine* (Sept. 1965): 22–26, illus.

The dance critic for the *Chicago-American* discusses the role of film and the filmmaker and the history of a private collection of dance sequences she filmed.

Q1457. **Bouchard, Thomas.** THE PRESERVATION OF THE DANCE SCORE THROUGH FILMING THE DANCE. In: SORELL, WALTER, ED. THE DANCE HAS MANY FACES. New York: World Publishing Co., 1951. p. 62–70.

An essay on motion pictures as a means of recording and preserving dance compositions.

Q1458. **Lomax, Alan.** CHOREOMETRICS AND ETHNOGRAPHIC FILMMAKING. *Filmmakers Newsletter* (Feb. 1971): 22–30, illus.

The description of a study, undertaken by the author with Irmgard Bartenieff and Forrestine Paulay, using choreometrics and film to devise and test a graphic rating system that compares movement styles crossculturally. Included is a sample chart illustrating the value and potential value of the rating system for further research in the field. Technical and practical advice is provided for filming documentaries for dance/behavior/movement research.

Q1459. **Rogers, Helen Priest.** FILMS FOR NOTATION: EDUCATIONAL INSTITUTIONS AND COMPANIES ARE GREATLY ASSISTED IN RECONSTRUCTING DANCE WORKS. *Dance Magazine* (Sept. 1965): 55–57.

A short account of the author's experiences in using dance films for notation and for study.

Q1460. **Snyder, Allegra Fuller.** FILMS: WHO CAN MAKE THEM? HOW CAN WE USE THEM? *Dance Magazine* (Apr. 1969): 38–41.

A report on today's expanding dance film scene.

Q1461. **Snyder, Allegra Fuller.** THREE KINDS OF DANCE FILM: A WELCOME CLARIFICATION. *Dance Magazine* (Sept. 1965): 34–39, illus.

The different purposes of the three categories of dance film clearly explained: "choreo-cinema," in which filmmaker and choreographer work together to create a fusion of the two arts: film as dance notation, in which it serves as a record for study and reconstruction; the documentary film, in which film records the experience of seeing a dance on stage in a live performance.

NOTATION

Q1462. **Burchess, Jessie.** NOTATION AND MODERN DANCE REPERTORY. *Dance Observer* (Oct. 1949): 113–14, 116.

An evaluation of the future role of notation in modern dance and of its contribution to the maintenance of repertory.

Q1463. **Hutchinson, Ann.** THE PRESERVATION OF THE DANCE SCORE THROUGH NOTATION. In: SORELL, WALTER ed. THE DANCE HAS MANY FACES. 2d ed. New York: Columbia University Press, 1966. p. 151–63, diagrs.

Ann Hutchinson, dancer, notator, and teacher of the Labanotation system, presents a brief historical survey of such systems and examples of Laban scores being used in the revival of partially forgotten twentieth-century ballets. She discusses preserving and reconstructing choreography through film and through Labanotation scores. Also in FIRST EDITION: (New York: World Publishing Co., 1951).

PHILOSOPHY AND AESTHETICS

Q1464. ART IS. PRODUCED, DIRECTED, AND WRITTEN BY JULIAN KRAININ AND DeWITT L. SAGE, JR. FILMED BY HENRY STRAUSS ASSOCIATES. CHOREOGRAPHED BY GEORGE BALANCHINE. Motion picture. New York: Sears-Roebuck Foundation in cooperation with Associated Councils of the Arts, producing organization. 28 min.; sound, color, 16 mm.

[*See* Q601.]

Q1465. **Beiswanger, Barbara Page.** THE PHILOSOPHY OF THE DANCE. American Physical Education Association, *Research Quarterly* 4 (May 1933): 5–49.

Contents: Historical survey of the dance; psychological components of the dance; religious manifestations of the dance; the dance as a socializing agency; dance and the sex life; dance as an art. Bibliography.

Q1466. **Cohen, Selma Jeanne.** AVANT-GARDE CHOREOGRAPHY, PTS. 1–3. *Dance Magazine* Pt. 1 (June 1962): 22–24, 57; Pt. 2 (July 1962): 29–31, 58; Pt. 3 (Aug. 1962): 45, 54–56, illus.

[*See* Q358.]

Q1467. **Cohen, Selma Jeanne.** A PROLEGOMENON TO AN AESTHETICS OF DANCE. In: NADEL, MYRON HOWARD, ed. THE DANCE EXPERIENCE. New York, 1970. p. 4–14.

[*See* Q1195.]

Q1468. **Cohen, Selma Jeanne.** SOME THEORIES OF DANCE IN CONTEMPORARY SOCIETY. *Journal of Aesthetics and Art Criticism* 9 (Dec. 1950): 111–18.

A discussion of the work of four dance critics who view dance as an art that can represent and communicate ideas of value to society. Rayner Heppenstall, Lincoln Kirstein, John Martin, and A. V. Coton believe that dance forms can be neither studied nor created in an aesthetic vacuum; that an intimate relation exists between the environment and the choreographic works conceived within that environment; and that the dance has the power to exert a valuable influence on the life of the community.

Q1469. **Copeland, Roger.** A CONVERSATION WITH ALWIN NIKOLAIS. *Dance Scope* 8 (fall/winter 1973/1974): 41–46, illus.

[*See* Q769.]

Q1470. **Barron, Frank, et. al.** CREATIVITY. *Impulse* (1968): 29–37.

Discussions by Frank Barron, Eugene Loring, Bonnie Bird, Jack Morrison, Vera Embree, Eleanor Lauer, and Alvin Ailey on the essence of the creative impulse. This collection of essays is based on a presentation at the Developmental Conference on Dance, University of California at Los Angeles, Nov. 24–Dec. 3, 1966.

Q1471. DANCE AS AN ART FORM. WRITTEN, DIRECTED,

NARRATED, AND CHOREOGRAPHED BY MURRAY LOUIS. DIRECTOR OF PHOTOGRAPHY, WARREN LIEB. MUSIC BY FREE LIFE COMMUNICATIONS, OREGON ENSEMBLE, CORKY SIEGEL. ELECTRONIC SOUND BY ALWIN NIKOLAIS. COSTUMES DESIGNED BY FRANK GARCIA. Motion picture. Chicago: Jack Lieb Productions for Chimera Foundation for Dance, New York, producing organization, 1973. Five films, each approximately 30 min.; sound, color, 16 mm.

[See Q755.]

Q1472. DANCE MAGAZINE AWARDS, 1957: MARTHA GRAHAM AND AGNES DE MILLE. Phonotape. New York: WNYC, broadcaster, 1957. 20 min.; 1 reel (7 in.) 7-1/2 in./sec. Dance Collection, The New York Public Library.
PARTIAL PROCEEDINGS ON THE WNYC SERIES TODAY IN BALLET.

[See Q676.]

Q1473. A DANCER'S WORLD, PRODUCED BY NATHAN KROLL. DIRECTED AND FILMED BY PETER GLUSHANOK. COMPOSER AND PIANIST, CAMERON MCCOSH. CHOREOGRAPHED BY MARTHA GRAHAM. Motion picture. Pittsburgh: WQED–TV, producing organization, 1957. 30 min.; sound, black and white, 16 mm.

[See Q677.]

Q1474. **Denby, Edwin.** THE CRITICISM OF EDWIN DENBY. PHOTOGRAPHS BY WALKER EVANS. *Dance Index* (Feb. 1946): 28–56, illus.

Articles reprinted from the *New York Herald Tribune* and *Modern Music,* with an introduction by Elaine de Kooning. An immensely readable body of excellent dance criticism, primarily on ballet but also on modern and ethnic dance.

Q1475. **Denby, Edwin.** DANCERS, BUILDINGS, AND PEOPLE IN THE STREETS. *Center: A Magazine of the Performing Arts* (Dec. 1954): 19–22, illus.

[See Q1427.]

Q1476. **Duncan, Isadora.** THE DANCE. New York: Forest Press, 1909. 28 p., illus.

An essay by Isadora Duncan on dance as an art form. Includes programs and program notes for performances by Duncan with the New York Symphony Orchestra under the direction of Walter Damrosch. There is an introduction by Mary Fanton Roberts.

Q1477. **Duncan, Isadora.** THE DANCE IN RELATION TO TRAGEDY. *Theatre Arts* (Oct. 1927): 755–61, illus.

[See Q1061.]

Q1478. **Erdman, Jean.** THE DANCE AS A NONVERBAL POETIC IMAGE. In: SORELL, WALTER, ED. THE DANCE HAS MANY FACES. New York: World Publishing Co.,1951. p. 197–212.

[See Q375.]

Q1479. **Graham, Martha.** THE AUDACITY OF PERFORMANCE. *Dance Magazine* (May 1953): 24–25.

Martha Graham discusses the need for dancers to strive for complete simplicity in performance, achieved through a total mastery of their art.

Q1480. **Hawkins, Erick.** WHAT IS THE MOST BEAUTIFUL DANCE? In: SORELL, WALTER, ED. THE DANCE HAS MANY FACES. 2d ed. New York: Columbia University Press, 1966.

Thirty-one replies to the question by this prominent artist.

Q1481. **H'Doubler, Margaret Newell.** DANCE, A CREATIVE ART EXPERIENCE. Madison: University of Wisconsin Press, 1957. 168 p., illus.

A discussion of the basic qualities of dance in an effort to see dance scientifically as well as artistically.

Q1482. **Kirstein, Lincoln.** MOVEMENT AND METAPHOR: FOUR CENTURIES OF BALLET. New York: Praeger Publishers, 1970. 290 p., illus.

[See Q169.]

Q1483. **Langer, Susanne Katherina Knauth.** THE DYNAMIC IMAGE: SOME PHILOSOPHICAL REFLECTIONS ON DANCE. *Dance Observer* (June–July 1956): 85–87.

An address given at the Women's College of the University of North Carolina, Greensboro, on Feb. 3, 1956.

Q1484. **Langer, Susanne Katherina Knauth.** THE EXPRESSION OF FEELING IN DANCE. *Impulse* (1968): 15–27.

The author defines feeling, projection, the subjective, the objective, and intuition in relation to dance. Based on a presentation at the Developmental Conference on Dance, at the University of California at Los Angeles, Nov. 24–Dec. 3, 1966.

Q1485. **Langer, Susanne Katherina Knauth.** PHILOSOPHY IN A NEW KEY. Cambridge, Mass.: Harvard University Press, 1942. 313 p., illus., music.

A major twentieth-century work on philosophy and aesthetics containing numerous references to dance in the six chapters: language; life-symbols: the roots of sacrament; life-symbols: the roots of myth; on significance in music; the genesis of artistic import; the fabric of meaning. The author sees art as one of the intellectual activities determined by "symbolic modes." The essentially "transformational" nature of human understanding is the basis of man's use of symbolic transformation and abstraction in art. Bibliography. Index of topics and names.

Q1486. THE LANGUAGE OF DANCE: LECTURE-PERFORMANCES BY PAULINE KONER. PRODUCED BY TV SINGAPURA. Motion picture. 1967. 29-1/2 min.; sound, black and white, 16 mm.

[See Q738.]

Q1487. **Marks, J.** MOTION, IMAGE, AND FORM: STUDIES IN CHOREOGRAPHY. San Francisco, 1967. 168 leaves.

[See Q1209.]

Q1488. **Nikolais, Alwin.** Nik, a Documentary. Edited and with an introduction by Marcia B. Siegel. Brooklyn: Dance Perspectives Foundation, 1971. 56 p., illus. (color).
Dance Perspectives, no. 48.
[See Q777.]

Q1489. **Nikolais, Alwin.** The Dance and Multimedia: Forum Discussion. Phonotape. Amherst, Mass.: WFCR, broadcaster, 1969. 60 min.; 2 reels (7 in.) 7-1/2 in./ sec. Dance Collection, The New York Public Library.
[See Q406.]

Q1490. **Nikolais, Alwin.** Growth of a Theme. In: Sorell, Walter, ed. The Dance Has Many Faces. 2d ed. New York: Columbia University Press, 1966. p. 229–37.
[See Q775.]

Q1491. **Shawn, Ted.** Dance We Must. 2d ed. Pittsfield, Mass.: Eagle Printing Co., 1963. 148 p., illus.
[See Q422.]

Q1492. **Sorell, Walter.** The Dance Has Many Faces. 2d ed. New York: Columbia University Press, 1966. 276 p., illus.
[See Q428.]

Q1493. **Sorell, Walter.** The Duality of Vision: Genius and Versatility in the Arts. Indianapolis: Bobbs-Merrill Co., 1970. 360 p., illus. (color), facsims.

According to the introductions, a study of "the geniuses with more than one talent, about the great talents not limited to one form of artistic expression." An investigation of talent, genius, creativity, and environment as a creative stimulus. The section on the performing artist includes discussions of Isadora Duncan, Ruth St. Denis, Vaslav Nijinsky, Angna Enters, Geoffrey Holder, and Alwin Nikolais.

Q1494. **Sorell, Walter.** Marginal Notes: Paean on Poetry. Dance Scope 7 (spring/summer 1973): 37–42, illus.

A dance critic's observations on poetry, movement, and the American audience.

Q1495. **Beiswanger, George; Hofmann, Wilfried A.; and Levin, David Michael.** Three Essays in Dance Aesthetics. Brooklyn: Dance Perspectives Foundation, 1973. 47 p., illus.
Dance Perspectives, no. 55.
[See Q1452.]

Q1496. Why Do We Dance? Produced by Lynn Poole. Introduction by Dr. Milton Eisenhower. Motion picture. Baltimore, 1958. 29 min.; sound, black and white, 16 mm.
From the series Johns Hopkins File Seven.
[See Q809.]

SCENARIOS

Q1497. **Balanchine, George.** New Complete Stories of the Great Ballets. Edited by Francis Mason. Drawings by Marta Becket. Garden City, N.Y.: Doubleday, 1968. 626 p., illus.
[See Q569.]

Q1498. **Balanchine, George, and Mason, Francis.** One Hundred and One Stories of the Great Ballets. Garden City, N.Y.: Doubleday, 1975. 541 p.
[See Q145.]

Q1499. **Krokover, Rosalyn.** The New Borzoi Book of Ballets. New York: Alfred A. Knopf, 1956. 320 p., illus.

Plots and brief histories of fifty-seven ballets, including the older ballet classics such as Sleeping Beauty as well as major twentieth-century work. Contains an introductory essay, "Looking at Ballet." An appendix provides a comprehensive list of ballets presented in the United States by four major American-based companies active since 1933: Ballets Russes, Ballet Theatre, New York City Ballet, and the Marquis de Cuevas Grand Ballet de Monte Carlo. Index of names and titles.

Q1500. **Lawrence, Robert.** The Victor Book of Ballets and Ballet Music. New York: Simon & Schuster, 1950. 531 p., illus., music.

Plots of approximately 120 ballets from the repertoire of twentieth-century American companies. Contains illustrations and musical excerpts from the scores; a brief introductory essay that surveys the history of ballet with emphasis on American developments since the 1920s; a selective discography of RCA Victor recordings available in 1950; indexes of choreographers and composers.

Q1501. **Kirstein, Lincoln.** Movement and Metaphor: Four Centuries of Ballet. New York: Praeger Publishers 1970. 290 p., illus.
[See Q169.]

R

Music

BERTRUN DELLI

CONTENTS

INTRODUCTION

It is the nature of all bibliographies to be incomplete; the present bibliography shares this characteristic. The attempt was made, however, to include a variety of writings diverse in their approach to American music and its history rather than to limit the selection either to the newest titles or to publications that have become classical studies. The purpose is to offer the student a fundamental work tool and a comprehensive guide for his studies in the field of American music literature. Considering the many areas and topics in musical research, widespread material has been reported on the following pages. Sometimes writings of lesser value were included on the grounds of their popularity, frequent presence in public libraries, or general nature as a handbook. An effort to reach for a certain depth was not to be lessened at the same time—depth, that is, in respect to topics less popular or with regard to the historical dimension, such as early American works of the eighteenth and nineteenth centuries. Hence one of the aims of this bibliography is, quite apart from compiling a list of titles, to engender a greater awareness of the wealth of past and present literature about American music and musical practice throughout our country.

There is an accompanying awareness, one must confess, of literary lacunae in some areas of musical research. For instance, an unevenness in coverage becomes obvious when one glances through this bibliography. There is an abundance of publications pertaining mainly to three areas: jazz, folk music, popular music. All three, if judged only by the amount of literature written about them, are significant and truly American in nature. Likewise, there is much material available on regional studies, including writings about opera as part of local musical activity. A comparative scarcity is noticeable, on the other hand, in the documentation of church and religious music, despite some valuable publications in this field. Another area which has not received enough attention is that of musical journalism from the past to the present.

All the material cited here concerns writing about American music and musical practice in America from the early days to now. Some works included here devote only part of their content to the subject at hand. They present, however, a comprehensive or somewhat unusual view of American music, or contain valuable material, so that their incorporation into this American bibliography seems justified. This is true particularly for bibliographies, indexes, and other general reference works that incorporate information worth reporting to a student in American studies. An example in point is Theodore N. Finney, *Catalogue of Music and Books Printed before 1801* [R31], which, despite its international orientation, may be valuable since it refers to eleven American titles of the eighteenth century.

Of the two bibliography groups under the rubric Reference Works, the *first* lists international or more general material which does not deal exclusively with American music. Here, as in similar cases, the partial contents on American topics are mentioned in the annotation. The *second* bibliography group refers to American literature only. I already implied that the rare, or even the obscure, is favored at times while more current publications may be neglected. My intent here is to suggest that some obsolete titles, apparently unpromising, might round out information about specific details or simply arouse the appetite of the curious.

As mentioned before, this bibliography on American music primarily embraces material *about* music, while any publications *of* music are not within its scope. Also included are noncommercial catalogs and discographies, both demonstrative of musical creativity in America and relevant as research and reference works about music, particularly when limited to specific topics. Contrary to that, commercial catalogs or current listings of music and records are omitted. Hence no mention has been made of *Phonolog Reports*,[1] the most comprehensive listing of commercial American record releases (including pop and jazz) currently available on the market. No entry has been given to the Schwann catalog for the same reason, despite its special issue, *Bicentennial Music U.S.A.* (July 1975), which provides a sampling of American titles on records, with listings of records, tapes, articles by Irving Lowens and Oliver Daniel, and a bibliography by Richard Jackson.

Remembering that this is a bibliography of American music literature, consideration had to be given to popular and especially folk song collections. A selection is included that is significant in respect to contents or introductory text. This contribution to the history of American musical literature is clearly an accomplishment resulting from the research of collectors.

As catalogs and discographies are not included in this bibliography, neither are commercial indexes or trade listings included. Much information can be obtained from such publications as the *Billboard Encyclopedia of Music*,

[1]*Phonolog Reports*, published by Phonolog Publishing Division Trade Service Publications, Inc., Los Angeles, furnishes replacement sheets of listings three times per week, thus supplying the most up-to-date listing of records made in the United States, inclusive of releases by Deutsche Grammophon Gesellschaft and Telefunken.

published annually by Billboard Publishing Co., Inc., *Billboard* being the music industry's weekly trade newspaper. *Billboard Encyclopedia*, a yearbook, furnishes a compilation of data concerning singers, choral groups, folk music, motion pictures, records, and television. In like fashion, *The Piano and Organ Purchaser's Guide* (New York: Music Trade Co.) constitutes a New York history of the music trade since 1897. The *Guide* has been published for eighty years, more recently as *The Purchaser's Guide to the Music Industries* (Englewood, N.J.). This guide presents an extended listing of the trade, classified by many specializations, providing a description of manufacturers and other firms, their history, specialization, reputation in the trade, and other details.

Only *collective* biographies and biobibliographies are included here as a rule. Some rare exceptions were made in cases where bibliographies on single artists, or other forms of documentation, are believed to be exemplary.

Periodical and magazine literature is not included, excepting a few articles or bibliographies that have special merit. The exhaustive coverage of periodical literature on music in the *Music Index* speaks for itself, so that neither the *Music Index* nor any other periodical literature is mentioned within the body of this bibliography. [But see the editorial *Commentary* following R655.]

Publications on American music education are extremely numerous and constitute a literature of their own. This literature leans more towards matters of education and is not so much a part of the general body of historical material on music. Included in this bibliography, however, are a few items—like school histories or historical surveys—that cast a light on musical education and its social acceptance at various periods.

For the reason that we are concerned here mainly with American writing about music, foreign literature about the subject generally has been disregarded. Entries on a few foreign publications have been included if they are significant for the American scene or if they add an authentic interpretation.

A few standard reference works have also been included. Owing to its international scope, the bibliography by Vincent Dickles, *Music Reference and Research Materials* [R8], contains many books on American literature and discography. Another bibliography, also with an international orientation, appeared recently; *see now* Guy A. Marco, *Information on Music: A Handbook of Reference Sources in European Languages* (Littleton, Colo.: Libraries Unlimited, 1975), vol. 1: *Basic and Universal Sources*. Some of the titles listed in both these reference works are also shown as entries in this bibliography. The fundamental bibliography of Richard Jackson, *United States Music: Sources of Bibliography and Collective Biography* [R18] is the only publication that conforms with our objective in respect to American music. Here especially, duplication in the citation of titles could hardly be avoided; yet the difference between bibliographers becomes obvious in the design of their respective works.

ARRANGEMENT

The arrangement and classification of the materials in this bibliography follows the usual pattern. Reference books, when specialized, are placed under subject subheads rather than in the general section on reference material. In cases where contents refer to more than one subject category, code numbers are used for cross-references. Such internal references are supplied sparingly.

Most of the work for this bibliography was done in the Music Division of The New York Public Library at Lincoln Center, and in the Music Division and Archive of Folk Song of the Library of Congress, Washington, D.C. The massive holdings of both libraries would have justified continued pursuit of documentation which, unfortunately, had to draw to a close. The work would not have been possible without the generosity and kind assistance I received from Richard Jackson, chief of the American Collection in the Music Division of The New York Public Library; the staff of the Music Division; Gary G. Gisondi and his colleague of The Rodgers and Hammerstein Archives of Recorded Sound, The New York Public Library, Lincoln Center; Joseph C. Hickerson, Head of the Archive of Folk Song, Music Division, Library of Congress; Jon Newsom, Reference and Acquisitions Librarian, Music Division, Library of Congress. To all my sincere thanks. Above all, I thank Bernard Karpel, editor of the over-all work, for the encouragement he has extended.

BERTRUN DELLI

GENERAL WORKS AND REGIONAL STUDIES

Reference Works

GENERAL BIBLIOGRAPHY

Bibliographies of a general nature — concerning all topics in the literature about music — offer a substantial body of writing. Bibliographies appended to monographs are not listed under this rubric, but rather are annotated in individual entries.

R1. **American Council of Learned Societies.** COMMITTEE ON MUSICOLOGY: A REPORT ON PUBLICATION AND RESEARCH IN MUSICOLOGY AND ALLIED FIELDS IN THE UNITED STATES, 1932–1938. Washington, D.C., 1938. 86 p.

Included are a bibliography of titles collected from non-musicological publications; twenty-six periodical articles on American music; and a listing of graduate theses accepted in the United States between 1932 and 1938. This list of theses contains fifteen titles on American music.

R2. **Basart, Ann Phillips.** SERIAL MUSIC: A CLASSIFIED BIBLIOGRAPHY OF WRITINGS ON TWELVE-TONE AND ELECTRONIC MUSIC. Berkeley and Los Angeles: University of California Press, 1961. 164 p. UNIVERSITY OF CALIFORNIA BIBLIOGRAPHICAL GUIDES.

A bibliography of philosophical, historical, and analytical works on serial music, written in English, German, French, and Italian. Included are selections by and about American composers such as Milton Babbitt, John Cage, Hans Jelinek, Ernst Krenek, R. Leibowitz, Humphrey Searle. Igor Stravinsky and others are also included.

R3. **Morgan, Hazel B., comp.** BIBLIOGRAPHY OF RESEARCH: THESES PROJECTS, DISSERTATIONS. Evanston, Ill.: Northwestern University School of Music, 1958. 47 p.

A bibliography, listed alphabetically by author, on topics of research in the fields of the history, education, and the theory of music and organography. Studies in progress are included, as are entries for Afro-American, American, Spanish-American, twentieth-century American, and some local American topics. The bulk of the entries (927 entries, in fact) are on non-American topics.

R4. **Bryant, Eric Thomas.** MUSIC. New York: Philosophical Library, 1965. 84 p.

This descriptive bibliography is a guide to some 250 titles

in print. An introduction for the amateur music lover and young librarian, the work does not include books for the professional musician. Included are a gramophone record guide; bibliographies; standard reference aids.

R5. **Coover, James B.** A BIBLIOGRAPHY OF MUSIC DICTIONARIES. Typewritten. Denver: Denver Public Library, Center for Bibliographic Research, 1952. 81 p. SPECIAL BIBLIOGRAPHIES, NO. 1.

A bibliography of approximately eight hundred musical dictionaries; half of these are distinct titles, and half are varied editions of the same works. This is a most interesting compilation of hard-to-find bibliographical material, in particular on American publications of the late nineteenth century and earlier. Recommended to all musicology students.

R6. **Darrell, R. D., comp.** SCHIRMER'S GUIDE TO BOOKS ON MUSIC AND MUSICIANS. New York: G. Schirmer, 1951. 402 p.

One of the key listings of music literature available at the time of publication. Full bibliographical information, often with succinct annotations. Apparent prevalence of American publications. Subject and author entries. An introduction and notes are included.

R7. **Davies, John H.** MUSICALIA: SOURCES OF INFORMATION ON MUSIC. Oxford and New York: Pergamon Press, 1969. 196 p.

In a useful textbook, the music librarian of the British Broadcasting Corporation presents a conversational bibliography and discography, mostly of British and American publications. Working from his many years of practical experience, the author supplies guidelines to American music and its sources in American jazz and secular music.

R8. **Duckles, Vincent.** MUSIC REFERENCE AND RESEARCH MATERIALS: AN ANNOTATED BIBLIOGRAPHY. 3d enl. ed. New York: Free Press, 1974. 542 p.

The third enlarged edition of this standard publication for music research adds to its already wide coverage of international reference works new material on the history of music in pictures, and new individual composer entries. Though international in scope, the bibliography cites an extensive number of publications pertaining to American music, composers, recordings, and activities.

R9. **Krohn, Ernst C., comp.** THE HISTORY OF MUSIC: AN INDEX TO THE LITERATURE AVAILABLE IN A SELECTED

GROUP OF MUSICOLOGICAL PUBLICATIONS. Typewritten. St. Louis: Washington University, 1952. 484 p. WASHINGTON UNIVERSITY LIBRARY STUDIES, NO. 3.

An index of articles and book reviews of twelve scholarly periodicals, among them the publications of the American Musicological Society: *Musical Quarterly* and *Modern Music.* Classified by historical periods, the index contains no annotations, but does include considerable information on American composers and topics, as well as notes on book reviews and music reviews.

R10. **Mixtera, Keith E.** AN INTRODUCTION TO LIBRARY RESOURCES FOR MUSIC RESEARCH. Typewritten. Columbus: Ohio State University, College of Education, School of Music, 1963. 64 p.

A concise bibliography of international literature on music, including many standard American publications of music bibliography and history. Classified by published form: periodicals, collections of essays, editions of complete works.

R11. **New York. The New York Public Library.** SELECTED LISTS OF WORKS IN THE NEW YORK PUBLIC LIBRARY. New York, 1908. 36 p.

The bibliography is divided into two main sections: a listing of general works on music history; and a listing of works on music history in specific countries. The first section includes selections in English, French, German, and Italian. The section on the United States consists of local topics on music, dating from the late nineteenth century.

R12. **Pruett, James, comp.** A CHECKLIST OF MUSIC BIBLIOGRAPHIES AND INDEXES IN PROGRESS AND UNPUBLISHED. Typewritten. Ann Arbor: University of Michigan, School of Music. 1969. 25 p. MUSIC LIBRARY ASSOCIATION SERIES, NO. 3.

One hundred and fifty entries of publications in musicology (history, music bibliography, indexes) in preparation at various universities and colleges or by private individuals in the United States. Various entries on American topics.

R13. **Krehbiel, Henry Edward.** MUSIC. In: STURGIS, RUSSEL, ed. ANNOTATED BIBLIOGRAPHY OF FINE ART. Philadelphia and Boston: American Library Association, 1897. 89 p.

Issued by the publishing section of the Library Bureau of the American Library Association, this bibliography of music literature still reflects a European-oriented view of music prevailing during the nineteenth century. There are only seven citations of American publications on American topics and four citations of American music journals. Descriptive critical annotations.

R14. **Taut, Kurt.** VERZEICHNIS DER IN ALLEN KULTURLÄNDERN IM JAHRE 1929 ERSCHIENENEN BÜCHER UND SCHRIFTEN ÜBER MUSIK. SONDERDRUCK AUS DEM JAHRBUCH DER MUSIKBIBLIOTHEK PETERS FÜR 1929. Leipzig: Verlag C. F. Peters, 1930. 55 p.

A classified bibliography of German, French, Italian, Dutch, English, and American music literature, listing nearly forty publications by American authors on American topics.

AMERICAN BIBLIOGRAPHY

R15. **Bloomfield, Daniel.** A GUIDE TO MUSICAL LITERATURE IN CURRENT PERIODICALS. *The Musician* (July 1910): p. 445.

A short guide, published by Oliver Ditson Co., of the current periodical literature at the beginning of the twentieth century in America.

R16. **Edmunds, John, and Boelzner, Gordon.** SOME TWENTIETH-CENTURY AMERICAN COMPOSERS: A SELECTIVE BIBLIOGRAPHY. New York: New York Public Library, 1959. vol. 1. 57 p., illus. (ports.).

A bibliography for fifteen composers, with selections by and about them, covering the period between 1940 and 1959. Alphabetical listing of composers with bibliographies classified by type of writing or work. References to Bakers's Biographical Dictionary of Musicians and other standard publications. Listed are Henry Brant, John Cage, Elliott Carter, Aaron Copland, Henry Cowell, Roy Harris, Lou Harrison, Alan Hovhaness, Charles Ives, Harry Partch, Wallingford Riegger, Carl Ruggles, Roger Sessions, Virgil Thomson, and Edgar Varèse. The introduction by Peter Yates gives short stylistic characterizations of the composers listed, noting some of their traditional roots or differences. [*See* R16a.]

R16a. **Edmunds, John, and Boelzner, Gordon.** SOME TWENTIETH-CENTURY AMERICAN COMPOSERS: A SELECTIVE BIBLIOGRAPHY. New York: New York Public Library, 1960. vol. 2. 55 p., illus. (ports.).

Lists seventeen composers and their bibliographies. Classification of writings "by and about," as in vol. 1. Listed are Samuel Barber, Leonard Bernstein, Marc Blitzstein, Paul Creston, Norman Dello Joio, David Diamond, Lukas Foss, Peggy Glanville-Hicks, Howard Hanson, Leon Kirchner, Peter Mennin, Douglas Moore, Walter Piston, Quincy Porter, William Schuman, Randall Thompson, and Ben Weber. Definition of individual styles in introduction. Appendix supplies index of composers listed in standard reference works. Included is an introductory essay by Nicolas Slonimsky. [*See* R16.]

R17. **Hixon, Donald L.** MUSIC IN EARLY AMERICA: A BIBLIOGRAPHY OF MUSIC IN EVANS. Typewitten. Metuchen, N.J.: Scarecrow Press, 1970. 623 p.

This bibliography is an index to the music of seventeenth- and eighteenth-century America published in Charles Evans's *American Bibliography* and in the Readex Corporation's MICROPRINT EDITION of *Early American Imprints, 1639–1800,* edited by Clifford K. Shipton of the American Antiquarian Society. Every item containing printed musical notation, books, pamphlets, or broadsides (issued separately or as part of a larger collection)

has been entered. Periodicals, newspapers, and other serial publications have been omitted. *Pt. 1:* Music in early America, a bibliography: an alphabetic listing of composers, editors, compilers of all items currently available in the *Early American Imprints* microprint edition, including serial number supplied by Evans. Title entries are mentioned only when the author is unknown. Composer-title analytics are given only for each collection of secular music. *Pt. 2:* Music currently not reproduced in *Early American Imprints*, 1639–1800: an alphabetical listing of composers, editors, compilers found in Evans and representing those items not yet reproduced in *Early American Imprints* microprint. *Pt. 3:* Biographical sketches of the composers. *Pt. 4:* Composer-compiler index. *Pt. 5:* Title index. *Pt. 6:* Numerical index.

R18. **Jackson, Richard.** UNITED STATES MUSIC: SOURCES OF BIBLIOGRAPHY AND COLLECTIVE BIOGRAPHY. New York: The City University of New York, Brooklyn College, Department of Music, Institute for Studies in American Music, 1973. 87 p.
INSTITUTE FOR STUDIES IN AMERICAN MUSIC MONOGRAPHS, NO. 1.

The first and only reference guide to sources in American studies, comprising biographic and bibliographic works that pertain to historical, regional, and topical studies. An excellent basic collection of titles with descriptive critical annotations.

R19. **Krohn, Ernst C.** THE BIBLIOGRAPHY OF MUSIC. *The Musical Quarterly* 5 (1919): 231–54.

Krohn's article in *The Musical Quarterly*, edited by Oscar G. Sonneck, is a brief review of music bibliography from the fifteenth century (the work of Tinctoris) to the twentieth century and the bibliographical leadership of Sonneck at the Library of Congress. It describes the music collections in the Boston Public Library, the Lenox Library of New York City, and the Newberry Library in Chicago. Also listed are the standard bibliographies and all publications on American music between 1860 and 1917.

R20. **Larson, William S.** BIBLIOGRAPHY OF RESEARCH STUDIES IN MUSIC EDUCATION, 1949–1956: A PUBLICATION OF THE MUSIC EDUCATORS NATIONAL CONFERENCE, WASHINGTON, D.C. *Journal of Research in Music Education* 5 (fall 1957): 61–225.

This bibliography covers most of the research studies in music education that were done in the United States between 1949 and 1956. It is supplementary to the previous compilation: "Bibliography of Research Studies in Music Education 1932–1948." Presented in 1949 by the Music Educators Research Council at the Music Educators National Conference in Chicago. The titles are listed by state, university, and college, and also in a topical index. The bibliography reflects music education in the United States, pertaining to all levels of education and types of schools, including summer camps, as well as festivals and experimental and methodical studies. This volume is the *1950 supplement* to the SECOND EDITION and is included in the volume under discussion for 1949–1956.

R21. **Sonneck, Oscar G.** BIBLIOGRAPHY OF EARLY SECULAR AMERICAN MUSIC: EIGHTEENTH CENTURY. Rev. and enl. ed. Washington, D.C.: Library of Congress, Music Division, 1945. 632 p.

This bibliography, edited by William Treat Upton and prefaced by O. G. Sonneck, is the first fundamental reference work on early printed music in America, mostly before 1800. Listed alphabetically by title are original American hymns, songs, airs, marches, anthems, ballads, chamber music compositions, as well as arrangements of European works. Included are indexes of articles and essays; an index of composers, with dates, composition titles, and occasional biographies; and an index of publishers, printers, engravers (with valuable information about early American music publishing). Listings are by city and subdivided by type, including music publishers, general publishers, printers, and engravers; songsters; first lines; American patriotic music and opera librettos. Also included are additional notes about singers, actors and actresses, playwrights, and pseudonyms.

R22. **Turpie, Mary C.** AMERICAN MUSIC FOR THE STUDY OF AMERICAN CIVILIZATION. Typewritten. Minneapolis: University of Minnesota, Program in American Studies. 1955. 91 p.

This bibliography serves as a guide to resources for the study of American civilization through music. Included is a list of compositions; about 130 composer entries, including long-playing records with label and number; and short annotations, noting mood and folk idiom. In addition, 474 entries of American folk and popular songs are listed by title, with information about author, bibliography, and recordings. Fourteen entries on musical shows are also provided.

R22a. Washington, D.C. **Library of Congress.** CATALOG OF PRINTED CARDS: MUSIC M: ML: MT, COMPILED BY LIBRARY OF CONGRESS. Chicago: Bibliography Press, 1976. 10 vols.

Announcement: "Of the over 6 million titles cataloged by the Library of Congress through 1975, over 290,147 are classified under Music (which create by far the most complete, up to date, and comprehensive bibliography of books on Music M:ML:MT." This edition has two parts: 1. Pre-1976 cumulation, 10 vols., full L.C. card information, 5,802 p.; 2. 1976 quarterly supplements. Cards arranged by L.C. classification, index (vol. 10) by author, title, series, L.C. number, L.C. subject heading, Dewey decimal number. Also transliteration into English of "non-Roman alphabet titles." Edition available as printed volumes or as microfiche in binders.

R23. Washington, D.C. **Library of Congress.** A GUIDE TO THE STUDY OF THE UNITED STATES OF AMERICA: REPRESENTATIVE BOOKS REFLECTING THE DEVELOPMENT OF AMERICAN LIFE AND THOUGHT. PREPARED UNDER THE DIRECTION OF ROY P. BASLER BY DONALD H. MUGRIDGE AND BLANCHE P. MCCRUM. Washington, D.C.: Library of Congress, 1960.

Chaps. 24 and 25 of this bibliography are of particular interest to the researcher in American music. The former

contains material on folklore; folk music; folk art; folk songs and ballads; and games and dances. The latter is a bibliography on music, classified by categories, with a general introduction to the bibliography of American music of the past. Extensive annotations are provided.

R24. **Weichlein, William J.** A CHECKLIST OF AMERICAN MUSIC PERIODICALS, 1850–1900. Typewritten. Detroit: Information Coordinators, 1970. 103 p.
DETROIT STUDIES IN MUSIC BIBLIOGRAPHY, NO. 16.

Many of the periodicals concern areas other than music and are listed under the original title with cross references to later titles. Complete subtitles and reference to citations in other lists and catalogs are also included. Appendixes include a chronological register of American music periodicals from 1850 to 1900, with number, year, title, location of publication, and geographical distribution.

R25. **Wolfe, Richard J.** SECULAR MUSIC IN AMERICA, 1801–1825: A BIBLIOGRAPHY. New York: New York Public Library, Astor, Lenox & Tilden Foundations, 1964. 3 vols., illus.

This work is an extensive study of all secular music published in America from 1800 to 1825. It includes nearly ten thousand musical titles. The titles are listed by composer, with detailed annotations. Also provided are the address of printer or publisher, listing all individual pieces of bound collections as well as identifying the various prints of the same piece. The three appendixes supply information to eighteenth-century printed material and the work of Upton and Sonneck [*see* R21]. Biographical sketches of relatively unknown composers and arrangers are included. Indexes include titles, first lines, publisher, engravers, printers, publisher's plate, and numbering systems. Introduction by Carleton Sprague Smith.

CATALOGS

R26. **The American Society Composers, Authors, and Publishers.** THE AMERICAN SOCIETY OF COMPOSERS, AUTHORS, AND PUBLISHERS SYMPHONIC CATALOG. 2d ed., New York, 1966. 375 p.

Mentioned are approximately 17,000 works, nearly all by American composers who are members of the American Society of Composers, Authors and Publishers. *Supplement* (1966).

R27. **Atwater, Lewis.** PROGRAM OF MUSIC OF WASHINGTON'S TIME. Washington, D.C., 1932. folio.

This is a one-folio program of a concert presented at a Unitarian church in Washington, D.C., by the organist L. Atwater and bass Charles Tittmann. The music dates from George Washington's era and was probably known to him. Listed are works by Philip Phile, Francis Hopkinson, John Palma, Alexander Reinagle, Dr. Samuel Arnold, Pierre Landrin Duport, James Brenner, and Ray-

nor Taylor. Annotations on the composers are also provided.

R28. **Burr, Willard.** A CATALOG OF AMERICAN MUSIC COMPRISING CAREFULLY SELECTED LISTS OF THE BEST VOCAL AND PIANOFORTE COMPOSITIONS BY AMERICAN COMPOSERS, GIVING KEY, GRADE, COMPASS, AND PRICE. Philadelphia: Theodore Presser Publisher, 1887. 10 p.

This "first catalog of representative American music" as claimed by the author, was prepared from lists that had previously appeared in monthly issues of *Etude*. It lists 220 piano pieces and 66 vocal pieces by composers such as Dudley Buck, Stephen Albert Emery, William Mason, W. F. Studds, and others.

R29. **Illinois Federation of Music Clubs.** A CATALOG OF REPRESENTATIVE WORKS BY RESIDENT LIVING COMPOSERS OF ILLINOIS. EDITED BY WILL GAY BOTTJE. Southern Illinois University, Carbondale, Ill. 1960. 28 p.

A catalog of works for piano, organ, voice, chorus, and chamber music combinations up to eight players, classified by instrumental or vocal categories. The biographical sketches of all composers listed may be valuable as some of the artists are known only regionally.

R30. **Eagon, Angelo.** CATALOG OF PUBLISHED CONCERT MUSIC BY AMERICAN COMPOSERS. Metuchen, N.J.: Scarecrow Press. 1969. 348 p.

An extensive collection of works from various categories of music, generally available for purchase in printed form. Information provided includes composer, title of work, publisher, voice range solo or type of accompaniment, author of score and duration for choral and instrumental works. Indexes include composers, authors and sources of texts for vocal music and narrations. *Supplement to* SECOND EDITION (1971, 150 p.) contains a list of organizations from which electronic music can be rented.

R31. **Finney, Theodore Mitchell.** A UNION CATALOG OF MUSIC AND BOOKS ON MUSIC PRINTED BEFORE 1801 IN PITTSBURGH LIBRARIES. Typewritten. 2d ed. University of Pittsburgh, 1963. 109 p.

A list of works in Carnegie Library, the University of Pittsburgh Library, Finney private library, and Library of St. Vincent College, Latrobe, Pa. This catalog serves as a complementary list to the Library of Congress: Catalogue of Early Books on Music, by Julia Gregory and O. G. T. Sonneck, supplemented by Hazel Bartlett. The list contains mostly European publications, with the exception of eleven American titles of the second half of the eighteenth century; some are second or later editions of previously cited items. *Supplement* (1964), 42 p.

R32. **Fisher, Gladys W.** A GUIDE TO PENNSYLVANIA MUSIC. Typewritten. Pennsylvania Federation of Music Clubs, 1951. 35 p.

Provided are nearly five hundred compositions of composers, listed by name. The works are categorically classified, covering all periods of the state's history.

R33. The Edwin A. Fleisher Music Collection in the Free Library of Philadelphia: A Descriptive Catalogue. Philadelphia: Privately printed, 1965. 2 vols.

Vol. 1 lists the basic collection of scores collected by E. A. Fleisher for his orchestras of young players between 1909 and 1933. Vol. 2 continues the list of works added to the collection from 1933–1945 with a supplementary list for 1945–1955. The catalog contains, besides an international music repertoire, a large number of American orchestral works, many of which were not published but obtained for the library by copying from the original manuscript. (Between 1934 and 1943 nearly 2000 unpublished works were copied.) In an appended geographical summary based on the composers' birthplace, more than thirty-eight American states are represented. *Supplement* (1945–1966), 9 p.

R34. **Handy, W. C.** Negro Authors and Composers of the United States. New York: Handy Brothers Music Co., 24 p., illus. (port.)

Provided are lists of black composers and other authors, their major compositions, and other music-related accomplishments. Included also is data on compositions published by Handy Brothers, with composers listed by race. Bibliography.

R35. **International Music Council.** Musique Symphonique, 1880-1954, vol. 1. In: Répertoires internationaux de Musique contemporaine a l'Usage des Amateurs et des Jeunes. Frankfurt, London, and New York: C. F. Peters, 1957. vol. 1, 63 p.

Contemporary music for amateur and youth orchestras, compiled by representatives of various countries. Works are listed by country; for the United States, forty-nine orchestral works by twenty-five composers. Foreword by Benjamin Britten; preface by Samuel Band-Bovy; introduction and tables by Vladimir Federov.

R36. **Lowens, Irving.** Choral Music of America before the Civil War: A List of Works Available in Modern Editions. Typewritten. New York: New York Public Library, 1958. 7 p.

Classified listing of titles by historical groups, including one chapter containing pre–Civil War choral music. Listing by composer, if known, or by title, with year and symbol of reviewing magazine. A list of about 150 titles.

R37. **Playground and Recreation Association of America.** Music Composed by Negroes. Typewritten. 192(?). 7 p.

Provided here are songs in the form of sheet music, listed by publisher. Other works are listed under the following composers: Harry T. Burleigh, Will Marion Cork, S. Coleridge-Taylor, R. Nathaniel Pett, Carl R. Diton, J. Rosamond Johnson, Clarence Cameron White. Bibliography.

R38. **United States Information Agency.** Catalog of Published Concert Music by American Composers. Washington, D.C.: USIA, Information Center Service, Music Branch, 1964. 175 p.

A list of American concert compositions, classified by categories, including nearly 430 American composers. Also identified are titles, voices, and types of instrument. A list of publishers with addresses is included.

R39. Dallas and Tyler, Tex. **Whittle Music Company.** Texas Composers: A Listing of Their Works and Arrangements. Dallas and Tyler. 1955. 16 p.

A published list of 791 compositions, classified by category, listed by composer.

INDEXES

R40. **Belknap, S. Yancey, comp.** Guide to the Musical Arts: An Analytical Index of Articles and Illustrations, 1953-56. Typewritten. New York: Scarecrow Press, 1957. unpag.

This is an index of approximately five hundred pages consisting of about 15,000 articles and 6,000 illustrations appearing in leading American, Canadian, and British periodicals from 1953 to 1956. The work includes material from a Spanish, an Italian, and a French periodical. Much information is provided about contemporary music life, American composers, and American works.

R41. **De Charms, Désirée, and Breed, Paul F.** Songs in Collections: An Index. Detroit: Information Service, 1966. 627 p.

With this index of 9,493 songs from 411 collections, the authors continue the tradition of song reference books that was started by Minnie Earl Sears [R47] and Helen Grant Cushing [R42]. Foreign compositions are indicated by language, although the majority of songs are American. Listed in two parts: by composer and song title (or all titles of large work), first line, first line in English, text author; song title, title of tune, variations of title. All of the songs that the authors have included have piano accompaniment and were published between 1940 and 1957. Although the collections consist mainly of art and operatic songs, some folksong anthologies, Christmas carols, sacred and community songs are also included.

R42. **Cushing, Helen Grant, comp.** Children's Song Index: An Index to More Than 22,000 Songs in 189 Collections Comprising 222 volumes. New York: H. W. Wilson Co., 1936. 840 p.

Songs mainly in English, but with some French, Dutch, and German songs included. By using the same indexing policies, the author intended to relate this index to the index compiled by Minnie Earl Sears [R47]. Indexes include song titles (in the case of variations), with entries under title, composer, author, and subject, as well as references for first lines of songs. Eleven song collections indexed overlap with Sears's. Also contains the collections that were incorporated into the index by Margery Closey Quigley [R46]. Bibliography.

R43. **Devine, George Johne.** American Songsters, 1806-1815. M.A. thesis, Brown University, 1940. 380 p. [*cont.*]

The Harris Collection, which contains a listing of 1,780 songs of 38 songsters, is housed at Brown University, Providence, R.I., and at the American Antiquarian Society, Worcester, Mass. George Devine has here identified 747 of these songs. Indexes (first line, authors and composers, and topic); and bibliographies (individual and general).

R44. **Leigh, Robert.** INDEX TO SONG BOOKS. A TITLE INDEX TO OVER 11,000 COPIES OF ALMOST 6,800 SONGS IN 111 SONG BOOKS PUBLISHED BETWEEN 1933 AND 1962. Stockton, Calif.: Privately published, 1964.

A title index of songs with words and tunes in American publications. Some of these song books contain songs from all over the world, also operatic songs. The index supplies references from alternate titles and memorable lines, yet gives no composer or author entries, nor information about genre or nationality. Different from Sears *Song Index* [R47] with regard to indexing methods and information rendered, this index continues with recorded songs for quick reference where the Sears *Supplement* (1934) [R47] left off.

R45. **Lewis, Arthur Ansel.** AMERICAN SONGSTER, 1800–1805. M.A. thesis, Brown University, 1937. 306 p.

This thesis examines twenty-one songsters published in the first five years of the nineteenth century, now included in the Harris collection at Brown University, Providence, R.I. The author indexed the contents of these songbooks, listing 1,300 songs, many of which the author or composer identified. Also provided are indexes of first lines; authors and composers; topics; and individual songsters. A tool for further research in related areas, this index complements two other theses: Thorpe [R48] and Devine [R43].

R46. **Quigley, Margery Closey.** INDEX TO KINDERGARTEN SONGS INCLUDING SINGING GAMES AND FOLK SONGS. Chicago: American Library Association Publishing Board, 1914. 298 p.

Indexed are sixty-three songbooks containing kindergarten and folk songs mostly of American origin. They are listed by title with name of author, if known. The work of this index was continued and amplified by Helen Grant Cushing [R42].

R47. **Sears, Minnie Earl; with the assistance of Phyllis Crawford.** SONG INDEX: AN INDEX TO MORE THAN 12,000 SONGS IN 177 SONG COLLECTIONS COMPRISING 262 VOLUMES. New York: H. W. Wilson Co., 1926. 2 vols.
STANDARD CATALOG SERIES.

Most of the 177 song collections indexed in these two combined volumes were published in the United States, some in Great Britain, one in Germany. Although the majority of the material indexed is representative of the American song, many of the collections contain songs from all over the world, mostly translated into English. The songs are entered under title, composer, author of text, with references from the first lines of songs to titles.

The collections comprise national and folk songs, chanteys, Christmas carols, sacred songs, school and college songs. A publication complementary to this 682-page index was issued in 1936 by Helen Grant Cushing [R42]. *Supplement* (1934). REPRINT (Hamden, Conn.: Shoe String Press, 1966), 2 vols in 1, 682 p.

R48. **Thorpe, Alice Louise.** AMERICAN SONGSTERS OF THE EIGHTEENTH CENTURY. M.A. thesis, Brown University, 1935. 2 vols., 365 p.

An analysis of eighteenth-century American songsters—mostly without melodies—published in the second half of the eighteenth century, particularly during the 1790s. Most of these songsters are contained in the Harris Collection at Brown University. Thorpe presents twenty-two of the eighty-four songsters known to have existed, identifying the authors and composers in 480 cases. Sixteen songsters alone account for 1,451 songs. The songs are listed by first lines, authors, and topics. This work supplies valuable material for studies in related areas and should be considered together with theses by Devine [R43] and Lewis [R45]. List of songsters; bibliography.

DISCOGRAPHY

Discographies listed here comprise American works or international records and tapes, mostly serious music. Specialized discographies are located under their respective subjects. Discographical listings within textbooks are pointed out in the annotation or collation of the entry.

R49. **American Music Center.** AMERICAN MUSIC ON RECORDS: A CATALOG OF RECORDED AMERICAN MUSIC CURRENTLY AVAILABLE. New York: American Music Center; in cooperation with the National Music Council, Committee on Recordings of American Music, 1956. 39 p.

A discography of standard or serious American works listed by composer. Included are titles of other works on the same records and publisher information.

R50. CO-ART TURNTABLE. Beverly Hills, Calif. 1:4–3:5 (Dec. 1941–May 1943).

A California music magazine with the stated objectives of a "noncommercial promotion of the best of art"; Arthur Lange, publisher; Henry Lloyd Clement, editor. Annotated discography of recordings cut by *Co-Art Turntable*, presenting so far unpublished and unrecorded compositions of serious music by the following composers: César Franck, Sol Kaplan, Willy Stahl, Joseph Achron, George Tremblay, Adolph Weiss, William Grant Still, Alice Barnett, Clifford Vaughan, Arthur Lange, and Charles Wakefield Cadman.

R51. **Hall, David, and Levin, Abner.** THE DISC BOOK. New York: Long Player Publications, 1955. 493 p., illus. (ports.).

Serious music on records. A guide for building a private

record library: discussion of records, classified by instruments, periods, categories, and countries. General presentation of American music on long-playing records; issue numbers provided.

R52. **Keits, Sheila.** AMERICAN MUSIC ON LP RECORDS: AN INDEX. *Juilliard Review* 2:1–3 (1955); 3:3 (1956); 4:1, 3 (1957).

Serious American music listed by composer, title of album, noting performing orchestra and soloist, conductor, and additional compositions recorded.

R53. **Maleady, Antoinette O., comp.** RECORD AND TAPE REVIEWS INDEX. Metuchen, N.J. 1–4 (1971–1975).

This annual publication, published by Scarecrow Press, comprises an international repertoire of serious music, with many American works included. A valuable reference tool for the student of American studies. A list of record and tape reviews, which by the issue of its third volume in 1974 had grown to 571 pages. Materials are listed by composer, manufacturer, or (in the case of anonymous works) by title. Performer index.

R54. **Miller, Philip Lieson.** PHONOGRAPHIC RECORDINGS OF AMERICAN ART MUSIC. *Boletín Latino-Americano* 5 (1939).

This paper by Miller was read at the Interamerican Conference of Music held at the Library of Congress, Washington, D.C., conducted by the United States State Department in October 1939. The work includes early recordings of American music (with label and issue number), helpful for research of records available in the late 1930s. [*See* R118.]

R55. **Moses, Julian Morton.** COLLECTOR'S GUIDE TO AMERICAN RECORDINGS, 1895–1925. New York: American Record Collector's Exchange, 1949. 200 p.

A discography of single artist's recordings—singers, pianists and other instrumentalists—mostly presenting a repertoire of opera and classical music. Also provided are brief histories of some major record companies of the time. Foreword by Giuseppe De Luca.

R56. **United States Information Agency.** CATALOG OF LONG-PLAYING RECORDS: AMERICAN MUSIC. Typewritten. Florence, Italy: 1960–1961. 98 p.

A discography of some 1,200 records, listed by composer or album; an international repertoire, performed by American artists and choirs, with a majority of American compositions of varying types.

CHRONICLES, DIRECTORIES, AND HANDBOOKS

R57. **Cullen, Marion Elizabeth, comp.** MEMORABLE DAYS IN MUSIC. Metuchen, N.J.: Scarecrow Press, 1970. 233 p., illus. (ports.)

A chronicle of musical events and related data, including birth and death dates and debuts of musicians for both European and American history. The chronicle is organized by daily entries.

R58. **The National Federation of Music Clubs.** DIRECTORY OF AMERICAN WOMEN COMPOSERS; WITH SELECTED MUSIC FOR SENIOR AND JUNIOR CLUBS. COMPILED AND EDITED BY JULIA SMITH. 1970. 51 p.

An alphabetical listing of more than 850 composers, with state of origin, address, composition type and publisher. Also included is a selective list of music suitable for junior and senior clubs.

R59. **Lahee, Henry C.** ANNALS OF MUSIC IN AMERICA: A CHRONOLOGICAL RECORD OF SIGNIFICANT MUSICAL EVENTS, FROM 1640 TO THE PRESENT DAY, WITH COMMENTS ON THE VARIOUS PERIODS INTO WHICH THE WORK IS DIVIDED. Boston: Marshall Jones Co., 1922. 305 p.

This chronology presents a yearly record of music in America and of historic events, noting in particular first appearances of artists, outstanding performances, festivals, and founding dates of musical institutions. Each chapter is introduced with historical sketches, relating political and other events of each fifty- or twenty-five year period. Provided is an index of compositions by composer and various lists, e.g., of ballad operas; of debuts of singers and musicians; and of festivals.

R60. **Pavlakis, Christopher.** THE AMERICAN MUSIC HANDBOOK. New York: New York Free Press, 1974. 856 p.

The standard reference guide to current activities, facts and resources of present-day American music. Over 5,000 entries provide information about performing artists and groups, communication media, educational institutions, music festivals, music industries and periodicals. Succinct description of specialization of performers with indication of major recordings. Included is a *Supplement* with information about foreign festivals, competitions, awards, and publishers.

R61. New York. **The New York Public Library, Astor, Lenox & Tilden Foundation. Committee of the Association for Recorded Sound Collections.** A PRELIMINARY DIRECTORY OF SOUND RECORDINGS COLLECTIONS IN THE UNITED STATES AND CANADA. Typewritten. New York: New York Public Library, 1967. 157 p.

The information about the collections was obtained by questionnaires, listed by state; with address, name of owner, archivist or curator. Information about the subject and the size of the collection is provided. Catalogs, articles, or additional notes about the collection are noted. Also mentioned is the curator's willingness to exchange materials.

R62. **Redway, Virginia Larkin.** MUSIC DIRECTORY OF EARLY NEW YORK CITY: A FILE OF MUSICIANS, MUSIC PUBLISHERS, MUSICAL INSTRUMENT MAKERS LISTED IN NEW YORK DIRECTORIES FROM 1786 THROUGH 1835, TOGETHER WITH THE MOST IMPORTANT NEW

YORK CITY MUSIC PUBLISHERS FROM 1836 THROUGH 1875. New York: New York Public Library, 1941. 114 p.

"A guide to date music imprints"—for this purpose, the main sections (pts. 1 and 3) should be especially helpful since there are lists of publishers, printer-lithographers, dealers, and instrument makers. All names listed, of musicians, teachers, dancing masters, are supplied with address, years of residence, and change of address. Chronological list of all firms and individual names for 1786–1811; list of musical societies for 1789–1799.

R63. **Siegmeister, Elie, ed.** THE NEW MUSIC LOVERS HANDBOOK. Irvington-on-Hudson, N.Y.: Harvey House Publishers, 1973. 620 p., illus. (ports.).

A handbook by eighty-eight contributors giving a survey of various aspects of music, such as folk music, technique and structure, historical periods, theater, ethnomusicology and biographical sketches on modern composer. Twelve authors write in twelve articles about jazz, rock and folk music in America. Among the American composers mentioned are Charles Ives, Virgil Thomson, George Gershwin, Aaron Copland, John Cage, and Leonard Bernstein. Music extracts; bibliography.

R64. **Slonimsky, Nicolas.** MUSIC SINCE 1900. New York: Charles Scribner's Sons. 1971. 614 p.

This descriptive chronology is meant to be "a sort of newsreel of musical events": recording facts and complete programs of festival events, and descriptions of concert premieres, with information on composers, performers, and notes on the new works. Collection of letters and documents in second section. Bibliography.

R65. THE YEAR IN AMERICAN MUSIC. New York. 1 (Sept. 1946–May 1947). 591 p.

This yearbook published by Allen, Towne & Heath discusses concert activities in the United States during the winter season of 1946/1947, recorded chronologically by month. Cross-referenced. Special attention is given to new developments, personalities, and areas in which music was playing a more important role, such as radio, theater, and film. Appendixes include composers in America listed alphabetically, with information about training, first performances, published works, awards, and honors. Orchestras are listed by city, with number of yearly concerts provided. Pertinent information is provided on individual orchestras and opera companies, both of which are listed by city. Annotated bibliography of American publications; discography. Edited by Julius Bloom. [See also R 65a.]

R65a. THE YEAR IN AMERICAN MUSIC. New York. 2 (June 1, 1947–May 31, 1948). 551 p.

Vol. 2 serves as a daily chronicle of significant events and developments in American concert life from June 1, 1947 to May 31, 1948. Appendixes include musicians in the news, composers in America, world premieres, American premieres, festivals, orchestras, opera companies, and awards. Discography; bibliography. Edited by David Ewen. [See also R 65.]

DICTIONARIES AND ENCYCLOPEDIAS

Of the many encyclopedias on music, those listed here were chosen because they give special attention to American references. By this criterion, many standard works had to be excluded despite their inclusion of extended articles on American music; see, for example, *Die Musik in Geschichte und Gegenwart*, ed. Friedrich Blume (Kassel and Basel: Bärenreiter Verlag, 1949–1967), 14 vols. plus supplements.

R66. **Apel, Willi.** HARVARD DICTIONARY OF MUSIC. 2d rev. and enl. ed. Cambridge, Mass.: Belknap Press of Harvard University, 1969. 935 p.

One of the standard, internationally used dictionaries. This work provides extensive articles on American music surveying its history, trends, and personalities in the nineteenth and twentieth centuries; American Indian music, with a bibliography of sources from 1909 to 1961; folk songs, with an Anglo-American bibliography; Jewish music; the organ in American music; jazz and Negro music. Libraries in the United States constitute a large section.

R67. **Pratt, Waldo Selden, and Charles N. Boyd, eds.** GROVE'S DICTIONARY OF MUSIC AND MUSICIANS. 3d ed. New York: Macmillan Co., 1935. vol. 6, 445 p., illus. (ports.).

This appended volume to Grove's dictionary, the American *supplement*, is entirely devoted to domestic music, musicians, and musical institutions. The paragraph on the Chicago Symphony includes a list of works by American composers or works that are associated with America, all of which (about 150 works) were played by the orchestra since 1891. A short and general introduction to the history of American music. Also short lists of the earliest concerts and operas performed, 1785–1793; of early organizations and institutions (1744–1800) that influenced musical life in America. Includes music.

R68. **Thompson, Oscar.** THE INTERNATIONAL ENCYCLOPEDIA OF MUSIC AND MUSICIANS. 3d. rev. and enl. ed. New York: Dodd, Mead & Co., 1956. 2,394 p.

Although international in its scope "it is not by chance that more space is devoted to American composers," listed with their works, dates of composition or first performances, or publications. The various articles and entries pertaining to American music include American associations and societies; music schools and colleges; American Indian music by Charles Sanford Skilton; American composers and organizations; American opera singers; opera and symphony, American folk music (with bibliography); musical instrument collections in America; Jewish music; and music libraries. Includes music.

R68a. **Tinctoris, Jean.** DICTIONARY OF MUSICAL TERMS. TRANSLATED AND ANNOTATED BY CARL PARRISH. New York: Free Press, 1963. 108 p.

ORIGINAL EDITION: *Johannes Tinctoris: Terminorum musicae diffinitorium* (Naples, 1472/73).

R69. **The Lynn Farnol Group, comp. and ed.** THE ASCAP BIOGRAPHICAL DICTIONARY OF COMPOSERS, AUTHORS, AND PUBLISHERS. New York: American Society of Composers, Authors, and Publishers, 1966. 850 p.

Short entries for composers, authors, and publishers who are members of the society: indication of professional specialization; biographical data; education and training; professional achievements; list of outstanding compositions. A compilation of 5,238 entries for mostly American composers and authors of serious and popular works. Separate listing of publishers.

COLLECTIVE BIOGRAPHY

Some of the publications compiled here are biographical dictionaries; others comprise collections of biographical sketches or extended articles on musicians. Biographical information can be found also in handbooks, dictionaries and discographies. For biographical material on musicians active in folk music, jazz, and popular music, see R214 et seq., R273 et seq., R407 et seq., and R517 et seq. See also R97, R117, R135, R153, R155, R159, R173, R174, R194, R209, and R271.

R70. **Bakelees, Katherine Little.** IN THE BIG TIME: CAREER STORIES OF AMERICAN ENTERTAINERS. Philadelphia and New York: J. B. Lippincott Co., 1953. 211 p., illus. (ports.)

Biographical chapters on thirteen personalities, seven of whom are musicians and singers: Marian Anderson, Bing Crosby, Hildegarde, Burl Ives, Patrice Munsel, Eugene List, and Yehudi Menuhin. Included are descriptions of their artistic education and early careers. Bibliography.

R71. **Baker, Theodore.** BIOGRAPHICAL DICTIONARY OF MUSICIANS. 5th ed. Revised by Nicolas Slonimsky. 1958. 1870 p.

Originally compiled by Dr. Theodore Baker (1851–1934), the standard biographical dictionary in English has an international scope; many American artists are recorded. Lists of major compositions with dates of first performance, pertinent publications, including significant periodical articles, professional accomplishments, and dates of European and American debuts. ORIGINAL EDITION (1900). FOURTH EDITION (1940). *Supplement* (1971), 262 p. Includes popular artists.

R72. **Barnes, Edwin N. C.** AMERICAN WOMEN IN CREATIVE MUSIC: TUNING IN ON AMERICAN MUSIC. Washington, D.C.: Music Education Publications, 1936?. 44 p.

A record of American women active in musical composition, mostly during the first third of this century. Biographical sketches arranged by birth date describe professional accomplishments and list compositions. Included are sketches of about ninety personalities, with an additional list of names.

R73. **Baxter, Clarice Howard, and Polk, Videt.** GOSPEL SONG WRITERS BIOGRAPHY. Dallas: Stamps-Baxter Music & Printing Co., 1971. 306 p., illus. (ports.)

An alphabetical listing, with individual biographies, of 102 gospel song writers. Includes portraits of each artist. Many of the writers are personally known to the Stamps-Baxter Music Printing Company, or represent church organizations such as the Handel and Haydn Society.

R74. **District of Columbia Historical Records Survey. Work Projects Administration.** BIO-BIBLIOGRAPHICAL INDEX OF MUSICIANS IN THE UNITED STATES OF AMERICA SINCE COLONIAL TIMES. Typewritten. Washington, D.C.: Pan American Union, Music division; 1941. 462 p.
MUSIC SERIES, NO. 2.

Forewords by Charles Seeger and Harold Spivacke. Introduction by H. B. Dillard. Alphabetical listing of the names of musicians, with life dates and professional specialization. References to basic bibliography of standard indexed works on American music. This list contains close to 10,000 names.

R75. **Claghorn, Charles Eugene.** BIOGRAPHICAL DICTIONARY OF AMERICAN MUSIC. West Nyack, N.Y.: Parker Publishing Co., 1973. 491 p.

An all-American biography of individuals and groups active in all fields of music, from the seventeenth century to the present. An alphabetical list of over 5,200 individuals, with short biographical sketches focusing on education, training, and musical careers. There is extensive information—on musicians and singers—otherwise hard to find in reference works.

R76. COMPOSERS OF THE AMERICAS: BIOGRAPHICAL DATA AND CATALOGS OF THEIR WORKS. Washington, D.C. (1955—).

A continuing annual published by the Pan American Union containing biographical sketches, a facsimile of a manuscript page and the compositions, listed by year, of outstanding composers of all the Americas. Composers representative of the United States are included in almost all issues.

R77. **Eichhorn, Ermene Warlick, and Mathis, Treva Wilkerson.** NORTH CAROLINA COMPOSERS AS REPRESENTED IN THE HOLOGRAPH COLLECTION OF THE LIBRARY OF THE WOMAN'S COLLEGE OF THE UNIVERSITY OF NORTH CAROLINA. Greensboro, N.C., 1945. 39 p., illus. (ports.)

A record of mid-twentieth-century composers in North Carolina. Provided is a brief history of musical activities and music clubs in North Carolina as well as fifteen biographical sketches about composers, their education, professional achievements and interests. Each entry includes short definitions of personal musical styles or citations from newspaper reviews, a list of works and a bibliography.

R78. **Hall, J. H.** BIOGRAPHY OF GOSPEL SONG AND HYMN WRITERS. New York: AMS Press, 1971. 419 p., illus. (ports.)

Fifty-six short biographical sketches on authors of gospel

songs and hymns, all with portraits. This REPRINT EDI-
TION starts with Dr. Lowell Mason, the "father of Ameri-
can church music." No bibliographic information. ORIGI-
NAL EDITION (Fleming H. Revell Co., 1914).

R79. **Howard, John Tasker.** STUDIES OF CONTEMPOR-
ARY AMERICAN COMPOSERS. New York: J. Fischer &
Bro. 1925–1929. 10 parts in one vol., illus. (ports.)

A collection of ten unpaged biographical studies that ap-
peared as individual publications between 1925 and 1929.
Each biography is accompanied by a portrait photo-
graph. In addition, reviews of the composer's work,
analysis of style and aesthetics of significant composi-
tions are provided. Included are thematic examples and a
list of published works. Biographies on Alexander
Russell, Eastwood Lane, James P. Dunn, A. Walter
Kramer, Deems Taylor, Emerson Whithorne, Bambridge
Crist, Charles Sanford Skilton, and Cecil Burleigh are in-
cluded.

R80. **Hughes, Langston.** FAMOUS NEGRO MUSIC
MAKERS. New York: Dodd, Mead & Co., 1955. 179 p.,
illus. (ports.)

Biographical sketches and success stories of the Fisk
Jubilee singers, James A. Bland, Bert Williams, Bill Robin-
son, Leadbelly, Jelly Roll Morton, Roland Hayes, William
Grant Still, Bessie Smith, Duke Ellington, Ethel Waters,
Louis Armstrong, Marian Anderson, Bennie Benjamin,
Mahalia Jackson, Dean Dixon, and Lena Horne. Also in-
cluded is a survey of famous jazz musicians.

R81. **Hughes, Rupert.** CONTEMPORARY AMERICAN
COMPOSERS; BEING A STUDY OF THE MUSIC OF THIS
COUNTRY, ITS PRESENT CONDITIONS AND ITS FUTURE,
WITH CRITICAL ESTIMATES AND BIOGRAPHIES OF THE
PRINCIPAL LIVING COMPOSERS AND AN ABUNDANCE
OF PORTRAITS, FACSIMILE MUSICAL AUTOGRAPHS,
AND COMPOSITIONS. Boston: L. C. Page, 1900. 470 p.,
illus. (ports.).

The records of one composer generation at the turn of the
century, presented in biographical chapters on musi-
cians, describing their backgrounds, musical education
and career. Included are reviews of some of the works of
Edward Alexander McDowell, Edgar Stillman Kelley,
Harvey Worthington Loomis, Ethelbert Nevin, John
Philip Sousa, Henry Schoenefeld, Maurice Arnold,
N. Clifford Page, John Knowles Paine, Dudley Buck,
Horatio W. Parker, Frank van der Stucken, W. W.
Gilchrist, G. W. Chadwick, Arthur Foote, S. G. Pratt,
Henry K. Hadley, Adolph M. Foerster, Charles Crozat
Converse, L. A. Coerne, and many more who are men-
tioned in chapters on colonists, women composers, and
foreign composers. The material is compiled from
catalogs of music publishers, manuscripts, and bio-
graphical data supplied by the composers themselves. In-
cludes music.

R82. **Knippers, Ottis J.** WHO'S WHO AMONG SOUTHERN
SINGERS AND COMPOSERS. Hot Springs National Park,
Ark.: Knippers Bros., 1937. 168 p., illus. (ports.).

Short biographies of singers and song composers, includ-

ing their education, professional activities, citations of
compositions, and portraits. Composer and song index.

R83. **Metcalf, Frank J.** AMERICAN WRITERS AND COM-
PILERS OF SACRED MUSIC. New York and Cincinnati:
Abingdon Press, 1925. 373 p., illus. (ports.).

A record of nearly one hundred eighteenth- and nine-
teenth-century hymn composers and collections, mostly
all active before 1800. Recorded is practically all informa-
tion available about the composer's work, publications,
life. Includes descriptions of various editions of his pub-
lications. Metcalf has culled his information from almost
every periodical of the nineteenth century about sacred
music, beginning with *Euterpeiad* (Boston, 1820–1823).
Also included is information from the composer's per-
sonal correspondence and from interviews with their
surviving relatives.

R84. **Parker, John Rowe.** A MUSICAL BIOGRAPHY.
Detroit: Information Coordinators, 1975. 265 p.

This work is a REPRINT of the first American biographi-
cal music dictionary published in 1824, of which some
rare copies are extant. According to the new foreword
five copies of the 1824, and nineteen of the 1825 editions
exist. The author is the eminent personality of Boston's
music life of the era, editor of the first important music
periodical, the *Euterpeiad*, from 1820 to 1823, and author
of *A Catalogue of Music and Musical Instruments* (1820).
This musical biography embraces the whole musical
world of the time reflected in biographies of world
renowned composers and performers, twenty-five of
whom are European. Listed are sketches of eight artists
active in the New World: George K. Jackson, Raynor
Taylor, Thomas Smith Webb, Miss Broadhurst, Nancy
Oldmixon, Sophia Ostinelli, Alexi Eustaphieve, and Eliza
Salmon. The compendium is concluded by eight articles
on church music and related subjects "interspersed with
an epitome on interesting musical matter." Introduction
by Frederick Freedman.

R85. **Reis, Claire Raphael.** AMERICAN COMPOSERS OF
TODAY: A CATALOGUE. New York: The International
Society for Contemporary Music, United States Sec-
tion, 1930. 50 p.

Biographical sketches of composers, American born or
living in America during the 1930s. Composers of popu-
lar music or music for voice and piano are not included.
[*See* R86.]

R86. **Reis, Claire Raphael.** COMPOSERS IN AMERICA: BI-
OGRAPHICAL SKETCHES OF CONTEMPORARY COM-
POSERS WITH A RECORD OF THEIR WORKS. Rev. and
enl. ed. New York: Macmillan Co., 1947. 415 p.

Provided are more than 330 brief biographies of com-
posers, listing their recordings, fellowships, awards, and
commissions. Included are their broadcast or recorded
works and some major performances, with years of com-
pletion, publisher and performing times. Listed are musi-
cians with at least one major performance of one of their
pieces of a larger work. No consideration is given to op-
erettas or musical comedies and their composers.

EARLIER EDITIONS (The International Society for Contemporary Music, 1930, 1932 [see R85]).

R87. **Schonberg, Harold C.** THE LIVES OF THE GREAT COMPOSERS. New York: W. W. Norton & Co., 1970. 599 p., illus. (ports.).

A European-oriented history of music presented in biographical accounts. One chapter on the "Rise of an American Tradition" discusses Louis Moreau Gottschalk, Edward Alexander MacDowell, Charles Ives, and Aaron Copland. Small bibliography.

R88. **Trotter, James M.** MUSIC AND SOME HIGHLY MUSICAL PEOPLE; CONTAINING BRIEF CHAPTERS ON A DESCRIPTION OF MUSIC, THE MUSIC OF NATURE, A GLANCE AT THE HISTORY OF MUSIC, THE POWER, BEAUTY, AND USES OF MUSIC FOLLOWING WHICH ARE GIVEN SKETCHES OF THE LIVES OF REMARKABLE MUSICIANS OF THE COLORED RACE, WITH PORTRAITS AND AN APPENDIX CONTAINING COPIES OF MUSIC COMPOSED BY COLORED MEN. New York: Johnson Reprint Corp., 1968. 504 p., illus. (ports.)

This is an early work presenting the musical achievements of black Americans. Four introductory chapters reveal a romantic view of music rooted in nature and history, succeeded by biographical sketches. Included are press reviews of concerts and other performances. Some articles on the Colored American Opera Company, the Fisk Jubilee Singers, and the Georgia Minstrels. Appendix includes thirteen complete pieces for piano or piano arrangement by William Brady, Jacob Sawyer, Justin Holland, J. T. Douglas, H. F. Williams (two pieces), Edmund Dédé, Basil Barés, Lucien Lambert, Sidney Lambert, W. F. Craig, F. E. Lewis, and S. Snaer. ORIGINAL EDITION (Boston: Lee & Shepard); and (New York: Charles T. Dillingham, 1881).

R89. **Wiggin, Frances Turgeon.** MAINE COMPOSERS AND THEIR MUSIC: A BIBLIOGRAPHICAL DICTIONARY. Rockland, Me.: Maine Federation of Music Clubs, 1959. 138 p.

An alphabetical list of composers containing biographical notes including list of compositions with publication data.

R90. **Wisconsin Federation of Music Clubs.** WISCONSIN COMPOSERS. Wisconsin Federation of Music Clubs, 1948. 88 p.

A list of composers with brief data including compositions, compiled for the Wisconsin State Centennial, 1848–1948. The composers listed were born between 1875 and 1900.

General, Historical, and Critical Studies

MUSIC IN THE UNITED STATES

R91. **Allen, Warren Dwight.** PHILOSOPHIES OF MUSIC HISTORY. New York and Boston: American Book Co., 1939. 408 p., illus.

A historiographical survey and analysis of the philosophies of music history. The appended bibliography mentions histories or encyclopedic works.

R92. **Barnes, Edwin N. C.** AMERICAN MUSIC FROM PLYMOUTH TO TIN PAN ALLEY: A RÉSUMÉ OF THREE CENTURIES OF AMERICAN MUSIC. Washington, D.C.: Music Education Publications, 1936. 22 p.

A summary of major trends and events in American music life, divided into approximate fifty-year periods. Sections on the musical theater, American folk music, and various aspects of the period between 1890 and 1920.

R93. **Barzun, Jacques.** MUSIC IN AMERICAN LIFE. Gloucester, Mass.: Peter Smith, 1958. 126 p.

A critical examination of contemporary musical activities, viewed as part of a social and intellectual revolution. Barzun explores the impact of economy and society on music, contending that they affect the listener as well as the composer. Foreword by Edward N. Waters. Bibliography. ORIGINAL EDITION (Garden City, N.Y.: Doubleday).

R94. **Benson, Norman Arthur.** THE ITINERANT DANCING AND MUSIC MASTERS OF EIGHTEENTH-CENTURY AMERICA. Ph.D. thesis, University of Michigan, 1963. 480 p.

A survey of cultural activities and analysis of the society of Williamsburg, Charleston, Philadelphia, New York, and Boston. Benson defines the various systems of patronage and discusses the significance of itinerant musicians and their role in the development of American concert life. Annotated bibliography includes sections on travelers' accounts of the eighteenth century, published letters from journals, and diaries, the history of music and related subjects, and local histories.

R95. **Burk, Cassie; Meierhoffer, Virginia; and Phillips, Claude Anderson.** AMERICA'S MUSICAL HERITAGE. Chicago, Dallas, New York, Atlanta, and San Francisco: Laidlaw Bros., 1942. 368 p., illus.

A survey of the history of American music presented in brief paragraphs for scholastic use "to magnify the importance of music in the development of the culture of the people in America." Exercises (questions and problems) are provided at the end of larger chapters. Some songs and ballads and their histories are included. Illustrated by Milo Winter. Bibliography.

R96. **Chase, Gilbert.** AMERICA'S MUSIC FROM THE PILGRIMS TO THE PRESENT. New York: McGraw-Hill Book Co., 1966. 780 p. [cont.]

This work is a standard reference of American music history. Chase traces the establishment of musical traditions and practice during the nineteenth century, to the rise of popular and experimental music of the twentieth century. Included are appendixes with short conversational discography; and bibliography, containing 680 titles. Foreword by Douglas Moore. Short conversational discography; bibliography of 680 titles.

R97. **Chase, Gilbert, ed.** THE AMERICAN COMPOSER SPEAKS: A HISTORICAL ANTHOLOGY, 1770–1965. Baton Rouge: Louisiana State University Press, 1966. 328 p.

Introductory survey of the historical prominence of the composers included, expressing some of their attitudes towards American or nationalistic music. A brief biography of each composer, his works, writings, publications, and a character sketch. Included are separate notes of each of the quotations with bibliographical sources. The anthology is composed of writings by such individuals as Stephen Collins Foster, Louis Moreau Gottschalk, Charles Ives, George Gershwin, and Virgil Thomson.

R98. **Despard, Mabel H.** THE MUSIC OF THE UNITED STATES: ITS SOURCES AND HISTORY, A SHORT OUTLINE. New York: J. H. H. Muirhead, 1936. 96 p.

An abbreviated and simplified history of music in America dating from prehistoric times, tracing the background of musical instruments, song, and concert and opera life. A picture book for children. Bibliography. Includes music.

R99. **Edwards, Arthur Co. and Marrocco, W. Thomas.** MUSIC IN THE UNITED STATES. Dubuque, Ia.: William C. Brown Co., 1968. 190 p., illus.

An excellent, succinct survey designed for an introductory course in American musical history on the college level. The author discusses music and musical activities from the time of the first immigrants to present-day electronic music. There also are chapters on Indian tribal music, Negro music and folk music. References in footnotes; bibliography; discography.

R100. [Deleted.]

R101. **Elson, Louis C.** THE HISTORY OF AMERICAN MUSIC. New York: Macmillan Co., 1915. 400 p., illus. (ports.).

Elson traces the conflicts of music with religion in colonial times, noting its acceptance and growth in America prior to 1904. Although some of the chapters are outdated, a lively description of music in nineteenth-century America is provided. The musical scene and activities of New England and the Midwest are highlighted by newspaper articles of the era.

R102. **Geib, George.** PANTENT: ANALYTICAL AND GRAMMATICAL SYSTEM OF TEACHING THE SCIENCE OF THE COMPOSITION OF MUSIC IN ALL ITS BRANCHES, AND THE PRACTICE OF THE PIANO FORTE BY THE RULES OF CONSTRUCTION, DEPENDING ON THE PRINCIPLES OF COMPOSITION MADE CLEAR AND SIMPLE TO JUVENILE CAPACITIES; WITH A VIEW TO RENDER THE ACQUIREMENT OF A PROFOUND KNOWLEDGE OF MUSIC EASY, SURE, SPEEDY, TO ALL LEARNERS. FIRST FOLLOW NATURE AND YOUR JUDGEMENT, FRAME BY HER JUST STANDARDS WHICH IS STILL THE SAME UNERRING NATURE STILL DIVINELY BRIGHT, ONE CLEAR, UNCHANGED AND UNIVERSAL LIGHT. Microfilm. The New York Public Library.

A book of methods for teaching basic harmony and music theory, and piano instruction with finger exercises and music composition. Included is a chapter on tuning the piano. ORIGINAL EDITION (New York: J. Ridley, Sr., 1818), 234 p., illus. (music).

R103. **Gottschalk, Louis Moreau.** NOTES OF A PIANIST DURING HIS PROFESSIONAL TOURS IN THE UNITED STATES, CANADA, THE ANTILLES, AND SOUTH AMERICA. EDITED BY CLARA GOTTSCHALK. TRANSLATED FROM FRENCH BY ROBERT E. PETERSON. Philadelphia: J. B. Lippincott Co., 1881. 471 p., illus. (ports.).

Gottschalk's diary notes written while on concert tours serve as an important personal document of the nineteenth century, conveying the atmosphere of many places and concerts. Gottschalk's diary is preceded by a biographical sketch with contemporaneous criticism. Bibliography.

R104. **Grunfeld, Frederic V.** MUSIC AND RECORDINGS, 1955. New York: Oxford University Press, 1955. 313 p., illus.

A review of opera and orchestral music of visiting artists in New York in relation to business, 1954–1955. This is a general guide to the records of this season by Jacques Barzun (classical records), Tom Scott (collections), and Clifford McCarty (jazz records). Bibliography.

R105. **Hanson, Howard.** MUSIC IN CONTEMPORARY AMERICAN CIVILIZATION: DEVELOPMENT OF THE CREATIVE ART; THE DECADES OF MATURATION; AND OBSTACLES TO PROGRESS. Lincoln: University of Nebraska, 1951. 48 p.
MONTGOMERY LECTURES ON CONTEMPORARY CIVILIZATION.

In this series of three lectures, the author critically evaluates music in America as a progressive evolution in creativity. The first lecture concerns music criticism, its growth, and its principles. The second lecture pertains to the beginning and growth of orchestral composition. The third deals with the development of professional music education.

R106. **Hastings, Thomas.** THE HISTORY OF FORTY CHOIRS. New York: Mason Bros., 1854. 241 p.

This is a work about a choirmaster who reveals his numerous experiences with church choirs. Although historical facts are not presented, it emphasizes the church's involvement in the creation of the country's musical tradition.

R107. **Howard, John Tasker.** THE MUSIC OF GEORGE WASHINGTON'S TIME. Washington, D.C.: George Washington Bicentennial Commission, 1932. 34 p., illus.

Included is music written and performed in Washington's time: early concerts, popular songs, dances, and military airs. Howard provides lists of: eighteenth-century American music in modern editions; modern music commemorating George Washington; and musical program suggestions for celebrations at schools, colleges, and clubs. Bibliography; music.

R108. **Howard, John Tasker.** OUR AMERICAN MUSIC: THREE HUNDRED YEARS OF IT. 4th ed. Thomas Y. Crowell Co., 1965. 956 p., illus. (ports.).

The author traces the impact of music through the fugitives of European revolutions. In his account of New England history he includes the first immigrants in 1620 through the Puritans in the late eighteenth century. From 1860 on, the time of "the awakening of national consciousness," the evolution of American music is represented through biographical sketches and the critical evaluation of individual styles (rather than by focusing on general trends as in the complementary work by Chase [R96]). Additional chapters include twentieth-century religious music, twentieth-century war songs, musical theater, and popular song composers. The bibliography was revised and updated for the edition under discussion by Karl Kroeger. THIRD EDITION (1954). Contains supplementary chapters by James Lyon.

R109. **Howard, John Tasker, and Bellows, George Kent.** A SHORT HISTORY OF MUSIC IN AMERICA. New York: Thomas Y. Crowell Co., 1967. 523 p., illus. (ports.).

A succinct outline of the musical evolution in America from the native Indians to the mid-twentieth century. Includes brief biographical data on significant musicians, as well as discussions of memorable musical events in perspective with related arts and the growing country. Details in short chapters highlight individual trends and movements in mostly ten-year periods. Considered required reading and helpful reference for all students. Bibliographies to each chapter; supplementary bibliography; discography.

R110. **Hubbard, William Lines, ed.** THE AMERICAN HISTORY AND ENCYCLOPEDIA OF MUSIC. New York, Toledo, and Chicago: Irving Squire, 1908. vol. 4, 356 p., illus. (ports.).

Of the four volumes of Hubbard's world history of music, the fourth pertains to the history of American music. Even today, this 1908 publication presents some interesting insights in its "Summary and Outlook." Included in the volume is useful information on music trades, with short histories of instrument makers and publishers. Introduction by George W. Chadwick and Frank Damrosch. Selective bibliography.

R111. **Ives, Charles E.** ESSAYS BEFORE A SONATA. New York: Knickerbocker Press, 1920. 124 p.

A sketch of musical aesthetics, in which the author attempts to integrate intuition, perception, and the consciousness of creativity by presenting sketches of Emerson, Hawthorne, the Alcotts, and Thoreau. The work is to be an inspirational source intended for Ives's piano sonata *Concord, Mass. 1845*: "... to present one person's impression of the spirit of transcendentalism." A reflection of the writer's own creative processes is found in the epilogue, where Ives defines the nature of genius by analyzing the process of musical composition.

R112. THE JUILLIARD REVIEW, festival issue: American Music. 3 (winter 1955–56). illus. (ports.).

A festival issue celebrating the fiftieth anniversary of the Juilliard School of Music. Foreword by William Schuman. Contributions include Alfred Frankenstein, on American music at home and abroad; a symposium edited by Charles Jones; Jacques Barzun, composer and critic; Robert Ward, on the composer and the music business. Collaborators include Boris Blacher, Paul Henry Lang, Rolf Liebermann, Ricardo Malipiero, Jacque de Menasce, and Darius Milhaud.

R113. **Kaufmann, Helen L.** FROM JEHOVAH TO JAZZ: MUSIC IN AMERICA FROM PSALMODY TO THE PRESENT DAY. Port Washington, N.Y.: Kennikat Press, 1969. 316 p., illus.

A REPRINT EDITION of a synopsis of previous studies, relying on the classic writings in American musical history. The book serves as an introduction for the beginning music student. Illustrated by Alajalov. ORIGINAL EDITION (1937).

R114. **Lang, Paul Henry, ed.** ONE HUNDRED YEARS OF MUSIC IN AMERICA. New York: G. Schirmer, 1961. 322 p., illus.

An anthology that was published for the one hundredth anniversary of G. Schirmer, Inc., with articles on the historical, industrial, educational, and legal aspects of American music. Includes two bibliographical articles. Bibliography by Richard Gilmore Appel.

R115. **Lowens, Irving.** THE EASY INSTRUCTOR, 1798–1831: A HISTORY AND BIBLIOGRAPHY OF THE FIRST SHAPE NOTE TUNE BOOK. In: LITTLE, WILLIAM, AND SMITH, WILLIAM. MUSIC AND MUSICIANS IN EARLY AMERICA. New York: W. W. Norton & Co., 1964.

In chapter six and Appendix B of *Music and Musicians*, Lowens compares the first manuscript to later editions and imitations published until 1831. The 1801 and 1802 editions contain 105 compositions, almost all American, of which forty-one are claimed as never before published. Appendix B consists of a checklist of editions and issues. [*See* R116.]

R116. **Lowens, Irving.** MUSIC AND MUSICIANS IN EARLY AMERICA. New York: W. W. Norton & Co., 1964. 328 p., illus.

A collection of articles and separate studies, on various topics of early American musical history, which had pre-

viously appeared in periodicals and elsewhere. Some main topics are psalters and the early instruction books for singing schools [R115] and bibliographical research. There are biographical studies on Daniel Read, the Edsons, James Hewitt, Anthony Philip Heinrich, William Henry Fry, and Louis Moreau Gottschalk. Studies on nineteenth-century American music and its society also appear in this work. Supplementary information (mostly bibliographical) in appendixes.

R117. **Marrocco, W. Thomas, and Gleason, Harold.** Music in America: An anthology from the Landing of the Pilgrims to the Close of the Civil War, 1620–1865. New York: W. W. Norton & Co., 1964. 371 p., illus.

A panorama of musical landmarks that have played an important part in the religious, social, and cultural life of the United States. Taken from the first or earliest editions available, the compositions cited are complete except in multimovement works. Each chapter includes an introduction to the background of the works, their description, and a historical evaluation of noteworthy characteristics and performance practices. Concise information is provided on some main lines of musical development in America, beginning with the metrical psalmody in New England, followed by the description of the first instruction books and singing schools. The musical activities of the Moravians, of native American composers, and of musician immigrants are also presented. Other topics include Southern folk hymns, minstrel shows, and the romantic and nationalist movement, along with biographical notes about seventy composers and musicians.

R118. **Mason, Daniel Gregory.** The Dilemma of American Music. *Boletín Latino-Americano* 5 (1939), 6 p.

This paper by Mason was read at the Interamerican Conference on Music held at the Library of Congress, Washington, D.C., conducted by the United States State Department in October 1939. The work is a historical survey of style, trends, and musical taste of late nineteenth- and early-twentieth-century American composers.

R119. **Matthews, W. S. B.** German Influence upon American Music, as Noted in the Work of Dudley Buck, J. K. Paine, William Mason, J. C. D. Parker, and Stephen A. Emery. *The Musician* 15 (Mar. 1910).

Biographical notes on the American composers cited, including an evaluation of their work in light of national trends.

R120. **Milligan, Harold Vincent.** Pioneers in American Music. *The American Scholar* 3 (spring 1934): 224–237.

In this brief survey of music in early America, the author attributes the rejection of music to the lack of artistic stimulation and the hostile Puritan attitude. According to Milligan, the musical spirit finally was released with the appearance of the first choruses and the first American composers.

R121. **Reis, Claire Raphael.** Composers, Conductors, and Critics. New York: Oxford University Press, 1955. 177 p., illus. (ports.).

A kaleidoscopic record of contemporary music in the 1920s and 1930s in America, focusing on the musical life in New York City, reflected as a partially autobiographical account. The author was the cofounder and executive chairman of the League of Composers for twenty-five years. Foreword by Darius Milhaud.

R122. **Ritter, Frédéric Louis.** Music in America. New York: Charles Scribner's Sons, 1884. 437 p.

This authoritative work is still one of the fundamental readings on American music. The table of contents reveals the basic trends of musical development from the time of the Puritan immigrants through the following 260 years. Structured into six periods, this compendium notes the rise of musical activities, trends in theory, the instruction of singing, musical grammars and dictionaries, musical societies, the growth of orchestras, and the progress of opera. Ritter presents a history of growing awareness in musical taste, a cultural history of the major cities rather than a compilation of biographical information. Included is a list of operas performed in New York City prior to 1880. revised edition (1890), 535 p.

R123. The Concert Goer's Annual, 1. New York: Doubleday, 1957. 168 p.

The work is an account of musical events performed by visiting artists to music centers in New York, the East Coast, and the West, particularly San Francisco. The articles written by various authors review the year 1956–57 in an American as well as an international perspective, encouraging closer musical contacts throughout the world. Evan Senior edited this annual.

R124. **Sessions, Roger.** Reflections on the Music Life in the United States. New York: Merlin Press, ca. 1955. 184 p.

This limited edition is a polemic review of the status of American music and its audience, based on the most recent history of American music in concert, opera, and education. Mainly concerned with the time between 1918 and about 1950, the author evaluates American culture and attitudes towards music, tracing its nineteenth-century background.

R125. **Sonneck, Oscar G.** Early Concert-Life in America, 1731–1800. Leipzig: Breitkopf & Härtel, 1907. 338 p.

One of the classic writings on concert life in America, this volume describes the formative period of American music activity traced in detail by newspaper reviews, individual concert announcements, descriptions, and programs. Related aspects include the beginning of music engraving and publishing in America and the manufacturing of musical instruments. Included also is a description of the cultural-musical instruments. Included also is a description of the cultural-musical scene and musical societies located in Charleston (and other culturally re-

lated cities in the South), Philadelphia, New York, Boston, and New England. Sonneck also discusses first subscription, public, and benefit concerts. Mentioned also are the leading musicians who shaped eighteenth-century American secular music life. Bibliography.

R126. **Sonneck, Oscar G.** Francis Hopkinson (1737–1791), the First American Composer. *Sammelbände der Internationalen Musikgesellschaft* 5 (Oct.–Sept. 1904): 119–154.

Biography of the Philadelphia lawyer and composer, harpsichordist, teacher of psalmody, concert performer, organist, and critic who wrote "Washington's March at the Battle of Trenton."

R127. **Sonneck, Oscar G.** A Survey of Music in America. Washington, D.C.: Privately printed by the McQueen Press, 1913, 30 p.

This critical survey of early twentieth-century musical life in America was presented at the Schola Cantorum in New York City on April 11, 1913. The address promoting music in America concerns the problems of municipal, state, and federal subvention of music education in schools and colleges. Sonneck advocates the establishment of a national conservatory of music, expressing concern about the musical ignorance of the population in rural Ameria. The author also deplores the mediocre level of music magazines and the lack of American music in concert programs. Seventy-five copies printed.

R128. **Spell, Lota M.** The First Music Books Printed in the United States. *Boletín Latino-Americano* 5 (1939).

This paper by Spell was read at the Interamerican Conference on Music held at the Library of Congress, Washington, D.C., conducted by the United States State Department in October 1939. Edited by Francisco Curt Lange, this paper presents a description of the first music books printed in America and of some early prints, at least ten of them printed in Mexico City during the sixteenth century and used in the American colonies.

R129. **Stevenson, Robert.** Philosophies of American Music History. Washington, D.C.: Louis Charles Elson Memorial Fund; for the Library of Congress, 1970. 21 p.

This lecture by Stevenson was presented in the Whittall Pavilion of the Library of Congress on January 9, 1969. A critical review of the approaches to American musical history, here and in Latin America. Examples by Frédéric Louis Ritter, John Tasker Howard, and Gilbert Chase. Bibliography.

R130. **Thomson, Virgil.** The Art of Judging Music. New York: Alfred A. Knopf, 1948. 346 p.

A collection of feature articles, concert and book reviews that appeared in the *New York Herald Tribune* between September 1944 and August 1947; also included is one article in *Atlantic Monthly*. This historical document reflects New York's musical life of the war and postwar era, a time of great pianists, conductors, and other well known personalities. [*See also* R131.]

R131. **Thomson, Virgil.** The Musical Scene. New York: Alfred A. Knopf, 1945. 330 p.

A selection of essays and reviews that had previously been published by the *New York Herald Tribune* between October 9, 1940 and July 23, 1944. The work is arranged by subjects, including some articles on music aesthetics constituting a documentary of musical America and the New York scene during the early 1940s. The critiques presented about historical styles in music often reflect opinions now outdated. [*See also* R130.]

R132. **Tremaine, C. M.** History of National Music Week. New York: National Bureau for the Advancement of Music, 1925. 232 p., illus. (ports.), map.

This work pertains to National Music Week, its genesis and history since 1924, its objectives, operations, and local participation. The high spots of local observances included in this work are listed by city and state.

R133. George Washington as a Friend and Patron of Music. Washington, D.C.: George Washington Bicentennial Commission, 1931. 13 p., illus.

A biographical sketch of George Washington and his predilection for music. The information was taken mostly from diaries. This piece is extracted from O. G. Sonneck, *Essays in Music* (New York: G. Schirmer, 1916).

R134. **Howard, John Tasker.** The Music of George Washington's Time. Washington, D.C.: George Washington Bicentennial Commission, 1931. 96 p., port.

A concise survey of eighteenth-century American music which includes the first public concerts with a selection of their programs; popular songs as a reflection of eighteenth-century history; dances of the time; musical instruments; and music (songs and marches) associated with historical events. Included is a catalog of authentic eighteenth-century music in modern editions, along with a catalog of modern music commemorating George Washington. Musical program suggestions for Bicentennial celebrations are also provided. Preface by Sol Bloom.

R135. **Upton, William Treat.** Art Song in America: A Study in the Development of American Music. Boston and New York: Oliver Ditson & Co., 1930. Series in American Studies.

A study of composer groups with short biographical introductions to musicians; historical-critical evaluation of individual works and styles; historical episodes about singers; business relations; concert performances; and foreign influences through immigrants or studies abroad. Contents structured by periods from 1750 to 1800, and by twenty-year periods approximately, from 1800 to the date of this publication. *Supplement:* W. T. Upton, *Art Song in America, 1930–1938* (1938), 41 p. Reprint (New York: Johnson Reprint Corp., 1969), 290 p.

R136. **Wolverton, Byron Adams.** KEYBOARD MUSIC AND MUSICIANS IN THE COLONIES AND UNITED STATES OF AMERICA BEFORE 1830. Ph.D. thesis, Indiana University, 1966. 502 p., illus.

A summary of thorough investigations of theatrics, diaries, archival materials, and concert records, which indicates a strong tradition in keyboard music and its practice since the late seventeenth century. The author traces records of existing instruments (harpsichords, clavichords, pianofortes, and organs), of those first imported as well as of those first made in this country. He takes into consideration not only the type of music that was played but also the attitudes towards music within various religious and ethnic groups. Music; bibliography.

R137. **Wunderlich, Charles Edward.** A HISTORY AND BIBLIOGRAPHY OF EARLY AMERICAN MUSICAL PERIODICALS, 1782–1852. Ann Arbor: University of Michigan, University Microfilms, 1962. 794 p., illus.

An in-depth analysis of musical journalism, tracing the individual histories of most of the forty-nine musical magazines and journals that were located. Included are biographical sketches of the editors and critical magazine reviews. Topics include musical criticism, concert programs, reviews, announcements, ladies' department, and music supplements. Appendix includes chronological and descriptive bibliography of early American music periodicals, 1782–1852; and a geographical index of the periodicals and register of authors and publishers. This dissertation adds another perspective to the musical and social history of the postrevolutionary era, which has been previously neglected. Includes music. [*See* R138.]

R138. **Yerbury, Grace Helen.** STYLES AND SCHOOLS OF ART SONG IN AMERICA (1720–1850). Ann Arbor: University of Michigan, University Microfilm, 1968. 441 p., illus. DOCTORAL DISSERTATION SERIES.

A tediously written history of art song in America based on various local histories and on Sonneck and Upton, *Bibliography of Early Secular American Music: Eighteenth Century* [R21]. The author tries to define early American style, and specifically national characteristics in art song. Includes music and bibliography.

THE TWENTIETH CENTURY

R139. **Austin, William W.** MUSIC IN THE TWENTIETH CENTURY: FROM DEBUSSY THROUGH STRAVINSKY. New York: W. W. Norton & Co., 1966. 728 p., illus. (ports.).

Mainly concerned with the international, especially the European scene of modern music, this book offers a different approach to jazz within the context of its time. Included is comment on the early jazz age until 1923, and the shock caused by its new harmonic and rhythmic qualities. Also explained is the influence of jazz on popular and serious music, with an analysis of some outstanding examples. The work serves as a general survey of serious American music, interpreted by several generations of leading American composers. Music included.

R140. **Bauer, Marion.** TWENTIETH CENTURY MUSIC, HOW IT DEVELOPED, HOW TO LISTEN TO IT. New York and London: G. P. Putnam's Sons, 1947. 477 p.

Although the author surveys the international music scene, certain sections of the book are devoted entirely to American music, jazz, American composers of the twentieth century, new aesthetic, new Americanism. Emphasis is on American composers and their works, largely drawing on opinions and quotations. Bibliography; music examples.

R141. **Boretz, Benjamin, and Cone, Edward T.** PERSPECTIVES ON AMERICAN COMPOSERS. New York: W. W. Norton & Co., 1971. 276 p., illus.

An anthology consisting of historical-critical essays on the development of personal compositional styles, recorded interviews previously published in *Perspectives of New Music* (Princeton University Press; for the Fromm Music Foundation). These articles document American music and its composers as of 1970. Included are Howard Boatwright, on "Ives' Quartertone Impressions"; Dennis Marshall, "Charles Ives' quotations — Manner or Substance?"; Edgar Varèse, "The Liberation of Sound"; Gunther Schuller, "Conversation with Varèse"; Milton Babbitt, "Edgar Varèse, a Few Observations of His Music"; Andrew Imbrie, "Roger Sessions, in Honor of his Sixty-fifth Birthday"; Edward T. Cone, "Conversation with Roger Sessions"; Roger Sessions, "To the Editor"; Ernst Krenek, "A Composer's Influences"; Edward T. Cone, "Conversation with Aaron Copland"; Peter Evans, "Copland on the Serial Road, an Analysis of Connotations"; Peter Westergaard, "Conversation with Walter Piston"; Clifford Taylor, "Walter Piston, for His Seventieth Birthday"; Edward Levy, "Stefan Wolpe, for His Sixtieth Birthday"; "Gunther Schuller, Conversation with Steuermann"; Martin Boykan, "Elliott Carter with the Postwar Composers"; Elliott Carter, "Expressionism and American Music"; John MacIvor Perkins, "Arthur Berger, The Composer as Mannerist"; Henry Onderdonk, "Aspects of Tonality in the Music of Ross Lee Finney." Music included.

R142. **Chasins, Abram.** MUSIC AT THE CROSS ROADS. New York: Macmillan Co., 1972. 252 p.

An attempt to observe and interpret the public response and critical pretensions of electronic and pop music. Other topics include musical careers; skills and training at conservatories, colleges, and universities; competitions; the music business; and state support and subsidies.

R143. **Cohn, Arthur.** THE COLLECTOR'S TWENTIETH-CENTURY MUSIC IN THE WESTERN HEMISPHERE. Philadelphia and New York: J. B. Lippincott Co., 1961. 256 p.

A discussion of recorded music by twenty-seven contemporary composers, twenty-three of whom are American: with short surveys of the composers' recorded music issued until May 1960. The aesthetic characterization of

the individual styles are interpreted in a historical context, rather than focusing on biographical data or the recorded sound. Works are discussed by Samuel Barber, Ernest Bloch, Elliott Carter, Aaron Copland, Henry Cowell, Paul Creston, Norman Dello Joio, Irving Fine, Lukas Foss, Howard Hanson, Roy Harris, Alan Hovhaness, Charles Ives, Leon Kirchner, Gian-Carlo Menotti, Walter Piston, Wallingford Riegger, William Schuman, Roger Sessions, Harold Shapiro, Virgil Thomson, Edgar Varese, and Ben Weber. Discography.

R144. **Cope, David.** NEW DIRECTIONS IN MUSIC. Dubuque, Iowa: Wm. C. Brown Co., 1971. 152 p.

A report about avant-garde and post–avant-garde music, surveying the experimental music of the decades 1950–1970; designed as an introduction useful as reference for music students at the college and graduate level. Included are a glossary of terms (modern, modern-technical, and traditional), and biographical data on composers. Bibliographies with each chapter.

R145. **Copland, Aaron.** THE NEW MUSIC, 1900–1960. Rev. and enl. ed. New York: W. W. Norton & Co., 1968. 194 p.

An over-all clarification of the historical position of the new music and its exponents. The author surveys the development of the new music movement in Western Europe, and places the American school into an international context. Discussion of Charles Ives, Roy Harris, Roger Sessions, Walter Piston, Virgil Thomson, and Marc Blitzstein. Also included is an autobiographical sketch, and the music and philosophy of chance by John Cage and his followers. Succinct summary on jazz in "Jazz Interlude" and the effects of the jazz idiom on the serious composer. ORIGINAL EDITION: *Our New Music* (1941). Music included.

R146. **Cowell, Henry, ed.** AMERICAN COMPOSERS ON AMERICAN MUSIC. Stanford, Calif.: Stanford University Press, 1933. 238 p.

A survey of tendencies in American art-music viewed by the composer himself: twenty articles by American composers dealing with one another's compositions and style. Composers' views in a discussion of how creative music should progress, presented in individual articles: Roy Harris, "Problems of American Composers"; Carlos Chavez, "Music of Mexico"; Alexandro Garcia Caturla, "Development of Cuban Music"; Amadeo Roldan, "The Artistic Position of the American Composer"; Lazare Saminsky, "American Tonal Speech"; Wallingford Riegger, "Materials and Musical Creation"; William Grant Still, "An Afro-American Composer's Point of View"; Dane Rudhyar, "Oriental Influence in American Music"; George Gershwin, "The Relation of Jazz to American Music"; John J. Becker, "Imitative Versus Creative Music in America"; Charles Ives, "Music and Its Future"; Biographical notes on twenty-eight composer-authors cited in this book. Information about education, training, and principal works.

R147. **Gordon, Philip.** AMERICA IN AMERICAN MUSIC. *Common Ground* (spring 1947): 23–26.

Topics covered include the individualist freedom of the American composer, free of any "specifically musical idiom"; and the lively productivity and musical activity in America.

R148. **Gordon, Philip.** THE AVAILABILITY OF CONTEMPORARY AMERICAN MUSIC FOR PERFORMING GROUPS IN HIGH SCHOOLS AND COLLEGES. New York: Columbia University Teachers College Bureau of Publications, 1950. 152 p.
COLUMBIA UNIVERSITY TEACHERS COLLEGE CONTRIBUTIONS TO EDUCATION, NO. 961.

The author discusses the problems of making music available to schools and colleges. He is concerned with the production and availability of contemporary music during the late 1940s and with performance problems among student groups. Valuable bibliography, and annotated list of books, periodical literature, program notes, recordings, film music, and references for research. Valuable also are various lists of contemporary music recommended for student groups, sample programs, and analyses of methods of performing modern music with students. Bibliography; discography.

R149. **Kostelanetz, Richard, ed.** THE NEW AMERICAN ARTS. New York: Horizon Press, 1965. 270 p.

An anthology about arts and music that intends to define American characteristics within each field and "to set the American scene in the context of foreign achievements. Contribution by Eric Salzman, "The New American Music," defines electronic music. A selected discography lists recorded works by fifty contemporary American composers.

R150. **Krenek, Ernst.** MUSIC IM GOLDENEN WESTEN. DAS TONSCHAFFEN DER U.S.A. Vienna: Verlag Brüder Hollinek, 1949. 73 p., illus. (ports.).

Topics included are the cultural-intellectual and economic conditions that modern music and its composers encounter in America; the generation of composers born around 1900; immigrant composers. A personal view and interpretation by an immigrant composer.

R151. **Lefkoff, Gerald, ed.** PAPERS FROM THE WEST VIRGINIA UNIVERSITY CONFERENCE ON COMPUTER APPLICATIONS IN MUSIC. Morgantown, W.Va.: West Virginia University Library, 1967. 105 p.

The Conference on Computer Applications in Music was held Apr. 29 and 30, 1966, at West Virginia University to convey the significance of computer application for the advancement of musical art and scholarship. A document on new methods in composition and research being explored at American universities: Berry S. Brook, "Music Bibliography and the Computer"; Allen Forte, "Computer-implemented Analysis of Musical Structure"; Gerald Lefkoff, "Computers and the Study of Musical Style"; Lejaren A. Hiller, "Programming a Computer for Musical Composition"; Charles S. Cook, "An Introduction to the Information Processing Capabilities of the Computer."

R152. **Lincoln, Harry B., ed.** THE COMPUTER AND MUSIC. Ithaca and London: Cornell University Press, 1970. 368 p.

A collection of papers written by computer specialists and musicologists teaching at colleges and universities in the United States. The articles focus on these major areas: opportunities in composition made possible through the use of the computer; computer in research: analysis of harmony and styles; development of data banks (indexes, statistical studies); and computer-assisted instruction in music theory. Future development is indicated in view of new technical devices, such as the automated printing of music.

R153. **Machlis, Joseph.** INTRODUCTION TO CONTEMPORARY MUSIC. New York: W. W. Norton & Co., 1961. 737 p., illus. (ports.).

A guide to twentieth-century music, this work consists of a formal analysis of musical material, survey of the European scene, and a description of trends and schools in American music from 1900 to 1960. Classification by compositional styles, biographical sketches of composers with analysis of some of their works, highlighting musical influences and tendencies. Profiles of about thirty American composers, among whom are Charles Martin Loeffler, Charles T. Griffes, Charles Ives, Hugo Weisgall, and Mel Powell. Comparative chronology of music, political events, literature, and art. Discography; bibliography; music.

R154. **Nyman, Michael.** EXPERIMENTAL MUSIC: CAGE AND BEYOND. New York: G. Schirmer, 1974. 154 p., illus. (ports.).

The first full publication on experimental music, the sophisticated counterpart to the peoples' rebellion in rock against traditional idioms. Both trends arose in the early 1950s, and both have reverted toward tonal material, traditional meter, and disciplined structure during recent years. This experimental music has been written mainly by a number of American composers: John Cage, Earle Brown, Morton Feldman, and Christian Wolff.

R155. **Rossi, Nick, and Choate, Robert A.** MUSIC OF OUR TIME: AN ANTHOLOGY OF WORKS OF SELECTED CONTEMPORARY COMPOSERS OF THE TWENTIETH CENTURY. Boston: Crescendo Publishing Co., 1969. 417 p., illus. (ports.).

This introductory survey concerns the musical history in general and jazz in particular. The first part deals with music in Europe and Latin America. The second deals with music in the United States. The anthology consists of biographical sketches of composers, and discussion and analysis of one or two of their major works, enlivened by explanations and statements by the composer himself. The following composers are represented: Charles Ives, Edgar Varèse, Walter Piston, William Grant Still, Howard Hanson, Virgil Thomson, Henry Cowell, Roy Harris, George Gershwin, Aaron Copland, George Antheil, Samuel Barber, Vladimir Ussachevsky, Otto Luening, John Cage, Milton Babbitt, Ned Rorem, Gunther Schuller, and Morton Subotnick. Music included.

R156. **Saminsky, Lazare.** LIVING MUSIC OF THE AMERICAS. New York: Howell, Saskin & Crown Publishers, 1949. 284 p., illus.

The author attempts to identify national characteristics in twentieth-century American music. His aesthetic evaluation is based on idioms of folk song and folk heritage in the works of composers such as Roy Harris, Charles Ives, Ernest Bacon, Dean Taylor, Howard Hanson, Emerson Whithorne, Douglas Moore, and others. This tradition is defined in a historical and racial sense as an integration of various cultures that took place from the seventeenth to the nineteenth centuries. Music included.

R157. **Schwartz, Elliott, and Childs, Barney, eds.** CONTEMPORARY COMPOSERS ON CONTEMPORARY MUSIC. New York, Chicago and San Francisco: Holt, Rinehart & Winston, 1967. 396 p.

An anthology designed to create an awareness of the changes that have taken place in music since the late nineteenth century. The author discusses the emancipation of dissonance, the growth of unusual musical material, and new attitudes in composition. Though the first part of this publication refers to European music before 1945, the second section concerns experimental music and recent American developments. Schwartz bases artist profiles on interviews, writings, and lectures by the composers which explain the artists' approaches to music and composition.

R158. **Sternfeld, Frederick William, ed.** MUSIC IN THE MODERN AGE. New York and Washington, D.C.: Praeger Publishers, 1973. 115 p.

An international spectrum of major trends and representative composers. The chapter on North America, by Wayne D. Shirley, discusses the move towards musical independence, especially through the Wa-Wan Press [see R642], through the impact of experimental music and particularly of jazz. Jazz chart: list of jazz events, 1900–1971. The bibliography includes basic literature, monographs, and periodical articles, composer and artist biographies. Discography; music.

R159. **Thomson, Virgil.** AMERICAN MUSIC SINCE 1910. In: KALLININ, ANNA, AND NABOKOV, NICOLAS. TWENTIETH-CENTURY COMPOSERS. London: Weidenfeld & Nicolson, 1971. vol. 1, 220 p., illus., (ports.).

Nicolas Nabokov has written the introduction for vol. 1. Thomson discusses the profusion of experimentation, breakdown of academic rules, and variety of new directions. A survey of American ballet, film, concert, and opera music in the 1930s. Character analyses of composers and their music, with 106 short biographies of American composers, most of whom were born between 1890 and 1920, including accomplishments and publications. Music and bibliography included.

MUSIC AND SOCIETY

R160. **American Guild of Musical Artists.** THE COMING OF AGE OF THE AMERICAN ARTIST. 1958. 38 p., illus.

The work is a series of public discussions by eminent singers, instrumentalists, composers, conductors, choreographers, concert managers, teachers, critics, government administrators, and other prominent personalities in the performing arts. These discussions were held in observance of the twentieth anniversary of the founding of the American Guild of Musical Artists. A report of three panel discussions: the concert artists need for a growing public; the lyric theater and the American scene; the American artist in the international scene.

R161. Clark, Kenneth S. MUSIC IN INDUSTRY. New York: National Bureau for the Advancement of Music, 1929. 390 p., illus.

A documentation of musical activities in industrial centers, including company bands and choruses, this work is the outcome of a survey held throughout the United States and parts of Canada. Included are summaries about specific local conditions.

R162. Hamm, Charles; Nettl, Bruno; and Byrnside, Ronald. CONTEMPORARY MUSIC AND MUSIC CULTURES. Englewood Cliffs, N.J.: Prentice-Hall, 1975. 282 p.

Social, political, and cultural processes reflected in mid-twentieth-century music: changes and new trends in music among American Indians, acculturation processes of popular and folk music, the new musical style of rock. Some chapters have extensive bibliographies.

R163. Washington, D.C. National Education Association. MUSIC EDUCATORS NATIONAL CONFERENCE, 1968. 72 p., illus.

This interpretive report of the Tanglewood Symposium is prefaced by Robert A. Choate and foreworded by Louis G. Wersen, president of MENC. The report is representative of the fifty-member symposium, shared by musicians, sociologists, scientists, labor leaders, educators, representatives of corporations, foundations, and government. Definition of value systems within the present society; the role of music and the other arts; the objectives of music education.

R164. Mussulman, Joseph A. MUSIC IN THE CULTURED GENERATION: A SOCIAL HISTORY OF MUSIC IN AMERICA, 1870-1900. Evanston, Ill.: Northwestern University Press, 1971. 311 p., illus.

This journalistic study of music magazines emphasizes the interrelationship between the society and the musical life of a nation. A definition of musical Americanism; of the growth and development of musical taste; and of the establishment of symphonic and operatic traditions. Bibliographies of articles pertaining to music from *Atlantic Monthly*, 1857–1900; *Harper's New Monthly Magazine*, 1850–1900; *Scribner's Monthly, Century Monthly, Century Illustrated*, and *Scribner's Magazine*, 1887–1900. Bibliography of periodical articles, essays in collections, documents. Music included.

R165. Zanzig, Augustus Delafield. MUSIC IN AMERICAN LIFE, PRESENT AND FUTURE. New York: Oxford University Press, 1932. 569 p., illus.

This work prepared for the National Recreation Association discusses the potential of music in America. Zanzig presents a broad survey of musical activities, their organization, leadership, methods, and funding. Succinct summaries of his investigations about various types of such activities in ninety-seven cities, at schools, colleges, in communities, settlements, churches, and private groups are included. The purpose of this interdisciplinary study is to help establish a broad music culture through the encouragement and support of amateur musical activities. Foreword by Daniel Gregory Mason. Bibliography.

Regional Studies

CITIES, STATES, AND LOCALITIES

The following publications about local histories and musical activities involve many personalities. For additional biographical material, *see* R70–R90. For works on opera and musical theater, even though part of local history, *see* R483 *et seq.*, R572 *et seq.*

R166. Aldrich, Richard. CONCERT LIFE IN NEW YORK, 1902-1923. New York: G. P. Putnam's Sons, 1941. 812 p., illus. (ports.).

Foreword by Otto Kinkeldey about the *New York Times* Sunday essays by Richard Aldrich. Biographical sketch of Richard Aldrich by his son Richard C. Aldrich. The reviews and essays are arranged by chapters following the twenty-one concert seasons from 1902–1903 to 1922–1923. The selection was made by Harold Johnson, Library of Congress, Washington, D.C. Index of concert performances, from R. Aldrich scrapbooks; index of concert artists and organizations performing in New York; chronological list of Sunday articles by R. Aldrich; New York concert performances, beginning with the opening concert of the Philharmonic Society's sixty-first season with Walter Damrosch conducting. A monument of music journalism in the early twentieth century and one of the most valuable documentations of New York's concert life, written in a highly critical, concise yet eloquent style. ORIGINAL EDITION: *Musical Discourse* (Oxford University Press, 1928). This compilation constitutes the first publication of a number of the essays here covered.

R167. Andrus, Helen Josephine. A CENTURY OF MUSIC IN POUGHKEEPSIE, 1802-1911. Poughkeepsie, N.Y.: F. B. Howard, 1912. 286 p., illus. (ports.). [*cont.*]

The growth of musical activities during the second half of the nineteenth century, reviewed in ten-year periods. Mentioned are the promoters of musical interest: teachers, organists, and societies, events, visiting artists, and personalities, in particular Frederic Louis Ritter.

R167a. THE BOSTON MUSICAL YEARBOOK. Boston, 1–2 (1884–1886).

[See R212.]

R168. **Crews, Emma Katherine.** A HISTORY OF MUSIC IN KNOXVILLE, TENNESSEE, 1791–1910. Ed.D. thesis, Florida State University, 1961. 236 p.

A record of musical events and developments in Knoxville, which is considered typical of the inland cities of the South. This dissertation offers a perusal of all branches of musical activities and the people involved, with information gathered from newspapers, periodicals, books, program notes, diaries, records of historical societies and organizations, and interviews. Bibliography; music.

R169. **Cron, Theodore O., and Goldblatt, Burt.** POR-TRAIT OF CARNEGIE HALL: A NOSTALGIC PORTRAIT IN PICTURES AND WORDS OF AMERICA'S GREATEST STAGE AND THE ARTISTS WHO PERFORMED THERE. New York: Macmillan Co., 1966. 217 p., illus. (ports.).

Carnegie Hall: a picture album and history, from its opening in 1891 to the present, especially its musical life under the great conductors; the great soloists; theatrical and musical performances; and special events with lectures and political speeches. Also includes discussion on its architectural structure, the upper-floor studios, its decline, and renaissance. This work is a cornerstone in the musical history of New York City. Discography.

R169a. DWIGHT'S JOURNAL OF MUSIC. Boston. 1–41 (1852–1881).

The famous Boston weekly, later fortnightly, established and edited by John Sullivan Dwight (1813–1893). One of the foremost accomplishments in musical journalism that reflects nineteenth-century musical Boston and its involvement with the national and European music scene. Includes music news from abroad and translations of French and German writings on music and art. REPRINT: Microfiche (New York: University Music Editions, 1976).

R170. **Eaton, Quaintance.** MUSICAL U.S.A.: HOW MUSIC DEVELOPED IN THE MAJOR CITIES; A HISTORICAL PANORAMA BY LEADING AUTHORITIES ON MUSICAL AMERICA. New York: Allen Towne & Heath Inc., 1949. 207 p., illus.

An anthology, covering the major trends of the development of music in American cities, discussing singing societies; early opera performances and concerts; the foundation of symphony orchestras, and their leading personalities. The collection is an outgrowth of articles that appeared previously in *Musical America*. Contributions by Herbert F. Peyser, Cyrus Durgin, Robert A. Gerson, Cecil Smith, George Kent Bellows, Mary Leighton, Norman

Houk, Thomas B. Sherman, Harry Brunswick Loeb, John Rosenfield, Alexander Fried, Albert Goldberg, and Hazel Gertrude Kinsella.

R171. **Engle, Donald L.** FIFTY YEARS OF HIGHLIGHTS WITH THE PHILADELPHIA ORCHESTRA, 1900–1950. Philadelphia: Philadelphia Orchestra Association, 1950. 62 p., illus. (ports.).

Concerts, guest orchestras, and performers, including Fritz Scheel, Carl Pohlig, Leopold Stokowski, and Eugene Ormandy. Engle also discusses the growth of the orchestra; concert tours; radio and recording sessions; and many significant details. List of members, 1900–1950; list of first performances.

R172. **Erskine, John.** THE PHILHARMONIC SYMPHONY SOCIETY OF NEW YORK: ITS FIRST HUNDRED YEARS. New York: Macmillan Co., 1943. 177 p., illus. (ports.).

A summary of the history of the Philharmonic Society since its founding in 1839, with a survey of major events and achievements, the locations of engagements, and the conductors. Programs of subscription concerts from the seventy-sixth to one-hundredth season (date, program, soloists), 1917–1942; roster of conductors and guest conductors, 1920–1942; programs of subscription concerts, 1917–1942.

R173. THE EUTERPEIAD OR MUSICAL INTELLIGENCER. Boston. 1— (1820–1823).

Edited by John Rowe Parker. New introduction by Charles Wunderlich. This early nineteenth-century musical magazine is considered not only a record of Boston's musical life for the time indicated but a pioneer work in musical journalism as well. Details about the music organizations of Boston, in particular the Handel and Haydn Society and the Philharmonic; musical activities of other New England towns; memoirs and sketches of personalities in music; concert announcements and reviews; supplements of sheet music, songs, and piano pieces. REPRINT (New York: Da Capo Press, 1974), 3 vols. in 1. 715 p.

R174. **French, Florence.** MUSIC AND MUSICIANS IN CHI-CAGO: CITY'S LEADING ARTISTS, ORGANIZATIONS, AND ART BUILDINGS; PROGRESS AND DEVELOPMENT. Chicago: Privately printed, 1899. 238 p., illus. (ports.).

Most of the material is a compilation of reviews and articles which appeared earlier in the *Musical Courier*, Chicago's leading nineteenth-century musical magazine. A wealth of information by various authors about Chicago's cultural life of the era. The musical history of the city, beginning with its first concerts in 1836 and continuing through the Civil War years. Includes discussion of entertainment after the Great Fire, musical festivals, Florenz Ziegfeld's Musical College, the World's Fair of 1893, musical events to 1900, the city's influential forces in music. Included are almost exclusively biographical chapters on leading personalities in music, recitalists, concert artists; their careers and importance. Index to biographical sketches.

R175. Furlong, William Barry. SEASON WITH SOLTI: A YEAR IN THE LIFE OF THE CHICAGO SYMPHONY. New York and London: Macmillan Co., 1974. 372 p., illus. (ports.).

The orchestra, its concerts and tours, seen as a panorama of individuals with private interests and passions. Featured is Georg Solti, the dynamic figure responsible for molding the orchestra into one harmonious unit. Included are the various topics: the mechanics of running an orchestra; scheduling guest artists; cross-country tours; and the engineering and economics of classical music recording.

R176. Haas, Oscar. A CHRONOLOGICAL HISTORY OF THE SINGERS OF GERMAN SONGS IN TEXAS. New Braunfels, Tex.: By the author, 1948. 73 p.

A chronicle of German singing societies in Texas, with extensive notes, reflecting mainly the local history of musical activities and festivals in New Braunfels, Tex. The records are collected from local newspaper files and from the minutes of the various singing societies from 1845 to 1948.

R177. Holderness, Marvin E. CURTAIN TIME IN FOREST PARK: A NARRATIVE OF THE SAINT LOUIS MUNICIPAL OPERA, 1919–1958. Saint Louis, Mo.: Saint Louis Municipal Theatre Association, 1958. 154 p., illus. (port.).

The musical history of Saint Louis since the 1880s: physical properties, organizations, business and performances of the outdoor operatic theater. List of officers, directors, works performed, stars, and attendance.

R178. Howe, M. A. De Wolfe. THE BOSTON SYMPHONY ORCHESTRA: AN HISTORICAL SKETCH. Boston and New York: Houghton Mifflin Co., 1914. 290 p., illus. (ports.).

Topics include the music life in Boston in the nineteenth century prior to the founding of the orchestra, and the founding of the Boston Symphony and *its* success story under its leaders Georg Henschel, Wilhelm Gericke, Arthur Nikisch, Emil Paur, Karl Muck, and Max Fiedler. Included are programs and newspaper clippings from the orchestra archives.

R179. James-Reed, Mint O. MUSIC IN AUSTIN, 1900–1956. Austin, Tex.: Von Boeckmann-Jones Co., 1957. 145 p., illus.

Musical events and other performances in Austin presented in episodic style and written with the experience of an impresario who was also the president of the Austin Amateur Choral Club. The series starts with the first of Ignace J. Paderewski's piano recitals given in Austin on March 3, 1900. Includes all seasons, with visiting artists, celebrities, opera companies, and other groups until 1956. Included also are the activities of the music clubs of Austin (the Matinee Music Club, the Austin Music Festival Association, the Amateur Music Club); of the public schools; of Texas University. Appendixes; musical attractions; list of artists.

R180. Johnson, Frances Hall. MUSICAL MEMORIES OF HARTFORD. Hartford, Conn.: Witkower's, 1931. 313 p., illus. (ports.).

Hartford's musical history recounted through the lives of its leading personalities during the nineteenth and early twentieth century. Recalls some of the memorable recitals, concerts, and events, such as the founding of the Beethoven Society; the concerts by Jenny Lind and Paderewski and the guest performances by Seidl, Gericke, Nikisch, Mahler, and Toscanini. The history concludes with the dedication of the Music Hall in 1930. The work is based on public and private records.

R181. Johnson, H. Earle. SYMPHONY HALL, BOSTON. Boston: Little, Brown & Co., 1950. 440 p., illus.

The history of the building from its opening for the Boston Symphony on October 19, 1900, to the middle of the century, focusing on the description of the hall. Includes sketches on its musical personalities and leaders such as W. Gericke, K. Muck, M. Fiedler, and P. Monteux. Mentioned are the Koussevitzky era and concert life with soloists and visiting orchestras. Supplementary and detailed information in six appendixes: lists of works performed by the Boston Symphony Orchestra; conductors and guest conductors; soloists with orchestra; visiting symphony orchestras, 1900–1949; selective list of concert artists appearing in Symphony Hall; and the Symphony Hall organ. This work was compiled by staff members of Symphony Hall. The introduction is by Mark Antony De Wolfe Howe. Included are list of works performed by the Boston Symphony Orchestra.

R182. Keefer, Lubov. BALTIMORE'S MUSIC: THE HAVEN OF THE AMERICAN COMPOSER. Baltimore, 1962. 360 p.

Description of Baltimore and its involvement with music: the city's population of various ethnic backgrounds; the trends in music, and in theaters and halls; dynamic personalities; and the establishment of the Institute "towards the improvement of the moral and intellectual cultures of Baltimore..." through the bequest by George Peabody. Extensive bibliography.

R183. Krohn, Ernst C. MISSOURI MUSIC. New York: Da Capo Press, 1971. 134 p.

The history of musical activities in Missouri since its beginning in the nineteenth century. This perusal of the *Missouri Gazette* elucidates the growth of Protestant church music in Saint Louis, the Bach renaissance, the development of the Saint Louis Symphony Orchestra, and amateur orchestras and societies, the growth of chamber music and opera. Index with biographical data and activities of musicians; list of Missouri composers, musicians, and musicologists; bibliography on Krohn prepared by Frederick Freedman. REPRINTED from Ernst C. Krohn, "A Century of Missouri Music," Missouri Historical Society, *Bulletin* (1924).

R184. Kupferberg, Herbert. THOSE FABULOUS PHILADELPHIANS: THE LIFE AND TIMES OF A GREAT ORCHESTRA. New York: Charles Scribner's Sons, 1969. 267 p., illus. (ports.).

The life of the Philadelphia orchestra under the baton of

Stokowski and of Eugene Ormandy. Profiles of the two conductors. An inside view of a great orchestra. List of members, 1900–1969; discography of Ormandy recordings.

R185. **Madeira, Louis C., comp.** ANNALS OF MUSIC IN PHILADEPHIA AND HISTORY OF THE MUSICAL FUND SOCIETY FROM ITS ORGANIZATION IN 1820 TO THE YEAR 1858. EDITED BY PHILIP H. GOEPP. Philadelphia: J. B. Lippincott Co., 1896. 206 p., illus. (ports.).

The musical history of Philadelphia in the first half of the nineteenth century. Topics include early conditions of church music, the musical practices of the Moravians, the beginnings of public entertainment, first concerts and visiting artists. Information is collected mainly from concert announcements, notes, and press reviews.

R186. **Mendel, Henry M.** DIE GESCHICHTE DER MUSIKALISCHEN ENTWICKLUNG DER STADT MILWAUKEE. *Milwaukee Herald* (Oct 1895). 32 p.

The nineteenth-century musical history of Milwaukee, a city strongly supported by its musical and singing societies. Includes information on concerts performed under the leadership of Hans Balatka and on the Singing Festival (*Sängerfest*) of 1886. REPRINTED from the *Milwaukee Herald*, Oct. 13, 1895.

R187. **Miller, J. Wesley, III.** SYMPHONIC HERITAGE. Typewritten. Springfield, Mass.: Classical Press, 1958. unpag.

The musical activities and leadership of choral and other musical societies during the nineteenth and twentieth centuries; the Springfield Symphony Orchestra, its history since 1943. Biographies of musicians and music personalities are included.

R188. **Minor, Andrew C.** PIANO CONCERTS IN NEW YORK CITY 1849–1865. M.A. thesis, University of Michigan, 1947. 592 p.

A collection of copied piano concert programs, compiled by season and date, also giving location, source of magazine, and review citations in some cases. At the end of the chapters tables are provided with all concerts and operas of the season, including the number of performances. The introduction gives a historical survey of piano concerts held before 1849. Interpretation of the compiled material notes the successes of L. M. Gottschalk, Thalberg, M. Strakosch, and others. List of composers, works performed, and number of performances; index of pianists with biographical notes; index of concert halls, with description, history, and location of building. Bibliography.

R189. **The Old Stoughton Musical Society.** AN HISTORICAL AND INFORMATIVE RECORD OF THE OLDEST CHORAL SOCIETY IN AMERICA; TOGETHER WITH INTERESTING DATA OF ITS ORGANIZATION, MEETINGS, REUNIONS, AND OUTINGS, AND A COMPLETE LIST OF PAST AND PRESENT OFFICERS AND MEMBERS. Stoughton, Mass., 1928. 188 p., illus. (ports.).

A historical summary from the Society's records since

Puritan times, tracing the beginnings of music publishing in New England. Alphabetical list of twenty-seven Old New England composers, with biographical sketches and annotated publications; bibliography of sixteen titles (1786–1886) from the Society's collection.

R190. **Otis, Philo Adams.** THE CHICAGO SYMPHONY ORCHESTRA: ITS ORGANIZATION, GROWTH AND DEVELOPMENT, 1891–1924. Chicago: Clayton F. Summy Co., 1924. 466 p., illus. (ports.).

Musical conditions in Chicago before the foundation of the symphony; the orchestra's organization and influential personalities. Detailed information about the orchestral seasons with excerpts from accounts, letters, and programs. List of members of the orchestra.

R191. **Perkins, Charles C.** FROM THE FOUNDATION OF THE SOCIETY THROUGH ITS SEVENTY-FIFTH SEASON 1815–1890. In: HISTORY OF THE HANDEL AND HAYDN SOCIETY OF BOSTON, MASSACHUSETTS. Boston: Alfred Mudge & Son, 1883–1893. 128 p., illus. (ports.).

The second part of vol. 1, covering the period between 1851 and 1890, was written by John S. Dwight. Two subsequent volumes for 1890–1903 by William F. Bradbury, and for 1903–1933 by Courtenay Guild were published respectively in 1903 and 1934. All volumes chronicle the events of the Society, including board meetings, budgetary items, and programs, and also describe the musical seasons in detail. This chronicle provides an uninterrupted history of musical performance of the Society since 1815. The history is typical of the larger American cultural centers during the nineteenth century and early twentieth century.

R192. **Pichierri, Louis.** MUSIC IN NEW HAMPSHIRE, 1623–1800. New York: Columbia University Press, 1960. 312 p.

A comprehensive record of New Hampshire's musical history, collected from unpublished wills, documents, letters, diaries, contemporary newspapers, periodicals, and tunebooks. Presents a thorough account of various musical forms: ballad operas, pantomimes, harlequinades, and farces. An excellent study of musical life in the Northeast. Profiles on John Hubbard, Benjamin Dearborn, and Samuel Holyoke. Foreword by Otto Kinkeldey. Bibliographical notes by chapters.

R193. **Rodriguez, José, ed.** MUSIC AND DANCE IN CALIFORNIA. Hollywood, Calif.: Bureau of Musical Research, 1940. 467 p., illus. (ports.).

One of the local survey studies directed by the Bureau of Musical Research. A description of regional and local activities organized by local societies, in schools and colleges. Includes some general articles.

R194. **Rohrer, Gertrude Martin.** MUSIC AND MUSICIANS OF PENNSYLVANIA. Philadelphia: Theodore Presser Co., 1940. 127 p., illus. (ports.).

Diverse aspects of music and its history in Pennsylvania;

contributions by various authors. Index of Pennsylvania musicians, with biographical data.

R195. **Saunders, Richard Drake, ed.** MUSIC AND DANCE IN CALIFORNIA AND THE WEST. Hollywood: Bureau of Musical Research, 1948. 311 p., ports.

One of the area survey studies of musical activities, edited by Sigmund Spaeth and José Rodriguez. This study includes a number of general articles on opera, dance, teaching, libraries, films, radio, with some feature articles of particular interest written by A. Schoenberg, G. Antheil, and Igor Stravinsky. Directory of leading universities and music schools. For a complementary study, *see* E. Clyde Whitlock and R. D. Saunders, eds., *Music and Dance in Texas, Oklahoma, and the Southwest* (Hollywood: Bureau of Musical Research, 1950), 256 p.

R196. **Saunders, Richard Drake, ed.** MUSIC AND DANCE IN THE CENTRAL STATES. Hollywood: Bureau of Musical Research, 1952. 173 p., ports.

Aspects and opinions in general articles of locally oriented surveys; personalities in music and dance, their biographies and portraits.

R197. **Schiffman, Jack.** UPTOWN, THE STORY OF HARLEM'S APOLLO THEATRE. New York: Cowles Book Co., 1971. 222 p., illus., ports.

The story of the Apollo Theatre in Harlem, written by the son of Frank Schiffman, the founder of the Apollo. Includes discussion of the Harlem neighborhood, the Harlem theaters in the 1920s, the combos in the 1930s and 1940s, big bands, their leaders, singers, dancers, and special shows. New York's show biz', written from personal experience. Entertaining episodes.

R198. **Shanet, Howard.** PHILHARMONIC: A HISTORY OF NEW YORK'S ORCHESTRA. Garden City, N.Y.: Doubleday, 1975. 809 p., illus. (ports.).

One of the very rare orchestral histories that covers the rich musical tradition established earlier than the orchestra itself. Also included is an account of the orchestra in transition in an evolving society. Lively presentation of great personalities such as Toscanini, Mahler, Mitropoulos, Stokowski, Walter, and Bernstein. Concert roster and repertory, 1942–1971.

R199. **Smith, Caroline Estes.** THE PHILHARMONIC ORCHESTRA OF LOS ANGELES: THE FIRST DECADE, 1919-1929. Los Angeles: United Printing Co., 1930. 283 p., illus. (ports.).

A review of early orchestral and symphonic activities that eventually coalesced into the Philharmonic Orchestra; additional coverage of its first ten years. Smith also includes mention of the Hollywood Bowl; such leading personalities as William Andrews Clark, Jr., and Walter Henry Rothwell; press reviews; premieres; solo performances; repertoires and personnel.

R200. **Spaeth, Sigmund, ed.** MUSIC AND DANCE IN NEW YORK STATE. New York: Bureau of Musical Research, 1952. 435 p., illus. (ports.). MUSIC AND DANCE SERIES.

The purpose of the anthologies that compose this series is to document activities and growth of music and dance in America. Specific articles discuss instruments, voice, dance activities in various cities and cultural centers and in schools and colleges. Perhaps more valuable, in retrospect, are the short biographical articles listed in the professional directory of music and dance personalities. The same format and some of the articles are included in the following volumes [R201–R203], all edited by Spaeth.

R201. **Spaeth, Sigmund, ed.** MUSIC AND DANCE IN THE SOUTHEASTERN STATES INCLUDING FLORIDA, GEORGIA, MARYLAND, NORTH AND SOUTH CAROLINA, VIRGINIA, AND THE DISTRICT OF COLUMBIA. New York: Bureau of Musical Research, 1952. 331 p., illus. (ports.). MUSIC AND DANCE SERIES.

R202. **Spaeth, Sigmund, ed.** MUSIC AND DANCE IN NEW ENGLAND STATES INCLUDING MAINE, NEW HAMPSHIRE, VERMONT, MASSACHUSETTS, RHODE ISLAND, AND CONNECTICUT. New York: Bureau of Musical Research, 1953. 347 p., illus. (ports.). MUSIC AND DANCE SERIES.

R203. **Spaeth, Sigmund, ed.** MUSIC AND DANCE IN PENNSYLVANIA, NEW JERSEY, AND DELAWARE. New York: Bureau of Musical Research, 1954. 339 p., illus. (ports.). MUSIC AND DANCE SERIES.

R204. **Spell, Lota M.** MUSIC IN TEXAS: A SURVEY OF AN ASPECT OF CULTURAL PROGRESS. Austin Tex.: Privately printed, 1936. 157 p., illus. (ports.).

A report compiled from newspaper clippings and archival materials of clubs and societies about culture and music since the time of the Spanish missions. The work discusses folk music, customs, and the progress of music, music publishing and education in various ethnic settlements until the 1920s.

R205. **Stoutamire, Albert.** MUSIC OF THE OLD SOUTH: COLONY TO CONFEDERACY. Hackensack, N.J.: Fairleigh Dickinson University Press, Associated University Presses, 1972. 349 p., illus. (ports.).

A cultural history of music in Virginia, particularly in Williamsburg and Richmond, from 1780 to 1865. Collected material from newspaper files, historical records, music and rare book collections. List of public buildings used for musical performances; selected programs of concerts.

R206. **Swan, Howard.** MUSIC IN THE SOUTHWEST, 1825-1950. San Marino, Calif.: Huntington Library, 1952. 326 p., illus.

A history of the musical and cultural evolution of the American Southwest. Focuses on the history of the Mormons, their devotion to music, their hymns (with text

samples), their bands and choirs, the music of the mining frontier in camps and the desert, and the band music on Southern California ranches. The broad sweep of cultural and musical expansion in Southern California, especially in Los Angeles with its transformation since the 1880s; and the promotion of music by Lynden Ellsworth Behymer. Appendixes; bibliography.

R207. Thrasher, Herbert Chandler. TWO HUNDRED AND FIFTY YEARS OF MUSIC IN PROVIDENCE, RHODE ISLAND, 1636–1886: RHODE ISLAND COMPOSERS NATIVE AND ADOPTED. Providence: Rhode Island Federation of Music Clubs, 1942. 31 p.

Cursory review of musical practice and events which started in 1768 with a first concert leading to a livelier atmosphere in the nineteenth century: organs and organists, the conservatory, visiting singers, and soloists. A second part contains Rhode Island composers, compiled by Dorothy Joslin Pearce in 1942. This is an alphabetical list of composers, including brief biographical data, titles, and dates of compositions.

R208. Tunison, Frank E. PRESTO! FROM THE SINGING SCHOOL TO THE MAY MUSICAL FESTIVAL. Cincinnati: Press of E. H. Beasley, 1888. 98 p.

A brief survey of music education, musical societies, and opera festivals in Cincinnati from around 1830 to 1888.

R209. United States. Works Progress Administration. CALIFORNIA. HISTORY OF MUSIC IN SAN FRANCISCO SERIES. EDITED BY CORNEL LENGYEL. New York: AMS Press, 1972. 7 vols. REPRINT EDITIONS of 1939–1940 WPA publications.

Vol. 1: MUSIC OF THE GOLD RUSH ERA. [1939]. Typewritten. 215 p.
The miniature melting pot in the West during the time of the Gold Rush is described as having laid the foundation for the city's cultural life. Descriptions are given of the first centers of musical activity at Mission Dolores, various festivals and balls; the formation of choirs, choral societies, and first orchestras; the rise of the grand opera, visiting virtuosi and local personalities. Lists of musical organizations, choirs, orchestras, opera companies, music teachers, dealers, publishers, visiting celebrities (with dates of performance, instrument, and concert location). Bibliography.

Vol. 2: A SAN FRANCISCO SONGSTER, 1849–1939. [1939]. Typewritten. 210 p.
"An anthology of songs and ballads sung in San Francisco from the Gold Rush era to the present, illustrative of the city's metamorphosis from camp to metropolis, and serving as lyric footnotes to its dramatic history." A textbook about the history of song in and around San Francisco, with explanatory and bibliographic footnotes; the forty-niners' balladry; camp songs; the metropolitan song. One hundred eighteen titles listed. Statistical material in appendixes about sources of song texts; of music; San Francisco song composers; publishers; and other songsters.

Vol. 3: THE LETTERS OF MISKA HAUSER, 1853. [1939]. Typewritten. 185 p., illus. (ports.), map.
"Selections from Hauser's travel book containing the celebrated virtuoso's impressions of early San Francisco and its musical life, with digressions on curious local customs, gambling houses, duels, festivals, fires, economics, Lola Montez and the Chinese." Translated from German by Eric Benson, Donald Peet Cobb, and Horatio F. Stoll, Jr. Source: *Aus dem Wanderbuche eines oesterreichischen Virtuosen.* Leipzig, 1859. Letters to the brother Sigmund Hauser in Vienna who in turn gave them to the newspaper *Ostdeutsche Post.* They were published in book form in 1859 in Leipzig and form perhaps the richest single source of early San Francisco musical history, spanning the time between January and July 12, 1853. Supplementary biographies of fifteen artists, including a list of their local San Francisco debuts.

Vol. 4: CELEBRITIES IN EL DORADO, 1850–1906. [1940]. 270 p.
"A biographic record of 111 prominent musicians who visited and performed in San Francisco from the earliest days of the Gold Rush Era to the time of the great fire, with additional lists of visiting celebrities (1906–1940), chamber music ensembles, bands, orchestras, and other music-making bodies." Musical history of San Francisco in biographies, spanning the periods 1850–1865; 1865–1880; and 1880–1906. Musical records for 1850–1940 in the appendixes, listing visiting musicians, and orchestras. Biographies with special emphasis on concert and other performances in San Francisco and reviews in the local press. Bibliography.

Vol. 5: FIFTY LOCAL PRODIGIES, 1906–1940. [1940]. 216 p., illus. (ports.).
"A survey of musical prodigies developed in San Francisco during the past four decades (1900–1940), with additional data presented in graphs, tables, appendixes on patrons, pedagogues, conservatories, schools, scholarships, and a selected list of bibliographical references." Biographies, description of the local musical scene, teachers, and patronage. Appendixes: statistical records of prodigies; occupational and musical background of their families; their teachers, awards, scholarships, schools, and music patrons.

Vol. 6: EARLY MASTER TEACHERS. [1940]. 159 p., illus. (ports.).
"Genre pictures of musical life in provincial San Francisco, revealed through the personal histories of such original temperments as Hugo Mansfeldt, disciple of Liszt, Sir Henry Heyman, perennial host to visiting virtuosos; Oscar Weil, critic, satirist, master teacher of counterpoint; Hartmann, Pasmore, Hinrichs, and others." Biographies of seventeen personalities who were active in San Francisco's musical life: Ernst von Hartmann, Henry Heyman, Hugo Mansfeldt, Henry Bickford Pasmore, Oscar Weil, Eugenio Bianchi, Gustav Hinrichs, Louis Lisser, John P. Morgan, John Haraden Pratt, Julian Rehn Waybur, Margaret Alonson, Emil Bath, John B. Bentler, Giovanna Bianchi, Inez Fabbri, and Louisa Mariner-Campbell. Included are excerpts from concert reviews and articles. Foreword by Albert Elkus. Bibliography.

Vol. 7: AN ANTHOLOGY OF MUSIC CRITICISM. [1942]. 476 p.

Musical life in San Francisco voiced through the contemporary press. A summary of newspaper criticism, reviews, and articles with short introductory texts, covering the following periods: pioneer criticism, 1850–1875; 1876–1906; 1906–1940; Calendar of musical events, 1849–1940.

R210. **Upton, George P.** MUSICAL MEMORIES: MY RECOLLECTIONS OF CELEBRITIES OF THE HALF CENTURY, 1850-1900. Chicago: A. C. McClury & Co., 1908. 345 p., illus., ports.

An account of fifty years of music, mainly in Chicago, as witnessed by its contemporary critic. Colorful recollections of Chicago's musical history, from conversations, managerial statements, newspaper reviews, programs, and the author's personal diary, bringing back to life the great opera singers of the nineteenth century as well as some of the world's famous virtuosos.

R211. **Van Name, Fred.** THE GOODSPEED OPERA HOUSE, EAST HADDAM, CONNECTICUT. East Haddam: Goodspeed Opera House Foundation, 1963. 27 p., illus. (ports.).

The history of the theatrical building from 1876 to 1963 and the profile of its founder, William H. Goodspeed.

R212. THE BOSTON MUSICAL YEARBOOK. Boston. 1–2 (1884–1886).

Vol. 1 chronicles the Boston musical season, 1883–1884. Compositions performed are listed under composer; performing artists, and concert sponsors are given. Separate organization listing, which includes the Boston Symphony Orchestra, the Handel and Haydn Society, the Boston Opera, and various clubs, details all works performed. Vol. 2 covers the musical season 1885–1886 and lists concerts performed in other cities of the United States and Canada. Superseded by the *Boston Musical Yearbook of the United States* 3 (1887); and by *Musical Yearbook of the United States* 4— (1888—). This yearbook was written by George Henry Wilson.

R213. **Wister, Frances Anne.** TWENTY-FIVE YEARS OF THE PHILADELPHIA ORCHESTRA, 1900-1925. Philadelphia: Women's Committee for the Philadelphia Orchestra, 1925. 264 p., illus. (ports.).

A summary of the first twenty-five years of the orchestra, reflected in the seasons' programs, newspaper articles and reviews, letters, announcements, and records of the orchestra. Presented are substantial historical data pertaining to the orchestra periods under conductors Fritz Scheel, Carl Pohlig, and Leopold Stokowski. Detailed information in various appendixes.

TOPICAL STUDIES

Church and Religious Music

BIBLIOGRAPHY

R214. BIBLIOGRAPHY OF EARLY RELIGIOUS AMERICAN MUSIC (EIGHTEENTH CENTURY). In: BRITTON, ALLEN PERDUE. THEORETICAL INTRODUCTIONS IN AMERICAN TUNE BOOKS TO 1800. Ph.D. thesis, University of Michigan, 1949. p. 472–686.

This bibliography complements Sonneck-Upton, *Bibliography of Early Secular American Music:* Eighteenth Century. Included in the present volume are works containing religious music published in the United States before 1801. Some later works are included by authors who began publishing before 1800; also includes some hymn and psalm books, anthems, and musical instruction books. Each entry gives chapter or subdivision titles; content analysis; known editions and their locations; and pagination, dimensions, and location for each book.

R215. **Mason, John Russell.** AMERICAN HYMNOLOGY. A BIBLIOGRAPHY. Typewritten. New York: Columbia University, 1933. 13 p.

The author calls attention to the need for a scholarly treatment of the American hymn as part of American literature. Descriptive annotated bibliography of thirty-seven titles.

R216. **Metcalf, Frank J.** AMERICAN PSALMODY OR TITLES OF BOOKS, CONTAINING TUNES PRINTED IN AMERICA FROM 1721 TO 1820. New York: Charles F. Heartman, 1917. 54 p., illus.

A bibliography of psalm books, from the first English psalmody printed in America (by the Rev. John Tufts, 1721) until 1820. The work is based on James Warrington's *Short Titles* [R217]. Metcalf's work is collected from twenty-five libraries and other private collections. The titles are alphabetically listed by author, with indication of number of edition and symbol for library where located. EDITION: seventy-three copies.

R217. **Warrington, James.** SHORT TITLES OF BOOKS, RELATING TO OR ILLUSTRATING THE HISTORY AND PRACTICE OF PSALMODY IN THE UNITED STATES, 1620–1820. New York: Burt Franklin, 1971. 98 p.

This bibliography on psalmody and related topics was published as a preliminary checklist of titles preceding the author's monograph, *History of Psalmody in the United States, 1620–1820.* One of the earlier classical publications in bibliographical studies of eighteenth-century American works. Titles (including author and publisher) listed by year, covering from 1538 to 1898. Included are foreign publications, such as the Strasburg Psalter (1541), the various editions of the Geneva Psalter; and "Etliche schone christliche Lieder" (Basel, 1583) and its various reprints, published in Germantown, Pa. (1742–). American ·publications became more frequent after 1700. Among the more ephemeral though church-related materials listed: W. Dunlap, *Lawfulness of Instrumental Music* (Philadelphia, 1763); and *Catalogue of All the Books Printed in the United States* (Boston, 1804). ORIGINAL EDITION (1898). REPRINT (Lenox Hill Publishing and Distributing Co.).

GENERAL REFERENCES

R218. **Davison, Archibald Thompson.** PROTESTANT CHURCH MUSIC IN AMERICA. Boston: E. C. Schirmer Music Co., 1933. 191 p.

An analytical study of "attitudes and conditions affecting Protestant church music," calling for a thorough church music renaissance. The author offers a concrete program for a reform mainly through more effective music education. The author also proposes an ideal of Protestant church music, in analyzing sacred and secular styles.

R219. **Doughty, Gavin Lloyd.** THE HISTORY AND DEVELOPMENT OF MUSIC IN THE UNITED PRESBYTERIAN CHURCH IN THE UNITED STATES OF AMERICA. Ph.D. thesis, University of Iowa, 1966. 420 p.

A survey not only of church history and music but also of social history of music in the United States: the Presbyterian church, from the Reformation in the British Isles to present practices in America. A combined history of the church, its liturgy, and music based on the study of church periodicals, books, church archives, and letters. Doughty discusses the Calvinistic doctrines, the attitudes of people involved in music programs, and the influence of noted personalities on the acceptance of music and liturgical change. Lists of hymns, vocal and instrumental music used in contemporary services. Music; bibliography.

R220. **Ellinwood, Leonard.** THE HISTORY OF AMERICAN CHURCH MUSIC. New York: Morehouse Gorham Co., 1953. 288 p., illus. (ports.).

The work discusses American church music, influenced by congregational and ethnic variants; the Spanish colonization; the early Franciscan mission work; and certain European-rooted group practices. Also discussed are eighteenth century choir practices and their tune books; the beginning of boys choirs; nineteenth century revival movements and their leaders. About seventy biographies of church musicians are provided in the appendix in addition to those in the text. Bibliography.

R221. **Ellinwood, Leonard.** RELIGIOUS MUSIC IN AMERICA. In: RELIGIOUS PERSPECTIVES IN AMERICAN CULTURE. Princeton University Press, 1961. p. 289–359.

The development of religious music in America, previously documented in individual studies, presented here as a descriptive survey. Discussed are the music of the Indians, early religious groups (Franciscans, Moravians, and others), performing practices, and various musical forms: the early Psalmody, Negro spirituals, gospel songs, and modern styles. Bibliographical footnotes.

R222. **Foote, Henry Wilder.** THREE CENTURIES OF AMERICAN HYMNODY. Cambridge: Harvard University Press, 1940. 428 p.

A cumulative study compiled from lectures on American hymnody given at Harvard Summer School of Theology, July 1936, celebrating the Tricentennial of the *Bay Psalm Book* (1640), the first book printed in English speaking North America. A study of the development of worship song in the United States, primarily concerned with the text of psalms and hymns, which reflect ideas of their time. Beginning with a text analysis of the Bay Psalm Book, Foote examines hymns of various settlements and regional areas, until the appearance of religious song in the nineteenth and early twentieth centuries.

R223. **Gould, Nathaniel D.** CHURCH MUSIC IN AMERICA. COMPRISING ITS HISTORY AND ITS PECULIARITIES OF DIFFERENT PERIODS WITH CURSORY REMARKS ON ITS LEGITIMATE USE AND ITS ABUSE; WITH NOTICES OF THE SCHOOLS, COMPOSERS, TEACHERS AND SOCIETIES. Boston: A. N. Johnson, 1853. 240 p.

A survey of music in schools and churches from the 1770s to the mid-nineteenth century, with citations from publications and newspapers. Included are comments on the aesthetics of music and its effects on people throughout history, as well as methods of teaching music and singing. The author is a music teacher. List of collections of sacred music for schools and churches in the United States since 1810 (seventy-six titles). A valuable list for the bibliographer and researcher in church music. Bibliography; music.

R224. **Hood, George.** A HISTORY OF MUSIC IN NEW ENGLAND. Boston, Mass.: Wilkins Carter & Co., 1846. 252 p.

A history of psalmody and of the church in New England during the seventeenth and eighteenth centuries. Comprehensive description of psalters, the first printed music, reforms, singing schools and societies, American organs and a history of books. Included is a list of works published before 1800; an account of the history of some New England choirs; and biographical sketches of six reformers and nine American psalmists.

R225. **Hunter, Stanley Armstrong.** MUSIC AND RELIGION. New York, Cincinnati and Chicago: Abingdon Press, 1930. 231 p.

An anthology of fifteen articles or sermons written by ministers of various denominations about music in church and the value of music in the conduct of worship. Brief introductions to the authors; some hymn texts.

R226. **Lutkin, Peter Christian.** MUSIC IN THE CHURCH. New York: AMS Press, 1970. 286 p.

This reprint represents a survey and history of music in the Anglican church in England and its development in America. Lutkin also discusses hymn tunes, their tradition, and the American versions; practices of congregational singing; the organ in worship, its acceptance in America and American organ building; male choirs in America, their history and their leaders; American leaders in Anglican church music; and the American school of church music. Index of tunes. Bibliography. ORIGINAL EDITION (Milwaukee, 1910).

R227. **MacDougall, Hamilton C.** EARLY NEW ENGLAND PSALMODY: AN HISTORICAL APPRECIATION, 1620–1820. Brattleboro, Vt.: Stephen Daye Press, 1940. 187 p., illus.

Historical survey in descriptive chapters: the European psalters and their influence on English psalmody, the psalters and tunebooks used in early America; the influence of T. Rosencroft, John Playford, Tate, and Brady on New England psalmody; the work of John Tufts, William Billings, Lowell Mason and others; singing schools and their teachers, notation, and the use of instruments. Succinct presentation of many essential details of New England's cultural past. Bibliographical footnotes.

R228. **Marshall, William.** A SERMON: THE PROPRIETY OF SINGING THE PSALMS OF DAVID IN NEW TESTAMENT WORSHIP: APRIL 1774. Perth, 1776. 68 p.

The sermon is a justification of the singing of psalms and hymns in church, or a justification of music in church. Embellished with the pastoral language of the epoch, it is a historical document of eighteenth-century America.

R229. **Messiter, Arthur Henry.** A HISTORY OF CHOIR AND MUSIC OF TRINITY CHURCH, NEW YORK. New York: Edwin S. Gorham, 1906. 335 p., illus. (ports.).

This history of music at Trinity Church reflects the organization and growth of music within the Anglican Church in America. Also discussed is the local musical history of New York City, where the first service at Trinity Church was held on March 13, 1698: description of musical services, leading organists, the organs (with specifications), and the church choral society.

R230. **Moe, William C. H.** THREE CENTURIES OF CHURCH MUSIC. CHANGES FROM THE TIME OF JOHN CALVIN TO THE PRESENT DAY. Guilford, Conn.: 1938. 11 p., illus. [*cont.*]

A brief survey of the history of church music in New England since the time of the Puritans; the books used during the nineteenth century; the installment and functioning of the organs. This short history is a typical account of the practice of church music in the Northeast. This work was delivered by William C. H. Moe on Nov. 13, 1938, the thirteenth anniversary of the dedication of the Hall Organ.

R231. National Society of the Colonial Dames of America. CHURCH MUSIC AND MUSICAL LIFE IN PENNSYLVANIA IN THE EIGHTEENTH CENTURY. Philadelphia, 1926–1947. 3 vols., illus.

A unique study investigating the history of religious and ethnic settlements of various regions, tracing the beginnings and growth of its musical life from the seventeenth to the nineteenth century.

Vol. 1, 274 p., illus. (ports.). Personality and biography of Johannes Kelpius, Pennsylvania's earliest hymnologist and musician; his hymnbook; Justus Falckner; the first German and Swedish settlements.

Vol. 2, 303 p., illus. (ports.). The German and Swiss Pietists, Mennonites and Dunkers; the Moravians. Musical practices, leading personalities; the hymnals used, first organs. Bibliography.

Vol. 3, 597 p., 1938 (pt. 1); 1947 (pt. 2). English settlements; English ballads, songs and ballad operas. Church music of the Episcopalians, Lutheran and Reformed, Roman Catholic churches; Jewish and Welsh music, and Freemason songs. Leading personalities such as Tony Aston, James Ralph, Francis Hopkinson, and Benjamin Franklin. Bibliography.

R232. Patterson, Floyd. PIONEERING IN CHURCH MUSIC: THE ORGANIZATION AND DEVELOPMENT OF THE STATE-WIDE CHURCH MUSIC PROGRAM AMONG BAPTISTS IN TEXAS. Waco, Tex.: Baylor University Press, 1949. 92 p.

A survey of Baptist musical practice and education in Texas, particularly of sacred music at colleges and related organizations. Advisory service to churches; curriculum support by the church; the church music department of the Texas Baptist General Convention.

R233. Pratt, Waldo Selden. THE MUSIC OF THE PILGRIMS: A DESCRIPTION OF THE PSALM BOOK BROUGHT TO PLYMOUTH IN 1620. Boston: Oliver Ditson Co., 1921. 80 p., illus.

The biography of Henry Ainsworth and the history of the Ainsworth and Pilgrim psalters. Description of the forty-eight texts of the psalter, thirty-nine of which are reproduced. Each psalm is accompanied by historical annotation, discussing its previous usage, derivations, special features of the melody, and other printed sources. In addition sixteen harmonized psalms in four parts from other sources are included, with music.

R234. Sankey, Ira David. SANKEY'S STORY OF GOSPEL HYMNS AND OF SACRED SONGS AND SOLOS. Philadelphia: Sunday School Times Co., 1906. 279 p., illus. (ports.).

Sankey's biography, his work as evangelist and singer. Index of hymns. Introduction by Theodore L. Cuyler.

R235. Hedge, Lemmel. THE DUTY AND MANNER OF SINGING IN CHRISTIAN CHURCHES, CONSIDERED AND ILLUSTRATED. Sermon preached at a singing lecture in Warwick. Boston, 1772. 41 p.

A historically revealing document that discusses late eighteenth-century Boston and the Puritan animosity towards music in church. As stated, the author wants to prove that "singing praises of God is a solemn part of public worship." The sermon was first delivered Jan. 29, 1772.

R236. Stevenson, Arthur Linwood. THE STORY OF SOUTHERN HYMNOLOGY. Roanoke, Va.: Stone Printing and Manufacturing Co., 1931. 193 p.

A survey of hymn singing and the old church hymnals used in the American South, by Baptists, Presbyterians, and Methodists. Also discussed are Moravian influence; early collections and first authors; gospel; "cheap" hymns and revival hymns; hymns used in Sunday schools, schools, and colleges.

R237. Trobian, Helen. THE INSTRUMENTAL ENSEMBLE IN THE CHURCH. New York and Nashville: Abingdon Press, 1963. 96 p.

Definition and interpretation of the role of instrumental music in church worship and education. Discussion of every type of instrumental repertory. Lists of suggested compositions; includes works for organ, instruments, voice, various kinds of ensembles; title, composer, publisher, degree of difficulty indicated. Bibliography.

HYMN COLLECTIONS

The hymn collections—in both recent and old editions—listed here are particularly interesting for their accompanying texts.

R238. Billings, William. THE CONTINENTAL HARMONY. EDITED BY HANS NATHAN. Cambridge, Mass.: Belknap Press of Harvard University Press, 1961. 201 p., illus.

Forty songs and anthems for four voices, including the historical introduction by Billings. This REPRINT of the 1794 edition (with the original title page) contains anthems, fugues, and choruses in several parts. Four citations from liturgical texts. Introduction by Hans Nathan includes a bibliography, and a description of the original work which discusses Billings's musical theory and personal style and evaluates his eight lessons in music theory and performance practice dating back to 1778. ORIGINAL EDITION: *The Continental Harmony* (1794), published according to an Act of Congress.

R239. Jenks, Stephen. THE DELIGHTS OF HARMONY, OR NORFOLK COMPILER; BEING A NEW COLLECTION OF PSALM TUNES, HYMNS AND ANTHEMS WITH A VARIETY OF SET PIECES FROM THE MOST APPROVED AMERICAN AND EUROPEAN AUTHORS; LIKEWISE THE

NECESSARY RULES OF PSALMODY MADE EASY: THE WHOLE PARTICULARLY DESIGNED FOR THE USE OF SINGING SCHOOLS AND MUSICAL SOCIETIES IN THE UNITED STATES. Dedham, Mass.: Printed by H. Mann for the author & co., 1805.

Close to seventy pieces of music, mostly for three parts (two sopranos and bass; some for four parts) and fifteen additional compositions. The accompanying text consists mainly of the rules of psalmody, or a basic course in teaching music measure, note value, chords and discords, and simple singing techniques. Musical dictionary of basic music terminology.

R240. **Mason, Lowell, and Ives, E.** JUVENILE LYRE OR HYMNS AND SONGS, RELIGIOUS, MORAL AND CHEERFUL, SET TO APPROPRIATE MUSIC. Boston: Richardson, Lord and Holbrook, 1832. 80 p.

A collection of religious and recreational songs—mostly from Europe and in particular from Germany— in vogue in America during the nineteenth century. The sixty-two songs for three parts were mostly collected by the Rev. William C. Woodbridge while on a trip to Germany. He considered these songs sufficently useful for the children and youth of his own country to form part of a scholastic music curriculum. The texts were mostly translated by F. Smith, the music being preserved as originally written.

R241. **Powell, John.** TWELVE FOLK HYMNS FROM THE OLD SHAPE NOTE HYMNBOOKS AND FROM ORAL TRADITION. New York: J. Fischer & Bro., 1934. 28 p.

A selection of twelve hymns from old shape hymnbooks of the South. Historical background of folk hymns and hymn practice. Harmonization for three and four parts. Explanatory note to each hymn, with information about title, mode, time and circumstances of collection, historical background, melody, and structure. The harmonizations are by John Powell, Annabel Morris Buchanan, and Hilton Rufty.

R242. **Wyeth, John.** WYETH'S REPOSITORY OF SACRED MUSIC. New York: Da Capo Press, 1974. 144 p.

This is a REPRINT of Wyeth's collection of 147 popular American hymn tunes, psalms and anthems, widely known and used in the 1800s. New introduction by Irving Lowens to early nineteenth century American musical history and religious practices, with identification and sources of the material collected. ORIGINAL EDITION (Harrisburg, Pa., 1810).

Choral Music

R243. **Finney, Theodore M.** CHORAL MUSIC IN THE UNITED STATES. *Boletín Latino-Americano* 5 (1939). 12 p.

This paper by Finney was read at the Interamerican Conference on Music held at the Library of Congress, Washington, D.C., conducted by the United States State Department in October 1939. This survey of choral tradition and singing societies discusses the historical importance of the development and acceptance of choral music in the curriculum of New England schools, colleges, and universities. Also described is the evolving awareness of ethnic idioms since the middle of the nineteenth century.

R244. **Swan, Alfred J.** THE MUSIC DIRECTOR'S GUIDE TO MUSICAL LITERATURE (FOR VOICES AND INSTRUMENTS). New York: Prentice Hall, 1941. 176 p.

The summary of a music teacher's practical experiences: a popular survey of musical history with regard to performance practices of the present time. The chapter about modern American music by James Giddings provides a selected list of choral works by American composers such as S. Barber, Seth Bingham, E. Bloch, A. Copland, H. Hanson, D. G. Mason, D. Moore, and R. Thompson.

Music of Ethnic and Religious Groups

AFRO-AMERICAN

The publications assembled here refer specifically to Afro-American characteristics in music or stress the meaning of "black" as a socio-political term. Additional works about music by black Americans are listed under Folk Music, Folk Song (*see* R314, R338, R368), and Jazz and Rhythm Music (*see* R436). *See also* R34, R37, R80, R88.

R245. **Garland, Phyl.** THE SOUND OF SOUL. Chicago: Henry Regnery Co., 1969. 252 p., illus. (ports.).

A journalistic account of interviews and personal opinions, defining race in music, in particular black characteristics. A brief history of the black people in America, their music, their attitudes, and moods. Vague definition of soul music and its relation to gospel music, blues, and jazz. Discography; bibliographical footnotes.

R246. **Haralambos, Michael.** RIGHT ON: FROM BLUES TO SOUL IN BLACK AMERICA. New York and London: Drake Publishers Inc., 1975. 187 p., illus. (ports.).

A fascinating, analytical history and definition of blues,

soul and modern black American music in its social context. Aesthetic definition of style; interrelationship between music, its changes, and society. Profiles and careers of blues singers and musicians, such as Moody Jones, Muddy Waters, Homesick James, Johnny Shines, Howlin' Wolf, and others. Charts about radio broadcasts of black music. Discography; bibliography.

R247. **Hare, Maud Cuney.** NEGRO MUSICIANS AND THEIR MUSIC. Washington, D.C.: Associated Publishers Inc., 1936. 451 p., illus.

Introduction by Clarence C. White, with a biographical sketch about the author. A critical and serious exploration of social and national characteristics of Negro music, through examination of African song and musical practices. Analysis of the specific Negro music rhythm and idiom. Reflection on modern music and European composers. Annotated list of African musical instruments, references to collections; descriptive bibliography of Negro folksongs; music examples.

R248. **Heilbut, Tony.** THE GOSPEL SOUND: GOOD NEWS AND BAD TIMES. New York: Simon and Schuster, 1971. 350 p., illus. (ports.).

Biographically descriptive chapters about individual singers and groups singing in gospel church services. An inside view of ghetto culture with its distinctive music, language, rhythms, rituals, and decorum. Definition of the liturgy and musical style of the traditional and modern gospel song. Individual chapters on Thomas A. Dorsey, Ira Tucker, Mahalia Jackson, Alex Bradford, and Dorothy Love Coates. Discography with notes about the singers. A revealing book about the black religious community, its music and musicians, listing performers who can rarely be found elsewhere in jazz literature.

R249. **Herskovits, Melville J.** THE STUDY OF NEGRO MUSIC IN THE WESTERN HEMISPHERE. *Boletín Latino-Americano* 5 (1939). 14 p.

An analysis of African elements in American music by white composers. The paper was read at the Interamerican Conference on Music held at the Library of Congress, Washington, D.C., conducted by the United States State Department in October 1939. Discography.

R250. **Jones, LeRoi.** BLACK MUSIC. New York: William Morrow & Co., 1967. 221 p., illus. (ports.).

A chronicle written between 1959 and 1967, mostly reviewing young musicians of the Harlem scene, such as Roy Haynes, Sonny Rollins, John Coltrane, Wayne Shorter, Dennis Charles, Bobby Bradford, Archie Shepp, Don Merry, Sonny Murray, and others. Episodes and opinions by black musicians which define modern jazz as an expression of a new characteristic of the black people. Discography.

R251. **Katz, Bernard, ed.** THE SOCIAL IMPLICATIONS OF EARLY NEGRO MUSIC IN THE UNITED STATES. WITH OVER ONE HUNDRED FIFTY OF THE SONGS, MANY OF THEM WITH THEIR MUSIC. New York: Arno Press; The New York Times Book Co., 1969. 188 p., illus.

A REPRINTED collection of early writings on the history of early Afro-American music and 150 songs, many with their melodies. Included is a concise literary review of the songs and music of the black slaves, first heard and recorded by white people. Prologue: "Of the Sorrow Songs," by William Edward Burghardt DuBois (1903). The preface contains portions of three of the most significant collections of early Afro-American songs, representing their history and heritage: An excerpt from: *Slave Songs of the United States* (1867) by William Francis Allen, Charles Pickard Ware, Lucy Mckim Garrison; excerpt from *The Books of American Negro Spirituals*, Book 1 (1925) by James Weldon Johnson; foreword to *Religious Folksongs of the Negro as Sung at Hampton Institute* (Hampton, Va. 1927) by R. Nathaniel Dett. Each of the reprinted articles of the collection includes a short introduction about the author, his publication, and dates: James Miller Mckim, "Negro Songs"; H. G. Spaulding, "Negro Shouts and Shout Songs"; Lucy Mckim Garrison, "Songs of the Port Royal Contrabands"; Thomas Wentworth Higginson, "Negro Spirituals"; James Mason Brown, "Songs of the Slaves"; George Washington Cable, "The Dance in Place—Congo and Creole Slave Songs"; Henry Cleveland Wood, "Negro Camp Meeting Melodies"; Marion Alexander Haskell, "Negro Spirituals"; and John Lowell, Jr., "The Social Implications of the Negro Spiritual."

R252. **Kofsky, Frank.** BLACK NATIONALISM AND THE REVOLUTION IN MUSIC. New York: Pathfinder Press, 1970. 280 p., illus. (ports.).

A socio-analytical study about the motivation and meaning of jazz as the blacks have attempted to assert their primacy in an art form of their own. Presented as a review of jazz in its development since the 1930s, in relation to the urban migration of black people and to the black liberation movement. Some essays written between 1961 and 1969 previously appeared in *Jazz* and *Monthly Review*. The essays illustrate the continual presence of social influences in jazz, such as black resentment. Some articles on individual musicians, such as John Coltrane, Albert Ayler, Elvin Jones, McCoy Tyler—and Malcolm X, whose personal career during the last two decades of his life is interpreted in relation to the history of jazz. Discography; bibliography.

R253. **De Lerma, Dominique-René.** BLACK MUSIC IN OUR CULTURE. CURRICULAR IDEAS ON THE SUBJECTS, MATERIALS AND PROBLEMS. Kent, Ohio: Kent State University Press, 1970. 263 p.

An anthology which was compiled from the material presented at a seminar on black music in college and university curricula held at Indiana University, 1969. Contributions by numerous authors. Aside from the incorporation of black music courses in higher education, the papers reflect a general concern to academically recognize black performers, musicians, and professionals and to recognize the influence of black music and culture on white America. Music; discography; bibliography.

R254. **De Lerma, Dominique-René.** REFLECTIONS IN AFRO-AMERICAN MUSIC. Kent, Ohio: Kent State University Press, 1973. 271 p.

Personal views of the twenty-one authors of sixteen articles concerned with black music in the undergraduate and graduate curriculum. Discusses the social role of the black composer, historical aspects of black music, and African musical culture. Focus on the documentation of black music history and the legacy of black music. Sample listing of black elements in European music; black artists in music and dance; black music in college music history texts; works by black performing composers.

R255. **Patterson, Lindsay, ed.** THE NEGRO IN MUSIC AND ART. In: INTERNATIONAL LIBRARY OF NEGRO LIFE AND HISTORY. New York, Washington, D.C., London: Publishers Co. under the auspices of the Association for the Study of Negro Life and History, 1969. vol. 5, 320 p., illus. (ports.).

An anthology of articles on the cultural and historical backgrounds of Negro-Americans, providing a detailed account on the black American's struggle for recognition and his contributions to American heritage. Articles by Maud Cuney Hare, Alain Locke, James Weldon Johnson, Sterling A. Brown, E. Simms Campbell, W. C. Handy, Arna Bontemps, William Russell, Stephen W. Smith, Wilder Hobson, Frank M. Davis, Ralph J. Gleason, Jack Yellen, George Hoefer, Charles Edward Smith, David Ewen, Leontyne Price, Phil Petrie, Raoul Abdul, Margaret Bonds, and Richard Plant. Preface by Charles H. Wesley. Bibliography.

R256. **Rivelli, Pauline, and Levin, Robert, eds.** BLACK GIANTS. New York and Cleveland: The World Publishing Co., 1970. 126 p., ports.

Personal opinions of musicians and reviewers about their records, lives, musician friends. Included are interviews that reveal the changes of musical style during the 1960s, new attitudes and a new expression in music which reveals the new black consciousness. Essays about and interviews with John Coltrane, John Carter, Bobby Bradford, Pharoah Sanders, Elvin Jones, Sunny Murray, Oliver Nelson, Horace Tapscott, Gary Bartz, Bayard Lancaster, Leon Thomas, Archie Shepp, and Alice Coltrane. Written by Frank Kofsky, David C. Hunt, Robert Levin, Pauline Rivelli, John Szwed, and Will Smith. Introduction by Robert Levin.

R257. **Roach, Hildred.** BLACK AMERICAN MUSIC: PAST AND PRESENT. Boston: Crescendo Publishing Co., 1973. 206 p., illus. (ports.), maps.

A guide to black composers and their works in various types of music, from the beginnings in colonial America until the 1970s. Also mentioned are African roots, the definition of African music, the essential African musical elements and instruments, musical forms of the American Negro. Short biographical chapters on Negro composers since the time of the minstrels; individual chapters on the new generation of African composers. The work analyzes historical facts and musical developments, presenting the prominent composers of each period. Music; discography; bibliography.

R258. **Roberts, John Storm.** BLACK MUSIC OF TWO WORLDS. New York, Washington, and London: Praeger Publishers, 1972. 204 p., illus. (ports.).

An informative work which reveals new aspects of a long-lasting musical interplay between the American and African continents. African music and its interrelations with other cultures throughout history. Its blending, development, and evolution of new musical forms in the Americas. Mutual musical achievement between Africa and North American jazz in modern times; exploitation of African music by jazz players; modern African pop forms. Discography; bibliography.

R259. **Southern, Eileen.** THE MUSIC OF BLACK AMERICANS: A HISTORY. New York: W. W. Norton & Co., 1971. 570 p., illus. (ports.).

The history of black American musicians and their music: their African heritage and the development of musical expression from colonial times in the northern and southern colonies, from the late nineteenth century to the present. Included is written and printed documentation of social conditions influencing music, especially from 1620 to 1900. Chronology of important events accompany each section. The supportive historical material was issued as a complementary compilation of readings. [*See* R260.] Music included.

R260. **Southern, Eileen, comp.** READINGS IN BLACK AMERICAN MUSIC. New York: W. W. Norton & Co., 1971. 314 p.

The companion work to: *The Music of Black Americans: a History* [R259]. This complementary volume presents a collection of authentic documents from the seventeenth to the twentieth century, taken from letters, early mission reports and travelogs, early newspapers, and other sources. Each selection includes an explanatory, introductory note supplying additional historical and biographical data. An excellent source book that offers a wealth of information on Americana. Includes music.

R261. **Walton, Ortiz.** MUSIC: BLACK, WHITE & BLUE: A SOCIOLOGICAL SURVEY OF THE USE AND MISUSE OF AFRO-AMERICAN MUSIC. New York: William Morrow, 1972. 189 p.

This work is basically a traditional history of jazz, introduced by a comparison of West-African music and European music. Precise definitions of the various forms (blues, ragtime, jazz, bebop); their rhythms, concepts; their background; the contemporary Afro-American musical scene interpreted from within the Afro-American movement.

JEWISH-AMERICAN

R262. **Sendrey, Alfred.** BIBLIOGRAPHY OF JEWISH MUSIC. New York: Columbia University Press, 1951. 445 p.

A comprehensive bibliography of almost 10,000 titles of Jewish music literature (pt. 1) and of Jewish music (pt. 2). It incorporates writings and music in all languages, and includes many American publications.

R263. **Binder, Abraham Wolf.** THE JEWISH MUSIC MOVEMENT IN AMERICA. Rev. ed. Typewritten. New York: National Jewish Welfare Board New York, National Jewish Music Council. 1963.

A brief survey of Jewish musical history in the United States and especially in New York City, starting with the first musical manifestations in the seventeenth-century synagogue. The actual focus of the lecture is on the past fifty years of the Jewish music movement, its supporting organizations, music publishers, recording industry, music education, musicology, performances and academic institutions. Bibliographical footnotes. This informal lecture was published in celebration of the American Jewish Tercentenary Sept. 1954–May 1955. This address was delivered at the Hebrew University in Jerusalem on March 20, 1952. The work was revised for publication in 1954 and for republication 1963.

R264. **Rubin, Ruth.** VOICES OF A PEOPLE: THE STORY OF YIDDISH FOLKSONG. New York: McGraw–Hill Book Co., 1973. 558 p.

A historical survey of Yiddish folk traditions in Eastern and Middle Europe and the socio-historical background of the people traced by its songs. Transplantation of songs and poetry to America during the mass-immigration in the 1880s and 1890s; preservation of traditions in the new country. Bibliography.

R265. **Soltes, Avraham.** OFF THE WILLOWS: THE REBIRTH OF MODERN JEWISH MUSIC. New York: Bloch Publishing Co., 1970. 311 p., illus.

Jewish music in America: its heritage, its role in the modern synagogue and community, the Hebrew Folk Song Society, the activities of the Jewish Music Council. Profiles of Jewish composers in America and the essence of their compositions. Samples for narrative-musical synagogue services. This book reveals a deep involvement with Jewish musical traditions; it is intended to strengthen Jewish-American communities through music. Bibliographical footnotes.

R266. **Yardeini, Mordecai S.** FIFTY YEARS OF YIDDISH SONG IN AMERICA. New York: Jewish Music Alliance, 1964. 312 p., illus. (ports.).

An anthology of Jewish music and folk customs in America: workmen's songs, folk choruses, mandolin orchestras, music organizations, societies, and personalities.

MORAVIANS

R267. **Rau, Albert G., and David, Hans T.** A CATALOGUE OF MUSIC BY AMERICAN MORAVIANS, 1742–1842. Bethlehem, Pa.: Moravian Seminary and College for Women, 1938. 118 p., illus.

Moravian musical traditions in Bethlehem and Lititz, Pa. List of Moravian composers, biographies, including list of descriptive or annotated compositions. Information about the following composers: John Frederick Peter,

Jacob van Vleck, John Christian Till, George Gottfrey Müller, John Herbert, David Moritz Michael, Johann Christian Bechler, Peter Ricksecker, Peter Wolle, and Francis Florentine Hagen. The work is located in the archives of the Moravian Church in Bethlehem, Pa.

R268. **Scott, Ruth Holmes.** MUSIC AMONG THE MORAVIANS. Bethlehem, Pennsylvania, 1741–1816. M.A. thesis. Rochester, N.Y.: Eastman School of Music, 1938. 267 p., illus.

Historical and religious background of the Moravians and Count von Zinzendorf; their first settlements in Pennsylvania, their musical practices and hymns. Biography of Johann Friedrich Peter; description of his compositions. Music; bibliography.

R269. **Walters, Raymond W.** THE BETHLEHEM BACH CHOIR: AN HISTORICAL AND INTERPRETATIVE SKETCH. Boston and New York: Houghton Mifflin Co., 1918. 301 p., illus. (ports.).

The Moravian song traditions; prominence of music and previous choral societies in Bethlehem during the nineteenth century. The beginnings of the Bach Choir and the work of J. Frederick Wolle and Charles M. Schwab (biographies). The Bach Festivals from 1900–1917, with reviews. Various appendixes, listing members, and repertoire.

OTHER GROUPS

R270. **Kendall, Raymond.** FRENCH MUSIC IN AMERICA. *Boletín Latino-Americano* 5 (1939) 12 p.

French influences on American culture: French colonies in the sixteenth century, first expedition to Florida; French and Cajun folk songs in Louisiana; French immigrants in Boston; cultural exchange in modern times. Bibliographical footnotes. This paper was read at the Interamerican Conference on Music held at the Library of Congress, Washington, D.C., conducted by the United States State Department in October 1939.

R271. **Schiavo, Giovanni Ermenegildo.** ITALIAN-AMERICAN HISTORY. New York: The Vigo Press, 1947. vol. 1.

The author discusses the Italian immigration in America since the seventeenth century in vol. 1, book 1: *Italian Music and Musicians in America.* Schiavo also includes the activities of early Italian musicians; the beginnings of Italian opera in New York and other cities; the triumphs of Italian opera singers; Italian composers and teachers, in orchestras, bands and radio. Vol. 1, book 2: *The Dictionary of Musical Biography* contains short biographies of singers and musicians, providing references at the end of each entry. Bibliography.

R272. **Simpson, Eugene E.** A HISTORY OF ST. OLAF CHOIR. Minneapolis, Minn.: Augsburg Publishing House, 1921. 192 p., illus. (ports.).

The beginnings of musical activity, church life and musi-

cal instruction on the frontier of the Norwegian-Lutheran community. The church, college and choir of St.Olaf; growth and change in Lutheran music; the first music director F. Melius Christiansen; concert tours of St.Olaf band and choir.

Folk Music and Folk Song

BIBLIOGRAPHY

R273. Association of American Railroads, School and College Service. RAILROAD MUSIC AND RECORDINGS: A BIBLIOGRAPHY. Washington, D.C., 1960 ?. 8 p.

A bibliography of fifty song collections and a list of about 150 song recordings with piano accompaniment, ballads and folk songs; also children's songs, railroad folk music and miscellaneous selections.

R274. Haywood, Charles. A BIBLIOGRAPHY OF NORTH AMERICAN FOLKLORE AND FOLKSONG. New York: Greenberg Publisher, 1957. 1322 p., maps.

This bibliography compiled in a course on American Folksong at Queens College, N.Y., in 1939 required ten years of research. It is well structured, nonannotated; classified by general, regional, and occupational topics. Each group subdivided by folklore and folk song. The second part of this volume contains bibliographic information about the North American Indians, classified by cultural areas. This is a standard tool for the student and researcher of folklore and folk song. Discography.

R275. Henry, Mellinger Edward. A BIBLIOGRAPHY FOR THE STUDY OF AMERICAN FOLK SONGS WITH MANY TITLES OF FOLK SONGS (AND TITLES THAT HAVE TO DO WITH FOLK SONGS) FROM OTHER LANDS. New York: New York Public Library 1937. 142 p.

A bibliography of song collections, which also includes American publications on Scottish, English, Irish, Puerto Rican, Jamaican, and Mexican songs. Listed by author, publisher or by title, if author is unknown. This is a limited edition of 750 copies.

R276. Herzog, George. BIBLIOGRAPHY OF FOLK MUSIC IN THE UNITED STATES AND THE WEST INDIES. Typewritten. Washington, D.C.: United States Report. 1935. p. 12–31.

A bibliography of monographs, periodical articles and folk song collections of about 260 titles, divided into two groups: United States, White (entries 1–117) and United States, Negro (entries 118–245).

R277. Hickerson, Joseph C. A BIBLIOGRAPHY OF AMERICAN FOLKSONG. In: EMRICH, DUNCAN. AMERICAN FOLK POETRY: AN ANTHOLOGY. Boston and Toronto: Little, Brown & Co., 1974. p. 775–816.

Pt. 1 of this bibliography *supplements* the poetry anthology by Emrich, supplying bibliographic information to each chapter. Pt. 2 presents an extensive bibliography on each subject, classified by four categories: general works on American folk song, general collections, regional collections, and general works and collections of American Negro folk song with explanatory introductions to the bibliographical material of each section. Entries are not annotated. A publishers' index of books, records, leading journals, and magazines specializing in folk music.

R278. Lane, Frederick W. A SELECTED ANNOTATED BIBLIOGRAPHY OF PERIODICAL ARTICLES DEALING WITH BALLADS AND FOLK SONGS, PUBLISHED IN FOUR UNITED STATES FOLKLORE JOURNALS BETWEEN 1937 AND 1954. M.A. thesis, Washington, D.C.: Catholic University of America, 1955. 71 p.

Articles listed by author, with short, descriptive annotations of contents. The compiler purposely selected material in order to include variants of text, music, background and source information, biographical and bibliographical information. The four journals indexed are geographically representative of the United States: *New York Folklore Quarterly* (1944–1954), *Southern Folklore Quarterly* (since 1937), *Midwest Folklore* (since 1951) including *Hoosier Folklore* (1942–1950), *California Folklore Quarterly* (since 1941), continued in *Western Folklore* (since 1947).

R279. Mattfeld, Julius. THE FOLK MUSIC OF THE WESTERN HEMISPHERE: A LIST OF REFERENCES IN THE NEW YORK PUBLIC LIBRARY. New York: New York Public Library, 1925. 74 p.

A classified list of periodical literature and monographs on folk music and song collections of all the Americas, including Cowboy, Creole, Eskimo, North American Indian, and Negro folk songs. The number of tunes and voices and any other specifics are noted in publications.

R280. Reuss, Richard A. A WOODY GUTHRIE BIBLIOGRAPHY, 1912–1967. Typewritten. New York: Guthrie Children's Trust Fund, 1968. 99 p.

Writings by Woody Guthrie since 1937 (pt. 1) and writings about him (pt. 2) with descriptive annotations.

INDEXES

For additional indexes, *see* R42–R48; R487–R495.

R281. Washington, D.C. **Library of Congress, Archive of Folk Song.** AMERICAN FOLKLORE: A BIBLIOGRA-

PHY OF MAJOR WORKS. COMPILED BY JOSEPH C. HICK-
ERSON. Typewritten. Washington, D.C.: Library of
Congress, 1975. 22 p.

An excellent list of titles, classified by race, region, and,
vocation. The sections on Negro folklore, folk song and
rhyme, play-party song, dance and game are helpful to
the researcher in folk music and folk song. [*See* also
R290.]

R282. Washington, D.C. **Library of Congress, Archive
of Folk Song.** AN INVENTORY OF THE BIBLIOGRAPHIES
AND OTHER REFERENCE AIDS. Typewritten. Washing-
ton, D.C.: Library of Congress, Archive of Folk Song,
n.d. 7 p.

An extensive checklist of folklore and folk music titles.
All works compiled in this list contain bibliographies or
other lists of reference.

R283. Berkeley. **University of California, Archive of
California Folk Music.** CHECKLIST OF CALIFORNIA
SONGS. Typewritten. 1940. 100 p.

This publication, sponsored by the Works Progress Ad-
ministration, is a bibliography of folk songs which were
published in pocket-size songsters in San Francisco be-
tween 1851 and 1892; and of broadsides printed as sheet
music (mostly in the 1860s). The indexed material is con-
tained in forty-nine songsters; the broadsides are stored
in five California libraries. Listing by title and first lines,
location of tunes indicated; name of publisher, place, and
date of publication, when given.

R284. **International Folk Music Council, London.**
FILMS ON TRADITIONAL MUSIC AND DANCE, A FIRST
INTERNATIONAL CATALOGUE. EDITED BY PETER KEN-
NEDY. Paris: UNESCO, 1970. 261 p.

A list of films of authentic folk dance performances with
song and instrumental music, displaying folk customs
and ceremonies. Classified by country. Included with
each of twelve American films are short synopsis, loca-
tion, characteristics, duration, production, and distribu-
tion.

R285. **Rosenberg, Bruce A., comp.** THE FOLKSONGS OF
VIRGINIA: A CHECKLIST OF THE WPA HOLDINGS.
Charlottesville, Va. University Press of Virginia, 1969.
165 p.

A list of more than 1600 folk songs and related material
collected by the WPA program that are located at the
Alderman Library, University of Virginia. Each song is
recorded by its national and local title, or first line; infor-
mation supplied about researcher, collector, date and
place, additional notes; some variants. Bibliography.

DISCOGRAPHY

R286. **Hall, Joseph S.** INVENTORY OF ITEMS IN THE
JOSEPH S. HALL COLLECTION OF SPEECH, MUSIC AND
FOLKLORE. The New York Public Library, n.d.

A microfilm of a pamphlet of various lists of field note-

books and research material. Includes a discography of
ninety-three records of traditional ballads and songs,
square dance and instrumental music, religious songs and
hymns. Songs listed by performer; detailed description of
contents. List of twenty-one tapes; description of con-
tents. Thirteen texts of ballads and folk songs with
variants.

R287. **International Folk Music Council.** INTERNA-
TIONAL CATALOGUE OF RECORDED FOLK MUSIC.
EDITED BY NORMAN FRASER. London: Archives of Re-
corded Music; Oxford University Press, 1954. 213 p.

A list of authentic folk music from all over the world,
available either on commercial records or on records
owned by institutions. List of commercial records, United
States, classified by producer: 204 single records or al-
bums by Library of Congress; 42 items by Ethnic Folk-
ways Library; general note regarding American-Indian
recordings by RCA-Victor and Columbia Records. Amer-
ican entries listing by institution and library information
about general and specialized holdings. Preface by
R. Vaughan Williams. Introduction by Maud Karpeles.

R288. **Lumpkin, Ben Gray, ed.** FOLK SONGS ON
RECORDS. Boulder and Denver, Colo.: Alan Swallow,
1950. 108 p.

List of folk songs, ballads, spirituals, and worksongs that
were issued on commercial records. Listed by name of
singer or group, with label and issue number, sometimes
with specific additional information. Also listed are In-
dian songs and dances (entries no. 642–658), folk dance
records and albums (no. 659–700) and Library of Con-
gress releases. List of collectors and contributors. Bibliog-
raphy. This is issue 3 (with Norman L. "Brownie"
McNeil and forty other collectors); cumulative, including
essential material in issues 1 and 2.

R289. **Spottswood, Richard Keith.** A CATALOG OF
AMERICAN FOLK MUSIC ON COMMERCIAL RECORD-
INGS AT THE LIBRARY OF CONGRESS, 1923–1940. M.A.
thesis, Washington, D.C.: Catholic University of Amer-
ica, 1962. 447 p.

Folk song recordings listed by name of singer or group,
with title, label and issue number, and size. Included are
contents of reverse side of record. The catalog contains
about 1,900 entries, most from the South and Southwest
of the United States.

R290. Washington, D.C. **Library of Congress, Archive
of American Folk Song.** CHECK LIST OF RECORDED
SONGS IN THE ENGLISH LANGUAGE IN THE LIBRARY OF
CONGRESS, ARCHIVE OF AMERICAN FOLK SONG, TO
JULY 1940. Typewritten. New York: Arno Press, 1971.
598 p.

The titles listed are part of the Archive's collection from
thirty-three states and parts of the West Indies. All the
material was recorded between 1933 and summer 1940.
This list represents most of the important types of Ameri-
can folk song, not including songs in foreign languages.
The entries contain the title, the name of the singer, per-
former, place, collector and year of the recording, and
call number of the disc. Each title is also listed by state or

country. Alphabetical list with geographical index: three vols. in 1. Foreword by H. Spivacke. [*See* also R281 and R282.]

R291. Washington, D.C. **Library of Congress, Archive of American Folk Song.** A LIST OF AMERICAN FOLK SONGS CURRENTLY AVAILABLE ON RECORDS. Typewritten. Washington, D.C.: Library of Congress, 1953. 180 p.

A list of nearly 1700 titles of American folk songs, issued by American record manufacturers. The entries contain name of performer and singer, title of album, label and issue number.

R292. **Wilgus, Donald Knight.** A CATALOGUE OF AMERICAN FOLK SONGS ON COMMERCIAL RECORDS. M.A. thesis, Ohio State University, 1947. 188 p.

A study of rural or semi-rural songs by white musicians, commercially classified as hillbilly. The author presents a short history of public hillbilly performances, radio presentations, and the influence on the traditional folk songs. The catalog consists of 382 entries, with information about sources, variants, and short annotation. Bibliography.

REFERENCE WORKS

R293. FOLK MUSIC YEARBOOK OF ARTISTS, 1964. Fairfax, Va.: Jandel Productions International, 1964. 128 p.

A survey of American folk and popular music of the 1960s, "featuring sections on traditional, popular, bluegrass, blues, gospel, the guitar, scenes of the 1963 Newport Folk Festival, the artist index," as stated on the book cover. Numerous listings of folklore and folk song societies, of singers, with photoportraits and description of artistic talents. Also lists of best selling folk music artists of 1963, best selling folk songs, record companies specialized in folk recordings, and others. Edited by Jim Clark, James Lee, Leroy Aarons, and Dick Reuss. Bibliography.

R294. **Lawless, Ray M.** FOLKSINGERS AND FOLKSONGS IN AMERICA: A HANDBOOK OF BIOGRAPHY, BIBLIOGRAPHY, AND DISCOGRAPHY. New York: Duell, Sloan and Pearce, 1965. 768 p.

This work includes a basic bibliography of folk song and references made to folksingers and country singers as they appear in American painting, literature, or design (Steuben Glass engravings). The listings are an alphabetical presentation of singers of ballads and folk songs; about 200 short biographical notes, first appearances, specialization, and location of performances and recordings. List of folk music instruments. Collections of ballads and folk songs; a bibliography with detailed annotations; archives and bibliographies; supplementary books. List of folk song societies and festivals. Folk song titles and discography: a checklist of folk song titles; long-playing records of individual singers, and of choral and other groups. Supplementary information to each section in appendix. Illustrations from paintings by Thomas Hart Benton and others, and from designs in Steuben Glass.

R295. **Tuft, Harry M.** CATALOGUE AND ALMANAC OF FOLK MUSIC SUPPLIES AND INFORMATION FOR THE FISCAL YEAR 1966. Denver: The Denver Folklore Center, 1965. 220 p., illus.

This publication discusses folk music instruments and supplies, and an extensive discography of Afro-American music. Contain blues collections, country blues, urban blues, revival blues, early jazz, gospel, jug and washboard bands, Negro folk singers and songsters. Listed by title are 950 Anglo-American records, with label and issue numbers, evaluative annotations, and a mention of participating singers. Bibliography of 258 folk song titles. Song indexes and index of articles in *Broadside* (Boston), the national topical song magazine, issues 1–57. *See also* the related work: Larry Sandberg and Dick Weissman, *The Folk Music Source Book* (New York: Alfred A. Knopf, 1976), 288 p.

GENERAL LITERATURE

R296. AMERICAN FOLK MUSIC. *Boletín Latino-Americano* 5 (1939).

This paper was read at the Interamerican Conference on Music held at the Library of Congress, Washington, D.C., conducted by the United States State Department in 1939. Part of the report prepared by the Committee on Folksong of the Popular Literature Section, of the Modern Language Association of America: definition of folk song, folk music, authorship, variations, alterations, the individuality of the folksinger. The work was originally published in *Southern Folklore Quarterly* vol. 1., p. 29–47 (June 1937).

R297. **Austin, Mary.** THE AMERICAN RHYTHM: STUDIES AND RE-EXPRESSIONS OF AMERINDIAN SONGS. New York: Cooper Square Publishers Inc., 1970. 174 p.

A study of rhythm, its physical source in motor impulses, its translation into basic modes of thought, emotion, verse forms: the poetry of American Indians, re-expressed from the original. Explanatory notes. REPRINT of 2d enl. ed. 1930.

R298. **Baynard, Samuel P.** INSTRUMENTAL FOLK MUSIC IN THE NORTH ATLANTIC STATES. *Boletín Latino-Americano* 5 (1939). 33 p.

A survey of folk music instruments in the United States and Canada; their use and some of their tunes. Short bibliography of collections of instrumental folk music. This paper was read at the Interamerican Conference on Music at the Library of Congress, Washington, D.C., conducted by the United States State Department in October 1939. Includes music.

R299. **Bernard, Kenneth A.** LINCOLN AND THE MUSIC OF THE CIVIL WAR. Caldwell, Ida.: Caxton Printers Ltd. 1966. 352 p. [*cont.*]

Episodes of Lincoln's life and their association with songs and music of the Civil War; with the background of specific events that inspired the music. Documented with quotations from letters, diaries, and reviews. Bibliography.

R300. **Botkin, Benjamin A.** THE AMERICAN PLAY-PARTY SONG. New York: Frederick Ungar Publishing Co., 1963. 400 p.

The author discusses the history of this form of combined game, dance and folk song. The survey was taken among students and teachers at the State University of Oklahoma in 1926–27. The first part pertains to the origin and background of the play-party song, its relation to game, dance, song; its style and language. Many citations of song texts, some with tunes. The second part comprises a collection of Oklahoma play-party songs with texts and tunes, notes about sources, where collected, variants. Separate indexes for both parts; song indexes for titles, tunes, and first lines. Bibliography.

R301. **Botkin, Benjamin A.** FOLKLORE AND SOCIETY: ESSAYS IN HONOR OF BENJAMIN A. BOTKIN. EDITED BY BRUCE JACKSON. Hatboro, Pa. Folklore Associates, 1966. 204 p., port.

A Festschrift for Benjamin A. Botkin at his sixty-fifth birthday. A collection of essays on folklore, folk song, and balladry. These are the contributions: "The Folkness of the non-folk versus the non-folkness of the Folk," Charles Seeger; "Folk Music, Old and New," Willard Rhodes; "The Question of Folklore in a New Nation," Richard M. Dorson; "The Ballad Scholar and the Long-playing Record," Kenneth S. Goldstein; "Plugging, Nailing, Wedging and Kindred Folk Medicinal Practices," Wayland D. Hand; "Negro Minstrelsy and Shakespearean Burlesque," Charles Haywood; "John Henry," MacEdward Leach; "Some Child Ballads on Hillbilly Records," Judith McCulloch; "Slavic Influences in Yiddish Folksong," Ruth Rubin; "Cents and Nonsense in the Urban Folksong Movement, 1930–1966," Ellen Stekert. Bibliography of B. A. Botkin's works from 1921–1966.

R302. **Brand, Oscar.** THE BALLAD MONGERS: RISE OF THE MODERN FOLK SONG. New York: Funk & Wagnalls Co., 1962. 247 p.

A textbook of folk song—its history, practice, sources; psychological effects on the younger generation; some personalities of the folk music movement (Alan Lomax, Cecil Sharp, the Seegers, the Weavers, and Belafonte). View of the modern folk song industry: its blacklist of producers and publishers, censorship, rights, and copyright. Foreword by Agnes de Mille. Bibliography.

R303. **Bronson, Bertrand Harris.** THE BALLAD AS SONG. Berkeley and Los Angeles: University of California Press, 1969. 333 p.

A collection of individual articles: concerning Anglo-Celtic roots and traditions of American folk songs; focusing on F. J. Child's *The English and Scottish Popular Ballade* (1882) and on subsequent studies by C. Sharp and G. P. Jackson. The author discusses ballad tunes and texts, their

interdependence, morphology, in tracing and comparing texts, tunes, and individual ballads. Music examples; bibliographic footnotes.

R304. **Emrich, Duncan.** AMERICAN FOLK POETRY: AN ANTHOLOGY: A BIBLIOGRAPHY OF AMERICAN FOLK-SONG, BY J. C. HICKERSON. Boston and Toronto: Little, Brown & Co., 1974. 862 p., illus.

The author offers a helpful study and analysis of folk poetry in the texts of ballads, songs, chants, hymns, and lullabies. Most are recorded on Library of Congress recordings in the Archive of American Folk Song; LC record numbers and available long-playing records are supplied. The songs are classified by topic; provenance is mentioned with each song analysis. With this exploration of the language of the people, research on American folk song has been considerably enriched.

R305. FOLK SONG SOCIETY OF THE NORTHEAST, BULLETIN. Cambridge 1–12 (1930–1937).

The objectives of this publication, which terminated in 1937, were the collection and preservation of traditional songs, ballads, fables and music of Maine and the adjacent regions of Canada. The work traces the traditional history of ballads, songs, and regional music. The twelve issues contain articles about related subjects, reviews of monographs and collections. Also contained are songs, ballads, texts, and tunes.

R306. **Glassie, Henry; Ives, Edward D.; and Szwed, John F.** FOLKSONGS AND THEIR MAKERS. Bowling Green, Bowling Green University Popular Press, 1971/72. 170 p.

Introduction by Ray B. Browne: "Folklore and popular culture. Three studies on the same theme, the creative process, sources and stimuli bearing on composition." H. Glassie, "Take That Night Train to Shenandoah," an essay about "Pop" Weir, Elial Glen Weir, and his family; E. D. Ives, "A Man and His Song"; Joe Scott and "The Plain Golden Band," with a descriptive list of songs and ballads by or about Joe Scott; J. F. Szwed, "Paul E. Hall, A Newfoundland Songmaker and his Community of Song." Music; Bibliographical footnotes.

R307. **Grafman, Howard, and Manning, B. T.** FOLK MUSIC U.S.A. New York: Citadel Press, 1962. 144 p., illus., ports.

This work is a pictorial representation of folk music in America during the 1960s, issued under the direction of art editor, Robert Amft. Included is a survey of the folklore movement and folk song collections. Fifty-eight single and group portraits appear with short annotations, followed by a collection of fifteen songs (texts with tunes and guitar chords). Articles include "The American Folk Music Revival," by Pete Seeger, and "The Old Town School and Folk Music in Chicago." Bibliography.

R308. **Green, Archie.** ONLY A MINER: STUDIES IN RECORDED COAL MINING SONGS. Carbondale, Ill.: University of Illinois Press, 1972. 518 p., illus.

A study on balladry, occupational lore, and labor history.

A survey of the research done in popular culture including early records of the 1920s. Analysis of some songs, their sources, their variants, recorded issues, previous research, relations of songs to social and political incidents and to labor life. Songs by or about John Wallace Crawford, Mother Jones, and Merle Travis with his films supporting folk song revival. Bibliography.

R309. **Greenway, John.** AMERICAN FOLKSONGS OF PRO-TEST. Philadelphia: University of Pennsylvania Press, 1953. 358 p.

This work traces the social history of America in a study of song texts. Survey of the genesis of protest folk song; with special attention to various groups of workmen's songs, considering social laws, land laws, feudal controls and the temperament of the people. Biographies of ballad writers: Ella May Wiggins, Aunt Mollie Jackson, Woody Guthrie, and Joe Glazer. Music; discography; bibliography.

R310. **Leach, MacEdward, and Coffin, Tristram P., eds.** THE CRITICS AND THE BALLAD. Carbondale, Ill. Southern Illinois University Press, 1961. 296 p.

A symposium of conflicting ideas in ballad and folksong scholarship, dealing with origin, variation and transmission, mostly concentrating on the Anglo-American tradition. These are the contributions: "The Scholar and the Ballad Singer," Joseph W. Hendron; "The English and Scottish Popular Ballads of Francis J. Child," Thelma G. James; "The Ballad and Communal Poetry," Francis B. Gummere; "Ballad and Dance," George McKnight; "Scottish Ballads: Their Evidence of Authorship and Origin," Alexander Keith; "The Part of the Folk Singer in the Making of Folk Balladry," Phillips Barry; "The Interdependence of Ballad Tunes and Texts," Bertrand H. Bronson; "Prolegomena to a Study of the Principal Melodic Families of Folk Song," Samuel P. Bayard; "Professionalism and Amateurism in the Study of Folk Music," Charles L. Seeger; "The meter of the popular ballad," George R. Stewart, Jr.; "Ballad Source Study: Child Ballad No. 4 as Exemplar," Holger Olaf Nygard; "Lambkin: A Study in Evolution," Anne G. Gilchrist; "Some Effects of Scribal and Typographical Error on Oral Tradition," W. Edson Richmond, "The Scottish ballads," John Speirs; "Mary Hamilton and the Anglo-American Ballad as an Artform," Tristram P. Coffin. Music; bibliographical footnotes.

R311. **Nettel, Reginald.** SING A SONG OF ENGLAND: A SOCIAL HISTORY OF TRADITIONAL SONG. London: Adams & Dart and Phoenix House, 1969. 282 p.

A chronicle of folk song traced by the history of individual songs. Included are American songs (with texts and tunes) and their background, such as "I Gave My Love a Cherry," "There's a Tavern in the Town," "Yankee Doodle," "Shenandoah," and other British songs in America.

R312. **Nettl, Bruno.** FOLK AND TRADITIONAL MUSIC OF THE WESTERN CONTINENTS. Englewood Cliffs, N.J.: Prentice-Hall, 1973. 271 p.

A panoramic view of the musical cultures of Europe, Africa and the two American continents. Separate chapters on the American Indians, Latin America, Afro-American folk music in North and Latin America, folk music in modern North America, and ethnic minorities in rural America; the role of folk music in urban American culture; the rural Anglo-American tradition. The chapters on Latin America are written by Gérard Behague. Drawings of musical instruments; music examples. Bibliographies and discographies at the end of each chapter.

R313. **Okun, Milton.** SOMETHING TO SING ABOUT! THE PERSONAL CHOICES OF AMERICA'S FOLK SINGERS. New York: Macmillan Co., 1968. 241 p., illus. (ports.).

An introduction to the 1950s folk revival. Collection of songs (with piano accompaniment) which were important or influential in the singers' musical lives. Brief profile of each singer with description of personality, career, and artistic achievements. Combined index of names, song titles, and first lines.

R314. **Russell, Tony.** BLACK, WHITES AND BLUES. New York: Stein & Day Publishers, 1970. 112 p., illus. (ports.).

A study of both Afro-American and American traditions in American folk music: their musical interchange, the song topics, preferences of the black or white singer, of the black and white audience. Black and white traditions in the West and East. References to long-playing records. Bibliography.

R315. **Scarborough, Dorothy.** ON THE TRAIL OF NEGRO FOLKSONGS. Hatboro, Pa.: Folklore Associates Inc., 1963. 304 p.

A foreword by Roger D. Abrahams about the work of the author and other Texan folklore collectors. A portrait of the Southern black people and their songs: a collection of songtexts and a social history of the South. Some tunes with music included. The text analyses focus on social and psychological backgrounds; classified as ballads, reels, game songs, and lullabies. ORIGINAL EDITION (Harvard University Press, 1925).

R316. **Scott, John Anthony.** THE BALLAD OF AMERICA: THE HISTORY OF THE UNITED STATES IN SONG AND STORY. New York, Toronto, and London: Bantam Books Inc., 1966. 415 p., illus.

A collection of songs classified by historical periods and topics. Introduction to each song: its history, tradition, versions, and distinctive characteristics. This is a history of America revealed by its songs, with a wealth of historical and social information in the accompanying text, culminating in a last chapter with the revival of the folk song and its bibliography. A pocket book recommended for the American student. Discography; music.

R317. **Seeger, Charles.** THE IMPORTANCE TO CULTURAL UNDERSTANDING OF FOLK AND POPULAR MUSIC. Typewritten. Washington, D.C. United States State Department, Division of Cultural Relations, 1940. 10 p. [*cont.*]

A lecture on the significance of folk and popular music in the process of cultural integration and communication of different races (black and white). This paper was presented in 1939 at the Interamerican Conference in the field of music held in Washington, D.C.

R318. **Seeger, Pete.** THE INCOMPLEAT FOLKSINGER. EDITED BY JO METCALF SCHWARTZ. New York: Simon and Schuster, 1972. 596 p.

A footnote to the title refers to a 1653 guide to fishing by Izaak Walton: *The Compleat Angler.* Citation of songs, photographic illustrations and some sketches. An autobiographical chronicle, revealing the influence of the old country music revival on other folksingers such as Leadbelly, Woody Guthrie, Jack Elliott. List of record manufacturers; list of folk music films. Discography; bibliography.

R319. **Shelton, Robert.** THE FACE OF FOLK MUSIC. New York: Citadel Press, 1968. 372 p.

A pictorial text book of the folk movement and its festivals; a retrospective view of its past and its revival since 1958. Photos by David Gahr.

R320. **Smith, Reed.** THE TRADITIONAL BALLAD IN NORTH AMERICA. *Boletín Latino-Americano* 5 (1939). 17 p.

This paper by Smith was read at the Interamerican Conference on Music held at the Library of Congress, Washington, D.C., conducted by the United States State Department in October 1939. The author discusses East Coast and Appalachian ballads.

R321. **Van Der Horst, Brian.** FOLK MUSIC IN AMERICA. New York: Franklin Watts, 1972. 79 p., illus. (ports.).

The author discusses three hundred years of American folk music. Topics include American Indians, Puritans, ballads, blues, Civil War songs and Western music; folk music today and folk musicianship, folk music instruments, and the stories of individual folksingers (from Lightnin' Hopkins to the Carter family, the Guthrie family, Bob Dylan, the Beatles, and the Rolling Stones). Music, bibliography.

R322. **Vassal, Jacques.** FOLKSONG: UNE HISTOIRE DE LA MUSIQUE POPULAIRE AUX ETATS UNIS. Paris: Edition Albin Michel, 1971. 348 p., illus.

A historical survey of American folklore: the American Indians, their past and present socio-political conditions; the black people, the background of the Negro spiritual, gospel song, worksong, blues; analysis of musical form and expression; the white tradition, based mainly on British folklore and the Americanization of Irish and Scottish ballads. The second part summarizes the modern American movement as an urban folklore renaissance. Biographies of folksingers with analysis of their musical style: Woodie Guthrie, Cisco Houston, Derroll Adams, Jack Elliott, Pete Seeger, Malvina Reynolds, Odetta, the Newport Festival 1963, Peter Paul and Mary, Bob Dylan, and the new generation. Discography; bibliography.

NATIONAL BALLADS

R323. **Browne, C. A.** THE STORY OF OUR NATIONAL BALLADS. New York: Thomas Y. Crowell Co., 1931. 327 p., illus. (ports.).

Elaborate background stories about eighteen songs, among them are "Yankee Doodle," "Hail Columbia," "Star-Spangled Banner," "The Battle Hymn of the Republic," "America the Beautiful," and others.

R324. **Sonneck, Oscar G.** CRITICAL NOTES ON THE ORIGIN OF "HAIL COLUMBIA." Sammelbände der Internationale Musikgesellschaft (Oct. 1901–Sept. 1902): p. 139–166.

The history of the song.

R325. United States. **Congress, House. Judiciary Committee.** TO MAKE THE STAR-SPANGLED BANNER THE NATIONAL ANTHEM: REPORT TO ACCOMPANY H.R. 14. 71st Cong. 2d sess. House Report No. 627. 1930. vol. 2: 9191, 4 p.

Report submitted to Congress on Feb. 6, 1930, proposing "... that the composition consisting of the words and music known as the Star Spangled Banner [be] designated the national anthem of the United States of America." Included are a brief history of the song and a description of parts of the battle that began on the morning of Sept. 13, 1814, on which occasion Francis Scott Key wrote the song.

FOLK SONG COLLECTIONS

R326. **Abrahams, Roger D., ed.** A SINGER AND HER SONGS: ALMEDA RIDDLE'S BOOK OF BALLADS. Baton Rouge: Louisiana State University Press, 1970. 191 p.

The autobiography of the singer (born in 1898) and her singing family. Songs included with the text which focuses on folklore, emphasizing performance and transmission of folk songs. Song notes; bibliographical notes on individual songs.

R327. **Solomon, Maynard, ed.** AMERICAN BALLADS AND FOLK SONGS FROM THE JOAN BAEZ SONGBOOK. New York: Ryerson Music Publishers; distributed by Crown Publishers. 1967. 24 p.

Twenty-three of Baez's songs with chord progressions for the guitarist. Arrangements for voice and piano by Elie Siegmeister. Introduction by John M. Conly. Illustrated in color by Eric von Schmidt. Discography.

R328. **Arnold, Byron, comp.** FOLKSONGS OF ALABAMA. Birmingham: University of Alabama Press, 1950. 206 p., illus. (ports.).

A collection of 153 songs collected within six weeks in 1945, including many Negro spirituals and worksongs. All songs with text and tune grouped by singer and in the order they were recalled and sung. Biographies of singers

with photo portraits are included of those artists who contributed more than three songs. No variants of songs. Song indexes: American and Alabama origin; Negro spirituals and work songs; play-party songs; and songs of English origin, compiled by Francis J. Child in *The English and Scottish Popular Ballads* (Boston, 1882–1898).

R329. **Barry, Phillips, ed.** THE MAINE WOODS SONGSTER. Cambridge, Mass.: The Powell Printing Co., 1939. 102 p., illus. (port.).

Fifty work and camp songs of the Maine lumbermen: texts (usually more than four stanzas) and tunes; a collection of ballads. Notes on the history of the individual songs, including sources of collection, special features of the song, previous melody which was combined with the text, and bibliographical references. One portrait of John Ross, "Old Dan Golden" of Bangor, Maine, 1867, known as ballad maker and singer.

R330. **Barry, Phillips; Eckstorm, Fannie Hardy; and Smith, Mary Winslow.** BRITISH BALLADS FROM MAINE: THE DEVELOPMENT OF POPULAR SONGS WITH TEXTS AND AIRS. New Haven, Conn.: Yale University Press, 1929. 581 p., port.

Introduction to the three groups of ballads included: their geographical distribution; text-tune relations including some observations on melodic structures, and variants. Fifty-six ballads are identified as recorded by F. J. Child in *The English and Scottish Popular Ballads*, 1882. Contrary to Child's text study, the authors investigate the relationship of text and tune as one unit. Opposite the title page is the portrait of Mrs. Mary Soper Carr, 1793–1869, "whose old ballads and ballad airs, traditional in the Soper family, are now preserved in this book." Recorded are texts, sometimes in several versions, and their simple tunes. Notes about the recording of text and tune, including the informant; explanatory remarks on texts and their variants; historical notes and bibliographic information on individual songs. Indexes of titles, melodies, subjects, and first lines. Bibliography.

R331. **Belden, Henry M., ed.** BALLADS AND SONGS: COLLECTED BY THE MISSOURI FOLKLORE SOCIETY. Columbia, Mo.: University of Missouri Press, 1966. 552 p. UNIVERSITY OF MISSOURI STUDIES, VOL. 15, NO. 1.

This collection of 287 Missouri ballads and folk songs became a model for other state and regional collections after its first publication in 1940. Mainly a study of folklore literature, giving variants of the texts and introductory notes to each ballad and song: tracing its historical connections with F. J. Child's *English and Scottish Popular Ballads* (Boston, 1882–1898) and Grundtrig's *Danish Ballads*. The headnotes include references to the ballad's appearance in other publications, noting place of performance; further indications about informant, tune, and location of recording. Often there is no mention of which tune was sung with the text, with the exception of about sixty tunes. Classified by topic or provenance. Bibliography.

R332. **Blesh, Rudi.** O SUSANNA: A SAMPLER OF THE

RICHES OF AMERICAN FOLK MUSIC. New York: Grove Press, 1960. unpag., illus.

A collection of twenty-four folk songs with simple, unaccompanied tunes. Each song with short note about its history and author, or other information; also short historical paragraphs about blues and personalities of New Orleans' tradition. The following songs are included: "O Susanna," "Battle Hymn of the Republic," "Rye Whisky," "Frankie & Johnny," "Grasshoppers in My Pillow," "Johnny Has Gone for a Soldier," "Little Girl, Little Girl," "Voyageur's Song; We'll Hunt the Buffalo," "Shenandoah," "Ballad of Henry Green," "Fireman's Song," "Didn't It Rain," "Swing Low, Sweet Chariot," "All God's Children Got Shoes," "Jonah and the Whale," "Gospel Train," "Down by the Riverside," "When the Saints Go Marching In." Illustrations by Horst Geldmacher. Musical scores by Herman Wilson. Discography.

R333. **Boette, Marie, ed.** SINGA HIPSY DOODLE AND OTHER FOLK SONGS OF WEST VIRGINIA. Parkersburg, W.Va.: Junior League of Parkersburg, 1971. 193 p.

A songster with 140 songs (tunes and texts sometimes in two versions or with additional text). Each song included with its local historical origin, the singer, the name and location of the singer's informant. Classified by topic, geographic area or the original collection. Music notes drawn by John Laflin. Illustrated by Marcia Ogilvie.

R334. **Botkin, Benjamin A., ed.** A TREASURY OF AMERICAN FOLKLORE: STORIES, BALLADS, AND TRADITIONS OF THE PEOPLE. New York: Crown Publishers, 1944. 959 p.

Detailed study of folklore and its interrelations wih folk song, stage play, party play, and rhymes. Although the main part of the study consists of folkloric material, pts. 1 and 6 are of particular interest to the music student and folk song specialist. Contains hero tales and boaster stories and their translations into music; description of stageplays; song texts and tunes cited as counterparts to tales. In pt. 6 a collection of songs and rhymes: play rhymes (three tunes); singing and play party games (nine song texts with tunes); ballads and songs (sixty-seven texts and tunes, classified by topic). Historical introductions, background, form and contents for each section. Footnotes to songs with information about sources, short comments on socio-historical background. Indexes of authors, titles, and first lines; of subjects and names. Foreword by Carl Sandburg.

R335. **Bush, Michael E.** FOLK SONGS OF CENTRAL WEST VIRGINIA. Ravenswood, W. Va.: Custom Printing Co., 1970. 2 vols.

Vol. 1: 41 songs, vol. 2: 44 songs, tune and text on opposite pages. Each song accompanied by short history about its origin, the name of the singer, his or her address or any other available information, some tunes, and bibliographic references.

R336. **Campbell, Olive, Dame, and Sharp, Cecil J.** ENGLISH FOLKSONGS FROM THE SOUTHERN APPALA-

CHIANS, COMPRISING 122 SONGS AND BALLADS, AND 323 TUNES. New York and London: G. P. Putnam's Sons, 1917. 369 p., map.

A first and fundamental collection and publication from which Cecil Sharp continued his monumental work in the research of American folk song [R357 and R358]. This is a collection of songs from English communities in the southern Appalachians. The collection contains fifty-five ballads, thirty-seven of which were recorded in various text forms in Child's *English and Scottish Popular Ballads;* fifty-five songs and twelve nursery songs. Texts (mostly longer than four stanzas) and simple unaccompanied tunes; in addition, variations of tunes. All songs with indication of style, name of singer, place and date of recording. Additional footnotes to all 122 items with information about other sources and variants. Introduction and notes.

R337. **Cheney, Thomas E., ed.** MORMON SONGS FROM THE ROCKY MOUNTAINS: A COMPILATION OF MORMON FOLKSONG. Austin and London: University of Texas Press, 1968. 240 p.

This collection published for the American Folklore Society contains songs which have some specific relation to the Mormon history, religion, and social order. Ninety-nine texts with their tunes. Mentions singer, date and place where collected, and short introductions. Index of titles and first lines.

R338. **Courlander, Harold, with Ruby Pickens Tartt and Emma Courlander.** NEGRO FOLK MUSIC OF ALABAMA. Phonograph record. New York: Folkways Records and Service Corp. Ethnic Folkways Library Albums, 1956. 6 vols., illus., ports.

Courlander's six record albums were made in central and western Alabama in 1950 under the sponsorship of the Wenner-Gren Foundation. Introduction traces West African elements in musical motifs and in enduring religious traditions. Collection of song texts of the record albums (1 vol., 43 p.) and also a selection of several hundred collected songs.

R339. **Cox, John Harrington, ed.** FOLK SONGS OF THE SOUTH. New York: Dover Publications, 1967. 577 p., illus. (ports.), map.

A REPRINT of a text study and collection of 185 ballads and songs and their variants, collected under the auspices of the West Virginia Folklore Society. With bibliographic references to British and American versions, including names of researchers and subjects, place, and date of recording. Separate section of 26 tunes; indexes of titles, and of first lines. ORIGINAL EDITION (Harvard University Press, 1925).

R340. **Bilden, Henry M., and Hudson, Arthur Palmer, ed.** In: FOLK BALLADS FROM NORTH CAROLINA. THE FRANK C. BROWN COLLECTION OF NORTH CAROLINA FOLKLORE. Durham, N.C.: Duke University, 1952. vol. 2, 772 p., illus.

Vol. 2, *Folk Ballads from North Carolina,* is part of a 7 vol.

edition, a literary collection and study of probably the most important part of the Dr. Brown collection. It incorporates about nine hundred ballads and songs, chiefly from the oral tradition, collected by Frank Brown, Trinity College and Duke University, and members of the North Carolina Folklore Society. Most of the songs and ballads are derived from the Old World. Forty-nine correspond to ballads in Francis J. Child's *The English and Scottish Popular Ballads,* which date from the seventeenth and eighteenth centuries. Pt. 1: The older ballads — mostly British (207); Pt. 2: native nineteenth and twentieth-century ballads from outside North Carolina (68); Pt. 3: North Carolina ballads (37). Each ballad with a headnote, indicating where known and sung, with literary references as to the geographical occurrence; sometimes with a short note reflecting the editor's opinion about the ballad's origin. Index of titles, variant titles, titles mentioned in headnotes. Tunes in corresponding vol. 4. Bibliography.

R341. **Schinham, Jan Philip, ed.** THE MUSIC OF THE BALLADS. In: THE FRANK C. BROWN COLLECTION OF NORTH CAROLINA FOLKLORE. Durham, N.C.: Duke University, 1957. vol. 4, illus.

Vol. 4, *The Music of the Ballads,* is the corresponding volume to the collection of ballad texts in vol. 2 [R340]. Collection of 1,250 songs, mostly transcribed from wax rolls. Contains information about singer, place and date of recording, references to melodic relationships, and scale. The tune is followed by all the melodic variations the singer made while singing various stanzas, analysis of each individual song, based on scales and modes; range, melodic line; meter; structure; rendition; including references to other publications, with citations and criticisms.

R342. **Dyer-Bennet, Richard.** THE RICHARD DYER-BENNET FOLK SONG BOOK: FIFTY SONGS ARRANGED FOR VOICE AND GUITAR. New York: Simon & Schuster, 1971. 176 p., illus.

A collection of fifty songs with indications of their origin, such as English ballad, Irish traditional tune, American folk song, and American. Contains eighteen American songs which the author "felt could benefit by the more musically developed treatment typical of the European tradition." Piano arrangements by Harry A. Rubinstein. Illustrations by Rodney Shackell. Discography.

R343. **Works Progress Administration, National Service Bureau.** FEDERAL THEATER PROJECT. Typewritten. 1938. 114 p.
PUBLICATION NO. 73–75.

This work by R. W. Gordon consists of fifteen articles which appeared in the *New York Times Sunday Magazine* from 1927 to 1928. A collection of song texts classified by type and topic, such as mountain songs from North Carolina, Negro work songs and Negro spirituals from Georgia, Negro chants, outlaw songs, jailhouse songs, lumberjack songs, noting background description and singing practices in various areas. There is no mention of

sources or any information about the process of collecting the individual songs. No index or listing of first lines.

R344. Hubbard, Lester B., ed. BALLADS AND SONGS FROM UTAH. Salt Lake City: University of Utah Press, 1961. 496 p., illus.

The 250 ballads and songs were collected in Utah from Latter-Day Saints, or Mormons. The collected material dates mostly from the second half of the nineteenth century. Each song and ballad contains several stanzas, tune, if available, and text variants in some cases. Songs classified by topic. Each song accompanied by headnote, selected references to other versions, history of the song, data on when and where collected. Introduction gives brief history of the Mormons, their leaders, and group consciousness. Music transcription by Kenly W. Whitelock.

R345. Jewell, James William. KENTUCKY MOUNTAIN MELODIES. Typewritten. Lexington, Ky., 1950. 272 p.

One hundred sixty-eight songs, classified by topics; texts (one stanza only) and tunes with guitar symbols; some with piano accompaniment. Some recent history, and names of contemporary musicians are mentioned in old and traditional texts. Brief foreword. Not a scholarly publication, but a valuable collection.

R346. Langstaff, John. GATHER MY GOLD TOGETHER: FOUR SONGS FOR FOUR SEASONS. Garden City, N.Y.: Doubleday, 1971. unpag.

Free poetry as an example for variations in folksong and folk poetry. As stated in the book, " . . . I took the words for this picturebook from many different ways of singing the same song, and then I chose one of the tunes I liked best. This kind of folksong is easy to teach your friends . . ." Spring: the tree in Yonders field; Summer: I had a little cat; Autumn: One man shall mow my meadow; Winter: Children, go, where I send thee. Four tunes to the texts, with accompaniment in the back. Illustrations by Julia Noonan.

R347. Leisy, James F. THE FOLK SONG ABECEDARY. New York: Hawthorn Books Inc., 1966. 410 p., illus.

A collection of popular, standard, contemporary versions of American folk song heritage of the twentieth century (texts and tunes). Musical autography by Alfredo Seville. Introductory commentary to each song to provide background information of customs, historical events and inspiration which lead to the song; sometimes several versions. Bibliography.

R348. Lomax, Alan. THE FOLK SONGS OF NORTH AMERICA IN THE ENGLISH LANGUAGE. Garden City, N.Y.: Doubleday, 1960. 653 p., illus., maps.

Three hundred seventeen songs from the Lomax Collection and other regional collections. Organized geographically (North, Southern mountains and backwoods, West, Negro South); and classified by topics. Each section with introduction, describing the region, singing practices, and the attitudes implied by the songs. Additional information for each song, noting its sociocultural background; text interpretation; sources of other publications; and in which areas the song is known. Performance aids: chord symbols and indication of dynamics. Indexes of song titles; first lines. Melodies and guitar chords transcribed by Peggy Seeger. One hundred piano arrangements by Matyas Seiber and Don Banks. Illustrated by Michael Leonard. Discography.

R349. Lomax, Alan, comp. HARD HITTING SONGS FOR HARDHIT PEOPLE. New York: Oak Publications, 1967. 368 p., illus.

This work includes nearly two hundred folk songs, classified by topic; texts with simple, unaccompanied tunes; notes about collector, by whom recorded, sources where published elsewhere. Short introduction to each section, revealing sociological aspects of the songs of the working class. Included here is a group of songs that constitute testament to an unknown America. Foreword by John Steinbeck; publisher's foreword by Irwin Silber; introduction and song notes by Woody Guthrie; music transcribed and edited by Pete Seeger; compiler's postscript by Alan Lomax.

R350. Lomax, Alan. HARRIET AND HER HARMONIUM: AN AMERICAN ADVENTURE WITH THIRTEEN FOLK SONGS FROM THE LOMAX COLLECTION. London: Faber & Faber, 1955. 47 p., illus.

Songs with piano accompaniment. Re-edition of Harriet Foster's *American Journal and Songbook*, relating the story of her trip from England to San Francisco. Illustrated by Pearl Binder.

R351. Lomax, Alan, and Lomax, John A. THE 111 BEST AMERICAN BALLADS: FOLK SONG U.S.A. New York: Duell, Sloane & Pearce, 1947. 423 p.

A collection of folk songs as they were handed down in words and music; with arrangement for piano by C. and R. Seeger, approximating traditional accompaniment. Classified by topic. Each group with introductory and explanatory text. Additional notes which recreate the cultural and historical background of each song, discussing the peoples' life style, customs, and working conditions. According to Alan Lomax, this is the first attempt to develop a cultural historical canon of American folk song. Appendixes: sources and references for tunes, texts and other sources where the song is published. Annotated discography; annotated bibliography, including periodicals, collections; 126 entries. Charles Seeger and Ruth Crawford Seeger, music editors.

R352. Lomax, John A., and Lomax, Alan. AMERICAN BALLADS AND FOLKSONGS. New York: Macmillan Co., 1935. 664 p.

Twenty-five groups of 271 topical songs. Texts with unaccompanied tunes; text variants. Many songs with introductory note about background, collected in Southern prison camps and elsewhere. Groups of songs such as the Levee Camp, songs from the Southern chain gangs, Negro bad men, white desperados, blues, Creole Negroes,

reels, minstrel types, songs of childhood, and cowboy songs. No songs from American Indians or Spanish traditional ballads. Foreword by George Lyman Kittredge. Bibliography.

R353. **Lomax, John A., and Lomax, Alan.** COWBOY SONGS AND OTHER FRONTIER BALLADS. Rev. and enl. ed. New York: Macmillan Co., 1938. 469 p.

A history of cowboy and frontier life from Texas to Fort Dodge, and from Kansas and the meatmarkets. Includes more than two hundred topical groups of songs. Contains text and tune, with indications of tempo, style; comments about cowboy author if known and footnote about availability of sources. Sources other than field work include manuscripts from professional and amateur singers, various collections of cowboy lore; recordings from the Lomax collection, Archives of American Folk Song, Library of Congress. Preface by Edward N. Waters.

R354. Pittsburgh. **Pittsburgh Public Schools, Department of Music.** TWENTY WESTERN PENNSYLVANIA FOLKSONGS FROM THE COLLECTION OF SAMUEL P. BAYARD. Typewritten. 1946. 25 p.

This volume was created for elementary school music teachers at the annual music festival on April 17, 1946. Short introductory history to each song with information about its origin, where it was sung, and its provenance. Bibliographic sources; prefatory note about the collector, S. P. Bayard.

R355. **Randolph, Vance.** OZARK FOLKSONGS. Columbia, Mo.: State Historical Society of Missouri, 1946–1950. 4 vols., illus. (ports.).

This collection consisting of more than 900 Missouri ballads and songs is one of the outstanding collections of American folk song research. It was edited by Floyd C. Shoemaker and Frances G. Emberson. It represents the largest single collection of any region in the United States. Each song is quoted with all its known stanzas and its tune; with text variants, in some instances differing in dialectical peculiarities. The collection contains nearly 1,700 individual texts and over 800 tunes. All songs include data in the headnotes, providing the song's history, and other bibliographical sources. The collection is classified by topical or historical groups, each with an introduction discussing the song's history and any other specific or pertinent information. Bibliographies.
 Vol. 1: nos. 1–41, traditional English ballads and nos. 42–130, later borrowings of English ballads, some of which might still be known in the English countryside.
 Vol. 2: nos. 131–176, various groups of songs with origin and topic; a larger group about outlaws and murderers; nos. 177–208, Western songs and ballads; nos. 209–251, songs of the Civil War; nos. 252–305, Negro and pseudo-Negro songs; nos. 306–341, songs of temperance.
 Vol 3: nos. 342–515, lighter songs; nos. 516–594, play party songs.
 Vol 4: religious songs, hymns, nos. 595–663; miscellaneous songs and sentimental ballads, nos. 664–883. Indexes of titles; first lines; contributors and towns.

R356. **Scarborough, Dorothy.** A SONG CATCHER IN SOUTHERN MOUNTAINS: AMERICAN FOLKSONGS OF BRITISH ANCESTRY. New York: Columbia University Press, 1937. 492 p., illus.

Songs and ballads collected in the mountains of Virginia and North Carolina in 1930, giving some insights into the cultural background of the underprivileged mountain areas. Separate groups of ballad texts and song texts with short comments on informer and contents. Collection of song tunes with one stanza, sometimes with several variants of tunes in appendix. Drawings by Paul Laune.

R357. **Sharp, Cecil James.** ENGLISH FOLK SONGS FROM THE SOUTHERN APPALACHIANS, COMPRISING 273 SONGS AND BALLADS WITH 968 TUNES, INCLUDING 39 TUNES CONTRIBUTED BY OLIVE ARNOLD DAME CAMPBELL, EDITED BY MAUD KARPELES. 2d enl. ed. London: Oxford University Press, 1932. 2 vols.

A detailed and scholarly record of American folk songs which was begun by Sharp in 1916–1917 [R336]. Includes a selection of the songs recorded by Sharp and his assistant Karpeles from 1916 to 1918. Ethnic background of singers and songs. Bibliography. Vol. 1 Ballads, nos. 1–72; texts with all available stanzas and unaccompanied tunes. Each song with footnote, giving other sources for the same text, and information about formal diversions, and variants. Headnotes to tunes with indication of mode, and data about researcher, time and place of recording. Vol. 2: nos. 73–274; various groups of songs: hymns, nursery songs, jigs, and play party games. Index of titles with each volume. Informative notes.

R358. **Sharp, Cecil James.** SONGS COLLECTED IN THE SOUTHERN APPALACHIAN MOUNTAINS. Handwritten. 1918. 7 vols.

The collections do not include any introductory text; photostats were made by the Harvard College Library. The index is in vol. 1 and includes a listing of 540 folk songs, including 36 games and 19 religious songs. Vols. 1 and 2 contain a collection of texts with simple one-stanza tunes. Each entry lists informer or singer, location, and recording date. Vols. 3–7 include song texts with all available stanzas but no tunes.

R359. **Shay, Frank.** THE PIOUS FRIENDS AND DRUNKEN COMPANIONS, BEING A COMBINATION OF THOSE TWO STUPENDOUS BOOKS: MY PIOUS FRIENDS AND DRUNKEN COMPANIONS AND MORE PIOUS FRIENDS AND DRUNKEN COMPANIONS. COMPLETE AND PUBLISHED FOR THE FIRST TIME IN ONE VOLUME. New York: Macanlay Co., 1936. 190 p., illus.

A collection of 67 plus 63 songs with texts (many stanzas) and simple tunes. Songs and ballads of conviviality collected by Frank Shay. Illustrations by John Held, Jr. Musical arrangements by Helen Ramsey.

R360. **Silber, Irwin, ed.** SONGS OF THE CIVIL WAR. New York: Columbia University Press, 1960. 394 p., illus.

An anthology of 125 Civil War songs classified by topics: marching and inspirational songs of the Union (seven-

teen); marching and inspirational songs of the Confederacy (fifteen); songs of Abraham Lincoln (eight); sentimental war songs of a sentimental age (seventeen); songs the soldiers sang (twenty-five); songs of battles and campaigns (twelve); Negro spirituals, abolitionist songs, songs of the Negro soldier (twelve); dialect minstrel and comic songs (fourteen); postwar songs and songs inspired by the Civil War (five). Introduction to each group, giving the historical background of each song category as well as individual histories of songs cited. Names of text author and composer or other origin of each song are noted. References to sources in appendixes. Piano and guitar arrangements by Jerry Silverman. Bibliography; discography.

R361. **Silber, Irwin, ed.** SONGS OF THE GREAT AMERICAN WEST. New York: Macmillan Co., 1967. 400 p., illus.

Topical groups of ninety-two songs from the American West, including northern Mexico, western Canada, and Alaska, since the 1840s. Musical annotations and arrangements by Earl Robinson. Each section with a brief historical introduction; each song with information about its subject matter, its historical and cultural relevance. Headnotes with data about origin and source of the particular version. Discography; bibliography.

R362. **Silverman, Jerry.** THE LIBERATED WOMAN'S SONGBOOK. New York: Macmillan Co., 1971. 153 p., illus.

The women's movement in history and song: collection of seventy-seven songs, each with text and tune (no accompaniment); names of authors (text or tune) when known or brief information about the song, its origin, and its provenance. Included are songs of courting, marriage, and domestic life (twenty-eight songs), songs of struggle (twenty-three songs), "they did their thing" (twenty-six songs).

R363. **Swan, Roy Timothy.** THE SONGSTER MUSEUM OR A TRIP TO ELYSIUM: SELECTION OF THE MOST APPROVED SONGS, DUETS, ETC. NOW IN USE WITH THE NOTES, MANY OF WHICH WERE NEVER BEFORE PUBLISHED. Northampton, Mass.: Andrew Wright for S. and E. Butler, 1803. 204 p.

A late eighteenth century collection of 113 songs and their melodies, twenty-two of which are noted with tunes and bass line. Introductory observations on song and singing, typical for the practice in nineteenth-century singing schools and societies.

R364. **Thomas, Jean.** DEVIL'S DITTIES: BEING STORIES OF THE KENTUCKY MOUNTAIN PEOPLE WITH THE SONGS THEY SING. Chicago: W. Wilbur Hatfield, 1931. 188 p., illus.

A collection of fifty-five ballads with harmonization for the piano by Philip Gordon. Headnote for each song including researcher and subject, mood, and situation of performance. The accompanying text extensively describes the life style and the songs of the mountain people. Illustrated by Cyril Mullen.

R365. **Thorp, N. Howard (Jack).** SONGS OF THE COWBOYS. New York: Clarkson N. Potter, 1966. 346 p.

Biography of "Jack" Thorp and historical survey of cowboy ballads and songs and of the cowboy myth. Reprint of his "Banjo on the Cow Camps," the first and only description of the cowboys' singing and song making by cowboys seen from within camp and trailing life. The twenty-three songs, collected by Thorp and first published in 1908, are republished here and accompanied by historical and critical notes. Thorp's collected song texts are supplied with tunes from other sources. Contains variants of the texts, bibliographies of significant publications, commercial recordings, manuscript and field recordings, and discussion of literary sources, and a REPRINT of the original edition of the texts. The lexicon contains terminology of cowboy and Western lore. Variants, commentary, notes, and lexicon by Austin E. and Alta S. Fife. Music editor, Naunie Gardner.

R366. **Whitfield, Irène Thérèse.** LOUISIANA FRENCH FOLK SONGS. New Orleans: Louisiana State University Press, 1939. 173 p.
ROMANCE LANGUAGE SERIES, NO. 1.

A collection of Louisiana French folk songs (texts and tunes) classified by the language used: Louisiana French (thirty-one songs); Acadian or Cajun folk songs (forty-eight songs); Creole folk songs (twenty-four songs). Brief introduction to the character and the language of each ethnic group. Sometimes short explanation and translation from Cajun or Creole into French, added to individual songs. Index of songs. Bibliography.

R367. **Whitman, Wanda Willson.** SONGS THAT CHANGED THE WORLD. New York: Crown Publishers, 1969. 225 p.

A collection of social and political song texts with melodies, classified by topic. General introductions to groups of songs, as well as notes to each song; no exact historical data. Some of the themes are: revolution, patriotism, hard times, escape, songs against prejudice, songs for a moving world, and others.

R368. **Work, John W.** AMERICAN NEGRO SONGS: A COMPREHENSIVE COLLECTION OF 230 FOLKSONGS, RELIGIOUS AND SECULAR. New York: Howell, Soskin & Co., 1940. 266 p.

Most of the 230 songs in scores for four voices, about thirty as single tunes. History of the Negro folk songs which traces their African origins. Definition and description of the spiritual, the blues, worksongs and social songs. Bibliography. Foreword by the author.

SPIRITUALS

R369. **Cohen, Lily Young.** LOST SPIRITUALS. New York: Walter Neale, 1928. 143 p., illus.

Southern childhood memories; many episodes depicting the life style in Charleston in the 1890s, with songs and tunes mentioned; includes music.

R370. **Dett, R. Nathaniel.** RELIGIOUS FOLK-SONGS OF THE NEGRO AS SUNG AT HAMPTON INSTITUTE. Hampton, Va.: Hampton Institute Press, 1927. 276 p.

A collection of 165 spirituals or "cabin and plantation songs," classified by topic and arranged for unaccompanied chorus. Description of the affectivity of the hymns; of the practice of singing in the Southern black churches and in groups. Includes music.

R371. **Jackson, George Pullen.** ANOTHER SHEAF OF WHITE SPIRITUALS. Gainesville, Fla.: University of Florida Press, 1952. 251 p., illus.

The 363 religious folk songs in this volume represent about one third of over 900 tunes of so-called white spirituals collected and published by the author. [See R372.] Most of the group songs, using religious texts with secular folk airs, were collected from old printed sources, some from informers. Each song supplied with sources and bibliographical references. Explanatory foreword provided with each class of songs. Foreword by Charles Seeger.

R372. **Jackson, George Pullen.** DOWN-EAST SPIRITUALS AND OTHERS: THREE HUNDRED SONGS. New York: J. J. Augustin Publisher, 1943. 296 p., illus.

The second of three volumes of more than 900 spiritual folk songs collected by the author. [See R371.] This volume contains 60 religious ballads, 152 folk hymns and 88 revival spiritual songs (the latter originally collected by William Walker and Benjamin Franklin White). Recorded are the texts with their simple, unaccompanied tunes, with short notation of source, mode and scale, style, and individual history. The introduction outlines the history of these religious songs, tracing their English origins and following their Baptist and later Methodist tradition. Bibliography. *Supplement* to Jackson, George Pullen, *Spiritual Folk Songs of Early America.*

R373. **Johnson, James Weldon.** THE BOOK OF AMERICAN NEGRO SPIRITUALS. New York: Viking Press, 1925. 187 p.

Sixty-one spirituals—one stanza each, with piano accompaniment. The introductory essay surveys the history of the spiritual since the beginning of the African slave trade in 1619. Description of group singing and the resulting responsorial form of the spiritual, its rhythm, and its social acceptance and publication. One of the classics among the collections of American song. Musical arrangements by J. Rosamund Johnson with additional numbers by Lawrence Brown.

R374. **Johnson, James Weldon.** THE SECOND BOOK OF NEGRO SPIRITUALS. New York: Viking Press, 1926. 189 p.

A collection of sixty-one songs with piano arrangements. Preface about the affectivity of the spiritual, its esthetic value and its influence on the music of white Americans.

R375. **Marsh, J. B. T.** THE STORY OF THE JUBILEE SINGERS. Cleveland, Ohio: Cleveland Printing and Publishing Co., 1892. 319 p., illus.

The beginnings and organization of the Jubilee singers of Fisk University, their first concert tours under George L. White and the success of their six-year tour around the world under F. J. Loudin. Personal histories of the singers. Collection of 139 songs; includes music. SUPPLEMENT by F. J. Loudin.

R376. **Society for the Preservation of Spirituals.** THE CAROLINA LOW-COUNTRY. New York: Macmillan Co., 1932. 338 p., illus.

Contributions by various authors. Description of Carolina, its past and influences by Spanish, English and French settlers. The Negro spiritual as a hybrid but "a truly American product." Collection of forty-nine songs: texts, tunes, and rhythm (for foot or drum).

Jazz and Rhythm Music

BIBLIOGRAPHY

R377. **Ganfield, Jane.** BOOKS AND PERIODICAL ARTICLES ON JAZZ IN AMERICA FROM 1926–1932. Typewritten. New York: Columbia University, School of Library Service, 1933. 12 p.

A bibliography mostly of periodical articles with short evaluative annotations.

R378. **Kennington, Donald.** THE LITERATURE OF JAZZ: A CRITICAL GUIDE. Chicago: American Library Association, 1971. 157 p.

A selective bibliography, presenting jazz in a historical perspective. Classified by eight topics: general background; histories of jazz; lives of jazzmen; analysis, theory and criticism; reference sources; periodical literature; jazz and literature; organizations (in the United States and Europe). Appendix: jazz on film.

R379. **Markewich, Reese.** BIBLIOGRAPHY OF JAZZ AND POP TUNES SHARING THE CHORD PROGRESSIONS OF OTHER COMPOSITIONS. Typewritten. Riverdale, N.Y.: Privately printed, 1970. 58 p.

A listing of groups of compositions and improvisations with varying degrees of similar chord progressions. No compositions that are based on chord progressions of blues. Although the models of chord progressions are not represented, the name of the model heads each group of compositions. In addition to title: author, publisher with address, membership or copyright, recording, and show or movie.

R380. Mecklenburg, Carl Gregor Herzog zu. INTERNATIONAL JAZZ BIBLIOGRAPHY: JAZZ BOOKS FROM 1919 TO 1968. Strasbourg and Baden-Baden: Editions P. H. Heitz, 1969. 218 p.

An indispensible tool for research with an international scope, this reference work codifies *Collections d'études musicologiques* and *Sammlung Musikwissenschaftlicher Abhandlungen.* The collections contain a large number of American publications. Mecklenburg has arranged his bibliography alphabetically by author; he details information about illustrations and photographs. Name index, by profession (musician, singer, author, translator); subject index, with references to records; and discography. Foreword by Wolfram Röhrig.

R381. Merriam, Alan P., with Benford, Robert J. A BIBLIOGRAPHY OF JAZZ. New York: Da Capo Press, 1970. 158 p.

A valuable source of material that was available in the 1950s; alphabetically listed by author; periodical articles included; names of translators mentioned; letter code to indicate the main contents, list of jazz magazines, most of which are no longer printed. Valuable information about editor, dates of appearance, and address. Indexes of subject and names; periodical entries cited. REPRINT of 1954 edition [R382].

R382. Merriam, Alan P., with Benford, Robert J. A BIBLIOGRAPHY OF JAZZ. Philadelphia: American Folklore Society, 1954. 158 p.
BIBLIOGRAPHICAL SERIES, VOL. 4.

Introductory survey of jazz history from its beginning to the 1920s. Lists all jazz titles available until 1950; includes newspaper and periodical articles as well as books, pamphlets, and other material. It lists 3,324 entries by author. Most valuable is a list of magazines devoted entirely or partially to jazz; most of these are no longer issued. Subject index and list of periodicals cited. REPRINTED 1970 [R381].

R383. Reisner, Robert George, comp. THE LITERATURE OF JAZZ: A SELECTIVE BIBLIOGRAPHY. New York: The New York Public Library, 1959. 63 p.

According to its introduction, this is "the first" bibliography of jazz literature; sponsored by the Institute of Jazz Studies. Brief historical and aesthetic definition of jazz. Bibliography divided into four sections: books (listing about 500 entries); background books (about 120 entries); selective list of magazine references (about 850 entries); magazines devoted wholly or principally to jazz. Included are some European publications and articles; also some peripheral articles related to the subject, from medical and other periodicals. Introduction by Marshall W. Stearns.

DISCOGRAPHY

R384. Carey, Dave, and McCarthy, Albert J., comp. THE DIRECTORY OF RECORDED JAZZ AND SWING MUSIC. Fordingbridge, Hampshire, England: The Delphic Press, 1950. 2 vols.

Discography, alphabetically listed by name of singer or performing group; followed by title, date of recording, record label and number; also vocal and instrumental combination, names of participating musicians and singers, or their replacements.

R385. Carey, Dave A.; Albert J. McCarthy; and Venables, Ralph G. V. JAZZ DIRECTORY: THE DIRECTORY OF RECORDED JAZZ AND SWING MUSIC. Fordingbridge, Hampshire, England: The Delphic Press, 1949–1957. 6 vols.

The directory includes Negro spirituals, gospel, recordings, jive, and bebop. Listed alphabetically by name of performer or group; short notes about the groups' personnel; available British and American catalog numbers. The comprehensive and detailed listing of recorded jazz and related music was continued by Brian Rust and extended to an international scale by Jorgen Grunnet Jepsen. Vols. 5 and 6 were published under a different imprint: (London, Cassell).

R386. Dance, Stanley. JAZZ ERA, THE FORTIES. London: Macgibbon & Kee, 1961. 253 p.

A review of jazz in the 1940s presented in three different approaches: a historical-critical survey of jazz and its revival after World War II; a tape-recorded discussion about this period between John Steiner, Scoops Carey (1958) and Dickie Wells, Stanley Dance (1959); and a discography of recordings of the 1940s, classified by groups; each with historical introduction about the music, the band or performing artists, listing year, title, artist or album, label (no record number). This discography's collaborators: Yamick Bruynoghe, Stanley Dance, Max Harrison, Hugues Panassie, and Charles Wilford. A valuable documentation of one period of jazz, placed in a historical perspective through critical annotations.

R387. Delaunay, Charles. NEW HOT DISCOGRAPHY: THE STANDARD DIRECTORY OF RECORDED JAZZ. EDITED BY WALTER E. SCHAAP AND GEORGE AVAKIAN. New York: Criterion Music Corporation, 1963. 626 p.

In two parts: *Jazz until 1930:* recordings classified by historical groups indicating their development; and divided by black and white musicians, accounting for stylistic differences. *From 1930 on:* alphabetical listing by musicians; information about recording dates, matrix, and issue number.

R388. Elmenhorst, Gernot W., and von Bebenburg, Walter, comp. DIE JAZZ-DISKOTHEK. Hamburg: Rowohlt Taschenbücher, 1961. 361 p., illus. (ports.).

A guide for young enthusiasts, consisting mainly of short biographical chapters on musicians and singers who are rarely mentioned in American works. Each chapter is followed by a list of long-playing records, including instrumentation, playing time, titles recorded; focus on records on the German market, with some American and other productions. This is an unconventional publication

that offers access to biographical as well as recorded material otherwise hard for the American student to reach. Bibliography.

R389. Godrich, John, and Dixon, Robert M. W., comp. BLUES AND GOSPEL RECORDS, 1902–1942. Rev. ed. London: Storyville Publications, 1969. 912 p.

This compilation was undertaken "to list every distinctively Negroid folk music record" with details about issue and re-issue. Included are recordings which were made for the Library of Congress by John A. Lomax, and also some hillbilly performances. Alphabetical listing by artist or group, with details about accompaniments, date and place of recording, with matrix and issue numbers. Double listing under major participating musicians. Instructive and succinct information about the so-called race recordings by major record companies: brief history of this type of recording, activity for each of the nine listed companies, with dates, locations of recordings and singers recorded during field trips to the South. The listing, ending with 1942, is intended as a complementary work to *Jazz Records A–Z*, by Brian Rust [R395].

R390. Jepsen, Jorgen Grunnet, ed. JAZZ RECORDS, 1942–1962: A DISCOGRAPHY. Holte, Denmark: Karl Emil Knudsen, 1963–1970. 11 vols. in 8.

The most comprehensive discography covering 1942–1962, listing all jazz styles with the exception of the recordings of gospel and religious songs, rock ensembles, and semi-jazz by vocalists and dance bands. American and international repertory and record releases. Extensive coverage: listed by artist with names of participating personnel, recording place and date, matrix and issue numbers. In this work the author continues and complements the thorough discographical work of the jazz era begun by Brian Rust [R395] for the time period of 1897–1931 and 1932–1942. He intends purposely to complete the work done in [R384 and R385] by Dave A. Carey and Albert J. McCarthy.

R391. Leadbetter, Mike, and Slaven, Neil. BLUES RECORDS: JANUARY 1943 TO DECEMBER 1966. London: Hanover Books Ltd., 1968. 381 p.

Designed as a companion volume for Godrich [R389]. Alphabetical listing by artist, including artist's birth place; matrix and issue numbers of record; and participating artists. American blues releases only.

R392. New York: POPULAR JAZZ: A COMPLETE CATALOG OF POPULAR AND JAZZ LONGPLAY RECORDS. (1952[?]–).

Catalog.

This catalog, put out by Long Player Publications, is an alphabetical listing by singer or performer of long-playing records and high fidelity tapes of American popular music, jazz, theater, film, speech, folk music, children's songs, and Christmas songs, with all songs listed for albums. Monthly issues appeared with varying subtitles. A catalog of jazz and popular recordings ISSUED separately as *The Long Player* 1— (1957—). *See* especially *The*

Long Player 6:1 (1957), an exhaustive catalog of long-playing records and high fidelity tapes.

R393. Propes, Steve. GOLDEN OLDIES: A GUIDE TO SIXTIES RECORD COLLECTING. Radnor, Pa.: Chilton Book Co., 1974. 252 p.

The complementary volume to *Those Oldies But Goodies* [R394] is a guide through the 1960s rhythm and blues, soul music and rock 'n' roll, rock music, and single artists' and group recordings. Survey of social trends in music; introduction to individual artists and groups with description of career, musical style, and outstanding records; summarizations of the main song themes of the sixties.

R394. Propes, Steve. THOSE OLDIES BUT GOODIES: A GUIDE TO FIFTIES RECORD COLLECTING. New York: Collier Books, 1973. 203 p.

A listing of rhythm and blues vocalists and groups, of rock 'n' roll performers, introducing each person or group with a paragraph on "history and sound," specifying "rarity and value" of the records. Summarizing chapters about "history and sound" of individual years or time periods. The purpose of this discography is "to describe and define those elements that constitute a valid collection of 1950s music." Bibliography.

R395. Rust, Brian. JAZZ RECORDS: A–Z, 1897–1931. Hatch End, Middlesex, England: By the author, 1962. 736 p.

Information about records of this era cover ragtime, instrumental jazz, jazz-oriented dance music, and popular vocal music which is interesting because of its accompaniment. Detailed listing of matrix and issue numbers, also pseudonyms. Supplementary index to this first volume compiled by Richard Grandorge (1963), 62 p.; listing of all names with references from participating musicians of the group. Rust covers the next decade in vol. 2 (196?), 780 p. In the second volume the author reviews the jazz and swing scene up to the bebop era; details of the big swing bands, of small neo-Dixieland units, vocalists, instrumental soloists; information about the record labels of this period. Lists records of American origin or by American artists that were recorded elsewhere. Short annotations on the soloists or groups with names of group members.

R396. Schwaninger, A., and Gurwitsch, A. SWING DISCOGRAPHY. Geneva and Thonon: C. Grasset, 1945. 200 p.

A Swiss discography listing all the American and international jazz records available in Switzerland between 1939 and 1945; with short notes about the development of various ensembles, the history of certain familiar melodies, as well as brief stylistic and technical information. Pt. 1: American and international productions of American ensembles; Pt. 2: records of European musicians; Pt. 3: short biographical notes on European jazz musicians. A valuable source for swing and its records between 1939–1945.

REFERENCE BOOKS

R397. **Clergeat, André.** DICTIONNAIRE DU JAZZ. Paris: Seghers, 1966. 391 p., illus. (ports.).

This work lists mostly American, but also European musicians. Short definitions of styles, schools, and trends. Terminology of jazz with short definitions. Alphabetical listing of musicians; biographical notes. Great names as well as names of those who played only a passing role in jazz are included, with biographical notes. Included also are the years of the artists' affiliations with other musicians and their record labels.

R398. **Feather, Leonard.** THE ENCYCLOPEDIA YEARBOOK OF JAZZ. New York: Horizon Press, 1956. 190 p., illus. (ports.).

The general status and trends of jazz in 1956. Short biographies of jazz musicians; encyclopedia of recorded jazz; and jazz organizations and record companies. Foreword by Benny Goodman.

R399. **Feather, Leonard.** THE NEW EDITION OF THE ENCYCLOPEDIA OF JAZZ. Rev. and enl. ed. New York: Bonanza Books, 1962. 527 p., illus. (ports.).

This standard reference on jazz, first published in 1960 under the title *The Encyclopedia of Jazz*, presents a combination of survey articles and criticisms, as well as biographies, chronologies, and other data. Articles include "Sixty Years of Jazz: An Historical Survey"; "The Anatomy of Jazz"; "Jazz in American Society"; "The Jazzman as Critic" (reactions to jazz recordings by various musicians); "Jazz and Classical Music," by Gunther Schuller. Chronologies and lists of data include events in jazz history from 1900 to 1960; a reference guide to jazz musicians; biographies; international polls drawn from *Down Beat*'s critics' poll; jazz overseas; annotated histories of jazz on records; and other tabulations concerning jazz organizations and record companies. Included are comments by Duke Ellington, Benny Goodman, John Hammond. Bibliography.

R400. **Gold, Robert S.** A JAZZ LEXICON. New York: Alfred A. Knopf, 1964. 389 p.

A dictionary of jazz jargon. This is an excellently written and linguistically researched study of jazz slang. The foreword explores the sociological background of jazz, and sees its alienation as ferment for the formation of jazz slang. Word and phrase entries supplied with translation into standard English, with history of usage, bibliography of citations, cross references to related expressions. Excellent bibliography of recent jazz and related literature, listed by title.

R401. **Jörgensen, John, and Wiedemann, Erik.** MOSAIK JAZZLEXIKON. Hamburg: Mosaik Verlag, 1966. 399 p.

An excellent, succinct introduction to the sociopolitical and historical background of jazz. Definition of ragtime, spiritual, and blues. Contains about 1,800 biographies of jazz musicians, singers, band leaders, composers, orchestras, and groups, including some interpreters of the traditional folk blues. Biographical sketches of some non-American and Latin-American musicians, focusing on career, special engagements, personal characteristics in musical performance, and playing affiliations on records. Classified bibliography of mostly recent publications, including a discography and some peripheral material. This work was translated from Danish by Hans-Georg Ehmke.

R402. **Meeker, David.** JAZZ IN THE MOVIES: A TENTATIVE INDEX TO THE WORK OF JAZZ MUSICIANS FOR THE CINEMA. London: British Film Institute, 1972. 89 p., illus. (ports.).

A filmography with alphabetical listing of film titles, including country of origin, year, playing time, director, composer, and short annotation. Index of major jazz names.

R403. **Panassié, Hugues, and Gautier, Madeleine.** GUIDE TO JAZZ. TRANSLATED BY DESMOND FLOWER. EDITED BY A. A. GURWITSCH. Boston: Houghton Mifflin Co., 1956. 319 p., illus. (ports.).

An encyclopedic listing of historical and technical terms, instruments, standard tunes and musicians, providing a reference to all aspects of jazz. Listing of jazzmen as well as of prominent musicians on the fringes of jazz, with biographical data, description of style, list of best records (with year of recording). Included are also famous tunes, when used as vehicle for improvisations, with composer, year, form, best recordings. Appendix: selection of best jazz on long-playing records. Introduction by Louis Armstrong. ORIGINAL EDITION: *Dictionnaire du jazz* (Paris, 1954). REPRINT (Westport, Conn.: Greenwood Press, 1973).

R404. **Rohde, H. Kandy, with research assistance by Laing Ned Kandel.** THE GOLD OF ROCK 'N' ROLL, 1955–1967. New York: Arbor House Publishing Co., 1970. 352 p., illus. (ports.).

An annual index of the top fifty and weekly lists of rock performances (title, performer, source). Each yearly chapter with introduction surveying trends, moods, attitudes, social changes and, special events in rock 'n' roll. Bibliography.

R405. **Roxon, Lillian.** LILLIAN ROXON'S ROCK ENCYCLOPEDIA. New York: Grosset & Dunlap, 1971. 611 p., illus., ports.

Alphabetical listing of terms; individual and group names from "Acid rock" to "the Zombies." Included is information about records, singles and albums, no labels, sometimes with month and year of recording. No biographical data; paragraphs describe the voice, song types, mood, and atmosphere.

Appendix 1: Cash box top albums, 1960–1968. Titles listed by year; with names of singer or group; label (no number).

Appendix 2: Cash box singles, 1949–1968. Titles of records, listed by year; with name of performer or group; from 1961 on with label (no number). [*cont.*]

Appendix 3: Billboard's weekly lists, 1950–1967. Listed by year, data, title, performer, label (no numbers).

R406. Ulanov, Barry. A HANDBOOK OF JAZZ. New York: Viking Press, 1959, 248 p.

A general survey of jazz: its history in comparison with events in the other arts of the twentieth century; a definition by brief descriptions of melody, harmony and rhythm. Included are two annotated discographies: *a)* a history of jazz in thirty-seven long-playing records, and *b)* musical achievements by individual singers, instrumentalists and groups on seventy-four records. Jazz glossary; alphabetical listing of jazz musicians with dates, education, successes, and influences. Chart: Comparative chronology for jazz and other music; theater and film; and literature and art. Bibliography. ORIGINAL EDITION (1957).

COLLECTIVE BIOGRAPHY

R407. Chilton, John. WHO'S WHO OF JAZZ: STORYVILLE TO SWING STREET. London: Bloomsbury Book Shop, 1970. 447 p.

An alphabetical list of over 1,000 biographies of musicians born before 1920 and raised in the United States. Includes birthdate and place, musical education and career. Special bibliographical notes and film appearances listed at the end of each entry.

R408. Dance, Stanley. THE WORLD OF DUKE ELLINGTON. New York: Charles Scribner's Sons, 1970. 325 p., illus. (ports.).

This is not a biography or historical survey, but a panorama of interviews with Duke Ellington—his opinions about music, his experiences as a performer throughout the world—and with his aides-de-camp Billy Strayhorn, Mercer Ellington, and Thomas L. Whaley; topics include the various artists' work as arrangers and composers and their individual careers. Twenty-six interviews and chapters with the Duke's musicians, their careers and memories; his memories of special concerts and events, his diary of South America. Selective discography of Ellington's recordings and a chronology of Ellington's life until 1970; the tour to the Far East. Also included is a colloquium with Duke Ellington and his group of musicians, reflecting on their careers in the 1960s.

R409. Green, Benny. THE RELUCTANT ART: FIVE STUDIES IN THE GROWTH OF JAZZ. London: Macgibbon & Kee, 1962. 191 p.

This work consists of five individual chapters on Bix Beiderbecke, Benny Goodman, Lester Young, Billie Holiday, and Charlie Parker. In these critical sketches the author discusses the artists' personalities and careers as well as the myths about them.

R410. Reisner, Robert George. THE JAZZ TITANS; INCLUDING THE PARLANCE OF HIP. Garden City, N.Y., Doubleday, 1960. 168 p., illus.

Thirty-three short articles on thirty-three of the most important musicians in the development of jazz. Reisner has attempted to capture the essentials of the individual's biography, professional achievements, and personality. Provided in the appendix is a dictionary of Hippie language (expressions of the marijuana and drug subculture). Short bibliographies and discographies at the end of each chapter.

R411. Rose, Al, and Souchon, Edmond. NEW ORLEANS JAZZ: A FAMILY ALBUM. Baton Rouge: Louisiana State University Press, 1967. 312 p.

A family album of more than two hundred photographs, arranged by groups: New Orleans jazz names, alphabetical listing of musicians, with biographical notes, instrument, achievements, and playing affiliations. The authors discuss bands that made history, their members, type of band, locations of playing; brass bands; famous locations of jazz performances; Mississippi vessels and their bands; family photographs of musicians, and some of their graves.

R412. Stewart, Rex. JAZZ MASTERS OF THE THIRTIES. New York: Macmillan Co., 1972. 223 p., illus. (ports.).

A recollection of personal memories, mostly encounters with other jazz musicians, and the New York jazz scene in the 1930s, written by a jazz musician; with biographical sketches of other jazz people of the time. This is one volume of the six-volume series (by different authors) that covers jazz in ten-year periods from its beginning in New Orleans in the twenties to the end of the 1960s.

R413. Fredericks, Vic, ed. WHO'S WHO IN ROCK 'N' ROLL: FACTS, FOTOS AND FAN GOSSIP ABOUT THE PERFORMERS IN THE WORLD OF ROCK 'N' ROLL. New York: Frederick Fell, 1958. 96 p., illus. (ports.).

This work provides information on the lives and careers of rock 'n' roll performers. Includes biographies of Elvis Presley and Alan Freed; one-page listings of disc jockeys; record companies; and a dictionary of rock 'n' roll terms. The text also gives a short history of rock 'n' roll as a form.

R414. Williams, Martin. JAZZ MASTERS IN TRANSITION, 1957–1969. New York: Macmillan Co., 1970. 288 p., illus. (ports.).

Eighty-seven short chapters, most of which had appeared before in magazines as interviews or profiles of jazz musicians, or as record reviews, often of reissued records. No index nor listing of the records mentioned in the text.

R415. Wilmer, Valerie. JAZZ PEOPLE. 2d ed. London: Allicon & Busby, 1971. 167 p., illus. (ports.).

Fourteen chapters about individual musicians (with portrait photos); interviews expanded to personality profiles including their opinions on music. Chapters on: Art Farmer, Cecil Taylor, Eddie Lockjaw Davis, Thelonius Monk, Billy Higgins, Jimmy Heath, Randy Weston, Babs Gonzales, Clark Terry, Jackie Mclean, Buck

Clayton, Howard McGhee, Joe Turner, and Archie Shepp. Photographs by the author. ORIGINAL EDITION (1970).

R416. **Wilson, John S.** THE COLLECTOR'S JAZZ MODERN. Philadelphia and New York: J. B. Lippincott Co., 1959. 318 p.

This is the *supplement* to the author's 1958 volume [R417]. Concise summary of the changes in jazz that took place during the 1940s and fifties: bebop, cool jazz, funky jazz, and hard bop. List of leading artists with description of their style, influence, and outstanding or typical recordings.

R417. **Wilson, John S.** THE COLLECTOR'S JAZZ, TRADITIONAL AND SWING. Philadelphia and New York: J. B. Lippincott Co., 1958. 319 p.

This handy pocketbook serves as "a suggestive guide to open new paths of exploration." Coverage is limited to the jazz styles developed before World War II. Brief introductory history and definition of ragtime jazz, and the role of certain instruments in the early bands. Contains an alphabetical listing of artists, with commentary on their musical style, specific individual traits, and recordings. A discography lists recordings for hollers, work songs, folk blues, gospel singing, ragtime, and miscellaneous collections. Biographical data on artists is included.

BLUES, RAGTIME, JAZZ, AND SWING

For additional entries germane to this category, *see also* R369 *et seq.* and R605 *et seq.*

R418. **Armstrong, Louis.** SWING THAT MUSIC. London, New York, and Toronto: Longmans, Green and Co., 1936. 148 p., illus. (ports.).

Armstrong's autobiography and the first history of swing. The second part includes eleven pieces and eleven portraits, edited by Horace Gerlach. A discussion of Armstrong's playing technique, his improvisations, rhythmic and melodic obbligatos (examples of swing and ten improvisations for ten different instruments). Glossary of swing terms. Includes music. Introduction by Rudy Vallée.

R419. **Asriel, André.** JAZZ, ANALYSEN UND ASPEKTE. Berlin: VEB Lied der Zeit, Musikverlag Berlin, 1966. 287 p., illus. (ports.).

Jazz: its etymology and history from its African roots through its developmental stages to "snobbist jazz"— bebop, free jazz, cool jazz, and progressive jazz. Included is an interesting, less conventional second part concerned with the study of jazz as a musical form, discussing its basic rhythmic patterns; and structural and harmonic analyses. There is also an annotated jazz terminology, and a final chapter about jazz in serious music with short analyses of jazz patterns in Dvořak, Hindemith, Debussy, Ravel, Milhaud, W. Walton, M. Tippetts, and others. Music; bibliography.

R420. **Back, Jack.** TRIUMPH DES JAZZ. Vienna: Alfa Edition, 1949[?]. 239 p., illus. (ports.).

First Austrian publication about jazz after World War II. Traditional presentation of the history of jazz, with individual chapters about King Oliver and Louis Armstrong. *Contents:* an encyclopedic jazz terminology; and a section about jazz instrumentation, with typical combinations of instruments, as well as a description of the instruments themselves; a presentation of harmonic patterns and a discussion of various sound combinations; biographies of jazz musicians, including some European stars. Translated into German by Hardo Nüring.

R421. **Balliett, Whitney.** DINOSAURS IN THE MORNING: FORTY-ONE PIECES ON JAZZ. Philadelphia and New York: J. B. Lippincott Co., 1962. 224 p.

A selection from jazz criticism and reporting published in *The New Yorker* from 1951 to 1960; in 2 parts (1951–1959; 1960); about performances, people, records, with much information pertaining to the jazz scene of this period.

R422. **Balliett, Whitney.** THE SOUND OF SURPRISE: FORTY-SIX PIECES ON JAZZ. New York: E. P. Dutton & Co., 1959, 250 p.

The New York jazz scene—a chronicle of the years 1954 to 1959, excerpted from *The New Yorker*, containing notes and biographical data on jazz musicians of the period, concert and record reviews, observations of the Newport Jazz Festival and the Great South Bay Jazz Festival. Developments and trends in jazz during the 1950s.

R423. **Balliett, Whitney.** SUCH SWEET THUNDER: FORTY-NINE PIECES ON JAZZ. Indianapolis, New York, and Kansas City: The Bobbs-Merrill Co., 1966. 366 p.

A collection from more than seventy original pieces, written as critical and biographical chronicle notes on jazz for *The New Yorker* between 1962 and 1966. A combination of the chronicle that started in 1954, collected in the previous two volumes [R421 and R422].

R424. **Berendt, Joachim Ernst.** THE NEW JAZZ BOOK: A HISTORY AND GUIDE. New York: Hill & Wang, 1963. 322 p., illus. (ports.).

A historical survey of jazz, focusing on the styles of jazz between 1890 and 1970, trends and developments by decade; individual chapters on some of the great musicians (Buddy Bolden, Louis Armstrong, Bessie Smith, Bix Beiderbecke, Duke Ellington, Coleman Hawkins and Lester Young, Charlie Parker and Dizzie Gillespie, and Miles Davis). A section on the elements of jazz examines its harmony, melody, and rhythm. Description of the jazz instruments and the big bands; a definition of jazz. Discography by Dan M. Morgenstern with anthologies, collections, and artists. Tables, music included. Translated by Dan Morgenstern. ORIGINAL EDITION (Frankfurt: Fischer Bücherei, 1959).

R425. **Bernard, Edmond, and Vergnies, Jacques de.** APOLOGIE DU JAZZ. Brussels: Les Presses de Belgique, 1945. 234 p. [*cont.*]

This is a two-part work. The first part, by Bernard, has a preface written by John Ouwerx. The second part, by de Vergnies, has a preface written by J. Stehman. Pt. 1: the history and the characteristics of rhythm and improvisation of jazz interpreted in relation to the general developmental trends of classical music. Pt. 2: the history of jazz, regarding musical forms, musicians, the great soloists of jazz as well as small and large orchestras. Appendixes on European jazz and instrumentalists.

R426. **Bernhard, Paul.** JAZZ—EINE MUSIKALISCHE ZEIT-FRAGE. Munich: Delphin Verlag, 1927. 110 p.

An aesthetic and etymological study of jazz in the 1920s in and outside of the United States. The work is a cultural history of dance and jazz viewed from a European musical perspective.

R427. **Biamonte, S. G., and Micocci, Enzo.** IL LIBRO DEL JAZZ. Bologna: Cappelli, 1958. 197 p., illus. (ports.).

A history of jazz with definitions of terms and forms, from the beginning in New Orleans, through the 1920s and 1930s, to cool jazz, West Coast and East Coast jazz in the 1950s. A final chapter on jazz in Europe in the 1950s. International discography, arranged by chapters; bibliography, with critical review of the classics in jazz literature.

R428. **Blesh, Rudi.** THIS IS JAZZ: San Francisco: Privately printed, 1943. 36 p.

In a series of lectures given at the San Francisco Museum of Art, Blesh surveys jazz history from its African origins to hot jazz. A historical, musical, and aesthetic definition of jazz with an evaluation of its chief sources. Includes sample records.

R429. **Blesh, Rudi.** SHINING TRUMPETS. A HISTORY OF JAZZ. New York: Alfred A. Knopf, 1958. 476 p., illus. (ports.).

A survey that has become one of the standard publications on jazz, beginning with the importation of African music during the slave trade, and following the development of jazz as a musical form through the 1930s and 1940s. This history not only traces historical facts but also analyzes and defines changing styles and attitudes. Invaluable documentation through references to recordings. Nine appendixes: analyses of melody, rhythm, Negro and white characteristics, types of blues, and street cries. Twenty-four pages of music examples; list of all recordings cited.

R430. **Blesh, Rudi, and Janis, Harriet.** THEY ALL PLAYED RAGTIME: THE TRUE STORY OF AN AMERICAN MUSIC. New York: Alfred A. Knopf, 1950. 374 p., illus. (ports.).

This classic work of jazz and ragtime literature discusses the history of the musical form in relation to the local atmosphere of Sedalia, Mo., and the life and compositions of Scott Joplin. This outline is based on personal interviews with surviving ragtime musicians and their family members. Chronology of ragtime, and other composi-

tions (1841–1941). Listed are phonograph records; cylinder phonographs prior to 1914; player piano rolls. Includes music.

R431. **Boeckman, Charles.** COOL, HOT AND BLUE: A HISTORY OF JAZZ FOR YOUNG PEOPLE. Washington, D.C.: Robert Luce, 1968. 157 p.

This introduction to the history and world of jazz discusses the songs of the slaves, describing jazz beginnings in New Orleans and Louisiana, the Chicago scene, and some of the important musicians: Satchmo, Bix, Whiteman, and Goodman. A simplified history in conversational style; recommended for the beginning student.

R432. **Borneman, Ernest.** A CRITIC LOOKS AT JAZZ. London: Jazz Music Books, 1946. 53 p.

A study of the African roots and history of jazz until the 1940s; much information on the history of the American Negro and his music; historical, formal and aesthetic analyses of jazz, from an anthropological and sociological approach.

R433. **Bradford, Perry.** BORN WITH THE BLUES: PERRY BRADFORD'S OWN STORY; THE TRUE STORY OF THE PIONEERING BLUES SINGERS AND MUSICIANS IN THE EARLY DAYS OF JAZZ. New York: Oak Publications, 1965. 175 p., illus. (ports.).

A collection of eleven songs (with piano and/or guitar accompaniment), and two melodies. An autobiographical recollection of the first Negro recordings of blues and spirituals. The New York and Harlem scene from the 1920s through the 1940s, including an encounter with Mamie Smith and other black musicians. Music examples included.

R434. **Buerkle, Jack V. and Barker, Danny.** BOURBON STREET BLACK: THE NEW ORLEANS BLACK JAZZMAN. New York: Oxford University Press, 1973. 255 p., illus.

An outline of New Orleans and Louisiana history, a sociological study of its Creole and black population and its musicians; recorded from interviews with fifty-one musicians; insights into musical traditions of families and of New Orleans in general. Opinions about black music, its political relevance; and professional standards in New Orleans music. Bibliography.

R435. **Brunn, O. H.** THE STORY OF THE ORIGINAL DIXIELAND JAZZ BAND. London: Sidgwick & Jackson, 1961. 288 p.

The author traces the history of the Original Dixieland Jazz Band from its start in 1917 to January 17, 1938, when the band dissolved, portraying in a detailed account the five New Orleans men who created Dixieland jazz under the leadership of Dominic James LaRocca. Included are articles about the band by the New York music critic J. S. Moynahan, published in *The Saturday Evening Post.* Appendix: table of personnel of the Original Dixieland Jazz Band. A well-written book that can be considered to be one of the standard histories of jazz and entertaining music.

R436. Carles, Philippe, and Comolli, Jean-Louis. FREE JAZZ BLACK POWER. Paris: Edition Champ Libre, 1971. 328 p.

A comparative study of the history of jazz and the social and political history of black Americans: music and politics; the Black Nationalist Movement with King Jones, the movement of black culture and Afro-American studies and the propaganda of black masses. Jazz and free jazz as expression against white oppression and the capitalist system, especially in the recording industry. Alphabetical listing of one hundred free musicians, with biographies, work accomplishments, evaluation. Discography.

R437. Charters, Samuel B. THE COUNTRY BLUES. New York and Toronto: Rinehart, 1959. 288 p., illus. (ports.).

A first study of early blues singers and their recordings, beginning with W. C. Handy's first recording in 1920; the stories of musicians; their successes and failures reflected by the history of the marketing and sales of their records (record numbers included in text). Appendixes: recorded blues backgrounds (a history and interpretation of the holler, as collected and recorded by Folkways Records); the blues recordings (as recorded by Folkways Records, with record numbers).

R438. Charters, Samuel B., and Kunstadt, Leonard. JAZZ: A HISTORY OF THE NEW YORK SCENE. Garden City, N.Y.: Doubleday, 1962. 382 p., illus. (ports.).

A kaleidoscopic view of New York's music scene, in jazz and dance bars, emphasizing the importance of Harlem's music life and its interrelations with the big record business in the 1920s. This work is a history of jazz between 1900 and 1950, particularly in New York City, based on original source material, interviews, newspaper clippings, and advertising leaflets. Individual chapters on Jim Europe, Mamie Smith, Perry Bradford, P. Whiteman, Bix Beiderbecke, Ben Pollack, Fletcher Henderson, Duke Ellington, Clarence Williams, J. R. Morton, Joe King Oliver, Chick Webb, B. Goodman, and Count Basie. Bibliography.

R439. Coker, Jerry. IMPROVISING JAZZ. Englewood Cliffs, N.J.: Prentice-Hall, 1964. 127 p.

This is a theoretical and analytical study of jazz, providing the beginning jazz improvisor with rudimentary musical-theoretical tools needed for professional musicianship. A study of melody, rhythm, chord types, scales, chord superimpositions, functional harmony. Appendixes: aesthetic criteria, left-hand chord voicing, alternate chord progression to the blues, collection of tunes. Charts and music included.

R440. Condon, Eddie, and Gehman, Richard, eds. EDDIE CONDON'S TREASURY OF JAZZ. New York: The Dial Press, 1956. 505 p.

An anthology about the jazz world and many of its representatives such as Bix Beiderbecke, Fats Waller, Duke Ellington, Count Basie, Glenn Miller, Lionel Hampton, and others. A collection of writings revealing personal opinions, and memories, written by Eddie Condon, Ernest Borneman, Nat Hentoff, Gilbert Milstein, Whitney Balliett, and many others.

R441. Cook, Bruce. LISTEN TO THE BLUES. New York: Charles Scribner's Sons, 1975. 263 p., illus. (ports.).

An account of "the fundamental American music," its growth from the beginnings in the Delta country to the "Nashville Stonewall Blues." A lively representation of bluesmen and musicians, with profiles of Leadbelly, Bessie Smith, Big Bill Broonzy, Muddy Waters, B. B. King, Memphis Slim, and Son House.

R442. Criel, Gaston. SWING. Paris: Editions Universitaires francaises, 1948. 91 p.

A philosophical and aesthetic view of jazz, with the author's thoughts on human emotions. This work adds a dimension to jazz quite different from the usual attitudes in jazz literature. Introduction by Jean Cocteau and Charles Delaunay.

R443. Dexter, Dave, Jr. THE JAZZ STORY FROM THE NINETIES TO THE SIXTIES. Englewood Cliffs, N.J.: Prentice-Hall, 1964. 190 p., illus. (ports.).

The history of jazz from its beginning to the early 1960s, written from intimate experience in the jazz world and from interviews. Included are short articles about lesser known jazz musicians, their friendships, musical affiliations, and recordings. Discography, listing the jazz story in five parts, by disc number, with contents. A concise and readable survey of jazz history, enlivened by the author's personal involvement. Annotated bibliography. Foreword by Woody Herman.

R444. Erlich, Lillian. WHAT JAZZ IS ALL ABOUT. New York: Julian Messner, 1962. 181 p., illus. (ports.).

A history of jazz, tracing in detail its development from its African roots to the modern scene of the early 1960s, focusing on individual musicians and singers. Essentially, a conversational jazz history based on the earlier classical writings with a small bibliography of sixteen titles. Illustrated with portraits of jazz greats.

R445. Fox, Charles. JAZZ IN PERSPECTIVE. London: The British Broadcasting Corp., 1969. 88 p., illus. (ports.).

The history of jazz seen as a pattern parallel to European music, with beginnings in folk song and stages in a polyphonic, neoclassical and romantic period. A description of jazz history from its African roots to modern jazz and its international acceptance. Discography; music; bibliography.

R446. Gammond, Peter, ed. THE DECCA BOOK OF JAZZ. London: Frederick Muller, 1958. 431 p., illus. (ports.).

An anthology in 25 chapters, focusing on various stylistic forms of jazz rather than on the singers and musicians. The articles are: "Blues and Negro Folk Music," Paul Oliver; "The Ragtime Years," Charles Wilford; "New Orleans Jazz," Rex Harris; "Early White Jazz," Brian Rust; "The Classic Blues Singers," Francis Newton;

"Chicago Style," Sinclair Trail; "Harlem Jazz," Charles Fox; "New York White Jazz," George Lascelles; "From Kansas City to Minton's Playhouse," Raymond Horricks; "The Swing Era," Steve Race; "Dixieland Jazz," Peter Tanner; "Modern Jazz: East Coast," Alun Morgan; "The West Coast Jazz Scene," Keith Goodwin; "Revivalist Jazz," James Asman; "Pioneers of Piano Jazz," Peter Gammond; "The Development of the Saxophone," Benny Green; "Jazz Vocalists," Vic Bellerby; "Jazz in Britain: The Beginnings," Mark White; "The Growth of Modern Jazz in Britain," Tony Hall; "Jazz on the Continent," Daniel Halperin; "The African Rebound," Ernest Borneman; "Louis Armstrong," Jeff Aldam; "Duke Ellington," Stanley Dance; "Classic Jazz Clarinet," Graham Boatfield; and "Jazz and Modern Music," Burnett James. Discography. Foreword by Milton "Mezz" Mezzrow.

R447. **Gammond, Peter, and Clayton, Peter.** FOURTEEN MILES ON A CLEAR NIGHT: AN IRREVERENT, SCEPTICAL, AND AFFECTIONATE BOOK ABOUT JAZZ RECORDS. London: Peter Owen, 1966. 128 p., illus. (ports.).

Forty-eight short chapters of a history of jazz including a description of mostly rare recordings. Discography includes names of performers, date of release and record review. A conversational guide to the history of jazz based on recordings from the late 1920s to the early 1960s.

R448. **Gammond, Peter, and Clayton, Peter.** KNOW ABOUT JAZZ. London and Glasgow: Blackie, 1963. 62 p., illus. (ports.).

A concise history of jazz and an unconventional definition of its major trends, with short biographies of jazz people, recording their accomplishments, their recordings, and their style. Jazz terminology on inside covers. Illustrations by Rosalind Hoyte and Charles Pickard; foreword by Steve Race. Music included.

R449. **Gleason, Ralph J.** JAM SESSION: AN ANTHOLOGY OF JAZZ. New York: G. P. Putnam's Sons, 1958. 319 p., illus. (ports.).

A collection mostly of articles previously published in periodicals (with indication of source); included are poems and conversations (with quotations) covering a broad scope of jazz history. Styles and personalities from 1935–1958 are reflected in the following: "The Blues," Huddie Ledbetter (Leadbelly); "Spirituals, Blues and Jazz," Sterling A. Brown; "A New Orleans Funeral," Jelly Roll Morton; "A Discourse on Jazz," Jelly Roll Morton; "Breakfast Dance in Harlem," Otis Ferguson; "Chicago," Art Hodes; "Young Man with a Horn," Otis Ferguson; "Homage to Bunny," George Frazier; "Eddie Condon," George Frazier; "Number One Swing Man," Irving Kolodin; "An American Original," Jelly Roll Morton, Arna Bontemps and Jack Conroy; "The Bunk Johnson Story," Willie G. (Bunk) Johnson; "The Bunk Johnson Story (farewell)," Ralph J. Gleason; "Turk Murphy," Gilbert Millstein; "Fats," W. T. Ed Kireby; "Earl Fatha Hines," Ralph J. Gleason; "The Fabulous Gipsy," Gilbert S. McKean; "The Diz and the Bebop," Gilbert S. McKean; "Just Can't See for Lookin' (Nat King Cole)," Ralph J. Gleason; "Erroll Garner," Ralph J. Gleason; "What is This

Thing Called Jazz?," Henry Pleasants; "The Basis of Bop," Russell Hope Robbins; "A Portrait of the Hipster," Anatole Broyard; "U.S. Conquest: Hot Jahzz," Richard Hanser; "Aspects of the Jam Session," Bruce Lippincott; "To swing is to affirm," G. V. Kennard S.J.; "Jazz Perspective," Iola & Dave Brubeck; "The Cool Coast," Ralph J. Gleason; "You dig it, Sir?,": Lillian Ross; "Jazz is big business," Ralph J. Gleason; "Toward a new Form: Jazz and Poetry," Ralph J. Gleason; Excerpts from autobiography by Lawrence Ferlinghetti; Short selection from *The Donovan Train* by Kenneth Ford; "Sparrow's Last Jump," Elliott Grennard; and "Four-bay tag," Baby Dodds. Bibliography.

R450. **Graves, James.** DAMALS IN NEW ORLEANS. EINE BILDCHRONIK DES FRÜHEN JAZZ MIT ZEUGNISSEN VON SIDNEY BECHET, JELLY ROLL MORTON, LOUIS ARMSTRONG, BUNK JOHNSON, JOHNNY ST. CYR, UND ANDEREN. Zurich: Sanssouci Verlag, 1960. 51 p., illus. (ports.).

A pictorial chronicle and early history of jazz, describing the city of New Orleans, its history, population, folk festivals and customs, and some of its musical traditions. In the second part, a collection of autobiographical sketches of New Orleans jazz musicians. Translated from English by Ursula von Wiese.

R451. JAZZ REVIEW. EDITED BY MAX JONES AND ALBERT MCCARTHY. London: Jazz Music Books, 1945. 22 p.

A selection of notes and essays on live and recorded jazz, most of them written in the United States before the end of the war. Ken Hulsizer, "New Orleans in War Time," a description of New Orleans, with short paragraphs on Kid Rena, Sidney Desvigne, Herb Morand, Orin Blackstone, and John Hammond; Lyn Foersterling, "A Note on Lonnie Johnson," collector's notes; Albert J. McCarthy, "Discography of Little Brother Montgomery"; Richard A. Oxtot, "The story of Yerba Buena Band," an account of Lu Waters and his band in Oakland, Calif. in 1937; the Oliver Creole Jazz band in San Francisco until the early 1940s; Ernest Borneman, "The Piano and the Band." "Jazz and the collector," in which Thurman and Mary Grove review the jazz renaissance and report on American collector's present day activities. "Five Month's Records," by Max Jones and Charles Wilford, a collection of record reviews; "Okeh Race catalogue," Billy Neil, a list of records with titles and performers; and on jazz music books, "Folk: Review of People's Music," by Max Jones.

R452. THE JAZZFINDER '49. New Orleans: Privately printed; Orin Blackstone, 1949. 152 p., illus. (ports.).

Contributions by various authors include Sidney Finkelstein's *Jazz Searches a Turning Point* (which is a definition of bebop; trends in modern jazz and the recording business); Thurman and Mary Grove's *New Stars in the Making* which is an account of students' bands in the late 1940s; H. Meunier Harris's *A Jazz Bibliography*, which includes books, pamphlets, and magazines. Also included are sixteen pages of photographs from New Orleans; a detailed list of original small band jazz recordings re-

leased throughout the world from 1948 to summer 1949; with data of musicians and groups. A list of more than 1,000 record labels from 1900 to 1949 with address of issuing company.

R453. **Joplin, Scott.** THE COLLECTED WORKS OF SCOTT JOPLIN. EDITED BY VERA BRODSKY LAWRENCE. New York: The New York Public Library, 1971. 2 vols. illus. (ports.).
THE AMERICANA COLLECTION OF MUSIC SERIES, NO. 1.
Vol. 1: Works for piano. Introduction by Rudi Blesh. Original, collaborative, and miscellaneous works. Rollography; and discography of Joplin works.
Vol. 2: Works for voice. Three revised excerpts from the opera *Treemonisha*. Notes on *Treemonisha*, a historical and aesthetic evaluation, by Carmen Moore. This collection reproduces the sheet music editions by nineteen mostly unknown publishers. Cover designs are included, some with caricatures typical of the ragtime era.

R454. **Keepnews, Orrin, and Grauer, Bill, Jr., comp.** A PICTORIAL HISTORY OF JAZZ: PEOPLE AND PLACES FROM NEW ORLEANS TO MODERN JAZZ. New York: Crown Publishers, 1966. 297 p.
A "family album" of jazz from its beginning to the time of publication presenting its pictorial record in historical sequence, documenting a changing social and cultural scene. Short introduction to pictorial chapters. Names index.

R455. **Lucas, John.** BASIC JAZZ ON LONG PLAY. Northfield, Minn.: Carleton College, Carleton Jazz Club, 1954. 103 p.
A series of lectures; great soloists and bands; list of thirty long-playing records, including label number, and price. Individual chapters on leading jazz musicians, such as Leadbelly, Bessie Smith, Sidney Bechet, and Louis Armstrong. A second part on great bands and some of their leaders such as King Oliver, Bob Crosby, Muggsy Spanier, and Kid Ory. This work is an informative introduction to the history of jazz, as well as a valuable guide to records available in the early 1950s.

R456. **McCarthy, Albert J.; Morgan, Alun; Oliver, Paul; and Harrison, Max.** JAZZ ON RECORD: A CRITICAL GUIDE TO THE FIRST FIFTY YEARS, 1917–1967. London: Hanover Books, 1968. 422 p.
Not a discography, but an introduction "with additional contributions by [12] other authors" to jazz and jazz performances through reviews of "the best and most typical recorded works of the leading jazz and blues artists," sometimes in extended articles and artists' profiles. Pt. 1 lists individual artists; Pt. 2 provides collective headings for artists' groups and subjects. Inclusion of record releases from many countries; mostly American singers and musicians are represented.

R457. **McRae, Barry.** THE JAZZ CATACLYSM. South Brunswick and New York: A. S. Barnes, 1967. 193 p.
The history of jazz in the 1950s and 1960s, seen in perspective as a continuum of its previous development; focusing on the gradual changes in style from cool jazz to free form. An account of musicians and their musical achievements, and also of people outside the jazz and recording centers. Individual chapters on Sonny Rollins, John Coltrane, and Ornette Coleman. Valuable information about jazz in the 1950s and 1960s.

R458. **Margulis, Max.** PRESENT STATE OF JAZZ AND SWING. *Boletín Latino-Americano* 5 (1939). 9 p.
Hot jazz of the 1930s; a definition of swing and a historical survey of jazz including improvisation and commercial exploitation. This paper was read at the Interamerican Conference on Music held at the Library of Congress, Washington, D.C., conducted by the United States State Department in October 1939.

R459. **Mecklenburg, Carl Gregor Herzog zu, and Scheck, Waldemar.** DIE THEORIE DES BLUES IM MODERNEN JAZZ. Strasbourg and Baden-Baden: Editions P. H. Heitz/Verlag Heitz, 1963. 131 p.
An analysis of blues (form, rhythm, melody, harmony, tonality, paraphrases, accompaniment, sound) and its elements in jazz, with its return to tradition since the early 1950s. A thorough study which defines jazz as a musical style of its own, with its own tradition, specific elements, and laws. Appendix: musical material; theme analyses; tables of historical data; musicological essays; sixty-four music examples; and selected discography. Bibliography of mostly German literature.

R460. **Nanry, Charles, comp.** AMERICAN MUSIC: FROM STORYVILLE TO WOODSTOCK. New Brunswick, N.J.: Transaction Books; distributed by E. P. Dutton, 1972, 290 p.
A collection of papers presented by twelve authors at the conference: Jazz and All That Society, Rutgers Institute of Jazz Studies. General topic is analysis of jazz and rock, reflecting the sociohistorical and technological process of the period between the 1920s and 1970s. Pt. 1 centers around jazz, its changes since the 1920s. Pt. 2, around rock, its growth and establishment in the recording and film industries. Biographical data about authors. Bibliographies and discography with individual chapters. Foreword by Irving Louis Horowitz.

R461. **Oliver, Paul.** BLUES FELL THIS MORNING: THE MEANING OF BLUES. London: Cassell & Co., 1960. 375 p., illus.
This history of blues investigates the song texts, their ideas, their backgrounds and a complexity of social relations; a history of folksong which resembles a social history of Negro life in America. Foreword by Richard Wright. Discography of blues. Bibliography.

R462. **Panassié, Hugues.** THE REAL JAZZ. Rev. and enl. ed. New York: A. S. Barnes, 1960. 284 p.
In this work, Panassié defines and analyzes the origin of jazz by comparison with classical music, collective versus individual production, its forms and blues elements, and

by the nature of improvisation. Also included are unique and clarifying chapters on individual instruments, and their role in jazz. Discography. ORIGINAL EDITION (London: Thomas Yoseloff, 1942).

R463. Pleasants, Henry. SERIOUS MUSIC AND ALL THAT JAZZ: AN ADVENTURE IN MUSIC CRITICISM. New York: Simon & Schuster, 1969, 256 p.

The author discusses social prejudice in music appreciation. He defines serious music versus jazz in all its forms, examines the performance of the artist in both, the attitudes of the establishment toward both art forms. A critical revaluation of jazz—its aesthetics, history and social acceptance by a "serious" music critic. Recommended to the music and jazz student.

R464. Russell, William. TECHNICAL ASPECTS OF JAZZ. *Boletín Latino-Americano* 5 (1939).

This paper was read at the Interamerican Conference on Music held at the Library of Congress, Washington, D.C., conducted by the United States State Department in October 1939. An analysis of jazz in its basic elements: meter, rhythm, polyrhythms; melody, the use of scales, harmonic aspects, jazz progressions, thematic material; and its incorporation of dynamics and improvisation. Characteristics and jazz qualities of individual instruments with examples quoted by title. A valuable introduction to the composition and analysis of jazz. Bibliography.

R465. Schafer, William J., and Riedel, Johannes; with Pond, Michael, and Thompson, Richard. THE ART OF RAGTIME: FORM AND MEANING OF AN ORIGINAL BLACK AMERICAN ART. Baton Rouge, La.: Louisiana State University Press, 1973. 268 p., illus.

An historical and analytical definition of ragtime with a review of its growing social acceptance. Biographical sketches of Scott Joplin, James Scott, Joseph Lamb as well as of the second generation ragtimers. Ragtime style and playing instructions. Appendixes: the history of cover illustrations; ragtime versus jazz piano styles, including a collection of musical examples. An analysis of Scott Joplin's *Treemonisha*. Bibliography.

R466. Stearns, Marshall W. THE STORY OF JAZZ. New York: Oxford University Press, 1962. 379 p., illus. (ports.).

A colorful, historical, and stylistic analysis of jazz and its various forms within its social context. Survival of African cults and other African elements in the New World; social psychology and the role of blacks and jazz. Discography; bibliography.

R467. Toledano, Ralph de. FRONTIERS OF JAZZ. 2d rev. ed. New York: Frederick Ungar, 1962. 192 p.

A collection of rare writings about jazz that can now be considered as classical from an historical, critical, or philosophical view point. The articles had previously appeared in periodicals about musicians and trends in music, mostly dating from the 1930s and 1940s. Each arti-

cle is introduced by an editorial note, giving information about the musician discussed and his press coverage; the author; the importance of the article, and its reprint in this edition. The articles are: "The directions of jazz," Ralph de Toledano; "Harpsichords and Jazz Trumpets," Roger Pryor Dodge (1934); "The Blues," Abbe Niles (1926); "Notes on the Boogie Woogie," William Russell; "Jazz in America," Jean Paul Sartre; "They sang in jazz," R. de Toledano; "King Oliver," Preston Jackson; "The New Orleans Rhythm Kings," George Beall; "Jazz Pre-History and Bunk Johnson," Monroe Berger; "I Discovered Jazz in 1902," J. R. Morton (1938); "Jelly Roll Morton on Records," H. Panassié; "Bechet and Jazz Visit Europe" (1919), E. A. Ansermet; "The Wolverines and Bix," G. Johnson; "D. Ellington," Wilder Hobson (1938); "Benny Goodman and the Swing Period," Frank Norris; "Piano in the Band," Otis Ferguson; "Grandfather of Hot Piano," Ross Russell (1947). Musical examples; index. ORIGINAL EDITION (1947).

R468. Ulanov, Barry. A HISTORY OF JAZZ IN AMERICA. New York: Viking Press, 1964. 392 p.

This history can be considered required reading for jazz students. The author presents a readable account of the development of jazz, tracing its roots, defining its various forms; focusing on its personalities and bands that shaped its history: Louis Armstrong, the Original Dixieland Jazz Band, George Gershwin, Bix Beiderbecke and the great bandleaders such as Guy Lombardo, Glenn Miller, Ben Pollack, Benny Goodman and others. Glossary of jazz words and phrases.

R469. Williams, Martin. WHERE'S THE MELODY? A LISTENER'S INTRODUCTION TO JAZZ. New York: Pantheon Books, 1969. 221 p.

A discourse about jazz, "the American contribution to the arts," consisting of three parts: the music itself, descriptions of performances, and personal opinions. The first part is undoubtedly the most valuable one, including an analysis of forms of melody, with their possible variations; description and definition of blues; recorded solos by some of the popular musicians; and analysis of recordings. Well documented within the text and in annotated discographies. Bibliography.

ROCK 'N' ROLL AND ROCK

R470. Cohn, Nik. ROCK FROM THE BEGINNING. New York: Stein and Day Publishers, 1969. 256 p., illus. (ports.).

A review and highly critical account of the youth culture of the 1950s and 1960s in a sociological analysis of its music. This work includes rock from its beginning with Johnnie Ray in 1952 and Bill Haley to the rise and fall of superpop at the end of the 1960s. Description of the teenage culture, its musical scene and the people, their pop careers, personalities, and record hits. This account of rock is interpreted as a way "to catch currents, moods, teen obsessions" that "has made giant caricatures of lust, violence, romance and revolt."

R471. **Dallas, Karl.** SINGERS OF AN EMPTY DAY. London: Kahn and Averill, 1971. 208 p.

The British scene of rock 'n' roll: interviews, encounters, episodes; with chapters on Bob Dylan, Frank Sinatra, Elvis Presley, and others. Illustrations by Gloria Dallas. ORIGINAL EDITION (England: Stanmore Press).

R472. **Daufouy, Philippe, and Saston, Jean Pierre.** POP MUSIC ROCK. Paris: Editions Champ Libre, 1972. 201 p.

An extensive analytical study of the history, and the philosophical and sociological conditions of the hippie and rock movements. Traces the musical sources of rock 'n' roll to the Negro-blues of the South, the religious gospel songs, the black ballads, and the rhythm blues of the late 1940s and early 1950s. Its ideological roots are traced to student movements and social crisis, preconditioned by the 1950s generation gap. The author discusses the ideological role of the protest song, leading to hard or psychedelic rock, becoming free jazz, the expression of a comfortable avant-garde. Daufouy differentiates between the "white" rock and the music of the blacks, which is reverting back to the blues. Discography.

R473. **Dean, Maury.** THE ROCK REVOLUTION. Detroit, Mich.: Edmore Books, 1966. 143 p.

A developmental history of rock 'n' roll music since 1954, followed by a year by year account, focusing on prominent singers and musicians. A definition of the rock movement as "rebel without a course". Biographies (including photographs) of Elvis Presley, Buddy Holly, the Supremes, the Beatles, Pat Boone, Bill Haley, Little Richard, Chuck Berry, Roy Orbison, Jerry Lee Lewis, the Fleetwoods, Brenda Lee, Everly Brothers, Ben E. King and the Drifters, Richie Valens, and other singers and groups (altogether about seventy). Illustrations by Phil Frank.

R474. **Denisoff, R. Serge, and Peterson, Richard A.** THE SOUNDS OF SOCIAL CHANGE, STUDIES IN POPULAR CULTURE. Chicago: Rand McNally, 1972. 343 p.

An anthology, presenting descriptive writings, research findings and opinions that reveal socio-cultural interpretations of rock and popular music. Groups of writings emphasize the political engagement of music as an expression of protest; the use of music for political movement; diverse interpretation of rock by critics and other writers; the evolution of popular musical taste; the effect of mass media on the social message of music. A stimulating coverage of rock music with an interdisciplinary approach.

Contents: "Evolution of the Protest Song in America," by R. Serge Denisoff; "Sounds of Black Protest in Avant-Garde Jazz," by Lloyd Miller and James K. Skipper; "Country Music: Ballad of the Silent Majority," by Paul DiMaggio, Richard A. Peterson, and Jack Esco, Jr.; "The Industrial Workers of the World's 'Little Red Song Book'," by Richard Brazier; "The Nazi Use of Music as Instrument of Social Control," by Roland L. Warren; "Fundamentalism, Racism, and Political Reaction in Country Music," by Jens Lund; "The Soul Message," by Rochelle Larkin; "Folk Music and the American Left," by R. Serge Denisoff; "A New Awakening," by Greil Marcus; "A Cultural Revolution," by Ralph J. Gleason; "Dylan's Sellout of the Left," by Paul Wolfe; "More Subversion than Meets the Ear," by Gary Allen; "The Great Kid-Con," by Susan Huck; "The Degradation of Women," Marion Meade; "Popular Music Since the 1920s," by H. F. Mooney; "Changing Courtship Patterns in the Popular Song," by James T. Carey; "Brainwashing or Background Noise: the Popular Protest Song," by R. Serge Denisoff and Mark Levine; "Teenage Response to Rock and Roll Protest Songs," by John P. Robinson and Paul M. Hirsch; "Market and Moralist Censors of a Black Art Form: Jazz," by Richard A. Peterson; "The Professional Jazz Musician and his Audience," by Howard S. Becker; "So You Want to Be a Rock and Roll Star," by James T. Coffman; "The Black Market Roots of Rock," by Charlie Gillett; "Three Eras in the Manufacture of Popular Music Lyrics," by Richard A. Peterson and David G. Berger; "Talking Brainwashing Blues," by Spiro Agnew; and "Turning on the Vice-President," by Nicholas Johnson. Bibliography.

R475. **Eisen, Jonathan, ed.** THE AGE OF ROCK: SOUNDS OF THE AMERICAN CULTURAL REVOLUTION. New York: Vintage Books, 1969–1970. 2 vols., illus. (ports.).

Vol. 1 is an anthology which will possibly serve as a documentary of the rock movement and its terminology. Thirty-eight articles attempt to explore some of the ramifications of the rock movement, interpreted as an action of participation and revolt. The articles reveal facts and personal opinions about shifting tastes in history, the Hippie movement, and rock singers and groups. Contributions by: Nat Hentoff, H. F. Mooney, Burton H. Wolfe, Stanley Booth, Frank Kofsky, Ralph J. Gleason, Tom Nolan, Jan Birchall, Fred Newman, Alan Beckett, Richard Merton, Michael Parsons, Michael Wood, Joan Peyser, Alan Aldridge, Murray Kempton, Ned Rorem, Richard Poirier, Wilfried Mellers, Alfred G. Aronowitz, Richard Fariña, Laurence Goldman, Jan Landau, Robert Christgau, Richard Meltzer, Frank Kofsky, Doon Arbus, Sally Kempton, Michael Thomas, Paul Williams, Gene Lees, James Payne, Tom Wolfe, Harry Shearer, and Joan Didion.

Vol. 2 consists of forty-two articles, with somewhat broadened topics, such as festivals, interviews, some rock singers, sociological aspects of rock, merchandising, and attitudes. The authors are: Michael Rossman, Pete Stampfel, Walter Breen, Marc Eliot, Bobby Abrams, Michael Lydon, Nora Ephron, Susan Edmiston, Michael Zwerin, Geoffrey Cannon, Tom Smucker, Sandy Perlman, Howard Junker, Nick Browne, Jan Whitcomb, B. Pfohlman, T. Proctor Lippincott, Bobby Abrams, George Paul Csicsery, Tari Reim, Danny Fields, Jon Wiener, J. Lawrence, Richard Meltzer, Gary Allen, A. Martynova, Robert Somma, Borneo Jimmy, Michael March, Lar Tusb, A. Warhol, David Walley, Lenny Kaye, John Kriedl, Andrew Kopkind, J. Oliphant, Felix Dennis, and Jim Anderson.

R476. **Elmark, Walli, and Beckley, Timothy.** ROCK RAPS OF THE SEVENTIES. New York: Drake Publishers, 1972. 125 p., illus. (ports.). [*cont.*]

An informal review of rock groups and individual performers, with interviews throughout. This book gives an inside view of the rock-drug scene and its relations to occultism. Elmark discusses rock groups, their formation, social aspects and their performances mainly in New York City.

R477. Gillett, Charlie. THE SOUND OF THE CITY: THE RISE OF ROCK 'N' ROLL. New York: Outerbridge and Dienstfrey; distributed by E. P. Dutton, 1970. 382 p.

A definition of styles of singers, their appeal to black and white audiences; trends of preferences interpreted in relation to sociological perspectives: The evolution of rock 'n' roll and its preliminaries from 1945 to 1969. A socio-historical examination of thirty years of American popular music, with the citation of records from *Billboard, Variety, Cashbox,* and *Record World.* Discography of forty-five rpm releases and albums listed by year from 1954 to 1970. Bibliography.

R478. Jahn, Mike. ROCK: FROM ELVIS PRESLEY TO THE ROLLING STONES. New York: Quadrangle/New York Times Co., 1973. 336 p., illus. (ports.).

A detailed sociological analysis of the youth movement and its music since the late 1940s tracing the development of rock year by year, viewing it as a social force, rising from "the kids' song of joy" in the 1950s to political involvement as massive plea for rights, dignity, and respect, in the 1970s. Discography.

R479. Peck, Ira. THE NEW SOUND, YES! New York: Four Winds Press, 1966. 142 p., illus.

An anthology of rock 'n' roll, with articles about its history, its search for a new sound and a new meaning for the teenage world; about its songs and singers: Elvis Presley, B. Dylan, and Phil Spector and groups like the Beatles and the Rolling Stones. Contributing authors: Bruce Jay Friedman, Peter Bart, Louie Robinson, Norma Sue

Woodstone, Barbara Altshuler, Joyce Jenkins, Alfred G. Aronowitz, Vernon Scott, Henrietta Yurchenco, Tom Wolfe, Jeremy Larner, and James Michener. Introduction by Murray the K.

R480. Sinclair, John, and Levin, Robert. MUSIC AND POLITICS. New York and Cleveland: World Publishing Co., 1971. 140 p., illus. (ports.).

Collected articles and record reviews, originally written for and published by jazz and pop periodicals. Although Sinclair discusses records, rock musicians and their music, he stresses the political impact of music and not the quality of the music. The authors make use of a superficially applied Marxist terminology without conveying a message by an analytical approach. The title of the book implies more than the text is able to provide; however, the articles might be considered representative of a style of the seventies. Discography. Foreword by Pauline Rivelli.

R481. Taylor, Ken. ROCK GENERATION, THE INSIDE EXCLUSIVE. Melbourne, Australia: Sun Books, 1970. 149 p., illus. (ports.).

Taylor discusses sex, blackmail, and violence in the world of Australian pop idols in the 1950s with reflections on the American pop and music business.

R482. Williams, Paul. OUTLAW BLUES: A BOOK OF ROCK MUSIC. New York: E.P. Dutton & Co., 1969. 191 p., illus. (ports.).

Collected notes of the author and casual observations noted sporadically from 1966 to 1968. Included are short interviews. A leisure guide for record listening. Discography by chapters, with labels, no numbers or years of release. Bibliography.

R482a. WHO'S WHO IN ROCK 'N' ROLL. 1958. [*See* R413.]

Pop, Country and Western, Film, and Stage Music

BIBLIOGRAPHY

R483. Dunlap, Lloyd, comp. A PRELIMINARY AND TENTATIVE CHECKLIST RELATING TO THE COMPOSITION, HISTORY, LICENSING, PERFORMANCE, PUBLISHING, AND USE OF POPULAR MUSIC, 1900–1959. Typewritten. Washington, D.C., 1960. 272 p.

A list of periodical articles and monographs, such as bibliographies and other reference works, general works, surveys, biographies; works on jazz, minstrels, dancing, and other. Includes references in the *New York Times* between 1913 and 1938. Listed alphabetically by author. (A copy of this typescript is on file at the Library of Congress, Washington, D.C.)

R484. Fuld, James J. A PICTORIAL BIBLIOGRAPHY OF THE FIRST EDITIONS OF STEPHEN C. FOSTER. Philadelphia: Musical Americana, 1957. 25 p., 181 plates.

Reproduction of coverpages of 204 compositions which include every melody or lyric written by Foster. Criteria of description include edition, publisher, address, date, and imprint. Described are the copyright deposit copies and variations of other copies preserved in the Foster collection in the Music Division, Library of Congress, Washington, D.C. This publication, which was issued in limited edition for libraries only, was intended to be "a checklist for libraries, collectors, etc." providing key information about the published work of S. C. Foster. It is also a representative presentation of nineteenth-century American music. Foreword by Fletcher Hodges.

R485. **Fuld, James J.** AMERICAN POPULAR MUSIC, 1875–1950. Philadelphia: Musical Americana, 1956. 103 p., illus.

An annotated bibliography of first editions of songs, some of which were composed before 1875 but printed later. Minute descriptions of the publications including visual material on covers. Pseudonyms of some leading composers; chronological index of selected songs.

R486. **Mott, Margaret M., comp.** A BIBLIOGRAPHY OF SONG SHEETS; SPORTS AND RECREATIONS IN AMERICAN POPULAR SONGS. *Music Library Association Notes* 2d ser. 6 (June 1949); 7 (Sept. 1950); 9 (Dec. 1951); 14 (June–Sept. 1957) 3–4.

List of songs classified by types of sports, e.g. archery, target practice, basketball, baseball, football, etc.; annotated with regard to sheet illustration. Vol. 14, no. 4 includes silent film songs, compiled by Gerald D. McDonald.

INDEXES AND LISTS

R487. **American Society of Composers, Authors and Publishers.** FIFTIETH ANNIVERSARY: HIT TUNES. New York: American Society of Composers, Authors and Publishers, 1964. 101 p.

A segment of the Society's repertory of tunes written by its members between the founding of the Society in 1914 and 1964. In addition, popular works between 1892 and 1913. Listed chronologically by year, and by title, with names of composer and lyricist. List of Motion Picture Academy Award songs.

R488. **Chipman, John H., comp.** INDEX TO TOP-HIT TUNES, 1900–1950. Boston: Bruce Humphries, 1962. 249 p.

A list of over 3,000 titles of the most popular songs which have sold over a 100,000 copies of sheet music or records. Alphabetical listing by title (composer, author, publisher, date, comedy or film). Chronological index by year. Included are some songs from before 1900 which are still in repertory. Bibliography. Foreword by Arthur Fiedler.

R489. **Ellis, John F.** MUSICAL ALMANAC FOR 1863 FOR THE USE OF SEMINARIES, PROFESSORS OF MUSIC, AND THE MUSICAL PUBLIC, BEING A CONDENSED CATALOGUE TO WHICH IS ADDED A LIST OF OUR LATEST AND BEST PUBLICATIONS. Washington, D.C.: John F. Ellis, 1863. 95 p.

Sales Catalog.

A sales catalog advertising popular music (piano songs, comic songs, marches, quicksteps, and dance music for the piano). Contains one article by Thomas Fitzgerald: "The Literature of Music, An Extract from a Report on the Importance of Introducing Music into Public Schools of the United States."

R490. **Ewen, David, ed.** AMERICAN POPULAR SONGS: FROM THE REVOLUTIONARY WAR TO THE PRESENT. New York: Random House, 1966. 520 p.

Alphabetical list of over 3,600 song titles with information about composer, lyricist, including a brief history of the song and its performance with major stage and screen productions and best selling records. *Appendix:* chronological listing of the songs; list of best selling single-recordings listed by performer. Foreword by Sigmund Spaeth.

R491. **Lewine, Richard, and Simon, Alfred.** SONGS OF THE AMERICAN THEATER. New York: Dodd, Mead & Co., 1973. 830 p.

This comprehensive compilation is the sequel to the authors' 1961 publication: *Encyclopedia of Theatre Music.* Enlarged particularly is the list of songs from all Broadway and off Broadway theater productions from 1925 through 1971 as well as more than three hundred songs from productions prior to 1925; film songs or songs for television written by theater composers and lyricists. Alphabetical listing by song title and production; chronological listing by year, with data of composer, author, New York premieres, length of run, record albums, vocal score, and editions. The work comprises more than 12,000 songs.

R492. **Mattfeld, Julius.** VARIETY MUSIC CAVALCADE, 1620–1961. A CHRONOLOGY OF VOCAL AND INSTRUMENTAL MUSIC POPULAR IN THE UNITED STATES. Englewood Cliffs, N.J.: Prentice-Hall, 1962. 737 p.

A checklist of popular music from the time of the Pilgrims to the end of 1961; listed by long time periods until 1800, and by year since 1800. Survey of all major events other than musical as introductory chapters to each section or year. Some American popular compositions included, as well as hymns, secular and sacred songs, choral compositions, instrumental and orchestral works. Brief bibliographies of collections by period. Introduction by Abel Green.

R493. **Salem, James M.** A GUIDE TO CRITICAL REVIEWS. PT. II: THE MUSICAL FROM ROGERS AND HART TO LERNER AND LOEWE. Metuchen, N.J.: Scarecrow Press, 1967. 353 p.

The only one of four volumes that deals with music. A valuable tool to find reviews of Broadway musicals which appeared in American and Canadian periodicals, the *New York Times* and *New York Theatre Critic's Reviews.* Selected listing for the seasons from 1920/1921 to 1927/1928, with reference to works by the following composers and lyricists only: Irving Berlin, Rudolf Friml, George Gershwin, Oscar Hammerstein II, Lorenz Hart, Victor Herbert, Jerome Kern, Cole Porter, Richard Rodgers, Sigmund Romberg, and Vincent Youmans. From 1928/1929 to 1964/1965 record of all musicals which opened on Broadway; no operettas. Chronological listing by season; with information about number of performances, book, music, lyrics, staging, and opening date. Various appendixes and indexes.

R494. **Select Theaters Corporation and Century Library.** CATALOGUE OF ALL SHUBERT DRAMATIC AND MUSICAL SUCCESSES. New York: Select Theaters and Century Library, 1936. 99 p.

Catalog of dramas, comedies, farces, operettas, musical comedies, revue material; and orchestra parts for small and large orchestras. Alphabetical list of titles with synopsis, cast, description of characters and plot. Also included is a selected list of comedies and operas adapted for college and high school productions.

R495. **Shapiro, Nat, ed.** POPULAR MUSIC: AN ANNOTATED INDEX OF AMERICAN POPULAR SONGS. New York: Adrian Press, 1967. 5 vols.

The standard reference work for American popular songs, covering by decades the period from 1920 to 1959. Vol. 5 with introductory surveys on popular music, by N. Shapiro; theater and film music, by Miles Kreuger; jazz, by Frank Driggs. A selective and annotated list of significant popular songs, collected through performing rights societies, such as ASCAP, Broadcast Music, or the catalog of copyright entries, and individual writers and publishers. Each song is listed under the year of its original copyright, with title, alternate title as it appears on the Library of Congress copyright card, names of writer, composer, current publisher, some with additional information as to origin, first performer, and other. Vol. 1 includes some songs that were copyrighted before 1950; vol. 2, some that were copyrighted before 1940; vol. 3 with supplementary list of song titles that were copyrighted before 1960 and became popular between 1960 and 1964. No names index. Lists of titles and publishers are provided at the end of each volume.

DISCOGRAPHY

R496. **Armitage, Andrew D., and Tudor, Dean.** ANNUAL INDEX TO POPULAR MUSIC: RECORD REVIEWS 1972. Metuchen, N.J.: Scarecrow Press, 1973. 470 p.

List of record reviews that appeared in thirty-five periodicals, most of which are from the United States, some from Canada and Great Britain. Classified listing by genre (rock, mood-pop, country, folk, ethnic, jazz, blues, rhythm and blues, soul, popular religious music, stage and show, band, and humor). Also provided is the citation of artist, title, record, tape or cartridge number, price, and collation of periodical reviews.

R497. **American Society of Composers. Authors and Publishers (ASCAP).** THIRTY YEARS OF MOTION PICTURE MUSIC: THE BIG HOLLYWOOD HIT TUNES SINCE 1928. New York: American Society of Composers, Authors and Publishers, 1958. 150 p.

A discography of Hollywood tunes, from 1928 to 1958, chronologically listed with alphabetical title index. Lists song with film title, artist and specialization, record label and issue number, writer and publisher.

R498. **Danberg, A. R.** A PRELIMINARY STUDY OF THE

AMERICAN MINSTREL THEATER ON PHONOGRAPH RECORDS, 1894–1929. *Record Research* 21–39 (Sept. 1959–July 1961). Pts. 1–2, no. 24 (Sept.–Oct. 1959); Pt. 3, no. 25 (Nov.–Dec. 1959); Pt. 4, no. 27 (Mar.–Apr. 1960); Pt. 5, no. 30 (Oct. 1960); Pt. 6, no. 32 (Jan. 1961); Pt. 7, no. 33 (Mar. 1961); Pt. 8, no. 34 (Apr. 1961); Pt. 9, no. 36 (July 1961).

Annotated discography; a valuable documentation of the American variety of musical theater, equally valuable as a collection of very early recordings. Unfortunately, this compilation is scattered in many issues.

R499. **Limbacher, James L.** THEATRICAL EVENTS: A SELECTED LIST OF MUSICAL AND DRAMATIC PERFORMANCES ON LONG-PLAYING RECORDS. Dearborn, Mich.: Dearborn Public Library, 1968. 95 p.

A discography of outstanding theatrical events on long-playing records, with title, date of premiere or first American performance, composer, author, and label. Listed are recordings of plays, musical comedies, one-man shows, revues, operettas, readings, vaudeville, opera, and burlesque.

R499a. **Rust, Brian, and Debus, Allen G.** THE COMPLETE ENTERTAINMENT DISCOGRAPHY, 1897–1942. New Rochelle, N.Y.: Arlington House Publishers, 1973, 677 p.

Lists singers, comics, actors and actresses, vocal groups, and other show-biz personalities and entertainers in their recording careers from the beginning of recording through 1942, the date of the record ban. Brief biographical notes are supplied for most of the artists. Thorough discographical information.

R499b. **Rust, Brian.** THE AMERICAN DANCE BAND DISCOGRAPHY, 1917–1942. New Rochelle, N.Y.: Arlington House Publishers, 1975. 2 vols.

Vol. 1 from Irving Aaronson to Arthur Lange; vol. 2 from L to Bob Zurke. The recording careers of 2,373 dance bands, listing the recording dates, vocalists, band personnel, matrix numbers, take numbers, and pseudonyms. Not included are black bands which were covered earlier in the author's *Jazz Records, 1897–1942* [R395], and recordings by Glenn Miller and Benny Goodman, listed respectively in these publications: John Flower, *Moonlight Serenade* (New Rochelle, 1972), and D. Russell Connor and Warren W. Hicks, *BG on the Record: a Bio-Discography of Benny Goodman* (New Rochelle, 1969). This discography fills out pre–World War II record research completed only two years after the author's 1897–1942 discography [R499a].

R500. **Schleman, Hilton R.** RHYTHM ON RECORD; A COMPLETE SURVEY AND REGISTER OF ALL THE PRINCIPAL RECORDED DANCE MUSIC FROM 1906 TO 1936 AND A WHO'S WHO OF THE ARTISTS CONCERNED IN THE MAKING. London: Melody Maker, 1936. 333 p.

An alphabetical listing by artists or groups, with biographical sketches and lists of participating members. Although an international listing, it contains much information on a great number of American artists and recordings.

R501. **Smollan, Steven.** A HANDBOOK OF FILM THE-ATER, AND TELEVISION MUSIC ON RECORD, 1948–1969. New York: The Record Undertaker, 1970. 64 p.

Alphabetical listing of show titles; background music of films, and songs. All records were made in the United States. Composer index, mostly American. The only disc guide of this kind for collectors, to be continued for the years from 1970 on, and to include data about performances and record labels with numbers.

R502. **Whitburn, Joel.** JOEL WHITBURN'S RECORD RE-SEARCH. TOP COUNTRY AND WESTERN RECORDS, 1949–1971. Menomonee Falls, Wis.: Record Research, 1972. 152 p.

"Facts about 4,000 recordings listed in *Billboard's* Hot Country Singles; charts grouped under the names of 650 recording artists." The first of two volumes compiling *Billboard's* top record charts of twenty-three years: alphabetically listed by artist. Provided are statistics, record label, and number; index of song titles; and picture index of the top one hundred artists.

R503. **Whitburn, Joel.** TOP POP RECORDS, 1955–1972. Menomonee Falls, Wis.: Record Research, 1973. 416 p.

Noted are 2,735 artists and 11,041 records: listed alphabetically by artist; by song title; and chronologically by year. Photographs of the top one hundred artists. A compilation of the most popular recorded music from 1955 to 1972 as presented in *Billboard* with "top 100 pop" record charts, later known as "hot 100." A continuation of the *Record Research* listing of "best selling singles" from 1940 to 1955.

REFERENCE BOOKS

R504. **Burton, Jack.** THE BLUE BOOK OF TIN PAN ALLEY: A HUMAN INTEREST ENCYCLOPEDIA OF AMERICAN POPULAR MUSIC. Rev. and Enl. ed. Watkins Glen, N.Y.: Century House, 1962–1965. 2 vols., illus. (ports.).

BLUE BOOK SERIES.

The first of the Blue Book series, originally published in 1950, widely represented in libraries and referred to in bibliographies. Lists popular songs from the stage and film musicals. Listing in one-year periods with general introductions recalling episodes and musical events. For the years from 1900 on, there are additional biographical chapters on individual composers. Each song is anno-tated as to history, author, publisher, and first performer. Vol. 1: 1860–1910; vol. 2: 1910–1950. *Supplement* for 1950–1965 by Larry Freeman. Complemented by the three volumes listed below (*see* R505–R507).

R505. **Burton, Jack.** THE BLUE BOOK OF BROADWAY MUSICALS. Watkins Glen, N.Y.: Century House, 1969. 327 p., illus. (ports.).

BLUE BOOK SERIES.

Musicals, revues, operettas are listed by title with com-poser, author, cast, and principal songs. The arrangement is by ten-year periods, with general introductions. FIRST EDITION (1952).

R506. **Burton, Jack.** THE BLUE BOOK OF HOLLYWOOD MUSICALS. Watkins Glen, N.Y.: Century House, 1953. 269 p., illus.

BLUE BOOK SERIES.

Songs from the sound tracks performed by the stars who originally were featured. Shows included date back to the appearance of the talkies. Introduction to each year's list-ing of top performers. Lists film musicals, feature and Western films with songs, including composer, author, leading performers, songs.

R507. **Burton, Jack.** THE INDEX OF AMERICAN POPULAR MUSIC. Watkins Glen, N.Y.: Century House, 1957. un-pag.

BLUE BOOK SERIES.

This index is a compilation of all of the song titles appear-ing in the three Blue Books, including Larry Freeman's complementary collection of titles in his work, *The Memories Linger On* (Watkins Glen, New York: Century House), 1951. Covers American song from 1850 to 1950.

R508. **Ewen, David.** NEW COMPLETE BOOK OF THE AMERICAN MUSICAL THEATER. New York, Chicago, and San Francisco: Holt, Rinehart & Winston, 1970. 825 p., illus.

An account of the growing interest in musical theater, presenting a more comprehensive record of musical pro-ductions since 1866; cf. Ewen's *Story of America's Musical Theater* (1961). The 1970 EDITION lists nearly five hundred musicals, accompanied by production history, plot, stars, songs, opening date and place, and director. Only high-quality works of the popular musical theater, written by American composers, with box office successes are in-cluded.

R509. **Gammond, Peter, and Clayton, Peter.** A GUIDE TO POPULAR MUSIC. London: Phoenix House, 1960. 285 p., illus. (ports.).

A dictionary of names and subjects, including musical societies, with short biographical articles on musicians and composers. Information about education, activities, accomplishments, writings, and compositions. Covers non-American composers also. Chronological index from 1725 to 1960.

R510. **Gentry, Linnell.** A HISTORY AND ENCYCLOPEDIA OF COUNTRY, WESTERN AND GOSPEL MUSIC. Nashville, Tenn.: Clairmont Corp., 1969. 612 p.

An anthology of seventy-six articles and stories about country, Western, and gospel music that had been published in magazines, periodicals, newspapers, and brochures, between 1908 and 1968. Topics include the musical forms and styles, trends of the times, music busi-ness in Nashville, and radio broadcasting and recording. Contributions by: H. Leamy, E. S. Lorenz, A. D. Carlson, K. Chrichton, E. G. Grayson, M. Zolotov, D. K. Antrim,

R. Scherman, A. Churchill, D. Eddy, H. B. Teeter, R. Jarman, N. King. R. Harris, E. Waldron, A. Rankin, P. Dessauer, G. Lieberson, R. Marek, J. Czida, O. G. Pike, R. O'Donnell, M. Duff, D. K. Wilgus, E. Kahn, L. M. Smith, N. Cohen, R. Gehman, J. Hurst, C. Portis, W. P. Fox, Jr., E. Hinton, N. V. Rosenberg, E. A. Readling, K. Sawyer, B. Bucy, L. Gentry, and A. Cason. The second part contains a collective biography of over six hundred singers, musicians, comedians, active in country and Western music; information about education, profession or professional experiences, records, radio broadcasts, performances, other achievements, and address. Foreword by Tex Ritter.

R511. **Kinkle, Roger D.** THE COMPLETE ENCYCLOPEDIA OF POPULAR MUSIC AND JAZZ, 1900–1950. New Rochelle, N.Y.: Arlington House Publications, 1974. 4 vols.

A compendium combining a detailed historical introduction with diverse chronological, classified and biographical listings, covering the period between 1900 and 1950, cataloging close to 40,000 records, listed with title, label, number, in four integrated volumes. Introduction by George T. Simon.

Vol. 1: annual lists of Broadway musicals (with cast, book, lyrics, one or more lists); popular songs (title, author or composer); movie musicals, beginning with 1929 (cast, music, one or more hits); representative recordings (name of singer, title, label and issue number).

Vol. 3: biographical sketches of singers, orchestra leaders, musicians, arrangers, composers, lyricists active in pop and jazz, including light semi-classical music, outstanding blues performers with extensive recordings, and pioneers of country and Western. The biographies, in the majority of American artists, stress professional growth and accomplishments, musical affiliations, and have appended a representative list of records and long-playing records (title, label, and issue number).

Vol. 4: Down Beat and *Metronome* poll winners, 1937–1972; time chart of release dates for major record labels, 1924–1945; Academy Award winners and nominees for music, 1934–1973; hints for beginning record collectors; numerical listings of principal record labels (mid 1920s to 1940s); indexes.

R512. **Lewine, Richard, and Simon, Alfred.** ENCYCLOPEDIA OF THEATRE MUSIC: A COMPREHENSIVE LISTING OF MORE THAN 4,000 SONGS FROM BROADWAY AND HOLLYWOOD: 1900–1960. New York: Random House, 1961. 254 p.

This publication is devoted to a "complete alphabetical listing of published songs from every musical" opened on Broadway since 1925. Selective listing of theater songs prior to 1925. Included are some off Broadway shows. Brief introductory surveys to the periods of theater songs 1900–1924 and 1925–1960. List of motion picture songs by theater composers; show chronology 1925–1960.

R513. **Shestack, Melvin.** THE COUNTRY MUSIC ENCYCLOPEDIA. New York: Thomas Y. Crowell Co., 1974. 422 p., illus. (ports.).

Comprehensive and newest listing of country music stars and musicians, with brief biographical data and, sometimes extensive, characterization of personality, musical or performing style; with excerpts of interviews included. Discography listed by name of singer, with label and issue numbers. Eight sample songs that reflect the changes of country music. Also a list of country radio stations.

R514. **Stambler, Irwin, and Landon, Grelun.** ENCYCLOPEDIA OF FOLK, COUNTRY AND WESTERN MUSIC. New York: St. Martin's Press, 1969. 405 p., illus. (ports.).

An alphabetical listing of short biographies of individual artists and groups, with description of career, successes, and recordings. Some articles about related topics included. Lists of award-winning singers and musicans in appendix. Music; discography; bibliography.

R515. **Stambler, Irwin.** ENCYCLOPEDIA OF POPULAR MUSIC. New York: St. Martin's Press, 1965. 372 p., illus.

This volume precedes Stambler and Landon's folk encyclopedia [R514]. It presents highlights in careers and events in biographical or descriptive articles. Special material included by Vern Bushway, W. P. Hopper, Jr., Hal Levy, and Jean Mayors. Included are about seventy synopses of musicals of the major types: revue, musical comedy, musical play, operetta; with description of song histories. In appendixes: lists of various types of awards and their winners. Discography, bibliography.

R516. **Wemyss, Francis C.** WEMYSS' CHRONOLOGY OF THE AMERICAN STAGE FROM 1752 TO 1852. New York: Wm. Taylor & Co., 1852. 191 p.

A list of theaters, company managers, and performing artists from the beginning of the American stage in Yorktown, Va., in 1752 until 1852. A record of all the theatrical buildings in America, with dates and additional information listed by city in the appendix, with a supplementary list of detroyed buildings, and another list of theater managers. The main part of the book contains biographical notes of performing artists with data, first performance, and accomplishments. Wealth of information about early American theaters and their artists; helpful for researchers in theatrical and musical history.

COLLECTIVE BIOGRAPHY

R517. THE COUNTRY MUSIC'S WHO'S WHO. EDITED BY THURSTON MOORE. Cincinnati: Bob Austin and Sid Parnes, Publishers; for Cincinnati Enterprises, 1960. illus. (ports.).

An annual compilation of articles divided into eight parts (separately paged) about current topics of interest: audiences, country singers, places, television, and other. Classified directory. Discography.

R518. **Ewen, David.** GREAT MEN OF AMERICAN POPULAR SONG. Englewood Cliffs, N.J.: Prentice-Hall, 1972. 414 p.

As stated on the title page: "The history of the American popular song told through the lives, careers, achievements, and personalities of its foremost composers and lyricists—from William Billings of the Revolutionary War through Bob Dylan, Johnny Cash, Burt Bacharach." The biographies of twenty-nine composers and thirteen lyricists of popular songs: their personalities and musical careers, their discovery by critics, disc jockeys and others; stories about their songs and how they became popular; the changing of song lyrics and trends and the significance of the media.

R519. **Ewen, David, ed.** POPULAR AMERICAN COMPOSERS: FROM REVOLUTIONARY TIMES TO THE PRESENT. A BIOGRAPHICAL AND CRITICAL GUIDE WITH AN INDEX OF SONGS AND OTHER COMPOSITIONS. New York: H. W. Wilson Co., 1962. 217 p.

A biographical guide to one hundred and thirty American popular composers of the past and present, from William Billings to André Previn. It also includes composers of art songs which have gained a wide circulation. The biographies reveal information about family background, education and training, professional activities, and accomplishments. With portrait photographs when available, and bibliographical notes. Chronological list of popular American composers and index of songs and other compositions. Included is the first *supplement*, published in 1972 with song index, productions, and record albums; updating some of the biographies, with thirty-one new biographies of composers who have come into prominence since 1962. *Supplement*, 1972.

R520. **McCarty, Clifford.** FILM COMPOSERS IN AMERICA: A CHECKLIST OF THEIR WORK. New York: DaCapo Press, 1972. 213 p.

This amended version of the 1953 EDITION is the only record of its kind, listing 163 composers and their motion picture compositions: features, shorts, documentaries, and experimental films, for 5,200 movies listed in the index. Alphabetical listing by composer, with year of composition, title and type of movie, noting the producing and distributing organization. EARLIER EDITION (1953). Foreword by Lawrence Morton.

R521. **Montgomery, Elizabeth Rider.** THE STORY BEHIND POPULAR SONGS. New York: Dodd, Mead & Co., 1958. 269 p.

Biographical sketches of popular composers, their lyricists and their first successes in songwriting. A history of popular song and the musical reflected through the lives of their authors. Biographies of: Stephen Foster, James Bland, Harry and Albert von Tilzer, Ernest Ball, James Walker, E. Van Alstyne, Harry Williams, Gus Edwards, Will Cobb, Percy Wenrich, Stanley Murphy, Carrie Jacobs Bond, William C. Handy, George M. Cohan, Richard Whiting, Ray Egan, Ray Henderson, Mort Dixon, Billy Rose, Walter Donaldson, G. Whiting, Jimmy Mettugh, Dorothy Fields, Hoagy Carmichael, Mitchell Parish, Nacio Herb Brown, Arthur Freed, Milton Ager, Jack Yellen, Harry Ruby, Bert Kalmar, Duke Ellington, Irving Mills, Con Conrad, Herb Magidson, Harry Warren, Al Dubin, Frank Loesser, Irving Berlin, Jimmy van Heusen, Johnny Burke, Victor Herbert, Henry Blossom, Rudolf Friml, Otto Harbach, Oscar Hammerstein, George Gershwin, Ira Gershwin, Vincent Youmans, Irving Caesar, Sigmund Romberg, Oscar Hammerstein II, Jerome Kern, Cole Porter, Arthur Schwartz, Howard Dietz, and Richard Rodgers. Illustrated by Ernest Norlin.

R522. **Moore, Thurston.** THE HILLBILLY AND WESTERN SCRAPBOOK. Cincinnati: Enterprises Scrapbook Publications, 1949–1957. 10 vols.

Biographies and career stories of stars and groups in popular, country and Western, and hillbilly music, with photographs and caricatures. Titles of volumes vary.

R523. **Strang, Lewis C.** PRIMA DONNAS AND SOUBRETTAS OF LIGHT OPERA AND MUSICAL COMEDY IN AMERICA. Boston: L. C. Page, 1900. 284 p., illus. (ports.).

Twenty-two profiles of women in light opera characterized as "the majority who are, in fact, the happy victims of personality . . . rushed into fame chiefly by chance and a fortunate combination of circumstances."

R524. **Strang, Lewis C.** CELEBRATED COMEDIANS OF LIGHT OPERA AND MUSICAL COMEDY IN AMERICA. Boston: L. C. Page, 1901. 293 p., illus. (ports.).

Musical theater and minstrel show performances in New York, reflected in the profiles of singing actors at the end of the nineteenth century.

R525. **Wilder, Alec.** AMERICAN POPULAR SONG: THE GREAT INNOVATORS, 1900–1950. New York: Oxford University Press, 1972. 575 p.

A historical study through biographies of individual song writers, defining the characteristics (verbal, melodic, harmonic, rhythmic) of the American popular song of the 1890s and its successors. Investigation into American sheet music including the citation of sample tunes. Indexes of names and song. Introduction by James T. Maher.

POPULAR MUSIC

R526. **Boeckman, Charles.** AND THE BEAT GOES ON: A SURVEY OF POP MUSIC IN AMERICA. Washington and New York: Robert B. Luce, 1972. 224 p., illus.

A balanced compendium of popular music, with some perspectives of its interrelation with society, presenting a historical survey of music, of music publishing, and of the recording industry during the nineteenth and twentieth centuries. Special consideration of Stephen Foster, Louis Armstrong, Woodie Guthrie, Burl Ives, Bob Dylan, Elvis Presley, the Beatles, the Rolling Stones, and the rock festival in Woodstock.

R527. **Dachs, David.** ANYTHING GOES: THE WORLD OF POPULAR MUSIC. Indianapolis and New York: Bobbs-Merrill Co., 1964. 328 p., illus. (ports.).

The popular music industry and the various types of

agents in the industry: the song writers, the publishers, the trend setters, the arrangers, the disc jockeys, and others. The politics in the publishing and recording industries, the economics, and marketing for the teenage population. Dachs discusses business *versus* quality, making a plea for musical and lyrical quality in popular music.

R528. **Ewen, David.** HISTORY OF POPULAR MUSIC. New York: Barnes & Noble, 1961. 236 p.

A helpful summary of the classical writings on American musical history and popular music from the times of the New England psalm singers, to ragtime, blues, jazz, musical play, commercial, and film music. In his discussion of music Ewen emphasizes its sources rather than the performers. Included also is the development of radio, phonograph and television, as well as the history of musical societies and organizations. Bibliography.

R529. **Ewen, David.** THE LIFE AND DEATH OF TIN PAN ALLEY: THE GOLDEN AGE OF AMERICAN POPULAR MUSIC. New York: Funk & Wagnalls Co., 1964. 395 p.

The history of popular song from 1880 to 1930, focusing mainly on the music life in New York City, and the music publishing business in the 1880s and 1890s, the success stories of certain hits, their authors and composers, publishers, producers, and performers. Fifty years of American life reflected in song. Appendixes: the golden hundred; Tin Pan Alley standards (1880–1930); listing of songs, with year, author, and composer. The elect of Tin Pan Alley: lyricists and composers (1800–1930), listing their names with biographical data and professional specialization.

R530. **Ewen, David.** PANORAMA OF AMERICAN POPULAR MUSIC: THE STORY OF OUR NATIONAL BALLADS AND FOLK SONGS, THE SONGS OF TIN PAN ALLEY, BROADWAY AND HOLLYWOOD, NEW ORLEANS JAZZ, SWING AND SYMPHONIC JAZZ. Englewood Cliffs, N.J.: Prentice-Hall, 1957. 375 p.

The history of the American popular song, beginning with William Billings, including the early political songs, the songs of the Revolution and first national ballads; followed by descriptive accounts on the evolution of the various popular forms: folk songs, minstrel shows, vaudeville, musical comedy, ragtime-blues and jazz, revue, and the modern music business. A helpful introduction for beginning students.

R531. **Marks, Edward Bennet.** THEY ALL SANG. FROM TONY PASTOR TO RUDY VALLÉE, AS TOLD TO ABBOTT J. LIEBLING. New York: Viking Press, 1935. 332 p., illus. (ports.).

The memories of the songwriter, publisher and promoter of popular songs, E. B. Marks, summarizing the events and episodes of New York's entertainment world from the 1890s to about 1930. Entertainment places in New York City, songwriter personalities, publishing practices, varieties of shows, ball room dances and tango, radio, and film. *Appendix:* list of "1,545 songs outstanding in my memory"; famous names in minstrelsy; names list of variety and vaudeville; and places of entertainment.

R532. **Morris, Berenice Robinson.** AMERICAN POPULAR MUSIC. THE BEGINNING YEARS. New York: Franklin Watts, 1970. 63 p.

A brief history of popular songs in America with a collection of song texts as samples, including the history and text of "Yankee Doodle," "Hail Columbia," and "The Star-Spangled Banner." Illustrated by Leonard Everett Fisher.

R533. **Shaw, Arnold.** THE ROCKIN' FIFTIES: THE DECADE THAT TRANSFORMED THE POP MUSIC SCENE. New York: Hawthorn Books, 1974. 312 p., illus. (ports.).

An account of popular music and its transition from the Tin Pan Alley genre of the early fifties with Perry Como, Nat King Cole and many others to the rock 'n' roll years between 1956 and 1960 and its leading personalities. A presentation of the author's candid personal views, coming from his intimate acquaintance with the popular music scene. Includes press coverage about musical, political, and social events of the period. Discography, bibliography.

R534. **Spaeth, Sigmund.** A HISTORY OF POPULAR MUSIC IN AMERICA. New York: Random House, 1948. 744 p.

Although the author's most extensive list of popular songs has been superseded by two publications by Nat Shapiro [R495] and Roger D. Kinkle [R511], Spaeth's history remains as a valuable survey of individual song histories and biographical notes. This is a summary of facts about popular music paralleled by sociological and historical events, surveying eighteenth and early nineteenth century history, and examining ten-year periods from the 1860s to the 1940s. *Appendix:* "additional popular music from colonial times to the present," listing songs by year from 1770 through 1948. Bibliography.

R535. **Sullivan, Mark.** OUR TIMES, THE UNITED STATES, 1900–1925. Chautauqua, N.Y.: Chautauqua Press, 1931. vol. 3, illus.

A political and social history of the United States during the first quarter of the twentieth century. Its eleventh chapter is a social history of the popular song, analyzed with regard to social conditions, affected by the influx of immigrants, by events, vogues, changes of manners. Includes music.

POPULAR SONG COLLECTIONS

R536. **Geller, James J.** FAMOUS SONGS AND THEIR STORIES. New York: Garden City Publishing Co., 1940. 256 p.

A collection of songs dating from the 1870s to the early twentieth century; mostly with piano accompaniment. Historical note with each song: background, inspiration, and public recognition. Includes music. Introduction by Harry Staton.

R537. **Goodwin, George, ed.** SONG DEX TREASURY OF HUMOROUS AND NOSTALGIC SONGS. New York: Song Dex, 1956–1963. 2 vols.

A collection of 740 songs classified by thirty categories: included are comic song hits of stage and college, folk songs (not exclusively American), popular ballads, and others. All songs with one or more stanzas, simple tune with harmony in organmaster code; name of composer and lyricist. Classified index and composer index. The second part—with the same title, published in 1963—continues this collection of over 600 songs by Victor Herbert, George M. Cohan, Harry von Tilzer, Gus Edwards, Harry Lauder, Chauncey Olcott, Harrigan and Hart, and others. Also famous songs of the 1890s, folk songs, old musical comedy favorites, and popular ballads. This is claimed to be "the largest and most comprehensive collection of entertainment songs ever published." Each volume, 500 pages; unpaged index.

R538. HEART SONGS DEAR TO THE AMERICAN PEOPLE. Boston: National Magazine, Chapple Publishing Co., 1910. 517 p.

A collection of nearly 450 popular songs—love songs, hymns, college songs, ballads, patriotic songs, "assembled by the choice of the people from all over America," with contributions from some other countries. Mostly with piano accompaniment.

R539. **Okun, Milton, ed.** THE NEW YORK TIMES GREAT SONGS OF THE SIXTIES. New York: Quadrangle/New York Times Co.; distributed by Random House, 1970. 328 p.

A collection of more than eighty songs with piano accompaniment and guitar chords; indication of text author, composer, with current title and source of song. Photos and description of the 1960s, focusing on the youth rebellion and on social changes; discussing the explosion of American popular music, the folk revival, and rock. The rise of instruments and new musical styles, brought about in particular by the Beatles, Bob Dylan, Paul Simon, Burt Bacharach, and Hal David. The index of composers and lyricists consists of one hundred names. Introduction by Tom Wicker.

R540. **Vernon, Grenvill, comp.** YANKEE DOODLE-DOO: A COLLECTION OF SONGS OF THE EARLY AMERICAN STAGE. New York: Payson & Clarke, 1927. 165 p., illus.

Songs which appeared until 1860 in opera, comic opera and incidental plays, with texts by thirty-two authors; some anonymous; some incorporating traditional English, Irish, and Scottish tunes. Biographical sketches of the authors; including works, first performances, texts of songs, and some tunes.

SHEET MUSIC AND ILLUSTRATION

R541. **Board of Music Trade of the United States.** COMPLETE CATALOGUE OF SHEET MUSIC AND MUSICAL WORKS. New York: Da Capo Press, 1973. 601 p.

A catalog of music publications and books about music covering the period between 1825 and 1891, listing only publications of the twenty member firms comprising the Board of Trade. List of titles under categories then familiar to the trade including: title, code number of publisher, composer or author, and price. Hardcover publications include collective material, composers' letters and biographies, teaching methods, librettos, collections of church music. List of music board membership. One of the keystones to music, music appreciation, and music publishing in nineteenth-century America. The introduction to this REPRINT EDITION, by Dena J. Epstein, contains a study of the American music publishing industry during the nineteenth century. ORIGINAL EDITION (1870).

R542. **Dichter, Harry, comp.** HANDBOOK OF AMERICAN SHEET MUSIC. Philadelphia: Harry Dichter, 1947. 100 p., illus. (color).

This is the first issue of a continuing annual, containing American sheet music classified by topics, such as Americana, Bonaparte, Civil War and the North, dance, and others. Information about title, author, composer, location, publisher, and year with description of title page, portrait of person of dedication, instrument(s), plate number, and price. Reproduction of certain title pages, some in color.

R543. **Dichter, Harry, and Shapiro, Elliott.** EARLY AMERICAN SHEET MUSIC: ITS LURE AND ITS LORE, 1768-1889. New York: R. R. Bowker, 1941. 314 p., illus.

A survey of eighteenth century sheet music, classified by topic, indicating year, song title, author, first appearance, source, plate number, and music type. Also included is a *Directory of Early American Music Publishers*, and a listing of lithographers and artists dealing with American sheet music before 1870. Bibliography.

R544. **Klamkin, Marian.** FIG LEAF RAG: OLD SHEET MUSIC; A PICTORIAL HISTORY. New York: Hawthorn Books, 1975. 214 p., illus.

The author traces the development in the cover design of sheet music from early paintings and lithographs of the late eighteenth century to the Art Nouveau and art deco prints of the twentieth century. Photos by Charles Klamkin.

R545. **Levy, Lester S.** FLASHES OF MERRIMENT: A CENTURY OF HUMOROUS SONGS IN AMERICA, 1805-1905. Norman, Okla.: University of Oklahoma Press, 1971. 384 p., illus.

A collection of sheet music, with text, tune, and sheet illustration, presenting nineteenth-century musical humor. Ninety-seven songs, classified by topic, such as comic tale; men and women; history with a smile; and drink. Each chapter introduces the particular genre of songs included.

R546. **Levy, Lester S.** GRACE NOTES IN AMERICAN HISTORY: POPULAR SHEET MUSIC FROM 1820 TO 1900. Norman, Okla.: University of Oklahoma Press, 1967. 428 p., illus. [*cont.*]

An American social history, containing local episodes and particular stories and histories of the songs which are "a reflex action to events" and "an accompaniment of history." The songs identify customs and trades with their backgrounds, tools, and activities as presented in this "American history popularized around the piano." Music; bibliography.

R547. **Martin, Deac.** DEAC MARTIN'S BOOK OF MUSICAL AMERICANA. Englewood Cliffs, N.J.: Prentice-Hall, 1970. 243 p., illus.

An anthology of popular songs, tunes, and texts, noting characteristics, style, and local stories which gave rise to new songs. *Appendix:* list of song titles classifed by topic and historical period.

R548. **Tatham, David.** THE LURE OF THE STRIPED PIG: THE ILLUSTRATION OF POPULAR MUSIC IN AMERICA, 1820–1870. Barre, Mass.: Imprint Society, 1973. 157 p.

Limited edition of 1,950 copies, containing a historical survey of the development of pictorial title pages, the boom of publishing and pictorial printing since 1826, and the arrival of lithography. Sixty illustrations, reproduced directly from the originals, with names of illustrator, composer, printer or collection; year of appearance, medium (litho or other), and other comments. *Appendix:* list of artists, information of dates, works with regard to music pages, composer, publisher, and year of publication. Bibliography.

R549. **Unger, C. W.** CATALOG OF EARLY AMERICAN SHEET MUSIC. Pottsville, Pa.: By the author, 1929. folio.

Sales catalog, no. 822.

This sales list no. 822 issued by C. W. Unger lists 154 items of American sheet music published in New York before 1830. Listed by publisher as issued: Appel, Bancroft, Birch, and others; all in New York. Information about title, composer, printer, address, and date.

R550. **Warren, Louis A.** LINCOLN SHEET MUSIC, CHECK LIST. Fort Wayne, Ind.: Lincolniana Publishers, 1940. 10 p.

The volume includes 329 entries of song composers providing title, author if known, and date of publication. Warren discusses Abraham Lincoln, revealing stories and events about him. The author claims "this check list is the first attempt to compile and identify sheet music, and might be called a preliminary study in this field."

R551. Philadelphia. **Library Company of Philadelphia.** AMERICAN SONG SHEETS: SLIP BALLADS AND POETICAL BROADSIDES, 1850–1870. CATALOG BY EDWIN WOLF. Philadelphia, 1963. 220 p., illus.

Collection catalog.

An index of song sheets, consisting of 2,722 entries, among them 194 Confederate songs. Each entry consists of title; first line; number of stanzas; air to which text is sung; abbreviated information as to subtitle; and the type of illustration. Indexes of printers and publishers of sheet music, and of authors and publishers. The introduction provides historical background on song sheets, their publishers and market, and the topical interest of particular songs and styles.

COUNTRY AND WESTERN MUSIC

R552. **Bart, Teddy.** INSIDE MUSIC CITY, U.S.A. Nashville and London: Aurora Publishers, 1970. 164 p., illus. (ports.).

An introduction to Nashville, Tennessee, and its music-making business, this book is based on a collection of interviews with the top songwriters of Nashville. In presenting this literary portrait of musical craftsmen, the anthology includes Boudleaux Bryant, "Must One Have a Musical Education to Write Songs?"; Jack Clement, "Is There a Proper Atmosphere for Writing Songs?" Harlan Howard, "What is the Main Ingredient of a Good Song?"; Billy Ed Wheeler: "What Are the Most Frequent Mistakes Made?"; Hank Cochran, "Does One Write From Experience or Imagination?"; John D. Loudermilk, "Must a Songwriter Be Able to Perform?"; Willie Nelson, "Are There any Basic Rules for Writing a Song?"; Bobby Russell, "Is the Music Business More Difficult for Women?"; and "The Publisher: What is His Function?"; Chet Atkins, "What to Look for in a Song: The Publisher's View."

R553. **Goldblatt, Burt, and Shelton, Robert.** THE COUNTRY MUSIC STORY: A PICTURE HISTORY OF COUNTRY AND WESTERN MUSIC. Indianapolis, Kansas City, and New York: Bobbs-Merrill Co., 1966. 256 p., illus. (ports.).

This survey of forty years of country music is also a colorful social history of the American South and Midwest. Goldblatt discusses poor people's folk music, growth in radio and recording industries, development of styles, songwriters and personalities, the Nashville boom, and the effect on European audiences. Discography.

R554. **Hemphill, Paul.** THE NASHVILLE SOUND: BRIGHT LIGHTS AND COUNTRY MUSIC. New York: Simon and Schuster, 1970. 289 p.

An inside view of the country and pop music business in Nashville through interviews with about 150 singers and producers, such as Chet Atkins, Wesley Ryles, Tex Ritter, Billy Dillworth, Glen Campbell, and others.

R554a. **Hurst, Jack.** NASHVILLE'S GRAND OLE OPRY. New York: Harry N. Abrams, 1975. 403 p., illus.

The illustrated story of fifty years of American entertainment, recapturing Grand Old Opry's life in Nashville, the home of country music. The work is based on interviews with the stars and the people behind the scenes, and includes work recorded over many years. Appendix with discography, a selection of traditional country songs, and an extensive index. Introduction by Roy Acuff.

R555. **Malone, Bill C.** COUNTRY MUSIC U.S.A.: A FIFTY YEAR HISTORY. Austin: University of Texas Press; for

the American Folklore Society: 1968. 434 p., illus. (ports.).

The history of country music with its origin in folk song and its evolution towards commercialism and professionalism. The impact of mass media on a musical form, reflective of society and its changes. The study focuses more on society and economy than on the music itself. Bibliography includes interviews, letters, manuscripts, record catalogs, newspapers, record albums, articles, pamphlets, and books.

R556. **Shelton, Robert.** THE COUNTRY MUSIC STORY: A PICTURE HISTORY OF COUNTRY AND WESTERN MUSIC. Indianapolis and New York: Bobbs-Merrill Co., 1966. 256 p.

The history of country and Western music from poor beginnings to Grand Ole Opry, Tin Pan Alley, and the industry of Nashville, with profiles of singers and song writers, documented with illustrations and portraits. Discography. Photographs by Burt Goldblatt.

FILM MUSIC

R557. **Limbacher, James L., ed.** FILM MUSIC: FROM VIOLINS TO VIDEO. Metuchen, N.J.: Scarecrow Press, 1974. 835 p.

Articles by various authors: reminiscences, personal experiences in the movie business, description of scoring films, technical aspects. Chronological list of films with composers; list of film composers; and discography of musical scores. Bibliography.

R558. **McCarthy, Clifford.** FILM COMPOSERS IN AMERICA: A CHECKLIST OF THEIR WORK. New York: Da Capo Press, 1972. 193 p.

An alphabetical listing of 163 composers, with indication of specialization, such as serials, features, documentaries, cartoons, shorts, part score, and other. List of the works of these composers, with year, title of film, producing and distributing organization. List of Academy Awards. Indexes of film titles; orchestras. Foreword by Lawrence Morton.

R559. **Skinner, Frank.** UNDERSCORE. New York: Criterion Music Corp., 1960. 239 p., illus. (ports.).

An introduction to the basics of film music-making: the mechanics of film scoring, film footage, the use of a click track, making a click track, and other mechanics of coordinating a soundtrack with the movements and speed of a film; also techniques of writing a score, a review of orchestration (for different types of music and the various groups of instruments). Musical practice and some glimpses of Hollywood. Includes music. Photographs by Peter Gowland and Herb Carlton.

STAGE MUSIC AND MUSICAL THEATER

R560. **Engel, Lehman.** THE AMERICAN MUSICAL THEATER: A CONSIDERATION. New York: Macmillan Co., 1967. 236 p., illus. (ports.).
CBS LEGACY COLLECTION.

A brief history of opera in the United States and an autobiographical sketch by the author. A survey os musical theater: the productions in the early twentieth century, the musical revue, the contemporary musical (its libretto and the elements of the musical show), the Broadway opera (its physical conditions of pit and stage), the ensemble, orchestration, critics, and producers. A summarization of basic principles that determine the musical theater. Appendixes of published librettos and vocal scores. Discography. Introduction by Brooks Atkinson.

R561. FACT BOOK CONCERNING THE PLAYS OF RICHARD RODGERS AND OSCAR HAMMERSTEIN II. Typewritten. New York, 1954. 498 p.

Individual listing for Richard Rodgers and Oscar Hammerstein II, including films and film compositions. Combined list of works and productions by Richard Rodgers and Oscar Hammerstein II. All works include information about story, cast, musical numbers, production, and reviews. Bibliography. (A copy of this loose-leaf typescript is on file at The New York Public Library.)

R562. **Gilbert, Douglas.** AMERICAN VAUDEVILLE: ITS LIFE AND TIMES. New York and London: Whittlesey House, 1940. 438 p., illus. (ports.).

Vaudeville and entertainment history, its places, stage equipment, shows, and personalities, reflected mostly in the New York scene. The story of the intimate relation of performing arts and music, offering much detailed information (including songs and music) for the researcher. Music included.

R563. **Green, Stanley.** THE WORLD OF MUSICAL COMEDY: THE STORY OF THE AMERICAN MUSICAL STAGE AS TOLD THROUGH THE CAREERS OF ITS FOREMOST COMPOSERS AND LYRICISTS. New York: Ziff-Davis Publishing Co., 1960. 407 p., illus. (ports.).

Musical entertainment from the Civil War to the 1950s, described in biographies, success stories, and performances, incorporating the history of Broadway and the local color of New York City. Biographies of: Victor Herbert, George M. Cohan, Rudolf Friml, Sigmund Romberg, Jerome Kern, Irving Berlin, George Gershwin, Vincent Youmans, Richard Rodgers and Lorenz Hart, Cole Porter, Arthur Schwartz and Howard Dietz, E. Y. Harburg, Vernon Duke, Harold Arlen, Burton Lane, Harold Rome, Kurt Weill, Richard Rodgers and Oscar Hammerstein II, Leonard Bernstein, Alan Jay Lerner and Frederick Loewe, Jules Styne, Frank Loesser, Richard Adler, Jerry Ross, and Meredith Willson. *Appendix:* list of musical productions and discographies by composer; chronology of productions. Foreword by Deems Taylor.

R564. **Laufe, Abe.** BROADWAY'S GREATEST MUSICALS. New York: Funk & Wagnalls Co., 1969. 479 p.

A critical survey of Broadway musicals from the 1880s to the early 1960s, and an examination of the factors that

made these shows successful. The author summarizes the several periods and gives close-up views of the individual works. On balance, this is less a review of contents and histories of plays, and more an effort to account for their success. Included are records of performances for over five hundred musicals. *Appendix:* long-run musicals, number of performances. Bibliography.

R565. **Mackinlay, Sterling.** ORIGIN AND DEVELOPMENT OF LIGHT OPERA. London: Hutchinson and Co., 1927.

Chapter 28 of this book is a short description of American light opera, beginning with Reginald de Koven's *Canterbury Pilgrims* of 1861, and continuing with Victor Herbert, Julian Edwards, Sigmund Romberg, and Rudolf Friml.

R566. **Mates, Julian.** THE AMERICAN MUSICAL STAGE BEFORE 1800. New Brunswick, N.J.: Rutgers University Press, 1962. 342 p., illus. (ports.).

A stimulating coverage of early forms of the musical and music-related entertainments, concentrating on New York's eighteenth-century musical history. Included are descriptions of first theaters in many cities, their performing seasons, customs of audiences; musicians; traveling companies in the eighteenth century, their repertories and artists; biographical sketches of singers, dancers, librettists, and composers. A lively panorama of American cultural history. Music; bibliography.

R567. **Richards, Stanley, ed.** TEN GREAT MUSICALS OF THE AMERICAN THEATRE. Radnor, Pa.: Chilton Book Co., 1973. 604 p., illus.

Compendium of the complete librettos of: *Of Thee I Sing, Porgy and Bess, One Touch of Venus, Brigadoon, Kiss Me Kate, West Side Story, Gypsy, Fiddler on the Roof, 1776,* and *Company.* Edited with an introduction and notes on the plays, authors and composers, giving background information about the shows, such as notes on the copyright, the original cast, a synopsis, and a list of the musical numbers. Brief introduction to the history of the American musical.

R568. **Russak, Jon Ben.** THE FIRST COMIC OPERA IN AMERICA. Typewritten. New York: Works Progress Administration, Federal Theater Project, Play Bureau, 1935. 10 p.

Cast, synopsis, plot, list of songs, and historical commentary on Andrew Barton's *The Disappointment or The Force of Credulity, A New American Comic Opera of Two Acts,* 1767.

R569. **Smith, Cecil.** MUSICAL COMEDY IN AMERICA. New York: Theatre Arts Books, 1950. 384 p., illus. (ports.).

This book discusses "the history of the popular musical stage on Broadway and its interesting streets" in three parts, surveying the periods of 1864–1907, 1908–1925, and 1925–1950, with detailed descriptions of the making and producing of plays that made history such as the *Ziegfeld Follies* and *South Pacific.*

R570. **Wegelin, Oscar.** MICAH HAWKINS AND THE SAWMILL. A SKETCH OF THE FIRST SUCCESSFUL AMERICAN OPERA AND ITS AUTHOR. New York: Privately printed, 1917. 11 p., illus. (ports.).

Biographical sketch of Hawkins and the plot of the comic opera in two acts; description of its first production in 1824, including extracts from contemporary magazine reviews, and citations from letters and Hawkins's will. This is a LIMITED EDITION of fifty copies.

R571. **Wittke, Carl.** TAMBO AND BONES: A HISTORY OF THE AMERICAN MINSTREL STAGE. Durham, N.C.: Duke University Press, 1930. 278 p.

A contribution to American social history and the history of the stage; description and definition of the minstrel show, its origins and personalities. Local features of nineteenth century New York and the American West during the gold rush.

OPERA

R572. **Aufdemberge, Leon Maurice.** AN ANALYSIS OF THE DRAMATIC CONSTRUCTION OF AMERICAN OPERAS ON AMERICAN THEMES, 1896–1958. Ph.D. thesis, Northwestern University, 1965. 303 p.

The dissertation outlines the development of opera in American culture by surveying the periods between 1896–1919; 1920–1941; and 1942–1958. It analyzes general trends in the dramatic style of opera comparing them with the American operatic and artistic production. The author discusses plots with regard to their structure and the interrelation of the text and music. Bibliography includes scores, plot source material, books, articles, periodicals, and newspapers.

R573. **Blum, Daniel.** A PICTORIAL TREASURY OF OPERA IN AMERICA. New York: Greenberg Publisher, 1954. 320 p., illus. (ports.).

Introductory survey of early operatic performance, including ballad operas and others. Also included are photographs of individual operas, accompanied by the story of the opera, with notes about world and American premieres, first New York City performance, all with casts.

R574. **Cohen, Frederic.** OPERA SURVEY. Typewritten. New York: Sponsored by the Juilliard Musical Foundation and the Metropolitan Opera Association, 1954. 57 p.

This survey is a condensation of the preliminary report of Dec. 1, 1952 by Allen Wardwell. It examines opera in the United States, from interviews conducted during a fifteen-month period. Topics covered include the role of mass media, the architecture for a lyric theater, curriculum and student training; financing, opera funding and sponsorship. Each section is followed by recommendations for the organization of models and model plans in all areas studied. The purpose of this study was to urge support for the arts and to stimulate new works for the American operatic stage.

CHURCH, CHORAL, ETHNIC, FOLK, JAZZ, POP, AND COUNTRY MUSIC

R575. Cone, John Frederick. OSCAR HAMMERSTEIN'S MANHATTAN OPERA COMPANY. Norman, Okla., University of Oklahoma Press, 1966. 415 p., illus.

The definitive account of the four years' existence of New York's Manhattan Opera Company (1906–1910). A vivid portrait of Oscar Hammerstein, his background in opera production and his company's success in New York and Philadelphia. Evaluation of newspaper reviews of performances and artists. A chronicle of one section of American operatic history. Appendixes: Manhattan Opera casts for performances at the Manhattan Opera house, 1906–1910; the Philadelphia Opera house, 1908–1910; Manhattan Opera tour casts, 1908–1910. Includes the Manhattan–Metropolitan Opera contract of April 26, 1910, the power of attorney granted to Oscar Hammerstein, Jr. Bibliography.

R576. Davis, Ronald Leroy. A HISTORY OF RESIDENT OPERA IN THE AMERICAN WEST. Ph.D. thesis, University of Texas, 1961. 514 p.

A summary of the operatic histories of New Orleans, Chicago, and San Francisco from their beginnings to 1961, based on work done by previous researchers—such as George P. Upton, who wrote *Musical Memories* (Chicago). Bibliography.

R577. Davis, Ronald L. OPERA IN CHICAGO. New York: Appleton-Century, 1966. 406 p., illus. (ports.).

An account of the rich operatic life related to the history of Chicago. An American social and cultural history which focuses on Chicago's opera, beginning with the frontier life at Fort Dearborn and continuing through the prosperous 1890s. Topics covered include the visits of Damrosch, and the campaigns for a resident opera, supported by Karleton Hackett (music critic for *Chicago Evening Post*). General coverage continues through the 1960s. List of leading opera singers, listed by name with dates of performances from the 1910–1911 season (the first season of the Chicago Grand Opera under Cliofonte Campanini) until 1965 at the Lyric Opera of Chicago.

R578. Drummond, Andrew H. AMERICAN OPERA LIBRETTOS. Metuchen, N.J.: Scarecrow Press, 1973. 277 p.

This study attempts to judge the dramatic elements of American opera librettos performed at the New York City Opera between 1948 and 1971. In a historical survey from the late nineteenth century to 1948, the text presents a critical appraisal of dramatic elements, an analysis of plot and style in American opera, and a critical evaluation of newspaper and periodical reviews. Bibliography includes opera scores, books, articles. Appendixes: complete New York City Opera repertoire 1948–1971; synopses of opera librettos.

R579. Graf, Herbert. THE OPERA AND ITS FUTURE IN AMERICA. New York: W. W. Norton & Co., 1944. 305 p., illus.

A historical survey of opera including an appeal for the creation and the support of American opera. The author examines opera under Gatti-Casazza in New York during the 1930s and suggests plans for the development of American opera, created for a new audience. Bibliography.

R580. Graf, Herbert. OPERA FOR THE PEOPLE. Minneapolis: University of Minnesota Press, 1951. 289 p., illus.

A stimulating and succinct survey of American opera for large audiences. Discusses production technicalities of opera, with opinions on opera in community and school, in motion pictures and on television. The work attempts to pull together the experience of twenty-five years in the operatic field, in television and film, with the purpose of stimulating future opera productions in America. Bibliography.

R581. Graf, Herbert. PRODUCING OPERA FOR AMERICA. Zurich and New York: Atlantis Books, 1961. 212 p., illus.

The author, a well-known authority on opera, presents a cogent study on opera production in America and abroad. He suggests ways to stimulate the production of opera and means to integrate it into American education and society. Graf also discusses funding and sponsorship which would provide a secure artistic and economic existence for opera.

R582. Hackett, Karleton. THE BEGINNING OF GRAND OPERA IN CHICAGO, 1850–1859. Chicago: Laurentian Publishers, 1913. 60 p.

The story of the first decade of opera in Chicago, beginning with *La Somnambula* on July 29, 1850, the night before the Great Chicago Fire. Hackett discusses the operatic seasons with the Italian grand opera performances in 1853, the visit of the New Orleans English opera troupe in 1858, and the 1859 season of the opera company in Chicago.

R583. Hawn, Harold Gage. A SURVEY OF ONE HUNDRED FORTY-ONE CHAMBER OPERAS AND RELATED WORKS BY AMERICAN COMPOSERS FROM 1947 THROUGH 1966. Mus.D. thesis, Indiana University, 1966. 1,466 p., illus.

The dissertation explores the status and trends of the American chamber opera. It is based on statistics obtained through a questionnaire study and summarizes the information supplied by 102 American composers and 304 performing institutions. Statistical synthesis of the works. Description of 141 individual works; each with brief biography of composer; list of available recordings; 130 photographs of sets and costumes; number of known previous performances; relative production costs; description of opera and plot, including required performers, sets, instrumentation; problems and complexities of music and stage decor; appraisals, reviews, opinions considering music, drama, and orchestration of the works. Questionnaire and glossary in appendixes. A valuable tool for opera workshops. Discography; bibliography.

R584. **Hipsher, Edward Ellsworth.** AMERICAN OPERA AND ITS COMPOSERS: A COMPLETE HISTORY OF SERIOUS AMERICAN OPERA, WITH A SUMMARY OF THE LIGHTER FORMS WHICH LED UP TO ITS BIRTH. Philadelphia: Theodore Presser Co., 1927. 408 p., illus. (ports.).

The history of American serious opera, with a survey of its general development from its beginnings through the eighteenth, nineteenth, and early twentieth centuries. Also provided are biographical sketches of American opera composers, many of whom were born in the second half of the nineteenth century, and many with portrait etchings. Some of the biographies include opera plots, casts of first performances, and some musical examples. List of American opera companies of the 1926–1927 season. Includes music; bibliography.

R585. **Johnson, Harold Earle.** OPERAS ON AMERICAN SUBJECTS. New York: Coleman-Ross Co., 1964. 125 p.

A survey of American opera topics. Catalog of American opera subjects, listed by composer, historical annotations, first performance, background. Works composed by foreigners on American subjects are included. There is also a list by topics, such as Spanish-American, Indian, American Revolution, and others. Bibliography.

R586. **Kolodin, Irving.** THE METROPOLITAN OPERA, 1883–1966: A CANDID HISTORY. New York: Alfred A. Knopf, 1966. 830 p., illus. (ports.).

The history of the "Old Met" from its founding, through the seven years under Damrosch and Seidl, the years of Toscanini, the war seasons, the post-Caruso time, the Great Depression, the Johnson and Bing periods, until the final gala farewell, on Saturday, April 16, 1966, and the opening of Lincoln Center Opera with *Fanciulla del West.* A description of all opera seasons and their artists; the financial and managerial past of the Met, including inside stories about the supporting society; property rights of boxholders and inadequacies of the old auditorium, dictated by the social status of the sponsors. A compound account of New York's social structure and musical life centered around the old Met until its close in 1966. The Metropolitan Opera repertory for 1883 to 1966 is included. No bibliography.

R587. **Krehbiel, Henry Edward.** CHAPTERS OF OPERA, BEING HISTORICAL AND CRITICAL OBSERVATIONS AND RECORDS CONCERNING THE LYRIC DRAMA IN NEW YORK FROM ITS EARLIEST DAYS DOWN TO THE PRESENT TIME. New York: Henry Holt & Co., 1908. 452 p., illus. (ports.).

This is not a chronicle but an elaborate operatic history of New York from its beginnings. Episodes, description and sketches of opera personalities and their stories, institutions and nineteenth-century theatrical buildings, opera trends and tastes form the material of this work. Some casts are listed.

R588. **Krehbiel, Henry Edward.** MORE CHAPTERS OF OPERA, BEING HISTORICAL AND CRITICAL OBSERVATIONS AND RECORDS CONCERNING THE LYRIC DRAMA IN NEW YORK FROM 1908 TO 1918. New York: Henry Holt & Co., 1919. 490 p., illus. (ports.).

Ten seasons at the Metropolitan Opera, 1908–1918; the records and the rivalry of the Manhattan Opera House with the Metropolitan Opera. A compilation and summary of the author's articles and reviews that appeared in the *New York Herald Tribune.*

R589. **Lahee, Henry C.** GRAND OPERA IN AMERICA. Boston: L. C. Page, 1902. 348 p., illus.

A history of American opera during the eighteenth and nineteenth centuries in light of major historical events, focusing on the life stories of opera stars, conductors, and their involvement with American opera companies. Included are newspaper quotations, reviews and at times delightful anecdotes about singers and performances. Opera in America mainly since 1800, emphasizing the people who shaped opera life rather than the institutions and their growth. List of performances of the 1900–1901 New York season.

R590. **Lubbock, Mark.** THE COMPLETE BOOK OF LIGHT OPERA. London: Putnam, 1962. 953 p.

The major opera centers of the world: Paris, Vienna, Berlin, London, New York. Within sections, list of composers and their works, with author information about book and lyrics; stage director, date of first production, principal characters; historical background of the opera and short description of the plot. The chapter about New York introduced by David Ewen presents an abbreviated history of American opera from the first 1735 performance of *Flora* in Charleston, S.C. Listed in historical order: thirty-three American composers and their works, starting with de Koven and Sousa, continuing through to 1962 with Willson, Bock, Strouse. No bibliography.

R591. LYRIC OPERA OF CHICAGO, 1954–1963. Chicago: Lyric Opera of Chicago, 1963. 72 p., illus. (ports.).

A picture book, covering the first ten operatic seasons, which lists all opera performances (including date of performance and cast). Lists the Board of Directors, administrative staff, Women's Board and the Guild.

R592. **McSpadden, J. Walker.** OPERAS AND MUSICAL COMEDIES. New York: Thomas Y. Crowell Co., 1951. 637 p.

A historical survey of grand opera in Europe and the United States. The section on American opera lists thirteen composers and their major works, including V. Herbert, W. Damrosch, D. Taylor, H. Hanson, and G. C. Menotti, with reviews of their operas. Light opera and musical comedy, with twenty-five composers and their works for the United States. A historical sketch introduces each composer's work, the stage success of the operas mentioned, and information about the number of acts, author of the libretto, date of first performance, number of performances, cast, and a short plot summary. Critical notes are included.

R593. **Maretzek, Max.** SHARPS AND FLATS: A SEQUEL TO CROTCHETS AND QUAVERS. New York: American

Musician Publishing Co., 1890. 87 p., illus. (ports.).
Reminiscences and anecdotes of artists, maestros, impresarios, journalists, and patrons, describing opera life at the Academy of Music in New York between 1850 and 1890. Chapters on individual singers. An inside view of the opera company by its manager.

R594. **Martens, Frederick H.** LETTER FROM NEW YORK. *Monthly Musical Record.* 590 (Feb. 1920); 592 (Apr. 1920); 594 (June 1920); 596 (Aug. 1920); 597 (Sept. 1920); 598 (Oct. 1920).

Opera and concert life in New York and Chicago during 1920: reviews, observations, opinions.

R595. **Mattfeld, Julius.** A HUNDRED YEARS OF GRAND OPERA IN NEW YORK, 1825–1925: A RECORD OF PERFORMANCES. New York: New York Public Library, 1927. 107 p.

A brief history of grand opera dating from a presentation in Park Theatre, New York, in 1825; with surveys of operatic performance in and outside of New York during the nineteenth century. Grand Opera in New York 1825–1925, with opera performances listed by title, annotated information about librettist, composer, premiere, place, date, language of performance, and performances elsewhere in America. Chronology; bibliography.

R596. **Metropolitan Opera Association.** NATIONWIDE STUDY OF OPERA ACTIVITY IN AMERICA, TOGETHER WITH CONSIDERATIONS AND SUGGESTIONS FOR ITS FURTHER GROWTH. Typewritten. New York: Metropolitan Opera Association, National Activities Committee. 1965[?]. unpag.

This is an approximately 100-page critical study written by committee under chairmanship of Carleton Sprague Smith. It is a critical survey of the social and financial factors affecting opera attendance. The objectives of the study were to increase the percentage of the American population who attend opera performances; to find improved methods for broadening the financial base of opera productions; and to enhance local coordination in production, sharing packaged tours. Statistics are included of a city-by-city survey, giving facts and figures on fifty-two opera companies in forty-one cities and twenty-five states, stating name of city, company, frequency of performances per season or period, repertoire, and other data. Appendixes.

R597. **Moore, Edward Colman.** FORTY YEARS OF OPERA IN CHICAGO. New York: Horace Liveright, 1930. 430 p., illus.

A history of opera in Chicago since Dec. 10, 1889, the opening performance of Charles Gounod's *Romeo and Juliet.* An operatic account of each season's major events and premieres. Opera seen as the history and accomplishment of the company's management. The history of the mid-nineteenth century with its visiting opera troupes, orchestras, and artists is reflected in a general introductory survey. *Appendix:* Statistical summary by season of the Chicago Grand Opera Company, the Chicago Opera Association, and the Chicago Civic

Opera Company's performances from Nov. 3, 1910, to March 26, 1929. List of Chicago companies on tour.

R598. **New York Public Library.** TEN YEARS OF AMERICAN OPERA DESIGN, 1931–1941, AT THE JUILLIARD SCHOOL OF MUSIC. New York: New York Public Library, 1941, 20 p.

List of photographic material and original drawings of stage design that includes visual material for the following five American works: *Jack and the Beanstalk,* by Louis Gruenberg; *Helen Retires,* by George Antheil; *Maria Malibran,* by Robert Russell Bennett; *Garrick,* by Albert F. Stoessel; *The Sleeping Beauty,* by Beryl Rubinstein. This material was presented to the New York Public Library by the Juilliard School of Music.

R599. **Rhodes, Willard.** OPERA IN THE UNITED STATES. *Boletín Latino-Americano* 5 (1939). 14 p.

This paper by Rhodes was read at the Interamerican Conference on Music held at the Library of Congress, Washington, D.C., conducted by the United States State Department in October, 1939. A short account of the history of American opera, particularly in New York, from the founding of the Academy of Music in 1854 to the Manhattan Opera House under Oscar Hammerstein, including a short history of the Metropolitan Opera from its start in 1883. List of American operas which were produced by major institutions since 1910, including recording date, composer, work, producer, and thirty-five works.

R600. **Scholder, Herbert, ed.** A SAN FRANCISCO OPERA ALBUM, 1963. San Francisco: San Francisco Opera, 1963. unpag.

A photographic review (with more than 150 illustrations) of the years under Kurt Herbert Adler, general director of the San Francisco Opera since the death of Gaetano Merola in 1953. A publication for the twentieth anniversary of the general director's association with the San Francisco Opera and completion of the first decade under his guiding influence.

R601. **Sonneck, Oscar G.** EARLY OPERA IN AMERICA. New York: B. Blom, 1943. 238 p., illus. (ports.).

This work was originally written for serial publication in the *New Music Review:* June–Aug. 1907, Aug.–Oct. 1908. The pre- and post-revolutionary opera, a description of the operatic seasons and their productions. Included are English ballad operas, the producing companies and touring theaters, the interrelated activities between Charleston, Baltimore, Philadelphia and New York: and also the widespread influence of the Old American company controlling the entertainment industry between New York and Annapolis, representing essentially the early history of American opera. This volume is about stars, supporting or managing families, the artistic centers; with excerpts from the press and anecdotes about the artists. In the epilogue: French opera in Charleston. List of operas performed in Philadelphia, New York, Boston, Hartford, Rhode Island, Baltimore, Charleston, between 1787 and 1800. Includes tables, music. REPRINT EDITION (1963).

Programs, Professional Groups, and Publications

BANDS AND ORCHESTRAS

BANDS

R602. Berger, Kenneth, ed. Band Encyclopedia. Evansville, Ind.: Distributed by Band Associates, 1960. 604 p., illus. (ports.).

Informative handbook and index of a great variety of information about bands and band music. Band dictionary with definition of terms, including some detailed information about associations, laws, patents, musical instruments, and other topics. Alphabetical listing of bandmasters, sometimes with brief biographies; a list of publishers, instrument manufacturers, uniform companies, and band equipment. Also a list of municipal, industrial, professional bands, state college and university bands of North America; of great bands of the world, with short descriptions. Discography; bibliography.

R603. First Chair of America. The National Honor Yearbook for Outstanding Bands, Orchestras, Choruses, Honoring First Chair Members. Greenwood, Miss.: 1–21 (1940–1960), illus. (ports.).

"True honor yearbook for America's outstanding bands, orchestras and choruses—to honor the nation's finest high school musicians." This yearbook, published by R. R. Martin, contains short descriptions, histories and individual and group photographs; and curricula vitae of bandmasters.

R604. Buys, Peter. A Brief History of Bands in the United States. *Boletín Latino-Americano* 5 (1939). 20 p., illus.

A historical survey of bands and military music since the eighteenth century; mentioning instrumentation, printing, and publishing. This paper was read at the Interamerican Conference on Music held at the Library of Congress, Washington, D.C., conducted by the United States State Department in October 1939.

R605. Fernett, Gene. Swing Out: Great Negro Dance Bands. Midland, Mich.: Pendell Co., 1970. 175 p., illus. (ports.).

Twenty-five biographies and photographs of band leaders and their orchestras. Detailed information about bands, their social standing, and their recordings. Issue numbers are not provided.

R606. Fernett, Gene. Thousand Golden Horns: The Exciting Age of Americas Greatest Dance Bands. Midland, Mich.: Pendell Co., 1966. 173 p.

The rise and history of the big bands between 1935 and 1945, with chapters on individual famous leaders of America's name dance bands. Various bands and new singers of the time are represented by a collection of photographs. A picture documentation of a decennium of American entertaining music and its men. Concise biographical sketches, including musical development and professional achievements of Chick Webb, Hal Kemp, Glenn Miller, Jan Savitt, Count Basie, Duke Ellington, the Dorsey brothers, Artie Shaw, James Berigan, Jimmie Lunceford, Andy Kirk, and Erskine Hawkins.

R607. Rauscher, Frank. Music on the March, 1862–65, With the Army of the Potomac; 114th Regiment; P. V. Collis's Zouaves. Philadelphia: Wm. F. Fell & Co., 1892. 270 p., illus. (ports.).

A day-by-day account of the history of this military band, from its formation through the years of the Civil War, the impact of its music on the army, its fate and its survivors. A peripheral history of the Civil War, from the perspective of its military band. Includes music.

R608. Simon, George T. The Big Bands. New York: Macmillan Co., 1971. 600 p., illus. (ports.).

The book is a reportorial account, written by the music critic for *Metronome*. A general description of the life and work of big bands, giving details of the various social and professional responsibilities within a band, including the various professionals and agencies involved in dealing with bands. Individual chapters on band leaders, musicians and bands, with focus on their musical background, development, career, and professional relations. Recent interviews with Count Basie, Benny Goodman, Woody Herman, Harry James, Stan Kenton, Guy Lombardo, and Artie Shaw, discussing their careers in retrospect. Valuable information about band life, and individual bands and musicians. Discography. Foreword by Frank Sinatra.

R609. Simon, George T. Simon Says: The Sights and Sounds of the Swing Era, 1935–1955; On the Bands, Singers and Musicians of the Golden Age of Popular Music and Jazz. New York: Galahad Books, 1971. 491 p., illus. (ports.).

The inside view and collected magazine reviews of the

dance band era by one of the experts who has been involved with the popular music scene as critic for *Metronome*. Appendix: Complete listings of *Metronome* band reviews, 1935–1946, giving band, date, and rating. Discography.

R610. **Specht, Paul L.** How They Became Name Bands: The Modern Technique of a Dance Band Maestro. New York: Fine Arts Publications, 1941. 175 p., illus. (ports.).

An introduction and guidelines on how to run a band, written for young people by an experienced maestro of show business in the 1920s and 1930s. Letters, episodes, and professional attitudes are discussed, as is the repertoire in show business of the 1920s. Included are many names in popular and dance music of the same period. The introduction, entitled "Paul Specht and His Career," was written by Shepard Barclay.

R611. **Walker, Leo.** The Wonderful Era of the Great Dance Bands. Berkeley, Calif.: Howell-North Books, 1964. 315 p., illus. (ports.).

A historical review of the well-known dance bands since the 1920s, with many episodes, personal reminiscences and notable personalities involved. This is a good survey revealing much inside knowledge about band business.

R612. **White, William Carter.** A History of Military Music in America. New York: Exposition Press, 1944. 272 p., illus. (ports.).

The history from prerevolutionary times to 1943, reviewing regional bands in New England, New York, and Pennsylvania, and tracing the traditions of the various types of military bands. Included are musical examples and descriptions of army and navy music schools.

ORCHESTRAS

R613. **Graut, Margaret, and Hettinger, Herman S.** America's Symphony Orchestras and How They Are Supported. New York: W. W. Norton & Co., 1940. 326 p.

Based on a questionnaire, this is a study of the economic problems of American symphony orchestras and an examination of the common factors that determine the life of an orchestra. Forces of growth in the past and present, budgetary problems, sources of income, management, and promotion are enumerated in this survey of 150 orchestras in the United States. Tables included.

R614. **Mueller, John H.** The American Symphony Orchestra: A Social History of Musical Taste. Bloomington: Indiana University Press, 1951. 449 p., illus. (ports.).

An examination of social ramifications of American concert life and its history; a survey of the public life of orchestral compositions as performed in American orchestras; study of the American orchestra and its traditions, with profiles of seventeen major orchestras; and a study of the class structure of audiences. Mueller attempts to determine the social psychology in the formation of musical taste; the differences in musical taste between cities; and the shifting of taste in the course of history. These studies were conducted through an analysis of concert programs and press reviews of the past one hundred years, from 1850 to 1950. Charts; bibliography.

R615. **Mueller, Kate Hevner.** Twenty-seven Major American Symphony Orchestras: A History and Analysis of Their Repertoires, Seasons 1842–43 through 1969–70. Bloomington: Indiana University Press, 1973. 457 p. Indiana University Studies.

Brief analysis and interpretation of statistical records supplied in Pt. 1, with a survey of the history and methods of repertoire studies with short descriptions of twenty-seven orchestras and their conductors. This study, comprising program booklets of each year of the past 130 years, investigates the trends and changing tastes in concert life and provides insights into the relation of music to society. Pt. 2 provides records for every composition performed by the orchestras during this period with performance times, dates of all performances, name of composer, his life span and national origin. Tables; bibliography.

FESTIVALS

R616. **Hopkins, Jerry.** Festival! The Book of American Music Celebrations. New York: Macmillan Co., 1970. 191 p.

This picture book discusses the personalities and groups involved in music festivals: the San José Rock Festival, Newport Folk Festival, Woodstock Music and Art Fair, Monterey Jazz Festival, Ann Arbor Blues Festival, Memphis Blues Festival, Big Sur Folk Festival, Salinas Country and Western Music Festival, Galax (Va.) Fiddlers Convention, North Carolina Bluegrass and Square Dance Festival, Mt. Clemens Pop Festival, and the Berkeley Folk Festival. Description, history, and social background of the festivals are included. Photographs by Jim Marshall and Baron Wolman.

R617. **Howe, Mark A. De Wolfe.** The Tale of Tanglewood: Scene of the Berkshire Music Festivals. New York: Vanguard Press, 1946. 101 p., illus. (ports.).

Brought to life here is Tanglewood, whose name and romantic heritage have origins in Hawthorne's *Tales*. This work is a brief history of the Berkshire music festivals performed at Tanglewood. Included are the programs from 1934 to 1946. Introduction by Serge Koussevitzky.

EDUCATION, RESEARCH, AND LIBRARIES

R618. **Botstiber, Hugo.** Musicalia in der New York Public Library. *Sammelbande der Internationalen Musikgesellschaft,* 4 (Oct. 1902–Sept. 1903): 738 p. [*cont.*]

The holdings of manuscripts, mostly seventeenth century, and incunabula of theatrical works from the late fifteenth century and on, in the New York Public Library. For a reply to this article, *see* O. G. Sonneck [R625].

R619. **Bukofzer, Manfred.** THE PLACE OF MUSICOLOGY IN AMERICAN INSTITUTIONS OF HIGHER LEARNING. New York: Liberal Arts Press, 1957. 59 p.

A definition of musicology within the American educational system discussing its objectives and relation to other areas of research.

R620. **Einstein, Alfred.** MUSICOLOGY AND MUSIC LIBRARIES IN THE UNITED STATES OF AMERICA. Music Library Association, *Notes* 9 (1940): 4–8.

This is a statement on the lack of material in American libraries throughout the country, along with constructive suggestions on how to coordinate library services more effectively. This article has been mimeographed for distribution by the Music Library of Vassar College, Poughkeepsie, N.Y.

R621. **Kinkeldey, Otto.** MUSICOLOGY IN THE UNITED STATES. *Boletín Latino-Americano* 5 (1939). 11 p.

Survey of early scholarly accomplishments in musicology in the United States; the first chair of musicology and the first generation of American scholars; libraries and scholarly librarians. This paper was read at the Interamerican Conference on Music held at the Library of Congress, Washington, D.C., conducted by the United States State Department in October 1939.

R622. **Moore, Arthur Prichard.** MUSIC LIBRARIES IN THE UNITED STATES. *Boletín Latino-Americano* 5 (1939). 13 p.

A historical survey of the early stage of music libraries: Oberlin Conservatory, Library of Congress, music libraries of New York, Philadelphia, and Boston. This paper was read at the Interamerican Conference on Music held at the Library of Congress, Washington, D.C., conducted by the United States State Department in October 1939.

R623. **Riker, Charles.** THE EASTMAN SCHOOL OF MUSIC: ITS FIRST QUARTER CENTURY, 1921-1946. Rochester, N.Y.: University of Rochester, 1948. 99 p., illus. (ports.).

The history of the school; the work of George Eastman, Rush Ree, and Howard Hanson. Description of the library and the school's development. *Appendix:* lists of honorary degrees, honors and awards, publications.

R624. **Sherman, Clarence E.** IMPORTANT MUSIC COLLECTIONS IN PROVIDENCE. Music Library Association, *Notes* 9 (1940): 8–10.

Short descriptions of the music divisions at Brown University Library and Providence Public Library. This article was mimeographed for distribution by the Music Library of Vassar College, Poughkeepsie, N.Y.

R625. **Sonneck, Oscar G.** NORDAMERIKANISCHE MUSIK-

BIBLIOTHEKEN: EINIGE WINKE FÜR STUDIENREISENDE. *Sammelbände der Internationalen Musikgesellschaft* 5 (Oct. 1903–Sept. 1904): 329–35.

General music trends—old music versus new music—found in music divisions of American libraries, with description of the Newberry Library in Chicago, the Boston Public Library, and the Library of Congress. This article is an answer to Hugo Botstiber's article [R618].

R626. **Spivacke, Harold.** THE ARCHIVE OF AMERICAN FOLK SONG IN THE LIBRARY OF CONGRESS. Music Teachers National Association, *Proceedings* (1940): 123–27.

A brief history of the Archive of American Folk Song, begun by Carl Engel, and systematically built up by John A. Lomax and Alan Lomax through phonographic recording in the field. Cataloging of approximately 10,000 titles was accomplished under Charles Seeger. This article is reprinted (Pittsburgh, 1941) from the *Proceedings* issued for the sixty-fourth annual meeting of the Music Teachers National Association, held in Cleveland, Ohio, Dec. 28–31, 1940.

R627. **Spivacke, Harold.** THE ARCHIVE OF AMERICAN FOLK SONG IN THE LIBRARY OF CONGRESS IN ITS RELATIONSHIP TO THE FOLK SONG COLLECTOR. *Southern Musical Quarterly* 2 (Mar. 1938): 31–35.

Written by the director of the Music Division of the Library of Congress (in 1938), this article outines as the objective of the Archive of American Folk Song that it shall be a central place for study and appreciation of American folk songs, as well as a center of communication for individual collectors.

R628. **Steigman, Benjamin M.** ACCENT ON TALENT: NEW YORK'S HIGH SCHOOL OF MUSIC AND ART. Detroit: Wayne State University Press, 1964. 389 p., illus.

The history of the specialized school, with a description of course work, the student body, activities, and the objectives of the unique institution.

R629. **Sunderman, Lloyd Frederick.** HISTORICAL FOUNDATIONS OF MUSIC EDUCATION IN THE UNITED STATES. Typewritten. Metuchen, N.J.: Scarecrow Press, 1971. 453 p.

A study of school board reports, letters, local and state reports from the early nineteenth century to the present. An investigation of books and pamphlets is included as a secondary type of source. Bibliographies, charts, and statistics are included at the end of each chapter. The author discusses the beginnings of singing in America, the Pestalozzian concept in American education, Lowell Mason's philosophy, and the various stages of American music education up to World War II. Appendixes: leaders and educators in American music education; significant events; and statistics.

R630. **Tellstrom, A. Theodore.** MUSIC IN AMERICAN EDUCATION, PAST AND PRESENT. New York: Holt, Rinehart & Winston, 1971. 373 p.

This work presents a history of music education in relation to society and the disciplines of philosophy and psychology. The claims for music education are recognized as valid. The survey of historical systems includes the contemporary philosophies of education developed by Suzuki, Orff, Kodály, and Dalcroze. Bibliography.

R631. Washington, D.C. **Library of Congress.** THE MUSIC DIVISION: A GUIDE TO ITS COLLECTIONS AND SERVICES. Washington, D.C., 1972. 22 p., illus.

This history of the Music Division of the Library of Congress includes a description of its holdings and its services; its publications; and its supporting foundations, funds, endowments, and collections.

R632. **Welch, Roy Dickinson.** MUSIC IN AMERICAN COLLEGES AND UNIVERSITIES. *Boletín Latino-Americano* 5 (1939). 7 p.

Instruction of music at American colleges since the second third of the nineteenth century. Topics include diversity of accreditation and curricula. This paper was read at the Interamerican Conference on Music held at the Library of Congress, Washington, D.C., conducted by the United States State Department in October 1939.

R633. **Wiebe, G. D.** RADIO IN THE PUBLIC SCHOOL STUDENT'S MUSICAL ENVIRONMENT. *Boletín Latino-Americano* 5 (1939). 10 p.

Availability of musical material to the public school student, extracurricular activities and special radio programs for schools. This paper was read at the Interamerican Conference on Music held at the Library of Congress, Washington, D.C., conducted by the United States State Department in October 1939.

R634. **Willoughby, David.** COMPREHENSIVE MUSICIANSHIP AND UNDERGRADUATE MUSIC CURRICULA: CONTEMPORARY MUSIC PROJECT 6. Washington, D.C. CMP Music Educators National Conference, 1971. 129 p.

Contemporary Music Project 6 is a synthesis of the philosophy and practice of thirty-two experimental programs based on the concepts of comprehensive musicianship, active involvement, and personal discovery. This study aims to integrate all aspects of music study at all educational levels. Bibliography.

NOTATION AND PRINTING

R635. **Jackson, George Pullen.** BUCKWHEAT NOTES. *Boletín Latino-Americano* 5 (1939). 9 p.

This work discusses the early North American simplified form of notation (the treatise by William Little and William Smith, *The Easy Instructor; Or A New Method of Teaching Sacred Harmony* [Albany, 1802]), and the first attempts of teaching how to read music. This paper was read at the Interamerican Conference on Music held at the Library of Congress, Washington, D.C., conducted by the United States State Department in October 1939. The

paper is based on an article in *The Musical Quarterly* 19:393–400.

R636. **Krummel, Donald W.** GRAPHIC ANALYSIS: ITS APPLICATION TO EARLY AMERICAN ENGRAVED MUSIC. Music Library Association, *Notes* 16 (Mar. 1959): 213–33, illus.

The author studies punched engraving in America (1823–1864) by examination of the musical materials printed by George Blake and George Willig, both of Philadelphia. His purpose is to formulate a method of analysis of the printed musical page, with particular reference to American music engraved between 1800 and 1820.

R637. **Pooler, Frank, and Pierce, Brent.** NEW CHORAL NOTATION: A HANDBOOK. New York: Walton Music Corp., 1971. 60 p.

An extraction of notational symbols appearing with greatest frequency in current American choral compositions. The stated objectives of this list are "to help bring choral conductors an increased awareness of what is happening in their profession." Included are 105 items; list of special effects, with indication of source. This work is germane to American choir practice.

PUBLISHING AND PUBLISHERS

R638. **Ayars, Christine Merrick.** CONTRIBUTIONS TO THE ART OF MUSIC IN AMERICA BY THE MUSIC INDUSTRIES OF BOSTON, 1640 TO 1936. New York: H. W. Wilson Co., 1937. 341 p., illus. (ports.).

A thorough study about Boston's music publishing industry from the seventeenth century to the twentieth century, giving short summaries of the firms' histories with lists of published composers and including a discussion of methodological theories in music education which stimulated the publishing industry. Commentary on journals and house organs, with date of first appearance, title, publisher, price, editor, description of features, type of news, translations, and other details. Special section about music engraving and printing covering methods, lists of engravers and printers. Instrument making: list of manufacturers (classified by types of instruments), with addresses, production description and statistics. Additional material about Boston instrument makers in appendixes, with a list of some instruments of historical importance. Bibliography.

R639. **Epstein, Dena J.** MUSIC PUBLISHING IN CHICAGO BEFORE 1871; THE FIRM OF ROOT & CADY, 1858–1871. Detroit: Information Coordinators, 1969. 253 p. DETROIT STUDIES IN MUSIC BIBLIOGRAPHY, NO. 14.

This is a succinct presentation of the company's history: a biography of the three partners—George Frederick Root, Ebenezer Towner Root, and Chauncy Marvin Cady—with a discussion of the firm prior to, during, and after the Civil War. Included also are details on the firm's closing. Appendixes include a checklist of plate numbers

with indication of copyright and year; list of music books (mostly instruction books and collections of anthems); composer index to sheet music; a song index of Civil War music (omitted in table of contents). Directory of music trade in Chicago before 1871. Bibliography.

R640. **Fisher, William Arms.** ONE HUNDRED AND FIFTY YEARS OF MUSIC PUBLISHING IN THE UNITED STATES, 1783–1933: AN HISTORICAL SKETCH WITH SPECIAL REFERENCE TO THE PIONEER PUBLISHER, OLIVER DITSON COMPANY. Boston: Oliver Ditson & Co., 1933. 162 p., illus. (ports.), maps.

The history of music stores and music publishers in Philadelphia, Boston, and New York—as well as certain other cities—from the early-eighteenth century on, focusing on the Oliver Ditson Company and its involvement in the musical life of Boston. Chronology of the Oliver Ditson Company. Includes music.

R641. **Howe, Mabel Almy.** MUSIC PUBLISHERS IN NEW YORK CITY BEFORE 1850. New York: New York Public Library, 1917. 18 p.

An index of forty-eight firms (engravers, printers, music printers, and some dealers) listed in the New York City directory from 1786 on. Names with address, years of registration, and specification of trade. This compilation was made in order to date compositions published in New York City during the first half of the nineteenth century.

R642. THE WA-WAN PRESS, 1901–1911. COMPILED BY VERA BRODSKY LAWRENCE, New York: Arno Press and the New York Times, 1970. 5 vols.

This work is a compilation of a decade of issues of Arthur Farewell's Wa-Wan Press, and its promotion of American music. The single issues that form the contents of the present volumes comprise mostly vocal pieces with piano accompaniment, some pieces for piano solo, violin with piano, and recitation and piano. Preface to each issue by Farewell, introducing compositions and composers. In the prefatory essay, Gilbert Chase points out the significance of organization and scope of the Wa-Wan Press. Included is letter to the American composers by A. Farewell, 1903. One of the classics in American musical literature, recommended to all students. Introductory essay by Gilbert Chase. New index.

R643. **Waters, Edward N.** A SURVEY OF MUSICAL PUBLICATIONS IN THE UNITED STATES, 1900–1939. *Boletín Latino-Americano* 5 (1939). 54 p.

Bibliography of American music, purposes and perspectives. Included are lists of publishers, publications, and organizations devoted to the promotion of American music. This paper was read at the Interamerican Conference on Music held at the Library of Congress, Washington, D.C., conducted by the United States State Department in October 1939.

R644. **Witmark, Isidore, and Goldberg, Isaak.** THE STORY OF THE HOUSE OF WITMARK: FROM RAGTIME TO SWINGTIME. New York: Lee Furman Publishers, 1939. 480 p., illus. (ports.).

The biography of Isidore Witmark and the story of his family enterprise, reflecting the history of music publishing and the beginnings of show business in New York City, from the 1880s to 1928, when the enterprise was bought by Warner Brothers. While this is essentially the personal story of the Witmark brothers, appendixes contain valuable information about early New York show business and entertainment. Included are lists of the operettas by Victor Herbert (title, year, author of lyrics, producer, and cast), Julian Edwards, Gustav Luders, Karl Hoschna, and others. Listing of Isidore Witmark's personal works (musical numbers, books, and plays); operettas and musical comedy productions, published by M. Witmark & Sons; a chronological list of song successes; and a list of New York theaters and amusement places from 1882 to 1939.

MUSICAL INSTRUMENTS

R645. Washington, D.C. **National Museum of History and Technology, Smithsonian Institution.** MUSIC MACHINES: AMERICAN STYLE. CATALOG BY CYNTHIA A. HOOVER. INTRODUCTORY NOTES BY ERIK BARNOUW AND IRVING KOLODIN. Washington, D.C.: Smithsonian Institution Press, 1971. 139 p.

Exhibition.

A picture catalog of music machines, reproduced advertisements, lists of gramophone plates and cylinders, and a mention of the Moog synthesizer. There are expanded legends and captions to the reproductions. This survey of the development of music machines in America offers a view of how science and invention have affected the performer and his audience. Provided is a selected list of music produced on each type of music machine. Included is a historical survey of music broadcasting by Erik Barnouw extending from Alexander Graham Bell's demonstrations of the telephone in 1876/1877 to the 1968 broadcast relay via Apollo 8. There is also an introductory note, by Kolodin, on records and recording including their development and social impact. Foreword by Daniel J. Boorstin.

R646. **Young, Robert W.** THE MANUFACTURE OF MUSICAL INSTRUMENTS IN THE UNITED STATES. *Boletín Latino-Americano* 5 (1939). 6 p.

Conditions of manufacturing musical instruments in the 1930s. This paper was read at the Interamerican Conference on Music held at the Library of Congress, Washington, D.C., conducted by the United States State Department in October 1939.

RADIO AND RECORDING

R647. **Buxton, Frank, and Owen, Bill.** RADIO'S GOLDEN AGE: THE PROGRAMS AND THE PERSONALITIES. New York: Easton Valley Press, 1966. 428 p., illus. (ports.).

A list of nationally known radio programs from the earliest days of radio to about 1950. Alphabetical listing by title of show.

R648. **Davis, Clive, and Willwerth, James.** CLIVE: IN-
SIDE THE RECORD BUSINESS. New York: William Mor-
row Co., 1975. 300 p., illus. (ports.).

The autobiography of Clive Davis, describing the com-
petitive record business, and the inside politics of Colum-
bia Records—from Davis's personal view as the president
of that company between 1967 and 1973. Davis discusses
his personal and professional relationships with the stars
he brought to Columbia, as well as the tense corporate at-
mosphere and unrelenting pressure at CBS.

R649. **Lowens, Irving.** THE CURIOUS STATE OF AMERI-
CAN MUSIC ON RECORDS. Music Library Association,
Notes, 2d ser. 16 (June 1959): 371–76.

A survey of statistics about the availability of recorded
American music of a serious genre. *Appendix:* music writ-
ten by American composers before 1917, on long-playing
records. This article was mimeographed for distribution
by the Music Library of Vassar College, Poughkeepsie,
N.Y. Discography.

R650. **National Broadcasting Company.** AN ACCOUNT
OF MUSIC BROADCASTING BY NBC. New York: 1938.
unpag., illus. (ports.).

A brief history and survey of programs, opera broadcasts,
and many other musical activities of the NBC Orchestra
and Broadcast systems. List of first broadcasts over NBC.

R651. **Passman, Arnold.** THE DEEJAYS. New York: Mac-
millan Co., 1971. 320 p., illus. (ports.).

Disk jockeys; an inside view of the recording and broad-
casting business with descriptions and conversations
with many of the people involved.

MUSIC AND BUSINESS

R652. **Carpenter, Paul S.** MUSIC: AN ART AND A BUSI-
NESS. Norman, Okla.: University of Oklahoma Press,
1950. 255 p.

Carpenter discusses the negative effects of national radio
on regional culture; Hollywood and the recording in-
dustry; the individual composer; the quality and quantity
of American music; and the promotion of serious Ameri-
can music. Bibliography.

R653. **Moore, Earl Vincent.** THE WPA MUSIC PRO-
GRAM. *Boletín Latino-Americano* 5 (1939). 15 p.

Topics covered in this paper are the unemployment of
musicians during the Depression and the effects of the
new film synchronization, 1926–1928. The paper was
read at the Interamerican Conference on Music held at
the Library of Congress, Washington, D.C., conducted by
the United States State Department in October 1939.

R654. **Shemel, Sidney, and Krasilovsky, M. William.**
THIS BUSINESS OF MUSIC. EDITED BY PAUL ACKER-
MAN. New York: Billboard Publications, 1971, 601 p.

A handbook for contracts, agreements, licenses, rights,
and all legal aspects of music business, which provides a
detailed study of the music and recording industries.
With its simplified approach to legal concepts, this is a
guidebook for recording artists and composers to the
organization and structure of the music business, the per-
former's rights and obligations, and a guide for domestic
publishers and record companies in dealing with foreign
music business. [*See* R655.]

R655. **Shemel, Sidney, and Krasilovsky, M. William.**
MORE ABOUT THE BUSINESS OF MUSIC. EDITED BY LEE
ZHITO. New York: Billboard Publications, 1967. 172 p.

A handbook of business and legal facts of life for the re-
cording and publishing industry of serious music, in-
cluding information about performing rights societies,
managers, and agents. Alphabetical appendixes list mem-
bers of various organizations, forms of contracts, licenses.

SERIALS AND PERIODICALS: A COMMENTARY

Despite Dr. Delli's desire to direct the researcher to the *Music Index*, the customary elements of a periodical or serials record are scattered throughout the documentation reported elsewhere in this section. Dr. Delli preferred to assign such data to classified headings rather than to group them under the blanket subject: *serials*. The reader will be conscious of entries for articles, bibliographies, and specific journals, as for example R50, R54, R158, R164. R164 alone provides, in distinctive fashion, access to diversified material from 1850 to 1900 in important "nonmusical" sources such as *Harper's New Monthly Magazine, Scribner's Monthly, Century Illustrated,* and the *Atlantic Monthly.*

Further enrichment comes, of course, from the numerous bibliographies and indexes that are mentioned in almost every category, as for instance among the compact body of articles incorporated in entries R276--R279. By itself, R278 concentrates on indexing four journals, such as *Southern Folklore Quarterly,* while R378 typically is devoted to one field—jazz—and is supplemented by entries R382--R383. Only a complete inventory—achieved in the comprehensive index, vol. 4—can capture all the references, but the following are representative: R169a, *Dwight's Journal of Music* (Boston, 1852--1881); R173, *The Euterpeiad* (Boston, 1820--1823); R305, Folk Song Society of the Northeast, *Bulletin* (Cambridge, Mass., 1930--1937). Special issues—e.g., *Boletín Latino-Americano* 5 (1939) devoted to the Interamerican Conference on Music held at the Library of Congress, Washington, D.C., in October 1939—will turn up frequently owing to analysis and assignment of the individual articles. Anthologies derived from magazine articles also are included; *see* R170 (based on *Musical America*), R421 (based on *The New Yorker*), and R588 (based on the *New York Herald Tribune*). Even serials not part of the bibliography proper have been recognized, as, for example, in the preface, *Phonolog Reports,* the annual *Billboard Encyclopedia of Music,* and *The Purchaser's Guide to the Music Industries.* The *Music Index* provides additional data to supplement entries covering indexes (R15, R24, R295, R493) as well as the more specific entries, such as R9.

S

Serials and Periodicals on the Visual Arts

WILLIAM J. DANE

CONTENTS

INTRODUCTION

This bibliography of American art periodicals attempts to include a cross section of magazines related to the visual arts. The subject is one of great complexity, and researchers in the history of American art are strongly advised to acquaint themselves with the richness of material, both in text and illustration, that is available on the millions of pages of American fine arts periodicals. The growth of periodicals in the field of the visual arts in the United States has paralleled the over-all progress of our country. Beginning with the scant notices tucked away in columns of general magazines of the eighteenth century, attention to the fine arts slowly increased. America's popular or scholarly, richly illustrated, and well-produced specialized periodicals have contributed to the growth of interest in art not only in America, but throughout the world.

The first American magazine appeared in 1741, and those that followed expired after very brief runs. Most of them disappeared after a year or less. In the period before 1800, only two endured for as long as eight years. The publication and circulation of American magazines increased markedly in the nineteenth century. About fifty periodicals had appeared during the whole eighteenth century, but by 1825 there were almost twice that number. By 1850, the number had risen to 600, by 1885 to 3,300, and by 1900 to over 5,500. Special subject magazines began to be published by professional groups in the period from 1820 to 1840; after this date, American magazines stood on the brink of a golden age. The demand for magazines spread rapidly, printing and distribution problems were not as difficult as they had been, and technical advances moved forward with astonishing rapidity.

The first periodical notices directly related to American art were tangential and spotty; readers of general magazines were given news, for example, of the London success of John Singleton Copley or Benjamin West. After the Revolution, such artistic accomplishments were commented upon with nationalistic pride. For several generations, European fame was the solitary criterion for whatever fame or financial rewards American artists received. By the middle of the nineteenth century, the spread of art unions, the fascination with fashion, and the gradual awakening to our native potential in the arts combined to create a demand for periodicals in the fine arts. Our first art periodical, *Transactions* of the American Art-Union, began publication in 1839. Like periodicals published by other art unions shortly after this date, this early magazine simply stated the facts, reprinted reports and speeches, and made no attempt to shape aesthetic concepts or to editorialize on art topics. During the decade from 1840 to 1850, six art periodicals appeared. Only the *American Journal of Fine Arts* (1844) was truly independent, for the other five were published by various art unions. From 1850 to 1860, nine additional art periodicals appeared. In the last decade of the nineteenth century, there were about fifty art periodicals in domestic production; fourteen of these had begun publication before 1890. During this dynamic half century, public and private art collections increased in quantity and quality. Art academies and schools sprang up in most major American cities, and technical printing inventions appeared in a veritable flood. Art magazines began to specialize in particular disciplines such as drawing, ceramic decoration, furniture, and photography. Many journals reached tens of thousands of readers with each issue, and even the most casual glance at nineteenth-century art magazines impresses the viewer with the quantity of illustrations and improved techniques.

The general national prosperity was reflected in substantial art magazines that appeared in the first three decades of the twentieth century, but the Depression years of the 1930s witnessed the disappearance of many long-established titles. Those dealing with art subjects were hit especially hard; many were absorbed by other publications or ceased publication completely. After World War II, American artists captured the attention of the international art community, and, for the first time, the art center of the world shifted from Europe to the United States. During the twentieth century, the general level of taste in the United States has been steadily rising, and this is reflected in the high quality of typography and design in American art magazines.

In 1950, the Magazine Advertising Bureau of New York announced that more than 71,500,000 Americans fifteen years and older read magazines. This represented possibly the largest literate audience in the world and is evidence of one of the most impressive facts about our country. Walter Dorwin Teague, president of the American Institute of Graphic Arts in 1951, wrote in the introduction to the institute's second annual magazine exhibition: "The magazines of the United States are a laboratory for continuous experiment in the graphic arts . . . in typography, illustration, the arrangement of diverse matter on the printed page, methods of production. They serve the designer as temporary expositions serve the architect."

The late 1960s and early 1970s witnessed a proliferation of regional art magazines. This was a result partly of the nation's growing preoccupation with all aspects of the visual arts as well as its response to the efforts of the National Endowment for the Arts to decentralize art activity. These new magazines provide an opportunity for more current information and more relevant criticism from regions removed from New York and Los Angeles, our present art centers. A few examples of these regional

art periodicals are *Craft/Midwest* (Northbrook, Ill.), *Artweek* (Oakland, Calif.) [S89], and *New Jersey Music and Art* (Chatham, N.J.). Such periodicals, along with scores of others, can contribute enormously to the enrichment of contemporary arts and life. Fine arts periodicals provide a reliable barometer for the interests and activities of artists and the public. The remarkable growth of these periodicals reflects a national development of the arts, one of the glories of American culture. Our total art magazine production is a fascinating, incredibly rich source of information and illustration for both the general reader and the researcher. It is a metamorphosis in which we may all take pride.

As with periodicals in general, locating and using older art magazines is a time-consuming activity that requires patience and perseverance. The *Union List of Serials in Libraries of the United States and Canada* is incomplete, and inaccuracies abound in all libraries despite the dedication of serials librarians. For example, the magazine *Engraver and Printer* (1891–1896) appears in the *Union List* as part of the collections of The New York Public Library, and yet it is now missing from the library. The same sad story is the case for *Fine Arts: A Journal of the Polite World* (1872). The Library of Congress could not locate *Prang's Chromo* (1868–1869) until a special search turned it up five weeks after the original request. There is a pressing need for a centralized agency to assist in locating and securing back issues of American art magazines. As the situation stands, researchers must go from library to library in their bibliographic quest. A proposal for a National Periodical Resources Center to serve as a referral agency for periodical requests that cannot be met through local resources has been made by Vernon Palmour and others in *Access to Periodical Resources: A National Plan* (Washington, D.C.: Association of Research Libraries, 1974). Researchers in American art history would derive great benefit from the establishment of such a center.

Any researcher needing a reliable, general survey of the subject of art periodicals in America is urged to consult the monumental five-volume work by Frank Luther Mott, *A History of American Magazines, 1741–1905* [S·XX]. It won a Pulitzer Prize for the author and remains an indispensable work. An additional reference work is the historical survey published in 1976: Trevor Fawcett and Clive Phillpot, eds., *The Art Press: Two Centuries of Art Magazines* (London: Art Book Co., 1976), 63 p., illus. No. 1 in the series titled Art Documents, this work contains seven essays by the editors and others. It concentrates on European and American magazines of the nineteenth and twentieth century and provides an excellent index. This useful work was published by the Art Libraries Society (*ARLIS*) and was published in conjunction with an international conference on art periodicals and an exhibition, *The Art Press*, at the Victoria and Albert Museum, London.

The holdings of several libraries were used in compiling this bibliography. These institutions included The New York Public Library; the library of The Metropolitan Museum of Art; the library of The Frick Collection; the libraries of Columbia University, including the Avery Architectural Library; Princeton University Library; the library of The New-York Historical Society; the Library of Congress; and the Newark Public Library, Newark, N.J. Without exception, the staff of each institution was extremely helpful and cooperative. Recommendations were also received from Bernard Karpel, former Chief Librarian of The Museum of Modern Art, New York. A very special mention of appreciation is extended to The New York Public Library for its distinguished collection of American art periodicals, probably the most complete in the United States. This national treasure includes many nineteenth-century magazines with fold-out designs and patterns intact. Most of the older periodicals are in their original format, not photocopied or reprinted. For art periodicals in particular, the original format is of major importance, since it allows the user to see the image just as it was presented to the contemporary audience for whom it was prepared. The tactile quality of the paper is significant, as is the size of the page and the quality of the engraved works or color reproductions. In respect to art periodicals, libraries should retain the original issues just as long as it is physically possible. The many periodicals librarians, past and present, of The New York Public Library deserve special commendation from the profession and the greater art history community for the careful, precise attention they have lavished over the years on these rare and valuable materials.

In general, bulletins, newsletters, annual reports, and journals issued regularly by American museums and art organizations are not listed in this bibliography. A few exceptions are noted, however, to acknowledge the special contribution made through the publishing programs of major institutions such as The Museum of Fine Arts, Boston; The Metropolitan Museum of Art, New York; and The Museum of Modern Art, New York. By and large, the publications of most museums are concerned with their own programs, exhibitions, and educational activities, and are aimed directly at members, trustees, and the general public in the particular vicinity or region. Researchers, collectors, and curators are well aware of the value of serial publications issued by museums. The library or archive of each museum should be consulted for holdings when a question or topic relates directly to a specific institution. Some of the many museums that have published major bulletins or journals are The Brooklyn Museum; Albright-Knox Art Gallery, Buffalo, N.Y.; The Art Institute of Chicago; Cincinnati Art Museum; Cleveland Museum of Art; The Detroit Institute of Arts; Los Angeles County Museum of Art; Milwaukee Art Center; The Minneapolis Institute of Arts; The Newark Museum, Newark, N.J.; University of Pennsylvania, The University Museum; Philadelphia Museum of Art; Princeton University, The Art Museum; Rhode Island School of Design, Museum of Art, Providence, R.I.; Wadsworth Atheneum, Hartford, Conn.; Walters Art Gallery, Baltimore, Md.; Harvard University, Fogg Art Museum, Cambridge, Mass.; Worcester Art Museum, Worcester, Mass.; and Yale University Art Gallery, New Haven, Conn.

A number of magazines that are not classified as art periodicals have made a lasting contribution to the development of American art. During the twentieth century, for example, several periodicals opened their pages to social criticism and realism, using the work of contem-

porary artists to illustrate their editorial policies. Three of these magazines were *The Liberator* (1918–1924), *Good Morning* (1919), and *New Masses* (1926–1948). These publications featured the works of many American artists, including Louis Lozowick, George Bellows, Abraham Walkowitz, Morris Kantor, Niles Spencer, Wanda Gág, Ernest Fiene, Walt Kuhn, and Stuart Davis.

Publishers of art magazines change frequently, as do editors, and for this reason such names are not always listed in the annotations. The annotations are intended to highlight periodicals that are distinctive in their presentation, were a major influence in their time, or made a special contribution to the history of America's visual arts. With few exceptions, all of the selected periodicals were edited and published in the United States, giving further evidence of the vitality, endless variety, and quantity of America's production of art magazines over two centuries. The major visual arts—painting, sculpture, architecture, the decorative and graphic arts, and photography—are represented and reinforced by references in the index volume to specialized titles elsewhere in this over-all work. In addition, the Combined List of Serials and Periodicals at the beginning of this section serves as a finding list for main entries in other sections.

WILLIAM J. DANE

COMBINED LIST OF SERIALS AND PERIODICALS

Listed here are the *main entries* for publications included in this section and elsewhere in Volumes 1-3.

COMBINED LIST OF SERIALS AND PERIODICALS

REFERENCE WORKS ON SERIALS AND PERIODICALS

Union Lists, Indexes, and Catalogs

S·I. ARCHITECTURAL INDEX. Sausalito, Calif., and Boulder, Colo. 1— (1950—).

[*See* S36.]

S·II. ART INDEX: A CUMULATIVE AUTHOR AND SUBJECT INDEX TO A SELECTED LIST OF FINE ARTS PERIODICALS AND MUSEUM BULLETINS. New York: H. W. Wilson Co. 1— (1933—).

[*See* S62, and for additional details, L9. *See also* the headnote preceding S1.]

S·III. ARTbibliographies MODERN. Santa Barbara, Calif.: American Bibliographical Center; Oxford, England: Clio Press. 1— (1969—).

Vol. 1–3 (*see below*) issued as *LOMA, Literature on Modern Art* were edited by Alexander Davis who subsequently continued independent publication of *Art/Design/Photo* (1972) (London, Idea Books, 1973). *ARTbibliographies MODERN* is a semi-annual bibliography of books, periodical articles, and exhibition catalogs that deal with twentieth-century art and design. It features author and museum and gallery indexes, abstracts, and book reviews. More than 500 periodicals, 500 books, and 800 catalogs in a variety of languages are represented in the 1973 issue. PUBLISHED AS *LOMA, Literature on Modern Art* 1–3 (1969–1971); *ARTbibliographies MODERN* 4— (1973—). [*See also* L8.]

S·IV. Chicago. **The Art Institute of Chicago.** RYERSON LIBRARY INDEX TO ART PERIODICALS. Boston: G. K. Hall, 1962. 11 vols.

This is an invaluable subject index to the vast multilingual collection of The Chicago Art Institute's Ryerson Library; entries date back to 1907 or earlier for most magazines. The collection covers the fine, decorative, and useful arts in its assemblage of scholarly publications, popular magazines, and museum bulletins. The first *supplement* to this index was published in 1974.

S·V. New York. **Columbia University.** AVERY ARCHITECTURAL LIBRARY CATALOG. 2d ed. Boston: G. K. Hall, 1973. 15 vols.

The most comprehensive work in the field and an extraordinary resource, this unique record unlocks material on the decorative arts, archaeology, and city planning as well as architecture in its countless ramifications.

S·VI. EARLY AMERICAN PERIODICALS INDEX TO 1850. New York: Readex Microprint, 1964.

This index, consisting of approximately 650,000 cards, was prepared by WPA workers at New York University, Washington Square College. It was edited for publication by Nelson F. Adkins with the cooperation of the New York University Library. The subject listings include headings such as architecture, art exhibitions, art societies, engravings, painting (criticism), and sculpture.

S·VII. Winterthur, Del. **Henry Francis du Pont Winterthur Museum.** THE WINTERTHUR MUSEUM LIBRARIES' COLLECTION OF PRINTED BOOKS AND PERIODICALS. Wilmington, Del.: Scholarly Resources, 1974. 9 vols.

A reduced facsimile reproduction of the museum's card catalog, this index includes the general book catalog, auction catalogs, rare books, and the special Shaker collection in the Winterthur Libraries, which houses the greatest collection for the study of American decorative arts. In addition to books, the collection includes manuscripts, microfilm, slides, photographs, and periodicals. The general catalog, which is made up of the first seven volumes, includes some entries for art periodicals. The introduction to this publication describes the collection as follows: "Today the advanced collector, the historian and the graduate student can come to Winterthur and find a very large part of the material they need for research in the history of the English Empire in the United States, and they can also study the works of art produced or used in our country up to 1913."

S·VIII. NEW SERIAL TITLES: A UNION LIST OF SERIALS COMMENCING PUBLICATION AFTER DECEMBER 31, 1949. Washington, D.C. 1— (Jan. 1953—).

This is the continuation of the *Union List of Serials*. A record of the holdings of magazines in more than 700 libraries in the United States and Canada, it is issued monthly by the Library of Congress.

S·IX. **Cushing, Helen Grant; and Morris, Adah V., eds.** NINETEENTH-CENTURY READERS' GUIDE TO PERIOD-

ICAL LITERATURE. New York: H. W. Wilson Co., 1944. 2 vols.

Covers 1890–1899, with *supplemental* indexing, 1900–1922. This is an author, subject, and illustrator index to material in fifty-one periodicals. Fourteen of the titles included are indexed beyond 1899, some extending as far as 1922. Emphasis is on literary and general magazines with a few specialized titles, including those in the fine arts.

S·X. **Poole, William Frederick; with Fletcher, William Isaac.** POOLE'S INDEX TO PERIODICAL LITERATURE. Rev. ed. Gloucester, Mass.: P. Smith, 1963. 7 vols.

This is a basic index to American and English periodicals, spanning 105 years and listing about 590,000 articles in 479 periodicals. Listings are by subject and are gathered from general magazines with a few art and architecture periodicals included. ORIGINAL EDITION (Boston: Houghton, 1888); *supplements:* 1 (1882–1887), 2 (1887–1892), 3 (1892–1896), 4 (1897–1902), 5 (1902–1906).

S·XI. READERS' GUIDE TO PERIODICAL LITERATURE. New York: H. W. Wilson Co., (1905—).

This widely known index, begun in 1901 as a guide for small, general libraries, originally covered only fifteen of the more popular magazines. Over the years it added many more titles, with occasional references to art subjects. *Readers' Guide* now provides a balanced selection of American popular, nontechnical magazines, including a few entirely on the fine arts.

S·XII. RÉPERTOIRE D'ART ET D'ARCHÉOLOGIE. Paris: Morancé. (1910—).

ORIGINALLY PUBLISHED under the auspices of the Bibliothèque d'Art et d'Archéologie of the University of Paris and, from 1945 to 1965, by the Comité International d'Histoire de l'Art; after 1966, PUBLISHED by the Centre National de la Recherche Scientifique. This is a highly prestigious, scholarly, and comprehensive annual bibliography of books and perodicals from many countries. Includes author, artist, and place indexes, and summaries for many of the entries. Sections on sales catalogs emphasize European fine arts periodicals, but include entries from over fifty American art magazines and museum bulletins. ISSUED irregularly. [*See also* S43.]

S·XIII. RILA: RÉPERTOIRE INTERNATIONAL DE LA LITTÉRATURE DE L'ART / INTERNATIONAL REPERTORY OF THE LITTERATURE OF ART. New York: College Art Association. (1975—).

RILA is a scholarly, international index—supported by grants—which covers the entire span of art history in all fields. This is a project of the RILA International Center under the editorship of Michael Rinehart, Sterling and Francine Clark Art Institute, Williamstown, Mass., which sponsored the planning for this fresh and major bibliography and abstracting service. A demonstration number was issued in 1973. In 1975, vol. 1, pts. 1–2, were issued, the first covering "abstracts," the second the index. Vol. 2, pts. 1–2, were issued in 1976. Publication is planned twice a year, with reportage on 250 art periodicals from around the world, books, and exhibition catalogs in several languages. "American" is a subdivision under various subject categories.

S·XIV. UNION LIST OF SERIALS IN LIBRARIES OF THE UNITED STATES AND CANADA. 3d ed. New York: H. W. Wilson Co., 1965. 5 vols.

This opus lists more than 156,000 serials that began publication before 1950 and the holdings of 956 cooperating libraries. Although far from complete as a listing of the location of American art periodicals, this remarkable compilation is an essential tool for research in all disciplines. *Supplemented* by [S·VIII].

General Bibliographies: A Selection, 1916–1974

S·XV. **Bode, Carl.** THE ANATOMY OF AMERICAN POPULAR CULTURE, 1840-1861. Berkeley: University of California Press, 1959.

S·XVI. **Drewry, John Eldridge.** CONTEMPORARY AMERICAN MAGAZINES: A SELECTED BIBLIOGRAPHY. Athens: University of Georgia Press, 1938.

S·XVII. **Ford, Janos L. C.** MAGAZINES FOR MILLIONS: THE STORY OF SPECIALIZED PUBLICATIONS. Carbondale: Southern Illinois University Press, 1969.

S·XVIII. **Hoffman, Frederick J.; Allen, Charles; and Ulrich, Carolyn F.** THE LITTLE MAGAZINE: A HISTORY AND BIBLIOGRAPHY. Princeton, N.J.: Princeton University Press, 1946.

S·XIX. **Katz, William; and Gargal, Berry.** MAGAZINES FOR LIBRARIES: FOR THE GENERAL READER, AND SCHOOL, JUNIOR COLLEGE, COLLEGE, AND PUBLIC LIBRARIES. New York: R. R. Bowker Co., 1972.

S·XIXa. **Meserole, Harrison T., comp.** DIRECTORY OF JOURNALS & SERIES IN THE HUMANITIES: A DATA LIST OF THE PERIODICAL SOURCES ON THE MASTER LIST OF THE MLA INTERNATIONAL BIBLIOGRAPHY. New York: Modern Language Association of America, 1970. 135 p.

S·XX. **Mott, Frank Luther.** A HISTORY OF AMERICAN MAGAZINES, 1741-1905. New York: D. Appleton, 1930; Cambridge, Mass.: Harvard University Press, 1938, 1939, 1957, 1968. 5 vols.

S·XXI. **Pattee, Fred Lewis.** THE FIRST CENTURY OF

AMERICAN LITERATURE, 1770–1870. New York: Appleton-Century-Crofts, 1935.

S·XXII. **Paulee, Milton.** MAGAZINE AND EDITORIAL DIRECTORY, VOL. 2. In: THE WORKING PRESS OF THE NATION. Burlington, Ia.: National Research Bureau, 1974.

S·XXIII. **Peterson, Theodore Bernard.** MAGAZINES IN THE TWENTIETH CENTURY. Urbana: University of Illinois Press, 1956.
REVISED EDITION (New York: Macmillan Co., 1968).

S·XXIV. **Richardson, Lyon N.** A HISTORY OF EARLY AMERICAN MAGAZINES, 1741–1789. New York: Thomas Nelson & Sons, 1931.

S·XXV. **Roberts, Helene Emylou.** AMERICAN ART PERIODICALS OF THE NINETEENTH CENTURY. M.L.S. thesis, University of Washington, 1961.

S·XXVI. **Smyth, Albert H.** PHILADELPHIA MAGAZINES AND THEIR CONTRIBUTORS, 1741–1850. Philadelphia: Robert M. Lindsay, 1892.

S·XXVII. **Tassin, Algernon.** THE MAGAZINE IN AMERICA. New York: Dodd, Mead & Co., 1916.

S·XXVIII. **Tebbel, John.** THE AMERICAN MAGAZINE: A COMPACT HISTORY. New York: Hawthorn Books, 1969.

S·XXIX. **Ulrich, Carolyn F.; and Kup, Karl.** BOOKS AND PRINTING: A SELECTED LIST OF PERIODICALS. Woodstock, Vt.: Elm Tree Press, 1943.

S·XXX. **Whitehill, Walter Muir; Garrett, Wendell D.; and Garrett, Jane N., comps.** THE ARTS IN EARLY AMERICAN HISTORY: NEEDS AND OPPORTUNITIES FOR STUDY. Chapel Hill: University of North Carolina Press; for the Institute of Early American History and Culture at Williamsburg, Va., 1965. 170 p.
NEEDS AND OPPORTUNITIES FOR STUDY SERIES.

Includes a substantial bibliography. [See I·3.]

S·XXXI. **Wood, James Playsted.** MAGAZINES IN THE UNITED STATES. New York: Ronald Press, 1949.

INDIVIDUAL SERIALS AND PERIODICALS

The majority of recent art periodicals are now indexed or have at some time during their existence been indexed in *Art Index* [S69] or *Readers' Guide to Periodical Literature* [S·XI]. Therefore, index information on specific periodicals in this section is included only for indexes besides these two.

S1. ADVERTISER. East Stroudsburg, Pa. 1–28 (Oct. 1930–Dec. 1957).

In its early years this periodical included articles of merit and interest to commercial artists. A few topics to be found in issues from the 1930s are contemporary European typography, poster advertising, foreign advertising artists, and letterhead design. During the 1940s, World War II and radio advertising were dominant themes in the magazine's content. By the 1950s, the magazine mainly contained news of events and personalities in the advertising business with very little of interest to the commercial artist. PUBLISHED AS *Artist and Advertiser* (Oct. 1930–June 1933).

S2. AFRICAN ARTS / ARTS D'AFRIQUE. Los Angeles. 1— (autumn 1967—), illus.

Handsomely illustrated, and featuring authoritative articles in French and English, this quarterly magazine devotes its pages to the graphic, plastic, performing, and literary arts of Africa, traditional and contemporary. The purpose of the magazine is to record the art of the African past, to show the work of contemporary African artists, and to stimulate the creative arts in Africa. Afro-American art interests are reflected in book reviews, contributions from the faculties of American universities and colleges, advertisements of American galleries handling African art, and regular listings and reviews of major exhibitions of African art in American museums. The periodical also contains history and description of important American collections of African art such as the Burde Collection in Virginia and public collections of The Detroit Institute of Arts and the Los Angeles County Museum of Art. The magazine, associated with the University of California, is evidence of the broad spread of interest in African art in the United States beginning in the 1960s, and its scholarly articles and excellent photography have stimulated the development of and enthusiasm for black art in America.

S3. ALDINE. New York. 1–9 (Sept. 1868–Dec. 1879), illus.

This magazine had as subtitles *A Typographic Art Journal* (1868–1870) and *Art Journal of America* (1874–1879). After 1871, when its format was enlarged to quarto size and an abundance of original woodcuts appeared in each issue, this magazine was a notable example of good typography and illustrations. Sentimental subjects including animals, children, castles, the good and the bad, abounded—and the illustrations reflect a high Victorian addiction to genre scenes, nostalgic moral uplift, and the joys of pure motherhood. The text usually described each illustration, and there was regular commentary on art, including coverage of Boston exhibitions, advice to the judges at the Centennial Exposition, the progress of public museums, and the Paris Exposition of 1878. The preface to vol. 9 (1878) includes a glowing report on the current state of the fine arts in America. Engravings by European and American artists appear in profusion; some of our native talent included Elihu Vedder, Thomas Moran, George Henry Boughton, E. H. Blashfield, John S. Davis, John D. Woodward, and Eliza Greatorex. The magazine boasted that its pages were the place "where the best engraving is set off with the finest paper, the handsomest letterpress, and excellent mechanical work; no artist can wish for a better medium for the reproduction of his pictures." The text is large and clear with just the correct white margins and spaces for ease in reading. This periodical filled the public demand for quantities of illustrations, expertly reproduced from wood engravings and showing a variety of subjects, most of which reflected the mores of the time.

S4. AMERICAN ARCHITECT AND ARCHITECTURE. Boston and New York. 1–152 (Jan. 1876–Feb. 1938), illus.

The pages of this periodical provided a brilliantly written and illustrated parade of American architecture for the nearly seventy-two years during which it was published. Always in control of the subject, the magazine managed to cover the significant buildings and important styles of each era. In the early years, all the illustrations were line drawings or renderings with a brief description for each picture printed nearby. Indexes to each volume are arranged by subject, type of building, and location, with a separate listing for the illustrations. "Building News" from each state was listed around the turn of the century, by which time photographs were increasingly employed for illustrations. All types of structures were covered. A random sampling includes courthouses, churches, prisons, asylums, libraries, schools, customs houses, hotels, stables, synagogues, pumping stations, and all varieties of domestic architecture. Materials and technical subjects were also treated in articles on drainage, ventilation, flooring, brickwork, and lightning conductors. The history of architecture was approached in survey articles on Viollet-le-Duc, equestrian monuments, and Art Nouveau interiors and furnishings. By the 1930s the illustrations were clear, large photographs, so that its record of the Art Deco period is outstanding. PUBLISHED AS *American Architect and Building News* (1876–1908); *American Architect* (1909–Aug. 17, 1921); *American Architect and the Architectural Review* (Aug. 31, 1921–June 17,

1925); *American Architect* (July 1, 1925–May 1936). SUPER-SEDED BY *Architectural Record* [S37]. Indexed in "The Decennial Index of Photo-Lithographic and Other Illustrations," *American Architect and Building News*. AB-SORBED *Inland Architect and News Record* [S143].

S5. AMERICAN ART. Boston. 1–2 (Oct. 1886–Dec. 1887), illus.

This monthly magazine covered painting, engraving, sculpture, architecture, decoration, and industrial arts. It was a handsome quarto volume running to about forty pages per issue and was edited by Lyman H. Weeks, a writer and art critic for the *Boston Post*. He planned to make this periodical "an exponent of that which is highest and best in every branch of art endeavor or achievement." The columns of the magazine were to be prepared by the leading writers on art topics in our country, and the illustrations to be the work of the best artists. The frontispiece of each issue was an etching, photogravure engraving, or other print commissioned especially for the magazine. The approach was decidedly eclectic when it came to subject matter. There was material on the following general topics: American cut glass; the art of book illustration; Millet's pictures in Boston; Washington, D.C., as an art center; art instruction in the South; and public statuary. Specific topics give a fascinating insight into some of the art attitudes and particular interests of the times. For example, the magazine frowned on barroom art, and called the Statue of Liberty "more of an architectural and engineering achievement than a work of art." Other specific works or art events briefly discussed include the Boston statue of Crispus Attucks, new designs in portieres, photographing artists' studios, *Japonaiserie*, fern cases, the Leland Stanford Museum, L. Prang & Co.'s Christmas cards for 1886, and how to pack a bust.

Considerable writing for the magazine was done by Caryl Coleman, Charles De Kay, William Howe Downes, Marion A. McBride, Roger Riordan, Frank T. Robinson, and the editor, Lyman H. Weeks. The rising interest in art in the West received some attention on a regular basis. The first issue of the magazine comments as follows on some art interests in Chicago and beyond: "Decidedly art has as yet but a precarious existence in the West, and where one sees many of the bizarre things, which are sold in the name of art, he questions whether it exists at all. But, that the art wave is lapping these inland shores there can really be no doubt, although but a small number of persons as yet have more than wet their feet by the inundation. They seem somewhat afraid to venture in The numerous exhibitions of good and bad pictures in the Western cities have done much for the public—with much still to be done." So much for a lofty attitude from Boston on art in America's West in 1886. The magazine had brief, informative articles coupled with attractive black-and-white illustrations in ample quantity and is a good barometer of New England art attitudes during the brief period of its publication.

S6. AMERICAN ART IN BRONZE AND IRON. New York. 1–14 [1902–1914(?)], illus. [*cont.*]

This periodical presents a rich record of some of the elaborate metalwork that abounded on buildings and houses, in parks, and on monuments in America in the first decade or so of the twentieth century. An announcement in the first number comments as follows on the appearance of the first issue: "The gratifying success of our first venture, the publication issued in 1899, entitled 'Examples of Bronze Work to Special Design' has encouraged us to take the step. It is the intention to issue this publication at intervals, and illustrate therein the best examples of bronze and wrought iron as exemplified by work of Jno. Williams Bronze Foundry executed to the special designs of Architects, Decorators and Sculptors." The first number includes over forty pages of memorial tablets; later issues illustrate bronze entrance doors and grilles, bank counter screens, lamp standards and lanterns, monumental bronze statuary, and miscellaneous metalwork of architectural, decorative, and ecclesiastical character. No. 3 (1904) has excellent illustrations with descriptive captions of the works of a number of American sculptors, including J. Massey Rhind, Augustus Saint-Gaudens, A. Phimister Proctor, and Olin Levi Warner, among many others. Largely because of the excellence of the photographic illustrations on high-quality paper, the magazine has value to historians of sculpture and interior design.

S7. THE AMERICAN ART JOURNAL. New York. 1— (spring 1969—), illus.

American art history is the subject of this scholarly quarterly, jointly established by Kennedy Galleries of New York and Da Capo Press, and later published solely by Kennedy Galleries. Painting, sculpture, graphics, decorative arts, and architecture are covered in articles by art historians, essayists, critics, and new scholars in the field. The articles cover various topics in depth and average from 1,000 to 5,000 words. Scores of black-and-white illustrations appear along with the articles that are abstracted and indexed in *Historical Abstracts* and/or *American History and Life*. Separate index to vols. 1–4 (Charlottesville: University Press of Virginia, 1974). The scholarship and scope of the magazine which covers American art from the seventeenth to the twentieth century, are impressive and are a reflection of the growing interest in all aspects of the art of our country.

S8. AMERICAN ART REVIEW: A JOURNAL DEVOTED TO THE PRACTICE, THEORY, HISTORY, AND ARCHAE-OLOGY OF ART. Boston. 1–2 (Nov. 1879–Oct. 1881), illus.

This ambitious periodical was noteworthy, and it is unfortunate that its publication did not continue, for the feature articles were excellent, the art news and reviews quite complete, and its layout and illustrations entirely successful. The editors hoped to publish an American art periodical that would be as illustrious as European fine arts magazines such as the *Gazette des Beaux-Arts, Port Folio,* and the *Zeitschrift für bildende Kunst*. The first issue notes the rise in art interests in the United States over the preceding decade with the comment "The arts are no longer regarded as comparatively unimportant to our na-

tional growth and dignity, and an ever-increasing enthusiasm has replaced languid interest or indifference . . . A desire to keep up with the times in art matters, as in all else, seems to have taken possession of us." To help readers become well informed, the magazine was about evenly divided between European and American topics. The American chronicle included information on public and private collections, art education in various cities, exhibitions and sales, museums, clubs, and societies, mostly in the major cities but now and then in a smaller community such as Jacksonville, Illinois; Melrose, Massachusetts; or Zanesville, Ohio. A necrology section listed European and American death notices, usually only a few lines in length. Art books were reviewed regularly, and the comments were thorough and frequently frank. Biographical articles appeared on major artists such as William M. Hunt, Elihu Vedder, William Rimmer, William Merritt Chase, Daniel Huntington, and the Cincinnati artists of the Munich school. A series of original plates by American etchers deserves special mention as it contributed to the rising interest in all the graphic processes. Among the twenty artists whose original work appeared were Peter, Thomas, and Mary Nimmo Moran; R. S. Gifford; J. D. Smillie; W. M. Chase; and F. S. Church.

S9. AMERICAN ART REVIEW. Los Angeles. 1— (Sept.-Oct. 1973—), illus. (color).

Traditional and historic American art from the colonial period to 1950 is the special province of this relatively new bimonthly, which has many high quality color reproductions in each issue. A prospectus from the editor and publisher, Thomas R. Kellaway, noted that the magazine would chronicle the growth of American painting, drawing, printmaking, sculpture, and decorative arts, and that its sources "are the museums, galleries, archives, universities, private collections, family and friends of the artists, wherever the most significant American art now resides. We'll report on exhibitions, auctions, acquisitions and de-accessions." During the first year, articles appeared on collections and individual artists, including Frederic Remington, Winslow Homer, Everett Shinn, Stanton Macdonald-Wright, Edwin Austin Abbey, Marguerite Thompson Zorach, John Quidor, and Arshile Gorky. According to a reviewer commenting on the magazine for *Library Journal* in Aug. 1974, the "primary target audience is the university teacher, certainly the university graduate who has an interest in collecting and/or learning more about paintings, drawings, prints and sculpture. Comparatively speaking, it is not as ambitious as *Art in America*, and probably comes closer to *Art News* in terms of bias." More advertisements appeared in each issue, and these also include high quality color reproductions of lesser-known works by American artists. The appearance of this substantial magazine devoted to American art is an additional indication of the increased interest in our nation's visual arts.

S10. AMERICAN ART STUDENT AND COMMERCIAL ARTIST. New York. 1—10 (Sept. 1916—May 1927), illus.

This magazine was intended to encourage cooperation among art students, who were confused because of the rise of a number of modern art movements. The first editorial noted that the art student was "standing in the center gazing after one group and then after another, not knowing which to follow or what to do. The desire for cooperation has grown powerful and is no longer unconscious. The students of New York have produced this publication, inviting the art students of America to cooperate." The magazine was to be published monthly "to instruct, to inform and inspire students of art, reproduce their work, establish a medium for their thought." Every art student in America was invited "to control the construction of this magazine. It is of great importance that every art student in America make an effort to have printed in the pages of this magazine what he believes will be of value to the cooperative plan and to himself." Brief articles cover technique and general aesthetics. Small black-and-white illustrations appeared throughout, with early issues running to sixteen pages and later issues increased to thirty-four or more. *American Art Student* was temporarily discontinued when several of the staff went into the Army or Navy. Publication resumed with a notice that the magazine would be called *National Art Student*, but this title was never fully adopted. A survey of the founding and first years of the magazine is printed in the issue for Apr. 1921.

Figure drawing, poster design, pastel sketching, artists' materials, china painting, and dynamic symmetry were some of the topics briefly written about and illustrated. N. C. Wyeth wrote on "The Illustrator and His Development" (Dec. 1916), and George Bellows described "What Dynamic Symmetry Means to Me" (June 1921). By 1924, much of the pioneering spirit of the initial student enterprise was gone, although it continued to be published by the Association of American Art Students with Walter W. Hubbard as editor. The role of the commercial artist was given more prominence with reproductions from Hearst publications and historic costume design for the stage. PUBLISHED AS *American Art Student* 1—3 (Sept. 1916—May 1918), 4—7 (May 1921—Jan. 1923). ABSORBED BY *Touchstone* [S238] (Sept. 1918—Feb. 1921); *National Art Magazine* (Mar.—Apr. 1921).

S11. **American Art-Union,** BULLETIN. New York. 1—7 (1847—1853), illus.

From 1850 to 1853, the *Bulletin* also included the American Art-Union, *Transactions* [S12], and included the plan of the institution, a list of officers, and catalogs of paintings and other works of art at the association building. Established in New York, the American Art-Union exerted significant influence on professional art associations in other cities. This publication also set the pattern for journals issued slightly later. The editor was the engraver W. J. Hoppin, and first issues were modest in format, reporting only the barest facts. However, by 1850 the magazine had become a genuine art journal, international in coverage but national in viewpoint, with essays on technique, biographies of artists, critical articles, and reports of art activities in the United States and abroad. It aspired to be a monthly publication with a minimum of sixteen pages per issue, but publication

became highly irregular. *Supplements* were issued, and there were many engravings and etchings used as illustrations. For its time, the magazine enjoyed an enormous circulation, as indicated by the distribution of 130,000 copies to members in 1851. The American Art-Union lost its judicial battle regarding the legality of distributing its purchases by lottery, and the final *Bulletin* was extremely apologetic in its editorial comment. For a thoughtful account of this periodical, *see* Mary Bartlett Cowdrey, *American Academy of Fine Arts and American Art-Union* (New York: New-York Historical Society, 1953). AB-SORBED American Art-Union, *Transactions* (1850).

S12. **American Art-Union,** TRANSACTIONS. New York. 1–11 (1839–1849).

Each issue of these *Transactions* included a listing of the officers, a report of the annual meeting, honorary secretaries, a list of subscribers with place of residence, the charter, the constitution, and sometimes speeches made at annual meetings. Later issues included a list of paintings distributed by the American Art-Union and the fortunate recipients of the lottery drawings. The periodical had 814 subscribers in 1839, and by 1847 the number had risen to 9,666 members, among whom the association had distributed 272 paintings. The peak of membership enrollment was reached in 1849 with a total of 18,960 members, and in that year 21,000 copies of the periodical were printed for distribution. A careful account of the various issues of the *Transactions* appears in Vol. 1 of Mary Bartlett Cowdrey, *American Academy of Fine Arts and American Art-Union* (New York: New-York Historical Society, 1953). PUBLISHED AS Apollo Association for the Promotion of the Fine Arts in the United States, *Transactions* (1839–1843). SUPERSEDED BY American Art-Union, *Bulletin.*

S13. AMERICAN ARTIST. New York. 1— (Apr. 1937—).

Painting, drawing, illustrations, and graphic and commercial art are the main subjects of this monthly magazine, which stresses technique as well as commentary on major contemporary talents, frequently in the realistic realm. Andrew Wyeth, Robert Brackman, Will Barnet, Philip Pearlstein, and Whistler are among the many artists represented in articles concentrating on medium and technique. Regular features include a technical page, a professional page, book reviews, and an annual issue with an art school directory after 1963. PUBLISHED AS *Art Instruction* 1–3 (1937–1939).

S14. AMERICAN COLLECTOR: THE MONTHLY MAGAZINE OF ART AND ANTIQUES. New York. 1–17 (Dec. 5, 1933–Nov. 1948).

This was a monthly periodical geared to the interests of the antiques trade with news, columns, book reviews, and calendars of shows of special interest to collectors and dealers. In the 1940s the articles were more substantial and covered painters, restored buildings, and all aspects of antique decorative arts, including exotic items such as sausage guns, apple parers, and trivets. SUSPENDED (Dec. 1935–Jan. 1936). ISSUED biweekly from 1933 to 1936, and thereafter monthly.

S15. AMERICAN HERITAGE: THE MAGAZINE OF HISTORY. New York. 1–3 (Jan./Feb. 1947–Apr. 1949). New ser. 1— (Sept. 1949—), illus.

Although this is not primarily an art magazine, it merits special attention because of the fine reproductions of American art, which make up a sizable portion of its content. Historic sketches never before reproduced, antique maps, valentines, postcards, and trade cards, in addition to paintings and drawings by major artists, give the magazine a visual excitement which greatly enhances the subject of American history. In the first issue of this popular bimonthly the editor, Earle Newton, noted that it would concentrate on the "American heritage as seen at its grass roots" and emphasize many facets of our national history, including "expressions of our folkways in art." The publisher is the Amerian Association for the State and Local History, Society of American Historians. True to its word, the magazine has offered authoritative articles on such subjects as George Caleb Bingham, George Winter, Frederick Law Olmsted, the Index of American Design, and scrimshaw. The illustrations are expertly selected, and their visual interest adds immeasurably to the magazine's value. Cartoons, posters, photographs, broadsides, caricatures, and special drawings deserve mention as a source of portraits and iconographic items related to our national art history as well as to the political and social history.

S16. **American Institute of Architects,** JOURNAL. Washington, D.C. 1–16 (1913–1928). New ser. 1— (Jan. 1944—), illus.

The new series for this professional monthly was launched with notice that the institute earnestly hoped to "pick up, as with a microphone, the Voice of the profession, and amplify it to audibility. There is evidence that the architect himself would like to hear this Voice, as well as to help give it words." The editor, Henry H. Saylor, went on to claim that the "profession itself must assume responsibility for its own destiny." An article in June 1944 described "Our Responsibilities to Service Men," and in Aug. 1944 Louis Kahn wrote on "War Plants after the War." The format and content reflected the interests of the architectural profession in much the same depth and reporting style until May 1957. At that time the institute celebrated its first hundred years with a two-part issue of the *Journal.* The first part of this issue had an enlarged page format with many illustrations prepared under the new editor, Joseph Watterson. The second part was a 184-page history of the institute prepared by Henry H. Saylor.

In more recent times the magazine has had a contemporary, dynamic appearance with layouts, articles, and illustration to match a focused awareness by the profession of its problems and accomplishments. The new platform branched out in many directions and promised articles on the organization of architects' offices, environmental concepts, urban renewal and rehabilitation, and the preservation of historic buildings and sites. Leading architects contributed major articles. In the 1970s, the magazine continued to report on special conventions and other activities of the institute and also to publish mean-

ingful issues devoted, for example, to ecology, furniture as architecture, the architecture of Washington, D.C., and new materials for design and construction. PUBLISHED AS *Octagon* (1929–1943). ABSORBED American Institute of Architects, *Bulletin* (1957).

S17. **American Institute of Graphic Arts,** JOURNAL. New York. 1–5 (June 1947–Apr. 1953), illus.

Twenty-six months after the American Institute of Graphic Arts' *Newsletter* ceased publication, the *Journal* appeared with the following comment in the leading paragraph: "The AIGA *Journal* is an old friend with a new name, some new clothes and some new ideas. It's the '*News-Letter*,' necessarily neglected during the war, now picked up and brushed off." The editors hoped it would serve as a clearinghouse of news in all branches of the graphic arts, both in the United States and abroad, with no intention of competing with any general or trade magazine. There were articles on new type designs, medical illustration, pioneer presses in Hawaii, and a fascinating account of "Will Bradley's Magazine Memories" (vol. 3, no. 1). Vol. 3, no. 2 includes some especially attractive headpieces and tailpieces along with assorted illustrations. A history of the institute since its founding in 1914 appears in the last two issues. ABSORBED American Institute of Graphic Arts, *Newsletter* 1–81 (1922–Apr. 1945); (May 1949–Oct. 1950); *see also* [S18].

S18. **American Institute of Graphic Arts,** NEWSLETTER. New York. 1–81 (1922–Apr. 1945). New ser. 1–5 (Nov. 1949–Jan. 1950).

Beginning as a single sheet when Frederic W. Goudy was the president of the institute, the record of events, members, exhibitions, and gossip grew to twelve pages for a few issues, with an average of eight pages of material directed squarely at the members to keep them well informed on subjects of interest. Bookplate competitions, lists of the "Fifty Books of the Year," brief editorials, book reviews, private press news, calligraphy, and annual reports appeared regularly. Of special interest to typographers and those involved with the history of modern fine printing were frequent news and tributes concerning great printers of the period such as Goudy, Bruce Rogers, Henry Watson Kent, Rudolph Ruzicka, and the paper specialist Dard Hunter. The *Newsletter* contains the annual reports and lists of new members of the institute. SUPERSEDED BY American Institute of Graphic Arts, *Journal* [S17].

S19. AMERICAN JOURNAL OF FINE ARTS: DEVOTED TO PAINTING, SCULPTURE, ARCHITECTURE, MUSIC, ETC. New York. 1 (Nov. 1844).

This solitary twenty-four–page issue has the distinction of being the only independent art magazine published in America before 1853. Earlier art periodicals were sponsored by the art unions. Published by W. B. Taylor & Co., this magazine was edited by A. D. Paterson, who wrote at length on the plan and scope of his magazine. He pointed out that until 1844, our country was "a wilderness of surface" and that the settlers, who were few in number, did not have leisure for self-indulgence and gratification. By 1844, some of the American people had the time "to look into the fields of the Fine arts . . . the American school of Painting does not stand dishonored which can place upon its records the names of West, of Stewart [sic], of Allston, to say nothing of living artists whose names would swell this catalogue to too great an extent. In Sculpture the names of Greenough and Crawford will attest American genius, although the art itself be but in its infancy among us." Paterson notes that good specimens of architecture "are but very rare." Several of the articles were signed, and there are lively and detailed accounts of the development of the American Academy of Fine Arts and the National Academy of Design. There is a tribute to and obituary of the young American painter James de Vaux, who was a native of Charleston, S.C., and who died in Rome in 1844. Sections were assigned to sculpture, drama, architecture, and music, but no illustrations appeared. Unfortunately, the magazine quickly foundered, and no subsequent issues were published after this serious and thoughtful beginning. Except for the chronicles of the various art unions, a specialized fine arts periodical did not appear in the United States until nine years later, when *Pen and Pencil* [S193] revived the long parade of art magazines offered to the American public.

S20. AMERICAN LANDSCAPE ARCHITECT. Chicago. 1–7 (July 1929–Oct. 1932), illus.

Fountains, golf courses, penthouse plantings, and swimming pools, as well as walks, gardens, drives, and parks around houses of the early 1930s were expertly reviewed and illustrated in this authoritative magazine. Cemeteries, playgrounds, and the illumination of buildings and grounds were other subjects developed by professional landscape architects. Aerial views of Stockholm's municipal airport and the town of Beverly Hills, Calif., in the late 1920s and early 1930s are truly outstanding records of twentieth-century expansion; in a few decades they changed from quaint, rural sites to locations of international significance. The economic crisis of the early Depression killed off this special magazine just after the editor had congratulated himself on its third anniversary and announced its removal from Chicago to New York. SUSPENDED (Aug.–Sept. 1932).

S21. AMERICAN MONTHLY MAGAZINE. New York. 1–12 (Mar. 1833–Oct. 1838). New ser. 1–6 (1836–1838).

Although this monthly magazine was devoted to history, literature, poetry, bibliography, and general interests, in its early years there were a few reviews of notable New York art exhibitions. In 1833 these included commentary on paintings shown at the American Academy, on Barclay Street, and the National Gallery, at the corner of Broadway and Chambers Street. In 1834, reviews were published with substantial commentary on a number of paintings being shown at the American Gallery of Fine Arts. These few art items were completely dropped by 1837, but they have merit for surveying the visual arts in New York City at a relatively early period of our national history. ABSORBED *New England Magazine* (1836).

S22. AMERICAN PHOTOGRAPHY. Boston. 1–47 (July 1907–July 1953), illus.

The magazine INCORPORATED *American Amateur Photographer* (established in 1889), *Camera and Dark Room* (established in 1898), and *Photo Beacon* (established in 1889). The new periodical proposed to include all fields of photography: pictorial, professional, scientific, and technical. Eventually it served as the organ of the Camera Club of New York (1909–Apr. 1912); the organ of the Photo Pictorialists of Buffalo (Dec. 1909–Dec. 1914); and the organ of the Boston Photo-Clan (Dec. 1911–Dec. 1914). It ABSORBED *Camera Notes* in Jan. 1909; *Popular Photography* in Jan. 1917; *Amateur Photographer Weekly* in Nov. 1919; *Photo-Craft* in Feb. 1920; *Photo-Era* in Apr. 1932; *Photo Miniature* in Oct. 1930; *Photo Technique* in Jan. 1942; *Camera Craft* in Apr. 1940. Edited by Frank R. Fraprie, the first issues contain articles on techniques, including exposure, night photography, color, copying, focal length, shutter speeds, retouching, toning, and stereoscopic photography. Regular features include new patents, a portfolio, news of prize competitions, and book reviews, liberally interspersed with illustrations; all reflect the pictorial approach to photographs. In the 1920s the format was much the same, but the final issues reflect the new approach to photography, and Minor White and Berenice Abbott were invited to be consulting editors. SUPERSEDED BY *Photography: Magazine of Popular Photography.*

S23. AMERICAN QUARTERLY. Minneapolis and Philadelphia. 1– (spring 1949–).

Literature and history dominate the pages of this magazine, published by the University of Pennsylvania for its American studies program. Now and again, however, an art subject is given most thoughtful presentation by writers from the academic community such as Milton W. Brown on "The Ash Can School" (1949), Edwin Morgan on "American Art at Mid-Century" (1949), and Donald A. Ringe on "Paintings as Poem in the Hudson River Aesthetic" (1960). Contains book reviews. Issued in four numbers and one supplement per year. Indexed in *Social Sciences and Humanities Index.*

S24. American Society of Bookplate Collectors and Designers, BULLETIN. Washington, D.C. 1– (1932–).

This slight publication appears irregularly and contains news of interest to members of the society. A financial report, membership totals, news of the publication of its yearbooks, exchange lists, and the roll of active members are usually included in each issue. Other features are book reviews, brief obituaries, notes of interest to the members regarding affairs of the society, and news of other collections. Only one or two illustrations appear in the entire run.

S25. AMERICAN STUDENT OF ART. New York. 1 (Jan.–June 1906).

It is unfortunate that this magazine by the Art Students League of New York was not continued, since the six issues we have gave a clear picture of the ideals of the students and faculty at the league. Each issue contained a feature article or two on such leading lights as George De Forest Brush, Kenyon Cox, Charles W. Hawthorne, Louis Loeb, Edwin H. Blashfield, and George B. Bridgman. There was an editorial notice in each issue and a generous supply of art-related advertisements.

S26. ANALECTIC MAGAZINE; CONTAINING SELECTIONS FROM FOREIGN REVIEWS AND MAGAZINES OF SUCH ARTICLES AS ARE MOST VALUABLE, CURIOUS, OR ENTERTAINING. Philadelphia. 1–14 (Jan. 1813–1819). New ser. 1–2 (1820–Dec. 29, 1821), illus.

The subtitle varies. Washington Irving edited this magazine from 1813 to 1815, when he wearied of the task. The illustrations were one of the magazine's distinctions, with portraits and American views the usual subjects. Early examples of magazine illustration using wood engravings and lithography appeared here, and the Aug. 1817 issue included a notice regarding the development of lithography with the comment that this graphic process "is likely to extend, beyond calculation, the sphere and influence of the fine arts." A thirteen-page discussion of the state of the fine arts in the United States was printed in the Nov. 1815 issue, in which the artist stated his purpose as "merely to cast a rapid glance over the present state of the fine arts among us, and to aid in directing public attention to their great importance and value." Architecture and engraving are given a few paragraphs, for a change. ABSORBED *Select Review of Literature.* SUPERSEDED BY *Library Gazette; or Journal of Criticism, Science, and the Arts.*

S27. ANTHONY'S PHOTOGRAPHIC BULLETIN. New York. 1–33 (Feb. 1870–Apr. 1902), illus.

Articles on technique and new developments in photography were the basis for this magazine, which contains many illustrated advertisements for equipment of all types, including camera stands, dry plate lanterns, the airbrush, burnishers, paper, and a lounge on which to photograph children. Articles consisted of edited speeches or reprints of writings from newspapers and other magazines. For example, the Mar. 1884 issue includes an article that states that the great increase in insanity in America and abroad can be directly attributed to the introduction of dry plates: "We need search no further to find out why our lunatic asylums are crowded. The insidious dry plate and the plausible developer furnish the explanation that medical men have sought in vain." Actual photographs were sometimes pasted down on cardboard inserts in the magazine. News of camera clubs was a regular feature, as were accounts of meetings of photographic societies and exhibitions both in America and Europe. (*See,* for instance, the account of the International Photographic Congress at Paris in the Mar. 1890 issue.) SUPERSEDED BY *Photographic Times.*

S28. ANTIQUARIAN. New York. 1–17 (Aug. 1923–Nov. 1931), illus.

Brief articles on a wide assortment of American and European antiques were the main feature of this magazine. Quantities of black-and-white illustrations accompanied the articles. Until the years of the Depression,

advertisements made up over half of each issue, but these were also frequently illustrated and have some value to collectors. Ceramics, furniture, glass, pewter, pictures, sculpture, silver, and textiles were discussed, with specific antiques presented in survey articles on subjects such as silhouettes, tankards, Franklin stoves, book plates, porringers, and paintings on glass. SUSPENDED (July–Oct. 1932, Dec. 1932–Apr. 1933). SUPERSEDED BY *Fine Arts*.

S29. ANTIQUES. Boston, New York. 1— (1922—), illus. (color).

Encyclopedic in scope, brilliantly edited, and revealing a love of the material and expertise in subject matter, this monthly magazine immediately takes its place in any golden dozen listing of notable periodicals devoted to American art. The opening sentence of the first issue wisely noted that the magazine was "venturing into a super-modern world, a world self-consciously intent upon newness; purposefully disdainful of tradition." A half-century later, the mania for Americana was spreading throughout the land, and millions of people expressed a genuine appreciation for every aspect of American art. This dramatic reversal of attitude was due in part to the influence, authority, and popularity of this magazine. Articles have appeared on major antique subjects, artists, and craftsmen, in addition to specific topics such as armor, clocks, draperies, hardware, lace, medals, pewter, and samplers. Indexes were published at various intervals, and these reveal articles on potichomania, silhouettes, emblems, petit point, toy soldiers, punch bowls, Rockwood pottery, shovels, verandas, razors, mirrors, and beads, to indicate only a sampling. Issues published during the 1930s reveal the low esteem and poor market for American antiques in general. The irony of the situation is impressive after looking at articles and advertisements appearing a generation later. The articles are always reliable and authoritative. The text is quoted again and again as the ultimate authority, and being illustrated in *Antiques* gives an object lasting fame. Regular features over the years include a question-and-answer column, book reviews, a travel guide listing dealers, museum accessions, current and coming events, and quantities of advertisements of uncommon interest. The jubilee issue for Jan. 1972 glows with color pictures of exceptional quality and a lively visual presentation resulting from technical advances in design and printing. As the years roll along, newer antiques appear (Art Deco, for example). The magazine now covers twentieth-century collecting interests as it continues to document those of earlier centuries.

S30. ANTIQUES JOURNAL. Mount Vernon, Ohio. 1— (1946—), illus.

Devoted exclusively to the collecting of antiques, this monthly magazine treats specific collectibles with detailed but not scholarly attention. Subjects are covered by text of three or four pages, with many illustrations for each major article. Amateur or new collectors and busy dealers pick up all the necessary background information to be reasonably well informed about popular antiques in these highly readable articles. Timeliness and popularity

are two of the criteria for subjects. While American antiques are the primary interest of the magazine, information appears on collectibles from other nations, including England, Ireland, Turkey, China, and Russia. Twentieth-century items appear in recent years: Art Deco collectibles, original comic strip art, antiques of the occult, Pepsi-Cola materials, photography, and pulp magazines. The range of topics is remarkable. A brief listing includes go-carts, dye crafts, Vermont silversmiths, Buster Brown items, horse brasses, tin star-shaped sheriff's badges, amber, aprons, card cases, cash registers, wicker furniture, glass hats, keys, Mason jars, memory cups, pomanders, warming pans, cornets, and early Christmas tree lights. Each issue includes quantities of advertising, a directory of dealers, book reviews three or four paragraphs in length, a question-and-answer column, and a listing of antique shows, auctions, and flea markets. At the end of its twenty-fifth year of publication in 1972, the magazine was redesigned, expanded, and placed on newsstands throughout the United States. Since then, issues total over seventy pages with a general format that is lively and includes survey articles prepared for the ever-increasing audience for American collectibles and antiques. PUBLISHED AS *American Antiques Journal* (1946–1949).

S31. APERTURE. Rochester, N.Y., and Millerton, N.Y. 1— (Apr. 1952—), illus.

With Minor White as editor, this truly notable photography magazine is published intermittently four times a year. It is committed to the advancement of photography as an art and as a medium of personal expression. Over the years, the size of the pages has increased along with the number of pages. Special monographs on major photographers appear as part of the magazine's regular output. Some of the photographers honored in this way are Edward Weston, Paul Caponigro, W. Eugene Smith, Jerry N. Uelsmann, Clarence John Laughlin, Frederick H. Evans, and Ralph Eugene Meatyard. In each instance, the photographer's work was approached with extraordinary empathy and understanding, and the magazine is justly referred to as the mid-century counterpart of *Camera Work*. The photographs are not selected for their popular appeal yet are totally absorbing. Ansel Adams commented as follows on the unique quality of the magazine: "It deserves universal support among all serious photographers, educators, and practitioners of the art of photography." Among the outstanding issues are those on *French Primitive Photography* (1970) and the North American Indians of Edward S. Curtis (1972). Authoritative articles and beautifully printed reproductions in quantity assure this magazine a prominent position in the long history of American photography periodicals. Publisher's partial index covers 1–6 (1952–1958).

S32. APPLETON'S JOURNAL: A MAGAZINE OF FINE LITERATURE. New York. 1–15 (Apr. 1869–June 1876). New ser. 1–11 (July 1876–Dec. 1881), illus.

American art was the subject of frequent articles in this lively periodical from its beginning to 1876, when eclecticism became the editorial policy. The first issue stated

that "scientific subjects are to have a prominent share of attention," but subsequent articles were of a popular nature. Literature, poetry, and many illustrations provided a mirror of the variety of contemporary interests. A sampling of American art topics includes an account of seven sittings with Hiram Powers (1869), the acquisition of the Cesnola Cyprian Collection by The Metropolitan Museum of Art (1873), a critique of Inness, the art work on display at Tiffany's Union Square store (1875), color in architecture, the Cooper Institute Women's Art-School, an appreciation of Vedder's paintings (1875), and ceramic art at the Centennial Exposition (1876). After a few years, the illustrations become less frequent, but issues in the earlier years included works by Homer, Darby, Edwin Forbes, and Gaston Fay. There are slight variations in magazine title over the years.

S33. ARCHITECT. New York. 1–15 (Oct. 1923–Apr. 1931), illus.

The twenty to thirty large, clear photographs of new structures were the notable feature of this magazine, which asked a "carefully chosen" board of architects to make the selection for each issue. A different Piranesi drawing appeared on the cover each month, and some architects collected them. The text was less important, with commentary on specific new buildings, an occasional biography of a historic American architect, and high-principled advice to all architects. The buildings that were illustrated reflected all regions of the country. *Note* that vol. 15:5 is omitted and 15:6 is repeated in numbering.

S34. ARCHITECT, BUILDER, AND WOODWORKER. Chicago and New York. 1–31 (Mar. 1868–May 1895), illus.

Floor plans, fold-out detail drawings, and news of architectural developments combine to make this periodical a major source of information on American Victorian architecture. Churches, houses, porches, aviaries, summer houses, entrance lodges, butler's pantries, railway stations, and even ship designs are presented in text and large, clearly delineated drawings. The planting of shade trees, iron houses, cornices and moldings, and plans for a cheap Western cottage ($3,500 for at least ten rooms) were covered in 1873. All those concerned with the history, design, furnishings, and ornamentation of American architecture during the second half of the nineteenth century will find this magazine of enormous interest and value. Interior designers, architects, and those working in preservation of high Victorian structures of great variety will find authentic and invaluable material throughout the magazine. PUBLISHED AS *American Builder and Journal of Art* (1868–June 1873); *American Builder: A Journal of Industrial Art* (1873–July 1879); *Builder and Woodworker* (Jan. 1880–Mar. 1893, 1894); *Architectural Era* (Apr.–Dec. 1893). SUPERSEDED BY *National Builder*. ABSORBED *Illustrated Wood Worker* [S140].

S35. ARCHITECTURAL FORUM. Boston and New York. 1–140 (1892–Mar. 1974), illus.

In its early years, this magazine declared itself to be "an illustrated monthly devoted to the advancement of archi-

tecture in materials of clay" and featured a regular section on "Brick and Terra-Cotta Work in American and Foreign Cities." At the turn of the century there was a preoccupation with articles on fireproofing, the result of several spectacular fires in big cities, including both the Rogers, Peet, and the Home Life Insurance Building fires in New York in Dec. 1898. There was a regular series covering new public schools, since most were constructed of brick. The myriad advertisements focused on brick, cement, and clay products and machinery; they also told of elevators, mail chutes, screens, snow guards, ventilators, and window pulleys.

Over the next two decades, the magazine changed its content to become more varied, carefully reflecting new approaches to domestic, institutional, and business structures. In Jan. 1918, Fiske Kimball wrote an article on "The Development of American Architecture," which the editor prefaced with a note that "No attempt has hitherto been made to trace in connected fashion the development of American architecture from its origin to the present day." In the 1930s the magazine was acquired by Time, Inc., and it became one of the more avant-garde publications in the field, publishing many works of Frank Lloyd Wright, advocating urban design, and devoting issues to specific cities or to countries (such as Hungary and Czechoslovakia in 1934 in an "International Section"). In Feb. 1934, a special section included a timely survey of glass as an architectural medium, using nine small modern houses at the World's Fair as examples. In 1973, the circulation was 43,000 copies, with no newsstand sales. The final issue was devoted to Kevin Roche. Some of the staff of the eighty-two-year-old trade journal formed *Architecture Plus* [S41]. PUBLISHED AS *Bricklayer* 1–25 (1892–1916); *Magazine of Building, Architectural Forum* 96–101 (1952–1954). Indexed in *Applied Science and Technology Index*.

S36. ARCHITECTURAL INDEX. Sausalito, Calif., and Boulder, Colo. 1— (1950—).

This index is especially useful to working architects and interior designers. Eight of the leading periodicals in the field are indexed with entries under such major headings as building types and geographical or regional locations. Hundreds of names of firms and individuals are included under the major subject heading for "Architect or Designer." This is, in all, a timely and informative compilation.

S37. ARCHITECTURAL RECORD. New York. 1— (July 1891), illus. (color).

Well into its ninth decade, this monthly presents American architectural historians with a survey of major interests, trends, and developments of importance to the architectural profession, along with reports in depth on various types of buildings. The editorial emphasis and content have changed with the times yet the magazine has continuously proved to be of value. The first issues gave an indication of the magazine's ultimate worth, including articles on the Romanesque Revival in New York City, architecture as a fine art, iron construction in New York, and the Auditorium Building in Chicago. Articles

on technical problems such as fireproofing and sanitation soon appeared (1899). Illustrations appeared in quantity to augment the text; the pictures selected for articles on "The Small City House in New York" (1899), apartment houses, and "New York's Billionaire District" (1901) add greatly to the documentary value of the periodical. The life and works of individual architects were given some attention (see, for instance, the discussion of James Hoban, "the first government architect" [1901]), and a 106-page picture portfolio survey of the works of Ernest Flagg. Seaside homes, college buildings, country clubs, and architecture at the Brussels Exposition were covered in 1910. The format became slicker in the 1920s; page size was enlarged to present articles on a Norman village at Lake Arrowhead in California and on the houses of the very rich, as designed by the firm of Delano & Aldrich (1923). The photographs of Art Deco interiors and exteriors in 1933 issues are outstanding. Types of buildings were featured in individual issues during the 1930s, and "The New Architecture in Mexico" was presented with distinction in the issue for Apr. 1937.

After World War II, advertisements crowded the pages of the magazine, with some attention given to the specific interests of builders and engineers. Airports, military buildings, motor courts, schools, parking garages, and shopping plazas were themes of individual issues and reflected changes in the American way of life. The distinguished architectural historian Henry-Russell Hitchcock wrote an influential article, "The International Style," in Aug. 1951. More color illustrations appeared in the 1970s along with regular columns for "Architectural Business" and "Architectural Engineering." Cumulatively, the magazine preserves an accurate, sweeping record of the creations and interests of working architects from the last decade of the nineteenth century through today. ABSORBED American Architect and Architecture [S4] (Mar. 1938). Publishes a semiannual index. Indexed in Applied Science and Technology Index; Engineering Index.

S38. ARCHITECTURAL REVIEW. Boston. 1–17 (1891–Apr. 1910). New ser. 1–13 (Jan. 1912–July 1921), illus.

The first issues were short on text but included drawings and renderings from competitions for opera houses, villas, and crematories, along with detailed plans for actual buildings, all in official style. The architecture of the World's Columbian Exposition was discussed in 1892. In later years, the magazine included photographs and measured drawings of historic interiors. Architecture of the Pacific Coast was covered, as well as the colonial architecture of Maine, residences and gardens of the estate category, railroad stations, and hospitals. During its three decades of publication, the magazine represented the officially accepted architecture for public and private structures. SUSPENDED (May 1910–Dec. 1911, Apr. 1911–Aug. 1915). SUPERSEDED Technology Architectural Review. INCORPORATED WITH American Architect to form American Architect and Architectural Review, which became American Architect and Architecture [S4].

S39. ARCHITECTURE. New York. 1–73 (1900–May 1936), illus. [cont.]

The first issue of this outstanding architectural magazine noted that "the licensing of architects throughout the country is only a matter of time," and the editorial went on to encourage Governor Roosevelt of New York to approve such an act. The magazine was originally published by Forbes & Co. of New York, and the articles and illustrations covered a wide spectrum of buildings, mostly in the United States. The full-page, black-and-white photographs of interiors and exteriors are models of clarity and careful selection. In 1928, Lewis Mumford wrote on "American Architecture To-day," and in 1927 a series of special photographic portfolios surveyed 115 details such as stairways, iron railings, cupolas, gable ends, circular and oval windows, chimney tops, fanlights, garden gates, built-in bookcases, trellises, urns, and weather vanes. This series was celebrated, and with good cause. The early years showed a sampling of Art Nouveau, and the 1930s issues record quantities of Art Deco interiors and exteriors. INCORPORATED WITH American Architect to form American Architect and Architecture [S4] in June 1936.

S40. ARCHITECTURE AND BUILDING: A MAGAZINE DEVOTED TO CONTEMPORARY ARCHITECTURAL CONSTRUCTION. New York. 1–64 (Oct. 1882–Mar. 1932), illus. 32–43:5 also new ser. 1–11:5.

Contemporary design and construction techniques were the two major areas covered by this magazine, which had a life span of half a century and finally fell victim to the financial problems of the early Depression years. Excellent renderings in the 1880s and 1890s show cottages, suburban houses, theaters, stables, and corner drugstores with many details. Actual construction problems such as ventilation procedures, stonecutting, carpentry, and roofing are discussed. The masthead clearly states that the magazine would also interest "persons contemplating building." In Oct. 1899 an article appeared on New York's Dewey Arch, and by November of that year the article "Electric Wire in Buildings" noted that "in dwellings the electric wires are now installed as regularly as gas pipes." Buildings on Long Island and in Cleveland, Boston, Bermuda, Hartford, Philadelphia, and Washington, D.C., were regularly featured. Gradually the clear line drawings were replaced by photographs, but construction materials and appliances were regularly covered, as were book reviews. Thousands of structures, many still standing, are illustrated and described in this notable magazine, which recorded changing tastes and styles in American architecture from the period of ten-room cottages at the seashore in Queen Anne Style to the glories of Art Deco interiors and exteriors. Over the years this title was published as a monthly and for a while as a weekly (1886–1899). PUBLISHED AS Building (1882–1889); Architecture and Building. ABSORBED Builder's Magazine (1899).

S41. ARCHITECTURE PLUS: THE INTERNATIONAL MAGAZINE OF ARCHITECTURE. New York. 1– (Feb. 1973–), illus. (color).

Under the editorial direction of Peter Blake, this bimonthly magazine has aimed to interpret "architecture

in the broadest possible sense—geographically, conceptually, technologically, philosophically." The publication is truly international in coverage; the initial issue contained major stories from Britain, France, Austria, Italy, India, China, Australia, Okinawa, and the United States. The photographic coverage is spectacular, especially in the color illustrations. A fourteen-page treatment of windmills as a combination of romance and technology is an example of the brilliant survey articles that the new magazine occasionally features along with book reviews, reviews of films and drama, and international architectural news.

S42. Archives of American Art, JOURNAL. Detroit and New York. 1— (1960—), illus.

This publication began modestly as a vehicle to announce news of the Archives of American Art, encourage gifts, and report on special exhibitions and tours for members. Articles of unusual value on specific American art subjects related to the collections of the archives soon appeared. The acquisitions of personal papers relating to Walt Kuhn, Charles Sheeler, William Merritt Chase, George Luks, Charles Burchfield, David Smith, and other artists are noted in articles of permanent interest. The Oral History Project [*see also* J448] is another featured subject, and the July 1965 issue includes checklists of the etchings and lithographs of Yasuo Kuniyoshi.

The organization and collections of the Archives of American Art, now part of the Smithsonian Institution, represent one of the major accomplishments in the field of American art history. The *Journal* extends information on the archives by publicizing major new acquisitions, special projects, and current activities. Vol. 10, although not so identified, was REPRINTED AS Garnett McCoy, comp., *Archives of American Art: A Directory of Resources* (New York and London: R. R. Bowker Co., 1972), 163 p. [I·19]. / PUBLISHED AS Archives of American Art, *Bulletin* (May 1960–June 1962); Archives of American Art, *Quarterly Bulletin* (Sept. 1962–Oct. 1963).

S43. ARLIS/NA, NEWSLETTER. Glendale, Calif. (Nov. 15, 1972—).

Based on the English group called ARLIS (Art Libraries Society), which began in 1969, ARLIS/NA is an organization of North American art librarians and other interested people, which was formed in 1972. The *Newsletter*, edited by Judith Hoffberg, is crammed with information primarily of interest to members, including conference announcements and reports, news of visual resources, developments in the cataloguing and classification of art materials, current reference books, and summaries of activities from the many chapters across the country. Most issues have twenty-four pages. Frequently, major topics, such as the fine arts classification of the Library of Congress and the newly revised *Répertoire d'Art et d'Archéologie,* are given lengthy coverage. Of great value to the profession of art librarianship, this bimonthly periodical also includes information of concern to those working in the publishing and distribution of art books, exhibition catalogs, and fine art periodicals. [For the ARLIS/NA Survey of Visual Resources, *see* Section U of this bibliography.]

S44. ART AGE: A JOURNAL OF ARCHITECTURE AND THE FINE ARTS. New York. 1–10 (Apr. 1883–Oct. 1889), illus. (color).

This magazine began publication for readers "interested in artistic printing." As the decade moved along, the content came to include most of the visual arts. Furniture, mural decoration, sculpture, painting, and prints were given frequent coverage, and the world of architecture was of major importance. Special *supplements* (some in color) appeared. The magazine was made up largely of brief studio notes, art calendars, reviews, gossip, and questions and answers. Eclectic is the word for this well-designed magazine printed on good quality quarto paper and providing a record of art taste of the decade of the 1880s. SUSPENDED June–Sept. 1883.

S45. ART AMATEUR: A MONTHLY JOURNAL DEVOTED TO THE CULTIVATION OF ART IN THE HOUSEHOLD. New York and Boston. 1–49 (1879–1903), illus.

Large, bold headpieces announced the various major divisions of this magazine: "Gallery and Studio," "Decoration and Furniture," "Art Needlework," "Bric-A-Brac," "Art in Dress," and "Ceramics." Thousands of black-and-white drawings and sketches illustrate the articles; one wonders where these original drawings are now, along with the myriad works on which they were based. Continental and English art are said by this journal to be the models to follow. China painting, art needlework, and carving are discussed frequently. Household hints abound; a sampling of subjects includes mounting seaweed, making a cheap screen, washing embroidered linen, using colorless varnish, making sash curtains, and painting Jacqueminot roses. Chromolithographic and pyrographic reproductions appeared and were popular. Special *supplements* reproduced famous paintings with subjects such as mermaids, young ladies dozing, magnolias, a young calf (side view), and a long-haired girl carrying marguerites. Black-and-white *supplements* included designs for quilts and pillows, vases, cups and saucers, fireplace facings, and jewelry. / The editor from 1879 to 1897 was Montague Marks, who wrote much of the material in the early years. He came from England, worked on the Great Plains as a cowboy, and was a newspaperman in New York. He signed special articles with his pen name, "Montezama." The magazine's circulation rose to over ten thousand, which was remarkable for the period, and its popularity in the art field was challenged only by *Art Interchange* [S63]. A lively popular art magazine designed to please a broad spectrum of interests and tastes, *Art Amateur* advertised itself in 1889 as the "only practical art magazine in the world, and the only art periodical awarded a medal at the World's Fair."

S46. ART AND ARCHAEOLOGY: THE ARTS THROUGHOUT THE AGES. Baltimore and Washington, D.C. 1–35 (July 1914–May/June 1934), illus.

As a voice of the Archaeological Institute of America, this magazine was mainly concerned with the art of the ancient or classical world in Europe, Central America, and Asia. Nonetheless, there were many articles on the arts of the United States. The first issue commented on the Lin-

coln Memorial; twenty years later, the final issue told of the 142 American pictures in the Gellatly Collection at the National Gallery (now the National Collection of Fine Arts, Smithsonian Institution). In the years between, American architecture, sculpture, painting, and the decorative arts were regularly presented in survey articles amply sprinkled with black-and-white or sepia illustrations. The Corcoran Biennial was reviewed in Jan. 1933, and appreciations of the paintings of Wells Sawyer, Thomas W. Dewing, and Benjamin West appeared at various times. Sculpture surveys (Mar. 1926), Lincoln as a sculptural theme, American Indian art, early Philadelphia furniture, the State Capitol building for North Carolina, and The Carnegie Institute (an article written by Homer Saint-Gaudens [Nov. 1922]) indicate the diversity of topics found in the complete run. Throughout its two decades, the magazine published the nontechnical material that had formerly appeared in the Archaeological Institute of America, *Bulletin.* ABSORBED *Lotus Magazine* [S163] in 1920.

S47. ART AND ARTISTS OF TODAY. New York. 1— (Mar. 1937–June/July 1938), illus.

Nathaniel Pousette-Dart was the editor of this outstanding bimonthly magazine, which was dedicated to Alfred Stieglitz, Albert C. Barnes, Duncan Phillips, and Forbes Watson "in recognition of their achievements in the creation and appreciation of art." The credo in the initial issue stated the basic principles of the magazine and included the following statement: "We believe that the taste of the American people is fundamentally sound, and that they will love and appreciate the best art if it is presented to them in an interesting way We are definitely opposed to whatever is superficial, clever, tricky, foxy or false We believe that all indications point toward a great American Renaissance of art." The magazine had a certain excitement about the art of its period, and although articles were brief, they have documentary value of a permanent nature. Reginald Marsh reviewed his own training and career. Also, articles on the sculpture of Robert Laurent, the MacDowell Colony, the new Texas painters, art education, the Guggenheim Foundation, Kuniyoshi, Dali, and Rockwell Kent presented a particularly fresh point of view. Regular features included book reviews, letters to the editor, useful suggestions, and bits of gossip. The photographs, many of artists at the easel or standing in front of their work, are outstanding because they are seldom found elsewhere.

S48. ART AND DECORATION. New York. 1–3 (May 1885–July 1886), illus.

Elaborate and generous decorative patterns and designs typical of the high Victorian decades in Britain and America were constantly featured in full-page illustrations in this nicely produced periodical. Blending design sketches and how-to-do-it information for interior decoration was the special function of the magazine, which prefaced its first volume by announcing, "We believe that we are to be one of the instruments toward raising the people to a higher art standard; the people themselves have the instinct and the disposition to reach that plane where they must one day be, and they welcome every encouragement that is given them." The short notes on techniques indicate decorator and builder interests in many crafts and special skills, including how to fresco, how to color brass, how to silver copper, how to stain alabaster, how to stain wood blue, how to brighten brass ornaments, or how to make marble mosaics, to mention only a few of the special instructions given. Drawings and designs depicting details for houses, including corbels, chimneys, door knockers, gas fixtures, mantels, panels, stained glass, tapestries, and wrought iron work filled many pages. Many of the text pages had elaborate borders or headpieces and tailpieces, and the whole magazine demonstrates the abundance of materials and baroque approach to pattern and design, which have been recognized as primary characteristics of the high Victorian style in interior decoration.

S49. ART AND MUSIC. Cleveland. 1–17 (Mar. 1912–June 1917).

This monthly periodical was published for the designer, decorator, artist, musician, art needleworker, and craftsman, with a definite slant toward those living in the Cleveland area. The publishers were "actuated by a purpose to occupy a needed place in the art and musical world, namely, a magazine which will bring the trained artist and musician and the amateur together." They tried to serve the interests of artists and musicians in Cleveland yet at the same time to be national in scope and circulation. The contributors included the principal and teachers of the Cleveland School of Art; articles presented information on decorating china, corona and rococo embroidery, photography, art appreciation, and art in advertising. A directory in each issue served as "a cooperative department for the purpose of aiding our readers in the disposal of their handiwork and in the purchase of art and art needlework materials." This listing included teachers of china, miniature, oil, and watercolor painting, as well as illustrators and designers. Music was about equally covered. As a record of art activity (largely studio art) in Cleveland in the era preceding and during World War I, the magazine has considerable documentary value.

S50. ART AND UNDERSTANDING: A PHILLIPS PUBLICATION. Washington, D.C. 1 (Nov. 1929 and Mar. 1930), illus.

Published by the Phillips Memorial Gallery, this short-lived journal shows Duncan Phillips as editor and principal contributor. Articles and illustrations deal with nineteenth-century English and French artists and modern American and School of Paris painters, including Kantor, Burchfield, Weber, Marin, O'Keeffe, Kuhn, Picasso, Derain, Braque, and Matisse. When the Arno Press reprinted this magazine, Bernard Karpel, librarian of The Museum of Modern Art, described its content and special quality as follows: "First a distinguished collector and later an author, Phillips describes this most intimate of museum magazines as being 'devoted to the encouragement of tolerance and openmindedness in art and life and to the cultivation of intelligent enjoyment of the intentions of artists and the varied qualities of their work.' It was significant enough on appearance to be

immediately incorporated into the first volume of the *Art Index*. Setting as his ideal 'the detached and disinterested individualist who reverences human personality,' and his method 'a cultivated sensibility . . . and tolerant humanity,' the editor established No. 1 as a vehicle for characteristically gentle yet astute observations. Wisdom he gleans not only from art itself but the words of kindred spirits: John Galsworthy, Havelock Ellis, Clive Bell, Viscount Allenby, Sir Philip Gibbs, H. A. Overstreet. There are his own commentaries on Manet, Daumier, Derain, Knaths and a long essay on 'The Many Mindedness of Modern Painting.' Virgil Barker writes on John Marin, C. L. Watkins reflects on 'Art and the Business Man' and collaborates with the editor on 'Terms We Use in Art Criticism.' The texts are rounded out by an extensive review on 'The Current American Art Season,' by Ralph Flint, Will Hutchins on Puvis de Chavannes, a brilliant capsule on Rousseau by the matchless Henry McBride, A. V. Tack on subjective painting and Phillips himself on Tack's decorative panels. An earthy review of *The Whirligig of Taste* (1929) by the learned William M. Ivins, Jr., concludes what is after all, less a periodical than a personal anthology." REPRINT EDITION (New York: Arno Press, 1968).

S51. ART BULLETIN. New York 1— (1913—), illus.

Published by the College Art Association, this quarterly began modestly by including the officers, a report of the annual meeting, and the constitution of the association. During the half century of its publication, it has maintained the highest level of art history scholarship and has become a repository of some of the most valuable research by specialists. The periodical spans every aspect of art history, with emphasis on European and Oriental subjects; American art has been allotted only the most marginal treatment, especially during the first three decades. This orientation, however, accurately reflects a prevailing attitude toward our native art: it was not until the 1940s that university art history curricula acknowledged the importance, diversity, and value of American art. The growth of the teaching of art history in American academic life is spotlighted by contrasting the note that the association had a "cash balance on hand of nearly twenty-three dollars" at its annual meeting in Apr. 1917, with reports of the thousands upon thousands of people in attendance at similar meetings in the 1960s and 1970s.

The association's phenomenal growth is mirrored in the pages of its periodical, which is distinguished for high quality of content as well as high production values. Specifically *American* architecture, decorative arts, and artists are covered now and then with articles on major figures such as J. Alden Weir, Robert Feke, John Trumbull, Edward Hopper, Thomas Sully, Louis Sullivan, and Benjamin West. A fifty-one-page list of "Books for the College Art Library" in the Sept. 1929 issue includes a total of only a page and a half for entries in the American field, once again clearly revealing the paucity of interest on the part of academics in the art of the United States. An index for the first thirty volumes was compiled by Rosalie Green and published in 1950. Thoughtful and searching book reviews appear in each issue; the contents

of the past few years indicate an expanding interest in various fields, as evidenced in an article on visual sources used by D. W. Griffith in filming his motion pictures (Dec. 1972 issue). The magazine's importance is recognized by colleges and universities, and its development clearly indicates the rise of scholarship and over-all expansion of art history on the American scene during the twentieth century. SUSPENDED (1914–1916) because of the war. Kraus Reprint Co. reprints facsimile issues as needed to replace original issues. PUBLISHED AS College Art Association, *Bulletin* (1913–1918).

S52. ART COLLECTOR: A JOURNAL DEVOTED TO THE ARTS AND THE CRAFTS. New York. 1–9 (Nov. 1889–Oct. 1899).

The tone of this magazine was lofty, art being considered to be the province of the rich and educated. Foreign art notes were scattered throughout the issues, and American exhibitions, crafts, artists, and institutions were seriously covered. Exhibitions reviewed included the Brooklyn Institution of Arts and Sciences, the National Academy of Design, and the Pennsylvania Academy of Fine Arts, among others. Thoughtful criticism on works by Albert Ryder (1898), Ralph Blakelock, Winslow Homer, and Joseph Israels appeared. Interior decoration, graphic arts, and book craft were sometimes covered, and each issue included groupings of advertisements from dealers, mostly located in the New York area. Major sales were regularly noted with listings by artist, title of work, and price realized. PUBLISHED AS *Collector: A Current Record of Art* (1889–1897). SUSPENDED (July 1897–Oct. 1898). SUPERSEDED BY *Collector and Art Critic* [S106].

S53. ART CRITIC. New York. 1 (Feb.–Apr. 1916), illus.

Five numbers of this periodical devoted to criticism appeared under the editorship of S. Buffardi. Commentary was largely centered on paintings in New York collections and exhibitions. The editor pointed out that nearly all criticism of art in American periodicals "is ordinarily expressed by means of brief and preemptory affirmations of praise." In the first number, he noted that expressions of disapproval and rebuke were usually reserved for works by American artists, but on the other hand, any art work that "is imported here from beyond the seas is always accompanied and received by a triumphal chorus of praise, whose voices come from every part of the country. And so it happens often that a gilt wrapping with brilliant folds covers spurious or damaged merchandise, fascinating and charming public opinion by force of suggestion." Some of the artists whose work was discussed in detail were Benozzo Gozzoli, Raphael, Titian, Romney, Memling, and El Greco; the magazine regularly pointed out the hazards of spurious works and those that were attributed to the wrong artist. The editor strongly objected to criticisms of his comments, which were printed in two contemporary journals, *American Art News* and the *New York American*. Considerable space was occupied by letters and responses to letters detailing differences of opinion. The magazine opened a Restorer Studio where damaged works could be expertly restored by a number of skilled artists working under the guidance of the editor. The issues were illustrated but included no advertis-

ing so that opinions could remain uninfluenced. Appeals for more subscribers were printed but apparently general support for and interest in one self-appointed reviewer's opinions were lacking, and the magazine expired after three months.

S54. The Art Critic; Devoted to the Encourage-ment of American Art. Boston. 1:1–3 (Nov. 1893–Mar. 1894).

Edited by C. Sadakichi Hartmann, this art periodical had a unique purpose, which it pursued through the sixty pages of the three numbers that were published. The noted editor set down his goal—on the first page of the first issue—as follows: "*The Art Critic* endeavors to con-stitute itself the organ of all lovers of Art, who deem the encouragement of American Art by an annual support from the United States government, necessary or desir-able at least. *The Art Critic* will devote itself to the propa-gation of this idea, and the preparation of a plan for its successful execution. To discuss the details of this praise-worthy task (all are invited to submit their opinions, sug-gestions, etc., in as condensed form as possible) is the principal object of this paper, while the remaining col-umns will contain interesting reading matter with a special effort to chronicle every change and ripple on the surface of artistic endeavor, and to reflect and expose all the influences which develop modern art. Many sub-scribers had their doubts as to whether such a publication can really succeed in America. But it is to be remembered that this publication is a paper of enthusiasm and self-sacrifice (from the editor's point of view) and that he himself will undertake to publish *The Art Critic* until it has practically accomplished its aim, no matter whether it will take one or fifty years." Three issues were pub-lished. The articles were usually two or three pages in length and covered such topics as "How a National Art Could Be Developed," "Color in Architecture," "Who Are Our American Artists?," notes on the Boston artist F. H. Tompkins, "American Art Gossip," Puvis de Chavannes, art at the Chicago World's Fair in 1894, and the forty-ninth exhibition at the Boston Art Club. Hart-mann's manifesto was "American Art Must Be Encour-aged by the Government," and he gave the project con-siderable thought. Although the magazine's life was brief, the later development of the National Gallery of Art and the National Endowment for the Arts would have delighted Hartmann.

S55. Art Direction. New York. 1— (1949—), illus.

This is the official publication of the National Society of Art Directors, and as such it concentrates heavily on ad-vertising art, intermingling news of the field and articles illustrated with quantities of small illustrations. Topics such as unacceptable material and payment for overtime work are discussed. Award-winning work from various national exhibitions organized by regional art directors is regularly featured, and the advertisements are squarely aimed toward the trade. Biographical coverage of major or new art directors appeared now and then. Taken as a whole, the magazine provides a pictorial survey of the field of American commercial art since 1949. The com-

plexity, sophistication, and astounding quantity of ad-vertising art during these decades is clearly revealed. PUBLISHED AS *Studio News* 1–2 (1949–June 1950); *Art Director and Studio News* (July 1950–Dec. 1955).

S56. Art Education: A Journal Devoted to Manu-mental Training. New York. 1–7 (Oct. 1894–May 1901).

Dedicated to art education at all levels, this magazine specialized in articles, reports of teachers' conferences, advertisements, curriculum changes, and notes on tech-niques. A report on the first annual meeting of the Manual Training Teachers' Association held in Philadel-phia in July 1894 is typical of the type of article regularly carried in the magazine. An appreciative article on the posters of Alphonse Mucha appeared in Oct. 1898 and another on the latest drawings of Charles Dana Gibson in Feb. 1899. The ads tell a good deal about art supplies, equipment, casts, and reproductions that were available to art teachers at the time. Published by the J. C. Witter Co. of New York and edited by Witter, the magazine is a fine source of fact and opinion concerning general public art education in the United States at the turn of the cen-tury. The stated purpose of the magazine was to assist "in the development of hand and mind, body and soul as a harmonious whole, thereby bringing the human entity into true relation to the eternal forces, natural and divine, guiding mankind onward and upward toward perfec-tion." Manual training, industrial arts, penmanship, whittling, perspective drawing, and "The Decorative Uses of Sweet Peas" (June 1898) all receive ample coverage. PUBLISHED AS *Art and Decoration* (Apr.–May 1901). SUPERSEDED BY *Art Study*.

S57. Art Folio: A Popular Monthly Magazine for the People Devoted to Art, Science, Romance, Travel, Biography, History, and Current Events. Providence, R.I. 1–2 (June 1883–Aug. 1884), illus.

Large black-and-white illustrations are the outstanding feature of this magazine with an editorial goal of combin-ing the "best productions of the painter, the engraver, and the typographer." The subjects of the illustrations were romantic, sentimental, and dramatic. Each picture was neatly described in a column, "Our Illustrations," in each issue. The short notes on fashions, home art, and the fine arts in general are fragmentary and ephemeral.

S58. Art Front. New York. 1–3 (Nov. 1934–Dec. 1937), illus.

This was the official publication of the Artists' Union of New York and of various other regional artists' groups. Some issues were also sponsored by the Artists' Com-mittee of Action, and the magazine now provides a fas-cinating document of the early days of left-wing agita-tion in the American art world. The cover of the May 1935 issue, by Stuart Davis, consisted of a black-and-white collage of artist's materials bordered by the follow-ing wording: "For extension of art projects—union wage scale for artists—for social insurance—for free expres-sion." Issues averaged from sixteen to twenty-four pages

each and were originally priced at five cents per copy but gradually raised to ten and then fifteen cents per copy. Reports from the artists' unions in other cities such as Chicago, Cleveland, Baltimore, Washington, D.C., and Saint Louis were printed along with candid letters to the editor, which clearly stated the writer's point of view and gave contemporary evidence of the strong opinions on social and political issues held by artists during the four years of the magazine's existence. There were frequent references to the WPA and all federal arts legislation, denunciations of the Nazi regime in Germany, and editorial support of the government cause during the Spanish Civil War. Noted artists, including Fernand Léger, Salvador Dali, Lynd Ward, Philip Evergood, Max Weber, Hyman Warsager, Lincoln Kirstein, Stuart Davis, Meyer Schapiro, Louis Lozowick, Isamu Noguchi, and Berenice Abbott, submitted articles. Additional articles described Gorky's murals at the Newark Airport, John Marin in 1936, the role of the artist in Spain, painting in Fascist Italy, the work of William Gropper, the artists' boycott of mural painting for the German Olympic Games, and Mexican art in relation to the work of Diego Rivera, who is described as the "Morgan of the modern art market."

The illustrations were small, but they add greatly to the magazine's value as they expertly capture the editorial mood and approach to social and political changes. Other examples of art interests and preoccupations are found in advertisements for "all the coffee you can drink from 3 to 5 P.M. for five cents" at the Fifth Avenue Cafeteria and requests for funds for the Friends of the Abraham Lincoln Brigade to help "American artists, members of your union, who have proven their loyalty to democracy." The issue for Nov. 1937 included the following announcement: "To focus public attention on the role of the artist in the struggle against the rising Fascist encroachment on the lives of the democratic peoples now threatening the peace of the whole world, and to emphasize that the creative freedom of every single artist throughout the world is at stake in this crisis, Pablo Picasso, foremost living painter, has been invited to come to New York to speak at the opening of the Second American Artists' Congress in Carnegie Hall on the evening of December 17 Another international figure invited to appear on the platform is Mayor La Guardia, whose sharp denunciations of the Nazis have swept the press of the world." Artists as activists and as creative people with lasting responsibilities are well presented in this magazine during those crucial years when America was battered by the Great Depression and the rising military tide, which engulfed the country during World War II.

S59. ART GALLERY. Ivoryton, Conn. 1— (1957—).

Beginning as a basic list of art galleries with addresses, hours of operation, and the titles of current shows, this lively periodical has developed in size and content to become a substantial publication with articles of timely interest and regular columns or departments geared to the burgeoning New York art scene of the late 1950s and 1960s. The magazine was frequently given away in gal-

leries, especially to the hordes of visitors who needed factual information on the locations and titles of exhibitions at the many midtown and, later, downtown galleries. Throughout its publication, the magazine has included articles that focus on current events while retaining a centerfold (sometimes inserted) on the art gallery scene. The inserted section spotlights New York gallery and museum listings but also covers the national and international scene with numerous entries. A regular column, "Pertinent and Impertinent," is written by the editor, Jay Jacobs; his commentary (in the Mar. 1973 issue) on the deaccessioning policy of The Metropolitan Museum of Art is notable for its satiric bite. Feature articles or entire issues have been devoted to East Indian art, a salute to The Museum of Fine Arts, Houston; the Greenville County Museum of Art, Greenville, S.C.; and "Art in Revolution." In the 1970s the magazine advertised itself as "the first-class art magazine," indicating that it was sent to domestic subscribers via first-class mail and to foreign readers via air mail. With many small illustrations, scores of advertisements for current exhibitions in commercial galleries, the Gallery Guide listing, and an over-all sense of urgency in covering current art shows and dealings, the magazine fills a need not adequately covered by other fine art periodicals.

S60. ART IN ADVERTISING: AN ILLUSTRATED MONTHLY FOR BUSINESS MEN. New York. 1—14 (Mar. 1890—Mar. 1899), illus.

This modest, well-designed magazine was directed to readers in the business field to keep them informed on events, personalities, and changes in the rapidly expanding field of advertising. The illustrations were especial'y fine and included line drawings, cartoons of quality, "society drawings," photographs, and silhouettes, nicely spaced and arranged with taste and sophistication. There were lists of business managers for the largest newspapers, advertisements for photoengraving and other periodicals, plus notes on lithography. Articles covered many subjects, including advertising on elevated railways, the use of cuts in advertising (both in 1892), and an appreciation of *Harper's Bazaar* under the editorship of Margaret E. Sangster (1893).

S61. ART IN AMERICA: AN ILLUSTRATED MAGAZINE. New York. 1— (Jan. 1913—), illus. (color).

For many years this bimonthly concentrated on the most traditional of European art found in American public and private collections. Artists discussed in scholarly articles included Rembrandt, Tiepolo, Crivelli, Guardi, Lippi, and Corot with survey articles on tapestries, cassone, and twelfth-century French sculpture in individual American collections. Gradually American artists were given more space, and in the early 1950s, under the editorship of Jean Lipman, the magazine became primarily concerned with American art. At the same time the format of the magazine became more varied, and eventually color reproductions appeared in quantity. By the time of the fiftieth anniversary issue in 1963, the magazine was a visual joy, with contemporary and traditional art interspersed in each issue. The decorative arts, photography,

sculpture, and architecture received regular coverage. Anonymous and little-known artists and craftsmen were discovered or rediscovered and featured in text and illustrations. Hundreds of contributors, including Grandma Moses, A. Hyatt Mayor, Alfred H. Barr, Jr., John Rewald, Eleanor Roosevelt, and Ada Louise Huxtable have written for the magazine. Issues appearing in the 1970s are lively, extremely colorful, and successfully capture the diversity and extraordinary creative genius of our native art in imaginative layouts and serious text. PUBLISHED AS *Art in America and Elsewhere* (Dec. 1921–Apr. 1939).

S62. ART INDEX: A CUMULATIVE AUTHOR AND SUBJECT INDEX TO A SELECTED LIST OF FINE ARTS PERIODICALS AND MUSEUM BULLETINS. New York: H. W. Wilson Co. 1— (1933—).

This is an invaluable guide and a monumental record of magazines indexed by author and subject in one alphabetical listing. Although *Art Index* was first published in 1933, the indexing begins with periodicals dated Jan. 1929. Over 150 American and European periodicals are indexed, including museum bulletins, fine arts journals, and architectural publications. Archeology, art history, arts and crafts, fine and graphic arts, industrial design, interior design, photography and films, planning and landscape design, and other related topics are among those indexed. Indexed titles vary, depending upon selection by subscribers. Coverage of periodicals does not always begin with the first number, and may cease suddenly. Illustrations and reproductions are noted and cross-references appear frequently. Quarterly supplements made up of over 20,000 entries include new subjects such as body art, and multimedia and video art. Cumulative indexes are published regularly in bound form. The subtitle varies for different volumes. [For additional details on contents and methodology, *see* L9.]

S63. ART INTERCHANGE: A HOUSEHOLD JOURNAL. New York. 1–53 (1878–Nov. 1904), illus.

The subtitle of this periodical varies. Publication began in a modest manner with twelve-page issues selling for eight cents each and including more than three pages of small advertisements, mainly from New York firms. Within a few years the magazine had gained a much more substantial appearance and was adorned with many special supplements, which included designs for the decoration of furniture, architectural details, and all manner of decorative art pieces. Regular columns included news of the domestic art scene, foreign art notes, comments on the reproduction of contemporary European paintings appearing in each issue, and book reviews—under the heading "The Library"—which concentrated on novels. The editor, Josephine Redding, wrote on a great variety of topics. In the issue for Nov. 20, 1884, she described Oscar Wilde as representative of the "fleshy school of culture" and scorned his aesthetic and his general lack of morality in art as follows: "The effect of such teachings has been marked and deplorable. One conspicuous result has been the springing up in the western part of this country of a class of young women

rhymesters, whose verses are so thoroughly permeated with the spirit of earthly passion as to make them rival in indelicacy the grossness of some of the earlier English writers with whose works no refined woman acknowledges an acquaintance."

The basic popularity of the magazine rested on a substantial regular section, "Notes and Queries," and also in the special designs. Subscribers were encouraged to ask questions relating to techniques, and answers were printed directly under the questions. These referred to all manner of subjects: tapestry painting, photograph coloring, velvet-dye painting, decorating old gourds, oil colors for blonde complexion and hair, gold paint, and how to cleanse feathers of a white owl on which dust has settled. The answer to this last item was to take the owl to a taxidermist if the dust was really thick or to sprinkle the bird with very slightly dampened Indian meal and then gently brush the feathers. Such questions were of considerable interest at the time and give a good indication of the cluttered appearance of the interiors of late Victorian American homes. The publishing of designs and decorative patterns was another exceedingly popular aspect of the magazine. Many of the designs were in color; they were prepared for alms basins, embroidery, umbrella stands, mirror frames, screens, door panels, cups, saucers, plates, and vases. Toward the end of the 1880s, the fold-out color plates and black-and-white designs became larger in format and deluxe in quality. Many of the color plates were matted, framed, and hung. The magazine was popular; its great attention to minute details of technique and its lavish special designs and reproductions gave it a notable position in the history of American art periodicals of the final quarter of the nineteenth century.

S64. ART INTERNATIONAL: THE ART SPECTRUM. Zurich and Lugano, Switzerland. 1— (Nov. 1956—), illus. (color).

Although this periodical is published and edited in Switzerland, it includes substantial commentary on and illustrations of American art of the avant-garde. The magazine is prime evidence of the international concept of art, which developed in the decades after World War II and provides a continuing panorama of the worldwide influence that American artists, critics, galleries, and museums have exerted on contemporary art in major world centers. Issues include reports on exhibitions in Germany, Italy, Tokyo, Toronto, Paris, London, Chicago, Los Angeles, and New York; readers are quickly and expertly informed on contemporary art in the world beyond limited regional and national interests. Printed on large, glossy paper, the scores of black-and-white illustrations in each number are exceptionally clear and crisp. The occasional color illustrations are also of high quality. Major art movements are recorded in depth, from Abstract Expressionism to Pop, Op, Kinetic, Earth Art, hard-edge style, and Photorealism. American artists by the scores have been the subjects of feature articles, including Richard Diebenkorn, Roy Lichtenstein, Robert Motherwell, Barnett Newman, Wojciech Fangor, Adja Yunkers, Chryssa, Edward Kienholz, and Robert Good-

nough. Ten numbers are published annually. PUBLISHED AS *European Art This Month* 1 (1956). ABSORBED *Lugano Review* early in the 1970s.

S65. ART JOURNAL. New York. New ser. 1–13 (1875–1887), illus.

The American edition of this London periodical carefully mirrored the British publication and reflected English or Continental taste and art interests of the period. The magazine was handsomely produced with many fine quality steel engravings, mostly of the genre and portrait variety. Nearly all of the articles were illustrated with unusually fine drawings or engravings, and these coupled with descriptive texts produce a magazine of real historic value. Articles in 1875 describe the interior of the New York home of J. P. Kernochan, Victorian homes in Ohio, and the painters James D. and George H. Smillie. In 1878, Philadelphia's Fairmount Park is lauded, along with art notes from Brooklyn, Boston, and Pittsburgh, and a review of the exhibitions at the National Academy. Women artists are covered, and reviews of major American exhibitions at such institutions as The Metropolitan Museum of Art and the Century Club are regularly included. The works of Winslow Homer, F. A. Bridgman, Frederic E. Church, Benjamin C. Porter, and other American painters are discussed in some detail in this periodical aimed at informed, aristocratic subscribers.

S66. ART JOURNAL. New York. 1— (Nov. 1941—), illus.

As a publication of the College Art Association, this periodical took its place as the quarterly companion to their *Art Bulletin* [S51]. Articles are less scholarly, more timely, and generally more succinct than those in the *Art Bulletin;* regular columns keep readers up to date in the field of art education on the college level. New art museums are regularly reported on, as is news from academic art departments, book and art catalog reviews, and special collections in colleges. Of particular merit are lengthy listings, arranged by period, of the major acquisitions of college, university, public, and private museums across the country. Aesthetics, teaching in the studio, Afro-American art, Pop Art, the artist's role in higher education, standards for teaching, and reviews of exhibitions are typical subjects presented. The black-and-white illustrations often provide extensive coverage. The magazine successfully surveys the enlarged role of the visual arts in American higher education through articles, advertisements, regular columns, announcements, reviews, and illustrations. PUBLISHED AS *College Art Journal* 1–19 (1941–1959). ABSORBED *Parnassus* [S192].

S67. ART NEWS. New York. 1— (Nov. 29, 1902—), illus. (color).

This monthly lives up to its title, for it provides news, reviews exhibitions of current interest to its readers, and features major articles on art events and personalities worthy of special note at the time of issue. The reviews and previews of thousands of exhibitions provide a repository of information on American artists active in New York galleries. Major museum and gallery exhibitions are covered in depth; new movements, artists, and

trends are given lively and prominent coverage. Since World War II, color illustrations have appeared regularly, and the layouts are frequently visually arresting and of high technical quality. Regular features include art news from London, Paris, and galleries across the country, auction announcements, and book reviews. In 1931 the magazine began to publish a deluxe annual with many color illustrations and notable articles by leading art historians. The continuous record of exhibitions by American artists, accessible by various indexes, provides a massive archive of fact and opinion relating to American art in the twentieth century. PUBLISHED AS *Hyde's Weekly Art News* (1902–1904); *American Art News* (1904–1923).

S68. ART NOW: NEW YORK. New York. 1— (Jan. 1969–1974(?), illus. (color).

This is a unique art periodical with an unusual format. Each quarterly issue contains loose color plates, enclosed in a slight three-page wrapper with descriptive text. After the June 1972 issue, the magazine appeared irregularly with the illustrations in 2 x 2 in. color slide format. In the first issue the publishers, University Galleries, announced that they would "present a selection of the finest contemporary art from New York City's museums, galleries and artists' studios. Along with the reproductions, each issue will include statements by the artists describing their methods and ideas." The large full-color illustration and artist's statement for each work provides a special source of primary material about advanced work being done at the time of publication. Sculpture, Earth Art, Op Art, New Realism, and a fine representation of the more traditional approaches to contemporary art have all been selected for publication. [*See also* F84.]

S69. ART, PICTORIAL AND INDUSTRIAL: AN ILLUSTRATED MAGAZINE. London and New York. 1–6 (1870–1875), illus. 4–6 also new ser. 1–3 (July 1872–1875).

This periodical was published in New York by G. P. Putnam & Son, and in London by S. Low & Marston. The NEW SERIES was edited by John Forbes-Robertson. Salon paintings and sculpture were beautifully reproduced in this periodical, showing an almost totally English slant. The commentary refers to British events and personalities and centers around the South Kensington Museum (now the Victoria and Albert Museum). The issue for Jan. 1872 includes a remarkable photograph by Julia Margaret Cameron of the Isle of Wight. The accompanying commentary is also notable as a relatively early discussion of a photograph appearing in a fine art journal. The paper was of high quality and the illustrations were printed on large pages. The artists are not notable by today's standards, but the works of art are typical of the High Victorian period. As such, this English art periodical has some value to American researchers since much of our domestic art activity in the 1870s was influenced by British taste. ABSORBED *Photographic Art Journal.*

S70. ART QUARTERLY. Detroit. 1— (winter 1938—), illus. Published by The Detroit Institute of Arts, Founders

Society, this magazine devotes each issue to three or four specialized art subjects and reflects the highest standards of scholarship. Oriental art and the fine arts of the Classical and Renaissance periods are regular subjects. America's art has received more frequent attention since the establishment of the Archives of American Art at The Detroit Institute of Arts. The coverage of American themes is indicated by the following subjects, which have appeared from time to time in the magazine: "The Origin of the Great Seal of the United States," Winslow Homer's watercolor technique, portraits painted by John Wesley Jarvis, Frank Lloyd Wright and Pre-Columbian art, and mezzotint prototypes of colonial portraiture. Illustrations reveal unique sources for reproductions, and a quarterly listing of recent accessions of American and Canadian museums forms an impressive and valuable record. The magazine is a splendid example of the encouragement of research in art history through sustained and liberal support to the publication of authoritative papers by younger as well as established scholars.

S71. ART REVIEW. New York. 1–3 (Nov. 1886–Aug. 1888), illus.

This was a deluxe art periodical with original etchings (some signed on the plate), many photogravures, and articles of some depth concentrating on American artists, exhibitions, and topics of the period. Biographical articles on Whistler, Winslow Homer, and George H. Boughton were interspersed with others on the Grant Monument (Jan. 1887), the subjects of American paintings, methods of hanging pictures, and club buildings in New York. Charles de Kay wrote for the magazine, as did Ripley Hitchcock, Frederick Law Olmsted (on gardening in Sept. 1887), and several women writers, including Mariana Griswold van Rensselaer, Isa Carrington Cabell, Charlotte Adams, and Helena de Kay. Exhibitions were reviewed for shows at The Metropolitan Museum of Art, the National Academy, the Society of American Artists, and the American Art Galleries. The full-page illustrations are printed on high quality stock and are representative of major artists and subjects of the last years of the 1880s.

S72. ART REVIEW: MUSIC, DRAMA, LITERATURE, PAINTING, PHOTOPLAY, ARTCRAFTS. 1–2 (Oct. 1921–Dec. 1922), illus.

Art in a broad sense was the province of this periodical, which eventually concentrated on music and drama, with modest coverage of the visual arts. Articles, seldom more than two pages long, covered many European artists, such as Rodin, Giovanni Segantini (a painter of Alpine peasants), Gaudier-Brzeska, Meštrović, and Cézanne. Comments on the following American artists are representative of the subjects of interest to the editor: John Marin, Marsden Hartley, "Pop" Hart, Walt Kuhn, Mina Loy, and Willy Pogany. As a survey of current interest in all the arts, the magazine had considerable merit. The reproductions of paintings and drawings, and film, opera, and theater personalities or productions were selected with a discerning eye and have lasting value and interest.

S73. ART REVIEW PORTFOLIO. Boston. 1–24 (1882), illus.

This was a beautifully produced art magazine featuring illustrations and text covering European and American subjects. The title page indicated it was "an artistic periodical of original painter-etchings . . . with biographical sketches of the painters-etchers and their works . . . together with a series of able articles devoted to painting, sculpture, architecture, engraving, industrial art, archeology, and art education in America . . . profusely illustrated with steel and wood engravings, portraits, sketches, facsimile representations." Regular features included book reviews, a section entitled "American Art Chronicle," original etchings, and excellent biographical material on American artists. The magazine was founded to fill the need for a high-quality art publication similar to European periodicals and in answer to the ever-increasing public interest in the fine arts, which reflected an affluent society.

S74. ART STUDENT. Boston. 1–4 (June 1882–1884), illus.

The four issues of this magazine were published by students in the Museum of Fine Arts, Boston, School of Drawing and Painting. Issues consisted largely of full-page sketches showing student work, with nature and figure studies and portraits the usual subjects. The second issue contained an original etching by Frank W. Benson, and the third included a cartoon and humorous story relating to Eadweard Muybridge's photographs of figures in motion. The magazine's content, both text and illustrations, clearly indicates a controlled learning situation where strict rules had to be followed. The work of this Boston art students' association contrasts strongly with the tone of art student publications of the 1960s.

S75. ART STUDENT AND THE LIMNER. New York. 1–25 (1862–May/July 1909), illus.

How to draw, to illustrate, and to execute proper perspective were regular subjects in this modest magazine, which later branched out to include lithography, cartooning for newspapers, and how to read French. The page size was enlarged late in 1893. The price was ten cents per issue and the editor was Ernest Knaufft. After *Limner* [S156] became part of the magazine (in 1895), there was more news of art schools and art school literature. Shading, chalk, and anatomical drawing and good poster design were taught in relatively brief but nicely illustrated articles. The school of The Art Institute of Chicago, the school of the Cincinnati Art Academy, and the drawing instruction programs in selected public school systems were described. It is fascinating to follow the rise of interest in Art Nouveau through increasing coverage of work by Alfons Maria Mucha, Jules Cheret, and Theophile Alexandre Steinlen. Advertisements for art supplies, art schools, new books, materials for crafts, and other art magazines appear in each issue. All in all, this was a modest magazine, which did well by its subject and announced purpose while reflecting the general public interest in the dogmatic approach to traditional drawing so typical of the period. As usual for this kind of publication, there were variations in title and rate of issue; basically this was a monthly from 1892 to 1902 and

a quarterly from 1905 to 1907. ABSORBED *Limner* [S156] in Dec. 1895; nos. 7–126 of *Limner* were issued this way. Vols. 1–23 of this serial were issued under the title *Art Student: An Illustrated Monthly for Home Art Study.* Vols. 24–25 were also numbered as new series.

S76. ART-UNION. New York. 1–2 (Jan. 1884–Dec. 1885), illus.

This monthly was the official journal of the American Art-Union, a society of American artists who were organized to promote the general advancement of the fine arts. Selected American works of art were shown in a permanent exhibition and salesroom in New York; original etchings and engravings "of the highest grade" were published and works of art were purchased. There was to be no official commendation or condemnation of any particular school. Features included accounts of the work of the American Art-Union, a résumé of the art events of each month, art correspondence from various regions of the country and Europe, contributions from leading artists, illustrations of prominent pictures, articles on art schools and American public and private art collections, a list of painting sales each month, and art book reviews. Illustrations of works by many artists appeared, including those of Albert Bierstadt, F. S. Church, and J. Twachtman, providing an accurate record of art and related activities in New York during the two years the magazine appeared.

S77. **Art-Union of Philadelphia,** TRANSACTIONS. Philadelphia. 1844–1849.

This was a sober account of the basic business of the Art-Union of Philadelphia, an early and active association. Listings included the honorary secretaries from the various states and names of members, followed by the object and purpose of the association, the proceedings of the annual meeting, and a brief treasurer's report. After all this factual data, a major article on art, which was given earlier as a lecture at the Art-Union of Philadelphia, was printed in large type. The issue for 1849 contained an address presented by Henry Reed, a professor of the University of Pennsylvania and one of thirteen managers of the organization in that year. SUPERSEDED BY *Philadelphia Art-Union Reporter* [S198] in Jan. 1851.

S78. ART-WORKER: A JOURNAL OF DESIGN DEVOTED TO ART-INDUSTRY. New York. 1:1–12 (Jan.–Dec. 1878), illus.

This short-lived monthly was published by J. O'Kane. The twelve issues of the periodical contain ninety-four plates but not a word of text. The plates, however, include brief identification and consist of clear, concise drawings of stairways, designs, chimney pieces, mantels, and sundry examples of interior decoration and ornament. The furniture studies are especially good and include beds, chairs, bookcases, sideboards, desks, and all manner of "Artistic Furniture." The magazine has merit as a record of furniture and household interior designs in the New York area for the year 1878.

S79. ART WORLD: A MONTHLY FOR THE PUBLIC

DEVOTED TO THE HIGHER IDEALS. New York. 1–3 (Oct. 1916–Mar. 1918), illus.

This magazine's purpose was to reemphasize the creed "that the only Art worthy of the support of a nation is such as is truly Beautiful, Sane and Decent, a gospel which has, by word and deed, been derided by certain degenerate forces in Europe, until the World of Art is in a state of perplexity and Anarchy." The editors believed that the whole fabric of American civilization was lopsided. To correct this sad state of affairs they proposed to discuss every phase of the eight arts with frankness and common sense. The subjects covered were architecture, drama, landscape architecture, belles-lettres, music, painting, poetry, and sculpture. Contributors of special articles were distinguished; they include Daniel Chester French, Kenyon Cox, William Lyon Phelps, Otto H. Kahn, John Burroughs, Charles de Kay, Hamlin Garland, and Gilbert Murray. The editors were firmly opposed to all things modern. The June 1917 issue described "Cézannitis" as something akin to infantile paralysis. A series on degenerate or unethical works of art includes work by Degas, Renoir, Cézanne ("The Bathers"), and Manet, whose "Nana" is described in a three-page article as "too inane and artistically worthless to be worthy of comment . . . vicious in its suggestiveness and influence." A Cubist picture, reproduced in Mar. 1917, "violates every law of art"; the editors did "not know the title nor the author and do not care to know." Nevertheless, the magazine was relatively lively in format, with good reproductions, regularly featured articles by outstanding authorities, and ran photographs and commentary on good urban architecture and design with an advanced concept of city planning and environment. Subway stations, park preservation, smokestacks in Washington, D.C., gas tanks on New York's Riverside Drive, and ugly signs on Fifth Avenue are some of the urban embellishments described in detail. The variety of subject matter is demonstrated by articles ranging from silhouettes to the classic orders of architecture. The issue for Jan. 1918 contains articles on Stanford White's house at St. James, N.Y. (Long Island), silver service on battleships, and "Camouflage—War's Handmaid"; the final issue includes "Some Painters Who Happen to be Women," by Lida Rose McCabe. ABSORBED *The Craftsman* [S111]. SUPERSEDED BY *Arts and Decoration* [S85].

S80. ARTFORUM. San Francisco and New York. 1— (June 1962—), illus.

From its conception, this magazine has clearly been in the avant-garde prepared to cover current movements and contemporary artists along with divergent and contradictory opinions. Its first issues had a decided slant toward West Coast artists and exhibitions. Nonetheless, the editors claimed "the world of art as our domain," and over the years this universal posture has been typical of the magazine's approach and content. "Fifty California Artists" and "West Coast Art" are typical subjects for articles in the early 1960s, and reviews of exhibitions in Seattle, Houston, San Francisco, and Los Angeles are regularly featured. The works of up-to-the-minute artists are given prominent space; some artists have gained their in-

itial coverage in a national magazine here. Larry Poons, Joseph Raffael, Don Potts, Jack Tworkov, Phillip King, Gene Davis, Donald Judd, Billy Al Bengston, and Larry Bell are representative artists whose works have been commented upon or illustrated regularly. Major figures in the development of modern art have more recently received expert treatment in lengthy, scholarly articles on Manet, Matisse as a sculptor, Sheeler, and Hopper. Earth Art, serial imagery, optical art, Pop Art, computer images, and kinetic art have been discussed frequently and in depth. An index for the first six volumes (through 1968) was compiled and published by Laurence McGilvery. This index includes entries for names, places, subjects, and virtually every illustration, including those in advertisements. The magazine brilliantly documents an era crammed with change and throbbing with the vitality typical of America's art experience after World War II.

S81. THE ARTIST. New York. 23–32 (Sept. 1898–Jan. 1902), illus.

For several years this American edition of a British-based magazine included "The American Survey" as the opening pages of each issue. Illustrations accompany survey articles on such topics as Fabrile glass and reviews of annual exhibitions at the Pennsylvania Academy of the Fine Arts or The Architectural League, or by the American Water Color Society. Issues for 1899 commented on the Sargent exhibition at Copley Hall in Boston, The University Club building in New York, and the decorations for Admiral Dewey's New York reception. The main part of the magazine featured excellent articles of international interest, with a generous coverage of Art Nouveau subjects. Furniture, glass, and sculpture at the 1900 Paris Exposition and the work of Gustav Gurschner and C. M. Russell are samples of general art topics of interest to or having an influence on American readers.

S82. ARTIST'S PROOF: A MAGAZINE OF PRINTMAKING. New York. 1–11 (1961–1971), illus.

Eleven issues of this notable periodical were published by the Pratt Institute, Pratt Graphics Center, Brooklyn, N.Y. The final three issues of the magazine were subtitled *The Annual of Prints and Printmaking. Artist's Proof* was dedicated "to furtherance of an international community of the graphic arts and to the exchange of ideas on new print methods and media." The editor was Fritz Eichenberg, director of Pratt Graphics Center, assisted by Andrew Stasik. The periodical was printed by the Meriden Gravure Co., and the issues show the highest standards of printing for both text and print reproduction. 2,500 copies of the first number was printed, and later issues ran as high as 6,000 copies. In a 1963 editorial, Eichenberg commented as follows on the print renaissance and the magazine: "the printmaker begins to emerge after a long period of public indifference— slightly intoxicated by the sudden burst of appreciation and attention. Even large national magazines begin to notice the importance of the creative print, more so, it seems, than our art magazine. *Artist's Proof* is doing its best to record the accelerated pace, the new and in-

genious ways of the contemporary print maker. It will continue to try being entertaining as well as informative and will keep its eyes on the contemporary scene, on artists and print shops around the world." The articles are presented with distinguished layouts and cover a wide variety of topics, including new techniques, workshops, graphic work of individual artists, papermaking, miniatures, rubbings, families of printmakers, and histories of print societies. Extensive coverage was given to contemporary and old master artists such as Escher, Posada, Paul Wunderlich, Marsden Hartley, Rolph Nesch, Antonio Frasconi, Sir Francis Seymour Haden, John Marin, and Michael Mazur. A sampling of specialized topics covered includes a survey of print collections in the Boston area, the evolution of the Afro-American artist, prints of the thirties, Chinese folk prints, Asian graphics in 1969, photography as printmaking, Eskimo printmaking, the cast paper print, etched circuit-board prints, and photolithographic plate multiples. Unique material, high production values, and authoritative text put this magazine in a special niche among print enthusiasts. All the issues have become collector's items. REPRINT of the first eight issues, minus advertising material and two color inserts: Fritz Eichenberg, ed., *Artist's Proof: A Collector's Edition of the First Eight Issues of the Distinguished Journal of Prints and Printmaking* (Greenwich, Conn.: Pratt Graphics Center; in association with New York Graphic Society, 1971). [*See also* L267.]

S83. ARTS. Brooklyn, N.Y. 1–18 (Dec. 1920–Oct. 1931), illus.

American as well as European art was presented in this liberal monthly on the art of the time as well as of the past. The magazine was edited by Hamilton Easter Field until his death in 1922. When Forbes Watson took over in 1922, his brilliant and effective editorials did much for the progressive forces in American art. The periodical was characterized by verve and variety, coupled with handsome design and effective use of high-quality illustrations. Articles covered painting, sculpture, architecture, decorative art, and cinema. In describing the microfilm edition of *Arts*, Bernard Karpel wrote, "In its pages there is a sense of continuing awareness of the contemporary as a precondition to understanding and enjoying the art of yesterday and tomorrow." SUSPENDED (Mar.–Dec. 1922). SUPERSEDED BY *Arts Weekly*. REPRINT of the original edition in microfilm format (New York: Arno Press, 1973). ABSORBED *Touchstone* [S238] in June 1921.

S84. ARTS AND ARCHITECTURE. San Francisco. 1— (1911—).

Originally focused on California architecture, interior design, and arts and crafts, this is an excellent example of an American periodical that broadened its scope, moving away from West Coast regional interests such as Monterey houses and Navajo rugs to cover a country house in Maine by Harrison & Abramovitz. In 1957 appeared a two-part article, "A Century of Modern Design," by Edgar Kaufmann. The magazine regularly includes a long list of available product literature and information that is

geared to engineers and designers as well as to architects. Dore Ashton has reviewed art subjects and film; book and music reviews also keep architects well informed on related humanities. Case studies of houses are extremely well done, and cover topics of contemporary interest, including concrete shells, medical centers, playgrounds, and leisure time structures. PUBLISHED AS *Pacific Coast Architect* (1911–May 1915); *Architect* (June 1915–Mar. 1919); *Building Review* (Apr. 1919–Dec. 1923); *Pacific Coast Arts and Architecture* (Jan. 1924–Jan. 1929); *California Arts and Architecture* (Feb. 1929–Jan. 1944). ABSORBED *Inspector* (May 1927); *California Southland* (Feb. 1929); *California Homeowner* (May 1929). SUSPENDED (Mar. 1920–Feb. 1921).

S85. ARTS AND DECORATION. New York. 1–55 (Nov. 1910–Feb./Mar. 1942).

Interior decoration, American art history, architectural developments, and exhibition reviews were subjects regularly covered in illustrated articles. Authorities wrote on specific subjects: Charles de Kay on the studio home of L. C. Tiffany (1911), George Leland Hunter on tapestries (1916), and Frank Jewett Mather, Jr., on American realist painters (1916). There are articles on posters, the artists' colony at Provincetown, Mass., and symbolism in Oriental lamps. A regular column, "Who's Who in American Art," usually discussed painters (Robert Henri, John Sloan, Kenyon Cox) but occasionally treated other fields, such as in a feature article on Thomas E. Kirby, a New York auctioneer (1916). ABSORBED *Palette and Bench* [S190] in Feb. 1911, *Art World* [S79] in May 1918, *Spur* in Aug. 1940. SUSPENDED (July–Sept. 1935).

S86. ARTS FOR AMERICA. Chicago. 1–9 (1892–1900), illus.

This magazine was the national organ of the Central Art Association of America. The first object of the association as set down in its constitution was the "cultivation of *correct* ideals in the fine and industrial arts." An authoritative article usually appeared in each issue, usually a biography of a lesser European artist such as T. A. Ribot, Pascal Dagnan-Bouveret, or Edward Coley Burne-Jones; other articles were relatively brief, contributed by readers or reprinted from talks and papers given before the association. Illustrations included full-page drawings; numerous advertisements in each issue announced art-related materials available from business firms around Chicago. The magazine's major value rests in the record it provides of an active Midwestern group during the last decade of the nineteenth century. PUBLISHED AS *Arts* (1892–1895).

S87. ARTS IN SOCIETY. Madison, Wis. 1— (1958—), illus.

This periodical, founded as a triennial at the University of Wisconsin, covers the humanities in general in addition to the visual arts. Its aim is to serve "as a forum for the discussion, interpretation and illustration of the role and function of art in our time. It is designed for the art leader, scholar, artist, educator, student, and the layman with broad cultural interests. Each issue focuses on a particular area of art experiences, which is explored by authorities from a variety of fields and disciplines." Major themes covered in past issues include arts in the community, mass culture, government and the arts, the avant-garde, censorship, "happenings," and urban cultural centers. Vol. 5:2–3 (1968) surveyed "The Arts and the Black Revolution" with illustrations of Chicago's "Wall of Respect," done in 1967 on the side of a slum building and offered major articles such as "Afro-American Art at Floodtide," by James A. Porter. Indicative of the diversity of this magazine is an article on Greta Garbo in the midst of a black studies issue. Well-known contributors have included Jacques Barzun, August Heckscher, Archibald MacLeish, Marshall McLuhan, Herbert Read, Kenneth Rexroth, and Harold Stevens. Of major interest to the academic community, the magazine is indexed in *The Annual International Bibliography* of the Modern Language Association of America as well as in *Abstracts of English Studies, Current Contents, Education Index,* and *Index to Little Magazines.*

S88. ARTSMAN. Philadelphia. 1–4 (Oct. 1903–Apr. 1907), illus.

This modest periodical was the organ of the Rose Valley Association, an arts and crafts center located about fourteen miles southwest of Philadelphia. The association encouraged crafts and provided a favorable setting for work by "men and women of the quality that art and craft occupations develop," the rural setting providing an escape from the "average stuffy atmosphere of Philistinism and upholstery in town." Articles were sometimes illustrated with line drawings and covered such general topics as the true mission of art, ugly homes and bad morals, and beautiful things in daily life. Specific articles described a music stand, a porch chair, and a fireplace made in the valley, and Maxfield Parrish's home and how he built it (July 1906). Products approved by Rose Valley artisans bore a seal, which was a conventionalized rose with the letter *V* in the center. Rose Valley Association "demonstrated that useful things need not be clumsy and that beautiful things need not be fragile." Its history as reported in this magazine documents a most interesting group of craftsmen working in America just after the turn of the century.

S89. ARTWEEK: WEST COAST ART NEWS. Castro Valley and Oakland, Calif. 1— (Jan. 3, 1970—), illus.

Decidedly geared to a West Coast audience, this tabloid is published forty-five times a year. Several major exhibitions are reviewed at moderate length in each issue, and the "Gallery Calendar" lists shows from Seattle in the north to Corona del Mar in the south, with emphasis on the metropolitan centers of San Francisco and Los Angeles. Of considerable value to artists is a full listing of competitions: national, international, and regional. Crafts and photography are given particular treatment, and thirty to fifty small illustrations are included in most issues. This magazine is of major value for its current data on the Pacific Coast art scene in the 1970s. Issued weekly (Sept.–May), fortnightly (June–Aug.).

S90. AVANT GARDE. New York. 1— (Jan. 1968—), illus.

This controversial bimonthly edited by Ralph Ginzburg

is in no sense a fine art periodical. However, contemporary visual arts are brilliantly illustrated in paintings, posters, and photography. Bill Katz wrote, "The photography is excellent but not overly consequential The over-all impression is one of a Madison Avenue whiz kid serving up bohemia in terms of the suburbs" (*Library Journal* [Mar. 1, 1968]). Later issues proved to be more significant, as demonstrated by a twelve-page portfolio of serigraphs of Marilyn Monroe by photographer Bert Stern. In 1968 these stunning images in brilliant, fluorescent colors represented something new in magazine illustration. Other art topics covered were Picasso at eighty-six, the erotic tomb sculptures of Madagascar, the dollar bill as designed by nineteen artists, antiwar posters, and nudes by Tom Wesselmann, a leading Pop artist. The magazine reflected the new liberalism with a candid approach to sex and an awareness of the political and social turmoil current in America in the final years of the Vietnam War. The magazine was published irregularly and after a lapse of several years announced a revised publishing schedule. The new format was a tabloid, with issues appearing twice a month in 1975. The early issues show an appreciation of contemporary art and its effectiveness as a medium for social and political protest.

S91. BEAD JOURNAL: A QUARTERLY PUBLICATION OF ANCIENT AND ETHNIC JEWELRY. Los Angeles, Calif. 1— (summer 1974—), illus.

This is a quarterly publication devoted exclusively to beads and other perforated objects that can be strung, such as amulets, seals, and scarabs. The magazine plans to become a forum for exchange of information and news about beads and to include a question and answer column, letters, bibliographies, glossaries, and substantial articles. Edited by Robert K. Liu, the first issue included three articles by him and covered beads from Africa, glass mosaic or millefiore face beads, China cloisonné and enamel beads, and beads from Venice. With many photographs and drawings, the magazine hopes to encourage the collecting of beads in the same tradition as numismatists and antique collectors. It also provides a prime example of the diversity of art periodical publication on the eve of the third century of America's national history.

S92. BETTER HOMES AND GARDENS. Des Moines, Ia. 1— (July 1922—), illus. (color).

This great standard magazine in the field of interior design and decoration had an annual circulation of 7,777,777, according to the 1973 edition of Ulrich's *International Periodicals Directory*. The magazine, available on microfilm, is published in seven regional editions: New England, Middle Atlantic (including metropolitan New York), East North Central, West North Central, Central, Southwest, and Pacific. Its extraordinary success story is based in part on a relatively low subscription fee and a policy of consistency "to its original ideals of practical service and emphasis on quality for the middle-class American home and family." In 1928, when the magazine was only six years old, some issues ran to over 150 pages, and it reached a record circulation of one million. Primarily of interest to women, the magazine has long had a major influence on the appearance, management, and planning of all aspects and details of the American home. A fascinating history of this magazine appears in vol. 5 of Frank Luther Mott's Pulitzer Prize-winning *A History of American Magazines, 1741–1905* [S·XX], giving a data-packed summary along with a record of editorial and content changes over the decades. PUBLISHED AS FRUIT, GARDEN, AND HOME 1–2 (1922–1924).

S93. BLIND MAN. New York. 1–2 (Apr. 10, 1917–May 1917), illus.

This short-lived magazine was prepared by the New York Dada group, published by Beatrice Wood, and edited by Henri Pierre Roché and Marcel Duchamp. Their purpose was to encourage independent and radical artists and to urge special exhibitions of their work. Contributors included Charles Demuth, Frank Crowninshield, Erik Satie, Picabia, Mina Loy, and Stieglitz; illustrations are by Joseph Stella, Eilshemius, Duchamp, and Man Ray. No. 2 has an article on "Buddha of the Bathroom" (a ready-made) and an editorial on "The Richard Mutt Case." No. 2 was also issued in fifty deluxe copies. FACSIMILE REPRINT in the series *Documenti e periodici dada*, by Arturo Schwarz (Milan, 1970).

S94. **Museum of Fine Arts, Boston,** BULLETIN. Boston. 1— (1903—), illus.

This distinguished record of the major acquisitions, building changes, and activities of one of the world's leading museums was the first art bulletin to be regularly published by an American institution. Articles of medium length were written by curators or other authorities on major paintings, sculpture, prints, drawings, or examples of the decorative arts in the institution's collections. Many issues are devoted to Egyptian art, one of the major collections at the museum, but paintings by George Harvey and Thomas Eakins, sculpture by William Rimmer, and silver by Paul Revere and other Boston silversmiths were also described, indicating the American art strongly collected in Boston art circles. The issue for June 1907 proudly reveals the plans and hopes for the new museum, which will be the "shrine of the Muses . . . sacred to the nurture of the imagination." The cumulative value of this quarterly publication is immediately evident as the interests and collections of the Museum of Fine Arts, Boston, are of major importance in the history of American taste and museum development. Index published in vol. 13 (covering vols. 1–13) and in vol. 23 (covering vols. 14–23). REPRINT of 1–40 (1903–1942): (New York: Arno Press).

S95. BRADLEY, HIS BOOK. Springfield, Mass. 1–2:3 (May 1896–1897).

This unique little magazine, the work of the notable designer and typographer Will Bradley, reflected his interests in illustration, poster design, and good printing. Prepared with talent and skill, each issue is a gem in Art Nouveau style. The work of Aubrey Beardsley, Mucha, Bruce Rogers, William Morris, and Maxfield Parrish is

illustrated at various times. A spectacular extravaganza in two acts and ten scenes by Bradley entitled "Beauty and the Beast" appeared in vol. 1, no. 4 (1896). An unauthorized and spurious issue was published as vol. 2, no. 4 (Feb. 1897), lacking those highly individual and outstanding qualities that had earned this private periodical a place of distinction. Bradley's designs have left their mark on later generations. For a testament of his continuing vitality, *see* The Metropolitan Museum of Art, *Bulletin* (June–July 1972).

S96. BROOM: AN INTERNATIONAL MAGAZINE OF THE ARTS. Rome, Berlin, and New York. 1–6 (Nov. 1921–Jan. 1924), illus.

This little magazine is most valuable for its literary criticism concentrating on the European avant-garde. The controversial Surrealist and Dada movements receive considerable commentary, and photographs by Paul Strand appear along with reproductions of works by Marcoussis, Gleizes, Derain, Klee, Matisse, and Grosz. A group of notable editors, including Harold A. Loeb, Edward Storer, Lola Ridge, and Matthew Josephson captured much of the excitement rocking the European art world of the time. When Harold Loeb, who was publisher as well as an editor of this magazine, died in Jan. 1973, the *New York Times* commented as follows on *Broom:* "The monthly which described itself as 'an international magazine of the arts,' printed the early works of James Stephens, Malcolm Cowley, Matthew Josephson, Ilya Ehrenburg, Hart Crane, Marianne Moore, Guillaume Apollinaire, Gertrude Stein, Sherwood Anderson, Conrad Aiken, John Dos Passos, William Carlos Williams, e. e. cummings, Louis Aragon, and Kay Boyle. A showcase for Dadaism and Surrealism in letters and art, *Broom* was one of several so-called 'little magazines' of the post–World War I 'lost generation.' Its contributors were rebels against what they considered to be the gentility of their immediate forebears, and they were fashioning new modes of expression in fiction, poetry and criticism. Many of their experiments shaped American and European literature in succeeding decades and have come to be accepted as widening literary form and scope." SUSPENDED (Mar. 1922–July 1923). FULL REPRINT (New York: Kraus Reprint Co., 1967), in reduced format.

S97. BRUSH AND PENCIL: AN ILLUSTRATED MAGAZINE OF THE ARTS OF TODAY. Chicago. 1–19 (Sept. 1897–May 1907), illus.

"Eclectic" and "contemporary" are the two words that best describe the contents of this periodical. In addition to oil painting and figure drawing, the magazine contained articles on many topics, including mural painting, etching, photography, the design of book covers, sculpture, ceramics, embroidery, and bookbinding. Many clear black-and-white pictures illustrated the articles. Exhibitions of various kinds were reviewed at length, with a slight emphasis on those in the central states in cities such as Chicago, Pittsburgh, and Saint Louis. Group shows by the Society of Western Artists were reviewed, and the issue for Dec. 1903 was largely devoted to sculpture for the Saint Louis World's Fair. Biographies of artists appeared often, and these sometimes included critiques of the artist's work, as is the case for Henry O. Tanner's paintings (June 1900) and the photography of S. L. Willard (June 1903). Art Nouveau was often discussed, and Frederick Law Olmsted, Jr., was the author of an article "Reform in Public Advertising" (Sept. 1900), giving additional evidence of the variety of art interests appearing in the magazine. SUSPENDED (Aug.–Nov. 1904).

S98. [Deleted.]

S99. CALIFORNIAN AND OVERLAND MONTHLY. San Francisco. 1–6: 6 (1880–1882).

Mainly concerned with literature, poetry, and general subjects, this magazine has some relevance to the history of American fine arts through a column "Art and Artists," which appeared with some regularity during the two years the periodical was published. Centered on San Francisco and including commentary reflecting California interests and opinions, the art topics covered were individual artists, new societies and associations, and general aesthetics. There was news of the San Francisco Art Association and the Artists' League, "patterned much after one now in existence in New York." The editor hoped that critics in general would reverse a nasty trend and alter their attitudes so "that in future their writings will be instructive rather than abusive, and encouraging rather than demoralizing to the growth of art on the Pacific Coast." Art commentary follows in later issues, and among the topics discussed are Muybridge's photographs of animals in motion shown at the Art Rooms in May 1880. Other subjects were The Metropolitan Museum of Art in 1880, women painters, and the James Lick bequest to found a school of industrial arts in San Francisco along with "$160,000 for statuary for the embellishment of the new city hall and Golden Gate Park." Reviews of painting exhibitions at Morris & Kennedy's on Post Street at Mechanics' Fair provide an accurate measure of contemporary aesthetics in 1880. Of special interest is the brief commentary on the rising interest in Japanese art, which was eventually to have such an influence on American art and design.

Local artists were encouraged, and thoughtful commentary was printed on the work of Thaddeus Welch, David Neal, Thomas Hill, Theodore Wores, Julian W. Rix, William Keith, and the sculptor F. Marion Wells. A local committee to erect a monument to the late President Garfield was soundly scolded in 1882 for their clumsy method of handling a competition for designs in response to a public subscription exceeding $23,000. The lead article for Aug. 1882 ran for seven pages and described the Society of Decorative Art of California. Western events captured the interest of readers. For example, Thomas Hill's historical picture commemorating the driving of the last spike in the overland railroad—an event that linked Atlantic and Pacific—was described in detail. The art comments in this general magazine have value to those interested in early art criticism and organized development on the West Coast. Regionalism was rampant, and San Francisco in particular desperately tried to

develop local pride in the late nineteenth century. The following comment from the issue for July 1880 speaks eloquently for hurt feelings and artistic yearnings on the Pacific Coast: "Boston, with its well-known complacency, spares its own, but claims that an artist to be recognized must first gain its approval, and therefore has little sympathy to bestow upon those outside its charter limits. Faint pipings are heard from all parts of the Far West." PUBLISHED AS *Californian* 1–6:4. ABSORBED and SUPERSEDED BY *Overland Monthly and Out West Magazine* 1–15 (July 1868–Dec. 1875); new ser. 1–93 (1883–July 1935).

S100. CAMERA WORK: ILLUSTRATED QUARTERLY MAGAZINE DEVOTED TO PHOTOGRAPHY. New York. 1–50 (Jan. 1903–June 1917), illus.

Here is one of the monumental works in the history of American magazines devoted to the visual arts; both its content and influence are unparalleled in quality and impact. Alfred Stieglitz, the founder, edited and published the magazine throughout its history. In the first issue he proposed to publish a quarterly "which will appeal to the ever-increasing ranks of those who have faith in photography as a medium of individual expression, and, in addition, to make converts of many at present ignorant of its possibilities." In 1902, Stieglitz had organized the Photo Secession, a group made up of enthusiasts for pictorial photography, and the early issues of *Camera Work* included articles sympathetic to the ideals of the group. Later issues disseminated information on the latest developments in European and American painting. Gertrude Stein wrote on Picasso and Matisse, and important new artists were brought to the attention of the American public through this journal. The printing and typography are distinguished, as Stieglitz was a perfectionist and supervised the production of every issue. He wrote that it was "highly necessary that reproduction of photographic work must be made with exceptional care and discretion if the spirit of the originals is to be retained," and his success in this area was confirmed in 1924 when the Royal Photographic Society awarded him its Progress Medal. He was lauded for encouraging pictorial photography in America; his publication of *Camera Work* described as "the most artistic record of photography ever attempted." A representative list of the artists and photographers appearing in the fifty issues and three special numbers includes Steichen, Matisse, Picasso, Gertrude Käsebier, Julia Margaret Cameron, Walkowitz, David Octavius Hill, Marin, Marsden Hartley, Paul Strand, Man Ray, George Bernard Shaw, and Alvin Langdon Coburn. The three special numbers were issued Apr. 1906 (*Steichen Supplement*), Aug. 1912, and June 1913. REPRINT of issues 1–50 (Liechtenstein and New York: Kraus Reprint Co., 1969).

S101. CARTOONISTS PROFILES. Fairfield, Conn. 1– (winter 1969–), illus.

This quarterly is edited by Jud Hurd, a cartoonist with broad experience who brings enthusiasm and expertise to the publication, which approaches cartooning as an authentic art form. Subtitled *A Unique Quarterly Magazine for the Professional, the Cartoon Buff, the Student, and All Who Enjoy Cartoons*, issues are from sixty to eighty pages long and include excellent feature articles with quantities of crisp illustrations, many of which are line drawings. The magazine has a number of European subscribers and is wide ranging, covering current cartoon art in addition to providing articles on the history of the subject. Editorial, spot, and sports cartoons and their creators appear in each issue along with cartoons by famous feature artists such as Walt Disney, Hal Foster ("Prince Valiant"), Harold Gray ("Little Orphan Annie"), Milton Caniff ("Terry and the Pirates"), Al Capp ("Li'l Abner") and Chester Gould ("Dick Tracy"). Caricaturists, creators of animated films, and illustrators such as Ronald Searle receive regular coverage in text and illustrations. The issue for Sept. 1974 proudly announced the opening of the Museum of Cartoon Art in Greenwich, Conn., which was founded to meet the growing need of collecting, preserving, protecting, and exhibiting the cartoon art form. The museum, which is unique, will also house the Cartoon Hall of Fame. The establishment of such an institution is evidence of the tremendous worldwide interest in cartoons. This periodical treats the subject with respect and dedication and provides an excellent source for reliable information concerning all facets of this most popular of American art forms.

S102. CERAMIC MONTHLY. Chicago and New York. 1–10 (1895–Jan. 1900), illus.

This magazine was exclusively devoted to the subject of china painting, which attracted immense interest at the time. It was nicely illustrated, and a decorative design was issued with each number. Advertisements urged the subscribers to purchase quality products with intelligence and safety. Charles F. Binns wrote many articles; he was described as "perhaps the best Keramic critic of the present age." Other contributors were Carrie D. Clark, Magda Heuermann, Marshal Fry, Charles Volkmar, and Fanny Rowell Priestman. With its news, answers to subscribers' questions, articles, special designs, exhibition reviews, and advertisements, the magazine presents a rounded picture of the art of china painting.

S103. CERAMICS MONTHLY. Athens, Ohio. 1– (Jan. 1953–), illus.

Consistently covering the subject of ceramic art in its broadest interpretation, this magazine has grown during two decades of ever-expanding interest in crafts and fine hand workmanship. Brief, well-illustrated articles discuss technique, the work of individual ceramic artists, and pottery in other parts of the world, such as Nigeria, Ceylon, and Japan. New techniques seem infinite in their variety; some of the processes discussed are sgraffito through enamel on glass, wrapped slab pots, paper cone pottery, and coiling. The ceramic work of noted artists such as Harrison McIntosh, Hal Riegger, and Karl Martz is acknowledged in feature articles.

S104. CHINA DECORATOR: A MONTHLY DEVOTED EXCLUSIVELY TO THIS ART. New York. 1–27 June 1887–1901), illus. (color). [*cont.*]

This magazine was "devoted exclusively to the art of decorating china with mineral colors, and firing of same." It was founded to fill the need for the many men, women, and children who were avidly working in the art. The first issue informed potential advertisers that readers were "a refined and generally wealthy class of people." Issues contained articles and designs, some of which were in color. The articles discussed equipment and techniques such as photographing on china, printing on china, and paste work. Hints to beginners, biographies of American china decorators of note, and reviews of exhibitions were early staples; later, expanded interests included painting on glass and watercolor painting. The hundreds of designs, related advertisements, news reports, and articles combine to provide a thorough picture of late Victorian china decoration in America. The color studies of roses and pansies were avidly copied from Maine to California as well as in the territories.

S105. CHROMATIC ART MAGAZINE. New York. 1–2 (Aug. 1879–summer 1884), illus. (color).

The subtitle of this magazine reads *For the elevation of the Typographic and Lithographic Arts,* and it was the former that were emphasized over the latter. The magazine was nicely designed with color borders on every page, covers in color, and photoengraved art prints; the text covered the history of printing in a highly selective way. The covers, printed in seven colors, were illustrated with portraits of prominent people in the printing profession. The large pages abounded with illustrations of new presses, inks, job cases, and fonts. The few issues published give an indication of the rapid technical advances made in color printing in the last decades of the nineteenth century. SUSPENDED (1881–1883).

S106. COLLECTOR AND ART CRITIC. New York. 1–5 (Apr. 15, 1899–Feb. 1907).

This magazine was full of news of American and European exhibits, artists, critics, sales, and collections, with dozens of brief entries gathered at random from diverse sources. The magazine advertised itself as "A Journal Devoted To Art in all its Branches; Books, Their Contents and Also To Collecting." Long lists of works owned by particular collectors sometimes were printed, such as of 180 paintings owned by Frederick S. Gibbs of New York in 1899 and seventy-three pictures from the E. Burgess Warren Collection in Philadelphia in the same year. Corot, Daubigny, Troyon, and Millet were names that appear frequently. Long lists of sales held in New York and Paris were recorded, and a fine description and list of 119 works in the J. G. Johnson Collection in Philadelphia was printed in 1900. After four years of suspension, the magazine reappeared; promising to include "frank and unbiased criticism, it will deal with book-craft and collecting; it will be a medium of art information—native and foreign." The format was altered after 1905, with listing of art exhibitions given prominence, more art criticism, and fewer entries for gossip. The collection listings are most valuable. ABSORBED *Art Collector* [S52] in 1899. SUSPENDED (Nov. 1900–Jan. 1905).

S107. COLOPHON: A BOOK COLLECTORS' QUARTERLY. New York. 1–5 (Feb. 1930–Mar. 1935). New ser. 1–3 (July 1935–autumn 1938). New graphic ser. (1939–1940). Ser. 3, 1 (1939–Feb. 1940).

First editions, fine printing, incunabula, association books, Americana, bibliography, manuscripts, and collected and collectible books were the primary concerns of this celebrated periodical. Book illustration was treated royally; the contributors form a veritable who's who in the book and fine printing world of the decade during which the magazine was published. Signatures of various presses and printers were represented; articles included topics such as bookplates designed by Bruce Rogers, Rudolph Ruzicka's book illustrations, and handmade paper from Dard Hunter's mill in Connecticut. An index to the first five volumes, published in 1935, also contained a listing of types and papers that had been used, and a history of the quarterly by John T. Winterich.

S108. CORCORAN ART JOURNAL. Washington, D.C. 1–2 (Dec. 1892–Mar. 1894), illus.

This publication was sponsored by the Corcoran School of Art, with the aim that the pages of the *Journal* would present a faithful picture of the school. The editor, E. E. Newport, also hoped to sketch the progress of art in centers of culture and stressed the fact that in 1892 America had "many clever painters, but few artists." The editorial in the first issue pointed out the need for an art magazine in the nation's capital, noting, "Boston, New York, Chicago, Cleveland and almost every town of any size can boast one or more art magazines, and it is certainly most unfitting that Washington, long a noble and beautiful city, and of late developing much artistic merit, should lag behind her sister cities." There were a variety of columns, including "Foreign Notes," "Hints to Students," "Washington Notes," ' "Art in Washington," and one devoted to gossip of the students, along with kindly criticism and honorary mention. Short biographical sketches of great painters such as Giotto, Raphael, Leonardo, Titian, and Michelangelo were printed for the benefit of readers "who have neither time nor opportunity for deep research into those musty volumes which treat of artistic lore." The issue for Mar. 1893 included a one-page article on Frederic Edwin Church. The magazine was illustrated with line drawings and vignette sketches. The three coeditors in 1894 hoped to make the school better known in other cities. Several pages of small advertisements appeared in each issue, focusing on art products, services, and materials in the Washington area. These local announcements, along with quantities of notes on art in Washington, D.C., and accounts of the activities of the Corcoran School of Art and its many students, give this magazine a position of some value when tracing the rise of interest in art in our nation's capital.

S109. COSMOPOLITAN ART JOURNAL: A RECORD OF ART CRITICISM, ART INTELLIGENCE, AND BIOGRAPHY, AND REPOSITORY OF BELLES-LETTRES LITERATURE. New York. 1–5 (July 1856–Mar. 1861).

The Cosmopolitan Art Association was called into existence in New York in June 1854 for the purpose of "the

gratification of the Art-taste of the people through the dissemination of works of art and pure literature over the country." By the third year of its existence, the directors of the association found it necessary to adopt some means of communication with the membership, and established this periodical. The magazine provides a thorough and accurate survey of New York art interests of the period, as the subtitle boasted. Issues included engravings created expressly for the *Cosmopolitan Art Journal* and news of the activities and members of the association. There are lists of the works of art awarded to members at the annual distributions, including the names and hometowns of the new owners. Features include a "Department of Useful Art," covering such topics as "Envelopes: Their History, Uses, Progress of Manufacture, etc." (Mar. 1860) and Grover Baker's sewing machines. "Catalogues of the Premiums" to be given to subscribers contain many biographies of artists such as Rosa Bonhur, Lilly Martin Spencer, and Jerome B. Thompson. Articles on sculpture included commentary on the American sculptors in Italy and on the excitement caused by Hiram Powers's statue "The Greek Slave," which was awarded to a subscriber in Mar. 1858. The periodical championed American art and its future, strongly criticizing those who belittled native talent, including disappointed artists, invidious critics, and snobs. It stressed a faith in American art, which led it in Mar. 1857 to "assert for American minds a full capacity for a comprehensive and proper appreciation of true Art."

S110. CRAFT HORIZONS. New York. 1— (Nov. 1941—), illus.

A major magazine in its field, this publication is sponsored by the American Crafts Council, which, since the end of the World War II, has fostered the development of American crafts. Skills in crafts have expanded with such momentum that artisans are currently a highly sophisticated, strongly influential force. In the twenty-fifth—anniversary issue (June 1966), the chairman of the council, Aileen O. Webb, surveyed the magazine's development as follows: "Since its beginning in 1941, as a mimeographed newsletter for those who sold their work through America House, it has seen vast changes in the craft field the world over—and in its own, important way has contributed to them. A review of the articles which have filled *Craft Horizons'* pages would mirror the growth of interest in crafts in the United States of America, and above all, the growth of technical skills and the integration of crafts with the changing pattern of the arts in this last quarter of a century. Today, as the magazine goes into its twenty-sixth year, it boasts a printing of over 30,000 copies an issue, and a readership of craftsmen, artists, architects, designers, teachers and interested laymen in every State of the Union and in seventy-seven countries around the world." The magazine has continued to grow and reaches out to include new forms of crafts, as witnessed by the start of a regular column on film. In 1971, Denise Hare began this feature by noting that future columns would be devoted "primarily to the art documentary or to films on arts and crafts, a classification that is finally beginning to receive long overdue creative attention." Rose Slivka became editor-in-chief in Sept. 1959. The activities of the World Crafts Council are regularly reported, and the broadest interpretation of the crafts field is offered, including weaving, ceramics, jewelry, mosaics, glass, metal, and woodworking, and enameling. Special issues appear from time to time on such topics as "Crafts of the Southern Appalachians," and current developments are covered in depth. The magazine is well designed, with high quality paper and color printing, and liberal use of black-and-white photographs. Here again is an American art periodical that serves its subject with brilliance and style, revealing a love of the materials and a dedication to the field it covers. [As of June 1979 this serial is to be known as *American Craft,* and the sponsoring organization as American Craft Council.]

S111. THE CRAFTSMAN: AN ILLUSTRATED MONTHLY MAGAZINE IN THE INTEREST OF BETTER ART, BETTER WORK, AND A BETTER AND MORE REASONABLE WAY OF LIVING. Eastwood, N.Y. 1—31 (Oct. 1901—Dec. 1916).

The subtitle varies. Vol. 1 of this magazine reflects a definite English attitude toward crafts, with articles on William Morris, guilds of the Middle Ages, Irish industry, Ruskin quotations, and the Gothic Revival. American interests came along later with coverage of such topics as skyscrapers as a source of beauty, the destruction of American Indian civilization (Mar. 1907), home training in cabinet work, and the Acadian weavers of Louisiana. Garden design, suburban house plans, and lawn, tree, and plant culture were subjects frequently covered in 1913 and 1914. Jacob Riis contributed an article, and Joaquin Miller was the subject of another. The journal reflected a prosperous, moral era just before World War I when crafts, home designs, and all the arts were uplifting and inspirational, as typified by a 1911 article entitled "Symmetry in Building: The Result of Sincerity." SUPERSEDED BY *Art World: A Monthly for the Public Devoted to Higher Ideals* [S79].

S112. CRAYON: A JOURNAL DEVOTED TO THE GRAPHIC ARTS. New York. 1—8 (Jan. 3, 1855—July 1861).

This periodical began as a weekly and changed to a monthly; subtitle varies. Generally regarded as one of the best art magazines of the period, this is a reliable source of current opinion. Contributors included Rembrandt Peale, Asher B. Durand, Daniel Huntington; correspondents were John Ruskin, James Russell Lowell, and W. M. Rossetti. Regular features included domestic art gossip, exhibition reviews, book notices, and some attention to architecture and landscape gardening, the "two most popular departments of Art of the Day." A limited number of advertisements on the covers indicate diverse art activities during the years just prior to the Civil War. Feature articles reveal an emphasis on English, German, French, and Greek art history. [*See also* I·49.]

S113. CREATIVE ART: A MAGAZINE OF FINE AND APPLIED ART. New York. 1—12 (Oct. 1927—May 1933), illus. (color).

This is a distinguished art magazine affiliated with *The Studio* [London] until Apr. 1931. Published by Albert and

Charles Boni and edited by Rockwell Kent and later by Henry McBride, *Creative Art* represents most of the art of the period that later proved to have major significance. International in scope but with a strong American emphasis, it regularly noted art events in such diverse locations as Tokyo, Prague, Madrid, Moscow, Reykjavik, and New York, where gallery shows were sometimes reviewed by Marya Mannes. Illustrations, many in color, were notably successful and were published in quantity, occasionally including a tipped-in plate. Sculptors, architects, painters, graphic artists, photographers, bookbinders, and other craftsmen were given sympathetic treatment in both pictures and text. Art Deco abounds in every issue and in many media. Representative writers include Marsden Hartley, Ralph Pulitzer, Virgil Barker, Osbert Sitwell, Alexander Brook, Harold Clurman, Berenice Abbott, Julius Meier-Graefe, Ana M. Berry, and Walter Pach. Representative articles dealt with the art of the book, Eugene Speicher, the housing problem in Vienna, Paul Strand, art on the S.S. Ile de France, Wanda Gág, stage decoration and fantasy, Demuth, modern Italian ceramics, Alexander Brook, and concrete architecture. The material and its visual presentation are top quality, combining accurate appraisal and permanent value. SUSPENDED (July–Aug. 1932, June–Dec. 1933). SUPERSEDED BY *American Magazine of Art*.

S114. CREATIVE DESIGN IN HOMEFURNISHINGS. New York. 1–4 (fall 1934–Feb. 1939), illus.

Good design for house furnishings by contemporary manufacturers and designers was the subject for the articles and many photographs in this periodical, which is a parade of Art Deco furniture. The editorial statement in the first issue notes that "The little group of selective millionaires who are willing to go back, 3000 miles or 300 years for their choicest possessions no longer exists. We are in a mood to choose from the Here and Now This new magazine grows out of an authentic social mood, an attitude of interest in things created for our peculiar age." Lamps, wall and floor coverings, bedspreads, tableware, kitchen equipment, clocks, chairs, slip covers, tables, linens, glass, fabrics, and rugs were shown in nearly every issue. The July and Aug. 1937 issues include swatches for fabrics and rugs. Marketing information, store displays, color developments, and the latest blonde, brunette, and honey cocktail tables all reflected the scheme of living. Researchers interested in furniture and all aspects of the decorative arts on a popular level will find quantities of illustration and text relating to American interiors of the 1930s. Sometime PUBLISHED AS *Creative Design* (1934–winter 1935/1936).

S115. CRITIC: AN ILLUSTRATED MONTHLY REVIEW OF LITERATURE, ART, AND LIFE. New York. 1–49 (Jan. 15, 1881–Sept. 1906), illus. 4–32 (1884–1898) also new ser. 1–29.

Chiefly occupied with literature and employing a staff of specialized and expert book reviewers, this periodical also carried comments and criticism relating to the visual arts. From the first issue, which commented on the painting collection of The New-York Historical Society, the magazine regularly ran a column on art, which included reviews and commentary on exhibitions, art books, and monuments recently erected. The editors led the drive to have New York's Washington Memorial Arch constructed in marble to replace the wooden structure erected for the Centennial. They also commented on the wisdom of new laws encouraging the tax-free importation of antiquities and works of art. In the mid 1880s, the space allotted to art was reduced, but the front and back covers included advertisements for art auctions, art shops in New York, and new art books. PUBLISHED AS *Critic and Good Literature* (Jan.–June 1884); *Critic and Literary World* (1905). SUPERSEDED BY *Putnam's Monthly and The Critic*, later *Putnam's Magazine*.

S116. CRITIC: A WEEKLY REVIEW OF LITERATURE, FINE ARTS, AND THE DRAMA. New York. 1–2 (Nov. 1, 1828–June 20, 1829).

Fragmentary and scattered references to art exhibitions in New York City and opinions on specific pictures appeared now and again during the brief existence of this magazine. Book reviews, along with poetry, drama, essays, and biographical sketches, were the main concern of the editor. Art subjects commented on include Samuel F. B. Morse's painting "The House of Representatives," Martin's celebrated painting "The Deluge," the diorama at New York's Bowery Theater, and the Fourth Annual Exhibition of the National Academy of Design in 1829. SUPERSEDED BY *New York Mirror*.

S117. CRITIQUE: A REVIEW OF CONTEMPORARY ART. New York. 1:1–3 (1946–Jan./Feb. 1947), illus.

Edited by David Loshak, this short-lived magazine had many good things going for it. Each of the three issues included special articles of lasting value, reviews of current New York exhibitions (usually giving a thoughtful evaluation of the artist's work), book reviews, and halftone reproductions. A few of the highlights that appeared during the brief run of the magazine were "The Genesis of a Picture," by Robert Goldwater, "The Negro Artist's Dilemma," by the young American painter Romare Bearden, "Artists and Sculptors," by Hugo Robus, "Picasso's Guernica," by José Lopez-Rey, and a revised and updated article "Style and Medium in the Motion Pictures," by Erwin Panofsky, which had first been published in 1934 by the department of art and archaeology of Princeton University and later printed in *Transition* [S240] 26 (1937). The illustrations include "Political Cartoon," by A. D. F. Reinhardt and reproductions of works by Louis Shanker, Charles Howard, Arthur Dove, Philip Evergood, Morris Kantor, Kurt Seligmann, and Robert Gwathmey. The final issue was the largest and included seventy-four pages of what was described as the "best critical writing on contemporary arts—painting, sculpture, motion pictures—favoring no single school or trend but encouraging expression of a wide variety of ideas and opinions."

S118. CURIO: AN ILLUSTRATED MONTHLY MAGAZINE DEVOTED TO GENEALOGY AND BIOGRAPHY, HERALDRY AND BOOK PLATES, COINS AND AUTOGRAPHS, RARE

BOOKS AND WORKS OF ART, OLD FURNITURE AND PLATE, AND OTHER COLONIAL RELICS. New York. 1 (Sept. 1887–Jan./Feb. 1888), illus.

This magazine was published briefly and appeared in only five issues. This was a rambling publication with a historical bias that is evidenced in articles on American coats of arms, American pedigrees, the seals of the colonial governors of New York, and old sign boards, most of which had an English derivation. A column on bric-a-brac noted that New York was a city where everything was collected. American art received particular attention in some articles, such as a review of the first exhibition of the "New York Society for the Promotion of Art" written by the editor, E. de V. Vermont, in Nov. 1887. This exhibition was hung in an upper hall of the Eden-Musée building on West Twenty-Third Street in New York City. Another article covered notable examples of American art from the collection of Mrs. Hicks-Lord, including commentary on and a listing of the works of the sculptor Thomas Crawford.

A sampling of the multiplicity of subjects covered in text and illustration includes bookbinding, Japanese ceramics, heraldry, George Washington's library, and a long article on "The Morality of the Fig Leaf," by Alfred Trumble, who wrote fairly frequently for the periodical. The issue for Dec. 1887 includes a full-page drawing of Mrs. Frank Leslie with a gossipy commentary, which describes her as "the distributor of culture for the millions. The greatest woman-publisher ever known. In her office—a cool-headed, brainy, indefatigable money-maker In her parlor—has all the brilliant 'sang-froid' of a future grande dame." Well printed with many clear black-and-white line drawings, the magazine was eclectic in the extreme, and it is possible that this lack of focus contributed to its quick demise.

S119. DESIGN: THE MAGAZINE OF CREATIVE ART, FOR TEACHERS, ARTISTS, AND CRAFTSMEN. Syracuse, N.Y. and Columbus, Ohio. 1— (May 1, 1899—), illus.

The golden age for this bimonthly lasted from 1910 to 1930 when the interest in original decorative design for flat surfaces was at its peak among art students, teachers, and manufacturers. For a long time the magazine focused almost entirely on ceramics, with other crafts delegated to the "Happy Study Hours" department. The magazine's motto was "Keep The Fire Alive" and the subtitle was *A Monthly Magazine for the Potter and Decorator*. Many illustrations suggested patterns for ceramic design, and the index divided styles between "naturalistic" and "conventional," with a heavy emphasis on flower and fruit studies. Advertisements promoted kilns, transfers, color powders, and other materials for china and glass decoration. In 1921 the editors noted that most craftsmen "worked from application to art, instead of from art to application." The magazine continued to illustrate good design to fill a "great and crying need for instruction in design." In the 1920s, subject matter was expanded to include design on jewelry, lampshades, tablecloths, screens, rugs, quilts, and Easter eggs. In 1930, the magazine was devoted to the decorative arts in general, many articles of particular value to art teachers; this has been the main interest of the magazine over the past decades. PUBLISHED AS *Keramic Studio* 1–25 (1899–Apr. 1924); *Design and Keramic Studio* 26–31 (May 1924–Apr. 1930).

S120. DESIGN IN INDUSTRY. Newark, N.J. 1–3 (May 1930–Dec. 1932).

This monthly bulletin, published to promote interest and appreciation in the products of applied art, was issued jointly by The Newark Museum and the Newark Public Library. The magazine presented annotated bibliographic listings of the latest articles on design to be found in magazines, books, and pamphlets aimed at the manufacturer as well as the designer. In the first issue, the editor pointed out the practical uses of museum objects and current library literature to designers and noted, "the colors and markings of butterflies have been used for wallpaper, the color and texture of minerals have been used by manufacturers of enamels, fragments of Italian marble have been used in designing columns for a local theater . . .spearheads have been adapted for curtain tie-backs, Japanese prints and Japanese stencils are used for designing wallpaper, fabrics, lampshades and tooled leather." Under the heading "A Digest of What Is New in Design," entries appeared for architecture, art in industry, ceramics and glass, color, fashion in dress, furniture, interior decoration, jewelry, lighting, metalwork, packages, photography, printing and advertising, and textiles. In the twenty-six numbers that appeared, there were 1665 annotated listings, which gave an accurate picture of the state of industrial art in the hazardous and transitional early years of the great Depression. Commenting on trends in Sept. 1932, it was noted that "Big industry represented by ships, planes, and cars of all kinds shows a more pronounced inclination to ally itself with artistic design. Architecture and interior decoration constantly lead." This was a successful example of an art bibliography issued in periodical format, which succumbed to the reduced budgets universal in the United States in the early 1930s.

S121. DESIGN QUARTERLY. Minneapolis. 1— (1946—), illus.

Published by the Walker Art Center, this periodical for many years was subtitled *A Guide to Well Designed Products* and focused on exhibitions shown at the Center's Everyday Art Gallery. This gallery, opened late in 1945, had "received wide acclaim on the part of the public, educators, designers, manufacturers, as well as from the national press," and the magazine was issued in response to "literally, thousands of requests from visitors . . . for practical information and for literature on everyday art objects The *Quarterly* is written for the home makers, prospective home builders, and for the many others faced with the problem of furnishing their living quarters and buying objects for everyday use." All issues have been well illustrated with photographs, drawings, and renderings. The contributors of articles have been outstanding specialists in the field of contemporary design, including Alvin Lustig and Joseph Blumenthal on contemporary book design, Edgar Kaufmann, Jr., Charles Eames, and Gyorgy Kepes. Brief book reviews were in-

cluded for a decade or more, as well as a column entitled "Everyday Art in the Magazines."

A broad spectrum of design topics, including glass, jewelry, furniture, ceramics, lamps and lighting, chairs, product and fabric design, and modern ballet design by George Amberg, was thoroughly surveyed. There was a splendid double issue in the spring of 1951 entitled *Knife, Fork, Spoon*, which told the "story of our primary eating implements and the development of their form." Other outstanding issues presented the architecture of Gio Ponti, mass transit, design and the computer, and the architecture of fantasy. Since the mid-1960s the magazine's editors have moved into the most contemporary design problems, with an avant garde approach to ideas accompanied by distinguished layouts. During 1974 and 1975 the magazine presented an issue on signs, another on measuring the human experience in the designed environment, and double issues on the design of learning places and spaces and on design from agencies of the federal government. Over its nearly three decades of publication this magazine has championed superior design, and it is now in the forefront of periodicals covering this field. PUBLISHED AS *Everyday Art Quarterly* 1–28 (1946–1953).

S122. DIAL. Chicago, and New York. 1–86 (May 1880–July 1929), illus.

One of the leading critical journals in the history of American periodicals, in its early decades this magazine was principally devoted to literary criticism. The editors hoped to provide an intelligent guide and agreeable companion to the book-lover and book-buyer "with a promise to distinguish between literary criticism and literary cynicism." They also intended to add minor departments as the publication grew. One of these later additions was a column on art, which blossomed during the 1920s when the art criticism of Henry McBride made this magazine one of the most influential avant-garde publications in the field of the visual arts. Less traditional types of art were McBride's particular province and his commentary, bolstered by hundreds of illustrations of modern sculpture, painting, and drawing, introduced many major artists to a sympathetic American public. A sampling of these artists includes Gropper, Van Gogh, Stuart Davis, Vlaminck, Nadelman, Zorach, Picasso, Adolf Dehn, and Kuniyoshi. Always a major critical magazine, *Dial* underwent dramatic changes in the period from 1912 to 1920, during which it emerged as the leading voice of progressive arts and literature. Scofield Thayer and James Sibley Watson guided policy in these, its most famous, years. From 1920 to 1925, Gilbert Seldes was associate editor, and Marianne Moore was editor from 1926 to July 1929. With great intuition, Thayer realized the importance of Lachaise, Beardsley, Chagall, Brancusi, Burchfield, and many other significant figures in the development of twentieth-century art. Contemporary poetry, prose, art, theater, and criticism were brilliantly presented in this journal which marks a high point in the history of American magazines. Mott calls the last phase of *Dial* "a ten years' picnic as a literary, artistic and critical organ of modernism . . . an unques-

tioned leader." REPRINT EDITION (New York: Kraus Reprint Co.).

S123. THE DOLPHIN: A PERIODICAL FOR ALL PEOPLE WHO FIND PLEASURE IN FINE BOOKS. New York. 1–4:3 (1933–1941).

Four numbers of this periodical were published by the Limited Editions Club. The first number was subtitled *A Journal of the Making of Books* and was distributed in an edition of only 1,200 copies. The magazine received lavish praise from the critics and the large group of enthusiasts eager to learn more about typography and the arts of the book avidly bought up all the copies. The numbers contained international surveys of fine printing and contemporary bookmaking, articles prepared by typographers and bibliographers, the origin and development of the book, and printing history. Contributors included Philip Hofer, Hellmut Lehmann-Haupt, F. W. Goudy, Dard Hunter, Elmer Adler, and Ward Ritchie. The total result was a brilliant coverage of book arts, with an emphasis on the state of the art at the time of publication.

S124. DOT ZERO. New York. 1–5 (1966–1968).

Published by Dot Zero, this periodical is devoted to layouts, graphic design, exhibition ideas, and other aspects of high-level commercial and communication arts. Mildred Constantine and Jay Doblin were on the editorial board. Some of the contributors and their topics included Bosley Crowther on new film techniques, Kenneth Isaacs on alpha chambers, John Szarkowski on photography, and Harmon H. Goldstone on graphic designs for centers of public transportation. Graphics in mass media was the overall subject of issue No. 3 (1967), and this included paperback books, newspapers, photography, and film. No. 4 (1967) was devoted to world's fairs in general and Expo '67 in Montreal in particular; it discusses exhibition techniques, designs, and purposes for expositions. Transportation graphics was the general topic of No. 5 (1968). It included edited papers originally presented at a symposium at The Museum of Modern Art on Oct. 23, 1967. These articles are of particular value to architects, planners, and engineers, as well as to graphic designers. The magazine shows great skill in its stunning black-and-white layouts printed by offset lithography and using a variety of Helvetica, Italic, and Garamond fonts. The inside back covers usually included concrete poems, which were presented "in a series of visual experiences." Although announced as a quarterly, the magazine appeared irregularly. The profession of graphic arts was well served by this notable magazine, which was designed by Massimo Vignelli.

S125. FINE ARTS JOURNAL: DEVOTED TO ART, MUSIC, AND LITERATURE. Chicago. 1–37 (1899–Sept. 1919), illus.

Art exhibitions in Chicago galleries were regularly reviewed in this magazine, which displayed a conservative approach to the fine arts. In its later years, the subtitle noted that the magazine was *Devoted to the Fine and Decorative Arts, Civic Improvement and to Home Adornment.*

The articles on interior decoration covered "Oriental Rugs in the Home" (Mar. 1918) and lamps, but the topic of decoration was poorly treated. The issue for Mar. 1910 was devoted to a notable collection of American paintings and included 100 illustrations with descriptive captions. Group shows discussed included those by the Chicago Artists Annual, The Artists' Guild, and the Palette and Chisel Club. In 1918, several lengthy articles featured World War I in paintings and posters. Henry McBride occasionally reviewed art shows in New York galleries.

S126. FORMES: AN INTERNATIONAL ART REVIEW. Paris and Philadelphia. 1–33 (Dec. 1929–Mar. 1933), illus.

This periodical, whose subtitle varies, was published ten times a year in two editions, French and English. The intention was to present a "tribunal before which all current theories of art will be freely discussed." The emphasis was overwhelmingly on French art, for the School of Paris was riding the crest of the wave in international art circles. However, there were "foreign" correspondents, and these included A. E. Gallatin writing a New York letter. For a time in 1931, A. Hyatt Mayor was the editor of the American staff, writing four letters from New York that year. In the first he concluded that "Outside New York, little of interest ever happens." An editorial note in 1931 announced a new American slant: "In the future, *Formes* will, every month, give a complete picture of American artistic developments and consecrate copious documentary, critical and photographic space to them." Intentions may have been good, but later issues show nine out of ten pages were still devoted to French artists or exhibitions. In Feb. 1931, A. Hyatt Mayor gave a fascinating account of activity at the New York Art auction house of The American Art Association.

Published by Editions des Quatre Chemins in Paris, the magazine as to physical make-up was exceptional, including a large-font text enhanced by full-page reproductions. Six sanguine drawings by Derain (Nov. 1931) and works by Degas and Picasso were reproduced in facsimiles of remarkably rich tone. A *Special American Art Number* appeared in Jan. 1932, with articles by Waldemar George and Duncan Phillips, among others. The brief American letter by Maurice Sachs in this issue mentions Rousseau, Matisse, Daumier, Degas, and Dufresne, once again emphasizing American dependence upon French art. Beautifully produced with a French and European bias, this magazine reached out for American associations. During the early 1930s it had an influence on the approach in the United States to art history and aesthetics, especially in intellectual circles. Note that issue No. 1 was repeated in numbering but not in contents; there is a No. 1 (Dec. 1929) and a No. 1 (Jan. 1930). *Formes* was SUPERSEDED BY *L'Amour de l'Art* (1934). REPRINT of the American edition (New York: Arno Press), with an index.

S127. FORMS AND FANTASIES. Chicago. 1–2 (May 1898–July 1899), illus.

This was a most attractive art periodical, especially distinguished by the rich, elaborate border designs that appeared on each page of text. Aimed particularly at the field of interior decoration with some attention to architecture, the magazine was published at Steinway Hall in Chicago by the Forms and Fantasies Publishing Co. The purpose of the magazine as stated in the first issue was to "enter the arena inspired with only one wish to please; to create a vehicle upon which one may look with confidence, as worthily in touch with the beautiful, the majestic and the ideal in art life. We shall from time to time, reproduce celebrated works of art, monuments, architectural landmarks and oddities, and artistic bits of decoration here and there The borders surrounding the descriptive Art notes will be changed each month; ninety-six designs appearing in the year's series." Following the pages of text there was a series of sixteen to eighteen pages of clear photographs of contemporary interiors and more designs and drawings for tapestries, stained glass, posters, leaded glass, and floor patterns. Of particular interest are the drawings for a "Ballet Grotesque," by F. Richard Anderson and designs for tombs and their ornamentation by Louis H. Sullivan. With its luxurious border designs, illustrations of interiors, details of ornamentation and decoration, and glimpses of work by Sullivan and Frank Lloyd Wright, the magazine has value to those interested in furniture, architecture, and interior decoration in the American Midwest during the last two years of the nineteenth century. In 1899, the periodical announced a search for "responsible young men in every city, to call upon architects, decorators, builders, designers, etc. and solicit subscriptions." This apparently did not work out, and the resulting lack of subscriptions coupled with an elaborate printing program brought about the demise of the magazine.

S128. GALAXY: A MAGAZINE OF ENTERTAINING READING. New York. 1–25 (May 1866–Jan. 1878).

The subtitle of this magazine points out its purpose, and an article such as "Battling with the Sioux on the Yellowstone," by General Custer, is typical. However, when art articles appeared, they were thorough and thoughtful. The lives and art careers of Bierstadt and Frederic Edwin Church receive attention, and the celebrity of Paul Gustave Doré was such that three articles are devoted to him. Other art topics discussed are portrait painting, Strawberry Hill, the gateways of Central Park, English and French painting, and art at the Centennial Exposition in Philadelphia. The magazine was issued semimonthly (May 1866–Apr. 1867), monthly (May 1867–Jan. 1878). SUPERSEDED BY *Atlantic Monthly*. Complete REPRINT EDITION (New York: AMS Press, 1969).

S129. GODEY'S LADY'S BOOK. Philadelphia and New York. 1–137 (July 1830–Aug. 1898), illus. (color).

This highly successful magazine had an enormous subscription list for its time, with circulation at 150,000 just before the Civil War. Although its content was chiefly fiction, poetry, essays, biographical sketches, and general commentary directed at women readers, its success and subsequent fame were due in large part to the color fashion plates and frequent engravings: a combination that made the magazine "a blaze of beauty throughout."

From the first issue, the fashion plates were a regular feature, most of them hand colored. In 1861, a series of "extension plates" began. These were larger than the magazine's page size and had to be pulled out and refolded, a task that delighted subscribers. Steel and copper engravings appeared in each issue, and by 1870 the magazine had published over 1,000 steel plates using the creative talents of many distinguished engravers, including Pease, Croome, Tucker, Dick, and Rothermel. The mezzotints by Sartain were highly successful on all levels, and these along with countless other plates were removed from the magazine by subscribers and hung on the walls of thousands of homes. A contemporary reviewer for another magazine described *Godey's Lady's Book* as a treasure trove of invaluable material. The parade of nineteenth-century fashions is unparalleled and this magazine's wide influence on popular art taste in America cannot be overestimated. The periodical was most important from 1830 to 1898. PUBLISHED AS *Lady's Book* 1–6, 10–19 (1830–1839); *Monthly Magazine of Belles-Lettres and the Arts, the Lady's Book* 7–9 (1833–1834); *Godey's Lady's Book* and *Ladies American Magazine* 20–27 (1840–1843); *Godey's Magazine and Lady's Book* 28–36 (1844–June 1848); *Godey's Magazine* 126–137 (Oct. 1892–Aug. 1898). SUPERSEDED BY *Puritan.*

S130. GREAT PICTURES: A MONTHLY MAGAZINE OF ART, LITERATURE AND CRITICISM. Chicago. 1–6 [1897(?)–May 1, 1902], illus.

Published by the White City Art Co., the magazine attempted to preach art appreciation. The many nude or seminude studies indicate that the magazine was directed at that vast public interested in salon paintings of the most mediocre type, representing the most sentimental approach to mythological subjects, nudes, and vapid animal and child studies. Nonetheless, the magazine was well produced on glossy paper with excellent black-and-white reproductions. Many of the representations of paintings and photographs are undoubtedly still around in attics and bedrooms of turn-of-the-century houses, and the magazine would be most helpful for identifying these various original works. Some of the titles of the hundreds of reproductions are "Cupid Breaking His Bow," "Winter-Love Grown Cold," "The Bloom of Youth," "Camp Followers," "The Witchery of Melody," and "Bath of Court Ladies." Somehow the editors managed to include quantities of female nudes in each issue, no matter how lofty the articles. Mixed in with a few serious paintings are a multitude of calendar works that tended to be slightly wicked in pose and execution, especially for the time when they were issued.

S131. HANDICRAFT. New York. 1:1–3 (Mar.–June 1872).

Subtitled *A Popular Journal of Progress in the Industrial Arts Designed for Workers and Thinkers*, this slight periodical was issued only three times. Edited by John Phin, and published at 37 Park Row, New York City, the magazine had lofty ideals and long-range plans, all of which were aborted with its early demise. The editor hoped to present original and fresh material, including the following: practical hints for "workers in every department of the

arts," accounts of all new books of a practical character, and a list of "all the prominent articles published in our industrial journals." This listing of articles in other magazines was a worthwhile undertaking, and in a column entitled "Spirit of the Industrial Press" major articles from a dozen English and American periodicals were listed. Primarily aimed at the scientific community of readers, the magazine had occasional articles of interest to fine artists, such as those on ornamental vases, a suburban cottage with a mansard roof, a two-story dwelling with a French roof, and other slight bits and pieces of information. Of nebulous value because of its short duration and technical nature, the magazine nevertheless has some interest as an example of interaction between the disciplines of art and industry in the mid-Victorian era.

S132. HISTORIC PRESERVATION. Washington, D.C. 1— (Mar. 1949—), illus. (color).

Published by the National Trust for Historic Preservation, this periodical started as a mimeographed quarterly report. Over a quarter of a century, it has been notably improved as the association has prospered and expanded. In the spring of 1952, the magazine was first printed in letterpress, and by the 1970s the format had become enhanced with color and black-and-white illustrations of great clarity, and a large font for the text. Tom Engeman is responsible for the design of the magazine, which firmly stresses all aspects of preservation, including subway art, Mark Twain's Connecticut home, American circuses, the Union Terminal in Cincinnati, Renwick's churches, and WPA art. The concise articles on international preservation topics are especially well illustrated. Book reviews and a smattering of letters to the editor are regular features, but no advertising of any kind appears. PUBLISHED AS National Council for Historic Sites and Buildings, *Quarterly Report* (1949–1951).

S133. HOME AND COUNTRY. New York. 1–14 (1885– May 1897), illus.

The publishing history of this magazine is in its complexity typical of art periodicals of the time. Vols. 1–11:2 (1885–Sept. 1895) were published under the title *Home and Country*. In 1895, the magazine merged with *Monthly Illustrator* and from this time forward the new magazine assumed the sequence of volume numbers from *Home and Country*. Thus, vols. 11:3–13 (Oct. 1895–Jan. 1897) were published under the title *Monthly Illustrator and Home and Country*. For the period Feb.–May 1897, nos. 14:1–14:4 were published under the title simply of *Home and Country*. [For annotation on contents and format, *see* S217a.] A lucid summary of this publishing history is given in *National Union Catalogue: Pre-1956 Imprints* (London: Mansell, 1975), vol. 392, p. 401.

S134. HOME DECORATOR: A PRACTICAL MAGAZINE FOR HOME DECORATION. Cleveland. 1–14:10 (1910–1914), illus. (color).

Published by the decorative department of the Sherwin-Williams Co., this little magazine is highly informative concerning house exteriors, interiors, and furniture of the period. There are many color charts and quantities of

suggestions on how to use paint for stenciling and for decorating verandas, screens, wicker furniture, baby carriages, refrigerators, and even curtains. Vol. 1 was printed in an edition of 75,000 copies, quickly sold since the magazine was especially attractive, with excellent, clear photographs and renderings. The drawings of curtains, houses, and individual pieces of furniture are outstanding, valuable to researchers in furniture history and to stage designers. Some particular pieces of furniture illustrated and commented upon include a lawn swing, a magazine rack, den pillows with swastika designs, lampshades, wastebaskets, a bread box, towels for the nursery, a Morris chair, a clothes reel, a wheelbarrow, and even a garbage can painted enamel green. Houses were illustrated in full color, as were individual rooms. Home owners were given "how to" advice in every issue; subjects include cleaning old pewter, removing floor paints, painting the garage, coloring ostrich plumes, finishing a footstool, and brightening up an old rocker.

Contemporary art movements were acknowledged now and then in such articles as one in 1912, which depicted "an attractive living-room in modern style" showing the influence of Frank Lloyd Wright. Commentary for the stenciled decoration of a handbag in 1913 includes the following text: "We are showing this month a saucy little bag, decorated after the Cubist fashion, but made up of the simplest of patterns The color combination is typical of the latest movement that has been puzzling some of the best minds, but which is extremely fashionable with the smart set. Things of this kind are only fads, so that it is not always advisable to put much into them." Considerable attention is given to fenestration, including curtains, draperies, and portieres. The last issue for 1913 included a minuscule (2 x 1 in.) envelope in which eighteen color samples of paints and varnishes were placed. Researchers interested in furniture, interior design, and domestic architecture of the period will find this glorified house publication to be a gold mine of practical and authentic information.

S135. DECORATOR AND FURNISHER. New York. 1–32 (Oct. 1882–Mar. 1898), illus.

This is easily one of the most successful periodicals in the field of American furniture and interior decoration. The oversize pages of this substantial magazine were crammed with useful information, related commentary, and unusually fine illustrations. Early issues featured articles showing the high standard attained in "American factory work" furniture and included long letters from correspondents in Boston, Philadelphia, London, Paris, Cincinnati, Chicago, and Grand Rapids, Mich. Ralph A. Cram wrote in 1882 on "Furnishing Country Houses"; T. M. Clark covered the same topic for city houses. In the first issue, editor A. Curtis Bond urged readers "to examine every page; it will be found that even the advertising pages, in the back, the part of a paper that is so often tabooed by the ordinary reader, contain many hints that will undoubtedly be suggestive and useful." True to his word, the advertisements are copious, clearly illustrated, and crisply printed. A large color plate was included in many issues, and these studies give an accurate concept of

color preferences for house interiors during the 1880s and 1890s.

Venetian blinds, pottery, parquetry, curtains, the laying of linoleum, yacht furnishings, Anglo-Arab furniture, and terms used by decorators are some of the subjects covered in the years 1890 and 1891. Two fascinating articles tell how Mrs. Harrison changed the interiors of the White House (May 1891) and how to decorate and furnish a $1,100 cottage (Apr. 1891). In 1885 considerable space was given over to "Ladies Work in Decoration," and throughout the run of the magazine articles on the art and decorative patterns of Japan and China appear. In Sept. 1885, an unusual three-page article and seven illustrations recorded the façades of New York stores draped in mourning for the funeral of General Grant. Restorers and researchers in American furniture history and interior design will find this magazine to be a treasure trove of illustrations and information in these fields for the final two decades of the late or high Victorian period. PUBLISHED AS *Home Decorator and Furnisher* 31–32, numbered as new series.

S136. HORIZON MAGAZINE. New York. 1— (Sept. 1958—), illus. (color).

While this quarterly is not strictly an art publication by any definition, it regularly includes major articles on visual art subjects. These articles, coupled with superb illustrations ranging from art masterpieces to the best of modern photography, give the publication a definite place on any list of American art periodicals. The color printing is done in Switzerland. The publisher, American Heritage Publishing Co., also produces *American Heritage*, which is somewhat similar in size, format, design, and general excellence. *Horizon Magazine* reviews the civilizations of the world, and delves into history, philosophy, letters, manners, and morals, as well as the arts and archeology. Some of the art topics covered during the magazine's first quarter century are Louis Kahn, Rouault's "Passion Series," Persian art, Marisol's mannequins, crowns, great buildings never built, the nude, Henri Rousseau, Botticelli, porcelain, Goya, drawings of Claes Oldenburg, paintings of Jasper Johns, fashions by Paul Poiret, the photographs of Eugène Atget, and the art of the high Himalayas. In the first issue, the editors pinpointed the purpose of the periodical by noting, "some better guide than now exists in America is needed to the house of culture, with all its thousands of rooms. Never has there been in history such an opportunity to explore this imposing edifice, or so wide an horizon open to our sight. The world is suddenly growing very small, and its treasures are visible to all." The research for illustrations is notable, and the page layouts and reproduction standards in this hardcover, now softcover, magazine are equally fine. Cumulative indexes for three five-year spans (Sept. 1958–Nov. 1963; winter 1964–autumn 1968; and winter 1969–autumn 1973) have been published and issued in hardcover.

S137. HOUSE BEAUTIFUL. Chicago, Boston, and New York. 1— (Dec. 1896—), illus. (color).

The title of this celebrated magazine was derived from

"The House Beautiful," a poem by Robert Louis Stevenson, and the article "the" was part of the official title for the first thirty years of the magazine's history. The early issues were relatively slight, running to twenty-eight pages, including quantities of advertising and short, readable articles aimed at the average householders rather than at the wealthy homeowner. The magazine prospered by attracting attention with a series showing poor taste in the homes of the well-to-do (1904–1905), sponsoring competitions for house plans, and using many color illustrations in the late 1930s. Elizabeth Gordon was the dynamic editor from 1941 to 1964, and under her guidance the magazine's circulation soared to 900,000. She often presented a particular theme, which was fully developed in a single issue, such as house remodeling or *shibui*, the Japanese concept of design. By its seventy-fifth year, issues frequently ran over 200 pages, with heavy emphasis on seasonal material: wedding interests in June, Christmas and Thanksgiving topics in the appropriate months, patios, and outdoor living for the summer months, all illustrated with abundant color layouts. The section "Window Shopping," which regularly contains over thirty pages, is a mail-order catalog of advertisements from retailers, and provides absorbing reading for thousands of readers. Frank Luther Mott provides a full summary of the history of this periodical in vol. 5 of his monumental *A History of American Magazines, 1741–1905* [S·XX]. ABSORBED *Indoors and Out* (1908); *Modern Homes* (1909); *American Suburbs* (1912). PUBLISHED AS *The House Beautiful* (1896–1924); *House Beautiful combined with Home and Field* (Jan. 1934–Oct. 1943).

S138. HUMPHREY'S JOURNAL OF PHOTOGRAPHY AND THE ALLIED ARTS AND SCIENCES. New York. 1–21 (Nov. 1, 1850–July 15, 1870).

When this magazine began, S. D. Humphrey, editor and publisher, wrote with enthusiasm as follows: "Our bark is launched, and sails unfurled, and we are on the broad sea of Journalism A lack of pride among Daguerreians is one of the greatest disadvantages our art labors under . . . Daguerreian Artists! We hail you as brothers." This was America's first photographic journal, and it contained original articles along with extracts from foreign publications; pertinent, instructive, and newsy publishers' notes; and correspondence and extraordinary advertisements. The articles were frequently of a highly technical nature, relating to preparing the plate, the ferrotype (or tintype) process, polishing plates, and the use of acids and chemicals. The issue for Oct. 15, 1851 describes the formation of the American Daguerre Association in New York with a constitution that hoped "to create in America, a higher standard of taste in the Heliographic art, and to bring the Artists of our country in closer and more friendly intimacy." The advertisements, of value to American photographic history, include announcements of firms in New England, New York City, Troy, N.Y., Cincinnati, and Philadelphia and a register of daguerreotype artists in the early years of the magazine. Contributors notable in the development of photography included Thomas Sutton, H. P. Robinson, A. Bellac, Gustave LeGray, and F. T. Hardwich. PUB-

LISHED AS *The Daguerreian Journal; Devoted to the Daguerreian and Photogenic Art* 1–3 (1850–Dec. 15, 1851); *Humphrey's Journal of the Daguerreotype and Photographic Arts* 1–13 (Apr. 1852–Apr. 1862); *Humphrey's Journal of Photography and the Heliographic Arts and Sciences* 14 (May 3, 1862–Apr. 15, 1863).

S139. ILLUSTRATED MAGAZINE OF ART. New York and London. 1–4 (Jan. 1853–Dec. 1854), illus. 3–4 also new ser. 1–2.

True to the promise in the title, this magazine was abundantly illustrated with hundreds of engravings throughout the four volumes, whose contents were decidedly keyed to Continental and British art interests. A series "with some of the choicest treasures of Art, in the shape of specimens of the Works of Great Masters" was featured, and some of the artists covered in picture and text were Sebastian Bourdon, Albert Cuyp, Joseph Vernet, Edwin Landseer, Adrian Van Ostade, J. Louis David, and J. B. Oudry. Vol. 2:9 (1853) includes a notable article of fifteen pages and a foldout plate on "The American Crystal Palace" complete with statistical tables and charts. By 1854 the editors complimented themselves for providing several well-written and richly illustrated articles on subjects of interest to every citizen of the United States: American art, bank-note engravings in America, American scenery, John James Audubon, the machinist and bank-note engraver Cyrus Durand, and the great sculptor Hiram Powers. In vol. 3:13 "Photography as a Fine Art," the lead article, concluded, "Although Photography dates its existence but fourteen years back, its progress has been wonderfully rapid, considering upon how delicate and refined a series of observation its development is based." Although printed in New York City, the magazine was more directly concerned with European subjects. London Bridge, Napoleon's tomb, and the Doria Palace in Genoa were more typical topics covered in illustration and text, leaving little space for American themes. The subtitle of this journal is *Containing Selections from the Various Departments of Painting, Sculpture, Architecture, History, Biography, Art-Industry, Manufactures, Scientific Inventions and Discoveries, Local and Domestic Scenes, Ornamental Works, etc.*

S140. ILLUSTRATED WOOD WORKER. New York. 1 (Jan.–Dec. 1879), illus.

This tidy little trade journal was issued from New York by Charles D. Lakey, publisher of *American Builder*, who offered this magazine free to subscribers for one year. For others, the cost was one dollar per year. Prefatory remarks in the first issue noted, "Three hundred thousand workers in wood confess the want of a cheap illustrated journal Every man who feels rich enough to subscribe for this journal may depend on getting the full worth of his money." The magazine's content was aimed at workmen ("men at the bench") rather than at employers. It is neat in appearance and carefully edited, with clear cuts for illustrations. Articles covered isometric projection, practical carpentry, geometry, care of shop tools, oak graining, imitation marble, and a schedule of daily wages for woodworkers as reported from a dozen

cities in June 1879. There were drawings and plans for chairs, mantels, bay windows, newel posts, railings, bookcases, sideboards, details of Swiss architecture, and all manner of related objects. The final issue included comments relating to the success of the periodical's first year. All issues include material highly relevant to those engaged in restoration work and concerned with wood furnishings of the mid-Victorian period in America. Subtitled *For Joiners, Cabinet Makers, Stair Builders, Carpenters, Car Builders, etc.* SUPERSEDED BY *American Builder*, later *Architect, Builder, and Woodworker* [S34].

S141. IMPRESSION: A MAGAZINE OF THE GRAPHIC ARTS. Los Angeles. 1–4 (Sept. 1957–Sept. 1958), illus.

Four issues of this promising magazine devoted to original prints and drawings were published under the editorship of Jules Heller, artist and author of *Printmaking Today* (New York: H. Holt, 1958). Issues were slightly over thirty pages long and evidenced thoughtful consideration of page layout and general design. In the first number, Heller commented as follows on the hopes of the staff: "In some quarters we are regarded as 'rash young men' for venturing into the field of publications; for the record, we are a serious group of professionals who strongly believe that the people of our country will respond to and support an art magazine that offers a variety of approaches to the arts, an art magazine that has something 'new' for . . . the reader [including] analyses, interviews, reports, illustrations, reviews of books, surveys of print collections and other exciting and stimulating features." Feature articles with illustrations appeared on the work of Ben Shahn, Eugène Carrière, Antonio Frasconi, and Minna Citron. Survey articles commented on contemporary printmaking in Norway and Great Britain and the papermaking of Douglas Howell. The advisory board of the magazine was distinguished, including Gibson Danes, Vincent Price, Jean Renoir, and Peter Selz. Just as the magazine began to have cumulative value and an identity of its own, however, it ceased publication because of financial difficulties.

S142. INDEX OF TWENTIETH-CENTURY ARTISTS. New York. 1–4 (Oct. 1933–Apr. 1937).

The Research Institute of the College Art Association began this comprehensive listing to fill a large gap in information covering artists of the time, with the intention that the material would be useful "in the compilation of catalogues, the writing of books, the studying of contemporary art history, etc." Their purpose was brilliantly fulfilled by the monthly issues, which eventually covered one hundred and twenty artists (eighty-nine painters, twenty-eight graphic artists, and twenty-four sculptors). The entry for each artist included the following: a succinct biographical account; a listing of awards and honors along with professional affiliations; a record of public collections covering works by the artist with an indication of location and title; a chronological listing of large annual one-man, foreign, and special exhibitions; a full bibliography including separate listings for books, catalogs, encyclopedias, bibliographies, dictionaries, magazine articles, and monographs; and finally a list of

reproductions. As new material appeared on artists previously covered, supplementary data was published to bring the material up to date. Many of the artists are in the top rank of American art, and their work assured the richness of our visual heritage. A small group of editors and researchers accomplished a near miracle of bibliography in this index. REPRINT EDITION (New York: Arno Press, 1970) [I·4] in one volume with a specially prepared index covering all volumes, in the Contemporary Art Series edited by Bernard Karpel.

S143. INLAND ARCHITECT AND NEWS RECORD. Chicago. 1–52 (Feb. 1883–Dec. 1908), illus.

This magazine was devoted to architecture, construction, decoration, and furniture in the West and showed many new buildings in Illinois, Colorado, California, and Missouri. Philadelphia and New York structures were sometimes covered, as were occasional structures in Hawaii or New Orleans. The text on any particular subject was not lengthy. Articles described technical problems, new developments in construction techniques, and important new buildings such as banks, hospitals, homes, libraries, office buildings, and hospitals. The issue for Aug. 1905 includes an exterior view of a new Frank Lloyd Wright house in Oak Park, Ill., but there is no mention of it in the text beyond a contents listing. The illustrations are large and clear and include renderings, drawings, and photographs. The magazine concentrated on new Western architecture and therefore is important in that it showed the extraordinary expansion, prosperity, talent, and energy that went into buildings in the great cities of the western United States in the late nineteenth century. Published by the Western Association of Architects. PUBLISHED AS *Inland Architect and Builder* (1883–1887). SUPERSEDED BY *American Architect and Architecture* [S4].

S144. INTERIOR DESIGN. East Stroudsburg, Pa. 1— (Apr. 1932—), illus. (color).

This magazine was originally published and edited by Harry V. Anderson under the auspices of the American Institute of Decorators. The first issue consisted of four pages of advertising and eight pages of editorial content. Within two years, 3,200 decorators received the periodical each month, and it was enlarged to include twenty-eight pages of advertising and twenty-eight of editorial matter. Each issue included authoritative articles on furniture and interior design, advertisements from reliable dealers and suppliers, and national news from the American Institute of Decorators and its many state chapters. Stressing the fact that the magazine was aimed squarely at the professional decorator, editor Anderson wrote in 1937, "Let me repeat again that this magazine will never be sold at newsstands and that it is edited exclusively for you as a designer of interiors." The small-scale issues of the 1930s are peppered with quantities of black-and-white illustrations reflecting all aspects of the Art Deco style and concerning furniture as well as commercial and domestic interiors. Researchers needing authentic settings and designs for the 1930s will find excellent visual material here. [*cont.*]

By the 1950s, the page size was greatly enlarged and issues were expanded under the continuing guidance of Anderson. In June 1955 he wrote to subscribers concerning the aims and philosophy of the periodical: "Since its founding in 1932, the objective has been—then and now—to help interior decorators as individuals in their daily jobs in creating fine interiors, and to help them develop collectively on a high-professional plane The magazine itself has meanwhile grown within the framework of the interior decorating profession. We have carefully avoided catering to allied professional groups—such as the architects or individual designers—who are served by their own professional magazines." He also pointed out that his magazine was the first to spotlight the importance of the nonresidential, or contract, field of decorating. Still published exclusively for the professional designer, the magazine reveals the growing stature and importance of interior design. Throughout the late 1950s and 1960s, the magazine reflected unparalleled worldwide prosperity with products and lavish interiors splashed across pages vibrant with color spreads. Subscription orders in the 1970s required basic information on each subscriber's area of professional responsibility in the field of interior design, architecture, or industrial design. The magazine serves the trade with new sources and installations covering the whole spectrum of contract and residential interior design. PUBLISHED AS *Decorators Digest* (1932–1936); *Interior Design and Decoration* (Jan. 1937–Nov. 1950). SUSPENDED (May 1942–Mar. 1949).

S145. INTERIORS. New York. 1— (1888—), illus.

For the past thirty years, this magazine has been written for professional interior designers, architects and industrial designers who offer interior design services, and the interior decorating departments of retail stores. In the earlier days as *Upholsterer* the emphasis was on springs and horsehair. Gradually the magazine changed and came of age as the profession of interior designing became more diverse, demanding, and respected. The issue for Nov. 1960 provided a panorama in text and pictures of the dramatic changes in furniture and interiors over the decades. The thirtieth anniversary issue for Nov. 1970 featured the work of twenty-two progressive designers, underscoring the fact that the magazine has set the pace for the future of the profession. The value of the magazine is greatly enhanced by scholarly articles on building subjects such as The Octagon, a historic house in Washington, D.C., and periods of major importance in design development. Regular features report market news in depth, developments in the profession, book reviews, a wealth of advertisements, and exceptional photographs and line drawings, many prepared especially for the magazine. PUBLISHED AS *Upholsterer* 1–93 (1888–Jan. 1935); *Interior Decorator* 94–100 (1935–1940).

S146. **International Art-Union,** JOURNAL. New York. 1:1–10 (Feb.–Nov. 1849), illus.

The International Art-Union opened in Dec. 1848 at 289 Broadway in New York. Its purpose was to promote the "taste for the Fine Arts in the United States of America,

by introducing through the means of a perpetual Free Gallery, the chefs d'oeuvres of the European School of Art." It was published by Goupil, Vibert & Co., also the managers of the International Art-Union. The first issues included a plan of the association, a catalog of the paintings and other works of art on exhibit, and a list of honorary secretaries in the District of Columbia, Maine, Maryland, Massachusetts, New York, Vermont, and Wisconsin. There was also a listing of the names of 120 members and the committee of reference, which included Washington Irving and Asher B. Durand. A separate note on page four of the first issue states: "The idea of the first Journal devoted exclusively to the Fine Arts ever projected in the United States, belongs entirely to the International Art-Union—as the advertisement for the present number . . . appeared in the Catalogue of the Institution, for January, 1849." The objectives of the magazine were "simply to diffuse among all classes, in a cheap form, knowledge of the Fine-Arts, and those who have produced them; to present monthly, a biographical sketch of some distinguished artist with such notices of the goings-on in general in the world of art as we may be enabled to collect The almost incredible rapidity with which a taste for the Fine-Arts and a love of the beautiful are developing themselves in this country, and especially in New York, seems to us to require some recognized publication devoted exclusively to such interests."

The little pioneer magazine sold for six and one-quarter cents per copy, listed the name of the secretary from the District of Columbia under Delaware, and included a biographical sketch of Henry Inman in No. 1. Later sketches covered the lives and works of Ary Schaffer and Paul Delaroche. There was news from art organizations in Providence and Philadelphia. It appears that the journal quickly became a veritable house organ, listing and promoting the prints sold by Goupil, Vibert & Co. Its relatively brief appearance was probably due to this one-sided and slanted objective. However, the art news, occasional illustrations, and brief articles combined to produce an authentic art periodical. Its importance is largely due to the early date of publication and a pioneering attitude toward the visual arts.

S147. INWHICH; BEING A BOOK IN WHICH WE SAY JUST WHAT WE THINK. Detroit. 1–18 (June 1915–Nov. 1916).

Edited by Norman Bel Geddes, this little magazine commented on various subjects and proposed to publish "the newest and best ideas in art to those who understand and are striving to realize its connections with life."

S148. IT IS: A MAGAZINE FOR ABSTRACT ART. New York. 1–6 (spring 1958–autumn 1965), illus. (color).

Edited by P. G. Pavia, *It Is* was devoted to Abstract Expressionism and representative of the Eighth Street Group, containing articles and illustrations of work by major artists in these movements. Sculpture and painting are illustrated in many halftone and color plates, providing an accurate view of the important New York activi-

ties of the late 1950s and early 1960s. SUSPENDED spring 1960–summer 1965.

S149. JOURNAL OF AESTHETICS AND ART CRITICISM. New York. 1— (spring 1941—).

This quarterly was originally published by the Philosophical Library in New York and later by the American Society of Aesthetics, which was organized in 1942 for the advancement of philosophical and scientific studies of the arts and related fields. The magazine, issued without illustrations, is now under the dual sponsorship of Wayne State University in Detroit and the Cleveland Museum of Art. Editors and contributors cover the whole range of aesthetics on an international scale, writing articles and book reviews on film, music, theater arts, and occasionally American visual arts. A sampling of American topics includes "The Aesthetics of Horatio Greenough in Perspective," "The Art Museum and the American Scene," "Dewey's Aesthetics," and "American Painting in the 1960's." The lead article in the first issue was written by the late Thomas Munro of the Cleveland Museum of Art. Thirty years later in 1971, Munro was still serving the magazine as contributing editor and presenting a prime example of durability and dedication. Books were reviewed in all issues from the beginning, yet over the years the selection has become more comprehensive. Reviewers are usually college or university faculty; occasionally a candidate for an advanced degree has an opportunity to publish the results of his research. The periodical is indexed in *Music Index* and *Psychological Abstracts*.

S150. JOURNAL OF GLASS STUDIES. Corning, N.Y. 1— (1959—), illus.

Published by The Corning Museum of Glass, this annual records "discoveries, interpretations, acquisitions and publications which affect the art and history of glass making." The editors emphasize scholarly articles on European and Oriental glass and accounts of archeological finds relating to glass. American glass is covered in occasional articles such as those on Jamestown wine bottles, the Glastonbury Glass Factory, the Ontario [N.Y.] Glass Manufacturing Co., and New England pressed glass. Each issue includes an illustrated list of important acquisitions in public and private collections in the United States and abroad and a checklist of articles and books on glass, including a section for American entries. The *Journal* is handsomely printed with superb photographs, drawings, and charts.

S151. KENNEDY QUARTERLY. New York. 1— (Dec. 1959—), illus. (color).

Established in 1874 as a gallery of fine prints, over the decades Kennedy Galleries added American painting and sculpture to its areas of specialization. This periodical, which made its initial appearance during the firm's eighty-fifth year, provides a valuable survey of American visual arts. Although its function is to display items on sale at the gallery, it provides researchers, curators, and collectors with quantities of reproductions and reliable information. Originally approximately forty pages, the contents were expanded until issues ran to seventy or eighty pages by 1970. Reproductions appear on nearly every page. The data describing individual works is exceedingly valuable; for instance, the dimensions of prints and paintings are nearly always given. Major gallery exhibitions are frequently documented in issues that are virtually scholarly catalogs of a particular facet of American art: *The Fabulous Peale Family* (June 1960), *Western Themes* (June 1969), *American Primitives* (Dec. 1969). Other special issues are devoted to American portrait subjects: early American views dating from 1700 to 1880; three centuries of seafaring in prints, paintings, watercolors, and drawings; artists of the Civil War; the Civil War in prints; and the bronzes of Charles Russell. The magazine is written and edited by Rudolf G. Wunderlich. American art historians can only regret that the *Kennedy Quarterly* was not launched earlier in the firm's history. Julia E. Sabine of the Newark [N.J.] Public Library prepared indexes for the first eight volumes: vols. 1–4 (Kennedy Galleries, 1964); vols. 5–8 (Kennedy Galleries, 1970). By 1970 *Kennedy Quarterly* included an index by names of artists in the front of each issue, which serves as a basic list. In Jan. 1974 the page size of the magazine was increased and substantial issues continue this scholarly presentation of America's visual arts. Through it the gallery makes a lasting contribution to the museum and academic worlds. *Supplement: Kennedy Miscellany* (Aug. 1965—).

S152. KNICKERBOCKER; OR, NEW YORK MONTHLY MAGAZINE. New York. 1–66 (1833–Oct. 1865).

Throughout the magazine are articles or, more frequently, fragmentary editorial notes on art events and opinions. Reviews of exhibitions, and feature articles—such as "A Word on Original Paintings"—appeared. In Nov. 1839 an article began with the ominous sentence, "We are not among those anxious to see an American School of Painting," but went on to encourage institutional collections. An Allston exhibition in Boston in 1839 is reviewed in depth, as is the state of the fine arts in America in 1833 and 1839. PUBLISHED AS *Knickerbocker Monthly* (1863–Feb. 1864); *American Monthly Knickerbocker* (Mar.–Dec. 1864); *American Monthly* (Jan.–June 1865); *Federal American Monthly* (July–Oct. 1865).

S153. KNIGHT ERRANT: BEING A MAGAZINE OF APPRECIATION. Boston. 1:1–4 (Apr. 1892–Jan. 1893).

Printed quarterly for the proprietors of the Elzevir Press in an edition limited to 500 copies, this superbly printed magazine was modeled after the English publication *Hobby Horse*. The ideals of the Pre-Raphaelites were championed in text and illustrations that beautifully echoed the special sentiments of the aestheticians of the time. Ralph Adams Cram contributed several articles and verses, Bernard Berenson wrote on Correggio's paintings in Dresden, Hugh McCulloch, Jr., commented on Verlaine's verse, and Francis Watts Lee, who held the copyright for the magazine, expressed his thoughts on "The Beauty in Typography Suggested by the Work of Mr. William Morris at the Kelmscott Press." The headpieces and tailpieces, initial letters, occasional vignettes, top grade

paper, and the illustrated border for the cover all reveal an appreciation for and a debt to the cult of quality craftsmanship proclaimed by William Morris. The rising interest in Japanese art as well as in all Oriental art was reflected in several articles, including one by Ernest Francisco Fennellosa. Verses appeared in each of the four numbers; the poets included Bliss Carman, Richard Hovey, and Beatrice Witte. The final pages of No. 4 contained pertinent commentary on several new periodicals including the *Dial* [S122], the *Yellow Book,* and the new *Hobby Horse.* At the completion of vol. 1 the editors, still hopeful, enclosed a subscription form for vol. 2, which was to appear in Jan. 1895. A separate epilogue noted that it had "made a handsome showing in spirit and in attire. As a spectacle, it has been a success; as a business venture, which it vehemently disclaimed to be, it has naturally and consistently gone under." The magazine is a landmark in the history of fine printing in America; the experiment, however brief, was successful.

S154. LANDSCAPE ARCHITECTURE. Harrisburg, Pa., and Boston. 1— (Oct. 1910—).

Here is another quarterly representing a discipline and profession that grew along with the development of our nation. The magazine, published by the American Society of Landscape Architects, was founded to provide landscape architects with "some means of keeping in touch with their fellow workmen—some common meeting-ground for exchange of ideas and discussion of points of difference." The articles were to deal with the beauty of humanized landscape, containing illustrations of "ground-form and building and foliage-mass." Over the years, articles have appeared on all aspects of landscape architecture, including city planning, tidal marshes, plants and trees, lawn sprinklers, housing, fences, hillside development, monuments, parks, playgrounds, streets, ramps, war memorials, and irrigation. During World War II, timely articles covered camouflage and highways for defense. Biographies of major American landscape architects appeared regularly, often as obituaries of individuals who were long-time members of the society. The first issue leads off with an article by Frederick Law Olmsted on "Street-Traffic Studies"; fifty years later (in 1960) Olmsted was the subject of articles emphasizing his importance to the discipline. Changing interests were quickly reflected in the magazine's content. In recent years, considerable attention has been given to ecology and its many ramifications. Street furniture, conservation, shopping plazas, mobile homes, suicidal urban sprawl, environmental design, and airport landscaping are postwar topics that appear in text and illustrations with regularity. From the beginning, the magazine has carried thorough book reviews by experts in the field. The international coverage has been expanded; sites, structures, designs, and plans from Asia, Africa, and Europe have appeared more frequently since 1950. The magazine accurately reports all aspects of landscape gardening that have occurred over the decades and reflects the increase in America's concern for the out-of-doors and an appreciation of landscaped beauty. The publisher has issued an index for vols. 1–20 (1910–1930).

S155. LIFE. Chicago. 1–73 (Nov. 23, 1936–Dec. 15, 1972), illus. (color).

This was the greatest of the mass-audience picture magazines; its impact on the American public was unprecedented, especially during its first decade. Some of the photographers working for the magazine produced unquestionably great photographs, which rank among the finest ever made. Life often published stories on art subjects; according to the original prospectus an aim of the publication was "To see life . . . to see man's work— his paintings, towers, and discoveries . . . to see and take pleasure in seeing." Major art articles present lavish full-color reproductions along with highly readable texts prepared by a staff of editorial experts. Millions of adult Americans received some measure of art education by poring over the issues, which came out weekly for over a third of a century. The international world of art of all periods was covered with superb layouts on historic periods such as colonial America, the Renaissance, and the Middle Ages. Picasso, Michelangelo, and Bernini were given royal treatment. Particular artists were commissioned for specific assignments, and during wartime the magazine sent artists to paint and draw in combat areas. The art scope was overwhelming, encompassing dolls, geodesic domes, the Mona Lisa, Persepolis, the Pope's tiara, Grandma Moses on her 100th birthday, photographs of Garbo, the Gibson Girl, illustrations of Winnie-the-Pooh, and the Bay Psalm Book. Indexes for 1936 to 1963 including the listing "Art in Life" provide the key to a remarkable archive of reproductions. The magazine was ultimately the victim of the television tube, an unending kaleidoscope of photographs giving viewers a *déjà vu* feeling for still photograph magazine layouts. Historically, it absorbed the name of the old *Life* (1883–1936), but its policy took a new pictorial direction and fresh spirit beginning with the first imaginative issue.

S156. LIMNER. New York. 1:1–6 (Feb.–July 1895), illus.

This small, attractive magazine was published by and for students at the Art Students League of New York. The covers, characterized by bold silhouettes inspired by Aubrey Beardsley, are quite effective. It was noted in the first issue that each of the instructors at the Art Students League had agreed to write an article for the magazine and that two of these special articles would appear each month. There were also letters from Paris and Munich and supplements, consisting of two pages of representative drawings, from two art schools in the country. The first advertising cartoon to appear in the periodical was signed by J. M. Flagg. The three students who began and edited the magazine were E. P. Upjohn, P. C. Pentz, and E. O. Wardell. Edward Penfield discussed posters, Kenyon Cox wrote on constructive drawing, and Louise Cox wrote on the question "Should Woman Artists Marry?" The advertisements were neatly arranged at the back of each issue, and there was detailed news from other art schools. Some of the instructors at the school at the time were notable American artists such as George de Forest Brush, Augustus Saint-Gaudens, J. H. Twachtman, and J. Alden Weir. With this in mind, this experimental pub-

lication from a noted art school has particular merit. SUPERSEDED BY *Art Student and the Limner* [S75], but continued (nos. 7–126) as a section of the latter publication.

S157. LITHOGRAPHIC ART JOURNAL. New York. 1:1–52 (July 1890–July 27, 1891).

This was a weekly publication for the lithographic trade in the United States and Canada. It was published by the Lithographic Art Journal Publishing Co., New York, with George H. Davis as managing editor. Most of the issues were slight, running from four to eight pages and containing brief commentary on new technical developments in the trade, a listing of United States patents, advertisements for new lithographic presses and other large machinery, and letters to the editor. The attractive headpiece depicted Senefeleer, the inventor of lithography, enshrined in a splendid grouping of small figures, including herms and putti buttressed by appropriate vignettes. Now and then a color page appeared, but this was nearly always an advertisement. This period of tremendous technical progress in the printing arts resulted in innovations whose products ultimately appeared in art publications and in reproductions of paintings. The journal preserves some of the excitement of the time as well as providing a record of developments in the lithographic trade during the early 1890s in New York.

S158. LITHOPINION: THE GRAPHIC ARTS AND PUBLIC AFFAIRS JOURNAL OF LOCAL ONE. New York. 1–10 (1965–1975), illus.

This quarterly was jointly sponsored by Amalgamated Lithographers of America, Local One, and by lithographic employers, as represented by The Metropolitan Lithographers Association. *Lithopinion* was "devoted to experimentation in the arts that are graphic and to the elucidation of the changing patterns of public affairs." The layouts included collages, drawings, photographs, and maps, designed with imagination and skill. Art topics receive frequent coverage; the article "Weathervanes: Native American Sculpture" (summer 1973) is a sixteen-page survey of the subject typical of the outstanding pictorial work and frequent American themes found in the magazine.

S159. THE LITTLE REVIEW: LITERATURE, DRAMA, MUSIC, ART. Chicago, New York, and Paris. 1–12 (Mar. 1914–May 1929), illus.

This apparently modest journal, edited over its fifteen years of existence by Margaret Anderson, had a tremendous influence on American art and literature. In the beginning years references to the visual arts, such as comments on the Futurists, are brief and unexciting. Later, the commentary and photographs on art subjects became more significant. Such major figures as Gertrude Stein, Tristan Tzara, Jean Cocteau, and Man Ray wrote for the magazine. Ezra Pound, foreign editor from 1917 to 1921, described Brancusi's sculpture in autumn 1921; in 1922 an issue was devoted to Joseph Stella and his work with a special portrait photo of Stella and Duchamp taken by Man Ray. Guillaume Apollinaire's "Aesthetic Meditations" of 1913 concerning the Paris avant-garde were

translated in part. Hemingway, e. e. cummings, Fernand Léger, Louis Aragon, Arp, and Picabia, wrote for the periodical. The issue for autumn 1924–winter 1925, widely celebrated as the *Juan Gris Number,* contains commentary by major figures from twentieth-century literature and art. Once it hit its stride, the magazine became avant-garde and it is an extraordinary record of the genius of its editor and of the creative period it so brilliantly documents in its final issue, May 1929. The review was published in New York after 1917. SUSPENDED (autumn 1926–Apr. 1929). Subtitle varies, appearing as *Quarterly Journal* or *International Journal of Arts and Letters.* REPRINT EDITION (New York: Kraus Reprint Co.).

S160. LITURGICAL ARTS: A QUARTERLY DEVOTED TO THE ARTS OF THE CATHOLIC CHURCH. Concord, N.H., and New York. 1–40 (Oct. 1931–May 1972), illus.

This quarterly was published by the Liturgical Arts Society in New York City, whose purpose was to devise ways and means for improving the standards of taste, craftsmanship, and liturgical correctness in Catholic art in the United States. The editor was Maurice Lavanoux, a specialist in church art who was born in Greenwich Village in New York, went to school in France, and studied to become an architectural draftsman. In his obituary in the *New York Times* for Oct. 23, 1974, it was noted that Lavanoux "waged a determined campaign against what he called imitative, tasteless or unimaginative church art The idea for *Liturgical Arts* . . . took shape in 1928 when, one weekend, a group of clergymen, artists and architects complained about pseudo-Gothic buttresses, gaudy plaster statues and ready-made altars ordered from a catalogue." The editorial in the first issue noted that during the long missionary phase of the Catholic church in the United States, there was no time to concentrate on "the shaping of the material temple." Finally, by 1931, conditions were ripe for architects, artists, and clergymen to establish a publication that would give direction and education in artistic liturgical matters. The editorial policy was established to cover the following topics: the relation of the arts to the worship of the church; the history of Catholic art; detailed descriptions of the liturgical requirements governing the construction and decoration of churches; examples of outstanding modern work, particularly in America; and bibliography in the field.

Over the years the subject of religious art was well served with articles and illustrations on architecture, painting, crafts, heraldry, church music, sacred vessels, vestments, stained glass, and all manner of ecclesiastical topics. Unusual subjects such as chapels in auto trailers, churches at sea, the Hiroshima Memorial Church, and acoustics for the mass sometimes appeared, and the works of major modern artists including Jean Lurçat, Meštrović, Matisse, and William Congdon were covered. Of special merit were the thousands of crisply clear photographs, sketches, and drawings and the hundreds of book reviews, which were generally thorough in coverage and pertinent to the interests of readers. The magazine was basically a one-man operation with Lavanoux at the helm, for he served not only as editor, but also as adver-

tising manager, subscription director, and file clerk. The final issue noted that new subscribers were sorely needed and that the magazine was "in the position of a floor lamp that could bring a blazing liturgical light to many if only we could connect to the base plugs." The fortieth anniversary issue in Nov. 1971 included a partial list of contents for four decades. This abbreviated index reveals that the magazine had printed 567 articles, 615 reviews, many bibliographies on Africa and Ireland, and included coverage of architecture in thirty-seven of our fifty states. The magazine, loyal to its stated purpose, presented a rich record of official Catholic church art for the long span of its existence. REPRINT of vols. 1–20 (1932–1952): (Kraus Reprint Co.).

S161. LOCATION. New York. 1:1–2 (spring 1963–summer 1964), illus.

This periodical began as a pairing of art and literature and was a project of the Longview Foundation, which conducted the Creative Arts Program of the Edgar Stern Family Fund of New Orleans. The Arts Selection Committee of the foundation included Willem de Kooning, Adolph Gottlieb, Philip Guston, Hans Hofmann, and Gordon M. Smith. The editors were Thomas B. Hess and Harold Rosenberg, and under their direction the magazine provided a unique blend of the visual arts and literature. Painters and sculptors were invited to write about their work and to widen their description to include politics, ethics, and literature in an effort "to make the American art world the most important place in postwar international culture." In the first number, Larry Rivers wrote about his collaboration with poets in lithographs and paintings: how a word became a shape and how a color changed a word. Other features to the first issue were a group of photographs by Robert Rauschenberg, drawings on the nose problem by Saul Steinberg, and contributions by Willem de Kooning, Marshall McLuhan, and sculptors Robert Mallary and Reuben Nakian. The second issue, which appeared over a year later, included an equally distinguished list. Adolph Gottlieb produced some postcards, Hans Namuth photographed Willem de Kooning, Reuben Nakian produced a series of erotic drawings featuring a faun, photographs of Ray Johnson's collages were presented, Esteban Vicente wrote on painting, and David Hare wrote an appreciation of the work of William Baziotes. There were many illustrations in the magazine, organized "to focus on certain aspects of the artist's work that will reflect something of the logic and direction of his enterprise—in a necessarily limited way, because reproductions are amputee versions of the original." The magazine attempted to revive the spirit of reproductions for art's sake. It presented unique material including poetry, prose, criticism, original statements, and illustrations of major new works by contemporary American artists.

S162. LOS ANGELES INSTITUTE OF CONTEMPORARY ART, JOURNAL. Century City, Calif. 1— (June 1974—).

The institute opened in the ABC Entertainment Center in Century City in September of 1974, and announced that the journal would be published six times per year and that it would make a positive contribution "to the nation's second art city." The initial issue included interviews with artists, statements by artists, and a sizable selection of art-related advertisements from firms and organizations in southern California. A two-page chart of art galleries in Los Angeles from 1963 to date is of special interest as is a chronological record of meetings, ideas, and individuals responsible for the evolution of the institute. The periodical's first editor was Fidel Danieli. Apparently the future of this periodical is tied to the development of the new institute, which plans art exhibition programs.

S163. LOTUS MAGAZINE. New York. 1–11 (May 1909–Mar. 1920).

Edited by Gustav Kobbe, this periodical was originally published by the Authors' Bureau of Babylon, N.Y., and later by the Lotus Magazine Foundation in New York. The early issues include classic page layouts, handsome printing vignettes, and ornamentation. The art of Whistler, especially his "Nocturne in Black and Gold— The Falling Rocket," was featured in 1910, along with a poem on "Mr. Frick's Rembrandt" and a thoughtful review of a major rug exhibition at The Metropolitan Museum of Art. By Nov. 1913, the editor had adopted a lofty tone, describing the magazine as the "exclusive publication of the aristocracy of America Privately printed, it is issued only to its Patrons and their families, and to such of their exclusive clubs, societies and friends as have been designated by them to receive the magazine It does not print the fashion pictures, as its women patrons set the fashion *The Lotus* is the treasured magazine of the wealthy, refined and cultivated families of the United States; and for it to be seen in the Library of the man, or on the boudoir table of the woman, is an evidence of the wealth, position and importance of the family." Original patrons included J. P. Morgan, Otto H. Kahn, Henry C. Frick, George W. Elkins, P. A. B. Widener, and two Huntingtons. Advertisements tastefully promoted the firms of Worth, Colnaghi, Steinway, Brentano's, Cartier, and the New Midland Adelphi Hotel in Liverpool. Articles appeared on polo, the Metropolitan Opera, sporting prints, and news of the major museums. In a sense, the magazine reflects the cultural and leisure interests of the extremely wealthy new group of families who copied British and Continental taste in the visual arts. PUBLISHED AS *Lotus* (May 1909–Aug. 1911); *Art and Life* (1917–Mar. 1920). SUPERSEDED BY *Art and Archaeology* [S46].

S164. **Macbeth Gallery,** ART NOTES. New York. 1–88 (Oct. 1896–1930), illus.

The Macbeth Gallery specialized in American art during a time when the number of collectors in that field was exceedingly limited. This compact periodical was "published in the interest of the Macbeth Gallery" and presented news of the gallery's exhibitions and items of interest concerning artists. Over the decades the contents included material on many leading painters such as Blakelock, Chase, Duveneck, Hassam, Henri, Homer, Hunt, Inness, Pennell, Ryder, Stuart, and Weir. In the

first issue the editors stated, "from time-to-time, room will be found to note and comment on some of the passing events in the outside art world." These chatty pieces of art news were written in a lively manner and reveal much of lasting interest. Changing attitudes on gallery management are also indicated in commentary on the extended length of the art season in New York; on welcoming all visitors, even those with no means to purchase works of art; the forgeries appearing regularly; printing of prices in gallery catalogs; and other developments that were highly innovative at the time. The small illustrations appeared with greater frequency during the 1920s. Such a record of opinion and fact from a highly reputable gallery has value to American art historians since the gallery vigorously championed the work of American artists at a relatively early period. The owners maintained this attitude through several decades and stayed in business long enough to see their point of view gain wide acceptance.

S165. MAGAZINE OF ART. London, New York, and Paris. 1–28 (May 1878–July 1904), illus. 27–28 also new ser. 1–2.

Since this periodical originated in London, the emphasis was understandably on British and Continental art. The first volume included over a dozen articles on the Paris Universal Exhibition of 1878, covering ceramics, wallpaper, stained glass, furniture, and the Indian section. The nine artists in a Living Artists series were all members of the Royal Academy. In 1882 a "Monthly Record of American Art" was added, which provided a truly remarkable documentary of art exhibitions, sales, deaths, and miscellaneous information concerning the visual arts in the United States. Vol. 24 included Art Nouveau material, with an article on Gustave Moreau and others on decorative art in Germany and "Is Ruskin Out of Date?" There were hundreds of clear illustrations in each volume, which, combined with the authoritative articles on a variety of art disciplines, constituted an outstanding art periodical for the American public. In Dec. 1885 a review of the American edition in the Art-Union included the following opinion: "The Cassell Company are steadily building the American department of their Magazine of Art up into proportions calculated to make it the chief art monthly of the country in the more advanced line. The native department is under the editorship of Mr. S. R. Koehler." Because of high production values, authoritative content, and a sustained run of over a quarter of a century, this magazine exerted a strong influence. The numbers of the American edition are the same as those of the English editions, which appeared the previous month in London. Listed in Poole's Index to Periodical Literature [S·X].

S166. MAGAZINE OF ART. Washington, D.C., and New York. 1–46 (Nov. 1909–May 1953), illus. (color).

For forty-four years this periodical was an official publication of the American Federation of Arts and as such it is a major storehouse of American art activity and opinion for two generations of contributors and readers. The magazine provided a thorough survey of art exhibitions, art museum activities, book reviews, and a variety of international art events of major interest at the time of publication. In the early years, Duncan Phillips wrote on Chardin and Ryder (1916), A. E. Gallatin discussed William Glackens, and Homer Saint-Gaudens wrote on John W. Alexander. Reflecting the growing awareness of international art are articles on the New Palace in Tokyo (1910), the Venice Biennial, the Austrian Werkbund exhibition in Vienna, and the work of Italian masters in London. Native American art interests were also reflected in articles such as "The New Museum in Boston" (1910), "Soldiers' Monuments," "American Towers," and "Jules Guerin's Murals in the Cleveland Terminal" (1930). Major exhibitions and expositions received frequent and full reviews; special numbers appeared often. In the early 1930s, considerable space was devoted to the activities of the society with news of conventions, regional meetings, reports of the advisory service, traveling exhibitions, illustrated lectures, and a package library. In 1937, under the editorship of F. A. Whiting, Jr., the magazine reached its zenith. It was completely redesigned in larger format with fine illustrations. The articles continued their high level of connoisseurship and covered diverse topics. A special series of high quality color reproductions of American paintings was published and well received.

During the years of World War II this magazine, in common with other periodicals, suffered from the short supply of materials, manpower, and transportation facilities that could be allocated to cultural projects. During 1944, however, brilliant articles appeared regularly. A sampling includes articles on Siqueiros by Lincoln Kirstein, José de Creeft by Eudora Welty, Chippendale by Robsjohn-Gibbings, the work of Georgia O'Keeffe by Daniel Catton Rich, Ben Shahn by John D. Morse, Byzantine mosaics by Fernand Léger, and Alexander Calder by James Johnson Sweeney. After the war, the number of pages was reduced, but the authority of the articles was maintained. The final volumes under the editorship of Robert Goldwater were more lively, with excellent articles by leading museum curators and art historians. In the last issue, coeditors James Thrall Soby and Robert Goldwater wrote a valedictory, which noted that the magazine "began as a news organ, and quite naturally as an exponent of the genteel tradition, which looked then, especially from the semi-official perspective of Washington, as if it were the central stream of American art. Since that time, the wide diversification of styles and the embattled opinions that have come to the defense of each of them, the varied ways in which contemporary art fits —and does not fit into the scheme of things has not made editorial choice and judgment any easier." The periodical was always published at a financial loss, but during much of its history it successfully "married history and aesthetics, and knowledge of the past with a conviction about the present." Proceedings of the American Federation of Arts were published in issues for 1909, 1911–1930, and 1934. PUBLISHED AS Art and Progress (1909–Dec. 1915); The American Magazine of Art (Jan. 1916–Aug. 1936); Art, Including Creative Art (Sept.–Dec. 1936).

S167. THE MAGAZINE SILVER. Portland, Ore. (1969 —), illus. [cont.]

Specializing in the whole field of silver, this bimonthly contains survey and general articles on American, Canadian, English, and foreign silver. It contains regular columns featuring articles on dealers, exhibitions, collectors, manufacturers, silversmiths, figurals, spoons, collectibles of all kinds, sewing items, coins, table settings and decorative objects, modern craftsmen, and silverware pattern identification. Books are reviewed, questions are answered, wanted items are listed, and many advertisements extend interest in the field in a most practical way. Each issue is generously illustrated with photographs and drawings of satisfactory quality. Of great value to dealers and collectors, the magazine is a timely summary of current fashions in the collecting marketplace, as well as a reference source for reliable information on historic silver items and manufacturers. PUBLISHED AS *Silver-rama; Silver* (Vancouver, Wash.).

S168. MARSYAS: STUDIES IN THE HISTORY OF ART. New York. 1 — (1941 —), illus.

This scholarly annual, originally planned as a semiannual, is published by the students of New York University, Institute of Fine Arts, a graduate school for art history. The articles are brilliantly researched and represent the work of some of the best young scholars in the field. Most of the articles are on traditional Oriental and European art, especially the Renaissance. Now and then an American topic appears, such as the architecture of the "robber barons" in New York City, or a portrait bust of Franklin by Houdon. Each issue summarizes the dissertations submitted at the institute. Articles are illustrated with line drawings, plans, and photographs. REPRINT of vols. 1–4 (1941–1945/1947): (New York: Kraus Reprint Co.).

S169. MASTER DRAWINGS. New York. 1 — (spring 1963 —), illus.

This is a major publication sponsored by the Master Drawings Association, with articles of great authority written by the most eminent scholars in the subject area. Each quarterly issue includes a few special articles, often concluding with checklists, notes on new discoveries or special information, and reviews of books and important drawing exhibitions, frequently from Europe. The publication is edited by Felice Stampfle of The Pierpont Morgan Library with Jacob Bean of The Metropolitan Museum of Art as an associate editor. Distinguished contributors include Agnes Mongan, Otto Benesch, Winslow Ames, A.Hyatt Mayor, Douglas Cooper, Colin Eisler, and Erwin Panofsky. There are between forty and fifty excellent reproductions in each issue; the periodical was printed first by the Shorewood Press and later by Meriden Gravure. The advertisements, printed with classic restraint, are of immediate interest to curators, collectors, and all others concerned with master drawings. An index is compiled for each volume.

S170. MASTERS IN ART. Boston. 1–10 (Jan. 1900–Feb. 1909), illus.

This is a monthly series of monographs on famous artists, published by Bates & Guild Co. The pattern of these publications covering ninety-eight artists never varied and included ten or more black-and-white plates of the artist's most celebrated works, followed by the life of the artist, selected criticisms of his work, brief descriptions of the plates, and a bibliography including magazine articles. The artists selected were principally European old master painters, with an occasional sculptor (Phidias) or American artist (Copley, Stuart, Inness, William Morris Hunt) for variety. The approach was factual and choices conservative. The series became enormously popular by supplying descriptions of pictures to students of two generations in art survey courses.

S171. **The Metropolitan Museum of Art,** JOURNAL. New York. 1— (1968—), illus.

Published annually, this periodical contains articles and notes in all fields of art represented at The Metropolitan Museum of Art, one of the world's major art institutions. The articles, written by members of the staff and other scholars, explore art history in depth, in contrast to articles in The Metropolitan Museum of Art, *Bulletin* [S173], which are prepared for the general public. In the few years of its publication, the magazine has taken a place of importance in the literature of art history. [*See also* C475a.]

S172. METROPOLITAN MUSEUM STUDIES. New York. 1–5 (Oct. 1928–Sept. 1936), illus. (color).

The president of The Metropolitan Museum of Art, Robert W. de Forest, wrote that the purpose of this periodical was to fill "The need of communication between our staff and serious students of art throughout the world." He pointed out that the curatorial staff of the museum, numbering only four persons in 1905, had by 1928 expanded considerably and was eager to interpret the collections to the world of scholarship. The contributors were primarily members of the museum staff, but included outside contributors from time to time. The scholarship is unrivaled, and the writers comprise a pantheon of notables in the American museum world: Gisela M. A. Richter, James J. Rorimer, Fiske Kimball, William M. Ivins, Jr., Ananda K. Coomaraswamy, and Stephen V. Grancsay. A basic index appeared with each annual volume. The articles mainly deal with ancient, medieval, and Renaissance subjects, with only an occasional article on American topics such as "Alexander Jackson Davis and the Gothic Revival" and the Van Rensselaer wallpaper. There are many black-and-white illustrations and a few in color.

S173. **The Metropolitan Museum of Art,** BULLETIN. New York. 1–37 (Nov. 1905–June 1942). New ser. 1— (summer 1942—).

This periodical, which began as a house organ, soon became a public record of the museum. It is an important source of information on a whole range of art subjects. The *Bulletin* provides continuous commentary on exhibitions and acquisitions at The Metropolitan Museum of Art and a forum for texts by its staff of specialists from all departments, including, of course, the American Wing. REPRINT of vols. 1–37 (1905–1942): (New York: Arno

Press). [*See also* C475.]

S174. **The Metropolitan Museum of Art,** PAPERS. New York. No. 1–13 (1921–1961).

Most of the articles in this periodical were on topics from ancient art, with one or two exceptions. In 1923 (vol. 1: 2), Agnes Zimmermann wrote "An Essay towards a Catalogue Raisonné of the Etchings of Julian Alden Weir." The series was discontinued with this issue; when it was resumed in 1937, the parts were given the serial numbers 3, 4, 5, and the "volume" designation was abandoned. Vol. 1, pt. 1, became retroactively vol. 1 of the Publications of the Department of Egyptian Art when the latter series was begun in 1932. From 1937, monographs of Egyptian subjects which appeared in the *Papers* series were also numbered in a departmental series. None published from 1941 to 1960; publication was resumed in 1961. SUSPENDED (1924–1936), (1942–1960).

S175. MODERN ART. Boston. 1–5:1 (1893–1897), illus.

This periodical was published quarterly by L. Prang & Co., a famous lithographic firm of Boston and Roxbury, Mass.; each issue contained four full-page illustrations with many large initial letters, tailpieces, and other ornaments. The typography and layout indicated the influence of William Morris in the use of red ink on marginal headings and for topic emphasis. *Modern Art*, according to the editors, was "artistically printed with luxurious margins on an imported, rough-edge, French hand-made paper." Rembrandt, Puvis de Chavannes, Mauve, Mary Cassatt, and art criticism by George Bernard Shaw were "modern art" subjects that appeared in this handsome art periodical.

S176. MODERN PHOTOGRAPHY. New York. 1— (Sept. 1937—), illus. (color).

With an emphasis on technical aspects of photography and equipment, this magazine had a circulation of 370,000 in 1972. Readers find articles on equipment to be especially valuable, particularly an annual guide to the top cameras, compiled by the editors. Regular departments include book reviews, letters to the editor, techniques tomorrow, color photography, and a special mail order section. In recent years, major divisions of the monthly magazine have included "Picture Taking Ideas," "Technical Features," and "Movies." Pictorial essays by celebrated photographers such as Paul Caponigro, Bruce Davidson, Andreas Feininger, Eliot Porter, and Jay Maisel appear regularly with color reproductions and a written tribute to the photographer. Technical articles abound and cover a wide range of timely subjects, including electronic flash, 35 mm film, telephoto lenses, fluorescent light, interchangeable lenses, and flash cubes. Indexed in *Applied Science and Technology Index* and *Chemical Abstracts*. PUBLISHED AS *Minicam Magazine* 1–12 (Sept. 1937–1950), in Cincinnati.

S177. MONUMENTAL NEWS. Chicago and Madison, Wis. 1–51 (1889–1939), illus.

This monthly journal of monumental art records a spe-

cialized aspect of American art history. In its first decades, there was considerable emphasis on civic fountains, memorials, and monuments; in the final decades it concentrated on private gravestones and family mausolea. News of competitions and dedications of some of our grandest civic monuments may be found in issues for the nineteenth century. Other topics regularly covered included news of sculptors, proposed monuments, cremation, new firms, trade notes, quarries, and cemeteries. Hundreds of advertisements illustrate products from suppliers of granite, marble, trees, draftsmen's supplies and manufacturers of bronze and marble tablets, iron fences, lawn furniture, and rustic monuments. The illustrations in the early years were line drawings or photographs. By the 1930s nearly all of the illustrations were photographs of completed grave monuments. Annual conventions of the Association of American Cemetery Superintendents and the Memorial Craftsmen of America were reported regularly. In the late 1930s, subscribers were urged to plan and pay for their memorials in advance so that confiscatory death taxes could be partially avoided. Articles entitled "Build While You Live" stressed the point. The fiftieth-anniversary issue (Dec. 1939) announced that the magazine was merging with *Granite, Marble and Bronze* to form *Monumental News Review*, thereby consolidating the two oldest journals devoted to the monuments industry. This final issue also had several pages of interesting news items culled from issues spanning the previous half century. Issues for the first three decades are of definite value to researchers in the history of American sculpture for that was the era when civic monuments appeared in profusion in town squares, civic plazas, and large cemeteries. SUPERSEDED BY *Monumental News Review*. [*See also* F88.]

S177a. **The Museum of Modern Art,** BULLETIN. New York. 1–30 (June 1933–June 1963).

In announcing a reprint with a cumulative index, Arno Press noted the importance of this publication as follows: "In chronicling the exhibitions and the acquisitions of The Museum of Modern Art, the *Bulletin* provides a basic record of how modern art came to be—as well as what it has come to incorporate." No institution was more effective than The Museum of Modern Art in presenting exhibitions and disseminating literature on contemporary art to millions of Americans in the crucial decades of the mid-twentieth century. The periodical presents all the facts and considerable commentary on hundreds of exhibitions and the varied activities of the institution, which had an unequaled impact on the art of our time. Complete runs of the original issues are scarce because the *Bulletin* appeared irregularly during its early years. There were also shortages of paper and printing resources during World War II, and some early issues were ephemeral in format. The *Bulletin* was established as a means of communication between the museum and its members and was circulated as a privilege of membership. An excellent independent index to the thirty volumes was prepared by Cornelia Corson as part of the complete bound REPRINT (New York: Arno Press; for The Museum of Modern Art, 1967).

S178. MUSEUM NEWS. Washington, D.C. 1— (Jan. 1, 1924—), illus.

Originally published twice a month by the American Association of Museums, this magazine was a modest four-page publication for many years. It stayed right on target, printing only the most basic news events in the area of American museum activity. The column devoted to personnel was broken down under two headings: "Women Seeking Positions" and "Men Seeking Positions." A quarter of a century later, the issues had been expanded to eight pages but the format was basically the same, with news of national and regional museum conferences, announcements of staff changes and personal information, lists of current exhibitions and magazine articles. Now and then there appears a two-page article relating to some phase of museology, such as "Problems of Importing and Exporting Works of Art," by Dorothy H. Dudley of The Museum of Modern Art; "Research in Color Photography at The Art Institute of Chicago," by Lester Burbank Bridaham of the museum; and "Showmanship in the Conservative Museum," by Adelyn D. Breeskin of The Baltimore Museum of Art. Not confined to art museums, the magazine's content reflects the broad range of member institutions: historic houses, science museums, historical societies, atheneums and institutes, restored villages, college and university galleries, and state museums. Throughout the late 1950s and during the 1960s, the magazine was considerably expanded in size and scope with a layout that reflected the good design policies of contemporary museums. Illustrations are well selected and sharply reproduced and accompanying text is typeset using a modern font. Since 1970 issues, over forty pages long, have contained five or six feature articles and seven departments: "News Notes," "Museum Architecture," "Current Exhibitions," "Publications," "Within the Profession," "From the Director," and "At the AAM." Topics covered in depth include security, pension plans, conservation, funding, sales shops, accreditation, African art, arts councils, volunteers, and lighting effects. Copies of the magazine are mailed to all members, who are well served by this professional publication.

S179. National Alliance of Art and Industry, NEW YORK BULLETIN. New York. 1–9 (July 1922–Dec. 1931), illus.

The Art Center Building, located on New York's East 56th Street, housed an alliance of seven organizations devoted to applied arts and handicrafts. Their bulletin recounts lectures, exhibitions, elections, and general activities of the member groups: the American Institute of Graphic Arts, Pictorial Photographers of America, Art Alliance of America, New York Society of Craftsmen, Society of Illustrators, Art Directors Club, and The Stowaways. This record of an extremely active center indicates general art interests of the period. The illustrations also demonstrate the styles prevalent during the 1920s, with emphasis on Art Deco and studio photography. PUBLISHED AS *Art Center* (1920–Feb. 1932). SUPERSEDED BY *Art and Industry Journal*.

S180. NATIONAL BUILDING REGISTER. Washington, D.C., and Baltimore. 1–11 (1889–Sept. 22, 1900). [*cont.*]

Although not an architectural magazine in the purist sense, this ten-page periodical covers building, real estate, and architecture in Baltimore and Washington, D.C. The periodical, which contains little original writing, consists largely of lists of building permits, real estate sales, contracts awarded, and miscellaneous building announcements from private contractors and from various major United States government departments. Bright orange front and back covers included scores of small advertisements for regional building services and products, including a few line drawings. An editorial announcement in each issue read as follows: "This paper is the only reliable publication in Washington and Baltimore devoted to building. It gives all the news each week, and industriously endeavors to prove of genuine assistance to every member of the local building industry. Others may try to imitate the Register, but they invariably grow tired of the pace, and are compelled to 'lay up' for rest and repair. Moral: if you want reliable building news each week, you must read the *Register.*" As a record of Uncle Sam in the role of major builder and occasional architect, this factual record has value for details of buildings planned, erected, and altered during the final decade of the nineteenth century in the greater Washington and Baltimore areas. PUBLISHED AS *National Architect and Builder* (Nov. 14, 1896–1900).

S181. NATIONAL SCULPTURE REVIEW. New York. 1— (Dec. 1951—), illus.

This is a quarterly publication of the National Sculpture Society. The society was founded in 1893 as a result of the great success of the sculpture at the World's Columbian Exposition in Chicago. The issue for the summer of 1968 gives an example of contents. For it the editor, Adolph Block, wrote a survey of the development of the society in celebration of the seventy-fifth anniversary of its founding, and Theodora Morgan prepared a survey of "Seventy-Five Years of American Sculpture; 1893–1968." As in all numbers, the black-and-white photographs of sculpture are well selected and are reproduced with the utmost clarity. The society maintains files of the work of 250 professional members at its present headquarters, and provides advisory committees to any individual or group planning public or private sculpture. Issues average thirty-two pages and include a few advertisements for casters, tools, new books, and various sculpture services of value to subscribers, along with three or four feature articles and a brief editorial. Articles range over a wide field of related topics: the sculpture on the *S.S. United States*, sculpture at Rockefeller Center, church and architectural sculpture, medals and memorials, Malvina Hoffman, Anna Hyatt Huntington, Carl Milles, and all manner of technical articles. Definitely in the conservative camp, the society reflects the representational and traditional approach to form in space. The magazine is an excellent source of illustration, biography, and text in its field. [*See also* F89.]

S182. NEW HOPE: A RECORD OF THE CONTEMPORARY AMERICAN ARTS. New Hope, Pa. 1–2 (Aug. 1933–Oct. 1934), illus.

This regional monthly, "written for and by residents of

the Delaware Valley," contains advertisements and exhibition reviews centered almost exclusively on New Hope, Pa., and the geographic area close by. The editorial board, headed by Peter Keenan, included Thomas Benton, George Antheil, and Hilaire Hiler. The articles were well written and covered a wide variety of fine art topics such as "Boris Artzybasheff," by Bruce Lockwood; "Something about Caricature," by William Auerbach Levy; "An Adventure in Books," by Elmer Adler; "American Music—1933," by George Antheil; "Isamu Noguchi," by Edward M. M. Warburg; "The Angelus of Millet," by Salvador Dali; and "The American Mural," by Thomas Benton. Nicely designed and printed, the magazine has a professional appearance and a fresh slant. Just as it was in demand "from coast-to-coast in this country and abroad" it ceased publication, no doubt because of the economic crisis of the early Depression years, which witnessed the demise of hundreds of American magazines.

S183. NEW PATH. New York. 1–2 (May 1863–Dec. 1865).

Originally published by the Society for the Advancement of Truth in Art, this periodical on aesthetics appeared during the final years of the Civil War. Its appearance is remarkable evidence of the general rise of interest in the visual arts even during a period when so much of the nation's resources and energy were going into the massive war effort on both the Union and Confederate sides. The first paragraph of the initial issue stated the situation as viewed by the editor, Clarence Cook: "The future of Art in America is not without hope if looked at from certain points of view. The artists are nearly all young men; they are not hampered by too many traditions, and they enjoy the almost inestimable advantage of having no past, no masters and no schools. Add, that they work for an unsophisticated, and, as far as Art is concerned, uneducated public, which . . . will not be prevented by any prejudice or preconceived notions from accepting any really good work which may be set before it." The magazine laments the failure of the older generation of artists and notes that "after forty years uninterrupted labor they have given us not a single work we care to keep, for they have worked under influences hostile to study and to the culture of Art." A changing era was hailed as we were "fast sweeping into the glad new year when America shall sound the trumpet-call, and marshall her children to do her work in her own free way. The young men, therefore, have the field to themselves."

The society's "Articles," set down in essay form by Russell Sturgis, Jr., show that the members firmly believed that Ruskin, the Pre-Raphaelite school, and the restoration of so-called Gothic Art were founded on principles of eternal truth. In May of 1864, the journal was published independently of the society, but it championed the same aesthetic position as before. Considerable space was assigned to sculpture (Mar. 1864), including critiques of Harriet Hosmer's "Zenobia" and Erastus Dow Palmer's sculpture. There were reviews of exhibitions in New York City, including a lengthy criticism of Elihu Vedder's "The Lair of the Sea-Serpent" in the thirty-ninth annual exhibition at the National Academy of Design. The Civil War loomed up regularly, as in commentary on F. B. Carpenter's painting "President Lincoln Reading the Emancipation Proclamation to the Cabinet" and J. Hope's "Army of the Potomac at Cumberland Landing," which depicted 80,000 men encamped on a single field. The magazine advocated a unity of painting, architecture, and sculpture, and aspired to be "read, not only by every one who buys a picture or statue, but by every person who builds or has an influence to exert upon the design of a house." It differed from the usual art journal in that its major emphasis was on a new aesthetic. Changing times and the Civil War apparently overwhelmed that cause, and only sixteen issues were published. SUSPENDED (July 1864–Apr. 1865).

S184. THE NEW YORKER. New York. 1 –(Feb. 21, 1925 –), illus.

From its inception, this unique weekly has been a major literary and cultural force in America. It well merits a prominent position in any listing of American art periodicals because of its original cartoons and drawings, profiles of major art figures, and reviews and listings of art exhibitions in the New York area. For many readers the cartoons and drawings are the primary attraction of the periodical. Millions of Americans discuss and generally enjoy the cartoons, which represent some of the best satire and comic genius appearing anywhere during the half century of the magazine's existence. One cartoon often captures the spirit of a decade. Robert Owen Johnson, *An Index to Profiles in the New Yorker* (Metuchen, N.J.: Scarecrow Press, 1972) listed sixteen profiles on architects, twenty on art in general, and thirty-five on individual artists. These in-depth biographies are filled with insight and personal data that cannot be obtained elsewhere. Profiles are a continuing feature and a most perceptive and readable addition. Some art figures who have received this royal treatment include R. Buckminster Fuller, Frank Lloyd Wright, Albert C. Barnes, Alfred H. Barr, Jr., Chester Dale, René d'Harnoncourt, Robert C. Scull, Max Beerbohm, Milton Caniff, Richard Lippold, Georgia O'Keeffe, Betty Parsons, and John Sloan. *The New Yorker*'s cartoonists, the most celebrated names in the field, include Charles Addams, Peter Arno, Alan Dunn, Syd Hoff, John Held, Jr., Helen Hokinson, Mary Petty, Otto Soglow, Richard Taylor, James Thurber, and Gluyas Williams. Drawing anthologies include *The New Yorker War Album* (New York: Random House, 1942), *The New Yorker Album of Sports and Games* (New York: Harper & Bros., 1958), *The New Yorker Album 1925–1950* (New York: Harper & Bros., 1951), and *The New Yorker Album, 1955–1965* (New York: Harper & Row, 1965).

On June 9, 1975 the new president of *The New Yorker*, George Joseph Green, reported to the *New York Times* that the magazine's circulation was 487,206, the highest it has ever reached. To celebrate the magazine's first half century, the Grolier Club of New York mounted a special exhibition, which was received with great enthusiasm. Robert Owen Johnson, *Index to Literature in The New Yorker* (Metuchen, N.J.: Scarecrow Press, 1969, 1970, 1971) 3 vols., unlocks many of the art articles that have appeared through the decades. A writer for the *New York*

Review commented as follows on the magazine and its importance: "*The New Yorker*, which began life in 1925 as an 'irreverent, understaffed, comic weekly,' in Thurber's words, had become an institution by the mid-Thirties. It was a glossy monument to American culture at its casual best, a printed cousin to Fred Astaire's dance style . . . treating the big city as if it were a big city, and conscripting the provincials, who would feel they were being let in on the action, invited to become New Yorkers of the spirit. But more important, the tone of the magazine was to be the tone of a man with a monocle, a Wasp Erich von Stroheim looking down his nose and letting fall the odd witticism" (*New York Review* [May 15, 1975]). Researchers interested in American culture and visual arts from the 1920s on should not miss this treasure house.

S185. OLD-HOUSE JOURNAL: RENOVATION AND MAINTENANCE IDEAS FOR THE ANTIQUE HOUSE. Brooklyn, N.Y. 1 — (Oct. 1973 —), illus.

This new periodical is aimed directly at the owners of old houses, specifically nineteenth-century dwellings. The information is direct and practical. Articles are illustrated with strongly delineated line drawings and clear photographs. Issues, usually twelve pages in length, include a feature article on a specific house, a technical article, the description of a historic style, a book review, and other items of pertinent information. Feature articles cover the Ortner house in Park Slope, Brooklyn, N.Y.; a schoolhouse in Lyndon, Ky.; an Italian villa in New Haven, Conn.; a townhouse in Trenton, N.J.; a plantation in Virginia; and a Queen Anne house in St. Paul, Minn. Technical topics include preventing rot, removing paint, refinishing old floors, stripping shutters, running electrical wire, and restoring sandstone. Architectural history is covered in brief, readable texts on mansard roofs, Charles Eastlake and Eastlake style, and A. J. Downing. The magazine's real value rests on its practical approach to domestic preservation. Concentrating on the interests of new owners of old houses and giving direct, uncluttered information, the magazine fills a need for preservationists with little experience in techniques or background in historic styles. The periodical accepts no advertising and states that its primary objective is to promote historic preservation.

S186. OLD PRINT SHOP PORTFOLIO. New York. 1— (1941—), illus.

This is the publication of a durable New York firm chiefly engaged in buying and selling American prints, broadsides, maps, city views, valentines, and all manner of absorbing visual material reflecting American manners and customs, historic figures, events, and pastimes. The Old Print Shop was established by the late Harry Shaw Newman at 150 Lexington Avenue, where it is still located. During the first decade, the magazine published ample and authentic texts describing the old prints, which were illustrated in small but clear black-and-white reproductions. Later, the text was greatly reduced, and it now consists largely of captions under the reproductions. The price of the work provided at the end of each caption has been of immense value to dealers, appraisers, and the

general public interested in historic Americana. The magazine emphasizes American history, traditional holidays such as Thanksgiving and Christmas, and works by Currier & Ives, Audubon, and Bingham. Whaling and ships, sports, railroad scenes, panoramic city views, posters, broadsides, flower studies, caricatures, portraits, and horse racing items appear regularly, presenting a superb cumulative survey of popular American graphic art. The editors have included Marchal E. Landgren, Helen Comstock, Agnes Halsey, and, of course, Harry Shaw Newman and Kenneth M. Newman. Prints of English and Continental origin are occasionally listed, but the emphasis is on the American field. The collecting of nineteenth- and early twentieth-century American prints has been a major development in our art history. The contents of this business publication, even in its small format, have exerted a continuing influence on collections and collectors.

S187. OLD-TIME NEW ENGLAND. Boston. 1— (May 1910—).

This quarterly magazine is published by the Society for the Preservation of New England Antiquities, which was dedicated to the preservation of our architectural heritage long before the cause became popular. In 1973, the society held sixty properties representing seventy-seven major buildings and forty-nine barns, stables, greenhouses, and miscellaneous dependencies. The periodical, which specializes in news of the society and its properties, has been edited by Abbott Lowell Cummings since 1956. The articles show an increasing sophistication in methodological approach. The subject matter is highly relevant to historic Yankee buildings, their contents, and the surrounding communities. The society has published an index to vols. 1–10. PUBLISHED AS Society for the Preservation of New England Antiquities, *Bulletin* 1–10 (1910–1919).

S188. OPPOSITIONS. New York. 1— (Sept. 1973—), illus.

An important new magazine in the architectural field, this publication is prepared for readers who have some background in architecture and design. It is of permanent value to art historians, urban planners, architects, and students. The writing is generally excellent, scholarly, and authoritative; the many photographs and line drawings are expertly selected and well integrated into the text. Published by the Institute for Architecture and Urban Studies, the magazine is the result of the dedication of five highly talented young architects who set down their purpose in an editorial statement in the first issue: "*Oppositions* is an attempt to establish a new arena for architectural discourse in which a consistent effort will be made to discuss and develop specific notions about the nature of architecture and design in relation to the manmade world It will regularly feature a number of articles which critically examine either a building, a book, or a theoretical position with a view to interpreting and evaluating the general complex of ideas involved Naturally, our respective concerns as individuals for formal, socio-cultural and political discourse will make themselves felt in our joint editing of *Oppositions*. The

opposition alluded to in the title will first and foremost begin at home."

Issues, over one hundred pages long, include major articles expressing opposite points of view, history, theory, book reviews, and original documents related to the development of modern architecture. The comprehensive book reviews cover major titles by Reyner Banham, Robert Venturi, and Bernhard Leitner, among others. A nineteen-page bibliography of Alison and Peter Smithson appeared in the second issue. The contents page would be made more useful by including page numbers opposite a listing of the individual articles. The theory of symmetry is presented with great skill in an article by William Hoff; documentary material includes Giraudoux's "Introduction to the Athens' Charter," an account of the Architects' Ball in New York in 1931, and comments on a group of rejected architects and their projects by Philip Johnson. After the appearance of only a few issues, this magazine takes a prominent place in the sophisticated literature of modern architecture.

S189. PAINTING AND DECORATING. Philadelphia. 1–14 (Oct. 1885–Dec. 1898), illus. (color).

This magazine published quantities of useful information on house painting as well as "tasteful combinations of color as applied to the exterior of buildings and to the ceilings and the walls of interiors." It was outstanding in both content and form. By 1888 the magazine's editor, F. Maire, proudly claimed "we publish more original matter than all other French journals combined Our engravings and our color plates unite in placing us before the world as the most useful periodical devoted to our trade, and has elicited the admiration of other journals, and these place us on record as an artistic publication as well as a useful one." There were articles on drawing for painters, the history of decorative arts, trade notes, the letter box, and technical information on many topics, including shellacking, graining, varnishing, stairway draping, and amateur scene painting. At various times the official organ of the Master House Painters' Association of the State of Pennsylvania and of the Association of Master Painters and Decorators of Philadelphia, the periodical had a "sworn circulation of 10,000" in 1889.

A series of articles on carriage and business wagon painting and advertising signs is especially fascinating. An illustrated article on "Artistic Advertising Signs" in Pittsburgh in November of 1895 reveals that signboards of that period frequently included actual paintings of marine studies, landscapes, or genre subjects in addition to the names of the sponsoring advertiser. The plates, accurate samples of decoration during the last two decades of the nineteenth century, include wall and ceiling designs, signboards, house exteriors, wallpaper, and an occasional stencil for a frieze. Most are in color and include a basic color code for the project illustrated. *Painting and Decorating* also contains news of other Master House Painters' Associations from such diverse locations as Brooklyn, N.Y., New York, Connecticut, New Jersey, and Peoria, Ill. During the last years of its publication, the page size of the magazine was slightly enlarged, but the color plates were eliminated. Black-and-white stencil

designs took their place, and the magazine became an "independent trade journal, devoted to house, car, carriage and fresco painting, wallpaper and the kindred trades." Researchers restoring buildings to the late Victorian period will find this association publication to be of practical value. PUBLISHED AS *House Painting and Decorating* (1885–Sept. 1890). SUPERSEDED BY *Painters' Magazine*, later *National Painters Magazine*.

S190. PALETTE AND BENCH: FOR THE ART STUDENT AND CRAFTS-WORKER. Syracuse, N.Y., and Saint Louis, Mo. (Oct. 1908–Dec. 1910), illus. (color).

This magazine was established to fill a need for information on oil and watercolor painting, drawing, and allied arts and crafts for self-taught students who "are prevented from going to the large cities for aid." Articles of no great complexity appeared regularly on Japanese flower arrangement, illumination, miniature painting, how to model, stenciling, and silhouettes. Kenyon Cox wrote on making a mural. Questions were answered in a regular format. Some articles on art history appear, and major exhibitions are occasionally reviewed. Illustrations are frequent; each issue includes a large color reproduction of a traditional subject. In Nov. 1910, when the magazine had nearly 7,000 subscribers, Lewis Publishing Co. of Saint Louis gave up magazine publishing to devote its energies to the development of the American Woman's League and to the building up of its correspondence and art schools. During its two years of existence, the magazine proved valuable to amateur art students. Except for the final issue, the editor was Adelaide Alsop-Robineau. SUPERSEDED BY *Arts and Decoration* [S85].

S191. PALETTE AND CHISEL. Chicago. 1–9 (Feb. 1924–Apr. 1932), illus.

This was an informal newsletter prepared for members of the Palette and Chisel Club of North Dearborn Street in Chicago. The first issue was printed in an edition of 1,500 copies, 1,000 of which were sent to subscribers. It features news of the club, art activities in the Chicago area, and other notes relative to the art profession. Many issues contain biographical sketches of notable artists who were members of the club. The periodical contains a few illustrations and modest advertisements from Chicago art schools, suppliers, and galleries. The over-all philosophy was to champion the cause of the conservative artist. Both the club and its publication were hit hard by the financial crisis of the early Depression years. The newsletter was not issued in July and August.

S192. PARNASSUS. New York. 1–13 (1929–May 1941).

Published by the College Art Association of America, this periodical informed members of the activities of the association, art events in New York City, new books in the field, and museum acquisitions. Articles on art history tend to be brief but cover a wide range of topics. Distinguished contributors include Lincoln Kirstein, Charles R. Morey, Francis Henry Taylor, Walter Pach, and Ananda Coomaraswamy. H. W. Janson reviewed books, Henry-Russell Hitchcock wrote on American architectural his-

tory; and Stuart Davis discussed abstract American art (Jan. 1941). Modern art movements were struggling for recognition during the period when this periodical was published, and articles and letters indicate conflicting opinions and viewpoints. The works of major American artists of the period, especially printmakers, are discussed and illustrated. The magazine stressed good scholarship and teaching on the college and art school level and paved the way for the association's later publications, the *Art Journal* and *Index of Twentieth Century Artists*. Throughout the magazine there is a missionary tone, which indicates a dedication to the cause of art education on the college level and a belief in the new art movements. This tone in fact angered many. The struggle indicated within the pages of *Parnassus* shaped the course of the unprecedented spread of academic art history and studio teaching, which took place after World War II on American campuses and in art schools. SUPERSEDED BY *Art Journal* [S66].

S193. PEN AND PENCIL: A WEEKLY JOURNAL OF LITERATURE, SCIENCE, ART, AND NEWS. Cincinnati. 1–2 (Jan. 1–July 16, 1853).

In spite of its title, this periodical includes only the most casual notices of news on the visual arts. The column "Fine Arts, Etc." Contains two- and three-line entries, many of which cover music topics. According to the editor, W. Wallace Warden, "What! another Magazine?—and a Western one too! What presumption!" (*Pen and Pencil* 1:1 [Jan. 1, 1853]). The twenty-six issues are of slight interest to visual art researchers for attitudes and arts events in Cincinnati during the first six months of 1853. The major concern of the little magazine, however, was in the areas of poetry, literature, and history, with a local slant.

S194. PERRY MAGAZINE FOR SCHOOL AND HOME. Boston. 1–8 (Sept. 1898–June 1906), illus.

Published by Eugene Ashton Perry to promote his mail-order business in halftone reproductions, this magazine encouraged teachers to use Perry's pictures as visual aids in teaching just about everything: history, English literature, geography, nature studies, art appreciation, and Sunday school classes. All age groups were informed of the value of art appreciation, from viewing pictures on the kindergarten walls to a course in Italian art for women's clubs. The small pictures had enormous appeal for young people; from the firm's beginning, hundreds of small reproductions were offered for sale at one penny each (minimum order of twenty-five, please), and primary schools were enthusiastic about Perry's pictures and his ideas. The text usually described a particular picture or told how to use pictures in the classrooms. Contributors were officials of state boards of education, college professors, or supervisors in public schools. By 1900, an issue reached an edition of 25,000 copies, and the study of pictures was seriously considered in many elementary school curricula. Art appreciation on a large scale for students in elementary schools was given great impetus by the appearance of inexpensive Perry pictures. Thousands of young Americans over the years were

introduced to the visual arts via the publications of the Perry Pictures Co.

S195. PERSPECTA: THE YALE ARCHITECTURAL JOURNAL. New Haven, Conn. 1– (summer 1952–), illus.

This lively periodical is edited, designed, and published at irregular intervals by students at Yale University, School of Art and Architecture. The magazine offers a "place on the merry-go-ground" of ideas to the architects, teachers, and students associated with Yale University. The layout is imaginative, and the excellent illustrations and articles range from Borromini to Venturi, and include the relationship between art and society and random philosophical perspectives on painting and sculpture of the 1960s. This is an extremely successful example of a student group with unusual intellectual and financial wellsprings producing a publication of high quality and lasting value.

S196. PERSPECTIVES, U.S.A. New York and London. 1–16 (fall 1952–summer 1956), illus.

This periodical, sponsored by the Ford Foundation, is by no means a visual arts publication and was thus omitted from the *Art Index* [S62] and the *Ryerson Library Index to Art Periodicals* [S·IV]. However, every issue in its four years of publication contains an excellent article or two on American art. It was published four times a year in several different language editions: English, French, German, and Italian at the outset. The magazine planned to "present literary texts from and about the United States and examples of American art and music. Its editors will try to set materials before their readers that may enable them to view the culture of the United States in accurate perspective." The magazine showed that the spiritual and artistic elements in American life have not been sterile. The editors noted that America "has poets and novelists, painters and musicians, thinkers and scholars, critics and architects of the first order to give the world." The foreign language editions were available at low cost in local currencies, for the reason that the magazine was supported by grants from the Ford Foundation during its four year run. Each issue included a group of illustrations, and these usually extended coverage of an art topic. Contributors include William Alex, Wayne Andrews, Walter Gropius, Hugh Morrison, Una E. Johnson, William S. Lieberman, Beaumont Newhall, Robert Goldwater, Kenneth Rexroth, Selden Rodman, Francis Steegmuller, and many others. They wrote on many art subjects, including photography, the skyscraper, housing in America, American drawings and on artists such as Homer, Dove, Hartley, Bloom, Graves, Shahn, and Lebrun. No. 16, the final issue, includes an index to the entire run of the magazine, which was a successful exercise in cultural exchange among nations. REPRINT EDITION (New York: Kraus Reprint Co.).

S197. **Pewter Collectors' Club of America,** BULLETIN. 1– (1934–).

Printed in newsletter form, this semiannual publication concentrates on news of exhibitions, announcements of meetings, notes from the president, and obituaries of

prominent collectors. Wendell D. Garrett's bibliography in *The Arts in Early American History: Needs and Opportunities for Study* [S·XXX] includes the following commentary on this specialized magazine: "The articles are highly specialized tending to be either the historical analysis of a pewter form (e.g., chalices, flagons, communion tokens, etc.) or the discussion of new discoveries (e.g., a touch mark, an early newspaper advertisement of a pewterer, etc.). On the pragmatic side, there are notes on collecting, repairing, and restoring pewter. Even though the primary emphasis is on American pewter, the Continental and English metal is also discussed." The first five numbers were reprinted in photo facsimile as a supplement to the Feb. 1962 issue.

S198. PHILADELPHIA ART-UNION REPORTER. Philadelphia. 1— (Jan. 1851–Jan. 1852).

This is a fact-packed account of events, sales, and general activity by the Art-Union of Philadelphia, which was incorporated by the legislature of Pennsylvania "for the promotion of the arts of design in the United States." Published monthly, the magazine was "devoted to the promulgation of the proceedings of the association and the diffusion of general intelligence in reference to the fine, the useful, and the mechanic arts." It printed long lists of the honorary secretaries in the various states, followed by the names of members with their town of residence. Accounts of the institution's meetings and lectures, the plan of the institution, and a catalog of the paintings with their sales prices appear in nearly every issue. Feature articles were not illustrated but include a lengthy obituary of Thomas Birch and cover such diverse topics as the genius of Raphael, Greenough's new statuary, the work of the young sculptor Randolph Rogers, and a memoir of Canova. Three long articles on art by R. W. Haskins shed light on the aesthetics of the time; the issue for Sept. 1851 discusses the poor showing of American art and industry at the Crystal Palace Exposition. The writer points out that there was very little American representation in those areas because everyone expected Congress to make appropriations and appoint authorized persons "to select, reject, and despatch what they approved of." The magazine regularly included a section of three-line entries listing "Artists' Cards" and two pages of advertisements related quite naturally to art in the Philadelphia area. The final issue points up some of the tremendous problems facing the Art-Union of Philadelphia, namely the "unprecedented pressure in the money market in the United States," resulting in a drastic falling off of members, and a disastrous fire on Dec. 26, 1851 at the printing establishment, in which valuable steel plates owned by the Union were destroyed. The magazine is an important record of art activity in Philadelphia during the middle of the nineteenth century. The listings of members, works on exhibition, and the distribution of prizes combine to provide a document of real significance to American art historians. ABSORBED Art-Union of Philadelphia, *Transactions* [S77].

S199. PHILADELPHIA PHOTOGRAPHER. Philadelphia. 1–60 (1864–June 1923), illus. [*cont.*]

This was the most influential American photographic periodical during the quarter of a century when it was published under its original title. Edited by Edward L. Wilson, the magazine was a rallying point for professional causes and served as a forum for the presentation of new processes and techniques. The work of outstanding European photographers was given prominent coverage. The magazine was handsomely produced by Benerman & Wilson of Philadelphia. In 1865, each of the twelve monthly issues included a superb embellishment, an original sepia photograph of high quality and crystal clear detail. Subjects included nature studies, portraits, and, in Oct. 1865, a view of the "burnt district of Richmond, Va." There are book reviews, some on general subjects and others on photographic literature; letters to the editor; a few line drawings; and a heavy concentration of material on technical problems and developments. Some of the latter are on the solar camera, fixing solutions, aniline dyes for coloring photographs, pictures on opal glass, porcelain surface paper, and the procedure for washing two negatives at once from one faucet (July 1865). There are miscellaneous topics such as "The Trials of the Wife of an Amateur Photographer" written by "A Sufferer" (Apr. 1865); the construction of a model skylight; and photography in dentistry. The editor continually promised to present "the most useful and valuable Journal of Photography in existence." Appearing a good generation before Stieglitz and the photographic aesthetic of art for art's sake, the magazine concentrated on techniques for both the amateur and the highly professional photographer. PUBLISHED AS *Wilson's Photographic Magazine* 26–51 (1889–Dec. 1914); *Photographic Journal of America* 52–60 (1915–June 1923). SUPERSEDED BY *Camera*.

S200. PHOTOGRAPHIC AND FINE ART JOURNAL. New York. 1–12 (1851–1860), illus.

Heavily loaded with technical articles and information, and with an editorial policy that urged photographers to set high principles for their art, this magazine successfully combined aesthetics and techniques for a growing public interest in photography in general and in daguerreotypes in particular. Technical data includes the newest developments of the day, chemical information, heliography (which had become "a perfect rage" by 1852), cleaning of plates, and related material such as painting on glass and gallery lighting. There were lithographic portraits of noted photographers, gossip from all over, lives of American painters, photographic news from London, Paris, and other European capitals, and poems glorifying the new art. The magazine sought to elevate the photographic profession and succeeded by insisting on authoritative articles, timely news, and a horizon that was worldwide rather than provincial. PUBLISHED AS *Photographic Art Journal* 1–6 (1851–1853). Vols. 7–12 were issued under the revised title and were numbered as new series. [For the microfilm edition, *see* N333.]

S201. PICTURE AND GIFT JOURNAL. Chicago and Saint Louis, Mo. 1–85 (Dec. 1880–1965), illus.

Picture frames and framing were the topics of main con-

cern to this specialized periodical in its first decades. The aim of the publisher was to produce a "perfect Picture Trades Encyclopedia," and by 1897, moldings, art materials, all picture dealer's supplies, photographic goods, and apparatus were included in this practical journal. Primarily a business periodical, the publication announces changes in trade firms along with the latest designs, the newest goods, and important patents. The publishers attempted to promote the prosperity of the trade and to protect the interests of picture frame dealers. Frames are illustrated in the articles, which also discuss the preservation and restoration of paintings. By 1905, art in America was prospering and issues were nearly eighty pages long. There is an abundance of advertisements for reproductions, postcards, art supplies, and, of course, framers from all over the country, particularly those on the East Coast and in the Midwest. Over the years, the magazine was a barometer of popular taste in reproductions and various framing fashions. It also clearly indicates the growing public acceptance of and demand for pictures to be hung on the walls of most American homes. PUBLISHED AS *Picture and Art Trade* 1–58 (1880–1921); *Picture and Art Trade and Gift Shop Journal* (1922–Sept. 1930). SUPERSEDED BY *Decor.*

S202. PLASTIQUE. Paris and New York. 1–5 (spring 1937–1939).

This magazine, edited by modern painters and sculptors in Europe and America, was devoted to the study and appreciation of abstract art. The distinguished editors were Sophie H. Taeuber-Arp, her husband Hans Arp, and A. E. Gallatin, who shaped the magazine into an international review of the avant-garde in literature and the visual arts. Texts are in English, French, or German. A few articles are directly concerned with the American avant-garde; the American issue (3, spring 1938) in particular contains contributions by A. E. Gallatin (on New York University, Museum of Living Art), Balcomb Greene, George L. K. Morris, Charles G. Shaw. REPRINT EDITION (New York: Arno Press).

S203. PM: AN INTIMATE JOURNAL FOR ADVERTISING PRODUCTION MANAGERS, ART DIRECTORS, AND THEIR ASSOCIATES. New York. 1–6 (Sept. 1934–Feb./Mar. 1940), illus.

In the first issue, the editors announced that they were trying to fill a "crying need" for a magazine for those working in advertising art. They also stated that they did not "intend to take life too seriously" and that the editorial policy would be "flexible at all times." The magazine was slight in format, but the illustrations, including the covers, were highly original. Certain issues cover specific subjects: Lynd Ward writing on Hans Alexander Mueller (Nov. 1938), the Bauhaus and new typography (June 1938), a series on graphic arts firms (1934 and 1935), an issue devoted to Frederic W. Goudy (Apr. 1935), and another on Bruce Rogers (Jan. 1936). Robert L. Leslie and Percy Seitlin were imaginative editors, and over the years the magazine presented a selective survey of the commercial arts of interest to typographers, illustrators, printers, photographers, and others involved in the production of printed materials. SUPERSEDED BY *AD* [E1160] 6–8 (Apr./May 1940–Apr./May 1942).

S204. POPULAR PHOTOGRAPHY. Chicago and New York. 1— (May 1937—), illus. (color).

Similar in content and general approach to *Modern Photography* [S176], this monthly well deserves its title, for circulation figures soared to over half a million in the 1970s. Combining technical material, many practical hints, and the work of outstanding photographers in highly effective color spreads, the magazine keeps ahead of mass interests in most aspects of contemporary photography. The average reader is kept squarely in focus in the writing style, in technical material, and in advice for purchases of equipment. Each issue includes certain regular features such as book reviews, travel service, reviews of photography exhibitions, tools, and techniques, as well as quantities of advertisements. Issues are now over 200 pages long and are packed with color and black-and-white illustrations. For nearly four decades, the magazine has championed the cause of good photography for everyone, amateurs as well as professionals. Articles are timely, reflecting current and future interests. The development of photography from the casual hobby of a few to a national pastime is recorded in this journal. PUBLISHED AS *Photography* (Jan. 1952–Jan. 1955). ABSORBED *Prize Photography* (Dec. 1941); *Photo Arts* (July 1948); *Camera Magazine;* and *American Photography* [S22] (Aug. 1953). Indexed in *Chemical Abstracts.*

S205. PORT FOLIO. Philadelphia. 1–5 (1801–1805); new ser. 1–6 (1806–1808); ser. 3 1–8 (1809–1812); ser. 4 1–6 (1813–1815); ser. 5 1–20 (1816–1825); ser. 6 1–2 (July 1826–Dec. 1827), illus.

Principally a repository of social and political comment of its time, this magazine contains occasional references to the visual arts and during much of its later history includes at least one illustration in each issue. As early as 1801, the magazine began a column for the fine arts, which reported comments on paintings and prints from London journals. Nicholas Biddle was the editor from 1812 to 1814; during this period art was covered more frequently. In 1813, an article on the "Life of Poussin" was printed, together with engravings of paintings by Rembrandt, David, and Guerin. The Aug. 1813 issue includes a lengthy review of an exhibition of the Columbian Society of Artists and the Pennsylvania Academy of the Fine Arts with such comments as "The experience of the last three annual exhibitions . . . has proved to the entire satisfaction of the admirers of the arts, that our native genius can rise to excellence without the aid of foreign culture." A lengthy series of articles "On the Principles of Taste" appeared in later issues for the year 1826. Engravers of book illustrations were lauded in an article on "The Fine Arts" in 1821, and Strickland's Bank of the United States is illustrated and described by the architect himself. SUSPENDED (Jan.–June 1826; Jan.–June 1827). An index covering 1816–1825 was published in ser. 5, vol. 20 (1825).

S206. PRAIRIE SCHOOL REVIEW. Park Forest, Ill. 1—

(Jan.–Mar. 1964––), illus.

This quarterly confines itself to the Prairie School of Architecture (sometimes referred to as the Second Chicago School), and it covers the subject in articles and illustrations with authority and distinction. Measured drawings appear regularly in addition to ground plans and book reviews. Many issues include buildings and designs by Louis Sullivan or Frank Lloyd Wright. This period, of major importance in the history of American architecture, is notably recorded and celebrated in the pages of this magazine.

S207. PRANG'S CHROMO: A JOURNAL OF POPULAR ART. Boston. 1–2 (Jan. 1868–Apr. 1869), illus.

This special magazine was published by L. Prang & Co., of 159 Washington Street, Boston. Its main purpose was to publicize the current publications of this famous printing firm. Of the typical eight pages per issue, two or three pages contain careful listings, descriptions, and prices of the many items available. The firm printed a variety of products: picture cards, Sunday School certificates, books in the shape of paper dolls, illustrated rebus cards, games, views of the Hudson River, illustrated crosses, valentines, marriage certificates, alphabet tables, crayon pictures, magic cards, and military albums, to mention only a few of the extraordinary visuals. The first issue describes the name and aims of the journal: "This initial number is exclusively devoted to chromolithography, and is therefore published at our own charge, and made free to all; because we have often found, to our surprise and cost, that this interesting and wonderful process is comparatively unknown, even to educated men, and because, also, we wish to show by explaining how our pictures are made, that, in imitating oil-paintings, our aim is not to deceive, nor to aid in deceiving, but, on the contrary, to render it impossible for unprincipled persons to sell our reproductions as originals." Feature articles described how chromolithographs were made. Other material includes a letter on popular art by James Parton; "Chromolithography in America," by Charles Godfrey Leland; an article on framing, by Louis Prang; and commentary from Harriet Beecher Stowe, Longfellow, Frederic E. Church, and Whittier. There are a few postage-stamp-sized illustrations, with brief but accurate descriptions of the works illustrated. The firm prospered, and the issue for Christmas 1868 describes the company's large, new printing plant. L. Prang & Co. did much to popularize art by producing inexpensive reproductions for all tastes and occasions.

S208. PRINT: A QUARTERLY JOURNAL OF THE GRAPHIC ARTS. New York. 1–– (June 1940––), illus.

In its early years, this magazine was closely involved with fine printing and included articles on the history of printing, the techniques of printmaking, master prints, printer's marks, book illustration, silk-screen printing, and bookbinding. The contributors were leading authorities, and the page design and general layout were models for all publishing. Imaginative inserts included candy wrappers, original and facsimile prints, wallpaper samples, and a green feather (May 1941 issue). More recent

issues include inserts of advertisements for paper, color printing, and binding fabric with survey articles on Art Deco, postcards, current posters, children's book illustration, and similar topics of interest and value to commercial artists and printers. The layout is lively and colorful, reflecting the best in drawing, photography, and design for commercial purposes. This magazine reflects a sincere attempt to demonstrate the importance of the graphic arts; in publishing terms, it blends fine printing with high scholarship. A variant subtitle is *A Quarterly of the Graphic Arts.* ABSORBED *Printing Art* (summer 1942); *Print Collector's Quarterly* [S212] (winter 1950–1951). Places of publication have included New Haven, Conn., Woodstock, Vt., and Hartsdale, N.Y.

S209. PRINT COLLECTOR'S BULLETIN: AN ILLUSTRATED CATALOGUE FOR MUSEUMS AND COLLECTORS. New York. 1–3 (Mar. 1930–1932/1934), illus.

The *Bulletin* was issued by the New York gallery M. Knoedler & Co. to publicize prints that were generally available from the firm. Beautifully illustrated and revealing expertise, each issue was devoted to the graphic work of a particular artist or to a period of print history. Durer's drawings and etchings, drypoints by Muirhead, and bone etchings by Whistler, Charles Méryon, and Van Dyck were reproduced and described. British mezzotint portraits and French color prints were among the historic examples surveyed. The *Bulletin,* rather than being a record of American printmakers, constitutes a symbol of American taste during the 1930s.

S210. PRINT COLLECTORS' CHRONICLE. Kansas City, Mo. 1–2 (autumn 1938–Apr. 1940), illus.

The six issues of this periodical of the Print Society of Kansas City were edited by Alfred Fowler. Issues averaged sixteen pages and included many small black-and-white illustrations in addition to brief articles "devoted to all phases of the subject of fine prints." Articles covered bookplates, miniature prints, Cyrus LeRoy Baldridge, Peter Hurd, and Leonardo da Vinci as an engraver, and an illustrated catalogue raisonne of the Woodcut Society. The magazine stated that it enjoyed "the unique distinction of being the only publication printed in the English language dealing with fine prints which accepts advertising and therefore provides a medium not heretofore available." It was aimed at the interests of print collectors, owners, artists, and enthusiasts, and cost only one dollar for four issues a year. The classified advertisements, news of print clubs, reviews of shows, illustrations of contemporary prints, and an attractive layout combined to produce a unique documentary of American print interests during its all-too-brief publication span.

S211. PRINT COLLECTOR'S NEWSLETTER. New York. 1–– (Mar.–Apr. 1970––), illus.

This bimonthly publication illumines nearly all facets of the art and acquisition of prints by means of special articles and continuing features. The issues are usually twenty-four pages in length and include articles by and about leading graphic artists, scholars, curators, collectors, publishers, and dealers. Regular topics covered include print

prices from auctions throughout the world arranged by name of the artist; upcoming auction dates and locations; new prints, multiples, portfolios, and livres de luxe; major print acquisitions by museums of the world; reviews of print exhibitions; highly authoritative commentary on significant new books; and a listing of catalogs. Plans for the magazine "began when the growing activity amongst museum curators, artists, dealers and collectors became evident and it was clear that there was no information source to satisfy the interest. The major art magazines have always treated prints perfunctorily, if at all We hope to stimulate research and scholarship in contemporary graphics and to aid in developing and updating connoisseurship in prints of all periods." The magazine crams each issue with an abundance of factual information carefully selected for lasting value and two or three major articles prepared by recognized specialists. Photography and new technical developments in graphic art are given equal emphasis with the works of Old Masters. Prepared in notebook format with punched holes for tidy storage, this periodical provides a major record of print activity and historic information based on advanced scholarship. Publisher's index issued for vol. 1–6.

S212. PRINT COLLECTOR'S QUARTERLY. New York, Boston, London, Kansas City, Mo., and Woodstock, Vt. 1–33 (Feb. 1911–Mar. 1951), illus.

This periodical emphasized engravings and etchings by prominent artists of the past and present. It was published in turn by F. Keppel & Co., New York; Museum of Fine Arts, Boston; Houghton Mifflin Co., Boston; J. M. Dent, London; J. H. Bender, Kansas City, Mo.; and William E. Rudge, Woodstock, Vt. Index to vols. 1–13 (1911–1936). REPRINT (Kraus Reprint Co.). SUSPENDED (1918–1920, Apr. 1942–Nov. 1948). SUPERSEDED BY *Print* [S208]. [*See also* K43.]

S213. PRINT CONNOISSEUR. New York and Champlain, N.Y. 1–12 (Oct. 1920–Apr. 1932), illus. (color).

This is an important magazine to all interested in the history and progress of American graphic art. The editorial in the first issue noted the growing interest in art in America with the comment "Art is beginning to come into its own, the pioneer stage is over, and in every part of the country rich states, cities, and individuals are enthusiastically devoting themselves to art in one form or another—the interest is everywhere increasing." American topics abound in each volume and are discussed in scholarly text and well illustrated, mostly in black-and-white reproductions. Many of the frontispieces were printed directly from original plates. Book reviews and catalogues raisonnés of many artists are regular features. A sampling of American topics includes Paul Revere's print of the Boston Massacre, prints of the Mexican War, Currier & Ives, a checklist of 159 portraits of General Winfield Scott, and early maps of California. This is an example of a specialized art magazine that brilliantly succeeds in accomplishing what it set out to do.

S214. PRINT REVIEW. New York. 1— (Mar. 1973—), illus. (color). [*cont.*]

This magazine copublished by Pratt Institute, Graphics Center and Kennedy Galleries, is primarily intended for print collectors and students of the graphic arts. A prepublication announcement from the publishers expressed a hope that semiannual magazine would "fill a long neglected gap among art periodicals in the English language." The first two issues were models of professionalism in content and format, profusely illustrated and handsomely printed with the same high standards found in Pratt's earlier periodical, *Artist's Proof* [S82]. The magazine is edited by Andrew Stasik, printmaker and teacher at Pratt Institute, with an editorial advisory board comprised of prominent art historians and curators from a number of great print collections, including those at the Library of Congress, The Metropolitan Museum of Art, and Yale University Art Gallery. Feature articles have appeared on the prints of David Hockney, Jasper Johns, Toyokuni, and Dürer, computer graphics, printmaking in southern California and Japan, and chiaroscuro woodcuts. Regular features include book reviews, lists of recent museum accessions, and an international director of printmaking workshops. Advertisements for graphic art equipment and dealer's and publisher's announcements appear at the back of issues. The many illustrations combined with a beautiful layout and comprehensive articles result in a handsome print periodical that adds significantly to the literature of historic and contemporary printmaking. [*See also* L356.]

S215. PRINTS. New York. 1–8 (Nov. 1930–Feb. 1938), illus.

The purpose of this notable contribution to the literature of our graphic art was set down in the first issue: "the fine work being done by our etchers, engravers, lithographers, and makers of woodblock and other prints is such that it constitutes a world in itself. *Prints* will endeavor to reflect the achievements of that world." The editor from 1930 through May 1935 was William Salisbury, who was described as an "artist, not in graphic or plastic creation, but in a literary way, being the author of five books." Alice Kistler was the editor beginning with Oct. 1935. For the history of American prints the magazine is a prime source of excellent material. Some of the contributors or subjects appearing in the magazine were Bolton Brown, Currier & Ives, Peggy Bacon, Wanda Gág, Arthur B. Davies, Martin Lewis, Stow Wengenroth, Matisse, Childe Hassam, and John Groth. There are many black-and-white illustrations and reviews of books and print exhibitions. An index to articles and illustrations appears in each volume.

S216. PROFESSIONAL ART MAGAZINE. Madison, Wis. 1–8 (Sept. 1934–Oct. 1941).

Drawing, watercolor, pastel, airbrush, and cartooning techniques were the specialty of this magazine conceived for art students, teachers, and amateur and professional artists. Illustration, fashion drawing, and other commercial media were stressed; a directory of art buyers, contests to enter, and trade tips lists practical items of interest to students and free-lance commercial artists. PUBLISHED AS *Professional Art Quarterly* (Sept. 1934–June 1938).

S217. PROGRESSIVE ARCHITECTURE. New York and Stamford, Conn. 1— (June 1920—), illus.

This is easily one of the major architectural periodicals in the history of American magazine publishing. It was established under the aegis of *Architectural Review* [S38]. In the introduction to the first issue, the editor, Eugene Clute, wrote that the magazine "will be devoted to matter of interest to draftsmen, designers and specification writers The plates will include reproductions of detail drawings from the offices of architects of the highest standing, as well as drawings of both ancient and modern work from all parts of the world." Beginning in 1932, a series of comparative details appeared over several years; topics covered include dormers, fences and gates, closets, residence bars, eaves and gutters, gambrel gables, exterior steps, balconies, chimneys, and corner cupboards. These measured drawings are models of clarity, and the series was eagerly received by the architectural community. In the 1930s, Russell Whitehead, editor from 1925 to 1936, ran a series of technical articles on American historic architecture. The International Style was discussed with greater frequency, and after the end of World War II the magazine was completely committed to the modern idiom.

The magazine now stresses modern work and covers the international scene. In 1946, the magazine encouraged the design of modern architecture by establishing the annual Progressive Architectural Awards for the best residential and nonresidential buildings constructed during the year. In 1954, the magazine began a yearly Design Award. The issue for Jan. 1950 included a special feature on American architecture from 1900 to 1950 entitled "The Grand Detour." The number was noted for its thoroughness and included sections on construction methods, materials and equipment, and architectural practice. Moreover, the magazine continuously stresses the social and ethical responsibilities of the architect and the builder. Another memorable issue appeared in June 1970 to celebrate the fiftieth anniversary of the founding of the magazine. The editor, Forrest Wilson, commented as follows on the architect's future role: "The vital task of the designer of the seventies will be design for survival . . . The whole earth ecology is the design parameter of the architect of the seventies, whose ultimate professional concern is the preservation of the planet's life support system including every living thing, from aardvarks to zebras with man somewhere in between." An absorbing article by Suzanne Stephens, "Architectural Journalism Analyzed: Reflections on a Half Century," is of prime interest to architectural bibliographers. Other feature articles in the issue are "Beaux-Arts to Burned Arts," "Five Decades of Interior Design: From the Classes to the Masses," "From Product to Process: The Third Generation of Modern Architects," and "From Pencil Points to Computer Graphics." Books are reviewed in depth in each issue. Illustrations for the articles and advertisements give the magazine considerable value to the casual reader as well as to the professional architect and student, to whom it is directed. Indexed in *Applied Science and Technology Abstracts*. PUBLISHED AS *Pencil Points: A Journal for the Drafting Room* (June 1920—Sept. 1945).

S217a. QUARTERLY ILLUSTRATOR. New York. 1—3:9 (Jan. 1893—Jan. 1895), illus.

This is a magazine notable in the development of American periodicals covering the visual arts, for it was devoted to a specialized subject which it served with distinction. Each issue includes hundreds of illustrations accompanied by biographical sketches of artists and histories of other illustrated magazines. The four issues for 1893 contain 678 illustrations by 302 artists, and the numbers for 1894 increased to 1,400 reproductions by 433 contributors. Photographic portraits of many of the illustrators are printed. Articles are interesting; for example, Richard Harding Davis wrote on "The Origin of a Type of the American Girl," and Charles de Kay described "Grützner's Smiling Monks." An excellent article, "Newspaper Art and Artists," by Allan Forman, appeared in 1893. Other topics include the Moran family of artists, Inness, Elliott Daingerfield, and Alice Barber Stephens, described as a "clever woman illustrator." Drawing was stressed, and Henri Pène du Bois wrote on the student of drawing in 1893. Conventional, stiffly posed photography as illustration was also covered in this unique periodical. The magazine was extremely useful as a sort of clearing house for publishers, editors, and authors needing art work, as the names and addresses of artists included in the various issues are listed. Since the art of illustration was on a high level at the time the magazine appeared, it is unfortunate that the topic was not covered continuously. For these years, the illustrations are truly fascinating and reveal imagination and technical skills of a high order. SUPERSEDED BY *Monthly Illustrator* 3:10—5:1 (1895). MERGED: *Monthly Illustrator and Home and Country* 11:3—13:? (Oct. 1895—Jan. 1897); volume numbering was picked up from *Home and Country*. Publication was continued under the title *Home and Country* 14:1—14:4 (Feb. 1897—May 1897). For additional details on publishing dates, *see* [S133] and the *National Union Catalogue: Pre-1956 Imprints* London: Mansell, 1975), vol. 392, p. 401.

S218. THE QUILL: A MAGAZINE OF GREENWICH VILLAGE. New York. 1—20 (June 3, 1917—May 1929).

A guidebook to the cultural activity of Greenwich Village and chronicle of its history, this magazine includes lists of artists living there. Willy Pogany was one of a number of contributing editors who defended Greenwich Village and its artists against their detractors. PUBLISHED AS *Greenwich Village Quill* (July—Dec. 1926, May 1927, May 1929); *Overtures* (Feb. 1927).

S219. RAINBOW: DRAMA, LITERATURE, MUSIC, ART. New York. 1:1—3 (Oct.—Dec. 1920), illus.

It is unfortunate that this promising art magazine did not prosper and enjoy a long life since the three issues published held considerable promise. The principal subjects are poetry, prose, and art. Its editors, Boris de Tanko and Horace Brodzky, presented unusual material, which was contemporary in spirit and reflected European art activities. Illustrations include contemporary works by Arthur B. Davies, Pascin, Vlaminck, Gaudier-Brzeska, Torres-Garcia, and Derain. The final issue is of special merit be-

cause it includes sixteen reproductions of the works of Walt Kuhn, along with his page decorations and an article, "A Spiritual Adventure with Walt Kuhn," By Frederick James Gregg. A note in the last number explains that the first and second numbers of *Rainbow* were denied the use of the mails, which may explain the quick demise of this promising venture.

S220. REALITY: A JOURNAL OF ARTISTS' OPINIONS. New York. 1:1–3 (spring 1953–summer 1955).

This journal was published after a group of New York artists joined together to discuss mutual problems. They were representative of the more traditional painters who strongly objected to the predominance of abstraction. Their statement in issue No. 1 that "mere textural novelty is being presented by a dominant group of museum officials, dealers and publicity men," clearly points out their concern over the appeal of the abstract movement so prominent at the time. Participants included Henry Varnum Poor, Edward Hopper, Philip Evergood, Raphael Soyer, Jack Levine, and, by letter, Bernard Berenson and Thomas Hart Benton. No. 2 dated; Nos. 2 and 3 lack volume number.

S221. RONGWRONG. New York. 1 (July 1917).

This was an early American Dadaist document apparently published by Beatrice Wood in 100 copies. The directors included H. Pierre-Roché, Beatrice Wood, and Marcel Duchamp. There is prose by Carl Van Vechten, Francis Picabia, and Marcel Duchamp. FACSIMILE REPRINT EDITION (Milan: Arturo Schwarz, 1970).

S222. ROYAL AMERICAN MAGAZINE; OR, UNIVERSAL REPOSITORY OF INSTRUCTION AND AMUSEMENT. Boston. 1–2 (Jan. 1774–Mar. 1775).

This slight magazine has a place of importance in the development of illustration and periodicals in America, especially because it appeared at a time of political turmoil in the colonies. During its brief history, twenty-two copper plates appeared in its pages; a few were political cartoons engraved by Paul Revere, lively in spirit and technically well executed. These biting and telling satires warrant Revere's reputation as the father of the American political cartoon. Other plates or "embellishments" include work by Joseph Callender, a view of Boston, portraits of Hancock and Samuel Adams; the Sept. 1774 issue boasted of "an elegant Engraving of a Water-Spout." The covers include a vignette metal engraving of a seated Indian offering the calumet to an officious "Genius of Knowledge." The ornamental headpieces and borders were restrained and classic. Clearly aimed mainly at giving comfort to the rebels, the magazine also included poetry, essays, articles on medicine, agriculture, and religion, and advice to lovelorn ladies. The "Domestic Intelligence" columns included notes on the flying of Liberty flags, training of town militias, and British troop movements. After the Battle of Lexington, the magazine ceased publication, but in its brief history it made a real contribution to American art through use of copper engravings as popular illustration.

S223. S.M.S. New York. 1–6 (1968).

Published by the Letter Edged in Black Press, this highly imaginative series of portfolios appeared in six bimonthly issues. The editors did not regard it as a magazine, since the material was not bound and did not report on happenings in the art world. Editorial comment existed only in the selection and collation of the contributions of the participating artists, who were given freedom of style and theme, limited only by the fixed dimensions of the container. Each issue was made up of a mixture of materials of the most varied sizes, shapes, and media; each work was regarded as a valid multiple equivalent to the original, not a reproduction. Thus, the packaging is unique in the field of American art periodicals. Recordings, tapes, poetry, a burned bow tie, parking meter stickers, a folded hat, Xeroxed sheets, fold-out constructions, booklets, and luggage labels for the Lusitania, the Andrea Doria, and the Hindenburg provide some idea of the mixed bag of tricks provided by these six imaginative issues. Some of the artists whose work appears are Christo, Richard Hamilton, Marcel Duchamp, Ray Johnson, Meret Oppenheim, Enrico Baj, Roland Penrose, Man Ray, John Cage, Roy Lichtenstein, Yoko Ono, Mel Ramos, Diter Rot, and Claes Oldenburg. Subscriptions were $125.00 for the six issues, which blend the work of young, unheralded artists with older, original artists of the twentieth century, often in fascinating juxtaposition. There was no identification with any "ism" past or present, although several artists represented Pop Art, Surrealism, and Neo-Dadaism. To use their own words, the editors produced a "portable gallery of contemporary hyper-awareness," and in doing so they created a fresh and surprising format reflecting their experimental era.

S224. SARGENT'S NEW MONTHLY MAGAZINE OF LITERATURE, FASHION, AND THE FINE ARTS. New York. 1:1–6 (Jan. 1843–June 1843).

The title page of this periodical includes a description of the contents which reads: "upwards of twenty-five embellishments, including fine mezzotint, line and stipple engraving, original colored drawings of American Wild Flowers, Etchings on Steel, Fashions and copyright music." One article dubs Sir Thomas Lawrence the "portrait painter of the age." The most valuable article by H. T. Tuckerman, entitled "A Day among Artists," recounts his visits to C. G. Thompson of the University of New York and to the studios of Chapman and Inman, with added comments on works by Durand, Cole, Anelli, and Huntington.

S225. SCHOOL ARTS MAGAZINE: THE ART EDUCATION MAGAZINE FOR TEACHERS. Boston and Worcester, Mass. 1— (Sept. 1901—), illus.

In its beginning years, the page size was small to be consistent with the format of an average book. Subjects are always aimed at the art teacher in public schools, mostly on the elementary grade levels. Articles are succinct, nearly always illustrated, and in the early years were devoted to May baskets, the sewing room, normal school art training, drawing the figure, animals and birds, lettering and stenciling, and outlines for school courses. Seasonal and holiday material was stressed: in December, for example, there was a special design with reindeer, Santa

Claus, or trees, which could be pulled out of the magazine and copied. A conservative approach to techniques and aesthetics was admired as proper for the subscriber, and good copying apparently was commendable. Published from September to June. Over the decades the magazine changed with the temper of the times and by the 1970s, nonobjective sculpture, psychedelic posters environmental concern, electronic and plastic jewelry, drugs and creativity, and photography workshops reflected contemporary adaptations at this level of concern. Prepared by Davis Publications, this has been the major art education magazine for teachers during the twentieth century; its pages record the changing attitudes in public art education over seven decades. The advertisements, craft instructions, book reviews, lists of resource materials, editorial content, and many illustrations make this a source second to none for research on art teaching in the schools of America. PUBLISHED AS *Applied Arts Book* (vols. 1–2); *School Arts Book* (vols. 3–11).

S226. SKETCH BOOK: A MAGAZINE DEVOTED TO THE FINE ARTS. Chicago. 1–7 (Feb. 1902–Feb. 1907).

In the beginning, this magazine was aimed at art students attending the various academies, institutes, and design schools in the country. Representatives from ten or more major cities were listed. Articles cover figure drawing, illustration, bookplates, cartooning, sketching, design principles, and descriptions of the various art schools, some of which were for women only. The policy of the magazine was broadened beginning with the Sept. 1905 issue. Larger pages appeared in more substantial issues, and the editorial policy proclaimed "that American Art for Americans will always be the paramount issue." Articles of value appear on many topics such as Rockwood pottery, pictorial photography, and a house designed by Frank Lloyd Wright at Oak Park, Ill.

S226a. SMITHSONIAN. Washington, D.C. 1– (Apr. 1970–), illus. (color).

[This popular magazine is published by the Smithsonian Institution and sent to its members, the Smithsonian Associates, as a benefit of membership. Articles, which emphasize, but are not restricted to, connections with the Smithsonian Institution, cover a variety of subjects, especially science and history. One or more articles a month are usually devoted to art. Art stories, up to 3,000 words long, contain ample illustrations, all in color. The authors write in a descriptive rather than critical manner on museums, exhibitions, and artists, stressing personalities and general interest more than works of art themselves.]

S227. **Society of Architectural Historians,** JOURNAL. Amherst, Mass., and Philadelphia. 1– (Jan. 1941–), illus.

This notable quarterly devoted to architectural history of all countries in all periods has prospered over a third of a century; its format has continuously improved while the caliber of the contributors has remained authoritative, scholarly, and dedicated. The beginning subscription list contained about thirty names in Jan. 1941, when the periodical was produced in mimeographed format under the guidance of Turpin C. Bannister. After vol. 5 (1945–1946) the production quality was generally improved; eventually type was set by Stinehour Press and printed with great care by Meriden Gravure Co. Although the scope is international, there is unique material on American architectural history; illustrations are printed with the greatest clarity and in quantity on nearly every topic. Three or four featured articles make up each issue, along with book reviews which are comprehensive and informative. In Jan. 1974, the society published a comprehensive index covering the first twenty volumes (1941–1961). The indexer, Shirley Praeger Banner, included 35,000 entries on 472 pages and created a rich work of reference. This index was a pioneering effort in computerization in the humanities, and it is coded in such a way that it can be merged with other related indexes. A glance at the index also makes the extraordinary value of the magazine to researchers in American architectural history instantly apparent. Hundreds of American geographic locations and architects are listed, many with multiple entries. / The parade of scholars who filled the editorial chair began with Turpin Bannister (1941–1944), who was followed by Allan K. Lang (1945–1949), Walter L. Creese (1950–1952), J. D. Forbes (1953–1958), Paul F. Norton (1959–1963), Robert Branner, (1964–1966), Peter Collins (1967–1968), Osmund Overby (1968–1973), and James F. O'Gorman (1974–). Charles F. Peterson edited the celebrated "American Notes" section (1951–1967). Over the decades, this magazine has gained a secure position in the annals of American scholarship and has made a lasting contribution to American thought. PUBLISHED AS American Society of Architectural Historians, *Journal* (vols. 1–4). Indexed in *American History and Life* and *Historical Abstracts.*

S228. **Society of Architectural Historians,** NEWSLETTER. Philadelphia. 1– (Sept. 1957–).

Published six times a year, this publication presents quantities of timely news to the membership of the society. Regular sections of the *Newsletter* cover notices of the organization, news of members and of other societies, obituaries, listings of new books, activities of the various chapters, and historic preservation announcements and developments. There are a few advertisements for outstanding books. A study of the periodical over the years clearly reveals the marked rise in interest in architectural history in the United States, characterized by an expanded publications listing, increased numbers of tours and symposia, and the development of numerous related organizations such as The Victorian Society in America, the Friends of Cast-Iron Architecture, and the Society for the Preservation of Old Mills, to mention only a few.

S229. THE SOIL: A MAGAZINE OF ART. New York. 1:1–5 (Dec. 1916–July 1917), illus.

This monthly was concerned with the theater, films, literature, and poetry as well as with the visual arts. This diversity is demonstrated by articles such as "Making Fun," by Charles Chaplin; "Mrs. Th-y," by Gertrude Stein; and "Daisies in the Moon," by Maxwell Bodenheim. The literary editor was Enrique Cross; the art editor was R. J. Coady, who operated an art gallery in New

York City. Illustrations include works by Poussin, Rousseau, Max Weber, Renoir, and by some sculptors. Ambroise Vollard wrote on Renoir and authored a remarkable article entitled "Cézanne's Studio." The issue for Apr. 1917 included special material on Oscar Wilde with an announcement that "none of the documents on Oscar Wilde appearing in this issue have ever been published before. The impressions were written by his sister-in-law. The description of the house is the only one in existence and was made by his brother-in-law." The final issue includes lengthy commentary on the large exhibition held at Grand Central Palace by the Society of Independent Artists; the editor's notes comment on individual works by such artists as Braque, Demuth, Halpert, Hartley, Marin, Picasso, Stella, Walkowitz, Max Weber, and Mrs. Harry Payne Whitney.

S230. SOUTHERN ARCHITECTURE AND BUILDING NEWS. Atlanta. 1–58:8 (1889–1932).

Concentrating on the architecture of the Southeast with emphasis on the Atlanta area in its early years of publication, this magazine presents a detailed survey of all types of buildings designed and built during the four decades of its existence. Issues from before the turn of the century include technical articles, drawings and renderings of notable structures, quantities of small advertisements, and a "Buyer's Guide" listing sources of materials and services. Of unusual historic interest are long lists of projected construction for private residences and other buildings in the southern states. Architectural history is occasionally covered by articles on George W. Vanderbilt's house, Biltmore, in Asheville, N.C. (Dec. 1897); Jefferson as an architect (Feb. 1899); and the buildings at the Pan American Exposition (Jan. 1900). Technical topics include material on the clays of Georgia, the construction of dmes, the renascence of wrought iron, and the ventilation of cellars.

In Nov. 1908, the editor promised readers many notable special issues, on Southern skyscrapers, Southern churches, school buildings, theaters, modern railway stations, Southern bungalows "so well suited to the climate," historic surveys "devoted to the quaint architecture of our older Southern cities: Charleston, Savannah, St. Augustine, New Orleans, etc., which will prove the exceeding interest to every student of our early colonial building operations." In 1908, the glossy paper was of high quality, and photographs of buildings were well reproduced. In its final years during the Great Depression, the magazine covered architecture in seventeen southern states and usually featured superior homes of contemporary design and construction. The magazine is relatively hard to locate (notations in volumes at the New York Public Library gathered for binding in 1906 and in 1932 read "gave up hope for more"); however, this periodical provides a factual and accurate documentary survey of regional architecture in the United States. PUBLISHED AS *Southern Architect; Southern Architect and Contractor.*

S231. SPACE. New York. 1:1–3 (Jan.–June 1930).

This little magazine had a virtual all-star cast made up of artists, critics, colleitors, and dealers working on its edit-

ing and production. It is unfortunate for the documentation of American art that the magazine was not continued, but later generations can salute the daring of the editors in launching an art magazine during the darkest days of the Great Depression. The editor-in-chief was Holger Cahill. Edith Gregor, Stefan Hirsch, Robert Laurent, and Max Weber were some of those who contributed their services to the editorial board. The general policy was clearly stated in the first number: "The magazine will be devoted to contemporary American art and related subjects. It will provide an opportunity for artists to write about their own craft, and will be a forum for exchange of views between artists, critics, writers, museum officials, collectors, dealers, and the public *Spaie* is not a commercial magazine. No advertisements will be accepted from art galleries, exhibition societies, or artists." The first issue was given over to the topic of "The Problem of the Critic in Contemporary American Art"; and contributors included Forbes Watson, Henry McBride, Lloyd Goodrich, and Edward Alden Jewell. The topic for the second issue was "The Problems of the Museum in Contemporary American Art"; museum specialists who contributed brief articles were A. E. Gallatin, A. Conger Goodyear, and Fiske Kimball. The final issue included an announcement that an original print, "Circus Girl," by Kuniyoshi, would be sent gratis to each new ten-dollar subscriber. Duncan Phillips wrote on "Free Lance Collecting," and Stuart Davis, Louis Lozowick, Peggy Bacon, and John Sloan provided articles which give lasting distinction and value to this brief record of American aesthetics and art history in the first months of 1930.

S232. STUDENT PUBLICATION OF THE SCHOOL OF DESIGN. Raleigh, N.C. 1— (1951—), illus.

Issued by North Carolina State University's School of Design and with a worldwide circulation for the twenty-two volumes published over the first twenty-four years, this student publication earns particular merit for the high standards it has set and carefully maintained. The magazine is sustained by student fees, the sale of issues, donations, and apparently by selected dealers. Collection of material, editing, design, and circulation are all managed by students; editors are encouraged to continue the tradition of relevance and quality but are otherwise unrestricted. This attitude has resulted in the presentation of topics of timely interest to students, educators, and professionals in design. As examples of special numbers, the issue for 1964 was prepared with the assistance of Paolo Soleri, who did freehand sketches of the plans for the Cosanti Foundation in Arizona and prepared the captions that appear beside the sketches of his highly imaginative structures. The skeletons of ten buildings are the subjects of outstanding architectural drawings for a 1967 issue, which was published in portfolio format with loose plates. Other special issues have covered gardens, photography for designers, response to environment, structures of warped surfaces, and architectural education.

S233. THE STUDIO. New York. 1–3 (Jan. 6–Dec. 1883), illus. New ser. 1–9 (1884–Nov. 10, 1894). [*cont.*]

This magazine had two distinctly different phases of publication. During its first year, it was a weekly publication edited by Frank T. Lent, aided by well-known artists. He outlined the objectives of the magazine as follows: "*The Studio* is intended to be the organ of artists for the brief interchange of opinion on subjects of special interest to themselves Special and impartial attention will be given to studio and exhibition work. A weekly epitome of studio news will be furnished, with notices of all new work that may be undertaken and information as to the whereabouts and occupation of artists, together with suitable notice of whatever may be on exhibition or in the course of preparation. This will be accompanied by pen and ink drawings of fresh work, reproduced by photoengraving. A correspondence has been arranged for in our principal art centers, as well as in European cities where American artists work." The magazine, in 1883 subtitled *Devoted to Art, Artists and Their Friends*, was crammed with bits and pieces of information regarding exhibitions, addresses of New York artists, and notices from all over, including London and Munich.

All this changed dramatically in Aug. 1884 when a new editor took over. The *New York Times* for June 22, 1884 commented on the new arrangement as follows: "*The Studio*, a little art periodical, very neatly printed and furnished with a pretty decoration for its cover by Elihu Vedder, is about to enter a new lease of life under the able conduct of Mr. Clarence Cook The older periodical departs from its original intention and seeks a wider field—that of connoisseur and dilettante, as well as of artists." It began as a fortnightly publication and concentrated on reporting activities of groups such as the National Society of Arts, the National Academy of Design, and the American Art Association. Prizes, competitions, and exhibitions were commented on. Later, it became a weekly again, and emphasis was placed on European artists and subjects such as the French sculptor, Antoine Louis Barye, Etruscan objects, and Rembrandt. A section of "American notes," including reviews of museum and art association activities, was retained.

S234. STUDIO POTTER. Goffstown, N.H. 1—(fall 1972—), illus. (color).

Published semiannually and sponsored by the Daniel Clark Foundation, this recent entry in the field of crafts periodicals covers three areas of major interest. Issues deal with technical topics, current craftsmen, and historical surveys. Nineteen potters from North Carolina are described in the summer 1974 issue, followed by an article on Egyptian faience by Fong Chow of The Metropolitan Museum of Art. Nine articles on kilns provide detailed practical information on this complex subject, including the firing of kilns with methane gas generated from organic wastes and with solar energy. Pottery wheels are compared in a later issue. The magazine is successfully designed with many photographs, drawings, and diagrams and some printing vignettes. Down-to-earth in approach, the magazine has real value to the active potter and to all those involved in the ceramic arts.

S235. SUN AND SHADE: AN ARTISTIC PERIODICAL. New York. 1—8 (July 1888—Mar. 1896), illus. (color). [*cont.*]

High-quality illustrations on a wide variety of topics were the basis of this periodical, which was published by the Photo-Gravure Co., located on New York City's Broadway. Each issue includes a single page of text with an annotation describing each plate listed. Subjects ran the gamut of contemporary interests in an embryonic attempt at photojournalism. On the cover of the first issue "a photographic record of events" appears directly under the title. An average of eight full-page illustrations make up each issue, utilizing photo-gelatine as the means of reproduction. Salon paintings of European and American origin were photographed and are reproduced with regularity. Portraits of distinguished figures and current celebrities appear, sometimes with their signatures in facsimile directly under the portrait. Such personalities included Mrs. Potter Palmer, J. Alden Weir, Kate Field, Grover Cleveland, Catharine Lorillard Wolfe, Henry George, General Philip Sheridan, Ella Wheeler Wilcox, Francis Parkman, and Mrs. Frank Leslie. The magazine is located archivally in the Theater Collection of The New York Public Library as it included portraits of theater favorites: Lillian Russell, Joseph Jefferson, Alexandro Salvini as Hamlet, Pauline Hall, Rose Coughlan, Hortense Rhea, and Margaret Woffington as Sir Harry Wildair.

Diverse subjects are pictured. Small ships of all types are illustrated; a souvenir edition for Aug. 1895 showed the challengers and defenders of the American Cup. Architecture of merit appeared now and then; there are photographs of the hall of a residence at fashionable Newport, R.I., and a private residence in Springfield, Mass., which combined shingles and stone as designed by the architectural firm of Richmond & Seabury. The Christmas number for 1893 was made up of twelve pages of photographs of the Court of Honor at the World's Columbian Exposition in Chicago. Some of the photographs are memorable, including one reproduced Feb. 1893 showing a sizable flock of fat sheep being herded down Germantown Avenue in Philadelphia, the Eiffel Tower in 1889, a cockle gathering as taken by J. L. Williams in 1889 in Rye, England, and a flashlight photograph of a varnish mixer in Newark, N.J., taken by W. J. Mozart in 1889. The first issue included carefully selected groups of words on the cover such as sunlight, electricity, magnesium, and in quotation marks around the outer border "The glorious sun stays in his course and plays the alchemist." Color was used in issues in 1895. For an over-all view of popular American visual material in the final decade of the nineteenth century, this magazine has value to researchers. Its primary merit rests, however, on the photographs, with their special iconography and evidence of technical changes, and on the magazine's treatment of photography as an art form. Index issued for vols. 1—5 (1883—1893).

S236. TIGER'S EYE. Westport, Conn., and New York. 1—9 (Oct. 1947—Oct. 1949), illus. (color).

This "little magazine" was primarily concerned with aesthetics, especially in the realms of poetry, fiction, essays, and criticism. During its two years of publication, however, it lavishly printed the works of contemporary artists. It was edited by Ruth and John Stephan with various

associates for individual issues including, among others, Kurt Seligmann, Stanley William Hayter, Barnett Newman, and Jimmy Ernst for art. The intention of the magazine is stated in the initial issue: "to be a bearer of ideas and art. In the belief art is a quest that can be good only as water is good, there is no wish to reach for a halo of GOOD, which is a prudish proud ambition. It places its dependence instead on ingenuous and ingenious artists and writers whoever they are, as they move through the dimensions of curiosity." An unusual procedure allowed the reader to consider each work and its effect upon him without the advantage or prejudice of knowing the names of the author or artist until consulting the index, printed in the center of the magazine. The editors stated the magazine's official view of art as follows: "That a work of art, being a phenomenon of vision, is primarily within itself evident and complete; that the study of art remains an after thought to the spontaneous experience of viewing a work of art So it is our intention to keep separate art and the critic . . . and any text on art will be handled as literature."

The typography, layout, and general design were original and highly successful. Even the most casual glance through the magazine reveals to the reader that he has something special in hand. The art works selected indicate an awareness of the New York art scene and artists of growing prominence were sought out for reproduction. For example, the names of William Baziotes, Adolph Gottlieb, Mark Rothko, Herbert Ferber, Hedda Sterne, Robert Motherwell, Arshile Gorky, Jackson Pollock, Eugene Berman, and Matta Echaurren appeared regularly in New York galleries in the late 1940s, and their works appear frequently here. Fourteen sculptors wrote on aesthetics. Kurt Seligmann, Motherwell, Barnett Newman, and Nicolas Calas joined others to write on "What Is Sublime in Art?" The issue for Mar. 1949 includes nearly forty pages of the thoughts of poets writing on painters and sculptors. Surrealism is presented as a major movement in modern art with works by Tanguy, Ernst, Magritte, Seligmann, and Masson. The number for June 1949 is representative of what the magazine tried to do for art. Well over fifty pages show a selection of graphic art by Yunkers, Dubuffet, Hayter, Frasconi, Anne Ryan, and Misch Kohn. Several color plates were tipped in; five were hand printed in an "attempt to reproduce creative graphic art as near to a reduced facsimile as possible in the magazine, in contrast to the usual photo mechanical color process reproductions. The print by Boris Margo is printed from the original plates by the artist." Primarily literary, this periodical made a decided contribution to art opinion during the last years of the 1940s, a turning point for American artists. Aesthetic views were brilliantly surveyed, and the visual arts found a champion in this journal whose existence was all too brief. For some unknown reason, nos. 4–9 are also called vol. 1. REPRINT EDITION of 9 nos.: (New York: Kraus Reprint Co.).

S237. TIME: THE WEEKLY NEWS MAGAZINE. New York. 1– (Mar. 3, 1923—), illus. (color).

The "Art" department of this weekly magazine began with a single column of items largely rewritten from newspaper accounts, but over the years the space was enlarged until art coverage became an important part of the magazine's content. The periodical records international developments in painting, sculpture, and architecture, but American art has received major attention, especially after 1945, when full-color illustrations were introduced. During the 1950s and 1960s, when Abstract Expressionism and Pop Art were receiving worldwide interest, the magazine regularly printed highly authoritative articles accompanied by top-quality color reproductions. Many of the color plates later appeared in publications put out by Time-Life Books. In 1970, an index entitled *Art in Time* was published, listing all such reproductions in the magazine from the first number through 1969. *Time* readers are generally well educated, and the art coverage did much to spread interest in new artists, movements, and trends to this mass audience with leisure and money to support the visual arts.

S238. TOUCHSTONE. New York. 1–8 (May 1917–Feb. 1921), illus.

Not limited to the visual arts, this magazine was subtitled *Art, Music, The Stage, Fiction, Poetry, Education, Homes, Gardens, and the Crafts* and was edited and published by Mary Fanton Roberts. Isadora Duncan wrote on dance (Oct. 1917), John Masefield on poetry (Mar. 1918), and Sarah Bernhardt was the subject of an article in Nov. 1917 which focused on her statement "I'd rather be a Poilu fighting for France than be Bernhardt." During the years of World War I and up through 1919, considerable emphasis was placed on war activities such as canning, growing vegetable gardens, war posters, uniforms adopted by women in war work, and hobbies for the shell-shocked. However, all issues include good articles on art with an American emphasis. A sampling of artists and subjects includes Mahonri Young, John Sloan, Boardman Robinson, Arthur B. Davies, George Grey Barnard's Lincoln statue, Rodin, Meštrović, Gardner Hale's frescoes, George Luks, and etchings by Frank Brangwyn. General subjects, which indicate the broad scope of the magazine's contents, include beautiful new kitchens, artistic wrought iron, American furniture, color in California domestic architecture, brookside gardening, and the effects of the Communist Revolution on Russia as seen from the establishment point of view in "The Bolshevist and the Cubist" (Jan. 1919). There are many black-and-white and sepia illustrations. The magazine was notable for the celebrated artists it presented to its readers and for focusing on major art interests during the years of its publication. Skillfully edited by a firm hand pursuing a definite editorial policy, the journal provides a good all-around survey of American interests in the fine arts from 1917 to 1921. ABSORBED *American Art Student and Commercial Artist* [S10] in Sept. 1918. SUPERSEDED BY *Arts* [S83] in June 1921.

S239. TRANS/FORMATION: ARTS, COMMUNICATION, ENVIRONMENT—A WORLD REVIEW. New York. 1:1–3 (1950–1952).

This annual published by Wittenborn, Schultz had

contributors in Paris, Rome, Zurich, London, and India. The editors, Harry Holtzman and Martin James, affirmed that "art, science, technology are interacting components of the total human enterprise . . . but today they are too often treated as if they were cultural isolates and mutually antagonistic" and proposed to "cut across the arts and sciences by treating them as a continuum." The international contributors represented intellectuals and artists such as Alfred H. Barr, Jr., Buckminster Fuller, Sigfried Giedion, Le Corbusier, Gyorgy Kepes, Willem de Kooning, Kurt Seligmann, Stanley William Hayter, José-Luis Sert, and Sibyl Moholy-Nagy. Other texts came from Merce Cunningham, Margaret Mead, and Albert Einstein. Ad Reinhardt produced three double-paged highly satirical cartoons entitled "Museum Landscape," "Museum Racing Form," and "Art of Life of Art." The issues sometimes reprinted material previously available in book or lecture format. Nonetheless their critical and philosophical articles were highly authoritative and covered a variety of topics significant to the early 1950s.

S240. Transition: An International Quarterly for Creative Experiment. Paris and The Hague. 1–27 (Apr. 1927–spring 1938), illus.

Although published in Europe, this celebrated magazine had many American associations. The principal agent was the bookstore Shakespeare and Co., owned and operated by Sylvia Beach, an American. The works of many American writers and artists appeared in each issue. James Johnson Sweeney was an associate editor, and bookstores in New York, Boston, Buffalo, Cambridge, Mass., Chicago, Philadelphia, Detroit, Hollywood, Minneapolis, and Portland, Me., handled sales and subscriptions. The magazine itself boasted that it was "read by the most alert minds of both America and Europe." Under the editorship of Eugene Jolas, who was born in New Jersey, issues were extraordinarily rich gatherings of the writings and reproductions of art by the most influential and celebrated authors and artists of the first half of the twentieth century. The page size was small, but issues ran from 148 pages to 325 pages (for Mar. 1932). Some of the prominently featured American artists are Louis Lozowick writing on Lissitsky, Charles Sheeler's industrial photography, Berenice Abbott's portraits, Alfred Barr, Jr., writing on Soviet art, Alexander Calder's wire sculpture, Stuart Davis's paintings, Man Ray's writings and photographs, and Joseph Stella's painting.

The magazine was truly a collaboration between artists and writers, and it successfully combined the visual arts and literature on a fairly even basis. American writers were published continuously, with regular appearances of new work by Gertrude Stein, William Carlos Williams, and Hart Crane. A partial listing of the contents of a single issue, No. 26 (1937), gives an accurate summation of the unique contribution to modern art made by this little magazine. The cover by Marcel Duchamp is followed by the texts of James Agee, Paul Eluard, James Joyce, Hans Arp, Franz Kafka, and Randall Jarrell. Illustrative material includes the musical score of a song by Aaron Copland and works by Man Ray, Brassaï, Julio Gonzales, Naum Gabo, Henry Moore, and Ben Nicholson. Texts on

art came from Moholy-Nagy, Léger, Mondrian, and André Lhote; an essay on moving pictures was written by the distinguished art historian Erwin Panofsky. The horrors of World War II were just approaching in 1938, and the magazine closed publication after No. 27, a notable 382-page anthology with a cover by Kandinsky. Jolas stated that the magazine was founded "as a more or less eclectic organ, with the basic aim of opposing to the then prevailing photographic naturalism, a more imaginative concept of prose and poetry." SUSPENDED (July 1930–Feb. 1932). REPRINT EDITION (New York: Kraus Reprint Co.).

S241. Trend: An Illustrated Bimonthly of the Arts. Brooklyn, N.Y. 1–3 (Mar./May 1932–Apr. 1935), illus.

Published by the Society of Teachers and Composers, this magazine printed commentary and critical opinion on various events and exhibitions in seven areas of literary, performing, and visual arts, including painting, sculpture, architecture, dance, drama, literature, and, of course, music. Contributors include Frank Lloyd Wright, Buckminster Fuller, and Richard J. Neutra on American architecture; Martha Graham on dance; and reviews of art exhibitions by Marchal E. Landgren with articles on the sculpture of Richmond Barthé (1932) and the photography of Berenice Abbott (1935). Selected book and record reviews, notes on the contributors, and illustrations of the art of the period provide a survey of the humanities for a three-year period during the Depression. Subtitled A Quarterly of the Seven Arts (1932–June 1933). SUSPENDED (July 1933–Feb. 1934).

S242. Trimmed Lamp: A Periodical of Life and Art. Chicago. 1–5 (Oct. 191–May 916).

This magazine began as an advertising outlet for the O'Brien Galleries of South Michigan Avenue; its purpose was to keep the art world of Chicago and the West familiar with the contents of the galleries. At first there was no subscription fee, but by May 1913 the monthly was available at one dollar a year. Howard Vincent O'Brien, the editor, included the following statement in the first issue: "We propose to steer a middle course, not endeavoring to appeal to the dilettante, the specialist, the connoisseur, so much as to interest a greater number with a catholic love for beautiful things." Many articles were written by the editor on architecture, antiques, how to enjoy art, how to look at pictures, and the real founders of Post-Impressionism. World War I and moral philosophy were more prominently featured after Oct. 1914, and the magazine's content became even more eclectic and diffused. In 1915, the editor of Poetry, Harriet Monroe, judged a lyric contest; in Apr. 1916, a poem by Amy Lowell entitled "Impressionistic Picture of a Garden" appeared. A few advertisements are included in each issue, but the magazine clearly had no definite course to follow. Its value to America's art history is marginal although it gives some indication of art activity in Chicago during its three and one-half years of existence. PUBLISHED AS Art: A Monthly Magazine (Feb. 1912–Feb. 1914). SUPERSEDED BY Dial [S122], July 1916.

S243. 291. New York. 1:1–12 (Mar. 1915–Feb. 1916), illus.

Alfred Stieglitz's celebrated Photo Secession Gallery at 291 Fifth Avenue issued this monthly journal, which contained unique material such as experimental typography and unusual illustrations including photography. The 291 Gallery under Stieglitz introduced major modern artists of Europe and America to New York. Hilton Kramer has aptly described Stieglitz as the "first of our dealer-priests" and his gallery as "a physical place where the art could be seen (and purchased) and a spiritual space where it could be properly contemplated and understood." The magazine was a protest against the academic and the stereotyped. There were twelve numbers in all—six single and three double ones. Among them are many drawings by Picabia and a picture in type—an "idéogramme"—by Apollinaire. Other unconventional artists whose work was reproduced include Picasso, Walkowitz, Braque, Max Jacob, and John Marin. Stieglitz and others working on the magazine were influenced by the European avant-garde, free verse, and poetic and typographical experiments. One double issue featured as insert Stieglitz's famous photograph "The Steerage." The magazine was a deluxe affair but hardly a commercial success. However, it had a decided influence on the later Dada movement, as in the naming of Picabia's periodical *391*. The REPRINT (New York: Arno Press) contains an introduction by Dorothy Norman, and brief index to *291* compiled by Bernard Karpel for this title in the Arno Series of Contemporary Art.

S244. [SARTAIN'S] UNION MAGAZINE OF LITERATURE AND ART. New York and Philadelphia. 1–11 (July 1847–Aug. 1852), illus. (color).

Although it had no official connection with the American Art-Union, this magazine took its name from the art organization so popular at the time. Originally edited by Caroline M. Kirkland and later by John Sartain, the magazine was adorned with mezzotints, steel and wood engravings, and fashion plates in color. New books on painting and architecture were occasionally reviewed, and later issues featured articles on fine art. The well-executed steel and wood engravings and splendid mezzotints were the main art features of the magazine, which also paid some attention to drawing and dress. The final issue for Aug. 1852 included an article on the painter Daniel Huntington. PUBLISHED AS *Union Magazine of Literature and Art* 1–3 (1847–1848).

S245. VIEW: THROUGH THE EYES OF POETS. New York. 1–7 (Sept. 1940–Mar. 1947).

Edited by Charles Henri Ford, this magazine was appropriately subtitled because it included commentary on drama, Hollywood films, contemporary literature and poetry, and an occasional political observation in addition to "prophecy" and "fable." In the visual arts, the magazine regularly presented material on Surrealism, and ser. 2: 7–8 (1941) is a special issue on the movement. Articles on and by Surrealist artists such as André Breton, André Masson, Max Ernst, Marcel Duchamp, and Kurt Seligmann appear frequently. Parker Tyler wrote on

films, William Carlos Williams reviewed books, Marianne Moore was interviewed, and Kay Boyle wrote from France. Ser. 2:1, in reduced format, is devoted to Max Ernst; other double numbers cover the art of Tchelitchew and Yves Tanguy. The issue for Oct. 1942, the *Vertigo* number, shows the aesthetic possibilities of arrested or confused sensation. A major Duchamp number, in both ordinary and deluxe format, was published Mar. 1945. In 1943, Parker Tyler became assistant, then associate, editor. The irregular series are as follows: Ser. 1: 1–12 (Sept. 1940–Mar. 1942); ser. 2:1–4 (Apr. 1942–Jan. 1943); ser. 3:1–4 (Apr.–Dec. 1943); ser. 4 (Mar.–Dec. 1944); ser. 5:1–6 (Mar. 1945–Jan. 1946); ser. 6:1–4 (no. 3 repeated) (Feb.–May 1946); ser. 7:1–3 (Oct. 1946–Mar. 1947). OVERSIZE REPRINT: ser. 1 only (New York: Kraus Reprint Co.).

S246. VVV: POETRY, PLASTIC ARTS, ANTHROPOLOGY, SOCIOLOGY, PSYCHOLOGY. New York. 1–4 (June 1942–Feb. 1944), illus.

Edited by David Hare, *VVV* is an illustrated Surrealist magazine with a title taken from the World War II slogan for ultimate victory. The periodical was influenced by André Breton and the New York coterie of European Surrealist and abstract artists who fled from Europe. André Breton, Max Ernst, and Marcel Duchamp are noted as "editorial advisors." Texts in English and French include some poetry and prose. Pts. 1, 2/3, and 4 have covers designed by Ernst, Matta, and Duchamp, who also did a curious collage of George Washington for No. 4. A tongue-in-cheek, Surrealist bibliography by Kurt Seligmann appears in No. 2/3.

S247. **Western Art-Union,** TRANSACTIONS. Cincinnati. (1847–Apr. 1850).

This was an annual publication listing the Western Art-Union's officers, plan of operation, charter, constitution, bylaws, annual report, names of members, honorary secretaries, and treasurer's report. The annual distribution of works of art is also listed, giving the lucky recipient's name and home city. Some of the paintings distributed were by Bingham, Eastman, Heade, Krieghoff, Rembrandt Peale, and Sonntag.

S248. **Western Art-Union,** RECORD. Cincinnati. (May 1849–1850).

The Western Art-Union, established in Cincinnati in the spring of 1847, founded "in the Western Country . . . a popular system for promoting a knowledge and love of Art." This *Record* was largely a catalog of the sculpture and painings on view at the Union Gallery with free admission to members, their families, and strangers introduced by them. Strangers lacking introductions had to pay one dime to enter.

S249. WESTERN ARTIST. Denver. 1–3 (June 1934–Dec. 1936), illus.

This regional magazine was originally published by the Denver Artists Guild and was later issued independently. A regular column "With the Artists" lists activities of Western artists and organizations in Arizona, Colorado, Kansas, California, Missouri, New Mexico, Texas, Utah,

and Wyoming. Book reviews, black-and-white illustrations, and news of the Denver Art Museum are regular features of this Western "inspirational magazine devoted to the advancement of art." PUBLISHED AS *Denver Artist* 1 (June 1934).

S250. Western Arts Association, BULLETIN Milwaukee and Detroit. 1— (1916—).

No. 4 of each *Bulletin* prints the association's Annual Report. This association is dedicated to the advancement of the teaching of art, household arts, industrial arts, and allied subjects. The *Bulletin* concentrated on the activities of the association and in later years reported mainly on the annual convention, which was frequently held in Saint Louis or Grand Rapids, Mich. Some of the diverse areas of art education discussed in articles over the years include manual training, the educational program of the American Federation of Arts, home economics and related art, the cotton industry in Memphis, Tenn. (1925), creative dressmaking, furniture and education, and art training for industry. Notable speakers from the art world addressed annual conventions during the 1930s and 1940s. The roster included Ruth Reeves, speaking on the Index of American Design, Zorach on sculpture, Viktor Lowenfeld on art as a basic area in human experience, Richard J. Neutra on architecture, Grace L. McCann Morley on world unity, Stanley William Hayter on bridging barriers, and T. H. Robsjohn-Gibbings on changing times. Such talks are printed in the convention issue of each year's *Bulletin*. Art education principles and practice are documented in detail in this periodical covering the Midwestern scene, especially with regard to public schools.

S251. THE WHITE PINE SERIES OF ARCHITECTURAL MONOGRAPHS. New York. 1–14 (1915–1940), illus.

Measured drawings and clear, detailed photographs of early American architecture are the special province of this magazine, which is of immense value to restorers and those working on architectural history and preservation. Churches, gateways, doors, taverns, fences, and homes appear in profusion; each issue includes a brief text by an author with specific knowledge of the structure, town, or area under study. The photographs concentrate on architectural details and buildings from the colonial and Early Republic periods in both the North and South; there is one issue on Greek Revival buildings. Some of the areas covered include Cooperstown and Oswego, N.Y.; Litchfield, Suffield, and Essex, Conn.; the Boston Post Road; the Delaware Valley; Providence and Newport, R.I.; Bethlehem, Pa.; New Bern, N.C.; and Charleston, S.C. Massachusetts, Maine, and New Hampshire buildings appear in quantity. The photographs, with their soft glow of times gone by, add to the value of the magazine and show the buildings before modern technology and urban renewal projects drastically changed their appearance. The editor was Russell F.

Whitehead, and Weyerhaeuser Forest Products helped to support the magazine. This periodical, by encouraging construction in white pine, clearly demonstrated a love of the material and of our nation's superb heritage of historic architecture. PUBLISHED AS *Monograph Series Recording the Architecture of the American Colonies and the Early Republic* 15–17 (1929–1931). INCORPORATED IN *Pencil Points* (1932). [*See also* B58].

S252. Henry Francis du Pont Winterthur Museum. WINTERTHUR PORTFOLIO. Winterthur, Del. 1— (1964—), illus.

An annual publication of the Henry Francis du Pont Winterthur Museum, this hardcover periodical presents articles relating to the arts in America and American culture during the seventeenth, eighteenth, and nineteenth centuries. The contributors represent most of the major scholars of Americana who expound on architecture, painting, and bibliography as well as decorative arts, the central concern of the museum. The lead article in the early numbers is by its director, Edgar P. Richardson. Objects and their makers, manufacturers, distribution, use, and settings are the subject of many articles, which contribute to the knowledge of America's social, cultural, political, military, and religious heritage. Each issue includes a thorough, detailed index to the contents. Edited by Milo M. Naeve.

S253. WORKSHOP: A MONTHLY JOURNAL DEVOTED TO PROGRESS OF THE USEFUL ARTS. New York. 1–17 (1868–1884), illus. (color).

Extravagant and glorious full-page plates, a few in color, are the outstanding feature of this deluxe periodical, edited by various architects including Ad Schill, L. Eisenlohr, and C. Weigle. The plates, remarkably detailed and clear, illustrate historic and contemporary decorative arts in France, Italy, and especially Germany. Preceeding the plates there is a page or two of information on technical developments, generally edited from other periodicals such as *Furniture Gazette* and *Carriage Monthly*. The subjects ranged over various skills such as the removal of grease spots, the cracking of paint, the use of paper in railway car wheels, artificial gold, the use of ivory dust, and the manufacture of embossed silk velvet. A sampling of subjects covered includes a buffet in walnut, a chandelier from the new opera house in Paris (1878), a funeral monument in Nuremberg, a Parian vase, a pontifical throne, a fire screen, a piano candlestick, a library table, gas brackets, a portfolio stand, a washbasin, a fountain in colored cast iron, and an electric bedroom lamp (1883). All the contents are European designs, and the illustrated pieces represent deluxe manufacturers. The magazine—the American edition of Gewerbehalle—was printed in Stuttgart and distributed from New York. Without doubt, this journal influenced the taste for things in American homes of luxury status during the final quarter of the nineteenth century.

T

Dissertations and Theses on the Visual Arts

WILLIAM INNES HOMER
with the assistance of
Doreen Bolger and Gilbert T. Vincent

INTRODUCTION

This list of dissertations and theses is the outgrowth of the Index of Dissertations and Theses in American Art created jointly, under my direction, by the University of Delaware and the Archives of American Art. Our aim was to locate and list all known doctoral theses and dissertations dealing with American visual arts. We adopted a broad definition of art, including painting, sculpture, architecture, drawing, graphics, photography, decorative arts, folk art, crafts, design, iconography and symbolism, critics and criticism, collectors and collecting, patronage, biography, and the social and cultural history of art and artists. American art was defined as that produced by native-born artists who worked in the United States or by foreign-born artists who spent a substantial portion of their lives in the United States. American artists who worked abroad were also included. Although studies of contemporary art and artists were listed, graduate theses by artists writing exclusively about their own art or their creative processes were not included.

No attempt was made to evaluate the studies listed here. All of our time and effort was expended on making our search as complete as possible, covering the period up to the spring of 1975.

In addition to surveying published lists of dissertations and theses, we sent questionnaires to institutions known to offer the master's and doctoral degrees in American art, and solicited information by placing notices in the leading art journals. The Archives of American Art placed at our disposal the results of annual surveys of graduate theses in American art, published in the *Archives of American Art Journal*. I am indebted to Beverly H. Smith of the Archives for her willingness to share the information she gathered.

An indispensable source for master's theses was Kenneth C. Lindsay, "The Harpur Index of Master's Theses in Art," an unpublished typescript completed in 1955. Dr. Lindsay generously gave us permission to list pertinent theses in the present survey.

I am also grateful to two University of Delaware graduate students who did a great deal of the work on the Index. Doreen Bolger helped me on the original project. Gilbert T. Vincent joined me when Ms. Bolger completed her studies at the university, and he continued the work of the Index after the Archives of American Art entered the picture. Both students accepted major responsibilities in assembling material and were virtually coauthors. I also wish to thank Susan Reinhardt, who handled much of the correspondence, checked the material, and, with the assistance of Norma Zeller, did the final typing.

Several important conclusions emerged from this study. We found that the amount of research on American art by advanced degree candidates far exceeded our expectations. The scope and depth of the material is truly remarkable. There were, in addition to papers on major artists and movements, a surprisingly large number of studies of less-known artists who deserved to be brought to light. The arts—painting, sculpture, architecture, decorative arts, and city planning—of specific regions in the United States were particularly popular subjects for investigation. Theses outside the traditional fine arts often drew the attention of degree candidates. Hence, our list is rich in studies of the decorative arts, the arts of the home, and photography.

Significant contributions were made by students not only in departments of art history but also in departments of art, architecture, history, American studies, humanities, education, and home economics. We believe our research has shown that American art has *not* been ignored by graduate colleges and that the list presented here is an invaluable source for scholars in the field.

In many cases, several papers on the same topic were discovered, and we hope that the published list will make future graduate students aware of what has already been done. Also, an effort will be made by the University of Delaware and the Archives of American Art to keep this list active and current and to continue to record completed dissertations and theses and works in progress. Information from readers, addressed to the Archives of American Art, Smithsonian Institution, Washington, D.C. 20560, will always be welcome. American studies, past and present, must be founded on contemporaneous documentation.

WILLIAM INNES HOMER

LIST OF THESES AND DISSERTATIONS

Theses and dissertations are indexed in Volume 4, the general index, under author's name, artist's name, and medium.

T1. **Abell, Raymond.** A STUDY OF INTERRELATIONSHIPS BETWEEN CALLIGRAPHIC AND PHOTOGRAPHIC ELEMENTS IN THE PHOTOGRAPHY OF AARON SISKIND. M.F.A., Ohio University, 1968.

T2. **Adams, Celeste.** THE ADAMS MEMORIAL. M.A., University of Pennsylvania, 1970.

T3. **Adams, Joy Anna.** ECONOMIC PROBLEMS OF TODAY'S CREATIVE ARTISTS AND ATTEMPTED SOLUTIONS. M.F.A., University of Iowa, 1957.

T4. **Ahlborn, Richard E.** SPANISH COLONIAL WOOD CARVING IN NEW MEXICO, 1598–1848. M.A., University of Delaware, 1958.

T5. **Ahrens, Jacob Edward Kent.** EDWIN FORBES. M.A., University of Maryland, 1966.

T6. **Ahrens, Jacob Edward Kent.** ROBERT WALTER WEIR (1803–1889). Ph.D., University of Delaware, 1972.

T7. **Albers, Marjorie K.** THE DEVELOPMENT OF FURNITURE AND FURNITURE MAKING WITHIN THE AMANA SOCIETY. M.A., University of Iowa, 1968.

T8. **Alder, Gale S.** ROBERT MILLS AND UNITED STATES MARINE HOSPITALS. M.A., University of Missouri, 1974.

T9. **Alderks, Philip W.** THE SOURCES AND INFLUENCES OF THE EARLY AMERICAN INSTRUCTION BOOKS. M.F.A., University of Iowa, 1955.

T10. **Alex, William.** THE CHICAGO SCHOOL OF ARCHITECTS, 1800–1900. M.A., Columbia University, 1952.

T11. **Alexander, Drury Blakeley.** TOWN PLANNING IN THE AMERICAN COLONIES: A STUDY OF SEVEN OF THE MOST IMPORTANT TOWNS IN AMERICA UP TO 1733. M.A., Columbia University, 1953.

T12. **Alexander, Robert L.** THE ARCHITECTURE OF RUSSELL WARREN. M.A., New York University, 1952.

T13. **Alexander, Robert L.** THE ART AND ARCHITECTURE OF MAXIMILIAN GODEFROY. Ph.D., New York University, 1961.

T14. **Allara, Pamela B.** THE ILLUSTRATIVE WATERCOLORS OF CHARLES DEMUTH. Ph.D., Johns Hopkins University, 1970.

T15. **Allen, Philip Mark.** THE SOCIOLOGY OF ART IN AMERICA. Ed.D., Emory University, 1957.

T16. **Allicott, Ruth.** THE COMMERCIAL APPLICATION OF AMERICAN INDIAN DESIGNS. M.A., University of Wisconsin, 1928.

T17. **Allshouse, John C.** THE SCULPTURAL ART OF THE PACIFIC NORTHWEST COAST INDIANS. M.A., University of Oklahoma, 1942.

T18. **Ames, Kenneth Leroy.** RENAISSANCE REVIVAL FURNITURE IN AMERICA. Ph.D., University of Pennsylvania, 1970.

T19. **Andersen, Stanley Peter.** AMERICAN ICON: RESPONSE TO THE SKYSCRAPER, 1875–1934. Ph.D., University of Minnesota, 1960.

T20. **Anderson, Janet Alice.** ROMANTIC-NATURALISTIC LANDSCAPE PAINTING IN AMERICA: 1830–1870. M.A., Pennsylvania State University, 1958.

T21. **Anderson, Mary J. (Mrs. Robert Rinker).** A STUDY OF DRAWINGS BY FRENCH AND AMERICAN PAINTERS FROM 1850 TO 1943. M.A., Oberlin College, 1944.

T22. **Anderson, Neil R.** NON-OBJECTIVE PAINTING AND THE "ART NEWS." M.F.A., University of Iowa, 1957.

T23. **Andrew, Laurel Blank.** NINETEENTH-CENTURY MORMON ARCHITECTURE. Ph.D., University of Michigan, 1973.

T24. **Andrews, Alfred J.** GREEK REVIVAL HOUSES IN KENTUCKY. M.A., Columbia University, 1942.

T25. **Andrews, Dorothy.** PRELIMINARY GEOGRAPHICAL SURVEY OF THE BURIAL TYPES OF NORTH AMERICAN INDIANS. M.A., University of Pennsylvania, 1931.

T26. **Antal, Ann Slaughter.** "L'ART POUR L'ART" OF MARY CASSATT VIS-À-VIS NINETEENTH-CENTURY RHETORICAL PAINTING. M.A., Tufts University, 1973.

T27. **Appelhof, Ruth Ann.** LEE KRASNER: THE SWING OF THE PENDULUM. M.A., Syracuse University, 1974.

T28. **Arkin, Diane Lynn.** GEORGIA O'KEEFFE—HER WORK 1915–1930. M.A., University of Chicago, 1971.

T29. **Arnold, Laurel.** GEORGE INNESS AND SWEDENBORGIANISM. M.A., Oberlin College, 1970.

T30. **Arnold, Paul B.** THE INFLUENCE OF MAURICIO LASANSKY ON PRINTMAKING IN THE UNITED STATES. M.A., University of Minneapolis, 1955.

6



Content follows.

T65. **Becker, Eugene Matthew.** THE BARBIZON INFLUENCE ON AMERICA. M.A., University of Chicago, 1953.

T66. **Becker, Eugene Matthew.** WHISTLER AND THE AESTHETIC MOVEMENT. Ph.D., Princeton University, 1959.

T67. **Becker, Zelda Helfgott.** UNDERSTANDING MODERN PAINTING. M.F.A., Syracuse University, 1945.

T68. **Belding, Ann W.** LOUIS H. SULLIVAN AND WALT WHITMAN. M.A., Indiana University, 1951.

T69. **Bell, Natalie.** LONELINESS IN THE CITY: EDWARD HOPPER'S LOOK AT MODERN MAN. M.A., Syracuse University, 1968.

T70. **Belloli, Joseph A., IV.** ANDY WARHOL AND AMERICAN SOCIETY: AMBIVALENCE AND ACCEPTANCE. M.A., University of California, Berkeley, 1970.

T71. **Belz, Carl Irvin.** THE ROLE OF MAN RAY IN THE DADA AND SURREALIST MOVEMENTS. Ph.D., Princeton University, 1963.

T72. **Benson, Avis W.** MAN RAY — EXPERIMENTATION THROUGH MANIPULATION. M.A., University of Iowa, 1967.

T73. **Berg, Steven.** THE INFLUENCE OF ART AND PHOTOGRAPHY ON THE FORMATION OF THE U.S. NATIONAL PARK SYSTEM. M.A., University of Washington, 1974.

T74. **Bergen, Molly Paskind.** THE PERSONAL WORKS OF JOHN SINGER SARGENT: HIS WATERCOLORS, DRAWINGS, AND LITHOGRAPHS. M.A., Northwestern University, 1969.

T75. **Bergeron, Sister M. Leon.** A STUDY OF THE LITURGICAL DESIGNS IN THE NATIONAL SHRINE OF THE IMMACULATE CONCEPTION. M.A., Ohio University, 1945.

T76. **Bermingham, Peter.** JASPER CROPSEY: A STUDY OF HIS AUTUMNAL LANDSCAPES. M.A., University of Maryland, 1969.

T77. **Bermingham, Peter.** IMPORTATION AND INFLUENCE OF THE BARBIZON SCHOOL IN AMERICA. Ph.D., University of Michigan, 1972.

T78. **Bernstein, Allen.** CONTEMPORARY OPINION OF AMERICAN DECORATIVE ARTS, 1860–1895, AS SHOWN IN HOUSE DESIGN AND INTERIOR DECORATION BOOKS. M.A., University of Chicago, 1934.

T79. **Bernstein, Gerald.** TRUTH TO MEDIUM — THE THEORY OF THE LIMITS OF THE ARTS APPLIED TO MODERN SCULPTURE. M.A., New York University, 1950.

T80. **Bernstein, Gerald Steven.** IN PURSUIT OF THE EXOTIC: ISLAMIC FORMS IN NINETEENTH-CENTURY AMERICAN ARCHITECTURE. Ph.D., University of Pennsylvania, 1968.

T81. **Bernstein, Joel H.** ELIEL SAARINEN'S INFLUENCE ON AMERICAN SKYSCRAPER DESIGN IN THE PERIOD BEFORE WORLD WAR II. M.A., University of Minnesota, 1964.

T82. **Berryman, Nancy Dell.** CONTEMPORARY ROMAN CATHOLIC AND JEWISH RITUAL ART. Ed.D., Columbia University, 1964.

T83. **Bershen, Wanda.** THE FILMS OF MAYA DEREN. M.A., Yale University, 1971.

T84. **Best, Mary.** TWENTIETH-CENTURY AMERICAN CARICATURE. M.A., Smith College, 1937.

T85. **Beyer, Rita Marie.** MODERN AND TRADITIONAL ELEMENTS IN ST. JOHN'S ABBEY AND UNIVERSITY CHURCH, COLLEGEVILLE, MINNESOTA. M.A., University of Iowa, 1963.

T86. **Bieber, Sheldon.** THOMAS EAKINS: AN EXAMINATION OF HIS STYLE. M.A., Columbia University, 1968.

T87. **Bienvenu, J. Robert.** TWO GREEK REVIVAL HOTELS IN NEW ORLEANS, THE ST. CHARLES BY JAMES GALLIER, SR., AND THE ST. LOUIS BY J.N.B. AND J.I. POUILLY. M.A., Tulane University of Louisiana, 1961.

T88. **Billings, Catherine Avis.** REALISM IN AMERICAN PAINTING OF THE EARLY TWENTIETH CENTURY. M.A., University of Minnesota, 1948.

T89. **Biorn, Paul Andreas.** WHISTLER AND HIS CRITICS. M.A., University of Iowa, 1965.

T90. **Biosca, Joaquin G.** THE INFLUENCE OF SPANISH CULTURE UPON THAT OF THE UNITED STATES AS EVIDENCED BY THE ARTS, PARTICULARLY THAT OF COSTUME. M.A., Syracuse University, 1955.

T91. **Bishop, Jo Ann.** THE DILEMMA OF CONTEMPORARY CHURCH ARCHITECTURE: THE QUEST FOR RENEWAL IN THE SECOND HALF OF THE 20TH CENTURY. M.A., University of Cincinnati, 1974.

T92. **Blandino, Jerry S.** ASPECTS OF AMERICAN ART AT THE TIME OF THE CENTENNIAL, 1876. M.A., Syracuse University, 1953.

T93. **Bloch, Maurice.** BINGHAM: THE ARTIST AND HIS TIMES. Ph.D., New York University, 1957.

T94. **Bock, Joanne.** POP WIENER: NAIVE PAINTER. M.A., State University College at Oneonta, 1969.

T95. **Bohan, Peter J.** A SURVEY OF 17TH CENTURY HOUSES OF FARMINGTON, CONNECTICUT. M.A., Yale University, 1957.

T96. **Bois, Patricia B.** THOMAS GOLD APPLETON (1812–1884), ARTIST AND PATRON. M.A., University of Delaware, 1972.

T97. **Bolger, Doreen A.** HAMILTON EASTER FIELD AND THE RISE OF MODERN ART IN AMERICA. M.A., University of Delaware, 1973.

T98. **Bolt, Joseph Sullivan.** JOHN BERNARD FLANNAGAN, 1895–1942. Ph.D., Harvard University, 1962.

T99. **Bond, Leroy.** THE INFLUENCE OF MODERN ABSTRACT PAINTINGS ON ADVERTISING ART, 1930–1950. M.A., University of Oklahoma, 1950.

T100. **Booth, Bill R.** A SURVEY OF PORTRAITS AND FIGURE PAINTINGS BY FRANK DUVENECK, 1848–1919. Ph.D., University of Georgia, 1970.

T101. **Bouton, Margaret.** THE EARLY WORKS OF AUGUSTUS SAINT-GAUDENS. Ph.D., Radcliffe College, 1946.

T102. **Boyd, Sterling M.** DOMESTIC ARCHITECTURE OF THE EARLY REPUBLICAN PERIOD IN AMERICA: THE SOURCES AND DEVELOPMENT. M.A., Oberlin College, 1960.

T103. **Boyd, Sterling M.** THE ADAM STYLE IN AMERICA, 1770–1820. Ph.D., Princeton University, 1966.

T104. **Bradbury, Charles.** A COMPARATIVE STUDY OF THE AESTHETICS OF LEONARDO DA VINCI, SIR JOSHUA REYNOLDS AND ROBERT HENRI. M.A., Syracuse University, 1929.

T105. **Brandt, Frederick R.** HENRY KOERNER. M.A., Pennsylvania State University, 1963.

T106. **Brayman, Walter.** ART AND POLITICS, THE RADICAL ARTISTS MOVEMENT, 1926–1945. Ph.D., University of Missouri, 1973.

T107. **Bredt, Theodore L.** THE ART OF JAMES LECHAY. M.A., University of Iowa, 1948.

T108. **Breece, Helen M.** THE FUNCTION OF ART IN THE CULTURE OF THE AMERICAN INDIAN. M.A., Western Reserve University (Case Western Reserve University), 1932.

T109. **Breithaupt, Erwin M., Jr.** THE LIFE AND WORKS OF HERMON ATKINS MACNEIL. M.A., Ohio State University, 1947.

T110. **Brenner, Mildred E.** RICHARD MORRIS HUNT, ARCHITECT. M.A., New York University, 1945.

T111. **Brettell, Richard.** HISTORIC DENVER, 1858–1893. M.A., Yale University, 1974.

T112. **Brimo, René.** L'EVOLUTION DU GOÛT AUX ETATS-UNIS. Ph.D., University of Paris, 1938.

T113. **Broad, Harry A.** CONTEMPORARY AMERICAN LITHOGRAPHY. Ph.D., University of Michigan, 1946.

T114. **Brown, Elizabeth M.** THE ARCHITECTS OF CENTER CHURCH, NEW HAVEN, CONNECTICUT. M.A., Yale University, 1963.

T115. **Brown, Jack Perry.** THE DÜSSELDORF SCHOOL AND AMERICAN PAINTING, 1850–1865. M.A., Yale University, 1970.

T116. **Brown, Milton W.** AMERICAN PAINTING (1913–1929): FROM THE ARMORY SHOW TO THE DEPRESSION. Ph.D., New York University, 1949.

T117. **Brown, Robert F.** FRONT STREET, NEW CASTLE, DELAWARE: ARCHITECTURE AND BUILDING PRACTICES (1687–1859). M.A., University of Delaware, 1961.

T118. **Brown, Rosa L.** FIFTEEN OUTSTANDING MODERN AMERICAN WATER COLOR PAINTERS. M.A., Colorado State College of Education (University of Northern Colorado), 1943.

T119. **Brown, Sarah.** ART CRITICISM AND THE ACCEPTANCE OF THE AVANT-GARDE. M.A., University of Washington, 1970.

T120. **Brownell, Charles E.** IN THE AMERICAN STYLE OF ITALIAN: THE E. C. LITCHFIELD VILLA. M.A., University of Delaware, 1966.

T121. **Brumbaugh, Thomas Brendle.** HORATIO AND RICHARD GREENOUGH: A CRITICAL STUDY WITH A CATALOGUE OF THEIR SCULPTURE. Ph.D., Ohio State University, 1955.

T122. **Brunsman, Sue.** THE EUROPEAN ORIGINS OF EARLY CINCINNATI ART POTTERY: 1870–1900. M.A., University of Cincinnati, 1973.

T123. **Bryam, Jane.** TWO PUBLIC BUILDINGS IN ATCHISON, KANSAS: AN ARCHITECTURAL HISTORY. M.A., University of Missouri, 1971.

T124. **Bryan, John Morrill.** BOSTON'S GRANITE ARCHITECTURE, CA. 1800–1860. Ph.D., Boston University, 1972.

T125. **Buckley, Frank.** TRENDS IN AMERICAN PRIMITIVISM. Ph.D., University of Minnesota, 1939.

T126. **Budd, Dorothy.** A NEW PERSPECTIVE OF THE ARMORY SHOW. M.A., Columbia University, 1950.

T127. **Buettner, William Stewart.** AMERICAN ART THEORY, 1940–1960. Ph.D., Northwestern University, 1973.

T128. **Bumgardner, Gay.** ART OF THE CAHOKIA MOUNDS. M.A., University of Utah, 1973.

T129. **Bundy, Janice J.** THE CRAFTSMAN FABRICS OF GUSTAV STICKLEY. M.A., University of Iowa, 1970.

T130. **Bunnell, Peter C.** THE SIGNIFICANCE OF THE PHOTOGRAPHY OF CLARENCE HUDSON WHITE (1871–1925) IN THE DEVELOPMENT OF EXPRESSIVE PHOTOGRAPHY. M.F.A., Ohio University, 1961.

T131. **Bunnell, Peter C.** THE CRITICAL DECADE: A STUDY OF THE PHOTOGRAPH IN ENGLAND AND AMERICA BETWEEN TWO LONDON EXHIBITIONS OF 1851 AND 1862. M.A., Yale University, 1965.

T132. **Bunting, Bainbridge.** ARCHITECTURAL HISTORY OF THE BACK BAY REGION IN BOSTON, 1850–1917. Ph.D., Harvard University, 1952.

T133. **Burke, Bobbye.** THE LIBERTY CAP IN AMERICA AND FRANCE, 1765–1789. M.A., University of Pennsylvania, 1971.

T134. **Burke, Robert Francis.** LOST AMERICAN PAINTERS, 1900–1913. M.F.A., Ohio University, 1947.

T135. **Burkhart, R. C.** A CRITICAL SURVEY OF AMERICAN SCULPTURE, 1925–1950. M.A., University of Pittsburgh, 1953.

T136. **Burnside, Wesley.** MAYNARD DIXON, ARTIST OF THE WEST. Ph.D., Ohio State University, 1970.

T137. **Bush-Brown, Albert.** IMAGE OF A UNIVERSITY: A STUDY OF ARCHITECTURE AS AN EXPRESSION OF EDUCATION AT COLLEGES AND UNIVERSITIES IN THE UNITED STATES BETWEEN 1800 AND 1900. Ph.D., Princeton University, 1958.

T138. **Butler, Alexander R.** MCKIM'S RENAISSANCE: A STUDY IN THE HISTORY OF THE AMERICAN ARCHITECTURAL PROFESSION. Ph.D., Johns Hopkins University, 1953.

T139. **Butler, Joseph T.** WHEATLAND (1848–1868): THE HOME OF JAMES BUCHANAN. M.A., University of Delaware, 1957.

T140. **Butler, Patrick H., III.** ON THE MEMORIAL OF TIDEWATER VIRGINIA, 1650–1775. M.A., University of Delaware, 1969.

T141. **Caemmerer, H. Paul.** THE INFLUENCE OF CLASSICAL ART ON THE ARCHITECTURE OF THE UNITED STATES. Ph.D., American University, 1938.

T142. **Caldwell, Henry B.** JOHN FRAZEE, AMERICAN SCULPTOR. M.A., New York University, 1951.

T143. **Callow, James T.** KINDRED SPIRITS: KNICKERBOCKER WRITERS AND AMERICAN ARTISTS, 1807–1855. Ph.D., Case Western Reserve University, 1964.

T144. **Campbell, Kenneth Floyd.** DR. WILLIAM RIMMER AND THE AMERICAN SCHOOL OF ANATOMY. M.A., University of Iowa, 1953.

T145. **Campbell, Mary Schmidt.** ROMARE BEARDEN: A STUDY OF A BLACK AMERICAN ARTIST. M.A., Syracuse University, 1973.

T146. **Campbell, William P.** A BIOGRAPHY OF JOHN GADSBY CHAPMAN. Ph.D., Harvard University, 1963.

T147. **Canada, Evelyn Kehr.** SOME PHASES OF THE DEVELOPMENT OF THE CRITICISM OF PAINTING IN THE UNITED STATES. M.A., University of Missouri, 1920.

T148. **Canary, Robert.** THE SEARCH FOR AN AMERICAN AUDIENCE AND ART: THE CRITICAL OPINIONS OF WILLIAM DUNLAP, 1766–1839. M.A., University of Chicago, 1962.

T149. **Cannon, Margaret.** SOUTHWEST GEORGIA HOMES OF GREEK REVIVAL INFLUENCE AND THEIR FURNITURE, 1820–1890. M.S., Florida State University, 1963.

T150. **Cantieny, Joseph F.** CAST IRON AS A DECORATIVE MEDIUM IN AMERICA WITH SPECIAL REFERENCE TO ITS USE ON NINETEENTH-CENTURY HOUSES OF THE SOUTH AND IN OHIO. M.A., Oberlin College, 1936.

T151. **Cantini, V. D.** CONTEMPORARY CERAMICS IN THE UNITED STATES. M.A., University of Pittsburgh, 1948.

T152. **Cantor, Dorothy M.** CLAUDE BRAGDON AND HIS RELATION TO THE DEVELOPMENT OF MODERN ARCHITECTURAL THEORY. M.A., University of Rochester, 1963.

T153. **Cantor, Jay E.** THE PUBLIC ARCHITECTURE OF JAMES RENWICK, JR.: AN INVESTIGATION OF THE CONCEPT OF AN AMERICAN NATIONAL STYLE OF ARCHITECTURE DURING THE NINETEENTH CENTURY. M.A., University of Delaware, 1967.

T154. **Cantor, Robert Lloyd.** A STUDY OF THE INDUSTRY AND FIELD OF PLASTICS AS A CREATIVE MEDIUM FOR AVOCATIONAL AND VOCATIONAL USES OF THE LAYMAN. Ph.D., New York University, 1953.

T155. **Capillon, Helene Yvonne.** THE FASHION AND ART OF THE "JAZZ AGE." M.S., Rhode Island School of Design, 1958.

T156. **Carey, John Thomas.** THE AMERICAN LITHOGRAPH FROM ITS INCEPTION TO 1865 WITH BIOGRAPHICAL CONSIDERATIONS OF TWENTY LITHOGRAPHERS AND A CHECK LIST OF THEIR WORKS. Ph.D., Ohio State University, 1954.

T157. **Carlisle, John.** A BIOGRAPHICAL STUDY OF HOW THE ARTIST BECAME A HUMANITARIAN ACTIVIST: BEN SHAHN, 1930–1946. Ph.D., University of Michigan, 1972.

T158. **Carlson, Edith.** ARTISTIC TASTE IN THE UNITED STATES. M.A., Washington University, 1953.

T159. **Carnegie, M. L.** ILLUSTRATIONS IN AMERICAN LITERATURE FROM COOPER TO THE PRESENT. M.A., Boston University, 1925.

T160. **Caroselli, Henry J.** THE PHARMACY MURAL AND AN INVESTIGATION INTO CONTEMPORARY MEXICAN MURAL ART. M.A., University of New Mexico, 1951.

T161. **Carr, Eleanor.** THE NEW DEAL AND THE SCULPTOR. Ph.D., New York University, 1969.

T162. **Carr, Kathryn W.** THOMAS JEFFERSON'S DOMESTIC ARCHITECTURE. M.A., Columbia University, 1965.

T163. **Carr, Mother Eleanor.** SCULPTURE EXECUTED IN NEW YORK CITY UNDER THE FEDERAL ART PROJECT OF THE WORKS PROGRESS ADMINISTRATION, 1935–1943. Ph.D., New York University, 1969.

T164. **Carrott, Richard G.** THE EGYPTIAN REVIVAL: ITS SOURCES, MOVEMENTS AND MEANING (1808–1858). Ph.D., Yale University, 1961.

T165. **Carson, Cary.** SETTLEMENT PATTERNS AND VERNACULAR ARCHITECTURE IN SEVENTEENTH-CENTURY TIDEWATER VIRGINIA. M.A., University of Delaware, 1969.

T166. **Carter, Nancy Corson.** THE INNER CIRCLE: PORTRAITS IN ALFRED STIEGLITZ'S "CAMERA WORK." Ph.D., University of Iowa, 1972.

T167. **Casey, Warren Vale.** TRADITIONAL AND ABSTRACT BACKGROUNDS OF CONTEMPORARY SCULPTURE. Ph.D., Ohio State University, 1960.

T168. **Cass, Crystal Effie.** JOHN MARIN. M.A., University of California, Berkeley, 1972.

T169. **Casto, Donnelly.** JACKSON POLLOCK: A BIOGRAPHICAL STUDY OF THE MAN AND A CRITICAL EVALUATION OF HIS WORK. M.A., Arizona State University, 1964.

T170. **Castrodale, Anne.** DANIEL TROTTER, PHILADELPHIA CABINETMAKER. M.A., University of Delaware, 1962.

T171. **Catalano, Kathleen M.** CABINETMAKING IN PHILADELPHIA, 1820–1840. M.A., University of Delaware, 1972.

T172. **Cayford, Jane.** THE SULLIVAN DORR HOUSE IN PROVIDENCE, RHODE ISLAND. M.A., University of Delaware, 1961.

T173. **Celender, Donald Dennis.** PRECISIONISM IN TWENTIETH-CENTURY AMERICAN PAINTING. Ph.D., University of Pittsburgh, 1963.

T174. **Celentano, Francis M.** THE ORIGINS AND DEVELOPMENT OF ABSTRACT EXPRESSIONISM IN THE UNITED STATES. M.A., New York University, 1957.

T175. **Cervene, Richard.** BASIC PRINCIPLES OF CONTEMPORARY PRIMITIVES. M.F.A., University of Iowa, 1953.

T176. **Chafee, Richard S.** EDWARD TUCKERMAN POTTER AND MARK TWAIN. M.A., Yale University, 1963.

T177. **Chaine, Erika Tatjana.** BLACK PROTEST ART. M.A., University of California, Berkeley, 1973.

T178. **Challenger, Josephine S.** A COMPARATIVE STUDY OF THE SCULPTURE OF NEGRO ARTISTS STRESSING THE SPIRITUAL QUALITY OF THE WORK OF RICHMOND BARTHÉ. M.A., Catholic University of America, 1948.

T179. **Chamberlain, Georgia E.** THE ART HERITAGE OF SUMMIT COUNTY, 1800–1900. M.A., Western Reserve University (Case Western Reserve University), 1948.

T180. **Chamberlin, Carol Gilchrist.** SURREALISTS IN NEW YORK. M.A., Northwestern University, 1971.

T181. **Chambers, Bruce.** DAVID GILMOUR BLYTHE (1815–1865): AN ARTIST AT URBANIZATION'S EDGE. Ph.D., University of Pennsylvania, 1974.

T182. **Changnon, Michael J.** BOUCHER AND OLDENBURG: TWO ARTISTS' CONCERN FOR THE SENSUAL. M.A., Ohio University, 1968.

T183. **Chapman, Edmund H.** EARLY CLEVELAND — THE EVOLUTION OF A CITY. A STUDY OF URBAN DEVELOPMENT AND DISINTEGRATION IN THE FIRST THREE QUARTERS OF THE NINETEENTH CENTURY. Ph.D., New York University, 1951.

T184. **Chappell, Sally Anderson.** BARRY BYRNE: ARCHITECTURE AND WRITINGS. Ph.D., Northwestern University, 1968.

T185. **Charles, Clayton H.** RECENT AMERICAN SCULPTURE AND ITS RELATION TO THE CHANGING ARCHITECTURE. M.A., University of Wisconsin, 1939.

T186. **Charles, Lois Russell.** ALBERT C. BARNES'S PHILOSOPHY OF ART. M.A., University of Delaware, 1972.

T187. **Cheline, Paschal G.** AMERICAN INDIVIDUALISM AND ITS REFLECTIONS IN CARSON MCCULLERS AND EDWARD HOPPER. M.A., Bowling Green State University, 1973.

T188. **Chennault, Jeannie.** BRADLEY WALKER TOMLIN, ABSTRACT EXPRESSIONIST. Ph.D., University of Michigan, 1971.

T189. **Chi, John Wei-yi.** THE ORIENTAL INFLUENCE ON WHISTLER. M.A., University of Louisville, 1965.

T190. **Chiarenza, Carl D.** TERRORS AND PLEASURES: THE LIFE AND WORK OF AARON SISKIND. Ph.D., Harvard University, 1973.

T191. **Christ-Janer, Albert W.** GEORGE CALEB BINGHAM: MISSOURI GENRE PAINTER OF THE NINETEENTH CENTURY. M.A., Yale University, 1937.

T192. [Deleted.]

T193. **Cikovsky, Nicolai.** THE LIFE AND WORK OF GEORGE INNESS (1824–1894). Ph.D., Harvard University, 1965.

T194. **Claiborne, Deborah Ann.** THE COMMERCIAL ARCHITECTURE OF GRIFFITH THOMAS IN NEW YORK CITY. M.A., Pennsylvania State University, 1972.

T195. **Clark, Cynthia.** THE DEVELOPMENT OF WATERCOLOR AS AN EXPRESSIVE MEDIUM IN THE UNITED STATES, 1855–1900. M.A., Pennsylvania State University, 1962.

T196. **Clark, H. Nichols B.** CHARLES LANG FREER: PATRON OF AMERICAN ART IN THE GILDED ERA. M.A., University of Delaware, 1975.

T197. **Clark, Raymond B., Jr.** JONATHAN GOSTELOWE (1744–1795): PHILADELPHIA CABINETMAKER. M.A., University of Delaware, 1956.

T198. **Clarke, Claudia Louise.** FRANK DUVENECK IN

THE DEVELOPMENT OF AMERICAN PAINTING. M.F.A., Ohio University, 1967.

T199. **Clarke, Edna M.** EARLY AMERICAN CRAFTS. M.A., Ohio State University, 1925.

T200. **Clemmer, Phyllis.** WHAT IS/WAS FUNK ART? M.A., Arizona State University, 1971.

T201. **Coad, Oral Sumner.** WILLIAM DUNLAP: A STUDY OF HIS LIFE AND WORKS AND HIS PLACE IN CONTEMPORARY CULTURE. Ph.D., Columbia University, 1917.

T202. **Cock, Elizabeth.** [*See under* Lindquist-Cock, T728.]

T203. **Coe, Jayne Rucker.** ADAPTATION OF THE DESIGNS OF THE HAIDA, A NORTHWEST COAST INDIAN GROUP, TO CONTEMPORARY SITUATIONS. M.A., Washington State University, 1968.

T204. **Coe, Nancy (Mrs. William Wixom).** THE HISTORY OF THE COLLECTING OF EUROPEAN PAINTINGS AND DRAWINGS IN THE CITY OF CLEVELAND. M.A., Oberlin College, 1955.

T205. **Coe, Ralph T.** THE ROCKEFELLER BUILDING BY KNOX AND ELLIOT: A DOCUMENT OF SULLIVAN'S INFLUENCE IN CLEVELAND, OHIO. M.A., Yale University, 1956.

T206. **Coen, Rena Neumann.** THE INDIAN AS THE NOBLE SAVAGE IN NINETEENTH-CENTURY AMERICAN ART. Ph.D., University of Minnesota, 1969.

T207. **Coffey, Robert Dale.** THE SKULL PAINTINGS OF GEORGIA O'KEEFFE. M.A., Arizona State University, 1974.

T208. **Coffey, Rosemary.** STUDIES OF THE NEGRO IN WESTERN ART OF THE 18TH AND 19TH CENTURIES. M.A., University of Wisconsin, 1974.

T209. **Coffin, Robert M.** CATHEDRAL OF ST. FRANCIS OF ASSISI, SANTA FE, NEW MEXICO. M.A., Ohio State University, 1938.

T210. **Cohen, George Michael.** A REGIONAL STUDY OF AMERICAN GENRE PAINTING FROM 1830-1880. Ph.D, Boston University, 1962.

T211. **Cohen, Leslie.** MARIUS DE ZAYAS AND THE MODERN MOVEMENT IN NEW YORK. M.A., Queens College, City University of New York, 1973.

T212. **Cohn, Susan F.** AN ANALYSIS OF SELECTED WORKS BY GEORGIA O'KEEFFE. Ph.D., New York University, 1974.

T213. **Cole, Maureen O'Brien.** JAMES AKIN, ENGRAVER AND SOCIAL CRITIC. M.A., University of Delaware, 1967.

T214. **Cole, Wanda G.** THE PUBLIC LIFE AND WORK OF NAN SHEETS: OKLAHOMA ARTIST. M.A., University of Oklahoma, 1948.

T215. **Cole, Wilford P.** HENRY DAWKINS, ENGRAVER. M.A., University of Delaware, 1966.

T216. **Collins, Ruth A.** CONTEMPORARY CERAMIC SCULPTURE: A BRIEF SURVEY OF CERAMIC SCULPTURE IN THE UNITED STATES AND EUROPE SINCE 1900. M.A., Texas State College for Women (Texas Woman's University), 1949.

T217. **Colman, David Elliot.** THE SOCIAL COMMENTARY OF JOHN SLOAN, 1900-1916, IN THE CONTEXT OF AMERICAN PROGRESSIVISM. M.A., University of California, Berkeley, 1972.

T218. **Comiskey, Ernest Donald.** CORRELATIONS AND CONTRASTS BETWEEN PAINTING AND PHOTOGRAPHY AS MAJOR ART MEDIA. M.F.A., Ohio University, 1960.

T219. **Compton, Howard.** THE BUILDING OF THE UNIVERSITY OF KANSAS. M.A., University of Kansas, 1932.

T220. **Condit, John D.** PAUL SAMPLE. M.A., Columbia University, 1953.

T221. **Connally, Ernest A.** THE ECCLESIASTICAL AND MILITARY ARCHITECTURE OF THE SPANISH PROVINCE OF TEXAS. Ph.D., Harvard University, 1955.

T222. **Conrad, Terry Eugene.** A CRITICAL STUDY OF THE ETCHINGS OF GEORGE TAYLOR PLOWMAN. M.A., University of Oregon, 1969.

T223. **Contreras, Belisario Ramon.** THE NEW DEAL TREASURY DEPARTMENT ART PROGRAMS AND THE AMERICAN ARTIST: 1933 TO 1943. Ph.D., American University, 1967.

T224. **Cook, Mary H.** CONTEMPORARY CERAMICS IN THE UNITED STATES. M.A., Texas State College for Women (Texas Woman's University), 1944.

T225. **Cooledge, Harold Norman, Jr.** SAMUEL SLOAN (1815-1884), ARCHITECT. Ph.D., University of Pennsylvania, 1963.

T226. **Coolidge, John P.** LOWELL, MASS. 1820-1965: THE ARCHITECTURAL HISTORY OF AN INDUSTRIAL CITY. M.A., New York University, 1939.

T227. **Cooper, Mabel R.** NINETEENTH CENTURY HOMES OF MARSHALL, MICHIGAN. Ph.D., Florida State University, 1963.

T228. **Cooper, Wendy Ann.** THE FURNITURE AND FURNISHINGS OF JOHN BROWN, MERCHANT OF PROVIDENCE, 1736-1803. M.A., University of Delaware, 1971.

T229. **Corn, Wanda.** THE RETURN OF THE NATIVE: THE DEVELOPMENT OF INTEREST IN AMERICAN PRIMITIVE PAINTING. M.A., New York University, 1965.

T230. **Corn, Wanda M.** ANDREW WYETH: THE MAN, HIS ART, AND HIS AUDIENCE. Ph.D., New York University. 1974.

T231. **Corneil, Mary.** THE EVOLUTION OF THE ARCHITECTURE OF THE FIRST LARGE PUBLIC LIBRARIES IN THE UNITED STATES. M.A., University of Pennsylvania, 1969.

T232. **Cornish, Ned A.** THE AMERICAN MID-CENTURY GENRE TREND AND THE PAINTING OF DAVID G. BLYTHE. M.A., New York University, 1957.

T233. **Cosentino, Andrew J.** ANDREW JACKSON DOWNING'S AESTHETICS. M.A., University of Missouri, 1971.

T234. **Cotter, Edward Harold.** HANS HOFMANN: THE FATHER OF ABSTRACT EXPRESSIONISM. M.A., Pennsylvania State University, 1964.

T235. **Counihan, Sister Martha.** SIMEON LELAND'S CASTLE AT NEW ROCHELLE. M.A., University of Delaware, 1973.

T236. **Cox, Richard.** THE NEW YORK ARTIST AS SOCIAL CRITIC, 1918–1933. Ph.D., University of Wisconsin, 1974.

T237. **Cox, Ruth Y.** TEXTILES USED IN PHILADELPHIA, 1760–1775. M.A., University of Delaware, 1960.

T238. **Cox, William M.** AMERICAN LIMITED AUDIENCE CINEMA AS AN ART FORM. Ph.D., Ohio University, 1970.

T239. **Craig, Robert Michael.** MAYBECK AT PRINCIPIA: A STUDY OF AN ARCHITECT-CLIENT RELATIONSHIP. Ph.D., Cornell University, 1973.

T240. **Craven, George M.** GROUP F/64 AND ITS RELATION TO STRAIGHT PHOTOGRAPHY IN AMERICA. M.F.A., Ohio University, 1958.

T241. **Crawford, Elizabeth.** PRIVACY IN AMERICAN INTERIORS. M.S., University of North Carolina, Greensboro, 1967.

T242. **Creer, Doris.** THOMAS BIRCH: A STUDY OF THE CONDITION OF PAINTING AND THE ARTIST'S POSITION IN FEDERAL AMERICA. M.A., University of Delaware, 1958.

T243. **Creese, Walter L.** THE MODERN MOVEMENT IN AMERICAN ARCHITECTURE BETWEEN THE WORLD WARS. Ph.D., Harvard University, 1950.

T244. **Crocker, Leslie F.** THE GREEK REVIVAL ARCHITECTURE OF HOLLY SPRINGS, MISSISSIPPI, 1837–1867. M.A., University of Missouri, 1967.

T245. **Crocker, Leslie Frank.** DOMESTIC ARCHITECTURE OF THE MIDDLE SOUTH, 1795–1865. Ph.D., University of Missouri, 1971.

T246. **Crocker, Linda (Simmons).** JACOB FRYMIRE, EARLY AMERICA PORTRAIT PAINTER. M.A., University of Delaware, 1975.

T247. **Crosby, Margaret.** A STUDY OF THE WORK OF LARRY RIVERS, ROBERT RAUSCHENBERG, AND JASPER JOHNS AS A BRIDGE BETWEEN ABSTRACT EXPRESSIONISM AND POP ART. M.A., Ohio State University, 1968.

T248. **Crotty, Frances.** THE CINCINNATI UNION TERMINAL AND THE ART DECO MOVEMENT. M.A., University of Cincinnati, 1973.

T249. **Crouch, Donald E.** TYPES OF HOPEWELL EFFIGY PIPES. M.F.A., University of Iowa, 1965.

T250. **Crum, Priscilla.** AMERICAN MURAL PAINTING. M.A., Western Reserve University (Case Western Reserve University), 1940.

T251. **Crummie, Julia Elizabeth.** AMERICAN ARTISTS IN PARIS, 1900–1914. M.A., University of California, Berkeley, 1973.

T252. **Cruttenden, Barbara (Hall).** GEORGE FISK COMFORT, A BIOGRAPHY. M.A., Syracuse University, 1957.

T253. **Cullison, William R.** "ORANGE GROVE": THE DESIGN AND CONSTRUCTION OF AN ANTE-BELLUM NEO-GOTHIC PLANTATION HOUSE ON THE MISSISSIPPI RIVER, WITH REMARKS ON THE CAREER OF ITS ARCHITECT, WILLIAM L. JOHNSTON, AND NOTES CONCERNING THE MID-NINETEENTH-CENTURY ROMANTIC PICTURESQUE AESTHETIC. M.A., Tulane University, 1969.

T254. **Cummings, Abbott L.** DOMESTIC ARCHITECTURE OF THE 17TH CENTURY IN MASSACHUSETTS. M.A., Oberlin College, 1946.

T255. **Cummings, Abbott Lowell.** AN INVESTIGATION OF THE SOURCES, STYLISTIC EVALUATION AND INFLUENCE OF ASHER BENJAMIN'S "BUILDER'S GUIDE." Ph.D., Ohio State University, 1950.

T256. **Curlee, F. Lynn.** WILSON BROTHERS AND COMPANY: A BIOGRAPHICAL STUDY AND CRITICAL ANALYSIS. M.A., University of Pennsylvania, 1972.

T257. **Curran, Ona (Mrs.).** A STUDY OF PORTRAITS OF SCHENECTADY RESIDENTS IN 1715–1750. M.A., State University of New York, College at Oneonta, 1966.

T258. **Curtis, Philip H.** TUCKER PORCELAIN, 1826–1838: A REAPPRAISAL. M.A., University of Delaware, 1972.

T259. **Cutler, John B.** SACHEM'S WOOD: AN EARLY EXAMPLE OF THE GREEK REVIVAL IN AMERICAN DOMESTIC ARCHITECTURE. M.A., Yale University, 1963.

T260. **Cutler, John Baker.** GIRARD COLLEGE ARCHITECTURAL COMPETITION: 1832–1848. Ph.D., Yale University, 1969.

T261. **Daly, Norman D.** DERIVATION OF SOME DOMESTIC ARCHITECTURAL DETAIL OF THE GOTHIC REVIVAL FOUND IN COLORADO MOUNTAIN TOWNS. M.A., Ohio State University, 1940.

T262. **Danes, Gibson A.** A BIOGRAPHICAL AND CRITICAL STUDY OF WILLIAM MORRIS HUNT, 1824–1879. Ph.D., Yale University, 1949.

T263. **Danoff, Ira Michael.** SIX APOLOGISTS FOR THE NEW AMERICAN ART. Ph.D., Syracuse University, 1970.

T264. **Darcy, Sister Mary de Sales.** A CENTURY AND A HALF OF DECORATIVE ARTS IN AMERICA, 1690–1840. M.A., Syracuse University, 1941.

T265. **Darnall, Margareta Jean.** READY-MADE HOUSES IN AMERICA BEFORE 1890. M.A., Cornell University, 1970.

T266. **Daugherity, Louise A.** THE CHURCH ARCHITECTURE OF THE TEXAS MISSIONS IN THE SAN ANTONIO AREA. M.F.A., University of Colorado, 1948.

T267. **Davidson, Abraham A.** SOME EARLY AMERICAN CUBISTS, FUTURISTS AND SURREALISTS, THEIR PAINTINGS, THEIR WRITINGS, AND THEIR CRITICS. Ph.D., Columbia University, 1965.

T268. **Davis, James Wesley.** PLURAL CONSIDERATIONS ON THE WORK OF DONALD ROLLER WILSON (1938-). M.A., University of Colorado, 1969.

T269. **Davis, John D.** THE EVOLUTION OF THE EARLY AMERICAN SPOON, CA. 1650–CA. 1850. M.A., University of Delaware, 1962.

T270. **Davis, Kenneth.** STYLISTIC AND THEMATIC DEVELOPMENT IN THE WORK OF GEORGE W. BELLOWS. M.A., Ohio State University, 1968.

T271. **Davis, Melinda Dempster.** WINSLOW HOMER: AN ANNOTATED BIBLIOGRAPHY OF PERIODICAL LITERATURE. M.S., University of North Carolina, 1974.

T272. **Dawson, Steven K.** THE INTERIOR DESIGN OF THE HOUSE OF REPRESENTATIVES CHAMBER OF IOWA'S OLD CAPITOL, 1842–1857. M.A., University of Iowa, 1972.

T273. **Deardorff, D. D.** AN ANALYSIS OF THE INTEGRATION OF INTERIOR AND EXTERIOR SPACES IN HOUSES DESIGNED BY RICHARD NEUTRA. M.A., North Texas State College (North Texas State University), 1950.

T274. **De Bra, Mabel Mason.** LIFE FORMS AND SYMBOLS IN INDIAN CERAMIC DESIGN OF THE SOUTHWEST. M.A., Yale University, 1928.

T275. **De Gregorio, Vincent John.** THE LIFE AND ART OF WILLIAM J. GLACKENS. Ph.D., Ohio State University, 1955.

T276. **Dehoney, Martyvonne.** A RESOURCES GUIDE TO ART AND ARCHITECTURE IN NEW JERSEY FROM PRE-COLUMBIAN TIMES TO THE CIVIL WAR. Ed.D., Columbia University, 1968.

T277. **Delaney, Carolyn W.** PUVIS DE CHAVANNES AND AMERICAN MURAL PAINTERS. M.A., New York University, 1939.

T278. **Demer, John H.** JEDEDIAH NORTH'S TINNERS TOOL BUSINESS. M.A., University of Delaware, 1973.

T279. **Denney, Sandra Lee.** THOMAS ANSHUTZ: HIS LIFE, ART AND TEACHING. M.A., University of Delaware, 1969.

T280. **Dennis, James Munn.** KARL BITTER (1867–1915), ARCHITECTURAL SCULPTOR. Ph.D., University of Wisconsin, 1963.

T281. **De Schepper, Gerald R.** THE EVOLVING CONCEPTS OF FORM AND CONTENT WITHIN THE PAINTINGS OF A SOCIAL COMMENTATOR—BEN SHAHN. M.A., University of Iowa, 1966.

T282. **De Silva, Ronald A.** WILLIAM JAMES BENNETT: PAINTER AND ENGRAVER. M.A., University of Delaware, 1970.

T283. **Dethlefson, Edgar Raymond.** WILLIAM HENRY MILLER, ARCHITECT, 1848–1922. M.Arch., Cornell University, 1957.

T284. **De Vore, James H.** AN INVESTIGATION OF THE INFLUENCE OF EMANUEL SWEDENBORG UPON THE ART OF GEORGE INNESS. M.F.A., Ohio University, 1963.

T285. **De Zurko, Edward P.** FUNCTIONALIST TRENDS IN WRITING PERTAINING TO ARCHITECTURE WITH SPECIAL EMPHASIS ON THE PERIOD CA. 1700–1850. Ph.D., New York University, 1954.

T286. **Dickerman, Stella I.** COLONIAL SILVER: ORIGIN AND STYLISTIC DEVELOPMENT. M.A., Oberlin College, 1947.

T287. **Dickinson, Marjorie H.** A SURVEY OF APPLIED ARTS IN INDUSTRY AND COMMERCE IN SAN FRANCISCO. M.A., University of California, Berkeley, 1927.

T288. **Dickson, Harold Edward.** JOHN WESLEY JARVIS (1780-1840), A PAINTER OF THE EARLY REPUBLIC. Ph.D., Harvard University, 1942.

T289. **Dijkstra, Abraham Jan.** WILLIAM CARLOS WILLIAMS AND PAINTING: THE HIEROGLYPHICS OF A NEW SPEECH. Ph.D., University of California, Berkeley, 1967.

T290. **Dinnerstein, Lois.** A THOMAS SULLY SKETCHBOOK IN THE METROPOLITAN MUSEUM. M.A., New York University, 1960.

T291. **Dochterman, Lillian Natalie.** THE STYLISTIC DEVELOPMENT OF THE WORK OF CHARLES SHEELER. Ph.D., University of Iowa, 1963.

T292. **Dolbeare, Franzee P.** RICHARDSONIAN ARCHITECTURE IN LOUISVILLE. M.A., University of Louisville, 1961.

T293. **Dolphin, Harriet Sylvia.** "THE RACK" BY JOHN FREDERICK PETO. M.A., Arizona State University, 1969.

T294. **Domblewski, Mary Ellen.** THE ADIRONDACKS CAMP OF THE LAST QUARTER OF THE 19TH CENTURY: THE WILDERNESS CHARACTER. M.A., Cornell University, 1974.

T295. **Donaghy, Elisabeth.** Pierre Eugène du Simitière, Unsuccessful Civic and Natural Historian in Revolutionary America. M.A., University of Delaware, 1970.

T296. **Donaldson, Christine H.** The Centennial of 1876: The Exposition, and Culture for America. Ph.D., Yale University, 1948.

T297. **Donaldson, Jeff R.** Generation "306"—Harlem, New York, 1935–40. Ph.D., Northwestern University, 1974.

T298. **Donaldson, Mary Katherine.** Composition in Early Landscapes of the Ohio River Valley: Backgrounds and Components. Ph.D., University of Pittsburgh, 1971.

T299. **Donhauser, Paul Stefan.** A History of the Development of American Studio-Pottery. Ed.D., Illinois State University, 1967.

T300. **Donhauser, Robert.** The Colonial Sculpture of New Mexico. M.A., Yale University, 1942.

T301. **Donnelly, Marian Card.** Early Church Architecture in New Jersey. M.A., Oberlin College, 1948.

T302. **Donnelly, Marian Card.** New England Meeting Houses in the Seventeenth Century. Ph.D., Yale University, 1956.

T303. **Dorsey, Bettie J.** A Discussion of the Importance of Landscape Painting in Eighteenth Century America. M.A., Columbia University, 1953.

T304. **Dorsky, Morris.** The Formative Years of Ben Shahn: The Origin and Development of His Style. M.A., New York University, 1966.

T305. **Doty, Robert McIntyre.** Photo-Secession; Photography as a Fine Art. M.A., University of Rochester, 1961.

T306. **Doud, Richard K.** John Hesselius—His Life and Work. M.A., University of Delaware, 1963.

T307. **Downing, George E.** American Etching, c. 1875–c. 1900, Studied in Relation to Its Background in the Nineteenth-Century Theory and Practice of Art. Ph.D., Harvard University, 1946.

T308. **Drachler, Carole.** George Inness: American Landscape Painter (1825–1894). M.A., Northwestern University, 1969.

T309. **Drazon, Annabel.** Caricature in America as Illustrated in the Graphic Arts. M.A., Washington University, 1939.

T310. **Drey, John.** Evolution of the Skyscraper. M.A., University of Kansas, 1951.

T311. **Driesbach, David F.** The Dilemma of the Contemporary Artist. M.F.A., University of Iowa, 1951.

T312. **Dubin, Lydia S.** The Hotels of New York City, 1885–1900. M.A., Pennsylvania State University, 1969.

T313. **Du Bose, Doris.** Art and Artists in Arizona, 1847–1912. M.A., Arizona State University, 1975.

T314. **Duemling, Robert J.** Houseplanning: The Picturesque in England and America, 1790–1840. M.A., Yale University, 1953.

T315. **Duffey, Virginia N.** Quillwork and Beadwork of Nineteenth Century Teton Tipi Furnishings. M.A., University of Nebraska, 1974.

T316. **Dull, Elizabeth Helsing.** The Domestic Architecture of Oak Park, Illinois, 1900–1930. Ph.D., Northwestern University, 1973.

T317. **Duncan, Jean.** Twenty-Five Paintings in Oil of Historical Sites of Northern Minnesota. Ph.D., University of Minnesota, 1949.

T318. **Eager, Gerald.** Fantastic Painting in America. Ph.D., University of Minnesota, 1969.

T319. **Earl, Mary Ellen (Mrs. Harold E. Perry).** Imitators of Bartlett. M.A., State University of New York, College at Oneonta, 1965.

T320. **Early, James.** Romantic Thought and Architecture in the United States. Ph.D., Harvard University, 1953.

T321. **Early, Marcia A.** "The Craftsman" (1901–1916) as the Principal Spokesman of the Craftsman Movement in America with a Short Study of the Craftsman House Projects. M.A., New York University, 1963.

T322. **Eastman, Gene M.** The English Influence on Washington Allston's Landscapes. M.F.A., University of Iowa, 1958.

T323. **Eckels, Claire W.** Baltimore's Earliest Architects. Ph.D., Johns Hopkins University, 1950.

T324. **Edler, Daniel K.** The Craftsman House: Its Origins and Contribution to Twentieth Century American Domestic Architecture. M.A., University of Iowa, 1965.

T325. **Egan, Mary Virginia.** Earl Heika, Montana Sculptor: His Life and His Work. M.A., North Texas State University, 1973.

T326. **Egerman, Rosemary.** Since Feeling Is First: The Place of Arshile Gorky in Painting from 1930–1960, and an Analysis of His Painting "Agony." M.A., University of Iowa, 1966.

T327. **Ehrlich, George.** The International Exposition: An Index to American Art of the Nineteenth Century. M.A., University of Illinois, 1951.

T328. **Ehrlich, George.** Technology and Artist: Study of the Interaction of Technological

GROWTH AND 19TH CENTURY PICTORIAL ART. Ph.D., University of Illinois, 1960.

T329. **Elam,Charles H.** THE PORTRAITS OF WILLIAM DUNLAP (1766–1839) AND A CATALOGUE OF HIS WORKS. M.A., New York University, 1952.

T330. **Eldredge, Charles Child.** GEORGIA O'KEEFFE: THE DEVELOPMENT OF AN AMERICAN MODERN. Ph.D., University of Minnesota, 1971.

T331. **Ellesin, Dorothy E.** WOODLAWN PLANTATION. M.A., University of Delaware, 1968.

T332. **Elliott, Mary Jane.** LEXINGTON, KENTUCKY, 1792–1820, ATHENS OF THE WEST. M.A., University of Delaware, 1973.

T333. **Ellis, Edwin C.** CERTAIN STYLISTIC TRENDS IN ARCHITECTURE IN IOWA CITY. M.A., University of Iowa, 1947.

T334. **Emberson, Lulu Guthrie.** THE LIFE AND WORKS OF FREDERICK OAKES SYLVESTER, A MISSOURI ARTIST. M.A., University of Missouri, 1930.

T335. **Engelbrecht, Lloyd Charles.** THE ASSOCIATION OF ARTS AND INDUSTRIES: BACKGROUND AND ORIGIN OF THE BAUHAUS MOVEMENT IN CHICAGO. Ph.D., University of Chicago, 1973.

T336. **Engelson, Lois.** THE INFLUENCE OF DUTCH LANDSCAPE PAINTING ON THE AMERICAN LANDSCAPE TRADITION. M.A., Columbia University, 1566.

T337. **Engeseth, Karen Rinde.** THE IMPORTANCE OF THE PHOTOGRAPHY OF MATHEW BRADY AND HIS ASSOCIATES IN THE DOCUMENTATION OF THE WAR BETWEEN THE STATES. M.F.A, Ohio University, 1961.

T338. **England, Bess.** ARTISTS IN OKLAHOMA. M.A., University of Oklahoma, 1964.

T339. **Ent, Dorothy M.** ARCHITECTURAL DEVELOPMENT IN EARLY LANCASTER, OHIO. M.A., Ohio State University, 1945.

T340. **Epstein, Suzanne Latt.** THE RELATIONSHIP OF THE AMERICAN LUMINISTS TO CASPAR DAVID FRIEDRICH. M.A., Columbia University, 1964.

T341. **Epstein,Suzanne Latt.** THE INFLUENCE OF EUROPEAN PRINTS ON EARLY AMERICAN ART. Ph.D., Northwestern University, 1967.

T342. **Erickson, Harold A.** PERMANENT ASPECTS OF FOLK PAINTING IN THE UNITED STATES. M.A., Northwestern University, 1936.

T343. **Ericson, Philancy Nobles.** AVERY HANDLY, JR., TENNESSEE ARTIST: AN ASSESSMENT. M.A., Vanderbilt University, 1971.

T344. **Eusel, Rose M.** INTRODUCTION TO THE OBSERVATION OF NAVAHO SAND PAINTING. M.A., University of New Mexico, 1948.

T345. **Evans, Grace.** FOUNTAINS OF FAITH. M.A., University of Maryland, 1969.

T346. **Evans, Grose.** BENJAMIN WEST'S DEVELOPMENT AND THE SOURCES OF HIS STYLE. Ph.D., Johns Hopkins University, 1953.

T347. **Evans, Judith F.** THE EUROPEAN ETCHINGS OF JOHN MARIN. M.F.A., University of Iowa, 1964.

T348. **Evans, Linda Rose.** AN INVESTIGATION OF THE COLOR FOUND IN THE AMERICAN HOME KITCHEN DURING THE PERIOD OF 1945 UNTIL 1965. M.S., University of Tennessee, 1967.

T349. **Evans, Nancy Goyne.** FURNITURE CRAFTSMEN OF PHILADELPHIA, 1760–1780: THEIR ROLE IN A MERCANTILE SOCIETY. M.A., University of Delaware, 1963.

T350. **Evans-Decker, Barbara.** MORGAN RUSSELL: A REEVALUATION. M.A., State University of New York, Binghamton, 1974.

T351. **Faddis, William G.** THE ARMORY SHOW OF 1913. M.A., Pennsylvania State University, 1948.

T352. **Fadum, Ralph E.** OBSERVATIONS AND ANALYSIS OF BUILDING SETTLEMENTS IN BOSTON. Ph.D., Harvard University, 1950.

T353. **Failey, Dean Frederick.** ELIAS PELLETREAU, LONG ISLAND SILVERSMITH. M.A., University of Delaware, 1971.

T354. **Failing, Patricia Stipe.** DADA IN AMERICA: 1915–1921. M.A., University of California, Berkeley, 1973.

T355. **Fairbanks, Jonathan L.** JOHN NOTMAN: CHURCH ARCHITECTURE. M.A., University of Delaware, 1961.

T356. **Fairchild, Jennifer.** PATENT FURNITURE IN AMERICA FROM 1850 TO 1890: A STUDY OF COUNTER-HEROIC TENDENCIES IN AMERICAN INVENTION. M.A., Cornell University, 1969.

T357. **Farnham, Emily Edna.** CHARLES DEMUTH: HIS LIFE, PSYCHOLOGY AND WORKS. Ph.D., Ohio State University, 1959.

T358. **Faudie, Frederic L.** CONCERNING THE STYLE OF ROBERT RAUSCHENBERG. M.A., University of Iowa, 1965.

T359. **Favrao, William L., Jr.** JOHN SINGER SARGENT. M.A., Yale University, 1941.

T360. **Fehl, Philipp.** A STYLISTIC ANALYSIS OF SOME PROPAGANDA POSTERS OF WORLD WAR II. M.A., Stanford University, 1948.

T361. **Feldman, Arthur M.** ARCHITECTURE AND ARCHITECTURAL TASTE AT THE PHILADELPHIA CENTENNIAL, 1876. M.A., University of Missouri, 1970.

T362. **Feldman, Edmund B.** ART AND DEMOCRATIC CULTURE. Ed.D., Columbia University, 1953.

T363. **Feldman, Frances T.** AMERICAN PAINTING DURING THE GREAT DEPRESSION, 1929-1939. Ph.D., New York University, 1963.

T364. **Feldman, Walter S.** THE NEGRO: AN INDIVIDUAL IN AMERICAN PAINTING. M.A., Yale University, 1951.

T365. **Fennimore, Donald L.** ELEGANT PATTERNS OF UNCOMMON GOOD TASTE: DOMESTIC SILVER BY THOMAS FLETCHER AND SIDNEY GARDINER. M.A., University of Delaware, 1972.

T366. **Ferguson, Marjorie.** THE ACCULTURATION OF SANDIA PUEBLO. M.A., University of New Mexico, 1931.

T367. **Ferguson, Roger Lynn.** THE SKYSCRAPER AESTHETIC. M.A., University of Oregon, 1966.

T368. **Ferguson, Vicki Lee.** SYNCHROMISM: THE EARLY PAINTINGS OF MORGAN RUSSELL AND STANTON MACDONALD-WRIGHT. M.A., University of California, Berkeley, 1972.

T369. **Fern, Thomas Stern.** ASPECTS OF AMERICAN RELIGIOUS PAINTING: A STUDY OF ARTISTIC QUALITY AND THE ART POLICIES OF FIVE DENOMINATIONS AND A CREATIVE PROJECT EXPLORING TRADITIONAL CHRISTIAN THEMES IN MODERN FORM. Ph.D., New York University, 1968.

T370. **Fightner, Mary Ann.** RATTLE TYPES OF THE PACIFIC NORTHWEST COAST INDIANS. M.F.A., University of Iowa, 1960.

T371. **Fidell, Madeleine.** ARTHUR WESLEY DOW — CAREER AND INFLUENCE. M.A., New York University, 1968.

T372. **Field, Cynthia R.** "THE CHICAGO TRIBUNE" COMPETITION OF 1922. M.A., Columbia University, 1967.

T373. **Fields, Ronald.** FOUR CONCEPTS OF AN ORGANIC PRINCIPLE: HORATIO GREENOUGH, HENRY DAVID THOREAU, WALT WHITMAN AND LOUIS SULLIVAN. Ph.D., University of Ohio, 1968.

T374. **File, Sister Mary J.** AN EVALUATION OF THE AESTHETIC PRINCIPLES OF JOHN LA FARGE AS EXPRESSED IN HIS WORK IN GLASS. M.A., Catholic University of America, 1946.

T375. **Finch, Sheila Ann.** BYBEE HOUSES AND THE APPEARANCE OF GREEK REVIVAL IN OREGON. M.A., University of Oregon, 1970.

T376. **Fine, Elsa Honig.** EDUCATION AND THE AFRO-AMERICAN ARTIST: A SURVEY OF THE EDUCATIONAL BACKGROUND OF THE AFRO-AMERICAN AND HIS ROLE AS A VISUAL ARTIST. Ed.D., University of Tennessee, 1970.

T377. **Fink, Lois M.** THE ROLE OF FRANCE IN AMERICAN ART (1850-1870). Ph.D., University of Chicago, 1970.

T378. **Fink, Sylvia.** THE DYNATON: THREE ARTISTS WITH SIMILAR IDEAS — LEE MULLICAN, GORDON ONSLOW FORD, WOLFGANG PAALEN. M.A., Arizona State University, 1973.

T379. **Finkelstein, Irving Leonard.** THE LIFE AND ART OF JOSEF ALBERS. Ph.D., New York University, 1968.

T380. **Finkler, Robert A.** PHILIP GUSTON: A CONSTANT THEME, A CHANGING MEANS. M.F.A., University of Iowa, 1962.

T381. **Finn, Ella G.** A HISTORY OF AMERICAN ARCHITECTURE AS ILLUSTRATED BY BUILDINGS OF GREATER BOSTON. M.A., Boston University, 1943.

T382. **Firm, Ruth Mary.** ART IN A DEMOCRACY: 1900-1950. M.A., Columbia University, 1953.

T383. **Fisher, Elizabeth May.** AN ARCHITECTURAL ANALYSIS OF THE CAMPBELL-WHITTLESEY HOUSE, THE BOODY HOUSE AND THE GENERAL LEAVENWORTH MANSION. M.A., Columbia University, 1944.

T384. **Fisher, Reginald G.** A PLAN FOR AN ARCHAEOLOGICAL SURVEY OF THE PUEBLO PLATEAU. M.A., University of New Mexico, 1929.

T385. **Fisk, Alice C.** VERNACULAR GREEK REVIVAL ARCHITECTURE IN THE GENESEE AREA WITH SPECIAL EMPHASIS ON THE DISTYLE-IN-ANTIS TYPE. M.A., University of Rochester, 1970.

T386. **Fitch, Rebecca F.** THE USE OF NATIVE MATERIALS IN THE ANTE-BELLUM BUILDINGS OF HARRISON COUNTY, TEXAS. M.A., North Texas State College (North Texas State University), 1952.

T387. **Flanagan, Sister Mary Irene, C.S.J.** THE HISTORICAL DEVELOPMENT, DESIGN AND FURNISHINGS OF DOHENY HALL, THE RESIDENCE OF MR. AND MRS. DOHENY, NOW THE DOHENY CAMPUS OF MOUNT SAINT MARY'S COLLEGE, LOS ANGELES, CALIFORNIA. M.A., San Jose State University, 1967.

T388. **Fleischer, Roland.** THE DEVELOPMENT OF ROMANTIC-REALIST LANDSCAPE PAINTING. M.A., Johns Hopkins University, 1954.

T389. **Fleischer, Roland.** GUSTAVUS HESSELIUS. Ph.D., Johns Hopkins University, 1964.

T390. **Fleming, Sandra Carol.** AN INVESTIGATION OF THE INFLUENCING FACTORS UPON CONTEMPORARY CHURCH DESIGN IN METROPOLITAN NASHVILLE, TENNESSEE, SINCE 1947. M.S., University of Tennessee, 1969.

T391. **Floyd, Margaret.** A TERRA COTTA CORNERSTONE FOR COPLEY SQUARE: AN ASSESSMENT OF THE MUSEUM OF FINE ARTS, BOSTON, BY STURGIS AND BRIGHAM (1870-1876) IN THE CONTEXT OF ITS ENGLISH TECHNOLOGICAL AND STYLISTIC ORIGINS. Ph.D., Boston University, 1974.

T392. **Folsom, Betty Griggs.** THE PERMANENT COLLECTION OF PAINTINGS AT THE CARNEGIE INSTITUTE,

PITTSBURGH. M.A., Pennsylvania State University, 1961.

T393. **Fong, Michael W.** THE BAY AREA FIGURATIVE SCHOOL OF PAINTING. M.A., University of Iowa, 1964.

T394. **Forbes, Martha Keppler.** THE VICTORIAN GOTHIC AND ITS MANIFESTATIONS IN ROCHESTER, NEW YORK. M.A., University of Rochester, 1948.

T394a. **Ford, James Bacon.** CONRAD WISE CHAPMAN. Ph.D., Harvard University, 1942.

T395. **Forman, Benno M.** THE SEVENTEENTH-CENTURY CASE FURNITURE OF ESSEX COUNTY, MASSACHUSETTS, AND ITS MAKERS. M.A., University of Delaware, 1968.

T396. **Forman, Nessa.** WALT KUHN: WILLY LOMAN OF AMERICAN ART. M.A., University of Pennsylvania, 1968.

T397. **Forsyth, Robert Joseph.** JOHN B. FLANNAGAN: HIS LIFE AND WORK. Ph.D., University of Minnesota, 1965.

T398. **Fortuna, Ben.** A NEW EVALUATION OF WINSLOW HOMER. M.A., Wayne University (Wayne State University), 1943.

T399. **Forwood, William L., Jr.** JOHN SLOAN, JAPONISME AND THE ART NOUVEAU. M.A., University of Delaware, 1970.

T400. **Fosburgh, James W.** A JOURNAL OF THOMAS SULLY. M.A., Yale University, 1935.

T401. **Foss, Helen.** MONOGRAPH ON FLETCHER MARTIN. M.A., University of Iowa, 1943.

T402. **Foss, James.** WILLIS GAYLORD HALE AND PHILADELPHIA'S REBELLION OF THE PICTURESQUE: 1880–1890. M.A., Pennsylvania State University, 1964.

T403. **Foster, Kathleen.** PHILADELPHIA AND PARIS: THOMAS EAKINS AND THE BEAUX ARTS. M.A., Yale University, 1971.

T404. **Foster, Stephen.** THE CRITICS OF ABSTRACT EXPRESSIONISM. Ph.D., University of Pennsylvania, 1973.

T405. **Fowble, Eleanore McSherry.** REMBRANDT PEALE IN BALTIMORE. M.A., University of Delaware, 1965.

T406. **Fowble, Eleanore McSherry.** A CENTURY OF THE NUDE IN AMERICAN ART, 1750–1850. M.A., University of Delaware, 1967.

T407. **Fowler, Mary Dalton.** THE SIMILARITIES AND DISSIMILARITIES IN THE FULLY DEVELOPED GEORGIAN DOMESTIC ARCHITECTURE IN THE NEW ENGLAND AND SOUTHERN COLONIES IN PRE-REVOLUTIONARY TIMES. M.A., Columbia University, 1939.

T408. **Fracassini, Silvio Carl.** THE DILEMMA OF THE TWENTIETH-CENTURY AMERICAN ARTIST. M.F.A., University of Iowa, 1951.

T409. **France, Jean Reitsman.** EARLY CHURCH ARCHITECTURE IN THE WESTERN RESERVE. M.A., Oberlin College, 1948.

T410. **Francey, Mary Frankl.** JOSEPH PENNELL. M.A., University of Utah, 1974.

T411. **Frank, Peter.** RALSTON CRAWFORD. M.A., Columbia University, 1974.

T412. **Fraps, Clara L.** AN ARCHAEOLOGICAL SURVEY OF ARIZONA. M.A., University of Arizona, 1928.

T413. **Freedman, Henry.** THE W.P.A. PAINTING OF JACK LEVINE. M.A., University of Maryland, 1966.

T414. **Freeman, John C.** FORGOTTEN REBEL: GUSTAV STICKLEY. M.A., University of Delaware, 1965.

T415. **Frierman, J. D.** TASTE IN THE VISUAL ARTS IN THE SAN FRANCISCO BAY REGION OF CALIFORNIA, 1860–1890. M.A., Mills College, 1951.

T416. **Fritz, Robert Bradley.** THE SEVENTEENTH CENTURY ARTS OF NEW ENGLAND: THEIR ROLE IN FINE ARTS EDUCATION. Ph.D., Columbia University, 1963.

T417. **Frizzell, John S.** ART, SCULPTURE AND ARCHITECTURE OF PENNSYLVANIA IN THE TWENTIETH CENTURY. M.A., Pennsylvania State University, 1933.

T418. **Frost, Maygene.** THE AMERICAN WEST IN ART, 1840–1860: THE ARTISTS OF THE CORPS OF TOPOGRAPHICAL ENGINEERS AND THEIR WORK. M.A., Yale University, 1971.

T419. **Fuller, George.** INTERIOR ARCHITECTURE AND THE MEDIA FOR ITS ENRICHMENT. Ph.D., Ohio University, 1972.

T420. **Galloway, John.** AMERICAN PAINTING: ART CRITICISM IN THE UNITED STATES SINCE THE NEW YORK ARMORY SHOW IN 1913. M.A., American University, 1950.

T421. **Gandy, Martha Lou.** JOSEPH RICHARDSON, QUAKER SILVERSMITH. M.A., University of Delaware, 1954.

T422. **Gannon, William Louis.** CARRIAGE, COACH AND WAGON: THE DESIGN AND DECORATION OF AMERICAN HORSE-DRAWN VEHICLES. Ph.D., University of Iowa, 1960.

T423. **Ganschinietz, Suzanne.** AN ANALYSIS AND COMPARISON OF THE CHURCH ARCHITECTURE OF FRANK LLOYD WRIGHT AND RUDOLF SCHWARZ. M.A., Columbia University, 1965.

T424. **Garber, Ken.** ABSTRACT EXPRESSIONIST CERAMICS. M.A., University of California, Los Angeles, 1974.

T425. **Garner, John.** THE MODEL COMPANY TOWN IN NEW ENGLAND: HOPEDALE AND THE NEW TOWN TRADITION. Ph.D., Boston University, 1974.

T426. **Garrett, Wendell D.** THE NEWPORT, RHODE IS-

LAND, INTERIOR, 1780–1800. M.A., University of Delaware, 1957.

T427. **Garrison, Gail.** HOMER DODGE MARTIN: PAINTER OF ELYSIUM. M.A., Johns Hopkins University, 1974.

T428. **Garvin, James L.** BRADBURY JOHNSON, BUILDER-ARCHITECT. M.A., University of Delaware, 1969.

T429. **Gates, Gerald Francis.** THE ACANTHUS LEAF IN CLASSICAL PHASES OF AMERICAN ARCHITECTURE: 1800–1900. M.F.A., University of Colorado, 1949.

T430. **Gaudnek, Walter.** THE SYMBOLIC MEANING OF THE CROSS IN CONTEMPORARY AMERICAN PAINTING: A COMPARATIVE STUDY OF STATEMENTS BY SELECTED ARTISTS AND CRITICS. Ph.D., New York University, 1968.

T431. **Gay, Thomas B.** AMERICAN WATERCOLOR PAINTING. M.A., College of William and Mary in Virginia, 1950.

T432. **Geck, Francis Joseph.** AN ATTEMPT TO RETITLE WITH AMERICAN NOMENCLATURE THE PERIOD STYLES OF AMERICAN FURNITURE. M.F.A., Syracuse University, 1945.

T433. **George, Jane M.** ART DECO FURNITURE DESIGN IN THE UNITED STATES. M.A., University of Iowa, 1970.

T434. **George, Marilyn R.** JOHN GADSBY CHAPMAN: THE DILEMMA OF AN AMERICAN HISTORY PAINTER. M.A., Ohio State University, 1973.

T435. **Gerdts, William.** LIFE AND WORK OF HENRY INMAN. Ph.D., Harvard University, 1966.

T436. **Geske, Norman.** REMBRANDT PEALE: A CASE STUDY IN AMERICAN ROMANTICISM. M.A., New York University, 1953.

T437. **Getscher, Robert.** WHISTLER AND VENICE. Ph.D., Case Western Reserve University, 1970.

T438. **Gibbons, Kristin (Mrs. James K.).** THE VAN BERGEN OVERMANTEL. M.A., State University of New York, College at Oneonta, 1968.

T439. **Gibson, Dorothy B.** AN ANALYSIS OF SIXTY-EIGHT ENGLISH AND AMERICAN GRANDFATHER CLOCK DIALS DATING FROM 1685 TO 1850. M.S., Drexel University, 1965.

T440. **Gieschen, Martin J.** AN ART HISTORY OF ELMIRA, NEW YORK. M.F.A., Syracuse University, 1967.

T441. **Gifford, Robert Thomas.** THE CINCINNATI MUSIC HALL AND EXPOSITION BUILDINGS. M.A., Cornell University, 1973.

T442. **Gilbert, Barbara L.** AMERICAN CREWELWORK, 1700–1850. M.A., University of Delaware, 1965.

T443. **Gilbert, Lois E.** SANTOS OF THE SOUTHWEST. M.A., Western Reserve University (Case Western Reserve University), 1940.

T444. **Gilbert, Ruth H.** AMERICAN JEWELRY: FROM THE GOLD RUSH TO ART NOUVEAU. M.A., New York University, 1962.

T445. **Gillingham, Frank J.** COMPARISON BETWEEN THE TRIBES OF NORTHEASTERN ASIA AND NORTHWESTERN AMERICA. M.A., University of Pennsylvania, 1919.

T446. **Gilruth, Mary M.** THE IMPORTATION OF ENGLISH EARTHENWARE INTO PHILADELPHIA 1770–1800. M.A., University of Delaware, 1964.

T447. **Givan, Sister Gladys Ann, S.L.** RELIGIOUS ART AND ARCHITECTURE IN SOME CONTEMPORARY CHURCHES IN COLORADO. M.F.A., University of Colorado, 1964.

T448. **Glasgow, Vaughn L.** THE HOTELS OF NEW YORK PRIOR TO THE AMERICAN CIVIL WAR. M.A., Pennsylvania State University, 1970.

T449. **Glasson, Glenna M.** CONTEMPORARY AMERICAN ARCHITECTURE WITH SPECIAL REFERENCE TO COLOR AND LIGHT. M.A., Boston University, 1937.

T450. **Gleason, Vincent.** ARCHITECTURE IN CONFLICT. (A STUDY OF THE INTERACTION BETWEEN THE WORK OF FRANK LLOYD WRIGHT AND OF THE SO-CALLED "INTERNATIONAL STYLE.") M.A., Michigan State University, 1951.

T451. **Glezen, Judith A.** SOME ASPECTS OF FORM AND TECHNIQUE IN SOUTHWEST AMERICAN INDIAN POTTERY. M.A., University of Iowa, 1960.

T452. **Glynn, Elisabeth Louise.** GIDEON SHRYOCK, 1802–80, GREEK REVIVAL ARCHITECT IN KENTUCKY. Ph.D., Northwestern University, 1971.

T453. **Goeldner, Paul Kenneth.** TEMPLES OF JUSTICE: NINETEENTH-CENTURY COUNTY COURTHOUSES IN THE MIDWEST AND TEXAS. Ph.D., Columbia University, 1970.

T454. **Gold, James.** A STUDY OF THE MASTIN COLLECTION. M.A., State University of New York, College at Oneonta, 1968.

T455. **Goldberg, Kenneth Paul.** THE PAINTINGS OF GRANT WOOD. M.A., State University of New York, Binghamton, 1972.

T456. **Goldberg, Marcia.** WILLIAM RIMMER, AN AMERICAN SCULPTOR. M.A., Oberlin College, 1972.

T457. **Goldman, Ricard H.** CHARLES BIERSTADT, 1819–1903, AMERICAN STEREOGRAPH PHOTOGRAPHER. M.A., Kent State University, 1974.

T458. **Goldstein, Leslie.** ART IN CHICAGO AND THE WORLD'S COLUMBIAN EXPOSITION OF 1893. M.A., University of Iowa, 1970.

T459. **Good, Harry Gehman.** BENJAMIN RUSH AND HIS SERVICES TO AMERICAN EDUCATION. Ph.D., University of Pennsylvania, 1915.

T460. **Goodall, Donald B.** GASTON LACHAISE. Ph.D., Harvard University, 1969.

T461. **Goodyear, Frank H., Jr.** THE LIFE AND ART OF THOMAS DOUGHTY. M.A., University of Delaware, 1969.

T462. **Gorder, Judith E. (Von Baron).** JAMES MCNEILL WHISTLER: A STUDY OF THE OIL PAINTINGS, 1870–1885. M.A., University of Iowa, 1969.

T463. **Gorder, Judith E. (Von Baron).** JAMES MCNEILL WHISTLER: A STUDY OF THE OIL PAINTINGS, 1855–1869. Ph.D., University of Iowa, 1973.

T464. **Gordon, Allan.** CULTURAL DUALISM ON THE THEMES OF CERTAIN AFRO-AMERICAN ARTISTS. Ph.D., Ohio University, 1969.

T465. **Gordon, Margery Jean.** THE FINE ARTS IN BOSTON, 1815 TO 1879. Ph.D., University of Wisconsin, 1965.

T466. **Gores, Walter W.J.** A STUDY OF THE APPLIED ARTS IN THE INDUSTRIES OF LOS ANGELES. M.A., University of California, Berkeley, 1927.

G467. **Goss, Peter L.** "OLANA," THE HOME OF FREDERIC EDWIN CHURCH, PAINTER. Ph.D., Ohio University, 1973.

T468. **Gough, Sister Mary Rosalie, S.S.J.** A STUDY OF STAINED GLASS IN THE DISTRICT OF COLUMBIA AND ITS ENVIRONS. M.A., Catholic University of America, 1943.

T469. **Gouin, Clara.** WILLIAM H. POWELL (1820–1879), AMERICAN ARTIST. M.A., University of Maryland, 1966.

T470. **Goyne, Nancy A.** FURNITURE CRAFTSMEN IN PHILADELPHIA, 1760–1780. M.A., University of Delaware, 1963.

T471. **Gracey, Frank M.** A HISTORY OF SECONDARY SCHOOL ARCHITECTURE IN MASSACHUSETTS. Ph.D., Boston University, 1937.

T472. **Graham, Margaret E.** A HISTORY OF ARCHITECTURE IN BLAIR COUNTY, PENNSYLVANIA. M.A., Pennsylvania State University, 1942.

T473. **Gray, Donald L.** FRANK LLOYD WRIGHT: HIS ATTITUDE TOWARD NATURE. M.A., University of Iowa, 1962.

T474. **Gray, Thomas A.** GRAYLYN, A NORMAN REVIVAL ESTATE IN NORTH CAROLINA. M.A., University of Delaware, 1974.

T475. **Graybill, Samuel H., Jr.** A HISTORY OF DAVID HOADLEY'S CHRIST CHURCH, BETHANY, CONN., 1809. M.A., Yale University, 1953.

T476. **Graybill, Samuel H., Jr.** BRUCE PRICE, AMERICAN ARCHITECT, 1845–1903. Ph.D., Yale University, 1957.

T477. **Green, Dorothea.** A SURVEY OF THE ARTS OF THE PUEBLO PEOPLE AND THE NEW MEXICAN SPANIARDS. M.A., Ohio State University, 1952.

T478. **Green, Samuel McGee.** AN INTRODUCTION TO THE HISTORY OF AMERICAN ILLUSTRATION FROM ITS BEGINNING IN THE LATE SEVENTEENTH CENTURY UNTIL 1850. Ph.D., Harvard University, 1944.

T479. **Greenlaw, Barry A.** MICHEL FELICE CORNÈ. M.A., University of Delaware, 1962.

T480. **Greenthal, Kathryn.** DANIEL CHESTER FRENCH'S SCULPTURE GROUPS FOR PUBLIC BUILDINGS. M.A., New York University, 1974.

T481. **Gregory, Marion E.** NEGRO ART IN AFRICA AND THE UNITED STATES. M.A., Western Reserve University (Case Western Reserve University), 1941.

T482. **Greiffenberg, Karen.** ORONZO GASPARO: HIS LIFE AND ART. M.A., University of Washington, 1973.

T483. **Gresl, Kathleen Jacobs.** A HISTORY OF SHEBOYGAN FURNITURE MANUFACTURERS. M.S., University of Wisconsin, 1972.

T484. **Grigsby, Jefferson Eugene, Jr.** AFRICAN AND INDIAN MASKS: A COMPARATIVE STUDY OF MASKS PRODUCED BY THE BAKUBA TRIBE OF THE CONGO AND THE KWAKIUTL INDIANS OF THE NORTHWEST PACIFIC COAST OF AMERICA. Ph.D., New York University, 1963.

T485. **Grimmer, Anne E.** FRANK BLACKWELL MAYER, 1827–1899, GENRE AND HISTORY PAINTER. M.A., George Washington University, 1969.

T486. **Grindhammer, Lucille Wrubel.** THE POPULARIZATION OF THE FINE ARTS IN AMERICA, 1789–1860. Ph.D., Case Western Reserve University, 1972.

T487. **Grodner, Abigail R.** WASHINGTON ALLSTON'S "LECTURES ON ART"; AN AMERICAN PAINTER'S DOCUMENT OF AESTHETICS. M.A., Columbia University, 1964.

T488. **Groseclose, Barbara.** EMANUEL LEUTZE, 1816-1868: A GERMAN-AMERICAN HISTORY PAINTER. Ph.D., University of Wisconsin, 1974.

T489. **Gross, Katherine W. (Farnham).** THE SOURCES OF FURNITURE SOLD IN SAVANNAH, 1789–1815. M.A., University of Delaware, 1967.

T490. **Grubar, Francis S.** THE WORKS OF WILLIAM CATON WOODVILLE. Ph.D., Johns Hopkins University, 1966.

T491. **Grusendorf, William Edward.** ARSHILE GORKY: A STUDY OF HIS ARTISTIC DEVELOPMENT WITH EMPHASIS ON LINE AND CONTOUR SHAPES. M.F.A., University of Colorado, 1963.

T492. **Gunn, Virginia Lee Railsback.** HISTORICAL SURVEY OF NAVAHO BLANKETS AND RUGS: THE INFLU-

ENCES OF CULTURAL FORCES ON CHANGING DESIGNS IN A FOLK ART FORM. M.A., Syracuse University, 1972.

T493. **Haas, David Matthew.** "THE PASSION OF SACCO AND VANZETTI" RECONSTRUCTED THROUGH SOURCES. M.A., University of Colorado, 1972.

T494. **Haase, Nancy.** THE INTERNATIONAL EXHIBITION OF MODERN ART OF 1913 IN NEW YORK AND CHICAGO. M.A., Northwestern University, 1955.

T495. **Haggerty, Margaret.** DAVID SMITH POLYCHROMES. M.A., University of Maryland, 1968.

T496. **Haines, Robert Eugene.** IMAGE AND IDEA: THE LITERARY RELATIONSHIPS OF ALFRED STIEGLITZ. Ph.D., Stanford University, 1968.

T497. **Hale, Eunice.** CHARLES DEMUTH: HIS STUDY OF THE FIGURE. Ph.D., New York University, 1974.

T498. **Hale, John Douglass.** THE LIFE AND DEVELOPMENT OF JOHN H. TWACHTMAN. Ph.D., Ohio State University, 1957.

T499. **Hales, Marjorie V.** MARJORIE DODGE TAPP: HER LIFE AND HER ART, HER EDUCATIONAL IDEAS AND HER INFLUENCE ON THE ART OF OKLAHOMA. M.A., University of Oklahoma, 1949.

T500. **Hall, Daniel August.** FEDERAL PATRONAGE OF ART IN ARIZONA FROM 1933 TO 1943. M.A., Arizona State University, 1974.

T501. **Hall, Lee.** REALITY-CONCEPTS EXPRESSED IN AMERICAN ABSTRACT PAINTING, 1945–1960. Ph.D, New York University, 1965.

T502. **Hall, Louise.** ARTIFICER TO ARCHITECT IN AMERICA. Ph.D., Radcliffe College, 1954.

T503. **Hallam, John.** HOUDON'S WASHINGTON IN RICHMOND RE-EXAMINED. M.A., University of Washington, 1974.

T504. **Hallmark, Donald P.** RICHARD W. BOCK: SCULPTOR FOR FRANK LLOYD WRIGHT AND THE ARCHITECTS OF THE CHICAGO SCHOOL. M.A., University of Iowa, 1970.

T505. **Ham, Adrienne C.** THE IOWA RESIDENTIAL ARCHITECTURE OF FRANK LLOYD WRIGHT. M.A., University of Iowa, 1972.

T506. **Ham, Clifford Carmichael, Jr.** A STUDY OF BUILDING AND DECISION-MAKING IN SELECTED URBAN CHURCHES WITH IMPLICATIONS FOR CITY PLANNING. Ph.D., University of Pennsylvania, 1962.

T507. **Hamilton, Charles Mark.** AUTHORSHIP AND ARCHITECTURE INFLUENCES ON THE SALT LAKE TEMPLE. M.A., University of Utah, 1972.

T508. **Hamilton, George H.** HEZEKIAH AUGUR: AN AMERICAN SCULPTOR, 1791–1858. M.A., Yale University, 1934.

T509. **Hamilton, Helen C.** THE ARMORY SHOW, ITS HISTORY AND SIGNIFICANCE. M.A., American University, 1950.

T510. **Hamilton, Janet C.** THE INTERIOR RESTORATION OF ADENA WITH REFERENCE TO AMERICAN DECORATIVE STYLES OF THE EARLY NINETEENTH CENTURY. M.A., Ohio State University, 1949.

T511. **Hamlin, Gladys E.** MURAL PAINTINGS IN IOWA. M.A., Columbia University, 1937.

T512. **Hand, Frederick Ivor.** THE SKYSCRAPER: AN HISTORICAL SKETCH OF ITS CONCEPTION AND DEVELOPMENT. M.A., Northwestern University, 1949.

T513. **Handy, Elizabeth A.** H. G. MARATTA'S COLOR THEORY AND ITS INFLUENCE ON THE PAINTERS—ROBERT HENRI, JOHN SLOAN, AND GEORGE BELLOWS. M.A., University of Delaware, 1969.

T514. **Hanson, Frederick B.** THE INTERIOR ARCHITECTURE AND HOUSEHOLD FURNISHING OF BERGEN COUNTY, NEW JERSEY, 1800–1810. M.A., University of Delaware, 1959.

T515. **Harley, Ralph L., Jr.** FOUR TWENTIETH-CENTURY AMERICAN PRINTMAKERS AND THEIR TRENDS TOWARD A FORMALISM. M.A., University of Wisconsin, 1965.

T516. **Harper, Blanch W.** NOTES ON THE DOCUMENTARY HISTORY, THE LANGUAGE AND THE RITUALS AND CUSTOMS OF JUAREZ PUEBLO. M.A., University of New Mexico, 1929.

T517. **Harriman, Joyce C.** HAND-WOVEN COVERLETS OF THE SOUTHERN APPALACHIAN REGION. M.A., Ohio State University, 1938.

T518. **Harrington, James Robert.** THE SPANISH REVIVAL IN THE UNITED STATES: ITS INFLUENCE ON INTERIOR AND FURNITURE DESIGN. M.S., Southern Illinois University, 1969.

T519. **Harrington, Kirsten Beck.** WHY CLASSICISTIC ARCHITECTURE SUCCEEDED IN LATER NINETEENTH CENTURY AMERICA. M.A., Tulane University, 1968.

T520. **Harris, Frederick.** THE HISTORY AND EVOLUTION OF STAGE SCENERY IN NEW YORK FROM 1890 TO 1900. M.A., New York University, 1939.

T521. **Harrison, Helen.** SOCIAL REALISM IN FEDERAL ART. M.A., Case Western Reserve University, 1975.

T522. **Hassrick, Peter Heyl.** ARTISTS EMPLOYED ON UNITED STATES GOVERNMENT EXPEDITIONS TO THE TRANS-MISSISSIPPI WEST BEFORE 1850. M.A., University of Denver, 1969.

T523. **Hauserman, Dianne D.** JOHN COTTON DANA: MUSEUM PIONEER IN THE FIELD OF AMERICAN ART. M.A., New York University, 1965.

T524. **Hawley, Henry H.** CHARLES BUSCHOR, DESIGNER

AND MANUFACTURER OF FURNITURE AND INTERIOR DECORATIONS. M.A., University of Delaware, 1960.

T525. **Hawry, E. W.** SUCCESSION OF HOUSE TYPES IN THE PUEBLO AREA. M.A., University of Arizona, 1928.

T526. **Haydock, John Spahr.** THE POPULAR AMERICAN DOCUMENTARY FILM: AN ANALYSIS AND CASE STUDY. Ph.D., Emory University, 1974.

T527. **Hayes, Marian.** LIFE AND ARCHITECTURE IN THE CONNECTICUT VALLEY. Ph.D., Radcliffe College, 1945.

T528. **Haynes, Janice.** ARCHITECTURAL PRESERVATION IN ATHENS, GEORGIA: A RESOLUTION OF PROGRESS AND PRESERVATION. M.A., University of Georgia, 1971.

T529. **Hayward, Mary Ellen.** THE ELLIOTTS OF PHILADELPHIA: EMPHASIS ON THE LOOKING-GLASS TRADE, 1755–1810. M.A., University of Delaware, 1971.

T530. **Healy, Daty.** A HISTORY OF THE WHITNEY MUSEUM OF AMERICAN ART, 1930–1954. Ed.D., New York University, 1960.

T531. **Heckscher, Morrison H.** THE ORGANIZATION AND PRACTICE OF PHILADELPHIA CABINETMAKING ESTABLISHMENTS, 1790–1820. M.A., University of Delaware, 1964.

T532. **Heidelberg, Michelle Favrot.** WILLIAM WOODWARD. M.A., Tulane University, 1974.

T533. **Heintzelman, Patricia L.** ELYSIUM ON THE SCHUYLKILL, WILLIAM HAMILTON'S WOODLANDS. M.A., University of Delaware, 1972.

T534. **Hemenway, Pamela G. (Simpson).** CASS GILBERT'S BUILDINGS AT THE LOUISIANA PURCHASE EXPOSITION, 1904. M.A., University of Missouri, 1970.

T535. **Hendren, Harry O.** A STUDY OF THE ARCHITECTURAL HISTORY OF HOPKINSVILLE, KENTUCKY, DURING THE NINETEENTH CENTURY. M.A., Ohio State University, 1949.

T536. **Hendrick, Robert E. P.** JOHN GAINES II AND THOMAS GAINES I, "TURNERS" OF IPSWICH, MASSACHUSETTS. M.A., University of Delaware, 1964.

T537. **Hennington, Joseph F.** THE DEVELOPMENT OF CUBISM AS A SOURCE OF CONTEMPORARY AMERICAN PAINTING. M.A., Yale University, 1948.

T538. **Henry, Sara.** PAINTINGS AND STATEMENTS OF MARK ROTHKO AND ADOLPH GOTTLIEB, 1941 TO 1949: BASIS OF THE MYTHOLOGICAL PHASE OF ABSTRACT EXPRESSIONISM. M.A., New York University, 1966.

T539. **Herman, Edith L.** EARLY AMERICAN PORTRAIT SCULPTURE (CA. 1785–1870). M.A., Columbia University, 1956.

T540. **Hermann, Patricia B.** STONE ARCHITECTURE OF STONE CITY AND WAUBEEK, IOWA. M.A., University of Iowa, 1966.

T541. **Herrman, Robert Lewis.** STYLISTIC DEVELOPMENT OF CHARLES DEMUTH'S ART. M.A., Ohio State University, 1949.

T542. **Hertz, Elizabeth.** THE CONTINUING ROLE OF STANTON MACDONALD-WRIGHT AND SYNCHROMISM IN MODERN PAINTING. M.F.A., Ohio University, 1968.

T543. **Hewett, Olive Marie.** "ELEPHANT JOE" JOSEPHS AND THE SIGN SHOP: A THESIS. M.A., State University of New York, College at Oneonta, 1973.

T544. **Hewitt, Barnard W.** THE THEATRE AND THE GRAPHIC ARTS. Ph.D., Cornell University, 1935.

T545. **Hibdon, Judith Ann Harris.** A STUDY OF MISSION COMPLEXES OF THE JESUIT TYPE IN THE SOUTHWEST UNITED STATES. M.A., University of Colorado, 1973.

T546. **Higgins, Winifred Haines.** ART COLLECTING IN THE LOS ANGELES AREA, 1910–1960. Ph.D., University of California, Los Angeles, 1963.

T547. **Higginson, Peter.** JASPER JOHNS AND THE INFLUENCE OF LUDWIG WITTGENSTEIN. M.A., University of British Columbia, 1974.

T548. **Hight, Elton Thomas.** PHILIP CAMPBELL CURTIS (1907-): A STUDY OF HIS LIFE AND PAINTING. M.A., Arizona State University, 1969.

T549. **Hill, Anna J.** DELAIN HOUSES. M.A., Johns Hopkins University, 1946.

T550. **Hill, Edward.** A BIBLIOGRAPHY OF ART IN PENNSYLVANIA. M.A., Pennsylvania State University, 1946.

T551. **Hill, John H.** THE FURNITURE CRAFTSMEN IN BALTIMORE, 1783–1823. M.A., University of Delaware, 1967.

T552. **Hills, Patricia.** THE GENRE PAINTING OF EASTMAN JOHNSON: THE SOURCES AND DEVELOPMENT OF HIS STYLE AND THEMES. Ph.D., New York University, 1973.

T553. **Hinkle, Rita.** THE CRITICS OF GEORGIA O'KEEFFE. M.A., Bowling Green State University, 1974.

T554. **Hoag, John D.** TIMOTHY BISHOP HOUSE IN NEW HAVEN. M.A., Yale University, 1953.

T555. **Hoberg, Perry F.** WASHINGTON ALLSTON: BIOGRAPHY OF AN AESTHETIC EXPERIENCE. M.A., University of Delaware, 1965.

T556. **Hoene, Anne Fawes.** THE ORIGINS OF JACKSON POLLOCK'S STYLE. M.A., New York University, 1967.

T557. **Hogan, Sister Imelda M., O.P.** AN ANALYTICAL STUDY OF THE AESTHETIC VALUE OF THE ARCHITECTURE AND ICONOGRAPHY OF THE CHAPEL AT THE DOMINICAN HOUSE OF STUDIES, WASHINGTON, D.C. M.A., Catholic University of America, 1953.

T558. **Holaday, William H., III.** HARVEY DUNN,

PIONEER PAINTER OF THE MIDDLE BORDER. Ph.D., Ohio State University, 1970.

T559. **Holcomb, Grant, III.** THE LIFE AND ART OF JEROME MYERS. M.A., University of Delaware, 1970.

T560. **Holcomb, Grant, III.** A CATALOGUE RAISONNÉ OF THE PAINTINGS OF JOHN SLOAN, 1900-1913. Ph.D., University of Delaware, 1972.

T561. **Holden, Wheaton Arnold.** ROBERT SWAIN PEABODY OF PEABODY AND STEARNS IN BOSTON — THE EARLY YEARS (1870-1886). Ph.D., Boston University, 1969.

T562. **Holler, Katherine D.** HERBERT ADAMS, AMERICAN SCULPTOR. M.A., University of Delaware, 1971.

T563. **Hood, Walter Kelly.** WORDS, WARS AND WALLS: THE ART LIFE OF GEORGE MATTHEWS HARDING. Ph.D., Northwestern University, 1966.

T564. **Hook, Walter.** AN ANALYSIS OF FOUR AMERICAN WATER COLORISTS. M.A., University of New Mexico, 1950.

T565. **Hoover, Louis.** TWENTIETH-CENTURY ART IN AMERICA. Ed.D., New York University, 1943.

T566. **Hopkins, Rosemary.** CLARK MILLS: THE FIRST NATIVE AMERICAN SCULPTOR. M.A., University of Maryland, 1966.

T567. **Hoppin, Martha.** WILLIAM MORRIS HUNT: ASPECTS OF HIS WORK. Ph.D., Harvard University, 1974.

T568. **Horsley, Wendall Graham.** AN ANALYSIS OF CONTEMPORARY INTEREST IN THE SANTOS ART OF THE SOUTHWEST. M.A., University of Denver, 1966.

T569. **Hosfield, John David.** A STUDY OF THE ARCHITECTURE OF PIETRO BELLUSCHI: OREGON 1925-50. M.A., University of Oregon, 1960.

T570. **Houghton, Janet.** HOUSEHOLD FURNISHINGS IN SOUTHERN VERMONT, 1780-1800. M.A., University of Delaware, 1975.

T571. **Howard, Betty J.** A CATALOGUE OF 19TH CENTURY PORTRAITS IN THE OHIO STATE ARCHEOLOGICAL AND HISTORICAL MUSEUM. Ph.D., Ohio State University, 1948.

T572. **Hudson, William Parker.** THE HUDSON RIVER SCHOOL OF LANDSCAPE PAINTERS. M.A., Yale University, 1932.

T573. **Huffman, Robert E.** NEWSPAPER ART IN STOCKTON (CALIFORNIA), 1850-1892. Ph.D., Case Western Reserve University, 1955.

T574. **Hughes, Octavia.** THE EARLY WORK AND DEVELOPMENT OF HENRY KIRKE BROWN. M.A., Columbia University, 1960.

T575. **Hulick, Diana L.** RUDOLF EICKEMEYER, JR.: THE THIRD MAN. M.F.A., Ohio University, 1973.

T576. **Hull, Roger P.** "CAMERA WORK," AN AMERICAN QUARTERLY. Ph.D., Northwestern University, 1970.

T577. **Hummel, Charles F.** THE INFLUENCE OF ENGLISH DESIGN BOOKS UPON THE PHILADELPHIA CABINETMAKER, 1760-1780. M.A., University of Delaware, 1955.

T578. **Humphrey, Effingham P.** THE CHURCHES OF JAMES RENWICK, JR. M.A., New York University, 1942.

T579. **Hunt, K. Conover.** THE WHITE HOUSE FURNISHINGS OF THE MADISON ADMINISTRATION, 1809-1817. M.A., University of Delaware, 1971.

T580. **Hunter, Dard, Jr.** DAVID EVANS, CABINETMAKER: HIS LIFE AND WORK. M.A., University of Delaware, 1954.

T581. **Huntington, David C.** ORIENTAL INFLUENCE ON FRANK LLOYD WRIGHT. M.A., Yale University, 1953.

T582. **Huntington, David.** FREDERIC EDWIN CHURCH, 1826-1900: PAINTER OF THE ADAMIC NEW WORLD MYTH. Ph.D., Yale University, 1960.

T583. **Hunziker, Ernella Susette.** THE LEAGUE OF NEW HAMPSHIRE ARTS AND CRAFTS: 1931-1964. Ph.D., Columbia University, 1965.

T584. **Hurdis, Frank D., Jr.** THE ARCHITECTURE OF JOHN HOLDEN GREENE. M.A., Cornell University, 1973.

T585. **Hurley, Forrest Jack.** TO DOCUMENT A DECADE: ROY STRYKER AND THE DEVELOPMENT OF DOCUMENTARY PHOTOGRAPHY BY THE FARM SECURITY ADMINISTRATION. Ph.D., Tulane University, 1971.

T586. **Hutson, Martha (Holsclaw).** THE LIFE AND WORK OF GEORGE HENRY DURRIE, 1820-1863. Ph.D., Harvard University, 1972.

T586a. **Hyder, Darrell D.** FINE PRINTING IN PHILADELPHIA, 1780-1820. M.A., University of Delaware. 1961.

T587. **Hyers, Louise James.** STUDY OF THE HISTORICAL AND AESTHETIC CHARACTERISTICS OF TWO NINETEENTH-CENTURY HOUSES IN ATHENS, CLARKE COUNTY, GEORGIA. M.S., University of Georgia, 1969.

T588. **Ingalls, Hunter.** GENIUS OF THE EVERYDAY: THE ART OF WILLIAM SOMMER. M.A., Columbia University, 1963.

T589. **Ingalls, Hunter.** THE SEVERAL DIMENSIONS OF WILLIAM SOMMER. Ph.D., Columbia University, 1970.

T590. **Isaac, Oliver P.** ART IN ST. PAUL AS RECORDED IN THE CONTEMPORARY NEWSPAPERS. M.A., University of Minnesota, 1945.

T591. **Ives, Norman S.** LETTERING ON ARCHITECTURE OF THE BROWN DECADES IN THE URBAN EAST. M.A., Yale University, 1952.

T591a. **Jacobs, Stephen William.** ARCHITECTURAL PRE-

SERVATION: AMERICAN DEVELOPMENT AND ANTECEDENTS ABROAD. Ph.D., Princeton University, 1966.

T592. **Jacobsen, Elizabeth L.** A STUDY IN THE NEW ARCHITECTURE ARISEN. M.F.A., University of Iowa, 1950.

T593. **Jadwin, Diane Levine.** PAINTING FROM THE PHOTOGRAPH: A 20TH CENTURY REALISM. M.A., Hunter College of the City University of New York, 1972.

T594. **Jaffe, Irma Blumenthal.** JOSEPH STELLA: AN ANALYSIS AND INTERPRETATION OF HIS ART. Ph.D., Columbia University, 1966.

T595. **Jaffee, Cynthia J.** NAKIAN. M.A., Columbia University, 1967.

T596. **James, Bruce.** DRAWINGS OF JAMES DINE. M.A., Oberlin College, 1969.

T597. **Janson, Ellen Gutsche.** EDWIN AUSTIN ABBEY'S ILLUSTRATIONS TO DICKENS' "CHRISTMAS STORIES," 1875. M.A., Yale University, 1954.

T598. **Janson, Richard H.** TRINITY CHURCH ON THE NEW HAVEN GREEN: A STUDY OF EARLY GOTHIC REVIVAL IN AMERICA. M.A., Yale University, 1952.

T599. **Janson, Richard.** THE RAILROAD PASSENGER TRAIN: ARCHITECTURE, MACHINERY, AND MOTION, 1830–1950. Ph.D., Yale University, 1958.

T600. **Jareckie, Stephen Barlow.** AN ARCHITECTURAL SURVEY OF NEW YORK MILLS FROM 1808 TO 1908. M.A., Syracuse University, 1961.

T601. **Jedlick, William L.** LANDSCAPE WINDOW SHADES OF THE 19TH CENTURY IN NEW YORK STATE AND NEW ENGLAND. M.A., State University of New York, College at Oneonta, 1968.

T602. **Jehn, Dorothy (Fowles.)** THE CLINTON HOUSE: AN HISTORICAL ANALYSIS AND REHABILITATIVE PROPOSAL. M.A., Cornell University, 1964.

T603. **Jensen, Lawrence Neil.** SYNTHETIC MEDIA AND THEIR SIGNIFICANCE IN CONTEMPORARY PAINTING. Ed.D., Columbia University, 1962.

T603a. **Jensen, Robert Earl.** BOARD AND BATTEN IN AMERICA—ITS ORIGINS AND ITS CHARACTER. M.A., Cornell University, 1968.

T603b. **Jerdee, Doris Guy.** THE ICONOGRAPHY OF GRANT WOOD'S AMERICAN GOTHIC. M.A., Arizona State University, 1969.

T604. **Jetton, Betsey M.** EDWARD STEICHEN: THE SEARCH AND DEVELOPMENT OF A PHOTOGRAPHER, 1899–1922. M.F.A., University of Iowa, 1965.

T605. **Johannesen, Eric.** A STUDY OF THE TRENDS IN CHURCH ARCHITECTURE IN DETROIT, 1946–1951. M.A., Wayne University (Wayne State University), 1952.

T606. **Johns, Sara Elizabeth Bennett.** WASHINGTON ALLSTON'S THEORY OF THE IMAGINATION. Ph.D., Emory University, 1974.

T607. **Johnson, Charlotte B.** THE LIFE AND WORK OF ALVAN FISHER. M.A., New York University, 1951.

T608. **Johnson, Diane Chalmers.** WILL H. BRADLEY AND ART NOUVEAU IN AMERICA. Ph.D., University of Kansas, 1970.

T609. **Johnson, Dorothy.** ARTHUR DOVE: THE YEARS OF COLLAGE. M.A., University of Maryland, 1967.

T610. **Johnson, Eugene.** CAMERON BOOTH, PAINTER AND TEACHER. M.F.A., University of Iowa, 1953.

T611. **Johnson, Eunice.** THE ART OF THE NEGRO. M.F.A., University of Iowa, 1953.

T612. **Johnson, Marilynn A.** CLOCKMAKERS AND CABINETMAKERS OF ELIZABETHTOWN, NEW JERSEY, IN THE FEDERAL PERIOD. M.A., University of Delaware, 1963.

T613. **Johnson, Stewart T.** NEW YORK CABINETMAKING PRIOR TO THE REVOLUTION. M.A., University of Delaware, 1964.

T614. **Johnson, Wallace Nils.** PAUL SARKISIAN: A SEARCH FOR A NEW REALISM. M.A., University of Oregon, 1972.

T615. **Johnston, Norman John.** HARLAND BARTHOLOMEW: HIS COMPREHENSIVE PLANS AND SCIENCE OF PLANNING. Ph.D., University of Pennsylvania, 1964.

T615a. **Johnston, Philip M.** A CHECKLIST OF BOOKS RELATING TO ARCHITECTURE AND THE DECORATIVE ARTS AVAILABLE IN PHILADELPHIA IN THE THREE DECADES FOLLOWING 1780. M.A., University of Delaware, 1974.

T616. **Jolson, Betty K.** MORRIS GRAVES. M.A., New York University, 1969.

T617. **Jones, Arthur.** REGIONAL IMPRESSIONISM: THE ART OF PAUL SAWYIER. Ph.D., Case Western Reserve University, 1974.

T618. **Jones, Elizabeth Fitzpatrick.** HENRY WHITESTONE, 19TH CENTURY LOUISVILLE ARCHITECT. M.A., University of Louisville, 1974.

T619. **Jones, George H. G.** THE ITALIAN VILLA STYLE IN AMERICAN ARCHITECTURE, 1840–1865. Ph.D., Harvard University, 1966.

T620. **Jones, Harold Henry.** THE WORK OF THE PHOTOGRAPHERS PAUL STRAND AND EDWARD WESTON WITH AN EMPHASIS ON THEIR WORK IN NEW MEXICO. M.F.A., University of New Mexico, 1972.

T621. **Joyner, Brooks.** ARSHILE GORKY, EARLY DEVELOPMENT. M.A., University of Maryland, 1969.

T622. **Judson, William D., III.** PATRICK HENRY BRUCE, 1881–1936. M.A., Oberlin College, 1968.

T623. **July, Edythe M.** ANDREW JACKSON DOWNING: A GUIDE TO AMERICAN ARCHITECTURAL TASTE. M.A., New York University, 1945.

T624. **Jurgensen, Mary Ann (Keller).** PAPERBOARD FURNITURE: A SURVEY OF THE CURRENT FIELD PLUS ORIGINAL DESIGN. M.A., Cornell University, 1972.

T625. **Kahn, Evelyn S.** EUROPEAN EXPERIENCES OF THE HUDSON RIVER SCHOOL. M.A., Columbia University, 1964.

T626. **Kallman, Helene Barbara.** IRVING GILL: HIS PAST, HIS TIME, THE FUTURE HE HELPED TO SHAPE. M.A., Columbia University, 1964.

T627. **Kane, Patricia E.** THE SEVENTEENTH-CENTURY CASE FURNITURE OF HARTFORD COUNTY, CONNECTICUT, AND ITS MAKERS. M.A., University of Delaware, 1968.

T628. **Kane, William.** EDWIN AUSTIN ABBEY: THE AMERICAN YEARS: 1852-1878. M.A., Yale University, 1959.

T629. **Kantz, Charlotte.** THE PUBLIC ARCHITECTURE OF H. J. HARDENBERGH (1847-1918.) M.A., University of Delaware, 1975.

T630. **Kapetanakos, Stephanie A.** THE ARCHITECTURE OF NEEL REID: A STUDY OF THE RESIDENTIAL ARCHITECTURE OF NEEL REID OF ATLANTA. M.A., University of Georgia, 1971.

T631. **Kalan, Fredda.** THE ARCHITECTURE OF NEW YORK CITY HOTELS FROM 1860-1885. M.A., Pennsylvania State University, 1970.

T632. **Kaplan, Rose.** MARY CASSATT: HER WORK AND PLACE IN THE IMPRESSIONIST MOVEMENT. M.A., University of Chicago, 1945.

T633. **Karl, Adolph Joseph.** THE NEW YORK REALISTS. Ph.D., New York University, 1953.

T634. **Karlowicz, Titus Marion.** THE ARCHITECTURE OF THE WORLD'S COLUMBIAN EXPOSITION. Ph.D., Northwestern University, 1965.

T635. **Karlstrom, Paul.** LOUIS EILSHEMIUS, 1864-1941. Ph.D., University of California, Los Angeles, 1973.

T636. **Kase, Thelma Green.** THE ARTIST, THE PRINTER AND THE PUBLISHER: A STUDY OF PRINTING PARTNERSHIPS, 1960-70. M.A., University of Missouri, 1973.

T637. **Kashdin, Gladys Shafran.** ABSTRACT-EXPRESSIONISM: AN ANALYSIS OF THE MOVEMENT BASED PRIMARILY UPON INTERVIEWS WITH SEVEN PARTICIPATING ARTISTS. Ph.D., Florida State University, 1965.

T638. **Kasson, John Franklin.** CIVILIZING THE MACHINE: TECHNOLOGY, AESTHETICS, AND SOCIETY IN NINETEENTH-CENTURY AMERICAN THOUGHT. Ph.D., Yale University, 1968.

T639. **Kasson, Joy Schlesinger.** MUSES AND GUIDEBOOKS: THE IMPORTANCE OF TRADITION IN AMERICAN LITERATURE AND PAINTING, 1800-1860. Ph.D., Yale University, 1968.

T640. **Katz, Martha B. (Mrs. Katz-Hyman).** J. O. J. FROST, MARBLEHEAD ARTIST. M.A., State University of New York, College at Oneonta, 1972.

T641. **Katz, Ruth Berenson.** JOHN LaFARGE AS PAINTER AND CRITIC. Ph.D., Radcliffe College, 1951.

T642. **Kavanaugh, James V.** THREE AMERICAN OPERA HOUSES: THE BOSTON THEATRE, THE NEW YORK ACADEMY OF MUSIC, THE PHILADELPHIA AMERICAN ACADEMY OF MUSIC. M.A., University of Delaware, 1967.

T643. **Keefe, John W.** THE SETTING OF THE DESIGNS FOR THE PHILADELPHIA CITY HALL AND ITS BUILDING THROUGH THE LAYING OF THE CORNERSTONE, JULY 4, 1874. M.A., Yale University, 1965.

T644. **Keene, Elizabeth K.** DOMESTIC ARCHITECTURE IN MONTGOMERY, ALABAMA, BEFORE 1860. M.F.A., University of Colorado, 1945.

T645. **Keith, Graeme.** SOME RECENT TRENDS IN AMERICAN ART CRITICISM. M.A., Case Western Reserve University, 1935.

T646. **Keller, Isaac Clayton.** THOMAS BUCHANAN READ. Ph.D., University of Pittsburgh, 1932.

T647. **Keller, Mary C.** JOSEPH HENRY SHARP, TAOS COLONY. M.A., Ohio State University, 1934.

T648. **Kellner, Sydney.** THE EARLY HUDSON RIVER SCHOOL AND THE BEGINNING OF LANDSCAPE PAINTING IN AMERICA. M.A., New York University, 1936.

T649. **Kemp, Floyd Ralph.** THE POTTERY OF MICHAEL CARDEW. M.F.A., University of Iowa, 1965.

T650. **Kenefick, Kathryn G.** ART IN INDIAN LIFE OF THE SOUTHWEST. M.A., Northwestern University, 1947.

T651. **Kenny, Sister M. Kilian.** A HISTORY OF PAINTING IN MICHIGAN, 1850 TO WORLD WAR II. Ed.D., Wayne State University, 1965.

T652. **Kent, Frank Ward.** ILLUSTRATION AND ITS FUNCTION AS AN INTEGRAL PART OF SOCIAL CULTURE. M.F.A., SYRACUSE UNIVERSITY, 1938.

T653. **Kerr, Joellen Ayersman.** AMERICAN COTTAGE FURNITURE. M.S., Florida State University, 1969.

T654. **Kerrick, Jane.** WILLIS JEFFERSON POLK, SAN FRANCISCO ARCHITECT. M.A., Mills College, 1965.

T655. **Keyes, Donald.** ASPECTS OF THE DEVELOPMENT OF GENRE PAINTING IN THE HUDSON RIVER AREA BEFORE 1852. Ph.D., New York University, 1973.

T656. **Keyes, Margaret Naumann.** Nineteenth Century Home Architecture of Iowa City. Ph.D., Florida State University, 1965.

T657. **Kienitz, John F.** The Generations of the 1850s, 1860s, and 1870s in the Fine Arts of the United States in Relation to Parallel Phases of American Culture. Ph.D., University of Wisconsin, 1938.

T658. **Kies, Emily Bardack.** The City and the Machine: Urban and Industrial Illustration in America, 1880–1900. Ph.D., Columbia University, 1971.

T659. **Kihlstedt, Folke Tyko.** Formal and Structural Innovations in American Exposition Architecture, 1901–39. Ph.D., Northwestern University, 1973.

T660. **Kimball, Sidney Fiske.** Thomas Jefferson and the First Monument of the Classical Revival in America. Ph.D., University of Michigan, 1915.

T661. **Kindt, Joann.** Compositional Forms in the Landscape Genre and Their Persistence in the Twentieth-Century Abstract Painting, with an Exhibition of Paintings. Ph.D., Ohio State University, 1966.

T662. **King, Dale.** Archaeology of the Highlands of Eastern Colorado. M.A., University of Denver, 1931.

T663. **Kingsbury, Martha.** John Singer Sargent: Aspects of His Work. Ph.D., Harvard University, 1969.

T664. **Kirby, Anne P.** Architectural Beginnings of Industrial Long Island. M.A., New York University, 1945.

T665. **Kirk, John.** The Regional Characteristics of American Chairs. M.A., Yale University, 1963.

T666. **Kitchen, Elizabeth F.** The Influence of Syndicate Art on Government Subsidized Murals in the U.S. M.A., Yale University, 1948.

T667. **Klare, Michael T.** The Life and Architecture of Peter Bonnett Wight. M.A., Columbia University, 1968.

T668. **Klein, Michael E.** John Covert. M.A., Columbia University, 1965.

T668a. **Klein, Michael E.** The Work of John Covert. Ph.D., Columbia University, 1971.

T669. **Klinsky, Marianne T.** Extant Folk Art and Crafts of Czechoslovakia in Selected Iowa Cities. M.A., University of Iowa, 1969.

T670. **Koch, Robert.** The Poster in the Development of the Modern Movement (1880–1900). M.A., New York University, 1953.

T671. **Koch, Robert.** The Stained Glass Decades: A Study of Louis Comfort Tiffany (1848–1933) and the Art Nouveau in America. Ph.D., Yale University, 1957.

T672. **Koeper, Howard Frederick.** The Gothic Skyscraper: A History of the Woolworth Building and Its Antecedents. Ph.D., Harvard University, 1969.

T673. **Kofford, Ruth B.** Fifteen Contemporary Designers of Jewelry and Hollow Ware, U.S.A. M.A., Texas State College for Women (Texas Woman's University), 1952.

T674. **Korber, Louise A.** Studies in Drawing Using the Works of Thomas Eakins, John Sloan, Charles Sheeler, and Goerge Grosz. M.A., University of Delaware, 1962.

T675. **Kotynek, Roy Anthony.** 291: Alfred Stieglitz and the Introduction of Modern Art to America. Ph.D., Northwestern University, 1970.

T676. **Kouwenhoven, John A.** Made in America: The Arts in Modern Civilization. Ph.D., Columbia University, 1949.

T677. **Kowsky, Francis R.** Frederick Clarke Withers, 1828–1901. Ph.D., Johns Hopkins University, 1972.

T678. **Kramer, Ellen W.** The Domestic Architecture of Detlef Lienau, A Conservative Victorian. Ph.D., New York University, 1958.

T679. **Kramer, Gerald.** Max Weber's "Flute Soloist." M.F.A., University of Iowa, 1965.

T680. **Krauss, Rosalind Epstein.** The Sculpture of David Smith. Ph.D., Harvard University, 1969.

T681. **Krill, John William.** New York Salons of Modern Art in the Early Decades of the Twentieth Century. M.A., Pennsylvania State University, 1967.

T682. **Krumm, Frances.** Art Decoration in the Ohio State Museum. M.A., Ohio State University, 1933.

T683. **Kubler, George A.** The Religious Architecture of New Mexico. M.A., Yale University, 1936.

T684. **Kuharic, Martina.** Influences of Marcel Duchamp on Robert Morris. M.A., University of British Columbia, 1974.

T685. **Kulasiewicz, Frank Louis.** Offhand Blown Glass as a Contemporary Craft. Ed.D., Columbia University, 1970.

T686. **Kuspit, Donald B.** Philip Evergood's Social Realism. M.A., Pennsylvania State University, 1964.

T687. **Kvaalen, Arne K.** Abstract Expressionism and the Christian Consciousness. M.F.A., University of Iowa, 1965.

T688. **Kwiat, Alice B.** Frank Lloyd Wright in Buffalo and Rochester, New York. M.A., University of Rochester, 1964.

T689. **Kwiat, Joseph J.** THE REVOLT IN AMERICAN PAINTING AND LITERATURE, 1890–1915: A STUDY IN CULTURAL AND INTELLECTUAL ORIGINS AND INTER-RELATIONSHIPS. Ph.D., University of Minnesota, 1951.

T690. **Labiosa, Mary Ellen.** A STUDY OF THE RELATIONSHIP BETWEEN JACKSON POLLOCK'S DRAWINGS AND HIS PAINTINGS. M.A., Pennsylvania State University, 1963.

T691. **LaBudde, Kenneth James.** THE MIND OF THOMAS COLE. Ph.D., University of Minnesota, 1954.

T692. **Laffargo, Cosette L.** THOMAS WATERMAN WOOD: AMERICAN ARTIST OF THE NINETEENTH CENTURY. M.A., University of Chicago, 1947.

T693. **LaFond, Edward F.** THE HENRY FRANCIS DU PONT WINTERTHUR MUSEUM COLLECTION OF AMERICAN CLOCKS: A CATALOGUE. M.A., University of Delaware, 1965.

T694. **Lahuis, Sylvia.** RALPH EARL AND THE 18TH CENTURY NEW ENGLAND LANDSCAPE. M.A., Oberlin College, 1971.

T695. **Lamb, Robert J.** STUART DAVIS: DEFENDER OF ABSTRACT ART. M.A., University of Missouri, 1972.

T696. **Lancaster, Clay.** THE WORK OF JOHN MCMURTRY. M.A., University of Kentucky, 1939.

T696a. **Landau, Ellen.** AN INVESTIGATION OF THE FRENCH SOURCES FOR HANS HOFMANN'S COLOR THEORIES. M.A., George Washington University, 1974.

T697. **Landy, Jacob.** THE ARCHITECTURE OF MINARD LAFEVER IN RELATION TO THE NEW YORK SCENE FROM 1825 TO 1855. Ph.D., New York University, 1963.

T698. **Langer, Sandra L.** A CRITICAL ANALYSIS OF AMERICAN EAST COAST LANDSCAPES FROM 1817 TO 1860. Ph.D., New York University, 1974.

T699. **Langhorne, Elizabeth.** THE IMAGES OF JACKSON POLLOCK THROUGH 1941. M.A., University of Pennsylvania, 1971.

T700. **Langley, Ray E.** INFLUENCES UPON THE INFORMAL WRITING OF CONTEMPORARY AMERICAN CALLIGRAPHERS. M.F.A., University of Iowa, 1955.

T701. **Langsam, Walter.** THE NEW YORK STATE CAPITOL AT ALBANY: EVOLUTION OF THE DESIGN, 1866–1876. M.A., Yale University, 1968.

T702. **Lanmon, Dwight P.** GLASS IN BALTIMORE: THE TRADE IN HOLLOW AND TABLEWARES, 1780–1820. M.A., University of Delaware, 1968.

T703. **Lasley, James K.** EXTERIOR-INTERIOR TRANSITIONS IN THE FRANK LLOYD WRIGHT HOUSE. M.A., University of Iowa, 1966.

T704. **Law, Hazel J.** CHICAGO ARCHITECTURAL SCULPTURE. M.A., University of Chicago, 1935.

T705. **Lawall, David Barnard.** ASHER B. DURAND: HIS ART AND ART THEORY IN RELATION TO HIS TIMES. Ph.D., Princeton University, 1966.

T706. **Lawder, Standish D.** STRUCTURALISM AND MOVEMENT IN EXPERIMENTAL FILM AND MODERN ART, 1896–1925. Ph.D., Yale University, 1967.

T707. **Leavens, Ileana.** ALFRED STIEGLITZ AND "291." INTRODUCTION OF MODERN ART INTO AMERICA. M.A., University of Washington, 1972.

T708. **Leavitt, Thomas W.** THE LIFE, WORK AND SIGNIFICANCE OF GEORGE LORING BROWN, AMERICAN LANDSCAPE PAINTER. Ph.D., Harvard University, 1958.

T709. **Lee, Mrs. Ruth (Hudson).** A BRIEF HISTORY OF THE DEVELOPMENT OF WATERCOLOR PAINTING WITH SPECIAL EMPHASIS UPON ITS IMPORTANCE AS A VALUABLE CONTRIBUTION TO AMERICAN ART. M.A., Syracuse University, 1933.

T710. **Lee, Sherman E.** A CRITICAL SURVEY OF AMERICAN WATERCOLOR. Ph.D., Case Western Reserve University, 1941.

T711. **Leek, Marion L.** METHODS AND MATERIALS IN MODERN SCULPTURE. M.A., New York University, 1940.

T712. **Lehman, Arnold Lester.** THE NEW YORK SKYSCRAPER: A HISTORY OF ITS DEVELOPMENT, 1870–1939. Ph.D., Yale University, 1974.

T713. **Leibundguth, Arthur W.** THE FURNITURE-MAKING CRAFTS IN PHILADELPHIA, C. 1730–1760. M.A., University of Delaware, 1964.

T714. **LeMelle, Margaret Guillion.** AFRO-AMERICAN ART AS A SOCIALIZING AGENT. M.A., University of Colorado, 1971.

T715. **Lenfest, Marie.** JOSEPH STELLA—IMMIGRANT FUTURIST. M.A., Columbia University, 1959.

T716. **Leonard, Herbert S.** THE HISTORY OF ARCHITECTURE IN CHICAGO. M.A., University of Chicago, 1934.

T717. **Lerski, Hanna.** THE BRITISH ANTECEDENTS OF THOMAS JEFFERSON'S ARCHITECTURE. Ph.D., Johns Hopkins University, 1957.

T718. **Lerud, Ruth Eleanor.** A BRIEF STUDY OF THE BAUHAUS, SOME OF THE CONDITIONS THAT BROUGHT IT ABOUT AND SOME OF ITS EFFECTS ON DESIGN IN AMERICA. M.S., University of Tennessee, 1965.

T719. **Levin, Ellen D. (Mrs. C. Widlitz).** A HISTORY OF THE ILLUSTRATION OF AMERICAN CHILDREN'S BOOKS. M.A., Oberlin College, 1948.

T720. **Levine, Neil.** THE IDEA OF FRANK FURNESS' BUILDINGS. M.A., Yale University, 1967.

T721. **Levitt, Marilyn M.** THE FEDERAL ART PROJECTS: A STUDY IN DEMOCRATIC PATRONAGE. M.A., Syracuse University, 1950.

T722. **Lewis, Donald Sykes, Jr.** HERMAN HERZOG. M.A., University of Virginia, 1974.

T723. **Lewis, Dudley Arnold.** EVALUATIONS OF AMERICAN ARCHITECTURE BY EUROPEAN CRITICS, 1875–1900. Ph.D., University of Wisconsin, 1962.

T724. **Lewis, Stanley T.** THE NEW YORK THEATRE: ITS BACKGROUND AND ARCHITECTURAL DEVELOPMENT, 1750–1853. Ph.D., Ohio State University, 1953.

T725. **Ligo, Larry L.** THE CRITICISM OF TWENTIETH-CENTURY ARCHITECTURE WITH SUGGESTIONS TOWARDS A REORIENTATION OF CRITICAL METHODOLOGY. Ph.D., University of North Carolina at Chapel Hill, 1973.

T726. **Likes, Philip H.** FRANK H. SWEET: A STUDY IN NAIVETÉ. M.A., State University of New York, College at Oneonta, 1972.

T727. **Lincoln, Louise Hassett.** WALTER ARENSBERG AND HIS CIRCLE; NEW YORK: 1913–1920. M.A., University of Delaware, 1972.

T728. **Lindquist-Cock, Elizabeth.** THE INFLUENCE OF PHOTOGRAPHY ON AMERICAN LANDSCAPE PAINTING, 1839–1880. Ph.D., New York University, 1967.

T729. **Lindsay, G. Carroll.** ATHENS ON HIGH STREET: THE ARCHITECTURAL WORKS OF THOMAS U. WALTER IN WEST CHESTER, PENNSYLVANIA. M.A., University of Delaware, 1955.

T730. **Lindsley, Carol Ann.** HANS HOFMANN'S COLORS THEORY. M.A., University of California, Berkeley, 1966.

T731. **Lindstorm, Eleanor Inca.** "SATURDAY NIGHT IN TOWN," A STUDY OF HUMANISM IN AMERICAN PAINTING. M.F.A., University of Colorado, 1945.

T732. **Lineberger, James W.** SAMUEL ADLER: CATALOG FOR A RETROSPECTIVE EXHIBITION. M.A., University of Georgia, 1970.

T733. **Lingen, Sister Ramone Mary, B.V.M.** THE PLACE OF DEMUTH AND SHEELER IN TWENTIETH-CENTURY AMERICAN ART. M.A., University of Colorado, 1970.

T734. **Lipke, Catherine Hall.** THE STAINED GLASS WINDOWS OF MORRIS AND CO. IN THE UNITED STATES OF AMERICA. M.A., State University of New York, College at Binghamton, 1973.

T735. **Lipscomb, Mary Elizabeth.** THE ARCHITECTURE OF HARVEY ELLIS IN ROCHESTER, NEW YORK. M.A., University of Rochester, 1969.

T736. **Lisle, Forest Fletcher, Jr.** THE CENTURY OF PROGRESS EXPOSITION: 1933, CHICAGO'S ARCHITECTURE OF AMERICAN DEMOCRACY. M.A., Cornell University, 1970.

T737. **Liu, Tien-feng.** WRIGHT'S UNACKNOWLEDGED DEBT TO JAPAN. M.A., Columbia University, 1952.

T738. **Lockhart, David L.** JESSE HOWARD. M.F.A., University of Iowa, 1969.

T739. **Lockhart, Wood Alexander.** AIRPORT DEVELOPMENT AND DESIGN, A NEW ARCHITECTURAL PROBLEM. Ph.D., Northwestern University, 1972.

T740. **Loevy, Barbette.** THE REGIONAL MOVEMENT IN AMERICAN ART. M.A., Northwestern University, 1971.

T741. **Loft, Deborah.** COPLEY'S SEATED PORTRAITS AND THEIR PROTOTYPES. M.A., University of Pennsylvania, 1969.

T742. **Loftus, John.** ARSHILE GORKY, A MONOGRAPH. M.A., Columbia University, 1956.

T743. **Lombardo, Josef V.** CHAIM GROSS, SCULPTOR. Ph.D., Columbia University, 1951.

T744. **Long, Dorothy.** A COMPARISON OF THE ART AND DESIGN OF THE BASKETRY AND COSTUMES OF THE NEZ PERCE INDIANS WITH THAT OF THE NORTHWEST COAST INDIANS. M.A., University of Idaho, 1953.

T745. **Long, Kathryn.** THE EFFECTS OF BLACK MOUNTAIN COLLEGE ON CONCEPTS OF ART IN THE UNITED STATES. M.A., University of Georgia, 1973.

T746. **Loomis, Helen M.** AMERICAN CHURCH ARCHITECTURE AS INDICATIVE OF THE GROWTH OF THE CONCEPT OF RELIGIOUS EDUCATION. M.A., Boston University, 1927.

T747. **Lorenz, Melinda.** AUGUSTUS VINCENT TACK. M.A., University of Maryland, 1970.

T748. **Lotte, Clarissa.** THE EVOLUTION OF SKYSCRAPER DESIGN. M.A., Columbia University, 1936.

T749. **Love, Joseph P., S.J.** AN ANALYSIS OF THE ART THEORY OF HANS HOFMANN. M.A., Columbia University, 1967.

T750. **Love, Paul.** PATTERNED BRICKWORK IN THE AMERICAN COLONIES. Ph.D., Columbia University, 1950.

T751. **Love, Paul V.** SALEM TENTH: THE ORIGINS AND DEVELOPMENT OF ITS PATTERNED BRICKWORK (1690–1765). M.A., Columbia University, 1940.

T752. **Love, Richard H.** AMERICAN LIGHT. M.A., Northwestern University, 1970.

T753. **Lovell, Margaretta.** BOSTON BLOCKFRONT FURNITURE. M.A., University of Delaware, 1975.

T754. **Lovette, Dallas.** DEVELOPMENT OF TECHNIQUE IN AMERICAN WOODCARVING. M.A., Colorado State College of Education (University of Northern Colorado), 1940.

T755. **Ludwig, Allan I.** CARVED STONE MARKERS IN NEW ENGLAND. Ph.D., Yale University, 1964.

T756. **Ludwig, Coy Lee.** MAXFIELD PARRISH: HIS LIFE AND WORK. Ph.D., Syracuse University, 1973.

T757. **Luporini, Nadine C.** LANSDOWNE: A CULTURAL DOCUMENT OF ITS TIME. M.A., University of Delaware, 1967.

T758. **Lutzker, Marilyn L.** ATTITUDES TOWARDS ART IN AMERICA, 1835–1855: A STUDY OF ART THEORY, CRITICISM AND PATRONAGE. M.A., New York University, 1956.

T759. **Lycette, Diana.** JOHN R. COVERT, AMERICAN DADAIST. M.A., University of Washington, 1972.

T760. **Lynch, Lawrence V.** A STUDY OF THE EVOLUTION OF THE WORK OF CHARLES RAIN. M.A., Arizona State University, 1967.

T761. **Lynn, Catherine M.** SHIRLEY PLANTATION, A HISTORY. M.A., University of Delaware, 1967.

T762. **Lyons, Elizabeth.** THE IMPACT OF JAPANESE ART ON AMERICAN ART AND CULTURE IN THE GILDED AGE. M.A., Wayne State University, 1975.

T763. **MacDonald, Eleanor Kay Bruhn.** SANTOS: THE RELIGIOUS FOLK ART OF THE NEW MEXICO AND OF THE SANTA CRUZ VALLEY SANTEROS. M.A., University of Utah, 1970.

T764. **MacKenzie, Donald Ralph.** PAINTERS IN OHIO, 1788–1860, WITH A BIOGRAPHICAL INDEX. Ph.D., Ohio State University, 1960.

T765. **McBeath, Stuart H.** WISCONSIN CERAMICS. M.A., University of Wisconsin, 1939.

T765a. **McCabe, Ethel C.** THE DECORATIVE ARTS OF THE AMERICAN FEDERAL PERIOD, 1790–1825. M.A., Western Reserve University (Case Western Reserve University), 1933.

T766. **McCall, Jane F.** SOME EARLY FORT TYPES IN THE NORTHWEST TERRITORY (1679–1832). M.A., University of Illinois, 1949.

T767. **McClanahan, John D.** JOHN MARIN: HIS TAOS YEARS, 1929–1930. M.F.A., University of Iowa, 1964.

T768. **McClure, Jean B.** THE AMERICAN-CHINA TRADE IN CHINESE EXPORT PORCELAIN, 1785–1835. M.A., University of Delaware, 1957.

T769. **McCormick, Gene E.** FITZ HUGH LANE, GLOUCESTER ARTIST, 1804–1865. M.A., Yale University, 1951.

T770. **McCormick, Thomas Julian.** A STUDY OF CHURCH ARCHITECTURE IN SYRACUSE, NEW YORK, BASED ON BUILDINGS NO LONGER STANDING. M.A., Syracuse University, 1949.

T771. **McCready, Eric Scott.** THE ARCHITECTURE OF RICHARD TALIAFERRO. M.A., University of Oregon, 1968.

T772. **McCready, Eric Scott.** THE NEBRASKA STATE CAPITOL: ITS DESIGN, BACKGROUND AND INFLUENCE. Ph.D., University of Delaware, 1973.

T773. **McCulley, Lou Ann.** A SURVEY OF THE CRAFTS AND CRAFTSMEN OF TEN UPPER EAST TENNESSEE COUNTIES. M.S., University of Tennessee, 1968.

T774. **McCulloch, William Wrenshall, Jr.** OBSERVATION ON "AMERICAN SCULPTURE, 1951," THE METROPOLITAN MUSEUM OF ART, NEW YORK. M.A., Ohio State University, 1952.

T775. **McCulloch, William Wrenshall, Jr.** THOMAS EAKINS AND AMERICAN ART INSTRUCTION IN THE LATER NINETEENTH CENTURY. M.A., University of North Carolina, 1968.

T776. **McDonald, James E.** PUVIS DE CHAVANNES: HIS BOSTON MURALS. M.A., Catholic University of America, 1930.

T777. **McDonough, James Vernon.** WILLIAM JAY—REGENCY ARCHITECT IN GEORGIA AND SOUTH CAROLINA. Ph.D., Princeton University, 1950.

T778. **McDowell, Betty.** SYMBOLS AND SPACES OF MORRIS GRAVES. M.A., Wayne State University, 1972.

T779. **McElroy, Cathryn J.** FURNITURE OF THE PHILADELPHIA AREA: FORMS AND CRAFTSMEN BEFORE 1730. M.A., University of Delaware, 1970.

T780. **McElroy, Guy.** ROBERT DUNCANSON: A PROBLEM IN ROMANTIC REALISM IN AMERICAN ART. M.A., University of Cincinnati, 1973.

T781. **McGeady, Theresa.** MAJOR CRITERIA FOR CONTEMPORARY LITURGICAL ART. Ph.D., Ohio University, 1970.

T782. **McGehee, Mildred B.** LEVI WEEKS, EARLY NINETEENTH-CENTURY ARCHITECT. M.A., University of Delaware, 1975.

T783. **McGehee, Virginia (Elias).** MARIE HULL'S SEARCH FOR QUALITY. M.A., University of Mississippi, 1973.

T784. **McGinniss, John Dee.** JOHN SINGER SARGENT AND THE IRONIC TRADITION. Ph.D., Florida State University, 1968.

T785. **McGlinchee, Claire.** THE FIRST DECADE OF THE BOSTON MUSEUM. Ph.D., Columbia University, 1940.

T786. **McGrath, Grace E.** AN ARTISTIC ACHIEVEMENT OF EARLY AMERICAN CRAFTSMEN IN THE FIELDS OF DECORATIVE NEEDLEWORK, WEAVING, METAL WORK AND THE MANUFACTURE OF CLOCKS, GLASSWARE AND PEWTER. M.A., Ohio State University, 1936.

T787. **McKaig, Murray Peterson.** A SURVEY OF AMERICAN ILLUSTRATION. M.F.A., Syracuse University, 1949.

T788. **McKenna, George.** HORATIO GREENOUGH'S "WASHINGTON," A STUDY IN GREENOUGH'S THEORY

AND PRACTICE. M.A., Wayne University (Wayne State University), 1951.

T789. **McKenzie, Howard W.** A STUDY OF FOUR PRINT-MAKERS. M.A., University of Iowa, 1972.

T790. **McLanathan, Richard B. K.** CHARLES BULFINCH AND THE MAINE STATE HOUSE: A STUDY IN THE DEVELOPMENT OF AMERICAN ARCHITECTURE. Ph.D., Harvard University, 1951.

T791. **McNabb, William Ross.** ANOTHER LOOK AT WILLIAM STRICKLAND. M.A., Vanderbilt University, 1971.

T792. **McReynolds, William Irvin.** WALT DISNEY IN THE AMERICAN GRAIN. Ph.D., University of Minnesota, 1971.

T793. **McSwigan, K. L.** MODERN ARCHITECTURAL SCULPTURE IN AMERICA. M.A., University of Pittsburgh, 1936.

T794. **Mabee, Carleton.** THE AMERICAN LEONARDO: A LIFE OF SAMUEL F. B. MORSE. Ph.D., Columbia University, 1943.

T795. **Makler, Anita C.** THE VISUAL TRADITION IN THE ANALYSIS OF URBAN FORMS. M.A., Columbia University, 1966.

T796. **Mallach, Stanley I.** GOTHIC FURNITURE DESIGNS BY ALEXANDER JACKSON DAVIS. M.A., University of Delaware, 1966.

T797. **Mancini, Matthew J.** THE COVERT THEMES OF AMERICAN ANARCHISM, 1881–1908: TIME, SPACE AND CONSCIOUSNESS AS ANARCHIST MYTH. Ph.D., Emory University, 1974.

T798. **Mandel, Patricia.** HOMER DODGE MARTIN, AMERICAN LANDSCAPE PAINTER, 1836–1897. Ph.D., New York University, 1973.

T799. **Mann, Walter.** SOME EUROPEAN ROMANTIC INFLUENCES ON THOMAS COLE. M.A., Columbia University, 1951.

T800. **Manning, Eileen.** ARCHITECTURAL DESIGNS OF HARVEY ELLIS. M.A., University of Minnesota, 1953.

T801. **Manning, Margaret.** EDWARD HICKS, A PENNSYLVANIA FOLK PAINTER. M.A., Pennsylvania State University, 1938.

T802. **Manson, Grant Carpenter.** THE WORK OF FRANK LLOYD WRIGHT BEFORE 1910. Ph.D., Harvard University, 1941.

T803. **Mantle, Eric.** POP ART, AN ANALYSIS. M.F.A., Ohio University, 1968.

T804. **Mareska, Sharon L.** AN INVESTIGATION OF SOME OF THE FACTORS INFLUENCING THE EDUCATION OF AMERICAN ARTISTS BEFORE 1825. M.A., University of Iowa, 1972.

T805. **Marling, Karal Ann Rose.** FEDERAL PATRONAGE AND THE WOODSTOCK COLONY. Ph.D., Bryn Mawr College, 1971.

T806. **Marlow, Peter O.** WILLIAM MORRIS HUNT, HIS RELATIONSHIP TO THE BARBIZON SCHOOL. M.A., New York University, 1965.

T807. **Marter, Joan M.** ALEXANDER CALDER: THE FORMATIVE YEARS. Ph.D., University of Delaware, 1974.

T808. **Martin, Esther Johnson.** A CRITICAL ANALYSIS OF CONTEMPORARY AMERICAN PAINTING. M.A., State University of Iowa (University of Iowa), 1941.

T809. **Martin, Francis.** EDWARD WINDSOR KEMBLE: 1861–1933, AMERICAN ILLUSTRATOR. M.A., University of California, Los Angeles, 1974.

T810. **Martin, Marianne W.** ON THE ORIGIN AND DEVELOPMENT OF THE SIDE-HOUSE. M.A., Bryn Mawr College, 1951.

T811. **Martin, Shirley A.** CRAFTSMEN OF BUCKS COUNTY, PENNSYLVANIA, 1750–1800. M.A., University of Delaware, 1956.

T812. **Maruoka, Susanne K.** THE ARCHITECTURE OF ANDREW JACKSON WARNER IN ROCHESTER, NEW YORK. M.A., University of Rochester, 1965.

T813. **Marzio, Peter C.** THE EDUCATION OF THE ARTIST IN THE U.S. IN THE EARLY 19TH CENTURY. Ph.D., University of Chicago, 1969.

T814. **Mascaro, Jill Leslie McKeever.** A TRINITARIAN VERNICLE: A STUDY IN NEW MEXICAN ICONOGRAPHY. M.A., University of Colorado, 1971.

T815. **Mast, Alan Fredric.** AMERICAN ARCHITECTURE AND THE ACADEMIC REFORM, 1876–1893. M.A., University of Chicago, 1961.

T816. **Matson, Mary A.** A STUDY OF THE TECHNIQUES AND DEVELOPMENT OF CONTEMPORARY MOSAICS. M.F.A., University of Iowa, 1957.

T817. **Matthews, Eugene E.** CONTEMPORARY PAINTING AND VISUAL EXPERIENCE. M.F.A., University of Iowa, 1957.

T818. **Mattil, Edward L.** A BIBLIOGRAPHY OF ART IN PENNSYLVANIA. M.A., University of Pittsburgh, 1946.

T819. **Mattson, Julia.** SURVEY OF INDIAN POTTERY, ARTS AND CRAFTS WEST OF THE MISSISSIPPI RIVER. M.A., University of North Dakota, 1951.

T820. **Matzkin, Ruth.** INVENTORIES OF ESTATES IN PHILADELPHIA COUNTY, 1682–1710. M.A., University of Delaware, 1959.

T821. **Maurstad, Betty Louise.** A CATALOGUE OF PRINTS BY GEORGE EARL RESLER (1882–1954), ST. PAUL, MINN., ARTIST. M.A., University of Minnesota, 1969.

T822. **Mayer, Margery Moodey.** DOMESTIC ARCHITECTURE OF THE "REIGN OF TERROR" IN THE UNITED STATES. M.A., Oberlin College, 1938.

T823. **Maythem, Thomas.** SEVENTEENTH-CENTURY ARCHITECTURAL STYLE IN MILFORD, CONNECTICUT. M.A., Yale University, 1957.

T824. **Means, Mary Elizabeth.** EARLY AMERICAN TRADE CARDS. M.A., University of Delaware, 1958.

T825. **Medeiros, Walter Patrick.** SAN FRANCISCO ROCK CONCERT POSTERS: IMAGERY AND MEANING. M.A., University of California, Berkeley, 1972.

T826. **Meeks, Carroll L. V.** ARCHITECTURAL CRITICISM IN AMERICA, 1863-1929. M.A., Yale University, 1934.

T827. **Meeks, Carroll L. V.** THE ARCHITECTURAL DEVELOPMENT OF THE AMERICAN RAILROAD STATION. Ph.D., Harvard University, 1948.

T828. **Meeks, Oliver G.** THE FEDERAL ART PROGRAM IN OKLAHOMA (1934-1940). M.A., University of Oklahoma, 1941.

T829. **Mehrer, Jeannette S.** AMERICAN INTAGLIO PRINTS OF THE 1950'S. M.A., University of Iowa, 1967.

T830. **Meilach, Dona Z.** HANS HOFMANN: HIS INFLUENCE AND REPUTATION. M.A., Northwestern University, 1969.

T831. **Meisel, Jacqueline C.** ARCHITECTURAL SURVEY OF REPRESENTATIVE DOMESTIC STRUCTURES PREDATING 1810 IN GLOUCESTER COUNTY, NEW JERSEY. M.S., Drexel University, 1963.

T832. **Meisel, Jacqueline C.** OLD COLLEGE, THE FIRST BUILDING AT THE UNIVERSITY OF DELAWARE, ITS ORIGINS AND DEVELOPMENT. M.A., University of Delaware, 1971.

T833. **Melby, Danelle F. Jentges.** TEACHING THEORIES AND METHODS OF ROBERT HENRI, AN INFLUENTIAL AMERICAN ART EDUCATOR. M.A., Iowa State University, 1972.

T834. **Melnick, Denise Catherine.** ART AT THE "MEXICAN FRONT": ROBERT HENRI, GEORGE WESLEY BELLOWS AND LEON KROLL IN NEW MEXICO, 1916-1922. M.A., University of New Mexico, 1970.

T835. **Meloy, Margaret Mary.** CHARLES SHEELER: CUBIST-REALISM AND PHOTOGRAPHY. M.A., Northwestern University, 1972.

T836. **Menges, C. C.** SOME TRENDS IN INDUSTRIAL DESIGN, 1890-1940. M.A., Ohio State University, 1940.

T837. **Menocal, Narisco G.** LOUIS SULLIVAN: A REEVALUATION OF HIS ARCHITECTURAL THOUGHT. Ph.D., University of Illinois, 1974.

T838. **Merrill, David Oliver.** RICHARD MONDAY OF NEWPORT. M.A., Yale University, 1960.

T839. **Merrill, David Oliver.** ISAAC DAMON AND THE ARCHITECTURE OF THE FEDERAL PERIOD IN NEW ENGLAND. Ph.D., Yale University, 1974.

T840. **Merrill, Leslie Olmstead, Jr.** FURNITURE U.S.A.: 1939-1949. M.F.A., University of Colorado, 1949.

T841. **Metzler, Paul B.** THE SCULPTURE OF HIRAM POWERS. M.A., Ohio State University, 1939.

T842. **Mew, Thomas Joseph, III.** THE LATE PAINTINGS OF ARSHILE GORKY: THE INTEGRATION OF IDEAS EMPLOYED BY ARSHILE GORKY IN HIS PAINTINGS FROM 1942-1948 AND THE EXTENSION OF HIS APPROACH AS REVEALED IN A CONTEMPORARY SERIES OF PAINTINGS BY THE INVESTIGATOR. Ph.D., New York University, 1966.

T843. **Mey, Kenneth R.** CHICAGO PAINTERS AND THE MODERNIST MOVEMENT, 1909-1928. Ph.D., Emory University, 1973.

T844. **Meyer, Jerry.** THE RELIGIOUS PAINTINGS OF BENJAMIN WEST: A STUDY IN LATE EIGHTEENTH- AND EARLY NINETEENTH-CENTURY MORAL SENTIMENT. Ph.D., New York University, 1973.

T845. **Meyers, Jordan G.** A HISTORICAL STUDY OF THE ARMORY SHOW OF 1913 AS A FACTOR IN THE DEVELOPMENT OF AMERICAN ART. M.A., University of New Mexico, 1952.

T846. **Michel, Delbert Lee.** JACK LEVINE'S "GANGSTER FUNERAL." M.F.A., University of Iowa, 1964.

T847. **Michel, Viola C.** STAMPED BOOK COVER DESIGNS OF THE EARLY NINETEENTH CENTURY. M.A., Northwestern University, 1949.

T848. **Michels, Eileen M.** A DEVELOPMENTAL STUDY OF THE DRAWINGS PUBLISHED IN "AMERICAN ARCHITECT" AND IN "INLAND ARCHITECT" THROUGH 1895. Ph.D., University of Minnesota, 1971.

T849. **Milgrome, David.** THE ART OF WILLIAM MERRITT CHASE. Ph.D., University of Pittsburgh, 1969.

T850. **Miller, Dorothy.** THE LIFE AND WORK OF DAVID G. BLYTHE. Ph.D., University of Pittsburgh, 1946.

T851. **Miller, Harlow G.** ARTHUR G. DOVE, 1880-1946. M.F.A., University of Iowa, 1957.

T852. **Miller, J. Jefferson.** BALTIMORE'S WASHINGTON MONUMENT. M.A., University of Delaware, 1962.

T853. **Miller, Marion Graffan.** AN ACCOUNT OF THE DEVELOPMENT OF THE CREATIVE PROJECT OF THE REREDOS DECORATION IN ST. ANDREW'S EPISCOPAL CHURCH, EL PASO, ILLINOIS. Ph.D., Ohio State University, 1948.

T854. **Miller, R. Craig.** THE DOMESTIC ARCHITECTURE OF WILLIAM HALSEY WOOD. M.A., University of Delaware, 1972.

T855. **Milley, John.** JACOB EICHHOLTZ, 1776–1842: PENNSYLVANIA PORTRAITIST. M.A., University of Delaware, 1960.

T856. **Milligan, Carolyn F.** THE NAKED AND THE NUDE IN AMERICAN PAINTING SINCE 1960. M.F.A., Ohio University, 1967.

T857. **Milligan, Jean E.** A SURVEY OF RELIGIOUS PAINTING IN AMERICA. M.A., Oberlin College, 1946.

T858. **Mills, Laurence F.** PRE-COLUMBIAN SCULPTURE OF THE SOUTHEASTERN UNITED STATES. Ph.D., University of Iowa, 1963.

T859. **Mills, Mary A.** THE FLATIRON BUILDING IN NEW YORK CITY: AN ANALYSIS OF ITS PLACE IN THE WORK OF D. H. BURNHAM AND CO. AND IN THE ARCHITECTURAL ENVIRONMENT OF NEW YORK CITY IN 1902. M.A., New York University, 1958.

T860. **Mills, Paul Chadbourne.** DAVID PARK AND THE NEW FIGURATIVE PAINTINGS. M.A., University of California, Berkeley, 1962.

T861. **Miner, Frances Ann.** LANDSCAPE IN EIGHTEENTH-CENTURY AMERICA AND ITS EUROPEAN SOURCES. M.A., University of Delaware, 1969.

T862. **Minutillo, Richard G.** ORGANIC FORM AND THE SHAPES AND OUTLINES IN THE PAINTINGS OF ARSHILE GORKY. M.A., University of California, Santa Barbara, 1969.

T863. **Misner, Willie J.** AN EVALUATION OF ART ACTIVITY IN OKLAHOMA DURING THE FIRST THIRTY YEARS OF STATEHOOD. M.A., University of Oklahoma, 1940.

T864. **Mitchell, James R.** MARKED AMERICAN ANDIRONS MADE BEFORE 1840. M.A., University of Delaware, 1965.

T865. **Mitchell, Joan E.** WHISTLER'S EARLY ETCHING: THE FRENCH AND THAMES SETS. M.A., University of Iowa, 1967.

T866. **Moak, Peter.** CUBISM AND THE NEW WORLD: INFLUENCE OF CUBISM ON AMERICAN PAINTING, 1910–1920. Ph.D., University of Pennsylvania, 1970.

T867. **Moffatt, Frederick Campbell.** THE MAINE SCENE: JOHN MARIN AND MARSDEN HARTLEY. M.A., Arizona State University, 1967.

T868. **Monroe, Gerald.** THE ARTISTS UNION OF NEW YORK. Ed.D., New York University, 1971.

T869. **Moone, Charles Leslie.** ONTOLOGICAL ASPECTS OF CONTEMPORARY ART: THE DEVELOPMENT OF AN EXISTENTIAL THEORY OF ART. M.A., Ohio State University, 1962.

T870. **Moore, Charles Williard.** WATER AND ARCHITECTURE. Ph.D., Princeton University, 1958.

T871. **Moore, James C.** THE STORM AND THE HARVEST: LANDSCAPE PAINTING IN MID-NINETEENTH-CENTURY AMERICA. Ph.D., Indiana University, 1974.

T872. **Moore, John Clayton.** AN INVESTIGATION OF SELECTED AMERICAN-NEGRO PHILOSOPHIES OF ART: A BASIS FOR FORMULATING NEGRO LITERARY AESTHETIC THOUGHT WITHIN THE AMERICAN AESTHETIC SYNDROME. Ph.D., Syracuse University, 1970.

T873. **Mooz, Ralph P.** THE ART AND LIFE OF ROBERT FEKE. Ph.D., University of Pennsylvania, 1970.

T874. **Morgan, Ann Lee.** TOWARD THE DEFINITION OF EARLY MODERNISM IN AMERICA: A STUDY OF ARTHUR DOVE. Ph.D., University of Iowa, 1973.

T875. **Morgan, Keith N.** THE LANDSCAPE GARDENING OF JOHN NOTMAN, 1810–1865. M.A., University of Delaware, 1973.

T876. **Morgan, Robert.** THE INFLUENCE OF A NATION'S FOLK-ART UPON ITS CULTIVATED MUSIC . . . M.Mus., Syracuse University, 1940.

T877. **Morgan, William D.** THE ARCHITECTURE OF HENRY VAUGHAN. Ph.D., University of Delaware, 1971.

T878. **Morris, Earl H.** ACCOUNT OF THE ANTIQUITIES OF THE REGION BETWEEN THE MANCOS AND LA PLATA RIVERS IN SOUTHWEST COLORADO. M.A., University of Colorado, 1919.

T879. **Morrison, Elizabeth M.** THE DEVELOPMENT OF SKYSCRAPER STYLE, 1874–1922. M.A., University of Chicago, 1931.

T880. **Morse, Cecily.** THE PRINT AND THE FINE ARTS IN EIGHTEENTH-CENTURY AMERICA. M.A., New York University, 1966.

T881. **Mosher, Nancy M.** FUNCTIONALISM IN CONTEMPORARY AMERICAN ARCHITECTURE AND PAINTING. M.A., University of Chicago, 1935.

T882. **Moss, Roger W., Jr.** MASTER BUILDERS, A HISTORY OF THE COLONIAL PHILADELPHIA BUILDING TRADES. Ph.D., University of Delaware, 1972.

T883. **Mount, Marshall W.** ALASKAN ESKIMO REPRESENTATIONAL ART: A REFLECTION OF THE CONTROLS OF A SIMPLE HUNTING SOCIETY IN AN ARCTIC ENVIRONMENT. M.A., Columbia University, 1952.

T884. **Moyer, Ellen.** OSCAR BLUEMNER—COLOR THEORY. M.A., George Washington University, 1974.

T885. **Moyes, Norman Barr.** MAJOR PHOTOGRAPHERS AND THE DEVELOPMENT OF STILL PHOTOGRAPHY IN MAJOR AMERICAN WARS. Ph.D., Syracuse University, 1966.

T886. **Muehlberger, Richard C.** WILLIAM H. RANLETT. M.A., Johns Hopkins University, 1967.

T887. **Mueller, Jean Gillies.** THE TIMELESS SPACE OF EDWARD HOPPER. Ph.D., Northwestern University, 1970.

T888. **Muhlert, Jan Keene.** ARTHUR G. DOVE, EARLY AMERICAN MODERNIST. M.A., Oberlin College, 1967.

T889. **Mullen, Philip.** PARTICIPATORY EVENTS AS ART. Ph.D., Ohio University, 1970.

T890. **Mulvihill, Elise E.** EARLY AMERICAN ARCHITECTURE, COMPOSITION AND COLOR; WITH SPECIAL REFERENCE TO THE ORIGIN AND DEVELOPMENT OF HOUSE PAINTING AND THE COLORS USED IN THE INTERIORS. M.A., Ohio State University, 1944.

T891. **Munier, Margaret B.** WASHINGTON'S HEADQUARTERS AT THE BATTLE OF THE BRANDYWINE: A RECONSTRUCTION OF THE BENJAMIN RING HOUSE. M.A., University of Delaware, 1955.

T892. **Murell, Dorothy C.** THE EFFECTS OF FOREIGN INFLUENCES UPON AMERICAN PORTRAIT PAINTING. M.A., Ohio State University, 1948.

T893. **Murtagh, William John.** MORAVIAN ARCHITECTURE AND CITY PLANNING: A STUDY OF EIGHTEENTH CENTURY MORAVIAN SETTLEMENTS IN THE AMERICAN COLONIES WITH PARTICULAR EMPHASIS ON BETHLEHEM, PENNSYLVANIA. Ph.D., University of Pennsylvania, 1963.

T894. **Myers, Denys Peter, Jr.** FROM CARPENTER TO ARCHITECT: OBSERVATIONS ON THE CAREER OF MINARD LAFEVER. M.A., Columbia University, 1948.

T895. **Myers, Eugene Russell.** THE DEVELOPMENT OF MID-TWENTIETH-CENTURY AMERICAN METAL AND GLASS ARCHITECTURE IN THE CURTAIN WALL STYLE. Ph.D., University of Pittsburgh, 1963.

T896. **Myers, Mary.** SADAKICHI HARTMANN'S "ALBERT PINKHAM RYDER": THE STORY OF AN AMERICAN PAINTER, TO THOSE WHO OCCASIONALLY BOTHER ABOUT ESTHETIC FUNCTIONS. M.A., Vanderbilt University, 1974.

T897. **Myron, Robert Elias.** HOPEWELLIAN FIGURATIVE SCULPTURE. Ph.D., Ohio State University, 1953.

T898. **Naeve, Milo M.** JOHN LEWIS KRIMMEL: HIS LIFE, HIS ART, AND HIS CRITICS. M.A., University of Delaware, 1955.

T899. **Nasci, Gaetano F.** THE IMAGE OF THE AMERICAN INDIAN IN THE VISUAL ARTS TO 1800. M.A., Syracuse University, 1963.

T900. **Nathanson, Carol.** THE AMERICAN RESPONSE, IN 1900–1913, TO THE FRENCH MODERN ART MOVEMENTS AFTER IMPRESSIONISM. Ph.D., Johns Hopkins University, 1973.

T901. **Negishi, Koaki.** NAUM GABO. M.A., University of Iowa, 1968.

T902. **Neilson, Reka.** CHARLES F. WIMAK AND THE MIDDLE WESTERN PAINTING OF THE EARLY NINETEENTH CENTURY. M.A., Washington University, 1943.

T903. **Nelson, Christina H.** A SELECTED CATALOGUE OF THE LIVERPOOL-TYPE HISTORICAL CREAMWARES AND PEARLWARES IN THE HENRY FRANCIS DU PONT WIN-

TERTHUR MUSEUM. M.A., University of Delaware, 1974.

T904. **Nelson, Donna-Belle.** THE GREEK REVIVAL ARCHITECTURE OF JAMES C. BUCKLIN. M.A., University of Delaware, 1969.

T905. **Nelson, Robert Allen.** HEROIC IMAGERY IN TWENTIETH-CENTURY PAINTING. Ed.D., New York University, 1971.

T906. **Netherton, Frederick John.** AN AMERICAN UNITARIAN ARCHITECTURAL AESTHETIC. M.A., University of Victoria, 1974.

T907. **Newland, Randa A.** TWENTY-FIVE YEARS AND THE IOWA PRINT GROUP. M.A., University of Iowa, 1970.

T908. **Newman, Richard K., Jr.** YANKEE GOTHIC: MEDIEVAL ARCHITECTURAL FORMS IN THE PROTESTANT CHURCH BUILDING OF NINETEENTH-CENTURY NEW ENGLAND. Ph.D., Yale University, 1949.

T909. **Newman, Roslyn.** THE DEVELOPMENT OF THE DEPARTMENT OF ARCHITECTURE BEGUN AT THE BAUHAUS AND ITS CONTINUATION IN THE ILLINOIS INSTITUTE OF TECHNOLOGY. M.A., Northwestern University, 1971.

T910. **Niccolls, Thomas.** TWENTIETH-CENTURY CLOWN—TOWARD A DEFINITION OF THE FUNCTION AND SIGNIFICANCE OF THE CLOWN IN ART, FILM AND THEATRE. Ph.D., Ohio University, 1970.

T911. **Nichols, J. B.** A HISTORICAL STUDY OF SOUTHERN BAPTIST CHURCH ARCHITECTURE. Ph.D., Southwestern Baptist Theological Seminary, 1954.

T912. **Niebling, Howard.** MODERN BENEDICTINE CHURCHES: MONASTIC CHURCHES ERECTED BY AMERICAN BENEDICTINES SINCE WORLD WAR II. Ph.D., Columbia University, 1973.

T913. **Nixon, Nick.** IRONY IN TWENTIETH-CENTURY AMERICAN PHOTOGRAPHY. M.F.A., University of New Mexico, 1975.

T914. **Noel, Francis Joseph, III.** THE PHOTOGRAPH AND CONTEMPORARY PRINTMAKING. M.F.A., University of Colorado, 1965.

T915. **Noffsinger, James P.** THE INFLUENCE OF THE ECOLE DES BEAUX-ARTS ON THE ARCHITECTS OF THE UNITED STATES. Ph.D., Catholic University of America, 1955.

T916. **Nonemaker, James A.** THE NEW YORK TOWN HOUSE, 1815–1840. M.A., University of Delaware, 1958.

T917. **Nordquist, Delmar L.** THE DEVELOPMENT OF AN IMMIGRANT COMMUNITY IN ARCHITECTURE: ARTS AND CRAFTS. M.A., University of Iowa, 1947.

T918. **North, Anne.** CONTEMPORARY ART ACTIVITIES

OF COMPARABLE AMERICAN INDIAN CULTURES. M.A., Ohio University, 1944.

T919. **North, Phylis B.** ARTHUR DOVE AND THE EARLY YEARS OF ABSTRACTION. M.A., Pennsylvania State University, 1968.

T920. **North, Phylis B.** MAX WEBER: THE EARLY PAINTINGS (1905–1920). Ph.D., University of Delaware, 1975.

T921. **Norton, Paul Foote.** LATROBE, JEFFERSON AND THE NATIONAL CAPITAL. Ph.D., Princeton University, 1952.

T922. **Novak, Barbara.** COLE AND DURAND: CRITICISM AND PATRONAGE (A STUDY OF AMERICAN TASTE IN LANDSCAPE, 1825–1865). Ph.D., Harvard University, 1957.

T923. **Novak, David P.** THE FUNCTIONS OF SYMBOLISM IN CONTEMPORARY ABSTRACT PAINTING: A STUDY OF THE AESTHETIC OBJECT. M.A., University of Iowa, 1966.

T924. **Nye, George, Jr.** THE HISTORY OF THE CONSTRUCTION OF SAINT JOSEPH'S CATHEDRAL CHURCH. M.A., Ohio State University, 1948.

T925. **Nygren, Edward J.** ART INSTRUCTION IN PHILADELPHIA, 1795–1845. M.A., University of Delaware, 1960.

T926. **Nylander, Richard C.** JOSEPH BADGER, AMERICAN PORTRAIT PAINTER. M.A., State University of New York, College at Oneonta, 1972.

T927. **O'Brian, Mabel D.** A SURVEY OF ART IN 388 NORTH DAKOTA HOMES. M.A., American University, 1931.

T928. **Obst, Frances M.** THE INFLUENCES OF CHINESE AND JAPANESE ART ON AMERICAN INTERIOR FURNISHINGS. M.A., University of Minnesota, 1938.

T929. **O'Connor, Elizabeth.** ARTHUR B. CARLES, 1882–1952: COLORIST AND EXPERIMENTER. M.A., Columbia University, 1965.

T930. **O'Connor, Francis V.** THE GENESIS OF JACKSON POLLOCK. Ph.D., Johns Hopkins University, 1965.

T931. **O'Donnell, Mary E.** BELL BOTTOM BANK: THE FIRST NATIONAL BANK OF CHICAGO. M.A., University of Iowa, 1974.

T932. **Oedel, William T.** THE AMERICAN SKETCHBOOK OF BENJAMIN WEST. M.A., University of Delaware, 1973.

T933. **Oelsen, Laure.** GEORGE I. BARNETT, 1815–1898. M.A., University of Missouri, 1973.

T934. **Oglesby, Resa C.** HISTORY OF THE FORT WORTH ART ASSOCIATION. M.A., Texas Woman's University, 1950.

T935. **Ohman, Marian.** JESSE HALL AND THE ARCHITEC-TURE OF M. FRED BELL. M.A., University of Missouri, 1970.

T936. **Ohman, Marian.** LATITUDINARIANISM, AN ARCHITECTURAL THEORY AND ITS APPLICATION IN ENGLAND AND AMERICA FROM 1840 TO 1895. Ph.D., University of Missouri, 1973.

T937. **Oliver, Zelma.** CRAFTS IN OKLAHOMA. M.A., University of Oklahoma, 1951.

T938. **Olpin, Robert Spencer.** ALEXANDER HELWIG WYANT (1836–1892). AMERICAN LANDSCAPE PAINTER: AN INVESTIGATION OF HIS LIFE AND FAME, AND A CRITICIAL ANALYSIS OF HIS WORK WITH A CATALOGUE RAISONNÉ OF WYANT PAINTINGS. Ph.D., Boston University, 1971.

T939. **Olsen, James L.** DOMESTIC ARCHITECTURE AND FURNISHINGS OF THE SANTA FE REGION, 1850–1970. M.A., University of Denver, 1970.

T940. **Olshansky, Joan R.** THE SUBURBAN HOUSES OF WILSON EYRE. M.A., Columbia University, 1968.

T941. **Olson, Eleanore L.** A CORRELATIVE STUDY OF THE MAJOR ARTS AND LITERATURE IN AMERICA FROM THE WORLD'S FAIR TO THE WORLD WAR—WITH SPECIAL REFERENCE TO PAINTING. M.A., New York University, 1933.

T942. **Omoto, Sadayoshi.** SOCIAL PROTEST ARTISTS IN WESTERN ART. M.A., Michigan State College, 1950.

T943. **Omoto, Sadayoshi.** SOME ASPECTS OF THE SO-CALLED "QUEEN ANNE" REVIVAL STYLE OF ARCHITECTURE. Ph.D., Ohio State University, 1954.

T944. **Ornstein, Jeanette.** MEXICAN AND AMERICAN MURAL PAINTING (A SOCIAL EVALUATION). M.A., Oberlin College, 1943.

T945. **Orr, Tina.** AN ANALYSIS OF ELMWOOD, THE LOCKWOOD MANSION, BY DETLEF LIENAU. M.A., Yale University, 1974.

T946. **Osgood, Mildred M.** THE INFLUENCE OF THE SKYSCRAPER UPON MODERN DECORATIVE ARTS. M.A., University of Chicago, 1929.

T947. **Ott, Ethelbert N.** WILLIAM D. WASHINGTON (1833–1870), ARTIST OF THE SOUTH. M.A., University of Delaware, 1968.

T948. **Ott, Sister Mary E.** ALLUSIONS TO ART IN "THE MARBLE FAUN" OF NATHANIEL HAWTHORNE. M.A., Catholic University of America, 1946.

T949. **Overby, Osmund R.** THE ARCHITECTURE OF COLLEGE HILL, 1770–1900: RESIDENTIAL DEVELOPMENT IN THE AREA OF THE ORIGINAL TOWN OF PROVIDENCE, RHODE ISLAND. Ph.D., Yale University, 1963.

T950. **Palmer, Arlene M.** THE WISTARBURG GLASSWORKS OF COLONIAL NEW JERSEY. M.A., University of Delaware, 1973.

T951. **Paprotta, Gertrude.** AN INVESTIGATION OF REA-

SONS FOR THE EXTENT AND MANNER OF THE USE OF EARLY AMERICAN FURNITURE BY EXTENSION CLUB MEMBERS IN THREE SELECTED COUNTIES OF NORTHERN KENTUCKY. M.S., University of Tennessee, 1965.

T952. **Parker, Lawrence Edward.** A STUDY OF MODERN ARCHITECTURAL HISTORIOGRAPHY, 1929–1969. M.A., Cornell University, 1969.

T953. **Parker, Robert J.** A HAPPENING BY ALLAN KAPROW. M.A., University of Iowa, 1970.

T954. **Parry, Ellwood Comly, II.** THOMAS COLE'S "THE COURSE OF EMPIRE": STUDY IN SERIAL IMAGERY. Ph.D., Yale University, 1970.

T955. **Parsons, Melinda Boyd.** THE REDISCOVERY OF PAMELA COLMAN SMITH. M.A., University of Delaware, 1975.

T956. **Paschal, Mother Mary.** A STUDY OF THE SIGNIFICANT FEATURES OF PENNSYLVANIA DUTCH FOLK ART. M.F.A., Syracuse University, 1946.

T957. **Paskus, Benjamin.** AN INTRODUCTION TO BARNETT NEWMAN STUDIES. Ph.D., University of North Carolina, Chapel Hill, 1974.

T958. **Patrick, Ransom R.** THE EARLY LIFE OF JOHN NEAGLE, PHILADELPHIA PORTRAIT PAINTER. Ph.D., Princeton University, 1959.

T959. **Patterson, Ruth G.** THE INFLUENCE OF HOWARD PYLE ON AMERICAN ILLUSTRATION. M.L.S., Case Western Reserve University, 1954.

T960. **Patton, Charles E.** OLD MARIETTA BUILDINGS AND THEIR BUILDERS. M.A., Case Western Reserve University, 1936.

T961. **Patton, Helen Frances.** PUBLIC SCHOOL ARCHITECTURE IN RACINE, WISCONSIN, AND VICINITY FROM THE TIME OF SETTLEMENT TO 1900. Ph.D., University of Wisconsin, 1965.

T962. **Pavlik, Merrick A.** THOMAS COLE: PAINTER AND ARCHITECT, 1801–1848. M.A., Wayne State University, 1973.

T963. **Pearce, John N.** THE EARLY BALTIMORE POTTERS AND THEIR WARES, 1763–1850. M.A., University of Delaware, 1959.

T964. **Pearman, Sara Jane.** A CATALOGUE OF THE GLASS COLLECTION IN THE MUSEUM OF ART AT THE UNIVERSITY OF KANSAS. M.A., University of Kansas, 1964.

T965. **Peck, Edward S., Jr.** THE SPANISH-INDIAN ARCHITECTURE OF THE SOUTHERN AND WESTERN STATES WITH SPECIAL EMPHASIS UPON THE MONUMENTS IN NEW MEXICO. M.A., Oberlin College, 1933.

T966. **Peirce, Donald C.** MITCHELL AND RAMMELSBERG: CINCINNATI FURNITURE MAKERS. M.A., University of Delaware, 1975.

T967. **Peisch, Mark L.** THE CHICAGO SCHOOL AND WALTER BURLEY GRIFFIN, 1893–1914. GROWTH AND DIS-

SEMINATION OF AN ARCHITECTURAL MOVEMENT AND A REPRESENTATIVE FIGURE. Ph.D., Columbia University, 1959.

T968. **Pennal, Billy E.** AN ANALYSIS OF TRAILER HOMES PRODUCED IN THE UNITED STATES IN 1953. M.A., North Texas State University, 1953.

T969. **Perez, Rodolfo Paros.** MARK TOBEY: HIS TIME AND HIS VISION, THE FACTORS OF TIME AND SPACE. M.A., University of Minnesota, 1961.

T970. **Perkins, D. E.** THE HISTORY OF AMERICAN ILLUSTRATION UP TO 1900. M.A., Mills College, 1929.

T971. **Perkins, Dorothy Wilson.** EDUCATION IN CERAMIC ART IN THE UNITED STATES. Ph.D., Ohio State University, 1956.

T972. **Perkins, F. E.** AMERICAN MURAL PAINTING. M.A., Washington University, 1912.

T973. **Perry, Regenia Alfreda.** THE LIFE AND WORKS OF CHARLES FREDERICK SCHWEINFURTH, CLEVELAND ARCHITECT, 1856–1919. Ph.D., Case Western Reserve University, 1967.

T974. **Persick, Roberta Stokes.** ARTHUR EUGENE BAGGS, AMERICAN POTTER. Ph.D., Ohio State University, 1963.

T975. **Peterson, Frederick William.** PRIMITIVISM IN MODERN AMERICAN ART. Ph.D., University of Minnesota, 1961.

T976. **Peyton, Ruth Margaret.** SAMUEL F. B. MORSE: HIS TRAINING, HISTORICAL PAINTINGS AND PORTRAITS. M.A., Northwestern University, 1959.

T977. **Pfouts, Clytie (Mead).** HENRY HORNBOSTEL: A TRADITIONAL ARCHITECT. M.A., Cornell University, 1968.

T978. **Pier, Eldredge C.** EXPOSITION DESIGN IN THE UNITED STATES WITH RELATION TO THE DEVELOPMENT OF NINETEENTH-CENTURY ARCHITECTURE. M.A., New York University, 1941.

T979. **Pierson, William H., Jr.** INDUSTRIAL ARCHITECTURE IN THE BERKSHIRES. Ph.D., Yale University, 1949.

T980. **Pietan, Norman.** GOVERNMENT AND THE ARTS: THE W.P.A. FEDERAL ARTS PROJECT. Ed.D., Columbia University, 1949.

T981. **Pillsbury, William M.** THE PROVIDENCE FURNITURE MAKING TRADE, 1772–1834, AS SEEN IN THE ACCOUNT BOOKS OF JOB DANFORTH AND WILLIAM, SAMUEL AND DANIEL PROUD. M.A., University of Delaware, 1975.

T982. **Pitluga, George Elliot, Jr.** A STUDY OF THE ARCHITECTURE OF WOLCOTT, NEW YORK, FROM 1810 TO 1895. M.A., Syracuse University, 1963.

T983. **Pockrandt, Florence D.** LOTUS WARE: A CERAMIC PRODUCT OF THE NINETIES. M.A., Ohio State University, 1942.

T984. **Poesch, Jessie J.** TITIAN RAMSAY PEALE: ARTIST-NATURALIST. M.A., University of Delaware, 1956.

T985. **Pokinski, Deborah Frances.** THE LEGEND OF THE CHICAGO SCHOOL OF ARCHITECTURE: A STUDY IN THE HISTORIOGRAPHY OF MODERN AMERICAN ARCHITECTURE. M.A., Cornell University, 1973.

T986. **Porter, James A.** THE AMERICAN NEGRO AS ARTIST: 1724–1900. M.A., New York University, 1937.

T987. **Porter, Janis Sue.** CUBISM AND EARLY AMERICAN MODERNISM. M.A., University of California, Berkeley, 1973.

T988. **Porter, Lucinda Christian.** JACKSON POLLOCK, THE INNOVATOR OF THE TWENTIETH CENTURY. M.A., University of Denver, 1967.

T989. **Porter, Richard James.** THE ARCHITECTURE OF EDWARD HALE KENDALL IN MANHATTAN. M.A., Pennsylvania State University, 1973.

T990. **Powell, Earl A., III.** ENGLISH INFLUENCES IN THE ART OF THOMAS COLE. Ph.D., Harvard University, 1974.

T991. **Prendergast, Eleanor.** J. A. M. WHISTLER. M.A., Columbia University, 1927.

T992. **Prestiano, Robert Vincent.** "THE INLAND ARCHITECT": A STUDY OF THE CONTENT, INFLUENCE AND SIGNIFICANCE OF CHICAGO'S MAJOR, LATE NINETEENTH-CENTURY ARCHITECTURAL PERIODICAL. Ph.D., Northwestern University, 1973.

T993. **Preston, Malcolm Harold.** CONTEMPORARY PAINTING IN AMERICA: AN INTERPRETATION. Ed.D., Columbia University, 1951.

T994. **Priddy, Bennie H.** NINETEENTH-CENTURY CHURCH ARCHITECTURE IN MEMPHIS: TEN SURVIVING STRUCTURES. M.A., Vanderbilt University, 1972.

T995. **Prior, David Alean.** HUMOR AND POP ART. M.F.A., University of Colorado, 1966.

T996. **Prior, Ronene Denise.** CHARACTERISTICS OF THE AMERICAN DESIGNER CRAFTSMAN IN QUANTITY PRODUCTION. M.S., University of Tennessee, 1966.

T997. **Prokes, Francis Anthony.** THE THEOLOGICAL DIMENSION OF ARCHITECTURE. Ph.D., Princeton University, 1964.

T998. **Prown, Jules.** WASHINGTON IRVING'S INTEREST IN ART AND HIS INFLUENCE UPON AMERICAN PAINTING. M.A., University of Delaware, 1956.

T999. **Prown, Jules.** THE ENGLISH CAREER OF JOHN SINGLETON COPLEY, R.A. Ph.D., Harvard University, 1961.

T1000. **Pulliam, Ruth J.** A HISTORY OF ART IN TEXAS. M.A., University of Northern Colorado, 1943.

T1001. **Purdy, Mary L.** DESIGN IN MONTANA INDIAN ART. M.A., University of Northern Colorado, 1941.

T1002. **Quade, Willis V. O. (Mrs.)** JOHN CRANCH. M.A., George Washington University, 1969.

T1003. **Quimby, Ian M. G.** APPRENTICESHIP IN COLONIAL PHILADELPHIA. M.A., University of Delaware, 1963.

T1004. **Quinton, Sister Mary M.** RHODE ISLAND SAMPLERS AND EMBROIDERED PICTURES. M.A., Catholic University of America, 1944.

T1005. **Raafat, Aly Ahmed.** REINFORCED CONCRETE AND THE ARCHITECTURE IT CREATES. Ph.D., Columbia University, 1957.

T1006. **Raben, Mary K.** AMERICAN LUMINISM, 1830–1870. M.A., New York University, 1966.

T1007. **Racker, Morris L.** THE EFFECTS OF MASS PRODUCTION ON INDUSTRIAL DESIGN IN THE STATES. M.F.A., University of Iowa, 1959.

T1008. **Raddant, Mary Kay.** THE ANNUNCIATION GREEK ORTHODOX CHURCH: A LATE WORK OF FRANK LLOYD WRIGHT. M.A., Cornell University, 1971.

T1009. **Radde, Bruce F.** FRANK LLOYD WRIGHT'S WORK IN CALIFORNIA. M.A., University of California, Berkeley, 1967.

T1010. **Rains, Nola S.** MODERN ARCHITECTURE IN DALLAS, TEXAS. M.A., North Texas State University, 1950.

T1011. **Raley, Robert L.** THE BALTIMORE COUNTRY HOUSE, 1785–1815. M.A., University of Delaware, 1959.

T1012. **Ramsay, George Collinson.** INDUSTRIAL DESIGN IN THE UNITED STATES, 1950–1960. M.F.A., Ohio University, 1965.

T1013. **Rankell, Judith Novack.** A STUDY OF AESTHETIC SIGNIFICANCE IN THE COMBINED FORMS OF CONTEMPORARY CHURCH ART AND RELIGIOUS ARCHITECTURE IN THE UNITED STATES. Ph.D., New York University, 1968.

T1014. **Rasmussen, Bonnie A.** THE UNITY OF POE AND RYDER. M.A., University of Iowa, 1959.

T1015. **Rasmussen, Bonnie A.** ALBERT PINKHAM RYDER: "DEATH ON A PALE HORSE." M.F.A., University of Iowa, 1961.

T1016. **Rasmussen, William M. S.** ART OF THE NINETEENTH-CENTURY GOVERNMENT EXPLORATIONS IN THE WEST: CHANGING CONCEPTS OF THE WESTERN LANDSCAPE. M.A., University of Delaware, 1975.

T1017. **Ravenal, Carol Bird Myers.** THE MODEST ARCHITECTURAL MODE: AN ANALYSIS OF FIVE DOMESTIC BUILDINGS IN PROVIDENCE, RHODE ISLAND, CIRCA 1780–1812. Ph.D., Harvard University, 1963.

T1018. **Ray, Mary Lyn.** HEAVEN INVALIDATED: DIVERGENCE FROM ORTHODOXY IN SHAKER PERSUASION

AND FURNITURE FORMS. M.A., University of Delaware, 1970.

T1019. **Raymond, Herbert David.** THE PERSISTENCE OF ILLUSION IN AMERICAN NON-REFERENTIAL PAINTING IN THE 1960S. Ph.D., New York University, 1970.

T1020. **Rea, Carol.** THE NATURE OF THE QUEEN ANNE MODE IN AMERICAN ARCHITECTURE. M.A., Pennsylvania State University, 1967.

T1021. **Read, David Dolloff.** PAUL STRAND: A CONCEPT IN PHOTOGRAPHIC INTEGRITY. M.F.A., Ohio University, 1965.

T1022. **Reckmeyer, William.** THE DIDACTIC FUNCTION OF ARCHITECTURE AS AN ART IN THE TWENTIETH CENTURY. Ph.D., Ohio University, 1969.

T1023. **Reed, John W.** A COMPARATIVE ANALYSIS OF FURNITURE PRODUCED AS ART BY SELECTED SCULPTORS. M.S., Oklahoma State University, 1971.

T1024. **Reed, Thomas L.** THE WORK OF JOHN QUINCY ADAMS WARD. Ph.D., Harvard University, 1948.

T1025. **Reeve, James K.** THE ARCHITECTURAL HISTORY OF THE METROPOLITAN MUSEUM OF ART IN NEW YORK CITY (1870-1931). M.A., New York University, 1954.

T1026. **Reich, Sheldon.** A STYLISTIC ANALYSIS OF THE WORKS OF WILLIAM SIDNEY MOUNT, 1807-1868, AN AMERICAN GENRE PAINTER. M.A., New York University, 1957.

T1027. **Reich, Sheldon.** JOHN MARIN. Ph.D., University of Iowa, 1966.

T1028. **Reid, Suzanne.** ANIMAL SCULPTURE ON PUBLIC BUILDINGS AND MONUMENTS IN WASHINGTON. M.A., Catholic University of America, 1950.

T1029. **Reiff, Daniel Drake.** ARCHITECTURE IN WASHINGTON, 1791-1861. Ph.D., Harvard University, 1970.

T1030. **Reiff, Robert Frank.** A STYLISTIC ANALYSIS OF ARSHILE GORKY'S ART FROM 1943 TO 1948. Ph.D., Columbia University, 1961.

T1031. **Reise, Barbara M.** "PRIMITIVISM" IN THE WRITINGS OF BARNETT NEWMAN: A STUDY IN THE IDEOLOGICAL BACKGROUND OF ABSTRACT EXPRESSIONISM. M.A., Columbia University, 1965.

T1032. **Rembert, Virginia Pitts.** MONDRIAN, AMERICA AND AMERICAN PAINTING. Ph.D., Columbia University, 1970.

T1033. **Render, Lorne Edgar.** GOTHIC REVIVAL CHURCHES ON THE WEST COAST BEFORE 1890. M.A., University of Oregon, 1967.

T1034. **Reynolds, Gary H.** DUCHAMP AND JOHNS: THE IRONISTS. M.A., University of Iowa, 1972.

T1035. **Reynolds, Stephen James.** THE ORIGIN AND DE-VELOPMENT OF POP ART. M.F.A., University of Colorado, 1965.

T1036. **Reynolds, William A.** GIFFORD REYNOLDS BEAL, 1879-1956. M.A., Tulane University of Louisiana, 1972.

T1037. **Rhoades, Eleanor.** THE INTERNATIONAL STYLE IN THE UNITED STATES AS REPRESENTED BY RICHARD J. NEUTRA, WILLIAM LESCAZE AND GEORGE HOWE. M.A., New York University, 1938.

T1038. **Rhoades, Elizabeth A.** HOUSEHOLD FURNISHINGS IN PORTSMOUTH, NEW HAMPSHIRE, 1750-1775. M.A., University of Delaware, 1972.

T1039. **Rhys, Hedley Howell.** MAURICE PRENDERGAST: THE SOURCES AND DEVELOPMENT OF HIS STYLE. Ph.D., Harvard University, 1953.

T1040. **Rice, Arthur Brownell.** STYLES OF NINETEENTH CENTURY ARCHITECTURE IN FAYETTEVILLE, NEW YORK. M.A., Syracuse University, 1950.

T1041. **Richards, Nancy E.** THE AMERICAN ACADEMY OF FINE ARTS, 1802-1816, NEW YORK'S FIRST ART ACADEMY: THE FORMATIVE YEARS. M.A., University of Delaware, 1965.

T1042. **Richardson, James Bushnell.** THE DOUBLE CURVE MOTIF IN THE DECORATIVE ART OF THE NORTHEASTERN ALGONKIAN; DIFFUSION AND ORIGIN. M.A., Syracuse University, 1963.

T1043. **Richardson, Susan A.** A STUDY OF JOHN LAFARGE. M.A., Northwestern University, 1965.

T1044. **Richeda, Noreen M.** SAN FRANCISCO BAY AREA "NEW FIGURATIVE" PAINTERS, 1950-1965. Ph.D., University of California, Los Angeles, 1969.

T1045. **Richman, Michael Tingley.** THE EARLY CAREER OF DANIEL CHESTER FRENCH, 1869-1891. Ph.D., University of Delaware, 1974.

T1046. **Rifner, Ben O.** EARLY ARCHITECTURE OF INDIANA. M.A., Ohio State University, 1942.

T1047. **Rimbach, Gretchen.** THE DEVELOPMENT OF CHURCH ARCHITECTURE IN PITTSBURGH SINCE 1933. M.A., University of Pittsburgh, 1953.

T1048. **Riordan, John C.** THE ART AND THOUGHT OF THOMAS COLE: A STUDY OF THE ARTISTIC INTENTIONS OF AN AMERICAN ROMANTIC PAINTER. M.F.A., Syracuse University, 1967.

T1049. **Riordan, John C.** THOMAS COLE: A CASE STUDY IN THE PAINTER-POET THEORY OF ART IN AMERICAN PAINTING FROM 1825-1850. Ph.D., Syracuse University, 1970.

T1050. **Rippe, Peter M.** DANIEL CLAY OF GREENFIELD, "CABINETMAKER." M.A., University of Delaware, 1962.

T1051. **Rivard, Nancy Marcotte.** ELIEL SAARINEN IN AMERICA. M.A., Wayne State University, 1973.

T1052. **Robb, David M.** THOMAS SULLY: THE BUSINESS OF PAINTING. M.A., Yale University, 1967.

T1053. **Roberson, Samuel A.** THOMAS JEFFERSON AND THE EIGHTEENTH-CENTURY LANDSCAPE GARDEN MOVEMENT IN ENGLAND. Ph.D., Yale University, 1974.

T1054. **Robertson, Thomas B.** JOHN WELLBORN ROOT, ARCHITECT (1850-1891). M.A., New York University, 1942.

T1055. **Robinson, D. Duncan.** GERTRUDE STEIN: THE LEGEND OF A COLLECTOR. M.A., Yale University, 1967.

T1056. **Roche, Elizabeth A.** THE EXTENT TO WHICH FLORIDA BUILDERS UTILIZE THE SERVICES OF PROFESSIONALLY TRAINED DESIGNERS. M.S., Florida State University, 1967.

T1057. **Rodgers, Nell F.** THE MINIATURE PORTRAITS OF CHARLES FRASER. M.A., New York University, 1954.

T1058. **Rodriguez, Oswaldo.** THREE ESSAYS IN THE ART OF THOMAS COLE. M.A., Yale University, 1975.

T1059. **Rogers, Ava Darcy.** THE HOUSING OF OGLETHORPE COUNTY, GEORGIA: 1790-1860. Ph.D., Florida State University, 1967.

T1060. **Rogers, Elizabeth Anne.** HOUSING AND FAMILY LIFE OF THE ICARIAN (IOWA) COLONIES. M.A., University of Iowa, 1973.

T1061. **Rogers, Ruby.** TERANCE J. KENNEDY, 1820-1883. M.A., State University of New York, College at Oneonta, 1972.

T1062. **Roos, Frank J., Jr.** AN INVESTIGATION OF THE SOURCES OF EARLY ARCHITECTURAL DESIGN IN OHIO. Ph.D., Ohio State University, 1938.

T1063. **Rose, George Eugene.** JOHN MARIN: THE VISION OF AN AMERICAN PAINTER. M.F.A., University of Colorado, 1964.

T1064. **Rosenberry, Vivien V.** DESIGNS OF THE PUEBLO TRIBES OF THE SOUTHWEST. M.A., Stanford University, 1935.

T1065. **Roth, Leland Martin.** THE URBAN ARCHITECTURE OF MCKIM, MEAD AND WHITE: 1870-1910. Ph.D., Yale University, 1973.

T1066. **Roth, Moira Rumney.** MARCEL DUCHAMP AND AMERICA, 1913-1974. Ph.D., University of California, Berkeley, 1974.

T1067. **Roth, Rodney.** ZEN BUDDHISM AND THE NEW YORK SCHOOL. M.F.A., University of Iowa, 1953.

T1068. **Roth, Rodris C.** THE INTERIOR DECORATION OF CITY HOUSES IN BALTIMORE, 1783-1812. M.A., University of Delaware, 1956.

T1069. **Rovetti, Paul.** THE JOURNAL OF JOSEPH WHITING STOCK, 1815-1855. M.A., State University of New York, College at Oneonta, 19'

T1070. **Rowan, Herman T.** VISUALISM IN CONTEMPORA[...] M.F.A., University of Iowa, 1[...]

T1071. **Rowell, Louisa F.** TH[...] NEW MEXICO. M.A., Columb[...]

T1072. **Royer, Kathryn M.** N[...] NINETEENTH-CENTURY AM[...] vania State University, 1941.

T1073. **Ruben, Leonard.** A HIS[...] OF AWARD-WINNING ADVER[...] York University, 1970.

T1074. **Rubenstein, Lewis C.** [...] University of Delaware, 1958[...]

T1075. **Rubin, Ronnie.** TH[...] 1887. M.A., New York Univ[...]

T1076. **Rubin, Sharon Goldm[...]** THE CAREER OF AN ARTIST I[...] CONTEXT, 1906-1965. Ph.D., [...] 1972.

T1077. **Rudd, J. William.** GEORGE W. MAHER—ARCHITECT. M.A., Northwestern University, 1964.

T1078. **Rudisill, Richard C.** MIRROR IMAGE: THE INFLUENCES OF THE DAGUERREOTYPE ON AMERICAN SOCIETY. Ph.D., University of Minnesota, 1967.

T1079. **Rudolph, Mary.** THE PRINTS OF EDWARD HOPPER. M.A., University of Iowa, 1973.

T1080. **Rueppel, Merrill Clement.** THE GRAPHIC ART OF ARTHUR BOWEN DAVIES AND JOHN SLOAN. Ph.D., University of Wisconsin, 1955.

T1081. **Rumford, Beatrix.** DEATH AS REFLECTED IN THE ART AND FOLKWAYS OF THE NORTHEAST IN THE 18TH AND 19TH CENTURIES. M.A., State University of New York, College at Oneonta, 1966.

T1082. **Runk, Eva Epp.** MARIUS DEZAYAS: THE NEW YORK YEARS. M.A., University of Delaware, 1973.

T1083. **Ruppe, Reynold J., Jr.** THE ACOMA CULTURE PROVINCE: AN ARCHEOLOGICAL CONCEPT. Ph.D., Harvard University, 1953.

T1084. **Rusk, Fern Helen (Shapley).** LIFE AND WORKS OF GEORGE CALEB BINGHAM. M.A., University of Missouri, 1914.

T1085. **Sachs, Samuel, II.** THOMAS MORAN—DRAWINGS AND WATERCOLORS. M.A., New York University, 1963.

T1086. **Saff, Donald Jay.** CONTEMPORARY MASTERS AND METHODS OF INTAGLIO. Ed.D., Columbia University, 1964.

T1087. **Sandberg, John R.** THE EARLY PAINTINGS OF JAMES WHISTLER. M.A., Yale University, 1962.

T1088. **Sande, Theodore A.** THE ARCHITECTURE OF THE RHODE ISLAND TEXTILE INDUSTRY, 1790–1860. Ph.D., University of Pennsylvania, 1972.

T1089. **Sandstedt, Jean Marilyn.** AN EXAMINATION OF THE APPROACH TO THE OBJECT AND ITS SURFACE: AMERICA: ABSTRACT EXPRESSIONISM IN THE MID-TWENTIETH CENTURY AND TROMPE-L'OEIL IN THE LATE NINETEENTH AND EARLY TWENTIETH CENTURIES. M.F.A., University of Colorado, 1957.

T1090. **Sanstrom, Robert Louis.** JOHN MARIN'S PAINTINGS OF THE MAINE SEACOAST: AN INVESTIGATION OF THE USE AND APPEARANCE OF THE NATURAL ELEMENTS IN THE MARINE PAINTINGS OF JOHN MARIN AND THEIR IMPORTANCE TO THE ARTIST. Ed.D., New York University, 1969.

T1091. **Sato, Nagiko.** THE INFLUENCE OF JAPANESE ARTS ON MARY CASSATT. M.A., Ohio State University, 1959.

T1092. **Saunders, Martha Jane.** AN HISTORICAL STUDY OF THREE PIECES OF ANTIQUE FURNITURE FROM STRATFORD HALL, RENOWNED HOME OF THE LEES OF VIRGINIA. M.S., University of Tennessee, 1968.

T1093. **Saunders, Richard H.** AMERICAN DECORATIVE ARTS COLLECTING IN NEW ENGLAND, 1840–1920. M.A., University of Delaware, 1973.

T1094. **Sawin, Martica R.** ABRAHAM WALKOWITZ: THE YEARS AT "291," 1912 TO 1917. M.A., Columbia University, 1967.

T1095. **Scanlon, Lawrence Eugene.** THE CENTER IS MAN: A CORRELATIVE STUDY OF LATE NINETEENTH-CENTURY AMERICAN ART AND PHILOSOPHY. Ph.D., Syracuse University, 1958.

T1095a. **Scantz, Michael William.** "WATSON AND THE SHARK": A FORMAL AND ICONOGRAPHICAL ANALYSIS. M.A., San Diego State University, 1975.

T1096. **Schell, Mary Isabel.** TYPES OF AMERICAN HOUSES, 1840–1890. M.A., Yale University, 1933.

T1097. **Schermerhorn, Charles.** THE PLACE OF THOMAS MORAN, THOMAS HILL AND WILLIAM KEITH IN RELATION TO THE AMERICAN LANDSCAPE TRADITION. M.A., University of Iowa, 1959.

T1098. **Schloss, Christine.** THE BEARDSLEY LIMNER. M.A., Yale University, 1971.

T1099. **Schlotterback, Thomas.** THE BASIS FOR CHINESE INFLUENCE IN AMERICAN ART, 1784–1850. Ph.D., University of Iowa, 1972.

T1100. **Schmidt, Frank J.** ROCK FORD, THE HOME OF GENERAL EDWARD HAND. M.A., University of Delaware, 1959.

T1101. **Schmidt, Phillip F.** CHARLES LORING ELLIOTT (1812–1868), AMERICAN PORTRAIT PAINTER. M.A., University of Minnesota, 1955.

T1102. **Schmidt, Richard Galen.** EARLY ELEGANCE IN PHILADELPHIA—EDWARD SHIPPEN'S GREAT HOUSE, 1695–1792. M.A., University of Delaware, 1974.

T1103. **Schmiegel, Karol A.** PATRONAGE OF ARTISTS BY THE LLOYD FAMILY OF MARYLAND'S EASTERN SHORE. M.A., University of Delaware, 1975.

T1104. **Schnur, Anna Marie.** THE CARNEGIE INTERNATIONAL EXHIBITIONS (1896–1955). M.A., Pennsylvania State University, 1959.

T1105. **Scholl, Phoebe Kent.** A STUDY OF THE STYLES AND TECHNIQUES OF SOME OUTSTANDING RECENT AMERICAN WATERCOLOR PAINTERS. Ed.D., Columbia University, 1970.

T1106. **Schoof, Jack F.** A STUDY OF DIDACTIC ATTITUDES ON THE FINE ARTS IN AMERICA AS EXPRESSED IN POPULAR MAGAZINES DURING THE PERIOD 1786–1800. Ph.D., Ohio University, 1967.

T1107. **Schultz, Douglas George.** ALFRED STIEGLITZ' PHOTOGRAPHY AND THE STIEGLITZ CIRCLE. M.A., University of California, Berkeley, 1972.

T1108. **Schurtz, Ann Vanderwicken.** HOME ARCHITECTURE IN IOWA CITY, IOWA, 1900–1940. M.A., University of Iowa, 1967.

T1109. **Schwartz, Marvin D.** THE MEANING OF PORTRAITS: JOHN SINGLETON COPLEY'S AMERICAN PORTRAITS AND EIGHTEENTH-CENTURY ART THEORY. M.A., University of Delaware, 1954.

T1110. **Schwartzberg, Miriam B.** THE SCULPTURE OF JACQUES LIPCHITZ. M.A., New York University, 1941.

T1111. **Schwarz, Ellen.** FREDERICK KIESLER: HIS LIFE, IDEAS AND WORKS. M.A., University of Maryland, 1970.

T1112. **Schweiger, Catharine M.** TECHNIQUES FOR THE ANALYSIS OF DYES ON HISTORIC TEXTILES. M.A., University of Nebraska, 1971.

T1113. **Schweizer, Paul.** THE GENTEEL MANNER: A STUDY OF THE MAJOR STYLES AND CLASSES OF AMERICAN PAINTING EXHIBITED AT THE NATIONAL ACADEMY OF DESIGN'S ANNUAL EXHIBITIONS BETWEEN 1891 AND 1910. M.A., University of Delaware, 1974.

T1114. **Scott, Charles Christie.** THE ASH CAN SCHOOL. M.F.A., Ohio University, 1956.

T1115. **Scott, Charles Franklin.** AN HISTORICAL STUDY OF SELECTED ANTE-BELLUM HOUSES, INCLUDING FURNITURE, OF THE CHEROKEE AND CHOCTAW NATIONS, 1830–1850. M.S., Oklahoma State University, 1963.

T1116. **Scott, Wilford W.** FRANK STELLA'S PAINTINGS, 1966–1974. M.A., Florida State University, 1974.

T1117. **Scott-Thevenin, Diana E.** THE PENNSYLVANIA GERMAN PIE PLATE. M.A., Ohio State University, 1951.

T1118. **Scully, Vincent J., Jr.** THE COTTAGE STYLE (AN ORGANIC DEVELOPMENT IN LATER 19TH CENTURY WOODEN DOMESTIC ARCHITECTURE IN THE EASTERN UNITED STATES). Ph.D., Yale University, 1949.

T1119. **Seckler, Elizabeth Ann.** A COMPARATIVE STUDY OF INTERIORS OF HOMES OF THREE CULTURAL GROUPS IN IOWA. M.A., Iowa State University, 1972.

T1120. **Seeley, Edith P.** A SURVEY OF CONTEMPORARY CERAMICS IN THE UNITED STATES. M.A., Colorado State College (University of Northern Colorado), 1943.

T1121. **Seeley, Sidney Waldor.** WPA ART IN AMERICA, REGIONAL STUDY OF MICHIGAN. M.F.A., Syracuse University, 1939.

T1122. **Seiberling, Frank A., Jr.** GEORGE BELLOWS, 1882–1925: HIS LIFE AND DEVELOPMENT AS AN ARTIST. Ph.D., University of Chicago, 1948.

T1123. **Seitz, William Chapin.** ABSTRACT EXPRESSIONIST PAINTING IN AMERICA: AN INTERPRETATION BASED ON THE WORK AND THOUGHT OF SIX KEY FIGURES. Ph.D., Princeton University, 1955.

T1124. **Selig, J. Daniel.** LEMON HILL MANSION. M.A., Yale University, 1962.

T1125. **Sellers, Mary Josephine.** THE ROLE OF THE FINE ARTS IN THE CULTURE OF SOUTHERN BAPTIST CHURCHES. Ph.D., Syracuse University, 1968.

T1126. **Severin, Werner Joseph.** PHOTOGRAPHIC DOCUMENTATION BY THE FARM SECURITY ADMINISTRATION, 1935–1942. M.A., University of Missouri, 1959.

T1127. **Sewell, Pearl E.** THE IMPACT OF FAUVISM, CUBISM, AND FUTURISM IN THE ARMORY SHOW ON AMERICAN CRITICISM, 1913. M.A., Howard University, 1953.

T1128. **Shaffer, Robert Breese.** CHARLES ELIOT NORTON AND ARCHITECTURE. Ph.D., Harvard University, 1951.

T1129. **Shaffer, Sandra (Mrs. H. Stetson Tinkham).** DEBORAH GOLDSMITH, 1808–1836: A NAIVE ARTIST IN UPSTATE NEW YORK. M.A., State University of New York, College at Oneonta, 1968.

T1130. **Sharp, Lewis I., III.** THE OLD MERCHANT'S HOUSE: AN 1831/32 NEW YORK ROW HOUSE. M.A., University of Delaware, 1968.

T1131. **Shaw, Sarah Herron.** ELIZABETH WILLIAMS. M.A., University of Pittsburgh, 1950.

T1132. **Shelley, Donald A.** THE PENNSYLVANIA GERMAN STYLE OF ILLUMINATION. Ph.D., New York University, 1953.

T1133. **Shelley, June.** THE EAST AND WEST AS SEEN THROUGH THE BIRD AND FLOWER PRINTS OF ANDO HIROSHIGE AND JOHN JAMES AUDUBON. M.A., Northwestern University, 1971.

T1134. **Shepherd, Raymond V.** JAMES LOGAN'S "STENTON": GRAND SIMPLICITY IN QUAKER PHILADELPHIA. M.A., University of Delaware, 1968.

T1135. **Shobaken, Bruce R.** ABSTRACT EXPRESSIONISM (NEW YORK SCHOOL). M.A., University of Minnesota, 1953.

T1136. **Shulof, Suzanne.** AN INTERPRETATION OF LOUIS SULLIVAN'S ARCHITECTURAL ORNAMENT BASED ON HIS PHILOSOPHY OF ORGANIC EXPRESSION. M.A., Columbia University, 1962.

T1137. **Sibenman, Barbara.** A CRITICAL ANALYSIS AND SURVEY OF THE CALIFORNIA SCHOOL OF WATERCOLOR PAINTING, 1930–1948. M.A., Stanford University, 1949.

T1138. **Siegel, Jeanne.** FOUR AMERICAN NEGRO PAINTERS, 1940–1965: THEIR CHOICE AND TREATMENT OF THEMES. M.A., Columbia University, 1966.

T1139. **Siegel, Priscilla.** ABRAHAM WALKOWITZ: THE EARLY YEARS OF AN IMMIGRANT ARTIST. M.A., University of Delaware, 1975.

T1140. **Sifton, Paul Ginsburg.** PIERRE EUGÈNE DU SIMITIÈRE (1737–1784), COLLECTOR IN REVOLUTIONARY AMERICA. Ph.D., University of Pennsylvania, 1960.

T1141. **Sikorski, Jerome.** OUT OF INDIANAPOLIS: JANET PAYNE BOWLES, GOLDSMITH. M.A., Wayne State University, 1974.

T1142. **Simmons, Harold Champion.** A STUDY OF LIGHT AS A MEDIUM OF CREATIVE EXPRESSION IN THE VISUAL AND PRACTICAL ARTS. Ph.D., New York University, 1956.

T1143. **Simon, Sidney.** JAMES MCNEILL WHISTLER, HIS ART AND THEORIES. Ph.D., Harvard University, 1956.

T1144. **Simon, Walter Augustus.** HENRY O. TANNER — A STUDY OF THE DEVELOPMENT OF AN AMERICAN NEGRO ARTIST: 1859–1937. Ed.D., New York University, 1961.

T1145. **Simoni, John Peter.** ART CRITICS AND CRITICISM IN NINETEENTH-CENTURY AMERICA. Ph.D., Ohio State University, 1952.

T1146. **Simpson, Pamela Hemenway.** THE SCULPTURE OF CHARLES GRAFLY. Ph.D., University of Delaware, 1974.

T1147. **Simpson, Shirley Joyce Scott.** SYNCHROMISM: A HISTORICAL STUDY OF THE FIRST ABSTRACT ART MOVEMENT IN THE UNITED STATES. M.A., University of Colorado, 1968.

T1148. **Sissel, Dewey Kent.** THE OCTAGON FORM IN NINETEENTH-CENTURY DOMESTIC ARCHITECTURE IN IOWA. M.A., University of Iowa, 1968.

T1149. **Skidmore, Maria E.** THE AMERICAN EMBLEM BOOK AND ITS SYMBOLISM. Ph.D., Ohio State University, 1946.

T1150. **Skilton, John Davis.** PRE-REVOLUTIONARY AMERICAN ENGRAVERS AND THEIR PRINTS. M.A., Yale University, 1936.

T1151. **Skinner, Robert G.** PERCEPTIONS OF SOME ARTISTS IN RESIDENCE IN OHIO COLLEGES AND UNIVERSITIES. Ph.D., Ohio University, 1971.

T1152. **Slavin, Barbara (Mrs. Tetsuga Kataoka).** A STUDY AND CLASSIFICATION OF THE ILLUSTRATIONS OF TOMPKINS H. MATTESON BETWEEN 1845 AND 1855. M.A., State University of New York, College at Oneonta, 1970.

T1153. **Slota, Loretta Elaine.** A CATALOGUE OF THE TWENTIETH CENTURY AMERICAN PAINTINGS IN THE COLLECTION OF THE DENVER ART MUSEUM. M.A., University of Denver, 1965.

T1154. **Smart, Jermayne.** THE FOLK ART OF THE WESTERN RESERVE. Ph.D., Case Western Reserve University, 1939.

T1154a. **Smith, Herbert R.** THE SCULPTURE OF HEINZ WARNEKE. M.A., George Washington University, 1964.

T1155. **Smith, Malcolm S.** ALEXANDER ANDERSON AND AMERICAN WOOD ENGRAVING. M.A., University of Delaware, 1973.

T1156. **Smith, Mary Ann Clegg.** THE COMMERCIAL ARCHITECTURE OF JOHN BUTLER SNOOK. Ph.D., Pennsylvania State University, 1974.

T1157. **Smith, Norris Kelly.** A STUDY OF THE ARCHITECTURAL IMAGERY OF FRANK LLOYD WRIGHT. Ph.D., Columbia University, 1961.

T1158. **Smith, Patricia Anne.** NEW ENGLAND MEETING HOUSES AND CHURCHES. M.A., Oberlin College, 1945.

T1159. **Smith, Raymond.** ANTICIPATION OF MEMORY: PHOTOGRAPHS OF EMERSON HAZARD (1854–1926) OF SOUTHINGTON, CONNECTICUT. Ph.D., Yale University, 1974.

T1160. **Smith, Stuart B.** THE WALNUT STREET THEATRE, 1809–1834. M.A., University of Delaware, 1960.

T1161. **Smith, Vincent Raymond.** ART INFLUENCES WITHIN THE CHURCHES OF THE DISCIPLES OF CHRIST DENOMINATION. M.F.A., Ohio State University, 1954.

T1162. **Snively, Tamara Jane.** THE SCULPTURE OF RAYMOND PHILLIPS SANDERSON. M.A., Arizona State University, 1973.

T1163. **Snyder, Daniel Gyger.** AMERICAN FAMILY MEMORIAL PHOTOGRAPHY: THE PHOTOGRAPH AND THE SEARCH FOR IMMORTALITY. M.F.A., University of New Mexico, 1971.

T1164. **Snyder, Ruth Geraldine.** THE ARTS AND CRAFTS OF THE AMANA SOCIETY. M.A., University of Iowa, 1949.

T1165. **Sober, Marion.** THE AMERICAN NINE OF TWENTIETH-CENTURY ART. M.A., Wayne State University, 1948.

T1166. **Sokol, David Martin.** JOHN QUIDOR, HIS LIFE AND WORK. Ph.D., New York University, 1971.

T1167. **Sonnenstrahl, Deborah Mernaski.** ANALYSIS OF THE ETCHINGS OF CADWALLADER LINCOLN WASHBURN. M.A., Catholic University of America, 1967.

T1168. **Spada, Emma.** BARNS OF PENNSYLVANIA, NEW YORK STATE, AND NEW ENGLAND. M.Arch., Cornell University, 1954.

T1169. **Sparks, Esther.** THE SYNCRETISTIC PAINTING OF BENJAMIN WEST: ITS BASIS IN QUAKER INFORMALITY. M.A., Northwestern University, 1968.

T1170. **Sparks, Esther.** A BIOGRAPHICAL DICTIONARY OF PAINTERS AND SCULPTORS IN ILLINOIS, 1808–1945. Ph.D., Northwestern University, 1971.

T1171. **Spaulding, Robert.** HOPI KACHINA SCULPTURE. M.A., University of Denver, 1953.

T1172. **Spence, James Robert.** MISCH KOHN: A CRITICAL STUDY OF HIS PRINTMAKING. Ph.D., University of Wisconsin, 1965.

T1173. **Spinar, Melvin F.** OSCAR HOWE, ARTIST OF THE DAKOTA SIOUX. M.F.A., University of Iowa, 1966.

T1174. **Sprague, Paul E.** ARCHITECTURAL ORNAMENT OF LOUIS SULLIVAN AND HIS CHIEF DRAFTSMEN. Ph.D., Princeton University, 1969.

T1175. **Spring, Janet Gilchrist.** AN ANALYSIS OF AMERICAN ART CRITICS' REACTIONS TO THE 1913 ARMORY SHOW. M.A., University of Denver, 1969.

T1176. **Stallworth, Mary G.** THE DEVELOPMENT OF SECULAR GOTHIC ARCHITECTURE IN THE UNITED STATES. M.A., University of Chicago, 1925.

T1177. **Stanley, Ward.** MILTON AVERY, 1893–1965. M.A., University of Pennsylvania, 1969.

T1178. **Stark, Carolyn C.** STAINED GLASS IN THE DENVER AREA. M.A., University of Denver, 1970.

T1179. **Starks, Elliot R.** A SURVEY OF CONTEMPORARY ART IN WISCONSIN (1936–1946). M.A., University of Wisconsin, 1946.

T1180. **Starr, Nina Howell.** AMERICAN ABSTRACT PHOTOGRAPHY TO 1930. M.F.A., University of Florida, 1963.

T1181. **Steadman, William E.** GREAT HEART (A BIOGRAPHY OF LENDALL PITTS). M.A., Yale University, 1951.

T1182. **Stebbins, Theodore E., Jr.** THE LIFE AND WORKS OF M. J. HEADE. Ph.D., Harvard University, 1971.

T1183. **Steele, Benjamin.** THE EXECUTION OF THE MURAL ARTS OF THE WEST. M.A., University of Denver, 1955.

T1184. **Stein, Donna.** LUMIA, THE ART OF LIGHT AND THE WORK OF THOMAS WILFRED. M.A., New York University, 1965.

T1185. **Steingart, June Greenfield.** REALISM IN AMERICAN PAINTING IN THE THIRTIES: A STUDY OF THE INFLUENCES OF THE WORLD DEPRESSION ON ART AND ARTISTS. M.A., University of California, Berkeley, 1972.

T1186. **Stetson, George.** THE 1704 HOUSE, BUILT IN CHESTER COUNTY, PENNSYLVANIA, BY WILLIAM BRINTON, THE YOUNGER. M.A., University of Delaware, 1961.

T1187. **Stevens, William.** ACADEMIC ART TEACHING IN THE UNITED STATES: 1865–1895. M.A., New York University, 1967.

T1188. **Stewart, Carol Ann Ivey.** A CONSIDERATION OF THE FUNCTION OF CONTEMPORARY PAINTING IN THE UNITED STATES. M.A., University of Oregon, 1965.

T1189. **Stewart, Ian Richard.** CENTRAL PARK 1851–71: URBANIZATION AND ENVIRONMENTAL PLANNING IN NEW YORK CITY. Ph.D., Cornell University, 1973.

T1190. **Stewart, Patrick L., Jr.** ANDREW WYETH AND THE AMERICAN DESCRIPTIVIST TRADITION. M.A., State University of New York, Binghamton, 1972.

T1191. **Stillman, S. Damie.** ARTISTRY AND SKILL IN THE ARCHITECTURE OF JOHN MCCOMB, JR. M.A., University of Delaware, 1956.

T1192. **Stinson, Robert E.** MAURICIO LASANSKY: A MONOGRAPH. M.A., University of Iowa, 1948.

T1193. **Stoddard, Richard Foster.** THE ARCHITECTURE AND TECHNOLOGY OF BOSTON THEATRES, 1794–1854. Ph.D., Yale University, 1971.

T1194. **Stokes, Charlotte.** A CATALOGUE OF LANDSCAPE PAINTINGS IN THE HENRY COLLECTION PAINTED BY AMERICAN ARTISTS BORN BEFORE 1861, THE BEGINNING OF THE CIVIL WAR. M.A., University of Washington, 1972.

T1195. **Stolz, Thelma.** MURAL PAINTING IN TEXAS: A SURVEY OF THE WORK AND AIMS OF ARTISTS WHO HAVE PAINTED HISTORIC OR INDUSTRIAL THEMES FOR WALLS. M.A., Texas State College for Women (Texas Woman's University), 1939.

T1196. **Storrer, William.** A COMPARISON OF EDWARD ALBEE'S "WHO'S AFRAID OF VIRGINIA WOOLF?" AS DRAMA AND FILM. Ph.D., Ohio University, 1968.

T1197. **Strauss, Ruth Rachel.** THE LEADERS OF AMERICAN IMPRESSIONIST PAINTING. M.A., Columbia University, 1946.

T1198. **Streichler, Jerry.** THE CONSULTANT INDUSTRIAL DESIGNER IN AMERICAN INDUSTRY FROM 1927 TO 1960. Ph.D., New York University, 1963.

T1199. **Streifthau, Donna Largent.** CINCINNATI CABINET AND CHAIRMAKERS, 1819–1830. Ph.D., Ohio State University, 1970.

T1200. **Stroh, Mary K.** THE COMMERCIAL ARCHITECTURE OF ALFRED ZUCKER IN MANHATTAN. M.A., Pennsylvania State University, 1973.

T1201. **Strong, Donald Sanderson.** A STUDY OF THE ARCHITECTURE OF THE PUBLIC SQUARE (CLINTON SQUARE), SYRACUSE, NEW YORK, FROM 1820 TO 1831. M.A., Syracuse University, 1958.

T1202. **Sullivan, Noreen Ann.** MAURICE PRENDERGAST: HIS STYLISTIC DEVELOPMENT AND RELATIONSHIP WITH AMERICAN ART. M.A., Northwestern University, 1953.

T1203. **Summers, Maud G.** A STUDY OF PUEBLO INDIAN TEXTILE DESIGNS OF THE PRE-COLUMBIAN PERIOD. M.A., University of New Mexico, 1948.

T1204. **Sutter, James S.** THE ROLE OF MODERN SCULPTURE IN ARCHITECTURE. M.A., University of Iowa, 1965.

T1205. **Swanson, Louise E.** VICTORIAN DOMESTIC ARCHITECTURE IN THE UNITED STATES, 1865–1895. M.F.A., University of Colorado, 1943.

T1206. **Sweeney, John A. H.** THE CORBIT HOUSE AT ODESSA, DELAWARE. M.A., University of Delaware, 1954.

T1207. **Swift, Geoffrey.** THE BOSTON CITY HALL COMPETITIONS OF 1962. M.A., Yale University, 1966.

T1208. **Swift, Gustavus F.** THE POTTERY OF THE AMUQ, PHASES K TO O, AND ITS HISTORICAL RELATIONSHIPS. Ph.D., University of Chicago, 1959.

T1209. **Symonds, Susan.** PORTRAITS OF ANDREW JACKSON: 1815–1845. M.A., University of Delaware, 1968.

T1210. **Takach, Mary.** THOMAS DOUGHTY, AMERICAN PAINTER. M.A., State University of New York, Binghamton, 1973.

T1211. **Talbot, William.** JASPER F. CROPSEY, 1823–1900. Ph.D., New York University, 1972.

T1212. **Talbott, E. Page.** THE FURNITURE INDUSTRY IN BOSTON, 1810–1835. M.A., University of Delaware, 1974.

T1213. **Talcott, Ralph Clayes.** THE WATERCOLORS OF GEORGE LUKS. M.A., Pennsylvania State University, 1970.

T1214. **Tarbell, Roberta K.** JOHN STORES AND MAX WEBER: EARLY LIFE AND WORK. M.A., University of Delaware, 1968.

T1215. **Tarr, Gary.** THE ARCHITECTURE OF THE EARLY WESTERN CHALUKYAS. Ph.D., University of California, Los Angeles, 1969.

T1216. **Tatham, David Frederick.** WINSLOW HOMER IN

BOSTON: 1854–1859. Ph.D., Syracuse University, 1970.

T1217. **Tatum, George Bishop.** ANDREW JACKSON DOWNING: ARBITER OF AMERICAN TASTE, 1815–1852. Ph.D., Princeton University, 1950.

T1218. **Taylor, Dorothy Voorhees.** JO DAVIDSON: THE PARIS PEACE CONFERENCE BUSTS OF JUNE 1919. M.A., University of Delaware, 1972.

T1219. **Taylor, Joshua C.** WILLIAM PAGE, THE AMERICAN TITIAN. Ph.D., Princeton University, 1956.

T1220. **Tegtmeier, Faith Anne.** SCULPTORS OF THE AMERICAN WEST, 1850–1925. M.A., University of Denver, 1970.

T1221. **Tellin, James A.** SOME CONCEPTS OF SPACE IN CONTEMPORARY AMERICAN ABSTRACT PAINTING. M.F.A., University of Iowa, 1958.

T1222. **Teres, Michael J.** MAN RAY, PAINTER AND PHOTOGRAPHER. M.A., University of Iowa, 1965.

T1223. **Terhune, Anne Gregory.** THE SCULPTURE OF REUBEN NAKIAN FROM 1920 TO 1964. M.A., New York University, 1967.

T1224. **Thomas, Carolyn Tolliver.** A STUDY OF CONTEMPORARY UNITED STATES DESIGNERS. M.A., University of Missouri, 1963.

T1225. **Thomas, Franklin Richard.** THE LITERARY ADMIRERS OF ALFRED STIEGLITZ. Ph.D., Indiana University, 1970.

T1226. **Thompson, Carolyn.** THE LOWER EAST SIDE: IMAGES OF A SLUM ENVIRONMENT. M.A., Cornell University, 1971.

T1227. **Thompson, Susan Otis.** KELMSCOTT INFLUENCE ON AMERICAN BOOK DESIGN. Ph.D., Columbia University, 1972.

T1228. **Thompson, William Paul.** DOWNING AND THE DISSENT: A STUDY OF AMERICAN DOMESTIC ARCHITECTURAL HANDBOOKS, 1840 TO 1876. M.A., Cornell University, 1967.

T1229. **Tibbs, Thomas S.** THE ARMORY SHOW OF 1913. M.A., University of Rochester, 1948.

T1230. **Tilleux, Geneva Frances Morgan.** THE PAINTINGS OF JAMES MCNEILL WHISTLER, 1857–1873. Ph.D., University of Wisconsin, 1962.

T1231. **Tobe, Lawrence David.** CONTEMPORARY CHURCH ARCHITECTURE IN LOUISVILLE. M.A., University of Louisville, 1958.

T1232. **Tong, Darlene.** NOGUCHI. M.A., University of Washington, 1974.

T1233. **Torbert, Donald R.** MINNEAPOLIS ARCHITECTURE AND ARCHITECTS, 1848–1908: A STUDY OF STYLE TRENDS IN ARCHITECTURE IN A MIDWESTERN CITY TOGETHER WITH A CATALOGUE OF REPRESENTATIVE BUILDINGS. Ph.D., University of Minnesota, 1951.

T1234. **Torche, Judith Helene.** NEW DEVELOPMENTS IN AQUEOUS ART MEDIA. Ed.D., Columbia University, 1965.

T1235. **Torraca, M. Frances.** LAFAYETTE'S TRIUMPH: THE TRADITION OF THE TRIUMPH AND TRIUMPHAL ARCH AND THE SIGNIFICANCE OF LAFAYETTE'S TRIUMPH AND TRIUMPHAL ARCHES WITHIN THIS TRADITION. M.A., Tulane University, 1966.

T1236. **Trabold, Jeanne Louise.** AN HISTORICAL STUDY OF AMERICAN REGIONALISM AND WORLD REALISM DURING THE PERIOD 1920 TO 1939. M.A., University of Missouri, 1954.

T1237. **Trapp, Kenneth.** MARIA LONGWORTH STORER: A STUDY OF HER BRONZE OBJETS D'ART IN THE CINCINNATI ART MUSEUM. M.A., Tulane University, 1972.

T1238. **Trapp, Regina Antoinette.** TOM DOYLE, A NEW AWARENESS OF SPACE. M.A., New York University, 1974.

T1239. **Trent, Robert F.** THE JOINERS AND JOINERY OF MIDDLESEX COUNTY, MASSACHUSETTS, 1630–1730. M.A., University of Delaware, 1975.

T1240. **Trimmer, E. Prince.** THOMAS COLE: THE COURSE OF EMPIRE. M.A., Yale University, 1960.

T1241. **Tritschler, Thomas.** THE AMERICAN ABSTRACT ARTISTS, 1937–1941. Ph.D., University of Pennsylvania, 1974.

T1242. **Truax, Harold Arthur, Jr.** DANIEL RHODES: A STUDY OF HIS WORK AS EXEMPLARY OF CONTEMPORARY AMERICAN STUDIO GRAPHICS. Ed.D., Columbia University, 1969.

T1243. **True, David F.** CLAES OLDENBURG: GENRE ARTIST. M.F.A., Ohio University, 1966.

T1244. **Trump, Richard Shafer.** LIFE AND WORKS OF ALBERT BIERSTADT. Ph.D., Ohio State University, 1963.

T1245. **Tuck, James Alexander.** IROQUOIS CULTURAL DEVELOPMENT IN CENTRAL NEW YORK. Ph.D., Syracuse University, 1969.

T1246. **Tucker, James E.** MODERN TEXAS PAINTING: REGIONALISM AND INTERNATIONAL STYLE. M.F.A., University of Iowa, 1959.

T1247. **Tucker, Mary Louise.** JACQUES G. L. AMANS, PORTRAIT PAINTER IN LOUISIANA, 1836–1856. M.A., Tulane University, 1970.

T1248. **Tully, Wanda Kathryn.** AN HISTORICAL STUDY OF FIVE BUILDINGS SELECTED AS OKLAHOMA LANDMARKS AND LOCATED IN PATTAWATOMIE COUNTY, OKLAHOMA. M.S., Oklahoma State University, 1969.

T1249. **Turak, Theodore.** WILLIAM LE BARON JENNEY: A NINETEENTH-CENTURY ARCHITECT. Ph.D., University of Michigan, 1966.

T1250. **Turner, David Graves, III.** IMOGEN CUNNING-

HAM: A CRITICAL STUDY IN THE HISTORY OF PHOTOGRAPHY. M.A., University of Oregon, 1974.

T1251. **Turner, Louise Boone.** A MARYLAND MANOR IN TRANSITION. M.S., University of Maryland, 1966.

T1252. **Turner, Theodore R.** ARTHUR G. DOVE, 1880–1946. M.A., New York University, 1950.

T1253. **Tuton, Patricia Pepper.** CONTEMPORARY CERAMICS. M.F.A., University of Colorado, 1970.

T1254. **Vance, Phillip.** ROBERT HENRI: LANDSCAPE, CITYSCAPE, AND GENRE PAINTINGS. M.A., New York University, 1967.

T1255. **Van Omer, Geraldine Good.** LOUIS SULLIVAN'S ORNAMENTATION AS EXEMPLIFIED IN THE CARSON, PIRIE, SCOTT BUILDING. M.A., Pennsylvania State University, 1960.

T1256. **Van Rensselaer, Susan (Davis).** DESIGN FOR CONTINUITY IN THE URBAN RENEWAL PROCESS. M.A., Cornell University, 1966.

T1257. **Van Wagner, Judith K.** WALTER MURCH. Ph.D., University of Iowa, 1972.

T1258. **Vardac, Alexander Nicholas.** FROM GARRICK TO GRIFFITH: TRANSITION FROM STAGE TO SCREEN. A DETERMINATION OF THE ORIGINS OF THE CINEMA IN THE STAGING METHODS OF THE NINETEENTH CENTURY. Ph.D., Yale University, 1942.

T1259. **Vastokas, Joan Marie.** ARCHITECTURE OF THE NORTHWEST COAST INDIANS OF AMERICA. Ph.D., Columbia University, 1966.

T1260. **Vaughan, Mack D.** THE CARICATURES OF OSCAR BERGER AND DAVID LOW. M.A., Texas Woman's University, 1949.

T1261. **Vecchione, Constance.** MEMORIAL ART IN NORTH AMERICAN CHURCHES, EIGHTEENTH AND NINETEENTH CENTURIES. SOME SOURCES, STYLES AND IMPLICATIONS. M.A., University of Delaware, 1968.

T1262. **Vervoort, Patricia M.** EERO SAARINEN. M.A., University of Iowa, 1966.

T1263. **Vichery, V. F.** THE HISTORY AND ANTIQUITIES OF AMERICA. M.A., University of Illinois, 1926.

T1264. **Vincent, Arlene Steffen.** SURVEY AND SUMMARY OF IOWA CRAFTS AND CRAFTSMEN. M.A., Iowa State University, 1968.

T1265. **Vincent, Clare.** JOHN HENRY BELTER, MANUFACTURER OF ALL KINDS OF FINE FURNITURE. M.A., New York University, 1963.

T1266. **Vincent, Gilbert T.** ROCKWOOD, A ROMANTIC VILLA IN BRANDYWINE HUNDRED. M.A., University of Delaware, 1972.

T1267. **Vishny, Michele.** THE DADA MOVEMENT IN AMERICA. M.A., Northwestern University, 1965.

T1268. **Vivian, Patricia Bryan.** KACHINA—THE STUDY OF ANIMISM AND ANTHROPOMORPHISM WITHIN THE CEREMONIAL WALL PAINTINGS OF POTTERY MOUND AND THE JEDDITO. M.F.A., University of Iowa, 1961.

T1269. **Volo, Sharon.** PETER BLUME: REBIRTH, RENEWAL AND RESURRECTION IN "THE ETERNAL CITY." M.A., State University of New York, Binghamton, 1974.

T1270. **Von Erffa, Helmut.** THE DRAWINGS OF BENJAMIN WEST. Ph.D., Princeton University, 1940.

T1271. **Wagner, Ronald F.** THE INNER WORLD OF MORRIS GRAVES. M.F.A., University of Iowa, 1954.

T1272. **Wahl, Jo Ann.** ART UNDER THE NEW DEAL. M.A., Columbia University, 1966.

T1273. **Waldman, Diane.** THE ART OF JOSEPH CORNELL. M.A., New York University, 1965.

T1274. **Walker, Lester C.** ART IN AVERAGE AMERICA: THE CULTURAL PATTERN OF DES MOINES, IOWA. Ph.D., Ohio State University, 1952.

T1275. **Walker, Steven.** THE DOMESTIC ARCHITECTURE OF HENRY HOBSON RICHARDSON IN ST. LOUIS. M.A., University of Denver, 1973.

T1276. **Wallace, David Harold.** JOHN ROGERS, THE PEOPLE'S SCULPTOR. Ph.D., Columbia University, 1961.

T1277. **Wallach, Alan Peter.** ORIGINS OF THOMAS COLE'S "THE COURSE OF EMPIRE." M.A., Columbia University, 1965.

T1278. **Wallach, Alan Peter.** THE IDEAL AMERICAN ARTIST AND THE DISSENTING TRADITION; A STUDY OF THOMAS COLE'S POPULAR REPUTATION. Ph.D., Columbia University, 1973.

T1279. **Walsh, John J., Jr.** WINSLOW HOMER: EARLY WORK AND THE JAPANESE PRINT. M.A., Columbia University, 1965.

T1280. **Walsh, Robert A.** LOUIS SULLIVAN IN IOWA. M.A., University of Iowa, 1969.

T1281. **Walton, Elisabeth B.** THE BUILDING ART OF WILSON EYRE, A STUDY OF "QUEEN ANNE" MOTIFS IN AMERICAN ARCHITECTURE. M.A., Pennsylvania State University, 1962.

T1282. **Walton, Elisabeth B.** "MILL PLACE" ON THE WILLAMETTE, A NEW MISSION HOUSE FOR THE METHODISTS IN OREGON, 1841–1844. M.A., University of Delaware, 1966.

T1283. **Ward, John.** THE EARLY INNESS. M.A., Yale University, 1962.

T1284. **Warner, Beverly.** A PSYCHOLOGICAL-HISTORICAL EXAMINATION OF THE INTERRELATIONSHIPS OF THE ARTS AS SEEN IN THE PAINTING "ULTIMATE PAINTING #19" (1953–1960) BY AD REINHARDT AND THE MUSICAL COMPOSITION "FILIGREE STRING QUARTET" (1960) BY MEL POWELL. Ph.D., Ohio University, 1969.

T1285. **Warwick, James Francis.** THE GRAPHIC DESIGN OF COLLEGE PUBLICATIONS. Ed.D., Columbia University, 1966.

T1286. **Washburn, Jean.** REHABILITATION OF SKANEATELES, NEW YORK. M.Arch., Syracuse University, 1940.

T1287. **Watrous, James S.** MODERN ARCHITECTURE IN AMERICA. M.A., University of Wisconsin, 1933.

T1288. **Watrous, James S.** MURAL PAINTING IN THE UNITED STATES: A HISTORY OF ITS STYLE AND TECHNIQUE. Ph.D., University of Wisconsin, 1939.

T1289. **Wattenmaker, Richard Joel.** THE ART OF WILLIAM GLACKENS. Ph.D., New York University, 1972.

T1290. **Watts, Douglas Robert.** THE PROFESSIONAL AND HIS OFFICE PRACTICES: A STUDY INTO ASPECTS OF AMERICAN ARCHITECTURE. M.Arch., Syracuse University, 1972.

T1291. **Watts, Raymond J.** RACIAL PREJUDICE IN THE PLASTIC ARTS IN AMERICA. M.A., University of Iowa, 1970.

T1292. **Watts, Robert S.** THE MASKS OF THE ALASKAN ESKIMO. M.A., University of California, Berkeley, 1951.

T1293. **Waxman, Lorraine.** FRENCH INFLUENCE ON AMERICAN DECORATIVE ARTS OF THE EARLY NINETEENTH CENTURY: THE WORK OF CHARLES-HONORÉ LANNUIER. M.A., University of Delaware, 1958.

T1294. **Weale, Mary Jo.** CONTRIBUTIONS OF DESIGNERS TO CONTEMPORARY FURNITURE DESIGN. Ph.D., Florida State University, 1968.

T1295. **Weaver, Elinor Van Valkenburgh.** A GUIDE FOR THE SELECTION AND USE OF FABRIC IN THE RESTORATION OF THE HARRY WHITE HOME, CRAYLAND AVENUE, INDIANA, PENNSYLVANIA, AS EXEMPLIFIED IN THE BEDROOM OF JUDGE HARRY WHITE. M.Ed., University of Pennsylvania, 1969.

T1296. **Weaver, Faythe.** STUDIES ON FOUR BLACK ARTISTS: A CRITICAL ESSAY. M.A., Ohio State University, 1973.

T1297. **Weber, Louis A.** ARCHITECTURE IN CINCINNATI BEFORE 1845. M.A., Ohio State University, 1947.

T1298. **Weber, Nicholas.** THE ARCHITECTURAL HISTORY OF LITCHFIELD. M.A., Yale University, 1971.

T1299. **Webster, Richard J.** STEPHEN D. BUTTON: ITALIANATE STYLIST. M.A., University of Delaware, 1963.

T1300. **Weil, Martin E.** INTERIOR ARCHITECTURAL DETAILS IN EIGHTEENTH-CENTURY ARCHITECTURAL BOOKS AND PHILADELPHIA COUNTRY HOUSES. M.A., University of Delaware, 1967.

T1301. **Weimer, Aloysius G.** J. FRANK CURRIER. M.A., New York University, 1935.

T1302. **Weimer, Aloysius G.** THE MUNICH PERIOD IN AMERICAN ART. Ph.D., University of Michigan, 1940.

T1303. **Weinberg, Helene Barbara.** THE DECORATIVE WORK OF JOHN LAFARGE. Ph.D., Columbia University, 1973.

T1304. **Weinberger, Gerald Louis.** ART, CITIES, AND AMERICAN POLITICS. Ph.D., Syracuse University, 1971.

T1305. **Weinstein, Beatrice J.** MINIMAL ART: AN OUTGROWTH OF CONSTRUCTIVISM. M.F.A., Ohio University, 1969.

T1306. **Weisman, Winston R.** THE ARCHITECTURAL SIGNIFICANCE OF ROCKEFELLER CENTER. Ph.D., Ohio State University, 1942.

T1307. **Weiss, Ila Joyce Solomon.** SANFORD ROBINSON GIFFORD (1823–1880). Ph.D., Columbia University, 1968.

T1308. **Weissman, Rebecca.** ROBERT MOTHERWELL AND THE SYMBOLIST TRADITION. M.A., University of Pennsylvania, 1970.

T1309. **Welchans, Roger.** THE ART THEORIES OF WASHINGTON ALLSTON AND WILLIAM MORRIS HUNT. Ph.D., Case Western Reserve University, 1970.

T1310. **Welling, Ann Lorraine.** ROSE HILL, GREEK REVIVAL FARM MANSION: A STUDY OF THE FORCES THAT SHAPED IT. M.A., University of Delaware, 1969.

T1311. **Wells, Karen (Mrs. R. Burton Lamont).** FRITZ G. VOGT: HIS WORK AS SOCIAL DOCUMENT. M.A., State University of New York, College at Oneonta, 1968.

T1312. **Weltfish, Gene.** THE INTERRELATIONSHIP OF TECHNIQUE AND DESIGN IN NORTH AMERICAN BASKETRY. Ph.D., Columbia University, 1950.

T1313. **Wendorf, Denver F., Jr.** ARCHAEOLOGICAL STUDIES IN THE PETRIFIED FOREST NATIONAL MONUMENT, ARIZONA. Ph.D., Harvard University, 1953.

T1314. **Wertheim, Arthur F.** "THE FIDDLES ARE TUNING": THE LITTLE RENAISSANCE IN NEW YORK CITY, 1908–1917. Ph.D., New York University, 1970.

T1315. **Westervelt, Robert F.** EARLY 19TH CENTURY AMERICAN VISUAL ARTS AS AN EXPRESSION OF DEMOTIC CULTURE. Ph.D., Emory University, 1970.

T1316. **Wetherald, D. Houghton.** AN ARCHITECTURAL HISTORY OF THE NEWBERRY LIBRARY. M.A., Oberlin College, 1964.

T1317. **White, Bernice T.** THE EFFECT OF THE GEOGRAPHY OF ARIZONA ON THE ART EXPRESSION OF THE PEOPLES OF THAT REGION. M.A., Stanford University, 1935.

T1318. **White, Carolyn Pitt.** ANDREW WYETH: A STUDY

OF AN ARTIST'S SUCCESS. M.A., Northwestern University, 1967.

T1319. **White, George Edward.** THE EASTERN ESTABLISHMENT AND THE WESTERN EXPERIENCE: THE WEST OF FREDERIC REMINGTON, THEODORE ROOSEVELT, AND OWEN WISTER. Ph.D., Yale University, 1967.

T1320. **Whitmore, Helen Straw.** THE CARROLL MANSION, 800 EAST LOMBARD STREET, BALTIMORE, MARYLAND: AN HISTORICAL AND ARCHITECTURAL STUDY. M.S., University of Maryland, 1969.

T1321. **Widmer, Melba Rae.** NINETEENTH-CENTURY HOME ARCHITECTURE OF MOUNT PLEASANT, IOWA. M.A., University of Iowa, 1969.

T1322. **Wildman, Alanna Ivey.** INDIVIDUAL STYLES OF CHARLESTON FURNITURE BEFORE 1800. M.A., Vanderbilt University, 1972.

T1323. **Williams, Hobart L.** CHILDE HASSAM, AN AMERICAN IMPRESSIONIST. M.A., Columbia University, 1957.

T1324. **Williams, Lewis.** COMMERCIALLY PRODUCED FORMS OF AMERICAN CIVIL WAR MONUMENTS. M.A., University of Illinois, 1948.

T1325. **Williams, Lewis.** LORADO TAFT: AMERICAN SCULPTOR AND ART MISSIONARY. Ph.D., University of Chicago, 1958.

T1326. **Williamson, Jerry Max.** THE TRANSITIONAL PERIOD BETWEEN ROMANTICISM AND REALISM IN THE AMERICAN ARTS. Ph.D., Florida State University, 1963.

T1327. **Wilmerding, John.** A HISTORY OF AMERICAN MARINE PAINTING UP TO THE AGE OF STEAM. Ph.D., Harvard University, 1965.

T1328. **Wilson, Hult L.** THE CATHEDRALS OF PATRICK CHARLES KEELY. M.A., Catholic University of America, 1952.

T1329. **Wilson, James Benjamin.** THE SIGNIFICANCE OF THOMAS MORAN AS AN AMERICAN LANDSCAPE PAINTER. Ph.D., Ohio State University, 1955.

T1330. **Wilson, Richard Guy.** CHARLES F. McKIM AND THE DEVELOPMENT OF THE AMERICAN RENAISSANCE: A STUDY IN ARCHITECTURE AND CULTURE. Ph.D., University of Michigan, 1972.

T1331. **Winston, Virginia.** THE HISTORY OF THE CHAIR IN RELATION TO THE HOME: THE DESIGN AND EXECUTION OF FURNITURE FOR THE TEXAS SUNE HOUSE, TEXAS STATE COLLEGE FOR WOMEN. M.A., Texas Woman's University, 1943.

T1332. **Witzmann, Hugh Leo.** WORKS OF FAITH TRANSFORMED INTO WORKS OF ART: A STUDY OF BULTOS IN NEW MEXICO. M.F.A., University of Colorado, 1963.

T1333. **Wodehouse, Lawrence Michael.** ROMANTICISM AND ARCHITECTURE FROM PUGIN TO WRIGHT. M.Arch., Cornell University, 1963.

T1334. **Wolanin, Barbara.** ALFRED STIEGLITZ' "291": AMERICA'S FIRST GLIMPSE OF MODERN ART. M.A., Oberlin College, 1969.

T1335. **Wolcott, Eliza.** GEORGE READ (II) AND HIS HOUSE. M.A., University of Delaware, 1971.

T1336. **Wolf, Carol Kay.** THE AMERICAN ARTIST-CRAFTSMAN, HIS PHILOSOPHY AND HIS STUDIO. M.S., Iowa State University, 1963.

T1337. **Wolf, Nancy K.** KROTOK. M.A., University of Kansas, 1952.

T1338. **Wolf, Peter Michael.** JEAN HYACINTHE LACLOTTE. M.A., Tulane University, 1963.

T1339. **Wolfer, George.** ARTHUR G. DOVE. M.A., Hunter College of the City University of New York, 1961.

T1340. **Wong, Roberta.** WILL BRADLEY—A STUDY IN AMERICAN ILLUSTRATION AT THE TURN OF THE 19TH CENTURY. Ph.D., Johns Hopkins University, 1971.

T1341. **Wood, Harry E.** THE ACCEPTED AMERICAN MEANING OF COLOR. Ph.D., Ohio State University, 1941.

T1342. **Wood, Reid.** ROBERT RAUSCHENBERG: LITHOGRAPHS AND OTHER RELATED WORKS, 1962-1970. M.A., Oberlin College, 1972.

T1343. **Woodman, Betsy H.** JOHN FRANCIS RAGUE: MID-NINETEENTH CENTURY REVIVALIST ARCHITECT (1799-1877). M.A., University of Iowa, 1969.

T1344. **Wooldridge, Laura A.** THE EAST FELICIANA PARISH COURTHOUSE AND LAWYERS' ROW IN CLINTON, LOUISIANA: A STUDY IN THE GREEK REVIVAL. M.A., Tulane University of Louisiana, 1973.

T1345. **Woolf, Katharine.** GEORGE INNESS. M.A., University of Chicago, 1928.

T1346. **Worcester, Lucille Portman.** AMERICAN HAND-WEAVING IN THE TWENTIETH CENTURY. M.A., Oberlin College, 1966.

T1347. **Worley, Catherine V.** RICHARD J. NEUTRA, ARCHITECT. M.A., New York University, 1948.

T1348. **Wosstroff, Nancy Jane.** GRAEME PARK: AN EIGHTEENTH CENTURY COUNTRY ESTATE IN HORSHAM, PENNSYLVANIA. M.A., University of Delaware, 1958.

T1349. **Wray, Patricia Donham.** FRANK LLOYD WRIGHT'S THEORY OF ORNAMENT. M.A., Northwestern University, 1969.

T1350. **Wright, Russell Joseph.** COLLEGE HILL FIVE YEARS LATER. M.R.P., Cornell University, 1964.

T1351. **Wriston, Barbara.** THOMAS ALEXANDER TEFFT:

ARCHITECT AND ECONOMIST. M.A., Brown University, 1942.

T1352. **Yavitz, Joan.** THE INITIAL PERIOD OF FITZ HUGH LANE: 1830–1850. M.A., University of Iowa, 1974.

T1353. **Yeh, Chung Chi.** A GENERAL SURVEY OF THE AMERICAN SINGLE-FAMILY DWELLINGS OF TODAY. M.A., University of Kansas, 1949.

T1354. **Yost, Philipp R.** SEEING AMERICA'S IDEALS (A HANDBOOK ON AMERICAN ART). M.A., Stanford University, 1949.

T1355. **Zajec, Edward F.** GIORGIO MORANDI AND ANDY WARHOL: DIFFERENCES AND SIMILARITIES. M.F.A., Ohio University, 1968.

T1356. **Zakon, Ronnie L.** ICE CREAM AND THE SODA FOUNTAIN IN THE AMERICAN ARTS: A HISTORY OF STYLE AND TASTE. M.A., Yale University, 1974.

T1357. **Zaug, D. D.** NEWCOMB POTTERY. M.F.A., Tulane University, 1965.

T1358. **Zawisa, Bernard J.** CHANGING CONCEPTS OF REALITY AND ITS RELATION TO CONTEMPORARY ABSTRACT ART. M.F.A., University of Iowa, 1954.

T1359. **Zilczer, Judith.** THE AESTHETIC STRUGGLE IN AMERICA, 1913–1918: ABSTRACT ART AND THEORY IN THE STIEGLITZ CIRCLE. Ph.D., University of Delaware, 1975.

T1360. **Zinn, Edith G.** NORTH, CENTRAL AND SOUTH AMERICAN INDIAN DESIGN MOTIFS AND THEIR OCCURRENCE IN THE CULTURES OF OTHER RACES. M.A., Pennsylvania State University, 1946.

T1361. **Zserdin, Sister, B.V.M.** THE GROWTH OF AMERICAN CERAMIC ART: A BRIEF SUMMARY. M.A., University of Iowa, 1962.

U

Visual Resources

A SURVEY OF PICTORIAL MATERIALS ON AMERICANA AVAILABLE FOR STUDY AND PURCHASE IN INSTITUTIONS IN THE UNITED STATES

JUDITH A. HOFFBERG, COORDINATOR

Compiled by the Art Libraries Society of North America
(ARLIS/NA) Committee on Visual Resources

Helen Chillman, Eleanor Collins, Nancy DeLaurier, Mary Ann Grasso,
Gail Grisé, Louise Henning, Stanley W. Hess, Barbara R. Maxwell,
Jo Nilsson, Margaret P. Nolan, Linda J. Owen, Sharon Petrini,
Ruth Philbrick, Nancy Schuller, Luraine Tansey, Patricia Toomey

CONTENTS

INTRODUCTION

Readers' Guide to Use of the Inventory and Handlist

Bibliography is customarily conceived of as a system applied to books and other verbal materials. It has been less frequently used in relationship to other kinds of documentation, especially visual, which show many varieties of shape: flat prints and reproductions, photographs and lantern slides, films and microfiche. We began with the assumption that a bibliography on visual resources of Americana is basically disorganized and that it would be our aim to inventory these visual resources (photographs, negatives, slides, postcards, films, videotapes, posters, microfiche) available in institutions in the United States.

The bibliography presents two major listings, the main inventory of institutions and the subject handlist or index to the holdings of these institutions. The inventory of institutions is an enumeration grouped alphabetically by state of a substantial body of academic institutions, libraries, museums, distinctive centers, and commerical firms that collect or reproduce visual materials of American interest.

The subject handlist presents a breakdown *by subject area* of the major holdings of the institutions inventoried. Together the inventory and the handlist allow researchers looking for relevant depositories of pictorial materials—for study or purchase—to use a fair guide.

While we do not presume comprehensiveness (of the 2200 institutions canvased, 25 percent responded), we know this is a reasonable first step in building a list of institutions showing correct title, address, telephone, person in charge, hours, access, reproduction services, size of collection, special collections, and major holdings by medium and subject.

This bibliography was prepared by the Committee on Visual Resources of the Art Libraries Society of North America. Three teams worked on the survey: one compiled the mailing list; one helped to construct the questionnaire; and the third collected and compiled the data. The questionnaire sheets used to gather information are reproduced at the end of this introductory Readers' Guide. The system employed for coordinating the data is based on the *Dictionary of Subject Strengths in Connecticut Libraries*, edited by Charles E. Funk, Jr. (Hartford, 1968).

The Coordinator of this project wishes to acknowledge, with thanks, the help of:

Margaret Nolan and her staff at The Metropolitan Museum of Art Slide and Photograph Library, whose work assured success of the questionnaire;

Stanley Hess, who coordinated the team for developing the mailing list;

Amy Navratil, who diligently worked out instructions for codes, abbreviations, and collation of data;

Lindy J. Narver, who helped collate the subject data; and Bernard Karpel, for having faith in us.

This survey was conducted in April 1975, and collation of data was completed in January 1976.

JUDITH A. HOFFBERG

The Inventory of Institutions

Institutions (academic institutions, libraries, museums, commercial firms) are grouped according to state and arranged in alphabetical sequence under each state rubric. The alphanumeric (of the style U1.) at the top of each entry is the same kind of designation given to each entry in the over-all bibliography (U indicates the section, 1 indicates the sequence within the section). These alphanumerics are used in the over-all index (Volume 4), but they do not have an internal function within the section.

The designation of code letters (of the style PAPHUP$_f$) is the familiar device derived from the *Union List of Serials*. Five or six letters are used, as well as subscript abbreviations. The first two letters, replicating the Postal Service's zipcodes—*and shown on the Table of Contents here*—identify the state in which the institution is located. The third and fourth letters identify the city or town in the state. The fifth and sixth letters identify the specific institution. Subscript abbreviations are used as necessary to identify the distinctive center within the institution. Thus, PAPHUP$_f$ means Pennsylvania, Philadelphia, University of Pennsylvania, Fine Arts Library.

A finding List of Institutions and Matching Code Letters is given below. A Glossary of Subscript Abbreviations for the distinctive centers within institutions is also provided. These code letters are used for indexing purposes in the Subject Handlist.

Major holdings of pictorial materials (if reported) are shown as the last component of each entry in the inven-

tory. These holdings show subject coverage (of the style GD–3P) according to the List of Subject Abbreviations and the following system of notation:

1 = architecture
2 = sculpture
3 = painting
4 = decorative arts
P = photographs
S = slides

In short, GD–3P means Great Depression 1930–40: painting, photographs. (In cases where institutions reported visual resources other than photographs or slides, the subject is listed with the type of resource or medium following. If type of resource or medium was not reported by the institution, the historical subject is listed alone.)

The Subject Handlist

The Subject Handlist comprises entries U545–U568. This breakdown by subject is another way of collating and indexing the *major holdings data* shown in the inventory under individual institutions. In the subject handlist, subjects are arranged alphabetically according to the (unabbreviated) subject head. This sequence is shown in the Alphabetical List of Subjects (preceding U545), which also serves as a table of contents for the subject handlist. For convenience, here is a finding list of subject abbreviations arranged alphabetically according to the abbreviation.

LIST OF SUBJECT ABBREVIATIONS

Abbreviation	Subject
AE	Age of Exploration
AI	American Indian
AJ	Age of Jackson, Clay and Calhoun: 1828–1850
AL	Agricultural Life
AR	American Revolution: 1770–1790
C	Colonial Period: 1620–1770
CW	Civil War: 1860–1865
E	Entertainment
ETW	Early Twentieth Century: 1910–1914
F	Federal Period: 1790–1812
GD	Great Depression: 1930–1940
I	Industrial Expansion: 1865–1910
M	Maritime Life
MW	Mexican War: 1848
P	Postwar America: 1946–
S	Sports
SA	Space Age
T	Turn of the Century/Spanish-American War: 1880–1910
TW	Nineteen Twenties
W	War of 1812
WI	Waves of Immigration
WM	Westward Movement
WWI	World War I: 1914–1918
WWII	World War II: 1940–1945

How to Use the Inventory and the Subject Handlist

For information about a specific institution, as for example the University of Pennsylvania Fine Arts Library, follow this route: Go to the List of Institutions and Matching Code Letters (directly following this introduction). Look up University of Pennsylvania under the Pennsylvania rubric. The code letters shown are PAPHUP$_f$. Now go to the inventory. In the inventory itself, institutions are grouped by state, and under the state rubric are arranged alphabetically according to code letters. Thus, within the Pennsylvania section of the inventory, the entry for PAPHUP$_f$ follows the entry for PAPHPR and precedes the entry for PAPHUP$_m$. If you do not know the name of an institution but do know its location, consult the List of Institutions.

For information about a specific subject, as for example the decade of the 1930s, follow this route: Go to the Chronological List of Subjects at the beginning of the handlist to identify the subject heading that covers the historical period or topic to be researched. The decade of the 1930s is covered by the subject heading: Great Depression 1930–1940. Then go directly to the handlist, which follows an alphabetical sequence of subject headings. On the page headed Great Depression 1930–1940 are lists of the institutions loaded with reproductions related to this period. Consult the List of Institutions and Matching Code Letters and the Glossary of Subscript Abbreviations given below to identify by name the institutions and distinctive centers shown.

Glossary of Subscript Abbreviations

a	Arents Research Library	s	sales desk
a	art and music department	s	slide collection
a	art department	sa	school of art
a	audiovisual	sah	Society of Architectural Historians
a	Avery Library	sc	slide collection
aa	art and archaeology	sl	slide library
ah	art history	sp	slide and photograph department
av	audiovisual	su	Syzallus Library Collection
c	collection		
d	department of reproductions		
da	department of art		
daa	department of art and archaeology		
e	education department		
f	fine arts library		
f	Franzheim Architecture Library		
f	Frick Fine Arts Department		
fl	film library		
g	gallery		
hc	history collection		
l	library		
m	museum		
ma	museum of art		
me	museum education		
p	photography		
p	photography department		
ph	photography		
r	reference department		
r	Rockefeller		
re	Rockefeller Folk Art		
rl	reference library		

The Questionnaire and the Ongoing Program

While further refinements are foreseen in the future, the present survey as embodied in this bibliography—both the inventory and the handlist—represents a first attempt to collect and organize information on visual resources.

The questionnaire sheets used to collect data are reproduced here for two reasons—for one, to indicate the ideas animating the committee, and for the other, to reach out to institutions that may still wish to contribute to the ongoing program of ARLIS/NA.

BICENTENNIAL INVENTORY OF VISUAL RESOURCES
(Reproductions)

Please return to: Bicentennial Visual Resources Committee, ARLIS/NA
P.O. Box 3692, Glendale, CA 91201

Date _____

Institution _____

Name of Library/Collection _____

Person in Charge & Title _____

Address _____ Telephone _____
Area Code & Number

City State Zip Code

Please mark spaces with x to indicate a positive reply.

Collections (Media) Represented

Approximate number or size of collection.

Photographs	_____	_____
Negatives	_____	_____
Slides	_____	_____
Postcards	_____	_____
Other	_____	_____

Please list (posters, films, videotapes, etc.):

NOTE: *DO NOT report graphics, i.e. prints, engravings, etc., which are held in the collections of museums and historical societies.*

Availability for Study and/or Purchase

Open to Public _____ Hours _____

Open by Appointment _____ Restricted Use _____ Scholars Only _____ Students _____

Purchase Only _____

Other

Reproduction Services

Photographic Prints _____

Photocopy _____ Microfilm _____

Slides: Color _____
 Black & White _____

Large Format Color Transparency: 4x5 _____ 5x7 _____ 8x10 _____

Other

Description of Reproduction Services

Catalogue Available _____

Listings _____

Fee Schedule _____

Special Collections

Please add remarks about special collections which you have in depth (e.g., photographs of Art Deco architecture, slides of Tiffany glass, etc.). Indicate format or media for each collection. Kindly use a supplemental page for your commentary.

COLLECTIONS QUESTIONNAIRE

(Major Holdings)

Subjects for which Material is Available	1. Architecture			2. Sculpture			3. Paintings			4. Decorative Arts & Other *e.g., Furniture, ceramics, mosaics; costume design, firearms, railroad engines.*		
	P	S	Other	P	S	Other	P	S	Other	P	S	Other
American Indian (AI)												
Age of Exploration (AE)												
Colonial Period 1620–1770 (C)												
American Revolution (AR) 1770–90												
Federal Period 1790–1812 (F)												
War of 1812 (W)												
Age of Jackson, Clay, and Calhoun 1828–50 (AJ)												
Westward Movement (WM)												
Mexican War 1848 (MW)												
Civil War 1860–65 (CW)												
Waves of Immigration (WI)												
Industrial Expansion (I) 1865–1910												
Turn of the Century/ Spanish-American War 1880–1910 (T)												
Early Twentieth Century 1910–14 (ETW)												
World War I 1914–18 (WWI)												
Nineteen Twenties (TW)												
Great Depression 1930–40 (GD)												
World War II 1940–45 (WWII)												
Postwar America 1946– (P)												
Space Age (SA)												
Agricultural Life (AL)												
Maritime Life (M)												
Sports (S)												
Entertainment (E)												

Code
P Photographs
S Slides

List of Institutions and Matching Code Letters

STATE	INSTITUTION	CODE LETTERS
ALABAMA	Museum of the City of Mobile	ALMOC
	Oakleigh Period House Museum	ALMOOP
	University of Alabama	ALUNI
	University of South Alabama	ALMOS
ARIZONA	Arizona Historical Society	AZTUA
	Arizona State University	$AZTEU_{av}$
	Arizona State University	$AZTEU_{p}$
	COM-S, Inc., a division of Sickles, Inc.	AZTEC
	Cosanti Foundation	AZSCC
	Navajo Tribal Museum	AZWRN
	Northern Arizona University Library	AZFLN
	Phoenix Art Museum	AZPHP
	Sharlot Hall Historical Society	AZPRS
	Sharlot Hall Museum	AZPRSM
	Tombstone Courthouse State Historic Park	AZTOT
	Tumacacori National Monument	AZTUMM
	University of Arizona	AZUnAV
ARKANSAS	Arkansas Arts Center	ARLRA
	College of the Ozarks	ARCLA
	Sheldon Jackson Museum	ARSIT
CALIFORNIA	Academy of Motion Picture Arts and Science	CABVA
	Art Council Aids	CABVAR
	Burbank Public Library	CABURPL
	California Institute of the Arts	CAVAIA
	California State University, Sacramento	CASCSU
	Creative Concepts of California	CACAC
	Dr. Block Color Productions	CALAB
	El Camino College Art Gallery	CATOEC
	Environmental Communications	CAVEEC
	The Gamble House, University of Southern California	CAPGH
	The Gateway Group, Inc.	CASFG
	Heritage Park Delano	CADEH
	John Muir National Historic Site	CAMAMU
	KaiDib Films International	CAGLK

Los Angeles County Museum of Art	CALABK
Los Angeles County Museum of Art	CALAS
Los Angeles Public Library	CALAPL
Mills College	CAOKM
Norton Simon Museum at Pasadena	CAPNSM
Oakland Museum	CAOKO
Oakland Museum, Oakes Gallery	CAOOG
Orange Empire Railway Museum, Inc.	CAPEO
Palomar College	CASMPC
Pasadena Historical Society Museum	CAPAH
Pomona Public Library	CAPOPL
R. H. Lowie Museum of Anthropology, University of California, Berkeley	CABRM
Richmond Art Center	CARIAC
San Bernardino County Museum	CARESB
San Francisco Art Institute	CASFAI
San Francisco Maritime Museum	CASFMM
San Francisco Museum of Modern Art	CASFMA
San Francisco State University, Art Department	CASFSU
San Jose State University	CASJSU
Scripps College	CACLS
The Sea Library	CALASL
Shasta College Museum	CARDS
Simi Valley Historical Society	CASVHC
Sonoma Valley Historical Society	CASOPV
Southwest Museum	CALASW
Stanford University Art Department	CASTUA
Stanford University Museum of Art	CASTUM
University Art Museum, Berkeley	CABRU
University of California, Berkeley	CABRAR
University of California	CALAIM
University of California, Los Angeles	CALAUS
University of California, Riverside	CARVU
University of California at Santa Barbara	CASBUC
University of California, Santa Cruz	CASCUC

	University of Southern California	CALASC
	Ventura County Historical Museum	CAVNHM
	Wells Fargo Bank	CASFWF

COLORADO	Aspen Historical Society Museum	COASP
	Denver Art Museum	CODVMC
	Denver Art Museum	CODVME
	Denver Art Museum	CODVMS
	Denver Public Library	CODVPL
	Overland Trail Museum	COSTOT

CONNECTICUT	Central Connecticut State College	CTNBCC
	Farmington Museum	CTFAM
	Hill-Stead Museum	CTFAH-S
	James C. Burchard Postcard Collection	CTNHBu
	Litchfield Historical Society	CTLIHS
	Mark Twain Memorial	CTHAMT
	The New Britain Museum of American Art	CTNBMA
	Prudence Crandall Museum	CTHAPC
	Sandak, Inc.	CTSTSA
	Stowe-Day Foundation	CTHAS-D
	Trinity College	CTHATR
	Wadsworth Atheneum	CTHAWA
	Wesleyan University	CTMIWU
	Yale Divinity School	CTYUDS
	Yale University	CTYUAA
	Yale University Library	CTYUBA
	Yale University Library	CTYUBW

DELAWARE	Delaware Art Museum	DEWIAM
	Eleutherian Mills Historical Library	DEWIEM
	Henry Francis du Pont Winterthur Museum	DEWIMU

DISTRICT OF COLUMBIA	The American Institute of Architects	DCAIA
	Archives of American Art	DCSmAA
	Catalog of American Portraits, see under Smithsonian Institution, National Portrait Gallery	
	DAR Museum	DCDAR
	The Dimock Gallery	DCGWU
	Hirshhorn Museum and Sculpture Garden, see under Smithsonian Institution	
	Historic American Engineering Record	DCHAER
	Howard University	DCHOWU
	Index of American Design, National Gallery of Art	DCNGAI

	Library of Congress	DCLCPP
	National Archives and Records Service	DCNAR
	National Audio Visual Center	DCNARAV
	National Collection of Fine Arts, see under Smithsonian Institution	
	National Gallery of Art	DCNGAE
	National Gallery of Art	DCNGAS
	National Museum of History and Technology, see under Smithsonian Institution	
	National Portrait Gallery, see under Smithsonian Institution	
	National Trust for Historic Preservation	DCNTHP
	The Phillips Collection	DCPC
	Photographic Archives, National Gallery of Art	DCNGAP
	Smithsonian Institution, Hirshhorn Museum and Sculpture Garden	DCHIM
	Smithsonian Institution, National Collection of Fine Arts	DCCFAB
	Smithsonian Institution, National Collection of Fine Arts	DCCFAP
	Smithsonian Institution, National Collection of Fine Arts/National Portrait Gallery	DCCFAL
	Smithsonian Institution, National Museum of History and Technology	DCSmHT
	Smithsonian Institution, National Portrait Gallery	DCNPG
	Smithsonian Institution, National Portrait Gallery, Catalog of American Portraits	DCNPGC
	Smithsonian Institution, Photographic Services	DCSmPS

FLORIDA	Florida State University	FLTAFS
	Henry Morrison Flagler Museum	FLPBFM
	Museum of Fine Arts of St. Petersburg, Florida, Inc.	FLSPMU
	Norton Gallery and School of Art	FLWPBN
	Rollins College	FLWPRC
	T. T. Wentworth, Jr., Museum	FLPEWM
	University of Miami	FLCGUM
	University of Florida	FLGAUF

| GEORGIA | Atlanta College of Art Library | GAATCHA |
| | Atlanta Historical Society | GAATHS |

	Fort Frederica National Monument	GASTFF
	Fort Jackson Maritime Museum	GASVFJ
	Georgia Institute of Technology	GAATIT
HAWAII	Bishop Museum	HIHOBM
	Honolulu Academy of Arts	HIHOAA
IDAHO	Custer Museum	IDCLCM
	Idaho State Historical Society	IDBSHS
ILLINOIS	The Art Institute of Chicago	$ILCHAI_{me}$
	The Art Institute of Chicago	$ILCHAI_{ph}$
	The Art Institute of Chicago	$ILCHAI_{sp}$
	Chicago Public Library	ILCHPL
	The Dusable Museum	ILCHDM
	Elmhurst Historical Society	ILELHM
	Illinois State Museum	ILSPSM
	Illinois State University	ILNOSU
	LaSalle County Historical Society Museum	ILOTHS
	Madison County Historical Museum	ILEDMH
	Museum of Contemporary Art	ILCHCA
	Northern Illinois University	ILDKNI
	Northwestern University	ILEVNW
	Public Art Workshop	ILCHPA
	The Roland Collection	ILNFPE
	Rosenthal Art Slides	ILCHRO
	Society for Visual Education, Inc.	ILCHSVE
	University of Chicago	ILCHUC
	University Galleries	ILCASI
	University of Illinois, Chicago	ILCHUI
	University of Illinois, Urbana	ILUIVA
INDIANA	Ball State University	INMUBS
	Earlham College	INRIEC
	Evansville Museum of Arts and Sciences, Inc.	INEVMU
	Herron School of Art, IUPUI	ININHE
	Indiana State University	INTHSU
	Indiana University	INBLUS
	Indianapolis Museum of Art	$ININMA_{fl}$
	Indianapolis Museum of Art	$ININMA_{rl}$
	Indianapolis Museum of Art	$ININMA_{sc}$

	Lincoln National Life Foundation	INFWLI
	Marshall County Historical Society Museum	INPLMC
	Purdue University	INWLPU
	University of Notre Dame	INNDU
IOWA	Des Moines Art Center	IADMAC
	Herbert Hoover Residential Library	IAWBHH
	Norwegian-American Museum	IADRNA
	State Historical Society of Iowa	IAICSHS
KANSAS	Cherokee Strip Living Museum	KSARCH
	Fort Hays Kansas State College	$KSHASC_a$
	Fort Hays Kansas State College	$KSHASC_1$
	Kansas State Historical Society	KSTOHS
	Pioneer Museum	KSASPM
	Sod Town Pioneer Homestead Museum	KSCOST
	University of Kansas	$KSLANK_s$
	University of Kansas	$KSLAUK_m$
	Wichita Art Museum	KSWIAM
	Wilson County Historical Society Museum	KSFRHS
KENTUCKY	Berea College	KYBEPC
	Center for Photographic Studies	KYLOPS
	University of Louisville	KYLOUL
	Western Kentucky University	KYBGWK
LOUISIANA	Anglo-American Art Museum	LABRAA
	Louisiana State Museum	LANOLS
	The R. W. Norton Art Gallery	LASHNA
MAINE	Bar Harbor Historical Society	MEBHHS
	Bath Marine Museum	MEBAMM
	Bowdoin College Department of Art	$MEBRBC_{da}$
	Bowdoin College Museum of Art	$MEBRBC_{ma}$
	Castine Scientific Society	MECASS
	Dexter Historical Society	MEDXHS
	Montpelier Historical Museum	METHMP
	Portland Society of Art	MEPOSA
	Ruggles House Society	MECFRH
	William A. Farnsworth Library and Art Museum	MEROFA

MARYLAND	Antietam National Battlefield Site, NPS	MDSHAN
	Goucher College	MDTOGC
	Johns Hopkins University	MDBAJA
	Maryland Historical Society	MDBAHS
	Maryland Institute College of Art	MDBAMI
	Peale Museum	MDBAPM
	University of Maryland	MDCPUM
	University of Maryland Baltimore County	MDBAUM
	Walters Art Gallery	MDBAWA

MASSACHUSETTS	American Antiquarian Society	MAWOAA
	Boston Architectural Center	MABOAC
	The Bostonian Society, Old State House	MABOBS
	Chesterwood/National Trust for Historic Preservation	MASTKC
	The Dunlap Society	MABODS
	Essex Institute	MASAEI
	Fogg Art Museum, Harvard University	MACAFO
	Forbes Library	$MANHFL_a$
	Forbes Library	$MANHFL_c$
	Gore Place	MAWAGP
	Isabella Stewart Gardner Museum	MABOGM
	Lexington Historical Society, Inc.	MALXAS
	Louisa May Alcott Memorial Association	MACOOH
	Massachusetts College of Art	MABOCA
	Massachusetts Historical Society	MABOHS
	Massachusetts Institute of Technology	MACAIT
	Merrimack Valley Textile Museum	$MANATX_{pd}$
	Museum of Fine Arts, Boston	MABOFA
	Museum of the American China Trade	MAMICT
	North Andover Historical Society	MANAHS
	Old Sturbridge Village	MASTUV
	Peabody Museum	MASAPM
	Peabody Museum, Harvard University	MACAPM
	Petersham Historical Society, Inc.	MAPEHS
	Plymouth Antiquarian Society	MAPLAS
	Salem Maritime National Historic Site	MASAHS
	Smith College, Hillyer Art Library	$MANOSM_l$

	Smith College Museum of Art	$MANHSC_m$
	Society for the Preservation of New England Antiquities	MABOPR
	Sterling and Francine Clark Art Institute	$MAWMCI_p$
	Sterling and Francine Clark Art Institute	$MAWMCI_s$
	Tales of Cape Cod	MAWHCC
	Worcester Art Museum	MAWOAM

MICHIGAN	Albion College	MIALBC
	Architecture and the Related Arts Educational Transparencies	MIDEME
	Detroit Public Library	MIDEPL
	Henry Ford Centennial Library	MIDRHF
	Kalamazoo Institute of Arts	MIKAIA
	Marshall Historical Society, Archives	MIMAHS
	Marygrove College/University of Detroit	MIDEMC
	University of Michigan	$MIAAUM_{av}$
	University of Michigan	$MIAAUM_{sp}$
	Wayne Andrews	MIGPWA
	Wayne State University	MIDEWS
	Western Michigan University	MIKAWM

MINNESOTA	Blue Earth County Historical Society Museum	MNMABE
	Cook County Historical Society	MNGMCC
	Minneapolis Institute of Arts	MNMPIA
	Minneapolis Public Library and Information Center	MNMPPLA
	Minneapolis Public Library and Information Center	$MNMPPL_{hc}$
	Vermilion Community College	MNELVC
	Walker Art Center	$MNMPWA_e$
	Walker Art Center	$MNMPWA_s$

| MISSISSIPPI | Mississippi Department of Archives and History | MSJAAH |
| | University of Mississippi | MSUNMF |

MISSOURI	Harry S Truman Presidential Library	MOINTL
	Missouri Western State College	MOSJMW
	National Museum of Transport	MOSLMT

On the Wall Productions	MOSLWP	
St. Louis Art Museum	MOSLAM	
University of Missouri	MOCOUM$_{ah}$	
University of Missouri	MOCOUM$_{mu}$	
University of Missouri—Kansas City Libraries	MOKCUM$_{sah}$	
Washington University	MOSLWU$_l$	
Washington University	MOSLWU$_s$	
Watkins Woolen Mill State Historical Site	MOLAWM	

MONTANA	Douglas Grimm	MTMIDG
	Stella A. Foote—Western Heritage Center	MTBIWH
	University of Montana	MTMIUM

NEBRASKA	Fort Robinson Museum	NECRFR
	Joslyn Art Museum	NEOMJA$_c$
	Joslyn Art Museum	NEOMJA$_r$
	Pony Express Station	NEGOPE
	Willa Cather Pioneer Memorial	NERCWC

NEVADA	Nevada Historical Society	NVRENH
	Northeastern Nevada Museum	NVELNN

NEW HAMPSHIRE	Currie Gallery of Art	NHMACG
	Strawbery Banke	NHPOSB

NEW JERSEY	Art Now, Inc.	NJKEAN
	Bergen Community College	NJPABC
	E. Teitelman, Photography and Architectural History	NJCATE
	Fairleigh Dickinson University, Madison	NJMaFD
	Gloucester County Historical Society	NJWOGC
	Historical Society of Princeton	NJPRHS
	Johnston Historical Museum, Boy Scouts of America	NJNOBS
	Keller Color, Inc.	NJCLKC
	Monmouth County Historical Association	NJFRMC
	Montclair Art Museum	NJMOMA
	Newark Museum	NJNENM
	Newark Public Library	NJNEPL
	Princeton University	NJPRPU$_a$
	Princeton University, The Art Museum	NJPRPU$_m$
	Rutgers NCAS	NJNERU
	Visual Media for the Arts and Humanities	NJCHVM

NEW MEXICO	Aztec Ruins National Monument	NMAZAZ
	Museum of New Mexico	NMSFMN
	University of New Mexico	NMALTI
	University of New Mexico, Albuquerque	NMALUN
	Roswell Museum and Art Center	NMRORM

NEW YORK	Albany Institute of History and Art	NYALAI
	Albright-Knox Art Gallery	NTBUAK
	Allan Boutin	NYNYBO
	American Crafts Council	NYNYAC
	American Heritage Publishing Company, Inc.	NYNYAH
	American Life Foundation and Study Institute	NYW
	Archaeological Institute of America	NYNYAR
	Avery Library	NYNYCU$_a$
	Berkey K and L Custom Services, Inc.	NYNYB
	The Bettmann Archive, Inc.	NYNYBA
	Brooklyn College	NYBRBC
	Brooklyn Museum	NYBRBM
	Brooklyn Public Library	NYBRPL
	Buffalo and Erie County Historical Society	NYBUBE
	Canal Museum	NYSYCM
	Castelli-Sonnabend Tapes and Films	NYNYCS
	The Center for Humanities, Inc.	NYWPCH
	Chemung County Historical Society	NYEXCC
	Columbia University	NYNYCU$_{daa}$
	The Corning Museum of Glass	NYCORM
	The Dunlap Society	NYESDU
	Eastchester Historical Society	NYESEH
	Elmira College	NYEXEC
	Essex County Historical Society Library	NYETEC
	Frick Art Reference Library	NYNYFA
	The Frick Collection	NYNYFC
	The Friends of Rayham Hall, Inc.	NYOYRH
	G. D. Hackett Studio	NYNYHA
	Geneva Historical Society and Museum	NYGEGH
	The Granger Collection	NYNYGC
	Grey Art Gallery and Study Center	NYNYU
	Guild Hall	NYEHGH
	Hall of Fame for Great Americans	NYNYHF
	Hall of Fame of the Trotter	NYGOHF
	The Hudson River Museum	NYYOHR

International Museum of Photography at George Eastman House	NYRoIM
The Landmark Society of Western New York, Inc.	NYRoLS
McGraw-Hill Films/ Contemporary Films	NYNYMC
The Metropolitan Museum of Art	NYNYMM
The Metropolitan Opera	NYNYMO
Mohawk Valley Museum	NYUTMV
Morris Gerber Collection/"Old Albany"	NYALOA
Munson-Williams-Proctor Institute	NYUTMW
Museum at Large, Ltd.	NYNYMR
Museum of the American Indian	NYNYMV
Museum of the American Indian	NYNYMV
The Museum of Modern Art	NYNYMU$_a$
The Museum of Modern Art	NYNYMU$_d$
The Museum of Modern Art	NYNYMU$_f$
Nassau County Museum	NYEMNC
National Baseball Hall of Fame and Museum, Inc.	NYCONB
The New York Historical Society	NYNYHS
The New York Public Library	NYNYPL
New York State Museum, Office of State History	NYAINY
"Old Albany" Photos, see Morris Gerber Collection	
Phyllis Lucas Gallery and Old Print Center	NYNYLU
Pierpont Morgan Library	NYNYMP
Pratt Institute	NYBRPR
Remington Art Museum	NYOGRA
Rensselaer County Historical Society	NYTRRC
Rensselaer Polytechnic Institute	NYTRRP
Rochester Institute of Technology	NYRoRI
The Schenectady Museum	NYSCSM
Society of Illustrators	NYNYSI
Society for the Preservation of Long Island Antiquities	NYSESP
Society for the Preservation of Long Island Antiquities	NYSeLI
State University of New York at Albany	NYALSU
State University of New York at Binghamton	NYBISU
State University of New York at Buffalo	NYBUSU
Syracuse University	NYSYSU$_a$
Syracuse University	NYSYS$_g$

	Three Lions Inc.	NYNYTH
	Time Incorporated	NYNYTI
	United States Military Academy, West Point	NYWEUX
	The University of the State of New York	NYSCUS
	York College of City University of New York	NYJAYC
NORTH CAROLINA	Guilford Courthouse National Military Park	NCGRGC
	High Point Museum	NCHPHP
	Kings Mountain National Military Park	NCKMKM
	Moores Creek National Military Park	NCCUMC
	Museum of Early Southern Decorative Arts	NCWSME
	North Carolina Museum of Art	NCRANC
	North Carolina State University	NCRASU
	University of North Carolina at Chapel Hill	NCCHUN
NORTH DAKOTA	North Dakota State University	NDFASU
OHIO	Akron Art Institute	OHAKAA
	Allen County Historical Society	OHLIAC
	The Butler Institute of American Art	OHYOBI
	Clark County Historical Society	OHSPCC
	Cleveland Institute of Art	OHCLCI
	The Cleveland Museum of Art	OHCLCM
	Educational Art Transparencies	OHCFEA
	Geauga County Historical Society—Century Village	OHBUGC
	Mound City Group National Monument	OHCHMC
	Mt. Pleasant Historical Center	OHMPHC
	Ohio State University	OHCOOS
	Public Library of Cincinnati and Hamilton County	OHCIPL
OKLAHOMA	Bartlesville Public Library	OKBPL
	Cherokee National Historical Society, Inc.	OKTACH
	Ponca City Cultural Center and Indian Museum	OKPCCC
	Stephens County Historical Museum	OKDUSC
	Tulsa Junior College	OKTUJC
	University of Oklahoma, School of Art	OKNOU$_s$
	University of Oklahoma, Museum of Art	OKNOUM
	Woolaroc Museum	OKBWM

OREGON	Collier State Park Logging Museum	ORKFCP
	Portland Art Museum/Museum Art School	ORPAM
	University of Oregon	OREUO
	University of Oregon Slide Library	OREUO$_s$

PENNSYLVANIA	Allentown Art Museum	PAALAM
	American Philosophical Society	PAPHAM
	Athenaeum of Philadelphia	PAPHAT
	Brandywine River Museum	PACHBR
	Bryn Mawr College	PABMC
	Carnegie Institute Museum of Art	PAPICI
	Carnegie Library of Pittsburgh	PAPICL
	Clarion State College	PACLSC
	Fort Necessity National Battlefield	PAFAFN
	Free Library of Philadelphia	PAPHFL
	Haverford College Library	PAHAVC
	Historical Society of Pennsylvania	PAPHHS
	INA Corporation Museum and Archives	PAPHIC
	Library Company of Philadelphia	PAPHLC
	Longwood Gardens, Inc.	PAKSLG
	Pennsylvania Academy of the Fine Arts	PAPHPA
	Pennsylvania Dutch Folk Culture Society, Inc.	PALDFS
	Pennsylvania Historical and Museum Commission	PAHARH
	Philadelphia College of Art	PAPHPC
	Philadelphia Historical Commission	PAPHPH
	Philadelphia Maritime Museum	PAPHPI
	Philadelphia Museum of Art	PAPHPM$_{oc}$
	Philadelphia Museum of Art	PAPHPM$_p$
	The Print Club	PAPHPR
	Swigart Museum	PAHUSM
	Temple University	PAEPTU
	Union County Bicentennial	PALUCB
	University Museum of the University of Pennsylvania	PAPHUP$_m$
	University of Pennsylvania	PAPHUP$_f$
	University of Pittsburgh	PAPIUP$_f$

	University of Pittsburgh	PAPIUP$_g$
	Ursinus College	PACOUC
	Valley Forge Historical Society	PAVFHS
	Warren County Historical Society	PAWARC
	Washington Crossing Foundation	PAWASC
	Westmoreland County Museum of Art	PAGRWC
	William Penn Memorial Museum	PAHAPM

RHODE ISLAND	Budek Films & Slides, Inc.	RIEPBU
	Rhode Island School of Design	RIPRRI
	Rhode Island School of Design, Museum of Art	RIPRRI$_m$

SOUTH CAROLINA	Gibbes Art Gallery, Carolina Art Association	SCCHGA
	Miriam B. Wilson Foundation, Old Slave Mart Museum	SCSUOS
	South Carolina Historical Society	SCCHSC

SOUTH DAKOTA	Historical Resource Center, Robinson Museum	SDPISH
	South Dakota Memorial Art Museum	SDBRSD
	St. Francis Indian Mission	SDSFIM
	W. H. Over Museum	SDVEOM

TENNESSEE	Andrew Johnson National Historic Site	TNGRAJ
	Brooks Memorial Art Gallery	TNMEBM
	Chucalissa Museum	TNMECM
	The Memphis Academy of Arts	TNMEMA
	Memphis State University	TNMESU
	The University of the South	TNSEUS
	University of Tennessee at Chattanooga	TNCHUT
	Vanderbilt University	TNNAVU

TEXAS	Amon Carter Museum of Western Art	TXFWCM
	Art Museum of South Texas	TXCCAM
	Carson County Square House Museum	TXPHCC
	Fort Belknap Archives, Incorporated	TXNEFP
	Fort Concho Preservation and Museum	TXSAFC
	Fort Davis National Historic Site	TXFDHS

	Fort Worth Art Museum Library	TXFWFW
	Institute of Texas Cultures	TXSNTC
	Kimbell Art Museum	TXFWKM
	L. B. J. Library	TXAULJ
	Museum of Fine Arts, Houston	TXHOMFA
	Rice University	TXHORU
	Star of the Republic Museum	TXWASR
	University of Houston Art Department	TXHOUH$_a$
	University of Houston	TXHOUH$_f$
	University of Texas at Austin	TXAUUT
	Varner-Hogg State Park	TXWCVH
	Witte Memorial Museum	TXSNWM
UTAH	Brigham City Museum—Gallery	UTBCBC
	Bryce Canyon National Park	UTBRBC
	Zion National Park	UTSPZN
VERMONT	Middlebury College	VTMIMC
	University of Vermont	VTBUUV
	Woodstock Historical Society, Inc.	VTWOWH
VIRGINIA	Abby Aldrich Rockefeller Folk Art Collection	VAWICW$_r$
	Association for the Preservation of Virginia Antiquities	VARIAP
	Booker T. Washington National Monument	VAHABT
	Colonial Williamsburg Foundation	VAWICW$_a$
	Colonial Williamsburg Foundation/Abby Aldrich Rockefeller Folk Art Collection	VAWICW$_{re}$
	George Washington Birthplace National Monument	VAWBNM
	Hampton Association for the Arts and Humanities	VAHAAH
	Madison College	VAHRMC
	The Mariners Museum	VANNMM
	The Museum of the Confederacy	VARIMC
	Old Stone Jail Museum	VAPAOS
	Petersburg National Battlefield	VAPENB
	Roanoke Valley Historical Society	VARORV
	Richmond National Battlefield Park	VARIRN
	Robert E. Lee Memorial Association, Inc.	VASTRL

	Sweet Briar College	VASWC
	The Valentine Museum Library	VARIVA
	Virginia Commonwealth University	VARIVC
	Virginia Historical Society	VARIVH
	Washington and Lee University	VALXWL
	Woodlawn Plantation	VAMVWP
	Woodrow Wilson Birthplace Foundation, Inc.	VASTAW
WASHINGTON	Eastern Washington State Historical Society	WASPEW
	Fort Lewis Military Museum	WAFLMM
	Fort Nisqually Museum	WATAFN
	Museum of History and Industry	WASEMH
	Roslyn Arts	WARPRA
	Seattle Art Museum	WASESM
	Skagit County Historical Society Museum	WALCSC
	T. G. Reed Personal Collection	WABERC
	University of Washington	WASEUW$_{su}$
	University of Washington	WASEUW$_{sa}$
WEST VIRGINIA	The Charleston Art Gallery of Sunrise	WVCHAG
	Fort Savannah Museum	WVLEFS
	Huntington Galleries	WVHUHG
WISCONSIN	Circus World Museum	WIBACW
	Gateway Technical Institute	WIKEGT
	Milwaukee Art Center	WIMIMC
	Old Indian Agency House	WIMIOI
	State Historical Society of Wisconsin	WIMASH
	University of Wisconsin, Madison	WIMAUW
	University of Wisconsin, River Falls	WIRFUW
	University of Wisconsin, Stevens Point	WISPUW
	Viterbo College	WILCVC
WYOMING	Anne Miller Museum	WYNEAM
	Bradford Brinton Memorial Museum	WYBHBB
	Sweetwater County Historical Museum	WYGRSC
	University of Wyoming	WYLAUW
	Warren Military Museum	WYWAWM
	Yellowstone National Park Collection, National Park Service	WYYENP



Hours: 10:00–5:00, Tu–Sa; 1:00–5:00, Su

Access: Open to public except on Sunday (docents and staff only); slide collection open to public by appointment only for restricted use

Reproduction Services: Photographic prints, color slides

Size of Collection: 11,000 slides, 10 objects reproduced on postcards

Major Holdings: AI–2S, 3S; AE–1S, 2S, 3S; C–1S, 2S, 3S, 4S; AR–1S, 2S, 3S, 4S; F–1S, 2S, 3S, 4S; W–1S, 2S, 3S, 4S; AJ–1S, 2S, 3S, 4S; WM–1S, 2S, 3S, 4S; MW–3S; CW–1S, 2S, 3S, 4S; WI–3S; I–1S, 3S, 4S; T–1S, 3S, 4S; ETW–1S, 2S, 3S, 4S; WWI–1S, 2S, 3S, 4S; TW–1S, 2S, 3S, 4S; GD–1S, 2S, 3S, 4S; WWII–1S, 2S, 3S, 4S; P–1S, 2S, 3S, 4S; SA–2S, 3S, 4S; AL–2S, 3S, 4S; M–3S; E–3S

U7. **AZPRS**

Sharlot Hall Historical Society
Sharlot Hall Museum
415 W. Gurley Street
Prescott, Arizona 86301
(602) 445-3122
Kenneth Kimsey, Director

Hours: 9:00–5:00, Tu–Sa
Access: Open to public
Reproduction Services: Photographic prints, photocopy
Size of Collection: 5,000 photographs, 5,000 negatives
Special Collections: Photographs deal with Prescott vicinity and Central Arizona

Major Holdings: I–4P; T–4P; ETW–4P; TW–4P; GD–4P; AL–4P

U8. **AZPRSM**

Sharlot Hall Museum
415 W. Gurley Street
Prescott, Arizona 86301
(602) 445-3122

Hours: 9:00–5:00, Tu–Sa
Access: Open to public
Reproduction Services: Photographic prints, photocopy
Size of Collection: 10,000 photographs, 4,000 negatives
Special Collections: Photographs primarily of Arizona 1860–1970

Major Holdings: AI–4P; I–4P; ETW–4P; AL–4P; S–4P

U9. **AZSCC**

Cosanti Foundation
Paolo Soleri
6433 East Doubletree
Scottsdale, Arizona 85253
(602) 948-6526
Ivan Pintar, Photographer

Access: Purchase only, 35mm slides
Special Collections: Soleri Slide Series

U10. **AZTEC**

COM-S, Inc., a division of Sickles, Inc.
1200 N. Sickles Drive
Tempe, Arizona 85281
(602) 967-1492
Robert Sickles, Vice-President

Reproduction Services: Microfilm, color slides, color microfiche from slides or hard copy

U11. **AZTEU**$_{av}$

Arizona State University
College of Architecture A–V Department
Slide Library
Tempe, Arizona 85218
(602) 965-7253
Helen Ziffer, Slide Curator

Hours: 7:00–7:00
Access: Restricted to faculty use
Reproduction Services: Black and white slides
Size of Collection: 38,000 slides

Major Holdings: AI–1S, 2S, 3S, 4S; AE–1S, 2S, 3S, 4S; C–1S, 2S, 3S, 4S; AR–1S, 2S, 3S, 4S; F–1S; AJ–1S, 2S; WM–1S, 2S, 3S, 4S; MW–1S, 2S; CW–1S, 2S, 3S, 4S; I–1S, 2S, 3S, 4S; T–1S, 2S, 3S, 4S; ETW–1S, 2S; WWI–1S, 2S; TW–1S, 2S, 3S, 4S; GD–1S, 2S; WWII–1S, 2S, 3S, 4S; P–1S, 2S; SA–1S; AL–1S, 2S, 3S, 4S

U12. **AZTEU**$_p$

Arizona State University
Photography Service
Matthews Hall
Tempe, Arizona 85281
(602) 965-3637
David V. Poor, Supervisor

Hours: 8:00–5:00, M–F
Access: Purchase only by anyone of the university community
Reproduction Services: Photographic prints, photocopy, color and black and white slides, 4x5 color transparencies, fee schedule available
Size of Collection: 2,000 negatives, 1,000 slides

U13. **AZTOT**

Tombstone Courthouse State Historic Park
P.O. Box 216
Tombstone, Arizona 85638
(602) 457-3531
John P. Marvin, Curator of Collections
Robert Wing, Park Supervisor

Hours: 8:00–5:30 daily
Access: Open by appointment only, restricted to scholars
Reproduction Services: none
Size of Collection: 300 photographs, 100 negatives, 30 views on postcards, 250 transparent stereopticon slides, 60 stereopticon slides
Special Collections: 75 black and white photographs of Tombstone and area by C.S. Fly,

Tombstone photographer in 1880s

Major Holdings: AI—1P, 2P; I—1P, 1P; T—1P, 2P; ETW—1P; WWI—1P; TW—1P

U14. **AZTUA**

Arizona Historical Society
949 East 2nd Street
Tucson, Arizona 85705
(602) 882-5774
Margaret Bret Harte, Research Librarian

Hours: 9:00—4:00, M—F; 9:00—12:00, Sa
Access: Open to public
Reproduction Services: Photographic prints, photocopy
Size of Collection: 350,000 photographs, 250,000 negatives, 100 slides, postcards

Major Holdings: AI—1P; T—1P; WWI—1P; TW—1P

U15. **AZTUMM**

Tumacacori National Monument
Visitor Center and Museum
 (Mission Church and Associated Grounds)
Tumacacori, Arizona 85640
(602) 398-2341
Joe L. Sewell, Superintendent

Hours: 8:30—6:00 daily
Access: Open to public
Reproduction Services: none
Size of Collection: Photographs, negatives, slides, postcards
Special Collections: Spanish Colonial Period

Major Holdings: AI—1P, 1S; AE—1P, 1S; C—1P, 1S, 2P, 2S

U16. **AZUnAV**

University of Arizona
Bureau of Audio Visual Services
1325 E. Speedway
Tucson, Arizona 85719
(602) 884-3282
Dr. C.E. Eddleblute, Director

Hours: 8:00—5:00, M—F
Access: Open to public, rental library only, catalog and listings available
Reproduction Services: none
Size of Collection: 6,500 16mm films

U17. **AZWRN**

Navajo Tribal Museum
Museum and Research Department
P.O. Box 797
Window Rock, Arizona 86515
(602) 871-4941
Martin Link

Hours: 8:00—5:00, M—F
Access: Open to public with restricted use
Reproduction Services: Color slides
Size of Collection: 2,000 photographs, 2,000 negatives, 500 slides, 25 films

Major Holdings: AI—1P, 1S, 3S, 4P, 4S; WM—4P; WWII—4P

ARKANSAS

U18. **ARCLA**

College of the Ozarks
Dobson Memorial Library
College and Ward Streets
Clarksville, Arkansas 72830
(501) 754-3964
Mrs. Lucille Murphy, Head Librarian

Access: Restricted use by students
Reproduction Services: none
Size of Collection: 3,200 slides, 2 16mm films

Major Holdings: ETW—3S; WWI—3S; TW—2S, 3S; GD—3S; WWII—3S; P—1S, 2S, 3S

U19. **ARLRA**

Arkansas Arts Center
MacArthur Park
Little Rock, Arkansas 72203
(501) 376-3671
Dana Durst, Slide Librarian

Size of Collection: 3,100 slides (approx.)

Major Holdings: C—1S, 2S, 3S; AR—1S, 2S; F—1S, 2S, 3S; W—1S, 2S, 3S; AJ—1S, 2S, 3S; WM—1S, 2S, 3S; MW—1S, 2S, 3S; CW—1S, 2S, 3S; WI—1S, 2S, 3S; I—1S, 2S, 3S; T—1S, 2S, 3S; ETW—1S, 2S, 3S; WWI—1S, 2S, 3S; TW—1S, 2S, 3S; GD—1S, 2S, 3S

U20. **ARSIT**

Sheldon Jackson Museum
Box 479
Sitka, Arkansas 99835
(907) 747-5228
Esther Billman, Curator

Hours: Summer, 10:00—5:00; Winter, 1:00—4:00
Access: Open to public, restricted use
Reproduction Services: none at present
Size of Collection: 200 photographs, 3,000 negatives, 600 slides, 200 postcards
Special Collections: Merrill Collection of photographs of early Sitka; Smith Collection of photographs of early Sitka; negative and contact prints of museum artifacts

Major Holdings: AI—2P, 4P; T—4P

CALIFORNIA

U21. **CABRAR**

University of California, Berkeley
Department of Architecture
Visual Aids Collection
315 Wurster Hall
Berkeley, California 94720
(415) 642-3439
Judy Weiss, Visual Aids Librarian

Access: Open to faculty member of UCB Architecture Dept.
Size of Collection: 10,000 photographs, 90,000 slides [*cont.*]

Major Holdings: C−1P, 1S; AR−1P, 1S; F−1P, 1S; AJ−1P, 1S; WM−1P, 1S; MW−1P, 1S; CW−1P, 1S; WI−1P, 1S; I−1P, 1S; T−1P, 1S; ETW−1P, 1S; WWI−1P, 1S; TW−1P, 1S; GD−1P, 1S; WWII−1P, 1S; SA−1P, 1S; AL−1S

U22. **CABRM**

R.H. Lowie Museum of Anthropology, University of California, Berkeley
103 Kroeber Hall, U.C. Berkeley
Berkeley, California 94702
(415) 642-3681
Dr. William Bascom, Director

Access: Open by appointment
Reproduction Services: Photographic prints, color slides, 4x5 large color transparencies
Size of Collection: 40,000 negatives, 7,000 slides
Special Collection: Negatives primarily of California Indian artifacts; ethnographic negatives of California Indians and related subjects from 1900−1930s

Major Holdings: AI−1P; 2P; 2S

U23. **CABRU**

University Art Museum, Berkeley
University of California, Berkeley
2625 Durant Avenue
Berkeley, California 94720
(415) 642-0346
Nan Rosenbloom, Curatorial Assistant/Publications

Hours: 9:00−12:00, 1:00−5:00, M−F
Access: Open to public
Reproduction Services: Photographic prints; 4x5, 5x6, 8x10 large format color transparencies; color slides
Size of Collection: 700 photographs, 700 negatives, 300 slides, postcards, posters, color transparencies
Special Collections: Largest collection of Hans Hofmann paintings in the world (48); black and white photographs and color transparencies available

Major Holdings: AI−3P, 3S; AR−3P, 3S

U24. **CABURPL**

Burbank Public Library
Warner Research Collection
110 North Glenoaks Blvd.
Burbank, California 91503
(213) 947-9743
Mary Ann Grasso, Research Librarian
Doris Crutcher, Picture Curator

Hours: 9:00−6:00, M−F
Access: Open by appointment, restricted use, fee schedule
Reproduction Services: Photocopy
Size of Collection: Inestimable
Major Holdings: AI−1P, 3P, 4P; AE−3P; C−1P, 2P, 3P, 4P; AR−1P, 2P, 3P, 4P; F−1P, 2P, 3P, 4P; W−1P, 2P, 3P, 4P; AJ−1P, 2P, 3P, 4P; WM−1P,

3P; MW−1P, 3P; CW−1P, 2P, 3P, 4P; WI−1P, 2P, 3P, 4P; I−1P, 2P, 3P, 4P; T−1P, 2P, 3P, 4P; ETW−1P, 2P, 3P, 4P; WWI−1P, 2P, 3P, 4P; TW−1P, 2P, 3P, 4P; GD−1P, 2P, 3P, 4P; WWII−1P, 2P, 3P, 4P; P−1P, 2P, 3P, 4P; SA−1P, 2P, 3P, 4P; AL−1P, 2P, 3P, 4P; M−1P, 2P, 3P, 4P; S−1P, 2P, 3P, 4P; E−1P, 2P, 3P, 4P

U25. **CABVA**

Academy of Motion Picture Arts and Sciences
Margaret Herrick Library
8949 Wilshire Blvd.
Beverly Hills, California 90211
(213) 278-8990
Mildred Simpson, Librarian

Hours: 9:00−5:00, M−F
Access: Open to public
Reproduction Services: Photographic prints, photocopy, fee schedule available
Size of Collection: Photographs, negatives, slides, posters, pressbooks
Special Collections: All material has to do with motion pictures; photographs generally show scenes from a film and therefore illustrate the period depicted in the film in a secondary way

U26. **CABVAR**

Art Council Aids
P.O. Box 641
Beverly Hills, California 90213
(213) 462-7567
John V. Twyman, Director/Owner

Access: Purchase only
Size of Collection: 222 slides (6 series)
Special Collections: Slide series and written commentary: (ACA−20) Alaskan Eskimo Art; (ACA−12) Art of the Northwest Coast Indian; (ACA−29) The Tlingit; (ACA−21, 22) American Painters, 1815−1865; (ACA−23) Noted Jewelry Craftsmen

Major Holdings: AI−2S, 3S, 4S; AJ−3S; WM−3S; P−4S

U27. **CACAC**

Creative Concepts of California
P.O. Box 649
Carlsbad, California 92008
(714) 273-2555
Robert L. Goddard

Access: Purchase only (mail order)
Reproduction Services: Color slides, catalog available free
Size of Collection: 29,000 slides
Special Collections: Colonial houses and building; Jefferson's architecture; missions of Southwest and California; modern architecture, including Frank Lloyd Wright, Le Corbusier, Richardson, Sullivan, etc.; collection of Victorian U.S. houses; eclectic architecture

Major Holdings: C–1S; AR–1S; F–1S; ETW–1S, 2S, WWI–1S; TW–1S; GD–1S; WWII–1S; P–1S

U28. **CACLS**

Scripps College
Scripps College Slide Collection
Claremont, California 91711
(714) 626-8511
Arthur D. Stevens, Associate Professor, Art History

Hours: 9:00–5:00, M–F
Access: Restricted use, open to public (somewhat)
Size of Collection: 30,000 slides

Major Holdings: AI–1S, 3S, 4S; C–3S, 4S; AR–3S, 4S; F–2S, 3S, 4S; W–1S, 3S, 4S; AJ–1S, 3S, 4S; CW–1S, 2S, 3S, 4S; I–1S, 2S, 3S, 4S; T–1S, 2S, 3S, 4S; ETW–1S, 3S; WWI–1S, 2S, 3S; TW–1S, 2S, 3S; GD–1S, 2S, 3S; WWII–1S, 2S, 3S; P–1S, 2S, 3S

U29. **CADEH**

Heritage Park Delano
Delano Historical Society
1123 Cecil Avenue
Delano, California 93215
(805) 725-0529

Hours: By appointment
Access: By appointment
Size of Collection: 1,000 photographs, 1,000 slides, 50 other
Special Collections: Western; farm machinery

Major Holdings: T–1P, 1S; ETW–1P, 1S, 3P; WWI–1P, 1S; TW–1P, 1S; GD–1P, 1S; AI–1P, 1S

U30. **CAGLK**

KaiDib Films International
P.O. Box 261
Glendale, California 91209

Access: Purchase only
Size of Collection: 1,400 slides
Special Collections: "Theatre USA," a survey of American theater to present; concrete architecture in North America; survey of modern California's architecture; Simon Rodia Towers (Watts Towers); "50 Years of Lipchitz," retrospective of Jacques Lipchitz

Major Holdings: WWII–1S, 2S, 4S; P–1S, 2S; E–4S

U31. **CALAB**

Dr. Block Color Productions
1309 N. Genesee Avenue
Los Angeles, California 90046
(213) 876-3290
Mrs. Fred Block, owner

Access: Purchase only
Reproduction Services: Catalog available
Size of Collection: 3,300 slides

Major Holdings: AI–1S, 2S, 3S, 4S

U32. **CALABK**

Los Angeles County Museum of Art
Bookshop
5905 Wilshire Blvd.
Los Angeles, California 90036
(213) 937-4250
Patricia Caspary, Publications Sales Director

Hours: 10:00–5:00, Tu–Su
Access: Open to public, purchase only
Size of Collection: 175 slides, 75 postcards, V.N. posters, reproductions, audio-tapes

Major Holdings: AI–4S; AR–3S; F–3S; W–3S; AJ–3S; WM–3S; MW–3S; CW–3S; WI–3S; I–3S; ETW–3S; WWI–3S; TW–3S; GD–3S; WWII–3S; P–3S

U33. **CALAIM**

University of California
UCLA Media Center
Instructional Media Library
8 Royce Hall
405 Hilgard Avenue
Los Angeles, California 90024
(213) 825-0755

Access: Open by appointment, rental
Reproduction Services: Catalog available

U34. **CALAPL**

Los Angeles Public Library
California Room
630 W. Fifth Street
Los Angeles, California 90017
(213) 626-7461
Bettye Ellison, Librarian

Hours: 10:00–9:00, M–Th; 10:00–5:30, F, Sa
Access: Open to public, restricted use
Reproduction Services: Commercial photographer, fee schedule
Size of Collection: 12,000 photographs, 1,657 negatives, 250 postcards
Special Collections: Collection of California scenes with emphasis on Los Angeles and surrounding communities; largest holdings in the categories of street scenes, buildings (businesses, residences, hotels, theaters), panoramic views, adobes, missions, and portraits of early Southern Californians

Major Holdings: ETW–1P; WWI–1P; TW–1P; E–1P

U35. **CALAS**

Los Angeles County Museum of Art
Slide Library
5905 Wilshire Blvd.
Los Angeles, California 90036
(213) 937-4250, ext. 303
Robin Kaplan, Slide Librarian

Hours: 11:00–4:50, Tu–F
Access: Rental to lecturers and teachers on a local basis
Size of Collection: 77,000 slides [*cont.*]

Special Collections: LACMA collection on slides

Major Holdings: AI–1S, 2S, 3S, 4S; AE–1S, 2S, 3S, 4S; C–1S, 2S, 3S, 4S; AR–1S, 2S, 3S, 4S; F–1S, 2S, 3S, 4S; W–1S, 2S, 3S, 4S; AJ–1S, 2S, 3S, 4S; WM–1S, 2S, 3S, 4S; MW–1S, 2S, 3S, 4S; CW–1S, 2S, 3S, 4S; WI–1S, 2S, 3S, 4S; I–1S, 2S, 3S, 4S; T–1S, 2S, 3S, 4S; ETW–1S, 2S, 3S, 4S; WWI–1S, 2S, 3S, 4S; TW–1S, 2S, 3S, 4S; GD–1S, 2S, 3S, 4S; WWII–1S, 2S, 3S, 4S; P–1S, 2S, 3S, 4S

U36. CALASC

University of Southern California
Architecture and Fine Arts Library
University Park
Los Angeles, California 90007
(213) 746-2798
Hilde Waldo, Slide Curator

Hours: 8:30–5:00, M–F
Size of Collection: 91,000 slides (entire collection), 1,000 postcards

Major Holdings: AI–1S, 2S, 3S; AE–1S, 2S, 3S; C–1S, 2S, 3S; AR–1S, 2S, 3S; F–1S, 2S, 3S; W–1S, 2S, 3S; AJ–1S, 2S, 3S; WM–1S, 2S, 3S; MW–1S, 2S, 3S; CW–1S, 2S, 3S; WI–1S, 2S, 3S; I–1S, 2S, 3S; T–1S, 2S, 3S; ETW–1S, 2S, 3S; WWI–1S, 2S, 3S; TW–1S, 2S, 3S; GD–1S, 2S, 3S; WWII–1S, 2S, 3S; P–1S, 2S, 3S; SA–1S, 2S, 3S; AL–1S, 3S; M–3S

U37. CALASL

The Sea Library
8391 West Waring Avenue
Los Angeles, California 90069
(213) 653-2922
Jill E. Fairchild, Director/Owner

Hours: 9:00–5:00
Access: Open by appointment
Reproduction Services: Photographic prints, fee schedule
Size of Collection: 200 photographs, 40,000 slides
Special Collections: Original slides of complete whaling industry, coastal development, pollution, native life-styles, mariculture, Great White sharks; photo essays of tropical reef areas such as the Great Barrier Reef; historical slides of man and the sea including early diving systems designs; slides of all habitats and submersibles including William Beebe's bathoscaphe

Major Holdings: TW–4S; M–1S, 2S, 4S; S–1S, 2S, 4S

U38. CALASW

Southwest Museum
Southwest Museum Library
P.O. Box 128, Highland Park Station
Los Angeles, California 90042
(213) 221-2163
Mrs. Ruth Christensen, Librarian

Hours: 1:00–4:45, Tu–Sa
Access: Open to public

U39. CALAUS

University of California, Los Angeles
Dickson Art Center, Slide and Photography Library
3213 Dickson Art Center
UCLA Los Angeles, California 90024
(213) 825-3725
Karin Ozudogru, Curator Slides and Photographs

Hours: 8:00–5:00, M–F
Access: Restricted use, scholars only, graduate students
Reproduction Services: Color and black and white slides
Size of Collection: 40,000 photographs, 172,560 slides, 12,000 clippings
Special Collections: Late 19th and 20th c. architecture; American photography, American 20th c. painting

Major Holdings: AE–1S, 2S, 3S, 4S; C–1S, 2S, 3S, 4S; AR–1S, 2S, 3S, 4S; F–1S, 2S, 3S, 4S; T–1S, 2S, 3S, 4S; ETW–1S, 2S, 3S, 4S; WWI–1S, 2S, 3S, 4S; TW–1S, 2S, 3S, 4S; GD–1S, 2S, 3S, 4S; WWII–1S, 2S, 3S, 4S

U40. CAMAMU

John Muir National Historic Site
Park Collection
4204 Alhambra Avenue
Martinez, California 94553
(415) 228-8860
P.J. Ryan, Park Historian

Hours: 8:30–4:30, M–Su
Access: Open to public, subject to personal supervision of park staff
Reproduction Services: Photographic prints, fee schedule
Size of Collection: 134 photographs, 134 negatives
Special Collections: Historic photographs dealing with the life and times of naturalist and conservationist, John Muir

Major Holdings: T–4P; ETW–4P

U41. CAOKM

Mills College
Mills College Slide Library
Oakland, California 94613
(415) 632-2700, ext. 263, 364
Cheryl Lee, Slide and Photograph Curator

Hours: 10:00–3:00, M–F
Access: Open to public, open by appointment, restricted use
Reproduction Services: Photocopy, color and black and white slides, fee schedule
Size of Collection: 150 photographs, 6,500 slides
Special Collections: Multi-media slide presentations: "Sports in the 19th c.," "Whistler's Nocturnes," "The Image of Women in 19th Century Art," "Mrs. Trollope's America"

Major Holdings: AI–1S, 2S, 3S, 4S; C–1S, 2S, 3S, 4S; AR–1S, 2S, 3S, 4S; F–1S, 2S, 3S, 4S; W–1S, 2S, 3S, 4S; AJ–1S, 2S, 3S, 4S; WM–1S, 2S, 3S, 4S; MW–3S; CW–1S, 2S, 3S, 4S; WI–1S, 2S, 3S, 4S; I–1S, 2S, 3S, 4S; T–1S, 2S, 3S, 4S; ETW–1S, 2S, 3S, 4S; WWI–1S, 2S, 3S, 4S; TW–1S, 2S, 3S, 4S; GD–1S, 2S, 3S, 4S; WWII–1S, 2S, 3S, 4S; P–1S, 2S, 3S, 4S; AL–3S; M–3S, 4S; S–1S, 3S, 4S; E–1S, 2S, 3S, 4S

U42. CAOKO

Oakland Museum
Oakland Museum Art Department, Library
1000 Oak Street
Oakland, California 94607
(415) 273-3005
Odette Mayers, Acting Librarian
Jeffrey Long, Slides

Access: Restricted use, purchase only
Size of Collection: 2,880 photographs, 670 negatives, 14,500 slides, postcards (10 variations), notecards (14)
Special Collections: Slides reflect collection of California art with emphasis on the California Decorative Style of Arthur and Lucia Mathews and California photographers and craftsmen

Major Holdings: AI–1S, 2S, 3S, 4S; AE–3S; C–1S, 3S, 4S; AR–1S, 2S, 3S, 4S; F–1S, 2S, 3S, 4S; W–1S, 2S, 3S, 4S; AJ–1S, 2S, 3S, 4S; WM–1S, 2S, 3P, 3S, 4S; MW–1S, 2S, 3P, 3S, 4S; CW–1S, 2S, 3P, 3S, 4S; I–1S, 2S, 3S, 4S; T–1S, 2S, 3S, 4S; ETW–1S, 2P, 2S, 3P, 3S, 4P, 4S; WWI–1S, 2P, 2S, 3P, 3S, 4P, 4S; TW–1S, 2P, 2S, 3P, 3S, 4P, 4S; GD–1S, 2P, 2S, 3P, 3S, 4P, 4S; WWII–1S, 2P, 2S, 3P, 3S, 4P, 4S; P–1S, 2P, 2S, 3P, 3S, 4P, 4S; SA–1S, 2P, 2S, 3P, 3S, 4P, 4S; AL–1S, 2S, 3S, 4S; M–3P, 3S

U43. CAOOG

Oakland Museum
Oakes Gallery
1000 Oak Street
Oakland, California 94607
(415) 273-3931
Therese Heyman, Senior Curator Prints/Photo

Hours: 10:00–5:00, Tu–Su
Access: Open to public, open by appointment
Reproduction Services: Photographic prints, photocopy, black and white slides, 4x5, 5x7 large format color transparencies, catalog available
Size of Collection: Photographs, negatives, slides
Special Collections: Dorothea Lange Collection (American exodus, Depression, Japanese evacuation); Estey-Rogers Collection (people and places); Moses Cohen Collection (local people and places); Edward Weston (San Francisco earthquake prints); Arnold Genthe San Francisco prints

Major Holdings: AI–2P; WM–2P; WI–2P; T–2P; ETW–2P; WWI–2P; GD–2P; TW–2P; WWII–2P; P–2P; SA–2P; AL–2P; M–2P; S–2P

U44. CAPAH

Pasadena Historical Society Museum
470 W. Walnut
Pasadena, California 91105
(213) 577-1660
Pauline De Witt, Librarian

Hours: 1:00–4:00, Tu, Th
Access: Open to public
Size of Collection: 500 photographs, 100 negatives, 100 slides, 200 postcards
Special Collections: Pictures, postcards, slides related to Pasadena history

U45. CAPGH

The Gamble House, University of Southern California
Greene and Greene Library
4 Westmoreland Place
Pasadena, California 91103
(213) 793-3334
Randell L. Makinson, Curator

Hours: 10:00–3:00, Tu–Th
Access: Open to public (some restriction), open by appointment
Size of Collection: 200 photographs, 200 slides, 3 views of postcards, microfilm
Special Collections: Specialized concentrated collection of the drawings, papers, photographs of the work of American architects Greene and Greene; books dealing with the Arts and Crafts movement in America

Major Holdings: I–1P, 1S, 4P, 4S; ETW–1P, 1S, 4P, 4S

U46. CAPEO

Orange Empire Railway Museum, Inc.
2201 South 'A' Street
P.O. Box 548
Perris, California 92370
(714) 657-2605
William Wootton, Secretary-Librarian
Access: Open by appointment, restricted use, students
Size of Collection: 200 photographs, 100 negatives, 100 slides, 100 postcards

Major Holdings: TW–4P; GD–4P; WWII–4P; P–4P, 4S

U47. CAPNSM

Norton Simon Museum at Pasadena
Pasadena Museum Library
411 W. Colorado Blvd.
Pasadena, California 91105
(213) 449-6840
Amy R. Navratil, Librarian
Access: Open by appointment
Reproduction Services: Photocopy [cont.]

Size of Collection: 3,000 slides
Major Holdings: TW–2S, 3S; GD–2S, 3S; WWII–2S, 3S; P–2S, 3S; SA–2S, 3S

U48. **CAPOPL**

Pomona Public Library
California and Special Collections Room
625 S. Garey Avenue
P.O. Box 2271
Pomona, California 91766
(714) 620-2026
David Streeter, Special Collections Librarian

Hours: 9:00–9:00, M–Th; 9:00–5:00, Sa; 1:00–5:00, Su
Access: Open to public
Reproduction Services: Photocopy
Size of Collection: 70,000 photographs; 80,000 negatives; 500 slides; 30,000 postcards; 4,000 orange-crate labels; 2,500 glass plate negatives
Special Collections: 40,000 negatives and prints relating to life in Arizona, California, New Mexico, Nevada, Utah, Oregon, Washington, partially indexed, taken 1920–40; many views of small towns, main streets, hotels, motels, interiors;

20,000 negatives and prints relating to California taken between 1930–40; largely pictorial landscapes;

30,000 picture postcards of views of cities and countries of the world; largely 1900–1915; approximately 8,250 views of California;

10,000 photographs of the Pomona Valley, 1880s—;

4,000 orange-crate labels; this is a unique record of an ephemeral expression of a local art form; the California landscape and spirit of the times may be identified; 1890s–1940s;

2,500 glass plate negatives, unindexed, unidentified, of California subjects prior to 1920

Major Holdings: I–1P; ETW–1P; TW–1P, 4P; GD–1P, 4P; AL–1P, 4P; M–1P; S–1P; E–1P

U49. **CARDS**

Shasta College Museum
Shasta College Museum and Research Center
1065 North Old Oregon Trail
Redding, California 96001
(916) 241-3523
Ann Hunt, Curator

Hours: 12:00–4:00, M–F; 1:00–5:00, Sa
Access: Open to public, open by appointment
Reproduction Services: Photographic prints, photocopy, color slides, fee schedule
Size of Collection: 3,500 photographs, 24,000 negatives, 300 slides, 200 postcards, 30 posters
Major Holdings: AI–2S; WM–1P; T–1P; ETW–1P; WWI–1P; TW–1P; AL–1P; M–4P; S–4P; E–4P

U50. **CARESB**

San Bernardino County Museum
2024 Orange Tree Lane
Redlands, California 92316
(714) 825-4825
Dr. Gerald A. Smith, Director

Access: Open by appointment
Reproduction Services: Photographic prints, fee schedule
Size of Collection: 10,000 photographs, 20,000 negatives, 8,000 slides, 7,000 postcards, 30 films, 75 posters
Special Collections: Photographs depicting the history of San Bernardino County; slides entitled "Nature on Film Library"

U51. **CARIAC**

Richmond Art Center
25th and Barrett Avenue
Richmond, California 94805
(415) 234-2397
Mr. Ernie Kim, Art Center Director

Access: Restricted use
Size of Collection: 3,000 slides

Major Holdings: AI–2S; AR–3S; AJ–3S; MW–3S; T–2S, 3S; ETW–2S, 3S; WWI–2S, 3S; TW–2S, 3S; GD–2S, 3S; WWII–2S, 3S; P–2S, 3S, 4S; SA–2S, 3S, 4S; E–2S, 3S

U52. **CARVU**

University of California, Riverside
Art History Department, Slide and Photograph Library
Humanities Building
Riverside, California 92502
(714) 787-4242
Mary L. Andonov, Slide/Photograph Librarian

Hours: 8:00–5:00, M–F
Access: Restricted use, scholars only, students
Reproduction Services: Photographic prints, photocopy, color and black and white slides, fee schedule
Size of Collection: 18,000 photographs, 200 negatives, 65,000 slides, 500 postcards, 2,500 posters, reproductions

Major Holdings: AI–3P, 3S; C–1P, 1S, 3P, 3S; AR–1P, 1S, 3P, 3S; F–1P, 1S; WM–2S; I–1S, 3S; ETW–1P, 1S, 3P, 3S; TW–1S, 3S; P–1P, 1S; AL–3S; S–3S; E–3S

U53. **CASBUC**

University of California at Santa Barbara
Slide Collection, Art Department
Art Department, UCSB
Santa Barbara, California 93106
(805) 961-2509
Sharon Petrini, Slide Curator

Access: Teaching faculty only
Size of Collection: 15,000 negatives, 185,000 slides
Major Holdings: AI–1S, 2S, 3S, 4S; AE–1S, 2S, 3S, 4S; C–1S, 2S, 3S, 4S; AR–1S, 2S, 3S, 4S;

F–1S, 2S, 3S, 4S; W–1S, 2S, 3S, 4S; AJ–1S, 2S, 3S, 4S; WM–1S, 2S, 3S, 4S; CW–1S, 2S, 3S, 4S; WI–3S; I–1S, 2S, 3S, 4S; T–1S, 2S, 3S, 4S; ETW–1S, 2S, 3S, 4S; WWI–1S, 2S, 3S, 4S; TW–1S, 2S, 3S, 4S; GD–1S, 2S, 3S, 4S; WWII–1S, 2S, 3S, 4S; P–1S, 2S, 3S, 4S; SA–1S, 2S, 3S, 4S; AL–1S, 3S; M–1S, 3S; S–1S, 3S; E–1S, 3S

U54. CASCSU

California State University, Sacramento
Department of Art
6000 'J' Street
Sacramento, California 95819
(916) 454-6166
Elizabeth June O'Brien, Technical Asst. II

Access: Faculty, students
Reproduction Services: Photocopy, color slides
Size of Collection: Slides
Special Collections: 714 black art slides

Major Holdings: AI–2S, 3S; C–3S; AR–3S; F–3S; AJ–3S; WM–3S; MW–3S; CW–1S, 3S; WI–3S; I–3S; T–3S; ETW–1S, 3S; WWI–1S, 3S; TW–1S, 3S; GD–1S, 3S; WWII–1S, 3S; P–1S, 3S

U55. CASCUC

University of California, Santa Cruz
McHenry Library, Slide Collection
UCSC Library
Santa Cruz, California 95064
(408) 429-2791
Kathleen Hardin, Head of Slide Collection

Hours: School year: 10:00–12:00, 1:00–5:00, M–F
Access: Open to public, restricted use
Reproduction Services: none
Size of Collection: 95,000 slides

Major Holdings: AI–2S, 3S, 4S; C–1S, 2S, 3S, 4S; AR–1S, 2S, 3S, 4S; F–1S, 2S, 3S, 4S; W–1S, 2S, 3S, 4S; AJ–1S, 2S, 3S, 4S; WM–1S, 2S, 3S, 4S; MW–1S, 2S, 3S, 4S; CW–1S, 2S, 3S, 4S; WI–1S, 2S, 3S, 4S; I–1S, 2S, 3S, 4S; T–1S, 2S, 3S, 4S; ETW–1S, 2S, 3S, 4S; WWI–1S, 2S, 3S, 4S; TW–1S, 2S, 3S, 4S; GD–1S, 2S, 3S, 4S; WWII–1S, 2S, 3S, 4S; P–1S, 2S, 3S, 4S; SA–1S, 2S, 3S, 4S

U56. CASFAI

San Francisco Art Institute
Anne Bremer Memorial Library
800 Chestnut Street
San Francisco, California 94133
(415) 771-7020
Janis Lipzin, Slide Curator
Harry Mulford, Library Assistant

Access: Open by appointment, restricted use, faculty, students
Reproduction Services: Photographic prints, photocopy, color and black and white slides, fee schedule available
Size of Collection: 1,230 photographs, 4,700 slides
Special Collections: Bay Area artists; Edward Curtis' American Indian Portraits; Views of Yosemite by Muybridge; minutes of San Francisco Art Association 1871–1889, 1906 to date; minutes of California School of Design 1873–1905

Major Holdings: AI–3P, 4S; AR–3S; F–3S; W–3S; AJ–3S; WM–3S; MW–3S; CW–3S; WI–3S; I–3S; T–3S; ETW–3S; WWI–3S; TW–3S; GD–3P; WWII–3S; P–2S, 3S

U57. CASFG

The Gateway Group, Inc.
2023 Franklin Street
San Francisco, California 94123
c/o Robert Bennett

Access: Open by appointment, restricted use, purchase only
Size of Collection: 800 photographs, 300 slides
Special Collections: Barns of West Coast, wooden foundry patterns

Major Holdings: I–4S; AL–3P, 3S

U58. CASFMA

San Francisco Museum of Modern Art
Louise Sloss Ackerman Fine Arts Library
McAllister at Van Ness
San Francisco, California 94102
(415) 863-8800
Eugenie Candau, Librarian

Hours: 10:00–5:00, M–W
Access: Open to public
Reproduction Services: Photocopy
Special Collections: 88 vertical file drawers containing ephemeral material of 20th c. artists

U59. CASFMM

San Francisco Maritime Museum
Foot of Polk Street
San Francisco, California 94109
(415) 776-1175
Mrs. Matilda Dring, Photograph Archivist

Hours: 10:00–5:00, M,W,F
Access: Open to public, prefer appointment, some restricted use, purchase only
Reproduction Services: Photographic prints, fee schedule
Size of Collection: 100,000 photographs and negatives; 400 slides; 1,000 postcards; posters, calendar art, films
Special Collections: Collections deal mainly with deep-water sail, coastal commerce by sea, wrecks, ports, steamers, Bay craft of all kinds; river and ferry boats of this area and others; WWI and WWII ship-building in Bay Area; Alaska fishing and lumber trade

Major Holdings: M–4S

U60. CASFSU

San Francisco State University, Art Department
Slide Library, Art Department
1600 Holloway Avenue
San Francisco, California 94132
(415) 469-1166 [cont.]

Irene Andersen, Photographer

Access: Restricted use

Reproduction Services: Photocopy, color and black and white slides

Size of Collection: 60,000 slides, 150 reproductions

Special Collections: Comprehensive coverage of painting and photography areas from the earliest to the latest works; also sculpture, architecture, oriental arts, primitive arts, minor arts, miscellaneous categories

Major Holdings: AI−1S, 2S, 3S, 4S; AE−1S, 2S, 3S, 4S; C−1S, 2S, 3S, 4S; AR−1S, 2S, 3S, 4S; F−1S, 2S, 3S, 4S; W−3S; AJ−1S, 2S, 3S, 4S; WM−1S, 2S, 3S, 4S; MW−1S, 2S, 3S; CW−1S, 2S, 3S, 4S; WI−3S; I−1S, 2S, 3S, 4S; T−1S, 2S, 3S; ETW−1S, 2S, 3S, 4S; WWI−1S, 2S, 3S, 4S; TW−1S, 2S, 3S, 4S; GD−1S, 2S, 3S, 4S; WWII−1S, 2S, 3S, 4S; P−1S, 2S, 3S, 4S; SA−1S, 2S, 3S, 4S; AL−1S, 3S, 4S; M−3S, 4S; S−1S, 3S

U61. **CASFWF**

Wells Fargo Bank
History Room
420 Montgomery Street
San Francisco, California 94104
(415) 396-2648
Merrilee A. Dewty, Director

Hours: 10:00−3:00, M−F

Access: Open to public, appointments for study preferred

Reproduction Services: Photographic prints

Size of Collection: 10,000 photographs, 1,000 negatives

Special Collections: Photographs of staging and Wells Fargo people and places; photographs of 1906 San Francisco fire and earthquake, 1915 San Francisco Panama-Pacific International Exposition

Major Holdings: WM−1P, 3P

U62. **CASJSU**

San Jose State University
Department of Art
San Jose, California 95192
(408) 277-2562
Bruce Radde, Assistant Professor of Art History

Hours: 8:00−5:00, M−F

Access: Restricted use, scholars only, students with supervision

Reproduction Services: Color and black and white slides

Size of Collection: 15,000 slides, 50 videotapes

Special Collections: 18th-20th c. documents; 20th c. Afro-American painting and sculpture; 20th c. architecture

Major Holdings: C−1S, 3S, 4S; AR−1S, 2S, 3S, 4S; F−1S, 2S, 3S, 4S; W−1S, 2S, 3S, 4S; AJ−1S, 2S, 3S, 4S; WM−3S; MW−3S; CW−1S, 2S, 3S, 4S; WI−1S, 2S, 3S, 4S; I−1S, 2S, 3S, 4S; T−1S, 2S, 3S, 4S; ETW−1S, 2S, 3S, 4S; WWI−1S, 2S, 3S, 4S;

TW−1S, 2S, 3S, 4S; GD−1S, 3S; WWII−1S, 3S; P−1S, 2S, 3S, 4S; SA−4S

U63. **CASMPC**

Palomar College
San Marcos, California 92069
(714) 744-1150
Dee S. Lewbel, Assistant−Art/Visual Department

Access: Open by appointment, restricted use, scholars only

Size of Collection: Slides

Major Holdings: CW−3S; WI−3S; I−1S, 3S; T−1S, 3S; ETW−1S, 3S; WWI−1S, 3S; TW−1S, 3S; GD−1S, 3S; WWII−1S, 2S, 3S; P−1S, 2S, 3S

U64. **CASOPV**

Sonoma Valley Historical Society
P.O. Box 861
Sonoma, California 95476
Mrs. Geraldine Hunter

Access: Open by appointment, restricted use

Size of Collection: 50 photographs

Special Collections: Historic people and places, local photographs

Major Holdings: WM−4P; WI−4P; ETW−4P; TW−4P

U65. **CASTUA**

Stanford University Art Department
Slide Library
Stanford, California 94305
(415) 497-3320
Carol Ulrich, Slide Librarian

Hours: 8:30−5:00, M−F

Access: Restricted use, students, department faculty

Size of Collection: 120,000 slides

Special Collections: The collection reflects courses taught in the department and special interests of the professors

Major Holdings: AI−1S, 2S, 4S; C−1S, 3S, 4S; AR−1S, 3S, 4S; F−1S, 3S, 4S; W−1S, 2S, 3S, 4S; AJ−1S, 2S, 3S, 4S; WM−1S, 2S, 3S, 4S; MW−1S, 2S, 3S, 4S; CW−1S, 2S, 3S, 4S; WI−1S, 2S, 3S, 4S; I−1S, 2S, 3S, 4S; T−1S, 2S, 3S, 4S; ETW−1S, 2S, 3S, 4S; WWI−1S, 2S, 3S, 4S; TW−1S, 2S, 3S, 4S; GD−1S, 2S, 3S, 4S; WWII−1S, 2S, 3S, 4S; P−1S, 2S, 3S, 4S; SA−1S, 2S, 3S, 4S

U66. **CASTUM**

Stanford University Museum of Art
Photography
Museum Way and Lomita Drive
Stanford, California 94305
(415) 497-4177
Anita V. Mozley

Hours: 10:00−5:00, Tu−F; 1:00−5:00, Sa, Su

Access: Open by appointment

Reproduction Services: Photographic prints

Size of Collection: 500 photographs, 40 negatives

Special Collections: 19th c. photographs of Western America

Major Holdings: AI–4P; WM–4P; CW–4P

U67. **CASVHC**
Simi Valley Historical Society
Robert P. Strathearn Historical Park
1647 Deodora Street
Simi Valley, California 93065
(805) 526-0897
Mrs. Neil Havens, Museum Director

Hours: 1:00–4:00, Su
Access: Open to public, open by appointment, restricted use
Size of Collection: 1,000 photographs
Special Collections: Furniture from industrial period, early 20th c. and 1920s; implements, tools from agricultural period
Major Holdings: I–4P; ETW–4P; AL–4P

U68. **CATOEC**
El Camino College Art Gallery
El Camino College
Via, Torrance, California 90506
(213) 532-3670
David Patterson, Art Gallery Supervisor

Size of Collection: 1,000 slides
Special Collections: Collection consists of 35mm slides of general art works and art in installation in Los Angeles area

U69. **CAVAIA**
California Institute of the Arts
Slide Library
McBean Parkway
Valencia, California 91355
(805) 255-1050
Elizabeth Armstrong, Head Librarian
Vaughan Kaprow, Slide Coordinator

Hours: 9:00–5:00, M–F
Access: Faculty, students (with written permission)
Size of Collection: 30,000 slides
Special Collections: Slides of women artists (19th and 20th c.); photography history (19th c. to present); slides of post-studio artists (20th c.)
Major Holdings: P–1S, 2S, 3S

U70. **CAVEEC**
Environmental Communications
62 Windward Avenue
Venice, California 90291
(213) 392-4964
Sheri Tanibata, Associate Director

Access: Purchase only
Reproduction Services: Photographic prints, 4x5 large format color transparencies, catalogue available, listings, fee schedule
Size of Collection: 20,000 photographs, slides
Special Collections: We specialize in the documentation of art and architecture in the con-

temporary environment—the often transient or ephemeral environmental phenomena that are a part of urban living

Major Holdings: AI–1S, 4S; WWI–1S; TW–1S; GD–1S; WWII–1S; P–1S, 2S, 3S, 4S; SA–1S; E–1S

U71. **CAVNHM**
Ventura County Historical Museum
77 North California Street
Ventura, California 93001
(805) 648-6131, ext. 2550
Richard R. Esparza, Executive Director

Hours: 9:00–4:30, M–F; 12:00–4:00, Sa
Access: Open to public
Reproduction Services: Photographic prints, fee schedule (available within the year)
Size of Collection: 3,000 photographs, negatives, 100 postcards
Major Holdings: WM–1P; MW–1P; CW–1P; WI–1P; I–1P; T–1P; ETW–1P; WWI–1P; TW–1P; GD–1P; WWII–1P; P–1P; SA–1P; AL–1P; M–1P

COLORADO

U72. **COASP**
Aspen Historical Society Museum
620 W. Bleeker Street
P.O. Box 1323
Aspen, Colorado 81611
(303) 925-7071, 925-3721
Ramona Markalunas, President

Access: Open by appointment
Reproduction Services: Photographic prints, photocopy, microfilm, color and black and white slides
Size of Collection: 4,000 photographs, 1,000 negatives, 250 slides, postcards, 15 films, 5 videotapes
Special Collections: Materials restricted to material dealing with Aspen and Pitkin Counties, Colorado

U73. **CODVMC**
Denver Art Museum
100 W. 14th Avenue Parkway
Denver, Colorado 80204
(303) 297-2793
Thomas Maythem, Director
Richard Conn, American Indian Curator
Robert Stroessner, New World Curator

Access: Scholars only, purchase only
Reproduction Services: Photographic prints; color slides; 4x5, 5x7, 8x10 color transparencies; fee schedule available
Size of Collection: Photographs, slides
Major Holdings: AR–1P, 1S, 2P, 2S; F–1P, 1S,

3P, 3S, 4P, 4S; AJ–3P, 3S; WM–2P, 2S, 3P, 3S; CW–3P, 3S; I–3P, 3S; T–3P, 3S; ETW–3P, 3S; TW–3P, 3S; GD–3P, 3S; WWII–3P, 3S; AL–3P, 3S; M–3P, 3S

U74. CODVME

Denver Art Museum
Art Education Department
100 W. 14th Avenue Parkway
Denver, Colorado 80204

Access: Open by appointment, restricted use
Reproduction Services: Color and black and white slides, $1.00; 4x5 color transparencies; fee schedule available
Size of Collection: 150 negatives, 2,150 slides, 3 postcards
Special Collections: Russell House and American Indian slides

Major Holdings: AI–1S, 2S, 3S, 4S; C–1S, 2S, 3S; AR–3S; F–3S; WM–2S, 3S; ETW–3S; P–1S, 2S, 3S

U75. CODVMS

Denver Art Museum
Slide Library
100 W. 14th Avenue Parkway
Denver, Colorado 80204
(303) 297-2295
Barbara Lencicki, Slide Librarian

Hours: 9:00–5:00, M–F
Access: Open to public, purchase only
Reproduction Services: Photographic prints; color slides; 4x5, 8x10 color transparencies
Size of Collection: Negatives, slides

Major Holdings: AI–1S, 2S, 3P, 3S, 4P, 4S; C–1S, 2S, 3S; AR–1P, 1S, 2S, 3S, 4S; W–3P, 3S; AJ–3P, 3S; WM–3P, 3S; T–3P, 3S, 4P, 4S; ETW–1S, 2S, 3S; TW–2S, 3P, 3S; GD–3P, 3S; WWII–2S; P–2P, 2S, 3P, 3S; AL–3P, 3S; M–3P, 3S; E–3P, 3S

U76. CODVPL

Denver Public Library
Western History Department
1357 Broadway
Denver, Colorado 80203
(303) 573-5152, exts. 246, 247
Eleanor M. Gehres, Head

Reproduction Services: Photographic prints, black and white slides, 4x5 color transparencies, fee schedule available
Size of Collection: 1,250 photographs

Major Holdings: AI–1P, 2P, 4P; WM–1P, 4P; ETW–1P, 4P; TW–1P, 4P; AL–1P; E–1P, 4P

U77. COSTOT

Overland Trail Museum
317 North 4th Street
Sterling, Colorado 80751
(303) 522-3895
Mrs. Mildred Elliott

Access: Open to public, restricted use to scholars and students

Reproduction Services: 1,000 photographs, 200 postcards
Major Holdings: AI–3P

CONNECTICUT

U78. CTFAH-S

Hill-Stead Museum
Library
671 Farmington Avenue
Farmington, Connecticut 06032
(203) 677-9064
Jarold D. Talbot, Curator

Hours: 2:00–5:00, W, Th, Sa, Su
Access: Open to public, open by appointment to groups, restricted use, scholars only
Reproduction Services: Photographic prints, color slides, 4x5 color transparencies, catalog available, fee schedule
Size of Collection: 50 photographs, 25 negatives, 35 slides, 9 postcards

Major Holdings: C–4P, 4S; F–4P, 4S; T–4P; ETW–4P; WWI–4P; TW–4P

U79. CTFAM

Farmington Museum
37 High Street
Farmington, Connecticut 06032
(203) 677-9222
Mrs. Janice Riemer, Curator

Size of Collection: Postcards
Major Holdings: C–1P, 4P; AR–4P

U80. CTHAMT

Mark Twain Memorial
351 Farmington Avenue
Hartford, Connecticut 06105
(203) 247-0998
Dexter B. Peck, Acting Director

Hours: June-August; tours daily, 10:00–4:30; September-May: tours, 9:30–4:00, 1:00–4:00, Su
Access: Open to public, open by appointment
Reproduction Services: Photographic prints, color slides
Size of Collection: Several hundred photographs, negatives; 2,000 slides; postcards
Special Collections: Largest collection of photographs of Mark Twain

Major Holdings: T–1P, 1S, 2P, 2S, 3P, 3S, 4P, 4S

U81. CTHAPC

Prudence Crandall Museum
59 S. Prospect Street
Hartford, Connecticut 06106
(203) 566-3005
Richard R. Kuns, Museum Director

Access: Restricted use
Size of Collection: 250 photographs, 500 negatives

Special Collections: All photographs in this collection are black history and Prudence Crandall

U82. CTHAS-D

The Stowe-Day Foundation
The Nook Farm Research Library
77 Forest Street
Hartford, Connecticut 06105
(203) 522-9258
Joseph S. Van Why, Director
Diana Royce, Librarian

Hours: 9:00—5:00, M—F except holidays
Access: Open to public
Reproduction Services: Photographic prints, photocopy, 4x5 color transparencies, catalog available, fee schedule
Size of Collection: 4,200 photographs, 350 negatives, 1,100 slides
Special Collections: 19th c. Americana with emphasis on Lyman Beecher family; photographs of William H. Gillette (known for his portrayal of Sherlock Holmes); 120 microfilm reels of Henry-Russell Hitchcock bibliography of American architecture

Major Holdings: AJ—1P, 1S, 3P, 3S, 4P, 4S; CW—1P; I—1P, 1S, 3P, 3S, 4P, 4S; T—1P, 1S, 3P, 3S, 4P, 4S; ETW—1P, 1S, 3P, 4P, 4S; E—1P, 1S, 3P, 4P, 4S

U83. CTHATR

Trinity College
Austin Arts Center
Slide Library
Hartford, Connecticut 06106
(203) 527-3151
Trudy Buxton, Slide Librarian

Access: Not open to public
Size of Collection: 70,000 slides

U84. CTHAWA

Wadsworth Atheneum
Hartford, Connecticut 06103
(203) 278-2670
Address inquiries to: Museum Education Office

Access: Open to public
Size of Collection: Commercial: 5,000 American art slides; museum: 1,200 (c. 800 American painting slides, c.400 decorative arts and costume slides)
Special Collections: Slides of American costumes in the Wadsworth Atheneum collection

Major Holdings: AI—3S; AE—3S; C—3S, 4S; AR—3S, 4S; F—3S, 4S; AJ—4S; WM—3S; CW—3S, 4S; I—3S, 4S; T—3S, 4S; ETW—3S, 4S; TW—3S; GD—3S; P—3S; AL—3S; M—3S; E—3S

U85. CTLIHS

Litchfield Historical Society
Ingham Memorial Library
P.O. Box 385
Litchfield, Connecticut 06759

(203) 567-5862
Lockett Ford Ballard, Jr., Director
Hours: 9:00—5:00, Tu—Sa
Access: Open to public, restricted use
Reproduction Services: Photographic prints
Size of Collection: 2,000 photographs; 800 negatives; 1,200 slides; 1,500 postcards; 3,000 posters, prints, paper ephemera
Special Collections: Old photographs of Litchfield architecture

Major Holdings: C—1P, 1S, 3P, 3S, 4P, 4S; AR—1P, 3P, 4P, 4S; F—1P, 3P, 4P, 4S; AJ—1P, 3P, 4P 4S; WM—3P, 4P; MW—3P, 4P; CW—3P, 4P

U86. CTMIWU

Wesleyan University
Davison Art Center
Middletown, Connecticut 06457
(203) 347-9411, ext. 653
Judy Bothell, Slide Librarian

Access: Restricted use
Size of Collection: 5—6,000 slides, 30 films
Special Collections: 17th through 19th c. American architecture, 3¼x4 and 2x2 slides

Major Holdings: AI—4S; C—1S, 3S, 4S; AR—1S, 3S, 4S; F—1S, 4S; AJ—1S; I—1S, 4S; T—1S; ETW—1S, 4S; WWI—1S, 4S; TW—1S, 2S, 3S, 4S; GD—1S, 2S, 3S, 4S; WWII—1S, 2S, 3S, 4S; P—1S, 2S, 3S, 4S; SA—1S, 2S, 3S, 4S

U87. CTNBCC

Central Connecticut State College
Stanley Street
New Britain, Connecticut 06023
(203) 225-7481
Persons in charge: Allen Brown,
Edith Hoffman

Access: Restricted use, college staff only
Reproduction Services: Slides, black and white and color; for staff only
Size of Collection: 12,000 slides pertaining to U.S.A. posters (limited number)
Special Collections: Slides of town planning and ecology

Major Holdings: AI—1S, 2S, 3S, 4S; C—1S, 2S, 3S, 4S; AR—1S, 2S, 3S, 4S; F—1S, 2S, 3S, 4S; W—1S, 2S, 3S, 4S; AJ—1S, 2S, 3S, 4S; WM—1S, 2S, 3S, 4S; MW—1S; CW—1S, 3S, 4S; WI—1S; I—1S, 2S, 3S, 4S; T—1S, 2S, 3S, 4S; ETW—1S, 2S, 3S, 4S; WWI—1S, 2S, 3S, 4S; TW—1S, 2S, 3S, 4S; GD—1S, 2S, 3S, 4S; WWII—1S, 2S, 3S, 4S; P—1S, 2S, 3S, 4S; SA—1S; E—1S, 4S

U88. CTNBMA

The New Britain Museum of American Art
56 Lexington Street
New Britain, Connecticut 06052
(203) 229-0257
Charles Ferguson, Director
Lois Blomstrann, Assistant

Hours: 1:00—5:00 daily, except Monday and holidays [cont.]

Access: Open to public, purchase only

Reproduction Services: Photographic prints, color slides

Size of Collection: 500 photographs, 500 slides, 10 postcards

Special Collections: American art dating from 1739 to present

Major Holdings: C–3P, 3S; AR–3P, 3S; F–3P, 3S; AJ–3P, 3S; WM–2P, 2S; MW–3P, 3S; CW–3P, 3S; I–3P, 3S; T–3P, 3S; ETW–3P, 3S; TW–3P, 3S; GD–3P, 3S; WWII–3P, 3S; P–3P, 3S; AL–3P, 3S; M–3P, 3S; S–3P, 3S; E–3P, 3S

U89. **CTNHB_u**

James C. Burchard Postcard Collection
P.O. Box 293
34 Livingston Street
New Haven, Connecticut 06512
(203) 777-9645
2:00–6:00 M–F, via phone recorder

Access: Open by appointment, scholars only, postcards for use in historical books and magazines for a fee

Size of Collection: 100,000 postcards

Major Holdings: (Postcards only): AI–1P, 4P; C–1P, 4P; AR–1P, 4P; AJ–1P, 4P; WM–1P, 4P; MW–1P, 4P; CW–1P, 4P; WI–1P, 4P; I–1P, 4P; T–1P, 4P; ETW–1P, 4P; WWI–1P, 4P; TW–1P, 4P; GD–1P, 4P; WWII–1P, 4P; SA–1P, 4P; AL–1P, 4P; M–1P, 4P; S–1P, 4P

U90. **CTSTSA**

Sandak, Inc.
180 Harvard Avenue
Stamford, Connecticut 06902
(203) 348-3721
Francine Koenig, Art Historian

Hours: 8:15–4:30, M–F

Access: Purchase only

Reproduction Services: Color and black and white slides; 4x5, 5x7, 8x10 color transparencies; listings and fee schedules available

Size of Collection: 6,500 negatives, 6,500 slides

Special Collections: Extensive collection of American Indian art and artifacts; American architecture (Colonial to present); American painting (17th, 18th, 19th, and 20th c.)

Major Holdings: AI–1S, 2S, 3S, 4S; C–1S, 2S, 3S, 4S; AR–1S, 2S, 3S, 4S; F–1S; W–1S, 2S, 3S, 4S; AJ–1S, 2S, 3S, 4S; WM–1S, 2S, 3S, 4S; CW–1S, 2S, 3S, 4S; WI–1S, 2S, 3S, 4S; I–1S, 2S, 3S, 4S;T–1S, 2S, 3S, 4S;ETW–1S, 2S, 3S, 4S; WWI–1S, 2S, 3S, 4S;TW–1S, 2S, 3S, 4S;GD–1S, 2S, 3S, 4S;WWII–1S, 2S, 3S, 4S; P–1S, 2S, 3S, 4S; SA–1S, 2S, 3S, 4S; AL–1S, 2S, 3S, 4S; M–1S, 2S, 3S, 4S; S–1S, 2S, 3S, 4S; E–1S, 2S, 3S, 4S

U91. **CTYUAA**

Yale University
Slide and Photograph Collection
Art and Architecture Library
Box 2009 Yale Station
New Haven, Connecticut 06520
(203) 436-4272, 436-4271
Helen Chillman, Librarian

Hours: 8:30–5:00, M–F

Access: Open to public, restricted use, photographs open for reference and study, slides for university use only

Size of Collection: 34,000 photographs, 35,000 slides, 5,000 postcards

Special Collections: Carroll L.V. Meeks papers including photographs of Connecticut architecture (largely domestic) and railroad stations

Major Holdings: AI–1P, 1S, 2P, 2S, 3P, 3S, 4P, 4S; AE–1P, 1S, 2P, 2S, 3P, 3S, 4P, 4S; C–1P, 1S, 2P, 2S, 3P, 3S, 4P, 4S; AR–1P, 1S, 2P, 2S, 3P, 3S, 4P, 4S; F–1P, 1S, 2P, 2S, 3P, 3S, 4P, 4S; AJ–1P, 1S, 2P, 2S, 3P, 3S, 4P, 4S; WM–1P, 1S, 2P, 2S, 3P, 3S, 4P, 4S; I–1P, 1S, 2P, 2S, 3P, 3S, 4P, 4S; T–1P, 1S, 2P, 2S, 3P, 3S, 4P, 4S; ETW–1P, 1S, 2P, 2S, 3P, 3S, 4P, 4S; WWI–1P, 1S, 2P, 2S, 3P, 3S, 4P, 4S; TW–1P, 1S, 2P, 2S, 3P, 3S, 4P, 4S; GD–1P, 1S, 2P, 2S, 3P, 3S, 4P, 4S; WWII–1P, 1S, 2P, 2S, 3P, 3S, 4P, 4S; P–1P, 1S, 2P, 2S, 3P, 3S, 4P, 4S

U92. **CTYUBA**

Yale University Library
Beinecke Rare Book and
 Manuscript Library
American Literature Collection
New Haven, Connecticut 06520
(203) 436-0236
Donald Gallup, Curator

Hours: 8:00–5:00, M–F; 8:30–12:15, Sa

Access: Open to public

Reproduction Services: Photographic prints

Size of Collection: 1,000 photographs, 50 negatives

Special Collections: Photographs of paintings in Alfred Stieglitz art collection; paintings by artists in Société Anonyme collection; paintings owned by Gertrude and Leo Stein, paintings featuring Negroes

Major Holdings: ETW–3P; TW–3P; GD–3P

U93. **CTYUBW**

Yale University Library
Beinecke Library, Western Americana
 Collection
Drawer 1603A, Yale Station
New Haven, Connecticut 06520
(203) 436-0235
Archibald Hanna, Curator

Hours: 8:30–5:00, M–F; 8:30–12:00, Sa

Access: Open to public

Reproduction Services: Photographic prints, microfilm, color slides, 4x5 color transparencies

Size of Collection: 1,000 photographs, 500 negatives

Major Holdings: AI–4P; WM–3P

U94. CTYUDS

Yale Divinity School
Visual Education Service
409 Prospect Street
New Haven, Connecticut 06511
(203) 436-0651
Burton Everist, Director

Hours: 2:00–5:00, M–F
Access: Open to public, slides for rental and sale
Reproduction Services: Color and black and white slides, listings
Size of Collection: 2,000 slides
Major Holdings: Slides of a religious-historical nature

DELAWARE

U95. DEWIAM

Delaware Art Museum
2301 Kentmore Parkway
Wilmington, Delaware 19806
(302) 655-6288
Rowland Elzea, Curator of Collections

Hours: 10:00–5:00, M–F
Access: Open to public
Reproduction Services: Photographic prints, photocopy, color slides, 4x5 large format color transparencies, listings available
Size of Collection: 200 photographs, 150 negatives, 1,500 slides, 10 postcards
Special Collections: English pre-Raphaelite art (slides and photographs), American book and magazine illustration (slides and photographs), John Sloan (slides and photographs)
Major Holdings: I–3P, 3S; T–3P, 3S; ETW–3P, 3S; WWI–3P, 3S; TW–3P, 3S; GD–3P, 3S; WWII–3P, 3S; P–3P, 3S

U96. DEWIEM

Eleutherian Mills Historical Library
Pictorial Collections
Greenville
Wilmington, Delaware 19807
(302) 658-2401
Daniel T. Muir, Curator

Hours: 8:30–4:30, M–F
Access: Open to public
Reproduction Services: Photographic prints, photocopy, microfilm, color slides, 4x5 large format color transparencies, brochure available
Size of Collection: Photographs, negatives slides
Special Collections: History of American business and industry, Delaware Valley; industrial photography

U97. DEWIMU

Henry Francis du Pont Winterthur Museum
Slide Library
Winterthur, Delaware 19735

(302) 656-8591, ext. 287
Kathryn K. McKenney, Librarian

Hours: 8:30–4:30, M–F
Access: Scholars only
Reproduction Services: Photographic prints, color and black and white slides, 4x5 large format color transparencies, fee schedule available
Size of Collection: 48,000 negatives, 60,000 slides
Special Collections: Specialize in collecting examples of decorative arts in America from 1640 to 1840, but collection contains art and artifacts from pre-historic to modern
Major Holdings: AI–4S; C–1S, 2S, 3S, 4S; AR–1S, 2S, 3S, 4S; F–1S, 2S, 3S, 4S; W–1S, 2S, 3S, 4S; AJ–1S, 2S, 3S, 4S; CW–1S, 2S, 3S, 4S; I–1S, 2S, 3S, 4S; T–1S, 2S, 3S, 4S; E–3S, 4S

DISTRICT OF COLUMBIA

U98. DCAIA

The American Institute of Architects
Library
1735 New York Avenue, N.W.
Washington, D.C. 20006
(202) 785-7295
Kathleen L. Kalt, Audio-Visual Librarian

Hours: 8:30–5:00, M–F
Access: Open to public for reference, AIA members may borrow items
Reproduction Services: None
Size of Collection: 400 photographs, 4,500 slides, 25 films, 3 video cassettes
Major Holdings: C–1S; AR–1S; F–1S; AJ–1S; CW–1S; I–1S; T–1S; ETW–1S; WWI–1S; TW–1S; GD–1S; WWII–1S; P–1S; SA–1S

U99. DCCFAB

National Collection of Fine Arts
Bicentennial Inventory of American Paintings Executed Before 1914
Smithsonian Institution
F Street at 8th Street, NW
Washington, D.C. 20560
(202) 381-6365
Abigail Booth, Coordinator

Hours: 10:00–5:00, M–F
Access: Available to anyone with legitimate research concern in the material
Reproduction Services: None
Size of Collection: 50,000 photographs, postcards, reproductions
Major Holdings: AI–3P; AE–3P; C–3P; AR–3P; F–3P; W–3P; AJ–3P; WM–3P; MW–3P; CW–3P; WI–3P; I–3P; T–3P; ETW–3P; AL–3P; M–3P; S–3P; E–3P

U100. DCCFAL

Library of the National Collection of Fine Arts and National Portrait Gallery
Smithsonian Institution [*cont.*]

F Street at 8th Street, NW
Washington, D.C. 20560
(202) 381-5118, 5541
William Bond Walker, Branch Librarian

Hours: 10:00—5:00, M—F

Access: Restricted use, scholars only, students (graduate/undergraduates apply for permission), open to other qualified adult researchers

Reproduction Services: Photographic prints (except items under copyright), photocopy, Xerox available (not for publication), fee schedule

Size of Collection: 140,000 photographs, 500 negatives, 20,000 slides

Special Collections: Entire collection of photographs from Peter Juley and Son, N.Y.C. photographers whose collection documents N.Y.C. artists' work for past 60 years; outdoor sculpture in Washington, D.C.; Ferdinand Perret Library of clippings, catalogs, and reproductions on art of world, including 180 scrapbooks with card index on California art and artists

Major Holdings: AI—2S, 3P, 3S, 4S; AE—3P, 3S; C—1S, 2S, 3P, 3S, 4S; AR—1S, 2S, 3P, 3S, 4S; F—1S, 2P, 2S, 3P, 3S, 4S; W—1S, 2S, 3P, 3S, 4S; AJ—1S, 2P, 2S, 3P, 3S, 4S; WM—1S, 2P, 2S, 3P, 3S, 4S; MW—1S, 2S, 3P, 3S, 4S; CW—1S, 2P, 2S, 3P, 3S, 4S; WI—1S, 2P, 2S, 3P, 3S, 4S; I—1S, 2P, 2S, 3P, 3S, 4S; T—1S, 2P, 2S, 3P, 3S, 4S;ETW—1S, 2P, 2S, 3P, 3S, 4S;WWI—1S, 2P, 2S, 3P, 3S, 4S;TW—1S, 2P, 2S, 3P, 3S, 4S; GD—1S, 2P, 2S, 3P, 3S, 4S; WWII—1S, 2P, 2S, 3P, 3S, 4S; P—1S, 2P, 2S, 3P, 3S, 4S; AI—3P, 3S; M—3P, 3S; S—2P, 2S, 3P, 3S; E—2P, 2S, 3P, 3S

U101. **DCCFAP**

National Collection of Fine Arts
Photo Services, Office of the Registrar
Smithsonian Institution
F Street at 8th Street, NW
Washington, D.C. 20560
(202) 381-6328
W. Robert Johnston, Registrar

Hours: 10:00—5:15, M—F

Access: Open to public

Reproduction Services: Photographic prints, color slides, 4x5 color transparencies

Size of Collection: 9,000 photographs, 3,000 negatives, 2,250 slides, 2,000 color transparencies (loan)

Special Collections: Indian paintings by George Catlin

Major Holdings: AI—3P, 3S; AR—2P, 2S, 3P, 3S; F—2P, 2S, 3P, 3S; W—2P, 2S, 3P, 3S; AJ—2P, 2S, 3P, 3S; WM—2P, 2S, 3P, 3S; MW—2P, 2S, 3P, 3S; CW—2P, 2S, 3P, 3S; WI—2P, 2S, 3P, 3S; I—2P, 2S, 3P, 3S; T—2P, 2S, 3P, 3S; ETW—2P, 2S, 3P, 3S; WWI—2P, 2S, 3P, 3S; TW—2P, 2S, 3P, 3S; GD—2P, 2S, 3P, 3S; WWII—2P, 2S, 3P, 3S; P—2P,

2S, 3P, 3S; SA—2P, 2S, 3P, 3S; AL—2P, 2S, 3P, 3S; M—2P, 2S, 3P, 3S; S—2P, 2S, 3P, 3S; E—2P, 2S, 3P, 3S

U102. **DCDAR**

DAR Museum
1776 D Street, N.W.
Washington, D.C. 20006
(202) 628-4980
Ms. Conauer Hunt, Director

Hours: 8:30—4:15, M—F

Access: Open by appointment, restricted use, some items by purchase only: photographs, postcards, slide sets, some slides; other slides available for study only on the premises

Reproduction Services: None specified

Size of Collection: 500 photographs, negatives, 75 color transparencies, 160 slides, 50 postcards

Special Collections: 35mm slides of museum's decorative art collection

Major Holdings: C—1S, 3P, 3S, 4P, 4S; AR—1P, 1S, 3P, 3S, 4P, 4S; F—1P, 1S, 3P, 3S, 4P, 4S; W—1P, 1S, 3P, 3S, 4P, 4S; AJ—3P, 4P, 4S; T—2S; ETW—2S

U103. **DCGWU**

The Dimock Gallery
George Washington University
Lower Lisner Auditorium
21st and H Streets, NW
Washington, D.C. 20052
(202) 676-7091
Lenore D. Miller, Curator of Art

Hours: 10:00—5:00, M—F

Access: Open to public, slides and photographs available to students, scholars, university resource center

Reproduction Services: Duplicates made of slide collection, color and black and white slides

Size of Collection: 100 photographs, 2,500 slides, 10—15 reproductions

Special Collections: W. Lloyd Wright Collection of Washingtoniana (includes documentary photos of historic Washington); Ulysses S. Grant III Collection (historic photographs of Civil War Era—memorabilia and documents of President Ulysses S. Grant); reproductions: Art in Science (32 plates from Scientific America); Costumes of the World in Wool (Wool Bureau, Inc., 8 prints, mid-19th c.)

Major Holdings: AI—3S; AR—2S, 3S; F—1P, 1S, 2S, 3P, 3S, 4S; W—1S, 3S; AJ—1P, 1S, 2S, 3S; WM—4S; MW—3S, 4S; CW—1P, 1S, 2P, 4P, 4S; WI—3P; T—1S, 2S, 3S; ETW—3S; WWI—2S, 3S; TW—3S; GD—3S; P—1S, 3S; SA—3S; AL—3S; M—3S

U104. **DCHAER**

Historic American Engineering Record
National Park Service
U.S. Department of the Interior
Washington, D.C. 20240

(202) 523-5460

Douglas L. Griffin, Chief

Hours: 7:45–4:15, M–F

Access: Open to public

Reproduction Services: Photographic prints; 4x5, 5x7 color transparencies; catalog available

Size of Collection: 1,100 photographs, 1,100 negatives, 1,000 slides, 350 measured architectural and engineering drawings

Special Collections: Photographs, drawings and written accounts pertinent to the industrial, engineering and technological heritage of the United States

Major Holdings: AJ–1P; WM–1P; MW–1P; CW–1P; WI–1P; I–1P; T–1P; ETW–1P

U105. **DCHIM**

Hirshhorn Museum and Sculpture Garden

Smithsonian Institution

8th Street and Independence Avenue, SW

Washington, D.C. 20007

(202) 381-6702

Anna Brooke, Librarian

Hours: 10:00–5:00

Access: Scholars only

Reproduction Services: Photographic prints, color slides, 4x5 color transparencies

Size of Collection: 4,500 negatives, 1,000 slides

Major Holdings: CW–3P, 3S; WI–2P, 2S, 3P, 3S; I–3P, 3S; T–3P, 3S; ETW–2P, 2S, 3P, 3S; WWI–2P, 2S, 3P, 3S; TW–2P, 2S, 3P, 3S; GD–2P, 2S, 3P, 3S; WWII–2P, 2S, 3P, 3S; P–2P, 2S, 3P, 3S

U106. **DCHOWU**

Howard University

Architecture and Planning Library

School of Architecture and Planning

Washington, D.C. 20059

(202) 636-7773/4

Mod Mekkawi, Librarian

Hours: 9:00–8:00, M–Th; 9:00–5:30, F

Access: Restricted to students, faculty, staff, alumni of Consortium of Universities of Washington, D.C.

Reproduction Services: None specified

Size of Collection: 520 photographs, 13,432 slides, 96 filmstrips

Major Holdings: ETW–1S; TW–1S; GD–1S; WWII–1S; P–1P, 1S

U107. **DCLCPP**

Library of Congress

Prints and Photographs Division

2nd Street and Independence Avenue, SE

Washington, D.C. 20540

(202) 426-5836

Hours: 8:30–5:00, M–F

Access: Open to public, reader should select in person or cite published reproductions credited to LC; limited number of picture lists available

Reproduction Services: Photographic prints, photocopy, microfilm, color and black and white slides, 4x5 and 8x10 color transparencies, fee schedule

Size of Collection: Photographs, negatives, slides, postcards, posters, drawings, prints and motion pictures

Special Collections: Mathew Brady's portrait and Civil War photos, Brady-Handy Collection, Roger Fenton's Crimean War photographs, Arnold Genthe photographs, National Photo Company files, Frances Benjamin Johnston's early news and portrait photographs, Farm Security Administration photographs of Depression years, Office of War Information photographs, Historic American Buildings Survey, Archive of Hispanic Culture's photographs and slides of Latin American arts, Currier and Ives prints, Pennell Collection of Whistleriana, Gardiner Green Hubbard Collection, Guidol photographs of Spanish medieval art, Gernsheim photographs of old master drawings, Forbes and Waud drawings of Civil War, Cabinet of American Illustration and Clifford Berryman political cartoons, Detroit Publishing Co., original *New Yorker* cartoons, posters of all periods

Major Holdings: Unspecified [according to "Picture Sources," most of the categories would probably be covered]

U108. **DCNAR**

National Archives and Records Service

Audiovisual Archives Division

Washington, D.C. 20408

(202) 963-6493

James W. Moore, Director

Hours: 8:45–5:00, M–F

Access: Open to public

Reproduction Services: Photographic prints, microfilm, color and black and white slides, 8x10 color transparencies, fee schedule

Size of Collection: 200,000 photographs, 200,000 negatives, 1,000 slides, 10,000 posters, films

Special Collections: Afro-American and African artists ca. 1922–70; paintings, murals, and sculpture produced for installation in public buildings and sketches submitted in several competitions, 1933–43 (in the Records of the Works Projects Administration and the Records of the Public Building Service); over 10,000 posters produced by various Federal agencies during WWI and WWII, includes work of Ben Shahn, James Montgomery Flagg, Howard Chandler Christy; Collections of work by noted American photographers: William Henry Jackson (Hayden Geological Survey of the Territories, 1869–78); John K. Hillers (Powell Survey and other Eastern and Western Geological Surveys, 1871–1900); Mathew Brady, Timothy O'Sullivan, Alexander Gardner and

others (Civil War period); Dorothea Lange (Japanese relocation, WWII period, states, migratory labor, community facilities, taken for the Bureau of Agricultural Economics Community Studies, 1939–42); Ansel Adams (National Parks and Monuments in the West, Boulder Dam, and Indian activities, 1936–41); Henry Peabody (scenic areas, parks, monuments, and historic sites in the U.S.A., Cuba, Mexico, and Canada, ca. 1890–1935); Russell Lee (Solid Fuels Administration for War, 1946, survey in coal communities); Lewis Hine (National Research Project photographs, WPA)

Major Holdings: AI–3P, 4P; AE–3P; C–1S, 3P, 3S; AR–3P, 3S; F–1P, 3P; W–3P; AJ–3P; WM–3P; MW–3P; CW–1P, 2P, 3P; WI–3P; I–2P, 3P; T–1P, 3P; ETW–1P, 2P; WWI–3P, 4P; GD–1P, 2P, 3P; WWII–3P

U109. **DCNARAV**

National Audio-Visual Center
National Archives
GSA
Washington, D.C. 20409
(301) 763-7420

Access: Purchase or rental only
Size of Collection: Two 16mm films: "Mirror of America," a visual history of early motion pictures from the Ford Collection; "Stamps— A Nation's Calling Cards," informative film about the art of postage stamps

U110. **DCNGAE**

National Gallery of Art
Extension Service
4th Street and Madison Drive
Washington, D.C. 20565
(202) 737-4215
Frank Figgins, Manager

Hours: 10:00–5:00, M–F
Access: Open to public, photographs and slides by purchase only; free loan, borrower pays return postage and postal insurance
Size of Collection: Hundreds of photographs— Photo Archives; slides—Slide Library and Publications Fund; postcards—Publications Fund; 3 films, 32 slide lectures, 1 film strip— Extension Service
Special Collections: Folk art: pottery, wood carvings, costumes, textiles, furniture, toys; films: "A Nation of Painters" (7-minute film) shows work of American artists between the Revolution and Civil War; "Copley" examines paintings of Copley before and after 1774; slide programs: survey of American Painting (40-minute film), American Folk Art, American Realism; slidesets from Index of American Design (23) contains notes, examples of American crafts and folk arts 1700–1900

Major Holdings: C–3F; AR–3F; F–3F; WM–3F

U111. **DCNGAI**

National Gallery of Art
Index of American Design
Department of Photographic Services
6th Street and Constitution Avenue
Washington, D.C. 20007
(202) 737-4215

Access: Open by appointment, limited study facilities, black and white photographs available for purchase
Reproduction Services: Photographic prints, 4x5 color transparencies, fee schedule
Size of Collection: 22,000 photographs
Special Collections: Watercolor renderings of Americana

Major Holdings: AI–4P; AR–4P; F–4P; AJ–4P; WM–4P; MW–4P; CW–4P; WI–4P; I–4P

U112. **DCNGAP**

Photographic Archives
Center for Advanced Study in the Visual Arts
National Gallery of Art
Washington, D.C. 20565
(202) 737-4215

Hours: Center will open in 1980
Access: Scholars only
Reproduction Services: Photographic prints, fee schedule
Size of Collection: 450,000 photographs, 150,000 negatives

Major Holdings: Unspecified, principally West European

U113. **DCNGAS**

National Gallery of Art
6th Street and Constitution Avenue, NW
Washington, D.C. 20565
(202) 737-4215
Anne von Rebhan, Slide Librarian

Hours: 10:00–5:00, M–F
Access: Open to public, also by purchase
Reproduction Services: None provided by the National Gallery, but upon request borrowers of slides from the National Gallery's collections may reproduce slides at their own expense
Size of Collection: 67,000 slides
Special Collections: Slides of most every American painting in the Gallery's collection; slides also available of objects in the Index of American Design

Major Holdings: AR–3S; F–3S; AJ–3S; CW–3S; I–3S; T–3S; ETW–3S

U114. **DCNPG**

National Portrait Gallery
Smithsonian Institution
F Street at 8th Street, NW
Washington, D.C. 20560
(202) 381-5976
Monroe H. Fabian, Associate Curator

Hours: 8:45–5:15

Access: Open by appointment, restricted use, purchase, fees must be paid to publish materials

Reproduction Services: Photographic prints, color and black and white slides, 4x5 color transparencies, color and black and white prints, catalog available

Size of Collection: Only negatives specified as 500; photographs, slides, postcards, unspecified

Special Collections: Portraits only

Major Holdings: AI–2P, 2S, 3P, 3S; C–2P, 2S, 3P, 3S; AR–2P, 2S, 3P, 3S; F–2P, 2S, 3P, 3S; W–2P, 2S, 3P, 3S; AJ–2P, 2S, 3P, 3S; WM–2P, 2S, 3P, 3S; MW–2P, 2S, 3P, 3S; CW–2P, 2S, 3P, 3S; WI–2P, 2S, 3P, 3S; I–2P, 2S, 3P, 3S; T–2P, 2S, 3P, 3S; ETW–2P, 2S, 3P, 3S; WWI–2P, 2S, 3P, 3S; TW–2P, 2S, 3P, 3S; GD–2P, 2S, 3P, 3S; WWII–2P, 2S, 3P, 3S; P–2P, 2S, 3P, 3S; SA–2P, 2S, 3P, 3S; M–2P, 2S, 3P, 3S; S–2P, 2S, 3P, 3S; E–2P, 2S, 3P, 3S

U115. DCNPGC

National Portrait Gallery
Catalog of American Portraits
Smithsonian Institution
F Street at 8th Street, NW
Washington, D.C. 20560
(202) 381-5861
Mona Dearborn, Keeper of the Catalog

Hours: 2:00–4:00, M–F

Access: Open to public, open by appointment

Reproduction Services: None, referral to owning institution

Size of Collection: 25,000 photographs

Special Collections: Study files of 25,000 portrait records of American portraits of all periods, by sitter name but cross-indexed by artist; records contain photos and cataloging data for American portraits throughout the country; referrals to owning institutions for photographs; no reproductions

Major Holdings: AI–2P, 3P; C–2P, 3P; AR–2P, 3P; F–2P, 3P; W–2P, 3P; AJ–2P, 3P; WM–2P, 3P; MW–2P, 3P; CW–2P, 3P; WI–2P, 3P; I–2P, 3P; T–2P, 3P; ETW–2P, 3P; WWI–2P, 3P; TW–2P, 3P; GD–2P, 3P; WWII–2P, 3P; P–2P, 3P; SA–2P, 3P; AL–2P, 3P; M–2P, 3P; S–2P, 3P; E–2P, 3P

U116. DCNTHP

National Trust for Historic Preservation
740 Jackson Place, NW
Washington, D.C. 20006
(202) 638-5200

Access: Open by appointment

Reproduction Services: Unspecified

Size of Collection: 6,000 photographs, 17,000 slides, 1,000 postcards, 15 16mm films on topics related to historic preservation, 12 slide lectures

Special Collections: Emphasis of collection is on architecture

Major Holdings: C–1P, 1S; AR–1P, 1S; F–1P, 1S; AJ–1P, 1S; CW–1P, 1S; I–1P, 1S; T–1P, 1S; ETW–1P, 1S; WWI–1P, 1S; TW–1P, 1S; GD–1P, 1S; WWII–1P, 1S; P–1P, 1S

U117. DCPC

The Phillips Collection
1600–1612 21st Street, NW
Washington, D.C. 20009
(202) 387-2151
Laughlin Phillips, Director

Hours: 10:00–5:00, Tu–Sa; 2:00–7:00, Su

Access: Gallery, open to public; library, open by appointment; purchase only, scholars only, some students

Reproduction Services: Photographic prints, 4x5, 5x7, 8x10 color transparencies, listing of slides and reproductions available

Major Holdings: Unspecified

U117a. DCSmAA

Archives of American Art
Smithsonian Institution
National Collection of Fine Arts
and National Portrait Gallery Building
F Street at 8th Street, NW
Washington, D.C. 20560
(202) 381-6174
William E. Woolfenden, Director

Hours: 9:00–5:00, M–F

Access: Scholars only

Reproduction Services: Photographic prints; limited photocopy; microfilm; black and white slides; 4 x 5, 5 x 7 and 8 x 10 color transparencies; fee schedule

Size of Collection: 200,000 photographs; 10,000 slides. Slides are noted for collections of personal papers of artists or art organizations

Major Holdings: Photographs and slides are of artists, sculpture, paintings, decorative arts (and a few of architecture) from the Colonial period to the present, but chiefly of the 20th c.

The Washington facilities are the curatorial and processing center and area research center.

Administrative headquarters and area research and collecting center:

Archives of American Art
41 East 65th Street
New York, N.Y. 10021
(212) 656–5722

Area research and collecting centers:

Archives of American Art
5200 Woodward Avenue
Detroit, Michigan 48202
(313) 226–7544

Archives of American Art
87 Mt. Vernon Street
[*cont.*]

Boston, Massachusetts 02108
(617) 223-0951

Archives of American Art
M. H. de Young Memorial Museum
Golden Gate Park
San Francisco, California 94118
(415) 556-2530

U118. **DCSmHT**

National Museum of History and Technology
Smithsonian Institution
14th Street and Constitution Avenue, NW
Washington, D.C. 20560
(202) 628-4422

Access: Open to public, open by appointment (some items on display, the majority of items are located in reference collections), purchase only

Reproduction Services: Photographic prints, photocopy, microfilm, color and black and white slides, 4x5 and 8x10 color transparencies, limited lists available, fee schedule

Size of Collection: Photographs (thousands), ca. 500 slides, ca. 50 postcards

Major Holdings: Holdings in every category except Space Age; although collection is composed of both slides and photographs, a breakdown by category was not given

U119. **DCSmPS**

Smithsonian Institution
Photographic Services
CB054 MHT
Washington, D.C. 20560
(202) 381-5164
Mr. Joseph Kennedy, Chief, Services Branch

Hours: 9:00–5:00, M–F
Access: Open to public, purchase only
Reproduction Services: Photographic prints, color and black and white slides, 4x5 color transparencies, fee schedule

Major Holdings: AI–3P, 3S, 4P; C–4P; AR–4P; F–4P; AJ–4P, 4S; I–4P, 4S; T–3S; ETW–4P, 4S; WWI–3P, 3S; TW–4P, 4S; SA–4P, 4S; AL–4P; M–4P

FLORIDA

U120. **FLCGUM**

University of Miami
Lowe Art Museum
1301 Miller Drive
Coral Gables, Florida 33146
(305) 284-3535
John J. Baratte

Access: Restricted use
Reproduction Services: None
Size of Collection: 1,500 photographs, 200 slides, 3,500 slides, 4 postcards, 10 other
Special Collections: American painting and sculpture

Major Holdings: AI–2P; C–1S, 3P, 3S; AR–1S, 3S; F–1S, 2S, 3S; W–3P; T–1S, 2S, 3S; ETW–1S, 2S, 3P, 3S; GD–1S, 2S, 3S; P–1S, 2S, 3S

U121. **FLGAUF**

University of Florida
Audio-Visual Library
College of Architecture and Fine Arts
Gainesville, Florida 32601
(904) 392-0209
Pamela A. Schneider, Audio-Visual Librarian

Hours: 8:00–12:00, 1:00–5:00, M–F
Access: Restricted use
Reproduction Services: None
Size of Collection: 10,000 photographs, 70,000 slides, 16 films
Special Collections: Slides of Mathew Brady photographs

Major Holdings: AI–2S, 3S, 4S; C–1P, 1S, 2S, 3S, 4S; AR–1P, 1S, 2S, 3S, 4S; F–1P, 1S, 2S, 3S, 4S; AJ–1S, 4S; CW– ; I–1S, 2S, 3S; T–1S, 2S, 3S; ETW–1S, 2S, 3S; WWI–1P, 1S, 2P, 2S, 3P, 3S; TW–1P, 1S, 2P, 2S, 3P, 3S; GD–1P, 1S, 2P, 2S, 3P, 3S; WWII–1P, 1S, 2P, 2S, 3P, 3S, 4S; P–1P, 1S, 2P, 2S, 3P, 3S, 4S

U122. **FLPBFM**

Henry Morrison Flagler Museum
Box 969
Palm Beach, Florida 33480
(305) 655-2833
Charles B. Simmons, Executive Director

Hours: 10:00–5:00, Tu–Su
Access: Open to public, open by appointment
Reproduction Services: Photocopy, can arrange for prints of photos at cost
Size of Collection: 100+ photographs, 100–200 negatives, 200–300 slides for study, 10 slides for sale, 15 postcards (modern) for sale, 100+ postcards (old)
Special Collections: Construction of Key West Extension of Florida East Coast Railroad, 1905–1915; East Coast Florida, 1885–1915

Major Holdings: I–1P, 1S, 3S, 4P, 4S; ETW–1P, 2P, 3S, 4P; AL–4P; S–4P

U123. **FLPEWM**

T.T. Wentworth, Jr., Museum
T.T. Wentworth, Jr., Library
8382 Palafox Highway (mailing address, P.O. Box 896, Pensacola, Florida 32504)
Pensacola, Florida 32504
(904) 438-3638
T.T. Wentworth, Jr., in charge

Hours: 2:00–6:00, Sa, Su
Access: Open to public, open by appointment
Reproduction Services: Photographic prints, photocopy
Size of Collection: 6,000 photographs, 1,500 negatives, 2,000 postcards
Special Collections: Floridiana, Tiffany lamps

U124. **FLSPMU**

Museum of Fine Arts of St. Petersburg,
Florida, Inc.
255 Beach Drive North
St. Petersburg, Florida 33701
(813) 896-2667
Lee Malone, Director

Hours: 9:00–5:00, Tu–F
Access: Open to public, open by appointment
Reproduction Services: Arrangements can be made for photographs or slides
Size of Collection: 120 photographs, 4,500 slides, 15 videotapes, 30 World War I posters

Major Holdings: AI–2S; F–1S, 3S, 4S; W–3S; AJ–3S; WM–3S, 4S; CW–3S; WI–3S; I–1S, 3S; T–1S, 3S; ETW–1S, 2S, 3S; WWI–1S, 3S; TW–1S, 2S, 3S; GD–3S; WWII–1S, 3S; P–1S, 2S, 3S; SA–3S

U125. **FLTAFS**

Florida State University, Art Department
Slide Library
Fine Arts Building
Tallahassee, Florida 32306
(904) 644-3436
Juliann Bamberg, Slide Curator

Access: Restricted to use by FSU faculty and students only
Reproduction Services: None
Size of Collection: 50,000 art history slides, 10,200 American slides

Major Holdings: AI–2S, 4S; AE–4S; C–1S, 2S, 3S, 4S; AR–1S, 2S, 3S, 4S; F–1S, 2S, 3S, 4S; W–1S, 2S, 3S, 4S; AJ–1S, 2S, 3S, 4S; WM–1S, 2S, 3S, 4S; MW–1S, 2S, 3S, 4S; CW–1S, 2S, 3S, 4S; WI–1S, 2S, 3S, 4S; I–1S, 2S, 3S, 4S; T–1S, 2S, 3S, 4S; ETW–1S, 2S, 3S, 4S; WWI–1S, 2S, 3S, 4S; TW–1S, 2S, 3S, 4S; GD–1S, 2S, 3S, 4S; WWII–1S, 2S, 3S, 4S; P–1S, 2S, 3S, 4S

U126. **FLWPBN**

Norton Gallery and School of Art
P.O. Box 2300
West Palm Beach, Florida 33402
(305) 832-5194
Richard A. Madigan, Director

Access: Open by appointment
Reproduction Services: Photographic prints, color slides, 4x5 large format color transparencies, Fall '75 catalog
Size of Collection: 50 photographs (American artists), 36 slides (American artists), 4 postcards (American artists), posters

Major Holdings: F–3P, 3S; ETW–3P, 3S; TW–3P, 3S; GD–2P, 3P, 3S; WWII–3P, 3S; P–2P, 3P, 3S; SA–3P, 3S; M–3P

U127. **FLWPRC**

Rollins College
Mills Memorial Library
Winter Park, Florida 32789

(305) 646-2676
The Archivist and Circulation Department

Hours: 91 hours per week
Access: Open to public
Reproduction Services: Xerox, photocopy
Size of Collection: 15,100 photographs (mostly people), 1,550 postcards
Special Collections: Portraits of people from 1890 to present; postcards with decorative art subjects

GEORGIA

U128. **GAATCHA**

Atlanta College of Art Library
1280 Peachtree Street
Atlanta, Georgia 30309
(404) 892-3600, ext. 212
Anne Kaye Wakefield, Head Librarian

Hours: 9:00–6:00 M–F
Access: Open to public, restricted use, scholars only (slides)
Reproduction Services: None
Size of Collection: 24,000 slides, 50 posters

Major Holdings: AI–3S, 4S; AE–1S; C–1S, 2S, 3S, 4S; AR–1S, 2S, 3S, 4S; F–1S, 2S, 3S, 4S; W–1S, 3S, 4S; AJ–1S, 2S, 3S, 4S; WM–1S, 4S; MW–1S, 2S, 3S, 4S; CW–1S, 2S, 3S, 4S; WI–2S, 4S; I–1S, 2S, 3S, 4S; T–1S, 2S, 3S, 4S; ETW–1S, 2S, 3S, 4S; WWI–1S, 2S, 3S, 4S; TW–1S, 2S, 3S, 4S; GD–1S, 2S, 3S, 4S; WWII–1S, 2S, 3S, 4S; P–1S, 2S, 3S, 4S

U129. **GAATHS**

Atlanta Historical Society
Archives
P.O. Box 12423
Atlanta, Georgia 30305
(404) 261-1837
Dr. William L. Pressly, Administrator

Hours: 9:00–5:00, M–F
Access: Open to public
Reproduction Services: Photographic prints, photocopy, color slides, black and white slides, fee schedule
Size of Collection: 9,500 photographs, 2,400 negatives, 500 slides, 450 postcards, 70 WWI women's suffrage posters, 400 architectural drawings

Major Holdings: CW–1P; I–1P; T–1P, 4P; ETW–1P, 4P; WWI–1P, 4P; TW–1P, 4P; GD–1P

U130. **GAATIT**

Georgia Institute of Technology
Price Gilbert Memorial Library
Atlanta, Georgia 30332
(404) 894-4877
Mary J. Warren, Slide Curator
Hours: 8:00–5:00, M–F [*cont.*]

Access: Open by appointment, restricted use, scholars only

Reproduction Services: None

Size of Collection: 35,000 slides (excludes a 2,500 slide set, "Arts of the United States," edited by William H. Pierson, Jr., and Martha Davidson)

Special Collections: Maps and plans

Major Holdings: AI–1S; C–1S; AR–1S, 3S, 4S; F–1S, 2S, 3S, 4S; W–1S, 3S; AJ–1S, 3S, 4S; MW–1S, 3S; CW–1S, 3S; I–1S, 3S; T–1S, 3S, 4P; ETW–1S, 3S; WWI–1S, 3S; TW–1S, 2S, 3S; GD–1S, 2S, 3S; WWII–1S; P–1S, 2S, 3S

U131. **GASTFF**

Fort Frederica National Monument
The Library
Box 286-C
St. Simons Island, Georgia 31522
(912) 638-3639
Janet Chess Wolf, Superintendent

Hours: 8:00–5:00

Access: Open to public, restricted use

Reproduction Services: None

Size of Collection: 2 films

Special Collections: Margaret Davis Cate collection is currently being microfilmed (books only)

U132. **GASVFJ**

Fort Jackson Maritime Museum
P.O. Box 2132
Savannah, Georgia 31402
(912) 234-8547
Frances E. Wilson, Curator

Hours: 9:00–5:00, Tu–Sa

Access: Open to public

Reproduction Services: Photographic prints, photocopy, color slides

Size of Collection: 250 photographs, 200 negatives, 400+ slides

Major Holdings: M–1P, 1S, 4P, 4S

HAWAII

U133. **HIHOAA**

Honolulu Academy of Arts
Audio-Visual Department
900 S. Beretania Street
Honolulu, Hawaii 96814
(808) 538-3693, ext. 52
Miss Brone Jameikis,
Keeper Audio-Visual Department

Hours: 1:00–4:00, Tu–F; 8:00–12:00, Sa

Access: Open to public

Size of Collection: 4,500 slides (American collection), slide-cassette sets, filmstrips

Special Collections: Slide cassette on the Hawaiian quilt, Salish American; Indian weaving; slide set on Indian art of the Ameri-

cas; filmstrips on Thomas Eakins, Winslow Homer, Jackson Pollock

Major Holdings: AI–1S, 4S; AE–1S, 2S, 3S, 4S; C–1S, 2S, 3S, 4S; AR–1S, 2S, 3S, 4S; F–1S, 2S, 3S, 4S; W–1S, 2S, 3S, 4S; AJ–1S, 2S, 3S, 4S; WM–1S, 2S, 3S, 4S; MW–1S, 2S, 3S, 4S; CW–1S, 2S, 3S, 4S; WI–1S, 2S, 3S, 4S; I–1S, 2S, 3S, 4S; T–1S, 2S, 3S, 4S; WWI–1S, 2S, 3S, 4S; TW–1S, 2S, 3S, 4S; GD–1S, 2S, 3S, 4S; WWII–1S, 2S, 3S, 4S; P–1S, 2S, 3S, 4S; SA–1S, 2S, 3S, 4S; AL–1S, 2S, 3S, 4S; M–1S, 2S, 3S, 4S; S–1S, 2S, 3S, 4S; E–1S, 2S, 3S, 4S

U134. **HIHOBM**

Bishop Museum
Bishop Museum Photograph Collection
P.O. Box 6037
Honolulu, Hawaii 96822
(808) 847-3511
Lynn Davis, Photograph Librarian

Hours: 1:00–4:00, Tu, W, Th

Access: Open to public

Reproduction Services: Photographic prints, color photocopy, black and white slides, color slides, fee schedule

Size of Collection: 100,000 photographs, 150,000 negatives, 5,000 slides, 500 postcards, films on agricultural life

Special Collections: Collection restricted to Hawaii and Pacific Islands

Major Holdings: WI–4P; T–4P; ETW–4P; WWI–4P; TW–4P; GD–4P; WWII–4P; P–4P; AL–4P; M–4P; S–4P; E–4P

IOWA

U135. **IADMAC**

Des Moines Art Center
Des Moines Art Center Library
Greenwood Park
Des Moines, Iowa 50312
(515) 277-4405
Peggy Buckley, Librarian

Hours: 11:00–5:00, Tu–Sa

Access: Open to public, restricted to reference use only, scholars only may make slide loans, students may use library facilities

Reproduction Services: Photocopy, color slides, fee schedule

Size of Collection: 4,000 slides (for sale and for loan from Education Department), 60 postcards (for sale only at sales desk)

Major Holdings: AI–4S; C–1S, 2S, 3S, 4S; AR–1S, 2S, 3S, 4S; W–1S, 2S, 3S, 4S; AJ–1S, 2S, 3S, 4S; WM–1S, 2S, 3S, 4S; MW–1S, 2S, 3S, 4S; CW–1S, 2S, 3S, 4S; WI–1S, 2S, 3S, 4S; I–1S, 2S, 3S, 4S; T–1S, 2S, 3S, 4S; ETW–1S, 2S, 3S, 4S; WWI–1S, 2S, 3S, 4S; TW–1S, 2S, 3S, 4S; GD–1S, 2S, 3S, 4S; WWII–1S, 2S, 3S, 4S; P–1S, 2S, 3S, 4S; SA–1S, 2S, 3S, 4S

U136. IADRNA

Norwegian-American Museum
502 W. Water Street
Decorah, Iowa 52101
(319) 382-3856
Marion Nelson, Director
Darrell Henning, Curator

Hours: Works on display daily May- October; May: 10:00–4:00; June-August: 9:00-5:00; September-October: 10:00–4:00
Access: Files and archives available by appointment to scholars and students
Reproduction Services: Photographic prints, slides, listings
Size of Collection: 10,000 photographs, 10,000 negatives, 600 slides, 15 postcards, 1 videotape ("Folk Musicians of Decorah"), 1 poster (Norwegian-American woman in traditional costume)
Special Collections: Traveling exhibit, selected black and white photographs of the Norse-American Centennial, 1825–1935 (25 photographs); approximately 150 portraits (photographs) of prominent Norwegian-Americans; "Rosemaling in Norway," 2 volumes include 50 color photographs
Major Holdings: WI–1P, 3P, 4P; AL–1P, 3P

U137. IAICSHS

State Historical Society of Iowa
Photograph Collection
402 Iowa Avenue
Iowa City, Iowa 52240
(319) 338-5471
Joyce Giaquinta, Manuscript Librarian

Hours: 8:00–4:30, M–F
Access: Open to public
Reproduction Services: Photographic prints, photocopy, fee schedule
Size of Collection: 400 linear feet unprocessed film (photographs), 1,000 negatives, 3,000 postcards, posters, slides
Major Holdings: AI–3P; MW–3P; CW–1P, 3P; I–1P, 3P; T–1P, 3P; ETW–1P, 3P; WWI–1P; TW–1P; GD–1P; P–3P; AL–1P, 3P; E–1P

U138. IAWBHH

Herbert Hoover Presidential Library
Box 488
West Branch, Iowa 52358
(319) 643-5301
Thomas T. Thalken, Director

Access: By application to the Director of the Library
Reproduction Services: Photographic prints, photocopy, microfilm, film, slides and transparencies can be arranged through commercial outlet, fee schedule
Size of Collection: 20,000 photographs, 20,000 negatives, 1,000 slides, 150,000 films
Special Collections: Photographs of U.S. Food Administration poster paintings; photographs of WWI Liberty Loan and enlistment posters; photographs of examples of medallic art, 1914–1964; photographs of furnishings of the White House during Hoover's administration
Major Holdings: WWI–3P, 3S; TW–1P; GD–4P

IDAHO

U139. IDBSHS

Idaho State Historical Society
610 N. Julia Davis Drive
Boise, Idaho 83706
(208) 384-2150
James H. Davis, Archivist

Hours: 8:30–5:00, M–F
Access: Open to public, for study purposes only, materials can be copied on premises
Reproduction Services: Photographic prints, photocopy, color and black and white slides, 4x5 color transparencies, fee schedule available
Size of Collection: 100,000 photographs, 75,000 negatives, 1,000 slides, 1,500 postcards, films
Special Collections: Materials relate primarily to agriculture, irrigation, and mining of the area
Major Holdings: AI–1P, 4P; WM–1P, 4P; T–1P, 4P; ETW–1P, 4P; WWI–1P, 4P; TW–1P, 4P; WWII–1P, 4P; P–1P, 4P; AL–1P, 4P; S–1P, 4P; E–1P, 4P

U140. IDCLCM

Custer Museum
Yankee Fort Ranger Station
Clayton, Idaho 83227
(208) 838-2219
District Forest Ranger

Hours: Museum: June 15–September 5, 10:00–7:00 Ranger Station: 8:00–5:00 daily
Access: Open to public
Size of Collection: 200 photographs
Special Collections: Photographs, old and recent, dealing with area

ILLINOIS

U141. ILCASI

University Galleries
Southern Illinois University at Carbondale
Carbondale, Illinois 62901
(918) 453-3493
Evert A. Johnson, Curator

Access: Restricted use
Size of Collection: 40 photographs

U142. ILCHAI_{me}

The Art Institute of Chicago
Museum Education [cont.]

Michigan at Adams Street
Chicago, Illinois 60603
(312) 443-3680
Barbara Wriston, Director
of Museum Education

Access: Purchase only through Rosenthal Art
Slides, 5456 South Ridgewood Court,
Chicago, Illinois 60615
Size of Collection: Postcards, slides (museum
store)
Major Holdings: C—3S, 4S; AR—3S, 4S; F—3S, 4S;
W—3S, 4S; I—4S; ETW—4S.

U143. **ILCHAI_{ph}**
The Art Institute of Chicago
Museum Photography Department
Michigan at Adams Street
Chicago, Illinois 60603
(312) 443-3656
Howard Kraywinkel

Hours: 9:00—5:00
Access: Open to public
Reproduction Services: Purchase only, 8x10
photographic prints, color slides, color prints
Size of Collection: 60,000 negatives covering en-
tire museum collection, 60,000 8x10 photo-
graphs of the above negatives

U144. **ILCHAI_{sp}**
The Art Institute of Chicago
Ryerson Library
Slide and Photograph Department
Michigan at Adams Street
Chicago, Illinois 60603
(312) 443-3672
Mrs. Ruth Zawierucha, Head of Slide
and Photograph Department

Hours: 10:00—4:30, M—F
Access: Restricted
Size of Collection: 14,239 photographs, 13,106
slides, 7,845 postcards, 4,429 other
Special Collections: Photographs: World's Col-
umbian and Century of Progress Exposition;
slides: Art Institute exhibitions and collec-
tions; U.S. architecture, Prairie School

Major Holdings: AI—1P, 1S, 2P, 2S, 3P, 3S, 4P, 4S;
C—1P, 1S, 3P, 3S, 4P, 4S; AR—1P, 1S, 2S, 3P, 3S,
4P, 4S; F—1P, 1S, 2P, 2S, 3P, 3S, 4P, 4S; AJ—1P,
1S, 2P, 2S, 3P, 3S, 4P, 4S; CW—1P, 1S, 2S, 3P, 3S,
4P, 4S; I—1P, 1S, 2P, 2S, 3P, 3S, 4P, 4S; T—1P, 1S,
2P, 2S, 3P, 3S, 4P, 4S; ETW—1P, 1S, 2P, 2S, 3P,
3S, 4P, 4S; WWI—1P, 1S, 2P, 2S, 3P, 3S, 4P, 4S;
TW—1P, 1S, 2P, 2S, 3P, 3S, 4P, 4S; GD—1P, 1S,
2P, 2S, 3P, 3S, 4P, 4S; WWII—1P, 1S, 2P, 2S, 3P,
3S, 4P, 4S; P—1P, 1S, 2P, 2S, 3P, 3S, 4P, 4S

U145. **ILCHPL**
Chicago Public Library
Fine Arts Division
Art Section Picture Collection
78 East Washington Street
Chicago, Illinois 60602 [*cont.*]

(312) 269-2858
Ann P. Caplin, Librarian of Picture Collection

U146. **ILCHCA**
Museum of Contemporary Art
237 East Ontario Street
Chicago, Illinois 60611
(312) 943-7755
Matilda Kelly, Librarian

Hours: 10:00—5:00, M—F
Access: Appointment, scholars only
Size of Collection: 3,000 slides

Major Holdings: P—2S, 3S

U147. **ILCHDM**
The Dusable Museum
740 East 56th Place
Chicago, Illinois 60637
(312) 947-0600
Margaret Burroughs, Director

Access: Open to public
Size of Collection: Color slides, tapes, movies,
filmstrips
Special Collections: Afro-American history

U148. **ILCHPA**
Public Art Workshop
5623 E. Madison Street
Chicago, Illinois 60644
(312) 626-1713
Mark Rogovin, Director
of Public Art Workshop
Barbara T. Russum, Director Resource Center

Hours: 9:00—6:00, M—F; other hours by appoint-
ment
Access: Open to public; by appointment
Reproduction Services: Occasionally sell dupli-
cates of slides; exchange slide service
Size of Collection: 75 photographs, 500 slides, 25
postcards, 100 other, 75 negatives
Special Collections: Murals: Mexican, WPA in Il-
linois, Chicago murals since 1967, other con-
temporary U.S. murals

Major Holdings: GD—3P, 3S; SA—3P, 3S

U149. **ILCHRO**
Rosenthal Art Slides
5456 South Ridgewood Court
Chicago, Illinois 60615
(312) 324-3367
John W. Rosenthal, owner

Access: Open by appointment
Reproduction Services: Slides, color and black
and white, catalog available ($2.50 to in-
dividuals, free to museums, art departments
and libraries), fee schedule
Size of Collection: 10,000 color slides, 40,000
black and white negatives to be sold or
donated
Special Collections: American Indian blankets;

Arts and Crafts movement in America, 1876–1916 show; American photographers

Major Holdings: AI–4S; C–1S, 3S, 4S; AR–1S, 3S, 4S; F–1S, 3S, 4S; W–1S, 3S, 4S; AJ–1S, 3S, 4S; WM–1S, 3S, 4S; MW–1S, 3S, 4S; CW–1S, 3S, 4S; WI–1S, 3S, 4S; I–1S, 3S, 4S; T–1S, 2S, 3S, 4S; ETW–1S, 2S, 3S, 4S; WWI–1S, 2S, 3S, 4S; TW–1S, 2S, 3S, 4S; GD–1S, 2S, 3S, 4S; WWII–1S, 2S, 3S, 4S; P–1S, 2S, 3S, 4S; SA–1S, 2S, 3S, 4S

U150. ILCHSVE

Society for Visual Education, Inc.
1345 Diversey Parkway
Chicago, Illinois 60614
(312) 525-1500
Reproduction: Purchase only
Size of Collection: 120 slides, many filmstrips
Major Holdings: C–4S; AR–4S; F–4S; W–4S; AJ–4S; WM–4S; MW–4S; CW–4S; WI–4S; I–4S; ETW–4S; P–3S; SA–3S

U151. ILCHUC

University of Chicago
Epstein Archive
1050 E. 59th Street
Chicago, Illinois 60637
(312) 753-2887
Ms. Ruth Philbrick, Curator

Hours: 9:00–5:00, M–Sa
Access: Restricted to holders of University of Chicago library privileges
Reproduction Services: Photocopy
Size of Collection: 10,000 photographs

Major Holdings: C–1P, 2P, 3P, 4P; AR–1P, 2P, 3P, 4P; F–1P, 2P, 3P, 4P; AJ–1P, 2P, 3P, 4P; WM–1P, 2P, 3P; I–1P, 2P, 3P, 4P; T–1P, 2P, 3P, 4P; ETW–1P, 2P, 3P, 4P; WWI–1P, 2P, 3P, 4P; TW–1P, 2P, 3P, 4P; GD–1P, 2P, 3P, 4P; WWII–1P, 2P, 3P, 4P; P–1P, 2P, 3P, 4P; AL–3P; M–3P; S–3P; E–3P

U152. ILCHUI

University of Illinois, Chicago Circle Campus
Slide and Photograph Library
4100C Architecture and Art
Chicago, Illinois 60680
(312) 996-3312
Heidi Holliger, Audio-Visual Curator

Hours: 8:00–5:15
Access: Restricted
Reproduction Services: Color and black and white slides, for own use
Size of Collection: 3,000 photographs, 160,000 slides
Special Collections: Slides: Frank Lloyd Wright, Mies van der Rohe and Skidmore, Owings and Merrill architecture; 20th c. advertising
Major Holdings: AI–1S, 2S, 3S, 4S; AE–1S, 2S, 3S, 4S; C–1P, 1S, 2S, 3S, 4S; AR–1P, 1S, 2S, 3S, 4S; F–1P, 1S, 2S, 3S, 4S; W–1S, 2S, 3S, 4S;

AJ–1S, 2S, 3S, 4S; WM–1P, 1S, 2S, 3S, 4S; MW–1S, 2S, 3S, 4S; CW–1S, 2S, 3S, 4S; WI–3S; I–1P, 1S, 3S, 4S; T–1P, 1S, 3S, 4S; ETW–1P, 1S, 2S, 3S, 4S; WWI–1P, 1S, 2S, 3S, 4S; TW–1P, 1S, 2S, 3S, 4S; GD–1P, 1S, 2S, 3S, 4S; WWII–1P, 1S, 2S, 3S, 4S; P–1P, 1S, 2S, 3S, 4S; SA–1S, 2S, 3S, 4S; AL–1S; M–1S; E–1S, 3S, 4S

U153. ILUIVA

University of Illinois, Urbana
Visual Arts Service
1325 South Oak Street
Champaign, Illinois 61820
(217) 333-1362
Thomas H. Boardman, Director

Hours: 9:00–12:00, 1:00–5:00, M–F
Access: Open to public
Size of Collection: 11,000 16mm films (26,000 prints)
Major Holdings: AI–1, 2, 3; AE–1, 2, 3; C–1, 2, 3; AR–1, 2, 3; F–1, 2, 3; W–1, 2, 3; AJ–1, 2, 3; WM–1, 2, 3; MW–1, 2, 3; CW–1, 2, 3; WI–1, 2, 3; I–1, 2, 3; T–1, 2, 3; ETW–1, 2, 3; WWI–1, 2, 3; TW–1, 2, 3; GD–1, 2, 3; WWII–1, 2, 3; P–1, 2, 3; SA–1, 2, 3; AL–1, 2, 3; M–1, 2, 3; S–1, 2, 3; E–1, 2, 3

U154. ILDKNI

Northern Illinois University
Art Department, Slide Library
DeKalb, Illinois 60115
(815) 753-0293
Alice T. Holcomb, Slide Librarian

Access: Restricted
Size of Collection: Slides, no estimate given
Special Collections: Afro-American, 1,700 slides
Major Holdings: AI–1S, 3S, 4S; AE–3S, 4S; C–1S, 2S, 3S, 4S; AR–1S, 2S, 3S, 4S; F–1S, 2S, 3S, 4S; W–3S, 4S; AJ–1S, 2S, 3S, 4S; WM–3S, 4S; MW–3S, 4S; CW–1S, 2S, 3S, 4S; WI–3S, 4S; I–1S, 2S, 3S, 4S; T–1S, 2S, 3S, 4S; ETW–1S, 2S, 3S, 4S; WWI–1S, 2S, 3S, 4S; TW–1S, 2S, 3S, 4S; GD–1S, 2S, 3S, 4S; WWII–1S, 2S, 3S, 4S; P–1S, 2S, 3S, 4S; SA–1S, 4S

U155. ILEDMH

Madison County Historical Museum
715 N. Main Street
Edwardsville, Illinois 62025

U156. ILELHM

Elmhurst Historical Museum
P.O. Box 84
Elmhurst, Illinois 60126
(312) 833-1457
Mrs. W.R. Harlan, Curator

Hours: 1:00–5:00, Tu, Th; 10:00–5:00, Sa
Access: Open to public
Size of Collection: 1,500 photographs, 50 negatives, 750 slides, 200 postcards

U157. **ILEVNW**
Northwestern University
Art History Department Collection
208 Kresge, Northwestern
Evanston, Illinois 60201
(312) 492-7077, 492-3230 (Curator)
Frances Friewald, Curator

Access: Scholars only, students
Reproduction Services: Photographic prints
Size of Collection: Photographs, negatives
Special Collections: Plans and drawings of Chicago School of Architecture; Andrews photographs of American architecture

Major Holdings: AI−1S, 2S, 3S, 4S; AE−1S, 2S, 3S; C−1S, 2S, 3S; AR−1S, 2S, 3S; F−1S, 2S, 3S, 4S; W−1S, 2S, 3S; AJ−1S, 2S, 3S; WM−1S, 2S, 3S; MW−1S, 2S, 3S, 4S; CW−1S, 2S, 3S, 4P, 4S; WI−1S, 2S, 3S; I−1S, 2S, 3S; T−1S, 2S, 3S; ETW−1S, 2S, 3S; WWI−1S, 2S, 3S; TW−1S, 2S, 3S; GD−1S, 2S, 3S; WWII−1S, 2S, 3S; P−1S, 2S, 3S; SA−1S, 2S, 3S; AL−1S, 2S, 3S; M−1S, 2S, 3S; S−1S, 2S, 3S; E−1S, 2S, 3S

U158. **ILNFPE**
The Roland Collection
Perennial Education
1825 Willow Road
Northfield, Illinois 60093
(312) 446-4153
Maureen Morey

Access: Rent or purchase only
Reproduction Service: None
Size of Collection: 16mm films

U159. **ILNOSU**
Illinois State University
Slide Library
Normal, Illinois 61761
(309) 436-6127
Mrs. Young S. Chung, Slide Librarian

Hours: 8:00−4:30, M−F
Access: Restricted use, scholars, students only
Reproduction Services: Color and black and white slides
Size of Collection: 50,000 slides

Major Holdings: AI−3S, 4S; C−2S, 3S; AR−1S, 2S, 3S; F−1S, 2S, 3S; W−1S, 2S, 3S; AJ−1S, 2S, 3S; WM−1S, 2S, 3S; MW−1S, 2S, 3S; CW−1S, 2S, 3S; WI−1S, 2S, 3S; I−1S, 2S, 3S; T−1S, 2S; ETW−1S, 2S, 3S; WWI−1S, 2S, 3S; TW−1S, 2S, 3S; GD−1S, 2S, 3S; WWII−1S, 2S, 3S; P−1S, 2S, 3S

U160. **ILOTHS**
LaSalle County Historical Society Museum
P.O. Box 577
Ottawa, Illinois 61350
(815) 434-0188
Mrs. Constance E. Fetzer

Hours: 2:00−4:00, M−Sa; 10:00−5:00, Su
Access: Open to public
Size of Collection: Photographs [*cont.*]

Major Holdings: I−4P; ETW−4P; WWI−4P; P−4P; AL−4P

U161. **ILSPSM**
Illinois State Museum
Spring and Edwards
Springfield, Illinois 62706
(217) 782-2272
Marlin Roos, Photographer

Hours: 8:30−5:00, M−Sa; 2:00−5:00, Su
Access: Open to public, restricted use, scholars only
Reproduction Services: Photographic prints, photocopy, color slides, owner's permission necessary
Size of Collection: 400 photographs, 400 negatives, 300 slides
Special Collections: Arts, crafts and archaeology of Illinois, slide collection

Major Holdings: F−1P, 1S; AJ−1P, 1S, 4P, 4S; CW−1P, 3P, 3S, 4P, 4S; WI−1P; I−1P, 3P, 3S, 4P 4S; T−1P, 3P, 3S, 4P, 4S

INDIANA

U162. **INBLUS**
Indiana University
Slide Library and Photo Archives
Fine Arts Library
Bloomington, Indiana 47401
(812) 337-5743
Betty Jo Irvine, Head of Fine Arts Library

Hours: 8:00−5:00, M−F (slides); photograph archives by appointment
Access: Open to public, restricted use, scholars, students only
Size of Collection: 5,000 photographs, 50,000 slides, 50 posters
Special Collections: Slides: old Indiana state fairs (lantern slides), architecture of Indiana; photographs: Indiana architecture, particularly courthouses

Major Holdings: AI−1S, 2S, 3S, 4S; AE−1S; C−1P, 1S, 2P, 3P, 3S, 4S; AR−1P, 1S, 2P, 2S, 3P, 3S; F−1P, 1S, 2P, 2S, 3P, 3S, 4S; W−1P, 1S, 2P, 2S, 3P, 3S, 4S; AJ−1P, 1S, 2P, 2S, 3P, 3S, 4S; WM−1P, 1S, 2P, 2S, 3P, 3S; MW−1P, 1S, 2P, 2S, 3P, 3S; CW−1P, 1S, 2P, 2S, 3P, 3S, 4S; WI−1P, 1S, 2P, 2S, 3P, 3S; I−1P, 1S, 2P, 2S, 3P, 3S, 4S; T−1P, 1S, 2P, 2S, 3P, 3S; ETW−1P, 1S, 2P, 2S, 3P, 3S; WWI−1P, 1S, 2P, 2S, 3P, 3S; TW−1P, 1S, 2P, 2S, 3P, 3S; GD−1P, 1S, 2P, 2S, 3P, 3S; WWII−1P, 1S, 2P, 2S, 3P, 3S, 4S; P−1P, 1S, 2P, 2S, 3P, 3S, 4S; SA−1P, 1S, 2P, 2S, 3P, 3S, 4S; E−4S

U163. **INEVMU**
Evansville Museum of Arts and Sciences, Inc.
Henry B. Walker, Jr., Memorial Art Library
411 S.E. Riverside Drive
Evansville, Indiana 47713

(812) 425-2406

Charlotte B. Stone, Curator of Collections

Hours: 10:00–5:00, Tu–F

Access: Restricted use

Reproduction Services: Photographs available, duplicate slides available, photocopy

Size of Collection: Photographs, negatives, slides

Special Collections: Black and white photographs: local 19th c. architecture, railroad engines, steamboats; black and white negatives: arts and crafts in museum collection, including the Bickerton Collection of Western Indian artifacts, ca. 300, chiefly baskets. Sprinklesburg, Goosetown, & Independence Rail Road train now on exhibit

U164. **INFWLI**

Lincoln National Life Foundation

Lincoln Library and Museum

1301 S. Harrison Street

Fort Wayne, Indiana 46801

(219) 742-5421, ext. 352

Dr. Mark E. Neely, Jr., Director

Hours: 8:00–4:30, M–Th; 8:00–12:30, F

Access: Open to public

Reproduction Services: Photographic prints, photocopy, free to students, scholars, journals, newspapers, etc.

Size of Collection: 1,500 photographs, 2,500 negatives, 1,000 postcards

Special Collections: Original photographs of Abraham Lincoln and associates; photo-reproductions of prints, paintings, sculptures of Lincoln's life and times

Major Holdings: CW–2P, 3P

U165. **ININHE**

Herron School of Art, IUPUI

Herron School of Art Library

1701 N. Pennsylvania Street

Indianapolis, Indiana 46202

(317) 923-3651, ext. 32

David V. Lewis, Slide Curator

Hours: 8:00–7:00, M–Th; 8:00–5:00, F

Access: Restricted to faculty

Size of Collection: 20,000 slides (500 American)

Special Collections: Slide collection of the New York Museum of the American Indian (approx. 2,000 slides)

Major Holdings: AI–1S, 2S, 3S, 4S; C–1S, 2S, 3S; AR–1S, 2S, 3S; F–1S, 2S, 3S; W–1S, 2S, 3S; AJ–1S, 2S, 3S; WM–1S, 2S, 3S; MW–1S, 2S, 3S; CW–1S, 2S, 3S; WI–1S, 2S, 3S; I–1S, 2S, 3S; T–1S, 2S, 3S; ETW–1S, 2S, 3S; WWI–1S, 2S, 3S; TW–1S, 2S, 3S; GD–1S, 2S, 3S; WWII–1S, 2S, 3S; P–1S, 2S, 3S; SA–1S, 2S, 3S; AL–1S, 2S, 3S; M–1S, 2S, 3S; S–1S, 2S, 3S; E–1S, 2S, 3S

U166. **ININMA**fl

Indianapolis Museum of Art

Film Library

1200 W. 38th Street

Indianapolis, Indiana 46208

(317) 923-1381

Robert Yassin, Acting Director and Chief Curator

Hours: 9:00–5:00, Tu–F

Access: Open to the public and by appointment

Reproduction Services: Films available for rental fee of $6.50

Size of Collection: 12 films, 45 videotapes

Major Holdings: AI–1, 2, 3, 4

U167. **ININMA**rl

Indianapolis Museum of Art

Reference Library

1200 W. 38th Street

Indianapolis, Indiana 46208

(317) 923-1331, ext. 46

Martha Blocker, Librarian

Hours: 11:00–5:00, Tu–Su

Access: Open to public

Reproduction Services: Photocopy

U168. **ININMA**sc

Indianapolis Museum of Art

Slide Collections

1200 W. 38th Street

Indianapolis, Indiana 46208

(317) 923-1331

Carolyn J. Metz, Assistant Curator of Slide Collection

Hours: 1:00–5:00, Tu–Sa

Access: Restricted to museum staff and professional members

Size of Collection: 40,000 slides

Special Collections: Slides: Indiana crafts and decorative arts, museum exhibitions, urban walls, greentown glass (Indiana)

Major Holdings: AI–1S, 2S, 3S, 4S; C–1S, 2S, 3S, 4S; AR–1S, 2S, 3S, 4S; F–1S, 2S, 3S 4S; W–3S; AJ–1S, 2S, 3S; WM–2S, 3S, 4S; CW–3S; WI–3S; I–1S, 2S, 3S, 4S; ETW–1S, 2S, 3S, 4S; WWI–1S, 2S, 3S, 4S; TW–1S, 2S, 3S, 4S; GD–1S, 2S, 3S, 4S; WWII–1S, 2S, 3S, 4S; P–1S, 2S, 3S, 4S; SA–1S, 3S; AL–3S; M–3S; S–2S, 3S; E–3S

U169. **INMUBS**

Ball State University

College of Architecture and Planning

CAP Library

Muncie, Indiana 47306

(317) 285-4776

Steven E. Kells, Curator

Hours: 8:00–5:00, M–F

Access: Open to public

Size of Collection: 30,000 slides

Major Holdings: AI–1S; C–1S; AR–1S; F–1S, 3S; W–1S, 3S; AJ–1S, 3S; WM–1S, 3S; MW–1S, 3S; CW–1S, 3S; WI–1S, 3S; I–1S, 3S; T–1S; ETW–1S, 3S; WWI–1S, 3S; TW–1S, 3S; GD–1S, 3S; WWII–1S, 3S; P–1S, 3S; SA–3S

U170. **INNDU**
University of Notre Dame
Department of Art Slide Library
Notre Dame, Indiana 45665
(219) 283-7452
Mrs. Betty Dodge, Slide Librarian

Access: Restricted use, students
Reproduction Services: Photocopy, color and
 black and white slides, catalog available
Size of Collection: 43,000 slides

Major Holdings: AI–1S, 2S, 3S; C–1S, 2S, 3S;
AR–1S, 2S, 3S; F–1S, 2S, 3S; AJ–1S, 2S, 3S;
CW–1S, 2S, 3S; I–1S, 2S, 3S, 4S; T–1S, 2S, 3S,
4S; ETW–1S, 2S, 3S, 4S; WWI–1S, 2S, 3S, 4S;
TW–1S, 2S, 3S, 4S; GD–1S, 2S, 3S, 4S;
WWII–1S, 2S, 3S, 4S; P–1S, 2S, 3S, 4S; SA–1S,
2S, 3S, 4S

U171. **INPLMC**
Marshall County Historical Society Musem
317 W. Monroe
Plymouth, Indiana 46563
(219) 936-2306
Mrs. Mary L. Durham, Curator

Hours: 9:00–5:00, M–Sa; 1:00–5:00, Su
Access: Open to public
Size of Collection: 150 photographs, 75 negatives,
 200 slides, 200 postcards

Major Holdings: I–1P, 1S, 4P, 4S; T–1P, 1S, 4P,
4S; ETW–1P, 1S, 4P, 4S; WWI–1P, 4P; TW–1P,
4P, 4S; AL–1P, 4P; S–1P, 4P

U172. **INRIEC**
Earlham College
Slide Collection
Richmond, Indiana 47374
(317) 962-6561
Nancy McDowell, Curator of Slides

Hours: 9:00–5:00
Access: Open to public, student use
Size of Collection: 3,000 slides
Special Collections: Slides: 20th c. American,
 Sardak Collection of American art

Major Holdings: P–1S, 2S, 3S; SA–1S, 2S, 3S

U173. **INTHSU**
Indiana State University
Slide Collection, Humanities Department
Terre Haute, Indiana 47809
(812) 232-6311, ext. 2318

Hours: 8:00–5:00, M–F
Access: Restricted to faculty and students
Size of Collection: 70,000–80,000 slides

Major Holdings: C–1S, 3S; AR–1S, 3S; F–1S, 3S;
W–1S, 3S; AJ–1S, 2S, 3S; WM–1S, 2S, 3S;
MW–1S, 2S, 3S; CW–1S, 2S, 3S; WI–1S, 2S, 3S;
I–1S, 2S, 3S; T–1S, 2S, 3S; ETW–1S, 2S, 3S;
WWI–1S, 2S, 3S; TW–1S, 2S, 3S; GD–1S, 2S, 3S;
WWII–1S, 3S; P–1S, 2S, 3S

U174. **INWLPU**
Purdue University
Audio-Visual Center, Stewart Center
West Lafayette, Indiana 47907
(317) 749-6202
Carl Snow, Film Librarian

Hours: 7:20–10:00, M–F
Access: Open to public
Reproduction Services: Catalog available
Size of Collection: Slides: 1,000 sets or 20,000
 slides; films: 5,000

Major Holdings: C–1S, 2S; AR–1S, 2S; F–1S, 2S

KANSAS

U175. **KSARCH**
Cherokee Strip Living Museum
Cherokee Strip Land Rush
South Summit Street Road
Box 230
Arkansas City, Kansas 67005
(316) 442-6705
Herbert Marshall

Hours: September 1–May 16: 1:00–5:00; June
 1–August 31: 10:00–5:00
Access: Open to public, open by appointment,
 restricted use, scholars and students only
Reproduction Services: None
Size of Collection: 1,000 photographs, 200
 postcards
Special Collections: Documents pertaining to the
 Cherokee Strip Run of 1893

Major Holdings: AI–2P, 3P, 4P; WM–3P, 4P;
T–3P, 4P; ETW–3P, 4P; WWI–3P, 4P;
WWII–1P, 3P; TW–3P, 4P

U176. **KSASPM**
Pioneer Museum
Steele Collection-Western
 Kansas-Clark County
P.O. Box 613
430 W. 4th Street
Ashland, Kansas 67831
(316) 635-2227
Florence E. Hurd, Curator

Hours: October 1–June 1: 12:30–4:30; June
 1–October 1: 10:30–6:00
Access: Open to public
Reproduction Services: Photocopy, black and
 white slides, fee schedule varies according to
 size
Size of Collection: 200 photographs

Major Holdings: WM–1P; AL–1P; E–1P

U177. **KSCOST**
Sod Town Pioneer Homestead Museum
Historical Collection of the
 Sod House Society of America
Box 393
Colby, Kansas 67701
(913) 462-2021
Ronald E. Thiel, Director of Research

Hours: Museum: May–October, 8:00–8:00 daily; photograph collection: by appointment

Access: Museum: Open to public; photograph collection: open by appointment, restricted use, some postcards and booklets available for purchase

Reproduction Services: Photographic prints, photocopy, some color slides

Size of Collection: 500 photographs; some negatives, slides, postcards, newspaper clippings

Special Collections: Photographs of old pioneer and homestead era; sod, part sod, and dugout buildings in U.S.A., Canada, and Mexico (to a limited degree), which show pioneer homestead families, scenes, etc.

Major Holdings: WM–1P

U178. **KSFRHS**

Wilson County Historical Society Museum
P.O. Box 477
Fredonia, Kansas 66736
(316) 378-3143
Doris Cantrall

Hours: 1:30–4:30, M–F
Access: Open to public, open by appointment
Reproduction Services: Photographic prints
Size of Collection: 1,000 photographs, 300 slides, sets of postcards (5 each)
Special Collections: Artifacts and WPA dolls
Major Holdings: AI; GD

U179. **KSHASC$_a$**

Fort Hays Kansas State College
Art Department
Hays, Kansas 67601
(913) 628-4287
John C. Thorns, Jr., Chairman

Hours: 8:00–12:00, 1:00–5:00, M–F
Access: Open to public, open by appointment
Reproduction Services: Photographic prints, photocopy, color and black and white slides
Size of Collection: 20,000 slides

Major Holdings: C–1S; AR–1S; F–1S; I–1S; ETW–1S, 2S, 3S; TW–1S, 2S, 3S; GD–1S, 2S, 3S; WWII–1S, 2S, 3S; P–1S, 2S, 3S

U180. **KSHASC$_l$**

Fort Hays Kansas State College
Forsyth Library
Hays, Kansas 67601
(913) 628-4431
Marc T. Campbell

Access: Open by appointment
Reproduction Services: Color and black and white slides
Size of Collection: 200 photographs, 200 slides
Special Collections: Photographs of early history of the college, slides of natural science and ornithology of Western Kansas

Major Holdings: ETW–4P, 4S; TW–4P, 4S; AL–4S

U181. **KSLANK$_s$**

University of Kansas
Department of History of Art, Slide Collection
Spooner Museum of Art
Lawrence, Kansas 66045
(913) 864-4170
Diane Anthes, Slide Librarian

Access: Restricted use
Reproduction Services: Available to only those faculty within the University of Kansas who have been granted special permission
Size of Collection: 120,000 slides

Major Holdings: AI–1S, 2S, 4S; C–1S, 2S, 3S, 4S; AR–1S, 3S, 4S; F–1S, 2S, 3S, 4S; W–3S, 4S; AJ–1S, 3S, 4S; WM–3S, 4S; CW–1S, 2S, 3S, 4S; I–1S, 2S, 3S, 4S; T–1S, 2S, 3S, 4S; ETW–1S, 2S, 3S, 4S; WWI–3S; TW–1S, 2S, 3S, 4S; GD–1S, 2S, 3S, 4S; WWII–2S, 3S; P–1S, 2S, 3S, 4S

U182. **KSLAUK$_m$**

University of Kansas
Museum of Art
Lawrence, Kansas 66045
(913) 864-4710

Access: Restricted use, purchase only
Reproduction Services: 8x10 photographic prints, color slides, 4x5 color transparencies, fee schedule available on request
Size of Collection: 1,000 negatives

U183. **KSTOHS**

Kansas State Historical Society
Photographic Collection
Memorial Building
120 W. Tenth
Topeka, Kansas 66612
(913) 296-3251
Eugene D. Decker, Archivist

Hours: 8:00–5:00, M–F
Access: Open to public
Reproduction Services: Photographic prints, microfilm, black and white slides, 4x5 color transparencies, fee schedule
Size of Collection: 66,000 photographs, 12,000 negatives, 1,500 slides, 58 lithographs, 130 movies

U184. **KSWIAM**

Wichita Art Museum
619 Stackman Drive
Wichita, Kansas 67203
(316) 264-0324
Howard E. Wooden, Director

Access: Restricted use, purchase for educational purposes
Reproduction Services: Photographic prints, color slides, 4x5 transparencies, catalog available for the Roland P. Murdock Collection, fee schedule
Special Collections: Roland P. Murdock Collection of American paintings, drawings and

sculpture; M.C. Naftzger Collection of Charles M. Russell's paintings, drawings, and sculpture; Gwen Houston Naftzger Collection of Edward Boehm and Dorothy Doughty's porcelain birds; Powell Collection of American and European fashion prints; Mrs. Cyrus M. Beachy 19th c. doll collection; and the Clare A. Hannum Collection of American Indian baskets and weaving

KENTUCKY

U185. **KYBEPC**

Berea College
Art Department
Berea, Kentucky 40403
(609) 986-9341, ext. 292
Lester F. Pross, Chairman

Hours: 8:00–5:00, M–F
Access: Open to public, restricted use
Reproduction Services: None
Size of Collection: 4,000 photographs, 50 posters
Special Collections: Doris Ulmann photographs of southern Appalachian culture

Major Holdings: GD–1P, 4P; AL–1P, 4P

U186. **KYBGWK**

Western Kentucky University
Kentucky Library and Museum
Bowling Green, Kentucky 42101
(502) 745-2592
Riley Handy, Kentucky Librarian

Hours: 9:00–5:00
Access: Open to public
Reproduction Services: Photocopy
Size of Collection: 6,000 photographs, 300 postcards

Major Holdings: AJ–1P, 4P; CW–1P, 4P; I–1P, 4P; T–1P, 4P; ETW–1P, 4P; WWI–1P, 4P; TW–1P, 4P; GD–1P, 4P; WWII–1P, 4P; P–1P, 4P; AL–1P, 4P; M–1P, 4P

U187. **KYLOPS**

Center for Photographic Studies
722 W. Main Street
Louisville, Kentucky 40202
(502) 583-5140
Conrad J. Pressma, Director

Access: Open by appointment
Reproduction Services: Color and black and white slides, catalog available
Size of Collection: 300 photographs, 5,000 slides

U188. **KYLOUL**

University of Louisville
Slide Collection
Fine Arts Department
Belknap Campus
Louisville, Kentucky 40208
(502) 636-4233

Anne S. Coates, Curator of Slides

Access: Open by appointment to public, restricted to use by faculty and staff of university
Reproduction Services: None
Size of Collection: 16,500 slides
Special Collections: Kugelman Collection of slides showing WWI; Patterson collection of city planning slides (contemporary); Carnegie "Arts of the United States" slides

Major Holdings: AI–2S, 3S, 4S; AE–1S, 2S, 3S, 4S; C–1S, 2S, 3S, 4S; AR–1S, 2S, 3S, 4S; F–1S, 2S, 3S, 4S; W–1S, 2S, 3S, 4S; AJ–1S, 2S, 3S, 4S; WM–1S, 2S, 3S, 4S; MW–1S, 2S, 3S, 4S; CW–1S, 2S, 3S, 4S; WI–1S, 2S, 3S, 4S; I–1S, 2S, 3S, 4S; T–1S, 2S, 3S, 4S; ETW–1S, 2S, 3S, 4S; WWI–1S, 2S, 3S, 4S; TW–1S, 2S, 3S, 4S; GD–1S, 2S, 3S, 4S; WWII–1S, 2S, 3S, 4S; P–1S, 2S, 3S, 4S; E–4S

LOUISIANA

U189. **LABRAA**

Anglo-American Art Museum
Memorial Tower
Louisiana State University
Baton Rouge, Louisiana 70803
(504) 388-4003
H. Parrott Bacot, Curator

Hours: 9:00–4:30, M–F; 9:00–12:00, 1:00–4:30, Sa; 1:00–4:30, Su
Access: Open to public, restricted use
Reproduction Services: Photographic prints, black and white slides, 4x5 and 8x10 transparencies, fee of $2.00 per 8x10 print
Major Holdings: C–1P, 3P, 4P; AR–1P, 3P, 4P; F–1P, 3P, 4P; W–3P, 4P; AJ–1P, 3P, 4P; CW–3P; T–2P; GD–3P; P–3P

U190. **LANOLS**

Louisiana State Museum
751 Chartes Street
New Orleans, Louisiana 70116
(504) 581-4321
Robert R. Macdonald, Director

Hours: 9:00–5:00, Tu–Sa
Access: Open to public
Reproduction Services: Photographic prints, photocopy, color slides, 4x5 color transparencies available for rental fee of $25.00 for four months
Size of Collection: Photographs, slides
Special Collections: French colonial material, 1699–1808, well represented

Major Holdings: AI–3P, 3S, 4P, 4S; AE–3P, 3S, 4P, 4S; C–1P, 1S, 2P, 2S, 3P, 3S, 4P, 4S; F–1P, 1S, 2P, 2S, 3P, 3S, 4P, 4S; W–3P, 3S, 4P, 4S; AJ–1P, 1S, 2P, 2S, 3P, 3S, 4P, 4S; WM–3P, 3S, 4P, 4S; MW–1P, 1S, 2P, 2S, 3P, 3S, 4P, 4S;

CW—2P, 2S, 3P, 3S, 4P, 4S; WI—4P, 4S; I—4P, 4S; T—3P, 3S, 4P, 4S; ETW—3P, 3S, 4P, 4S; WWI—4P, 4S; TW—4P, 4S; GD—4P, 4S; WWII—4P, 4S; P—4P, 4S; AL—4P, 4S; M—3P, 3S, 4P, 4S; S—4P, 4S; E—3P, 3S, 4P, 4S

U191. LASHNA

The R.W. Norton Art Gallery
4747 Creswell Avenue
Shreveport, Louisiana 71106
(318) 865-4201
Jerry M. Bloomer, Librarian

Hours: 1:00—5:00, W, Sa
Access: Open to public, restricted use
Reproduction Services: Photographic prints, color slides, 8x10 color transparencies, listing available
Size of Collection: Photographs, negatives, slides
Major Holdings: AI—2P, 3P; C—2P, 4P; AR—3P, 4P; F—3P, 4P; AJ—3P; WM—2P, 3P; MW—3P; CW—3P; I—4P

MAINE

U192. MEBAMM

Bath Marine Museum
Mark W. Hennessey Archives
963 Washington Street
Bath, Maine 04530
(207) 443-6311
Marion Lilly, Registrar

Access: Open by appointment
Reproduction Services: Photographic prints, photocopy, color and black and white slides
Size of Collection: 1,000 photographs, 1,000 negatives, 100 slides, 500 postcards
Special Collections: Photographic collection of shipbuilding and Maine built vessels (sail, steam, merchant, military), 1607—present. Color slide collection of ship portraits and ship models in collection of Bath Marine Museum
Major Holdings: WWI—4P; M—3P, 3S

U193. MEBHHS

Bar Harbor Historical Society
Bar Harbor Historical Society Exhibit
34 Mt. Desert Street
Bar Harbor, Maine 14609
(207) 288-4245
Gladys O'Neil, Curator

Hours: 1:00—4:00, M—F (mid-June—mid-September); 10:00—12:00, W, F
Access: Open to public
Size of Collection: 500 photographs, 100 negatives, 150 postcards
Special Collections: 100 stereoscopic views of early Bar Harbor 1870s and 1800s
Major Holdings: T—1P

U194. MEBRBC$_{da}$

Bowdoin College Department of Art
Art Department Library
Art Department, Bowdoin College
Brunswick, Maine 04011
(207) 725-8731, ext. 276, 277
Susan D. Simpson, Teaching Aids Librarian

Access: Open by appointment, restricted use
Reproduction Services: Color and black and white slides
Size of Collection: 20,000 photographs, 55,000 slides
Special Collections: Winslow Homer
Major Holdings: AI—1S, 2S, 3S, 4S; AE—1P, 1S, 2P, 2S, 3P, 3S, 4P, 4S; C—1P, 1S, 2P, 2S, 3P, 3S, 4P, 4S; AR—1P, 1S, 2P, 2S, 3P, 3S, 4P, 4S; F—1P, 1S, 2P, 2S, 3P, 3S, 4P, 4S; W—1P, 1S, 2P, 2S, 3P, 3S, 4P, 4S; AJ—1P, 1S, 2P, 2S, 3P, 3S, 4P, 4S; WM—1P, 1S, 2P, 2S, 3P, 3S, 4P, 4S; CW—1P, 1S, 2P, 2S, 3P, 3S, 4P, 4S; I—1P, 1S, 2P, 2S, 3P, 3S, 4P, 4S; T—1P, 1S, 2P, 2S, 3P, 3S, 4P, 4S; ETW—1P, 1S, 2P, 2S, 3P, 3S, 4P, 4S; WWI—1P 1S, 2P, 2S, 3P, 3S, 4P, 4S; GD—1P, 1S, 2P, 2S, 3P, 3S, 4P, 4S; WWII—1P, 1S, 2P, 2S, 3P, 3S, 4P, 4S; P—1P, 1S, 2P, 2S, 3P, 3S, 4P, 4S

U195. MEBRBC$_{ma}$

Bowdoin College Museum of Art
Brunswick, Maine 04011
(207) 725-8731, ext. 275
Dr. R. Peter Mooz, Director

Hours: Closed for renovation until Spring 1976
Access: Open to public
Reproduction Services: Color slides, 8x10 large format color transparencies (upon request at expense of purchaser), purchase of photographs and other media only
Size of Collection: Photographs, negatives, slides, postcards, posters, color transparencies
Special Collections: Colonial and Federal; Old Master drawings; the Warren Collection of Classical Antiquities; the Winslow Homer Collection; important works by 19th and 20th c. American artists such as Thomas Eakins, Martin Johnson Heade, George Inness, Robert Henri, John Sloan, Leonard Baskin, and Hyman Bloom; the Molinari Collection of Renaissance and Baroque medals and plaquettes
Major Holdings: C—1P, 1S; AR—1P, 1S; F—1P, 2S; CW—1P; ETW—1P

U196. MECASS

Castine Scientific Society
Wilson Museum
Castine, Maine 04421
(207) 826-8753
E.W. Doudiet, Director

Access: Open by appointment, scholars only, serious students [*cont.*]

Reproduction Services: Photographic prints and slides of collection available

Size of Collection: Photographs ("a few library drawers")

Special Collections: Tools from agricultural and maritime life; local photographs from 1850 to present

Major Holdings: AI—2S, 4P, 4S; C—1P, 1S; AR—1P, 1S, 4P, 4S; F—1P, 4P, 4S; AJ—1P, 4P, 4S; I—1P

U197. **MECFRH**

Ruggles House Society
Bar Harbor, Maine 04609
(207) 288-3597
Mrs. Edward Browning, Jr., President

Hours: 8:30—4:30, M—F; 10:00—4:00, Su (June 1—October 15)

Access: Open to public

Size of Collection: Negatives, postcards

Special Collections: Ruggles House, built in 1818, has period furnishings including china and glass

U198. **MEDXHS**

Dexter Historical Society
Dexter, Maine 04930
Frank Spizuoco, President

Hours: 1:00—5:00, daily (June 15—September 15)

Access: Open to public, by appointment

Size of Collection: 500 photographs, 200 negatives

U199. **MEPOSA**

Portland Society of Art
Portland Society of Art Library
97 Spring Street
Portland, Maine 04101
(207) 773-1233
Barbara J. Best, Librarian

Hours: 9:00—5:00, M—F

Access: Open to public, restricted use

Size of Collection: 6,000 slides

Major Holdings: AI—4S; C—3S; AR—3S; F—1S, 3S; AJ—3S; T—3S; ETW—1S, 2S, 3S, 4S; WWI—1S, 2S, 3S, 4S; TW—1S, 2S, 3S, 4S; GD—1S, 2S, 3S, 4S; WWII—1S, 2S, 3S, 4S; P—1S, 2S, 3S, 4S

U200. **MEROFA**

William A. Farnsworth Library
and Art Museum
Box 466 19 Elm Street
Rockland, Maine 04841
(207) 596-6457
Beatrice B. Grant, Administrative Assistant

Hours: October-May: 10:00—5:00, Tu—Sa; 1:00—5:00, Su
June-September: 10:00—5:00, M—Sa; 1:00—5:00, Su

Reproduction Services: Black and white photographic prints, fee schedule

U201. **METHMP**

Montpelier Historical Museum
33 Knox Street
Thomaston, Maine 04861
(207) 354-6731
Lafayette French

Special Collections: Furniture of General Henry Knox as well as family books and papers; slides and postcards of collection on sale to public

MARYLAND

U202. **MDBAHS**

Maryland Historical Society
201 W. Monument Street
Baltimore, Maryland 21201
(301) 685-3750
P. William Filby, Director

Hours: 11:00—4:00, Tu—Sa

Access: Open to public, open by appointment; restricted use, scholars only, students

Reproduction Services: Photographic prints, color and black and white slides, 4x5 large format color transparencies, fee schedule available

Size of Collection: 500 photographs, 1,000 negatives, 500 slides, 200 postcards

Special Collections: Old photographs of Maryland views and personages; ambrotypes and daguerreotypes included, portraits only; Cartes de Visite

Major Holdings: C—1P, 3P, 3S, 4P, 4S; AR—1P, 2P, 3P, 3S, 4P, 4S; F—1P, 3P, 3S, 4P, 4S; W—1P, 3P, 3S, 4P, 4S; AJ—1P, 2P, 3P, 3S, 4P, 4S; WM—3P, 3S, 4P, 4S; MW—3P, 3S, 4P, 4S; CW—1P, 2P, 3P, 3S, 4P, 4S; WI—4P; I—1P, 1S, 3P, 4P, 4S; T—1P, 3P, 4P, 4S; ETW—1P, 3P, 4P; WWI—1P, 3P; TW—3P; GD—1P, 3P; WWII—1P, 3P; P—1P, 3P; AL—1P, 3P, 4P; M—1P, 3P, 4P

U203. **MDBAJA**

Johns Hopkins University
Department of History of Art
Baltimore, Maryland 21218
(301) 366-3300
Agota Gold, Slide
and Photograph Collection Curator

Access: Restricted use, scholars only, students

Size of Collection: 7,000 slides

Major Holdings: C—1S, 2S, 3S; AR—1S; F—1S, 4S; AJ—1S, 3S; CW—2S; I—1S, 2S, 3S; ETW—1S, 2S; WWI—2S; TW—1S; GD—1S, 2S, 3S; WWII—2S, 3S; P—1S, 2S, 3S

U204. **MDBAMI**

Maryland Institute College of Art
The Decker Library (Slide Library)
1400 Cathedral Street
Baltimore, Maryland 21201

(301) 669-9200, Ext. 45

Pamela A. Potter, Slide Librarian

Hours: 8:30–4:30, 6:00–10:00, M; 8:30–4:30, Tu–F

Access: Restricted use, students

Size of Collection: 55,000 slides

Special Collections: 750 2x2 slides of the Lucas Collection (19th c. prints and paintings; approximately 8,000 lantern slides

Major Holdings: AI–1S, 2S, 3S, 4S; AE–1S, 2S, 3S, 4S; C–1S, 2S, 3S, 4S; AR–1S, 2S, 3S, 4S; F–1S, 2S, 3S, 4S; W–1S, 2S, 3S, 4S; AJ–1S, 2S, 3S, 4S; WM–12S, 2S, 3S, 4S; MW–1S, 2S, 3S, 4S; CW–1S, 2S, 3S, 4S; WI–1S, 2S, 3S, 4S; I–1S, 2S, 3S, 4S; T–1S, 2S, 3S, 4S; ETW–1S, 2S, 3S, 4S; WWI–1S, 2S, 3S, 4S; TW–1S, 2S, 3S, 4S; GD–1S, 2S, 3S, 4S; WWII–1S, 2S, 3S, 4S; P–1S, 2S, 3S, 4S

U205. MDBAPM

Peale Museum

(Municipal Museum of Baltimore)

225 Holliday Street

Baltimore, Maryland 21202

(301) 396-2523

Wilbur H. Hunter, Director

Hours: Weekdays by appointment

Access: Open by appointment, restricted use

Reproduction Services: All reproduction done by commercial firm on our orders, fee schedule

Size of Collection: 10,000 photoprints, 25,000 negatives, 2,000 slides

Special Collections: A. Aubrey Bodine Photographic Collection, 1924–70; photographs of Baltimore, 1850–1975; photographs of Baltimore buildings

Major Holdings: AR–1P, 1S; F–1P, 1S, 2P, 3P, 3S; W–1P, 1S, 3P, 3S; AJ–1P, 1S, 3P, 3S; WM–1P, 1S, 3P, 3S; MW–1P, 3P, 3S; CW–1P, 1S, 3P, 3S; WI–1P, 1S, 3P, 3S; I–1P, 1S, 3P, 3S; T–1P, 1S, 3P, 3S; ETW–1P, 1S, 3P, 3S; WWI–1P, 1S, 3P, 3S; TW–1P, 1S, 3P, 3S; GD–1P, 1S, 3P, 3S; WWII–1P, 1S, 3P, 3S; P–1P, 1S, 3P, 3S; SA–1P, 1S, 3P, 3S; AL–1P, 1S, 3P, 3S; M–1P, 1S, 3P, 3S; S–1P, 1S, 3P, 3S; E–1P, 1S, 3P, 3S

U206. MDBAUM

University of Maryland Baltimore County

University of Maryland

Baltimore County Library

5401 Wilkins Avenue

Baltimore, Maryland 21228

(301) 455-2356

Antonio R. Raimo, Director

Hours: Photographic collection: 1:00–3:00; slide collection: 8:30–3:30

Access: Open to public, by appointment, students

Reproduction Services: Photographic prints, photocopy, color slides

Size of Collection: 12,000 photographs, 2,000

negatives, 28,646 slides, 250 sound effect items

Special Collections: Socially significant images, Hines Collection; Jackson Book Portfolios by most major photographers, both historical and contemporary

Major Holdings: AI–2S, 3P, 3S, 4S; AE–2S, 3S; C–1S, 2S, 3P, 3S, 4S; AR–1S, 2S, 3P, 3S, 4S; F–1S, 2S, 3P, 3S, 4S; W–2S, 3S; AJ–1S, 2S, 3P, 3S, 4S; WM–1S, 2S, 3P, 3S, 4S; MW–3S; CW–1S, 2S, 3S; WI–3S; I–1S, 2S, 3S, 4S; T–1S, 2S, 3S; ETW–2S, 3S; WWI–2S, 3S; TW–2S, 3S, 4S; GD–2S, 3S; WWII–2S, 3S; P–1S, 2S, 3S, 4S; SA–1S, 2S, 3S, 4S; AL–1S, 2S, 3S, 4S; M–1S, 2S, 3S, 4S; S–1S, 2S, 3S, 4S; E–1S, 2S, 3S, 4S

U207. MDBAWA

Walters Art Gallery

600 N. Charles Street

Baltimore, Maryland

(301) 547-9000

Access: Purchase only

Reproduction Services: Photographic prints

Size of Collection: 600 photographs

Special Collections: Watercolors by Alfred Jacob Miller recording his 1837 trip to the American West

Major Holdings: AJ–3P; WM–3P; WI–3P

U208. MDCPUM

University of Maryland

School of Architecture

Slide Collection

College Park, Maryland 20742

(301) 454-5422

Elizabeth D. Alley, Curator of Slides

Access: Faculty only

Reproduction Services: None

Size of Collection: 65,000 slides (15,000 ca. American architecture slides)

Major Holdings: AI–1S,4S; AE–1S,4S; C–1S,4S; AR–1S,4S; F–1S,4S; W–1S,4S; AJ–1S,4S; WM–1S,4S; CW–1S,4S; WI–1S,4S; I–1S,4S; T–1S,4S; ETW–1S,4S; WWI–1S,4S; TW–1S,4S; GD–1S,4S; WWII–1S,4S; P–1S,4S; SA–1S,4S; AL–1S,4S; M–1S,4S; S–1S,4S; E–1S,4S

U209. MDSHAN

Antietam National Battlefield Site, NPS

Antietam NBS Library

P.O. Box 158

Sharpsburg, Maryland 21782

(301) 432-5124

Superintendent

Hours: 8:30–5:00

Access: Open by appointment, restricted use, scholars only, students

Reproduction Services: None

Size of Collection: 500 photographs, 300 negatives, 300 slides, 25 postcards, 3 films (Mathew Brady, "Battle at Antietam Creek")

[*cont.*]

Special Collections: Civil War diaries, histories, biographies and special accounts

Major Holdings: CW

U210. **MDTOGC**

Goucher College
Julia Rodgers Library/Art Office
Dulaney Valley Road
Towson, Maryland 21204
(301) 825-3300, ext. 367
Dorothy Cartridge Campbell, Art Assistant

Access: Restricted use, faculty and students
Size of Collection: 26,000 photographs, 600 negatives, 44,000 slides

MASSACHUSETTS

U211. **MABOAC**

Boston Architectural Center
Slide Library
320 Newbury Street
Boston, Massachusetts 02109
(619) 536-9018
Susan Pietsch, Slide Librarian

Hours: 2:00−10:00, M; 10:00−10:00, Tu−Th; 9:00−5:00, F; 10:00−3:00, Sa; 12:00-5:00, Su
Access: Restricted use, for study only
Reproduction Services: None
Size of Collection: 14,000 slides

Major Holdings: AI−1S; AE−1S; C−1S; AR−1S; F−1S; W−1S; AJ−1S; WM−1S; MW−1S; CW−1S; WI−1S; I−1S; T−1S, 4S; ETW−1S, 4S; WWI−1S, 4S; TW−1S, 4S; GD−1S, 4S; WWII−1S, 4S; P−1S, 4S; SA−1S; AL−1S; M−1S; S−1S; E−1S.

U212. **MABOBS**

The Bostonian Society, Old State House
The Bostonian Society
Old State House
206 Washington Street
Boston, Massachusetts 02109
Mrs. Ropes Cabot, Curator

Hours: 9:00−4:00 (subject to change)
Access: Scholars only, students
Reproduction Services: Photographic prints, photocopy, microfilm, black and white and color slides; any item can be photographed on order
Size of Collection: 10,000 photographs, 5,000 negatives, 500 slides, 500 postcards, 200 stereos
Special Collections: Colonial period relics associated with people; American Revolution militia to 1865; Federal period volunteer fire and police items to 1822; westward movement ship models; Mexican War posters; Civil War envelopes; Spanish-American War firearms and war relics; World War I posters; maritime figureheads and models; sailing cards; theater and hotel relics, posters

Major Holdings: C−1P, 3P, 4P; AR−1P, 2P, 3P, 4P; F−1P, 2P, 3P, 4P; W−3P, 4P; AJ−1P, 2P, 3P, 4P; WM−4P; CW−1P, 2P, 3P, 4P; M−1P, 2P, 3P, 4P; E−1P, 3P, 4P

U213. **MABOCA**

Massachusetts College of Art
Massachusetts College of Art Library
364 Brookline Avenue
Boston, Massachusetts 02215
(617) 731-2340, Ext. 26

Hours: 8:00−7:00, M; 8:00−9:30, Tu−Th; 8:00−5:00, F
Access: Open to public
Reproduction Services: None
Size of Collection: 60,000 slides, 250 16mm films, 5,000 pictures file, 250 film strips, 40 videotapes, 200 art reproduction prints, 130 film loops
Special Collections: Mounted magazine covers from 1900−1930s by artists Jessie Wilcox Smith, Norman Rockwell, Frank Mcintosh, Leyendecker, etc.; slides of contemporary crafts, textiles, glass, ceramics, metal; slides and microfiche of children's art; slides of contemporary illustration

Major Holdings: AI−1S, 2S, 3S, 4S; AE−1S, 2S; C−1S, 2S, 3S, 4S; AR−1S, 2S, 3S, 4S; F−1S, 2S, 3S, 4S; W−1S, 2S, 3S, 4S; AJ−1S, 2S, 3S, 4S; WM−1S, 2S, 3S, 4S; MW−1S, 2S, 3S, 4S; CW−1S, 2S, 3S, 4S; WI−1S, 2S, 3S,4S; I−1S, 2S, 3S, 4S; T−1S, 2S, 3S, 4S; ETW−1S, 2S, 3S, 4S; WWI−1S, 2S, 3S, 4S; TW−1S, 2S, 3S, 4S; GD−1S, 2S, 3S, 4S; WWII−1S, 2S, 3S, 4S; P−1S, 2S, 3S, 4S; SA−1S, 2S, 3S, 4S; AL−3S, 4S; M−3S; S−1S, 2S, 3S, 4S; E−1S, 2S, 3S, 4S

U214. [*See* U326.]

U215. **MABOFA**

Museum of Fine Arts, Boston
Slide Library
Huntington Avenue
Boston, Massachusetts 02115
(617) 267-9300, ext. 318
Barbara Koppelman, Supervisor

Hours: 10:00−4:00, Tu−F
Access: Open to public, restricted use; rental of slides by Massachusetts public school teachers at no charge, all others, $5.00 for 40 slides for two weeks
Reproduction Services: Color slides, listings available
Size of Collection: 65,000 slides
Special Collections: Early U.S. furniture and silver; Massachusetts architecture; U.S. textiles and ceramics and American Indian art

Major Holdings: AI−2S, 3S, 4S; C−1S, 3S, 4S; AR−1S, 2S, 3S, 4S; F−1S, 2S, 3S, 4S; AJ−1S, 2S, 3S, 4S; WM−1S, 3S, 4S; I−1S, 2S, 3S, 4S; T−1S, 2S, 3S, 4S; ETW−1S, 2S, 3S, 4S; WWI−1S, 2S, 3S, 4S; TW−1S, 2S, 3S, 4S; GD−1S, 2S, 3S, 4S; WWII−1S, 2S, 3S, 4S; P−1S, 2S, 3S, 4S

U216. MABOGM

Isabella Stewart Gardner Museum
2 Palace Road
Boston, Massachusetts 02115
(617) 566-1401

Access: Sales desk open to public; museum restricted use, by appointment
Reproduction Services: Photographic prints, color; detailed fee listing on request; color transparencies, 4x5
Size of Collection: 700 photographs, 1,500 slides, 90,000 postcards, 1,200 posters, American artists only represented
Major Holdings: C–3P; T–4P, 4S; ETW–2P, 2S, 3P, 3S, 4P, 4S; WWI–3P, 3S

U217. MABOHS

Massachusetts Historical Society
1154 Boylston Street
Boston, Massachusetts 02215
(617) 536-1608
Stephen T. Riley, Director

Hours: 9:00–4:45, M–F; closed holidays
Access: Scholars only
Reproduction Services: Photographic prints of portraits
Size of Collection: 400 photographs (all portraits)
Major Holdings: AE–1P; C–1P; AR–1P; F–1P; AJ–1P; CW–1P

U218. MABOPR

Society for the Preservation of New England
 Antiquities
Library of Daniel M. Lohnes
141 Cambridge Street
Boston, Massachusetts 02114
(617) 227-3956
Daniel M. Lohnes

Access: Restricted use, open by appointment
Reproduction Services: Photographic prints, photocopy, color and black and white slides, 4x5 color transparencies, fee schedule
Size of Collection: 200,000 photographs, 100,000 negatives, 2,000 slides, 30,000 postcards, 6,000 daguerreotypes and ambrotypes
Special Collections: Stebbins and Coolidge Marine Collections
Major Holdings: AE–1P, 4P; C–1P, 1S, 3P, 4P; AR–1P, 1S, 3P, 4P; F–1P, 1S, 3P, 4P; AJ–1P, 1S; CW–1P, 1S, 4P; I–1P, 4P; T–1P, 4P; ETW–1P; WWI–1P; TW–1P; AL–1P, 4P; M–1P, 4P; E–1P

U219. MACAFO

Fogg Art Museum, Harvard University
Fine Arts Library
32 Quincy Street
Cambridge, Massachusetts 02138
(617) 495-3376
Wolfgang Freitag, Librarian
Helen Roberts, Curator of Photographs and
 Slides

Hours: 9:00–10:00, M–Th; 9:00–5:00, F, Sa
Access: Restricted use, scholars, students
Reproduction Services: Photographic prints; color slides (few); large format color transparencies: 4x5, 5x7, 8x10; fee schedule
Size of Collection: 450,000 photographs, 12,000 negatives, 200,000 slides, 50,000 postcards

Major Holdings: AI–2P, 2S, 3P, 3S, 4S; AE–1P, 1S, 2P, 2S, 3P, 3S; C–1P, 1S, 2P, 2S, 3P, 3S, 4P, 4S; AR–1P, 1S, 2P, 2S, 3P, 3S, 4P, 4S; F–1P, 1S, 2P, 2S, 3P, 3S, 4P, 4S; W–1P, 1S, 2P, 2S, 3P, 3S, 4P, 4S; AJ–1P, 1S, 2P, 2S, 3P, 3S, 4P, 4S; WM–1P, 1S, 2P, 2S, 3P, 3S, 4P, 4S; MW–1P, 1S, 2P, 2S, 3P, 3S, 4P, 4S; CW–1P, 1S, 2P, 2S, 3P, 3S, 4P, 4S; WI–1P, 1S, 2P, 2S, 3P, 3S, 4P, 4S; I–1P, 1S, 2P, 2S, 3P, 3S, 4P, 4S; T–1P, 1S, 2P, 2S, 3P, 3S, 4P, 4S; ETW–1P, 1S, 2P, 2S, 3P, 3S, 4P, 4S; WWI–1P, 1S, 2P, 2S, 3P, 3S, 4P, 4S; TW–1P, 1S, 2P, 2S, 3P, 3S, 4P, 4S; GD–1P, 1S, 2P, 2S, 3P, 3S, 4P, 4S; WWII–1P, 1S, 2P, 2S, 3P, 3S, 4P, 4S; P–1P, 1S, 2P, 2S, 3P, 3S, 4P, 4S; SA–1P, 1S, 2P, 2S, 3P, 3S, 4P, 4S; AL–1P, 1S, 2P, 2S, 3P, 3S, 4P, 4S; M–1P, 1S, 2P, 2S, 3P, 3S, 4P, 4S; S–1P, 1S, 2P, 2S, 3P, 3S, 4P, 4S; E–1P, 1S, 2P, 2S, 3P, 3S, 4P, 4S

U220. MACAIT

Massachusetts Institute of Technology
Rotch Library, Visual Documents Collection
Room 7-304
Cambridge, Massachusetts
(617) 253-7053
Mrs. Lenis Williams,
 Visual Documents Librarian

Hours: 9:00–5:00, M–F; closed holidays
Access: Restricted use
Reproduction Services: None
Size of Collection: 40,000 photographs, 15,000 negatives, 150,000 slides

Major Holdings: C–1P, 1S, 2P, 2S, 3P, 3S; AR–1P, 1S, 2P, 2S, 3P, 3S; F–1P, 1S, 2P, 2S, 3S; AJ–1P, 1S, 2P, 2S, 3P, 3S; ETW–1P, 1S, 3P, 3S

U221. MACAPM

Peabody Museum, Harvard University
11 Divinity Avenue
Cambridge, Massachusetts 02138
(617) 495-2248
Katherine B. Edsall, Archivist

Hours: 9:00–4:00
Access: Open by appointment to scholars and students for research
Reproduction Services: Photographic prints, 4x5 color transparencies
Size of Collection: 10,000 photographs, 10,000 negatives
Special Collections: American Indian people, places, artifacts; photographs only
Major Holdings: AI–4P; WM–4P

U222. **MACOOH**
Louisa May Alcott Memorial Association
Orchard House P.O. Box 343
Concord, Massachusetts 01742
(617) 369-4118
Mrs. Jayne K. Gordon, Director

Hours: April–October, daily; call for appointment
Access: Open to public, items for purchase and rental
Reproduction Services: Items may be borrowed for 3 weeks for reproduction; no fee, but borrower must provide Orchard House with negative if photocopied and pay postage; color slides
Size of Collection: Photographs, negatives, slides and postcards (small)
Special Collections: Exterior and interior views of the Louisa May Alcott historic site; slides of Louisa May Alcott's artwork may be used in scholarly publication with special permission
Major Holdings: CW–1P, 1S, 2P, 2S, 3P, 3S, 4P, 4S

U223. **MALXAS**
Lexington Historical Society, Inc.
15 Belfry Terrace
Lexington, Massachusetts 02173
(617) 862-0626
S. Lawrence Whipple, Archivist-Historian

Access: Open by appointment, restricted use
Reproduction Services: Photographic prints, photocopy
Size of Collection: 500 photographs, 275 negatives
Major Holdings: AR–1P

U224. **MAMICT**
Museum of the American China Trade
215 Adams Street
Milton, Massachusetts 02186
(617) 696-1815
Greer Hardwicke, Research Associate

Hours: 10:00–4:00, M–F
Access: Restricted, open by appointment, other individual arrangements possible
Reproduction Services: Can be arranged
Size of Collection: 450 photographs (ambrotypes, daguerreotypes), 50 slides
Special Collections: Forbes family and residences; Americans (traders) in China; Ebenezer Linnel (sea captain 19th c.), family and friends; Lincolniana (The Mary Bowditch Forbes Collection)

Major Holdings: F–1P; AJ–1P, 1S, 3P, 3S, 4S; I–1P; T–1P, 4P, 4S; M–3P, 3S

U225. **MANAHS**
North Andover Historical Society
153 Academy Road
North Andover, Massachusetts 01845
(617) 686-4035

Mary Flinn, Administrator

Hours: 1:00–5:00, Su; and by appointment
Access: Open to public, by appointment also
Reproduction Services: Commercial service available
Size of Collection: 1,000 photographs, 100 negatives, 250 slides
Special Collections: Slides of local architecture

Major Holdings: C–1P, 1S, 4P, 4S; AR–1P, 1S, 4P, 4S; F–1P, 1S, 4P, 4S; AJ–1P, 1S, 4P, 4S; I–1P, 1S; ETW–1P, 1S

U226. **MANATX**$_{pd}$
Merrimack Valley Textile Museum
800 Massachusetts Avenue
North Andover, Massachusetts 01845
(617) 686-0191
Helena Wright, Assistant Curator for Prints

Hours: 9:00–5:00, M–F
Access: Open to public, appointment preferred, students over 16
Reproduction Services: No in–house service; fee schedule available for reproduction service available by reputable commercial firm; photographic prints, photocopy, microfilm, color and black and white slides; 4x5, 5x7, 8x10 color transparencies
Special Collections: Photographs of industrial textile machinery, ca. 1890–1930; slides of insurance surveys of textile mill buildings, ca. 1870–1950; slides of American coverlets and blankets, ca. 1800–1930

Major Holdings: C4P, 4S; F–4P, 4S; AJ–1P, 1S, 4P, 4S; I–1P, 1S, 4P, 4S; T–1P, 1S, 4P, 4S; ETW–1P, 1S, 4P, 4S

U227. **MANHFL**$_a$
Forbes Library
Art and Music Department
20 West Street
Northampton, Massachusetts 01060
(413) 584-8550
James F. Hazel, Director
Hollee Haswell-Bowman, Art and Music Librarian

Hours: 9:00–6:00, M, Sa; 9:00–9:00, W
Access: Open to public, some collections not in easy access area and must be requested a day ahead
Reproduction Services: Some items may be reproduced with special permission of librarian
Size of Collection: 8,000–10,000 photographs and picture collection
Special Collections: 2,000 pictures of Northampton and surrounding towns, ca. 1900 on; Calvin Coolidge Memorial Room, memorabilia includes photographs, scrapbooks, campaign buttons, mounted game specimens, Indian bead work and headdress, furniture from Coolidge's law office, chair from the

Senate, and phonograph recordings of Coolidge speeches

Major Holdings: AJ–4P; T–1P, 4P; ETW–1P, 4P; WWI–1P; TW–1P, 3P

U228. **MANHFL**c

Forbes Library
Coolidge Memorial Room
22 West Street
Northampton, Massachusetts 01060
(413) 584-8550
Lawrence E. Wikander, Curator

Hours: 9:00–5:00, M–Sa
Access: Open by appointment, restricted use, scholars only
Reproduction Services: Photographic prints: $2,00 per print, size 8x10, black and white only
Size of Collection: 200 photographs, 50 negatives
Special Collections: Coolidge memorabilia

Major Holdings: TW–3P

U229. **MANHSC**m

Smith College Museum of Art
Northampton, Massachusetts 01060
(413) 584-2700, ext. 236
Charles Chetham, Director

Hours: 11:00–4:30, Tu–Sa; 2:00–4:30, Su; Summer: 1:00–4:00, Tu–Sa
Access: Open to public
Reproduction Services: Photographic prints, color slides, color transparencies 4x5, 8x10; fee schedule
Size of Collection: 300 photographs, 25 negatives, 25 slides, 4 postcards

Major Holdings: AI–2P, 2S, 4P, 4S; C–3P, 3S, 4P, 4S; AR–3P, 3S, 4P, 4S; F–3P, 3S, 4P, 4S; AJ–3P, 3S, 4P, 4S; WM–3P, 3S; CW–4P, 4S; I–2P, 2S, 3P, 3S, 4P, 4S; T–1P, 1S, 2P, 2S, 3P, 3S, 4P, 4S; ETW–2P, 2S, 3P, 3S, 4P, 4S; WWI–3P, 3S; TW–2P, 2S, 3P, 3S; GD–2P, 2S, 3P, 3S; WWII–2P, 2S, 3P, 3S; P–2P, 2S, 3P, 3S; AL–2P, 2S, 3P, 3S; M–3P, 3S; S–3P, 3S; E–3P, 3S

U230. **MANOSM**₁

Smith College, Hillyer Art Library
Photograph and Visual Resources Collection
Elm Street
Northampton, Massachusetts 01060
(413) 584-2700, ext. 173
Sharon L. Poirrier, Curator

Hours: 8:00–4:30
Access: Open to public for browsing only, restricted use for Smith faculty and students
Size of Collection: 58,000 photographs; 1,000 slides; 2,500 postcards; 3,000 posters, drawing reproductions, facsimiles; 7 tape cassettes

Major Holdings: AI–2P; C–1P, 3P, 4P; AR–1P, 2P, 3P, 4P; F–1P, 2P, 3P, 4P; W–1P, 2P, 3P, 4P; AJ–1P, 2P, 3P, 4P, 4S; WM–3P; CW–1P, 2P, 3P; I–1P, 3P; T–1P, 2P, 3P; ETW–1P, 2P, 3P; WWI–2P, 3P; TW–1P, 2P, 3P; GD–2P, 3P;

WWII–1P, 2P, 3P; P–1P, 2P, 3P, 4P; SA–1P, 2P, 2S, 3P, 3S, 4P, 4S

U231. **MAPEHS**

Petersham Historical Society, Inc.
Petersham Historical
West Street
Petersham, Massachusetts 01366
(617) 724-3380
Mrs. Donald F. Haines

Hours: May–October: 2:00–4:00, Su
Access: Open to public and by appointment
Reproduction Services: None
Size of Collection: 500 photographs, 100 negatives, 30 postcards
Special Collections: Indian arrowheads; Colonial furniture; American Revolution powder horns; Federal period furniture; Mexican War bedspreads; Civil War furniture; palm leaf baskets (waves of immigration); wooden articles (industrial expansion, 1865–1910)

Major Holdings: T–1P; ETW–1P; WWI–1P; TW–1P; GD–1P; WWII–1P; P–1P; AL–1P

U232. **MAPLAS**

Plymouth Antiquarian Society
27 North Street
Plymouth, Massachusetts 02360
(617) 746-0012
Mrs. Margaret Clark, Curator

Hours: Mid-May-mid-September: 10:00–5:00
Access: Open to public, by appointment, restricted use
Size of Collection: 20 slides, 6 postcards
Special Collections: Late 18th c. through 1920s costume collection; three completely furnished historic houses: Harlow House 1677, Spooner House 1750, Antiquarian House 1809

U233. **MASAEI**

Essex Institute
James Duncan Phillips Library
132–134 Essex Street
Salem, Massachusetts 01970
(617) 744-3390, 3391
Dorothy M. Potter

Hours: 9:00–4:30, Tu–F; June–October, M also
Access: Open to public
Reproduction Services: Photographic prints, photocopy, color and black and white slides, 4x5 color transparency, fee schedule
Special Collections: Photographs, slides and postcards of Essex County and Salem, Massachusetts, streets and houses

U234. **MASAHS**

Salem Maritime National Historic Site
Custom House, Derby Street
Box 847
Salem, Massachusetts 01970
(617) 744-4323
H. John Dobrovolny, Superintendent [*cont.*]

Access: Open to public

No study collections or exhibits

A National Historic Site: Tour folder available: Captain Richard Derby House; Captain Simon Forrester House; Captain Benjamin Crowninshield House; Custom House (1819); Bonded Warehouse; Hawkes House (designed by Samuel McIntire); Elias Hasket Derby House; West India Goods Store; Scale House

U235. **MASAPM**

Peabody Museum

East India Square

Salem, Massachusetts 01970

(617) 745-1876

Markham W. Sexton, Photographer

Hours: 9:00−4:00, M−F except holidays

Access: Open to public

Reproduction Services: Photographic prints, photocopy, fee schedule

Size of Collection: 1,000,000 photographs, negatives, slides, postcards

Special Collections: Over one million prints and negatives covering fields of maritime history, ethnology of non−European peoples and natural history

Major Holdings: M−1P, 3P, 4P

U236. **MASTKC**

Chesterwood/National Trust
 for Historic Preservation

Chesterwood/Daniel Chester French Sculpture

Chesterwood, Box 248

Stockbridge, Massachusetts 01262

(413) 298-3579

Paul Ivory, Administrator

Susan Frisch, Archivist

Hours: 9:00−5:00, M−F

Access: Open by appointment, restricted use

Reproduction Services: Photographic prints, fee schedule

Size of Collection: 3,310 photographs; 3,500 negatives; 3,731 slides; 500 postcards; 450 posters, blueprints, drawings, film, tapes

Special Collections: Visual resources include photographs, slides, movies, blueprints, drawings, etc., pertaining to Daniel Chester French, the Cresson family and Chesterwood, the sculptor's summer estate; minor collection relating to late 19th−20th c. artists and sculptors

Major Holdings: AI−2P, 2S; AE−2P, 2S; C−2P, 2S, 3P, 3S, 4P, 4S; AR−2P, 2S, 4P, 4S; F−4P, 4S; AJ−2P, 2S; CW−2P, 2S; I−2P, 2S; T−1P, 1S, 2P, 2S; ETW−1P, 1S, 2P, 2S, 3P, 3S, 4P, 4S; WWI−2P, 2S, 4P, 4S; TW−1P, 1S, 2P, 2S, 3P, 3S, 4P, 4S; GD−2P, 2S; WWII−2P, 2S; P−2P, 2S; AL−1P, 1S, 2P, 2S; M−2P, 2S

U237. **MASTUV**

Old Sturbridge Village [*cont.*]

Research Library

Sturbridge, Massachusetts 01566

(617) 347-3362

Etta Falkner, Librarian

Hours: 8:30−5:00, M−F

Access: Open to public

Reproduction Services: Photographic prints, photocopy

Size of Collection: 13,000 photographs, 13,000 negatives, 15,000 slides

Special Collections: Views of Old Sturbridge Village, a recreated early 19th c. rural New England village, 3,600 slides, 3,000 photographs and negatives; Josephine Pierce Collection; 18th−19th c. stoves (most American), 350 photographs and negatives; decorative arts include American Indian pottery; Colonial furniture, glassware, Revolutionary lighting equipment; Federal period textiles

Major Holdings: AI−4P, 4S; AE−4P, 4S; C−4P, 4S; AR−1S, 4P, 4S; F−1S, 3P, 3S, 4P, 4S; W−1S; AJ−1S

U238. **MAWAGP**

Gore Place

52 Gore Street

Waltham, Massachusetts 02154

(617) 894-2798

Charles Hammond, Curator

Hours: April 15−November 15: 10:00−5:00, Tu−Sa; 2:00−5:00, Su; closed M

Access: Open to public

Size of Collection: Postcards available; an historic house museum

Special Collections: Appropriate house furnishings; decorative arts include furniture, ceramics, costume design

Major Holdings: C−4S; AR−4S; F−1S, 2S, 3S, 4S

U239. **MAWHCC**

Tales of Cape Cod

Tales of Cape Cod Taped Interviews

c/o Mrs. Marion Vuilleumier, Secretary

Box 111

W. Hyannisport, Massachusetts 02672

(617) 775-4811

Louis Cataldo, President, (617) 775-2439

Herbert McKinney, Library Director

(617) 362-2131

Access: Open by appointment

Reproduction Services: None; copies may be purchased at the Cape Cod Community College Library

Special Collections: Photographs of early Cape Cod scenes; slides of people interviewed; tales of early residents and of historic interest (tapes have been recorded over a period of 25 years)

U240. **MAWMCI$_P$**

Sterling and Francine Clark Art Institute

Photograph and Slide Collection [*cont.*]

South Street
Williamstown, Massachusetts 01267
(413) 458-8109
Dustin Wees, Photograph and Slide Librarian

Hours: 9:00—5:00, M—F
Access: Open by appointment, restricted use, scholars, students
Size of Collection: 1,500 photographs, 3,400 slides, 4,750 clippings
Special Collections: Photographs of paintings by late 19th c. artists
Major Holdings: I—3P, 3S; T—3P, 3S; ETW—3P, 3S

U241. **MAWMCI**ₛ
Sterling and Francine Clark Art Institute
Sales Desk
Box 8
Williamstown, Massachusetts 01267
(413) 458-8109
Mrs. Pat Roy, Sales Supervisor

Hours: 10:00—5:00, Tu—Su
Access: Open to public, visual resources for purchase only
Size of Collection: American only: 88 photographs, 88 negatives, 28 slides, 10 postcards, 10 posters
Special Collections: Photographs and slides of paintings by American artists including Gilbert Stuart, Homer, Sargent, Remington, Inness, and Cassatt
Major Holdings: F—3P, 3S; I—3P, 3S; T—3P, 3S

U242. **MAWOAA**
American Antiquarian Society
185 Salisbury Street
Worcester, Massachusetts 01609
(617) 755-5221
Marcus A. McCorison, Director and Librarian

Hours: 9:00—5:00, M—F
Access: Open to public, by appointment to scholars, purchase only
Reproduction Services: Photographic prints, photocopy, microfilm, color and black and white slides, fee schedule available
Size of Collection: 2,000 negatives
Special Collections: Georgia B. Bumgardner, Curator of Graphic Arts; the Society's collection concentrates on U.S. history through 1876; 18th and 19th c. graphics; books, newspapers, periodicals, broadsides and music are among other collections; most items may be photographed
Major Holdings: C—1P, 3P; AR—1P, 3P; F—1P; W—1P; AJ—1P; WM—1P; MW—1P; CW—1P

U243. **MAWOAM**
Worcester Art Museum
Worcester Art Museum Slide Library
55 Salisbury Street
Worcester, Massachusetts 01608
(617) 799-4406

Maureen Killoran, Slide Librarian
Hours: 10:00—1:00, 2:00—5:00, M—F
Access: Open to public
Size of Collection: 32,000 slides
Major Holdings: AI—2S; C—1S, 3S, 4S; AR—3S; F—1S

MICHIGAN

U244. **MIAAUM**ₐᵥ
University of Michigan
Audio—Visual Education Center
416 Fourth Street
Ann Arbor, Michigan 48103
(313) 764-5360
Ford L. Lemler, Director

Hours: 8:00—5:00, M—F
Access: Available for rent or purchase, serves general public
Reproduction Services: None
Size of Collection: 16,500 films, 15 filmstrips
Major Holdings: AI—1, 2, 3, 4; C—1, 4; AR—4; F—4; W—4; AJ—4; WM—1, 4; CW—2, 3, 4; WI—4; I—1, 4; T—4; ETW—4; WWI—4; TW—4; GD—1, 4; WWII—4; P—2, 4; SA—4; AL—4; M—4; S—4; E—4

U245. **MIAAUM**ₛₚ
University of Michigan
Department of the History of Art,
 Slide and Photograph Collection
107 Tappan Hall
Ann Arbor, Michigan 48104
(313) 764-5404
Linda J. Owen, Curator

Hours: 8:30—5:00, M—F
Access: Restricted use; university faculty personnel and students only, other scholars and students by appointment
Reproduction Services: None
Size of Collection: 53,000 photographs, 176,000 slides
Special Collections: 350 35mm color slides illustrating work by Michigan artists done since WWII
Major Holdings: AI—1S, 2S, 3S, 4S; AE—1S, 4S; C—1P, 1S, 2S, 3P, 3S, 4P, 4S; AR—1P, 1S, 2S, 3P, 3S, 4P, 4S; F—1P, 1S, 2P, 2S, 3P, 3S, 4P, 4S; W—1P, 1S, 2S, 3S, 4S; AJ—1P, 1S, 2P, 2S, 3P, 3S, 4P, 4S; WM—1P, 1S, 2P, 2S, 4P, 4S; MW—1P, 1S, 2S, 3P, 3S, 4S; CW—1P, 1S, 2P, 2S, 3P, 3S, 4P, 4S; WI—1P, 1S, 2P, 2S, 3S, 4P, 4S; I—1P, 1S, 2P, 2S, 3P, 3S, 4P, 4S; T—1P, 1S, 2P, 2S, 3P, 3S, 4P, 4S; ETW—1P, 1S, 2P, 2S, 3P, 3S, 4P, 4S; WWI—1P, 1S, 2P, 2S, 3P, 3S, 4P, 4S; TW—1P, 1S, 2P, 2S, 3P, 3S, 4P, 4S; GD—1P, 1S, 2P, 2S, 3P, 3S, 4P, 4S; WWII—1P, 1S, 2P, 2S, 3P, 3S, 4P, 4S; P—1P, 1S, 2P, 2S, 3P, 3S, 4P, 4S; SA—1S

U246. **MIALBC**

Albion College
Visual Arts Department
Albion, Michigan 49224
(517) 629-5511, ext. 249
Vernon L. Bobbitt
Hours: 9:00–5:00, M–F
Access: Open by appointment
Reproduction Services: None
Size of Collection: 200 photographs, 5,000 slides
Major Holdings: AI–1S, 2S, 3S; AE–1S, 2S, 3S,
4S; C–1P, 1S, 2P, 2S, 3P, 3S, 4P, 4S; AR–1P, 1S,
2P, 2S, 3P, 3S, 4P, 4S; F–1P, 1S, 2P, 2S, 3P, 3S,
4P, 4S; W–1P, 1S, 2P, 2S, 3P, 3S, 4P, 4S; AJ–1P,
1S, 2P, 2S, 3P, 3S, 4P, 4S; WM–1P, 1S, 2P, 2S,
3P, 3S, 4P, 4S; CW–1P, 1S, 2P, 2S, 3P, 3S, 4P, 4S;
WI–1P, 1S, 2P, 2S, 3P, 3S, 4P, 4S; I–1P, 1S, 2P,
2S, 3P, 3S, 4P, 4S; T–1P, 1S, 2P, 2S, 3P, 3S, 4P,
4S; ETW–1P, 1S, 2P, 2S, 3P, 3S, 4P, 4S;
WWI–1P, 1S, 2P, 2S, 3P, 3S, 4P, 4S; TW–1P, 1S,
2P, 2S, 3P, 3S, 4P, 4S; GD–1P, 1S, 2P, 2S, 3P, 3S,
4P, 4S; WWII–1P, 1S, 2P, 2S, 3P, 3S, 4P, 4S;
P–1P, 1S, 2P, 2S, 3P, 3S, 4P, 4S; SA–1P, 1S, 2P,
2S, 3P, 3S, 4P, 4S; AL–1P, 1S, 2P, 2S, 3P, 3S, 4P,
4S; M–1P, 1S, 2P, 2S, 3P, 3S, 4P, 4S; S–1P, 1S,
2P, 2S, 3P, 3S, 4P, 4S; E–1P, 1S, 2P, 2S, 3P, 3S,
4P, 4S

U247. **MIDEMC**

Marygrove College/University of Detroit
Consolidated Art Department
Detroit, Michigan 48221
(313) 862-8000
Helen Sherman, Assistant Professor
Access: Restricted use, scholars and students
only
Reproduction Services: None
Size of Collection: 20,000 slides
Major Holdings: C–1S, 2S, 3S; AR–1S, 3S; F–1S,
3S; AJ–1S, 3S; CW–1S, 2S, 3S; I–1S, 2S, 3S;
T–1S, 3S; ETW–1S, 3S; WWI–1S, 2S, 3S;
TW–1S, 2S, 3S; GD–1S, 2S, 3S; WWII–1S, 2S,
3S; P–1S, 2S, 3S; SA–1S, 2S, 3S

U248. **MIDEME**

Architecture and the Related Arts
Educational Transparencies
5574 Lakewood Avenue
Detroit, Michigan 48213
(313) 821-6619
Joseph P. Messana, Photographer
Access: Purchase only
Reproduction Services: 35mm color slides,
catalogs available, fee schedule
Size of Collection: 25,000 slides
Special Collections: 35mm slides of architecture,
monumental sculpture, plazas, fountains,
gardens, stained glass, interior and exterior
views, day and night views, all composed for
study in composition
Major Holdings: AI–1S; C–1S; F–1S; W–1S;
AJ–1S; WM–1S; MW–1S; CW–1S; I–1S; T–1S;
ETW–1S; WWI–1S; TW–1S; GD–1S;
WWII–1S; P–1S; SA–1S

U249. **MIDEPL**

Detroit Public Library
Fine Arts Department/Picture Collection
5201 Woodward Avenue
Detroit, Michigan 48202
(313) 833-1469
Shirley B. Solvick, Chief
Hours: 9:30–9:00, M, W; 9:30–5:30, Tu–Sa
(winter months: 1:00–5:00, Su)
Access: Open to public, no mail requests
Reproduction Services: Photocopy, fee schedule
Size of Collection: 2,000 photographs
Special Collections: Photographs illustrating
Detroit architecture and history

U250. **MIDEWS**

Wayne State University
Art and Art History Department Slide Library
150 Community Arts
Detroit, Michigan 49202
(313) 577-2988
Ms. Marjorie Lynn Barry
Hours: 8:30–4:30, M–F
Access: Open by appointment
Reproduction Services: None
Size of Collection: 120,000 slides, photographs
Special Collections: 35mm slides of Tiffany glass,
antebellum homes, photography, glass, tex-
tiles, Afro-American art, furniture, ceramics,
tombstones, Pennsylvania Dutch subjects,
carriages, automobiles, folk art, weather-
vanes, costume design
Major Holdings: AI–2S, 3S, 4S; AE–1S, 2S, 3S;
C–1S, 2S, 3S; AR–1S, 2S, 3S; F–1S, 2S, 3S;
W–1S, 2S; AJ–1S, 2S, 3S; WM–1S, 2S, 3S;
MW–1S, 2S, 3S; CW–1S, 2S, 3S; WI–1S, 2S, 3S;
T–1S, 2S, 3S; ETW–1S, 2S, 3S; WWI–1S, 2S, 3S;
TW–1S, 2S, 3S; GD–1S, 2S, 3S; WWII–1S, 2S,
3S; P–1S, 2S, 3S; SA–2S, 3S; AL–1S, 3S; M–1S,
2S, 3S; S–1S, 2S, 3S; E–1S, 2S, 3S

U251. **MIDRHF**

Henry Ford Centennial Library
Audio-Visual Division
16301 Michigan Avenue
Dearborn, Michigan
(313) 271-1000
James L. Limbacher, AV Librarian
Size of Collection: 3,800 16mm and 8mm films

U252. **MIGPWA**

Wayne Andrews
521 Neff Road
Grosse Pointe, Michigan 48230
Access: Purchase only
Size of Collection: 2,700 negatives (for slides and
prints)
Special Collections: American architecture,
17th–20th c. (35mm slides)

U253. **MIKAIA**

Kalamazoo Institute of Arts
Art Center Library
314 South Park Street
Kalamazoo, Michigan 49006
(616) 349-7775
Bertha Stauffenberg, Librarian
Hours: 11:00—4:30, Tu—F; 9:00—4:00, Sa (winter hours: 1:30—4:30, Su)
Access: Open to public, only members may borrow books, anyone may borrow slides
Reproduction Services: Photocopy
Size of Collection: 3,000 slides

U254. **MIKAWM**

Western Michigan University
Art Department Slide Library
Sangren Hall
Kalamazoo, Michigan 49001
(616) 383-1858
Robert P. Johnston, Area Chairman of Art History

Hours: 8:00—5:00, M—F
Access: Restricted use to students and faculty of university and by arrangement with others
Reproduction Services: Would allow scholars and interested, serious students to make slide reproductions of their significant Afro-American artist collection, and collection of modern American artists and architects
Size of Collection: 10,000 slides, 100 color reproductions, 100 films (housed in university library)
Special Collections: Afro-American artists and American painting, sculpture, prints, and architecture since 1865 (35mm slides)
Major Holdings: AI—1S, 2S, 3S; C—1S, 2S, 3S; AR—1S, 2S, 3S; F—1S, 2S, 3S; W—2S, 3S; AJ—1S, 2S, 3S; WM—3S; CW—3S, 4S; WI—3S, 4S; I—1S, 2S, 3S; T—1S, 2S, 3S; ETW—1S, 2S, 3S, 4S; WWI—1S, 2S, 3S, 4S; TW—1S, 2S, 3S, 4S; GD—1S, 2S, 3S, 4S; WWII—1S, 2S, 3S, 4S; P—1S, 2S, 3S, 4S; AL—4S

U255. **MIMAHS**

Marshall Historical Society, Archives
P.O. Box 15
Marshall, Michigan 49224
(616) 781-8544
Mrs. Doris Borthwick, Archivist

Access: Open by appointment
Reproduction Services: Photographic prints, photocopy
Size of Collection: 2,000 photographs, 200 negatives, 300 slides, 300 postcards, 200 lantern slides
Special Collections: 35mm color slides of Marshall, Michigan, homes built before 1920; Martin Ryan Collection of photos and data relating to the Michigan Central Railroad; portraits of Marshall residents; views of Marshall stores, industries, festivals, entertainment, etc.

Major Holdings: AJ—1P, 1S, 3P; CW—1P, 2P, 3P; I—1P; T—1P; ETW—1P; AL—1P, 2P; E—1P

MINNESOTA

U256. **MNELVC**

Vermilion Community College
Library
1900 E. Camp Street
Ely, Minnesota 55731
(218) 365-3256
Susan Walls, Librarian

Hours: 8:00—3:30, school days
Access: Open to public, restricted use, students and faculty
Reproduction Services: Photocopy
Size of Collection: 2,000 slides, 15 videotapes

Major Holdings: C—1S, 2S, 3S; AR—1S, 2S, 3S; WM—1S, 2S, 3S; I—1S, 2S, 3S; ETW—1S, 2S, 3S; GD—1S, 2S, 3S; P—1S, 2S, 3S

U257. **MNGMCC**

Cook County Historical Society
Museum and File Collection
Grand Marais, Minnesota 55604
Miss Olga Soderberg

Access: Restricted use
Reproduction Services: Photographic prints
Size of Collection: 12 photographs, 8 negatives
Special Collections: Local history

U258. **MNMABE**

Blue Earth County Historical Society Museum
606 South Broad Street
Mankato, Minnesota 56001
(507) 345-4154
Mrs. Marcia T. Schuster, Director

Hours: 1:00—5:00, Tu—Su
Access: Open to public, by appointment
Reproduction Services: Photocopy, 10¢ each
Size of Collection: Photographs, small
Special Collections: Blue Earth County history

Major Holdings: AI; CW; E; T; ETW; WWI; TW; GD; WWII; P; A; S; E

U259. **MNMPIA**

Minneapolis Institute of Arts
A-V Center/Slide Library
2400 3rd Avenue, South
Minneapolis, Minnesota 55404
(612) 874-0200, ext. 281
Ms. Wendy Knight, A-V Services Supervisor

Hours: 8:30—5:00, M—F
Access: Open by appointment
Reproduction Services: Photographs, black and white, $3.00 per photograph; color transparencies for reproduction (8x10), $75.00
Size of Collection: 100 photographs (purchase only), 5,000 slides, postcards (museum shop)
Major Holdings: AI—1S, 2P, 2S, 3P, 3S, 4P, 4S;

AE–1S, 2S, 3S, 4S; C–1P, 1S, 2S, 3S, 4P, 4S; AR–1P, 1S, 2S, 3P, 3S, 4P, 4S; F–1P, 1S, 2S, 3P, 3S, 3S, 4P, 4S; W–3P, 4P; AJ–2P, 3P, 4P; WM–4P; CW–4P; I–2P, 3P, 4P; T–2P, 3P, 4P; ETW–2P, 3P, 4P; WWI–1P, 3P, 4P; TW–2P, 3P, 4P; GD–2P, 3P; WWII–2P, 3P; P–1P, 2P, 3P

U260. **MNMPPLA**
Minneapolis Public Library
 and Information Center
Art, Music and Films Department
300 Nicollet Mall
Minneapolis, Minnesota 55401
(612) 372-6500
Mrs. Zella Shannon, Department Head
Dorothy Burke, MHC Librarian

Hours: 9:00–9:00, M–Th; 9:00–5:30, F, Sa
 (closed Sa during the summer)
Access: Open to public
Reproduction Services: None
Size of Collection: 1,200 slides

Major Holdings: AI–2S, 3S, 4S; AE–2S, 3S; C–1S, 2S, 3S, 4S; AR–1S, 2S, 3S, 4S; F–2S, 3S, 4S; W–3S; AJ–3S; WM–3S, 4S; MW–3S, 4S; CW–3S, 4S; WI–3S; I–3S; T–3S; ETW–3S; WWI–2S, 3S; TW–2S, 3S, 4S; GD–3S, 4S; WWII–3S, 4S; P–3S; SA–3S; AL–3S; M–3S; S–3S; E–3S

U261. **MNMPPL_hc**
Minneapolis Public Library and
 Information Center
History Department–Minneapolis
 History Collection
300 Nicollet Mall
Minneapolis, Minnesota 55401
(612) 372-6500
Mrs. Zella Shannon, Department Head
Dorothy Burke, MHC Librarian

Hours: 9:00–9:00, M–Th; 9:00–5:30, F, Sa
 (closed Sa during the summer)
Access: Open to public
Reproduction Services: None
Size of Collection: 5,000–6,000 photographs (plus 100 five-drawer file cabinets), 1,600 negatives
Special Collections: Minneapolis *Daily Times* morgue photographs, black and white, from May 1, 1941 to May 15, 1948; Minneapolis History Collection: Bromley Collection 1851–1914, 1,600 glass negatives; WPA collection, 2,000 photographs; 3,000–4,000 photographs of Minneapolis and Minnesota

Major Holdings: CW–4P; WI–4P; I–4P; T–4P; ETW–4P; WWI–4P; TW–4P; GD–4P; WWII–4P; P–4P

U262. **MNMPWA_e**
Walker Art Center
Education Department
Vineland Place
Minneapolis, Minnesota 55403
(612) 377-7500

Hours: 9:00–5:00, M–F
Access: Restricted use, scholars only
Reproduction Services: Photographic prints, slides: color, black and white (limited); catalog under publication; listings (permanent collection, not all available); black and white prints, $3.50; color transparencies on rental basis, $25.00 per month
Size of Collection: Photographs, negatives, 2,000 slides, postcards, posters, films, videotapes
Special Collections: American art of the 1950s through 1970s

Major Holdings: AI–4P, 4S; T–3P, 3S; ETW–2P, 2S, 3P, 3S; WWI–2P, 2S, 3P, 3S; GD–2P 2S, 3P, 3S; WWII–2P, 2S, 3P, 3S; P–2P, 2S, 3P, 3S

U263. **MNMPWA_s**
Walker Art Center
Slide Collection
Vineland Place
Minneapolis, Minnesota 55403
(612) 377-7500
Ms. Bonita L. Everts, Slide Curator

Access: Restricted use
Reproduction Services: Slides, color and black and white (limited), catalog in progress
Size of Collection: 25, 000 slides
Special Collections: 19th and 20th c.; slides of the permanent collection

MISSISSIPPI

U264. **MSJAAH**
Mississippi Department of Archives
 and History
Library Division
P.O. Box 571
Jackson, Mississippi 39205
(601) 354-6218
Mrs. Patricia Black, Division Director

Hours: 8:00–5:00, M–F
Access: Open to public
Reproduction Services: Photographs, black and white and color slides, photocopy, microfilm
Size of Collection: 19,763 photographs, 7,487 negatives, 1,560 slides, 611 postcards, posters, broadsides, 133 reels of film

Major Holdings: AI–4P; AE–1P; C–1P; AJ–1P; CW–1P, 1S, 3P, 4P; T–1P, 3P, 4P; ETW–1P, 3P, 4P; WWI–4P; TW–1P, 4P; GD–1P, 4P; WWII–1P, 4P; P–1P; AL–1P, 4P; M–3P; S–1P; E–1P

U265. **MSUNMF**
University of Mississippi
Educational Film Library
University, Mississippi
(601) 232-7350
Dr. Burl Hunt, Director of Film Library

Access: Rental
Size of Collection: Slides

Major Holdings: C—1S; CW—4S; WWI—4S; WWII—4S

MISSOURI

U266. **MOCOUM**ah
University of Missouri
Art History and Archaeology Department
329 Jesse
Columbia, Missouri 65201
(314) 882-6711
Lora Holtz, Curator of Slides and Photographs

Hours: 8:00—5:00, M—F
Access: Restricted to scholars and students
Size of Collection: 37,000 photographs, 80,000 slides
Major Holdings: AE—1S, 2S, 3S, 4S; C—1S, 2S, 3S, 4S; AR—1S, 2S, 3S, 4S; F—1S, 2S, 3S, 4S; W—1S, 2S, 3S, 4S; AJ—1S, 2S, 3S, 4S; WM—1S, 2S, 3S, 4S; MW—1S, 2S, 3S, 4S; CW—1S, 2S, 3S, 4S; WI—1S, 2S, 3S, 4S; I—1S, 2S, 3S, 4S; T—1S, 2S, 3S, 4S; ETW—1S, 2S, 3S, 4S; WWI—1S, 2S, 3S, 4S; TW—1S, 2S, 3S, 4S; GD—1S, 2S, 3S, 4S; WWII—1S, 2S, 3S, 4S; P—1S, 2S, 3S, 4S

U267. **MOCOUM**mu
University of Missouri, Columbia
Museum of Art and Archaeology
Francis Quadrangle
Columbia, Missouri 65201
(314) 882-8363
Dr. Saul S. Weinberg, Director

Hours: 2:00—5:00 daily
Access: Open to public, restricted use
Major Holdings: AJ; I; T; ETW; WWI; TW; GD; P

U268. **MOINTL**
Harry S Truman Presidential Library
Independence, Missouri 64050
(816) 833-1400
Benedict K. Zobrist, Director

Hours: 8:45—4:45, M—F
Access: Open to public, letter of introduction necessary to use collection
Reproduction Services: Photographic prints, photocopy, microfilm, slides (color and black and white), large color transparencies: 4x5, 5x7, 8x10
Size of Collection: 70,000 photographs, negatives, 2,000 slides, 250 films, 500 recordings
Special Collections: Photographs, slides, sound recordings, motion pictures covering the life of President Harry S Truman and the Truman administration.

U269. **MOKCUM**sah
University of Missouri—Kansas City Libraries
Missouri Valley Chapter of Society of
 Architectural Historians Archives
5100 Rockhill Road
Kansas City, Missouri

(816) 276-1531
Dr. Kenneth J. LaBudde, Director of Libraries

Access: Open by appointment, restricted use, scholars only
Special Collections: 3,000 blueprints of architectural drawings of Kansas City, Missouri buildings; late 19th and 20th c. commercial and public buildings.

U270. **MOLAWM**
Watkins Woolen Mill State Historical Site
Watkins Mill Library
Route 2
Lawson, Missouri 64062
Site Administrator

Hours: Open by appointment
Reproduction Services: None
Size of Collection: 150—200 photographs, 150—200 negatives, 50 slides
Major Holdings: AJ—1P; CW—1P, 4P; I—1P, 4P

U271. **MOSJMW**
Missouri Western State College
Slide Library
4525 Downs Drive
St. Joseph, Missouri 64504
(816) 233-7192
Mark Lavatelli

Hours: 8:00—4:30, M—F
Access: Open by appointment
Reproduction Services: None
Size of Collection: 2,900 slides

Major Holdings: AI—2S, 3S, 4S; C—1S, 2S; AR—1S, 2S, 3S; F—1S, 2S; AJ—1S, 2S; WM—1S; CI—2S; I—1S, 4S; T—1S; ETW—1S; WI—1S; TW—1S; GD—1S; WWI—1S; P—1S, 4S; AL—2S; M—3S

U272. **MOSLAM**
Saint Louis Art Museum
Richardson Memorial Library
St. Louis, Missouri 63110
(314) 721-0067
Ann B. Abid, Librarian

Hours: September—May: 2:30—9:00, Tu; all year: 10:00—5:00, W—F; June—August: 2:30—5:00, Tu
Access: Open to adults
Reproduction Services: Photographic prints, photocopy, slides (color and black and white); color transparencies of museum holdings can be rented or made to order, 4x5, 5x7, 8x10, for a fee
Size of Collection: 2,400 photographs, 8,000 slides, postcards (uncounted) 120 posters
Special Collections: Paintings by William Glackens; St. Louis artists and architecture

Major Holdings: AI—2P, 2S, 3P, 4P, 4S; C—1P, 1S, 2P, 2S, 3P, 3S, 4P, 4S; F—1P, 1S, 2P, 2S, 3P, 3S, 4P, 4S; WM—1P, 1S, 2P, 2S, 3P, 3S, 4P, 4S; CW—1P, 1S, 2P, 2S, 3P, 3S, 4P, 4S; ETW—1P, 1S,

2P, 2S, 3P, 3S, 4P, 4S; WWI–1P, 1S, 2P, 2S, 3P, 3S, 4P, 4S; TW–1P, 1S, 2P, 2S, 3P, 3S, 4P, 4S; GD–1P, 1S, 2P, 2S, 3P, 3S, 4P, 4S; WWII–1P, 1S, 2P, 2S, 3P, 3S, 4P, 4S; P–1P, 1S, 2P, 2S, 3P, 3S, 4P, 4S

U273. **MOSLMT**

National Museum of Transport
Transportation Library
3015 Barrett Station Road
St. Louis, Missouri 63122
(314) 965-6885
Janice Ming Holt

Hours: By appointment
Access: Scholars
Size of Collection: Photographs, negatives, slides, postcards

U274. **MOSLWP**

On the Wall Productions
3457 Shenandoah
St. Louis, Missouri 63104
(314) 771-5404
Sarah Lingquist

Access: Open by appointment
Reproduction Services: Color slides, listing, and fee schedule
Size of Collection: 120 slides
Special Collections: Outside wall murals of U.S.A., especially of the Midwest
Major Holdings: P–3S

U275. **MOSLWU₁**

Washington University
Art and Architecture Library
Steinberg Hall
St. Louis, Missouri 63130
(314) 863-0100, ext. 4392

Hours: 8:30–10:00, daily during the school year; weekends vary
Access: Open to public
Reproduction Services: Photocopy
Size of Collection: Photographs

Major Holdings: AI–3P; AE–3P; C–1P, 3P; AR–3P; F–1P, 3P; W–3P; AJ–3P; WM–3P; MW–3P; CW–3P; WI–3P; I–3P; T–3P; ETW–1P, 3P; WWI–3P; TW–1P, 3P; GD–3P; WWII–3P; P–1P, 3P; SA–3P; AL–3P; M–3P; S–3P; E–3P

U276. **MOSLWU₈**

Washington University
Slide Library
Skinker and Forsyth
St. Louis, Missouri 63130
(314) 863-0100
Jeannine Quinn, Slide Librarian

Hours: 8:30–5:00
Access: Scholars only
Reproduction Services: Color and black and white slides
Size of Collection: 5,000 photographs, 85,000 slides

MONTANA

U277. **MTBIWH**

Stella A. Foote–Western Heritage Center
Treasures of the West
1207 Hillhaven Way
Billings, Montana 59102
(406) 259-1504
Stella A. Foote, Owner

Hours: 10:00–5:00, Tu, Su
Access: Open to public
Reproduction Services: 4x5 color transparencies, catalog available
Size of Collection: Postcards
Major Holdings: AI; AE; WM; Wi

U278. **MTMIDG**

Douglas Grimm
Route 7, W. Rattlesnake
Missoula, Montana 59801
(406) 543-7970
Douglas Grimm, photographer

Access: Open to public
Reproduction Services: Color slides
Size of Collection: 15,000 slides
Major Holdings: WWII–2S, 3S; P–2S, 3S, 4S; SA–2S, 3S, 4S

U279. **MTMIUM**

University of Montana
Department of Art, Slide Collection
Missoula, Montana 59801
(406) 243-4091
Dr. Joel H. Bernstein

Access: Restricted use, scholars only
Reproduction Services: None
Size of Collection: 10,000–15,000 slides
Special Collections: American Indian art
Major Holdings: AI–1S, 2S, 3S, 4S

NEBRASKA

U280. **NEOMJA꜀**

Joslyn Art Museum
2200 Dodge Street
Omaha, Nebraska 68102
(402) 342-3996
Mrs. Kenneth Anderson, Curatorial Registrar

Hours: 10:00–4:30, Tu–F
Access: Open by appointment
Reproduction Services: Photographic prints, color slides, 4x5 color transparencies, fee schedule available
Size of Collection: 1,500 negatives, 151 slides
Special Collections: Maxmilian-Bodmer Collection (paintings 1832–34 of trip from Germany through eastern United States up Missouri River to Great Falls) and Stewart-Miller Collection (paintings of 1887 trip through Missouri Valley to Wind River

Mountains); reproductions of works in both collections

Major Holdings: AI–3P, 3S; WM–3P, 3S; GD–3P

U281. **NEOMJA**ᵣ

Joslyn Art Museum
Joslyn Art Museum Reference Library
2200 Dodge Street
Omaha, Nebraska 68102
(402) 342-3996
Evelyn A. Sedlacek, Research Librarian

Hours: 10:00–4:30, Tu–F (slides Th only)

Access: Restricted use

Reproduction Services: Photographic prints, 8x10 available at $5.00; color transparencies, 4x5; slides available from museum sales shop

Size of Collection: 3,000 negatives, 22,000 slides, 10, 038 postcards

Major Holdings: AI–2P, 2S, 3P, 3S, 4S; AE–3P; C–1S, 2S, 3S, 4S; AR–1S, 3S, 4S; F–1S, 3S, 4S; W–3S; AJ–3S, 4S; WM–2S, 3S, 4S; MW–3S; CW–3S; WI–3S, 4S; I–3S, 4S; T–3S; ETW–1S, 2S, 3S, 4S; WWI–1S, 2S, 3S, 4S; TW–1S, 2S, 3S, 4S; GD–1S, 2S, 3S, 4S; WWII–1S, 2S, 3S, 4S; P–1S, 2S, 3S, 4S

U282. **NEGOPE**

Pony Express Station
1617 Avenue A
Gothenburg, Nebraska 69138
(308) 537-2680
Mr. and Mrs. Merle Block, Managers

Hours: 8:00–9:00, May–October

Access: Open to public

Reproduction Services: None

U283. **NECRFR**

Fort Robinson Museum
Nebraska State Historical Society
Box 304
Crawford, Nebraska 69339
(308) 665-2852
Vance E. Nelson

Hours: 8:00–5:00, M–Sa; 1:00–5:00, Su, April–November

Access: Open to public, April–November; open by appointment, December–March

Reproduction Services: Done through Nebraska State Historical Society Museum in Lincoln

Major Holdings: AI–1P, 1S, 3P; WM–1P, 1S, 4P; T–1P, 1S, 3P; TW–1P, 1S; WWII–1P, 3P, 3S

U284. **NERCWC**

Willa Cather Pioneer Memorial
Red Cloud, Nebraska 68970
(402) 746-2653
JoAnna Lathrop, Director of Research

Hours: 10:30–5:00, M–F; 1:00–5:00, Sa, Su

Access: Open to public; postcards may be purchased, slides may be rented

Reproduction Services: Color and black and white slides

Size of Collection: 5,000 photographs, 60 slides

Special Collections: Materials include photographs of area and of dioramas depicting local historic events

Major Holdings: AI–3P; WM–1P, 1S, 4P, 4S; WI–1P, 1S, 4P, 4S; T–1P, 1S, 4P, 4S; ETW–1P, 1S, 4P, 4S; WWI–1P, 1S, 4P, 4S; TW–1P, 1S, 4P, 4S; AL–1P, 1S, 4P, 4S; E–1P, 1S, 4P, 4S

NEVADA

U285. **NVELNN**

Northeastern Nevada Museum
P.O. Box 503
Elko, Nevada 89801
(702) 738-3418
Howard Hickson, Director

Size of Collection: 1,000 photographs (all history, no art), 1,400 negatives, 2,000 slides

U286. **NVRENH**

Nevada Historical Society
1650 N. Virginia
Reno, Nevada 89503
(702) 784-6397
John M. Townley, Director

Hours: 8:00–5:00, M–F; 9:00–5:00, Sa, Su

Access: Open to public

Reproduction Services: Photographic prints, fee schedule

Size of Collection: 50,000 photographs; negatives; slides

Major Holdings: AI–1P, 3P, 4P; WM–1P, 2P, 3P, 4P

NEW HAMPSHIRE

U287. **NHMACG**

Currier Gallery of Art
192 Orange Street
Manchester, New Hampshire 03104
(603) 669-6144
Marian Woodruff, Director of Education

Access: Open to public (in the area)

Size of Collection: 2,000 color reproductions

Special Collections: The Dartmouth College teaching collection of color reproductions, some mounted, is a general collection touching all periods; the collection was donated to the Currier Gallery for use in the schools of New Hampshire

U288. **NHPOSB**

Strawbery Banke
Box 300
Portsmouth, New Hampshire
(603) 436-8010
Peggy Armitage [*cont.*]

Hours: May 1–October 1: 9:30–4:45

Access: Open to public, open for research by appointment only

Reproduction Services: Photographic prints

Size of Collection: 3,000 photographs, 5,000 negatives, 500 slides, 1,000 postcards

Special Collections: 2,000 glass plate negatives dating from the late 1800s to the early 1900s, mostly scenes of the Portsmouth, New Hampshire, area; prints may be ordered

Major Holdings: C–1P, 1S, 3P, 3S, 4P, 4S; AR–1P, 1S, 3P, 3S, 4P, 4S; F–1P, 1S, 3P, 3S, 4P, 4S; W–4P, 4S; AJ–3P, 3S, 4P, 4S; CW–1P, 1S, 4P, 4S; I–1P, 1S, 4P, 4S; TW–4P; M–1P, 1S, 2P, 2S, 3P, 3S, 4P, 4S

NEW JERSEY

U289. **NJCATE**

E. Teitelman, Photography and
 Architectural History
305 Cooper Street
Camden, New Jersey 08102
(609) WO6-6093
Edward Teitelman

Access: Open by appointment, restricted use, slides and photographs primarily for purchase

Reproduction Services: Photographic prints, color slides, catalog, listings and fee schedule available

Size of Collection: 2,000 negatives, 8,000 slides

Special Collections: Card index of Philadelphia architecture; card index of work of Wilson Eyre, Jr.; research material on Wilson Eyre early mental hospital architecture

Major Holdings: AI–1P, 1S; AE–1P, 1S; C–1P, 1S; AR–1P, 1S; F–1P, 1S; W–1P, 1S; AJ–1P, 1S; WM–1P, 1S; MW–1P, 1S; CW–1P, 1S; WI–1P, 1S; I–1P, 1S; T–1P, 1S, 4P, 4S; ETW–1P, 1S, 2S, 4P, 4S; WWI–1P, 1S, 2S, 4P, 4S; TW–1P, 1S, 2S, 4P, 4S; GD–1P, 1S; WWII–1P, 1S; P–1P, 1S; SA–1P, 1S; AL–1P, 1S; M–1P, 1S

U290. **NJCHVM**

Visual Media for the Arts and Humanities
P.O. Box 737
Cherry Hill, New Jersey 08003
(609) 795-5099
Dr. George Conrad

Access: Purchase only

Reproduction Services: Microfilm, color slides, microfiche in color, catalog, listings available

Size of Collection: 100,000 slides (masters)

Major Holdings: AI–2S, 3S, 4S; C–1S, 2S, 3S, 4S; AR–1S, 2S, 3S, 4S; F–1S, 2S, 3S, 4S; W–1S, 2S, 3S; AJ–1S, 2S, 3S; WM–2S, 3S; MW–3S, 4S; CW–1S, 2S, 3S, 4S; WI–1S, 2S, 3S, 4S; I–1S, 2S, 3S; ETW–1S, 2S, 3S, 4S; WWI–1S, 2S, 3S, 4S; TW–1S; GD–1S, 2S, 3S, 4S; WWII–1S, 2S, 3S, 4S; P–1S, 2S, 3S, 4S; SA–1S, 2S, 3S, 4S; M–1S

U291. **NJCLKC**

Keller Color, Inc.
P.O. Box 1061
187 Rutherford Blvd.
Clifton, New Jersey 07014
(201) 471-7533
Oscar Keller

Access: Purchase only, listing available on request

Reproduction Services: Keller Color, Inc., produces color slides and postcards on request; write for information on time when Keller photographer will be in your vicinity

Major Holdings: C–1S; AR–1S; F–1S; W–1S; AJ–1S; WM–1S; MW–1S; CW–1S; WI–1S; I–1S; T–1S; ETW–1S; WWI–1S; TW–1S; GD–1S; WWII–1S; P–1S; SA–1S

U292. **NJFRMC**

Monmouth County Historical Association
70 Court Street
Freehold, New Jersey 17728
(201) 462-1466
Charles T. Lyle, Director

Hours: 10:00–5:00, Tu–Sa; 2:00–5:00, Su

Access: Open to public

Reproduction Services: Photographic prints, color slides, 4x5 color transparencies; publications loaned for $25.00 use fee for one month payable in advance; arrangements available to purchase items in the collection

Size of Collection: 30 photographs, 10 negatives, 12 slides, 18 postcards, 1 film

Special Collections: Slides of American furniture and paintings in their collection, exterior and interior views of buildings in Monmouth County

Major Holdings: C–1P, 1S, 3P, 3S, 4P, 4S; AR–1P, 1S, 3P, 3S, 4P, 4S; F–1P, 1S, 3P, 3S, 4P, 4S

U293. **NJKEAN**

Art Now, Inc.
144 N. 14th Street
Kenilworth, New Jersey 07033
(201) 272-5006
Roger Peskin, Publisher

Access: Purchase only

Reproduction Services: Photographic prints, color slides, catalogue, fee schedule, listings available

Major Holdings: T–3S; ETW–3S; WWI–3S; TW–3S; GD–3S; WWII–3S; P–2P, 2S, 3P, 3S; SA–2P, 2S, 3P, 3S

U294. **NJMaFD**

Fairleigh Dickinson University,
 Madison Campus
Outdoor Advertising Association,
 American Archives
Madison, New Jersey 07940
(201) 377-4700

James Fraser, Library Director

Access: Open by appointment, restricted use
Size of Collection: 1,000 photographs, 100 slides, 16mm films, posters
Special Collections: Billboard sheets; OAAA yearbooks, 16mm film; lithographers' working prints of 3, 6 and 24 sheet posters, 1920—39

Major Holdings: ETW; WWI; TW; GD; WWII; P

U295. **NJMOMA**

Montclair Art Museum
LeBrun Library
3 South Mountain Avenue
Montclair, New Jersey 07042
(201) 746-5555
Edith A. Rights, Librarian

Hours: 10:00—5:00, Tu—F; 10:00—1:00, Sa (September—June)
Access: Open to public
Reproduction Services: Photocopy
Size of Collection: Slides, mounted reproductions
Special Collections: Bookplates

Major Holdings: AI—2S, 3S, 4S; C—2S, 3S, 4S; AR—2S, 3S, 4S; F—2S, 3S, 4S; W—2S, 3S, 4S; AJ—2S, 3S, 4S; WM—2S, 3S, 4S; MW—2S, 3S, 4S; CW—2S, 3S, 4S; WI—2S, 3S, 4S; I—2S, 3S, 4S; T—2S, 3S, 4S; ETW—2S, 3S, 4S; WWI—2S, 3S, 4S; TW—2S, 3S, 4S; GD—2S, 3S, 4S; WWII—2S, 3, 4S; P—2S, 3S, 4S

U296. **NJNENM**

Newark Museum
Newark Museum Library
43—49 Washington Street
Newark, New Jersey 07101
(201) 733-6585
Mrs. Barbara Lipton, Librarian

Hours: 12:00—5:00, M—F
Access: Open to public
Reproduction Services: Photographic prints, color and black and white slides, 4x5 color transparencies
Size of Collection: 15,000 photographs, 15,000 negatives, 3,000 slides, 5,000 postcards (uncataloged)
Special Collections: American 18th—20th c. (slides, photographs) paintings, sculpture, glass, pottery, quilts; photographs and slides of historical Newark and New Jersey

Major Holdings: C—3P, 3S, 4P, 4S; AR—3P, 3S, 4P, 4S; F—2P, 2S, 3P, 3S, 4P, 4S; W—3P, 3S, 4P, 4S; AJ—2P, 2S, 3P, 3S, 4P, 4S; WM—2P, 2S, 3P, 3S, 4P, 4S; CW—2P, 2S, 3P, 3S, 4P, 4S; WI—3P, 3S, 4P, 4S; I—1P, 1S, 2P, 2S, 3P, 3S, 4P, 4S; T—2P, 2S, 3P, 3S, 4P, 4S; ETW—2P, 2S, 3P, 3S, 4P, 4S; WWI—2P, 2S, 3P, 3S, 4P, 4S; TW—2P, 2S, 3P, 3S, 4P, 4S; GD—2P, 2S, 3P, 3S, 4P, 4S; WWII—2P, 2S, 3P, 3S, 4P, 4S; P—2P, 2S, 3P, 3S, 4P, 4S

U297. **NJNEPL**

Newark Public Library
Art and Music Department
5 Washington Street
Newark, New Jersey 07101
(201) 733-7840
William J. Dane, Supervising Librarian, Art and Music
Hours: 9:00—9:00, M, W, Th; 9:00—6:00, Tu, F; 9:00—5:00, Sa
Access: Open to public
Reproduction Services: Photographic prints, photocopy, microfilm
Size of Collection: 500 photographs, 15,000 slides, 3,000 postcards, 1,000 posters
Special Collections: The New Jersey Division of this library under the supervision of Charles Cummings has four to five million pictures (nearly all photographs) from the files of the Newark *News*; this collection also includes 35,000 other photographs, 8,000 negatives and 5,000 postals

U298. **NJNERU**

Rutgers NCAS
Art Department, Slide Library
College of Arts and Sciences
Newark, New Jersey 08903
Access: Restricted use
Reproduction Services: By special request
Size of Collection: 20,000 slides

Major Holdings: AE—1S, 2S, 3S; AR—3S; I—1S, 2S, 3S; T—1S, 2S, 3S; ETW—1S, 2S, 3S; WWI—1S, 2S, 3S; TW—1S, 2S, 3S; GD—1S, 2S, 3S; WWII—1S, 2S, 3S; P—1S, 2S, 3S; SA—1S, 2S, 3S

U299. **NJNOBS**

Johnston Historical Museum, Boy Scouts of America
Route 1 and 130
North Brunswick, New Jersey 08902
(201) 249-6000, ext. 428
Avery Chenoweth, Director
Carolyn Hughes, Curator
Hours: 9:00—4:30, Tu—Sa; 1:00—4:30, Su
Access: Open to public, restricted use, archives and collection open for legitimate research under guidance of staff
Reproduction Services: Photographic prints, photocopy, fee schedule
Size of Collection: 1,000 photographs, 100 postcards (scouts themes, ca. 1910—1950), 4 films (non-scouting), 7 films (on scouting), posters ca. 1910—1975
Special Collections: 50 scouting recruiting posters, ca. 1910—1975; reproductions (prints) of 44 Norman Rockwell paintings with scouting themes

U300. **NJPABC**

Bergen Community College
Library and Learning Resources Center
400 Paramus Road
Paramus, New Jersey 07652 [cont.]

(201) 447-1500
James Cremona, Media Distribution
Shirley Kale, Media Cataloger

Hours: 8:00—10:30, M—F; 9:00—4:00, Sa
Access: Open to public, collections for in-library use only
Size of Collection: 4,836 slides (1,100 in special collection), 33 16mm films, 44 film loops, 4 audiotapes and records
Special Collections: 1,100 slides: Mathew Brady Collection of Civil War photographs (originally in microfilm)

Major Holdings: C—3S; AR—3S; W—1S; AJ—1S; WM—1S; MW—1S; CW—1S, 4S; WI—1S; I—1S; T—1S, 3S; ETW—1S; WWI—1S; TW—1S; GD—1S; WWII—1S; P—1S, 2S, 3S, 4S; SA—1S

U301. **NJPRHS**

Historical Society of Princeton
Photographic Archives
158 Nassau Street
Princeton, New Jersey 08540
(609) 921-6748
Helen D. Hamilton, Administrator

Access: Restricted use
Size of Collection: 7,000 negatives
Special Collections: 7,000 glass place negatives of everyday Princeton life from 1880 to 1920 taken by a local photographer

U302. **NJPRPU_m**

The Art Museum, Princeton University
Princeton, New Jersey 08540
(609) 452-3787
Robert Lafond, Museum Registrar

Access: Purchase only
Reproduction Services: Photographic prints; color slides; 4x5, 5x5, 8x10 color transparencies; catalog and fee schedule available for slides only
Size of Collection: Photographs and negatives (almost entire museum's collection), slides and postcards (limited)

Major Holdings: AI—4P; AR—2P, 3P, 4P; F—3P, 4P; AJ—2P, 3P, 4P; T—2P, 3P, 4P; ETW—2P, 3P, 4P; WWI—2P, 3P, 4P; TW—2P, 3P, 4P; GD—2P, 3P, 4P; WWII—2P, 3P, 4P; P—2P, 3P, 4P

U303. **NJPRPU_a**

Princeton University
Department of Art and Archaeology
Section of Slides and Photographs/Research Collections
205—207 McCormick Hall
Princeton, New Jersey 08540
(609) 452-3776
Cynthia L. Clark, Director of Section of Slides and Photographs
Shari S. Taylor, Curator of Research Collections
Hours: 9:00—5:00, M—F
Access: Departmental collection mainly for use

of departmental faculty and students; restricted use to public with serious interest in studying from the photograph collection
Size of Collection: 160,000 photographs, 155,000 slides, 45,000 postcards
Special Collections: (noncirculating) Wayne Andrews Collection, principally American architecture; La Farge Collection of photographs, modern U.S.A., principally architecture; Berenice Abbott Federal Art Project Collection: photographs of New York City taken in the 1930s

U304. **NJWOGC**

Gloucester County Historical Society
Gloucester County Historical Society Library
17 Hunter Street
Woodbury, New Jersey 08096
(609) 845-4771
Mrs. Kurt (Edith) Hoelle, Librarian

Hours: 1:00—4:00, M—F; 7:00—9:30, F evening; 2:00—5:00, last Su of month
Access: Open to public
Reproduction Services: 8x10 photographic prints of photographs may be ordered from local photographer
Size of Collection: 450 photographs, 300 negatives, 50 slides, 185 postcards, 15 commercial posters, 50 vendue notices, sales, etc.

Major Holdings: C—1P; AR—1P, 4P; F—1P; CW—1P; I—1P; ETW—1P; AL—1P; S—1P

NEW MEXICO

U305. **NMALTI**

University of New Mexico
Tamarind Institute
Albuquerque, New Mexico 87131
(505) 277-3901
Clinton Adams, Director

Access: Purchase only
Reproduction Services: Color slides
Size of Collection: 300 slides
Special Collections: Slides of color lithographs created at Tamarind Lithography Workshop, Los Angeles (1960—1970) and at Tamarind Institute Albuquerque (1970—)

Major Holdings: P—4S

U306. **NMALUN**

University of New Mexico, Albuquerque
Fine Arts Slide Library
Room 2010 Fine Arts Center
Albuquerque, New Mexico 87131
(505) 277-4908
Arlene K. Richardson, Slide Curator

Hours: 8:00—5:00, M—F
Access: Scholars only, graduate seminar students
Reproduction Services: Black and white slides

Size of Collection: 3,000 photographs, 200,000 slides

Major Holdings: AI–1S, 2S, 3S, 4S; AE–1S, 2S, 3S, 4S; C–1S, 2S, 3S, 4S; AR–1S, 2S, 3S, 4S; F–1S, 2S, 3S, 4S; W–1S, 2S, 3S, 4S; AJ–1S, 2S, 3S, 4S; WM–1S, 2S, 3S, 4S; MW–1S, 2S, 3S, 4S; CW–1S, 2S, 3S, 4S; WI–1S, 2S, 3S, 4S; I–1S, 2S, 3S, 4S; T–1S, 2S, 3S, 4S; ETW–1S, 2S, 3S, 4S; WWI–1S, 2S, 3S, 4S; TW–1S, 2S, 3S, 4S; GD–1S, 2S, 3S, 4S; WWII–1S, 2S, 3S, 4S; P–1S, 2S, 3S, 4S; SA–1S, 2S, 3S, 4S

U307. **NMAZAZ**

Aztec Ruins National Monument
Box U
Aztec, New Mexico 87401
(505) 334-6174
Clarence N. Gorman, Superintendent

Hours: 8:00–5:00
Access: Open to public
Reproduction Services: None
Size of Collection: 500 photographs, 1000 negatives, 500 slides

Major Holdings: AI–1P, 1S, 4P, 4S

U308. **NMRORM**

Roswell Museum and Art Center
100 West 11th Street
Roswell, New Mexico 88201
(505) 622-4700
Wendell Ott, Director

Hours: 9:00–5:00, daily; 1:00–5:00, holidays
Access: Open to public
Reproduction Services: Photographic prints, rental or purchase fee; brochure available
Special Collections: Peter Hurd collections of paintings; Robert H. Goddard collection of rocketry from early experiments in New Mexico, 1930–1942

U309. **NMSFMN**

Museum of New Mexico
Photographic Archives
P.O. Box 2087
Santa Fe, New Mexico 87501
(505) 827-2559
Arthur L. Olivas, Photographic Archivist

Hours: 9:00–5:00, Tu–F; by appointment, M, Sa
Access: Open to public, open by appointment, purchase only
Reproduction Services: Photographic prints, color and black and white slides, 4x5 large format color transparencies, fee schedule and catalog available
Size of Collection: 70,000 photographs, 50,000 negatives, 2,000 slides, 2,000 postcards
Special Collections: Spanish Colonial religious crafts and arts

Major Holdings: AI–1P, 1S, 2P, 2S, 3P, 3S, 4P, 4S; C–4P, 4S; WM–1P, 1S, 4P, 4S; MW–1P, 1S, 3P, 3S, 4P, 4S; I–1P, 1S, 3P, 3S, 4P, 4S; T–1P, 1S, 3P,

3S; ETW–1P, 1S, 2P, 2S, 3P, 3S; WWI–1P, 1S, 3P, 3S: TW–1P, 1S, 3P, 3S; GD–1P, 1S, 2P, 2S, 3P, 3S; WWII–1P, 1S, 3P, 3S; P–1P, 1S, 2P, 2S, 3P, 3S; SA–3P, 3S; AL–1P, 1S, 3P, 3S; S–1P, 1S

NEW YORK

U310. **NYALAI**

Albany Institute of History and Art
McKinney Library
125 Washington Avenue
Albany, New York 12210
(518) 463-4478
James R. Hobin, Librarian

Hours: 8:30–4:00, M–F; 8:30–3:30, Sa
Access: Open to public
Reproduction Services: Photographic prints, photocopy, black and white slides
Size of Collection: 3,500 photographs, 1,000 postcards
Special Collections: Albany and upper Hudson area

U311. **NYALNY**

New York State Museum,
 Office of State History
New York State History Collections
99 Washington Avenue, Twin Towers
Albany, New York 12230
(518) 474-5353
John S. Still

Hours: 8:30–5:00
Access: Open by appointment, restricted use
Reproduction Services: Photographic prints, color and black and white slides; if no negatives are available, will take upon request
Size of Collection: 5,000 photographs, 1,500 negatives, 1,600 slides, 5,000 postcards, 600 posters, 2,000 glass plate negatives
Special Collections: Group of decorative art slides from the Winterthur Collection (not for reproduction); group of about 2,000 glass plate negatives of upstate New York subjects

U312. **NYALOA**

"Old Albany" Photos
Morris Gerber Collection
55 Sycamore Street
Albany, New York 12208
(518) 489-3051
Morris Gerber, Owner

Hours: After 4:00
Access: Open to public, open by appointment, restricted use, picture service agency
Reproduction Services: Photographic prints, photocopy, microfilm, black and white slides, catalog available (3 volumes hard cover, available at most area libraries and book shops), fee schedule
Size of Collection: 25,000 photographs, 10,000 negatives, 2,000 slides, 10,000 postcards,

microfilm (not inventoried), rare books (not inventoried)

Special Collections: Part of collection published as vols. 1–3 of "Old Albany" pictorial history; also annual "Old Albany" pictorial calendars published from collection; collection also includes rare cameras and other photographic equipment, much of which is now housed in the "South Mall" or Empire State Plaza Museum; collection includes contents of an area newspaper morgue and includes many old original photographs and negatives

Major Holdings: AI–1P, 1S; AE–1P, 1S; C–1P, 1S; AR–1P, 1S; F–1P, 1S; W–1P; AJ–1P; WM–1P; MW–1P; CW–1P; WI–1P; I–1P; T–1P; ETW–1P, 1S; WWI–1P; TW–1P; GD–1P; WWII–1P, 1S; P–1P, 1S; AL–1P; M–1P; S–1P; E–1P

U313. **NYALSU**

State University of New York at Albany
Slide Library, Department of Art History
1400 Washington Avenue
Albany, New York 12222
(518) 457-8908
Dawn Donaldson, Slide Curator

Hours: 9:00–4:30, M–F
Access: Open to public
Reproduction Services: None
Size of Collection: 65,000–70,000 slides

Major Holdings: AI–1S, 2S, 3S, 4S; AE–1S, 3S; C–1S, 2S, 3S; AR–1S, 2S, 3S; F–1S, 2S, 3S; W–2S, 3S; AJ–1S, 2S, 3S; WM–1S, 2S, 3S; MW–1S, 2S, 3S, 4S; CW–1S, 2S, 3S, 4S; WI–1S, 4S; I–1S, 2S, 3S, 4S; T–1S, 2S, 3S, 4S; ETW–1S, 2S, 3S, 4S; WWI–1S, 2S, 3S, 4S; TW–2S, 3S, 4S; GD–1S, 2S, 3S, 4S; WWII–1S, 2S, 3S, 4S; P–1S, 2S, 3S, 4S; SA–1S, 2S, 3S, 4S

U314. **NYBISU**

State University of New York
 at Binghamton
Visual Resources Library,
 Department of Art and Art History
Binghamton, New York 13901
(607) 798-2215
Carol L. Aronson, Curator of Visual Resources

Hours: 8:30–5:00, M–F
Access: Restricted use, scholars and students only
Reproduction Services: Photographic prints, color and black and white slides
Size of Collection: 35,000 photographs, 115,000 slides
Special Collections: Visual Resources Library contains photographs and slides of architecture, sculpture, paintings, and other media but is not classified according to historical period or subject area

Major Holdings: AI–3P, 3S; C–3P, 3S; AR–3P, 3S; F–3S; AJ–3S; WM–3S; CW–3S; I–3S;

T–3S; TW–2S, 3S; GD–2S, 3S; WWII–2S, 3S; P–2S, 3S; SA–2S, 3S

U315. **NYBRBC**

Brooklyn College
Art Department Slide Library
Art Department, Brooklyn College
Brooklyn, New York 11210
(212) 780-5182
Stephen Margolies, Curator of Slides

Hours: 9:30–5:30, M–F
Access: Open by appointment (occasionally), restricted use, faculty, graduate students and approved visiting scholars
Reproduction Services: Color and black and white slides (restricted service)
Size of Collection: 70,000 slides

Major Holdings: AI–2S, 3S, 4S; AE–1S; C–1S, 2S, 3S; AR–1S, 2S, 3S, 4S; F–1S, 2S; AJ–1S, 2S, 3S, 4S; WM–2S, 3S; MW–1S, 2S, 3S; CW–1S, 2S, 3S, 4S; I–1S, 2S, 3S, 4S; T–1S, 2S, 3S, 4S; ETW–1S, 2S, 3S; WWI–1S, 2S, 3S; TW–1S, 2S, 3S, 4S; GD–1S, 2S, 3S; WWII–1S, 2S, 3S, 4S; P–1S, 2S, 3S, 4S

U316. **NYBRBM**

Brooklyn Museum
Art Reference Library
188 Eastern Parkway
Brooklyn, New York 11238
(212) 638-5000
Mrs. Margaret B. Zorach, Chief Librarian

Hours: 1:00–9:00, W; 1:00–5:00, Th, F
Access: Open to public, open by appointment, slide purchase available through Museum Bookshop, catalog list available
Reproduction Services: Photographic prints, large format color transparency (4x5), fee schedule; requests should be directed to Photo Service Department
Size of Collection: 3,500 slides

Major Holdings: AI–2S, 3S, 4S; AE–3S, 4S; C–1S, 2S, 3S, 4S; AR–1S, 2S, 3S, 4S; F–1S, 2S, 3S, 4S; W–1S, 2S, 3S, 4S; AJ–1S, 2S, 3S, 4S; WM–1S, 2S, 3S, 4S; MW–1S, 2S, 3S, 4S; CW–1S, 2S, 3S, 4S; WI–1S, 2S, 3S, 4S; I–1S, 2S, 3S, 4S; T–1S, 2S, 3S, 4S; ETW–1S, 2S, 3S, 4S; WWI–1S, 2S, 3S, 4S; TW–1S, 2S, 3S, 4S; GD–1S, 2S, 3S, 4S; WWII–1S, 2S, 3S, 4S; P–1S, 2S, 3S, 4S; SA–1S, 2S, 3S, 4S; E–4S

U317. **NYBRPL**

Brooklyn Public Library
Art and Music Division
Grand Army Plaza
Brooklyn, New York 11238
(212) 636-3214
William R. Johnson, Chief

Hours: 9:00–8:00, M–F; 10:00–6:00, Sa; 1:00–5:00, Su
Access: Open to public, circulating and reference collections

Reproduction Services: Photocopy
Size of Collection: 100,000 photographs, 650 negatives, 500 postcards, 400 maps
Special Collections: Brooklyn materials (local history)

U318. **NYBRPR**
Pratt Institute
Pratt Institute Library, Slide Collection
215 Ryerson Street
Brooklyn, New York 11205
(212) 636-3685
Lynn Slome, Slide Assistant

Hours: 9:00–9:00, M–Th; 9:00–5:00, F
Access: Restricted use, Pratt Institute faculty only
Reproduction Services: Photocopy, microfilm (reference department)
Size of Collection: 56,000 slides
Special Collections: 16,000 mounted reproductions of works of art (by artist)

U319. **NYBUAK**
Albright-Knox Art Gallery
Education Department
1285 Elmwood Avenue
Buffalo, New York 14222
(716) 882-8700
Charlotte Buel Johnson, Curator of Education

Hours: 12:00–4:40, Tu–F; 9:00–12:00, Sa
Access: Open to public, restricted use (limited to teachers and leaders of study groups, and staff use only)
Reproduction Services: Photographic prints, color slides, large format color transparency (4x5, 5x7, 8x10); photograph and transparency service arranged through Registrar's Office; slide sales through Gallery Shop
Size of Collection: 100 photographs, 16,587 slides, color reproductions (available for sale)
Special Collections: Education Department, loan service (brochures available), museum publications

U320. **NYBUBE**
Buffalo and Erie County Historical Society
25 Nottingham Court
Buffalo, New York 14216
(716) 873-9644
Walter S. Dunn, Jr., Director

Size of Collection: ca. 240,000 items including photographs, negatives, posters, television news film, architectural plans, lantern slides
Special Collections: Emphases on the history of western New York state and the Buffalo area; iconographic sections include presidents, public officials, families, photographers, Buffalo–Pan American, harbors and waterways, maps and plans, education, general photographs; photographers of western New York include C. D. Arnold, George F. H. Bartlett, Bob Hauser, Harlow H. Boyce,

Wilbur H. Porterfield, Daniel W. Streeter, Fitzgerald air views

U321. **NYBUSU**
State University of New York at Buffalo
Art History Department
325 Foster Hall
Buffalo, New York 14214
(716) 831-2240
Curator of Visual Resources

Access: Art and Art History Department, State University of New York at Buffalo
Size of Collection: Slides
Special Collections: Carnegie survey: arts of the United States

U322. **NYCONB**
National Baseball Hall of Fame and Museum, Inc.
National Baseball Library
Main Street
Cooperstown, New York 13326
(607) 547-9988
John Redding, Librarian

Hours: 9:00–5:00, M–F
Access: Open to public, by appointment, for research
Reproduction Services: Photocopy
Size of Collection: 84,000 photographs, 1,000 negatives, 100 slides, 112 films, 392 tapes

U323. **NYCORM**
The Corning Museum of Glass
The Corning Museum of Glass Library
Corning Glass Center
Corning, New York 14830
(607) 937-5371
Carol Hull, Research Assistant

Hours: 9:30–5:00, Tu–F
Access: Open to public
Reproduction Services: Photographic prints, color slides, large format color transparency (4x5), slide catalog available, listings, fee schedule
Size of Collection: 3,000 photographs, 2,500 negatives, 3,000 slides, 10 postcards; new additions since the 1972 flood, which severely damaged the photographic collection
Special Collections: Collection limited to art and history of glass; includes slides and photographs of glass objects, glassmaking tools and techniques, glass factories, trade catalogs, craftsmen; slides available of American glass dating from the 18th c. to the present

U324. **NYEHGH**
Guild Hall
Guild Hall Museum Section
158 Main Street
East Hampton, New York 11937
(516) 324-0806
Enez Whipple, Director
Rae Ferren, Exhibition Coordinator [*cont.*]

Hours: 10:00–5:00, M–F; 2:00–5:00, Su; closed M during the winter

Access: Open to public, open by appointment, please call in advance

Size of Collection: 4 posters

Special Collections: At present there are no slides for sale of the approximately 500 items in the collection, which is mainly paintings and graphics of artists who have lived or worked in the East Hampton area (i.e., Thomas Moran, Childe Hassam, Lee Krasner; small works by Jackson Pollock and Willem de Kooning; prints by Peggy Bacon)

Major Holdings: I; ETW; TW; P

U325. **NYEMNC**
Nassau County Museum
Nassau County Museum Reference Library
Eisenhower Park
East Meadow, New York 11554
(516) 292-4162
Marylouise Matera, Librarian

Hours: 9:00–5:00, M–F

Access: Open to public

Reproduction Services: Photographic prints, photocopy, fee schedule

Size of Collection: 10,000 photographs, 8,000 negatives, 2,000 slides, 500 postcards, 100 posters, films

Special Collections: Nassau County and Long Island History

Major Holdings: I–3P; T–1P; ETW–1P, 3P; WWI–1P; TW–1P; GD–1P; WWII–1P; P–1P; SA–1P; AL–1P, 1S; M–1P; S–1P

U326. **NYESDU**
The Dunlap Society
Shore Road (P.O. Box 297)
Essex, New York 12936
(518) 963-7373
Isabel Barrett Lowry, Coordinator

Access: Purchase only; all material will be on microfiche

Reproduction Services: Photographic prints, color slides, catalog on microfiche

Size of Collection: Photographs, slides, microfiche; presently limited to the architecture of Washington, D.C.; rest of U.S. architecture and arts to follow soon

Special Collections: The Dunlap Society is undertaking the creation of a Visual Archive of American Art from which one may purchase slides, photographs, microfiche; it is a nonprofit organization

Major Holdings: C–1S; AR–1S; F–1S; W–1S; AJ–1S; WM–1S; MW–1S; CW–1S; WI–1S; I–1S; T–1S; ETW–1S; WWI–1S; TW–1S; GD–1S; WWII–1S; P–1S

U326a. **NYESEH**
Eastchester Historical Society
108 Servanoy Blvd.

Eastchester, New York 10707
(914) DE7-1770
A. H. Bienchi, Curator

Access: Open by appointment, restricted use

Reproduction Services: None

Size of Collection: 200 photographs, 25 negatives, 100 slides, 100 postcards

Major Holdings: I–1P, 4P; T–1P; ETW–1P; WWI–1P; TW–1P; WWII–1P

U327. **NYETEC**
Essex County Historical Society Library
Adirondack Center Museum
Court Street
Elizabethtown, New York 12901
(518) 873-6466
James Bailey, Director

Hours: 9:00–3:00, Tu, Th

Access: Open to public, open by appointment

Reproduction Services: Photocopy

Size of Collection: 1,000 photographs, 300 slides (glass), 200 postcards

Major Holdings: I–1P; T–1P, 1S; ETW–1P, 1S; WWI–1P; TW–1P; GD–1P; WWII–1P; AL–1P; M–1P

U328. **NYEXCC**
Chemung County Historical Society
Arthur W. Booth Memorial Library
304 William Street
Elmira, New York 14904
(607) 737-2900
Asaph B. Hall, President

Hours: 1:00–4:30, Tu, W, F

Access: Open to public

Reproduction Services: None

Size of Collection: Photographs, postcards

Major Holdings: AI–1P; AE; AR; I; ETW; GD; WWII; AL; S

U329. **NYEXEC**
Elmira College
Gannett-Tripp Learning Center
Elmira, New York 14901
(607) 734-3911 ext. 241
James D. Gray, Director

Hours: Library hours

Access: Restricted use, students

Reproduction Services: Photographic prints, color and black and white slides, fee schedule

Size of Collection: 2,500 slides

Major Holdings: AI–1S, 3S; C–1S, 3S, 4S; AR–1S, 3S, 4S; F–1S, 3S, 4S; W–1S, 3S; WM–3S; CW–1S; I–3S; T–3S; ETW–1S, 3S, 4S; WWI–1S, 3S; TW–1S, 3S; GD–1S, 3S; WWII–1S, 3S; P–1S, 3S, 4S; SA–1S; AL–1S; S–1S; E–1S, 3S, 4S

U330. **NYGEGH**
Geneva Historical Society and Museum
543 S. Main Street

Geneva, New York 14456
(315) 789-5151
Elanor Clise, Archivist

Hours: 1:30–4:30, Tu–Sa
Access: Open to public
Reproduction Services: None
Size of Collection: 2,000 photographs, postcards

Major Holdings: F–1P; AJ–1P; I–1P; T–1P; ETW–1P; WWI–1P; TW–1P; GD–1P; WWII–1P

U331. **NYGOHF**

Hall of Fame of the Trotter
240 Main Street
Goshen, New York 10924
(914) 294-6330
J. C. Dill, Education Officer

Hours: 10:00–5:00, M–F
Access: Open to public
Reproduction Services: None
Size of Collection: 1,000 photographs, 2,000 negatives, 300 slides, 200 postcards, broadsides, posters, films, videotapes
Special Collections: Glass negatives showing the sport of trotting horses around the turn of the century

Major Holdings: S–3P, 3S

U332. **NYJAYC**

York College of City University of New York
Slide Library
Jamaica, New York 11451
(212) 969-4485
Alan Forman, Curator

Access: Restricted use, students; collection for college art history classes and student studies
Reproduction Services: None
Size of Collection: 13,500 slides

Major Holdings: AI–2S, 4S; C–1S, 2S, 3S; AR–1S, 2S, 3S; F–1S, 2S, 3S; WM–3S; CW–1S, 2S, 3S; I–1S, 2S, 3S; ETW–1S, 2S, 3S; WWI–1S, 2S, 3S; TW–1S, 2S, 3S; GD–1S, 2S, 3S; WWII–1S, 2S, 3S; P–1S, 2S, 3S; SA–1S, 2S, 3S

U333. **NYNYAC**

American Crafts Council
Research and Education Department
22 W. 55th Street
New York, New York 10019
(212) 397-0600
Lois Moran, Director

Hours: 10:00–5:00, Tu, W, F (subject to change)
Access: Open to public
Reproduction Services: None; approximately 80 35mm color slide kits are available for purchase or rental as well as for reference use in library
Size of Collection: 5,000 photographs, 30,000 slides, 6 films (16mm), 100 videotapes
Special Collections: All of the slides, photographs, and reference material are concerned

with the contemporary American craftsman and his work

Major Holdings: P–4P, 4S

U334. **NYNYAH**

American Heritage Publishing Company, Inc.
American Heritage Picture Collection
1221 Avenue of the Americas
New York, New York 10020
(212) 997-4767
Peggy Buckwalter,
Head of the Picture Collection

Access: Restricted use, not open to public
Reproduction Services: None
Size of Collection: 200,000 photographs, slides

Major Holdings: AI–3P, 4P; AE–1P, 3P, 4P; C–1P, 2P, 3P, 4P; AR–1P, 2P, 3P, 4P; F–1P, 2P, 3P, 4P; W–1P, 2P, 3P, 4P; AJ–1P, 2P, 3P, 4P; WM–1P, 2P, 3P, 4P; MW–1P, 2P, 3P, 4P; CW–1P, 2P, 3P, 4P; WI–1P, 2P, 3P, 4P; I–1P, 2P, 3P, 4P; T–1P, 2P, 3P, 4P; ETW–1P, 2P, 3P, 4P; WWI–1P, 2P, 3P, 4P; TW–1P, 2P, 3P, 4P; GD–1P, 2P, 3P, 4P; WWII–1P, 2P, 3P, 4P; P–1P, 2P, 3P, 4P; SA–1P, 2P, 3P, 4P; AL–1P, 2P, 3P, 4P; M–1P, 2P, 3P, 4P; S–1P, 2P, 3P, 4P; E–1P, 2P, 3P, 4P

U335. **NYNYAR**

Archaeological Institute of America
Slide Archives
260 West Broadway
New York, New York 10013
(212) 925-7333
Hanson Wong

Hours: 9:00–3:00, M–F
Access: Open to public, open by appointment, purchase only
Reproduction Services: Color slides, catalog available, listings ("Archaeology World"), fee schedule $1.10–$1.25
Size of Collection: 10,000 negatives
Special Collections: Anasazi Indians, American Southwest

Major Holdings: AI–1S

U336. **NYNYB**

Berkey K and L Custom Services, Inc.
222 E. 44th Street
New York, New York 10017
(212) 661-5600
Kenneth Lieberman, Executive Vice President

Hours: 9:00–5:30
Access: Open by appointment
Reproduction Services: Photographic prints, photocopy, microfilm, color and black and white slides, large format color transparency (4x5, 5x7, 8x10)
Size of Collection: 17,000 slides, negatives
Special Collections: Available from Berkey K and L Custom Services, Inc.: *Documerica*, United States Environmental Protection Agency, National Park Service

U337. **NYNYBA**
The Bettmann Archive, Inc.
136 E. 57th Street
New York, New York 10022
(212) 758-0362
Melvin Gray, President

Hours: 9:00—5:00, M—F
Access: Restricted use, open only to publishing and media trade
Reproduction Services: Photographic prints, catalog available at $19.50 plus postage and handling
Size of Collection: 3—5 million total collection of photographs, negatives, slides, postcards
Special Collections: Sedge Leblang Metropolitan Opera photographs (1950s); Springer/ Bettmann Film and Stage Collection; color transparencies, historical and modern

Major Holdings: AI—1P, 1S, 2P, 2S, 3P, 3S; AE—1P, 1S, 2P, 2S, 3P, 3S; C—1P, 1S, 2P, 2S, 3P, 3S, 4P, 4S; AR—1P, 1S, 2P, 2S, 3P, 3S, 4P, 4S; F—1P, 1S, 2P, 2S, 3P, 3S, 4P, 4S; W—1P, 1S, 2P, 2S, 3P, 3S, 4P, 4S; AJ—1P, 1S, 2P, 2S, 3P, 3S, 4P, 4S; WM—1P, 1S, 2P, 2S, 3P, 3S, 4P, 4S; MW—1P, 1S, 2P, 2S, 3P, 3S, 4P, 4S; CW—1P, 1S, 2P, 2S, 3P, 3S, 4P, 4S; WI—1P, 1S, 2P, 2S, 3P, 3S, 4P, 4S; I—1P, 1S, 2P, 2S, 3P, 3S, 4P, 4S; T—1P, 1S, 2P, 2S, 3P, 3S, 4P, 4S; ETW—1P, 1S, 2P, 2S, 3P, 3S, 4P, 4S; WWI—1P, 1S, 2P, 2S, 3P, 3S, 4P, 4S; TW—1P, 1S, 2P, 2S, 3P, 3S, 4P, 4S; GD—1P, 1S, 2P, 2S, 3P, 3S, 4P, 4S; WWII—1P, 1S, 2P, 2S, 3P, 3S, 4P, 4S; P—1P, 1S, 2P, 2S, 3P, 3S, 4P, 4S; SA—1P, 1S, 2P, 2S, 3P, 3S, 4P, 4S; AL—1P, 1S, 2P, 2S, 3P, 3S, 4P, 4S; M—1P, 1S, 2P, 2S, 3P, 3S, 4P, 4S; S—1P, 1S, 2P, 2S, 3P, 3S, 4P, 4S; E—1P, 1S, 2P, 2S, 3P, 3S, 4P, 4S

U338. **NYNYBO**
Allan Boutin
76 Franklin Street
New York, New York 10013
(212) 925-4867
Allan Boutin

Access: Purchase only
Reproduction Services: Color slides, catalog available
Size of Collection: 400 slides
Special Collections: Chicago school of architecture, New York architecture, Allegheny County Jail (Pittsburgh) by Richardson

Major Holdings: C—1S; F—1S; CW—1S; I—1S; T—1S; WWI—1S; WWII—1S; P—1S

U339. **NYNYCS**
Castelli-Sonnabend Tapes and Films
420 West Broadway
New York, New York 10012
(212) 431-5160
Joyce Nereaux, Director

Access: Open by appointment
Reproduction Services: Videotapes and films are available for purchase and rental; catalog available; fee schedule
Size of Collection: 225 videotapes and films
Special Collections: All of the videotapes and films are by artists affiliated with either the Castelli or Sonnabend Galleries

U340. **NYNYCU**ₐ
Avery Library
Columbia University
New York, New York 10027
(212) 280-3501
Adolf K. Placzek, Avery Librarian

Hours: Vary, check with library
Access: Open to public
Reproduction Services: Photographic prints, photocopy, microfilm, black and white slide; all reproductions made to individual order; fee schedule included with order form, supplied at time of request
Size of Collection: (Collections not part of Library) Photographs (Art History Department), slides (School of Architecture and Art History)

U341. **NYNYCU**daa
Columbia University
Department of Art History and Archaeology
Edwin C. Vogel Study Room
420 Schermerhorn Hall
New York, New York 10027
(212) 280-5203
Caroline Boyle, Curator

Hours: 10:00—6:00, M—F
Access: Scholars only, students
Size of Collection: 125,000 photographs
Special Collections: Two collections of New York gallery announcements of the past decade and a half

Major Holdings: C—3P; AR—3P; F—3P; W—3P; AJ—3P; I—3P; T—3P; ETW—1P, 3P; WWI—1P, 3P; TW—1P, 3P; GD—1P, 3P; WWII—1P, 2P, 3P; P—1P, 2P, 3P

U342. **NYNYFA**
Frick Art Reference Library
10 E. 71st Street
New York, New York 10021
(212) BU8-8700
Miss Mildred Steinbach, Librarian

Hours: 10:00—4:00, M—F; 10:00—12:00, Sa (Closed: August; Sa: June—August)
Telephone and letter service strictly limited; a personal visit is necessary for checking and research
Access: Open by appointment, scholars only
Reproduction Services: Photographic prints, photocopy
Size of Collection: 60,000 photographs, 10,000 negatives
Special Collections: American paintings and drawings from the colonial period to ca. 1860

Major Holdings: C–3P; AR–3P; W–3P; AJ–3P; WM–3P; MW–3P; CW–3P

U343. **NYNYFC**

The Frick Collection
One E. 70th Street
New York, New York 10028
(212) 288-0700
Everett Fahy, Director

Hours: 10:00–6:00, Tu–F; 1:00–6:00, Su, Election Day; closed M. June-August: 10:00–6:00, Th, F, Sa; 1:00–6:00, Su, W, holidays

Access: Open to public, purchase only

Reproduction Services: Photographic prints, color slides, large format color transparency (8x10); catalog available of postcards and slides; fee schedule

Size of Collection: Photographs of all major objects in collection, 70 slides, 71 postcards, color transparencies

Major Holdings: F–3P; T–3P,3S

U344. **NYNYGC**

The Granger Collection
1841 Broadway
New York, New York 10023
(212) JU6-0971
William Glover, Director

Hours: 10:00–5:00

Access: Open by appointment, restricted use

Reproduction Services: Photographic prints, photocopy, color and black and white slides, large format color transparency (4x5, 5x7, 8x10). The Granger Collection is a commercial historical picture library serving professional users of illustrations (e.g., publishers, audiovisual producers, etc.) to whom reproduction rights only are made available; prints and transparencies are loaned to facilitate reproduction, but are never sold outright

Size of Collection: 3,000,000 total, including photographs, negatives, slides, postcards, posters, cartoons

Major Holdings: AI–1P, 2P, 3P, 4P; AE–1P, 2P, 3P, 4P; C–1P, 2P, 3P, 4P; AR–1P, 2P, 3P, 4P; F–1P,2P, 3P, 4P; W–1P, 3P, 4P; AF–1P, 2P, 3P, 4P; WM–1P, 2P, 3P, 4P; MW–1P, 3P, 4P; CW–1P, 2P, 3P, 4P; WI–1P, 2P, 3P, 4P; I–1P, 2P, 3P, 4P; T–1P, 2P, 3P, 4P; ETW–1P, 2P, 3P, 4P; WWI–1P, 2P, 3P, 4P; TW–1P, 2P, 3P, 4P; GD–1P, 2P, 3P, 4P; AL–4P; M–4P; S–4P; E–4P

U345. **NYNYHA**

G. D. Hackett Studio
130 W. 57th Street
New York, New York 10019
(212) 265-6842
Mr. Gabriel D. Hackett, ASMP, ISP

Hours: 2:00–8:00

Access: Open by appointment, restricted use, purchase only

Reproduction Services: Large format color transparency 35mm, 4x5, 5x7, 8x10; catalog available

Size of Collection: Photographs, negatives, slides, postcards

Special Collections: 3,000 American Indian pictures, mainly documentary but including objects, fashions, works of art

Major Holdings: AI; TW; GD; WWII

U346. **NYNYHF**

Hall of Fame for Great Americans
2 Washington Square Village
New York, New York 10012
(212) 533-4450
Dr. Jerry Grundfest, Executive Director

Hours: 9:00–5:00 daily

Access: Open to public (Hall of Fame Colonnade, Hall of Fame Terrace and Sedgwick Avenue, Bronx, New York, Bronx Community College Campus of the City University of New York)

Reproduction Services: Photographic prints

Size of Collection: Photographs, postcards

Major Holdings: C–2P; AR–2P; F–2P; W–2P; AJ–2P; WM–2P; MW–2P; CW–2P; WI–2P; I–2P; T–2P; ETW–2P; WWI–2P; TW–2P; GD–2P; WWII–2P

U347. **NYNYHS**

The New-York Historical Society
170 Central Park West
New York, New York 10024
(212) 873-3400
James Gregory, Librarian

Hours: 10:00–5:00, M–Sa

Access: Open to public

Reproduction Services: Photographic prints, photocopy, microfilm, large format color transparency (4x5, 8x10), fee schedule

Size of Collection: Photographs, 54,000 negatives, 48 postcards

Special Collections: 80,000 photographs from Public Service Commission on New York City elevateds and subways

Major Holdings: AI–3P; C–3P; AR–1P,3P,4P; F–1P,3P,4P; W–1P,2P,3P,4P; AJ–1P,2P,3P,4P; WM–3P,4P; MW–3P,4P; CW–1P,2P,3P,4P; WI–1P,3P,4P; I–1P,3P,4P; T–1P,4P; TW–1P,4P; M–3P,4P; E–3P,4P

U348. **NYNYLU**

Phyllis Lucas Gallery and Old Print Center
981 2nd Avenue at 52nd Street
New York, New York 10022
(212) PL5-1516 or PL3-1441
Phyllis Lucas, Director

Hours: 9:30–6:00, Tu–Sa; July-August, closed Sa

Access: Open to public, purchase or rental only

Reproduction Services: None

Size of Collection: Old prints

Special Collections: Art deco architecture [*cont.*]

Major Holdings: AI: AE; C; AR; F; W; AJ; WM;
MW; CW; WI; I; T; ETW; WWI; TW; GD; WWII;
P; AL; M; S; E

U349. **NYNYMC**
McGraw-Hill Films/Contemporary Films
1221 Avenue of the Americas
New York, New York 10020
(212) 997-2804
Alan C. Kellock, Vice President
and General Manager

Access: Purchase only, motion pictures also
available for 1–day rental
Reproduction Services: None
Size of Collection: 16mm motion pictures, 35mm
sound and captioned filmstrips, multimedia
kits
Major Holdings: AI; AE; C; AR; F; W; AJ; WM;
MW; CW; WI; I; T; ETW; WWI; TW; GD; WWII;
P; SA; AL; E

U350. **NYNYMM**
The Metropolitan Museum of Art
Photograph and Slide Library
Fifth Avenue and 82nd Street
New York, New York 10028
(212) 879-5500
Margaret P. Nolan, Chief Librarian

Hours: 10:00–4:45, Tu–F (Please call to confirm
hours)
Access: Open to public, rental of slides by fee
schedule, purchase of photographs of
museum collections
Reproduction Services: Photographic prints,
photocopy, large format color transparency
(8x10), catalog available (transparency collec-
tion), fee schedule
Size of Collection: 50,000 photographs (American
section), 30,300 color slides (2x2, American
section) 18,000 black and white slides (2x2,
American section)
Special Collections: Photographs, American
Wing of the Metropolitan Museum and its
collections (17th–early 20th c.); reference
photographs of American architecture,
sculpture and painting; color slides, Ameri-
can decorative arts (17th–early 20th c.); 19th
c. American painting, sculpture, and decora-
tive arts based on the museum's Centennial
Exhibition; art deco; art nouveau; American
rooms
Major Holdings: AI–2S, 4S; AE–2P, 3P, 4P;
C–1P, 1S, 2S, 3P, 3S, 4P, 4S; AR–1P, 1S, 2P, 2S,
3P, 4P, 4S; F–1P, 1S, 2P, 2S, 3P, 4P, 4S; W–1P,
1S, 2S, 3P, 4P, 4S; AJ–1P, 1S, 2P, 2S, 3P, 4S;
WM–1S, 2P, 2S, 3P; MW–4P; CW–1P, 1S, 2P,
2S, 3P, 4S; WI–4P; I–1S, 2S, 3P, 4P; T–1P, 1S,
2P, 2S, 3P, 4P, 4S; ETW–1P, 1S, 2P, 2S, 3P, 4P,
4S; WWI–1S, 3P, 4S; TW–1P, 1S, 2P, 2S, 3P, 4P,
4S; GD–1S, 2P, 3P, 4S; WWII–1S, 2P, 2S, 4S;
P–1P, 1S, 2S, 3P, 4S; SA–2S; AL–3P, 4S; M–3P;
S–1S, 3P, 4S; E–1S, 3P, 4S

U351. **NYNYMO**
The Metropolitan Opera
Metropolitan Opera Archives
B9, Metropolitan Opera House
Lincoln Center
New York, New York 10023
(212) 799-3100 ext. 246
Mrs. John DeWitt Peltz, Archivist

Hours: 10:00–5:00, Tu–Th, October-May
Access: Open by appointment, scholars only,
students; gifts or loans of surplus
Reproduction Services: Photographic prints, color
slides, fee schedule (at cost for photographic
prints)
Size of Collection: 1,000 photographs, 200 nega-
tives, 400 slides, Metropolitan programs
Special Collections: Programs of all Metropolitan
Opera performances, either original or
Xerox; there have been 24 American operas
presented since 1910 (19 were world pre-
mieres); only three had American subjects

U352. **NYNYMP**
Pierpont Morgan Library
29 E. 36th Street
New York, New York 10016
(212) 685-0008
Charles A. Ryskamp, Director

Hours: 9:30–4:45, M–F
Access: Open by appointment, restricted use,
scholars only, students; admission by Morgan
Library reader's card
Reproduction Services: Photographic prints,
microfilm, color slides, large format color
transparency (8x10), fee schedule
Special Collections: Library manuscript collec-
tion

U353. **NYNYMR**
Museum at Large, Ltd.
157 W. 54th Street
New York, New York 10019
(212) CI7-3592
Mrs. Marjorie Page, Administrator

Reproduction Services: Rental and sale of 16mm
color motion picture films
Size of Collection: 16mm color motion picture
films
Special Collections: Art, architecture, dance,
music

U354. **NYNYMU_a**
The Museum of Modern Art
Audio-Visual Archive
11 W. 53rd Street
New York, New York 10019
(212) 956-2689
Esther M. Carpenter, Archival Assistant

Hours: 11:00–5:00, M–F
Access: Open to public, open by appointment,
restricted use, scholars only
Reproduction Services: Photographic prints, large

format color transparency (4x5, 5x7, 8x10), fee schedule

Size of Collection: 125,000 photographs, 50,000 negatives, 2,500 slides (slide collection restricted to staff use), 350 slides available for purchase from Museum Bookstore

Major Holdings: ETW—1P, 2P, 3P; WWI—1P, 2P, 3P; TW—1P, 2P, 3P; GD—1P, 2P, 3P; WWII—1P, 2P, 3P; P—1P, 2P, 3P; SA—1P, 2P, 3P

U355. **NYNYMU_d**

The Museum of Modern Art
Department of Rights and Reproductions
11 W. 53rd Street
New York, New York 10019
(212) 956-7255
Richard Tooke

Hours: 9:30—5:30, M—F
Access: Open by appointment, restricted use, purchase only (postcards)
Reproduction Services: Photographic prints, photocopy, color and black and white slides, large format color transparency (4x5, 5x7, 8x10), fee schedule
Size of Collection: 150,000 photographs (black and white), 50,000 negatives, 2,700 slides (color 2x2), postcards (purchase only), 2,000 color transparencies (4x5 or larger), 2,000 posters, 4,500 films
Special Collections: Photographs are available of almost every work in the collections, as well as of all the museum's exhibitions; in addition, historical photographs relating to the collections; collections consist of architecture, design, drawings, prints, painting, sculpture, photography, and film from 1800s to the present

Major Holdings: AI—3P, 4P; WM—4P; MW—4P; CW—4P; WI—4P; I—1P, 2P, 3P, 4P; T—1P, 2P, 3P, 4P; ETW—1P, 2P, 3P, 4P; WWI—1P, 2P, 3P, 4P; TW—1P, 2P, 3P, 4P; GD—1P, 2P, 3P, 4P; WWII—1P, 2P, 3P, 4P; P—1P, 2P, 3P, 4P; AL—3P, 4P; M—3P, 4P; S—1P, 3P, 4P; E—1P, 3P, 4P

U356. **NYNYMU_f**

The Museum of Modern Art
Film Stills Archive
21 W. 53rd Street
New York, New York 10012
(212) 956-4213
Mary Corliss, Stills Archivist

Hours: 1:30—5:00, M—F
Access: Open by appointment, restricted use, scholars only, students
Reproduction Services: Photographic prints (8x10), purchase, made on order
Size of Collection: 3,000,000 photographs
Special Collections: Film stills from foreign and American releases, as well as photographs of film personalities
Major Holdings: E—4P

U357. **NYNYMV**

Museum of the American Indian
Photography Department
Broadway at 155th Street
New York, New York 10032
(212) 283-2420
Carmelo Guadagno, Staff Photographer

Hours: 9:30—5:00, Tu—F
Access: Open to public, open by appointment, purchase only
Reproduction Services: Photographic prints, color slides, large format color transparency (4x5), catalog available for slides only
Size of Collection: 21,500 photographs, 40,000 negatives, 2,500 slides, 14 films
Major Holdings: AI—1P, 1S, 2P, 2S, 3P, 3S, 4P, 4S

U358. **NYNYPL**

The New York Public Library
The Research Libraries
5th Avenue and 42nd Street
New York, New York 10023
(212) 790-6262
James W. Henderson, Andrew W. Mellon Director of the Research Libraries

Hours: Call library for specific departmental hours
Access: Open to public, restricted use for special collection, students and scholars only
Reproduction Services: Photographic prints, photocopy, microfilm, color and black and white slides, large format color transparency (4x5, 8x10), fee schedule
Size of Collection: Photographs, negatives, slides, postcards
Special Collections: For listings see *American Library Directory* or *Subject Collections,* edited by Lee Ash, 4th ed. (New York, 1974)
Major Holdings: AI—1P, 1S; AE—1P, 1S; C—1P, 1S; AR—1P, 1S; F—1P, 1S; W—1P, 1S; AJ—1P, 1S; WM—1P, 1S; MW—1P, 1S; CW—1P, 1S; WI—1P, 1S; I—1P, 1S; T—1P, 1S; ETW—1P, 1S; WWI—1P, 1S; TW—1P, 1S; GD—1P, 1S; WWII—1P, 1S; P—1P, 1S; SA—1P, 1S; AL—1P, 1S; M 31P, 1S; S—1P, 1S; E—1P, 1S

U359. **NYNYU**

Grey Art Gallery and Study Center
New York University Art Collection
New York University
100 Washington Square E.
New York, New York 10012
(212) 598-3479 or 598-3483
Kenneth L. Mathis, Director
Joy Gordon, Curator

Hours: (Gallery) 10:00—7:00, Tu, W; 10:00—5:00, Th, F; 11:00—5:00, Sa
Access: Open to public, by appointment (for use of photographs, slides, tapes or any other research material)
Reproduction Services: Photographic prints, color

slides, large format color transparencies (4x5), catalog available of gallery collection, fee schedule

Size of Collection: 800 photographs; 200 slides; posters; taped interviews with artists, gallery owners, museum directors

Special Collections: The collection is primarily 20th c. American paintings, sculpture, prints; large collection of WPA prints, as well as several Puerto Rican santos

U360. **NYNYSI**
Society of Illustrators
Permanent Collection
128 E. 63rd Street
New York, New York 10021
(212) TE8-2560
Alvin Pimsler, President

Access: Purchase only (slides)
Reproduction Services: Color slides
Size of Collection: 1,000 slides, 200 original paintings and drawings

U361. **NYNYTH**
Three Lions Inc.
150 Fifth Avenue
New York, New York 10011
(212) 691-8640
Max G. Lowenherz

Hours: 9:00–5:00, M–F
Access: Purchase only
Reproduction Services: Large format color transparencies 4x5, 5x7, and 35mm
Size of Collection: 2,000,000 photographs (black and white and color), negatives
Special Collections: American history, world history, nature, science, art, religion, geography, animals
Major Holdings: AI–3P; AE–3P; C–3P; AR–3P; W–3P; AJ–3P; WM–3P; MW–3P; CW–3P; WI–3P; T–3P; ETW–3P; WWI–3P; TW–3P; WWII–3P; P–3P; SA–3P

U362. **NYNYTI**
Time Incorporated
Time-Life Picture Collection
Time and Life Building, Rockefeller Center
New York, New York 10020
(212) 556-2244
Doris C. O'Neil, Curator

Access: Open by appointment, purchase only
Reproduction Services: Photographic prints, photocopy, microfilm, color and black and white slides, large format color transparency (4x5, 5x7, 8x10), fee schedule
Size of Collection: Photographs, negatives, slides
Major Holdings: AI–2P, 2S, 3P, 3S, 4P, 4S; AE–3P, 3S, 4P, 4S; C–1P, 1S, 3P, 3S, 4P, 4S; AR–1P, 1S, 2S, 3P, 3S, 4P, 4S; F–1P, 2P, 2S, 3P, 3S, 4P, 4S; W–1P, 1S, 3P, 3S, 4P, 4S; AJ–1S, 3P, 3S, 4P, 4S; WM–3P, 3S, 4P, 4S; MW–1S, 3P, 3S, 4P 4S; CW–1P, 1S, 3P, 3S, 4P, 4S; WI–3P, 3S,

4P, 4S; I–3P, 3S; T–3P, 3S; ETW–1P, 1S, 2P, 2S, 3P, 3S, 4P, 4S; WWI–1P, 1S, 2P, 2S, 3P, 3S, 4P, 4S; TW–1P, 1S, 3P, 3S, 4P, 4S; GD–1P, 1S, 3P, 3S, 4P, 4S; WWII–1P, 1S, 3P, 3S, 4P, 4S; P–1P, 1S, 2P, 2S, 3P, 3S, 4P, 4S; SA–1P, 1S, 2P, 2S, 3P, 3S, 4P, 4S; AL–3P, 3S; M–3P, 3S; S–3P, 3S; E–3P, 3S

U363. **NYOGRA**
Remington Art Museum
Western Art Collection
303 Washington Street
Ogdensburg, New York 13669
(315) 393-4123
Mildred B. Dillenbeck, Acting Director

Hours: 10:00–5:00, M–Sa; June–September, 1:00–5:00, Su
Access: Open to public, restricted use
Reproduction Services: Large format color transparency 4x5, fee schedule

Major Holdings: AI–2S,3S,4S

U364. **NYOYRH**
The Friends of Raynham Hall, Inc.
20 W. Main Street
Oyster Bay, New York 11771
(516) 922-6808
Patricia P. Sands, President

Hours: 10:00–12:00, 1:00–5:00, M–Sa; 1:00–5:00, Su (Closed Tu)
Access: Open to public, purchase only
Reproduction Services: None
Size of Collection: 12 postcards
Special Collections: Colonial house museum with Victorian wing; photographs of furnishings can be taken at visitor's expense

U365. **NYRoIM**
International Museum of Photography
at George Eastman House
900 East Avenue
Rochester, New York 14607
(716) 271-3361
Robert J. Doherty, Director

Hours: 10:00–5:00, Tu–Su
Access: Open to public
Reproduction Services: Photographic prints, photocopy, color and black and white slides, large format color transparency (4x5), partial catalog available, fee schedule
Size of Collection: 400,000 photographs, 150,000 negatives, 85,000 slides, 10,000 postcards, 15,000 stereograph cards, 2,000 posters, 6,000 films, 1,400,000 motion picture stills
Special Collections: Lewis Hine, A. L. Coburn, Nikolas Muray, etc.; see *University of Rochester Library Bulletin*, XXVIII:2 (Winter 1975)
Major Holdings: AI–1P, 1S, 2P, 2S, 4P, 4S; AE–1P, 1S, 4P, 4S; AJ–1P, 1S, 2P, 2S, 4P, 4S; WM–1P, 1S, 2P, 2S, 4P, 4S; CW–1P, 1S, 2P, 2S,

4P, 4S; WI–1P, 1S, 2P, 2S, 4P, 4S; I–1P, 1S, 2P, 2S, 4P, 4S; T–1P, 1S, 2P, 2S, 4P, 4S; WWI–1P, 1S, 2P, 2S, 4P, 4S; TW–1P, 1S, 2P, 2S, 3P, 3S, 4P, 4S; T–1P, 1S, 2P, 2S, 4P, 4S; WWI–1P, 1S, 2P, 2S, 4P, 4S; TW–1P, 1S, 2P, 2S, 3P, 3S, 4P, 4S; GD–1P, 1S, 2P, 2S, 3P, 3S, 4P, 4S; WWII–1P, 1S, 2P, 2S, 3P, 3S, 4P, 4S; P–1P, 1S, 2P, 2S, 3P, 3S, 4P, 4S; SA–1P, 1S, 2P, 2S, 3P, 3S, 4P, 4S; AL–1P, 1S, 2P, 2S, 3P, 3S, 4P, 4S; M–1P, 1S, 2P, 2S, 3P, 3S, 4P, 4S; S–1P, 1S, 2P, 2S, 3P, 3S, 4P, 4S; E–1P, 1S, 2P, 2S, 3P, 3S, 4P, 4S

U366. **NYRoLS**

The Landmark Society of
 Western New York, Inc.
The John C. Wenrich Memorial Library
130 Spring Street
Rochester, New York 14608
(716) 546-7029
Ann Parks, Assistant Director
 for Museum Programs

Hours: 9:00–5:00, M–F
Access: Open to public
Reproduction Services: Photographic prints, color slides, fee schedule
Size of Collection: 3,500 photographs, 875 negatives, 6,000 slides
Special Collections: Slides and photographs of local architecture (Rochester and Monroe County)

Major Holdings: F–1P, 1S; W–1P, 1S, 3P, 3S, 4P, 4S; AJ–1P, 1S, 3P, 3S, 4P, 4S; WM–1P, 1S; MW–1P, 1S; CW–1P, 1S; I–1P, 1S; T–1P, 1S; ETW–1P, 1S; WWI–1P, 1S; TW–1P, 1S; GD–1P, 1S; WWII–1P, 1S; P–1P, 1S; S–1P, 1S

U367. **NYRoRI**

Rochester Institute of Technology
Wallace Memorial Library Slide Collection
1 Lomb Memorial Drive
Rochester, New York 14623
(716) 464-2555
Richard K. Zimmer,
 Assistant Audiovisual Coordinator

Hours: 8:30–10:00, M–F
Access: Restricted use, students and scholars only
Reproduction Services: None
Size of Collection: 62,000 slides
Special Collections: Photography and crafts

Major Holdings: AI–1S, 2S, 3S, 4S; C–1S, 2S, 3S; AR–1S, 2S, 3S; W–1S, 2S, 3S, 4S; AJ–1S, 2S, 3S, 4S; WM–1S, 2S, 3S, 4S; MW–1S, 2S, 3S, 4S; CW–1S, 2S, 3S, 4S; WI–1S, 2S, 3S, 4S; I–1S, 2S, 3S, 4S; T–1S, 2S, 3S, 4S; ETW–1S, 2S, 3S, 4S; WWI–1S, 2S, 3S, 4S; TW–1S, 2S, 3S, 4S; GD–1S, 2S, 3S, 4S; WWII–1S, 2S, 3S, 4S; P–1S, 2S, 3S, 4S; SA–1S, 2S, 3S; AL–1S, 2S, 3S, 4S; M–1S, 2S, 4S; E–1S, 2S, 3S, 4S

U368. **NYSCSM**

The Schenectady Museum
Nott Terrace Heights
Schenectady, New York 12308
(518) 372-3386
Mark Winetrout,
 Associate Curator of Education

Hours: 10:00–4:30, Tu–F; 12:00–5:00, Sa, Su
Access: Open to public, open by appointment
Reproduction Services: None
Size of Collection: 200 photographs, 50 negatives, 200 slides, few postcards, planetarium
Special Collections: Charles Proteus Steinmetz (1865–1923) photography Collection; Stokely Collection of Glass Slides; chromograph color-separation lantern slides; daguerreotypes and tintypes; photographs by Hans Namuth of American artists
Major Holdings: I–1P, 1S, 4P; GD–1S; P; SA–1P, 1S

U369. **NYSCUS**

The University of the State of New York
The State Education Department
Office of State History
Rotterdam Industrial Park Building 8
Schenectady, New York 12306
Jan S. Plog, Registrar

Access: Open by appointment
Reproduction Services: Photographic prints, color and black and white slides, large format color transparency (8x10 or smaller), fee charges
Size of Collection: 5,000 photographs, 1,600 slides, postcards (study collection)

U370. **NYSYCM**

Canal Museum
Research Library and Documentation Center
Weighlock Building, Erie Blvd. E.
Syracuse, New York 13202
(315) 471-0593
Frank B. Thomson, Director

Hours: Library open same hours as museum
Access: open by appointment
Reproduction Services: Photographic prints, photocopy, black and white slides, fee schedule
Size of Collection: 5,000 photographs, 13,000 negatives, 12,000 slides, 1,250 postcards, 25 films, 1,500 plans, 2,500 maps, 25 filmstrips, 70 videotapes
Special Collections: 640 pen and ink sketches; central New York historical architecture; Wallace Hamilton Campbell Collection
Major Holdings: WM–1P, 1S, 3P, 3S, 4P, 4S; WI–4P, 4S; I–1P, 1S, 4P, 4S; M–1P, 1S, 2P, 2S, 3P, 3S, 4P, 4S

U371. **NYSeLI**

Society for the Preservation
 of Long Island Antiquities
Architectural and Decorative Arts Archives
93 North Country Road

Setauket, New York 11733
(516) 941-9444
Mr. Dean F. Failey, Curator

Hours: 9:00–5:00

Access: Open by appointment, restricted use, students and scholars

Reproduction Services: Photographic prints, photocopy, black and white and color slides, fee schedule

Size of Collection: 1,500 photographs, negatives, 1,000 slides

Special Collections: Slides of exterior and interior Long Island architecture from the 17th through 20th c., decorative arts from the 17th to the mid–19th c.

Major Holdings: C–1P, 1S, 4P, 4S; AR–1P, 1S, 4P, 4S; F–1P, 1S, 4P, 4S; W–1P, 1S, 4P, 4S; AJ–1P, 1S; I–1P, 1S; T–1P, 1S; ETW–1P, 1S

U372. [Deleted.]

U373. **NYSYSU**$_a$

Syracuse University
George Arents Research Library
E. S. Bird Library
Syracuse, New York 13210
(315) 423-2697
Metod Milac, Assistant Director

Hours: 8:30–5:00, M–F; 10:00–2:00, Sa (subject to change)

Access: Open to public, restricted use, students and scholars (some collections are restricted; researchers advised to contact library prior to coming to use collections)

Reproduction Services: Photographic prints, photocopy, microfilm, fee schedule

Size of Collection: 6,000 photographs, 12,250 negatives, 1,500 postcards

Special Collections: Margaret Bourke-White photographs; Clara Sipprell photographs

Major Holdings: WM–4P; WI–4P; I–4P; ETW–4P; WWI–4P; TW–4P; GD–4P; WWII–4P; P–4P; SA–4P; AL–4P; S–4P

U374. **NYSYS**$_g$

Syracuse University
Bird Library, Slide Collection
205A Bird Library
Syracuse, New York 13210
(315) 423-2916
Ramona Roters, Slide Curator

Hours: 8:30–5:00, M–F

Access: Restricted use

Reproduction Services: Slides (limited to faculty and graduate students)

Size of Collection: 1,163 photographs, 26,733 slides (American section only)

Special Collections: Arts of the United States by Pierson; photography from the George Eastman Collection; *Art Now* color slide series; subject collection

Major Holdings: AI–1S, 2S, 3S, 4S; AE–3S; C–1S, 3S; AR–3S; F–3S; W–3S; AJ–3S; WM–3S; MW–3S; CW–3S; WI–3S; I–3S; T–3S; ETW–3S, 4S; WWI–3S, 4S; TW–3S, 4S; GD–3S, 4S; WWII–1S, 3S, 4S; P–3S; SA–1S; M–3S; S–3S; E–1S, 3S, 4S

U375. **NYTRRC**

Rensselaer County Historical Society
59 Second Street
Troy, New York 12180
(518) 272-7232
Mrs. Frederick R. Walsh

Hours: 10:00–4:00, Tu–Sa

Access: Open to public, restricted use (research and reference collection only)

Reproduction Services: Photographic prints, photocopy

Size of Collection: 2,000 photographs, 2,000 negatives, 400 slides

Special Collections: Negatives and prints of many 19th c. buildings in the city of Troy, New York

Major Holdings: W–4P, 4S; AJ–3P, 3S, 4P, 4S; MW–4P; CW–1P, 3P, 4P, 4S; I–1P, 3P, 3S, 4P, 4S

U376. **NYTRRP**

Rensselaer Polytechnic Institute
Architecture Library
Greene Building
Troy, New York 12181
(518) 270-6465
Mrs. Virginia S. Bailey, Architecture Librarian

Hours: 8:30–10:00, M–Th; 8:30–6:00, F; 9:00–5:00, Sa; summers and vacations: 8:30–5:00, M–F

Access: Open to public, restricted use

Reproduction Services: None

Size of Collection: 8,240 slides

Major Holdings: AI–1S, 2S, 3S, 4S; C–1S, 2S, 3S, 4S; AR–1S, 2S, 3S, 4S; F–1S, 2S, 3S, 4S; W–2S, 3S; AJ–1S, 2S, 3S, 4S; WM–2S, 3S; MW–2S, 3S; CW–1S, 2S, 3S, 4S; WI–3S; I–1S, 2S, 3S, 4S; T–1S, 2S, 3S, 4S; ETW–1S, 2S, 3S, 4S; WWI–2S, 3S, 4S; TW–1S, 2S, 3S, 4S; GD–1S, 2S, 3S, 4S; WWII–1S, 2S, 3S, 4S; P–1S, 2S, 3S, 4S; SA–1S, 2S, 3S, 4S; AL–1S, 2S, 3S, 4S; M–1S, 3S, 4S; S–1S, 2S, 3S, 4S; E–1S, 3S, 4S

U377. **NYUTMV**

Mohawk Valley Museum
620 Memorial Parkway
Utica, New York 13501
(315) 724-2075
Dr. Eino Kivisalu, Director

Hours: 10:00–5:00 daily except M

Access: Open to public

Reproduction Services: None

Special Collections: Eight historical dioramas of the Mohawk Valley on display, owned by

the Oneida Historical Society in Utica, New York

U378. **NYUTMW**
Munson-Williams-Proctor Institute
310 Genesee Street
Utica, New York 13502
(315) 797-0000 ext. 23
Martha A. Maier, Librarian

Hours: 10:00–5:00, M–Sa
Access: Open to public
Reproduction Services: Photographic prints, color slides, large format color transparency (4x5), listings, fee schedule; copies of slides and photographs of works in the collections are available for sale, prices furnished on request
Size of Collection: 2,000 photographs, 15,000 slides

Major Holdings: C–3P; AR–3P, 4P; F–3P, 3S, 4P; W–3P; AJ–3P, 4P; MW–3P; CW–4P; I–4P, 4S; T–1S, 3P, 3S, 4P, 4S; ETW–3S, 4P; TW–3P, 3S, 4P; GD–3P, 3S; P–3P; AL–3P; E–3P

U379. **NYW**
American Life Foundation
 and Study Institute
Library
Irelandville
P.O. Box
Watkins Glen, New York 14891
(607) 535-4004 or 535-4737
John Crosby Freeman, Director

Access: Open by appointment, scholars and students only
Reproduction Services: None
Size of Collection: Photographs, slides, postcards
Special Collections: Very extensive collection of slides on art history, architecture, and landscaping

Major Holdings: C–1S; F–1S; WM–1S; CW–3P; ETW–1S

U380. **NYWEUX**
United States Military Academy, West Point
West Point Museum Collections
West Point Museum, USMA
West Point, New York 10996
(914) 938-2203
Richard E. Kuehne, Director

Reproduction Services: Photographic prints, color and black and white slides, large format color transparency (4x5), catalog available, fee schedule
Size of Collection: Photographs, negatives, slides
Special Collections: Alexander McCook Craghead Collection; Walter S. Sturgill Collection; William and Bernice C. Garbisch Collection; Alexander Robertson sketches; Peter Rindisbacher Collection; Jonas Lie Collection; Pretyman Collection; Madden Collection; Thomas Nast Drawings; E. Forbes prints

Major Holdings: AI–2P, 2S, 3P, 3S, 4P, 4S; AE–4P, 4S; C–4P; AR–3P, 3S, 4P, 4S; F–3P, 3S, 4P, 4S; W–3P, 3S, 4P, 4S; AJ–3P, 3S, 4P, 4S; WM–4P, 4S; MW–3P, 3S, 4P, 4S; CW–2P, 2S, 3P, 3S, 4P, 4S; WI–4P, 4S; I–3P, 3S, 4P, 4S; T–3P, 3S, 4P, 4S; ETW–3P, 3S, 4P, 4S; WWI–2P, 2S, 3P, 3S, 4P, 4S; TW–4P, 4S; GD–4P, 4S; WWII–2P, 2S, 3P, 3S, 4P, 4S; P–4P, 4S; SA–3P, 3S, 4P, 4S

U381. **NYWPCH**
The Center for Humanities, Inc.
2 Holland Avenue
White Plains, New York 10603
(914) 946-0601
Margaret Lloyd, Director, Special Markets

Access: Purchase only (can be ordered on approval), catalog available
Reproduction Services: None
Size of Collection: 2 sound-slide programs
Special Collections: Two programs available, *American Civilization 1873–1876* and *Paintings about America 1650–1969*

Major Holdings: AR–3S; F–3S; W–3S; AJ–3S; WM–3S; MW–3S; CW–3S; WI–3S; I–1S, 3S; T–3S; WWII–3S; P–3S; SA–3S

U382. **NYYOHR**
The Hudson River Museum
511 Warburton Avenue
Yonkers, New York
(212) 963-4550
Donald M. Halley, Jr., Director
John Zukowsky, Archivist

Access: Open to public, open by appointment, restricted use (stored collection may be seen by qualified researchers by appointment only)
Reproduction Services: Photographic prints, photocopy, color slides, large format color transparency (4x5), fee schedule
Size of Collection: 400 photographs, 1,000 negatives (glass plates), 200 slides (glass), 2,000 postcards, 50 posters
Special Collections: Archive of Westchester County architecture; color slides and photographs of significant buildings

Major Holdings: AI–4P, 4S; C–1P, 1S; AR–1P, 1S; F–1P, 1S; AJ–1P, 1S; CW–1P, 1S, 2P, 3P, 3S, 4P, 4S; I–1P, 1S, 3P, 3S, 4P, 4S; T–1P, 1S, 2P, 2S, 4P, 4S; ETW–1P, 1S, 2P, 2S, 4P, 4S; TW–4P, 4S

NORTH CAROLINA

U383. **NCCHUN**
University of North Carolina at Chapel Hill
Slide and Photo Collection
 of the Department of Art
Ackland Art Center
Chapel Hill, North Carolina 27514 *[cont.]*

(919) 933-3034
Cecil Gayle, Curator

Hours: 8:30—5:00, M—F
Access: Restricted use, scholars and students
Reproduction Services: None
Size of Collection: 30,000 photographs, 100,000 slides, 1,000 postcards, 200 posters

Major Holdings: AI—1S, 2S, 3S, 4S; C—1P, 1S, 2S, 3S, 4S; AR—2P, 3P, 3S, 4P, 4S; F—1P, 2P, 2S, 3S, 4S; W—3S, 4S; AJ—3S, 4S; WM—2S, 3S, 4S; MW—3S; CW—1P, 3S; WI—3S; I—1S, 2S, 3S, 4S; T—3P, 3S, 4S; ETW—1P, 1S, 2S, 3P, 3S, 4S; WWI—1S, 2S, 3S, 4S; TW—1P, 1S, 2P, 2S, 3P, 3S, 4S; GD—3S, 4S; WWII—1S, 2S, 3S, 4S; P—1P, 1S, 2P, 2S, 3P, 3S, 4S; SA—1S; AL—3S; M—3S; S—3S; E—3S, 4S

U384. **NCCUMC**

Moores Creek National Military Park
Park Library
Box 69
Currie, North Carolina 28435
(919) 283-5591
Raymond L. Ives, Superintendent

Hours: 8:00—5:00, M—F
Access: Open to public, by appointment, restricted use
Reproduction Services: None
Size of Collection: 200 photographs, 200 negatives, 50 slides, 6 postcards

U385. **NCGRGC**

Guilford Courthouse National Military Park
Box 9334, Plaza Station
Greensboro, North Carolina 27408
(919) 288-1776
Superintendent

Hours: 8:30—5:00 daily
Access: Limited public use
Reproduction Services: None
Size of Collection: 100 photographs, 100 slides, postcards for sale to public
Special Collections: Photographs and slides of military equipment; firearms and paintings in park's collection

Major Holdings: AR—3P, 3S, 4P, 4S

U386. **NCHPHP**

High Point Museum
1805 E. Lexington Avenue
High Point, North Carolina 27262
(919) 885-6859
John S. Bauckman, Director

Access: Open to public by appointment, restricted use, scholars and students
Reproduction Services: Photocopy
Size of Collection: 3,000 photographs, slides, postcards
Special Collections: Largest tool collection in the world

Major Holdings: AI—4; C—4; AR—4; F—4; CW—4; T—4; ETW—4; WWI—4; WWII—4

U387. **NCKMKM**

Kings Mountain National Military Park
P.O. Box 31
Kings Mountain, North Carolina 28086
(803) 936-7508

Hours: 8:30—5:00, M—Sa
Access: Open to public
Reproduction Services: None
Size of Collection: Photographs, negatives, slides, postcards

U388. **NCRANC**

North Carolina Museum of Art
North Carolina Museum of Art Library
107 E. Morgan Street
Raleigh North Carolina
(919) 829-7568
Cheryl Warren, Art Reference Librarian

Hours: 10:00—5:00, M—F
Access: Open to public
Reproduction Services: Photographic prints, photocopy, color slides, large color transparencies (4x5), listings
Size of Collection: 2,000 photographs, 8,425 negatives, 1,500 slides, 500 postcards
Special Collections: Photographs, slides and negatives are of museum holdings

Major Holdings: AI—3P, 3S; AE—3P, 3S; C—2P, 2S; AR—3P, 3S; F—3P, 3S; W—3P, 3S; AJ—2P, 2S, 3P, 3S, 4P, 4S; WM—3P, 3S, 4P, 4S; CW—2P, 2S, 3P, 3S; WI—3P, 3S; I—3P, 3S; T—3P, 3S; ETW—3P, 3S; P—3P, 3S; AL—3P, 3S; M—3P, 3S; E—3P, 3S

U389. **NCRASU**

North Carolina State University
Harry Lyons Design Library
209 Brooke Hall
Raleigh, North Carolina 27607
(919) 737-2207
Mrs. Helen Zschau, Librarian

Hours: 8:30—9:30, M—Th; 8:30—5:00, F; 9:00—1:00, Sa; 1:00—5:00, Su
Access: Open to public
Reproduction Services: None
Size of Collection: 4,765 slides
Special Collections: Janson's *History of Art*; Weisse Collection; history of photography; environmental communications; architecture without architects; synthetic color; planned unit development; history of the modern movement

Major Holdings: C—1S; AR—1S; F—1S; W—1S; AJ—1S, 3S; CW—1S, 3S; I—1S; T—1S, 3S, 4S; ETW—1S, 3S; WWI—1S; TW—1S; WWII—1S, 2S; P—1S, 2S,3S; SA—1S, 2S, 3S, 4S

U390. **NCWSME**

Museum of Early Southern
 Decorative Arts
CESDA (Catalog of Early Southern
 Decorative Arts)

Drawer F, Salem Station
Winston-Salem, North Carolina 27108
(919) 722-6148
Frank L. Horton, Director

Hours: 9:00–5:00, M–F
Access: Open to public, restricted, appointments recommended
Reproduction Services: For items in the museum collection only, photographic prints, color slides
Size of Collection: Photographs, negatives, slides
Special Collections: Decorative arts from 1600s–1820 from Maryland, Virginia, North and South Carolina, Georgia, Tennessee, and Kentucky
Major Holdings: C–3P, 3S, 4P, 4S; AR–3P, 3S, 4P, 4S; F–3P, 3S, 4P, 4S; W–3P, 3S, 4P, 4S

NORTH DAKOTA

U391. **NDFASU**

North Dakota State University
North Dakota State University Library
Fargo, North Dakota 58102
Michael M. Miller

Hours: 8:00–12:00, M–Th; 8:00–5:00, F; 9:00–5:00, Sa; 2:00–12:00, Su
Access: Open to public
Reproduction Services: Photographic prints, photocopy, color slides, black and white slides
Size of Collection: 8,000 slides, 150 posters, filmstrips, videotape
Special Collections: North Dakota Institute for Regional Studies: excellent collection of photographs, prints, slides on North Dakota Red River Valley and agriculture; Herbst costume doll collection (100 dolls representing the United States); 16th–20th c. costumes, furniture, and interiors
Major Holdings: AI–1S, 4P, 4S; AE–4P; C–1S, 4P, 4S; AR–1S, 4P, 4S; F–1S, 4P, 4S; W–4P; AJ–1S, 4P, 4S; WM–1S, 4P, 4S; CW–1S, 4P, 4S; I–1S, 4P, 4S; T–1S, 2S, 4P, 4S; ETW–1S, 2S, 4P, 4S; WWI–1S, 4P, 4S; TW–1S, 2S, 4P, 4S; GD–1S, 4P, 4S; WWII–1S, 4P, 4S; P–1S, 4P, 4S; SA–1S, 4S; AL–1S

OHIO

U392. **OHAKAA**

Akron Art Institute
69 E. Market Street
Akron, Ohio 44308
(216) 376-9185
Marjorie Harvey,
 Librarian/Registrar

Hours: 9:00–5:00, M–F
Access: Open to public

Reproduction Services: Photocopy
Size of Collection: 5,000 negatives, videotapes
Special Collections: 20th c. art

U393. **OHBUGC**

Geauga County Historical Society–
 Century Village
Box 153
Burton, Ohio 44021
(216) 834-4012
B. J. Shanower, President

Hours: Open by appointment
Reproduction Services: Unspecified
Size of Collection: 200 photographs, 250 slides, 10 postcards
Major Holdings: F–1S; W–1S; AJ–1S; AL–4P, 4S

U394. **OHCFEA**

Educational Art Transparencies
Richard N. Campen Architectural Collection
27 Summit Street
Chagrin Falls, Ohio 44022
(216) 247-4323
Richard N. Campen,
 Author/Photographer/Proprieter

Access: Purchase only
Reproduction Services: Color slides, catalog available
Size of Collection: 5,000 slides
Major Holdings: C–1S; F–1S; AJ–1S; CW–1S; I–1S; T–1S; ETW–1S; WWI–1S; TW–1S; GD–1S; WWII–1S; P–1S

U395. **OHCHMC**

Mound City Group National Monument
P.O. Box 327
Chillicothe, Ohio 45601
(614) 774-1125
William C. Birdsell, General Superintendent

Hours: 8:00–5:00, M–F
Access: Open to public, open by appointment
Reproduction Services: 3,000 photographs, 3,000 negatives, 1,500 slides, 12 postcards
Size of Collection: Slides and photographs of prehistoric Hopewell people and their artwork; archaeological investigations conducted at this site during recent decades
Major Holdings: AI–1P,1S,2P,2S,4P,4S

U396. **OHCIPL**

Public Library of Cincinnati
 and Hamilton County
Films and Recordings Department
800 Vine Street
Cincinnati, Ohio 45202
(513) 369-6924
Janie L. Pyle, Head

Hours: 9:00–9:00, M–F; 9:00–6:00, Sa
Access: Open to public, 16mm film borrowers must be registered with the department, out of county residents must have fee card
[*cont.*]

Reproduction Services: None

Size of Collection: 16,061 slides, 2,195 films (1,642 titles), 591 8mm films, 1,280 filmstrips, 21,383 records, 1,429 cassettes

Special Collections: 35mm slides illustrating Cincinnati history; 16mm films on the American Indian, Colonial period, and postwar America; filmstrips on the American Indian, Colonial period, American Revolution, Federal period and postwar America

Major Holdings: AI–4S; C–1S,4S; AR–1; F–1; TW–1S; GD–1S; P–1S,3S,4S

U397. **OHCLCI**

Cleveland Institute of Art
Media Center, Jessica Gund Memorial Library
11141 East Blvd.
Cleveland, Ohio
(216) 421-4322
Vivien Abrams, Director, Media Center
Karen Tschudy, Head Librarian

Access: Open by appointment, restricted use, scholars only

Size of Collection: 30,000 slides

Special Collections: Postwar painting and drafts; arts and crafts movement, 1890–1918 (slides)

Major Holdings: AI–4S; C–1S, 2S, 3S, 4S; AR–1S, 2S, 3S, 4S; F–1S, 3S, 4S; W–1S; AJ–1S, 2S, 3S, 4S; CW–1S, 2S, 3S, 4S; I–1S, 2S, 3S, 4S; T–3S, 4S; ETW–1S, 3S, 4S; WWI–3S, 4S; TW–1S, 3S, 4S; GD–1S, 3S, 4S; WWII–2S, 3S; P–1S, 2S, 3S, 4S; SA–1S, 2S, 3S

U398. **OHCLCM**

The Cleveland Museum of Art
Photograph and Slide Library
11150 East Blvd.
Cleveland, Ohio 44106
(216) 421-7340
Stanley W. Hess, Associate Librarian
for Photographs and Slides

Hours: (Slide Library, rental collection) 10:00–5:30, Tu–F; September–May, 9:00–4:30, Sa; (Photograph Library) 10:00–5:30, Tu–F

Access: (Slide Library, rental collection) Circulation limited to greater Cleveland area; (Photograph Library) Nonlending collection for research on premises only

Reproduction Services: Photographic prints, color slides, 8x10 color transparency for rental only; catalog available of museum collection; listings for commercial slides; handbook bulletin

Size of Collection: 5,000 photographs, negatives, 14,000 slides (155,000 total), 5,000 postcards (43,000 total), 4 microfilms

Special Collections: Slides of Ohio-Cleveland area, regional art and architecture; Cleveland Museum of Art collection; photographs of painting, architecture and sculpture, Cleve-

land Museum of Art collection; Ohio-Cleveland area regional art and architecture (photographs)

Major Holdings: AI–2P, 2S, 3P, 3S, 4P, 4S; C–1P, 1S, 2P, 2S, 3P, 3S, 4P, 4S; AR–1P, 1S, 3P, 3S, 4P, 4S; F–1P, 1S, 2P, 2S, 3P, 3S, 4P, 4S; AJ–1P, 1S, 3P, 3S; WM–3P, 3S; CW–1P, 1S, 3P, 3S; I–1P, 1S, 2P, 2S, 3P, 3S; ETW–1P, 1S, 2P, 2S, 3P, 3S, 4P, 4S; WWI–1P, 1S, 2P, 2S, 3P, 3S, 4P, 4S; WWII–1P, 1S, 2P, 2S, 3P, 3S, 4P, 4S; P–1P, 1S, 3P, 3S; AL–3P; S–3P; E–3P

U399. **OHCOOS**

Ohio State University
Slide Room,
 Division of the History of Art Department
College of the Arts
246 Hopkins Hall
128 North Oval Drive
Columbus, Ohio 43210
(614) 422-8591
Sarah Englehart Evans,
 Curator, Slides and Prints

Hours: 8:00–5:00, M–F

Access: Open to public on a limited basis, restricted use, scholars and graduate students only, items may be borrowed for teaching purposes only

Reproduction Services: None

Major Holdings: AI–1P, 1S, 2P, 2S, 4P, 4S; C–1P, 1S, 3P, 3S, 4P, 4S; AR–1P, 1S, 2P, 2S, 3P, 3S, 4P, 4S; F–1P, 1S, 2P, 2S, 3P, 3S, 4P, 4S; W–1P, 1S, 2P, 2S, 3P, 3S, 4P, 4S; AJ–1P, 1S, 2P, 2S, 3P, 3S, 4P, 4S; WM–2P, 2S, 3P, 3S; CW–1P, 1S, 2P, 2S, 3P, 3S, 4P, 4S; WI–3P, 3S, 4S; T–1P, 1S, 2P, 2S, 3P, 3S; ETW–1P, 1S, 2P, 2S, 3P, 3S; WWI–2P, 2S, 3P, 3S; TW–2P, 2S, 3P, 3S; GD–2P, 2S, 3P, 3S; WWII–2P, 2S, 3P, 3S; P–2P, 2S, 3P, 3S; AL–2P, 2S, 3P, 3S; M–3P, 3S

U400. **OHLIAC**

Allen County Historical Society
620 W. Market Street
Lima, Ohio 45801
(419) 222-9426
Joseph Dunlap, Curator

Hours: 1:30–5:00, Tu-Su

Access: Open to public, restricted use to scholars only

Size of Collection: 1,000 photographs, 200 negatives, 100 slides, 200 postcards

Special Collections: Builders' photographs of most locomotives made at Lima Locomotive Works

Major Holdings: CW–1P; I–1P, 4P; T–1P, 2P, 3P, 4P; ETW–4P; WWI–4P; TW–4P; GD–4P; WWII–4P; AL–1P, 4P; E–1P

U401. **OHMPHC**

Mt. Pleasant Historical Center
Mt. Pleasant, Ohio 43939 [*cont.*]

Rev. Lloyd Smith

Special Collections: Some photographs of places and early people of the area

U402. **OHSPCC**
Clark County Historical Society
300 W. Main Street
Springfield, Ohio 45504
(513) 324-0657
George H. Berkhofer,
 Executive Director and Curator

Hours: 9:00–12:00, 1:00–4:00, M-Tu; 9:00–4:00, W; 9:00–12:00, 1:00–4:00, Th; 9:00–12:00, Sa; 2:00–4:30, 2nd and 4th Su
Access: Open to public
Reproduction Services: No staff, must hire outside agency
Special Collections: Relics and art of historical value which have a close connection with Springfield and Clark County; oil paintings of and by Springfield artists
Major Holdings: AI–3P, 4P

U403. **OHYOBI**
The Butler Institute of American Art
524 Wick Avenue
Youngstown, Ohio 44502
(216) 743-1711
Clyde Singer, Associate Director

Access: Restricted use, purchase only
Reproduction Services: Photographic prints; color slides; 4x5, 5x7, 8x10 color transparencies; catalog available, listings
Size of Collection: 1,000 photographs, 1,000 negatives, 500 slides, 14 postcards

Major Holdings: AI–3P, 3S; C–3P; AR–3P; F–3P; WM–3P; CW–3P; T–3P; ETW–3P; M–3P

OKLAHOMA

U404. **OKBPL**
Bartlesville Public Library
History Room
6th and Johnstone
Bartlesville, Oklahoma 74003
(918) 336-2220
Ruby Cranor, Curator

Hours: 9:00–5:00, M–F
Access: Open to public
Reproduction Services: Photocopy
Size of Collection: Photographs
Special Collections: Historical Delaware Indian photographs; photographs of Washington County; Oklahoma history; manuscripts

Major Holdings: AI–1P

U405. **OKBWM**
Woolaroc Museum
Route 3
Bartlesville, Oklahoma 74003

(918) 336-6747
Robert R. Lansdown, Director

Access: Open by appointment; purchase or loan
Reproduction Services: Photographic prints, color slides, large format color transparencies (2¼x2¼, 4x5), listings
Size of Collection: 100 photographs, 200 negatives, 200 slides, 25 postcards, 4 prints
Major Holdings: AI–2P, 2S, 3P, 3S, 4S; WM–2P, 2S, 3P, 3S

U406. **OKDUSC**
Stephens County Historical Museum
916 Main
Duncan, Oklahoma 73533
(405) 255-0970
Mrs. George E. Jenkins

Hours: 2:00–5:00, Tu, Th, Sa
Access: Open to public
Reproduction Services: None
Size of Collection: 150 photographs, 150 negatives
Special Collections: Photographs of Halliburton Cementing Co. (oil wells)

U407. **OKNOU**₈
University of Oklahoma, School of Art
Slide Library
520 Parrington Oval, Room 202
Norman, Oklahoma 73069
(405) 325-5048
Nancy L. Kelker, Curator

Hours: 8:00–12:00, M–F
Access: Open by appointment, restricted use, students, will lend to area schools and other university faculty
Reproduction Services: Photographic prints (black and white), color slides, black and white slides, prints $2.00 each, bound slides 70 cents each, reproductions limited to educational use of university faculty
Size of Collection: 9,500 slides
Special Collections: Building collection of American photography from early daguerreotypes through early 20th c.

Major Holdings: AI–1S, 2S, 3S, 4S; AE–1S; C–1S, 2S, 3S, 4S; AR–1S, 2S, 3S, 4S; F–1S, 2S, 3S, 4S; W–1S, 2S, 3S, 4S; AJ–1S, 2S, 3S, 4S; WM–1S, 2S, 3S, 4S; MW–1S, 2S, 3S, 4S; CW–1S, 2S, 3S, 4S; I–1S, 3S; T–1S, 3S, 4S; ETW–1S, 2S, 3S, 4S; WWI–1S, 2S, 3S, 4S; TW–1S, 2S, 3S, 4S; GD–1S, 3S, 4S; WWII–1S, 3S, 4S; SA–1S, 3S, 4S

U408. **OKNOUM**
University of Oklahoma, Museum of Art
Museum of Art Permanent Collection
410 W. Boyd Street
Norman, Oklahoma 73069 [*cont.*]

(405) 325-3272

Sam Olkinetzky, Director

Hours: 10:00–4:00, Tu–F; 10:00–1:00, Sa; 1:00–4:00, Su

Access: Open by appointment, restricted use, scholars, students, purchase only (in stock 2x2 color slides, 50¢; postcards, 10¢)

Reproduction Services: Photographic prints, color slides, fee schedule (2x2 color slides, $2.50; 8x10 black and white prints, $5.00)

Major Holdings: AI–3P, 3S; P–2P, 2S, 3P, 3S

U409. **OKPCCC**

Ponca City Cultural Center
and Indian Museum
1000 E. Grand
Ponca City, Oklahoma 74601
(405) 762-6123
Delia F. Castor, Curator

Hours: 10:00–5:00, M, W–Sa; 1:00–5:00, Su, holidays

Access: Open to public

Reproduction Services: Photographic prints

Size of Collection: 200,000 negatives, 50 slides

Special Collections: Matzene Collection of old Chinese art; paintings of American and Indian artists; fingerweaving; Navajo weaving; Indian paintings; Indian clothing; arrowheads; kachinas; tools; Ray Falconer collection of old glass negatives and photographs

Major Holdings: AI–1P; AE–1P; ETW–1P

U410. **OKTACH**

Cherokee National Historical Society, Inc.
Cherokee National Archives and Library
(temporary facility)
P.O. Box 515, TSA–LA–GI
Tahlequah, Oklahoma 74464
(918) 456-6007
M.A. Hagerstrand, Executive Vice-President

Hours: 8:00–4:30, M–F

Access: Open by appointment

Reproduction Services: Photocopy, microfilm

Size of Collection: 1,000+ photographs, 100 negatives, 1,500+ slides, 8 postcards

Special Collections: Cherokee Indian history and culture

Major Holdings: AI–1P, 1S, 2P, 2S, 3P, 3S, 4P, 4S

U411. **OKTUJC**

Tulsa Junior College
Learning Resources Center
10th and Boston
Tulsa, Oklahoma 74119
Shirley Smith

Access: Students may use

Reproduction Services: None

Size of Collection: 4,000 slides

Special Collections: Small collection of history of art and survey of art history slides

OREGON

U412. **OREUO**

University of Oregon
Special Collections Division, Library
Eugene, Oregon 97403
(503) 686-3069
Martin Schmitt, Curator, Special Collections

Hours: 10:00–12:00, 1:00–5:00

Access: Open to public

Reproduction Services: Photographic prints, photocopy, microfilm, color and black and white slides

Size of Collection: 2,000 photographs, 100,000 negatives, 2,000 posters

Special Collections: Original art by illustrators of magazines and books about 1925–1970; drawings and plans of architects of the United States, particularly the Pacific Northwest

Major Holdings: AI–4P; WI–1P, 4P; I–1P, 4P; T–1P, 4P; ETW–1P, 4P; WWI–1P, 4P; TW–1P, 4P; GD–1P, 4P; AL–1P, 4P

U413. **OREUO**~s~

University of Oregon Slide Library
School of Architecture and Allied Arts
Architecture and Allied Arts Library
Eugene, Oregon 97403
(503) 686-3052
Gail Burkhart, Slide Librarian

Hours: 8:00–4:00, M–F

Access: Scholars only, students with special permission

Reproduction Services: Available through Photographic Service, University of Oregon main library

Size of Collection: 21,122 photographs, 200,000 slides

Special Collections: Indian Art

Major Holdings: AI–1S, 2P, 2S, 3P, 3S, 4P, 4S; AE–2S; C–1P, 1S, 2S, 3S, 4S; AR–1P, 1S, 3S, 4S; F–1P, 1S, 3S, 4S; W–1P, 1S, 3S, 4S; AJ–1P, 1S, 3S, 4S; WM–1P, 1S, 3S, 4S; MW–1P, 1S, 3S, 4S; CW–1P, 1S, 3S, 4S; WI–1P, 1S, 3S, 4S; I–1P, 1S, 3S, 4S; T–1P, 1S, 2P, 3P, 3S, 4S; ETW–1P, 1S, 2P, 2S, 3P, 3S, 4S; WWI–1P, 1S, 2P, 2S, 3P, 3S, 4S; TW–1P, 1S, 2P, 2S, 3P, 3S, 4S; GD–1P, 1S, 2P, 2S, 3P, 3S, 4S; WWII–1P, 1S, 2P, 2S, 3P, 3S, 4S; P–1P, 1S, 2P, 2S, 3P, 3S, 4S

U414. **ORKFCP**

Collier State Park Logging Museum
P.O. Box 428
Klamath Falls, Oregon 97601
(503) 884-5145
Alfred D. Collier, Curator

Access: Restricted use

Reproduction Services: Photographic prints, black and white slides, fee schedule

Size of Collection: 1,000 photographs, 1,000 nega-

tives, 250 slides, 12 sets of 4,000 postcards, 500 catalogs

Special Collections: Indian stone cooking and grinding utensils; turn of century and 1920s logging equipment; wood canoe; pictures of WWI

U415. ORPAM

Portland Art Museum/Museum Art School
Portland Art Museum Slide Library
S.W. Park and Madison
Portland, Oregon 97401
(503) 226-2811
James H. Hicks, Slide Librarian

Hours: 3:00–6:00, M; 9:00–1:00, 3:00–6:00, Tu–F; 12:00–3:00, Sa
Access: Restricted use, students
Reproduction Services: Color and black and white slides, fee schedule
Size of Collection: 1,000 photographs, 30,000 slides

Major Holdings: AI–2S, 3S; C–1S, 2S, 3S; AR–1S, 2S, 3S; F–1S, 2S, 3S; W–1S, 2S, 3S; AJ–1S, 2S, 3S; WM–1S, 2S, 3S; MW–1S, 2S, 3S; CW–1S, 2S, 3S; WI–1S, 2S, 3S; I–1S, 2S, 3S; T–1S, 2S, 3S; ETW–1S, 2S, 3S; WWI–1S, 2S, 3S; TW–1S, 2S, 3S; GD–1S, 2S, 3S; P–1S, 2S, 3S

PENNSYLVANIA

U416. PAALAM

Allentown Art Museum
Box 117
Allentown, Pennsylvania
(215) 432-4333
Richard N. Gregg

Hours: 11:00–5:00, Tu–Sa
Access: Open by appointment, students
Reproduction Services: Color slides, listings, fee schedule
Size of Collection: 50 photographs, 20 slides, 6 postcards
Special Collections: Pennsylvania quilts and folk art ca. 1828–1850

Major Holdings: ETW–1P

U417. PABMC

Bryn Mawr College
Department of History of Art
Thomas Library
Bryn Mawr, Pennsylvania 19010
(215) LA5-1000, ext. 250
Mrs. Carol W. Carpenter,
 Curator of Slides and Photographs

Hours: 9:30–5:30, M–F
Access: Restricted use, scholars (outside, with credentials), departmental students
Reproduction Services: Photographic prints (photography studio available), color and black and white slides

Size of Collection: (Art and archaeology) 1,500 photographs, 2,000 lantern slides, 4,500 35mm slides

Major Holdings: C–1P, 1S, 2P, 2S, 3P, 3S; AR–1P, 1S, 2P, 2S, 3P, 3S; F–1P, 1S, 2P, 2S, 3P, 3S; W–1P, 1S, 2P, 2S, 3P, 3S; AJ–1P, 1S, 2P, 2S, 3P, 3S; WM–1P, 1S, 2P, 2S, 3P, 3S; MW–1P, 1S, 2P, 2S, 3P, 3S; CW–1P, 1S, 2P, 2S, 3P, 3S; WI–1P, 1S, 2P, 2S, 3P, 3S; I–1P, 1S, 2P, 2S, 3P, 3S, 4S; T–1P, 1S, 2P, 2S, 3P, 3S, 4P; ETW–1P, 1S, 2P, 2S, 3P, 3S, 4S; WWI–1P, 1S, 2P, 2S, 3P, 3S, 4S; TW–1P, 1S, 2P, 2S, 3P, 3S, 4S; GD–1P, 1S, 2P, 2S, 3P, 3S, 4S; WWII–1P, 1S, 2P, 2S, 3P, 3S, 4S; P–1P, 1S, 2P, 2S, 3P, 3S, 4S

U418. PACHBR

Brandywine River Museum
P.O. Box 141
Chadds Ford, Pennsylvania 19317
(215) 388-7601
Mrs. Anne E. Mayer, Curator

Hours: 9:30–4:30 daily
Access: Museum open to public, library and reproduction files by appointment only
Reproduction Services: Photographic prints, photocopy, color slides, 4x5 and 8x10 color transparencies, listings, fee schedule
Size of Collection: 500 photographs, 500 negatives, 500 slides, 500 posters, films
Special Collections: Photographic collections feature the illustrations of Howard Pyle and his students, N. C. Wyeth, E. E. Schoonover, Stanley Arthurs, Clifford Ashley, Harvey Dunn, and Maxfield Parrish; the collection also includes significant works by Andrew Wyeth, James Wyeth, John McCoy, Carolyn Wyeth, Henriette Wyeth, and Peter Hurd

Major Holdings: AI–3P, 3S: C–3P, 3S; AR–3P, 3S; WM–3P, 3S; CW–3P, 3S; ETW–3P, 3S; WWI–3P, 3S; TW–3P, 3S; GD–3P, 3S; WWII–3P, 3S; P–3P, 3S; AL–3P, 3S; M–3P, 3S

U419. PACLSC

Clarion State College
Art Department
Clarion, Pennsylvania 16214
(814) 226-600, ext. 379
Dr. Robert Hobbs, Chairperson

Hours: 8:00–5:00 weekly
Access: Restricted use
Size of Collection: 500 photographs, 15,000 slides, 100 posters, 200 films, 150 filmstrips

Major Holdings: AI–2S, 3S, 4S; C–1S, 2S, 3S, 4S; AR–1S, 2S, 3S, 4S; F–1S, 2S, 3S, 4S; WM–3S; ETW–1S, 2S, 3S; WWI–2S, 3P, 3S; TW–1S, 2S, 3P, 3S, 4S; GD–3S; WWII–2S, 3S, 4S; P–1P, 1S, 2P, 2S, 3P, 3S, 4P, 4S

U420. PACOUC

Ursinus College
Myrin Library
Collegeville, Pennsylvania 19426 [cont.]

(215) 489-4111, ext. 283

Anne Pilgrim, Assistant Reference Librarian

Hours: 8:00–11:00, M–Th; 8:00–10:00, F; 9:00–5:00, Sa; 2:00–11:00, Su; summer: 9:00–4:00, M–F

Access: Open to public

Size of Collection: 5,500 slides

Special Collections: Black studies resources, 465 slides (Educational Resources, Inc.)

Major Holdings: C–4S; F–4S; AJ–3S, 4S; WI–4S; I–3S, 4S; T–1S, 3S; ETW–3S; TW–3S, 4S; GD–1S, 3S, 4S; P–1S, 2S, 3S, 4S

U421. PAEPTU

Temple University

Tyler School of Art

Beech and Penrose Avenues

Elkins Park, Pennsylvania 19117

(215) CA4-7575, ext. 247

Barbara Ianacone, Slide Curator

Hours: 8:15–4:15, M–F

Access: Restricted use

Reproduction Services: Color and black and white slides

Size of Collection: 80,000 slides

Major Holdings: AI–1S, 2S, 3S, 4S; AE–1S, 2S, 3S, 4S; C–1S, 2S, 3S, 4S; AR–1S, 2S, 3S, 4S; F–1S, 2S, 3S, 4S; W–1S, 2S, 3S, 4S; AJ–1S, 2S, 3S, 4S; WM–1S, 2S, 3S, 4S; MW–1S, 2S, 3S, 4S; CW–1S, 2S, 3S, 4S; WI–1S, 2S, 3S, 4S; I–1S, 2S, 3S, 4S; T–1S, 2S, 3S, 4S; ETW–1S, 2S, 3S, 4S; WWI–1S, 2S, 3S, 4S; TW–1S, 2S, 3S, 4S; GD–1S, 2S, 3S, 4S; WWII–1S, 2S, 3S, 4S; P–1S, 2S, 3S, 4S

U422. PAFAFN

Fort Necessity National Battlefield

Route 1, Box 360

Farmington, Pennsylvania 15437

(412) 329-5512

Superintendent

Access: Open by appointment

Size of Collection: 250 photographs, 150 negatives, 500 slides, 100 postcards

Major Holdings: C–1P, 1S; I–3P

U423. PAGRWC

Westmoreland County Museum of Art

Art Reference Library

221 N. Main Street

Greensburg, Pennsylvania 15601

(412) 837-1500

Mrs. Jean K. Maguire, Registrar/Librarian

Access: Open to public, open by appointment

Reproduction Services: Photographic prints, color slides (special request), catalog available sometime in 1976–77

Size of Collection: 1,000 photographs, 500 slides, 25 postcards

Special Collections: Photographs and/or slides of extensive toy collection may be available in 2–3 years

Major Holdings: AR–3P, 3S; F–3P, 3S, 4P, 4S; CW–3P, 3S, 4P, 4S; I–3P, 3S, 4P, 4S; T–4P, 4S; ETW–2P, 2S, 3P, 3S, 4P, 4S; WWI–4P, 4S; TW–2P, 2S, 3P, 3S, 4P, 4S; GD–3P, 3S, 4P, 4S; P–3P, 3S

U424. PAHAPM

William Penn Memorial Museum

3rd and North Streets

Harrisburg, Pennsylvania 17120

(717) 787-4978

Terry Musgrave, Photographer

Hours: 9:00–5:00 daily; 1:00–5:00, Su

Access: Open by appointment, purchase only

Reproduction Services: Photographic prints, photocopy, color and black and white slides, 4x5 color transparencies, 8x10 black and white at $1.00 each, 5x7 at 75¢, negatives at 50¢

Size of Collection: 500 Photographs, 500 negatives, 1,000 slides

Special Collections: Pennsylvania archaeology, history, decorative arts; slides and photographs of the extensive collections can be made on request

U425. PAHARH

Pennsylvania Historical and Museum Commission

Archives Division

P.O. Box 1026

Harrisburg, Pennsylvania 17120

(717) 787-3051

Hours: 9:00–5:00, M–F (except certain holidays)

Access: Open to public

Reproduction Services: Photographic prints, photocopy, color and black and white slides, fee schedule

Size of Collection: Photographs, negatives, slides

Special Collections: Photographs of railroad locomotives

Major Holdings: CW–4P; WI–4P; I–4P; T–4P; ETW–4P; WWI–4P; TW–4P; GD–1P, 4P; P–1P

U426. PAHAVC

Haverford College Library

James P. Magill Library

Haverford, Pennsylvania 19041

(215) MI9-9600

Edwin B. Bronner, Librarian

Hours: 9:00–5:00, M–F (closed for noon lunch hour)

Access: Open to public

Reproduction Services: Photographic prints

Size of Collection: 1,000 photographs, 200 postcards

Special Collections: Photographs and drawings of Quakers and of Quaker meetinghouses

U427. PAHUSM

Swigart Museum [*cont.*]

Swigart Museum Library
Museum Park, Box 214
Huntingdon, Pennsylvania 16652
(814)643-3000
William E. Swigart, Jr., Owner

Access: Open by appointment, restricted use
Reproduction Services: Photocopy
Size of Collection: Photographs, postcards, films
Special Collections: Manuals, sales material, automobiliana, printed material of all descriptions

Major Holdings: I–4P; T–4P; ETW–4P; WWI–4P; TW–4P; GD–4P; WWII–4P; P–4P

U428. **PAKSLG**

Longwood Gardens, Inc.
Sales-Information Center
Kennett Square, Pennsylvania 19348
(215) 388-6741
Photographer

Hours: 9:00–6:00, daily (Gardens); film shown hourly 10:00–3:00, M–Sa
Access: Open to public, slides and postcards for purchase
Size of Collection: 40 slides, 30 postcards, 2 films (films rented at $20.00, slides on loan free to groups and organizations)

U429. **PALDFS**

Pennsylvania Dutch Folk Culture Society, Inc.
Pennsylvania Dutch Folklife Museum
Lenhartsville, Pennsylvania 19534
(215) 562-8701 or 562-4803
Florence Baver, President

Hours: June-August, 10:00–5:00
Access: Open to public, or open by appointment
Reproduction Services: Color slides
Size of Collection: 50 slides, postcards
Special Collections: Folk art as practiced among the early Pennsylvania Germans; publications "News and Views in the Gay Dutch Country" available to libraries upon request

Major Holdings: ETW–1S, 4S; AL–1S, 4S

U430. **PALUCB**

Union County Bicentennial
Oral Traditions/Folk Culture Project
Union County Court House
Lewisburg, Pennsylvania 17837
(215) 524-4461, ext. 56
Jeannette Lasansky

Access: Open by appointment, scholars, students
Reproduction Services: Photographic prints, color and black and white slides
Size of Collection: Photographs, negatives, 1,400 slides, oral tapes that complement visual material, multimedia shows in process
Special Collections: Quilts and coverlets, local central Pennsylvania and Kentucky rifles, Indian artifacts, tinsmith and blacksmith products, local pottery

Major Holdings: F–4P, 4S; W–4P, 4S; AJ–4P, 4S; WM–4P, 4S; MW–4P, 4S; CW–4P, 4S; WI–4P, 4S; I–4P, 4S; T–4P, 4S; AL–4P, 4S

U431. **PAPHAM**

American Philosophical Society
Library
105 S. 5th Street
Philadelphia, Pennsylvania 19106
(215) 925-9545
Whitfield J. Bell, Librarian

Hours: 9:00–5:00
Access: Exhibits open to public, library open to scholars and students
Reproduction Services: Photographic prints, photocopy, microfilm, 8x10 black and white prints, fee schedule
Size of Collection: 1,000 photographs, 600 negatives, 100 slides
Special Collections: Photographs, slides and negatives pertaining to the American Philosophical Society membership and collection; printed catalog available

U432. **PAPHAT**

Athenaeum of Philadelphia
219 S. 6th Street
Philadelphia, Pennsylvania 19106
(215) 925-2688
Dr. Roger W. Moss, Jr., Secretary and Librarian

Hours: 9:00–4:00, M–F
Access: Open to public, scholars, graduate students
Reproduction Services: Photographic prints, photocopy, microfilm
Size of Collection: 6,000 photographs
Special Collections: 600 architectural drawings, American, 1910–1940

Major Holdings: ETW–1P; WWI–1P; TW–1P; GD–1P

U433. **PAPHFL**

Free Library of Philadelphia
Rare Book Department; Print and Picture Department
Logan Square
Philadelphia, Pennsylvania 19103
Howell Heaney, Head, Rare Book Department
Robert F. Looney, Head, Print and Picture Department

Hours: 9:00–5:00, M–F
Access: Open to public, open by appointment, restricted use
Reproduction Services: Photographic prints, photocopy, fee schedule
Special Collections: Pennsylvania German Fraktur, Philadelphia views, angling prints, rare book department; print department—portrait prints, Philadelphia views, graphic art

U434. **PAPHHS**

Historical Society of Pennsylvania [*cont.*]

Print Collection
1300 Locust Street
Philadelphia, Pennsylvania 19107
(215) 732-6200
P. J. Parker, Chief of Manuscripts

Hours: 1:00–9:00, M; 9:00–5:00, Tu–F

Access: Open to public, restricted use, scholars only

Reproduction Services: Photographic prints, photocopy, microfilm, color slides, 4x5 color transparencies

Size of Collection: 10,000 photographs, 2,000 negatives, 750 slides, 4,500 postcards, 750 posters, 16mm film (3000 feet)

Special Collections: J. G. Brill Collection of photographs of trolleys and railroad cars

Major Holdings: AI–3P; AE–3P; C–3P; AR–3P; F–3P; W–3P; AJ–1P, 3P; MW–3P; CW–1P, 2P, 3P; WI–1P; I–1P, 2P, 3P, 4P, 4S; T–1P, 2P, 3P, 4P; ETW–1P, 4P, 4S; WWI–1P, 4P; TW–1P, 4P; GD–1P

U435. **PAPHIC**

INA Corporation Museum and Archives
INA Museum
1600 Arch Street
Philadelphia, Pennsylvania 19101
(215) 241-4415
Lynne A. Leopold, Curator

Hours: 8:00–4:30, M–F

Access: Open to public

Reproduction Services: Photographic prints, photocopy, color slides, color transparencies (4x5, 5x7, 8x10); all services at cost, make arrangements with museum photographer

Size of Collection: 1,500 photographs, 1,500 negatives, 400 slides

Special Collections: More than half of the photographs and slides illustrate 19th century firefighting through uniforms, equipment, other memorabilia, prints, and paintings showing firemen in action

Major Holdings: C–3P, 3S, 4P, 4S; AR–3P, 3S, 4P, 4S; F–3P, 3S, 4P, 4S; W–3P, 3S, 4P, 4S; AJ–3P, 3S, 4P, 4S; CW–3P, 3S, 4P, 4S; I–3P, 3S, 4P, 4S; T–3P, 3S, 4P, 4S; M–3P, 3S, 4P, 4S

U436. **PAPHLC**

Library Company of Philadelphia
1314 Locust Street
Philadelphia, Pennsylvania 19107
(215) KI6-3181
Edwin Wolf 2nd, Librarian

Hours: 7:00–4:45

Access: Open to public

Reproduction Services: Photographic prints, microfilm, color slides, color and black and white slides, color transparencies (4x5, 5x7, 8x10), fee schedule

Size of Collection: Photographs and slides

Special Collections: Philadelphia photographs

(1855–75) include portraiture, architecture and commerce; 18th–19th c. photographs of Americana

Major Holdings: C–1P, 3P, 4P; AR–1P, 3P, 4P; F–1P, 2P, 3P, 4P; W–1P, 2P, 3P; AJ–1P; CW–1P, 2P; I–1P

U437. **PAPHPA**

Pennsylvania Academy of the Fine Arts
Broad and Cherry Streets
Philadelphia, Pennsylvania 19103
(215) 299-5060
Richard J. Boyle, Director

Hours: 10:00–5:00

Access: Open to public, purchase only

Reproduction Services: Photographic prints, color slides, fee schedule (photographs $2.00, slides 75¢)

Size of Collection: 2,200 photographs, 120 slides, 20 postcards

Major Holdings: C–3P, 3S; AR–2P, 3P, 3S; F–2P, 3P, 3S; W–3P, 3S; AJ–3P; WM–3P; T–3P; ETW–3P; WWI–3P; TW–3P; GD–3P

U438. **PAPHPC**

Philadelphia College of Art
Slide Library
Broad and Pine Streets
Philadelphia, Pennsylvania 19102
(215) KI6-0545
Eleanor Greinke, Supervisor

Hours: 8:00–5:00, M–F

Access: Restricted use, art history and studio faculty, students

Size of Collection: 130,000 slides

Special Collections: Contemporary crafts slides; European street furniture slides; Turkish anthropology slides; portraiture catalog alphabetically by subject keyed to paintings, drawings, sculpture, photography

Major Holdings: AI–4S; C–1S, 3S; AR–1S, 3S; F–1S, 3S; AJ–1S, 2S, 3S; WM–3S; CW–3S; I–1S, 2S, 3S, 4S; ETW–1S, 2S, 3S, 4S; WWI–1S, 2S, 3S; TW–1S, 2S, 3S, 4S; GD–1S, 2S, 3S, 4S; WWII–1S, 2S, 3S, 4S; P–1S, 2S, 3S, 4S; AL–3S; M–3S.

U439. **PAPHPH**

Philadelphia Historical Commission
1313 City Hall Annex
Philadelphia, Pennsylvania 19107
(215) MU6-4583
Richard Tyler, Historian

Access: Open to public

Reproduction Services: Photographic prints, photocopy, color and black and white slides

Size of Collection: 25,000 photographs, 2,500 slides

Special Collections: Photographs, insurance surveys, other documents relating to Philadelphia architectural history

Major Holdings: C–1P, 1S; AR–1P, 1S; F–1P, 1S; AJ–1P, 1S; MW–1P, 1S; CW–1P, 1S; I–1P; T–1P; ETW–1P; WWI–1P; TW–1P; GD–1P

U440. **PAPHPI**

Philadelphia Maritime Museum
321 Chestnut Street
Philadelphia, Pennsylvania 19106
(215) WA5-5439
Robert Bruce Inverarity, Director

Access: Open by appointment, scholars only
Reproduction Services: Photographic prints, fee schedule
Size of Collection: Photograph and slides
Major Holdings: M–2P, 3P, 4P

U441. **PAPHPM_{oc}**

Philadelphia Museum of Art
26th Street and the Parkway
Philadelphia, Pennsylvania 19130
(215) PO3-8100
Evan H. Turner, Director

Hours: 9:00–5:00, Tu–Su
Access: Open to public
Reproduction Services: Photographic prints, color slides, 5x7 color transparencies, catalog available, listings, fee schedule
Size of Collection: Photographs, negatives, slides, postcards, posters

U442. **PAPHPM_{p}**

Philadelphia Museum of Art
Photographic Department 26th and Parkway
P.O. Box 7646
Philadelphia, Pennsylvania 19101
Alfred J. Wyatt, Director of
Photographic Services

Hours: 10:00–12:00, 2:00–4:00, Tu–F
Access: Open to public
Reproduction Services: Photographic prints, 8x10 black and white, 5x7 color transparencies
Size of Collection: 500,000 photographs, 500,000 negatives
Special Collections: John G. Johnson Collection (paintings ca. 1500–1900); Arensberg Collection (paintings, 20th c.); White Collection (paintings, 1800–1900); Stern Collection (paintings, 1800–1900); Ars Medica Collection (prints with medical subjects); Garbisch Collection (paintings and watercolors of American artists, 1700–1800s); Zieget Collection (Shaker furniture and artifacts)

Major Holdings: AI–4P; C–1P, 2P, 3P, 4P; AR–1P, 2P, 3P, 4P; F–1P, 2P, 3P, 4P; AJ–2P, 3P, 4P; CW–2P, 3P, 4P; I–2P, 3P, 4P; T–2P, 3P, 4P; ETW–2P, 3P, 4P; WWI–2P, 3P, 4P; TW–2P, 3P, 4P; GD–2P, 3P, 4P; WWII–2P, 3P, 4P; P–2P, 3P, 4P; SA–2P, 3P, 4P; M–3P; S–3P

U443. **PAPHPR**

The Print Club
1614 Latimer Street

Philadelphia, Pennsylvania 19103
(215) 735-6090
Margo Devereux, Director

Hours: 10:00–5:30, M–F; 10:00–4:00, Sa (September–mid June)
Access: Open to public
Special Collections: Important contemporary prints always in stock; Print Club permanent collection housed at the Philadelphia Museum of Art, 15th c.–present

U444. **PAPHUP_{f}**

University of Pennsylvania
Fine Arts Library, Slide and
Photograph Collection
34th and Walnut Streets
Philadelphia, Pennsylvania 19174
(215) 243-7086
Miss Concetta Leone, Head

Access: Restricted use, scholars only
Size of Collection: 60,000 photographs and prints for study purposes, 140,000 slides
Special Collections: Slides of Philadelphia architecture, American decorative arts through the 19th c.

Major Holdings: AI–1S, 3S; AE–1S, 3S; C–1P, 1S, 2P, 2S, 3S, 4S; AR–1P, 1S, 2P, 2S, 3P, 3S, 4S; F–1P, 1S, 2P, 2S, 3P, 3S, 4S; W–1P, 1S, 2P, 2S, 3P, 3S, 4P, 4S; AJ–1P, 1S, 2P, 2S, 3P, 3S, 4P, 4S; WM–4S; MW–4S; CW–4S; WI–4S; I–1P, 1S, 2P, 2S, 3P, 3S, 4S; T–1P, 1S, 2P, 2S, 3P, 3S; ETW–1P, 1S, 2P, 2S, 3P, 3S, 4S; WWI–1P, 1S, 2P, 2S, 3P, 3S; TW–1S, 4S; GD–1S, 2S, 3S, 4S; WWII–1S, 2S, 3S, 4S; P–1S, 2S, 3S, 4S

U445. **PAPHUP_{m}**

University Museum of the University
of Pennsylvania
University Museum
33rd and Spruce Streets
Philadelphia, Pennsylvania 19174
(215) EV6-7400
Caroline Gordon Dosker, Assistant Registrar

Hours: 10:00–5:00, Tu–F; 10:00–1:00, Sa
Access: Open by appointment, restricted use, scholars, students
Reproduction Services: Photographic prints; photocopy; microfilm; 5x7, 8x10 or larger special order for fee; slide catalog available, fee schedule
Size of Collection: 2,000 photographs, 2,000 negatives, slides, ethnographic films

Major Holdings: AI–2P, 2S

U446. **PAPICI**

Carnegie Institute
Museum of Art
440 Forbes Avenue
Pittsburgh, Pennsylvania 15213
(412) 622-3204
Herdis B. Teilman, Curator of Painting and Sculpture [*cont.*]

Hours: 10:00–4:45 daily
Access: Open by appointment, restricted use, purchase only
Reproduction Services: Photographic prints
Size of Collection: 2,000 photographs, 2,000 negatives, 500 slides, 150 postcards

Major Holdings: F–3P; AJ–3P; MW–3P; CW–3P; ETW–3P; TW–3P; GD–3P; P–3P; M–3P

U447. **PAPICL**
Carnegie Library of Pittsburgh
Slide Collection
4400 Forbes Avenue
Pittsburgh, Pennsylvania 15213
(412) 662-3108 or 662-3107
Zanne M. Holt, Slide Coordinator

Hours: 9:00–9:00, M–Sa
Access: Open to public
Size of Collection: 90,000 slides

Major Holdings: AI–4S; C–1S, 3P, 3S, 4S; AR–3P, 3S; F–1P, 3S; AJ–3S; WM–3S; CW–4S; I–1P, 3S; T–3P; ETW–3S; TW–3S; GD–3S; WWII–3S; P–2S, 3S; SA–2S, 3S

U448. **PAPIUP**f
University of Pittsburgh
Frick Fine Arts Department,
 Collection of Slides and Photographs
116 Frick Fine Arts Building
Pittsburgh, Pennsylvania 15260
(412) 624-4121
Joan Abrams, Curator

Hours: 9:00–5:00, M–F
Access: Restricted use, primarily for faculty and students; interested persons admitted when materials are not in use
Reproduction Services: Color and black and white slides
Size of Collection: 70,000 photographs, 140,000 slides
Special Collections: Comprehensive compilation of slides of Pittsburgh architecture

Major Holdings: AI–4S; C–1S, 3S, 4S; AR–1S, 3S, 4S; F–1S, 3S, 4S; AJ–1S, 2S, 3S, 4S; CW–1S, 2S, 3S, 4S; I–1P, 1S, 2S, 3S, 4S; T–1P, 1S, 2S, 3S, 4S; ETW–1P, 1S, 2S, 3S, 4S; TW–1P, 1S, 2S, 3S, 4S; GD–1P, 1S, 2S, 3S, 4S; WWII–1P, 1S, 2S, 3S, 4S; P–1P, 1S, 2S, 3S, 4S

U449. **PAPIUP**g
University of Pittsburgh
University Art Gallery
Frick Fine Arts Building
Pittsburgh, Pennsylvania 15260
(412) 624-4116
Carl Nordenfalk, Director

Access: The Gallery does not deal in reproductions but is part of the Department of Art History and operates as a gallery only; slides are for teaching purposes only, as is the photography-print collection

U450. **PAVFHS**
Valley Forge Historical Society
Valley Forge, Pennsylvania 19481
(215) 783-0535
John F. Reed, Vice-President and Curator

Hours: 9:30–5:00 daily; 1:00–5:00, Su
Access: Open to public, purchase only
Reproduction Services: Photocopy; color and black and white slides; 4x5, 5x7, 8x10 color transparencies; photography permit with credit and donation to the Society
Size of Collection: Negatives, slides, postcards
Special Collections: Color transparencies of "Washington Reviewing His Troops at Valley Forge" by William T. Trego

Major Holdings: AR–3P, 3S, 4P, 4S

U451. **PAWARC**
Warren County Historical Society
210 Fourth Avenue, Box 427
Warren, Pennsylvania 16365
(814) 723-1795
Chase Putnam, Executive Director

Hours: 1:00–5:00, M–F
Access: Open to public, restricted use, collections may not be removed from building
Reproduction Services: Photographic prints of photographs made to order for fee
Size of Collection: 3,000 photographs, 1,000 postcards
Special Collections: Postcard and photograph collections, including portrait photography, representing approximately 100 years of the history of Warren and Warren County; earliest pictures date from the 1860s; small locally significant collection of fine oil portraits of early and prominent Warren County citizens

U452. **PAWASC**
Washington Crossing Foundation
Washington Crossing Library
 of the American Revolution
Washington Crossing, Pennsylvania 18977
(215) 493-6577
Dr. Helen McCracken Carpenter,
 Director Emeritus

Hours: 9:00–4:00, M–F
Access: Open to public, restricted use, research workers or students
Reproduction Services: Photographic prints, small duplicating machine, color and black and white slides
Size of Collection: Photographs, negatives, slides, postcards, color film ("Washington Crossing the Delaware," 30 minutes, for distribution to schools, organizations, individuals)
Special Collections: Collections limited to the American Revolution period; collections of photographs of historic sites and objects for distribution

Major Holdings: AR–1P, 1S, 3P, 3S, 4P, 4S

RHODE ISLAND

U453. RIEPBU

Budek Films & Slides, Inc.
Lawrence P. Allen
P.O. Box 4309
East Providence, Rhode Island 02914
(401) 434-5625

Access: By appointment, for purchase only
Reproduction Services: Color and black and white slides, catalogs, listing and fee schedule available
Size of Collection: 2,000 negatives, 2,000 slides
Major Holdings: C—1S, 3S, 4S; AR—1S, 2S, 3S, 4S; F—1S, 2S, 3S, 4S; W—1S, 2S, 3S, 4S; AJ—1S, 2S, 3S; WM—1S, 2S, 3S; MW—1S, 2S, 3S; ETW—1S, 2S, 3S; WWI—1S, 2S, 3S; TW—1S, 2S, 3S; GD—1S, 2S, 3S; WWII—1S, 2S, 3S; P—1S, 2S, 3S; SA—1S, 2S, 3S

U454. RIPRRI

Rhode Island School of Design
Rhode Island School of Design Library
2 College Street
Providence, Rhode Island 02903
(401) 331-3511, ext. 227
Ms. Reymour De Lissovoy, Head,
Slide and Photograph Department

Hours: 8:30—5:00, M—F; summer hours vary, please check
Access: Open to public, borrowing restricted to students and faculty
Reproduction Services: Photocopy
Size of Collection: Moderate size collection of slides, clippings, 35 posters
Special Collections: 35 original posters by Will Bradley and Edward Penfield

Major Holdings: Slides in almost every area faculty and students might require; superb clipping collection covers every subject and material conceivable

U455. RIPRRI_m

Rhode Island School of Design
Museum of Art
Education Department Slide Library
224 Benefit Street
Providence, Rhode Island 02903
(401) 331-3510, ext. 279
Jean S. Fain

Hours: 11:00—5:00, Tu—F
Access: Open to public, by appointment to teachers, also for purchase
Reproduction Services: Catalog available for purchase of slides, color slides at $2.00
Size of Collection: Slides
Special Collections: Slides of glass; Rhode Island architecture; graphics and prints belonging to the museum collection; American furniture (Pendleton House Museum of Art)

Major Holdings: AI—2S, 4S; C—1S, 4S; AR—1S, 3S, 4S; F—1S; AJ—1S; WM—3S; ETW—3S, 4S; WWI—3S; P—3S; SA—3S; S—3S

SOUTH CAROLINA

U456. SCCHGA

Gibbes Art Gallery, Carolina Art Association
Gibbes Art Gallery Library
135 Meeting Street
Charleston, South Carolina 29401
(803) 722-2706
Curator of Collections

Hours: 10:00—5:00, Tu—Sa; 2:00—5:00, Su
Access: Open to public with restricted use
Reproduction Services: Photographic prints; photocopy; color slides; 4x5, 5x7, 8x10 color transparencies; listing and fee schedule upon request
Size of Collection: 2,300 photographs, 1,300 negatives, 4,000 slides
Special Collections: Charleston and low country architecture photographs and Johnston negatives (ca. 1900) of Charleston and low country area

Major Holdings: C—1P, 1S, 3P, 3S; AR—1P, 1S, 2P, 2S, 3P, 3S; F—1P, 1S, 2P, 2S, 3P, 3S; AJ—1P, 1S, 3P, 3S; CW—1P, 1S, 2P, 2S, 3P, 3S; AL—3P, 3S

U457. SCCHSC

South Carolina Historical Society
Fireproof Building
Charleston, South Carolina 29401
Mrs. G. T. Prior, Director

Hours: 9:30—5:00, M—F; 9:00—1:00, Sa
Access: Open to public
Reproduction Services: Photographic prints, available on request
Size of Collection: Photographs, negatives

Major Holdings: C—3P; AR—3P; AJ—3P; CW—3P; WWI—3P; TW—3P; TW—3P; GD—3P; WWII—3P; P—3P; SA—3P; AL—3P

U458. SCSUOS

Miriam B. Wilson Foundation
Old Slave Mart Museum Collection
Box 446
Sullivan Island, South Carolina 29482
(803) 883-3797
Mrs. Judith Wragg Chase, Curator

Hours: 8:00—4:30, M—F
Access: Open by appointment, restricted use, scholars only
Reproduction Services: Photographic prints, photocopy, color slides; catalog available and fee schedule. (Reproduction rights available for purchase, nominal cost for study copies of print, rental fees for slide lecture series)
Size of Collection: 1,300 photographs, 1,100 negatives, 750 slides, 500 postcards, 100 photostats of early documents *[cont.]*

Special Collections: Photographs and slides of American slave crafts, African crafts, Afro-American life and customs; South Carolina Sea Island basketry; Charleston architecture and decorative ironwork photographs

SOUTH DAKOTA

U459. SDBRSD

South Dakota Memorial Art Center
Jeanette Lusk Library Collection
Brookings, South Dakota 57006
(605) 688-5423
Joseph Stuart, Director

Hours: 8:00–5:00, 7:00–10:00, M–F; 10:00–5:00, Sa; 1:00–5:00, Su
Access: Open to public, restricted use
Reproduction Services: None
Size of Collection: 1,500 slides, 100 reproductions
Special Collections: Art of South Dakota slides

Major Holdings: AI–3S, 4S

U460. SDPISH

Historical Resource Center, Robinson Museum
South Dakota State Historical Society
Memorial Building
Pierre, South Dakota 57501
(605) 224-3615
Mrs. Bonnie Gardner, in charge of photographs;
Mr. David Hartley, in charge of Museum

Hours: 8:00–5:00, M–F
Access: Open to public
Reproduction Services: Photographic prints, microfilm; fee schedule: 5x7, $2.00; 8x10, $4.00 (black and white glossy)
Size of Collection: 30,000 photographs, 6,000 negatives, 500 slides

Major Holdings: AI–1P, 3S, 4P, 4S; AE–1P, 4P; WM–1P, 4P; WI–1P, 4P; T–1P, 4P; ETW–1P, 4P; WWI–1P, 4P; TW–1P, 4P; GD–1P, 4P; WWII–1P, 4P; P–1P, 4P; AL–1P, 4P; S–1P, 4P; E–1P, 4P

U461. SDSFIM

St. Francis Indian Mission
Buechel Memorial Dakota Museum
St. Francis, South Dakota 57572
(605) 747-2296
Harold D. Moore, Director

Hours: 9:00–5:00, Memorial Day–Labor Day
Access: Open by appointment, restricted use, scholars only
Reproduction Services: Photographic prints, black and white slides
Size of Collection: 20,000 photographs, 15,000 negatives, 2,000 slides
Special Collections: Snapshots and posed pictures of local people; places and things on the Rosebud Sioux Reservation

Major Holdings: AI–4P, 4S; S–4P, 4S; E–4P, 4S

U462. SDVEOM

W. H. Over Museum
University of South Dakota
Vermillion, South Dakota 57069
(605) 677-5228
June Sampson, Director

Hours: 8:00–4:30, M–F; 10:00–4:30, Sa; 2:00–4:30, Su
Access: Open to public, open by appointment
Reproduction Services: Photographic prints, listings, fee schedule
Size of Collection: 600 photographs, 400 negatives
Special Collections: Stanley J. Morrow photographic collection of original stereographs taken in Dakota and Montana Territories from 1868 to 1883; photographic prints available from this collection

TENNESSEE

U463. TNCHUT

University of Tennessee at Chattanooga
Department of Art
Vine and Baldwin Streets
Chattanooga, Tennessee 37405
(615) 755-4178
George Cress, Head

Access: Restricted use
Reproduction Services: None
Size of Collection: 1,500 slides

Major Holdings: AI–2S, 3S, 4S; C–1S, 3S, 4S; I–1S, 2S, 3S, 4S; ETW–1S, 2S, 3S, 4S; WWI–1S, 2S, 3S, 4S; TW–1S, 2S, 3S, 4S; GD–1S, 2S, 3S, 4S; WWII–1S, 2S, 3S, 4S; P–1S, 2S, 3S, 4S

U464. TNGRAJ

Andrew Johnson National Historic Site
Park Library
Greeneville, Tennessee 37743
(615) 638-3551
Hugh A. Lawing, Park Historian

Hours: 9:00–5:00, daily except Christmas
Access: Open to public, purchase of slides and postcards available
Reproduction Services: Color slides
Size of Collection: Photographs, negatives, slides, postcards
Special Collections: Photographs relating to Johnson and family and site

U465. TNMEBM

Brooks Memorial Art Gallery
Brooks Memorial Art Gallery
 Reference Library
Overton Park
Memphis, Tennessee 38112
(901) 726-5266
Letitia B. Proctor, Librarian

Hours: 10:00–5:00, M–F

Access: Open to public, restricted use; postcards, reproductions and slides for sale

Reproduction Services: Photographic prints (black and white if no negative exists, $25.00; if negative available, $5.00), color slides (duplicate slide, $3.50 for first one, $1.00 for each additional), color transparencies (4x5, 5x7, 8x10, all sizes $35.00)

Size of Collection: 200 photographs, 100 negatives, 200 slides, 19 postcard views, 40 reproductions of paintings in permanent collection

Major Holdings: AJ–3P, 3S; WM–3P, 3S; CW–3P, 3S; ETW–3P, 3S; WWI–3P, 3S; TW–3P, 3S; WWII–2P, 2S, 3P, 3S; P–2P, 2S, 3P, 3S; SA–3P, 3S; AL–3P, 3S

U466. TNMECM

Chucalissa Museum
1987 Indian Village Drive
Memphis, Tennessee 38109
(901) 785-3160
Gerald P. Smith, Curator

Access: Open by appointment
Reproduction Services: None
Size of Collection: Photographs, slides
Special Collections: Photographs and slides of prehistoric pottery and stone tools of Mid-South and Chucalissa Indian village reconstruction; Choctaw crafts

Major Holdings: AI–1P, 1S, 4P, 4S

U467. TNMEMA

The Memphis Academy of Arts
G. Pillow Lewis Memorial Library
Overton Park
Memphis Tennessee 38112
(901) 726-4085
Patricia C. Hayley, Librarian

Hours: 8:00–10:00, M, W; 8:00–5:00, Tu, Th, F
Access: Open to public, restricted use
Reproduction Services: None
Size of Collection: 20,000 slides

Major Holdings: AI–2S, 3S, 4S; AE–1S, 2S, 3S, 4S; C–1S, 2S, 3S, 4S; AR–1S, 2S, 3S, 4S; F–1S, 2S, 3S, 4S; AJ–1S, 2S, 3S, 4S; WM–1S, 2S, 3S, 4S; CW–1S, 2S, 3S, 4S; WI–1S, 2S, 3S, 4S; I–1S, 2S, 3S, 4S; T–1S, 2S, 3S, 4S; ETW–1S, 2S, 3S, 4S; WWI–1S, 2S, 3S, 4S; TW–1S, 2S, 3S, 4S; GD–1S, 2S, 3S, 4S; WWII–1S, 2S, 3S, 4S; P–1S, 2S, 3S, 4S; SA–1S, 2S, 3S, 4S; AL–1S, 2S, 3S, 4S; M–1S, 2S, 3S, 4S, S–1S, 2S, 3S, 4S; E–1S, 2S, 3S, 4S

U468. TNMESU

Memphis State University
Slide Library
Jones Hall, Room 220
Memphis, Tennessee 38152
(901) 454-2071
Jana Ray, Slide Librarian

Hours: 8:00–4:00, M–F

Access: Open to public, restricted use, scholars only
Reproduction Services: None
Size of Collection: 73,000 slides, 77 film strips

Major Holdings: AI–1S, 2S, 3S, 4S; AE–1S, 2S, 3S, 4S; C–1S, 2S, 3S, 4S; AR–1S, 2S, 3S, 4S; F–1S, 2S, 3S, 4S; W–1S, 2S, 3S, 4S; AJ–1S, 2S, 3S, 4S; WM–1S, 2S, 3S, 4S; MW–1S, 2S, 3S, 4S; CW–1S, 2S, 3S, 4S; WI–1S, 2S, 3S, 4S; I–1S, 2S, 3S, 4S; T–1S, 2S, 3S; ETW–1S, 2S, 3S, 4S; WWI–1S, 2S, 3S, 4S; TW–1S, 2S, 3S, 4S; GD–1S, 2S, 3S, 4S; WWII–1S, 2S, 3S, 4S; P–1S, 2S, 3S, 4S; SA–1S, 2S, 3S, 4S; AL–3S; M–2S, 3S; S–2S, 3S

U469. TNNAVU

Vanderbilt University
Department of Fine Arts, Slide and Photograph Archive
Box 1801, Station B
Nashville, Tennessee 37235
(615) 322-2831
F. Hamilton Hazlehurst,
Chairman of Fine Arts Department

Access: Restricted use
Reproduction Services: None
Size of Collection: 55,000 photographs, 75,000 slides

Major Holdings: AI–4S; C–4S; AR–4S; F–4S; AJ–4S; WM–4S; I–4S; ETW–4S; TW–4S; P–4S

U470. TNSEUS

The University of the South
Gallery of Fine Arts and Museum Chambers
Sewanee, Tennessee 37375
Dr. Edward Carlos, Director of Gallery/Museum

Size of Collection: Photographs, negatives, slides

Major Holdings: F–4P, 4S; WM–2P, 2S; WWI–3P, 3S; WWII–3P, 3S; P–3P, 3S; SA–2P, 2S, 3P, 3S

TEXAS

U471. TXAULJ

L.B.J. Library, Audiovisual Archives
2313 Red River Street
Austin, Texas 78745
(512) 397-5137
John Fawcett

Hours: 9:00–5:00, M–F
Access: Open to public, restricted use
Reproduction Services: None
Size of Collection: 1,000 film titles, 4,000 hours videotape
Special Collections: All material specifically related to public life and career of Lyndon Baines Johnson

U472. **TXAUUT**
University of Texas at Austin
Department of Art Slide Library
University of Texas, Austin
Department of Art, Room 6
Austin, Texas 78712
(512) 471-3365
Nancy S. Schuller, Professional Librarian

Hours: 8:00—5:00, M—F
Access: Restricted use
Reproduction Services: None
Size of Collection: 180,000 slides

Major Holdings: AI—1S, 2S, 3S, 4S; C—1S, 2S, 3S,
4S; AR—1S, 2S, 3S, 4S; F—1S, 2S, 3S, 4S; W—1S,
2S, 3S, 4S; AJ—1S, 2S, 3S, 4S; WM—1S, 2S, 3S, 4S;
MW—1S, 2S, 3S, 4S; CW—1S, 2S, 3S, 4S; WI—1S,
2S, 3S, 4S; I—1S, 2S, 3S, 4S; T—1S, 2S, 3S, 4S;
ETW—1S, 2S, 3S, 4S; WWI—1S, 2S, 3S, 4S;
TW—1S, 2S, 3S, 4S; GD—1S, 2S, 3S, 4S;
WWII—1S, 2S, 3S, 4S; P—1S, 2S, 3S, 4S; SA—1S,
2S, 3S, 4S

U473. **TXCCAM**
Art Museum of South Texas
P.O. Box 1010
Corpus Christi, Texas 78403
(512) 884-3844
Michelle W. Locke, Lecturer-Librarian

Hours: 10:00—5:00, M—F
Access: Open to public, by appointment
Reproduction Services: Photographic prints,
photocopy, microfilm
Size of Collection: 100 photographs; 5,000 slides;
some video, posters and clippings

Major Holdings: AI—2S; C—1S, 2S, 3S, 4S;
AR—1S, 2S, 3S, 4S; F—1S, 2S, 3S, 4S; AJ—1S, 2S,
3S; ETW—1S; WWI—2S, 3S; GD—2S, 3S;
WWII—2S, 3S; P—1S, 2S, 3S; P—1S, 2S, 3P, 3S

U474. **TXFDHS**
Fort Davis National Historic Site
Box 145b
Fort Davis, Texas 79734
(915) 426-3225
Derek Hambly, Superintendent

Hours: 8:00—4:30 daily
Access: Open to public
Reproduction Services: None
Size of Collection: 1,000 photographs, 800 nega-
tives, 400 slides
Special Collections: Pictures pertain to the Indian
Wars, Fort Davis between 1854 and 1891
when it was active and later as property of
National Park Service

Major Holdings: AI—1P, 3P, 4P; WM—1P, 3P, 4P

U475. **TXFWCM**
Amon Carter Museum of Western Art
P.O. Box 2365 (mailing address)
3501 Camp Bowie Blvd.
Ft. Worth, Texas 76101
(817) 738-1933

Marjorie A. Morey,
Curator of Photographic Collections
Hours: 9:00—5:00, M—F
Access: Open by appointment
Reproduction Services: Photographic prints;
photocopy; slides, color and black and white;
large format color transparency, 4x5 and
8x10
Size of Collection: Photographs, negatives, slides,
postcards—total 275,000
Special Collections: Historical images of the
American West

Major Holdings: AI—1P; WM—4P; WI—1P; I—1P,
4P; T—4P; ETW—4P

U476. **TXFWFW**
Fort Worth Art Museum Library
1309 Montgomery
Fort Worth, Texas 76107
(817) 738-9215
Librarian
Hours: 10:00—1:00 and 2:00—5:00, Tu—F
Access: Open to public
Reproduction Services: Photographic prints,
photocopy, color slides, large color format
transparency, 4x5
Size of Collection: Photographs, 5,000 slides, 25
films, exhibition announcements
Special Collections: Most material deals with
post WWII art

Major Holdings: ETW—1S, 2S, 3S; WWI—1S, 2S,
3S; TW—1S, 2S, 3S; GD—1S, 2S, 3S; WWII—1S,
2S, 3S; P—1S, 2S, 3S; SA—1S, 2S, 3S

U477. **TXFWKM**
Kimbell Art Museum
P.O. Box 9440
Ft. Worth, Texas 76107
(817) 332-8451
Rebekah Connally, Slide Librarian
Hours: 10:00—5:00, Tu—F
Access: Scholars and graduate students only
Reproduction Services: None
Size of Collection: 13,000 slides, films

Major Holdings: AR—3S; F—3S; AJ—3S; CW—3S;
I—3S; T—3S; WWI—3S; TW—3S; GD—3S; P—3S;
SA—3S

U478. **TXHOMFA**
Museum of Fine Arts, Houston
1001 Bissonnet
Houston, Texas 77005
(713) 526-1361
William C. Agee, Museum Director
Hours: 10:00—5:00, Tu—F
Access: Restricted use, slides and postcards
available for sale in Museum Bookstore
Reproduction Services: Photographic prints
Size of Collection: Photographs, slides, postcards,
films
Special Collections: Bayou Bend Collection of
American Decorative Arts, 1 Westcott Street,
Houston, Texas 77019, (713) 529-8773

Major Holdings: AI–2P, 2S, 3P, 3S; C–2P, 2S, 3P, 3S, 4P, 4S; AR–2P, 2S, 3P, 3S, 4P, 4S; F–2P, 2S, 3P, 3S, 4P, 4S; W–3S; AJ–1P, 1S, 2P, 2S, 3P, 3S, 4P, 4S; WM–2P, 3P, 3S; MW–1S, 3S; CW–1S, 3S; WI–3S; I–1P, 1S, 3P, 3S; ETW–1S, 2S, 3P, 3S; WWI–1S, 2S, 3P, 3S; TW–1S, 2P, 2S, 3P, 3S; GD–1S, 2P, 2S, 3P, 3S; WWII–1S, 2P, 2S, 3P, 3S; P–1P, 1S, 2P, 2S, 3P, 3S

U479. **TXHORU**

Rice University
Art Department Slide Library
P.O. Box 1892
Houston, Texas 77001
(713) 527-8101, ext. 4836
Patricia Toomey, Curator Slide
 and Photograph Collections

Hours: 9:00–5:00, M–F
Access: Restricted use, scholars only
Reproduction Services: None
Size of Collection: 1,000 photographs, 12,000 slides
Major Holdings: AI–1S, 2S, 3S, 4S; C–1P, 2S, 3P, 3S, 4P, 4S; AR–1P, 1S, 2S, 3P, 3S, 4S; F–1P, 1S, 2S, 3P, 3S, 4S; W–3S; AJ–1S, 2S, 3S, 4S; WM–1S, 2S, 3S, 4S; MW–3S; CW–1S, 2S, 3S, 4S; WI–1S, 2S, 3S, 4S; I–1S, 2S, 3S, 4S; T–1S, 2S, 3S, 4S; ETW–1S, 2S, 3S, 4S; WWI–1S, 2S, 3S, 4S; TW–1P, 1S, 2P, 2S, 3P, 3S, 4S; GD–1P, 1S, 2P, 2S, 3P, 3S, 4S; WWII–1P, 1S, 2P, 2S, 3P, 3S, 4S; P–1P, 1S, 2P, 2S, 3P, 3S, 4S

U480. **TXHOUH_a**

University of Houston, Art Department
Slide Collection
Cullen Blvd.
Houston, Texas 77004
(713) 749-2601
Rosemary Jones, Slide Librarian

Hours: 8:00–5:00, M–F
Access: Scholars and students only
Reproduction Services: None
Size of Collection: 60,000 slides
Major Holdings: AI–2S, 3S, 4S; C–1S, 2S, 3S, 4S; AR–1S, 2S, 3S, 4S; F–1S, 2S, 3S, 4S; W–1S, 2S, 3S, 4S; AJ–1S, 2S, 3S, 4S; WM–1S, 2S, 3S, 4S; CW–1S, 2S, 3S, 4S; I–1S, 2S, 3S, 4S; T–1S, 2S, 3S, 4S; ETW–1S, 2S, 3S, 4S; WWI–1S, 2S, 3S, 4S; TW–1S, 2S, 3S, 4S; GD–1S, 2S, 3S, 4S; WWII–1S, 2S, 3S, 4S; P–1S, 2S, 3S, 4S; SA–1S, 2S, 3S, 4S

U481. **TXHOUH_f**

University of Houston
Franzheim Architecture Library
Cullen Blvd.
Houston, Texas 77004
(713) 749-1193
Charlotte Tannenbaum, Reference Assistant

Access: Restricted use, scholars only
Reproduction Services: Available on central campus, photographic prints, photocopy and color and black and white slides
Size of Collection: Slides

Major Holdings: AI–1S, 2S, 4S; C–1S; T–1S; ETW–1S, 2S, 3S; TW–1S; P–1S, 2S, 3S

U482. **TXNEFP**

Fort Belknap Archives, Incorporated
Box 68
Newcastle, Texas 76372
(817) 549-1956
Barbara Ledbetter, Assistant Archivist

Hours: 9:00–5:00 daily except F
Access: Open by appointment, scholars and students only
Reproduction Services: Photographic prints, photocopy, microfilm, color and black and white slides; any size color transparency, brochure available upon request, no fee
Size of Collection: Photographs, negatives, slides, postcards
Special Collections: Documents referring to Young County, Texas; Southwest and Western Heritage

U483. **TXPHCC**

Carson County Square House Museum
5th and Elsie
Panhandle, Texas 79068
(806) 537-3118
Mrs R.E. Randel, Museum Director

Hours: 9:00–6:00 daily except December 25th
Access: Open to public
Reproduction Services: None
Size of Collection: Photographs, slides, postcards

Major Holdings: AI–1P, 2P; AE–2P, 3P; WM–1P, 2P; T–1P; ETW–1P, 3P; WWI–1P, 3P; TW–1P; GD–1P; WWII–1P; P–1P; SA–1P; AL–1P

U484. **TXSAFC**

Fort Concho Preservation and Museum
Ragsdale Collection (primarily)
213 East Ave. D
San Angelo, Texas 76901
(915) 655-5089
G.F. Crabtree, Director

Hours: 9:00–12:00 and 1:00–5:00, M–F
Access: Open to public
Reproduction Services: None
Size of Collection: 2,000 photographs, 2,000 negatives

U485. **TXSNTC**

Institute of Texas Cultures
Library
P.O. Box 1226
San Antonio, Texas 78294
(512) 226-7651, ext. 41
Laura Simmons, Administrative Assistant

Hours: June 1–August 31, 1:00–6:00, T–Su; Sept. 1–May 31, 10:00–4:00, Tu–F and 1:00–6:00, Sa–Su
Access: Open to public
Reproduction Services: Photographic prints,

photocopy, color and black and white slides,
4x5 color transparency; catalog available

Size of Collection: 35,000 photographs, 35,000
negatives, 5,000 slides, 50 postcards

Major Holdings: AI–1P, 1S, 3P, 4P; AE–1P, 3P;
C–1P; AR–1P; WM–1P, 3P, 4P; MW–1P, 3P,
4P; CW–1P, 3P, 4P; WI–1P, 1S, 3P, 4P; T–1P,
1S, 4P; ETW–1P, 4P; WWI–1P, 4P; TW–1P, 4P;
GD–1P, 4P; WWII–1P, 4P; P–1P, 4P; SA–1P;
AL–1P, 4P; M–1P, 4P; S–1P, 4P; E–1P, 4P

U486. **TXSNWM**

Witte Memorial Museum
Eastman Slide Library
3801 Broadway
San Antonio, Texas 78209
(512) 826-0647

Access: Open to public, restricted use
Size of Collection: Slides

U487. **TXWASR**

Star of the Republic Museum
P.O. Box 317
Washington, Texas 77880
(713) 878-2461
John W. Crain, Director

Hours: 10:00–5:00, W–Su, September–May;
10:00–6:00 daily, June–August
Access: Open to public
Reproduction Services: Photographic prints
Size of Collection: Photographs
Special Collections: Texas architecture

Major Holdings: AJ–1P, 3P

U488. **TXWCVH**

Varner-Hogg State Park
Varner-Hogg Plantation House
P.O. Box 696
West Columbia, Texas 77486
(713) 345-4656
Joe W. Cariker, Park Superintendent

Hours: 10:00–11:30 and 1:00–4:30, Tu, Th, F, Sa
Access: Open to public
Reproduction Services: None
Size of Collection: Postcards

UTAH

U489. **UTBCBC**

Brigham City Museum–Gallery
Permanent Historical Collection
24 N. 3rd W.
Brigham City, Utah 84302
(801) 723-6769
Phyllis K. Owen, Director

Hours: 11:00–7:00
Access: Open to public, restricted only
Reproduction Services: None
Size of Collection: 500 photographs, 24 postcard
views

U490. **UTBRBC**

Bryce Canyon National Park
Bryce Canyon National Park Library
Bryce Canyon National Park, Utah 84717
(801) 834-5322
Faye Ott, Information Specialist

Access: Restricted use
Reproduction Services: Color slides
Size of Collection: 100 slides

Major Holdings: AI–1S, 2S, 3S, 4S; AP–1S, 4S;
WM–1S, 3S, 4S

U491. **UTSPZN**

Zion National Park
Zion National Park Library
Zion National Park
Springdale, Utah 84767
(801) 772-3256
Robert C. Heyden, Superintendent

Hours: 8:00–5:00, M–F
Access: Open by appointment; posters, slides
and postcards available for purchase at site or
by mail
Reproduction Services: Photocopy
Size of Collection: 200 photographs, 4,000 nega-
tives, 6,000 slides, 12 postcard views, 6 posters
Special Collections: Collection material deals
with archeological, botanical, and natural
history of the park

VERMONT

U492. **VTBUUV**

University of Vermont
Art History Program
c/o Fleming Museum
Burlington, Vermont 05401
(802) 656-2092
Alice S. Rydjeski

Hours: 8:30–5:00, M–F
Access: Restricted use, faculty only
Size of Collection: 10,000 photographs, 50,000
slides
Special Collections: The slide and photograph
collections reflect the history of Western art
as taught by the art history faculty of the
University of Vermont; all areas of American
art including architecture, sculpture, painting
and decorative arts are covered

U493. **VTMIMC**

Middlebury College
Department of Art
Middlebury, Vermont 05753
(802) 388-2762
Mrs. Jane H. Fiske, Curator of Slides
and Photographs

Access: Restricted use, students
Size of Collection: 10,730 slides

U494. **VTWOWH**

Woodstock Historical Society, Inc.
26 Elm Street
Woodstock, Vermont 05091
(802) 457-1822
Mrs. Raymond F. Leonard, Executive Secretary

Hours: June-October, 10:00–5:00, M–Sa, 2:00–5:30, Su; rest of year by appointment
Access: Open to public (staff member to be present) from June to October: open by appointment rest of year
Reproduction Services: Photographic prints, photocopy, black and white slides
Size of Collection: 2,000 photographs, 1,500 negatives, 500 postcards
Major Holdings: F–1P, 3P, 4P; AJ–1P, 3P, 4P; CW–1P, 3P, 4P; I–1P, 3P, 4P; T–1P, 3P, 4P; ETW–1P, 3P, 4P

VIRGINIA

U495. **VAHAAH**

Hampton Association for the Arts
and Humanities
P.O. Box 507
Hampton, Virginia 23669
(804) 723-1497
R. B. Easter, Jr., Executive Director

Hours: 10:00–6:00
Access: Open to public, restricted use
Reproduction Services: None
Size of Collection: 1,000 photographs, 1,000 negatives, 1,000 slides, postcards (very few)
Special Collections: Artifacts recovered in historical archeology in old or Colonial Hampton and the photo record of the process, as well as some slides; some traditional type historical-cultural heritage photos; few family portraits; visual resources include the original items themselves

U496. **VAHABT**

Booker T. Washington National Monument
Route l, Box 195
Hardy, Virginia 24101
(703) 721-2094
Sylvester Putman, Superintendent

Hours: 8:00–4:30, M-F
Access: Open to the public
Reproduction Services: None
Special Collections: The Booker T. Washington National Monument is a living historical farm (1856–1865), Western Piedmont, Virginia tobacco farm
Major Holdings: CW–1P, 1S, 3P; AL–1P, 1S, 3P

U497. **VAHRMC**

Madison College
Art Department Slide Library
Harrisonburg, Virginia 22801

(703) 433-6588
Christina B. Updike, Slide Curator

Hours: 8:00–12:00, 1:00–5:00
Access: Restricted use; teachers have first priority, then students if they have written permission from a teacher; finally the public if they have permission from the head of the Art Department
Reproduction Services: None
Size of Collection: 1,600–2,000 slides
Special Collections: Approximately 300 slides documenting the architecture of the Shenandoah Valley; approximately 30 slides of the work of the American contemporary artist-craftsman, Ronale Wyancko

Major Holdings: AI–2S, 3S, 4S; C–1S, 2S, 3S, 4S; AR–1S, 2S, 3S, 4S; F–1S, 2S, 3S, 4S; W–1S, 2S, 3S, 4S; AJ–1S, 2S, 3S, 4S; WM–1S, 2S, 3S, 4S; MW–1S, 2S, 3S, 4S; CW–1S, 2S, 3S, 4S; WI–1S, 2S, 3S, 4S; I–1S, 2S, 3S, 4S; T–1S, 2S, 3S, 4S; ETW–1S, 2S, 3S, 4S; WWI–1S, 2S, 3S, 4S; TW–1S, 2S, 3S, 4S; GD–1S, 2S, 3S, 4S; WWII–1S, 2S, 3S, 4S; P–1S, 2S, 3S, 4S

U498. **VALXWL**

Washington and Lee University
Lee Chapel Museum
Washington and Lee University
Lexington, Virginia 24450
(703) 463-9111, ext. 289
T. Patrick Brennan, Student Curator

Hours: 9:00–5:00, M–Sa (summer); 9:00–4:00, M–Sa (rest of year); 2:00–5:00, Su (year round)
Access: Open to the public
Reproduction Services: None
Size of Collection: 500 photographs, 10 negatives, 24,700 slides, 36,700 postcards
Special Collections: Photographs relating to the Lee family, Lee Chapel, and Washington and Lee University

Major Holdings: AR–3P, 3S; AJ–1P, 1S, 3P, 3S; I–1P, 1S, 2P, 2S, 3P, 3S

U499. **VAMVWP**

Woodlawn Plantation
Mount Vernon, Virginia 22121
(703) 780- 3118
George M. Smith, Administrator

Hours: 9:30–4:30 daily
Access: Open by appointment, restricted use
Reproduction Services: Photographic prints, color slides
Size of Collection: 200 photographs, 100 negatives, 100 slides, 10 postcards
Special Collections: Small collection of slides; photographs and paintings that are Woodlawn oriented

U500. **VANNMM**

The Mariners Museum
Museum Drive, Newport News, Virginia 23606
(804) 595-0368
William D. Wilkinson, Director

Hours: (Museum) 9:00–5:00 daily; (library)
9:00–5:00, M–F; irregularly on Sa
Access: Open to the public
Reproduction Services: Photographic prints,
photocopy, microfilm, color slides, black and
white slides, 4x5, 5x7, 8x10 large color
transparencies, fee schedule
Size of Collection: 150,000 photographs, 50,000
negatives, 2,000 slides, 5,000 postcards, 1,000
posters, 150 films

Major Holdings: AE–3P; W–3P; M–3P, 3S, 4P, 4S

U501. **VAPAOS**

Old Stone Jail Museum
Palmyra, Virginia 22963
(no phone listed)
W. S. Dennan, Curator

Hours: 12:00–4:00, W and Sa; 2:00–5:00, Su
Access: Open to the public; open by appoint-
ment; restricted use (approval of appropriate
officer, Fluvanna County Historical Society
or Curator)
Reproduction Services: None
Size of Collection: A number of uncataloged
photographs, 30 paintings
Special Collections: Point of Fork Arsenal ar-
tifacts; arrowheads, sea chest, furniture,
clothing, muskets

Major Holdings: AR–1P; F–1P; W–1P; AJ–1P;
CW–1P; I–1P; T–1P, 3P; ETW–1P, 3P; AL

U502. **VAPENB**

Petersburg National Battlefield
P.O. Box 549
Petersburg, Virginia 23803
(804) 732-3531
Neil C. Mangum, Historian

Hours: 8:00–5:00, M–Su
Access: Open to public, restricted use
Reproduction Services: None
Size of Collection: 500 photographs, 500 nega-
tives, 400 slides, 30 postcards

Major Holdings: CW–1P, 1S; WWI–1P; TW–1P

U503. **VARIMC**

The Museum of the Confederacy
The Library
1201 E. Clay Street
Richmond, Virginia 23219
(804) 649-0769
Eleanor Brockenbrough, Assistant Director
in charge of records

Hours: 9:00–5:00, M–F
Access: Open to public, open by appointment
Reproduction Services: Photographic prints, some
photocopy, 4x5 large format color transpar-

ency; fee schedule: 8x10 photographs, $5.00,
transparency rental, $25.00, commercial ren-
tal, $50.00
Size of Collection: 8,000 photographs, 3,000 nega-
tives, 300 slides (others made, on request, of
any items in the Museum's collection)
Special Collections: Hirst D. Milhollen study col-
lection of photographs on the Civil War (not
counted); collection of original photographs,
tintypes and daguerreotypes; Confederate
portraits; Conrad Wise Chapman paintings
Major Holdings: F–1P, 1S; CW–1P, 1S, 2P, 2S,
3P, 3S, 4P, 4S

U504. **VARIAP**

Association for the Preservation
of Virginia Antiquities
2705 Park Avenue
Richmond, Virginia 23220
(804) 359-0239
Robert A. Murdock, Executive

Access: Restricted use
Reproduction Services: None
Size of Collection: Photographs (for records on
their own restoration work), negatives, slides
(for insurance purposes), postcards
Special Collections: Maintains several historic
houses, open to public

Major Holdings: C–1S; AR–1S; F–1S

U505. **VARIVC**

Virginia Commonwealth University
School of the Arts Library
325 North Harrison Street
Richmond, Virginia 23220
(804) 770-7120
Mrs. Alice B. Deal, Director

Hours: 9:00–5:00, M–F
Access: Faculty and students only
Reproduction Services: None
Size of Collection: 17,268 slides
Special Collections: 19th and 20th c. photogra-
phy, 20th c. crafts (glass, ceramics, textiles),
20th c. design and illustration

Major Holdings: AI–1S, 2S, 3S, 4S; AE–1S, 2S,
3S; C–1S, 2S, 3S, 4S; AR–1S, 2S, 3S; F–1S, 2S,
3S; W–1S, 3S; AJ–1S, 2S, 3S; WM–1S, 2S, 3S;
MW–1S, 2S, 3S; CW–1S, 2S, 3S; WI–3S; I–1S,
2S, 3S; T–1S, 3S; ETW–1S, 3S; WWI–1S, 2S, 3S;
TW–1S, 2S, 3S, 4S; GD–1S, 3S; WWII–1S, 2S,
3S; P–1S, 2S, 3S; SA–1S, 2S, 3S, 4S; AL–2S, 3S,
4S; M–2S, 3S, 4S; S–2S, 3S, 4S; E–2S, 3S, 4S

U506. **VARIRN**

Richmond National Battlefield Park
3215 E. Broad Street
Richmond, Virginia 23223
(804) 226-1981
Kenneth Apschnikat, Chief,
Interpretation and Visitor Services

Hours: 9:00–5:00 daily

Access: Open to public, purchase only
Reproduction Services: None
Size of Collection: 15 slides, 38 postcards, 1 poster (Robert E. Lee)

Major Holdings: CW—3S

U507. **VARIVA**

The Valentine Museum Library
Bransford-Cecil House
1015 E. Clay Street
Richmond, Virginia 23219
(no phone listed)

Access: Open to public; material is filed in cabinets and can be seen by those visiting the Library
Reproduction Services: None
Size of Collection: 25,000 photographs, negatives; several thousand prints, drawings, paintings
Special Collections: Emphasis on 19th c. to present-day Richmond; Cook Collection of photographic prints and negatives; Richmond landscapes and genre; collection of works of Virginia artists

Major Holdings: CW

U508. **VARIVH**

Virginia Historical Society
P.O. Box 7311
Richmond, Virginia 23221
(804) 358-4901
Mrs. Kenneth W. Southall

Hours: 9:00—5:00, M—F
Access: Open to public, scholars use only
Reproduction Services: Photocopy; color slides; 4x5, 5x7, 8x10 large format color transparencies; fee schedule
Size of Collection: 26,000 photographs, 100,000 negatives, 3,500 postcards

Major Holdings: C—1P, 3P, 3S; AR—1P, 3P, 3S; F—1P, 3P, 3S; AJ—1P, 3P, 3S; CW—3P, 3S

U509. **VARORV**

Roanoke Valley Historical Society
P.O. Box 1904 (mailing address)
10 Franklin Road
Roanoke, Virginia 24008
(703) 344-3418
Mrs. Harold P. Kyle, President

Hours: 11:00—5:00, Tu—Sa
Access: Open to public, open by appointment, use restricted
Reproduction Services: None
Size of Collection: 200+ photographs, 10 negatives, 50 slides, 300+ postcards, 100+ printing plates
Special Collections: Photographs and postcards covering Roanoke Valley; original photographs of early Roanoke with some copies

Major Holdings: I—1P, 1S; T—1P, 1S; ETW—1P, 1S; WWI—1P, 1S; TW—1P, 1S; GD—1P, 1S; WWII—1P, 1S; P—1P, 1S; AL—1P, 1S

U510. **VASTAW**

Woodrow Wilson Birthplace Foundation, Inc.
P.O. Box 24
Staunton, Virginia 24401
(703) 885-0897
Raymond F. Pisney, Executive Director

Hours: 9:00—5:00, M—F
Access: Open by appointment
Reproduction Services: Photographic prints, photocopy, catalog available, listings, fee schedule
Size of Collection: 1,000 photographs, 100 negatives, 800 slides, 24 films, 30 audiotapes

Major Holdings: T—4P, 4S; ETW—4P, 4S; WWI—4P, 4S

U511. **VASTRL**

Robert E. Lee Memorial Association, Inc.
Stratford, Virginia 22558
(804) 493-3882
Admiral T.E. Bass III, Executive Director

Hours: 9:00—5:00
Access: Open by appointment
Reproduction Services: None
Size of Collection: Photographs, slides, postcards, movie film

Major Holdings: C—1P, 1S, 4P, 4S

U512. **VASWC**

Sweet Briar College
Art History Department
Sweet Briar, Virginia 24595
(804) 381-5451
Aileen H. Laing, Chairman

Access: Only for use within the College for teaching and study; scholars only; students
Reproduction Services: None
Size of Collection: 4,000 photographs, 50,000 slides

Major Holdings: C—1P, 1S, 3P, 3S; AR—1P, 1S, 3P, 3S; F—1P, 1S, 2P, 2S, 3P, 3S; I—1P, 1S, 2P, 2S, 3P, 3S; ETW—1P, 1S, 2P, 2S, 3P, 3S; WWI—1P, 1S, 2P, 2S, 3P, 3S; TW—1P, 1S, 2P, 2S, 3P, 3S; GD—1P, 1S, 2P, 2S, 3P, 3S; WWII—1P, 1S, 2P, 2S, 3P, 3S; P—1P, 1S, 2P, 2S, 3P, 3S

U513. **VAWBNM**

George Washington Birthplace National Monument
Washington's Birthplace, Virginia 22575
(804) 224-1732
Don Thompson, Superintendent

Access: Slides and postcards available for purchase through Wakefield National Memorial Association, Washington's Birthplace, Virginia 22575
Reproduction Services: None
Size of Collection: Slides, postcards

Major Holdings: C—4S

U514. **VAWICW**ₐ
Colonial Williamsburg Foundation
Audiovisual Distribution Section
Audiovisual Library
Box C
Williamsburg, Virginia 23185
(804) 229-1000
Ray W. Martin, Manager
(Audiovisual Distribution Section)
Barbara R. Miller, Head
(Audiovisual Library)

Hours: 8:30–5:00, M–F
Access: Open to public, open by appointment, restricted use, students, purchase only for study and research, loan for reproduction
Reproduction Services: Photographic prints; photocopy; color slides; black and white slides; 4x5, 5x7, 8x10 large format color transparencies; catalog available; listings; fee schedule
Size of Collection: 125,000 photographs, 125,000 negatives, 50,000 slides, postcards, 29 films, 13 tapes and records, 10 filmstrips
Special Collection: Abby Aldrich Rockefeller Folk Art Collection (slides and photographs)
Major Holdings: C–1P, 1S, 3P, 3S, 4P, 4S; AR–1P, 1S, 2P, 2S, 3P, 3S, 4P, 4S; F–4P, 4S; TW–1P, 1S; GD–1P, 1S; WWII–1P, 1S; P–1P, 1S; M–3P, 3S; S–3P, 3S, 4P, 4S

U515. **VAWICW**ᵣ
Abby Aldrich Rockefeller
Folk Art Collection
P.O. Drawer C, Williamsburg
Williamsburg, Virginia 23185
(804) 229-1000
Barbara Luck, Registrar

Hours: Winter, 12:00–6:00; Summer, 10:00–9:00
Access: Photographs and slides available for study purposes only; postcards, reproductions and commercial slides also available at Colonial Williamsburg Foundation Information Center, 8:30–10:00
Reproduction Services: Photographic prints, color slides, 4x5 large format color transparencies, fee schedule
Size of Collection: Photographs of most objects in the collection; 40 slides available for commercial sales, others must be specially ordered; 14 postcards; 8 large color reproductions
Special Collections: American folk art of the 19th c. including paintings, sculpture, weathervanes, watercolors, furniture, quilts, and coverlets
Major Holdings: AR–2P, 2S, 3P, 3S, 4P, 4S; F–2P, 2S, 3P, 3S, 4P, 4S

U516. **VAWICW**ᵣₑ
Colonial Williamsburg Foundation/
Abby Aldrich Rockefeller Folk Art Collection

Audiovisual Library
Colonial Williamsburg Foundation
Williamsburg, Virginia 23185
(804) 229-1000, ext. 2286
Barbara R. Miller, Head Audiovisual Librarian

Hours: 8:30–5:00, M–F
Access: Open to public, open by appointment, restricted use
Reproduction Services: Photographic prints; photocopy; microfilm (research); color slides; black and white slides; 4x5, 5x7, 8x10 large format color transparencies; catalog available, sales stock only; listings, sales stock only; fee schedule available upon request to the Director of Press Bureau
Size of Collection: 79,800 photographs, 105,800 negatives, 36,000 slides (all as of 1970); sales stock postcards; complete films, original and work print outs and trims; sound tapes and film
Special Collections: Photographs recording the city of Williamsburg before restoration; progress of restoration within the city and obsolete and completion views of various buildings within the city
Major Holdings: C–1P, 1S, 3P, 3S, 4P, 4S; AR–1P, 1S, 3P, 3S, 4P, 4S; F–4P, 4S

WASHINGTON

U517. **WABERC**
Personal Collection, T. G. Reed
5264–148th Avenue S.E.
Bellevue, Washington 98006
(206) 745-1582
T. G. Reed

Access: Purchase only
Reproduction Services: Color slides
Size of Collection: 200 slides
Special Collections: Art in public places of Seattle, Spokane, and other sites in the state of Washington; includes fountains of George Tsutakawa, James Fitzgerald; architectural ornament; Harold Balaz's sculpture; murals

U518. **WAFLMM**
Fort Lewis Military Museum
Research Library
Main Street
Fort Lewis, Washington 98433
(206) 968-4796
Barbara A. Dierking, Museum Curator

Hours: 12:00–4:00, Tu–Su
Access: Open to public, restricted use
Size of Collection: 2,500 photographs, 200 postcards
Major Holdings: WM–3P; MW–3P; CW–3P; I–3P; T–3P; ETW–3P; WWI–3P; TW–3P; WWII–3P; P–3P

U519. WALCSC

Skagit County Historical Society Museum
P.O. Box 32
La Conner, Washington 98257
(206) 466-3365
Elva Mary Giard, Director

Access: Appointment only, restricted use
Reproduction Services: Photographic prints, fee schedule
Size of Collection: 2,500 photographs, 150 slides, 100 postcards
Special Collections: With a Washington State Bicentennial Grant a committee is compiling a countywide series of slides of historic buildings to be loaned to schools, colleges and groups, including a taped commentary; edited and ready for use by Fall 1975

Major Holdings: AI–1P; AE–1P; WM–1P, 3P; CW–4P; WI–1P; I–1P, 1S; T–1P, 1S; ETW–1P, 1S; WWI–1P; TW–1P; GD–1P; AL–1P, 1S; M–1P

U520. WARPRA

Roslyn Arts
New Photographic Exhibits
Box 511
Roslyn, Washington 98926
James Sahlstrand, President

Access: Purchase only
Size of Collection: 240 slides (per exhibit annually)
Special Collections: Annual national photographics exhibits

U521. WASEMH

Museum of History and Industry
Sophie Frye Bass Library
2161 E. Hamlin Street
Seattle, Washington 98112
(206) 324-1125
Bertha N. Stratford, Librarian

Hours: 11:00–5:00, Tu–F
Access: Open to public
Reproduction Services: Photographic prints
Size of Collection: 14,000 photographs, 7,000 negatives, 2,500 slides
Special Collections: History of Seattle and the Pacific Northwest, including Alaska Maritime history and reference

U522. WASESM

Seattle Art Museum
Slide Library and Photograph Collection
Volunteer Park
Seattle, Washington 98112
(206) 447-4789
Jo H. Nilsson

Hours: 9:00–5:00, M–F; 10:00–1:00, Sa
Access: Open to public
Reproduction Services: Photographic prints; color and black and white slides; 4x5, 5x7 large color or format transparencies (selected items only); fee schedule
Size of Collection: 20,000 photographs, 9,600 negatives, 50,000 slides, films
Special Collections: Local northwest artists of the 20th c.; paintings, sculpture, and prints

Major Holdings: AI–4P, 4S; C–3P, 3S, 4P, 4S; WI–3P, 3S; I–3P, 3S; WWI–4P, 4S; TW–4P, 4S; GD–4P, 4S; WWII–4P, 4S; P–3P, 3S, 4P, 4S

U523. WASEUW_su

University of Washington
Suzallo Library Special Collections,
 Photography Collection
Seattle, Washington 98195
(206) 543-0742
Robert D. Monroe, Head,
 Special Collections Division

Hours: 8:00–12:00 and 1:00–5:00 M–F
Access: Open to public
Reproduction Services: Photographic prints, microfilm, fee schedule
Size of Collection: 157,541 photographs, 44,792 negatives, 60,000 postcards
Special Collections: Viola Garfield Totem Culture Collection; Elmer Fisher architecture collection; architecture study collection (1800–1929); public works of art collection, Washington State (1930s); Dearborn-Massar Archive (1943–1968); photographs and negatives

Major Holdings: AI–1P, 2P, 3P; I–1P; T–1P; ETW–1P; WWI–1P; TW–1P; GD–2P, 3P; WWII–1P; P–1P

U524. WASEUW_sa

University of Washington
School of Art, Slide Collection
120 Art Building
Seattle, Washington 98195
(206) 543-0649
Mildred E. Thorson, Slide Curator

Access: Restricted use; faculty, art museum personnel, teaching assistants only
Reproduction Services: Photocopy, color and black and white slides
Size of Collection: 140,000 slides
Special Collections: Civic art of Washington State, photographed by Professor Gervais Reed; color slides of art deco architecture of Seattle, photographed by Professor Howard Kottler; Carnegie set of *Arts of the United States*

Major Holdings: AI–2S, 3S, 4S; C–1S, 2S, 3S, 4S; AR–1S, 2S, 3S, 4S; F–1S, 2S, 4S; AJ–1S, 2S, 3S, 4S; WM–3S, 4S; CW–3P, 4S; I–1S, 2S, 3S, 4S; T–1S, 2S, 3S, 4S; ETW–1S, 2S, 3S, 4S; WWI–1S, 2S, 3S, 4S; TW–1S, 2S, 3S, 4S; GD–1S, 2S, 3S, 4S; WWII–1S, 2S, 3S, 4S; P–1S, 2S, 3S, 4S; E–1S, 4S

U525. **WASPEW**

Eastern Washington State Historical Society
Joel E. Ferris Memorial Library
W. 2316 First Avenue
Spokane, Washington 99204
(504) 456-3931
Elinor C. Kelly, Librarian

Hours: 10:00–5:00, Tu–Sa; 2:00–5:00, Su (Museum)

Access: Open to public, purchase available

Reproduction Services: Photocopy, photo prints made by local studio, fee

Size of Collection: 13,000 photographs, 3,000 negatives, 7,600 slides, 2,000 postcards, World War posters, 6 hours videotape on local history, Expo '74 records

Special Collections: Slide collection documents Northwest Indian artifacts held by museum; Expo '74 slides cover the activities, building, grounds of Expo; photography collection is primarily of the geographic area of the Inland Empire, with emphasis on the city of Spokane; art slide collection of both contemporary and traditional art

Major Holdings: AI–1P; T–1P, 1S; ETW–1P; TW–1P; GD–1P

U526. **WATAFN**

Fort Nisqually Museum
Ft. Nisqually, Pt. Defiance Park
Tacoma, Washington 98407
T. S. Bishop

WEST VIRGINIA

U527. **WVCHAG**

The Charleston Art Gallery of Sunrise
755 Myrtle Road
Charleston, West Virginia 26314
(304) 344-8035
Mrs. Mary Black, Curator of Fine Arts

Hours: Open by appointment

Access: Restricted use

Size of Collection: 3,500 slides

Special Collections: Heterogeneous collection of American art slides

U528. **WVHUHG**

Huntington Galleries
Park Hills
Huntington, West Virginia 25701
(304) 529-2701
Bernice A. Dorsey, Librarian

Hours: 10:00–4:00, M–Sa; 1:00–4:00, Su

Access: Open to public

Reproduction Services: Will supply slides of specific works upon request

Size of Collection: Slides

Major Holdings: AI–2S, 4S; F–4S; I–3S; T–3S; ETW–3S

U529. **WVLEFS**

Fort Savannah Museum
204 N. Jefferson
Lewisburg, West Virginia 24901
(304) 645-3055
Mrs. Rosalie S. Detch

Access: Open to public

Size of Collection: 150 postcards

Major Holdings: AI–4; C–4;AR–4; ETW–4; WWI–4

WISCONSIN

U530. **WIBACW**

Circus World Museum
Circus World Museum Library
Baraboo, Wisconsin 53913
(608) 356-8341
Robert L. Parkinson, Librarian and Historian

Hours: 8:00–5:00, M-F

Access: Open to public

Reproduction Services: Photographic prints, limited photocopy, color slides, 4x5 large format color transparency, catalog available in library only, fee schedule mailed on request

Size of Collection: 25,000 photographs, 13,000 negatives, 500 slides

Special Collections: Photographs of circus lithographs, beautifully carved circus wagons

Major Holdings: E–1P, 1S, 2P, 2S, 3P, 3S, 4P, 4S

U531. **WIKEGT**

Gateway Technical Institute
Learning Resource Center
3520 30th Avenue
Kenosha, Wisconsin 53140
(414) 658-4371
Gerald F. Perona, Reference Librarian

Hours: 8:00–5:00, M–F; 6:30–8:30, M–Th

Access: Open to public; residents of Kenosha, Racine, and Walworth counties may borrow; others by permission only

Reproduction Services: None

Size of Collection: 3,000 slides, 50 35mm filmstrips

Special Collections: Furniture, interior design, ornamentation, silverware, pottery, stained glass, glassware, costume design, floral art and design

Major Holdings: C–1S, 4S; AR–4S; F–1S, 4S; AJ–4S; CW–4S; I–1S, 4S; T–1S, 4S; ETW–1S, 4S; TW–1S, 4S; GD–1S, 4S; P–1S, 4S

U532. **WILCVC**

Viterbo College
Art Department
La Crosse, Wisconsin 54601
(608) 785-3450
Sister Carlene Unser, Chairman [cont.]

Hours: By appointment
Access: Restricted use
Reproduction Services: Color slides, can do color duplication
Size of Collection: ca. 6,000 slides
Special Collections: Strong in 20th c. painting
Major Holdings: AI—3S; T—1S; GD—1S, 3S; WWII—1S, 3S; P—3S

U533. WIMASH
State Historical Society of Wisconsin
Iconographic Collections
816 State Street
Madison, Wisconsin 53706
(608) 262-9581
George Talbot, Curator

Hours: 8:00—5:00, M—F
Access: Open to public and by appointment
Reproduction Services: Photographic prints; photocopy; microfilm; color slides; black and white slides; 4x5, 5x7, 8x10 large format color transparencies; fee schedule
Size of Collection: 500,000 images, 250,000 negatives
Special Collections: Local amateur and professional photographers, such as Charles Van Schalck collection of photographs; Hillier's portfolio of personal accounts of W. H. Jackson; midwest history; life and culture; also local Wisconsin history and culture; World War II, 1940—1945; historic prints; costume plates
Major Holdings: AI—3P, 3S, 4P, 4S; C—3P, 4P, 4S; F—3P, 4P; AJ—4P; WM—3P, 4P; MW—1P, 4P; CW—1P, 3P, 4P; WI—1P, 3P, 4P; I—1P, 3P, 4P; T—1P, 3P, 4P; ETW—1P, 3P, 4P; WWI—1P, 3P, 4P; TW—1P, 3P, 4P; GD—1P, 4P; WWII—1P, 3P, 4P; P—1P; SA—1P; AL—3P, 4P; E—3P, 4P

U534. WIMAUW
University of Wisconsin, Madison
Slide Library, Department of Art History
314 Elvehjem Art Center
Madison, Wisconsin 53706
(608) 263-2288
Christine L. Sundt, Slide Librarian

Access: Restricted use
Reproduction Services: None
Size of Collection: 10,000 photographs, 165,000 slides
Special Collections: Complete black and white set of photographs by James Austin of Romanesque and Gothic architecture and sculpture in France; Romanesque architecture and sculpture in Italy
Major Holdings: C—1S, 2S, 3S; AR—1S, 2S, 3S; F—1S, 2S, 3S; AJ—3S; WM—3S; CW—3S; I—3S; ETW—1S, 3S; WWI—3S; TW—1S, 3S; GD—1S, 3S; P—1S, 3S; SA—3S; AL—3S; M—3S

U535. WIMIMC
Milwaukee Art Center
Milwaukee Art Center Library
750 N. Lincoln Memorial Drive
Milwaukee, Wisconsin 53202
(414) 271-9508
Betty Karow, Librarian

Access: Open by appointment, purchase only, rent or purchase educational packets of 20—40 slides each
Reproduction Services: Photographic prints; fee schedule, arrange through registrar
Size of Collection: 150 photographs, 4,000 slides
Special Collections: American decorative arts, mostly furniture (850 slides kept at Villa Terrace, decorative arts museum)
Major Holdings: AI—3P, 3S; AE—3P; C—2P, 3P, 3S, 4S; AR—3P, 3S, 4S; F—2P, 2S, 3P, 3S, 4S; W—3P; AJ—2P, 2S, 3P, 4S; WM—2P, 2S, 3P, 3S; MW—2P, 2S, 3P, 3S; CW—2P, 2S, 3P, 3S; I—2P, 2S, 3P, 3S; 4S; T—1P, 2P, 2S, 3P, 3S; ETW—1P, 2P, 2S, 3P, 3S; WWI—1P, 2P, 2S, 3P, 3S; P—1P, 1S, 2P, 2S, 3P, 3S

U536. WIMIOI
Old Indian Agency House
7820 North Club Circle
Milwaukee, Wisconsin 53217
(414) 352-7213
Mrs. Stanley Stone, Chairman

Hours: 9:00—5:00
Access: Open to public, in winter open by appointment
Reproduction Services: None
Size of Collection: 12 slides, 12 postcards
Major Holdings: AJ—4P, 4S

U537. WIRFUW
University of Wisconsin, River Falls
Art History Slide Collection
Fine Arts Building
River Falls, Wisconsin 54022
(715) 425-3308
Dr. John J. Bushen

Access: Open by appointment, restricted use, scholars only, students
Reproduction Services: Color slides
Size of Collection: 3,000 American slides, 8,000 other slides
Major Holdings: AI—1S, 2S, 3S, 4S; AE—1S, 2S, 3S, 4S; C—1S, 2S, 3S, 4S; AR—1S, 2S, 3S, 4S; F—1S, 2S, 3S, 4S; W—1S, 2S, 3S, 4S; AJ—1S, 2S, 3S, 4S; WM—1S, 2S, 3S, 4S; MW—1S, 2S, 3S, 4S; CW—1S, 2S, 3S, 4S; WI—1S, 2S, 3S, 4S; I—1S, 2S, 3S, 4S; T—1S, 2S, 3S, 4S; ETW—1S, 2S, 3S, 4S; WWI—1S, 2S, 3S, 4S; TW—1S, 2S, 3S, 4S; GD—1S, 2S, 3S, 4S; WWII—1S, 2S, 3S, 4S; P—1S, 2S, 3S, 4S

U538. **WISPUW**

University of Wisconsin, Stevens Point
Art Department
Fine Arts Building
Stevens Point, Wisconsin 54481
(715) 346-2839

Hours: Varies, "whenever historians are present"
Access: Restricted use, students have limited use
Reproduction Services: Color slides
Size of Collection: 20,000 slides

Major Holdings: AI–2S, 4S; C–1S, 2S, 3S, 4S; AR–1S, 2S, 3S, 4S; F–1S, 2S, 3S, 4S; W–1S, 2S, 3S, 4S; AJ–1S, 2S, 3S, 4S; WM–1S, 2S, 3S, 4S; MW–1S, 2S, 3S, 4S; CW–1S, 2S, 3S, 4S; WI–4S; I–1S, 2S, 3S, 4S; T–1S, 2S, 3S, 4S; ETW–1S, 2S, 3S, 4S; WWI–1S, 2S, 3S, 4S; TW–1S, 2S, 3S, 4S; GD–3S; WWII–1S, 2S, 3S, 4S; P–1S, 2S, 3S, 4S; SA–1S, 2S, 3S, 4S

WYOMING

U539. **WYBHBB**

Bradford Brinton Memorial Museum
Box 23
Big Horn, Wyoming 82833
(307) 672-3173
James T. Forrest, Director

Hours: May 15–Labor Day, 9:00–5:00
Access: Open to public, restricted use (May 15–Labor Day); open by appointment, restricted use (Labor Day–May 14)
Reproduction Services: Photographic prints, color slides, 4x5 color transparencies; listings and fee schedule on request

Major Holdings: AI–3P, 3S; WM–2P, 2S, 3P, 3S; ETW–2P, 3P; TW–3P; AL–3P

U540. **WYGRSC**

Sweetwater County Historical Museum
50. W. Flaming Gorge Way
P.O. Box 25
Green River, Wyoming 82935
(307) 875-2611 ext. 47
Henry F. Chadey, Director

Hours: 10:00–4:30, M–F
Access: Open to public, by appointment
Reproduction Services: Photographic prints, photocopy
Size of Collection: 8,000 photographs, 200 negatives, 200 slides, 100 postcards

Major Holdings: T–4P; ETW–4P; WWI–4P; TW–1P, 4P; GD–4P; WWII–4P; P–1P, 4P; AL–1P

U541. **WYLAUW**

University of Wyoming
Art Department Slide Room
Box 3138, University Station
Laramie, Wyoming 82070
(307) 766-3371
Herb Gottfried, Head

Hours: 9:00–12:00, M–F
Access: Restricted to faculty and students
Reproduction Services: None
Size of Collection: 5,837 slides

Major Holdings: AI–4S; C–1S, 3S, 4S; AR–1S, 3S, 4S; F–1S, 3S, 4S; AJ–1S, 2S, 3S, 4S; WM–1S, 2S, 3S, 4S; CW–1S, 2S, 3S, 4S; T–1S, 2S, 3S, 4S; ETW–1S, 2S, 3S, 4S; TW–1S, 2S, 3S, 4S; GD–1S, 2S, 3S, 4S; WWII–1S, 2S, 3S, 4S; P–1S, 2S, 3S, 4S

U542. **WYNEAM**

Anne Miller Museum
P.O. Box 698
Newcastle, Wyoming 82701
(307) 746-4188
Mary A. Capps, Director

Hours: 9:00–5:00, M–F
Access: Open to public, restricted use
Reproduction Services: None
Size of Collection: 2,000 photographs, 1,200 slides
Special Collections: Local history of Weston County, Wyoming

Major Holdings: WM–1P, 1S, 4P, 4S; ETW–1P, 1S; AL–1P, 1S, 4P, 4S

U543. **WYWAWM**

Warren Military Museum
P.O. Box 9625
Francis E. Warren Air Force Base, Wyoming 82001
(307) 775-2331 or 775-3452
A. C. Einbeck, Director

Hours: July–September, 10:00–4:00 daily; year round, 1:00–4:00, Su
Access: Open to public by appointment
Reproduction Services: None
Size of Collection: 500 photographs, 150 negatives, 30 slides, postcards, 2 16mm films

Major Holdings: T–1P; TW–4P; SA–4P, 4S

U544. **WYYENP**

National Park Service
Yellowstone National Park Collection
Yellowstone National Park, Wyoming 82190
(307) 344-7831
Jack K. Anderson, Superintendent

Hours: 8:00–5:00 daily
Access: Open to public
Reproduction Services: Photographic prints, color slides
Size of Collection: 2,400 photographs, 10,000 negatives, 1,000 slides
Special Collections: Photographs and slides of Yellowstone National Park

THE SUBJECT HANDLIST

Chronological List of Subjects

Subjects listed here are those by which major holdings of institutions were classified. These subjects are listed here chronologically to show historical periods and topics.

AMERICAN INDIAN (AI)
AGE OF EXPLORATION (AE)
COLONIAL PERIOD: 1620–1770 (C)
AMERICAN REVOLUTION: 1770–1790 (AR)
FEDERAL PERIOD: 1790–1812 (F)
WAR OF 1812 (W)
AGE OF JACKSON, CLAY, AND CALHOUN:
 1828–1850 (AJ)
WESTWARD MOVEMENT (WM)
MEXICAN WAR: 1848 (MW)
CIVIL WAR: 1860–1865 (CW)
WAVES OF IMMIGRATION (WI)
INDUSTRIAL EXPANSION: 1865–1910 (I)
TURN OF THE CENTURY/SPANISH-AMERICAN WAR:
 1880–1910 (T)
EARLY TWENTIETH CENTURY: 1910–1914 (ETW)
WORLD WAR I: 1914–1918 (WWI)
NINETEEN TWENTIES (TW)
GREAT DEPRESSION: 1930–1940 (GD)
WORLD WAR II: 1940–1945 (WWII)
POSTWAR AMERICA: 1946— (P)
SPACE AGE (SA)
AGRICULTURAL LIFE (AL)
MARITIME LIFE (M)
SPORTS (S)
ENTERTAINMENT (E)

Alphabetical List of Subjects

Subjects listed here are those by which major holdings of institutions were classified. This handlist indexes—*under the individual subject heading*—institutions with substantial holdings of pictorial materials for the specific historical period or topic. Subjects are presented in the handlist alphabetically, as shown in the following list. An explanation of the institution code letters and subscripts is given in the introductory Readers' Guide to Use of the Inventory and Handlist.

AGE OF EXPLORATION (AE) U545
AGE OF JACKSON, CLAY, AND CALHOUN: U546
 1828–1850 (AJ)
AGRICULTURAL LIFE (AL) U547
AMERICAN INDIAN (AI) U548
AMERICAN REVOLUTION: 1770–1790 (AR) U549
CIVIL WAR: 1860–1865 (CW) U550
COLONIAL PERIOD: 1620–1770 (C) U551
EARLY TWENTIETH CENTURY: 1910–1914 (ETW) U552
ENTERTAINMENT (E) U553
FEDERAL PERIOD: 1790–1812 (F) U554
GREAT DEPRESSION: 1930–1940 (GD) U555
INDUSTRIAL EXPANSION: 1865–1910 (I) U556
MARITIME LIFE (M) U557
MEXICAN WAR: 1848 (MW) U558
NINETEEN TWENTIES (TW) U559
POSTWAR AMERICA: 1946— (P) U560
SPACE AGE (SA) U561
SPORTS (S) U562
TURN OF THE CENTURY/SPANISH-AMERICAN WAR: U563
 1880–1910 (T)
WAR OF 1812 (W) U564
WAVES OF IMMIGRATION (WI) U565
WESTWARD MOVEMENT (WM) U566
WORLD WAR I: 1914–1918 (WWI) U567
WORLD WAR II: 1940–1945 (WWII) U568

U545. AGE OF EXPLORATION (AE)

AZPHP	NJCATE
$AZTEU_{av}$	NJCHVM
AZTUMM	NJCLKC
CABURPL	NJNERU
CALAS	NMALUN
CALASC	NYALOA
CALAUS	NYALSU
CAOKO	NYBRBC
CASBUC	NYEXCC
CASFSU	NYNYAH
CTHAWA	NYNYBA
CTYUAA	NYNYGC
DCCFAB	NYNYLU
DCCFAL	NYNYMC
DCNAR	NYNYMM
DCSmHT	NYNYPL
FLTAFS	NYNYTH
	NYNYTI
GAATCHA	NYRoIM
HIHOAA	$NYSYS_g$
ILCHUI	NYWEUS
$ILCUI_{va}$	$OKNOU_s$
ILDKNI	OLPCCC
ILEVNW	OREUOS
INBLUS	PAEPTU
KYLOUL	PAPHFL
LANOLS	PAPHHS
MABOAC	$PAPHUP_f$
MABOCA	$RIPRRI_l$
MABOHS	SDPISH
MABOPR	TNMEMA
MACAFO	TNMESU
MASTKC	
MASTUV	TXSNTC
MDBAMI	TXWASR
MDBAUM	VANNMM
MDCPUM	VARIVC
$MEBRBC_{da}$	VTBUUV
$MIAAUM_{sp}$	WALCSC
MIALBC	WIMIMC
MIDEWS	WIRFUW
MNMPPLA	
$MOSLWU_l$	
MSJAAH	
MTBIWA	
NCRANC	
NCRASU	
NDFASU	
$NEOMJA_r$	

U546. AGE OF JACKSON, CLAY, AND CALHOUN: 1828–1850 (AJ)

ALMOC	GAATCHA	$MEBRBC_{da}$	NYRoIM	VAHRMC
ALUNI	GAATIT	MECASS	NYRoRI	VALXWL
ALMOOP	HIHOAA	MEPOSA	NYSeLI	VAPAOS
ARLRA	IADMAC	$MIAAUM_{av}$	NYSESP	VARIVC
AZPHP	$ILCHAI_{sp}$	$MIAAUM_{sp}$	$NYSYS_g$	VARIVH
CABURPL	ILCHRO	MIALBC	NYTRRC	$VAWICW_a$
CABVAR	ILCHSVE	MIDEMC	NYTRRP	VTBUUV
CACLS	ILCHUC	MIDEME	NYURMW	VTWOWH
CALABK	ILCHUI	MIDEWS	NYWPCH	$WASEUW_{sa}$
CALAS	$ILCUI_{va}$	MIGPWA	OHCFEA	WIKEGT
CALASC	ILDKNI	MIKAWM	OHCLCI	WIMASH
CAOKM	ILNDSU	MIMAHS	OHCLCM	WIMIMC
CAOKO	ILSPSM	MNMPIA	OHCOOS	WIMIOC
CARIAC	INBLUS	MNMPPLA	OHMPHC	WIRFUW
CASBUC	ININHE	$MOCOUM_{mu}$	$OKNOU_s$	WISPUW
CASCSU	$ININMA_{sc}$	MOLAWM	OREUOS	WYLAUW
CASCUC	INMUBS	MOSJMW	ORPAM	
CASFAI	INNDU	$MOSLWU_l$	PAALAM	
CASFSU	INTHSU	MSJAAH	PABMC	
CASJSU	$KSLANK_s$	NCCHUN	PACOUC	
CASTUA	LABRAA	NCRANC	PAEPTU	
CODVMC	LANOLS	NCRASU	PALUCB	
CODVMS	LASHNA	NHPOSB	PAPHFL	
CTHAS-D	MABOAC	NJCATE	PAPHHS	
CTHAWA	MABOBS	NJCHVM	PAPHIC	
CTLIHS	MABOCA	NJCLKC	PAPHLC	
CTMIWU	MABODS	NJMOMA	PAPHPA	
CTNBCC	MABOFA	NJNENM	PAPHPC	
CTNBMA	MABOHS	$NJPRPU_m$	PAPHPH	
$CTNHB_u$	MACAFO	NMALUN	$PAPHPM_p$	
CTSTSA	MACAIT	NYALOA	$PAPHUP_f$	
CTYUAA	MAMICT	NYALSU	PAPICI	
DCAIA	MANAHS	NYBISU	PAPICL	
DCCFAB	MANATX	NYBRBC	$PAPIUP_f$	
DCCFAL	$MANHFL_a$	NYBRBM	RIEPBU	
DCCFAP	$MANHSC_m$	NYESDU	$RIPRRI_l$	
DCDAR	$MANOSM_l$	NYGEGH	$RIPRRI_m$	
DCGWU	MAPEHS	NYNYAH	SCCHGA	
DCHAER	MASAEI	NYNYBA	SCCHSC	
DCNAR	MASTKC	NYNYBO	TNMEBM	
DCNGAS	MASTUV	NYNYCU	TNMEMA	
DCNPG	MAWOAA	NYNYFA	TNMESU	
DCNPGC	MDBAHS	NYNYGC	TNNAVU	
DCNTHP	MDBAJA	NYNYHF	TXAUUT	
DCSmHT	MDBAMI	NYNYHS	TXCCAM	
DCSMPS	MDBAPM	NYNYLU	TXFWKM	
DEWIMU	MDBAUM	NYNYMC	TXHOMFA	
FLGAUF	MDBAWA	NYNYMM	TXHORU	
FLPEWM	MDCPUM	NYNYPL	$TXHOUH_a$	
FLSPMU		NYNYTH	TXWASR	
FLTAFS		NYNYTI		

U547. AGRICULTURAL LIFE (AL)

AZFLN
AZPHP
AZPRS
AZPRSM
AZTEU$_{av}$
CABRAR
CABURPL
CADEH
CALASC
CAOKM
CAOKO
CAOOG
CAPOPL
CARDS
CARVU
CASBUC
CASFG
CASFSU
CASVHC
CAVNHM
CODVMC
CODVMS
CODVPL
CTHAWA
CTNBMA
CTNHB$_u$
CTSTSA
DCCFAB
DCCFAL
DCCFAP
DCGWU
DCNPGC
DCSmHT
DCSMPS
FLPBFM
FLPEWM
HIHOAA
HIHOBM
IADRNA
IAICSHS
IDBSHS
ILCHUC
ILCHUI
ILCUI$_{va}$
ILEVNW
ILOTHS
ININHE
ININMA$_{sc}$
INPLMC

KSASPM
KSHASCL
KYBERC
KYBGWK
LANOLS
MABOAC
MABOCA
MABOPR
MACAFO
MANHSC$_m$
MAPEHS
MASTKC
MDBAHS
MDBAPM
MDBAUM
MDCPUM
MIAAUM$_{av}$
MIALBC
MIDEWS
MIKAWM
MIMAHS
MIMPPLA
MOSJMW
MOSLWU$_1$
MSSAAH
NCCHUN
NCRANC
NDFASU
NERCWC
NJCATE
NJWOGC
NMSFMN
NYALOA
NYEMNC
NYETEC
NYEXCC
NYNYAH
NYNYBA
NYNYGC
NYNYLU
NYNYMC
NYNYMM
NYNYMU$_d$
NYNYPL
NYNYTH
NYNYTI
NYRoIM
NYRoRI
NYSYSU$_a$
NYSYS$_g$
NYTRRP

NYUTMW
OHBUGC
OHCLCM
OHCOOS
OHLIAC
OREUO
PACHBR
PALDFS
PALUCB
PAPHFL
PAPHPC
RIPRRI$_1$
SCCHGA
SCCHSC
SDPISH
TNMEBM
TNMEMA
TNMESU
TXPHCC
TXSNTC
TXWASR
VAHABT
VAPAOS
VARIVC
VARORV
VTBUUV
WALCSC
WIMAUW
WYBHBB
WYGRSC
WYNEAM

U548. AMERICAN INDIAN (AI)

AKSIT
ALMOC
ALUNI
AZPHP
$AZTEU_{av}$
AZTOT
AZTUA
AZTUMM
AZWRN
CABRM
CABRU
CABURPL
CABVAR
CACLS
CALAB
CALABK
CALAS
CALASC
CAOKM
CAOLO
CAOOG
CARDS
CARIAC
CARVU
CASBUC
CASCSU
CASCUC
CASFAI
CASFSU
CASTUA
CASTUM
CAVEEC
CODVME
CODVMS
CODVPL
COSTOT
CTHAWA
CTMIWU
CTNBCC
$CTNHB_u$
CTYUAA
CTYUBW
DCCFAB
DCCFAL
DCCFAP
DCGWU
DCNAR
DCNGA
DCNPG
DCNPGC

DCSmHT
DCSMPS
DEWIMU
FLCGUM
FLGAUF
FLPEWM
FLSPMU
FLTAFS
GAATCHA
GAATIT
HIHOAA
IADMAC
IAICSHS
IDBSHS
ILCHAI
ILCHRO
ILCHUI
$ILCUI_{va}$
ILDKNI
ILEVNW
ILNDSU
INBLUS
ININHE
ININMA
$ININMA_{sc}$
INMUBS
INNDU
KSARCH
KSFRHS
$KSLANK_s$
KYLOUL
LANOLS
LASHNA
MABOAC
MABOCA
MABOFA
MACAFO
MACAPM
MANHSCM
$MANOSM_l$
MASTKC
MAWOAM
MDBAMI
MDBAUM
MDCPUM
$MEBRBC_{da}$
MECASS
MEPOSA
$MIAAUM_{av}$
$MIAAUM_{sp}$

MIALBC
MIDEME
MIDEWS
MIKAWM
MNMABE
MNMPIA
MNMPPLA
$MNMPWA_e$
MOSJMW
MOSLAM
$MOSLWU_1$
MSJAAH
MTBIWA
MTMIUM
NCCHUN
NCHPHP
NDFASU
NECRFR
$NEOMJA_r$
NERCWC
NJCATE
NJCHVM
NJCLKC
NJMOMA
$NJPRPU_m$
NMALUN
NMAZAZ
NMSFMN
NVRENH
NYALOA
NYALSU
NYBISU
NYBRBC
NYBRBM
NYEXCC
NYEXEC
NYJAYC
NYNYAH
NYNYBA
NYNYGC
NYNYHA
NYNYHS
NYNYLU
NYNYMC
NYNYMM
$NYNYMU_d$
NYNYMV
NYNYPL
NYNYTH
NYNYTI

NYOGRA
NYRoIM
NYRoRI
$NYSYS_g$
NYTRRP
NYWEUS
NYYOHR
OHCHMC
OHCIPL
OHCLCI
OHCLCM
OHCOOS
OHSPCC
OHYOBI
OKBPI
OKBWM
$OKNOU_s$
OKNOUM
OKPCCC
OLTACH
OREUO
OREUOS
ORPAM
PACHBR
PACLSC
PAEPTU
PAPHFL
PAPHHS
PADHPC
$PAPHPM_p$
$PAPHUP_f$
$PAPHUP_m$
PAPICL
$PAPIUP_f$
$RIPRRI_1$
$RIPRRI_m$
SDBRSD
SDPISH
SDSFIM
SDVEOM
TNCHUT
TNMECM
TNMEMA
TNMESU
TNMAVU
TXAUUT
TXCCAM
TXFDHS
TXFWCM
TXHOMFA

TXHORU
$TXHOUH_a$
$TXHOUH_f$
TXPHCC
TXSNTC
TXWASR
VAHRMC
VAPAOS
VARIVC
VTBUUV
WALCSC
WASESM
$WASEUW_{sa}$
WASPEW
WILCVC
WIMASH
WIMIMC
WIRFUW
WISPUW
WVLEFS
WVHUHG

U549. AMERICAN REVOLUTION: 1770–1790 (AR)

ALMOC	DEWIMU	MAWOAM	NYJAYC	SCCHGA
ALUNI	FLCGUM	MDBAMI	NYNYAH	SCCHSC
ARLRA	FLGAUF	MDBAHS	NYNYBA	TNMEMA
AZPHP	FLPEWM	MDBAJA	$NYNYCU_a$	TNMESV
$AZTEU_{av}$	FLTAFS	MDBAPM	NYNYGC	TNNAVU
CABRAR	GAATCHA	MDBAUM	NYNYFA	TXAUUT
CABRU	GAATIT	MDCPUM	NYNYHF	TXCCAM
CABURPL	HIHOAA	$MEBRBC_{da}$	NYNYHS	TXFWKM
CACAC	IADMAC	$MEBRBC_{ma}$	NYNYLU	TXHOMFA
CACLS	$ILCHAI_{me}$	MECASS	NYNYMC	TXHORU
CALABK	$ILCHAI_{sp}$	MEPOSA	NYNYMM	$TXHOUH_a$
CALAS	ILCHRO	$MIAAUM_{av}$	NYNYPL	TXSNTC
CALASC	ILCHSVE	$MIAAUM_{sp}$	NYNYTH	UTBRBC
CALAW	ILCHUC	MIALBC	NYNYTI	VAHRMC
CAOKM	ILCHUI	MIDEMC	NYRoRI	VALXWL
CAOKO	$ILCUI_{va}$	MIDEWS	NYSeLI	VAPAOS
CARIAC	ILDKNL	MIGPWA	NYSESP	VARIVC
CARVU	ILEVNW	MIKAWM	$NYSYS_g$	VARIAP
CASBUC	ILNDSU	MNELVC	NYTRRP	VARIVH
CASCSU	INBLUS	MNMPIA	NYUTMW	VASWC
CASCUC	ININHE	MNMPPLA	NYWEUS	$VAWICW_a$
CASFAI	$ININMA_{sc}$	MOSJMW	NYOHR	$VAWICW_r$
CASFSU	INMUBS	$MOSLWU_l$	NYWPCH	VTBUUV
CASJSU	INNDU	NCCHUN	OHCIPL	$WASEUW_{sa}$
CODVMC	INTHSU	NCGRGC	OHCLCI	WIKEGT
CODVME	INWLPU	NCHPHP	OHCLCM	WIMAUW
CODVMS	$KSHASC_a$	NCRANC	OHCOOS	WIMIMC
CTFAM	$KSLANK_s$	NCRASU	OHYOBI	WIRFUW
CTHAWA	KYLOUL	NCWSME	$OKNOU_s$	WISPUW
CTLIHS	LABRAA	NDFASU	OREUOS	WVLEFS
CTMIWU	LASHNA	$NEOMJA_r$	ORPAM	WVLAUW
CTNBCC	MABOAC	NHPOSB	PABMC	
CTNBMA	MABOBS	NJCATE	PACHBR	
$CTNHB_u$	MABOCA	NJCHVM	PACLSC	
CTSTSA	MABOFA	NJCLKC	PAEPTU	
CTYUAA	MABOHS	NJFRMC	PAGRWC	
DCAIA	MABOPR	NJMOMA	PAPHFL	
DCCFAB	MACAFO	NJNENM	PAPHHS	
DCCFAL	MACAIT	NJNERU	PAPHIC	
DCCFAP	MALXAS	NJPABC	PAPHCL	
DCDAR	MANAHS	$NJPRPU_m$	PAPHPA	
DCGWU	$MANHSC_m$	NJWOGC	PAPHPC	
DCNAR	$MANOSM_l$	NMALUN	PAPHPH	
DCNGAE	MASAEI	NYALOA	$PAPHPM_p$	
DCNGAI	MASTKC	NYALSU	$PAPHUP_f$	
DCNGAS	MASTUV	NYBISU	PAPICL	
DCNPG	MAWAGP	NYBRBC	$PAPIUP_f$	
DCNPGC	MAWOAA	NYBRBM	PAVFHS	
DCNTHP		NYESDU	RIEPBU	
DCSmHT		NYEXCC		
DCSMPS		NYEXEC		

U550. CIVIL WAR: 1860–1865 (CW)

ALMOC	GAATCHA	MEBRBC$_{da}$	NYNYMC	TXFWKM
ALMOOP	GAATHS	MEBRBC$_{ma}$	NYNYMM	TXHOMFA
ARLRA	GAATIT	MIAAUM$_{av}$	NYNYMU$_d$	TXHORU
AZPHP	HIHOAA	MIAAUM$_{sp}$	NYNYPL	TXHOUH$_a$
AZTEU$_{av}$	IADMAC	MIALBC	NYNYTH	TXSNTC
CABRAR	IAICHS	MIDEMC	NYNYTI	TXWASR
CABURPL	IAICSHS	MIDEME	NYRoIM	VAHBT
CACLS	ILCHAI$_{sp}$	MIDEWS	NYRoLS	VAHRMC
CALABK	ILCHRO	MIGPWA	NYRoRI	VAPAOS
CALAS	ILCHUI	MIKAWM	NYSYS$_g$	VARIVC
CALASC	ILCUI$_{va}$	MIMAHS	NYTRRC	VARIRN
CAOKM	ILDKNI	MNMABE	NYTRRP	VARIVA
CAOKO	ILEVNW	MNMPIA	NYURMW	VARIVH
CASBUC	ILNDSU	MNMPPLA	NYW	VAWICW$_a$
CASCSU	ILSPSM	MNMPPL$_{he}$	NYWEUS	VTBUUV
CASCUC	INBLUS	MOLAWM	NYWPCH	VTWOWH
CASFAI	INFWLI	MOSJMW	NYYOHR	WALCSC
CASFSU	ININHE	MOSLAM	OKNOU$_s$	WASEUW$_{sa}$
CASJSU	ININMA$_{sc}$	MOSLWU$_l$	OHCFEA	WIKEGT
CASTUA	INMUBS	MSUNMF	OHCLCI	WIMASH
CASTUM	INNDU	MSJAAH	OHCLCM	WIMAUW
CASUPC	INTHSU	NCHPHP	OHCOOS	WIMIMC
CAVNMH	KSLANK$_s$	NCRANC	OHLIAC	WIRFUW
CODVMC	KYBGWK	NCRASU	OHYOBI	WISPUW
CTHAS-D	KYLOUL	NDFASU	OREUOS	WVHUHG
CTHAWA	LABRAA	NEOMJA$_r$	ORPAM	VYLAUW
CTLIHS	LANOLS	NHPOSB	PABMC	
CTNBCC	LASHNA	NJCATE	PACHBR	
CTNBMA	MABOAC	NJCHVM	PAEPTU	
CTNHB$_u$	MABOBS	NJCLKC	PAGRWC	
CTSTSA	MABOCA	NJMOMA	PAHARH	
DCAIA	MABOHS	NJNENM	PALUCB	
DCCFA	MABOPR	NJPABC	PAPHFL	
DCCFAB	MACAFO	NJPRHS	PAPHHS	
DCCFAL	MACOOH	NJWOGC	PAPHIC	
DCCFAP	MANHFL$_a$	NYALOA	PAPHLC	
DCGWU	MANHSC$_m$	NYALSU	PAPHPC	
DCHAER	MANOSM$_l$	NYBISU	PAPHPH	
DCHIM	MAPEHS	NYBRBC	PAPHPM$_p$	
DCLCPP	MASTKC	NYBRBM	PAPHUP$_f$	
DCNAR	MAWOAA	NYESDU	PAPICI	
DCNGAI	MDBAHS	NYEXEC	PAPICL	
DCNGAS	MDBAJA	NYJAYC	PAPIUP$_f$	
DCNPG	MDBAMI	NYNYAH	RIPRRI$_l$	
DCNPGC	MDBAPM	NYNYBA	SCCHGA	
DCNTHP	MDBAUM	NYNYBO	SCCHSC	
DCSmHT	MDCPUM	NYNYFA	TNMEBM	
DEWIMU		NYNYGC	TNMEMA	
FLGAUF		NYNYHF	TNMESU	
FLPEWM		NYNYHS	TXAUUT	
FLSPMU		NYNYLU		
FLTAFS				

U551. COLONIAL PERIOD: 1620–1770 (C)

ALMOC
ALUNI
ARLRA
AZPHP
$AZTEU_{av}$
AZTUMM
CABRAR
CABURPL
CACAC
CACLS
CALAS
CALASC
CALAUS
CAOKM
CAOKO
CARVU
CASCSU
CASFSU
CASJSU
CASTUA
CODVME
CODVMS
CTFAH-S
CTFAM
CTHAWA
CTLIHS
CTMIWU
CTNBCC
CTNBMA
$CTNHB_u$
CTSTSA
CTYUAA
DCAIA
DCCFAB
DCCFAL
DCDAR
DCNAR
DCNGAE
DCNPG
DCNPGC
DCNTHP
DCSmHT
DCSMPS
DEWIMU
FLCGUM
FLGAUF
FLTAFS
GAATCHA
GAATIT
GASTFF

HIHOAA
IADMAC
$ILCHAI_{me}$
$ILCHAI_{sp}$
ILCHRO
ILCHSVE
ILCHUC
$ILCUI_{va}$
$ILDKNI_l$
ILEVNW
ILNDSU
INBLUS
ININHE
$ININMA_{sc}$
INMUBS
INNDU
INTHSU
INWLPU
$KSHASC_a$
$KSLANK_s$
KYLOUL
LABRAA
LANOLS
LASHNA
MABOAC
MABOBS
MABOCA
MABOFA
MABOGM
MABOHS
MABOPR
MACAFO
MACAIF
MANAHS
MANATX
$MANHFL_a$
$MANHFL_c$
$MANHSC_m$
$MANOSM_l$
MAPLAS
MASAEI
MASTKC
MASTUV
MAWAGP
MAWOAA
MAWOAM
MDBAMI
MDBAHS
MDBAJA
MDBAUM

MDCPUM
$MEBRBC_{da}$
$MEBRBC_{ma}$
MECASS
MEPOSA
$MIAAUM_{av}$
$MIAAUM_{sp}$
MIALBC
MIDEMC
MIDEME
MIDEWS
MIKAWM
MNMPPLA
$MOSLWU_l$
MSJAAH
MSUNMF
NCCHUN
NCHPHP
NCRANC
NCRASU
NCWSME
NDFASU
$NEOMJA_r$
NHPOSB
NJCATE
NJCHVM
NJCLKC
NJFRMC
NJMOMA
NJNENM
NJPABC
NJWOGC
NMALUN
NMSFMN
NYALOA
NYALSU
NYBISU
NYBRBC
NYBRBM
NYEXEC
NYJAYC
NYNYAH
NYNYBA
NYNYBO
$NYNYCU_a$
NYNYFA
NYNYGC
NYNYHG
NYNYLU
NYNYMC

NYNYMM
NYNYPL
NYNYTH
NYNYTI
$NYRoRI$
$NYSeLI$
NYSESP
NYTRRP
NYUTMW
NYW
NYWEUS
NYYOHR
OHCFEA
OHCIPL
OHCLCI
OHCLCM
OHCOOS
OHYOBI
$OKNOU_s$
OREUOS
ORPAM
PABMC
PACHBR
PACLSC
PACOUC
PAEPTU
PAFAFN
PAHAPM
PAPHFL
PAPHHS
PAPHIC
PAPHLC
PAPHPA
PAPHPC
$PAPHPM_p$
$PAPHUP_f$
PAPICL
$PAPIUP_f$
RIEPBU
$RIPRRI_l$
$RIPRRI_m$
SCCHGA
SCCHSC
TNCHUT
TNMEMA
TNMESU
TNNAVU

TXAUUT
TXCCAM
TXHOMFA
TXHORU
$TXHOUH_a$
$TXHOUH_f$
VAHRMC
VAPAOS
VARIAP
VARIVC
VARIVM
VASTRL
VASWC
VAWBNM
$VAWICW_a$
$VAWICW_{re}$
VTBUUV
WASESM
$WASEUW_{sa}$
WIKEGT
WIMASH
WIMAUW
WIMIMC
WIRFUW
WISPUW
WVLEFS

U552. EARLY TWENTIETH CENTURY, 1910–1914 (ETW)

ALMOC	CTNBCC	INBLUS	MNMPPL$_{he}$	NYNYMU$_d$	TNCHUT
ALUNI	CTNBMA	ININMA$_{sc}$	MNMPWA$_e$	NYNYPL	TNMEBM
ALMOS	CTNHB$_u$	INMUBS	MOCOUM$_{mu}$	NYNYTH	TNMEMA
ARCLA	CTSTSA	INNDU	MOSJMW	NYNYTI	TNMESU
ARLRA	CTYUAA	INPLMC	MOSLAM	NYRoLS	TNNAVU
AZCLA	CTYUBA	INTHSU	MOSLWU$_1$	NYRoRI	TXAUUT
AZFLN	DCAIA	KSARCH	MSJAAH	NYSELI	TXCCAM
AZPHP	DCCFAB	KSHASC$_a$	NCCHUN	NYSESP	TXFWCM
AZPRS	DCCFAL	KSHASCH	NCHPHP	NYSYSU$_a$	TXFWFW
AZPRSM	DCCFAP	KYBGWK	NCRANC	NYSYS$_g$	TXFWKM
AZTEU$_{av}$	DCDAR	KYLOUL	NCRASU	NYTRRP	TXHOMFA
AZTOT	DCGWU	LANOLS	NDFASU	NYUTMW	TXHORU
CABRAR	DCHAER	MABOAC	NEOMJA$_r$	NYW	TXHOUH$_a$
CABURPL	DCHIM	MABOCA	NERCWC	NYWEUS	TXPHCC
CACAC	DCHOWU	MABOFA	NJCATE	NYYOHR	TXSNTC
CACLS	DCLCPP	MABOGM	NJCHVM	OHCFEA	VAHRMC
CADEH	DCNAR	MABOPR	NJCLKC	OHCLCI	VAPAOS
CALABK	DCNGAS	MACAFO	NJKEAN	OHCLCM	VARIVC
CALAPL	DCNPG	MACAIT	NJMAFD	OHCOOS	VARORV
CALAS	DCNPGC	MANAHS	NJMOMA	OHLICA	VASTAW
CALASC	DCNTHP	MANATX	NJNENM	OKNOU$_s$	VASWC
CALAUS	DCSmHT	MANHFL$_a$	NJNERU	OKPCCC	VAWICW$_a$
CAMAMU	DCSMPS	MANHSC$_m$	NJPRHS	OREUO	VTVUUV
CAOKM	DEWIAM	MANOSM$_1$	NJPRPU$_m$	OREUOS	VTWOWH
CAOKO	FLCGUM	MAPEHS	NJWOGC	ORPAM	WAFLMM
CAOOG	FLGAUF	MASTKC	NMALUN	PAALAM	WALCSC
CAPGH	FLPBFM	MAWHCC	NMSFMN	PABMC	WASEUW$_{sa}$
CAPOPL	FLPEWM	MAWMCI$_p$	NYALOA	PACHBR	WASPEW
CARDS	FLSPMU	MDBAHS	NYALSU	PACLSC	WILEGT
CAIAC	FLTAFS	MDBAJA	NYBISU	PACOUC	WIMASH
CARVU	FSWPBN	MDBAMI	NYBRBC	PAEPTU	WIMAUW
CASBUC	GAATCHA	MDBAPM	NYBRBM	PAGRWC	WIMIMC
CASCUSU	GAATHS	MDBAUM	NYEMNC	PAHARH	WIRFUW
CASCUC	GAATIT	MDCPUM	NYESDU	PAHUSM	WISPUW
CASFAI	HIHOAA	MEBRBC$_{da}$	NYESEH	PALDFS	WVLEFS
CASFSU	HIHOBM	MEBRBC$_{ma}$	NYETEC	PAPHAT	WYBHBB
CASJSU	IADMAC	MEPOSA	NYEXCC	PAPHFL	WYGRSC
CASMPC	IAICSHS	MIAAUM$_{av}$	NYEXEC	PAPHHS	WYLAUW
CASOPV	IDBSHS	MIAAUM$_{sp}$	NYGEGH	PAPHPA	WYNEAM
CASTUA	ILCHAI$_{me}$	MIALBC	NYJAYC	PAPHPC	
CASVHC	ILCHAI$_{sp}$	MIDEMC	NYNYAH	PAPHPH	
CAVNHM	ILCHRO	MIDEME	NYNYBA	PAPHPM$_p$	
CODVMC	ILCHSVE	MIDEWS	NYNYBO	PAPHUP$_f$	
CODVME	ILCHUC	MIGPWA	NYNYCU$_a$	PAPICI	
CODVMS	ILCHUI	MIKAWM	NYNYGC	PAPICL	
CODVPL	ILCUI$_{va}$	MNELVC	NYNYHF	PAPIUP$_f$	
CTFAH-S	ILDKNI	MNMABE	NYNYHS	RIEPBU	
CTHAS-D	ILEVNW	MNMPIA	NYNYLU	RIPRRI$_1$	
CTHAWA	ILOTHS	MNMPPLA	NYNYMC	RIPRRI$_m$	
CTMIWU	ILNDSU		NYNYMM	SCCHSC	
			NYNYMU$_a$		

U553. ENTERTAINMENT (E)

ALMOC
AZPHP
CABRUPL
CAGLK
CALAPL
CAOKM
CAPOPL
CARDS
CARIAC
CARVU
CASBUC
CAVEEC
CODVMS
CODVPL
CTHAS-D
CTHAWA
CTNBCCC
CTNBMA
CTNHB$_u$
CTSTSA
DCCFAB
DCCFAL
DCCFAP
DCNPG
DCNPGC
DCSmHT
DEWIMU
HIHOAA
HIHOBM
IDBSHS
ILCHUC
ILCHUI
ILCUI$_{va}$
ILEVNW
INBLUS
ININHE
ININMA$_{sc}$
KSASPM
KYLOUL
LANOLS
MABOAC
MABOBS
MABOCA
MABOPR
MACAFO
MANHSC$_m$
MDBAPM
MDBAUM
MDCPUM
MIAAUM$_{av}$

MIALBC
MIDEWS
MIMAHS
MNMABE
MNMPPLA
MOSLWU$_1$
MSJAAH
NCCHUN
NCRANC
NERCWC
NYALOA
NYBRBM
NYEHGH
NYEXEC
NYNYAH
NYNYBA
NYNYGC
NYNYHS
NYNYLU
NYNYMC
NYNYMM
NYNYMU$_d$
NYNYPL
NYNYTI
NYRoIM
NYRoRI
NYSYS$_g$
NYTRRP
NYUTMW
OHLIAC
PAPHFL
RIPRRI$_1$
SDPISH
SDSFIM
TNMEMA
TXSNTC
VARIVC
VTBUUV
WASEUW$_{sa}$
WIBACW
WIMASH

U554. FEDERAL PERIOD: 1790–1812 (F)

ALMOC	FLTAFS	MDBAMI	NYNYCU$_a$	SCCHGA
ALUNI	FLWPBN	MDBAHS	NYNYFC	TNMEMA
ARLRA	GAATCHA	MDBAJA	NYNYGC	TNNAVU
AZPHP	GAATIT	MDBAPM	NYNYHF	TNSEUS
AZTEU$_{av}$	HIHOAA	MDBAUM	NYNYHS	
CABRAR	ILCHAI$_{me}$	MDCPUM	NYNYLU	TXAUUT
CABURPL	ILCHAI$_{sp}$	MEBRBC$_{da}$	NYNYMC	TXCCAM
CACAC	ILCHRO	MEBRBC$_{ma}$	NYNYMM	TXFWKM
CACLS	ILCHSVE	MECASS	NYNYPL	TXHOMFA
CALABK	ILCHUC	MEPOSA	NYNYTI	TXHORU
CALAS	ILCHUI	MIAAUM$_{av}$	NYSeLI	TXHOUH$_a$
CALASC	ILCUI$_{va}$	MIAAUM$_{sp}$	NYSESP	VAHRMC
CALAUS	ILDKNI	MIALBC	NYSYS$_g$	VAPAOS
CAOKM	ILEVNW	MIDEMC	NYTRRP	VARIVC
CAOKO	ILNDSU	MIDEME	NYUTMW	VARIAP
CASBUC	ILSPSM	MIDEWS	NYW	VARIMC
CASCUSU	INBLUS	MIGPWA	NYWEUS	VARIVH
CASCUC	ININHE	MIKAWM	NYWPCH	VASWC
CASFAI	ININMA$_{sc}$	MNMPIA	NYYOHR	VAWICW$_a$
CASFSU	INMUBS	MNMPPLA	OKNOU$_s$	VAWICW$_r$
CASJSU	INNDU	MOSJMW	OHBUGC	VAWICW$_{re}$
CASTUA	INTHSU	MOSLAM	OHCFEA	VTBUUV
CODVMC	INWLPU	MOSLWU$_l$	OHCIPL	VTWOWH
CODVME	KSHASC$_a$	NCCHUN	OHCLCI	WASEUWSA
CTFAR-S	KSLANK$_s$	NCHPHP	OHCLCM	WIKEGT
CTHAWA	LABRAA	NCRASU	OHCOOS	WIMASH
CTLIHS	LANOLS	NCWSME	OHYOBI	WIMAUW
CTMIWU	LASHNA	NDFASU	OREUOS	WIMIMC
CTNBCC	MABOAC	NEOMJA$_r$	ORPAM	WIRFUW
CTNBMA	MABOBS	NHPOSB	PABMC	WISPUW
CTSTSA	MABOCA	NJCATE	PACLSC	WVHUHG
CTYUAA	MABOFA	NJCHVM	PACOUC	WVLAUW
DCAIA	MABOHS	NJCLKC	PAEPTU	
DCCFAB	MABOPR	NJFRMC	PAGRWC	
DCCFAL	MACAFO	NJMOMA	PALUCB	
DCCFAP	MACAIT	NJNENM	PAPHFL	
DCDAR	MAMICT	NJPRPU$_m$	PAPHHS	
DCGWU	MANAHS	NJWOGC	PAPHIC	
DCNGAE	MANATX	NMALUN	PAPHLC	
DCNGAI	MANHSC$_m$	NYALOA	PAPHPA	
DCNGAS	MANOSM$_l$	NYALSU	PAPHPC	
DCNPG	MAPLAS	NYBISU	PAPHPH	
DCNPGC	MASAEI	NYBRBC	PAPHPM$_p$	
DCNTHP	MASTKC	NYBRBM	PAPHUP$_f$	
DCSmHT	MASTUV	NYESDU	PAPICI	
DCSMPS	MAWAGP	NYEXEC	PAPICL	
DEWIMU	MAWMCI$_s$	NYGEGH	PAPIUP$_f$	
FLCGUM	MAWOAA	NYJAYC	RIEPBU	
FLGAUF	MAWOAM	NYNYAH	RIPRRI$_l$	
FLSPMU		NYNYBA	RIPRRI$_m$	
		NYNYBO		

U555. GREAT DEPRESSION: 1930–1940 (GD)

ALMOC	DCHOWU	MANHSC$_m$	NYBRBC	PAPHHS
ALMOS	DCLCPP	MANOSM$_l$	NYBRBM	PAPHPA
ALUNI	DCNAR	MAPEHS	NYEHGH	PAPHPC
ARCLA	DCNPG	MASTKC	NYEMNC	PAPHPH
ARLRA	DCNPGC	MDBAHS	NYESDU	PAPHPM$_p$
AZCLA	DCNRAAV	MDBAJA	NYETEC	PAPHUP$_f$
AZFLN	DCNTHP	MDBAMI	NYEXCC	RIEPBU
AZPHP	DCSmHT	MDBAPM	NYEXEC	RIPRRI$_l$
AZPRS	DEWIAM	MDBAUM	NYGEGH	SCCHSC
AZTEU$_{av}$	FLCGUM	MDCPUM	NYJAYC	SDPISH
CABRAR	FLGAUF	MEBRBC$_{da}$	NYNYAH	TNCHUT
CABURPL	FLSPMU	MEPOSA	NYNYBA	TNMEMA
CACAC	FLTAFS	MIAAUM$_{av}$	NYNYCU$_{daa}$	TNMESU
CACLS	FSWPBN	MIAAUM$_{sp}$	NYNYGC	TXAULJ
CADEH	GAATCHA	MIALBC	NYNYHA	TXAUUT
CALABK	GAATHS	MIDEMC	NYNYHF	TXFWFW
CALAS	GAATIT	MIDEME	NYNYLU	TXHOMFA
CALASC	HIHOAA	MIDEWS	NYNYMC	TXHORU
CALAUS	HIHOBM	MIGPWA	NYNYMM	TXHOUH$_a$
CAOKO	IADMAC	MIKAWM	NYNYMU$_a$	TXPHCC
CAOOG	IAICSHS	MNELVC	NYNYMU$_d$	TXSNTC
CAPEO	IAWBHH	MNMABE	NYNYPL	VAHRMC
CAPNSM	ILCHAI$_{sp}$	MNMPIA	NYNYTI	VARIVC
CAPOPL	ILCHPA	MNMPPLA	NYRoIM	VARORV
CARIAC	ILCHRO	MNMPPL$_{he}$	NYRoLS	VASEC
CASBUC	ILCHUC	MNMPWA$_e$	NYRoRI	VAWICW$_a$
CASCSU	ILCHUI	MOCOUM$_{mu}$	NYSCSM	VTBUUV
CASCUC	ILCUI$_{va}$	MOSJMW	NYSYSU$_a$	WALCSC
CASFAI	ILDKNI	MOSLAM	NYSYS$_g$	WASESM
CASFSU	ILEVNW	MOSLWU$_l$	NYTRRP	WASEUW$_{sa}$
CASJSU	ILDNSU	MSJAAH	NYUTMW	WASPEW
CASMPC	INBLUS	NCCHUN	NYWEUS	WIKEGT
CASTUA	ININHE	NDFASU	OHCFEA	WILCVC
CAVEEC	ININMA$_{sc}$	NEOMJA$_c$	OHCIPL	WIMASH
CAVNHM	INMUBS	NEOMJA$_r$	OHCLCI	WIMAUW
CODVMC	INNDU	NJCATE	OHCOOS	WIMIMC
CODVMS	INTHSU	NJCHVM	OHLIAC	WIRFUW
CTHAWA	KSFRHS	NJCLKC	OKNOU$_s$	WISPUW
CTMIWU	KSHASCA	NJKEAN	OREUO	WYGRSC
CTNBCC	KSLANK$_s$	NJMAFD	OREUOS	WYLAUW
CTNBMA	KYBERC	NJMOMA	ORPAM	
CTNHB$_u$	KYBGWK	NJNENM	PABMC	
CTSTSA	KYLOUL	NJNERU	PACHBR	
CTYUAA	LABRAA	NJPRPU$_m$	PACLSC	
CTYUBA	LANOLS	NJPRPU$_a$	PACOUC	
DCAIA	MABOAC	NMALUN	PAEPTU	
DCCFAL	MABOCA	NMSFNM	PAGRWC	
DCCFAP	MABOFA	NYALOA	PAHARH	
DCGWU	MACAFO	NYALSU	PAHUSM	
DCHIM		NYBISU	PAPHAT	
			PAPHFL	

U556. INDUSTRIAL EXPANSION: 1865–1910 (I)

ALMOC
ALMOS
ALUNI
ARLRA
AZPHP
AZPRS
AZPRSM
$AZTEU_{av}$
AZTOT
CABRAR
CABURPL
CACLS
CALABK
CALAS
CALASC
CAOKM
CAOKO
CAPGH
CAPOPL
CARVU
CASBUC
CASCSU
CASCUC
CASFG
CASFSU
CASJSU
CASMPC
CASTUA
CASVHC
CAVNHM
CODVMC
CTHAWA
CTMIWU
CTNBCC
CTNBMA
$CTNHB_u$
CTSTSA
CTYUAA
DCAIA
DCCFAB
DCCFAL
DCCFAP
DCHAER
DCHIM
DCLCPP
DCNAR
DCNGAI
DCNGAS
DCNPG
DCNPGC
DCNTHP
DCSmHT
DCSMPS

DEWIAM
DEWIMU
FLGAUF
FLPBFM
FLSPMU
FLTAFS
GAATCHA
GAATHS
GAATIT
HIHOAA
IADMAC
IAICSHS
$ILCHAI_{me}$
$ILCHAI_{sp}$
ILCHRO
ILCHSVE
ILCHUC
ILCHUI
$ILCUI_{va}$
ILDKNI
ILEVNW
ILNDSU
ILOTHS
ILSPSM
INBLUS
ININHE
$ININMA_{sc}$
INMUBS
INNDU
INPLMC
INTHSU
$KSHASC_a$
$KSLANK_s$
KYBGWK
KYLOUL
LANOLS
LASHNA
MABOAC
MABOCA
MABOFA
MABOPR
MACAFO
MAMICT
MANAHS
MANATX
$MANHSC_m$

$MANOSM_1$
MASTKC
MAWHCC
$MAWMCI_p$
$MAWMCI_s$
MDBAHS
MDBAJA
MDBAMI
MDBAPM
MDBAUM
MDCPUM
$MEBRBC_{da}$
MECASS
$MIAAUM_{av}$
$MIAAUM_{sp}$
MIALBC
MIDEMC
MIDEME
MIDEWS
MIGPWA
MIKAWM
MIMAHS
MNELVC
MNMPIA
MNMPPLA
$MNMPPL_{he}$
$MOCOUM_{mu}$
MOLAWM
MOSJMW
$MOSLWU_1$
NCCHUN
NCRANC
NCRASU
NEFASU
$NEOMJA_r$
NHPOSB
NJCATE
NJCHVM
NJCLKC
NJMOMA
NJNENM
NJNERU
NMALVN
NMSFMN
NYALOA
NYALSU
NYBISU
NYBRBC
NYBRBM
NYEMNC

NYESDU
NYESEH
NYETEC
NYEXCC
NYGEGH
NYJAYC
NYNYAH
NYNYBA
NYNYBO
$NYNYCU_a$
NYNYGC
NYNYGF
NYNYGS
NYNYLU
NYNYMC
NYNYMM
$NYNYMU_d$
NYNYPL
NYNYTH
NYNYTI
NYRoIM
NYRoLS
NYRoRI
NYSCSM
NYSeLI
NYSESP
$NYSYSU_a$
$NYSYS_g$
NYTRRC
NYTRRP
NYUTMW
NYWEUS
NYWPCH
NYYOHR
OHCFEA
OHCLCI
OHCLCM
OHLIAC
$OKNOU_s$
OREUO
OREUOS
ORPAM
PABMC
PACOUC
PAEPTU
PAFAFN
PAGRWC
PAHARH
PAHUSM
PALUCB
PAPHFL

PAPHHS
PAPHIC
PAPHLC
PAPHPC
PAPHPH
$PAPHPM_p$
$PAPHUP_f$
PAPICL
$PAPIUP_f$
RIEPBU
$RIPRRI_1$
SDPISH
TNCHUT
TNMEMA
TNMESU
TNNAVU
VAHRMC
VAPAOS
VARIVC
VARORV
VASTAW
$VAWICW_a$
VTBUUV
VTWOWH
WALCSC
WASESM
$WASEUW_{sa}$
WIKEGT
WIMASH
WIMAUW
WIRFUW
WISPUW
WVHUHG

U557. MARITIME LIFE (M)

AZPHP

CABURPL

CALASL

CALASC

CAOKM

CAOKO

CAOOG

CAPOPL

CARDS

CASBUC

CASFMM

CASFSU

CAVNHM

CODVMC

CODVMS

CTHAWA

CTNBMA

CTNHB$_u$

CTSTSA

DCCFAB

DCCFAL

DCCFAP

DCGWU

DCNPG

DCNPGC

DCSmHT

DCSMPS

FLPEWM

FLWPBN

GASVFJ

HIHOAA

HIHOBM

ILCHUC

ILCHUI

ILCUI$_{va}$

ILEVNW

ININHE

KYBGWK

LANOLS

MABOAC

MABOBS

MABOCA

MABOPR

MACAFO

MAMICT

MANHSC$_m$

MASAPM

MASTKC

MDBAHS

MDBAPM

MDBAUM

MDCPUM

MEBAMM

MIAAUM$_{av}$

MIALBC

MIDEWS

MNMPPIA

MOSJMW

MOSLWU$_1$

MSJAAH

NCCHUN

NCRANC

NHPOSB

NJCATE

NJCHVM

NYALOA

NYEMNC

NYETEC

NYNYAH

NYNYBA

NYNYGC

NYNYHS

NYNYLU

NYNYMM

NYNYMU$_d$

NYNYPL

NYNYTI

NYRoIM

NYRoRI

NYSYCM

NYSYS$_g$

NYTRRP

OHCOOS

OHYOBI

PACHBR

PAPHFL

PAPHIC

PAPHPC

PAPHPI

PAPHPM$_p$

PAPICI

RIPRRI$_1$

SCCHSC

TNMEMA

TNMESU

TXSNTC

VANNMM

VARIVC

VAWICW$_a$

VTBUUV

WALCSC

WIMAUW

U558. MEXICAN WAR: 1848 (MW)

ARLRA
AZPHP
AZTEU$_{av}$
CABRAR
CABURPL
CALABK
CALAS
CALASC
CAOKM
CAOKO
CARIAC
CASCSU
CASCUC
CASFAI
CASFSU
CASJSU
CASTUA
CAVNHM
CTLIHS
CTNBCC
CTNBMA
CTNHB$_u$
DCCFAB
DCCFAL
DCCFAP
DCGWU
DCHAER
DCNAR
DCNGAI
DCNPG
DCNPGC
DCSmHT
FLTAFS
GAATCHA
GAATIT
HIHOAA
IADMAS
IAICSHS
ILCHRO
ILCHSVE
ILCHUI
ILCUI$_{va}$
ILDKNI
ILEVNW
ILNDSU
INBLUS
ININHE
INMUBS
INTHSU

KYLOUL
LANOLS
LASHNA
MABOAC
MABOCA
MABODS
MACAFO
MAWOAA
MDBAHS
MDBAMI
MDBAPM
MDBAUM
MDCPUM
MIAAUM$_{sp}$
MIALBC
MIDEME
MIDEWS
MIGPWA
MNMPPLA
MOSLWU$_l$
NCCHUN
NDFASU
NEOMJA$_r$
NJCATE
NJCHVM
NJCLKC
NJMOMA
NMALUN
NMSFMN
NYALOA
NYALSU
NYBRBC
NYBRBM
NYESDU
NYNYAH
NYNYBA
NYNYFA
NYNYGC
NYNYHF
NYNYHS
NYNYLU
NYNYMC
NYNYMM
NYNYMU$_d$
NYNYPL
NYNYTH
NYNYTI
NYRoLS
NYRoRI
NYSYS$_g$

NYTRRC
NYTRRP
NYUTMW
NYWPCH
OKNOU$_s$
OREUOS
ORPAM
PABMC
PAEPTU
PALUCB
PAPHFL
PAPHHS
PAPHUP$_f$
PAPICI
RIEPBU
RIPRRI$_l$
TNMESU
TXAUUT
TXHOMFA
TXHORU
TXSNTC
VAHRMC
VARIVC
VAWICW$_a$
VTBUUV
WAFLMM
WIMASH
WIMIMC
WIRFUW
WISPUW

ALMOC	CTSTSA	LANOLS	NJMOMA	PABMC	WIKEGT
ALUNI	CTYUAA	MABOAC	NJNENM	PACHBR	WIMASH
ALMOS	CTYUBA	MABOCA	NJNERU	PACLSC	WIMAUW
ARCLA	DCAIA	MABOFA	$NJPRPU_m$	PACOUC	WIMIMC
ARLRA	DCCFAL	MABOPR	NMSFMN	PAEPTU	WIRFUW
AZCLA	DCCFAP	MACAFO	NYALOA	PAGRWC	WISPUW
AZFLN	DCGWU	$MANHFL_a$	NYALSU	PAHARH	WYBHBB
AZPHP	DCHIM	$MANHFL_c$	NYBISU	PAHUSM	WYGRSC
AZPRS	DCHOWU	$MANHFL_m$	NYBRBC	PAPHAT	WYLAUW
$AZTEU_{av}$	DCLCPP	$MANOSM_l$	NYBRBM	PAPHFL	WYWAWM
AZTOT	$DCNAR_{av}$	MAPEHS	NYEMNC	PAPHHS	
AZTUA	DCNPG	MASTKC	NYESDU	PAPHPA	
CABRAR	DCNPGC	MAWHCC	NYESEH	PAPHPC	
CABURPL	DCNTHP	MDBAHS	NYETEC	PAPHPH	
CACAC	DCSmHT	MDBAJA	NYEXEC	$PAPHPM_p$	
CACLS	DCSMPS	MDBAMI	NYGEGH	$PAPHUP_f$	
CADEH	FLGAUF	MDBAPM	NYJAYC	PAPICI	
CALABK	FLSPMU	MDBAUM	NYNYAH	PAPICL	
CALAPL	FLTAFS	MDCPUM	NYNYBA	$PAPIUP_f$	
CALAS	FSWPBN	MEPOSA	$NYNYCU_a$	RIEPBU	
CALASC	GAATCHA	$MIAAUM_{av}$	NYNYGC	$RIPRRI_l$	
CALASL	GAATHS	$MIAAUM_{sp}$	NYNYHA	SCCHSC	
CAOKO	GAATIT	MIALBC	NYNYHF	SDPISH	
CAOOG	HIHOAA	MIDEMC	NYNYHS	TNCHUT	
CAPED	HIHOBM	MIDEME	NYNYLU	TNMEBM	
CAPNSM	IADMAC	MIDEWS	NYNYMC	TNMEMA	
CAPOPL	IAWBHH	MIGPWA	NYNYMM	TNMESU	
CARDS	IAICSHS	MIKAWM	$NYNYMU_a$	TNNAVU	
CARIAC	IDBSHS	MNMABE	$NYNYMU_d$	TXAUUT	
CARVU	$ILCHAI_{sp}$	MNMPIA	NYNYPL	TXFWFW	
CASBUC	ILCHRO	MNMPPLA	NYNYTH	TXFWKM	
CASCSU	ILCHUC	$MNMPPL_{he}$	NYNYTI	TXHOMFA	
CASCUC	ILCHUI	$MOCOUM_{mu}$	NYRoIM	TXHORU	
CASFAI	$ILCUI_{va}$	MOSJMW	NYRoLS	$TXHOUH_a$	
CASFSU	ILDKNI	MOSLAM	NYRoRI	$TXHOUH_f$	
CASJSU	ILEVNW	$MOSLWU_l$	$NYSYSU_a$	TXPHCC	
CASMPC	ILNDSU	MSJAAH	$NYSYS_g$	TXSNTC	
CASOPV	INBLUS	NCCHUN	NYTRRP	VAHRMC	
CASTUA	ININHE	NCRASU	NYURMW	VAPENB	
CAVEEC	$ININMA_{sc}$	NDFASU	NYWEUS	VARWC	
CAVNHM	INMUBS	NECRFR	NYYOHR	VARORV	
CODVMC	INNDU	$NEOMJA_r$	OHCFEA	VASWC	
CODVMS	INPLMC	NERCWC	OHCIPL	$VAWICW_a$	
CODVPL	INTHSU	NHPOSB	OHCLCI	VTBUUV	
CTFAH-S	KSARCH	NJCATE	OHCLCM	WAFLMM	
CTHAWA	$KSHASC_a$	NJCHVM	OHCOOS	WALCSC	
CTMIWU	KSHASCL	NJCLKC	OHLICA	WASESM	
CTNBCC	$KSLANK_s$	NJKEAN	$OKNOU_s$	$WASEUW_{sa}$	
CTNBMA	KYBGWK	NJMAFD	OREUO	WASPEW	
$CTNHB_u$	KYLOUL		OREUOS		
			ORPAM		

U560. POSTWAR AMERICA: 1946— (P)

ALMOC	DCNPG	MDBAJA	NYJAYC	SCCHSC
ALMOS	DCNPGC	MDBAMI	NYNYAC	SDPISH
ALUNI	DCNTHP	MDBAPM	NYNYAH	TNCHUT
ARCLA	DCSmHT	MDBAUM	NYNYBA	TNMEBM
AZCLA	DEWIAM	MDCPUM	NYNYBO	TNMEMA
AZPHP	FLCGUM	$MEBRBC_{da}$	$NYNYCU_a$	TNMESU
AZSCC	FLGAUF	MEPOSA	NYNYHA	TNNAVU
$AZTEU_{av}$	FLSPMU	$MIAAUM_{av}$	NYNYLU	TNSEUS
CABURPL	FLTAFS	$MIAAUM_{sp}$	NYNYMC	TXAULJ
CABVAR	FLWPBN	MIALBC	NYNYMM	TXAUUT
CACAC	GAATCHA	MIDEMC	$NYNYMU_a$	TXCCAM
CACLS	GAATIT	MIDEME	$NYNYMU_d$	TXFWFW
CAGLK	HIHOAA	MIDEW	NYNYPL	TXFWKM
CALABK	HIHOBM	MIGPWA	NYNYTH	TXHOMFA
CALAS	IADMAC	MIKAWM	NYNYTI	TXHORU
CALASC	IAICSHS	MNELVC	NYRoIM	$TXHOUH_a$
CAOKM	IDBSHS	MNMABE	NYRoLS	$TXHOUH_f$
CAOKO	$ILCHAI_{sp}$	MNMPIA	NYRoRI	TXPHCC
CAOOG	ILCHCA	MNMPPLA	$NYSYSU_a$	TXSNTC
CAPEO	ILCHRO	$MNMPPL_{he}$	$NYSYS_g$	VAHRMC
CAPNSM	ILCHUC	$MNMPWA_e$	NYTRRP	VARIVC
CARIAC	ILCHUI	$MOCOUM_{mu}$	NYUTMW	VARORV
CARVU	$ILCUI_{va}$	MOSJMW	NYWEUS	VASWC
CASBU	ILDKNI	MOSLAW	NYWPCH	$VAWICW_a$
CASCSU	ILEVNW	$MOSLWU_l$	OHCFEA	VTBUUV
CASCUS	ILNDSU	MTMIDG	OHCIPL	WAFLMM
CASFAI	ILOTHS	NCCHUN	OHCLC	WASESM
CASFSU	INBLUS	NCRASU	OHCLCM	$WASEUW_{sa}$
CASJSU	ININHE	NDFASU	OHCOOS	WIKEGT
CASMPC	$ININMA_{sc}$	$NEOMJA_r$	OKNOUM	WILCVC
CASTUA	INMUBS	NJCATE	OREUOS	WIMASH
CAVAIA	INNDU	NJCHVM	ORPAM	WIMAUW
CAVEEC	INRIEC	NJCLKC	PAMBC	WIMIMC
CAVNHM	INTHSU	NJKEAN	PACHBR	WIRFUW
CODVME	$KSHASC_a$	NJMAFD	PACLSC	WISPUW
CODVMS	$KSLANK_s$	NJMOMA	PACOUC	WYGRSC
CTHAWA	KYBGWK	NJNENM	PAEPTU	WYLAUW
CTMIWU	KYLOUL	NJNERU	PAGRWC	
CTNBCC	LABRAA	NJPABC	PAHARH	
CTNBMA	LANOLS	$NJPRPU_m$	PAHUSM	
$CTNHB_u$	MABOAC	NMALTI	PAPHFL	
CTSTSA	MABOCA	NMALUN	PAPHPC	
CTYUAA	MABOFA	NMSFMN	$PAPHPM_p$	
DCAIA	MACAFO	NYALOA	$PAPHUP_f$	
DCCFAL	$MANHSC_m$	NYALSU	PAPICI	
DCCFAP	$MANOSM_l$	NYBISU	PAPICL	
DCGWU	MAPEHS	NYBRBC	$PAPIUP_f$	
DCHIM	MASTUV	NYNYBRBM	RIEPBU	
DCHOWU	MDBAHS	NYEMNC	$RIPRRI_l$	
DCLCPP		NYESDU	$RIPRRI_m$	
		NYEXEC		

U561. SPACE AGE (SA)

AZPHP	MDCPUM	SCCHSC
AZTEU$_{av}$	MIAAUM$_{av}$	TNMEMA
CABRAR	MIAAUM$_{sp}$	TNMESU
CABURPL	MIALBC	TNSEUS
CALASC	MIDEMC	TXAULJ
CAOKO	MIDEME	TXAUUT
CAOOG	MIDEWS	TXFWFW
CAPNSM	MNMPPLA	TXFWKM
CARIAC		TXHOUH$_a$
CASBUC	MOSLWU$_l$	TXPHCC
CASCUC	MTMIDG	TXSNTC.
CASFSU	NCCHUN	
CASTUA	NCRASU	VARIVC
CAVEEC	NDFASU	VTBUUV
CAVNHM	NJCATE	WIMASH
CTMIWU	NJCHVM	WIMAUW
CTNBBC	NJCLKC	WISPUW
CTNHB$_u$	NJKEAN	
CTSTSA	NJNERU	WYWAWM
DCAIA	NMALUN	
DCCFAP	NMSFMN	
DCGWU	NYALSU	
DCNPG	NYBISU	
DCNPGC	NYBRBM	
DCSMPS	NYEMNC	
FLPEWM	NYEXEC	
FLSPMU	NYJAYC	
FLWPBN	NYNYAH	
HIHOAA	NYNYBA	
IADMAC	NYNYMC	
ILCHPA	NYNYMM	
ILCHRO	NYNYMU$_a$	
ILCHSVE	NYNYPL	
ILCHUI	NYNYTH	
ILCUI$_{va}$	NYNYTI	
ILDKNI	NYRoIM	
ILEVNW	NYRoRI	
INBLUS	NYSCSM	
ININHE	NYSYSU$_a$	
ININMA$_{sc}$	NYSYS$_g$	
INMUBS	NYTRRP	
INNDU	NYWEUS	
INRIEC	NYWPCH	
MABOAC	OHCLCI	
MABOCA	OKNOU$_s$	
MACAFO	PAPHFL	
MANHFL$_a$	PAPHPM$_p$	
MANOSM$_l$	PAPICL	
MDBAPM	RIEPBU	
MDBAUM	RIPRRI$_l$	
	RIPRRI$_m$	

U562. SPORTS (S)

AZPHP
AZPRSM
CABURPL
CALASL
CAOKM
CAOOG
CAPOPL
CARDS
CARVU
CASBUC
CASFSU
CTNBMA
$CTNHB_u$
CTSTSA
DCCFAB
DCCFAL
DCCFAP
DCNPG
DCNPGC
DCNSmHT
HIHOAA
HIHOBM
IAICSHS
IDBSHS
ILCHUC
$ILCUI_{va}$
ILEVNW
ININHE
$ININMA_{sc}$
INPLMC
LANOLS
MABOAC
MABOCA
MACAFO
$MANHSC_m$
MDBAPM
MDBAUM
MDCPUM
$MIAAUM_{av}$
MIALBC
MIDEWS
MNMABE
MNMPPLA
$MOSLWU_l$
MSJAAH
NCCHUN
NJCLKC
NJWOGC
NMSFMN
NYALOA

NYEMNC
NYEXCC
NYEXEC
NYGOHF
NYNYAH
NYNYBA
NYNYGC
NYNYLU
NYNYMM
$NYNYMU_d$
NYNYPL
NYNYTI
NYRoIM
$NYSYSU_a$
$NYSYS_g$
NYTRRP
PAPHFL
$PAPHPM_p$
$RIPRRI_l$
$RIPRRI_m$
SDPISH
SDSFIM
TNMEMA
TNMESU
TXSNTC
VARIVC
$VAWICW_a$
VTBUUV

U563. TURN OF THE CENTURY/ SPANISH-AMERICAN WAR: 1880–1910 (T)

AKSIT
ALMOC
ALMOS
ARLRA
AZFLN
AZPHP
AZPRS
AZTEU$_{av}$
AZTOT
CABRAR
CABURPL
CACLS
CADEH
CALABK
CALAS
CALASC
CALAUS
CAMAMU
CAOKM
CAOKO
CARDS
CARIAC
CASBUC
CASCSU
CASFAI
CASFSU
CASJSU
CASMPC
CASTUA
CAVNHM
CODVMC
CODVMS
CTFAH-S
CTHAMT
CTHAS-D
CTHAWA
CTMIWU
CTNBCC
CTNBMA
CTNHB$_u$
CTSTSA
CTYUAA
DCAIA
DCFAB
DCCFAL
DCCFAP
DCDAR
DCGWU
DCHAER
DCHIM

DCLCPP
DCNAR
DCNPG
DCNPGC
DCNTHP
DCSmHT
DCSMPS
DEWIAM
DEWIMU
FLCGUM
FLGAUF
FLPEWM
FLSPM
GAATCHA
GAATHS
GAATIT
HIHOAA
HIHOBM
IADMAC
IAICSHS
IDBSHS
ILCHAI$_{sp}$
ILCHRO
ILCHUC
ILCHUI
ILCUI$_{va}$
ILDKNI
ILEVNW
ILNDSU
ILSPSM
INBLUS
ININHE
INMUBS
INNDU
INPLMC
INTHSU
KSARCH
KSLANK$_s$
KYBGWK
KYLOUL
LABRAA
LANOLS
MABOAC
MABOCA
MABOFA
MABOGM
MABOPR
MACAFO
MAMICT

MANATX
MANHFL$_a$
MANHSC$_m$
MANOSM$_l$
MAPEHS
MASTKC
MAWHCC
MAWMCI$_p$
MAWMCI$_s$
MDBAHS
MDBAMI
MDBAPM
MDBAUM
MDCPUM
MEBHHS
MEBRBC$_{da}$
MEPOSA
MIAAUM$_{av}$
MIAAUM$_{sp}$
MIALBC
MIDEMC
MIDEME
MIDEWS
MIGPWA
MIKAWM
MIMAHS
MNMABE
MNMPIA
MNMPPLA
MNMPPL$_{he}$
MNMPWA$_e$
MOSJMW
MOSLWU$_l$
MSJAAH
NCCHUN
NCHPHP
NCRANC
NCRASU
NECRFR
NEOMJA$_r$
NERCWC
NDFASU
NJCATE
NJCLKC
NJKEAN
NJMOMA
NJNENM
NJNERU
NJPABC
NJPRHS

NJPRPU$_m$
NMALUN
NMSFMN
NYALOA
NYALSU
NYBISU
NYBRBC
NYBRBM
NYEMNC
NYESDU
NYESEH
NYETEC
NYEXEC
NYGEGH
NYNYAH
NYNYBA
NYNYBO
NYNYCU$_a$
NYNYFC
NYNYGC
NYNYHF
NYNYHS
NYNYLU
NYNYMC
NYNYMM
NYNYMU$_d$
NYNYPL
NYNYTH
NYNYTI
NYRoIM
NYRoLS
NYRoRI
NYSeLI
NYSESP
NYSYSU$_a$
NYSYS$_g$
NYTRRP
NYUTMW
NYWEUS
NYWPCH
NYYOHR
OHCFEA
OHCLCI
OHCOOS
OHLIAC
OHYOBI
OKNOU$_s$
OREUO
OREUOS
ORPAM
PABMC

PACOUC
PAEPTU
PAGRWC
PAHARH
PAHUSM
PALUCB
PAPHFL
PAPHHS
PAPHIC
PAPHPA
PAPHPH
PAPHPM$_p$
PAPHUP$_f$
PAPICL
PAPIUP$_f$
RIEPBU
RIPRRI$_l$
SDPISH
TNMEMA
TNMESU
TXAUUT
TXFWCM
TXFWKM
TXHOMFA
TXHORU
TXHOUH$_a$
TXHOUH$_f$
TXPHCC
TXSNTC
VAHRMC
VAPAOS
VARIVC
VARORV
VASTAW
VAWICW$_a$
VTBUUV
VTWOWH
WAFLMM
WALCSC
WASCUW$_{sa}$
WASPEW
WIKEGT
WILCVC
WIMASH
WIMIMC
WIRFUW
WISPUW
WVHUHG
WYGRSC
WYLAUW
WYWAWM

U564. WAR OF 1812 (W)

ALMOC
ARLRA
AZPHP
CABURPL
CACLS
CALABK
CALAS
CALASC
CAOKM
CAOKO
CASBUC
CASCUC
CASFAI
CASFSU
CASJSU
CASTUA
CODVMS
CTNBCC
CTSTSA
DCCFAB
DCCFAL
DCCFAP
DCDAR
DCGWU
DCNAR
DCNPG
DCNPGC
DEWIMU
FLCGUM
FLSPMU
FLTAFS
GAATCHA
GAATIT
HIHOAA
IADMAC
ILCHAI$_{me}$
ILCHRO
ILCHSVE
ILCHUI
ILCUI$_{va}$
ILDKNI
ILEVNW
ILNDSU
INBLUS
ININHE
ININMA$_{sc}$
INMUBS
INTHSU
KSLANK$_s$
KYLOUL

LABRAA
LANOLS
MABOAC
MABOBS
MABOCA
MACAFO
MANOSM$_l$
MAWOAA
MDBAHS
MDBAMI
MDBAPM
MDBAUM
MDCPUM
MEBRBC$_{da}$
MIAAUM$_{av}$
MIAAUM$_{sp}$
MIALBC
MIDEME
MIDEWS
MIGPWA
MIKAWM
MNMPIA
MNMPPLA
MOSLWU$_l$
NCCHUN
NCRANC
NCRASU
NCWSME
NEOMJA$_r$
NHPOSB
NJCATE
NJCHVM
NJCLKC
NJMOMA
NJNENM
NMALUN
NYALOA
NYALSU
NYBRBM
NYESDU
NYEXEC
NYNYAH
NYNYBA
NYNYCU$_a$
NYNYFA
NYNYGC
NYNYHF
NYNYHS
NYNYLU
NYNYMC

NYNYMM
NYNYPL
NYNYTH
NYNYTI
NYRoRI
NYSeLI
NYSESP
NYSYS$_g$
NYTRRC
NYTRRP
NYURMW
NYWEUS
NYWPCH
OHBUGC
OHCLCI
OHCLCM
OHCOOS
OKNOU$_s$
OREUOS
ORPAM
PABMC
PAEPTU
PALUCB
PAPHFL
PAPHHS
PAPHIC
PAPHLC
PAPHPA
PAPHUP$_f$
RIEPBU
RIPRRI$_l$
TNMESU
TXAUUT
TXHOMFA
TXHORU
TXHOUH$_a$
VAHRMC
VANNMM
VAPAOS
VARIVC
VAWICW$_a$
VTBUUV
WIMIMC
WIRFUW
WISPUW

U565. WAVES OF IMMIGRATION (WI)

ARLRA
AZPHP
CABRAR
CABURPL
CALABK
CALAS
CALASC
CAOKM
CAOOG
CASBUC
CASCSU
CASCU
CASFAI
CASFSU
CASJSU
CASMPC
CASOPV
CASTUA
CAVNHM
CTNBDC
$CTNHB_u$
CTSTSA
DCCFAB
DCCFAL
DCCFAP
DCGWU
DCHAER
DCHIM
DCNAR
DCNGAI
DCNPG
DCNPGC
DCSmHT
FLSPMU
FLTAFS
GAATCHA
HIHOAA
HIHOBM
IADMAC
IADRNA
ILCHRO
ILCHSVE
ILCHUI
$ILCUI_{va}$
ILDKNI
ILEVNW
ILNDSU
ILSPSM
INBLUS
ININHE

$INIMA_{sc}$
INMUBS
INTHSU
KYLOUL
LANOLS
MABOAC
MABOCA
MACAFO
MANAHS
MDBAHS
MDBAMI
MDBAPM
MDBAUM
MDBAWA
MDCPUM
$MIAAUM_{av}$
$MIAAUM_{sp}$
MIALBC
MIDEMC
MIDEWS
MIGPWA
MIKAWM
MNMPPLA
$MNMPPL_{he}$
$MOSLWU_l$
MTBIWA
NCCHUN
NCRANC
$NEOMJA_r$
NERCWC
NJCATE
NJCHVM
NJMOMA
NJNENM
NMALUN
NYALOA
NYALSU
NYBRBM
NYESDU
NYNYAH
NYNYBA
NYNYGC
NYNYHF
NYNYHS
NYNYSU
NYNYMC
NYNYMM
$NYNYMU_d$
NYNYPL
NYNYTH

NYNYTI
NYRoIM
NYRoLS
NYRoRI
$NYSYSU_a$
$NYSYS_g$
NYTRRP
NYWEUS
NYWPCH
OHCOOS
OREUO
OREUOS
ORPAM
PABMC
PACOUC
PAEPTU
PAHARH
PALUCB
PAPHFL
PAPHHS
$PAPHUP_f$
$RIPRRI_l$
SDPISH
TNMEMA
TNMUSU
TXAUUT
TXFWCM
TXHOMFA
TXHORU
TXSNTC
VAHRMC
VARIVC
$VAWICW_a$
VTWOWH
WALCSC
WASESM
WIMASH
WIRFUW
WISPUW

U566. WESTWARD MOVEMENT (WM)

ARLRA
AZFLN
AZPHP
AZTEU$_{av}$
AZTUA
AZWRN
CABRAR
CABURPL
CABVAR
CALABK
CALAS
CALASC
CAOKM
CAOKO
CAOOG
CARDS
CARVU
CASBUC
CASCSU
CASCUC
CASFAI
CASFSU
CASFWF
CASJSU
CASOPV
CASTUA
CASTUM
CAVNHM
CODVMC
CODVME
CODVMS
CODVPL
CTHAWA
CTLIHS
CTNBCC
CTNBMA
CTNHB$_u$
CTSTSA
CTYUAA
CTYUBW
DCCFAB
DCCFAL
DCCFAP
DCGWU
DCHAER
DCNAR
DCNGAE
DCNGAI
DCNPG
DCNPGC
DCSmHT

FLSPMU
FLTAFS
GAATCHA
HIHOAA
IADMAC
IDBSHS
ILCHRO
ILCHSVE
ILCHUC
ILCHUI
ILCHI$_{va}$
ILDKNI
ILEVNW
ILNDSU
INBLUS
ININHE
ININMA$_{sc}$
INMUBS
INTHSU
KSARCH
KSASPM
KSCOST
KSLANK$_s$
LANOLS
LASHNA
MABOAC
MABOCA
MABODS
MABOFA
MACAFO
MACAPM
MANHSC$_m$
MANOSM$_l$
MAWOAA
MDBAHS
MDBAMI
MDBAPM
MDBAUM
MDBAWA
MDCPUM
MEBRBC$_{da}$
MIAAUM$_{av}$
MIAAUM$_{sp}$
MIALBC
MIDEME
MIDEWS
MIGPWA
MIKAWM

MNELVC
MNMPIA
MNMPPLA
MOSJMW
MOSLAM
MOSLWU$_l$
MTBIWA
NCCHUN
NCRANC
NDFASU
NECRFR
NEOMJA$_c$
NEOMJA$_r$
NERCWC
NJCATE
NJCHVM
NJCLKC
NJMOMA
NJNENM
NMALVN
NMSFMN
NVRENH
NYALOA
NYALSU
NYBISU
NYBRBC
NYBRBM
NYESDU
NYEXEC
NYJAYC
NYNYAH
NYNYBA
NYNYFA
NYNYGC
NYNYHF
NYNYHS
NYNYLU
NYNYMC
NYNYMM
NYNYMU$_d$
NYNYPL
NYNYTH
NYNYTI
NYRoIM
NTRoLS
NYRoRI
NYSYCM
NYSYSU$_a$
NYSYS$_g$
NYTRRP
NYUTMW

NYWPCH
OHCLCM
OHCOOS
OHYOBI
OKNOU$_s$
OREUOS
ORPAM
PABMC
PACHBR
PACLSU
PAEPTU
PALUCB
PAPHFL
PAPHPA
PAPHPC
PAPHUP$_f$
PAPICL
RIEPBU
RIPRRI$_l$
RIPRRI$_m$
SDPISH
SDVEOM
TNMEBM
TNMEMA
TNMESU
TNNAVU
TNSEUS
TXAUUT
TXFDHS
TXFWCM
TXHOMFA
TXHORU
TXHOUH$_a$
TXPHCC
TXSNTC
TXWASR
UTBRBC
VAHRMC
VARIVC
VAWICW$_a$
VTBUUV
WAFLMM
WALCSC
WASEUW$_{sa}$
WIMASH
WIMAUW
WIMIMC
WIRFUW
WISPUW
WYBHBB
WYLAUW

U567. WORLD WAR I: 1914–1918 (WWI)

ALMOC	DEWIAM	MDBAPM	NYGEGH	SDPISH	
ALMOS	FLGAUF	MDBAUM	NYJAYC		
ARCLA	FLPEWM	MDCPUM	NYNYAH	TNCHUT	
ARLRA	FLSPMU		NYNYBA	TNMEBM	
AZCLA	FLTAFS	$MEBRBC_{da}$	NYNYBO	TNMEMA	
AZFLN		MEPOSA	$NYNYCU_a$	TNMESU	
AZPHP	GAATCHA	$MIAAUM_{av}$	NYNYGC	TNSEUS	
$AZTEU_{av}$	GAATHS	$MIAAUM_{sp}$	NYNYHF		
AZTOT	GAATIT	MIALBC	NYNYHS	TXAUUT	
AZTUA	HIHOAA	MIDEMC	NYNYLU	TXCCAM	
CABRAR	HIHOBM	MIDEME	NYNYMC	TXFWFW	
CABURPL	IADMAC	MIDEWS	NYNYMM	TXFWKM	
CACAC	IAICSHS	MIGPWA	$NYNYMU_a$	TXHOMFA	
CACLS	IAWBHH	MIKAWM	$NYNYMU_d$	TXHORU	
CADEH	IDBSHS	MNMABE	NYNYPL	$TXHOUH_a$	
CALABK	$ILCHAI_{sp}$	MNMPIA	NYNYTH	TXPHCC	
CALAPL	ILCHRO	MNMPPLA	NYNYTI	TXSNTC	
CALAS	ILCHUC	$MNMPPL_{he}$	NYRoIM	VAHRMC	
CALASC	ILCHUI	$MNMPWA_e$	NYRoLS	VAPENB	
CALAUS	$ILCUI_{va}$	$MOCOUM_{mu}$	NYRoRI	VARIVC	
CAOKM	ILOTHS	MOSJMW	$NYSYSU_a$	VARORV	
CAOKO	ILDKNI	MOSLAM	$NYSYS_g$	VASTAW	
CAOOG	ILEVNW	$MOSLWU_l$	NYTRRP	VASWC	
CARDS	ILNDSU	MSUNMF	NYWEUS	VTBUUV	
CARIAC	INBLUS	MSJAAH	OHCFEA	VTWOWH	
CASBUC	ININHE	NCCHUN	OHCLCI	WAFLMM	
CASCSU	$ININMA_{sc}$	NCHPHP	OHCLCM	WALCSC	
CASFSU	INMUBS	NCRASU	OHCOOS	WASESM	
CASJSU	INNDU	NDFASU	OHLIAC	$WASEUW_{sa}$	
CASMPC	INPLMU	$NEOMJA_r$	$OKNOU_s$	WIMASH	
CASTUA	INTHSU	NERCWC	OREUO	WIMAUW	
CAVEEC	KSARCH	NJCATE	OREUOS	WIMIMC	
CAVNHH	$KSLANK_s$	NJCHVM	ORPAM	WIRFUW	
CTFAH-S	KYBCWK	NJCLKC	PABMC	WISPUW	
CTMIWU	KYLOUL	NJKEAN	PACHBR	WVLEFS	
CTNBCC		NJMAFD	PACLSC	WYGRSC	
$CTNHB_u$	LANOLS	NJMOMA	PAEPTU		
CTSTSA	MABOAC	NJNENM	PAGRWC		
CTYUAA	MABOCA	NJNERU	PAHARH		
DCAIA	MABOFA	$NJPRPU_m$	PAHUSM		
DCCFAL	MABOGM	NMALUN	PAPHAT		
DCCFAP	MABOPR	NMSFMN	PAPHFL		
DCGWU	MACAFO	NYALOA	PAPHHS		
DCHIM	$MANHFL_a$	NYALSU	PAPHPA		
DCLCPP	$MANHSC_m$	NYBISU	$PAPHPM_p$		
DCNAR	$MANOSM_l$	NYBRBC	$PAPHUP_f$		
DCNPG	MAPEHS	NYBRBM	RIEPBU		
DCNPGC	MASTKS	NYEMNC	$RIPRRI_l$		
DCNTH	MDBAHS	NYESEH	$RIPRRI_m$		
DCSmHT	MDBAJA	NYETEC	SCCHSC		
DCSMPS	MDBAMI	NYEXEC			

U568. WORLD WAR II: 1940–1945 (WWII)

ALMOC
ALMOS
ARCLA
ARLRA
AZCLA
AZPHP
AZTEU$_{av}$
AZWRN
CABRAR
CABURPL
CACAC
CACLS
CAGLK
CALABK
CALAS
CALASC
CALAUS
CAOKM
CAOKO
CAOOG
CAPEO
CAPNSM
CARIAC
CASBUC
CASCSU
CASCUC
CASFAI
CASFSU
CASJSU
CASMPC
CASTUA
CAVEEC
CAVNHM
CODVMC
CODVMS
CTMIWU
CTNBCC
CTNBMA
CTNHB$_u$
CTSTSA
CTVUAA
DCAIA
DCCFAL
DCCFAP
DCHIM
DCHOWU
DCLCPP
DCNAR
DCNPG
DCNPGC
DCNTHP
DCSmHT

FLGAUF
FLPEWM
FLGAUF
FLPEWM
FLSPMU
FLTAFS
FLWPBN
GAATCHA
GAATIT
HIHOAA
HIHOBM
IADMAC
IDBSHS
ILCHAI$_{sp}$
ILCHRO
ILCHUC
ILCHUI
ILCUI$_{va}$
ILDKNI
ILEVNW
ILNDSU
INBLUS
ININHE
ININMA$_{sc}$
INMUBS
INNDU
INTHSU
KSHASC$_a$
KSLANK$_s$
KYBGWK
KYLOUL
LANOLS
MABOAC
MABOCA
MABOFA
MACAFO
MANHSC$_m$
MANOSM$_l$
MAPEHS
MASTKS
MDBAHS
MDBAJA
MDBAMI
MDBAPM
MDBAUM
MDCPUM
MEBAMM

MEBRBC$_{da}$
MEPOSA
MIAAUM$_{av}$
MIAAUM$_{sp}$
MIALBC
MIDEMC
MIDEME
MIDEWS
MIGPWA
MIKAWM
MNMABE
MNMPIA
MNMPPLA
MNMPPL$_{he}$
MNMPWA$_e$
MOSJMW
MOSLAM
MOSLWU$_l$
MSJAAH
MSUNMF
MTMISF
NCCHUN
NCHPHP
NCRASU
NDFASU
NECRFR
NEOMJA$_r$
NJCATE
NJCHMV
NJCLKC
NJKEAN
NJMAFD
NJMOMA
NJNENM
NJNERU
NJPRPU$_m$
NMALVN
NMSFMN
NYALOA
NYALSU
NYBISU
NYBRBU
NYBRBM
NYEMNC
NYESDU
NYESEH
NYETEC
NYEXCC
NYEXEC
NYGEGH
NYJAYC

NYNYAH
NYNYBA
NYNYBO
NYNYCU$_a$
NYNYHA
NYNYHF
NYNYLU
NYNYMC
NYNYMM
NYNYMU$_a$
NYNYMU$_d$
NYNYPL
NYNYTH
NYNYTI
NYRoIM
NYRoLS
NYRoRI
NYSYSU$_a$
NYSYS$_g$
NYTRRP
NYWEUS
NYWPCH
OHCFEA
OHCLCI
OHCLCM
OHCOOS
OHLIAC
OKNOU$_s$
OREUOS
ORPAM
PABMC
PACHBR
PACLSC
PAEPTU
PAHUSM
PAPHFL
PAPHPC
PAPHPM$_p$
PAPHUP$_f$
PAPICL
PAPIUP$_f$
RIEPBU
RIPRRI$_l$
SCCHSC
SDPISH
TNCHUT
TNMEBM
TNMEMA
TNMESU
TNSEUS

TXAULJ
TXAUUT
TXCCAM
TXFWFW
TXHOMFA
TXHORU
TXHOUH$_a$
TXPHCC
TXSNTC
VAHRMC
VARIVC
VARORV
VASWC
VAWICW$_a$
VTBUUB
WAFLMM
WASESM
WASEUW$_{sa}$
WILCVC
WIMASH
WIMIMC
WIRFUW
WISPUW
WYGRSC
WYLAUW